DATE DUE			
AP 11 '87			
AG 12 '88			
OCT 1 8 1990			
OCT 2 8 1991			
OCT 25 '94			
FEB 11 97			
Feb 25			
NOV 1 1 '99			
APR 1 0 00			
DEC 1 4 2004			
AUG 1 9 2006			

ART AND MANKIND

LAROUSSE ENCYCLOPEDIA OF
BYZANTINE
AND MEDIEVAL ART

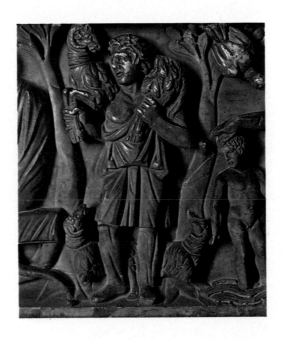

Above. EARLY CHRISTIAN. *The Good Shepherd.*
Detail of a sarcophagus. Marble. c. 270. Sta Maria Antiqua, Rome.
Photo: Vasari.

Frontispiece. BYZANTINE. *Detail of mosaic showing soldiers in the court of Justinian.*
S. Vitale, Ravenna. Photo: Scala.

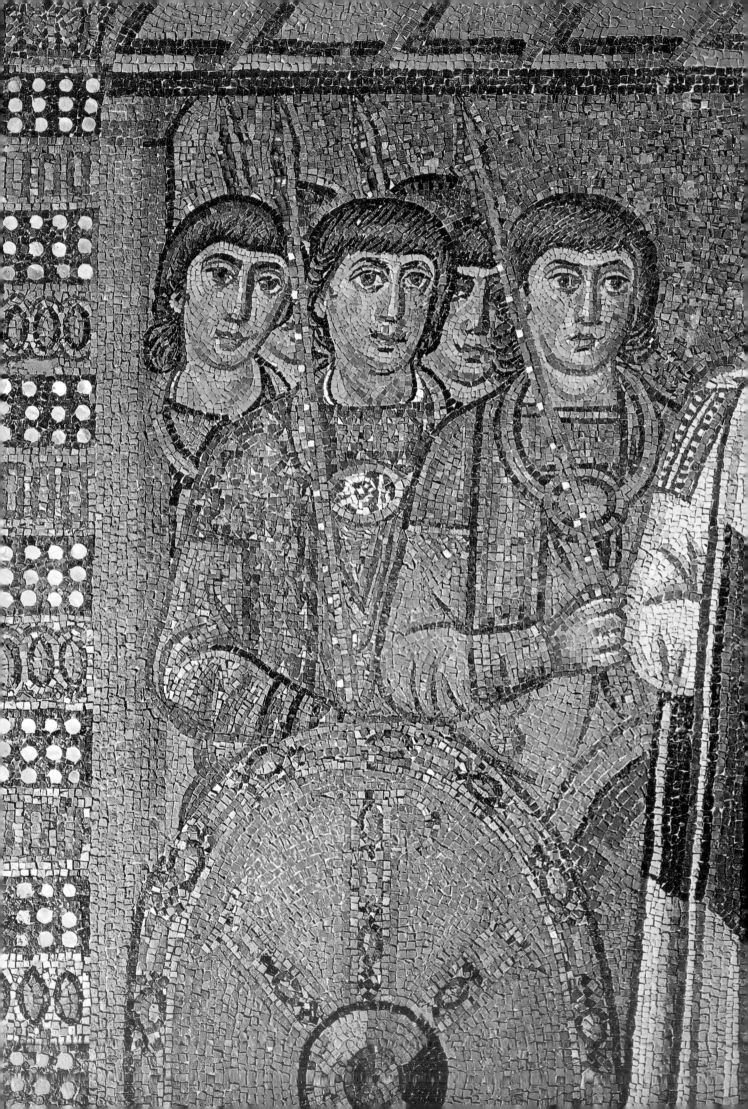

ART AND MANKIND

LAROUSSE ENCYCLOPEDIA OF

BYZANTINE
AND MEDIEVAL ART

General Editor
RENÉ HUYGHE

Member of the Académie Française
Professor in the Collège de France · Honorary Chief Curator of the Louvre

EXCALIBUR BOOKS
NEW YORK

Text prepared by Emily Evershed, Dennis Gilbert, Hugh Newbury,
Ilse Shreier and Wendela Schumann
from the French original
L'ART ET L'HOMME

Copyright © 1958 Augé, Gillon, Hollier-Larousse, Moreau et Cie
(Libraire Larousse, Paris)

English-language edition © 1963 The Hamlyn Publishing Group Limited;
Astronaut House, Hounslow Road, Feltham, Middlesex, England.

Revised edition 1968

First published in USA 1981
by Excalibur Books
Excalibur is a trademark of Simon & Schuster

Distributed by Bookthrift
New York, New York

ISBN 0-89673-080-8
Printed in Singapore

CONTENTS

CONTRIBUTORS

MARCEL AUBERT, *member of the Institut de France, honorary Professor at the Ecole Nationale des Chartes, honorary Chief Curator of the Louvre*

JEANNINE AUBOYER, *Curator of the French national museums (Asiatic art, Musée Guimet)*

MADELEINE PAUL-DAVID, *Deputy Curator at the Musée Cernuschi, Paris*

SIRARPIE DER NERSESSIAN, *D. ès L., Litt. D., L.H.P., Professor of Byzantine Art and Archaeology at Harvard University*

PAUL DESCHAMPS, *member of the Institut de France*

The late CHANOINE ETIENNE DRIOTON, *Professor in the Collège de France, Director General of the Service des Antiquités de l'Egypte, honorary Curator at the Louvre*

ROMAN GHIRSHMAN, *Director of the French Archaeological Missions in Iran*

LOUIS GRODECKI, *Curator at the Musée des Plans-Reliefs*

JEAN HUBERT, *Professor at the Ecole Nationale des Chartes, member of the Commission Supérieure des Monuments Historiques*

OLE KLINDT-JENSEN, *Curator at the National Museum in Copenhagen*

RAYMOND LANTIER, *member of the Institut de France, honorary Chief Curator of the Musée des Antiquités Nationales*

WILHELM STAUDE, *research assistant at the Centre Nationale de la Recherche Scientifique*

HENRI STERN, *Director of Research at the Centre Nationale de la Recherche Scientifique*

PHILIPPE STERN, *Chief Curator of the French national museums (Asiatic art, Musée Guimet), Professor at the Ecole du Louvre*

GASTON WIET, *Professor in the Collège de France, late Director of the Arab Museum in Cairo*

The late Sophie Essad-Arseven, Adeline Hulftegger, Lydie Huyghe, Josèphe Jacquiot and Evelyn King wrote the Historical Summaries

COLOUR PLATES

ACKNOWLEDGEMENTS

The Publishers wish to thank the following for supplying photographs: A. C. L., Brussels 531, 748, 763. Aerofilms, London 670, 989. Alinari, Florence 1, 2, 6, 10, 14, 15, 16, 17, 35, 37, 40, 41, 44, 45, 49, 50, 60, 61, 63, 64, 71, 72, 73, 74, 77, 78, 192, 271, 272, 274, 275, 276, 290, 305, 307, 308, 468, 474, 519, 581, 617, 659, 660, 681, 708, 709, 710, 712, 713, 714, 715, 716, 717, 719, 747, 896, 897, 898, 1025, 1026, 1028, 1029, 1030, 1032, 1034. J. Allan Cash, London 672, 692, 697, 699, 931, 994. Anderson—Giraudon 298. Archaeological Survey of India 342, 349, 352, 355, 356, 365, 369, 370, 371, 372, 775. Archives Photographiques, Paris 86, 123, 125, 129, 137, 159, 160, 177, 190, 221, 228, 259, 260, 261, 262, 264, 265, 306, 471, 489, 502, 503, 505, 506, 514, 517, 518, 569, 570, 631, 727, 742, 759, 761, 770, 836, 837, 838, 840, 848, 849, 925, 926, 945, 946, 969. Archivo Fotografico Vaticano 299. Ashmolean Museum, Oxford 421, 539, 540. A.T.A., Stockholm 178, 201, 204, 206, 209, 210, 211, 212. Barnaby's Picture Library, London 701, 990. Bayerische Staatsbibliothek, Munich 481, 549. Bibliothèque Nationale, Paris 153, 155, 288, 479, 521, 523, 528, 533, 917, 918, 920. Bildarchiv Foto Marburg 76, 278, 282, 499, 500, 501, 522, 534, 537, 542, 550, 552, 559, 601, 615, 618, 624, 636, 654, 655, 664, 675, 676, 677, 679, 689, 694, 700, 721, 722, 736, 791, 799, 805, 810, 867, 880, 889, 894, 912, 914, 915, 916, 932, 981, 1003, 1014, 1015, 1016, 1019, 1036. Bodleian Library, Oxford 480, 995. E. Boudot-Lamotte, Paris 127, 242, 245, 250, 252, 254, 460, 470, 492, 495, 504, 513, 520, 553, 556, 572, 573, 579, 580, 583, 585, 589, 592, 593, 597, 603, 619, 620, 621, 627, 673, 711, 720, 724, 735, 741, 765, 767, 772, 774, 776, 777, 778, 779, 780, 782, 783, 819, 828, 831, 834, 845, 854, 857, 865, 869, 874, 882, 883, 899, 901, 902, 903, 957, 1013, 1037, 1041, 1042, 1044, 1045. British Museum, London 11, 28, 116, 147, 461, 548, 633, 656, 657, 734, 919, 996, 997, 998. Bulloz, Paris 494. Camera Press, London 754, 814, 859, 929, 982, 1004. Church Information Office, London 991. Cleveland Museum of Art, Ohio 220. Danish National Museum, Copenhagen 196, 205, 475. Percival David Foundation, London 419, 420. Department of Archaeology, Mysore 357. Dijon Museum 9, 486. Dublin Museum 32, 140, 145, 148, 746. Dumbarton Oaks Collection 303, 304. Giraudon, Paris 4, 24, 29, 30, 31, 33, 42, 43, 58, 59, 75, 80, 81, 84, 85, 122, 130, 134, 136, 139, 157, 164, 170, 171, 188, 194, 266, 301, 302, 423, 464, 498, 509, 538, 543, 574, 586, 607, 637, 638, 641, 658, 667, 725, 739, 760, 768, 802, 806, 856, 908, 909, 911, 949, 953, 954, 958, 963, 966, 967, 968, 970, 971, 972, 973, 1007, 1011, 1040. Green Studio, Dublin 141, 142, 143. N. Hadjistylianos, Athens 281. Ernst Hahn, Zürich 341. Paul Hamlyn Archive 1005. Hirmer Verlag, Munich 934. Hunting Aerosurveys, London 935. Charles Hurault, Paris 144, 590. Institut Géographique National 338, 942. Luc Ionesco, Paris 331, 332, 334, 335, 339, 347, 363. Prem Chand Jain, Delhi 367. Susil Janah, Calcutta 379. A. F. Kersting, London 52, 53, 173, 256, 545, 546, 582, 651, 671, 674, 702, 705, 706, 707, 718, 862, 863, 887, 888, 890, 891, 892, 976, 977, 979, 980, 983, 984, 985, 987, 988, 1027, 1035, 1043, 1046. Kunsthistorisches Museum, Vienna 119, 737. Landesmuseum, Zürich 13. Larousse,

Paris 3, 5, 8, 12, 18, 19, 23a, 23b, 26, 34, 36, 38, 39, 47, 62, 65, 66, 79, 82, 83, 87, 88, 89, 90, 91, 92, 93, 94, 95, 96, 97, 98, 99, 100, 101, 102, 103, 104, 105, 106, 107, 109, 110, 111, 112, 113, 118, 120, 124, 125, 128, 131, 132, 133, 135, 138, 149, 154, 162, 163, 167, 168, 169, 174, 175, 176, 182, 184, 186, 189, 191, 193, 195, 197, 198, 199, 202, 215, 216, 217, 218, 219, 224, 225, 226, 227, 229, 230, 232, 233, 234, 235, 236, 237, 238, 246, 247, 248, 255, 257, 258, 263, 267, 268, 269, 273, 277, 279, 285, 286, 287, 289, 292, 293, 295, 296, 297, 300, 309, 310, 311, 312, 313, 314, 315, 316, 317, •319, 320, 321, 322, 323, 324, 328, 329, 336, 337, 343, 344, 345, 348, 350, 358, 359, 360, 361, 366, 373, 376, 377, 378, 382, 383, 384, 386, 387, 388, 389, 390, 391, 392, 393, 394, 395, 396, 397, 398, 399, 400, 401, 402, 403, 404, 405, 406, 407, 408, 409, 410, 413, 414, 415, 416, 417, 418, 424, 425, 426, 427, 428, 429, 430, 431, 432, 433, 435, 436, 438, 440, 447, 459, 462, 466, 467, 469, 476, 483, 487, 488, 490, 491, 496, 497, 507, 508, 510, 511, 512, 515, 527, 529, 532, 536, 558, 568, 576, 577, 600, 630, 632, 634, 635, 643, 649, 650, 680, 732, 733, 743, 744, 745, 750, 751, 755, 756, 757, 758, 762, 769, 771, 773, 786, 795, 801, 818, 820, 841, 842, 843, 844, 846, 847, 850, 851, 852, 853, 866, 870, 872, 877, 881, 893, 895, 905, 906, 910, 921, 922, 923, 924, 930, 937, 938, 944, 947, 950, 951, 952, 956, 959, 960, 961, 962, 964, 965, 978, 992, 1006, 1008. Laurenziana Library, Florence 146. London Electrotype Agency 152. Mansell/Alinari, London 20, 46, 48, 57, 231, 678. Mansell Collection, London 165, 860. S. Marti, Gerona 458. MAS, Barcelona 478. Metropolitan Museum of Art, New York 27, 172, 179, 222. Ministry of Public Building and Works, Edinburgh 151. Monitor Press, London 253, 368. H. Morscher, St Gall 150. Musée Cernuschi, Paris 422. Musée Guimet, Paris 330, 385, 437. Musée de l'Homme, Paris 156. Musée de St Germain 158, 181, 183, 185. Museo Arqueológico Nacional, Madrid 472, 616, 687. Museum of Fine Arts, Boston 411, 446. National Buildings Record, London 698. National Museum, Budapest 187. William Rockhill Nelson Gallery of Art, Kansas City 121. Oriental Institute, Chicago 161. Picturepoint, London 703, 704, 804, 974, 986. Paul Popper, London 283, 291, 691, 936, 940, 1022, 1023. Rapho, Paris 793. Radio Times Hulton Picture Library, London 578, 639. Ray-Delvert, Paris 243. Rex, Toulouse 22. Rheinisches Bildarchiv, Cologne 180, 535. Rijksmuseum, Amsterdam 380. Roger-Viollet, Paris 249, 251, 284, 294, 333, 346, 351, 362, 364, 560, 575, 587, 608, 644, 648, 661, 662, 668, 669, 723, 781, 826, 855, 900, 928, 933, 939, 943, 955, 975, 1009, 1012, 1024, 1039. Roloff Beny, Rome 241. Jean Roubier, Paris 456, 457, 473, 477, 482, 484, 493, 516, 554, 557, 561, 562, 563, 564, 565, 566, 567, 571, 584, 588, 591, 593, 594, 595, 596, 598, 599, 602, 604, 605, 606, 609, 610, 611, 612, 613, 614, 622, 623, 625, 626, 628, 629, 640, 642, 645, 646, 647, 652, 653, 663, 665, 666, 690, 693, 695, 696, 726, 728, 729, 730, 731, 749, 752, 753, 766, 784, 787, 788, 789, 790, 792, 796, 797, 798, 800, 803, 807, 808, 809, 811, 812, 815, 816, 817, 821, 822, 823, 825, 827, 829, 830, 832, 833, 835, 839, 858, 861, 864, 868, 871, 873, 876, 878, 879, 884, 885, 886, 904, 907, 913, 927, 948, 1010, 1017, 1018, 1020, 1021, 1031, 1041. Sakamoto, Tokyo 325, 326, 327, 434, 439, 441, 442, 443, 444, 445, 448, 449, 450,

451, 452, 453, 454, 455. W. Scott, Bradford 682, 993. Amal Sengupta, Calcutta 371, 374. Service de Documentation Photographique des Musées Nationaux 108. St Gall Library 530. Staatliche Museen, Berlin 117, 223. Staatsbibliothek, Trier 547. Wim Swaan, New York 240, 375, 381, Turkish Tourist Office 270. Victoria and Albert Museum, London 485, 738, 740, 999, 1000, 1001, 1002. Walters Art Gallery, Baltimore 114, 115. Warburg Institute, London 683, 684, 685, 686. J. W. Whitelaw 544. Universitetets Oldsaksamling, Oslo 200, 203, 208, 213. Yan, Toulouse 214, 456, 551, 688, 1038. York Museum 541.

INTRODUCTION

Our aim in compiling this book has been to achieve a synthesis.
CONCEPTION This synthesis will be carried out in three ways:
1. The many different art forms created in a certain place at a
certain time are simply the adaptation, to specific means of
expression, of the single spirit that gives unity to an age or school.
They are merely the various expressions of one basic constant
that it is essential to uncover. The Gothic cathedral, from its
soaring façade and spires to the glittering silver reliquaries on the
altar, has an undeniable unity not only of style in the forms
employed, but of the underlying motives that inspired them.
2. Art, in its turn, is only one of a number of ways in which man
expresses himself, a reflection of the spirit of the age that
characterises and gives life to everything produced in a certain
period. So we are led to wonder, for example, whether the
movement from Augustinian to Thomist philosophy in the Middle
Ages was not echoed by a similar change in art. Thus we shall have
to relate each philosophy to the art of its time viewed as a whole,
and the art itself to the whole culture of which it is an expression.
3. Every culture, similarly, forms a whole which it is tempting
to consider in isolation. Now, art more than anything else reveals
the strong ties linking mankind: like men, though with more
facility, forms and techniques make their way through the world.
A foreigner may not understand a language, but he can
immediately appreciate an image.
Human beings have always been anxious to preserve and enrich
their own repertoire of forms and images. They also absorb
others, passed on to them by means of the most fragile and
infrequent examples; these they incorporate, transform and adapt
to the needs of their own culture, but they never neglect them or
allow them to be wasted. When a form emerges from the right
conjunction of material and psychological circumstances, it travels
over enormous distances and lives for thousands of years.
Thus, in three separate stages, we shall outline a synthesis of the
techniques of which art is comprised, a synthesis of the art and
the other phenomena which make up cultures, and, lastly, a
synthesis of the cultures which form the history of the world.
PLAN These considerations have determined the plan of this
work: the sections on India, China and Japan are not grouped in
neat sections at the end of the book. Whatever their contribution
to the history of world art, it will be set in its proper place in the
story of human development.
By taking this faceted view, we hope to point a truth—namely,
that art, created by men, belongs to the entire world. For in spite
of the many reasons, both natural and artificial, why men have
divided themselves up into separate groups, in art they proclaim
a magnificent singleness of purpose as they strive towards a goal
which may be unknown but which is the same for them all.
In attempting to look at art from a more universal standpoint, we
have had to modify the usual conventional position. We have grown
used to a self-centred viewpoint that makes the traditions derived
from Greece and Rome the nucleus of art history, but this attitude
is no longer good enough. In the last fifty years, there has been
a growing and universal need for knowledge of things unfamiliar
and outside ourselves in order to reach a better understanding of

ourselves as we find our proper place in the relative scale. Modern man clearly feels that he needs to widen his horizons, and here, too, we hope that this volume will provide some satisfaction. An unusual amount of emphasis has been given to areas that until only recently were unexplored or else were the jealously guarded preserve of a few experts.

These were some of the considerations that were kept in mind during the planning of this work.

METHOD This book is divided into five chapters, each corresponding to an essential stage in the development of art.

1. We thought that first of all it was important to show in a few introductory pages *(Art Forms and Society)* how these stages were related to each other and what place they occupied in the development as a whole. For the rest, I have tried to relate the work of all those who have collaborated in the writing of this book and to forge an essential link between them. I have especially tried to stress the way in which the repertoire of forms and images of which art is comprised has been continually built up and enriched. I have also attempted to show how these forms and images of a period reflect both the social development and the main preoccupations of that period, which are, in another way, explicitly stated in the thought of the time.

2. After this article, which prefaces every chapter, come sections written by the most knowledgeable authorities from all over the world. They have all undertaken a survey of works of art and the available facts in order to present a clear picture of the general forces of inspiration at work and of causes that might offer some explanation. They have been more concerned with understanding than with cataloguing facts. In addition to this, they have tried to supply the most up-to-date information on their particular subjects rather than repeat established facts that are generally known; they have not hesitated to include theories still being tested —theories of the kind referred to by scientists as 'working hypotheses'—at least where they seem to be valuable and productive. There can never be a single static view of history, no matter how much school text books would make it appear otherwise; the picture is a constantly changing one. Here the reader will find history growing and developing and he should not be surprised if by chance two scholars put forward different solutions to a question.

3. But in order that readers should not sometimes be too confused, it was essential to provide a concise account of what might be called the body of facts. Each chapter is therefore followed by a brief memorandum *(Historical Summary)* where events, schools, artists and works of art are listed in normal chronological and geographical order.

But it is hardly necessary to spend so long upon the plans of a building; it has been built by hands far abler than mine, by all those people who have made this book what it is. Before I make way for them I should like to offer my deepest thanks for their valuable cooperation.

RENÉ HUYGHE

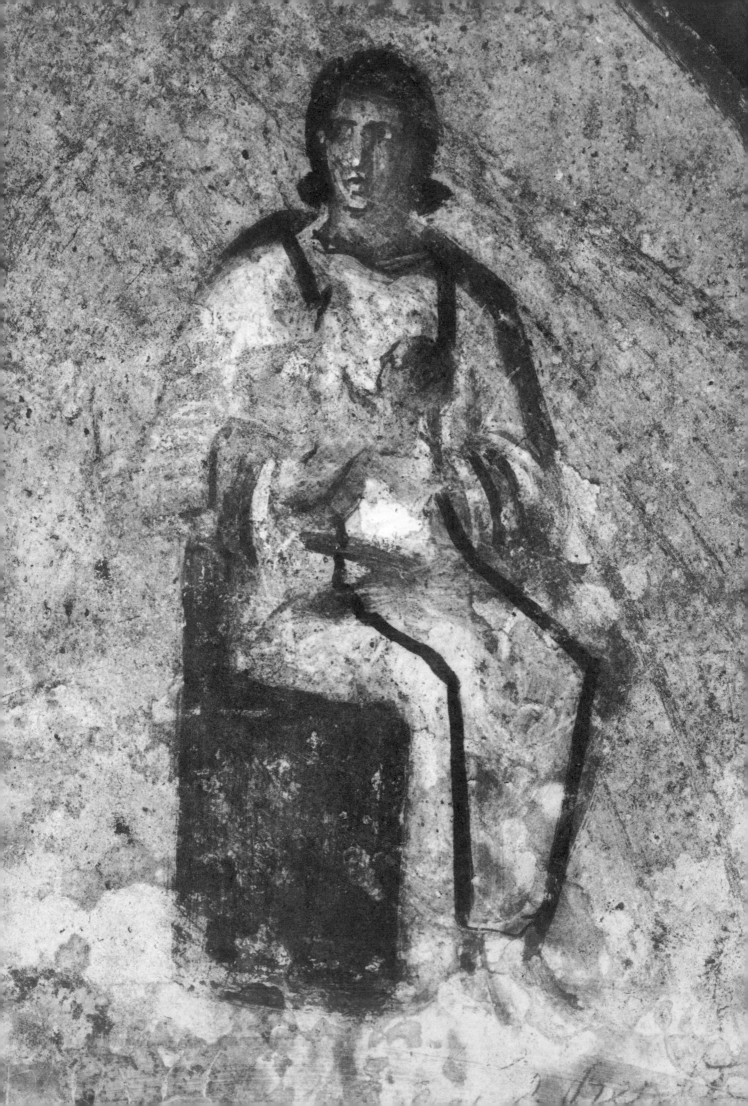

1 THE FIRST CENTURIES OF THE CHRISTIAN ERA

1. *Left*. EARLY CHRISTIAN. Virgin and Child. Fresco in the Priscilla catacomb, Rome. 3rd century A.D.

2. BYZANTINE. Central part of the apse mosaic in S. Apollinare in Classe, Ravenna. 6th century.

ART FORMS AND SOCIETY *René Huyghe*

The advent and spread of Christianity changed the course of history: without it, there would have been no more than a slow deterioration of the Mediterranean ideal manifested by Greece.

Recognised by Galerius as early as 311 (in fact, two years before the Edict of Milan, attributed to Constantine) and, by a decree of Theodosius, imposed as the state religion in 391, Christianity commuted this decomposition, already of long duration, into a forward movement whose development was to fill the centuries to come. A new faith and a new spirit postulate a new art and aestheticism, and it took Christianity just one century, the 4th, to accomplish this, at first hesitatingly in Early Christian art, and then with masterly authority in the art of the Byzantine Empire.

The impact of the Near East on Rome

General opinion, eager to simplify, sees the Imperial power of declining Rome merely transferred to ascendant Byzantium, and Byzantine art succeeding to Roman art. This is grossly to underestimate the influence of the Near East which, from Egypt and Syria to as far as Persia (pp. 47–65), seems to have played as prominent and initiative a role at this time in the intellectual and artistic spheres as it did in religion. It was at Antioch, about the year 40, that the name Christian (*Christianos*) first appeared; and it was at Alexandria and at Ephesus that the first councils were held to lay down the Christian dogma.

Alexandria played a role of considerable importance, not only as an intellectual centre where a new process of thought was forged, uniting the Platonic Hellenic ideas with those of Judaism and later of Christianity, but also as the heart of an artistic province whose influence was predominant. We have already seen what a dissolvent of the solid Roman positivism the art of Alexandria was, with its flights of fancy, which had mastered both Rome's painted representations of architecture and its landscape painting on which great emphasis was laid. It elaborated techniques which were later widely adopted: for example, there were the Fayum portraits (2nd–3rd centuries) which, as has recently been shown, were the prototypes for the Byzantine icons (for example, the 5th-century icon in the Kiev Museum); it propagated full-face representations, which had in fact appeared in Persia close on a thousand years earlier, but in which the now immense and obsessive eyes added a new meaning to the portrayal of the human face by revealing its hidden inner life; from the 4th century the full-face portrait had begun to replace the traditional profile, even on Roman medallions. Mosaics, which were seen to become the essential medium of artistic expression, owed so much to the Alexandrian workshops that men spoke of *Alexandrinum marmorandi genus*. Finally, it was the Alexandrian hinterland that, after the 3rd century, produced Coptic art, one of the first Christian arts to be developed.

Syria, Phoenicia and Palestine also contributed signally not only to the formation of early Christianity and to its tentative theological ideas, but also the transmission of the artistic influence of the more distant East. Palmyra, whose influence continued despite Aurelian's conquest in A.D. 273, and Baalbek received the desert caravans, mes-

sengers from Asia, and the hinterland produced the earliest monuments of the new art: the frescoes dating from the early 3rd century at Doura Europos, on the Euphrates, were examples of the new iconography. Moreover, as Josef Strzygowski pointed out, the arch, the vault and the dome which introduced into Roman art a circular rhythm virtually ignored in the angular architecture of Greece, and which were to figure so prominently in Byzantine architecture, had been raised to their high status in Persia which had inherited them from ancient Assyria. The vault, which had appeared in Chaldea by the second half of the 2nd millennium—for example at Tello—and which had also figured in Egypt, in particular in the Ramesseum at Thebes, subsequently scored a triumph in the Sassanian palace at Ctesiphon in the 6th century A.D., while the palace at Sarvistan, dating from the same period, certainly proves that the dome, which was known to the Assyrians, held no more secrets for the Sassanians, who were merely following in the steps of the Parthians and here imitating the Parthian palace at Firuzabad. It was logical that these forms should have appeared in those countries in which stone and wood, being rare, were supplanted by brick, a material that readily lends itself to curves. Though the square building in the shape of a Greek cross, with a central dome and lateral apses, is no longer believed to have originated in Armenia, on the northern boundary of the Persian world, one of the oldest examples is nevertheless to be found there, in the church at Etchmiadzin. Moreover, the Sassanian royal palace at Bishapur, dating from the end of the 3rd century, was already built on a cruciform plan with dome.

It was in fact to Persia that art turned for inspiration—this antagonist of Greece, by whom she was held in respect and then conquered, again exerted her irresistible influence, which had penetrated even to the far-off Roman world. It was hardly to be expected that neighbouring Byzantium, increasingly impregnated with the customs of the Persian court and inundated with Persian fabrics, would have resisted this influence. While the Western adversary moved his centre eastwards, the onslaught of the Arabs, who had become thoroughly imbued with Persian culture, carried the Persian example to the heart of Europe, and the waves of barbarian invasions introduced into the West many a decorative element that reflected the lasting prestige of Iran. A veritable reversal of the equilibrium was effected, and the West, even after it finally reasserted itself and returned to its ancient traditions with the vigour of the Renaissance, was never the same again. It had been too profoundly affected by a different spirit which it had at first rejected.

Ancient Rome had already unconsciously imbibed this spirit from the moment when, as an Imperial power, she found herself in constant contact with the Near East. Even her institutions reflected this duality: whereas the integrity of the senate was the symbol of the Western ideal, the Emperor tended to counteract it by promoting, to his own advantage, the ancient concept of the god-king, held by the first civilisations of the Near East. Beginning with Aurelian and Diocletian, he advanced irrevocably towards his own deification, which culminated at Byzantium. Modelling himself upon the hallowed and absolute mon-

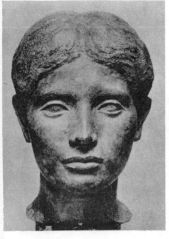
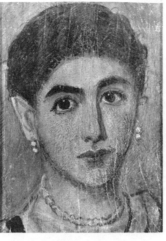

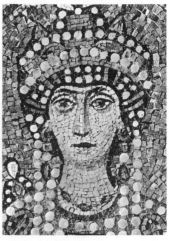

3. ROMAN. Portrait of an unknown woman. 1st century A.D. *Staatliche Museen, Berlin.*

4. *Right.* EGYPTO-ROMAN. Funerary portrait from Fayum. 2nd–3rd centuries. *Louvre.*

5. COPTIC. Icon. 5th century. *Kiev Museum.*

6. *Right.* BYZANTINE. The Empress Theodora with attendants. Detail of mosaic in S. Vitale, Ravenna. 6th century.

NATURALISM AND ABSTRACTION

The Roman bust was merely realistic [3]. Soon, and especially in the Fayum portraits [4], an inner flame illumined the expression; it seemed to consume the outer shell and it gave rise to the icon [5]; finally, the flat, symmetrical, stylised face was no more than a penetrating gaze which laid bare the soul [6]. Abstraction governed realism at random, and finally replaced it. The naturalism of the medallions (taken from an earlier monument) on the Arch of Constantine [7] clashed with the abstract style of the new sculpture. The illusion of depth was eliminated [9] in favour of a balanced arrangement that systematically followed the new concepts [8]. These latter interpreted the theological attitudes of late Byzantine art [173] and were used also in the great compositions of the Renaissance.

9. BYZANTINE. Christ teaching the Apostles. Ivory plaque. 5th century. *Dijon Museum.*

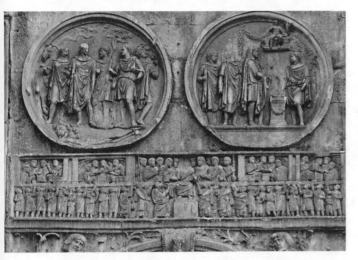

7. ROMAN. Relief carvings on the Arch of Constantine. Early 4th century. The frieze shows one of Constantine's periodic distributions of money. The medallions formed part of the decoration of a monument about two centuries older; one represents the Emperor Hadrian on a lion hunt, the other, a sacrifice to Hercules.

8. BYZANTINE. The Ascension. Miniature from the Gospels of the monk Rabula. A.D. 586. *Laurenziana Library, Florence.*

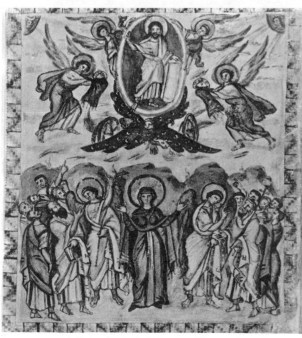

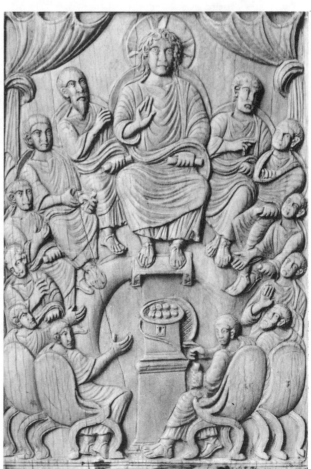

13

archs of the Near East, he isolated himself in his palace like a divinity and fossilised in the ritual of his court; from the time of Diocletian, people prostrated themselves before him as before a god, and kissed the hem of his mantle. At the same time, the senate that had been so judiciously respected by Augustus saw the last vestiges of its authority removed. More or less wittingly, the Emperor became identified with the splendour of the sun, of which, as has recently been shown, Constantine was long a worshipper before he was finally baptised: coins represent him side by side with the sun god, Apollo, who is now known to have been the subject of his first vision. Already Nero had adorned his brow with a rayed diadem, similar to that observed on the Lagidian coins, for instance on those of Ptolemy III, from the 3rd century B.C. This practice can also be traced back to Persia, to the cult of Mithras, *Sol invictus*, which the Roman legions under Pompey had encountered in Cilicia, where it had been introduced by emigrant Magi and which these same legions had propagated throughout the Empire as far as the north of England. For them, the Emperor was consubstantial with Mithras; thus it was but a short step to his future assimilation to the King of Kings, a step which was finally taken in the 7th century, by the Byzantine Emperor Heraclius, who, after defeating his adversary the Great King, assumed the title of Basileus.

It is therefore hardly surprising that Imperial Byzantine art began to imitate the Persian example. Even Christ became Pantocrator, the All-Powerful, just as the Basileus was omnipotent on earth; he was surrounded by a ritual 61 and hierarchic pomp, often reminiscent of the etiquette of the court, which exalted His sovereign majesty. Moreover, the interest in the sensual effects, the richness and the colourful splendour traditional to the Eastern outlook, replaced the more intellectual Graeco-Latin taste for proportion and harmony, satisfactions of the mind. Nothing is more revealing of this contrast than the amazement manifested by Philostratus, an Athenian rhetorician established in Rome, when, in the 2nd century A.D., he followed Julia Domna, Septimius Severus' Syrian wife, on her travels, which took her to Persia, and discovered this entirely different concept of art in the palace of the Parthian ruler Vologaeses. In this palace he saw a '. . . hall covered with a dome, the inside of which was adorned with sapphires sparkling with a celestial blue brilliance, and standing out against the blue background of the stones were golden images of the gods, glittering like stars in the firmament . . .' Is this not already Byzantium?

A new concept of the world

Such a transformation of art could only be the visible sign of an equivalent reversal of thought. It is not generally realised to how great an extent the ideas of the East had penetrated the Graeco-Latin world: from the time of Alexander, the rise of scepticism had indicated a counter-influence from India. With the extension of its commercial activities, the port of Alexandria constituted a permanent link with India, Ceylon and even China. In his celebrated *Life of Apollonius of Tyana*, Philostratus describes the Pythagorean philosopher as going from Ephesus to Babylon and from thence to India, where he came into contact with the Brahmins and studied their dogmas. During the following century—the 3rd—Plotinus (the man whose thought was perhaps to have the greatest influence for some time), in the words of his disciple

Porphyry, sought '. . . to obtain first-hand knowledge of the philosophy practised by the Persians and of that which is accredited by the Indians.' At thirty-nine, he accompanied the Emperor Gordian on his campaign against Shapur I. These men were celebrated intellectuals; we have already noted the extensive penetration of Eastern cults amongst the masses.

Persian thought in particular introduced a new idea into the West, that of dualism, against which Greek thought rebelled, based as it was on the principles of unity and harmony expressed in an art in which the proportions conceived by the spirit in quest of beauty were manifested in the human body; the Latin axiom *mens sana in corpore sano* summed up this conviction in a more positive way. Iranian Mazdaism, on the other hand, divided the universe between two irreconcilable powers, Light and Darkness, Good and Evil, Ahura Mazda and Ahriman. Little, alas, is known of this important philosophy. It is held that, to the cult of Ahura Mazda, spirit and power, which in the Achaemenian religion was the continuation of the prehistoric cult of fire introduced by the Aryans, a spirit of evil was set up as an opposing force. Preached as early as the 7th century B.C. by Zoroaster, this dualism was taught by the Median Magi, recognised as the official clergy in the 3rd century A.D. by the Sassanians, who were anxious to renew the Zoroastrian doctrines as a power with which to oppose the Graeco-Latin penetration. This dualism was further strengthened by the dogmas which were soon to predominate: Mithras, a pre-Zoroastrian deity, was first associated with Ahura Mazda and later more or less identified with the Hellenistic Apollo; Mithras, too, personified the solar fire, destined to conquer darkness and to prepare the way for 'salvation' in a future life; Manichaeism, which was founded only in the 3rd century A.D. by Mani, emphasised the conflict between God and his eternal adversary 'Anti-God', and stressed the doctrine of salvation, which would lead man to a world of light, a doctrine with which the last philosophers of antiquity had been much preoccupied.

Appearing at a time when this ferment of ideas was at its height, Christianity had to combat the all too categorical assertion of this dualism, the more so since Mani quoted Christ's teachings and based his arguments on the Gospels and on the Epistles of Paul. Nevertheless, the conflict between the spirit and the flesh remained fundamental to Christian thought, maintaining there the germ of dualism which was later developed by the great heresies: the Gnostics, in the middle of the 2nd century, emphasised the dual—spiritual and physical—nature of man and regarded the soul as divine in principle, but a prisoner of the evil world of the flesh. Rejected by the West, these heresies inevitably passed on into that East whence they had in fact originated. Nestorianism, which conceived Christ as two indivisible persons, human and divine, and which flourished in the schools of Antioch, Edessa and then Nisibis (the latter two in the heart of Mesopotamia), took refuge in Persia, where it flourished; thence it spread to Turkestan, Ceylon and even China. Monophysitism, which was so radical that it refused to accept the tenet of Christ's twofold nature, recognising only His divine nature, firmly established itself from Syria to Egypt, preferring, in its intransigence, the Arab conquest, and thus preparing the way eventually for the fall of Byzantium.

The concept of the world that developed under these diverse aspects could not but give rise to an art opposed to

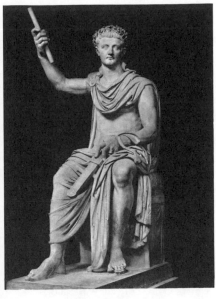

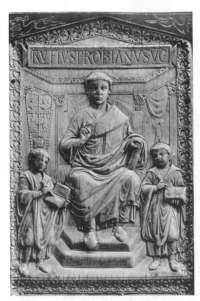

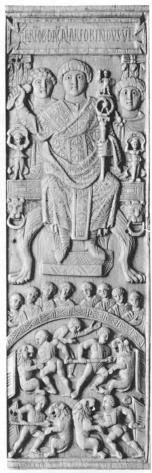

10. ROMAN. Statue of Tiberius. Early 1st century A.D. *Vatican Museum.*

11. Silver statuette. *c.* A.D. 400. *British Museum.*

THE DECLINE OF REALISTIC MODELLING

The breaking up of the Roman Empire and the transfer of its power to Byzantium saw the disintegration of classical art: the life-size statue [10], modelled in the round and reproducing the human body, had been the great achievement of classical art. Art reverted to two-dimensional representation by linear means. Relief carving was soon replaced by an effect of fixed and geometrical contours [12, 13] . . .

12. Detail of the diptych of Rufius Probianus. *c.* 400. *Berlin Library.*

13. Leaf from the diptych of Areobindus, consul in 506. *Musée National Suisse, Zürich.*

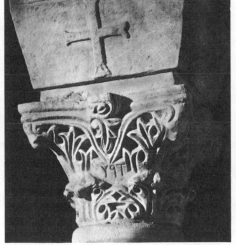

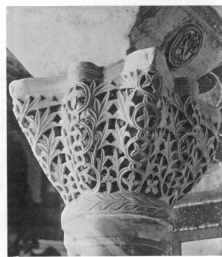

14. 4th-century capital. Now in the Baptistery of the Orthodox, Ravenna.

17. Early 4th-century capital. Now in the church of S. Miniato, Florence.

15. BYZANTINE. Capital in S. Apollinare Nuovo, Ravenna. Early 6th century.

16. BYZANTINE. Capital in S. Vitale, Ravenna.

18. *Right.* Detail of the decoration on the façade of the palace at Mshatta. Attributed to the 7th or first half of the 8th centuries. *Kaiser Friedrich Museum, Berlin.*

. . . Likewise, the fleshy naturalism of the Corinthian capital [14] was flattened into a dry, schematic simplification [17], which now became its definitive form [15]. Sculpture reverted to rigid conventions, and undercutting replaced the supple modelling of the chisel with the carving of abstract forms [16], thus preparing the way [18] for the decorative style of Islam.

that which had reigned in the classical Mediterranean world: nature, which the Greeks had considered necessary as an element from which the spirit could obtain form, the basis of all beauty, was in disgrace. It was felt that the earthly, physical world, regarded as the seat of evil, should no longer subsist except to testify and to give visible presence to spiritual realities. The body was compromised, whereas the soul was the instrument of salvation; the earth was matter, whereas heaven was light. The overwhelming development of monasticism, which started in Egypt and Syria during the 4th century, and which had been heralded by the Thalians and by the Hellenistic sects as well as by the monasteries of the Essenes—the Jewish community that has returned to the limelight with the discovery of the Dead Sea Scrolls—was a sign of this abandonment of the world. As already attested by Pliny the Elder, these people were 'weary of life' and aspired, according to Philo, to relieve their souls 'of the burden of sensations and the sensual world'. A current of such force could not but become manifest in art.

119 The first signs of it were already apparent in the iconography of Imperial Rome, which showed the Emperor removed from the human world and carried in apotheosis towards the celestial world, which had ceased to be merely the enhanced reflection of our own world as it had been portrayed by ancient mythology. This theme was 8 already the nucleus of the 'Transfigurations' and 'Ascen-76 sions', which were to assume such a prominent place in Christian iconography, and which Islam also adopted for the representation of Mohammed's journey up to the seventh heaven.

The practical consequences of this trend can readily be deduced: formal beauty and even its first condition, volume, receptacle of matter, were henceforth despised. 10–18 Figures tended to be flat and discarnate, and not in relief; in sculpture, the stone was undercut to produce shadows that created a play of light; and in painting, or in its substitute, mosaics, the drawing was abstract and schematic, and functioned wholly in the service of colour, its brilliance and its reflection, and was even totally eclipsed by the sheer sparkle of gold. Carried to its extreme consequences, this tendency gave rise to an art in which there was no longer any place for physical reality, an art which had ceased to represent anything at all and which was no more than a decorative combination of line and colour: such was the art of Islam, of iconoclastic Byzantium, or of the Irish monks. Whereas Christian art as a whole shunned this excess, it was nevertheless profoundly marked by the tendency which led to it.

Early Christian art; the disdain for plastic form

Defining this 'crucial moment in the history of ideas' which culminated in Christianity, Emile Bréhier, in his study on Philo, wrote: 'An interior world was created, which conflicted with the sensual world of sensations as the spirit conflicts with the flesh.' The earliest Christian art showed so great a disdain for the exterior world and so unique a preoccupation with the interior world that it reduced its characteristic forms to mere allusive signs. On the other hand, it sometimes adopted in full the forms current in pagan art, but endowed them with a new meaning: the Hermes Kriophoros of Greek art, known from the archaic period and already foreshadowed in 34 Cretan art, became the Good Shepherd (John, X: 'I am come that they might have life, and that they might have

it more abundantly. I am the good shepherd . . . I lay down my life for the sheep . . .'). The vine scroll, of im- 19–23 memorial decorative usage, was transmuted into an allusion to Christ (John, XV: 'I am the true vine, and my Father is the husbandman. I am the vine, ye are the branches . . .'). Or again, the image, in the total neutrality of its aspect, had no other purpose than to evoke a word, and was reduced to a summary diagram: such was the fish, whose form served merely as a reminder of its Greek name, *Ichthus* (**IXΘΥΣ**), which, in turn, was an acrostic on the name of Christ: *Iesos Christos Theou Uios Soter* (Jesus Christ, Son of God, Saviour). Can this be called art? It was no more than a clandestine and conventional language which, moreover, is explainable in view of the persecutions, the secrecy of the catacombs and the need to camouflage all signs of recognition.

However, by the 4th century the church was recognised, came out into the open and felt the need for an art commensurate with its extent. To its preoccupation with spiritual truths was added the problem of its establishment in society, in which it was to play an increasingly official role. To begin with, it merely adopted and adapted already existing forms.

The extent to which the first religious buildings were indebted to the civil constructions that preceded them has been abundantly demonstrated; likewise, the first Christian sarcophagi were such servile copies of ancient sculpture as to be distinguishable only by their symbolism. However, even this is sometimes equivocal; for example, no one has been able to decide whether the 4th-century sarcophagus from Ampurias, Spain, in the museum at Gerona, with its allegories of the four seasons, its putti, its vintage scenes, etc., is Christian or pagan.

This initial indifference precipitated the artistic decline already perceptible in the art of the Empire: the expansion of Imperial Rome had obliged her to resort to a simplified artistic language, intelligible to all her peoples, which meant that the Greek standard of quality had to be abandoned in favour of conventions that would be understood by people little touched by culture. Christianity, which was directed above all to the humble, was under an all the more imperious obligation to fulfil the expectations of this public which, it must be remembered, was mainly Near Eastern. The territories that are today Islamic, Egypt, North Africa, etc., originally numbered the largest Christian majorities. Thus, the pagan artistic language was not only endowed with a significance profoundly alien to its past, but was given a popular Eastern script which set art back into an earlier stage and served the conceptual realism peculiar to children and primitive peoples whose natural mental habits had not yet learned to cope with the effort of observation. Moreover, the importance assumed by the populations of Mesopotamia and Egypt in the Empire led to a nostalgia for the old artistic traditions that had prevailed before the intervention of Greece: once again, figures were governed by the law of frontality, and conformed more explicitly to the 10–13 theoretical idea they represented; they were portrayed with a few simplified lines that could easily be copied; their proportions bore no resemblance to reality, but corresponded to the importance it was intended they should assume. In order to preserve this demonstrative

BYZANTINE. Detail of mosaic, showing the port of Classis. 5th century. S. Apollinare Nuovo, Ravenna. *Photo: Scala.*

16

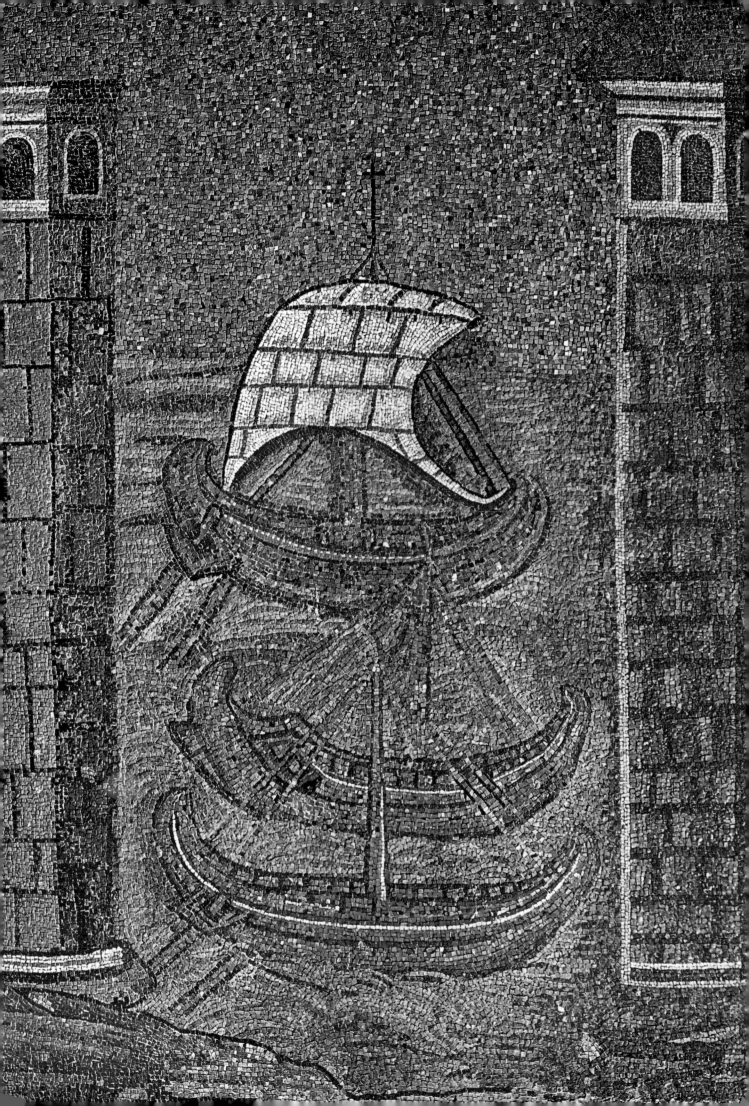

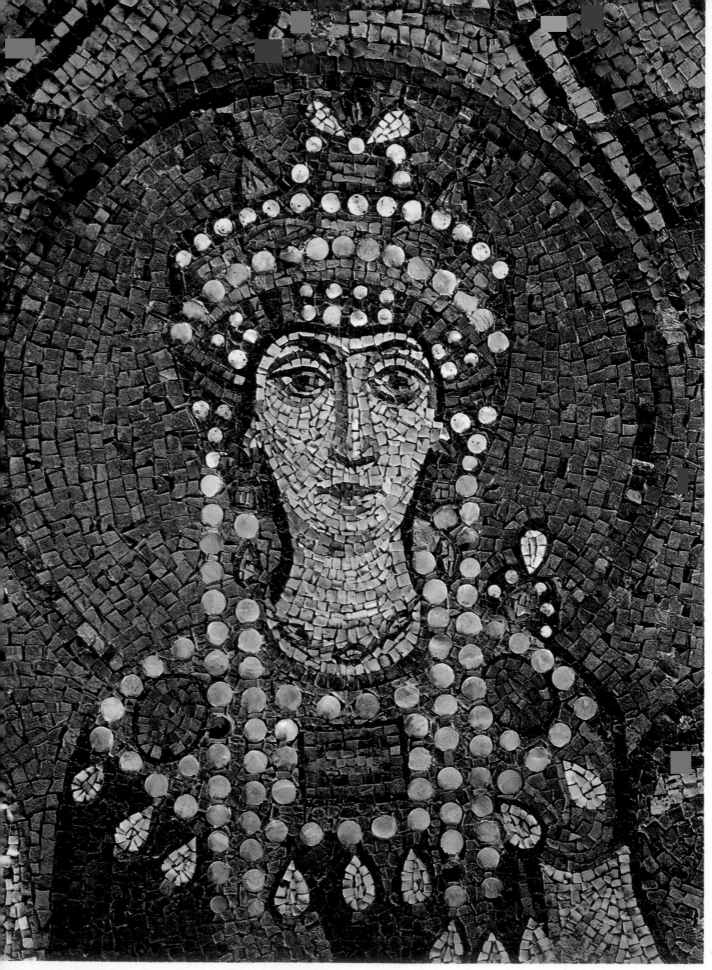

BYZANTINE. The Empress Theodora. *c.* 547. Detail from
mosaic in the apse of S. Vitale, Ravenna. *Photo: Scala.*

19. GREEK. The cult of Dionysus. Decoration on an Apulian vase. *(After Gerhard.)*

20. ROMAN. Fragment of a decorative frieze on the Ara Pacis, Rome. 9 B.C.

EVOLUTION OF THE SCROLL

Christianity was to ensure the continuity of this decorative theme by adding to it the allegorical significance inherent in the vine. In Greek art the scroll, inspired by the undulating movement of vine foliage, had already assumed the geometrical form which, with its flowing line, its rhythm and its flexibility, was eminently suited to the decoration of a large surface [19]. Rome inherited this motif [20] and transmitted it to Byzantine art; then it acquired its Christian symbolism—associated, for instance in S. Clemente in Rome, with the ancient symbol of the Tree of Life, which became the Cross [21]. From then on it continued to flourish, throughout both the Romanesque [22] and Gothic [23] Middle Ages and later.

21. BYZANTINE. Central part of the apse mosaic in S. Clemente, Rome. *c.* 12th century.

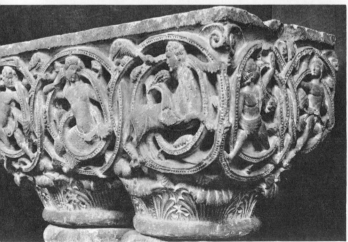

22. ROMANESQUE. Capital on twin columns. *c.* middle of the 12th century. *Musée des Augustins, Toulouse.*

23. GOTHIC. Details from the portal of St John in Rouen cathedral. Beginning of the 13th century. Note the difference in the treatment of the scrollwork, more realistic on the left, more stylised on the right.

appearance, perspective, which would have modified or concealed it, was eliminated in favour of a symmetrical disposition and an identical repetition which complied with the law of mental unity which, as we have stressed, had persisted from the beginning of prehistoric art.

This would eventually have led to an art representing no more than a rather sterile return to the past, had not the development of Christian thought made it the instrument of a new aesthetic concept. As from the 4th century, two divergent tendencies appeared in the Church: the one, determination to continue to have nothing to do with classical tradition and 'to preserve its own purity in this world'; the other, a tendency voiced by Clement of Alexandria and his pupil Origen from the beginning of the 3rd century, to profit from vanquished paganism's great culture and, in so doing, to succeed to it. This latter tendency was inevitably to prevail, since it followed the trend of history. 'From the intermingling of peoples,' observed Prudentius, 'a single race is born . . . The *Pax Romana* prepared the way for the coming of Christ.'

In place of the Imperial unity, Christianity introduced a spiritual unity. It began by playing the part of the inheritor. Moreover, once it was officially recognised, it was no longer associated above all with the popular masses, but was also associated with the ruling classes and was therefore led to satisfy to a greater extent than heretofore the needs of a cultivated aristocracy. Henceforth, instead of abominating and rejecting, it had to Christianise ancient thought.

A new aesthetic doctrine: neo-Platonism

It was in fact during the 3rd century, and in the Alexandrian crucible, that ancient thought came to achieve the syncretism already foreseen at the time of Christ by Philo the Jew, in which the anti-positivist tendencies of the most diverse origins converged. First, there were those of the ancient Egyptian religion, perpetuated in the 'hermetic' books: an inscription of the 8th century B.C., at the root of this tradition, described the Word (Ptah) as organising the world and then returning to the supreme god to whom it became assimilated; there was that of the Jews towards an allegorical interpretation of the Bible, in which material realities became symbols of ideas, and there were the last embodiments of ancient philosophy, neo-Pythagorean, neo-Stoic and, above all, neo-Platonic. There was, finally, a rising tide of Christianity, since Philo, in the eyes of Eusebius, passed for a Christian. Out of all this there developed neo-Platonism, which reached such heights with Plotinus during the 3rd century.

The world of the senses was considered to be merely an illusion, a nothingness (the 'non-being', as Plato termed it in that part of his philosophy most closely related to the ideas of the East). In this world, the soul inevitably became defiled and had therefore to escape from the physical body, 'to traverse the waves of the sensual world' and aspire towards God transcendent. Through Plotinus, born at Alexandria, neo-Platonism profoundly influenced Christianity; it is interesting to note that St Augustine, at the time of his conversion, was studying the works of Plotinus, which left a deep impression on him. During the 5th century the fusion was definitively accomplished, thanks to Dionysius the Areopagite who, during the Middle Ages, was taken to be the companion of St Paul and, as such, was accorded immense prestige, though in fact he was merely a writer of the 5th century who was much influenced by Plotinus' disciple, Proclus.

Applied to art, the ideas of Plotinus, who taught in Rome, engendered a new aestheticism, which—as André Grabar has pointed out—explains that of Byzantium. Matter is darkness, the νους (*nous*, spirit) light, and man should rise out of the one towards the other. Likewise in art, concrete and visible nature should only figure in so far as it leads to the spiritual. Hence the scorn of realistic observation, the elimination of positive details and the adoption of a completely abstract disposition. However, while nature thus figures only in order that form may be expressed, form in its turn should serve only to reveal the power operating through it, and it, too, should be transcended. The principal role thus passed from form to 'light and to colours which are a sort of light', and the brilliance of the latter represented the approach of the invisible soul. The 'eyes of the body', which are the first to operate, have only to be closed for 'the eyes of the soul to open' and activate 'that internal gaze', alone capable of seeing that which cannot be materially portrayed, 'the invisible image . . . the non-form'; to achieve this, one should 'withdraw into oneself . . . away from the things of this world.' Only when roused by the spectacle that serves as the starting point and leads the way does one arrive at 'that sort of ineffable contact or touch' with that which can be neither represented nor explained; the culmination of this will be 'ecstasy'. Such is the thesis set forth in the *Enneads*.

It was far more than the art of triumphant Christianity and of Byzantium which was established in the new doctrine, the seemingly popular retrogression of style in art being merely a discipline, a necessary asceticism; it was an essential and as yet not fully understood potentiality in art, which, from that time, has continually been exploited. In effect, art was no longer regarded as a means of reproducing or representing for the sake of magic, religious or official ends; it was no longer, as it had been for the Greeks, a means of improving upon and bringing harmony to the haphazard appearance of the world in order to extract its beauty. 'The pictorial representation of things' became a means to rouse sensitivity and to create new states of internal life, of which Plotinus affirmed that 'external impressions are needed to stimulate it.' However, far from being a slave to this message of the senses, it was sufficient, in the words of Pseudo-Dionysius the Areopagite, that art should be able 'totally to transcend the sensual and intelligible . . . to disregard the senses and intellectual activity'; in other words, art was required not only to satisfy the intelligence or the taste, but, as an object of contemplation, to move the soul. With the Greeks, art never left the lucid sphere of the senses and reason; it now discovered the zone which eluded both the eye and the mind, defied both visual description and logical explanation—the zone inhabited by what we today call the subconscious, in which Plotinus placed 'enthusiasm . . . delight . . . freedom of self'. This was no less than the course that was to be pursued, at a very much later date, by El Greco and Rembrandt and, in the 19th century, Delacroix and Baudelaire.

The fact that analogous ideas are encountered sixteen centuries later enables us to evaluate, beyond the characteristics of the period, the new possibilities thus opened up. Delacroix, in 1853, evoked 'the curious mystery . . .

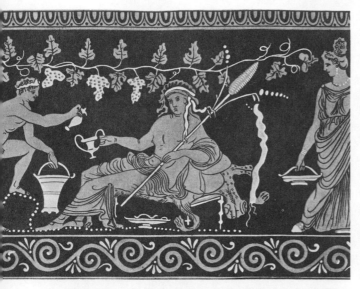

19. GREEK. The cult of Dionysus. Decoration on an Apulian vase. *(After Gerhard.)*

20. ROMAN. Fragment of a decorative frieze on the Ara Pacis, Rome. 9 B.C.

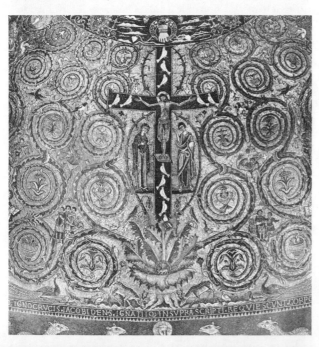

EVOLUTION OF THE SCROLL

Christianity was to ensure the continuity of this decorative theme by adding to it the allegorical significance inherent in the vine. In Greek art the scroll, inspired by the undulating movement of vine foliage, had already assumed the geometrical form which, with its flowing line, its rhythm and its flexibility, was eminently suited to the decoration of a large surface [19]. Rome inherited this motif [20] and transmitted it to Byzantine art; then it acquired its Christian symbolism—associated, for instance in S. Clemente in Rome, with the ancient symbol of the Tree of Life, which became the Cross [21]. From then on it continued to flourish, throughout both the Romanesque [22] and Gothic [23] Middle Ages and later.

21. BYZANTINE. Central part of the apse mosaic in S. Clemente, Rome. *c.* 12th century.

22. ROMANESQUE. Capital on twin columns. *c.* middle of the 12th century. *Musée des Augustins, Toulouse.*

23. GOTHIC. Details from the portal of St John in Rouen cathedral. Beginning of the 13th century. Note the difference in the treatment of the scrollwork, more realistic on the left, more stylised on the right.

appearance, perspective, which would have modified or concealed it, was eliminated in favour of a symmetrical disposition and an identical repetition which complied with the law of mental unity which, as we have stressed, had persisted from the beginning of prehistoric art.

This would eventually have led to an art representing no more than a rather sterile return to the past, had not the development of Christian thought made it the instrument of a new aesthetic concept. As from the 4th century, two divergent tendencies appeared in the Church: the one, determination to continue to have nothing to do with classical tradition and 'to preserve its own purity in this world'; the other, a tendency voiced by Clement of Alexandria and his pupil Origen from the beginning of the 3rd century, to profit from vanquished paganism's great culture and, in so doing, to succeed to it. This latter tendency was inevitably to prevail, since it followed the trend of history. 'From the intermingling of peoples,' observed Prudentius, 'a single race is born . . . The *Pax Romana* prepared the way for the coming of Christ.'

In place of the Imperial unity, Christianity introduced a spiritual unity. It began by playing the part of the inheritor. Moreover, once it was officially recognised, it was no longer associated above all with the popular masses, but was also associated with the ruling classes and was therefore led to satisfy to a greater extent than heretofore the needs of a cultivated aristocracy. Henceforth, instead of abominating and rejecting, it had to Christianise ancient thought.

A new aesthetic doctrine: neo-Platonism

It was in fact during the 3rd century, and in the Alexandrian crucible, that ancient thought came to achieve the syncretism already foreseen at the time of Christ by Philo the Jew, in which the anti-positivist tendencies of the most diverse origins converged. First, there were those of the ancient Egyptian religion, perpetuated in the 'hermetic' books: an inscription of the 8th century B.C., at the root of this tradition, described the Word (Ptah) as organising the world and then returning to the supreme god to whom it became assimilated; there was that of the Jews towards an allegorical interpretation of the Bible, in which material realities became symbols of ideas, and there were the last embodiments of ancient philosophy, neo-Pythagorean, neo-Stoic and, above all, neo-Platonic. There was, finally, a rising tide of Christianity, since Philo, in the eyes of Eusebius, passed for a Christian. Out of all this there developed neo-Platonism, which reached such heights with Plotinus during the 3rd century.

The world of the senses was considered to be merely an illusion, a nothingness (the 'non-being', as Plato termed it in that part of his philosophy most closely related to the ideas of the East). In this world, the soul inevitably became defiled and had therefore to escape from the physical body, 'to traverse the waves of the sensual world' and aspire towards God transcendent. Through Plotinus, born at Alexandria, neo-Platonism profoundly influenced Christianity; it is interesting to note that St Augustine, at the time of his conversion, was studying the works of Plotinus, which left a deep impression on him. During the 5th century the fusion was definitively accomplished, thanks to Dionysius the Areopagite who, during the Middle Ages, was taken to be the companion of St Paul and, as such, was accorded immense prestige, though in fact he was merely a writer of the 5th century who was much influenced by Plotinus' disciple, Proclus.

Applied to art, the ideas of Plotinus, who taught in Rome, engendered a new aestheticism, which—as André Grabar has pointed out—explains that of Byzantium. Matter is darkness, the νους (*nous*, spirit) light, and man should rise out of the one towards the other. Likewise in art, concrete and visible nature should only figure in so far as it leads to the spiritual. Hence the scorn of realistic observation, the elimination of positive details and the adoption of a completely abstract disposition. However, while nature thus figures only in order that form may be expressed, form in its turn should serve only to reveal the power operating through it, and it, too, should be transcended. The principal role thus passed from form to 'light and to colours which are a sort of light', and the brilliance of the latter represented the approach of the invisible soul. The 'eyes of the body', which are the first to operate, have only to be closed for 'the eyes of the soul to open' and activate 'that internal gaze', alone capable of seeing that which cannot be materially portrayed, 'the invisible image . . . the non-form'; to achieve this, one should 'withdraw into oneself . . . away from the things of this world.' Only when roused by the spectacle that serves as the starting point and leads the way does one arrive at 'that sort of ineffable contact or touch' with that which can be neither represented nor explained; the culmination of this will be 'ecstasy'. Such is the thesis set forth in the *Enneads*.

It was far more than the art of triumphant Christianity and of Byzantium which was established in the new doctrine, the seemingly popular retrogression of style in art being merely a discipline, a necessary asceticism; it was an essential and as yet not fully understood potentiality in art, which, from that time, has continually been exploited. In effect, art was no longer regarded as a means of reproducing or representing for the sake of magic, religious or official ends; it was no longer, as it had been for the Greeks, a means of improving upon and bringing harmony to the haphazard appearance of the world in order to extract its beauty. 'The pictorial representation of things' became a means to rouse sensitivity and to create new states of internal life, of which Plotinus affirmed that 'external impressions are needed to stimulate it.' However, far from being a slave to this message of the senses, it was sufficient, in the words of Pseudo-Dionysius the Areopagite, that art should be able 'totally to transcend the sensual and intelligible . . . to disregard the senses and intellectual activity'; in other words, art was required not only to satisfy the intelligence or the taste, but, as an object of contemplation, to move the soul. With the Greeks, art never left the lucid sphere of the senses and reason; it now discovered the zone which eluded both the eye and the mind, defied both visual description and logical explanation—the zone inhabited by what we today call the subconscious, in which Plotinus placed 'enthusiasm . . . delight . . . freedom of self'. This was no less than the course that was to be pursued, at a very much later date, by El Greco and Rembrandt and, in the 19th century, Delacroix and Baudelaire.

The fact that analogous ideas are encountered sixteen centuries later enables us to evaluate, beyond the characteristics of the period, the new possibilities thus opened up. Delacroix, in 1853, evoked 'the curious mystery . . .

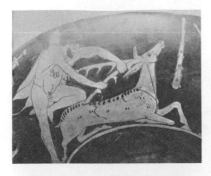

24. *Above left*. GREEK. Hercules and the hind. Detail from a bowl. 5th century B.C. *Louvre*.

25. *Below left*. Hercules and the deer. Marble relief. 4th century A.D. *Ravenna Museum*.

26. GALLO-ROMAN. Hercules and the Nemean lion. Silver dish. *Cabinet des Médailles, Bibliothèque Nationale, Paris*.

27. BYZANTINE. David and the lion. Silver dish. *c*. 6th century A.D. *Metropolitan Museum of Art*.

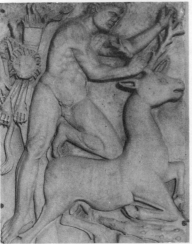

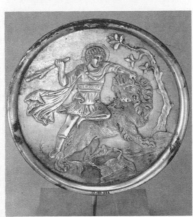

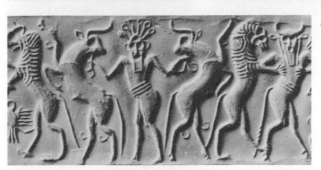

THE COMPLEX HERITAGE OF BYZANTIUM

The traditions of earlier arts reached Byzantium, and were progressively assimilated by Christian art. The ancient examples influenced the modelling [24, 25, 27], as well as the subject matter [24, 25] which entered religious iconography [26, 27]. Moreover, the legacy of the ancient East was revived. Persian influence, transmitted largely through textiles, ensured the continuity not only of Eastern art (and its fantastic beasts [29, 30]) but also of the early Mesopotamian civilisations: the hero between symmetrical wild beasts, a subject portrayed from the 3rd millennium [28, 31], was seen once again.

28. *Above*. SUMERIAN. Hero fighting animals. Cylinder seal. *c*. 2750 B.C. *British Museum*.

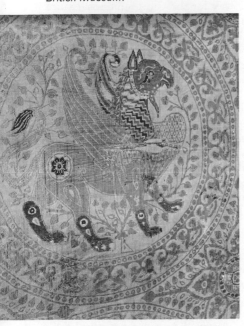

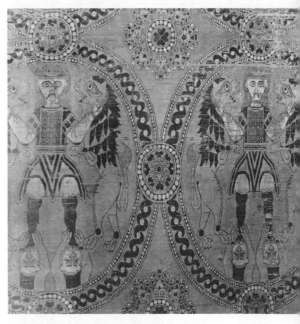

29. BYZANTINE. Detail from the shroud of St Siviard. Silk fabric. 8th century. *Sens Cathedral*.

30. SASSANIAN. Brooch having cloisonné ornamentation. *Cabinet des Médailles, Bibliothèque Nationale, Paris*.

31. BYZANTINE. Detail from the shroud of St Victor (Daniel in the Lions' Den?). Silk fabric. 8th century. *Sens Cathedral*.

of these impressions art produced on the sensual organism: confusing if described, forceful and clear when felt.' Elsewhere he adds: 'This emotion penetrates the most intimate recesses of the soul. It stirs up feelings which words can but vaguely express'; 'moves'. Now, this was the very term Plotinus was thinking of when he spoke of 'a sort of ineffable and non-intelligent contact or touch . . . To feel is not to think.'

The art that neither represents nor reasons, the art that moves, that touches, awakens the soul to new emotions and revelations, unknown and 'magic' (to quote Delacroix again) is surely Byzantine art, imperfectly consolidated and understood as it was then, which perhaps also contained that which would be best in the art of modern times. An immense step was taken towards the awareness of art, its role and its potentialities.

The persistence of tradition in Rome

By giving an entirely new understanding to the world, Christianity had gained an equally new concept of art. Though this was not born of Christianity, the latter alone was able to endow it with a fervour that justified its existence for centuries. However, this concept was not expressed in the same way throughout the Christian world. The vast area covered by the new religion included widely divergent territories, whose implanted heritage of ideas and forms lent itself to a greater or lesser degree to the new aestheticism.

Byzantium and its official art showed a subtle blending of the multiple tendencies of the Empire, in which East and West, administrative requirements and theological doctrines, converged. Hellenic culture, resolutely perpetuated in the capital, was perhaps the major contributor towards the rationally drawn-up intellectual programme, which, in the theme and distribution of its images, revealed a logically unfolded idea. However, the mystic element of the East remained sufficiently alive to prevent this art from becoming merely a dry, intellectual process and to maintain that magic in the material means, which pervades the nerves and the spirit and creates a sort of hypnosis of beauty.

Rome, on the other hand, remained stubbornly averse to the abandonment of the solid positivism of the classical tradition. From the time she recovered from her collapse before the barbarian invasions, and as soon as, deprived of temporal power, she was able to rally her forces around the Pope, whose position, keenly contested by the patriarchs of the East, was strengthened through his inflexible obstinacy, she opposed the new sensibility with the whole force of her traditional aim: a realism embellished by a combination of visual observation with intellectual elaboration. With her obstinate perseverance in her chosen course, it took her a thousand years finally to reassert herself with the Renaissance, while Byzantium, her once triumphant rival, slowly declined and eventually fell before the onslaught of the Turks.

In fact, a close examination of the situation reveals that Rome and her concept of art never capitulated. A hostile lack of comprehension had undermined her traditions, which early Christianity had adopted for lack of better, and they had certainly suffered from the increasing deterioration of technique and the return to popular forms of expression. We have seen how much this evolution owed to the influence of the Eastern peoples in the Empire and that it was merely precipitated by

Christianity. A mosaic from a Roman villa in Africa, now at the Bardo in Tunis, is already hardly distinguishable from those generally attributed to Byzantine art.

However, what Rome desperately sought to maintain, not only in its first great mosaics but also in the tradition of its sarcophagi, imitated as far away as Provence, was a sculptural sense, the representation or suggestion of form in the round that was so foreign to 'dematerialised' Eastern aestheticism. The 4th-century statue of Constantine in S. Giovanni in Laterano could be placed in the line of statues of the Emperors, just as the decoration in the mausoleum of his daughter Constantia perpetuated the tradition of pagan decoration. The togaed silhouettes of the Apostles in the Arian Baptistery at Ravenna (early 6th century) are Roman not only in their costumes and their modelling, but also in the realistic shadows they cast on the ground; the rigidity that was pervading art had merely stiffened them. The figure of Christ in Sta Pudenziana in Rome (end of the 4th century) recalls, with its still almost wholly realistic modelling, the statue of Nerva, while that in SS Cosma e Damiano (6th century) resembles the consular statues. 50 48 40

Ravenna at this time was strongly influenced by the personality of Justinian: there is no denying the speed of the increasing penetration of the new art which, with its emphasis on colour rather than plasticity, had already triumphed a century earlier in the decoration of the mausoleum of Galla Placidia, Theodosius' daughter. Justinian, however, was obsessed with a desire to resuscitate the Roman Empire; he spoke Latin instead of Greek and used Latin for his profoundly Roman codes, yet the pomp of his court represented a growing Easternisation inaugurated long before him by his Roman predecessors. The same dualism is manifest in the art he patronised: despite the ecstatic fascination of their gaze, the full-length figures in S. Vitale maintain the intense psychological presence of the Roman portraits. 61–63 73 6 63

The sculptural quality of Roman art, only in abeyance in the series of large mosaics culminating in those of Cavallini, paved the way for the Giottesque renaissance.

Rome's feeling for realistic sculpture, irreconcilable with the Byzantine lack of interest in material reality, was not only maintained in the territory subject to her jurisdiction; to the Byzantine centuries to come, she bequeathed her narrative sense which, diametrically opposed to neo-Platonic tendencies, took root wherever Rome's teaching had survived, that is, in the communities centred around the schools of rhetoric. The prestige of Cicero and Quintilian remained unrivalled in these schools, which also preserved their concept of art as a language designed to tell the eye with an image what a text tells the mind with words. It was a concept that corresponded to Horace's formula: *ut pictura poesis*, which was handed on to the Middle Ages by Isidore of Seville and Rabanus Maurus. The Ciceronian formula is very similar: *poema loquens pictura, pictura tacitum poema* (poetry is a spoken painting, painting is a silent poem).

Thus, from the 4th century, the Cappadocian fathers, who were past masters of sacred eloquence and were imbued with Quintilian's ideas, issued a series of positive statements assigning to Christian painting the role of a book of illustrations designed to tell the faithful what words could also tell. St Basil, who was bishop of Caesarea and had been a pupil of the rhetorician Labianus, declared that: 'What words tell the ear, mute painting shows by

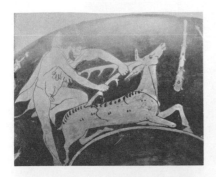

24. *Above left*. GREEK. Hercules and the hind. Detail from a bowl. 5th century B.C. *Louvre*.

25. *Below left*. Hercules and the deer. Marble relief. 4th century A.D. *Ravenna Museum*.

26. GALLO-ROMAN. Hercules and the Nemean lion. Silver dish. *Cabinet des Médailles, Bibliothèque Nationale, Paris*.

27. BYZANTINE. David and the lion. Silver dish. *c*. 6th century A.D. *Metropolitan Museum of Art*.

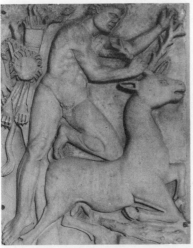

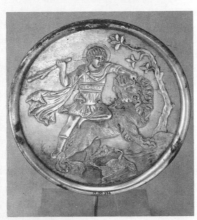

THE COMPLEX HERITAGE OF BYZANTIUM

The traditions of earlier arts reached Byzantium, and were progressively assimilated by Christian art. The ancient examples influenced the modelling [24, 25, 27], as well as the subject matter [24, 25] which entered religious iconography [26, 27]. Moreover, the legacy of the ancient East was revived. Persian influence, transmitted largely through textiles, ensured the continuity not only of Eastern art (and its fantastic beasts [29, 30]) but also of the early Mesopotamian civilisations: the hero between symmetrical wild beasts, a subject portrayed from the 3rd millennium [28, 31], was seen once again.

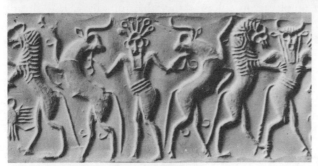

28. *Above*. SUMERIAN. Hero fighting animals. Cylinder seal. *c*. 2750 B.C. *British Museum*.

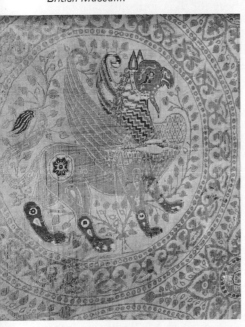

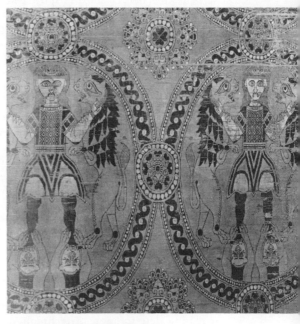

29. BYZANTINE. Detail from the shroud of St Siviard. Silk fabric. 8th century. *Sens Cathedral*.

30. SASSANIAN. Brooch having cloisonné ornamentation. *Cabinet des Médailles, Bibliothèque Nationale, Paris*.

31. BYZANTINE. Detail from the shroud of St Victor (Daniel in the Lions' Den?). Silk fabric. 8th century. *Sens Cathedral*.

of these impressions art produced on the sensual organism: confusing if described, forceful and clear when felt.' Elsewhere he adds: 'This emotion penetrates the most intimate recesses of the soul. It stirs up feelings which words can but vaguely express'; 'moves'. Now, this was the very term Plotinus was thinking of when he spoke of 'a sort of ineffable and non-intelligent contact or touch ... To feel is not to think.'

The art that neither represents nor reasons, the art that moves, that touches, awakens the soul to new emotions and revelations, unknown and 'magic' (to quote Delacroix again) is surely Byzantine art, imperfectly consolidated and understood as it was then, which perhaps also contained that which would be best in the art of modern times. An immense step was taken towards the awareness of art, its role and its potentialities.

The persistence of tradition in Rome

By giving an entirely new understanding to the world, Christianity had gained an equally new concept of art. Though this was not born of Christianity, the latter alone was able to endow it with a fervour that justified its existence for centuries. However, this concept was not expressed in the same way throughout the Christian world. The vast area covered by the new religion included widely divergent territories, whose implanted heritage of ideas and forms lent itself to a greater or lesser degree to the new aestheticism.

Byzantium and its official art showed a subtle blending of the multiple tendencies of the Empire, in which East and West, administrative requirements and theological doctrines, converged. Hellenic culture, resolutely perpetuated in the capital, was perhaps the major contributor towards the rationally drawn-up intellectual programme, which, in the theme and distribution of its images, revealed a logically unfolded idea. However, the mystic element of the East remained sufficiently alive to prevent this art from becoming merely a dry, intellectual process and to maintain that magic in the material means, which pervades the nerves and the spirit and creates a sort of hypnosis of beauty.

Rome, on the other hand, remained stubbornly averse to the abandonment of the solid positivism of the classical tradition. From the time she recovered from her collapse before the barbarian invasions, and as soon as, deprived of temporal power, she was able to rally her forces around the Pope, whose position, keenly contested by the patriarchs of the East, was strengthened through his inflexible obstinacy, she opposed the new sensibility with the whole force of her traditional aim: a realism embellished by a combination of visual observation with intellectual elaboration. With her obstinate perseverance in her chosen course, it took her a thousand years finally to reassert herself with the Renaissance, while Byzantium, her once triumphant rival, slowly declined and eventually fell before the onslaught of the Turks.

In fact, a close examination of the situation reveals that Rome and her concept of art never capitulated. A hostile lack of comprehension had undermined her traditions, which early Christianity had adopted for lack of better, and they had certainly suffered from the increasing deterioration of technique and the return to popular forms of expression. We have seen how much this evolution owed to the influence of the Eastern peoples in the Empire and that it was merely precipitated by Christianity. A mosaic from a Roman villa in Africa, now at the Bardo in Tunis, is already hardly distinguishable from those generally attributed to Byzantine art.

However, what Rome desperately sought to maintain, not only in its first great mosaics but also in the tradition of its sarcophagi, imitated as far away as Provence, was a sculptural sense, the representation or suggestion of form in the round that was so foreign to 'dematerialised' Eastern aestheticism. The 4th-century statue of Constantine in S. Giovanni in Laterano could be placed in the line of statues of the Emperors, just as the decoration in the mausoleum of his daughter Constantia perpetuated the tradition of pagan decoration. The togaed silhouettes of the Apostles in the Arian Baptistery at Ravenna (early 6th century) are Roman not only in their costumes and their modelling, but also in the realistic shadows they cast on the ground; the rigidity that was pervading art had merely stiffened them. The figure of Christ in Sta Pudenziana in Rome (end of the 4th century) recalls, with its still almost wholly realistic modelling, the statue of Nerva, while that in SS Cosma e Damiano (6th century) resembles the consular statues.

Ravenna at this time was strongly influenced by the personality of Justinian: there is no denying the speed of the increasing penetration of the new art which, with its emphasis on colour rather than plasticity, had already triumphed a century earlier in the decoration of the mausoleum of Galla Placidia, Theodosius' daughter. Justinian, however, was obsessed with a desire to resuscitate the Roman Empire; he spoke Latin instead of Greek and used Latin for his profoundly Roman codes, yet the pomp of his court represented a growing Easternisation inaugurated long before him by his Roman predecessors. The same dualism is manifest in the art he patronised: despite the ecstatic fascination of their gaze, the full-length figures in S. Vitale maintain the intense psychological presence of the Roman portraits.

The sculptural quality of Roman art, only in abeyance in the series of large mosaics culminating in those of Cavallini, paved the way for the Giottesque renaissance.

Rome's feeling for realistic sculpture, irreconcilable with the Byzantine lack of interest in material reality, was not only maintained in the territory subject to her jurisdiction; to the Byzantine centuries to come, she bequeathed her narrative sense which, diametrically opposed to neo-Platonic tendencies, took root wherever Rome's teaching had survived, that is, in the communities centred around the schools of rhetoric. The prestige of Cicero and Quintilian remained unrivalled in these schools, which also preserved their concept of art as a language designed to tell the eye with an image what a text tells the mind with words. It was a concept that corresponded to Horace's formula: *ut pictura poesis*, which was handed on to the Middle Ages by Isidore of Seville and Rabanus Maurus. The Ciceronian formula is very similar: *poema loquens pictura, pictura tacitum poema* (poetry is a spoken painting, painting is a silent poem).

Thus, from the 4th century, the Cappadocian fathers, who were past masters of sacred eloquence and were imbued with Quintilian's ideas, issued a series of positive statements assigning to Christian painting the role of a book of illustrations designed to tell the faithful what words could also tell. St Basil, who was bishop of Caesarea and had been a pupil of the rhetorician Labianus, declared that: 'What words tell the ear, mute painting shows by

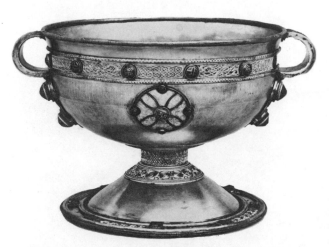

32. IRISH. The Ardagh chalice. 8th century. *National Museum, Dublin.*

imitation': an advocation of realism in intent as in execution! His brother, Gregory of Nyssa, an ex-sophist and rhetorician, voiced the same idea: 'Silent painting tells its story from a wall.' Two centuries later, Pope Gregory the Great, reaffirming the Roman tradition, still held the same view: 'Paintings figure in churches in order that the illiterate, looking at the walls, may read what they are unable to read in books.'

Realism and abstraction

The two religious aestheticisms, the Latin, which advocated realistic representation, and the Eastern, which tended to prohibit all material evocation, clashed in bitter controversy during the period of the iconoclastic crisis. It was in vain that Nicephorus, patriarch of Constantinople, who was deposed and banished by the iconoclastic Emperor Leo the Armenian, declared: 'Seeing is more conducive to faith than hearing'; the council of 753 nonetheless condemned 'the ignorant . . . sacrilegious artist . . .' who '. . . represented that which should not be represented and sought, with his defiled hands, to give form to that which should only be conceived in the heart.' Artistic 'abstraction' reached its climax during the 8th century, which witnessed not only the spread of Islamic nonfigurative art and Byzantium's adoption of this radical solution, but also saw, in north-western Europe, the creation by Irish art (which, during the 5th century, had been an isolated offshoot of Early Christian art, dominated by the neo-Platonic concept) of the most abstract works ever known in the West until our time.

However, material representation—what we today would call 'figurative art'—was finally to prevail. Paradoxically enough it owed its victory to a section of the people of the Byzantine East and to the monks, from whom one might have expected the greatest hostility to Western aestheticism. It came in fact from the circles which had resisted Hellenism, refusing to accept that intruder despite its domination of the administrative and intellectual circles. Moreover, it was precisely in these circles that neo-Platonism had been understood, assimilated and cultivated. Due to this unexpected association, a popular, narrative realism, which, needless to say, bore no relation to the plastic realism of the Graeco-Latin tradition, developed in opposition to the iconoclasm championed in influential circles. During the persecution, this new realism found refuge mainly in the illuminated manuscripts, which were entirely in the hands of the 80 monks. At an earlier date, the form established at Antioch 8 had already pitted the Syrian tradition, transmitted to Cappadocia (Gospel of the monk Rabula, 6th century), 82 against the Alexandrian form which, in both style and iconography, represented the Hellenistic tradition.

One would have thought that the monks, in order to remain faithful to their uncompromising rupture with the world of material reality, would have set themselves up as the champions of an art forbidden to represent the material forms of this world. They did so only in Ireland. The Egyptian, cenobitic type of monasticism (monastic communities) had spread not only eastwards, to Antioch, during the 4th century, but also westwards, to Gaul, where a celebrated monastery was founded, on the Lérins Isles. Cenobitic monasticism was then established on the Loire, under St Martin, and, in 432, was carried to Ireland by St Patrick, a former inmate of Lérins. In Ireland an amazing Christian and monastic civilisation was to flourish which preserved the primitive spirit of the Eastern Church. It remained exempt from Roman influence for close on three centuries and thus had only Coptic religious examples and the old Celtic traditions from which to elaborate its art. The abstract decoration of La Tène, renewed and transformed by the first influx of Germanic barbarians from Scandinavia, was combined with the Christian antimaterialism to produce the intricate harmonies of interlacements that were to fill the large 142–143 pages of the 8th-century manuscripts. This Irish Church, animated by an ardent spirit of proselytism, spread through the territory of the Franks and even advanced to that of the Lombards, in Italy, where it established a monastery at Bobbio.

It was these two tendencies of Christian art, the Roman figurative tendency and the Eastern abstract tendency that determined the destiny of Western art.

The papacy, by energetically asserting its primacy in, and imposing its discipline on a Christianity which because of its expansion was in danger of disintegrating into small groups, became identified with Rome and all the intellectual and artistic traditions she stood for. Prevailing over the opposing tendency that had become so strong towards the dawn of the Middle Ages, it ensured the maintenance and then the triumph of what could be called rational, Latin realism. It was Pope Gregory the Great, the former Roman rhetorician, who gave the signal for this artistic reconquest, in the last years of the 6th century. A disciple of St Benedict, he promoted the Latin monasticism initiated by his master, which, in place of Eastern monasticism, offered a new balance between spirituality and the handling of material reality. To ward off the barbarian threat to Rome, he sent out Roman Benedictine missions to distant lands, and as far away as England, in his effort to counteract the Irish influence. Realising how much art could contribute towards spreading and implanting ideas, he also set about imposing the ritual of the Latin liturgy and particularly the specifically Latin Gregorian chant.

Despite all his efforts, Western tradition has never come closer to perdition than during these centuries prior to the Middle Ages. It was compromised within Christianity by the Oriental influence on Byzantium, while Europe itself was invaded by barbarians from the north and Arabs from the south, who successively closed over it like the double grip of a vice.

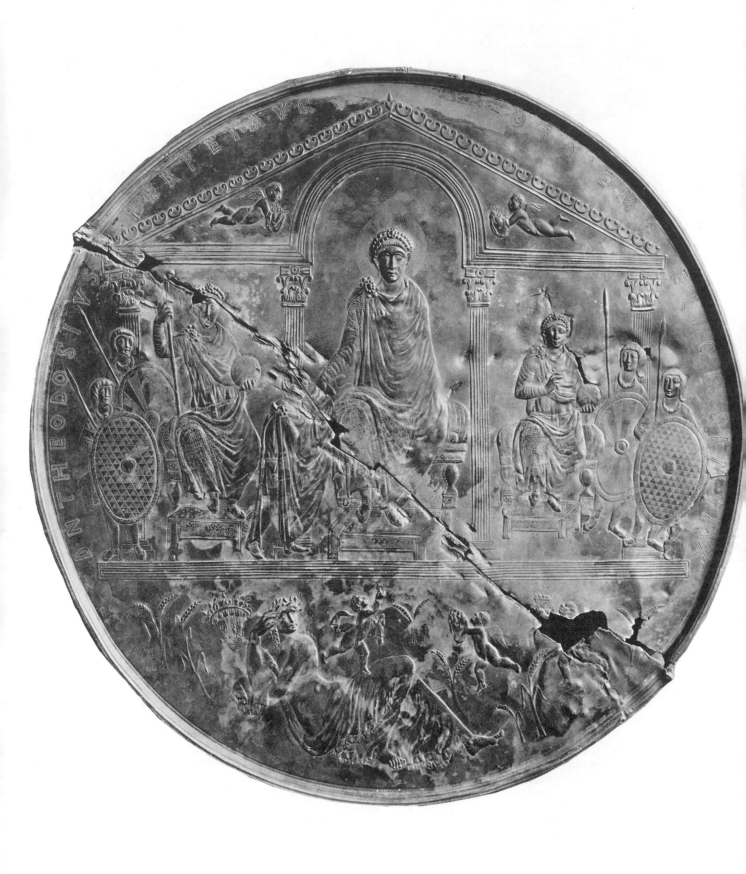

33. PRE-BYZANTINE. Repoussé and engraved silver disc.
A.D. 388. *Academia de la Historia, Madrid*.

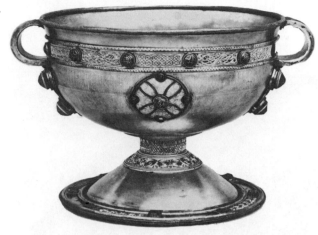

32. IRISH. The Ardagh chalice. 8th century. *National Museum, Dublin.*

imitation': an advocation of realism in intent as in execution! His brother, Gregory of Nyssa, an ex-sophist and rhetorician, voiced the same idea: 'Silent painting tells its story from a wall.' Two centuries later, Pope Gregory the Great, reaffirming the Roman tradition, still held the same view: 'Paintings figure in churches in order that the illiterate, looking at the walls, may read what they are unable to read in books.'

Realism and abstraction

The two religious aestheticisms, the Latin, which advocated realistic representation, and the Eastern, which tended to prohibit all material evocation, clashed in bitter controversy during the period of the iconoclastic crisis. It was in vain that Nicephorus, patriarch of Constantinople, who was deposed and banished by the iconoclastic Emperor Leo the Armenian, declared: 'Seeing is more conducive to faith than hearing'; the council of 753 nonetheless condemned 'the ignorant . . . sacrilegious artist . . .' who '. . . represented that which should not be represented and sought, with his defiled hands, to give form to that which should only be conceived in the heart.' Artistic 'abstraction' reached its climax during the 8th century, which witnessed not only the spread of Islamic non-figurative art and Byzantium's adoption of this radical solution, but also saw, in north-western Europe, the creation by Irish art (which, during the 5th century, had been an isolated offshoot of Early Christian art, dominated by the neo-Platonic concept) of the most abstract works ever known in the West until our time.

However, material representation—what we today would call 'figurative art'—was finally to prevail. Paradoxically enough it owed its victory to a section of the people of the Byzantine East and to the monks, from whom one might have expected the greatest hostility to Western aestheticism. It came in fact from the circles which had resisted Hellenism, refusing to accept that intruder despite its domination of the administrative and intellectual circles. Moreover, it was precisely in these circles that neo-Platonism had been understood, assimilated and cultivated. Due to this unexpected association, a popular, narrative realism, which, needless to say, bore no relation to the plastic realism of the Graeco-Latin tradition, developed in opposition to the iconoclasm championed in influential circles. During the persecution, this new realism found refuge mainly in the illuminated manuscripts, which were entirely in the hands of the monks. At an earlier date, the form established at Antioch had already pitted the Syrian tradition, transmitted to Cappadocia (Gospel of the monk Rabula, 6th century), against the Alexandrian form which, in both style and iconography, represented the Hellenistic tradition.

One would have thought that the monks, in order to remain faithful to their uncompromising rupture with the world of material reality, would have set themselves up as the champions of an art forbidden to represent the material forms of this world. They did so only in Ireland. The Egyptian, cenobitic type of monasticism (monastic communities) had spread not only eastwards, to Antioch during the 4th century, but also westwards, to Gaul, where a celebrated monastery was founded, on the Lérins Isles. Cenobitic monasticism was then established on the Loire, under St Martin, and, in 432, was carried to Ireland by St Patrick, a former inmate of Lérins. In Ireland an amazing Christian and monastic civilisation was to flourish which preserved the primitive spirit of the Eastern Church. It remained exempt from Roman influence for close on three centuries and thus had only Coptic religious examples and the old Celtic traditions from which to elaborate its art. The abstract decoration of La Tène, renewed and transformed by the first influx of Germanic barbarians from Scandinavia, was combined with the Christian antimaterialism to produce the intricate harmonies of interlacements that were to fill the large pages of the 8th-century manuscripts. This Irish Church, animated by an ardent spirit of proselytism, spread through the territory of the Franks and even advanced to that of the Lombards, in Italy, where it established a monastery at Bobbio.

It was these two tendencies of Christian art, the Roman figurative tendency and the Eastern abstract tendency that determined the destiny of Western art.

The papacy, by energetically asserting its primacy in, and imposing its discipline on a Christianity which because of its expansion was in danger of disintegrating into small groups, became identified with Rome and all the intellectual and artistic traditions she stood for. Prevailing over the opposing tendency that had become so strong towards the dawn of the Middle Ages, it ensured the maintenance and then the triumph of what could be called rational, Latin realism. It was Pope Gregory the Great, the former Roman rhetorician, who gave the signal for this artistic reconquest, in the last years of the 6th century. A disciple of St Benedict, he promoted the Latin monasticism initiated by his master, which, in place of Eastern monasticism, offered a new balance between spirituality and the handling of material reality. To ward off the barbarian threat to Rome, he sent out Roman Benedictine missions to distant lands, and as far away as England, in his effort to counteract the Irish influence. Realising how much art could contribute towards spreading and implanting ideas, he also set about imposing the ritual of the Latin liturgy and particularly the specifically Latin Gregorian chant.

Despite all his efforts, Western tradition has never come closer to perdition than during these centuries prior to the Middle Ages. It was compromised within Christianity by the Oriental influence on Byzantium, while Europe itself was invaded by barbarians from the north and Arabs from the south, who successively closed over it like the double grip of a vice.

80
8
82
142–143

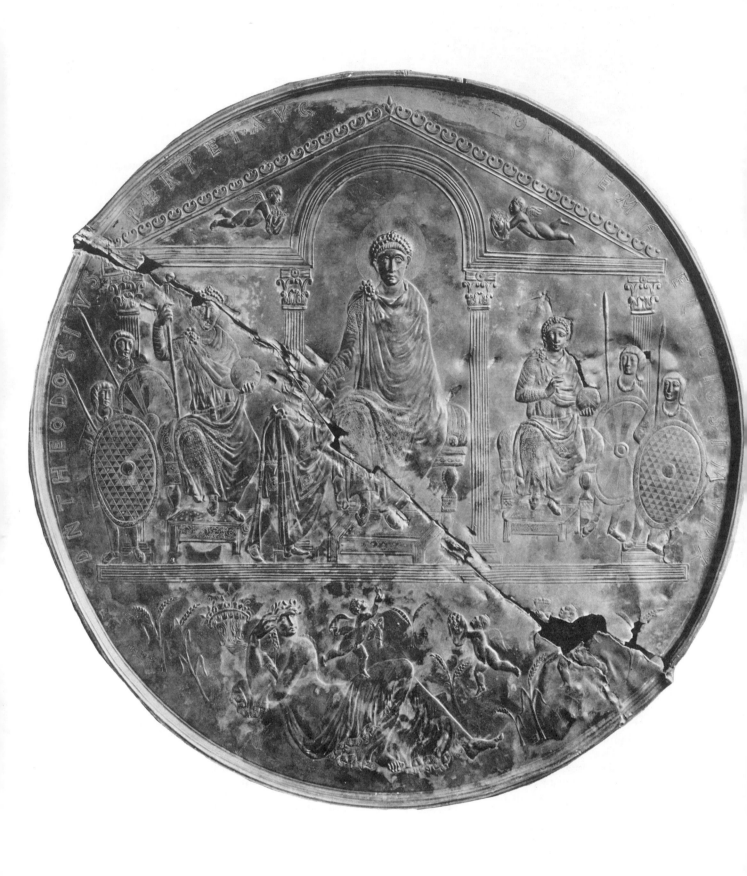

33. PRE-BYZANTINE. Repoussé and engraved silver disc.
A.D. 388. *Academia de la Historia, Madrid*.

CHRISTIAN ART FROM THE CATACOMBS TO BYZANTIUM *Henri Stern*

The advent of Christianity, whose rise was not to be stopped, marked the end of the ancient world and its aestheticism which had been based on a combination of realism and physical beauty. The decline was accelerated by the splitting up of the Empire and the growing predominance of Byzantium which, through various circumstances, favoured contact with the East. At first disdaining art, Christianity later imbued it with a new spirit and a new sensibility in which the visible, transfigured, became merely an instrument of the invisible; this tendency to look inwards led to a distrust of 'imagery', which, during the iconoclastic crisis of the 8th century, endangered the very continuity of art.

THE BEGINNINGS OF CHRISTIAN ART

Of the earliest Christian art, that is that prior to the reign of Constantine (305–337), we have scarcely any record in the history of art. One could even deny its existence in its own right and regard it as merely one of the multiple manifestations of that open sesame Graeco-Roman art, practised around the Mediterranean during the first centuries of the Empire. Certain scholars have done just that, and their reasons are obvious.

Origins of this art

Early Christian art was not the product of a specific region, nor was it based on any artistic tradition of its own; it derived its forms from the art around it. The Roman Empire, a vast melting-pot of races and civilisations, offered favourable conditions for its creation and initial development. It was not (nor, indeed, could it have been) born outside the limits of this Empire. Its entire early history was enacted within the *orbis romanus*.

In contrast to the art of other contemporary cults, Graeco-Roman or Eastern, it belonged moreover to a sect whose doctrine was averse and even hostile to figurative representation of any kind. The antipathy towards images and the Judaic ban on the representation of the Divinity were certainly never absolute. By the end of the 2nd century (or the beginning of the 3rd), Christian imagery had been developed and spread abroad. However it was not the fundamental doctrine of the new religion that was translated into images. Early Christian art seems to have been a concession to the needs of the faithful, accustomed to pagan art, rather than a response to an internal need of the new faith.

Yet the first works of this art determined the course of its subsequent history. Its contribution lay elsewhere than in the creation of form. For the first time in the history of the Western world, art expressed an abstract faith through images: the concept of the salvation of the soul, man's fervent desire to free himself from earthly ties and attain to eternal life.

The method of approaching the study of this art must be adapted to its particular nature. The analysis of style and form would teach us but little; it is the analysis of subject and theme that is the more enlightening. Its iconography, in the widest sense of the word, alone provides information on the new factor of universal significance that Early Christian art represents.

It is only in a few centres, relatively small in number, that this first phase of its history may be studied: in the catacombs in Italy and the frescoes in a baptistery at Doura Europos, a small frontier town in Mesopotamia, on the Euphrates. This art, of a tolerated but not officially recognised group, produced no great works comparable to those of the contemporary pagan cults.

The question of the origin of Early Christian art has given rise to lively controversy. As to the origin of the catacombs themselves, there can no longer be any possible doubt. This type of tomb, which was completely unknown in the West before the coming of the Christians, was certainly imported from the Near East by the first faithful, who were Jewish converts; in Palestine and the neighbouring countries, burial in subterranean chambers had been practised for centuries. In Italy, however, this tomb underwent a characteristic modification. The Eastern tomb was a family vault, arranged around a central assembly hall, while the catacomb was the burial 66 place of a community, and consisted of long passages 67 branching out in all directions, with small rooms leading off them and with niches to contain the bodies arbitrarily distributed throughout. This new arrangement is explainable by the growing number of the faithful and the limited possibilities for the purchasing of new ground.

Development and significance of the iconography

While the Eastern origin of the catacombs themselves is no longer in doubt, that of the paintings which adorn them is far more complex. At first, with the exception of specifically pagan themes, traditional motifs and subjects predominated. The Good Shepherd, symbol of Christ 34 saving the soul of the Christian, was portrayed as a shepherd carrying a lamb on his shoulder, or surrounded by his flock, a theme frequently represented in the profane art of the period. The story of Jonah was illustrated with 35 idyllic seascapes adapted to the life story of the prophet.

Other subjects retained not only the form but also the significance of the pagan models. Cupids and Psyches were images of the souls in the next world; the four seasons symbolised the renewal of nature for both Christ- 36 ians and non-Christians. Probably only a few perceived the deeper symbolism herein, an allusion to the rebirth in the hereafter. For both Christian and pagan, the peacock, a bird of luxury, represented the delightful place of sojourn which it was hoped would be that of the hereafter. Other birds, and plants and flowers, were also adopted by the Christians.

Besides these ambiguous subjects there were others, taken from the Bible and the Gospels, which are of more immediate interest for the history of Christian art. Opinions differ as to the origin and even the significance of these images. They are believed by some to have been created in Italy, and especially in Rome; by others, in the numerous Judaeo-Christian communities of the Near East, and especially at Alexandria. Some regard them as narrative images; others, as examples of the salvation desired, both for the living and for the deceased.

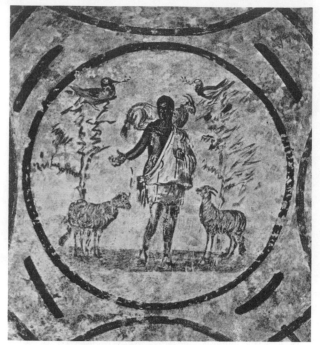
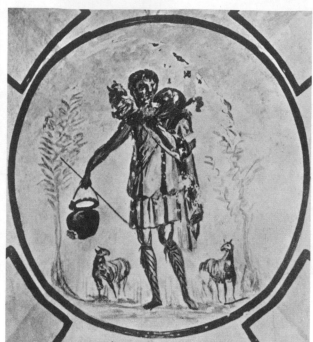

34. EARLY CHRISTIAN. Representations of the Good Shepherd in the Priscilla catacomb (left) and in the Calixtus catacomb (right). 3rd century. (After Wilpert.)

38, 39 The recent discovery (1932) of paintings in a synagogue at Doura, which were executed between A.D. 245 and 256, has opened up new perspectives. Up to the time of the discovery, it was not known that Jewish figurative imagery had existed to any extent. The interior of this synagogue was covered with frescoes representing numerous scenes from the Old Testament, certain of which, the Sacrifice of Isaac, Jacob's Ladder, Jacob Blessing Ephraim and Manasseh, the Finding of Moses and the Crossing of the Red Sea, also appeared in the catacombs during the 4th century, and a representation of Elijah's Prayer on Mount Carmel was to be seen among the mosaics (between 350 and 360) which adorned the dome of Sta Costanza in Rome. This group of frescoes at Doura may be closely related to the paintings in the catacombs in so far as their significance is concerned. Both could be examples of God's salvation of his people, possibly inspired by Jewish and Judaeo-Christian prayers enumerating the figures in sacred history who had been saved by the faith.

With a few exceptions, the subjects of these prayers were those of art. To the ones already named, we may add Noah's Deliverance from the Flood, Moses Striking Water 35–37 from the Rock in the Desert, David and Saul, Samuel at Shiloh, Mordecai and Esther, Jonah, Susanna and the Elders, the Three Hebrews in the Fiery Furnace and Daniel in the Lions' Den: all examples of God's miraculous intervention to save his people.

Whether or not this iconography was created especially for the catacombs we are unable to say, and the archaeologists are far from agreeing on the matter. Some, basing their arguments on the Doura frescoes, feel that such highly developed narrative cycles could not have been created for the cult buildings and the tombs, and assume the existence of illustrated books of the sacred texts which would have served as models for the painters. Others, on the contrary, regard this imagery as having indeed been created especially for the catacombs.

Be this as it may, the Early Christians, who were for the most part Jewish converts, may well have found the inspiration for these images of salvation within their own milieu. They adopted them, adding a few subjects from the New Testament—the Healing of the Paralytic, the Raising of Lazarus and the Marriage at Cana, whose significance is evident—and the Adoration of the Magi, which represented the first conversion of the Gentiles.

The frescoes in the baptistery at Doura, which are probably contemporary with those in the synagogue, prove that these images of salvation did not belong exclusively to the funerary art of the Christians, for they are characterised by the same juxtaposition of examples of salvation taken from the Old and New Testaments as we find in the catacombs. A ciborium (canopy supported by columns) above the baptismal font, its dais painted blue and dotted with stars, symbolised the celestial vault, the future resting place of those who had received grace through baptism. Adam, Eve and the Serpent were a reminder of the fall of Man, and appeared opposite the Good Shepherd, the image of redemption, while around the walls scenes of St Peter Walking on the Waters, the Healing of the Paralytic, and Christ with the Woman of Samaria appear to have been chosen especially to show the purifying action of the baptismal water.

For the Christians, both baptism and death signified a renewal: hence the similarity between the baptismal and funerary iconography.

Style

The majority of scholars regard the paintings in the catacombs merely as imitations of the contemporary pictorial

35. EARLY CHRISTIAN. Jonah ejected by the whale. Painting in the Calixtus catacomb. 4th century.

CHRISTIAN ART FROM THE CATACOMBS TO BYZANTIUM *Henri Stern*

The advent of Christianity, whose rise was not to be stopped, marked the end of the ancient world and its aestheticism which had been based on a combination of realism and physical beauty. The decline was accelerated by the splitting up of the Empire and the growing predominance of Byzantium which, through various circumstances, favoured contact with the East. At first disdaining art, Christianity later imbued it with a new spirit and a new sensibility in which the visible, transfigured, became merely an instrument of the invisible; this tendency to look inwards led to a distrust of 'imagery', which, during the iconoclastic crisis of the 8th century, endangered the very continuity of art.

THE BEGINNINGS OF CHRISTIAN ART

Of the earliest Christian art, that is that prior to the reign of Constantine (305–337), we have scarcely any record in the history of art. One could even deny its existence in its own right and regard it as merely one of the multiple manifestations of that open sesame Graeco-Roman art, practised around the Mediterranean during the first centuries of the Empire. Certain scholars have done just that, and their reasons are obvious.

Origins of this art

Early Christian art was not the product of a specific region, nor was it based on any artistic tradition of its own; it derived its forms from the art around it. The Roman Empire, a vast melting-pot of races and civilisations, offered favourable conditions for its creation and initial development. It was not (nor, indeed, could it have been) born outside the limits of this Empire. Its entire early history was enacted within the *orbis romanus*.

In contrast to the art of other contemporary cults, Graeco-Roman or Eastern, it belonged moreover to a sect whose doctrine was averse and even hostile to figurative representation of any kind. The antipathy towards images and the Judaic ban on the representation of the Divinity were certainly never absolute. By the end of the 2nd century (or the beginning of the 3rd), Christian imagery had been developed and spread abroad. However it was not the fundamental doctrine of the new religion that was translated into images. Early Christian art seems to have been a concession to the needs of the faithful, accustomed to pagan art, rather than a response to an internal need of the new faith.

Yet the first works of this art determined the course of its subsequent history. Its contribution lay elsewhere than in the creation of form. For the first time in the history of the Western world, art expressed an abstract faith through images: the concept of the salvation of the soul, man's fervent desire to free himself from earthly ties and attain to eternal life.

The method of approaching the study of this art must be adapted to its particular nature. The analysis of style and form would teach us but little; it is the analysis of subject and theme that is the more enlightening. Its iconography, in the widest sense of the word, alone provides information on the new factor of universal significance that Early Christian art represents.

It is only in a few centres, relatively small in number, that this first phase of its history may be studied: in the catacombs in Italy and the frescoes in a baptistery at Doura Europos, a small frontier town in Mesopotamia, on the Euphrates. This art, of a tolerated but not officially recognised group, produced no great works comparable to those of the contemporary pagan cults.

The question of the origin of Early Christian art has given rise to lively controversy. As to the origin of the catacombs themselves, there can no longer be any possible doubt. This type of tomb, which was completely unknown in the West before the coming of the Christians, was certainly imported from the Near East by the first faithful, who were Jewish converts; in Palestine and the neighbouring countries, burial in subterranean chambers had been practised for centuries. In Italy, however, this tomb underwent a characteristic modification. The Eastern tomb was a family vault, arranged around a central assembly hall, while the catacomb was the burial 66 place of a community, and consisted of long passages 67 branching out in all directions, with small rooms leading off them and with niches to contain the bodies arbitrarily distributed throughout. This new arrangement is explainable by the growing number of the faithful and the limited possibilities for the purchasing of new ground.

Development and significance of the iconography

While the Eastern origin of the catacombs themselves is no longer in doubt, that of the paintings which adorn them is far more complex. At first, with the exception of specifically pagan themes, traditional motifs and subjects predominated. The Good Shepherd, symbol of Christ 34 saving the soul of the Christian, was portrayed as a shepherd carrying a lamb on his shoulder, or surrounded by his flock, a theme frequently represented in the profane art of the period. The story of Jonah was illustrated with 35 idyllic seascapes adapted to the life story of the prophet.

Other subjects retained not only the form but also the significance of the pagan models. Cupids and Psyches were images of the souls in the next world; the four seasons symbolised the renewal of nature for both Christ- 36 ians and non-Christians. Probably only a few perceived the deeper symbolism herein, an allusion to the rebirth in the hereafter. For both Christian and pagan, the peacock, a bird of luxury, represented the delightful place of sojourn which it was hoped would be that of the hereafter. Other birds, and plants and flowers, were also adopted by the Christians.

Besides these ambiguous subjects there were others, taken from the Bible and the Gospels, which are of more immediate interest for the history of Christian art. Opinions differ as to the origin and even the significance of these images. They are believed by some to have been created in Italy, and especially in Rome; by others, in the numerous Judaeo-Christian communities of the Near East, and especially at Alexandria. Some regard them as narrative images; others, as examples of the salvation desired, both for the living and for the deceased.

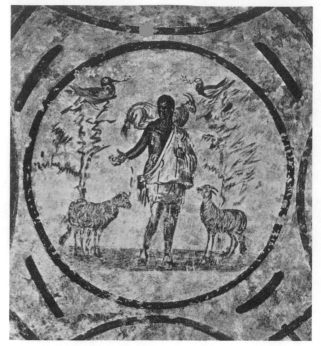
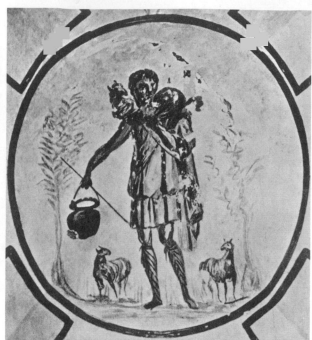

34. EARLY CHRISTIAN. Representations of the Good Shepherd in the Priscilla catacomb (left) and in the Calixtus catacomb (right). 3rd century. *(After Wilpert.)*

38, 39 The recent discovery (1932) of paintings in a synagogue at Doura, which were executed between A.D. 245 and 256, has opened up new perspectives. Up to the time of the discovery, it was not known that Jewish figurative imagery had existed to any extent. The interior of this synagogue was covered with frescoes representing numerous scenes from the Old Testament, certain of which, the Sacrifice of Isaac, Jacob's Ladder, Jacob Blessing Ephraim and Manasseh, the Finding of Moses and the Crossing of the Red Sea, also appeared in the catacombs during the 4th century, and a representation of Elijah's Prayer on Mount Carmel was to be seen among the mosaics (between 350 and 360) which adorned the dome of Sta Costanza in Rome. This group of frescoes at Doura may be closely related to the paintings in the catacombs in so far as their significance is concerned. Both could be examples of God's salvation of his people, possibly inspired by Jewish and Judaeo-Christian prayers enumerating the figures in sacred history who had been saved by the faith.

With a few exceptions, the subjects of these prayers were those of art. To the ones already named, we may add Noah's Deliverance from the Flood, Moses Striking Water 35–37 from the Rock in the Desert, David and Saul, Samuel at Shiloh, Mordecai and Esther, Jonah, Susanna and the Elders, the Three Hebrews in the Fiery Furnace and Daniel in the Lions' Den: all examples of God's miraculous intervention to save his people.

Whether or not this iconography was created especially for the catacombs we are unable to say, and the archaeologists are far from agreeing on the matter. Some, basing their arguments on the Doura frescoes, feel that such highly developed narrative cycles could not have been created for the cult buildings and the tombs, and assume the existence of illustrated books of the sacred texts which would have served as models for the painters. Others, on the contrary, regard this imagery as having indeed been created especially for the catacombs.

Be this as it may, the Early Christians, who were for the most part Jewish converts, may well have found the inspiration for these images of salvation within their own milieu. They adopted them, adding a few subjects from the New Testament—the Healing of the Paralytic, the Raising of Lazarus and the Marriage at Cana, whose significance is evident—and the Adoration of the Magi, which represented the first conversion of the Gentiles.

The frescoes in the baptistery at Doura, which are probably contemporary with those in the synagogue, prove that these images of salvation did not belong exclusively to the funerary art of the Christians, for they are characterised by the same juxtaposition of examples of salvation taken from the Old and New Testaments as we find in the catacombs. A ciborium (canopy supported by columns) above the baptismal font, its dais painted blue and dotted with stars, symbolised the celestial vault, the future resting place of those who had received grace through baptism. Adam, Eve and the Serpent were a reminder of the fall of Man, and appeared opposite the Good Shepherd, the image of redemption, while around the walls scenes of St Peter Walking on the Waters, the Healing of the Paralytic, and Christ with the Woman of Samaria appear to have been chosen especially to show the purifying action of the baptismal water.

For the Christians, both baptism and death signified a renewal: hence the similarity between the baptismal and funerary iconography.

Style

The majority of scholars regard the paintings in the catacombs merely as imitations of the contemporary pictorial

35. EARLY CHRISTIAN. Jonah ejected by the whale. Painting in the Calixtus catacomb. 4th century.

36. EARLY CHRISTIAN. Ceiling in the Lucina crypt in the Calixtus catacomb. First half of the 3rd century. In the centre, Daniel is seen in the Lions' Den; in the corners are figures of the Good Shepherd and orans figures. The heads of the four seasons(?), the Cupids and the plant motifs still belong entirely to the profane art of the period.

Like the frescoes in the synagogue at Doura (cf. 38, 39), the paintings in the Christian catacombs mostly represented episodes from the Old Testament which told of God's intervention to save His people: these were symbols of the salvation desired for the souls of the deceased.

37. EARLY CHRISTIAN. Susanna and the Elders before Daniel. Painting in the Priscilla catacomb. First half of the 3rd century.

38, 39. EARLY CHRISTIAN. Frescoes in the synagogue at Doura Europos. Middle of the 3rd century. *Below.* Painting above the niche which contained the scroll of the Law, representing, with the seven-branched candelabra and the temple at Jerusalem, the Sacrifice of Isaac. *Bottom.* Moses leading the Jews out of Egypt.

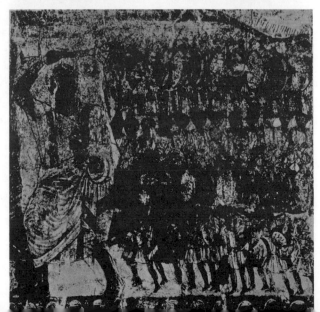

style, but a few, on the other hand, think that they can detect new elements in them, which herald the Christian art to come. A comparison with the fragmentary remains of the profane paintings of the period shows the majority to be right.

Whereas the frescoes in the baptistery at Doura were the work of an inexperienced and unschooled craftsman, certain of the oldest paintings in the Roman catacombs have an illusionistic style, a lightness of touch and an elegance that recall the best paintings of Pompeii and Rome. The decoration on the walls and vaults is comparable to the rare surviving ceilings in the columbaria of the 2nd and 3rd centuries, and to the decoration of the tombs in the cemetery at Ostia. However, the scenes represented are restricted to such figures and accessories as are indispensable to the story; there is nothing in the way of landscape or picturesque detail (the fresco of Daniel in the Capella Graeca is an exception); dramatic subjects are avoided, figures are frequently frontally portrayed in orans (in the attitude of prayer)—Daniel in the Lions' Den, Noah, the Three Hebrews, Susanna and the Elders—and their gaze is intense and fixed.

The elements of the decoration are extremely simple. Ceilings and walls were partitioned by red, dark brown or green bands, ornamented with small hooks, and garlands, bouquets of flowers or plants adorned the spaces between them. These plant motifs disappeared in the course of the 3rd century. Illusionistic architectural frames, similar to those of the second style at Pompeii, have come to light in the cubiculum of Ampliatus, of the 4th century. Throughout the period of catacombs painting (2nd–5th centuries), this decorative system underwent only minor changes.

To summarise: the question of 'the Orient or Rome', which has given rise to so much controversy in the study of Early Christian art, seems to be resolved in the light of the given facts. The subjects of this art were inspired by a Jewish literary and figurative tradition, which the Christians adopted and elaborated. This art had no unique place of origin; it was doubtless produced simultaneously in the various great urban centres of the Empire, such as

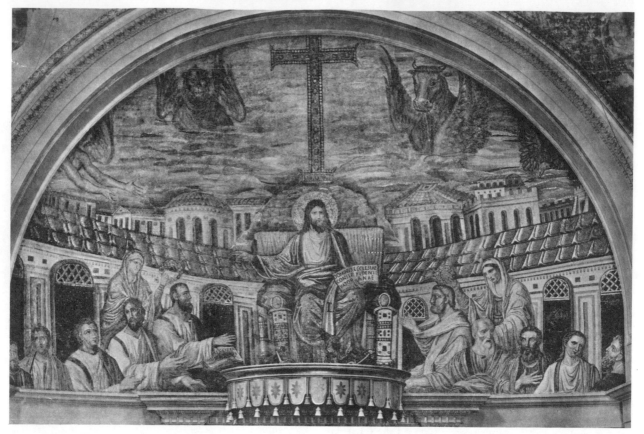

DIVINE CULT

40. PRE-BYZANTINE. Christ enthroned amidst the Apostles. Apse mosaic in Sta Pudenziana, Rome. End of the 4th century.

41. PRE-BYZANTINE. Jesus as Master of the universe, enthroned above the head of Coelus. Detail from the sarcophagus of Junius Bassus. 359. *Crypt of St Peter's, Rome.*

Rome, Alexandria, Antioch and Ephesus, inhabited by a large Judaeo-Christian community.

In each separate region its style was influenced by the local art. Nevertheless, this Early Christian art had a distinctive personality, characterised by detachment, spiritual intensity and an absence of any striving after external effects, characteristics which are the very essence of the new faith.

THE ART OF THE CHURCH TRIUMPHANT
(4th century and first half of the 5th century)

During the 4th century, a historical event of prime importance, Constantine's conversion (after 312), rapidly

changed the character of Christian art. The new faith, still the object of persecution in 303, under Diocletian and Maximianus, became a lawful religion and soon the state religion. It emerged from semi-secrecy to make a triumphal entry into all the fields of public and intellectual life.

Until then, Early Christian painting had been merely a humble means of expressing the idea of salvation, and the meeting places of the faithful had been modest, but now Christianity acquired the taste for pomp and pageantry characteristic of the period. The Emperor raised sanctuaries in Rome and in the provinces of the East, and the dignitaries of the Empire vied with one another in their efforts to show their devotion to the new religion. Every kind of artistic activity flourishing at that time became accessible to the Christians, and it was during this century that ecclesiastical architecture and its natural corollary, monumental painting, were born.

The first buildings: basilicas, martyria and baptisteries

From the very beginning this architecture differed from the architecture of the temple. Whereas the latter edifice had been merely the receptacle of the cult statue, the religious ceremonies taking place outside the building, the Christian church was above all a place of meeting for the celebration of a rite whose mysteries were revealed within its walls.

Thus its form was inspired by pagan assembly buildings, by mausoleums, and perhaps even by the halls of certain of the Roman baths. As with the catacomb paintings, specifically pagan models were rejected, only those constructions of a neutral or utilitarian character being adopted.

The churches of this period can be divided roughly into three categories: basilicas, buildings on a central plan and buildings that were a combination of the two. This classification is not purely formal; it corresponds to the different functions of each type.

The basilica, which was doubtless the type most often

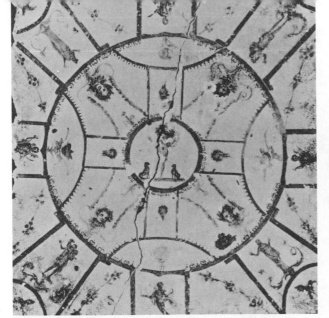

36. EARLY CHRISTIAN. Ceiling in the Lucina crypt in the Calixtus catacomb. First half of the 3rd century. In the centre, Daniel is seen in the Lions' Den; in the corners are figures of the Good Shepherd and orans figures. The heads of the four seasons(?), the Cupids and the plant motifs still belong entirely to the profane art of the period.

Like the frescoes in the synagogue at Doura (cf. 38, 39), the paintings in the Christian catacombs mostly represented episodes from the Old Testament which told of God's intervention to save His people: these were symbols of the salvation desired for the souls of the deceased.

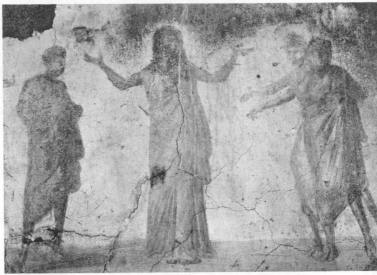

37. EARLY CHRISTIAN. Susanna and the Elders before Daniel. Painting in the Priscilla catacomb. First half of the 3rd century.

38, 39. EARLY CHRISTIAN. Frescoes in the synagogue at Doura Europos. Middle of the 3rd century. *Below*. Painting above the niche which contained the scroll of the Law, representing, with the seven-branched candelabra and the temple at Jerusalem, the Sacrifice of Isaac. *Bottom*. Moses leading the Jews out of Egypt.

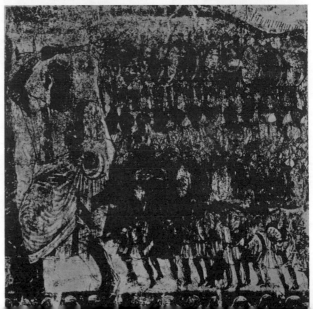

style, but a few, on the other hand, think that they can detect new elements in them, which herald the Christian art to come. A comparison with the fragmentary remains of the profane paintings of the period shows the majority to be right.

Whereas the frescoes in the baptistery at Doura were the work of an inexperienced and unschooled craftsman, certain of the oldest paintings in the Roman catacombs have an illusionistic style, a lightness of touch and an elegance that recall the best paintings of Pompeii and Rome. The decoration on the walls and vaults is comparable to the rare surviving ceilings in the columbaria of the 2nd and 3rd centuries, and to the decoration of the tombs in the cemetery at Ostia. However, the scenes represented are restricted to such figures and accessories as are indispensable to the story; there is nothing in the way of landscape or picturesque detail (the fresco of Daniel in the Capella Graeca is an exception); dramatic subjects are avoided, figures are frequently frontally portrayed in orans (in the attitude of prayer) — Daniel in the Lions' Den, Noah, the Three Hebrews, Susanna and the Elders — and their gaze is intense and fixed.

The elements of the decoration are extremely simple. Ceilings and walls were partitioned by red, dark brown or green bands, ornamented with small hooks, and garlands, bouquets of flowers or plants adorned the spaces between them. These plant motifs disappeared in the course of the 3rd century. Illusionistic architectural frames, similar to those of the second style at Pompeii, have come to light in the cubiculum of Ampliatus, of the 4th century. Throughout the period of catacombs painting (2nd–5th centuries), this decorative system underwent only minor changes.

To summarise: the question of 'the Orient or Rome', which has given rise to so much controversy in the study of Early Christian art, seems to be resolved in the light of the given facts. The subjects of this art were inspired by a Jewish literary and figurative tradition, which the Christians adopted and elaborated. This art had no unique place of origin; it was doubtless produced simultaneously in the various great urban centres of the Empire, such as

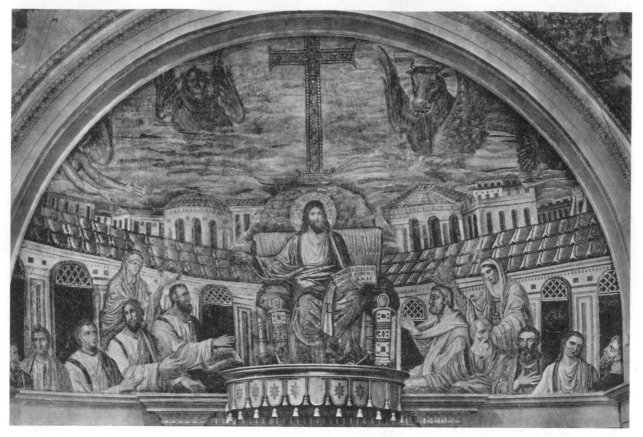

DIVINE CULT

40. PRE-BYZANTINE. Christ enthroned amidst the Apostles. Apse mosaic in Sta Pudenziana, Rome. End of the 4th century.

41. PRE-BYZANTINE. Jesus as Master of the universe, enthroned above the head of Coelus. Detail from the sarcophagus of Junius Bassus. 359. *Crypt of St Peter's, Rome.*

Rome, Alexandria, Antioch and Ephesus, inhabited by a large Judaeo-Christian community.

In each separate region its style was influenced by the local art. Nevertheless, this Early Christian art had a distinctive personality, characterised by detachment, spiritual intensity and an absence of any striving after external effects, characteristics which are the very essence of the new faith.

THE ART OF THE CHURCH TRIUMPHANT
(4th century and first half of the 5th century)

During the 4th century, a historical event of prime importance, Constantine's conversion (after 312), rapidly changed the character of Christian art. The new faith, still the object of persecution in 303, under Diocletian and Maximianus, became a lawful religion and soon the state religion. It emerged from semi-secrecy to make a triumphal entry into all the fields of public and intellectual life.

Until then, Early Christian painting had been merely a humble means of expressing the idea of salvation, and the meeting places of the faithful had been modest, but now Christianity acquired the taste for pomp and pageantry characteristic of the period. The Emperor raised sanctuaries in Rome and in the provinces of the East, and the dignitaries of the Empire vied with one another in their efforts to show their devotion to the new religion. Every kind of artistic activity flourishing at that time became accessible to the Christians, and it was during this century that ecclesiastical architecture and its natural corollary, monumental painting, were born.

The first buildings: basilicas, martyria and baptisteries

From the very beginning this architecture differed from the architecture of the temple. Whereas the latter edifice had been merely the receptacle of the cult statue, the religious ceremonies taking place outside the building, the Christian church was above all a place of meeting for the celebration of a rite whose mysteries were revealed within its walls.

Thus its form was inspired by pagan assembly buildings, by mausoleums, and perhaps even by the halls of certain of the Roman baths. As with the catacomb paintings, specifically pagan models were rejected, only those constructions of a neutral or utilitarian character being adopted.

The churches of this period can be divided roughly into three categories: basilicas, buildings on a central plan and buildings that were a combination of the two. This classification is not purely formal; it corresponds to the different functions of each type.

The basilica, which was doubtless the type most often

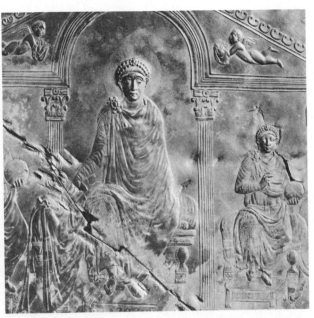

IMPERIAL CULT

42. PRE-BYZANTINE. Constantine II enthroned between his two brothers. Silver medal. *c.* 340. *Cabinet des Médailles, Bibliothèque Nationale, Paris.*

43. PRE-BYZANTINE. Theodosius I between his two sons, investing a high official. Detail of a repoussé and engraved silver disc (see 33). A.D. 388. *Academia de la Historia, Madrid.*

encountered, was the normal cult building, and was an oblong chamber with a nave and two or four side aisles. The nave, which was higher than the aisles, with its upper walls pierced with windows, was designed as the meeting place of the faithful; the chancel, in the form of an apse, served for the celebration of the religious rites. Much ink has flowed over the question of its origin. Despite its obvious resemblance to the Roman secular basilica, scholars have been unable to perceive any functional link between the two. Certain Mithraic halls, while they were of a similar plan, were far smaller, and the central nave was not elevated. In St Peter's and in S. Giovanni in Laterano, the large basilicas founded by Constantine, the chancel was extended by a projecting transept, an arrangement probably necessitated by the liturgy, which was in full development and required more space. With modifications this plan prevailed in Western architecture up to the Middle Ages.

In North Africa the basilica developed an unexpected variety and richness of plan. The basilica at Orléansville had an additional apse probably designed for funerary purposes, and in the one at Tipasa there were four aisles on either side of the nave. Generally speaking, the African and Syrian basilicas are set amidst extensive groups of subsidiary buildings such as hostelries, sacristies and baptisteries, which formed veritable Christian cities.

The central plan, at least when it was first used, appears to have been reserved for martyria (martyrs' churches) and baptisteries.

There is no doubt that the martyria were derived from the pagan mausoleums, to which their plan and use relate them. They were built to commemorate and house the mortal remains of a martyr, who was worshipped there. In the Holy Land they were raised over the spots that had been marked by Christ's passage (in Jerusalem, the Anastasis and the Church of the Ascension). In martyria the Eucharistic rites were celebrated only on the anniversaries of the death of the saint, and, in Palestine, on the day of the event in Christ's life commemorated

by the sanctuary. However, the church on a central plan seems soon to have been used also for the normal Eucharistic celebrations. It is known that the octagonal church at Antioch, founded by Constantine, was not a martyrium.

The baptisteries, the majority of which are built on a central plan, were largely inspired by the halls of certain baths, with which they have one structural element in common, a central pool; in this the neophyte was baptised by immersion. However, owing to the supreme importance of baptism in Christianity, the plan and the decoration of the baptisteries were influenced at a fairly early date by the liturgy (baptisteries at Doura, Naples and Ravenna).

In certain of Constantine's foundations in the Holy Land, the central plan was combined with that of the basilica, that is, the commemorative edifice or martyrium was combined with the assembly hall. In Bethlehem, the site of the birthplace was marked by an octagonal structure with a sloping roof, in front of which there was a hall with a nave and four aisles that is still standing. The entrance to the cave was situated in the centre of the octagonal structure. Over Christ's tomb in Jerusalem, Constantine built a rotunda (the Anastasis), that was used mainly for the Easter rites. A nearby basilica probably consisted of two parts, a basilican nave, and a rotunda over the site of the finding of the Cross. (At the time of the reconstruction done forty years ago—in ignorance of the octagonal structure at Bethlehem, discovered in 1933—the archaeologists had assumed there had been an apse over this spot, as in St Peter's in Rome.) Whereas mass appears to have been celebrated only on Maundy Thursday in the rotunda, the ordinary worship took place throughout the year in the nave.

The function and form of the Early Christian churches were thus closely related, and their plan and structure were determined by the ceremony which took shape from the liturgy. The basilica was the house of God, where the Lord sat enthroned and received the faithful.

The martyrium was an edifice built to perpetuate the memory of a martyr. However, the architects of Constantine's time did not start from scratch, but were inspired by the civil architecture of the period, whose plans they modified and transformed to suit the needs of the new faith. The walls in these sanctuaries were the perfect place on which to unfold an iconography and a style for figurative art that would make tangible the spiritual significance of these buildings.

Figurative art and the 'Imperial' influence

It is therefore not surprising that the main achievement of figurative art of the 4th century was the creation of a monumental style of Christian painting. The Constantinian epoch confirmed the absolute predominance of painting over sculpture, a predominance which had been foreshadowed in the preceding centuries.

The spiritualisation of religious thought, which was by no means limited to the Christian faith, doubtless contributed considerably to this evolution. Neo-Platonic philosophy regarded the gods of the ancient Pantheon as merely the symbols and emanations of a supreme god, whom it endeavoured to apprehend through an inner vision. The innumerable sects dedicated to the worship of such Graeco-Eastern divinities as Mithras, Isis, Cybele and Dionysus aimed above all at ensuring the initiated a life of bliss after death.

Pagan art reflected this evolution of thought. What is customarily referred to as the decadent phase of ancient art was nothing but a growing indifference to physical beauty, the beauty which had reached its fullest expression in the sculptural representations of the human body. In fact, pagan art of late antiquity never passed beyond this negative stage. It continued up to the end to repeat themes centuries old, just as pagan beliefs, despite their metaphysical tendencies, clung tenaciously to the traditional ceremonies and materialistic superstitious practices. Christianity alone treated the religious question without compromise and its art alone found adequate means to express the new spirituality.

However, a contemporary political and religious force, the 'Imperial' cult, had a profound and lasting influence on its formation. The widespread tendency of the period towards monotheism had first become crystallised in the cult of the Emperor, a cult whose development and propagation had been furthered largely by the rigorous administrative organisation of the Empire. Indeed, the Empire at that time has been described as an immense pyramid, with the Emperor, identified with the supreme god, Sol-Helios or Jupiter, constituting its apex. He was the Cosmocrator, the master of the universe, and as such, the destiny of each citizen depended on him. Although after Constantine's conversion his status tended to become more modest, especially under the influence of the ideas of the Christian theologians, he nevertheless continued to be regarded as the intermediary between the Christian God and mortals, and Bishop Eusebius of Caesarea, Constantine's court theologian, even compared him to Christ the Sun, whose functions he fulfilled on earth. It was therefore not unnatural that Christian imagery was partially modelled on Imperial imagery, from which it also derived a number of its principal motifs.

Up to the middle of the 5th century the West, and especially Italy, played a creative role of paramount importance in the process of its formation. But the East seems to have pursued a separate course after the division of the Empire (395). Although few examples of Eastern representational art have survived, there are indications that Eastern artistic production was considerable and was perhaps as important as that of the West. In any case, the controversies on the subject (J. Strzygowski versus J. Wilpert) seem outmoded today.

It is true that the surviving examples of monumental painting are hardly more numerous in the West, but because of the influence this painting exerted on other fields of art, such as the relief carvings on sarcophagi and the catacomb paintings, it is possible to reconstruct some of its essential traits.

Let us consider first the subjects of an 'Imperial' nature, among which are two compositions that appear to be particularly significant: Christ Dictating the Law (*Traditio Legis*) and Christ Enthroned amidst the Apostles, both, and especially the former, of Roman origin and closely related to Imperial iconography.

Initially the theme of the *Traditio Legis*, preserved in a few mosaics and on numerous sarcophagi of the second half of the 4th century and the beginning of the 5th, probably adorned one of the Roman sanctuaries founded by Constantine, such as the basilica of St Peter's or the Lateran Baptistery. Christ standing dictating the Law to St Peter, on His left, and raising His right hand towards St Paul represented an essential point of the faith, the transmission of the New Law to the faithful. The scene was doubtless suggested by an Imperial subject, the investiture of a high official, an example of which is to be seen on a silver dish of Theodosius I, dated 388. The 33 differences between the profane and the religious composition are most instructive. The hillock on which Christ is standing, the four rivers issuing from it (an allegory of the Gospels) and the four or twelve lambs (representing either the Evangelists or the Apostles) sometimes shown beside the rivers, the temples of Jerusalem and Bethlehem (which stand for the Old and the New Law), the two palm trees and the trail of clouds in the background all lend this scene the unreal and essentially religious atmosphere of paradise. At the same time a new idea is manifest, that of the end of the world, when Christ will reappear in glory to judge the quick and the dead.

The other monumental composition, Christ Enthroned amidst the Apostles, has much the same significance. Its origins can be traced back to purely pagan iconography, its prototype being the meetings of philosophers; but it must have been through Imperial art that it penetrated the Church. On the Arch of Constantine, the victorious Emperor is shown seated among his dignitaries and distributing gifts, and on the Arch of Galerius at Salonica, two Emperors are shown receiving the homage of the vanquished. Most instructive, however, are the coins and medals, beginning with those of Constantine, which show the Emperor enthroned. At Sta Pudenziana, Christ is shown surrounded by His disciples and seated, like the Emperor, on a throne resplendent with precious stones. At Sta Costanza He is to be seen seated on the globe of the universe; and on sarcophagi (that of Junius Bassius in the crypt of St Peter's, for example), He is shown with His feet resting on a veil billowing over the head of Coelus, an ancient personification of the heavens. He is Cosmocrator, master of the universe, as the Emperor is master of the earth. In Sta Pudenziana, however, the

7
42
40
41

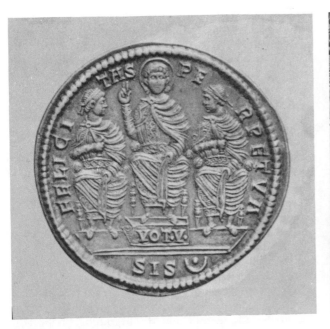

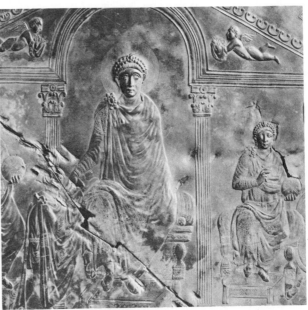

IMPERIAL CULT

42. PRE-BYZANTINE. Constantine II enthroned between his two brothers. Silver medal. *c.* 340. *Cabinet des Médailles, Bibliothèque Nationale, Paris.*

43. PRE-BYZANTINE. Theodosius I between his two sons, investing a high official. Detail of a repoussé and engraved silver disc (see 33). A.D. 388. *Academia de la Historia, Madrid.*

71 encountered, was the normal cult building, and was an oblong chamber with a nave and two or four side aisles. The nave, which was higher than the aisles, with its upper walls pierced with windows, was designed as the meeting place of the faithful; the chancel, in the form of an apse, served for the celebration of the religious rites. Much ink has flowed over the question of its origin. Despite its obvious resemblance to the Roman secular basilica, scholars have been unable to perceive any functional link between the two. Certain Mithraic halls, while they were of a similar plan, were far smaller, and the central nave was not elevated. In St Peter's and in S. Giovanni in 70 Laterano, the large basilicas founded by Constantine, the chancel was extended by a projecting transept, an arrangement probably necessitated by the liturgy, which was in full development and required more space. With modifications this plan prevailed in Western architecture up to the Middle Ages.

In North Africa the basilica developed an unexpected variety and richness of plan. The basilica at Orléansville had an additional apse probably designed for funerary purposes, and in the one at Tipasa there were four aisles on either side of the nave. Generally speaking, the African and Syrian basilicas are set amidst extensive groups of subsidiary buildings such as hostelries, sacristies and baptisteries, which formed veritable Christian cities.

The central plan, at least when it was first used, appears to have been reserved for martyria (martyrs' churches) and baptisteries.

There is no doubt that the martyria were derived from the pagan mausoleums, to which their plan and use relate them. They were built to commemorate and house the mortal remains of a martyr, who was worshipped there. In the Holy Land they were raised over the spots that had been marked by Christ's passage (in Jerusalem, 68 the Anastasis and the Church of the Ascension). In martyria the Eucharistic rites were celebrated only on the anniversaries of the death of the saint, and, in Palestine, on the day of the event in Christ's life commemorated

by the sanctuary. However, the church on a central plan seems soon to have been used also for the normal Eucharistic celebrations. It is known that the octagonal church at Antioch, founded by Constantine, was not a martyrium.

The baptisteries, the majority of which are built on a central plan, were largely inspired by the halls of certain baths, with which they have one structural element in common, a central pool; in this the neophyte was baptised by immersion. However, owing to the supreme importance of baptism in Christianity, the plan and the decoration of the baptisteries were influenced at a fairly early date by the liturgy (baptisteries at Doura, Naples and Ravenna). 72

In certain of Constantine's foundations in the Holy Land, the central plan was combined with that of the basilica, that is, the commemorative edifice or martyrium was combined with the assembly hall. In Bethlehem, the site of the birthplace was marked by an octagonal structure 69 with a sloping roof, in front of which there was a hall with a nave and four aisles that is still standing. The entrance to the cave was situated in the centre of the octagonal structure. Over Christ's tomb in Jerusalem, Constantine built a rotunda (the Anastasis), that was used mainly for the Easter rites. A nearby basilica probably consisted of two parts, a basilican nave, and a rotunda over the site of the finding of the Cross. (At the time of the reconstruction done forty years ago — in ignorance of the octagonal structure at Bethlehem, discovered in 1933 — the archaeologists had assumed there had been an apse over this spot, as in St Peter's in Rome.) Whereas mass appears to have been celebrated only on Maundy Thursday in the rotunda, the ordinary worship took place throughout the year in the nave.

The function and form of the Early Christian churches were thus closely related, and their plan and structure were determined by the ceremony which took shape from the liturgy. The basilica was the house of God, where the Lord sat enthroned and received the faithful.

The martyrium was an edifice built to perpetuate the memory of a martyr. However, the architects of Constantine's time did not start from scratch, but were inspired by the civil architecture of the period, whose plans they modified and transformed to suit the needs of the new faith. The walls in these sanctuaries were the perfect place on which to unfold an iconography and a style for figurative art that would make tangible the spiritual significance of these buildings.

Figurative art and the 'Imperial' influence

It is therefore not surprising that the main achievement of figurative art of the 4th century was the creation of a monumental style of Christian painting. The Constantinian epoch confirmed the absolute predominance of painting over sculpture, a predominance which had been foreshadowed in the preceding centuries.

The spiritualisation of religious thought, which was by no means limited to the Christian faith, doubtless contributed considerably to this evolution. Neo-Platonic philosophy regarded the gods of the ancient Pantheon as merely the symbols and emanations of a supreme god, whom it endeavoured to apprehend through an inner vision. The innumerable sects dedicated to the worship of such Graeco-Eastern divinities as Mithras, Isis, Cybele and Dionysus aimed above all at ensuring the initiated a life of bliss after death.

Pagan art reflected this evolution of thought. What is customarily referred to as the decadent phase of ancient art was nothing but a growing indifference to physical beauty, the beauty which had reached its fullest expression in the sculptural representations of the human body. In fact, pagan art of late antiquity never passed beyond this negative stage. It continued up to the end to repeat themes centuries old, just as pagan beliefs, despite their metaphysical tendencies, clung tenaciously to the traditional ceremonies and materialistic superstitious practices. Christianity alone treated the religious question without compromise and its art alone found adequate means to express the new spirituality.

However, a contemporary political and religious force, the 'Imperial' cult, had a profound and lasting influence on its formation. The widespread tendency of the period towards monotheism had first become crystallised in the cult of the Emperor, a cult whose development and propagation had been furthered largely by the rigorous administrative organisation of the Empire. Indeed, the Empire at that time has been described as an immense pyramid, with the Emperor, identified with the supreme god, Sol-Helios or Jupiter, constituting its apex. He was the Cosmocrator, the master of the universe, and as such, the destiny of each citizen depended on him. Although after Constantine's conversion his status tended to become more modest, especially under the influence of the ideas of the Christian theologians, he nevertheless continued to be regarded as the intermediary between the Christian God and mortals, and Bishop Eusebius of Caesarea, Constantine's court theologian, even compared him to Christ the Sun, whose functions he fulfilled on earth. It was therefore not unnatural that Christian imagery was partially modelled on Imperial imagery, from which it also derived a number of its principal motifs.

Up to the middle of the 5th century the West, and especially Italy, played a creative role of paramount importance in the process of its formation. But the East seems to have pursued a separate course after the division of the Empire (395). Although few examples of Eastern representational art have survived, there are indications that Eastern artistic production was considerable and was perhaps as important as that of the West. In any case, the controversies on the subject (J. Strzygowski versus J. Wilpert) seem outmoded today.

It is true that the surviving examples of monumental painting are hardly more numerous in the West, but because of the influence this painting exerted on other fields of art, such as the relief carvings on sarcophagi and the catacomb paintings, it is possible to reconstruct some of its essential traits.

Let us consider first the subjects of an 'Imperial' nature, among which are two compositions that appear to be particularly significant: Christ Dictating the Law (*Traditio Legis*) and Christ Enthroned amidst the Apostles, both, and especially the former, of Roman origin and closely related to Imperial iconography.

Initially the theme of the *Traditio Legis*, preserved in a few mosaics and on numerous sarcophagi of the second half of the 4th century and the beginning of the 5th, probably adorned one of the Roman sanctuaries founded by Constantine, such as the basilica of St Peter's or the Lateran Baptistery. Christ standing dictating the Law to St Peter, on His left, and raising His right hand towards St Paul represented an essential point of the faith, the transmission of the New Law to the faithful. The scene was doubtless suggested by an Imperial subject, the investiture of a high official, an example of which is to be seen on a silver dish of Theodosius I, dated 388. The **33** differences between the profane and the religious composition are most instructive. The hillock on which Christ is standing, the four rivers issuing from it (an allegory of the Gospels) and the four or twelve lambs (representing either the Evangelists or the Apostles) sometimes shown beside the rivers, the temples of Jerusalem and Bethlehem (which stand for the Old and the New Law), the two palm trees and the trail of clouds in the background all lend this scene the unreal and essentially religious atmosphere of paradise. At the same time a new idea is manifest, that of the end of the world, when Christ will reappear in glory to judge the quick and the dead.

The other monumental composition, Christ Enthroned amidst the Apostles, has much the same significance. Its origins can be traced back to purely pagan iconography, its prototype being the meetings of philosophers; but it must have been through Imperial art that it penetrated the Church. On the Arch of Constantine, the victorious **7** Emperor is shown seated among his dignitaries and distributing gifts, and on the Arch of Galerius at Salonica, two Emperors are shown receiving the homage of the vanquished. Most instructive, however, are the coins and medals, beginning with those of Constantine, which show the Emperor enthroned. At Sta Pudenziana, Christ is **42** shown surrounded by His disciples and seated, like the **40** Emperor, on a throne resplendent with precious stones. At Sta Costanza He is to be seen seated on the globe of the universe; and on sarcophagi (that of Junius Bassius in the crypt of St Peter's, for example), He is shown with **41** His feet resting on a veil billowing over the head of Coelus, an ancient personification of the heavens. He is Cosmocrator, master of the universe, as the Emperor is master of the earth. In Sta Pudenziana, however, the

symbols of the Evangelists (of which this is the oldest example) and the triumphal Cross transfer the scene to a celestial world.

The expansion of the iconography

The course pursued by art after the time of the catacomb paintings is easy to follow. It was no longer the simple events of sacred history and the miracles accomplished by God and Christ that were depicted to evoke redemption. These new images, doubtless initially created for the sanctuary of the church, the place where the mystery of salvation was daily renewed, showed the victorious coming of the Lord at the end of time.

45 The idea of the triumph of the faith also determined the composition of certain monumental ensembles. As Imperial victories were portrayed on the Roman arches, the supremacy of the new faith was represented on the triumphal arch in Sta Maria Maggiore. The Lord's empty throne, a pre-eminently Imperial symbol, was placed in the middle of and above the scenes of Christ's youth, to symbolise the submission of both the Jews and pagans to the Christian doctrine. In the circular buildings or in those of cruciform plan, such as baptisteries (Naples,
72
73 Ravenna) or mausoleums (Galla Placidia) the Cross, the instrument of this victory, was often represented in the
44 star-spangled vault of the dome (the image of the heavens), as were the Apostles, acclaiming the Cross or bearing the crowns of their martyrdom, the whole forming a scene of homage that had parallels in certain Imperial and other profane compositions (base of Arcadius' column; Rome acclaimed by the cities of the Empire).

In addition to these subjects there are other, simpler ones that illustrate the expansion of Christian iconography. Between 325 and 350 the sarcophagi, the earliest of which, of a semi-pagan character, date back to the beginning of the 3rd century, bore scenes from the Passion of Christ and from that of the Apostles Peter and Paul (scenes from the lives of the latter also figured on, and were doubtless inspired by, the decoration of the two basilicas dedicated to each of them in Rome). This is of the utmost significance in the history of Christian thought and its penetration into art, since it proves that there was no longer any hesitation about portraying the Lord's Passion, despite the fact that reticence with regard to the representation of Christ on the Cross had not yet

44. PRE-BYZANTINE. The Cross against a night sky of sparkling gold stars. Mosaic in the dome of the mausoleum of Galla Placidia, Ravenna. c. 450.

been entirely overcome. As late as the middle of the 4th century Cyril of Jerusalem, in his Easter sermon, condemned the aversion of the faithful to venerate a God who had suffered a degrading death.

Thus, for the time being, only a limited number of episodes from the Passion were represented, such as the Carrying of the Cross, the Crowning with Thorns and Christ before Pilate, while the Supreme Agony was treated symbolically: the empty Cross surmounted by 46 a triumphal crown and flanked by two soldiers mounting guard. It was as much a symbol of the Resurrection as of the Crucifixion, and it was not until the 5th century, and even then but rarely, that representations of Christ on the Cross began to appear. Moreover, in Eastern works that 49 probably originated in Palestine, it was only towards the end of the 6th century that the scene of Christ on the Cross was included in the Passion cycle.

As its contacts with daily life became more frequent, monumental Christian art developed narrative and realistic qualities. It portrayed episodes from the Old and the New Testaments in the same style and with the same iconographical formulas as the pagan illuminated manuscripts which, doubtless from an early date, had been

45. PRE-BYZANTINE. The presentation of Christ in the Temple. Mosaic on the upper register of the triumphal arch in Sta Maria Maggiore, Rome. 432–440.

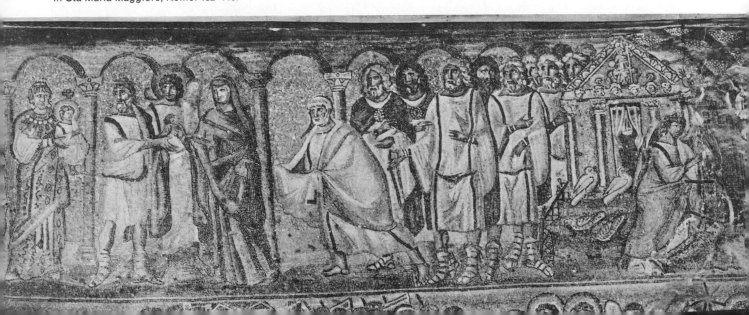

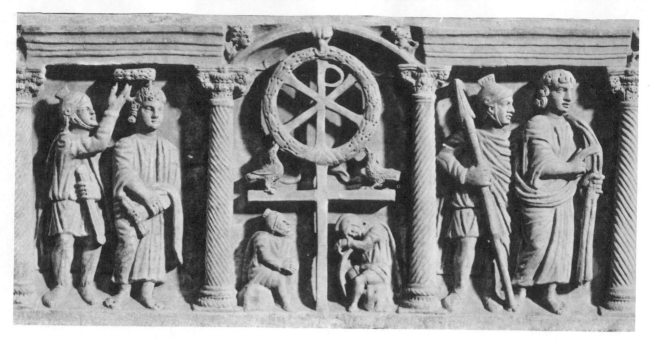

46. PRE-BYZANTINE. Scenes of the Passion: the Crowning with Thorns; the symbolic image of the Crucifixion and Resurrection; Christ led before Pilate. Detail from a sarcophagus of the middle of the 4th century. *Lateran Museum, Rome.*

adorned with miniatures. It was in the naves of the basilicas that these narrative cycles were unfolded. In Sta Maria Maggiore the story of the patriarchs Abraham, Isaac and Jacob was presented on the north wall, that of Moses and Joshua on the south wall. In St Peter's and in S. Giovanni in Laterano, a sequence from the Old Testament faced another taken from the Gospels. The fragments of the oldest known Christian illuminated manuscript date from the middle of the 4th century, as do certain miniatures accompanying the text of a Book of Judges.

Nevertheless, the early catacomb symbols of salvation did not disappear. They were maintained in the funerary art of the mausoleums, on sarcophagi and in the catacombs. The miracles from the Old Testament, which were represented in the mosaics of the dome of Sta Costanza, constituted the antitypes of those performed by Christ.

Finally, as a result of the official adoption of Christianity by the court and by the Roman aristocracy, pagan decoration penetrated the sanctuaries. Genre scenes, called 'Alexandrines', appeared below the mosaics in the dome of Sta Costanza, and it was due to the fact that the vault of the ambulatory of this church is covered with these 50 motifs that this Christian mausoleum was long regarded as a temple. However, by the end of the century these subjects had been discarded for purely Christian ones.

Formation of style

In Italy there was tangible progress in the evolution of the style during this period. At first artistic faculties seemed to be clearly on the decline, but by the second quarter of the 4th century a sort of classical Renaissance had come about, parallel to the progressive penetration of Christian art into public life. Whereas the style of the figures indicated a return to the traditional canon of beauty, their expression was of a hitherto unknown dignity and intensity. The return to the former tradition was visible in all media, from the carving on the sarcophagi to the illuminations and monumental painting. But nowhere was there a reappearance of ancient illusionism.

Realistic perspective was progressively abandoned in painting, and the choice of colour tended less towards an imitation of nature than towards a rich and brilliant palette. Moreover, it was not by chance that the preferred medium was mosaic, in which the brilliance of the materials—cubes of gold, silver, mother-of-pearl and glass paste—enhanced the brilliance of the colours. The play of light made the figures more alive and lent them an air of mystery that was an integral part of their significance.

During the 5th century, and especially at Ravenna, the classical style declined; drawing and modelling became summary, but the fervour of expression was accentuated. The sparkle of the colours and the blue backgrounds enhanced with gold gave these works a luminous and ethereal beauty foreshadowing the style of the 6th century. 47, 48

The small number of figurative monuments of this period that have survived in the Greek East do not suffice to distinguish a Graeco-Eastern iconography as apart from that of the Latin West. The question of style is quite another matter. The figures in the mosaics in St George at Salonica are at once more refined and more hieratic than those in Roman mosaics—nor, apparently, do they represent an isolated case. By comparing them with the relief carvings from the obelisk of Theodosius the Great (preserved at Istanbul) and with a series of coins and medals struck from the time of Constantius II in Greek 83 workshops (Salonica, Antioch and Constantinople), it is possible to reconstruct a group of works bearing the precocious stamp of a Byzantine style that will be discussed further on. Although more attached to tradition than the West, the Greek East created a style which combined a ritual stiffness with Greek refinement and sensibility, and which attained to a degree of subtlety in its choice of colours and in its psychological analysis that Latin art never knew.

Briefly, the hundred and fifty years following Constantine's conversion witnessed the formation of monumental Christian art. The principal types of church architecture were established, and from these developed the ecclesiastical architecture of the centuries to come.

symbols of the Evangelists (of which this is the oldest example) and the triumphal Cross transfer the scene to a celestial world.

The expansion of the iconography

The course pursued by art after the time of the catacomb paintings is easy to follow. It was no longer the simple events of sacred history and the miracles accomplished by God and Christ that were depicted to evoke redemption. These new images, doubtless initially created for the sanctuary of the church, the place where the mystery of salvation was daily renewed, showed the victorious coming of the Lord at the end of time.

45 The idea of the triumph of the faith also determined the composition of certain monumental ensembles. As Imperial victories were portrayed on the Roman arches, the supremacy of the new faith was represented on the triumphal arch in Sta Maria Maggiore. The Lord's empty throne, a pre-eminently Imperial symbol, was placed in the middle of and above the scenes of Christ's youth, to symbolise the submission of both the Jews and pagans to the Christian doctrine. In the circular buildings or in

72 those of cruciform plan, such as baptisteries (Naples,
73 Ravenna) or mausoleums (Galla Placidia) the Cross, the instrument of this victory, was often represented in the

44 star-spangled vault of the dome (the image of the heavens), as were the Apostles, acclaiming the Cross or bearing the crowns of their martyrdom, the whole forming a scene of homage that had parallels in certain Imperial and other profane compositions (base of Arcadius' column; Rome acclaimed by the cities of the Empire).

In addition to these subjects there are other, simpler ones that illustrate the expansion of Christian iconography. Between 325 and 350 the sarcophagi, the earliest of which, of a semi-pagan character, date back to the beginning of the 3rd century, bore scenes from the Passion of Christ and from that of the Apostles Peter and Paul (scenes from the lives of the latter also figured on, and were doubtless inspired by, the decoration of the two basilicas dedicated to each of them in Rome). This is of the utmost significance in the history of Christian thought and its penetration into art, since it proves that there was no longer any hesitation about portraying the Lord's Passion, despite the fact that reticence with regard to the representation of Christ on the Cross had not yet

44. PRE-BYZANTINE. The Cross against a night sky of sparkling gold stars. Mosaic in the dome of the mausoleum of Galla Placidia, Ravenna. *c.* 450.

been entirely overcome. As late as the middle of the 4th century Cyril of Jerusalem, in his Easter sermon, condemned the aversion of the faithful to venerate a God who had suffered a degrading death.

Thus, for the time being, only a limited number of episodes from the Passion were represented, such as the Carrying of the Cross, the Crowning with Thorns and Christ before Pilate, while the Supreme Agony was treated symbolically: the empty Cross surmounted by 46 a triumphal crown and flanked by two soldiers mounting guard. It was as much a symbol of the Resurrection as of the Crucifixion, and it was not until the 5th century, and even then but rarely, that representations of Christ on the Cross began to appear. Moreover, in Eastern works that 49 probably originated in Palestine, it was only towards the end of the 6th century that the scene of Christ on the Cross was included in the Passion cycle.

As its contacts with daily life became more frequent, monumental Christian art developed narrative and realistic qualities. It portrayed episodes from the Old and the New Testaments in the same style and with the same iconographical formulas as the pagan illuminated manuscripts which, doubtless from an early date, had been

45. PRE-BYZANTINE. The presentation of Christ in the Temple. Mosaic on the upper register of the triumphal arch in Sta Maria Maggiore, Rome. 432–440.

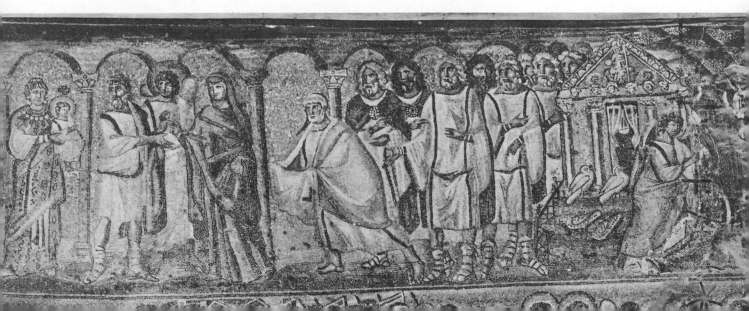

46. PRE-BYZANTINE. Scenes of the Passion: the Crowning with Thorns; the symbolic image of the Crucifixion and Resurrection; Christ led before Pilate. Detail from a sarcophagus of the middle of the 4th century. *Lateran Museum, Rome.*

adorned with miniatures. It was in the naves of the basilicas that these narrative cycles were unfolded. In Sta Maria Maggiore the story of the patriarchs Abraham, Isaac and Jacob was presented on the north wall, that of Moses and Joshua on the south wall. In St Peter's and in S. Giovanni in Laterano, a sequence from the Old Testament faced another taken from the Gospels. The fragments of the oldest known Christian illuminated manuscript date from the middle of the 4th century, as do certain miniatures accompanying the text of a Book of Judges.

Nevertheless, the early catacomb symbols of salvation did not disappear. They were maintained in the funerary art of the mausoleums, on sarcophagi and in the catacombs. The miracles from the Old Testament, which were represented in the mosaics of the dome of Sta Costanza, constituted the antitypes of those performed by Christ.

Finally, as a result of the official adoption of Christianity by the court and by the Roman aristocracy, pagan decoration penetrated the sanctuaries. Genre scenes, called 'Alexandrines', appeared below the mosaics in the dome of Sta Costanza, and it was due to the fact that the vault 50 of the ambulatory of this church is covered with these motifs that this Christian mausoleum was long regarded as a temple. However, by the end of the century these subjects had been discarded for purely Christian ones.

Formation of style

In Italy there was tangible progress in the evolution of the style during this period. At first artistic faculties seemed to be clearly on the decline, but by the second quarter of the 4th century a sort of classical Renaissance had come about, parallel to the progressive penetration of Christian art into public life. Whereas the style of the figures indicated a return to the traditional canon of beauty, their expression was of a hitherto unknown dignity and intensity. The return to the former tradition was visible in all media, from the carving on the sarcophagi to the illuminations and monumental painting. But nowhere was there a reappearance of ancient illusionism.

Realistic perspective was progressively abandoned in painting, and the choice of colour tended less towards an imitation of nature than towards a rich and brilliant palette. Moreover, it was not by chance that the preferred medium was mosaic, in which the brilliance of the materials—cubes of gold, silver, mother-of-pearl and glass paste—enhanced the brilliance of the colours. The play of light made the figures more alive and lent them an air of mystery that was an integral part of their significance.

During the 5th century, and especially at Ravenna, the classical style declined; drawing and modelling became summary, but the fervour of expression was accentuated. The sparkle of the colours and the blue backgrounds enhanced with gold gave these works a luminous and ethereal beauty foreshadowing the style of the 6th century. 47, 48

The small number of figurative monuments of this period that have survived in the Greek East do not suffice to distinguish a Graeco-Eastern iconography as apart from that of the Latin West. The question of style is quite another matter. The figures in the mosaics in St George at Salonica are at once more refined and more hieratic than those in Roman mosaics—nor, apparently, do they represent an isolated case. By comparing them with the relief carvings from the obelisk of Theodosius the Great (preserved at Istanbul) and with a series of coins and medals struck from the time of Constantius II in Greek 83 workshops (Salonica, Antioch and Constantinople), it is possible to reconstruct a group of works bearing the precocious stamp of a Byzantine style that will be discussed further on. Although more attached to tradition than the West, the Greek East created a style which combined a ritual stiffness with Greek refinement and sensibility, and which attained to a degree of subtlety in its choice of colours and in its psychological analysis that Latin art never knew.

Briefly, the hundred and fifty years following Constantine's conversion witnessed the formation of monumental Christian art. The principal types of church architecture were established, and from these developed the ecclesiastical architecture of the centuries to come.

47. St Peter. Detail from the ring mosaic in the dome of the Baptistery of the Orthodox, Ravenna. *c.* 450.

48. St Paul. Detail from the ring mosaic in the dome of the Arian Baptistery, Ravenna. First quarter of the 6th century.

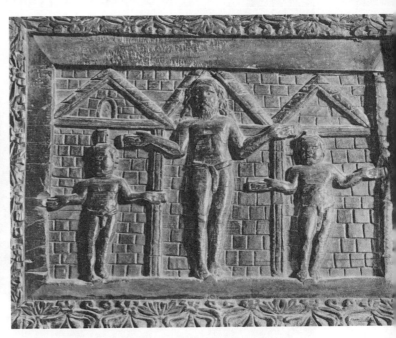

49. PRE-BYZANTINE. The Crucifixion. Carved panel of a wooden door in Sta Sabina, Rome. First half of the 5th century.

Christian imagery, deriving its inspiration from Imperial iconography, created the type of Christ in Majesty which was to take an all-important place in the art of the Middle Ages. Illustrations of scenes from the Bible and from the Gospels were developed in monumental art, as were the first representations of cycles of the Passion. A Christian style was born which instilled a new spirituality into the classical concept of the human body.

BYZANTINE ART: THE FIRST GOLDEN AGE

The progressive disintegration of the Western Empire after the 5th century went hand in hand with a gradual economic and intellectual decline, which was inevitably reflected in art. The Greek East, on the other hand, which had withstood the assault of the barbarians, had preserved its centres of civilisation intact. Under Justinian I (527–565), it consolidated its political power and even made a victorious return to Italy and North Africa. Greek theology prevailed over that of the Latin world and, indeed, all the Church councils, from Nicaea I (325) to Nicaea II (787), were Greek and were held in the East. The art of Byzantium and the Eastern provinces penetrated to the West. However, it is by no means easy to present an overall picture or synthesis of the history of the art of this period. The rise of the Christian East is directly apparent only in architecture. The figurative monuments are far less numerous in the Eastern than in the Western area of the Mediterranean, and we are faced with the task of reconstructing a lost world with the aid of rare and widely dispersed documents. A large number of questions will remain for ever unanswered; our conclusions will be tentative and, on many points, subject to revision.

Architecture: the domed church

While the Latin countries continued to build both basilicas and edifices on a central plan of traditional type, the East devised many variations on the latter plan. The domed church on a cruciform, cross-in-square, polygonal or polyfoil plan came increasingly to supplant the basilica. This evolution resulted, at Constantinople itself and

throughout its sphere of influence, in the creation of the domed basilica, the first authentic manifestation of Byzantine architectural genius, a genius that was to determine the form of Orthodox churches for the next thousand years. As to an explanation of this evolution of Christian architecture in the East, so different from that in the Latin West, it was probably largely influenced by the martyria in the Holy Land, which, for the most part, were domed buildings on a central plan. The veneration in which these sanctuaries were held, and which increased in the course of the 5th and 6th centuries, readily explains their success.

According to a recent theory, symbolic ideas would also appear to have contributed towards this veneration. A Syriac text of the first half of the 7th century, inspired by the writings of Dionysius the Areopagite (6th century), interpreted the domed church as an image of the cosmos

50. PRE-BYZANTINE. Mosaic on the vault of the ambulatory at Sta Costanza, Rome. Middle of the 4th century.

51, 52. BYZANTINE. Interior of Sta Sophia at Constantinople, consecrated in 537, and detail of the columns, noted for their impost capitals and their stylised foliate decoration.

—of the sky and the earth, the dome symbolising the heavens and the hall the earth below. The disposition of certain liturgical installations seems to have been directly determined by this notion. Moreover, a cosmological concept of the domed edifice had already existed during the pagan epoch. Thus, at a very early period, the starry sky, symbol of the next world, was represented in Christian buildings: above the baptismal font at Doura Europos, and with the addition of a triumphal Cross, in 44 the church of the 5th century already mentioned. This symbolism was henceforth to be applied to the building in its entirety.

Other Greek interpretations, apparently dating from the 4th century, explained the different parts of the church in the light of the liturgy. The sanctuary was at once the place of Christ's Passion and Resurrection, and of the

heavenly Jerusalem where He would reside at the end of time. Specific areas in the assembly hall of the faithful were reserved for scenes of the salvation, from the creation of the world and the history of the Jews up to the Passion. The West was never to know such an elaborate symbolism in a church.

The majority of the Christian countries of the East, Syria, Mesopotamia and especially Armenia, developed the church with central plan, but the various solutions that they found, however interesting they may be, fade into insignificance beside the domed basilica, which combined in a single structure the two plans typical of Christian architecture.

Little is known of the origin of this plan. It is prefigured in a few churches in Asia Minor (Meriamlik in Cilicia and Koja Kilisse in Isauria, of the 5th century), characterised by a dome over the nave. In the Byzantine type, however, the aisles, reduced to the role of vaulted ambulatories, are, as it were, overpowered by the dominating dome (the first plan of St Irene at Constantinople, the second Church of the Virgin at Ephesus and Basilica B at Philippi in Macedonia). This plan was developed impressively in Sta Sophia at Constantinople, the high 51–53 point of all Byzantine architecture. The exterior, of an 56 austere simplicity, is but a shell around the immense interior space which, with the judicious distribution of light, the facings of marble, the non-figurative mosaics and the undercut and pierced decoration, is of a sober magnificence. Inside, the spatial effect of the enormous dome is further enhanced by half-domes and semicircular arches. The dome is supported on powerful piers whose function is comparable to that of Gothic piers and flying buttresses. The walls are merely casing; the framework of the edifice has but a single function, to support the dome, which rises like a gigantic canopy, weightless, incorporeal and flooded with light, to an apparently immense height. The architectural form itself suggests

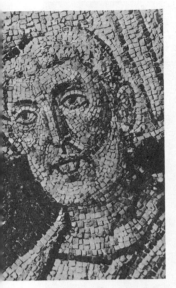
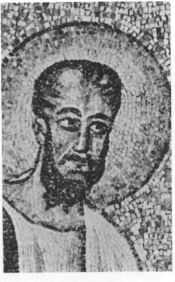

47. St Peter. Detail from the ring mosaic in the dome of the Baptistery of the Orthodox, Ravenna. *c.* 450.

48. St Paul. Detail from the ring mosaic in the dome of the Arian Baptistery, Ravenna. First quarter of the 6th century.

49. PRE-BYZANTINE. The Crucifixion. Carved panel of a wooden door in Sta Sabina, Rome. First half of the 5th century.

Christian imagery, deriving its inspiration from Imperial iconography, created the type of Christ in Majesty which was to take an all-important place in the art of the Middle Ages. Illustrations of scenes from the Bible and from the Gospels were developed in monumental art, as were the first representations of cycles of the Passion. A Christian style was born which instilled a new spirituality into the classical concept of the human body.

BYZANTINE ART: THE FIRST GOLDEN AGE

The progressive disintegration of the Western Empire after the 5th century went hand in hand with a gradual economic and intellectual decline, which was inevitably reflected in art. The Greek East, on the other hand, which had withstood the assault of the barbarians, had preserved its centres of civilisation intact. Under Justinian I (527–565), it consolidated its political power and even made a victorious return to Italy and North Africa. Greek theology prevailed over that of the Latin world and, indeed, all the Church councils, from Nicaea I (325) to Nicaea II (787), were Greek and were held in the East. The art of Byzantium and the Eastern provinces penetrated to the West. However, it is by no means easy to present an overall picture or synthesis of the history of the art of this period. The rise of the Christian East is directly apparent only in architecture. The figurative monuments are far less numerous in the Eastern than in the Western area of the Mediterranean, and we are faced with the task of reconstructing a lost world with the aid of rare and widely dispersed documents. A large number of questions will remain for ever unanswered; our conclusions will be tentative and, on many points, subject to revision.

Architecture: the domed church

While the Latin countries continued to build both basilicas and edifices on a central plan of traditional type, the East devised many variations on the latter plan. The domed church on a cruciform, cross-in-square, polygonal or polyfoil plan came increasingly to supplant the basilica. This evolution resulted, at Constantinople itself and

throughout its sphere of influence, in the creation of the domed basilica, the first authentic manifestation of Byzantine architectural genius, a genius that was to determine the form of Orthodox churches for the next thousand years. As to an explanation of this evolution of Christian architecture in the East, so different from that in the Latin West, it was probably largely influenced by the martyria in the Holy Land, which, for the most part, were domed buildings on a central plan. The veneration in which these sanctuaries were held, and which increased in the course of the 5th and 6th centuries, readily explains their success.

According to a recent theory, symbolic ideas would also appear to have contributed towards this veneration. A Syriac text of the first half of the 7th century, inspired by the writings of Dionysius the Areopagite (6th century), interpreted the domed church as an image of the cosmos

50. PRE-BYZANTINE. Mosaic on the vault of the ambulatory at Sta Costanza, Rome. Middle of the 4th century.

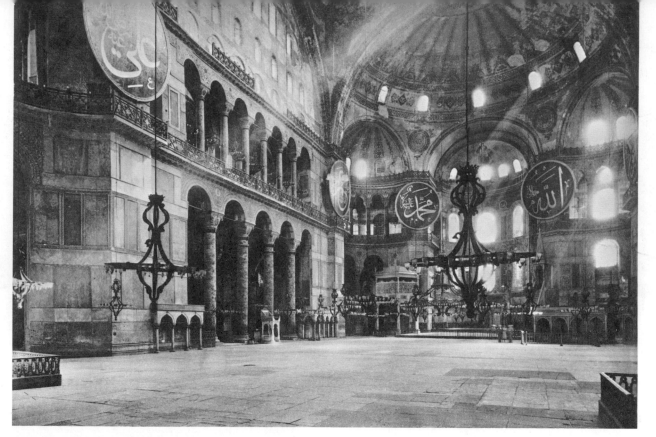

51, 52. BYZANTINE. Interior of Sta Sophia at Constantinople, consecrated in 537, and detail of the columns, noted for their impost capitals and their stylised foliate decoration.

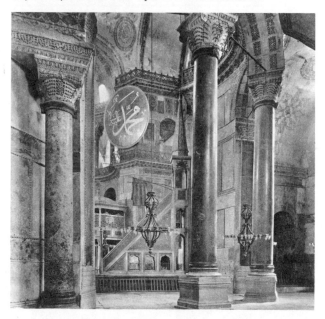

—of the sky and the earth, the dome symbolising the heavens and the hall the earth below. The disposition of certain liturgical installations seems to have been directly determined by this notion. Moreover, a cosmological concept of the domed edifice had already existed during the pagan epoch. Thus, at a very early period, the starry sky, symbol of the next world, was represented in Christian buildings: above the baptismal font at Doura Europos, and with the addition of a triumphal Cross, in the church of the 5th century already mentioned. This symbolism was henceforth to be applied to the building in its entirety.

Other Greek interpretations, apparently dating from the 4th century, explained the different parts of the church in the light of the liturgy. The sanctuary was at once the place of Christ's Passion and Resurrection, and of the heavenly Jerusalem where He would reside at the end of time. Specific areas in the assembly hall of the faithful were reserved for scenes of the salvation, from the creation of the world and the history of the Jews up to the Passion. The West was never to know such an elaborate symbolism in a church.

The majority of the Christian countries of the East, Syria, Mesopotamia and especially Armenia, developed the church with central plan, but the various solutions that they found, however interesting they may be, fade into insignificance beside the domed basilica, which combined in a single structure the two plans typical of Christian architecture.

Little is known of the origin of this plan. It is pre-figured in a few churches in Asia Minor (Meriamlik in Cilicia and Koja Kilisse in Isauria, of the 5th century), characterised by a dome over the nave. In the Byzantine type, however, the aisles, reduced to the role of vaulted ambulatories, are, as it were, overpowered by the dominating dome (the first plan of St Irene at Constantinople, the second Church of the Virgin at Ephesus and Basilica B at Philippi in Macedonia). This plan was developed impressively in Sta Sophia at Constantinople, the high 51–53 point of all Byzantine architecture. The exterior, of an 56 austere simplicity, is but a shell around the immense interior space which, with the judicious distribution of light, the facings of marble, the non-figurative mosaics and the undercut and pierced decoration, is of a sober magnificence. Inside, the spatial effect of the enormous dome is further enhanced by half-domes and semicircular arches. The dome is supported on powerful piers whose function is comparable to that of Gothic piers and flying buttresses. The walls are merely casing; the framework of the edifice has but a single function, to support the dome, which rises like a gigantic canopy, weightless, incorporeal and flooded with light, to an apparently immense height. The architectural form itself suggests

44

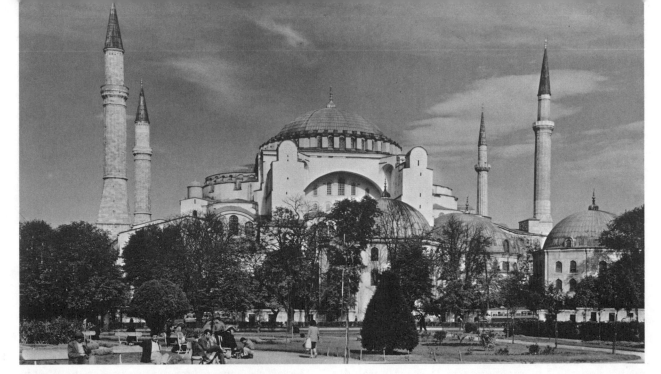

53. View of the exterior of Sta Sophia at Constantinople. The minarets and the wall buttresses date from the Turkish conquest in 1453.

the celestial vault; so, in any case, it appeared to the Byzantine poets who described it.

The influence of Byzantine architecture spread throughout the Balkans and as far as Ravenna. However, a comparison of the church of S. Vitale at Ravenna with that of SS Sergius and Bacchus at Constantinople does reveal a few features characteristic of this Western branch of the art of the capital. In the Byzantine church, which consists of an octagon within a square, the secondary areas, narthex, ambulatory and niches, form a block with the vast central hall. The drum (the upright part below the dome) is low, and the dome barely stands out above the edifice. In S. Vitale, the central hall and ambulatory, though communicating, are clearly separated one from the other. The dome, which is smaller, rises above an elevated drum, and the ambulatory, octagonal like the central hall, juts out considerably from the latter. There is no subtle transition, but a marked contrast between the tower and the ambulatory, each of which is covered with a gently sloping roof: the Italian conception is more plastic and more rational than that of Byzantium.

Figurative art

Although it is only with recourse to texts and to small-scale works of art that the iconography of the Greek church of this period can be reconstructed, there can be no doubt that the Greeks led the West in this field. Rome continued to work in the tradition of the 4th century, though certain modifications already foreshadowed By-

zantine art, while Ravenna achieved a fusion of Latin and Eastern elements.

Some recent publications have brought a few apsidal works of the East to our knowledge, certain of which (Hosios David at Salonica and the monastery of St Catherine on Mt Sinai) are of great artistic value.

The Greek Church, like the Latin Church, represented Christ in Majesty, symbol of redemption, but accentuated the visionary aspect of the representation. It favoured scenes of the Ascension or the Transfiguration, with details inspired by the prophetic books of the Old Testament. In that of the Ascension, which appears to have been the most frequently represented (apses in the oratories at Baouit in Egypt, 6th–8th centuries, the ampullae at Monza and a miniature from the Rabula Gospels), Christ appears in a mandorla (glory); with Him, cherubim and the four Evangelists sometimes appear. A four-wheeled chariot under His feet betrays the literary source of this composition, Ezekiel's vision (X, 1 and following). The witnesses to the scene, the Virgin and the Apostles in the Ascension and the three disciples in the Transfiguration (the prophets Ezekiel and Habakkuk in Hosios David at Salonica), make of these representations divine epiphanies of a striking character.

It is possible that this iconography was first created for the sanctuaries of Palestine, which glorified the events represented (Churches of the Transfiguration and of the Ascension, near Jerusalem). According to certain scholars its original source was probably the imagery of the

54. Plan of SS Sergius and Bacchus in Constantinople. Central plan. 526–527.

55. Plan of S. Vitale at Ravenna. Central plan. 547.

56. Basilica with dome: Sta Sophia in Constantinople. 537. *(After Holtzinger.)*

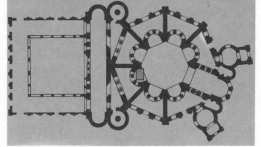

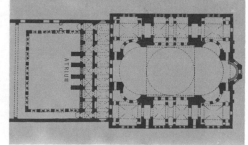

Hellenistic monarchs, whose accession to the throne was considered as an epiphany and was celebrated with annual festivities.

Another subject found in the Greek East, in apses, the Virgin enthroned or standing and holding Christ Emmanuel, probably developed out of considerations of a strictly theological nature, the decisions of the third ecumenical council (Ephesus, 431) which, in opposition to the Nestorians, had declared Mary to be the Mother of God. Several other examples of this composition are to 79 be found in frescoes and mosaics and on a few ivory diptychs.

The scenes from the Gospels, which continued widespread during the 4th and the early 5th centuries, were organised in accordance with far more rigorous rules and were assigned a fixed place in the churches. These were placed on the walls of the aisles leading to the sanctuary to prepare the thoughts of the faithful for the mystery of salvation which took place before the altar.

Although partly inspired by the narrative cycles of the manuscripts, this iconography was symbolic and liturgical. Like the scriptural readings during the offices of the ecclesiastical year, it evoked the successive epiphanies of the Lord, the Annunciation of His coming, His birth and youth, the miracles and, finally, the supreme revelation of His divine nature in the Passion and His appearances after the Resurrection.

The formation of these cycles, which has been attributed to about the Constantinian epoch, in fact dates back no further than the 5th century, and, though the earliest monumental example is to be found in S. Apollinare Nuovo at Ravenna (c. 520), it is probable that they originated in the Greek East. The choice of subjects and their sequence in the church at Ravenna, in which two 57 series, that of the miracles and that of the Passion, adorn

the upper part of the walls of the nave, were certainly dictated by the local liturgy, but the idea in itself was probably Greek and adapted to the Latin cult.

The Greek cycles proper are known from a 6th-century text, a description of the church at Gaza (Palestine) by Bishop Choricius, from ivory objects (the throne of 59 Maximianus and diptychs with five panels) and metal 58 objects (ampullae of Monza and the medallion of Adana), from enamels (Vatican) and paintings on reliquaries, from 62 a Syriac manuscript (Rabula Gospels) and from a few 8 frescoes at Baouit and in the Red Church at Perustica in Bulgaria. These cycles, which are found as late as the 11th century in the archaic paintings in the rock churches of Cappadocia, mainly illustrated apocryphal subjects (the Trial by Water, a form of the Annunciation) which were also Eastern. The Crucifixion was of the 'Syrian' type; Christ was not naked, as in the 5th-century representations, but was dressed in a long tunic; Longinus was shown piercing His side and a soldier handing Him the sponge.

These cycles appeared for the first time in the West in the frescoes and mosaics executed in Rome (in Sta Maria Antiqua and in the so-called Oratory of John VII) at the beginning of the 7th century for Pope John VII, who was of Greek origin. The paintings in Castelseprio, of the 8th or 9th centuries, mark the end of this cycle.

Ravenna and the 'Imperial' style of Byzantium

The creative centre of this iconography was most probably Palestine. The art of Ravenna, the only art of this period that presents a group of works of sufficient importance to permit of an analysis of the monumental style, perhaps reflects the official art of Byzantium. We hasten to add, however, that this is all largely conjectural. Even at Constantinople, no figurative images of this

57. Mosaic decoration covering a part of the left wall of the nave in S. Apollinare Nuovo, Ravenna.

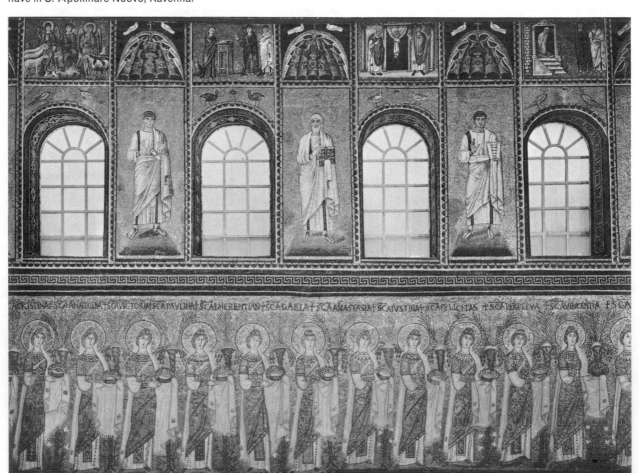

period have survived; we can only deduce their existence.

During the 5th and 6th centuries the Byzantine Emperor, developing the traditions of his Roman predecessors, became the head of a veritable theocratic state and, while centralised political power gradually disappeared in the West, the Byzantine Empire became ever more powerfully organised. The monarch was at once its temporal and spiritual head, and his court was governed by a rigid ceremonial, whose Roman etiquette was strongly admixed with Asiatic forms.

Although the influence of this court made itself felt in numerous works of art, it would seem to be most evident at Ravenna. In the two most important series of mosaics preserved there, in S. Apollinare Nuovo and in S. Vitale, the Imperial cortèges occupied the place of honour. On the north and south walls of the nave in S. Apollinare Nuovo, they were replaced, under Justinian I, by two long processions of male and female saints; the rest of the decoration is pre-Justinian. On the south wall in the basilica, King Theodoric and his retinue were shown coming forward from the sacred palace to pay homage to Christ; opposite, another figure, probably the queen, bowed low before the Virgin Mother. The surviving representations of the prophets and other personages of the Old Testament above these cortèges and, higher up, the cycles of the miracles and of the Passion of Christ, already mentioned, placed the Imperial processions in the centre of a Christological composition (the church had originally been dedicated to Christ the Saviour, and its name was only changed at a much later date) which could only have been inspired by the Imperial court.

The same idea is expressed in a Eucharistic cycle in S. Vitale. Justinian and his retinue on the north wall, and Theodora and her court on the south wall, are shown bringing their offerings in accordance with a typically Byzantine rite, while Christ as Cosmocrator sits enthroned in the apse on the globe of the universe (see the Christ in Sta Costanza) to receive them. The walls of the square chamber leading into the apse are figured with the biblical symbols of the Eucharistic sacrifice; the lamb on the keystone of the vault, surrounded by a paradisiacal decoration, symbolises Christ's death on the Cross and the sacrifice celebrated at the mass. The Crosses appearing on the summits of the arches throughout the basilica add a triumphal note to the whole.

The style of the works perfectly matches their content. The religious subjects are emphasised by a rational composition, by the rigid symmetry of the groups which are balanced from wall to wall and by a reduction of scenery to the bare essentials. Illusionistic perspective has been discarded, and the scenes unfold on a single plane. Trees, houses and mountains are grouped not in accordance with their relationship in space but according to a decorative rhythm which underlines the importance of the subjects represented.

The figures stand rigid and immobile, and their rare gestures are slow and conventional. Only the heads, in particular in the Imperial cortèges in S. Vitale, are of striking modelling and realism. The disproportionately large eyes, with their fixed gaze, betray an inner life that contrasts with the solemn tranquillity of the attitudes. The colour, of a wide variety of tones, never approaches to an imitation of nature: the greens, reds and yellows sometimes clash or are juxtaposed without transition, and

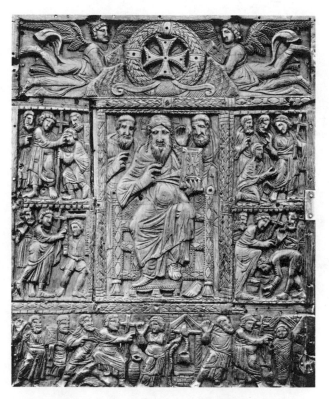

58. BYZANTINE. Panel of an ivory diptych of the 6th century. On either side of the enthroned Christ are scenes of the miraculous healings described in the Gospels: below are episodes from the story of the Woman of Samaria and the Raising of Lazarus. *Bibliothèque Nationale, Paris.*

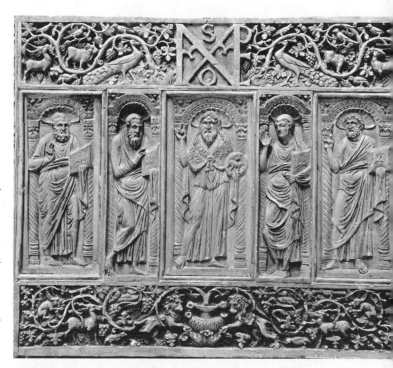

59. BYZANTINE. Front panel of the throne of Maximianus: St John the Baptist and the four Evangelists framed in a rich design of plant motifs and animals of all kinds. Middle of the 6th century. *Archiepiscopal Palace, Ravenna.*

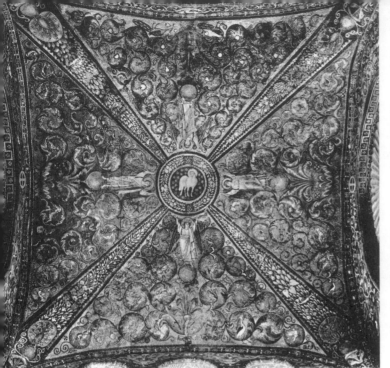

60. BYZANTINE. The glorification of the Mystic Lamb. Mosaic on the vault of the presbytery of S. Vitale. 532–547.

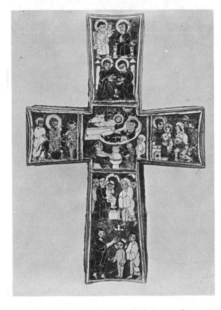

62. BYZANTINE. Reliquary cross of cloisonné enamel showing scenes from the Gospels: the Annunciation, the Visitation, the Flight into Egypt, the Nativity, the Adoration of the Magi, the Presentation in the Temple and the Baptism. 8th–9th centuries. *Museo Sacro, Vatican.*

63. Justinian, accompanied by his retinue. Mosaic in S. Vitale. *c.* 547.

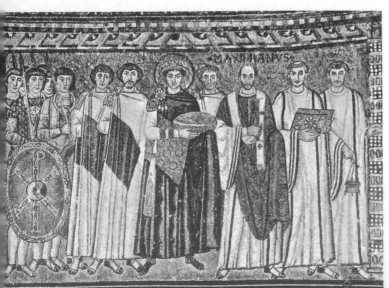

61. Christ seated on the globe of the universe and handing the martyr's crown to S. Vitale. Mosaic in the apse of S. Vitale.

the cubes of gold, silver and mother-of-pearl create an effect of sumptuousness which culminates in the image of Theodora, whose head seems to be encircled in a halo of jewels. Moreover, with their ornamental borders, the mosaics look like carpets hung around the walls.

The study of the formation and the antecedents of this style, which it has become customary to regard as the Byzantine style par excellence, has given rise to numerous controversies. Its creative centre has been sought at Byzantium, even at Ravenna, in Palestine and, more recently, at Alexandria. We have observed it, at the beginning of the 5th century, in St George at Salonica, where it remained implanted until the iconoclastic epoch. It dominates the mosaics of the 7th century in St Demetrius, in which the rigidity of the attitudes has been accentuated to the point of petrifaction. It is also encountered far further to the East, on Cyprus (Panaghia Angelokistos) and in the monastery on Mt Sinai.

In our opinion, the idea that it originated at Ravenna, whose political importance was not sufficiently great, should be discarded. The Imperial character of this art and the numerous peculiarities which betray the influence of the court ceremonial point towards the capital, whose part in the formation of this style was doubtless considerable if not decisive.

The early phases of its history elude us. Eastern influence seems certain, but to what extent it is hard to gauge. The paintings and sculpture at Doura, the mosaic pavements at Edessa (Urfa in northern Mesopotamia, present-day Turkey) and the art of Palmyra foreshadow this style, which is characterised as from the 1st century A.D. by a hieratic aspect and by groups of immobile figures in frontal positions, with narrow heads and wide-open eyes.

Attention has also been drawn to the undeniable resemblance of these Byzantine works, certain icons in particular (the most ancient of which are to be found on the Sinai Peninsula), to the portraits of Fayum and Antinoöpolis (1st–4th centuries). Elsewhere, moreover, within the confines of the Roman Empire, and at various times between the 2nd and the 5th centuries, there were portraits and groups of figures which herald this style (the art of the northern and north-eastern provinces of the

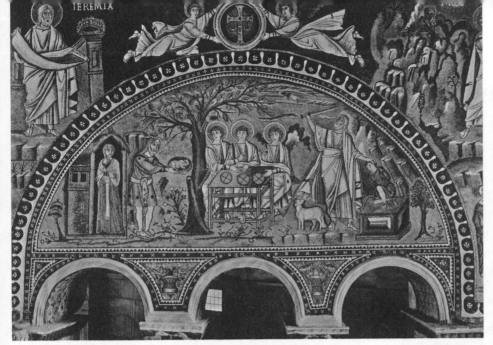

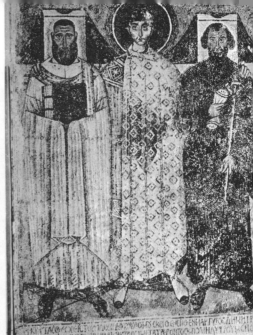

64. BYZANTINE. Two episodes in the life of Abraham – antitypes of the Eucharistic sacrifice: the meal offered to the angels who have come to announce the birth of his son; and the sacrifice of Isaac. Mural mosaic in the presbytery of S. Vitale. 532–547.

65. BYZANTINE. Mosaic in St Demetrius at Salonica, representing the patron saint and the founders of the basilica. 6th–7th centuries.

Empire). By the beginning of the 4th century, the frontal position had even penetrated to the Roman monetary art, which was conservative by definition.

In fact, 'Byzantine' art did not originate in any specific town or specific region. It was the outcome of an evolution of Graeco-Roman art, the causes of which are, in our opinion, multiple. The moment the classical canon of the human body was abandoned, because of a new outlook on the world, art became receptive to forms of widely diverse origins. Perhaps the Near East, where religious fervour was intense, made a particular contribution to the creation of Byzantine style, since certain of its features had for centuries been implanted there. Nevertheless, it was doubtless the Imperial capital which gave it its definitive character and which ensured, if not its coming to maturity, at least its spread.

An art comes to an end

Apart from a few centres in Italy, the period between 550 and 750 was a 'dark age' in the West, where the Graeco-Roman tradition disappeared and a barbarian style preceded the earliest works of Carolingian art. The group of Aquitanian sarcophagi in Gaul and the scattered remains of architecture in Spain, the 'Visigothic' churches, the dates of which are uncertain, attest to a reduced survival of ancient art. At Byzantium, the accession of the iconoclastic Emperors, at the beginning of the 8th century, marked a sudden break in the history of art. The works created during their reigns were systematically destroyed by their iconodulic successors. We only know them from descriptions and, perhaps, from the decoration of the palaces and mosques of the Umayyads, the first Moslem dynasty, that reigned from 651 to 749. This Umayyad occupation of the southern and eastern shores of the Mediterranean, which extended to Spain within the space of sixty years, certainly put an end to Christian art on a grand scale, though the Graeco-Roman tradition did not disappear as completely there as in the West. The art of the first caliphs continued and developed the art of the countries in which it took root, emptying it of its Christian content. The incomparable decorative richness of these Islamic works can only be explained by that of the

Christian monuments which preceded them, and which were hardly less rich. Ornamentation, which was initially of plant motifs and later abstract, became for the first time the central theme of a nonfigurative art. Of this style, which disappeared in the 8th century, only one Christian work is known, the mosaics in the Church of the Nativity at Bethlehem.

In the West as in the East, the 7th and 8th centuries marked the end of an epoch. The history of an art born on the soil of the Empire and nourished with Graeco-Roman civilisation came to an end. This art derived from two main sources: contemporary pagan art—and Imperial art in particular—and the Christian religion itself. The one determined its form, the other its content. In its early phase, during which the Latin West played the principal creative role, this art was still entirely fashioned on classical traditions. Later on, as the initiative passed to the Greek East, Christian thought predominated to an increasingly marked degree over that of the pagans. Liturgy and theology determined the choice and the disposition of the images in the churches. The style became more 'Oriental'; the classical ideal of physical beauty faded, and art concerned itself with the spirit.

Despite its diverse components, the art of this period formed a homogeneous ensemble whose unity is explainable by historical factors. The social and economic structure of the society that produced it had changed but little since Roman times. Urban civilisation had survived, sustained by the administrative and military organisation of the Empire, which had remained intact.

In the West, this framework gradually disintegrated, and finally disappeared in the 7th century. Though the break in development was less marked at Byzantium, profound changes came about due to the iconoclastic crisis, to the contraction of the borders of the Empire, and to social disorders. Byzantine art of the 9th century was an art of the Church rather than an art of an urban society. However, the architectural forms and iconographic formulas created during this period of intense intellectual and artistic activity were to endure and were to constitute the foundations of the art of the Middle Ages in both the East and the West.

HISTORICAL SUMMARY:
Early Christian and Byzantine art

EARLY CHRISTIAN ART

Archaeology. Towards the middle of the 16th century, Onofrio Panvinio, a monk, became interested in the (at that time buried) catacombs in Rome. Antonio Bosio (1576–1629) initiated the new science with the publication of the results of his thirty-five years of excavation. Research was continued during the 18th century by such scholars as Raffaele Fabretti and, in France, Séroux d'Agincourt (1730–1814). It was Gian Battista de Rossi (1822–1894), with the help of Pope Pius IX, who founded the Lateran Museum for Christian Art and Archaeology in 1854, who really promoted Christian archaeology. In the 20th century Dom Fernand Cabrol and Dom H. Leclercq undertook the publication of a dictionary of Christian archaeology.

THE BEGINNINGS OF CHRISTIAN ART

History. Christianity appeared at the end of Tiberius' reign (37) or the beginning of Caligula's (37–41), and at first consisted of a handful of Jews gathered at Jerusalem, assiduous temple-goers as they had recognised Christ as the Messiah. Within five centuries Christianity had conquered the different peoples of the Roman Empire, some of the Celts of Scotland and Ireland, various Germanic peoples, Persians, Arabs and Ethiopians. As an illegal religion, it was hated by the masses and feared by the state. Condemned under Nero, the Christians were for the next two and a half centuries constantly liable to the death penalty, but the persecutions were intermittent; apart from Nero's atrocities in 64, none equalled those of the 3rd and the beginning of the 4th centuries: edicts of Decius (249–251) and Valerian (257 and 258), and finally, under Diocletian (284–305), 'the great persecution' which began with the edict of 303. These persecutions gradually diminished: in the West, following Diocletian's abdication in 305; in the East, following the edict of Galerius (311).

Places of worship. During the persecutions the Christians only met at rare intervals in the catacombs and cemeteries. The Pope, St Sixtus, was beheaded on his episcopal chair in the St Praetextatus catacomb, for having disobeyed the decrees of Valerian and Gallienus against these reunions.

The first places of worship were:

Private houses, merely the villas of the rich Christians, opened to the community. History has preserved a few names: in Rome, the senators Clemens and Pudens; at Corinth, the matrons Aquila and Priscilla; in Gaul, where Gregory of Tours mentioned the house of the matron Victorina.

In some cases churches have been built on the ruins of these villas: in Rome (S. Clemente, Sta Anastasia, SS Giovanni e Paolo and Sta Sabina) and in the Loire-Atlantique and the Gironde departments in France.

Churches. In Rome, a decree of Alexander Severus (222–235) accorded the Christians a disputed site on which to build a church. In 260, by Gallienus' order, churches in Rome were restored to the Christians. Recent discoveries have shown that at the beginning of the 3rd century, due to Pope Calixtus' insistence, the Christian community acquired assembly halls (*tituli*) in various parts of Rome. There were over twenty of them before the time of Constantine; the church of S. Martino ai Monti, doubtless built during the 3rd century up against the Esquiline, is the oldest church in Rome. Its façade resembles that of a villa; a small vestibule precedes the rectangular hall, 46 × 52 ft without apse, covered by six groin vaults resting on wall pilasters and on central pillars. Walls and vaults are adorned with an unoriginal painted decoration. There are in addition two adjoining chambers and an upper storey. In the East, the chronicles of Edessa (in the 7th century) and Arbela mention churches in Syria and Asia Minor. Many were destroyed under Diocletian. Remains attest to their existence, but the chancel with three apses of the basilica at Emmaus, largely built during the time of the Crusades, may date from the 3rd century (this theory is disputed).

Catacombs. These subterranean burial places were merely long, narrow galleries; superimposed niches were hewn from the wall, to contain the bodies [**66, 67**]. Christian cemeteries, which did not differ in function from the pagan and Jewish catacombs, existed throughout the Empire from the end of the 2nd century: in Rome, at Naples, at Alexandria, at Syracuse, on Malta, in North Africa and in Asia Minor.

Iconography. The catacombs, whether Christian, pagan or Jewish, gave rise to a pictorial and sculptural art. The decoration of the Christian catacombs did not depart from that of the society in which it originated; it adopted the pagan pictorial themes—eliminating their idolatrous or sensual images—but interpreted them according to a secret symbolism. Thus a veritable system of religious iconography had been formed by the 3rd century. Christian art was not an original creation: it derived not only from Roman but also from Eastern art, from that of Palestine and the great semi-Oriental, semi-Hellenistic, cities: Alexandria, Antioch and Ephesus; nevertheless the Christian faith endowed it with a new spirit.

Adapted secular themes. These consisted of purely ornamental motifs (funerary chamber of Ampliatus in the Domi-

66. EARLY CHRISTIAN. View of the so-called 'Flavians' hypogeum, in Rome. 2nd century. At the far end is a niche for a sarcophagus; in the walls are niches in which the bodies were placed on the bare stone; the ceiling is decorated. *(After Styger.)*

67. Plan of a part of the Calixtus catacomb, Rome.

tilla catacomb and crypt of S. Gennaro in the Praetextatus catacomb, Rome, Constantinian epoch), or ancient mythological themes: Cupids, winged djinns or the putti frequent in Pompeian art (Domitilla catacomb, end of the 2nd century; Lucina crypt, 3rd century [36]); Victories (fresco in the St Agnes catacomb) sometimes alternated with Cupids. The artists who adorned the catacombs were often those who had worked on the pagan and Jewish houses and hypogea. Thus, the theme in the Jewish hypogeum at Palmyra resembles that in the Chapel of the Sacraments (3rd century).

Adapted themes of a mystic nature. (The decline of paganism reflected the preoccupation with the new beliefs.) These themes symbolised the immortality of the soul or the belief in a future life; Christian art could draw freely upon this funerary iconography, whose symbolic meaning conformed to Christian thought.

While pastoral scenes came to symbolise paradise, the myths of Orpheus (Priscilla and Domitilla catacombs, end of the 2nd century) and of Cupid and Psyche (reproduced three times in the Domitilla catacomb, beginning of the 3rd century) suggested the immortality of the soul.

Even the decorative motifs acquired a mystic significance (the vine: paintings on the ceiling of the entrance gallery in the Domitilla catacomb, end of the 2nd century).

Animals came to be included in Christian symbolism. A dove figured in scenes of the Baptism of Christ and in representations of Noah's Ark on epitaphs and on funerary frescoes (epitaph of Urbica, and Calixtus catacomb, end of the 2nd century). The lamb, the Christian symbol par excellence, was first represented in a fresco in the Domitilla catacomb at the end of the 1st century (inscription in the Calixtus catacomb, beginning of the 3rd century; fresco in the Calixtus catacomb; painting in the catacomb of SS Peter and Marcellinus; Praetextatus catacomb, 4th century). The fish, symbol of Christ, assumed an important place in both literature and iconography (fresco in the Lucina crypt; Chamber of the Sacraments in the Calixtus catacomb; fresco in the catacombs at Syracuse), and early figured in the East (Isaurian sarcophagus of the 3rd century). The peacock, symbol of immortality (S. Gennaro cemetery at Naples), became widely diffused as from the 4th century.

These themes, the majority of which were taken from Roman sarcophagi, also figured in the hypogea of the Oriental sects: Phrygian, Isiac and Mithraic (Praetextatus catacomb; sepulchre of Vicentius and Vivia, worshippers of the Phrygian god Sabazius), or again in the Jewish hypogea at Carthage, Rome and Palmyra (dating from 259) and even in the rock tombs of Sidon. This curious parallelism, added to that of the plan of the religious edifice (basilica-synagogue), raises the important question of the relationship between Jewish and Christian art.

Symbols not in current use. These became the signs of Christianity. The anchor does not figure in pagan tombs; it is found in Gaul and in Africa, rarely in the East. In the Priscilla catacomb it is associated with the word ἐλπίς (hope); on gems, with the fish. In frequent use from the end of the 2nd until the middle of the 3rd century, it subsequently disappeared completely. Only of importance in the Aegean religion, during the 2nd millennium, the Cross did not appear much before the 4th century on Christian monuments, and its origins are obscure.

Symbols arising from Christianity. Figures in orans (in the attitude of prayer) were often associated with the Good Shepherd [34] (vaulted ceiling of the Lucina crypt, first half of the 3rd century [36]).

There are few scenes from the Old Testament (Abraham's Sacrifice, Noah's Ark, Jonah and the Whale [35]), and still fewer from the New Testament (the odd reminder of the miracles of Christ: the Miracle of the Loaves and Fishes, and the Raising of Lazarus). In the 2nd century there were figures of Christ (fresco in the Praetextatus catacomb; baptistery at Doura Europos) and the Virgin [1] (painted in the Priscilla catacomb, first half of the 2nd century—which may be compared with Raphael's *Madonna of the Chair*.

THE ART OF THE CHURCH TRIUMPHANT

History. Diocletian's gigantic effort to stamp out Christianity failed. With the edict of Galerius, in 311, and the decree of Licinius, in 313, issued at the time he was negotiating with Constantine, to whom it is attributed under the name of Edict of Milan, the Church was recognised. Although Constantine did not hide his sympathy towards Christianity, he did not declare it unequivocally until after 324, when, having defeated Licinius, he founded his capital at Byzantium. The council of Nicaea (325) declared Christianity a state religion, after which began the struggle against paganism: a law of 341 abolished sacrifices; despite the brief reaction during the reign of Julian the Apostate (361–363), both widespread and local measures increased and the temples were closed (edict of Theodosius, 27th

68. Type of central plan: the octagonal sanctuary of the Ascension, Jerusalem. 4th century. *(After Grabar.)*

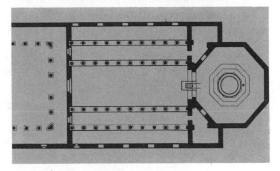

69. Type of composite plan: the Church of the Nativity, Bethlehem. 4th century. Combination of an octagon and a basilican hall with nave and four aisles. *(After Grabar.)*

70. Type of basilican plan. Old St Peter's Rome. Begun in 324 and finished in 344, this basilica had a nave and four aisles and was preceded by an atrium with four porticos. The building had a transept. *(After Dehio and Bezold.)*

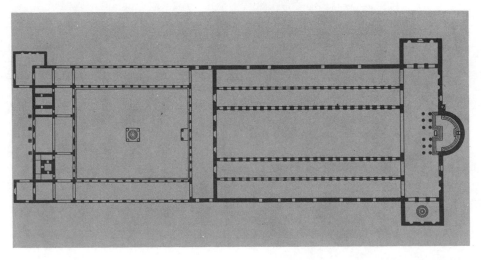

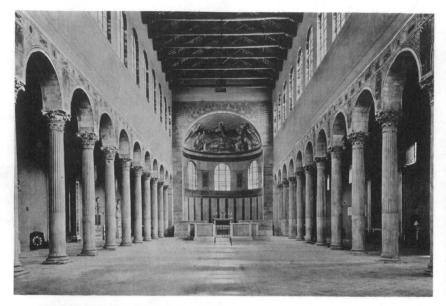

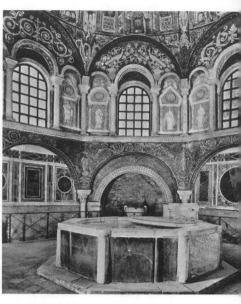

71. PRE-BYZANTINE. Interior of Sta Sabina, Rome (c. 425); church restored to its original state. This is a simple basilican plan, with nave and two aisles, of lesser height, and without a transept; it has a timber roof.

72. PRE-BYZANTINE. Interior of the Baptistery of the Orthodox, Ravenna. c. 450. It is on central plan with a dome resting on an octagon with a square base. Marble and mosaic decoration.

February 391). In Egypt, the stronghold of paganism, the Serapeum at Alexandria was destroyed (389).

Architecture. Since the houses of worship no longer sufficed, it became necessary to create a Christian architecture.

The basilica, whose name is taken from the civil basilicas in the forums, did not appear until the 4th century. In plan it is an elongated rectangle, divided by two rows of columns into a nave and two aisles of lesser height, covered with a timber roof, and ending in a semicircular vaulted apse [71]. The upper walls of the nave were sometimes pierced by windows (thus making a clerestory), and there was generally also an atrium. Basilicas, oratories, martyria and baptisteries sprang up everywhere and particularly in Rome, Constantinople, Antioch and Jerusalem.

Constantine built many basilicas in Rome: S. Giovanni in Laterano, with its baptistery; St Peter's, built over the Apostle's tomb; S. Paolo fuori le Mura; S. Lorenzo fuori le Mura; SS Peter and Marcellinus and Sta Agnese. St Peter's presented a peculiarity: a projecting transept at the far end of the nave preceding the apse [70]. There is some doubt as to whether this is a purely architectural element or a religious symbol.

In the East, Constantine may have begun Sta Sophia, which was completed in 360, under Constantius; this first church, together with the churches of St Irene and of the Holy Apostles, disappeared completely in the subsequent reconstructions. Constantine's principal foundations were in Palestine and Syria: at Antioch, where he began the Great Church or Golden Temple (331); at Jerusalem, where he built the basilica and rotunda of the Holy Sepulchre (326–336); at Bethlehem, where he built the Church

of the Nativity. Like their Roman counterparts, these basilicas are either rectangular or round in plan; an innovation was the fusion of the basilica and the rotunda into a single building [69].

Sculpture. The Early Christian sarcophagi, which appeared towards the end of the 2nd century, developed mainly from the 4th century onwards. The iconography gradually evolved from pagan, and especially Alexandrian, traditions; and the bearded Syrian type of Christ eventually replaced the clean-shaven, Hellenistic Christ. The principal centres of production were Rome, Arles, Spain and Asia Minor, where Eastern influence predominated.

Iconography and painting. The rise of the Church was followed by a remarkable development in dogma and theology, defined by the ecumenical councils (the council of Nicaea, in 325, directed against Arianism, defined the nature of the Trinity).

A twofold influence marked the new Christian art: that of the great theologians (St Basil, d. 379; St Gregory of Nazianzus, d. 390; St Gregory of Nyssa, d. 395; St Ambrose, d. 397; St John Chrysostom, d. 407; St Jerome, d. 420, and St Augustine, d. 430), and that of the custom of making pilgrimages, which grew out of the growing worship of saints and martyrs. It was thus on Palestinian soil that the iconography was renewed.

This led to the appearance of new symbols: the Monogram, the nimbus and the Cross. However, apart from the mosaics, nothing remains of the pictorial art in the basilicas built by Constantine. According to Eusebius, apses, mausoleums and oratories were adorned with

apocalyptic themes and with the new symbol of the Cross.

Mosaics became a more and more essential element of the decoration, and it was at this time that gold, silver and mother-of-pearl came into use.

PRE-BYZANTINE ART
(4th–6th centuries)

History. The period from the reign of Constantine to that of Justinian witnessed the steady widening of the gulf between the declining Western Empire and the East, which, with Byzantium (chosen by Constantine as his capital in 324), was henceforth predominant. About fifteen Emperors in succession pursued the struggle against invasion and heresy. The best known of them is Theodosius the Great (379–395), who revitalised Christianity. At his death, Theodosius divided the Empire between his two sons, Arcadius receiving the East, which from that time followed an independent course. Theodosius II (408–450) enlarged the capital, in which he founded a university. Religious art flourished from Italy to Asia Minor. Proto-Romanesque (Merovingian, early Carolingian) appeared in Gaul and Spain.

Architecture. The basilican church remained popular and two new elements appeared: the stone roof over the basilica and the centralised plans, cruciform [73] or cross-in-square.

The replacement of the architrave by the archivolt, under the influence of the East, modified the already simplified Corinthian capital, cut with the sculptor's drill, and led to its either being surmounted by an impost, with which it was sometimes carved out of a single block (Ionic impost), or being itself reduced to the trunk of an inverted pyramid (corbeil

capital), with openwork decoration. The new types were elaborated between the 4th and 6th centuries [**14–17, 52**].

Italy The early basilica is to be found in Rome: Sta Sabina [**71**]; at Naples: S. Giorgio Maggiore, S. Gennaro fuori le Mura, the baptistery of the cathedral, built by Bishop Soter (end of the 5th century) and adorned with exquisite mosaics. This last building introduced into the West the transition from a square base to a circular dome by the use of the squinch. The baptistery at Nocera (5th century), with its vast dome resting on two arches intersecting in its centre, would be the oldest example of rib vaulting, if it were certain that this dome was really a part of the original edifice.

Two pre-Justinian basilicas were built at Ravenna, St Ursus (4th century), now no longer standing, and S. Giovanni Evangelista which, founded by Galla Placidia towards 425 and contemporaneous with Sta Agata, has two small, square structures flanking the apse. On the central plan we find the Baptistery of the Orthodox (*c.* 450) and the Arian Baptistery (beginning of the 6th century): here the octagon is transformed into a square at the base of the edifice, through the addition of small apses on the four sides [**72**]. The mausoleum of Galla Placidia (*c.* 450), cruciform in plan, has a dome on pendentives; there are barrel vaults over the equal arms of the cross [**73**].

An innovation in the Baptistery of the Orthodox [**72**] is the ornamental arcading, subdivided into two small arches linked by a console; this formula continued to develop and became a characteristic feature of the first Romanesque art.

Greek school. The important churches are St John Studios (463) at Constantinople, a Constantinian type of basilica having a triforium gallery (passage above the side aisles with an arcade opening on to the nave) which was reserved for women, and, at Salonica for the church of St Paraskevi (Eski Djuma), of the 5th century, and St Demetrius, the latter representing one of the earliest examples of a crypt with an ambulatory (aisle encircling an apse). There are about thirty Constantinian basilicas in and around Greece.

Syria. Here Christian architecture occupies a very important position. North of Antioch and Aleppo there was the current type of rectangular basilica with a pitched timber roof, but with the chancel terminating in a semicircular apse between two square chambers: a sacristy and a martyrs' chapel. The western end of the buildings oriented towards the east sometimes contained a narthex (porch) flanked by two square towers connected by a gallery above the narthex. (See the basilicas of Fafirtin [**372**] and Serdjilla and the cathedral at Brad, with their interior arches supported on columns, and the church at Kalb Louzeh, dating from the 5th century, where pillars have replaced the columns.)

In the south, the timber roof was replaced by a flat roof of basalt tiles. The basilica had no side aisles, but was divided by transverse arches of dressed brick, as in

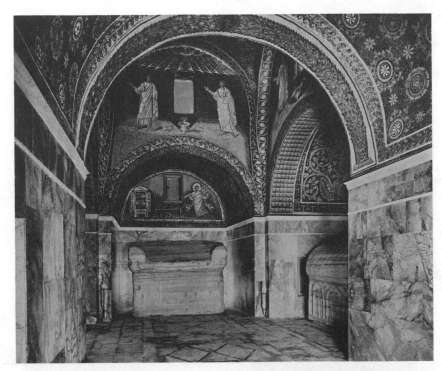

73. PRE-BYZANTINE. Interior of the mausoleum of Galla Placidia, at Ravenna. *c.* 450. This is of cruciform plan with a central dome on pendentives. It has a rich facing of mosaics.

the church of St Julianos, the oldest church in Syria (344), at Umm idj Djimal.

In churches on the central plan the interior is circular or octagonal with semicircular niches at the angles to give a square ground plan, as for instance in the cathedral at Bosra (512), St George at Ezra (515) and St John the Baptist at Gerasa (513). The church of the Prophets at Gerasa (474–475) is an example of the cruciform or cross-in-square plan, and St Elias at Ezra represents a transitional type, between the cruciform and the cross-in-square.

It is not known whether the dome was used in Syria (possibly in the cathedral at Bosra and in the monastery of Kalat Seman) or whether there were only wooden lanterns.

In the north-east and in upper Mesopotamia, the basilican type interior consisted of an aisleless nave covered with a barrel vault and with buttresses projecting inwards, the spaces between them permitting the insertion of side chapels, as in Catalan Gothic churches of the 13th century.

The influence of Asia Minor and Armenia is manifest in the nearby churches with domes (Mar Yakub at Nisibis [**359**] and Adhra at Hah).

Asia Minor. The Constantinian basilica, which, like those in Rome, sometimes had a transept, was either vaulted (in the region of Kara Dagh [5th century]; the barrel vault was sometimes reinforced with transverse arches resting on massive pillars with engaged half columns), or domed (this may have been the case at Meriamlik, in Cilicia [*c.* 474–491]), the dome supported on small niches.

74. PRE-BYZANTINE. Glass medallion with gold background, set into the centre of a cross. 4th–5th centuries. *Brescia Museum.*

75. PRE-BYZANTINE. Rothschild Cameo, showing either Honorius and Maria or Constantine II and his wife. 4th century. *R. de Rothschild Collection, Paris.*

76. PRE-BYZANTINE. Ivory panel showing Christ's Resurrection and the Holy Women at the Sepulchre. Beginning of the 5th century. *Munich Museum.*

77. BYZANTINE. Marble transenna with pierced decoration. Middle of the 6th century. *Ravenna Museum.*

78. PRE-BYZANTINE. Detail from an ivory reliquary casket, showing Ananias and his wife struck dead by St Peter for their dishonesty. Second half of the 4th century. *Brescia Museum.*

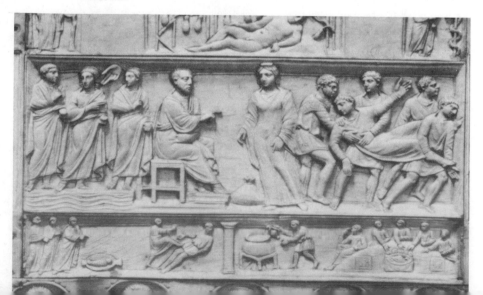

The central plan of the cathedral at Antioch, which has not survived but which Gregory of Nazianzus described in 374 as an octagonal edifice of the Constantinian period, was adopted in the chapels flanking the basilica at Dere Ahsy (Lycia), at Hieropolis (Phrygia), at Ulu Bunar (Isauria) and at Soasa (Cappadocia). The Greek cross appeared in association with the cruciform plan.

North Africa. The oldest church was at Orléansville (325). Inside, the churches were divided into numerous aisles (at Carthage, at Saint Cyprien and in the basilica Majorum: a nave and six aisles; in Damous al Karita: a nave and eight aisles). The discovery of the baptistery at Djemila (5th century) has proved that neither the central plan nor the dome was unknown in this region.

Sculpture. Whereas monumental sculpture declined, the Imperial busts and statues (colossus at Barletta) acquired a stiffness, and painted decoration or pierced stonework replaced carving in relief, the tradition of the sarcophagi was perpetuated at Ravenna until the end of the 6th century. The decoration on the columns of the ciborium, on the pulpit (ambo) and on the marble screens (transennas), done with the drill, often produced pierced ornamentation resembling embroidery and inspired by textiles.

The influence of ancient sculpture persisted, on a smaller scale, in the ivories, produced in all the great urban centres of the Empire (Constantinople, Alexandria, Antioch) [12, 13, 76, 78].

Painting. In contrast to the first Early Christian art, pre-Byzantine art evolved a rich, grandiose and brilliant style, which became a means of teaching, a theology in pictures; this new concept prevailed throughout the Middle Ages until the start of the Franciscan movement.

Mosaic work became the chief medium for this grandiose style; on a dark blue or a gold background, it covered walls and apses. Examples in Rome were in Sta Pudenziana [40], in Sta Maria Maggiore [45] and in SS Cosma e Damiano. An example at Ravenna was the mausoleum of Galla Placidia (*c.* 450) [44, 73].

Christ was glorified in the iconography and, from the beginning of the 4th century, became the central figure (Christ in Majesty, with long hair and a thick beard [40]; Christ Triumphant, enthroned and clad like an emperor), together with the Cross [44], the glorious instrument of salvation.

Old Testament (Elijah carried up to Heaven) and New Testament (the Passion [46, 49] and the Resurrection [76]) subjects and allegorical figures appeared, together with historical cycles [45], many of which are badly damaged or have vanished. But they can be reconstructed from the writings of St Paulinus of Nola on the basilicas built at Nola in 402; from those of Prudentius; from those of Choricius of Gaza, a contemporary of Justinian, on St Sergius at Gaza; from small monuments (wooden doors of Sta Sabina in Rome [49]; silver casket of S. Nazario at Milan, placed beneath the altar in 382; ivory casket in the Brescia Museum, 4th century [78]), and, finally, from the miniatures in Bibles and Gospel books [82] inspired by the historical cycles.

BYZANTINE ART

Archaeology. The study of Byzantium was begun as early as the 17th century by the French scholars Labbe and Du Cange, but the exclusive prestige of Rome long stood in the way of an accurate knowledge and a just appreciation. It was only with the publication of the completely novel though often exaggerated theses of the Viennese scholar, Josef Strzygowski (in *Orient oder Rom*, 1901) that it became possible to estimate the role of the East. N. P. Kondakov has since introduced a method for the study of the illuminated manuscripts, and Gabriel Millet has put the study of the architecture and iconography on a firm basis.

History. The scene of Byzantine civilisation was set in the countries of the eastern Mediterranean. Whereas by the 5th century the barbarian invasions had caused the collapse of the Western Empire, the Eastern Empire had stood firm; however, it had suffered some changes of boundaries due to the attacks of Persians, barbarians and Arabs. The Balkan peninsula and Hellas were ravaged on several occasions; the Slavs proceeded to the most appalling massacres within the Empire, seized Adrianople and reached the Adriatic at Durazzo; in 558, the Huns threatened Constantinople and, in 562, the Avars proved even more redoubtable than the former and wrought unprecedented havoc at Antioch. Byzantine civilisation, fighting these invasions and exposed to famine and earthquakes, owed its life and survival solely to its Emperors.

Justinian (527–565). At his accession, the Byzantine world consisted of the Balkan peninsula in Europe, Syria and Anatolia in Asia and Egypt in Africa. In an effort to revive the Roman Empire, he reconquered Africa from the Vandals, winning a victory at Decimum near Carthage (533); he wrested southern Spain and the Balearics from the Visigoths (533) and Italy from the Ostrogoths (battle of Vesuvius, 553). In the East, he

was defeated by Chosroes the Great, ruler of Sassanian Persia, and had to pay an indemnity of 30,000 pieces of gold annually at the conclusion of peace between the Empire and Persia (562).

Heraclius (610–641). Half a century after Justinian, Heraclius saved the Empire by removing the Persian and Avar threat (622–628). The Emperor repulsed the invaders on all sides, but the Arabs followed the Persians: Syria, Palestine and Egypt were lost (battle of the Yarmuk).

Leo III the Isaurian (717–740). He won important victories against the Arabs and repulsed their attack on Constantinople (717–718); he played a major role in the iconoclastic crisis, promulgating the first edict against images (726); the second, promulgated by his son Constantine V Copronymus (740–775), gave rise to bitter and violent controversy, which was finally brought to an end in 843 by the Empress Theodora's restoration of orthodoxy.

Basil I (867–886). He was the founder of the Macedonian dynasty, whose most famous members were Constantine Porphyrogenitus and Nicephorus Phocas; he settled the image controversy dividing the Empire, checked the Arabs in Asia and restored Byzantium's prestige.

Basil II Bulgaroctonus (963–1025). He completed the Hellenisation of southern Italy and conquered a part of Armenia; the Russian invasion was checked by the conversion of Vladimir, prince of Kiev (988). During the 11th century, the schism with the Church of Rome became final.

Comnene dynasty (1081–1185). Under this dynasty, the commercial competition between Constantinople and Venice increased and led to the capture of the former in 1204, during the fourth crusade, and to the establishment of the Latin Empire, the Greeks being reduced to the Nicene Empire.

Michael Palaeologus reconquered Constantinople in 1261. His dynasty vainly sought the help of the West (John VIII solicited it yet again at the council of Florence, in 1439), and attempted to withstand the Turkish threat, which ended in the sacking of Constantinople in 1453. However, Byzantine art continued to survive for several centuries in Russia and in the Balkan countries.

History of art. Byzantine art can be divided into three main periods: that lasting from the reign of Justinian to the end of the iconoclastic crisis (6th–9th centuries); that of the Macedonian and Comnene Emperors (9th–12th centuries); that of the Palaeologue Renaissance (13th–15th centuries).

The two latter periods in art, corresponding to what is sometimes called the Second Golden Age, will be studied in Chapter 2.

It has been possible to recognise in the succession a tendency towards symbolism during the first centuries of the Christian era, a historical trend during the time of Justinian, a trend towards dogmatism after the iconoclastic crisis and, finally, a narrative trend in the Palaeologue Renaissance.

BYZANTINE ART DURING THE AGE OF JUSTINIAN

Architecture. The materials used were dressed stone, rubble masonry, and gravel and mortar, but the foundations of the buildings were of brick.

Religious architecture. The column, which the Romans had often used as a decorative element, now assumed its true role as a support. It was sometimes replaced by square pillars. Various types of vaults were known to the Byzantines: the barrel vault; the groin vault, resulting from the intersection of two barrel vaults; and the spherical vault or dome, of very light-weight materials, which was generally on pendentives and occasionally on a system of spherical ribbing converging towards the summit; Sta Sophia at Constantinople is possibly the prototype of cross-rib vaulting [51].

The search for a new principle of equilibrium was expressed in the play of thrusts. The abutment was ensured either by barrel vaults (St Irene at Constantinople), by half-domes (Sta Sophia at Constantinople), or by a system of supporting domes (St John at Ephesus).

During the 6th century four different types of churches were found: 1. The simple basilica, in which the timber roof persisted. At Constantinople: St Mary of the Spring and St Mary of the Blachernae, which have both disappeared. At Ravenna: S. Apollinare in Classe. 2. The buildings on a central plan, such as the baptisteries, either circular: St John of the Hebdomon, St Michael on the Anaple; or octagonal: SS Sergius and Bacchus at Constantinople (526–527) [54] and S. Vitale at Ravenna (547) [55]. 3. The domed basilica, which was a combination of the two preceding types; it was vaulted like the Anatolian basilica and had a barrel vault over the nave and a domed chancel (St Irene at Constantinople and the Church of Direkler at Philippi) or else a central dome over the nave (Sta Sophia at Constantinople [56], Sta Sophia at Salonica, St Clement at Ancyra, the Church of the Dormition at Nicaea). 4. The Greek cross plan, a purely Byzantine type, which appeared during the 6th century: the edifice was a cross inscribed within a square and covered with a dome over the crossing. The future perfection of this plan was foreshadowed in the architecture of Asia Minor (Aladja Kisle, Bin Bir Kilisse and Mahaletch). Under Justinian, it was partially achieved in the Church of the Holy Apostles at Constantinople (536–546) and in St John at Ephesus. It reached perfection under the comnene dynasty.

Civil architecture. No monuments have survived: Justinian's sacred palace, whose gigantic plan has been reconstructed from its foundations, was a veritable inner city, similar to Diocletian's palace at Split.

Among the utilitarian structures, the cistern of Binbirderek (528) attests to the audacity and technical ability of the builders. The corbeil capital appeared for the first time.

Military architecture. The fortresses had a triple line of defences: a very high and thick enclosing wall, a wall in front of the enclosing wall and a moat. Numerous remains are to be seen in the East (Antioch, Nicaea and Anazarbus) and in Africa (Haïda, Aïn Tounga, Tebessa, Sétif, Mdaourouch, Lemsa and Timgad, where there are remarkable examples from the 6th century).

THE INFLUENCE OF CONSTANTINOPLE

In the East. The churches in Syria faithfully copied the early stone type. At Kasr-ibn-Wardan, where brick was substituted for stone (564), the monuments, church and palace are quite unlike any other buildings in Syria. Plan, style,

79. BYZANTINE. Central part of the apse mosaic in the basilica at Parenzo (Istria). Saints holding martyrs' crowns are being presented by two archangels to the enthroned Virgin, who holds Christ Emmanuel. First half of the 6th century.

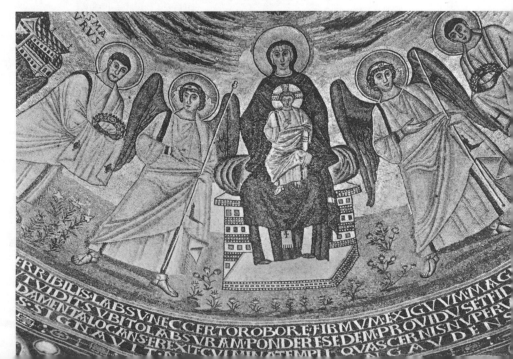

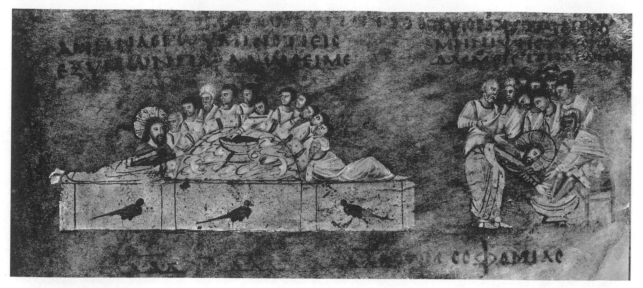

80. BYZANTINE. The Last Supper and the Washing of the Feet. Illustration from the Codex Rossanensis. 6th century.

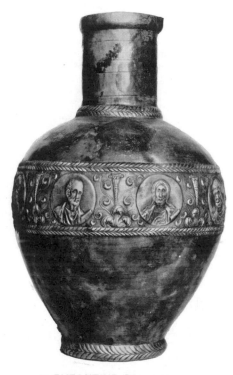

81. BYZANTINE. Silver vase decorated with medallions of Christ and saints, found at Emesa (Syria). 6th century. *Louvre.*

82. PRE-BYZANTINE. Illustration from the Vienna Genesis: Jacob's sons visit their brother Joseph. 5th–6th centuries.

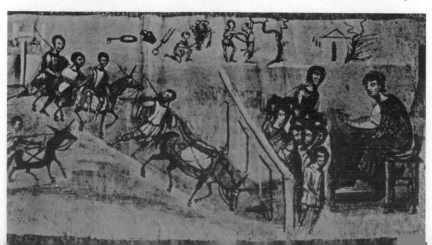

materials and the richness of the decoration are reminiscent of the Imperial buildings at Byzantium. The Castron at Andirin, near Kasr-ibn-Wardan, dated by an inscription of 558, shows the same characteristics.

In Palestine, all the monuments of the 6th and 7th centuries were inspired exclusively by Byzantine models: the church of St Sergius at Gaza (which according to Choricius' description seems to have been a 6th-century construction with a basilican nave and a dome on squinches and having triforium galleries); Rusafah (north gate and a martyrium of the Justinian epoch).

The palace at Ctesiphon, in Persia [102], was built of brick, in accordance with tradition, by architects who had been sent to Chosroes by Justinian.

In the West. Various monuments attest to the powerful westward expansion of Byzantine art during the 6th century.

At Parenzo in Istria the basilica of the first half of the 6th century was built by Bishop Euphrasius.

At Ravenna: the unrivalled monuments of Byzantine art, dating from the 5th and 6th centuries, include two basilicas: S. Apollinare Nuovo, begun under Theodoric and completed by the Byzantines, and S. Apollinare in Classe, consecrated in 549; and a church on central plan, S. Vitale, begun between 526 and 534 and completed in 547 (which resembles the octagonal church built by Constantine at Antioch and described by Eusebius).

In Africa. Architecture flourished in Africa after Justinian's reconquest. At Carthage, there was the basilica of Dermech; at Haïda, Announa, Matifou and Timgad were basilicas of Hellenistic type; at Sousse, a curious chapel that differs from the preceding monuments: a square

edifice with a ribbed dome on four squinches. The baptisteries of the Byzantine epoch present highly original forms: at Hammam-Lif, Upenna and Sfax are fonts in the shape of six- or eight-pointed stars.

Sculpture. Under the influence of the East, relief carving diminished steadily. The capitals were mainly foliate, occasionally with animal motifs. The artist sought to express the play of light and shade at the expense of line and volume.

All the buildings influenced by Byzantium show an affinity to Sta Sophia: the same richly decorated and incredibly varied capitals [15, 16, 52]; the same ornamental motifs on the chancel screens (in S. Vitale and S. Apollinare) [77], on the parapets which were adorned with wheels of six spokes and with long crosses, found in the Byzantine monuments of both Europe and Asia (in Sta Sophia at Constantinople, in St Demetrius at Salonica, at Ravenna and at Parenzo), on the tiles and on the stucco decoration.

Painting. The buildings of the 6th century show no attempt at exterior decoration; on the outside the basilica is a sober monument with bare walls. The artist's efforts were concentrated entirely on the decoration of the interior, where painting flourished in all its forms: mosaics, frescoes and icons.

6th-century mosaics. A large number were destroyed (during the iconoclastic crisis and also by the Moslems; they are often known from descriptions: those in the Church of the Holy Apostles at Constantinople, described by Constantine the Rhodian and Nicholas Mesarites, had episodes from the life of Christ (in the Holy Women at the Tomb, the painter portrayed himself in the figure of a soldier guarding the Sepulchre); those in the churches of St Sergius and St Stephen at Gaza were described by Choricius of Gaza (the founder of St Sergius was portrayed in the apse, near the Madonna surrounded by saints). The most important of the surviving and recovered mosaics are: 1. In the East, those in St Demetrius at Salonica, discovered in 1907 (and partially destroyed in 1917); they date from various periods; the majority seem to be of the 6th century [65]. This is

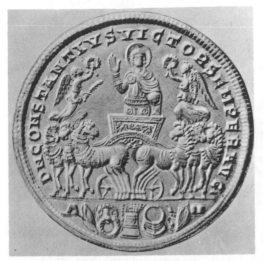

83. PRE-BYZANTINE. Gold medal of Constantius II, struck at Antioch in 343–344. The Emperor is represented in a triumphal chariot and is being crowned by two winged Victories.

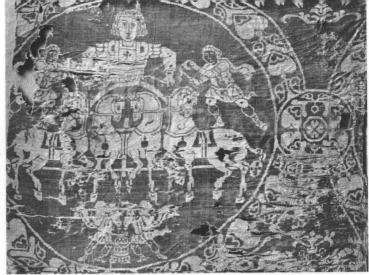

84. BYZANTINE. Triumphal scene on silk. 6th or 7th century. *Cluny Museum, Paris.*

85. *Below.* BYZANTINE. The Communion of the Apostles. Repoussé decoration on a silver platter found at Riha, near Antioch. 6th century. The duplication of Christ accentuates the symmetry of the composition. *Robert Woods Bliss Collection, National Gallery of Art, Washington.*

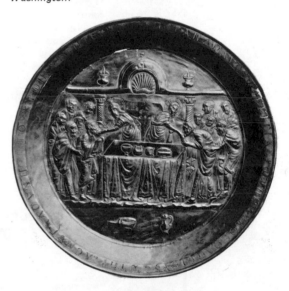

86. BYZANTINE. The triumph of an emperor. Detail from the Barberini ivory. Early 6th century. *Louvre.*

an ensemble of rare beauty, executed in a historical and monumental style, and shows a superior technique, comparable to that at S. Apollinare Nuovo and at Parenzo. The mosaics in Sta Sophia at Constantinople are of the highest quality. They were whitewashed over in 1453: the uncovering process began in 1932. 2. In the West, at Ravenna: S. Apollinare Nuovo [57], S. Vitale (extending from the floor to the summit of the vaulted ceiling, the mosaics are the product of a sumptuous art; they combine characteristics of Early Christian art with a tendency towards realism, and foreshadow a new historical style; two large scenes were completed in 547; Justinian and Theodora, each of them attended by a retinue [6, 60, 61, 63, 64]) and S. Apollinare in Classe (which shows both ancient traditions and new tendencies [2]); and at Parenzo (comparable to the best at Ravenna [79]).

Profane art, dedicated to the glorification of the monarch, was replaced by paintings of historical events and paintings of religious themes. (Procopius has left a description of the mosaics in the sacred palace at Constantinople.)

The decorative pavements differed from the mural mosaics in both their material and their subject matter, which was picturesque and mythological with geometrical motifs and with scroll patterns.

Frescoes. Used less often than mosaics because of their fragility, nearly all of these frescoes have disappeared. Choricius' description of St Sergius at Gaza attests to the growing predominance of the historical and monumental style. Frescoes have been preserved in Egypt (see Coptic art, p. 67) and on the rock walls of the underground churches at Cappadocia.

Icons. Purely Byzantine, they adorned the large sanctuaries and have now all disappeared. The style and technique came from Egypt, from the Fayum portraits. This type of painting only became fully developed during the 15th century, in Russia, with the iconostasis (a screen entirely covered with paintings, separating the sanctuary from the main body of the church).

Manuscript illumination. In the illumination of sacred or profane manuscripts, two parallel and conflicting tendencies finally became amalgamated: **1.** The pictorial tradition of Alexandrian art, of pagan allegories delicately and gracefully executed, such as: the Calendar of 354, reconstructed from 17th-century copies, whose style is reminiscent of the paintings at Pompeii; the Ambrosiana Iliad and the Vatican Virgil (5th century); the Vienna Genesis [82] (6th century), the Vienna Dioscorides (524) and the Joshua Roll (possibly a 7th-century copy). **2.** The monumental tradition of Asiatico-Eastern art, with its predilection for rich and elegant ornamentation: the disposition of the scenes followed that of certain celebrated mosaics of the period. In this tradition were such works as the Four Syriac Gospels of the monk Rabula (Laurenziana Library [8]) and the Codex Rossanensis [80], dating from the end of the 6th century; the Topography of Cosmas Indicopleustes, in the Vatican Library (7th century) and the fragments of the Sinope Gospel (c. 600), in the Bibliothèque Nationale, Paris.

The minor arts. *Ivory.* Many different objects were decorated, with the greatest skill: furniture; caskets and pyxes; diptychs [13, 58]; missal covers; episcopal thrones (Symmachi Diptych, 5th century; Barberini ivory [86] in the Louvre; the famous throne of Maximianus (c. 550) [59], in the cathedral at Ravenna).

Goldsmiths' work. Byzantium succumbed to the charm of the Sassanian work and adopted from Asia the cloisonné enamel technique [61], bringing it to perfection in both religious and profane objects: the Cross of Justin II (c. 570, treasure of the Sancta Sanctorum in Rome), bindings, caskets, rings, earrings and crowns. The antique style of repoussé retained its purity [85]: silver dishes in the Kyrenia treasure (6th century), in the Nicosia Museum (Cyprus) and in the Metropolitan Museum of Art [27].

Textiles. Justinian started a silk industry

at Byzantium in 552; Persian fabrics served as models, and certain designs are reminiscent of Chaldean art: silk from Mozac (7th century); shroud of St Victor (Sens cathedral treasury, 7th–8th centuries); Akhmin silk (Berlin, 8th century) [31, 84].

FROM JUSTINIAN TO THE ICONOCLASTS

The decay of the Byzantine Empire in the 7th century explains the lifelessness of its art: the traditional forms were repeated and there were no longer any new ones created; only a few works have survived.

Architecture. *Constantinople.* The buildings were continuations of the types of the preceding period. In the great palace the Chrysotriclinos, built by Justin II, was a building of the SS. Sergius and Bacchus and S. Vitale type. The former St Andrew church (now the mosque of Hodja Mustapha), probably dating from the 7th century, was inspired by Sta Sophia.

Profane painting continued to hold a prominent place in the decoration.

Armenia. Armenia and Georgia played a major role in post-Justinian Byzantine art and in that of the medieval West.

Its geographical position made Armenia accessible to both Mediterranean and Persian influence.

Armenia was converted during the 3rd century, and the building of churches began as soon as Christianity became the state religion. Up to the 7th century, barrel-vaulted basilicas seem to have predominated (Ereruk, Tekor); the earliest

have disappeared, but there are many examples from the second half of the 6th century to the 7th century.

Stone predominated. The centralised plan differed from the Hellenistic Roman type: it was generally square, never octagonal or circular. The dome, with a conical roof, was on a cylindrical drum. Apses, either projecting or inscribed, but always along the axes, were sometimes added in the middle of each side of the square.

The churches of the second half of the 6th century, at Ashtarak (middle of the 6th century), Avan (between 557 and 574) and Aghivard (between 574 and 604), derived from Anatolian models, have a nave and two aisles.

The churches of the 7th century are either of the basilica type with an aisleless nave (church in the citadel at Ani, of 622) or of the central plan with a dome: churches at Alaman (637, trefoil plan), Mastara, Artik, Agrak (middle of the 7th century; all three are of the same quatrefoil central plan and were perhaps built by the same architect), St Hripsimeh at Vargharshapat (618, quatrefoil square), St Gaiane at Vargharshapat (630–640), church at Mren (638–640), cathedral at Etchmiadzin (cross in square), projecting quatrefoiled square (built at the end of the 5th century, restored in 611 and 628), St Mary at Thalin (7th century, cruciform), and finally, St Gregory the Illuminator at Zwarthnotz (between 630 and 640), which returns to the Greek formulas.

The decoration is architectural or sculptural: coupled colonnettes, pilasters and arcades.

Georgia. Joined to Armenia until the 3rd century, Georgia was ruled by a Sassanian dynasty from 265 until the 8th century. Its monuments are a fusion of Christian plans and Asiatic forms. Side by side with types similar to those of Armenia, there are monuments of an unusual type: 'cloisonné basilicas' (Bolnis-Kapanaktehi, beginning of the 6th century; Uplis-Tsikhe, 7th century). The decoration is of a monumental style exceptional in the East: carved tympana at Ateni and at Djvari (early 7th century).

The West. Rome, towards the middle of the 7th century, had become a semi-Byzantine town: Sta Agnese (7th century, triforium galleries above the aisles, a characteristic of the type of basilicas current in the East), Sta Theodora (at the foot of the Palatine, 7th century) and Sta Anastasia were churches of circular plan; the basilica founded by Narses at the end of the 6th century was built on the plan of the Church of the Holy Apostles at Constantinople: a Greek cross with a dome over the crossing.

Painting. In the West, at the end of the 6th century, after an interval of fifty years, mosaics reappeared in Rome, with a transformed character. Byzantine influence henceforth was dominant: Sta Agnese fuori le Mura, apse mosaic done between 625 and 640; the Oratory of S. Zenone, and the Oratory of Pope John VII in Old St Peter's. Frescoes were added in the catacombs, during the 6th and 7th centuries (Commodilla cemetery), and in Sta Maria Antiqua.

Josèphe Jacquiot

THE CELTIC CHRISTIAN AND BYZANTINE WORLDS

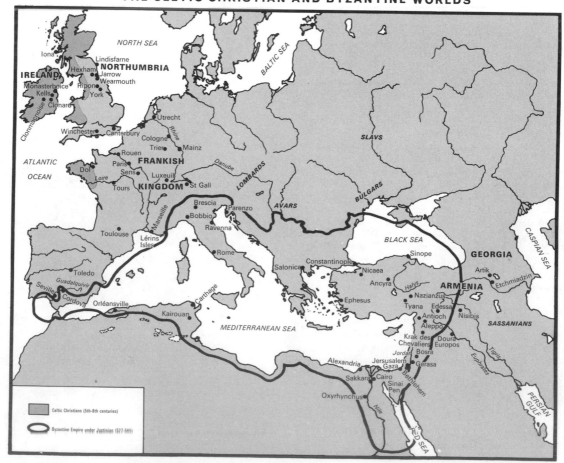

Celtic Christians (5th–8th centuries)

Byzantine Empire under Justinian (527–565)

PERSIAN ART IN PARTHIAN AND SASSANIAN TIMES *Roman Ghirshman*

With Alexander's short-lived conquest, the attempts of Greece and Persia to annex one another came to an end. Henceforth Persia, firmly barring first the Roman and then the Byzantine expansion, turned its attention increasingly towards Asia and, no longer content to be merely the traditional bridge between Asia and the West, extended to India, Turkestan, Siberia and even China a wealth of artistic influence such as has never been surpassed—an influence which was to stimulate Islam and to affect both Byzantine and Western medieval art.

THE PARTHIANS

The Parthian conquest of the Iranian plateau was quite unlike the series of victories which within a few short months placed the Achaemenid crown at Alexander's feet. Having risen against the Seleucids as early as the middle of the 3rd century B.C., the Parthians did not finally take Mesopotamia and Susiana until about a hundred years later, around 140, under Mithradates I, whom the Parthians compared to Cyrus the Great; moreover, it was only towards the end of the 2nd century, under Mithradates II, the 'Parthian Darius', that the boundaries of the kingdom were definitely established along the Euphrates. The death blow to the declining power of the Seleucids, who were Macedonians with mixed Persian

87. Bronze statue discovered at Shami. The head was cast separately and then joined to the body. Typical Iranian work. *Teheran Museum.*

blood, finally came from a coalition of the Parthians with the Greeks of Bactria. The struggle seems to have been long and the price of victory high. We may dismiss any idea of a crusade aimed at liberating the Persians from a foreign yoke; the Parthians were regarded as enemies rather than liberators, and in fact it took them over a hundred years to become the effectual as well as nominal overlords of the country. Thus it would be incorrect to talk of Parthian art in Iran as early as the 3rd century B.C.; a distinction, albeit artificial, must be made between the art of the Parthian period, which includes the works prior to the year 100, and Parthian art proper, which refers to the art produced from the time of Mithradates II (120–188) up to the Sassanian period.

ART BEFORE THE TIME OF MITHRADATES II

We must not minimise the importance of the steady influx of Western influence which spread through Iran after Alexander's conquest. The first Seleucid rulers continued for over a century to bring tens of thousands of Greeks and Macedonians into Iran, some of whom were established in the big urban centres—which subsequently became Greek cities such as Seleucia on the Tigris, which replaced Babylon, or Seleucia on the Eulaeus, formerly known as Susa—while others were sent to form military colonies near the Iranian villages. Nevertheless, it is hard to determine to what extent this Greek influx actually affected the Iranian world. On the relatively few monuments which may be regarded as prior to the 1st century B.C., the traces of Hellenistic influence are not always perceptible.

Outline of Iranian art

Soon after the destruction of Persepolis, probably towards the beginning of the 3rd century B.C., a prince, who was perhaps related to the Achaemenids, built a temple on the site. He himself is represented opposite his queen on the jambs of the doorway. A link with the preceding period is manifest in the presentation in profile and in the static pose and gesture, which are found on several Achaemenid gold plaques, for instance among those from the Oxus treasure. At the same time, however, there is a palpable deterioration in technique; the artist has outlined rather than modelled the figure, whose silhouette barely emerges from the surface of the stone, while a few incised lines serve to indicate the details of physique and costume. The work is entirely Eastern in character.

The contemporary fire temple at Nurabad, an isolated tower in Fars in the Zagros Mountains, is but a small-scale copy of the Achaemenian fire temples at Pasargadae and Naksh-i-Rustam; it has an inside stairway leading to the roof, where henceforth stood the fire altars, previously erected in the nearby plain. A magnificent bronze statue, which was found in a temple at Shami in the Bakhtiari Mountains, and which probably represents a local ruler, would seem to be of later date. A disfigured bronze head which lay alongside it seems to have been identified as a portrait of Antiochus IV. It is consequently assumed

87

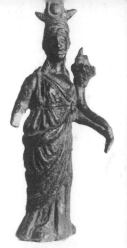

88. Bronze statuette of a Graeco-Iranian divinity, found at Nehavend. This is an example of Hellenistic workmanship. *Teheran Museum.*

89. Terra-cotta figurine found at Susa, in the Parthian level. The Macedonian head-dress is evidence of Hellenistic influence. *Louvre.*

90. Terra-cotta plaque from Susa. This hybrid work shows a local artist's interpretation of a Hellenistic ornamental motif. *Louvre.*

that the adjacent temple of Malamir, an important centre of the kingdom of Elymais, was one of the two sanctuaries plundered by Mithradates I during his conquest of western Iran, around 150 B.C., and that the Shami statue dates from the preceding half-century.

The figure, with its abundant mop of hair held back by a striated band, its trimmed beard and ample moustache, has a torque of the Achaemenid type (those of the Parthian kings are twisted two or three times around the neck). It is dressed in a short tunic that is crossed over its chest, with long, tight sleeves, and in leggings which are attached to a belt over its trousers. The torso was probably fashioned locally, in the mountains, while the head, which is of a different alloy, patina and workmanship, would appear to have come from one of the great bronze centres, possibly Susa. We know nothing of the statuary in the round of the Achaemenid period, which apparently represented standing figures as well as figures on horseback. In any case, the statue from Shami must be an offshoot of Achaemenian statuary. Its heavily implanted stance and the superimposed, semicircular folds of its leggings do not derive from any Western prototype. Moreover, the disproportionately small head, the too-powerful neck and the wide-open, staring eyes foreshadow the strict frontality governing the majority of the figures we find in Parthian Iranian art.

The extent of Hellenic influence

The Greeks certainly filled their Iranian temples with statuettes of their own gods, such as those in bronze that were recently found among the ruins of a temple at Nehavend (Laodicea), in which a long inscription by Antiochus III instituted a cult dedicated to his wife. Were these small images imported from Syria, or were they cast locally in moulds brought from afar?

The stone basin adorned with heads of Sileni and satyrs, found at Denaver near Kermanshah, is definitely a local product and shows a feeble attempt to render plastic form against a surface of striated shading; it has a faded lacklustre expression: art was degenerating into a decorative formula.

Western motifs and plans were adopted for the temples built during this period. A sanctuary of Artemis-Anahita, at Kangavar near Hamadan, had a gigantic hall of 2,150 square feet, pseudo-isodomic walls, columns with 'Attic' bases and Doric capitals under Corinthian abaci. The two

remaining 'Ionic' columns of an apparently older temple at Khura have capitals with rolled volutes, but placed on Achaemenian bases consisting of two plinths, such as are found at Susa. Local traditions were thus maintained, despite the ascendancy of the West.

The Seleucid and Parthian layers at Susa reveal the existence of a complex society in which a strong Graeco-Macedonian element had come to mix with the Iranian and Semitic population. Among the numerous terra-cotta figurines, those of horsemen, which had already become widely popular and had spread as far as Egypt during the preceding Achaemenid period, sometimes have the pointed Iranian head-dress (the *bashliq*, perhaps) and sometimes the flat *causia* worn by the Macedonian warriors; then, in addition to a host of 'nude goddesses', there are others draped in the Greek chiton; statuettes of Hercules were found alongside images which, judging from their ethnic type and costume, clearly represent Iranian divinities. An 'indigenous' house of Babylonian plan, with rooms grouped around an inner court, stood opposite a villa of Nordic origin, having a peristyle and pitched roof and adorned with a frieze of Greek fret pattern, interspersed with acroteria, in baked red clay.

In this hybrid society each group seems at first to have gone its own way, rarely mixing with the rest. Within a century, however, the power of the Iranian traditions proved the strongest, and Western art, like its propagators, became Easternised.

But the process was gradual, and the language of the Greek verses engraved in marble at Susa during the 1st century B.C. is remarkable for its purity. Indeed, the Parthian rulers drafted in Greek the edicts that they issued to the magistrature of Seleucia on the Eulaeus. And Apollonius of Tyana, who visited Arderikka near Susa towards the middle of the 1st century, the district to which the inhabitants of Eretria were deported by Darius the Great, found the latter's descendants speaking Greek and still retaining intact the memory of their origins. It would be idle to imagine that the two peoples could have lived side by side without their arts becoming mingled, as on the 'emblem' which was discovered in the 90

SASSANIAN. Parcel gilt silver dish, showing King Shapur II hunting. 4th century. *British Museum. Museum photograph.*

88

89, 117

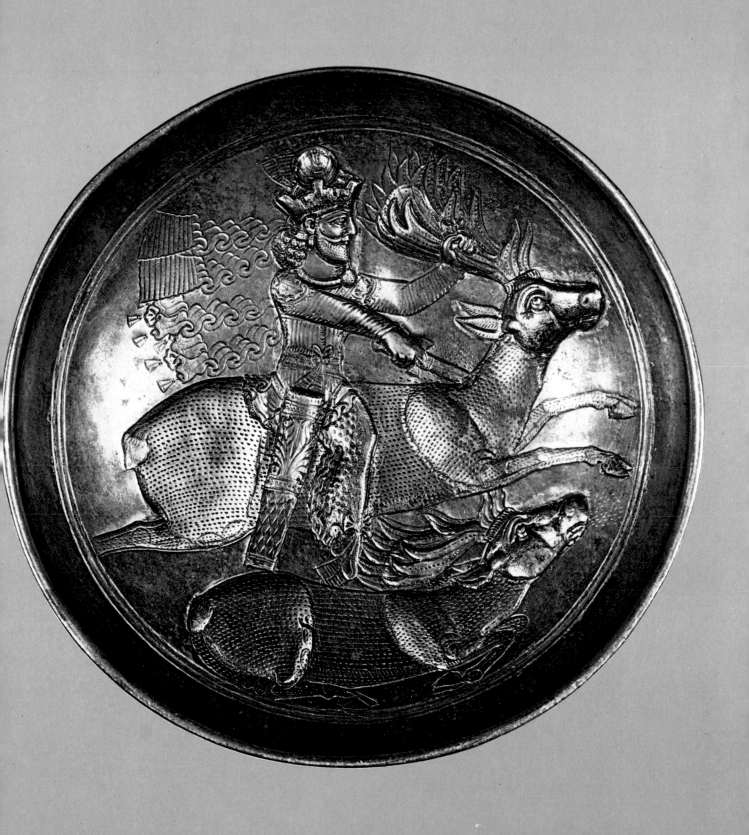

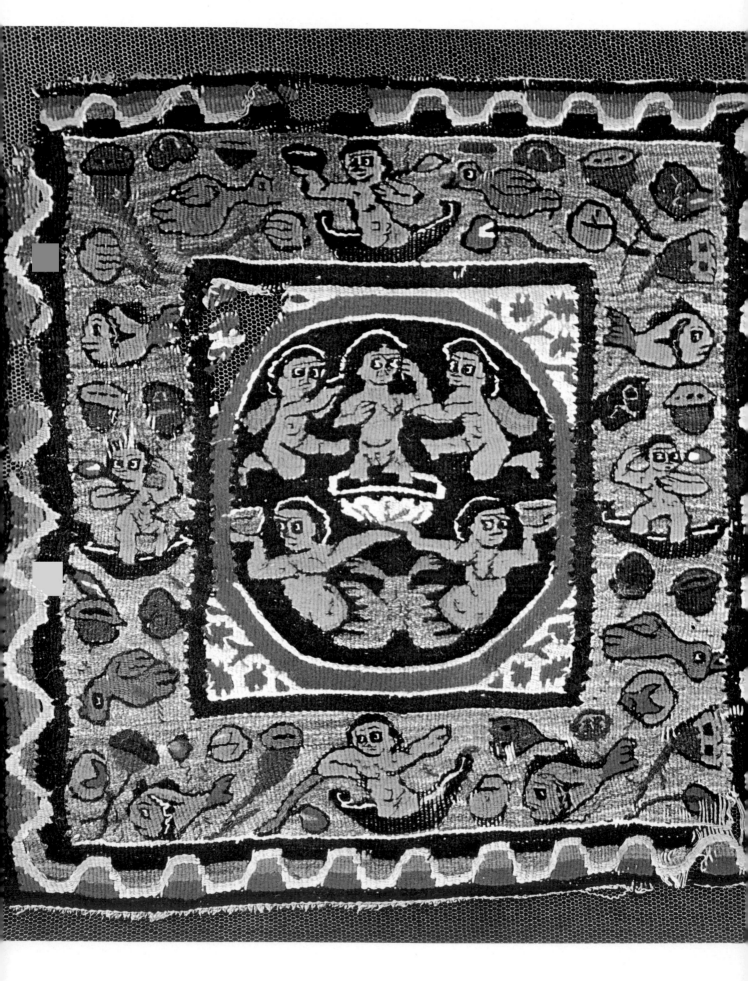

workshop of a coroplast (maker of artificial eyes) on the outskirts of Susa. The fashion among Hellenistic society for this kind of ornamentation, which is re-echoed in the plaster medallions found by Joseph Hackin at Begram, the gateway to central Asia, must also have spread through Iran. However, here a goddess (?) is shown squeezing her bosom over a bowl; moreover, a Greek artist would never have placed such a medallion in a square frame adorned with a pellet moulding. Nevertheless, the pediment and the modelling of the female form are alike reminiscent of Greek art.

PARTHIAN ART FROM THE TIME OF MITHRADATES II

The Parthian conquerors reached Seleucia on the Tigris towards 140 B.C. Instead of laying siege to the capital, which numbered several hundred thousand inhabitants, they mounted a vast military camp on the opposite bank of the river, a camp of circular plan, which became Ctesiphon and the capital of Iran until the overthrow of the Sassanids.

This circular plan was used again, not only at Hatra but also for the cities of Darabgird and Firuzabad, built by the founder of the Sassanid Dynasty, Ardashir I, before his revolt against the last Parthian ruler. It has been seen as a revival, in contrast to the rectangular plan of the Hellenistic towns, of the circular plan of the Assyrian military camps. Just conceivably it might also be the reproduction on a grand scale of a nomadic camp: a fresh proof of the Parthians' attachment to their traditions. These traditions reappear in the role allotted to the horse; in the animal style, as is shown on the plaque of engraved bone found at Doura, which betrays the ties with Scythian art and that of the Ordos region; in the violently polychromed jewellery which came to light at Doura and Taxila, but which the discoveries made at Begram have shown also to be peculiar to the Kushans (and those at Kerch and Novorossiisk, to the Sarmatians). The latter's predilection for gold objects set with semiprecious stones or glass paste was transmitted to the Goths and Huns and, through them, to Germanic jewellery, subsequently reaching both the Atlantic (with Merovingian art) and Scandinavia.

The complexities of influence in architecture

Of Parthian architecture, only that on the periphery of the Iranian plateau, at Hatra, Assur and Warka (formerly Erech) in Mesopotamia, and at Kuh-i-Khwaja in Seistan, is known to us. The use of dried brick or of mud-brick, common to Achaemenian architecture, continued, but the plan changed. Columns went out of fashion, and the flat ceiling was replaced by vaulting, which is justly considered to be an Iranian invention. A Babylonian plan, like that of the house at Susa, persisted at Doura, but at Assur, Ctesiphon and Hatra rose palaces with triple iwans (large halls with true vaults), an Iranian conception destined to survive throughout the centuries and to spread far and wide. The façade of the palace at Assur (1st century B.C.) retained elements of ancient Near Eastern architecture, which adorned the surface exposed to the sun with pro-

102

91, 92. Mural decoration in the palace at Kuh-i-Khwaja. 1st century A.D. *Above.* Geometric and plant motifs in stucco. *Below.* Fresco.

jections and recesses, though the pilasters were here replaced by engaged columns and the façade divided up into several storeys. The Hellenistic elements—the Doric or Corinthian capital, the Ionic volute transformed into a spiral, and the meander—are so 'barbarised' that they can only be regarded as clumsy adaptations foreign to the edifice.

The walls, which would otherwise be too bare, are 91 decorated either in stucco, with geometric and plant motifs or, more often, with paintings (as at Palmyra, Doura, Assur, Babylon, Kuh-i-Khwaja, in the tombs at Kerch 92 and on the stupas in Chinese Turkestan). Several of the painted panels in the palace at Kuh-i-Khwaja (attributed to the 1st century A.D.) show half-length figures (a theme 121 which frequently recurred during the Sassanian epoch and was executed in stucco) in flesh tones against white or grey backgrounds, and a palette of brick-red, sulphur-yellow and pale blue; others show three divinities or a

COPTIC. Tapestry of the second style. 5th–6th centuries. *Louvre. Photo: Giraudon.*

49

93. Façade with 'masks', from Hatra. This Iranian decorative motif was soon in wide use. *Teheran Museum.*

group of the king and queen, the latter foreshadowing not only the 'Byzantine compositions like those at Ravenna' but also the royal couples which were to figure in Sassanian relief carvings.

93 The palace and temple at Hatra were Iranian in plan, the former a triple iwan, the latter square. The busts in the vaults, in stone like the 'masks' on the façade, were also typically Iranian; indeed, these masks had figured in Iranian art from its earliest beginnings and were destined to be reproduced not only at Hamadan and at Qum, south of Teheran, but also, due to an unexpected diffusion, in Roman mosaics, in the paintings adorning the tombs in southern Russia and even on the bronze harness-trappings of Siberia.

The masonry at Hatra, however, consisted in the combination of the dressed stone and rubble of Greek architecture; moreover, the engaged columns flanking the entrance were reminiscent of a Roman triumphal arch. Since Western elements reappeared in the Hatra of the 2nd century, we should perhaps agree with O. Reuther, who inferred that a second wave of Hellenistic influence must have been spread abroad by Imperial Rome—an inference that the recently discovered relief carvings and also, possibly, the frescoes at Kuh-i-Khwaja would appear to confirm.

Sculpture and the Achaemenian tradition

The oldest known relief carving is that of Mithradates II, done on the lower part of the rock, at Behistun, in about 100 B.C. The great king is receiving the homage of four of his vassals, represented strictly in profile one behind the other. The technique has remained the same as in the relief carving of the prince at Persepolis: no third dimension, no depth, no modelling; the poses are rigid and the whole is symbolic. The ties with Achaemenian monuments are evident, but the workmanship is inferior.

Following an Achaemenian tradition, manifest in a scene on the same rock, that represents Darius before the rebel rulers he had conquered or, again, on his rock-cut tomb at Naksh-i-Rustam, inscriptions, now worn away

but capable of reconstruction from the drawings of European travellers of the 18th century, were engraved above each figure, bearing his name and titles. Mithradates, however, had these inscriptions cut in the Greek language, which continued to be cultivated at the Parthian court.

The relief carving on the tomb of Antiochus I of Com- 94 magene (69–34 B.C.), at Nemrud Dagh in northern Syria, representing the monarch, surrounded by his celestial and terrestrial ancestors, taking the hand of the god Mithras in token of alliance, shows heads in profile on bodies in three-quarters view hidden under stiff costumes—a flat and vapid relief carving with a disregard for anatomy, which reveals nevertheless, in contrast, minute attention to ethnic details and small points of dress. Here again, traces of the official art of the Achaemenids are visible, and, while the architecture of the tomb itself is largely of Hellenistic inspiration, the style of the sculpture is predominantly Parthian. Three different aesthetic currents thus meet in the same monument.

A relief carving executed three centuries later and recently discovered at Susa, which represents Artabanus V seated on his throne and presenting a crown of merit to Hwasak, his satrap at Susa, reveals the same poor workmanship together with an abundance of ethnic and dress detail. Neo-Iranian or Parthian art gained in nationalistic spirit what it lost in technique, passing the latter on just as it was to the Sassanians.

Again at Behistun, we find a weather-worn relief-carving showing, according to an inscription in Greek, Gotarzes II (38–51) who, mounted and followed by his page, charges at a flying gallop to unseat his adversary Meherdates, a pretender to the throne, backed by Rome.

94. Antiochus I Commagene and the god Mithras. Relief carving from Antiochus' tomb at Nemrud Dagh (northern Syria). Second half of the first century B.C. This work shows the predominance of the Near Eastern spirit over Hellenism.

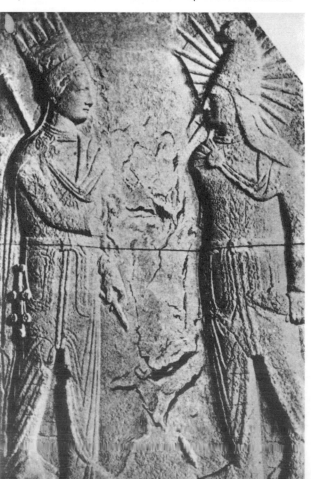

The winged Victory, crowning the triumphant king, alone suggests Hellenistic tradition, and whereas the technique in this pre-eminently Parthian scene has remained the same, the spirit of the composition has changed: an attempt has been made to render impetuous movement in stone, as in painting; here it takes the form of a victory of man over man, elsewhere of man over beast. Conventionalism has, however, frozen the action, and the artist has been fettered by his love of detail. Horses were represented in profile, and generally in the flying gallop that Iranian art had inherited at its inception and maintained up to the Sassanian epoch; however, the horsemen were frontally represented, but with their heads in profile.

Man on horseback, either hunting or in combat, was a favourite theme of the aristocrats and one that was reproduced by all the Iranian peoples. It is to be seen at Tang-i-Sarwak and at Doura (where frescoes and graffiti show either the god Mithras hunting or an armoured horse and rider charging) in Persia, and even on the frescoed walls of the Sarmathian tombs in southern Russia and the Caucasus: a beautiful silver dish, recently brought to light and believed to be of local workmanship, shows a mounted figure in a Parthian mitre hunting the bear. The Sarmathians communicated these images to the non-Iranians of Siberia and central Asia, intermediaries who in turn transmitted them to China, where a mounted archer at a flying gallop appears on tiles of the Han epoch. North-western India, where Parthian influence penetrated as early as the 1st century B.C., was also familiar with this galloping figure which, with its head frontally represented, may be observed on a pillar in the temple at Bharhut. Unknown to either Greek or Assyrian art, this marvellous gallop was transmitted by Parthian art to all Europe and Asia.

A third relief carving at Behistun completes the cycle of main themes in Parthian iconography. It has been carved in the same style on a free-standing rock and shows a man, possibly a prince, on the front, flanked by two winged creatures on the lateral faces. The central figure, wearing the Parthians' short tunic and baggy trousers, stands facing the viewer, holding a bowl or casket and burning incense on an altar. Likewise, at Tang-i-Sarwak, a Magian priest, full face and in Parthian costume, lays his right hand on an altar in token of adoration. The donors, the king and his retinue are lined up, rigid and immobile, in two registers. In a mural painting at Doura a certain Conon and his family are shown participating in a sacrifice before a pyre. The excavations at Doura have brought to light many variations on this theme. Sometimes the number of sacrificers is increased, as on a vase found at Assur. The same style may be observed in the paintings of Syria, southern Russia and

95. Rock at Tang-i-Sarwak, showing Parthian relief carvings. Two subjects dear to Parthian iconography break the monotony of the row of donors: above, a Magus; below, a horseman hunting a bear.

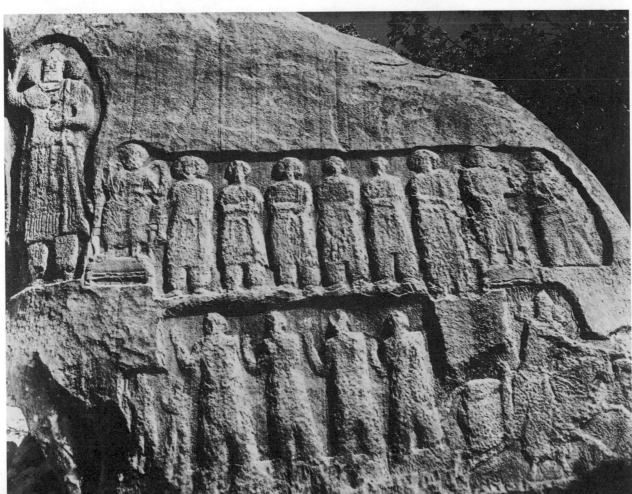

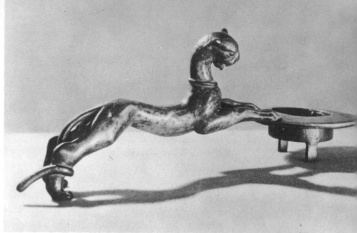

97. Bronze incense burner. 1st–3rd centuries A.D. This work shows a marked influence of the animal art of the steppes. *Private Collection.*

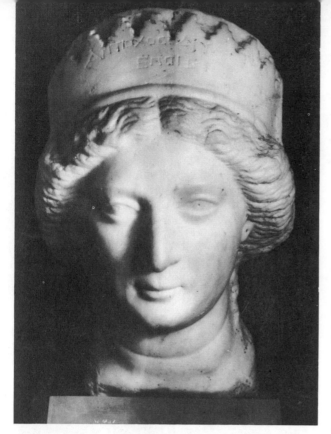

96. Alabaster head (of Queen Musa?), showing Hellenistic influence. Found at Susa. 1st century B.C. ? *Teheran Museum.*

the Far East. The artist sought neither the plasticity nor the individuality aimed at by the Western painters of the early Roman Empire. Yet the gaze of his figures often expressed an intense religious feeling which sufficed to animate the otherwise ritual inflexibility of his works. The figures on the coins of the Kushans, who stand before an altar in an attitude identical to that of their Parthian counterparts, were inspired by this same sacrifice.

Thus even in the subjects of its compositions Parthian art continued the Achaemenid traditions; this particular theme, which had reappeared on every one of the Achaemenid rock-tombs at Naksh-i-Rustam and Persepolis, disappeared completely in Sassanian art.

Representations of banquets, another theme recurrent in Parthian art, have as yet only been found in peripheral regions. A mural painting at Doura shows an assembled company reclining in the Iranian fashion and holding dishes; there is a floral wreath suspended over the head of each guest. The scene has neither depth nor perspective, and no attempt has been made to animate it by any suggestion of shared activity. Another banqueting scene appears on some tablets of carved bone, part of the decoration of a piece of furniture, which were brought to light at Olbia, in southern Russia: a prince is shown seated, full face, with his servitors and nobles standing in a row on either side of him, while a troupe of acrobats, mountebanks and nude dancers performs for the entertainment of the company. The attitudes are rigid and the bodies shapeless despite their nudity; there is not the slightest suggestion of unity between the different alignments of figures, and the feet are all pointed towards a nonexistent ground line: the whole faithfully adheres to the traditions of the period.

From statuary to minor arts

There are few sculptural monuments originating from the Iranian plateau that throw light on Parthian statuary in general. It is perhaps most nearly reflected in the

statues of the Kushan kings at Mathura, and in another Kushan statue recently discovered in the north of Afghanistan. From Susa come two heads which must have belonged to life-size statues, one of a man with a moustache and short pointed beard, with the wide-open, staring eyes dear to Parthian art, heavy eyelids and hair held back by a diadem of a different material, the other of a woman with her hair parted in the middle under a crenelated 96 diadem. She has been tentatively identified as Queen Musa, wife of Phraates IV and then of his son Phraates V, but the Greek inscription engraved on the diadem, 'Work of Antiochus, son of Dryas', may well suggest a different identification.

The carving in high relief on a hard green stone, just over 1 inch high, of the head and shoulders of a Parthian monarch, who wears the national head-dress with earflaps, adorned in front with a vertical row of square stones and held by a double diadem, seems to be a portrait. The realism and quiet dignity in the expression of this small bust, akin to those of Palmyra, places it among the masterpieces of the Parthian epoch. An inscription in Parthian Pahlavi, 'Arsaces Vologaeses, King of Kings', would seem to designate Vologaeses III (148–192).

The surviving bronze objects of this period are also rare; of these, the most representative would seem to be an incense burner with a handle in the form of a magni- 97 ficent beast. The suppleness and power of its elongated body, the slightly bent head on a sturdy neck and the tension in its stretched hind-legs, accentuated by the twisting tail, all relate it closely to the beast of the Novorossiisk treasure. Two similar objects, found in the Parthian town of Taxila, illustrate the taste of the period for the animal art of the steppes. The multiplicity and the diversity of the artistic and cultural influences which circulated through the Parthian empire are perhaps most clearly reflected in its pottery, for which wide use was made of green or blue glaze. A terra-cotta rhyton recently 98 discovered at Demavend, not far from Teheran, and adorned with the forequarters of an ibex, attests to the persistence of Achaemenid traditions; and, while amphoras with highly developed handles, inspired by Hellenistic pottery, have come to light at Doura, similar vases from Susa have only two small round handles: the Iranian potter evidently failed to appreciate their use.

The arrival of the first ambassador from China to the West at the end of the 2nd century B.C. opened an era of official relations between the Celestial Empire and Iran. The Chinese envoy apparently took the vine and the alfalfa back with him to China, and just as the Parthian horseman inspired the Chinese artists, so the forms of the

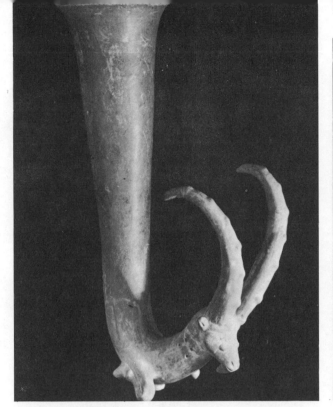

98. Terra-cotta rhyton terminating in the head of an ibex. From Demavend. 1st century B.C. This traditional motif was common to the art of Luristan and to Achaemenian art. *Private Collection.*

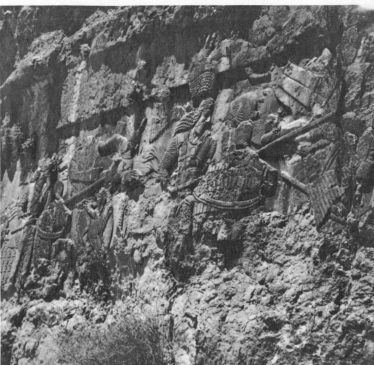

99. Relief carving in the rock at Firuzabad, illustrating, in the symbolic form of individual combat, the victory of Ardashir, founder of the Sassanid dynasty, over the last Parthian king, Artabanus V, in 224.

Han vases were not without interest to the Parthian potter, as is proved by a tripod vase with a green glaze and shell-shaped feet, found in a late Parthian tomb at Susa.

THE SASSANIANS

In 224, after several years of struggle, Ardashir Papakan, a minor prince of the province of Fars, won a decisive victory over the last Parthian ruler, Artabanus V, whom he slew with his own hand. The new dynasty claimed, as indeed had the Parthians, direct descent from the Achaemenids. No stone was left unturned to obliterate the memory of the foreign domination of the Arsacids, to whom the chronicles devote hardly more than a few lines.

The dedication to the national past

It is on the rocks in the gorge at Firuzabad, the town built by Ardashir, where the uprising started, that we find the largest and one of the oldest Sassanian relief carvings, in which the series of battles is evoked by three pairs of combatants: Ardashir and Artabanus; behind them, Shapur, the former's eldest son and successor, and the grand vizier; and then two pages. Art has remained as symbolic as before, and the scene represented has nothing to do with an actual event.

The technique is likewise traditional, thus making this monument merely a continuation of the Parthian relief carvings and, in particular, of that of Artabanus V at Susa, which is only slightly earlier. Here again are the flattened figures that barely stand out from the chiselled surface, and the careful attention to detail, as in the coats of mail —those of the Sassanians made up of small chains and those of the Parthians of scale-like plaques. The heads are in strict profile, while the torsos are frontally represented, a convention necessitating a severe foreshortening of the left shoulder and forearm, as may be observed in every Sassanian relief carving showing a horseman on the right. The aim to convey the heat and clash of battle has not

been successfully carried out, and the scene that was intended to be grandiose has remained inanimate and incapable of rousing any emotion.

On a nearby cliff overhanging the same side of the gorge, Ardashir had his investiture commemorated; in order to prove that he exercised his power by divine grace, it is the great god Ahura Mazda who hands him a diadem. The two figures, of the same height, frame an altar, and, following ancient tradition in the Near East, the scene is antithetic; nevertheless, the four figures lined up behind the king, a little page with a fly-whisk and the monarch's three sons, upset the balance of the composition. The tradition of Achaemenian art is continued in the alignment of these figures to face the great god and in the stereotyped silhouettes which, devoid of anatomical detail, are only distinguishable by the different emblems on their head-dresses. Even the figure of the little page recalls the parasol-bearer who stood behind Darius, and only the high relief differs from Persepolitan prototypes.

Another representation of Ardashir's investiture adorns the cliff at Naksh-i-Rustam, near Persepolis, the site of the great fire temple, which had formerly been administered by the new king's ancestors. The god and the king, both on horseback, face one another in a composition of heraldic symmetry.

Although no scenes of investiture on horseback appear among the known monuments of Achaemenian art, the subject does figure on a silver vase decorated in the Achaemenian style, which was found in a Scythian tomb in southern Russia; the Sassanian monarch desired that this scene, reproduced in stone, should surpass all the Achaemenian rock-carvings at Naksh-i-Rustam in magnitude and grandeur. However, it is a static monument, animated only by the cloaks which gently billow from the shoulders of the two protagonists.

Not far from Firuzabad, where he built his town, Ardashir had a great palace erected, with walls of rough stone held with mortar. In plan it is divided into two

99

100

101

53

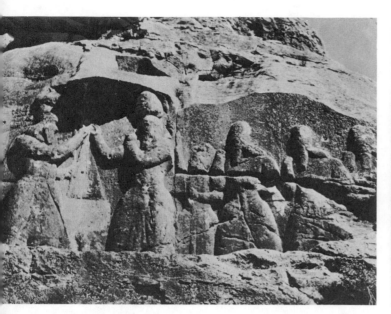

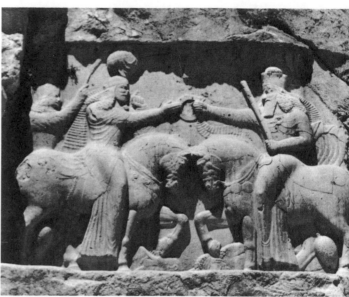

100. Relief carving in the rock at Firuzabad, representing the investiture of Ardashir I. The scene is less solemn here than at Naksh-i-Rustam, where the protagonists, whose majestic proportions dwarf their mounts, trample their conquered adversaries under foot.

101. Relief carving in the rock at Naksh-i-Rustam, showing the investiture of Ardashir I by the god Ahura Mazda. Second quarter of the 3rd century.

distinct sections: the iwan which, preceding a square chamber covered with a dome on squinches, forms the entrance and the reception hall or throne room; the living quarters behind it, which are grouped around a series of inner courts. As in western Asia, the surface of the façade is articulated with projections and recesses, but engaged columns, already used by the Parthians, have replaced the square pilasters. The walls were smoothed and decorated in stucco. Notable among the remains of the interior decoration is the Egyptian gorge over the doorways and niches; similarly featured in the palaces at Persepolis, there can be no doubt as to its origin here.

Like the first relief carving, which was governed largely by the principles applying in painting, the circular plan of the town attests to the continuation of Parthian traditions. The use of rough stone and mortar for the rubble walls in architecture is a technique which appears to have been invented in the province of Fars, where it prevails to this day. The plan of the palace combines into a structural whole two elements which existed under the Achaemenids: the apadana (audience hall), from which the iwan was derived, and the tachara (winter house), to which the living quarters correspond. This, with variations, was destined to remain the standard type of palace throughout the Sassanian epoch; the plan was thereafter taken over by Islam.

Adorning the lintels of dressed stone above the doors and windows in the palaces at Persepolis, the Egyptian gorge functioned as an architectural element. Reproduced in plaster and placed on the arches of niches or over doorways in the palace at Firuzabad, it became a foreign and artificial element. In their endeavour to reproduce Achaemenian art, an endeavour that is particularly apparent in their rock sculpture, the Sassanians even went to the lengths of engraving a trilingual inscription, in Sassanian Pahlavi, Parthian Pahlavi and Greek, on the third among these rock carvings.

This early art lived exclusively off the national past, as though in the hope that a cohesion of the two dynasties could thereby be effected which would justify and legalise the pretensions of the newcomers: whether by design or coincidence, not the least sign of Western influence was evident in it.

The flowering of art under Shapur I

The profound change which came about under the second ruler of the dynasty, and which was destined to have lasting effects, can be attributed to three main factors: the personal merits of the monarch, his successes in the wars against Rome and the presence of thousands of prisoners on Iranian soil.

Shortly after his victory over Valerian (260), Shapur had a royal residence, Bishapur (Beautiful Shapur), a sort of Sassanian Versailles, built on the road between Fars, his native province, and Ctesiphon, his capital. The urbanist, abandoning the Parthian system of town planning, designed it as a vast quadrilateral traversed by two main arteries which cross one another at right angles in the centre. The principles of Hellenistic town planning, laid down by Hippodamus, were not unknown to him; Doura Europos in Syria and Begram in Afghanistan were built according to a similar plan, the one by the Seleucids, the other by a Graeco-Bactrian ruler.

A whole quarter of Bishapur was taken up by princely edifices. The palace, a part of which has been excavated, consists of a great hall built on a cruciform plan, with four arched iwans opening on to the square central structure, measuring 72 feet a side; it was covered with a dome which must have risen to a height of about 80 feet. While the plan, the arches, the dome and the technique of rubble walls are all Iranian, the stucco decoration shows new, outside elements: the sixty-four niches around the hall, adorned with meanders and volutes, and the medallions of acanthus leaves on the arches are Western innovations. All this stucco decoration was enriched with bright colours, black, red, blue, yellow, attesting to a predilection for polychromy.

A triple iwan in the east wall of the great hall opened on

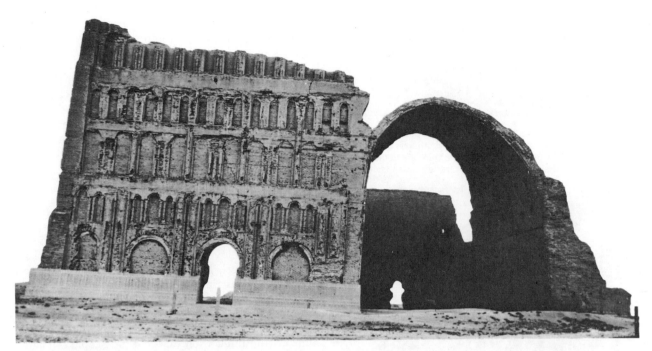

102. Ruins of the palace at Ctesiphon, showing part of the façade and great hall. The vault is particularly fine.

to a vast court; the floor of the central iwan was decorated with small panels of mosaics, which formed a border around the walls and a frame for the black polished flagstones in the middle. The whole imitated a carpet, a very ancient Achaemenid example of which has survived in the kurgans (barrows) at Pazyryk, in the Altai region. Some of these panels of mosaics showed themes such as female dancers and musicians and women plaiting wreaths, while a few of the narrower ones contained portrait heads, ending at the chin (that is, not showing the neck), of people of the court.

104, 105

103. Stucco niche in the great hall of the palace of Bishapur. The frame and its decoration—Greek fret and volutes—are largely of Hellenistic inspiration. *(Reconstruction by A. Hardy.)*

Created by the Western world and widely applied within the Roman Empire, mosaic decoration seems to have been unknown to Parthian art and probably came to Bishapur with the mosaic workers from Roman Antioch and their cartoons. Almost all the subjects figuring in the mosaic pavement recently discovered at Antioch reappear at Bishapur, though each has here been readapted to suit the Iranian taste: the ethnic types, the costumes, the headdresses and the seated position are all Persian.

Portraits ending at the chin of the model are neither Greek nor Roman. Full-face portraits had appeared in Iranian art by the beginning of the 1st millennium B.C. and had been constantly maintained. Under the Parthians, they spread both East (to Taxila) and West (to Rome), while the Sassanian period witnessed their adoption by Coptic religious art during the 6th century, and their arrival in France at about the same time. The 'Divine Countenance', the representation of Christ in the Orthodox Church at Edessa, a town inhabited by Nestorian Persians, should, we feel, be ascribed to the same source.

Another palace, built of dressed stone and now in ruins, gave on to the same court. Judging from two niches which have survived intact, this second palace was a copy of that at Persepolis; moreover, the small-scale relief carvings of charging horsemen or standing figures, which probably adorned the façade, would seem to indicate that Shapur, like his father before him, aimed at reproducing the monuments of Achaemenid Persepolis.

To the north-west of the cruciform hall rose a fire temple, a sanctuary which appears to have been dedicated to Anahita, goddess of water and of fertility. It consisted of a chamber 46 feet square and 46 feet high, built of enormous blocks of dressed stone bound together with iron dovetails; the roof beams were supported on forequarters of bulls copied from Persepolis, and the lintels over the four doorways were decorated with the Egyptian gorge from the same source.

While these details, together with the plan of the sanctuary, already known to the Achaemenians, are

121

104, 105. Mosaics in the palace of Bishapur: panel representing a harpist; frieze with heads of ladies and officials of the court. Second half of the 3rd century. The technique and motifs were borrowed from the West but treated in the Iranian style.

106. Model of the palace of Bishapur. Second half of the 3rd century. (*Reconstruction by A. Hardy.*)

typically Iranian, the technique applied in the elevation of the walls and the preparation of the stone betrays Roman, or rather Syrian, workmanship.

The victory over the Romans and its consequences

In the centre of the town the governor Apasai had a monument built in Shapur's honour, composed of three tiers of dressed stone on which rose two monolithic columns. A bilingual inscription, dating this monument to the year 266, thus not long after the victory over Valerian, implied that it had also included a statue of the King of Kings, flanked by two fire altars, in front of the tiered base.

This type of monument with two columns was a Roman creation known to Syria, and was introduced to Bishapur by the Syrian artisans who came there either as prisoners or seeking employment and who marked the blocks of stone with Greek letters. However, an Iranian note is added by the inscription that almost entirely covers one of the columns, and by the two altars on either side of the statue of the king.

The victory of the King of Kings over a Roman Emperor on Iranian soil captured the people's imagination; Shapur ordered the carving of no less than five colossal rock sculptures to celebrate his exploits. The first, representing his investiture, shows Ahura Mazda handing him the crown, and Ahriman, his hair made up of writhing snakes and his cavernous mouth hanging open, being trampled under the hooves of the god's horse, while defeated Rome is trampled under the hooves of the king's mount. Between the two protagonists the Emperor Valerian kneels with arms outstretched imploring mercy. The pathos expressed in the treatment of this figure with its moving gesture is so different from anything found in other, similar representations, that it is thought to be the work of a foreign artist.

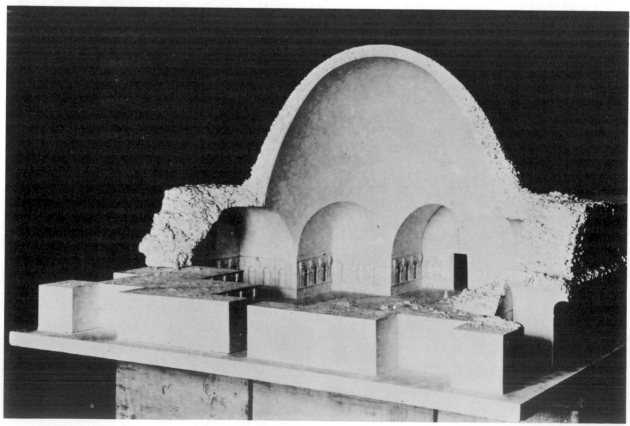

The second carving, done below Darius' tomb at Naksh-i-Rustam, again represents Valerian on his knees before his mounted conqueror, a diminutive figure in comparison to the overwhelming proportions of the Iranian monarch. In an attempt to animate the scene, the cloaks are shown fluttering in an imaginary breeze, but in opposite directions! The King of Kings is presenting the Romans with their new Caesar—Cyriadis, whose hand, in accordance with the gestures of respect demanded of those in the presence of the lord of Iran, is hidden inside his sleeve.

107 The same scene has been enlarged at Bishapur to include two Persian dignitaries and a putto who, supposedly representing a Nike, descends from the heavens bearing a crown of victory; even the Persian army has been added, in two registers: on the left, the nobles who formed the cavalry, and on the right, divided up into separate spaces, the infantry—an arrangement that maintained the traditions of Iranian art, which delighted in partitioning the subjects it represented.

The cycle ends, also at Bishapur, with a monumental composition in which a multitude of figures is distributed in four different registers: to the left, the cavalry, to the right, the Roman prisoners and the Persian troops carrying the booty. All the figures have been executed on a very small scale and barely stand out from the specially prepared concave surface, which is unique among these works; the artist evidently had a Roman triumphal monument in mind, possibly Trajan's Column.

111 In a mountainous valley some four miles from the town stands a huge statue of Shapur, carved out of a natural pillar supporting the roof at the entrance to a cave. It is 23 feet high and is the only free-standing statue in Sassanian art. The face is framed in a bush of long curls and displays a moustache, a beard tucked into a ring (a prerogative of reigning princes) and wide open, bulging eyes devoid of expression. The costume of thin silk is treated in a conventional manner with tongue-like pleats. There is every reason to believe that this statue marked the cave containing the mortal remains of the great monarch, who, according to Mani, died at Bishapur. The Zoroastrian religion forbade the burial of the dead; the bodies were exposed in the mountains or on specially built towers, after which the bones, stripped of flesh, were gathered together and placed in a cave or in some subterranean structure. One of these astodans (ossuaries) was unearthed near Bishapur. The square stone coffin, doubtless a product of late provincial Sassanian art, was adorned with relief carvings of Zoroastrian divinities: Mithras in his chariot drawn by winged horses, the god Zervan ('Infinite Time'), the fire god, and the goddess Anahita, distinguishable by a fish, who probably formed a tetrarchy of the Zoroastrian pantheon. No other religious monuments are known.

The effect of Shapur I's long reign (241–272) on Sassanian art, so far removed from that of the Parthians, was profound and lasting. The plastic arts in particular had undergone considerable modification since the time of Ardashir I, becoming refined and humanised. It is tempting to imagine that, during his journeys on horseback through the Syrian provinces of the Roman Empire, Shapur was sufficiently impressed by their art to introduce it into Iran. At any rate, Iranian art ceased to spurn motifs and elements from the West, adopting them and imbuing them, instead, with its own spirit.

107. Rock carving from Bishapur, showing the Emperor Valerian kneeling before Shapur I, to whom (in the Hellenistic tradition) a putto is bringing a crown of victory. Second half of the 3rd century.

The triumphal iconography of the King of Kings

After Shapur's death, rock sculpture continued to develop, reaching its apogee under his son and second successor, Bahram I (273–276). The relief carving representing this sovereign's investiture, with the balance of its composition, the modelling in the transition from the background to the raised surface, the noble and powerful proportions of the horses, the sweeping gesture traced by the god and majestically echoed in the outstretched arm of the king, the spirituality of the latter figure and the spontaneous treatment of the whole, deserves to be classed among the masterpieces of Persian plastic arts.

Next to Shapur I, it was Bahram II (276–293) who endowed Iran with the largest number of relief carvings, two of which are of subjects rarely chosen for rock monuments. At Naksh-i-Bahram, not far from Bishapur, the king is represented full face, seated on his throne and surrounded by dignitaries whose forefingers are bent in token of respect. The monarch is identifiable as Bahram II by the pair of wings on his crown, for each of the twenty-eight Sassanid kings wore a different crown, as may be seen from their coins.

Frontal representation, which was so strictly observed during the Parthian period, was not eliminated from Sassanian art; moreover, the rigid poses of the figures in this scene suggest that the high standard previously reached by the plastic arts was not maintained.

The theme of the king enthroned, though rare in rock sculpture, was frequently represented by the engravers of gold and silver. A silver dish in the Hermitage Museum bears a frontal representation of Chosroes I on his throne, surrounded by four dignitaries. However, the most famous of these pieces showing the king in majesty is incontestably the gold dish which belonged to the St Denis treasure and which is now in the Cabinet des Médailles of the Bibliothèque Nationale, Paris. It consists of a central medallion of rock crystal, surrounded by five concentric rings of chased medallions of rock crystal and

57

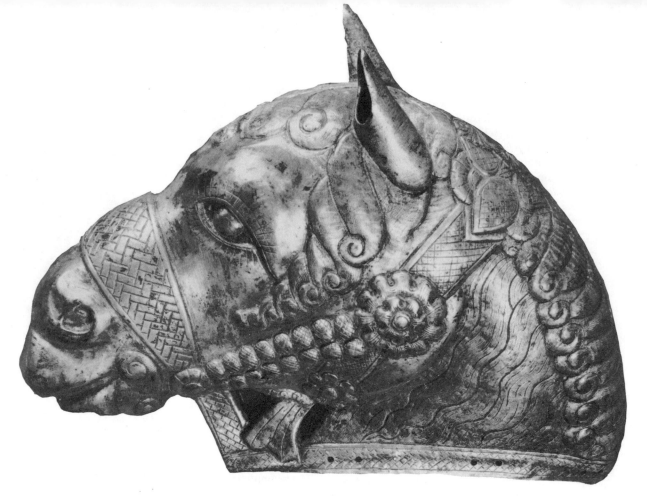

108. SASSANIAN. Silver-gilt horse's head. *Louvre.*

green and red glass. As on the dish in the Hermitage, the throne is supported by two winged horses which, for the Indo-European peoples, symbolised the immortality of the soul. Is it mere coincidence that this king's surname was Anushirvan ('of immortal soul')?

108 A silver-gilt horse's head recently acquired by the Louvre illustrates the delicacy of the work with which the goldsmiths and silversmiths decorated these thrones. The animal's ears, with their oblique cut, strongly resemble those of T'ang horses: the piece must therefore date from the end of the period under discussion.

Sassanian art thus glorified its monarch in the same way that Byzantine art, taking its inspiration from the former, subsequently was to glorify Christ. And just as the enthroned Sassanid monarch, regarded as an emanation of the divine on earth, was surrounded by his nobles, so Christ was to be surrounded by his Apostles. The king's person is exalted in yet another context in one of Bahram II's relief carvings at Sar-Meshed, south of Shiraz, which shows him plunging his sword into the breast of a lion while another beast lies felled at his feet. With a sweeping gesture he reassures the queen, who stands behind him between two dignitaries. In this scene, in which the artist has disregarded the balance generally prevailing in rock monuments, only the animals look unrealistic.

Two other relief carvings of hunting scenes, dating perhaps from the end of the Sassanian period, adorn the lateral walls of the great cave at Taq-i-Bustan, near 110 Kermanshah. The carving on the right shows the king hunting gazelles; that on the left shows him standing in a boat, followed by a troupe of musicians in other boats, shooting wild boar in the royal park. These hunting scenes are proof of the extent to which painting had influenced sculpture; following the principles applying

in painting, the artist has flattened out the shrubs and bushes constituting hedges. The herds of wild boar are shown in a flying gallop, and the portrayal of the elephants is striking in its realism.

As in the Sar-Meshed scene, the king is confronted by two boar which, in fact, are one and the same beast: hunted by the king, it cannot fail to be hit and is therefore shown dead at his feet from the start. This interpretation is confirmed by comparisons with other hunting scenes, such as that on a dish in the Metropolitan Museum, in which Chosroes I, on horseback, pursues two wild sheep while two of the same beast already lie felled by his arrows. This symbolism stands out particularly on a very beautiful silver-gilt dish in the Cabinet des Médailles, 118 showing two boar, a stag, a gazelle and a buffalo all fleeing before the monarch and the same five animals strewn dead over the ground.

The various different elements that were combined in the treatment of traditional subjects reappear in a relief carving at Naksh-i-Rustam figuring Hormuzd II (303–309), in which the artist was obviously trying to reproduce the scene at Firuzabad showing Ardashir I overthrowing Artabanus V. Later, rock sculpture became excessively overloaded with pictorial detail and gradually deteriorated in consequence.

The evolution of a pictorial style

Painting played an important part in the Near East from as early as the second millennium, when palaces were adorned with historical and religious frescoes. That the Persians inherited this type of decoration from the Achaemenians is proved by the fragments of red, white and blue painting which we ourselves found during the recent clearing of the apadana at Susa. Becoming ever more

58

widely used, it was passed on by the Parthians to the Sassanians, who gave it a decorative richness to which Islam would become heir. Ammianus Marcellinus, a contemporary of Shapur II, left an account of the Persian palaces and dwellings he had seen, describing how their walls were covered in frescoes of hunting scenes. And, indeed, the first Sassanian mural painting, probably dating from the first half of the 4th century, was recently brought to light at Susa. Painted with water-colours on a thick layer of loam coating the walls of unbaked brick, it appears to have landed face downwards when the wall caved in during the destruction of the town under Shapur II. The remains of two mounted huntsmen, almost twice life-size, one of whom wears a pink garment woven with gold thread, stand out against a blue background; a mass of different animals, some of which appear to be hurt while others continue their flying gallop, are only just discernible between the hunters' brown and red horses.

After destroying Susa, Shapur II built what is now Ivan-i-Karkha, some 10 miles upstream. Our preliminary investigations of the royal palace revealed that vast surfaces of the baked brick walls had been covered with real frescoes, executed on a thick layer of special mortar. The predilection for painting, which seems to have supplanted the vogue for stucco decoration, influenced other arts, particularly that of relief carving.

The only rock sculpture that can be attributed to Shapur II was found at Bishapur and commemorates this monarch's final conquest of the Kushan kingdom. It retains the disposition in registers of the nearby monuments: to the left of the king, who sits facing the spectator and leaning heavily on a long spear, stand his retinue, and on the right, bound prisoners are being brought before him, together with the severed head of the defeated ruler. The carving imitates the outline drawing traditional in early painting, while the coarse silhouettes barely stand out from the background surface. Iranian sculpture had now come under the influence of painting and its techniques, and was not to break free until the end of the Sassanid period.

After Shapur II's time, the ancestral province of Fars was abandoned for that of Kermanshah, where scenes of investiture show the monarch assisted by two gods instead of one: Ahura Mazda and Mithras in the relief carving representing the investiture of Ardashir II (379–383), at Taq-i-Bustan; Ahura Mazda and Anahita in the tympanum of the great cave on this site, attributed to Chosroes II (590–628). Although the relief was raised to the point where it became, in the latter monument, and particularly in the equestrian statue of the king, almost sculpture in the round, it never quite attained to three-dimensional status: the figures remained a lifeless mass of stone, on which the costumes were drawn with much care and detail.

109

112

The development of textiles

Shapur II, like his namesake, was brilliantly successful on the western front, and tradition attributes to him the deportation of a number of Syrian prisoners after his capture of Antioch. Among these, according to the chronicles, he picked out a group of expert weavers, whom he established in Susiana. Susa, Shushtar, Ivan-i-Karkha and Gundeshapur thus became important textile centres, especially of silk fabrics, which were destined for the court and the nobles and later for export.

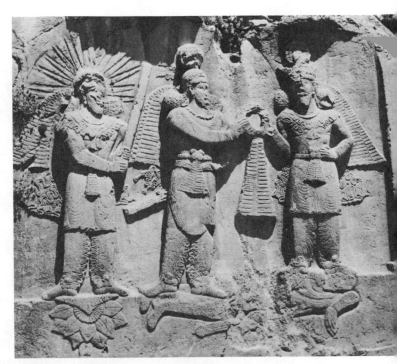

109. Rock carving at Taq-i-Bustan of the investiture of Ardashir II by Mithras, and by Ahura Mazda, who hands the crown to the new sovereign. They are shown trampling on the defeated enemy. Last quarter of the 4th century.

110. One of the carved panels in the great cave at Taq-i-Bustan (5th–7th centuries) representing scenes of the royal hunt.

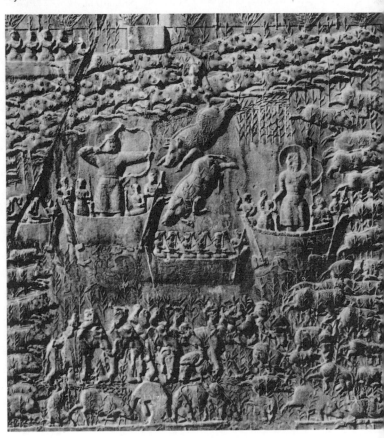

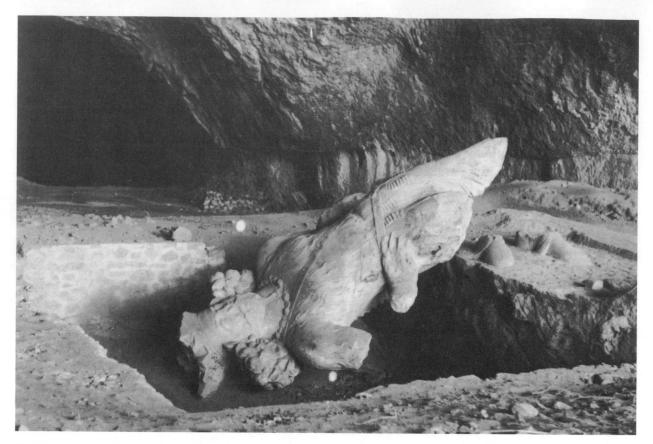

111. The colossal statue of Shapur I, found, badly damaged, in a cave near Bishapur. Second half of the 3rd century.

Towards the year A.D. 400, these precious silks began to circulate through the eastern Mediterranean basin, where their iconography influenced the local arts and notably the mosaics of Antioch. These Sassanian fabrics, or those which they inspired, have been preserved mainly in the sands of Egypt and in the churches and cathedrals of Europe, and of France in particular. Those in the Nelson Gallery of Art, Kansas City, which came from Egypt, display the classical subjects of Sassanian iconography, such as framed half-length portraits, birds facing each other and borders of palmettes with eight petals.

In 11th-century Europe there was a rising demand for saints' relics, piously brought from the Near East, and no fabric was considered too rich to hold these bones, which were mounted in gold or silver reliquaries, often set with precious stones. Thus, it was only a few years ago that yet another beautiful fragment of silk, adorned with scenes of King Bahram Gor at the chase, was found in the reliquary of St Calais (Calais cathedral). For centuries after the fall of the Sassanids the production of silks continued under the caliphs, the same themes and motifs being constantly repeated and also eagerly imitated by the Byzantine artisans. Some recently discovered fragments of Buyid fabric have demonstrated the late survival of a scene of investiture, which includes kings riding on winged elephants, lions pouncing on ibexes and two animals facing one another on either side of a Tree of Life, each motif framed within a pearled roundel.

The spread of Sassanian art

The Sassanid monarchs continued to build palaces right up until the fall of the dynasty, and the ruins of Kasr-i-Shirin cover an enormous area. Following the monarch's example, the nobles also built themselves sumptuous dwellings, whose walls were undoubtedly adorned with now vanished paintings. The excavations at Damghan on the plateau, and at Kish and Ctesiphon in Mesopotamia, have however brought to light a number of panels of stucco mural decoration. Some of these display busts of crowned rulers or other persons within a rich framework of plant motifs; others portray animals: beribboned sheep in pearled roundels, and birds among plants and flowers. The palmette and half-palmette were the chosen ornaments for friezes, and the stylised scroll-patterns foreshadowed the arabesques beloved of Islam.

It was probably during the 6th century, at a time when commerce was flourishing and the rich and refined of society were demanding luxury products, that the impact of Sassanian culture on the world reached its peak.

It is moreover from the Urals, southern Siberia, northeastern Russia and the Caucasus, the regions which at that time supplied the world with furs and semiprecious stones, that almost all the gold and silver plate known to us (now largely preserved in the Hermitage Museum) has come. This collection of chased ware, which is hard to date with any degree of accuracy, is far from homogeneous: a few of the pieces are late ones or are provincial products; others are copies made on the periphery of the empire. The great majority of the bowls and dishes are decorated with either hunting scenes or scenes of the banquets that often wound up the day. One of the bowls shows a king reclining on a couch and handing a wreath of flowers to his queen, while other wreaths, scattered nearby, indicate the presence of other guests; three boar's heads, by the same token, symbolise the successful outcome of the hunt. On another, boat-shaped, bowl an enthroned monarch is being presented with a festive wreath, while a servant waves a fly-whisk; two nude female dancers with long scarves adorn the narrow ends of the bowl. The beautiful silver-gilt carafe in the Teheran Museum, with its four female dancers framed under arches and its acrobatic musicians between volutes in the

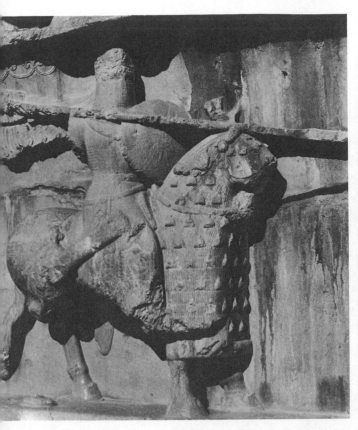

112. Equestrian statue of a king (Chosroes II?) carved in high relief beneath the scene of investiture in the great cave at Taq-i-Bustan.

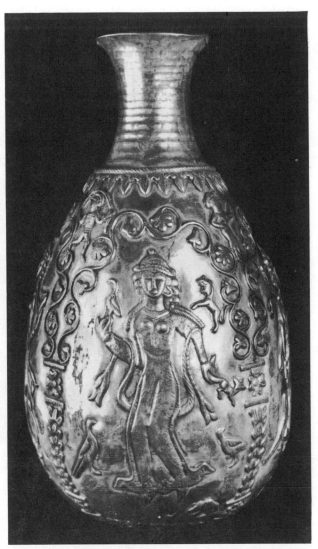

113. SASSANIAN. Silver-gilt carafe decorated in repoussé (5th–6th centuries), and a detail. *Teheran Museum*.

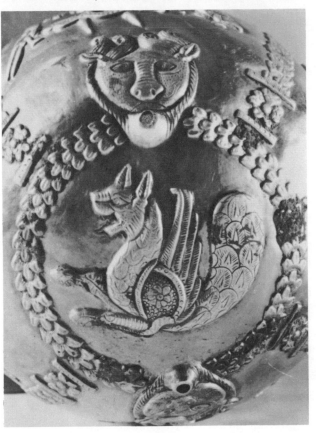

form of scrolls, was also made for the banqueting table.

A few other bowls and dishes are decorated with ferocious animals, composite creatures and lion-griffons with menacing fangs or serpents' tongues, and sometimes even with a female flautist riding on their backs. These subjects perhaps reflect the taste of society, in the West as in the East (since the beginning of the Christian era), for romance, travels through fabulous countries, the marvellous, the mysterious, the superhuman and the terrible. The composite creatures probably came from the legends which people liked to hear recounted, just as they enjoyed listening to tales of Bahram Gor's hunting exploits or as they still enjoy Firdousi's *Book of Kings* in Persia today.

Trade with Russia opened up a channel through which Sassanian art penetrated to the Dnieper region, where the Huns reassembled after Attila's downfall. Encouraged by the Avars, the Huns subsequently emigrated to Hungary and, through their contacts with the roving Germanic tribes, contributed to the transmission of these surviving Sassanian motifs as far as Scandinavia; even Merovingian art shows traces of their passage.

While the Parthian policy with regard to the Roman menace had been of an essentially defensive nature, the Sassanians firmly took up the offensive: the hitherto divided country was henceforth united under a central authority endowed with a powerful army and organised finances. With its vigour, wealth and variety, Sassanian civilisation asserted itself in the world, and Persia resumed the role of a propagator of both art and religion. Buddhism underwent the influence of Zoroastrian dualism; banished from Iran, Manichaeism spread to central Asia, to Egypt and even, through the Balkans, to France, where it led to the massacre of the Cathars of Béziers and Carcassonne (1209–1221). Nestorianism, the only Christian sect in Iran, penetrated as far as China; such was the amplitude of the propagation of religious ideas.

61

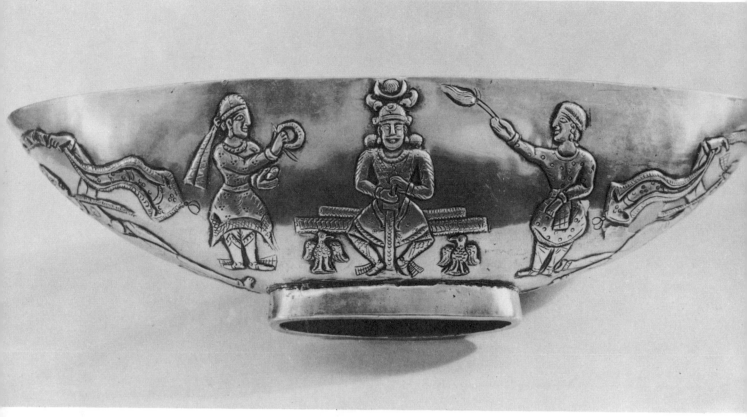

114, 115. SASSANIAN. Dishes decorated with scenes of royal banquets: an attendant hands the enthroned monarch a festive wreath; the monarch gives his queen the same symbolic offering. *Walters Art Gallery, Baltimore.*

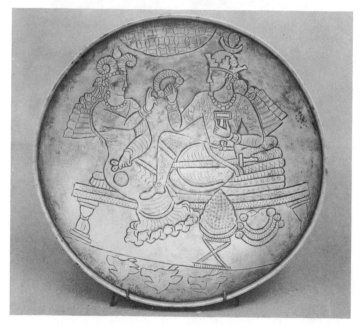

Sassanian art constituted the last phase of the art of the ancient East, the connecting link between the latter and Islamic art, on the one hand, and European medieval art on the other; it was neither the expression of a sudden renaissance, nor a late manifestation of Greek art. It embodied Iranian aestheticism, heir to the riches of western Asia and open to outside influences, transforming it in accordance with its own traditions.

The powerful expansion of the Sassanian iconography towards the East, which continued even after the fall of this dynasty, is only equalled by that of the great religions. A nomadic chieftain on his throne, dressed and armed in the Persian fashion and receiving the homage of his subjects, figures on various Sung vases, and Iranian influence is manifest in T'ang art, from the horses adorning the tomb of the founder of this dynasty to the hunting scenes on mirrors, ceramics and fabrics. Horsemen equipped in the Sassanian fashion appear in the frescoes of Chinese Turkestan; the horseman turning in his saddle to discharge an arrow was reproduced, as late as the 9th century, for the Kirghiz princes of the valley of the Yenisei, in southern Siberia; while the proto-Bulgarian treasure of Nagy-Szent-Miklos, which abounds in motifs derived from the Sassanian chased metal wares, forms but a single link in this chain which stretches across the globe from China to western Europe.

In the West, the Roman mosaic worker reproduced Sassanian themes on the pavements at Antioch. The Coptic monk adapted them to his paintings, and the Byzantine weaver drew abundantly from the same treasure, if only for the representation of the Triumphant Christ and his entourage, copied from that of the King of Kings. By sea and overland this rich iconography eventually reached France, where the church of Germigny des Prés was built on the lines of a fire temple, while the Tree of Life which figures in the frescoes adorning its walls is reminiscent of the same motif in the cave at Taq-i-Bustan. The stucco decoration on the tomb of Abbess Aguilberte, interred in 665 in the church at Jouarre, is of Sassanian inspiration, and pious sculptors reproduced Persian scenes and gestures, sometimes without knowing their original meaning, throughout the old churches of France. However, the true heir to Sassanian Iran was Islam, which long perpetuated and propagated the forms forged by Persian genius and expressed in this ancient Iranian art which cast its last seeds far and wide.

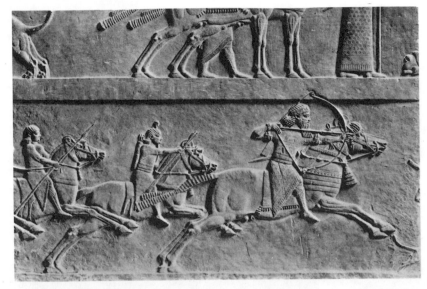

116. ASSYRIAN. Assurbanipal hunting the wild ass. Detail of a relief carving from the palace at Nineveh. 7th century B.C. *British Museum.*

117. PARTHIAN. Mounted archer. Terra-cotta relief. *Staatliche Museen, Berlin.*

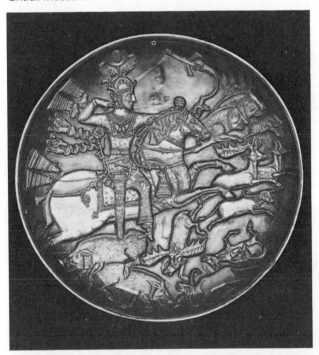

Destined to have a major influence on the civilisations of the Near and Far East, the art of Parthian and Sassanian Iran gathered up and sorted out the diverse legacies from earlier civilisations. This art principally asserted itself as the heir to the Near Eastern past, not only of Achaemenian Persia but also of ancient Mesopotamia, from which it derived many of its themes: the hunting monarchs of Assyria [116] were perpetuated in the riders mounted on horses in a flying gallop, represented with the same conventions and in the same stereotyped attitude as the archer [117, 118].

At the same time, however, this art showed signs of numerous exchanges with the Greek and Roman West: the Roman relief carving from Ephesus [119], which displays the concave-backed horse typical of the ancient civilisations of the Near East, betrays the classical origin of the winged Victories bearing crowns to be seen at Taq-i-Bustan [120], and of the partially draped female figures seated on the ground in the mosaic at Bishapur [104].
R. H.

118. SASSANIAN. Royal hunt. Silver-gilt dish inlaid with niello. 7th century A.D. *Cabinet des Médailles, Bibliothèque Nationale, Paris.*

119. GRAECO-ROMAN. The triumphant Marcus Aurelius in the solar chariot. Relief sculpture from Ephesus. 2nd century A.D. *Kunsthistorisches Museum, Vienna.*

120. SASSANIAN. Winged Victory, over the entrance to the cave at Taq-i-Bustan. 5th–7th centuries A.D.

HISTORICAL SUMMARY: Parthian and Sassanian art

Archaeology. Whereas the historical role of the Parthians was defined at an early date, their art was first tackled by C. Humann and D. Puchstein in 1890. A study of Parthian art was made by F. Sarre, some thirty years later.

The beauty of the Sassanian gold and silver plate and the quality of their textiles have inspired the specialists to pursue their studies in this field, and the French Archaeological Mission keeps up its excavation work on several sites.

History. Alexander the Great's death in 323 B.C. did not put an end to the struggle which had been going on between the East and the West for almost two centuries. Although Alexander had failed to realise his dream of a total fusion of the two worlds, the ascendancy of Hellenism over the vast territory extending from the Mediterranean to the Indus was too great for it to disappear at once. After the period of confusion following the downfall of the Achaemenids, Iran found new leaders who were prepared to oppose the encroachment of the West, which, with the passing of the supremacy from Greece to Rome, was experiencing a revival of Hellenism: the Parthians, Indo-Europeans who came from Scythia, founded the Arsacid Dynasty—named after their first sovereign, Arsaces—in 250 B.C., and inaugurated the Parthian era in 247.

Claiming a rather doubtful kinship to the Achaemenid Dynasty, the Parthians (250 B.C.–A.D. 238) inaugurated a long series of aggressive and defensive acts against the ascendancy of Rome, a series interrupted by truces and peace treaties. Nevertheless, though the West was repulsed in the military field, Hellenism continued to exert a powerful influence over the Iranian regions.

In 224 the Sassanid Dynasty, from Persia and of sacerdotal origin, overthrew the Arsacids and resumed the struggle against Rome on its own account, with varying success; certain of its kings, such as Shapur I, who captured the Emperor Valerian at Edessa in 260, were victorious. However, after a brilliant cultural flowering this dynasty fell before the onslaught of the Arabs, between 642 and 651.

Architecture. The monuments left by the Arsacids are relatively few; architecture could hardly have been of much interest to these descendants of nomads, whose periodical migrations in search of fresh pastures precluded any conception of a durable edifice. Discoveries recently made in Bactria, however, show that they were not without appreciation for the art of building: fire temples (at Pasargadae, Persepolis, Bishapur, etc.), palaces and columned halls were all executed in handsome materials and with large blocks of stone. The most characteristic feature of their architecture is its combination of Near Eastern and Greek traditions which, however, were interpreted in such a way that the elements derived from Hellenism always remained superficial. Some of the Parthian structures foreshadowed later architecture: for instance, the iwans, or large halls with true vaults which were completely open to an inner court (Kuh-i-Khwaja, in Seistan); or the engaged columns and the masks set into the walls of the monuments at Hatra [**93**], in northern Mesopotamia, which reappeared in both Sassanian and Byzantine architecture.

Sassanian architecture, which was more elaborate, drew heavily on the architecture that flourished under the Arsacid and Achaemenid Dynasties. Astonishingly varied through its incorporation of diverse traditions, it reflected the cosmopolitanism of the Sassanian empire. Brick, faced with stucco, then probably painted, was used in conjunction with stone, the latter being henceforth mainly reserved for the foundations. The high barrel vaults and the monumental entrances gave the buildings a majestic appearance, while their rather austere façades, adorned with niches and moulded string-courses, were of a somewhat frigid but grandiose order [**102, 106**]. No agreement has as yet been reached as to their dates: the ruins of Ctesiphon (the palace called Taq-i-Kisra), which are the most important, have been successively attributed to Shapur I (3rd century) and to Chosroes I (6th century).

Sculpture. Sculpture in the round was rare during the Parthian period. The known examples reflect the diverse races and types that circulated through the Near East at that time. The workmanship of certain heads is spontaneous and straightforward, others are of Hellenistic tradition. A bronze statue from Shami, now in the Teheran Museum, deserves special mention; it is 6 feet 4 inches high and represents a standing male figure in a frontal and rigid attitude [**87**]. The technique is impeccable and, despite its static and somewhat ponderous air, the statue compels respect for Parthian sculpture, besides being precious evidence for the costume of the period. Sculpture in the round was still rarer under the Sassanids.

It is mainly in the carvings in high and low relief that the sculptural concepts of both Arsacid and Sassanid times are embodied. Following the Achaemenid example, both dynasties had monumental compositions carried out to celebrate their victories [**99, 101, 107**]. The Arsacid ruler Gotarzes II (38–51), whose exploits were

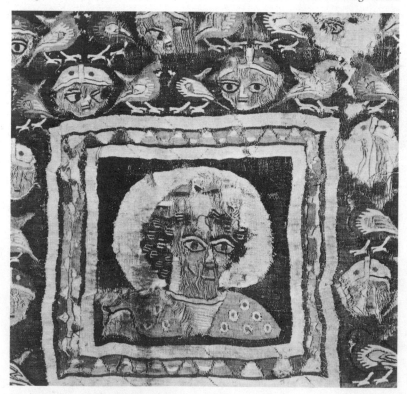

121. Detail of a Coptic textile having several Sassanian motifs: framed bust, heads without necks, etc. *Nelson Gallery of Art, Kansas City, Missouri.*

NORTHUMBRIAN. Page from the Lindisfarne Gospels (fo. 26 v.). Beginning of the 8th century. *British Museum.* Photo: *Urs Graf Verlag.*

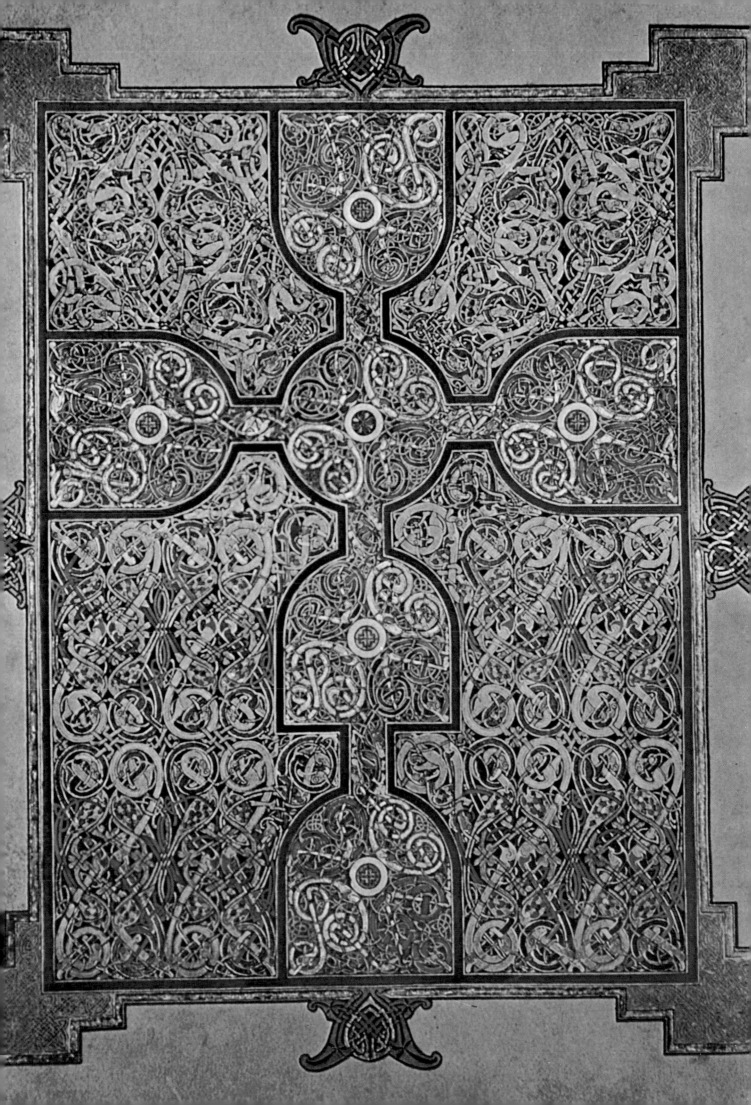

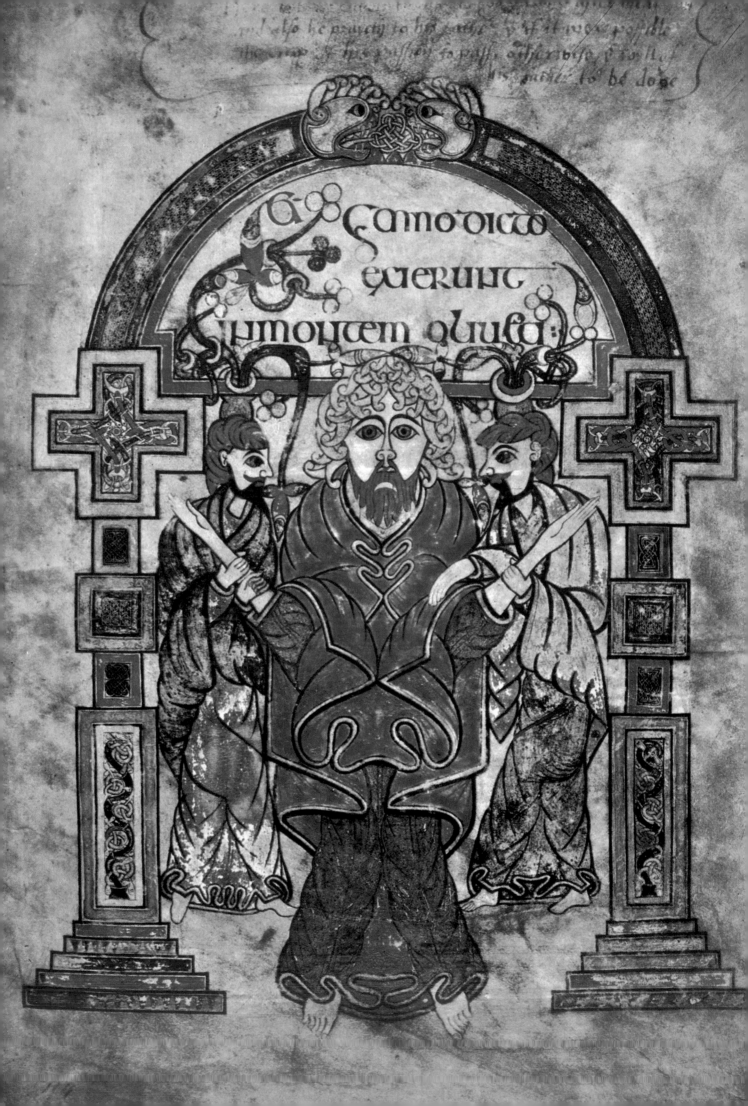

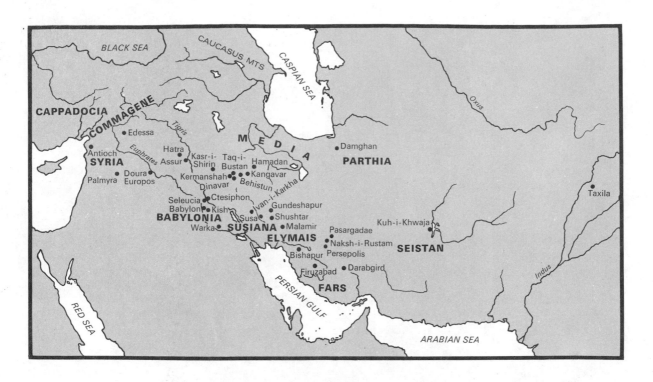

BLACK SEA
CAUCASUS MTS
CASPIAN SEA
CAPPADOCIA
COMMAGENE
Edessa
M E D I A
Damghan
Hatra
Antioch
SYRIA
Kasr-i- Taq-i-
Assur Shirin Bustan Hamadan
PARTHIA
Doura
Palmyra Europos Kermanshah Kangavar
Dinavar Behistun
Taxila
Seleucia Ctesiphon
Babylon Kish Ivan-i-Karkha Gundeshapur
BABYLONIA Susa Shushtar
Warka SUSIANA Malamir Kuh-i-Khwaja
ELYMAIS Pasargadae SEISTAN
Bishapur Naksh-i-Rustam
Persepolis
Firuzabad Darabgird
Indus
RED SEA PERSIAN GULF FARS
ARABIAN SEA

IRAN IN PARTHIAN AND SASSANID TIMES

recorded by Tacitus, is represented at Behistun defeating an adversary protected by Rome, while the Sassanid monarch Shapur I (242–272), who triumphed over Valerian at Edessa, is represented in all his glory at Naksh-i-Rustam, receiving the homage of the defeated Roman Emperor, who kneels humbly before him. Executed on rocky cliffs during the 3rd and 4th centuries (a group at Taq-i-Bustan would seem to date from the 6th or 7th century), these carvings in high relief (about thirty in all), with their colossal dimensions and gigantic figures, were conceived with the intention of overwhelming the spectator. They are Near Eastern in style, but with a strong admixture of Hellenistic elements visible in the treatment of the draperies, in the accentuated modelling of the figures and in the theme of the winged Victory [120] crowning the Emperor.

Painting. In the Arsacid period painting played a major role: the walls of the palaces were covered with frescoes, and the relief carvings were enhanced with colour that has since worn off. The remains of paintings found on the sites of towns like Palmyra, Doura Europos and Kuh-i-Khwaja [92] are extremely important for the study of Parthian civilisation and its relations with the rest of the world. The colours, sulphur-yellow, brick-red, violet, blue and pale flesh-tone, against white or pearl-grey backgrounds, constitute a vivacious and yet simple harmony. Many of the subjects were derived from

Hellenistic art and even show an affinity to the art of Gandhara which, at that time, constituted an extension of the Partho-Iranian world; some foreshadow Byzantine painting and, in particular, the Imperial compositions at Ravenna; others, in the Hellenistic taste, are purely decorative: leaves copied from the acanthus, busts, etc.

Pictorial art—often combined with that of mosaics [104, 105]—continued to flourish under the Sassanids, though few traces of it remain in Iran itself. At first strongly influenced by Roman painting, it gradually developed an individual style; it was in its most Iranian aspect that it was transmitted to central Asia, where it long survived and became mixed with Buddhist elements from India and China. A rather late but typically Sassanian fresco, at Dokhtar-i-Noshirwan (5th century?) represents a meeting of the Iranian and central Asiatic worlds; it shows a prince seated in majesty, encircled in a halo made up of the forequarters of animals, and it was no doubt executed by artists from Kapisa (Afghanistan), who were more used to portraying Buddhist subjects.

The minor arts. Goldsmiths' work was certainly the most important of the minor arts under both the Arsacids and the Sassanids; indeed, Iran has always been a centre for metallurgy. The Parthian masterpiece has already been mentioned in the paragraph on sculpture in the round. Gold and silver plate was produced in quantities and, like the other arts practised

in Iran during this period, combined Near Eastern and Hellenistic elements; jewellery was of cloisonné inlaid work and was often extremely elaborate.

The production of gold and silver plate was particularly abundant under the Sassanids. A large number of the dishes in these metals have been so highly appreciated that they have figured among the treasures of kings the world over; many of them bear scenes of the royal hunt [114, 115, 118]. Besides these dishes, there were elegantly shaped ewers and flasks adorned with typically Iranian subjects [113]. This sumptuous ware was decorated in repoussé with cloisonné inlays of rock crystal, coloured glass or enamel; like the Parthian ware, it shows both Hellenistic influence and that of the animal art of the steppes [97].

Sassanian coins are distinctly Near Eastern by comparison with those of the Arsacids, which were inspired by Graeco-Bactrian art.

Textiles were one of the main products of the Sassanian period; they acquired a universal reputation and were exported to both the Far East and the West. The technique was the same as that of Gobelin tapestries, and the decoration consisted of pearled roundels, mostly containing pairs of animals facing each other, a motif that recurred throughout Sassanian decoration; they circulated the whole length of the Silk Route and were imitated in both Europe and Japan.

Jeannine Auboyer

IRISH. Page from the Book of Kells, showing the Arrest of Christ. c. 800. *Trinity College, Dublin. Photo: The Green Studio.*

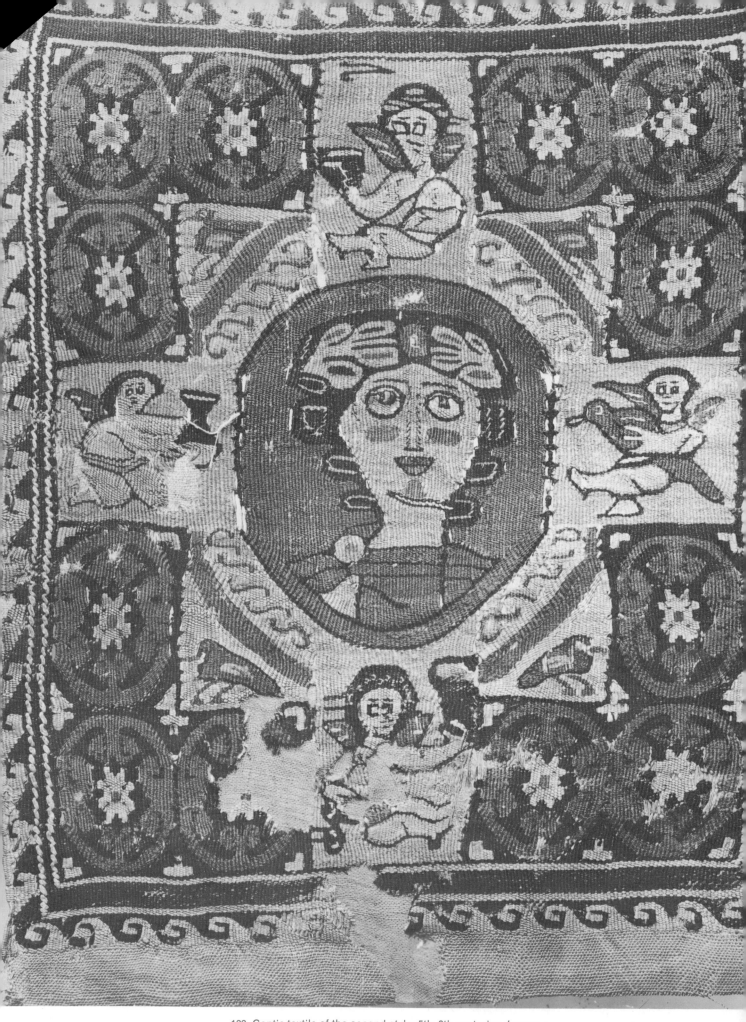

122. Coptic textile of the second style: 5th–6th centuries. *Louvre*.

EGYPT AND COPTIC ART *Etienne Drioton*

The vast expansion of Christianity promoted the development of local styles of art. One of the most important of these arose in Egypt, where the return to Eastern tradition on the breaking up of Hellenistic culture took the form of a national Renaissance. This art was prematurely interrupted by the Arab invasion in the 7th century, but though it disappeared it nevertheless contributed to the formation of the art of its conquerors, who were in search of traditions which they themselves lacked.

Coptic art is the art produced by the Christians in the Nile valley from the time of the Peace of the Church (313) until the Arab conquest of Egypt (640). The word 'Copt' is merely a corruption of the Greek word *aigyptios* (Egyptian), which in the Egypt under Roman and, later, Byzantine domination was used to designate the autochthonous Christian elements, who adhered to their own traditions and to the ancient language of the country.

The origins of Coptic art

This does not mean that Coptic art was related to ancient pharaonic art. This latter had been annihilated by Alexander who in destroying the old Eastern dynasties had also destroyed the prestige of their courtly arts, which he replaced everywhere with Hellenistic art.

124 The one and only symbol of the ancient art officially adopted by Egyptian Christianity was the ansate cross, the hieroglyphic sign for the word 'life'. The Coptic Church often used it to represent the Christian Cross, and did so with defensive intent. The statues of the ancient gods held this emblem in their hands and the Christians seized upon this fact as an argument against the pagans to the effect that even their own gods had extolled the new religion.

The origins of Coptic art are to be found in the Roman art common throughout the Near East, where it had succeeded to Hellenistic art. Of the buildings of this period, no remains of any importance have survived in Egypt, apart from the basilica at Hermopolis Magna, the Corinthian capitals of which conform to the rules of Vitruvius and explain the similar style of those in the 125 nearby monastic church at Baouit. Fragments of ornamental sculpture, discovered at Oxyrhynchus and dating from the 4th century, are still in the Roman style, but show signs of the infiltration of Eastern taste.

The transfer of the capital of the Empire to Byzantium, in 330, had far-reaching consequences. The political ascendancy of the East liberated and stimulated a latent taste of these regions, a fusion of centuries of aestheticisms, which Hellenistic art had dominated but not destroyed.

Coptic ornamentation presents a definite characteristic: it is no longer architectural. The decoration in preceding arts, and especially in Greek and Roman art, had never broken away from its association with the architecture, since dentils and triglyphs were permitted only on entablatures, egg-and-dart mouldings on cornices, acanthus leaves on capitals, and, on the Roman monuments in Syria, the imitations of inlaid work under the curve of an arch. For mosaics, there was a specialised repertory of geometrical or figurative designs disposed in subdivisions.

All these conventions were disregarded in Coptic art. The sculptor chose his models at random and applied them indiscriminately to any part of the building. As the mood took him, he decorated the shaft of a column or the border of a pediment with motifs copied from mosaics, 123 or he inserted a theme from a Roman sarcophagus in the string course of a frieze. The decoration was no more than a kind of rich embroidery in stone applied to any element or form regardless of its architectural function.

The pre-Coptic background and the earliest monuments

Since Coptic art, as the very meaning of the word implies, was the art of the Egyptian Christians, it is wrong to attribute to it, as is sometimes done, pagan sculpture more or less contemporary with its origins.

The sculpture at Oxyrhynchus, of the late Roman period (Graeco-Roman Museum at Alexandria), and those at Ahnas el-Medineh, discovered by E. Naville in 1890–1891 (Coptic Museum, Old Cairo) are a case in point. Owing to the similarity of their decorative repertory and style to authentic Christian sculpture, they have quite rightly been qualified as pre-Coptic. Moreover, among typically pagan works such as figures of Hercules, Aphrodite and Leda, the excavations at Ahnas el-Medineh brought to light two pediments divided in niches, which doubtless come from a church close to the temple where the former were installed. All this sculpture, both pagan and Christian, seems to be by the same hand or at least to have come from the same workshop. The obvious affinity of the decorative detail and of certain of the types with Mesopotamian sculpture suggests that they might be the work of a Palmyrene colony, established in these parts from the end of the 4th to the middle of the 5th centuries.

The discovery not only of sculpture but also of bronzes of the same style in various parts of Egypt proves that this pre-Coptic art was not a local phenomenon, but that it developed all along the Nile valley from the middle of the 4th to the middle of the 5th centuries, serving both ascendant Christianity and declining paganism; it was an art strongly influenced by that of eastern Syria, for whom the foreign colonies in Egypt acted as intermediaries.

Until recent years the two Christian pediments at Ahnas el-Medineh were regarded as the earliest known monuments of Coptic art. However, another small pediment from a limestone niche, in the Mirrit Boutros Ghali 131 Collection in Cairo, appears to date from the first half of the 4th century and is therefore still earlier. It is, moreover, of an entirely different type.

Its architectural composition is striking. It is a triangular segmental pediment, from the centre of which there emerges a half-length figure of Christ in benediction between two allegorical figures, placed above and below Him. In high relief on the constituent elements of the pediment, the artist has carved Early Christian emblems from the recently ended period of the persecutions: dolphins symbolising Christ the Saviour, roses, which stood for the Cross, and in the spandrels hares upsetting baskets of fruit; the significance of this last emblem has not yet been established.

This too is Roman art, overcrowded and mannered in

123. Part of a pediment having a decoration imitating mosaic work. *Louvre.*

124. A Coptic church unearthed in a court of the temple at Denderah. End of the 5th century. Note the ansate cross in the foreground.

the contemporary taste, but deriving from the same classical tradition as the earlier sculpture at Oxyrhynchus.

Thus Coptic art in its early stages differed not at all from the triumphal art which then prevailed throughout the Christian world. With the latter, it could have continued this tradition and in fact did so up to a point. Its sudden preference, at the end of the 4th century, for the art of the East can be explained by the then prevailing fashion in Egypt, as throughout the East, but also by a profound conviction held by the Church in Egypt. In their latent opposition to the rest of the Christian world, which was Greek speaking, the Christians of the Egyptian Church, who took pride in their anchorites and cenobites, whom they compared in dignity to the ancient prophets of Israel, regarded themselves as the chosen people of God within the Christian community, the Israel of the New Covenant. It was therefore quite natural that they sought to give tangible expression to this spiritual affiliation through the help of the ancient concepts of art which, in their estimation, had been those of biblical Israel, and which had been driven, before the advance of Hellenism, to the confines of civilisation. This doubtless also explains the surprising fact that the Christian art of Egypt was influenced by the hybrid arts that flourished on the eastern marches of the Byzantine Empire, rather than by the art of Syria, which was after all closer to it.

The golden age

Having started out on this course, Coptic art, during the three centuries of life allotted to it (4th–7th centuries), produced, if not masterpieces, at least works of great interest.

In the field of architecture, the churches of the White Monastery and the Red Monastery at Sohag, dating from 124 the middle of the 5th century, that at Denderah, which is only slightly later, the ruins found at Sakkara, of that of the monastery of St Jeremiah, founded in the second half of the 5th century and the chapels of the monastery at Baouit, which may be attributed to the 6th century, have furnished the major elements for the study of Coptic art. Whereas the interior of the surviving buildings had the 133 basilican plan inherited from the Constantinian churches, 132 together with a dome, a trefoil apse and an open-rafter ceiling over the nave, their exterior, conceived as a cubic mass with sloping walls surmounted by a cavetto (gorge), betrays a curious correspondence to ancient Egyptian

buildings. Their interior decoration, of colonnades and pedimented niches, generally followed the tradition of triumphal Christian art. It was in the decoration of the niches, the string courses of friezes or the capitals of columns that the Coptic artists' genius for innovation asserted itself.

Roman art in the East had shown a marked predilection for opulent foliate scrollwork and also for vine scrolls with clusters of grapes, in honour of Dionysus, whose cult was immensely popular in these regions. These decorative themes were taken over by the Christians, who made the 19–23 vine the emblem of the Church, the vine of the Saviour. However, the treatment of these motifs underwent a radical change throughout the East: the scrolls no longer projected in plastic relief from a light surface, but tended to be flattened and silhouetted on a deeply undercut surface, which thus constituted a background of shadow. The Coptic artists pursued this course to the limit of its possibilities. Even the leaves were often hollowed out with serrated edges which bore no resemblance to reality, but which, with the play of light thus created, were of a highly decorative effect. At the same time, these leaves were simplified to the point of becoming purely conventional, 129 and the geometrical treatment of the scrolls prepared the way for the arabesques of Islamic art. By following such a course, which no longer had anything in common with that of Graeco-Roman art, the Coptic artists of the 5th, 6th and 7th centuries succeeded in creating a wonderful repertory of decorative friezes for the monastic churches.

The capitals of their columns followed the same evolution. The type they adopted was that used in the Roman monuments, the Corinthian capital. However, all over the East the rich and supple acanthus leaf tended to be replaced by a deeply serrated leaf, each separate element of which fanned out into three sharply pointed fangs. The 125 Copts further accentuated this form. Moreover, carried away by the desire to free sculptural decoration from all architectural association, they even went so far as to dissociate the traditional arrangement of the acanthus leaves 126 and to juxtapose their component parts on the surface. This same conception of form enabled them to create a capital of vine scrolls which is also characteristic of 127 Coptic art.

As yet, little is known of Coptic paintings of the 5th to the 7th centuries, since the fragments of painted decoration in the monasteries, which were repainted from time

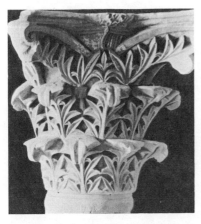

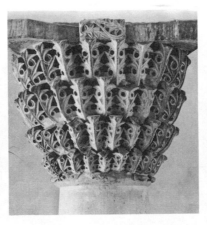

125. Corinthian capital from Baouit. 6th century. *Louvre.*

126. Capital from Baouit, with acanthus leaves. 6th century. *Louvre.*

127. Capital with leafy vine branches, from Sakkara. End of the 5th century.

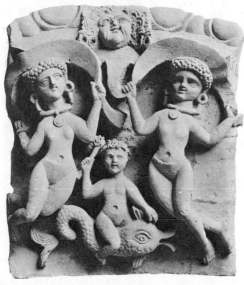

128. Dancing nereids, and a sea sprite riding a dolphin. Fragment of a cornice. 4th–5th centuries. *Trieste Museum.*

129. Fragment of a frieze from Chapel B at Baouit. 6th century. *Louvre.*

While Coptic sculpture derived its themes from Eastern Roman art, it treated them in a purely decorative manner, in which architectural conformity and regard for realistic modelling had no place. The geometrical motifs proper to mosaics were used indiscriminately to decorate pilasters and pediments [123]. The acanthus leaf became serrated and pointed [125], and was even used, as was the vine, to form new types of capitals [126, 127]. The scroll became flat and geometrical [129], or was reduced to a narrow band with pierced or undercut decoration [137].

to time up to the period of the Arab domination, have still not been accurately dated. The best collection, which appears to date back to the 6th century, was discovered in the ruins of the monastery at Baouit. It shows the same diversity of influence as may be observed in the other branches of Coptic art, certain compositions having directly derived from Alexandrian models, even to the detail of the white garments which are a perpetuation of Alexandrian tradition, others having been influenced by Persian art, and the majority, with their bearded figures, having been inspired by Syrian iconography.

A painting of still another style, unearthed in a part of the monastery dating from the 8th century, shows that Coptic painting in its decline did not escape the tendency, prevalent throughout the East, to idealise religious subjects: the Three Hebrews in the Fiery Furnace are portrayed as children in the arms of a gigantic angel. This is no longer a picture: it is an icon.

While Coptic painting in its golden age preserved all the freshness of the few Alexandrian motifs it adopted, the same is true, to an even greater extent, of the minor arts: decorated textiles, bronze lamp ornaments and carved ivories, the latter mostly used for the adornment of wooden coffers. During the Roman period, the Alexandrian industry had flooded the market with articles of this kind, bearing mythological scenes which were inspired in particular by the legends of Dionysus and Aphrodite and by the fable of the nereids (sea nymphs). Christianity did not

reject this repertory, since it regarded it as the illustration of purely literary fiction. Thus, despite the introduction of other, specifically Christian or Eastern subjects, Coptic art perpetuated these themes until the Arab conquest, treating them in a more and more summary manner as the ancient feeling for modelling declined.

What might have become of Coptic art if the progress it had made, after it came under a certain discipline in the monastic churches of the 6th century, had not been suddenly arrested by the Arab conquest? It is perhaps possible to obtain some idea from the 7th-century archivolt, found in Upper Egypt, and now in the Louvre Museum, on which the vine motif appears to have reached the limit of the evolution whose tendencies have been traced above: it is no more than a flattened scroll whose elements are interwoven, the one fitting into the space left by the other and the two no longer separated except by a deep incision, as in the engraved decoration on certain copper objects of Arabic art. An emblem at the top and musician angels at the bases, carved in high relief, offset the flatness of the rest of the decoration. This was a specifically Coptic ornamental formula, which could have had an interesting development. The Church of Egypt, conquered by the Arabs and cut off from the rest of the Christian world, adopted the artistic formulas of the invaders. The art produced during the periods after the 8th century can no longer be referred to as Coptic art: it was merely the 'art of the Copts', a Christian facet of Arabic art.

139

135

138

130
128

122, 134

137

69

HISTORICAL SUMMARY: Coptic art

Archaeology. Whereas the first Egyptologists scorned, and, in the interests of their excavations, even destroyed the Coptic edifices, J. Maspero, in 1882, set aside a room in the Boulac Museum for Coptic sculpture. In 1884, A. J. Butler published a summary of the churches in the Nile valley. Strzygowski and Monneret de Villard placed the Coptic works of art in the correct perspective of the Christian East.

History. Reduced to a Roman province after the battle of Actium (31 B.C.), Egypt, on the death of Theodosius (A.D. 395), was effectually incorporated into the Eastern Empire. Converted to Christianity, and invaded by the Persians in 615, she was above all the theatre of serious religious controversies. Rallying to the Christological doctrine of Eutyches, who denied the tenet of Christ's human nature, and becoming Monophysite following the example of her patriarch Dioscorus, Egypt seceded from the main body of the Church after the council of Chalcedon (451), which had condemned this doctrine. She received the Arabs (640) as liberators from the hated Byzantine yoke. As a result, Coptic art was extinguished on the threshold of its maturity. The Copts were those Monophysite Christians whose liturgical language remained the 'Coptic tongue', the last form of the pharaonic language, which disappeared from current use in the 17th century.

Architecture. The ruined basilica of St Menas, built by the Emperor Arcadius (395–408) in the desert near Alexandria, cannot be attributed to Coptic art. A unique and pure importation of the 'Imperial' Byzantine style, this basilica was without influence. The same is true of the necropolis at Bagawat, in the Kharga Oasis, in the middle of the desert. The Romans turned it into a place of exile for deportees from distant provinces and left a few monuments of uncertain date. Of the decorated domes of the two main funerary chapels, the one shows biblical representations coarsely copied from the Early Christian art of the catacombs, the other, allegorical figures of a more Byzantine character.

The characteristic monuments of Coptic art are: the churches of the White Monastery (built *c.* 430) and of the Red Monastery (more or less contemporary) at Sohag, in Middle Egypt: basilican plan with trefoil apse [**132, 133**], ceiling of open rafters, interior decoration of a triumphal style: in the apses are frescoes and two superimposed rows of Corinthian columns, separating extremely richly carved niches with pediments and jambs; the church unearthed in the first court of the temple at Denderah, in Upper Egypt (end of the 5th century) [**124**]: the superstructure has disappeared; there was the same general disposition. The monastery of St Jeremiah at Sakkara (end of the 5th

century), plundered by the Arabs, was brought to light between 1907 and 1909, and contained a large quantity of sculpture and a few paintings; there was also the ruined monastery of St Apollonius (5th century) at Baouit in Middle Egypt. (The interesting elements from the latter two buildings are in the Coptic Museum of Old Cairo and also, from the second, in the Louvre in Paris.)

The minor arts, textiles. Numerous small bronzes (lamp ornaments [**130**]) and plaques of carved ivory or bone (ornamentation for wooden coffers) survive from Coptic art. The textile industry, which had prospered at Hellenistic Alexandria, was continued by the Coptic artists, who perpetuated its pagan representations in the new style.

The celebrated textiles are almost the only ones in the ancient world to have survived; this was because of the dryness of the climate. The fragments of material recently discovered at Palmyra have revealed that, although Coptic decoration originally followed models of the Roman period, common throughout the East, it developed them in accordance with its own genius. They are woven like tapestries in wool or sometimes silk trefoils or roundels to decorate tunics or linen scarves.

They have been divided into three styles:

1. Post-Hellenistic period (4th–5th centuries): Graeco-Roman motifs; monochromes (of dark purple) or polychromes, of delicate tone [**134**].

2. Christian period (5th–6th centuries): introduction of the Cross, biblical scenes or Christian figures; the forms have stiffened and the ornamentation has become Easternised. The bright colours have been flatly applied and complementary colours are contrasted [**122**].

3. Coptic period (6th–7th centuries): exaggeration of the preceding tendencies and adoption of Byzantine or Sassanian motifs. Wine-coloured backgrounds imitate those of the illuminated manuscripts on papyrus or parchment washed with purple [**136**].

Josèphe Jacquiot

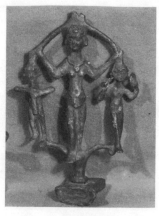

130. Aphrodite between two figures of Eros. Decoration on a bronze lamp. 4th–5th centuries. *Louvre.*

131. Pediment of a niche showing Christ giving blessing, surrounded by allegorical figures and Christian emblems. First half of the 4th century. *Mirrit Boutros Ghali Collection, Cairo.*

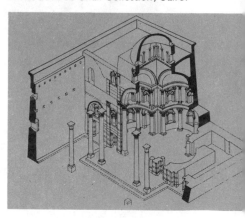

132, 133. Analytical perspective of the apse in the church of the Red Monastery, and reconstructed plan of the church of the White Monastery, at Sohag. Middle of the 5th century. (*From Monneret de Villard*, Couvents prés de Sohag.)

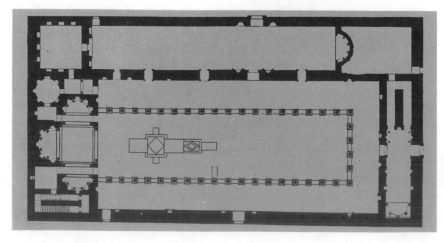

134. Coptic textile of the first style: 4th–5th centuries. *Louvre.*

136. Coptic textile of the third style: 7th century or later. *Louvre.*

138. The Three Hebrews protected from the Fiery Furnace by the Angel. Painting from Baouit. 8th century.

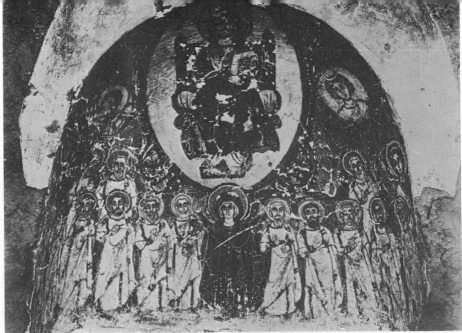

135. Christ in Glory, surrounded by the Virgin and saints. Painting in the monastery of St Apollonius at Baouit. *c.* 6th century.

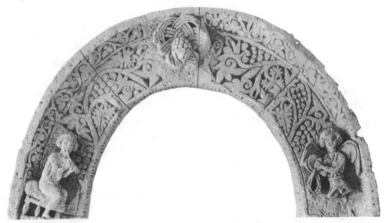

137. Archivolt of a niche or doorway, from Upper Egypt. 7th century. *Louvre.*

139. Christ and St Menas. Painting on wood, from Baouit. 7th–8th centuries. *Louvre.*

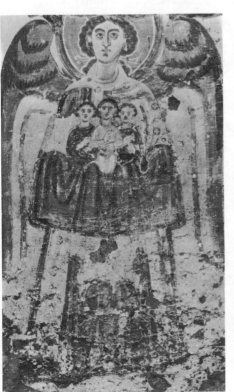

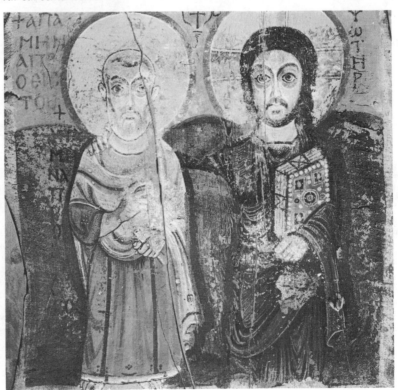

CHRISTIAN ART IN IRELAND AND NORTHUMBRIA *René Huyghe*

By the 5th century a Church had been formed in northern Europe, centred in Ireland, whose remoteness and isolation, accentuated by the barbarian invasions, contributed towards its independence. There an art developed which, based largely on local material, gave a new and unexpected lease of life to the old Celtic spirit, revitalised by the influence of the Germanic barbarians, who will be studied in the next chapter. This led in the 8th century to an art whose 'abstraction' lingered after the spirit of the primitive Church had passed.

Medieval Ireland is of an exceptional and unexpected interest: it developed a Christian art which reflected, to an even greater extent than that of Byzantium, the detachment from physical reality, to the point where realism was radically proscribed. The case is unique in the West, whose cultures, since the beginning of our era, have all been marked to a greater or lesser degree by Mediterranean influence with its feeling for nature and for man. This feeling was almost totally lacking in Ireland where, mainly during the 8th century, and in conjunction with Scotland and northern England, an art developed, which would today be called abstract. The suspicion is growing that this art, which was disseminated on the continent in part, at any rate, through the network of monasteries stretching as far afield as Switzerland and even Lombardy (Bobbio), founded by these zealous, missionary-minded Irish monks, exerted an as yet not fully appreciated influence on the Middle Ages, and introduced forms into its visual repertory that have enjoyed lasting popularity.

The conversion of Celtic Ireland to Christianity

Ireland's position at this time resembled that of no other country. She had seen the Romans establish themselves in nearby Great Britain on the coast opposite her, but never dared to cross the sea that separated them. During prehistory and especially in the Metal Ages, the country, which due to its gold mines had early attracted maritime commerce, had been the seat of a relatively brilliant civilisation. These Metal Ages, which had come to an end everywhere else due to the impact of the Roman conquest, which created a new and more 'modern' world, here continued uninterrupted. Scotland, to the north of Hadrian's wall, found herself in an analogous position. Graeco-Latin art was known only superficially through commercial exchanges, and was mainly referred to when technical perfection in the minor arts was sought.

The Celtic genius thus remained undisputed and, during the first centuries of the Christian era, continued to maintain the tradition of fine goldsmiths' work, the secret of which had been acquired mainly during the second Iron Age; the same lively forms were thus transmitted to the following centuries, during which they evolved and flourished anew, as is attested by a masterpiece like the gold torque of Broighter.

Christianity had already entered the country through its contacts with Gaul, but it was a total conversion that St Patrick undertook in the middle of the 5th century, as from 432. With him he brought objects of religious art and even craftsmen. He introduced the primitive monasticism whose traditions he had encountered at Lérins; these, it should be remembered, were essentially Egyptian: the art that he brought was therefore of Coptic origin.

As St Patrick, in accordance with the policy of the Church, did not wish to quarrel with the established civilisation of military chiefs and Druids, he doubtless contributed from the start towards a fusion. The Celtic themes used in goldsmiths' work, the principal art of the feudal lords, many of whose sons were converted and became monks, were combined with Coptic themes sustained by continued exchanges with Egypt and even with Syria. (The exchange of visits between the monks and even the transport of grape vines has been proved!) It must be remembered that sea voyages from the Mediterranean and along the coasts of Spain and Gaul had been undertaken from time immemorial and had ended in Ireland rather than along the dangerous shores of the Channel.

It was in the monasteries, despite the ascetic and harsh existence led by the monks, that a cultural life developed around the study of sacred texts and the production of manuscripts, to which, according to Irish tradition, the greatest saints of her Church devoted themselves. The scriptoria in these primitive buildings occupied the space between ceiling and stone vault.

The austere spirit which animated these monks was hardly propitious to art. During the 5th century, architecture, to all intents and purposes, did not exist: there were only large stone (sometimes only clay or wooden) huts. It was not until some generations later that painting and sculpture made their first appearance. Meanwhile the great invasions, which had started as early as the beginning of the 5th century, continued to sweep over Europe and to dispel the traces of Roman power. Ireland, protected by the sea and by her remoteness, thus found herself radically cut off from the Latin world and its traditions. Consequently, the new civilisation and art, brought her by the intrusion of Christianity into the heart of her Celtic tradition, matured as in a sealed bottle.

Ireland, Scotland and England

In contrast, Ireland felt the pull of Scotland, which she began to infiltrate. The first step was the founding, by St Columba in 565, of the monastery on Iona, off the west coast of Scotland. The Irish monks were born missionaries and energetically set out to convert the pagans. Bit by bit, they extended their activity to England. Their becoming established in Northumbria, where Aidan, from Iona, had founded Lindisfarne in 635, marked the peak of their influence. By the 6th century their monasteries had become schools, to which flocked pupils, not only from converted England but also from the continent, avid to draw afresh upon the founts of culture preserved in them. The monastery at Bangor with its 3,000 monks may be recalled here.

The Irish offered Christianity and learning. In exchange they were enriched by contact with Germanic art, a

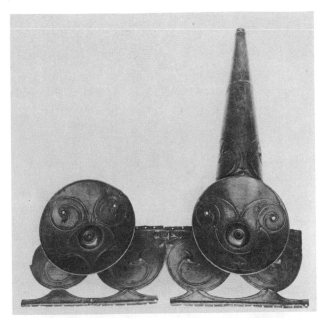

140. IRISH EARLY CHRISTIAN. Petrie crown. Fragment of a votive crown, perhaps designed to be hung in a church. Cast bronze. *National Museum, Dublin.*

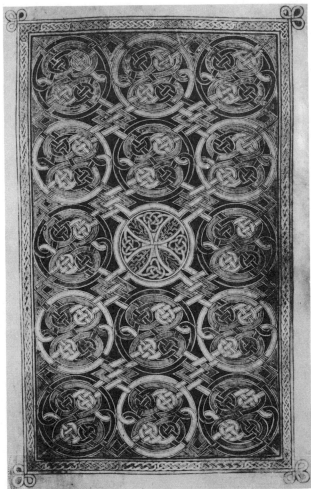

141. IRISH. Book of Durrow. End of the 7th century. Page showing interlaced designs. *Trinity College, Dublin.*

142. NORTHUMBRIAN. Lindisfarne Gospels. Beginning of the 8th century. Beginning of the Gospel according to St John, showing a mixture of Celtic and Germanic elements. *British Museum.*

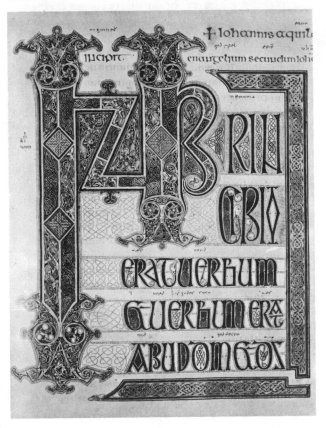

'cousin' of Celtic art, brought from the East by the Anglo-Saxons, who had infiltrated into England and established themselves there at about the time that St Patrick had arrived in Ireland.

The Celtic foundation was reinvigorated by this art, and its tendencies were strengthened by an influx of analogous forms inspired by a kindred spirit—it, too, abstract and extremely dynamic. Moreover, interlaced patterns were also known, though they had entered Germanic art through different channels, from the same Eastern source as Coptic art, and to this was added a whole fauna of monsters with gaping jaws.

As is often the case with nomads, goldsmiths' work was the technique preferred by these northern peoples in their art, a technique which was also to become one of the major forms of Irish art: the spiral and every sort of curve and twist, all the forms that evoke an impulsive manual gesture or the rebound of a spring, were here deployed. Spirals and coils soon began to undulate over the surfaces of pillars and stelae, which were traditionally associated with oratories and which were perhaps themselves the fruit of a collusion with the prehistoric megaliths, respected but Christianised; as yet, they hardly affected the manuscripts, in which the text predominated. The earliest examples that have survived (7th century) come for the most part from one of the great offshoots of the Irish Church set up by the nomadic Irish monks as far away as Italy, the ruined monastery at Bobbio. Here, in the decorated letters, and sometimes in a fully decorated page, may be traced the first essays of an art that was soon to be elaborated brilliantly in Irish illumination. It is all there, or rather, already on the way: the capital letters are preparing to invade the margin before going on to devour the page; the play of spirals and curves, from which an animal's head emerges here and there, is developing. However, all this is still dormant, like a fire that is laid and awaits only the application of a match. The flame has not yet been kindled.

Suddenly it burst forth, the first of the great manuscripts—a missal, like the majority of them—the Book of Durrow, which dates, at the earliest, from the last third of the 7th century. After that, one great manuscript followed another, covered, with ever increasing profu-

140

141

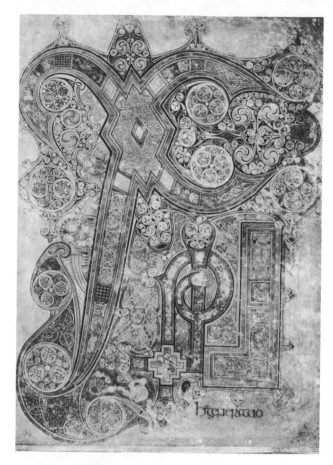

143. IRISH. Book of Kells. *c.* 800. Chi-Rho page. *Trinity College, Dublin.*

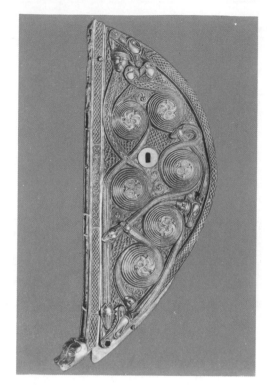

144. IRISH. Part of a lamp stand (?). Cast and gilded bronze. 8th century. *Musée de Saint Germain.*

145. IRISH. The Tara brooch. Gilt-bronze adorned with gold filigree and jewels. Beginning of the 8th century. *National Museum, Dublin.*

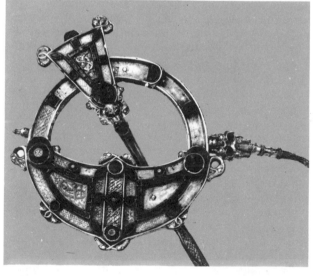

sion, in a decoration of a singular style. These, however, were the work of the 8th century: the Lindisfarne Gospels, the Lichfield Gospels and the Book of Kells, as its stars, covered more than a century of creative activity, since this last-named volume, in which a sort of baroque mannerism appears, already seems to belong to the 9th century.

In the gigantic groups of capital letters and on the vast tapestried pages, Coptic, Celtic and Germanic (Anglo-Saxon and Scandinavian) elements became ever more closely interwoven; they were thrown into a whirlpool of movement with neither beginning nor end, in which the line knotted and unknotted itself in complex mazes of interlacements, now disappearing, now reappearing and ending suddenly in a monster grasping the head or a limb of another monster in its open mouth.

The same dynamic frenzy seized the masterpieces of contemporary sculpture—high Crosses, stelae and pillars—and of goldsmiths' work, the Tara brooch, the Ardagh chalice, etc., in which enamel came to play the role played by colour in the illumination of manuscripts.

Ireland and Scotland were henceforth united in the unfolding of a common style. The most renowned scriptorium was situated at Lindisfarne, in Northumbria, between the walls of Hadrian and Antoninus, which had marked the northernmost limits of the Roman Empire.

The Northumbrian question

The flowering of Irish art thus dates from the time when its centres had been transferred to the monasteries established in Northumbria, where Scots and English closely intermingled with the aboriginal 'Scoti'. Moreover, not only its decorative repertory, but even the technique of its design, sharp and precise as that of an engraver, manifest the influence of Anglo-Saxon goldsmiths' work. Nothing like this had been produced in Ireland.

Were they then the authors of this flowering? Was it not rather accomplished by the Northumbrians? Indeed, was it not the latter who in fact transmitted this style to the continent? In short, is Irish art really Irish? Did not the long confusion caused by the romantic taste of the 19th century for the Celts lead to a veritable historical swindle? The theory has frequently been put forward and has recently gained particular weight due to the arguments of the Belgian scholar, M. Masai.

The surviving works alone do not furnish conclusive proof either way. The whole matter might be settled if the solution were sought in the history of the period.

During the 6th century, Rome, particularly under the brilliant leadership of Pope Gregory the Great, was seeking to ensure her disputed hegemony in the Church. This Pope sought astutely to boost Roman prestige by the diffusion of its liturgy and its art. He was obviously perturbed by the excessive expansion of this daughter of the

74

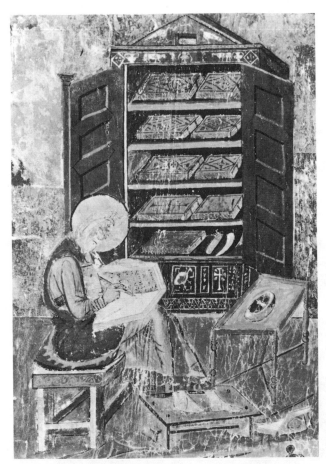

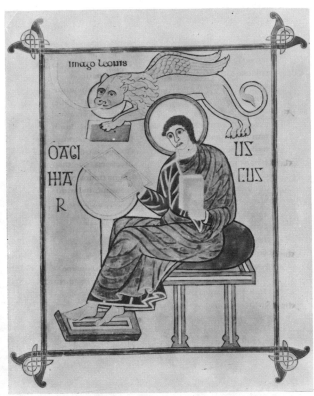

146. BRITISH BENEDICTINE. Miniature from the Codex Amiatinus. End of the 7th century. Copy made at Jarrow of a manuscript imported from Italy: the illustration shows Ezra writing. *Laurenziana Library, Florence.*

147. NORTHUMBRIAN. Lindisfarne Gospels. Beginning of the 8th century. One of the pages showing the Evangelists (here St Mark), inspired by the continental manuscripts (*cf.* 146). *British Museum.*

Eastern Church, the Church of Ireland. Her ambitious propagation knew no bounds, especially after St Columban, in 585, had undertaken the conversion of northern Gaul; nor had she, in 615, hesitated to found the monastery at Bobbio, near Milan, with the help of the very king of the Lombards who, in 593, had laid siege to Rome.

A mission under the direction of St Augustine, which St Gregory sent to convert the Franks, found itself preceded by an Irish mission; in 596, the Roman mission crossed to England.

The conflict between the two Churches was bitter: they not only fought over the conversion of the Saxon rulers, but, far more seriously, over the question of ritual (Paschal computation, tonsure of the monks, order of the Gospels, etc.). The Benedictines sent by Rome attacked the Irish in their cultural stronghold: York soon became the centre of a school destined to retrieve the youth of England. As advance bastions against Lindisfarne, monasteries were founded at Jarrow and Wearmouth, in the eastern coastal region near Durham, by Benedict Biscop. Here he set up a library and a scriptorium and brought books from Italy illuminated in the Benedictine manner, in the more realistic and humanistic style which Rome was soon successfully to impose. The inspiration came 146 from celebrated works such as the Codex Amiatinus, copied in England, and mural paintings. Finally, he had monuments built *more romanorum* (in Roman style).

And the Roman Benedictines triumphed. In 664, the synod of Whitby consummated the defeat of the Irish in the north, who had refused to yield. In 716 Iona, the last stronghold of resistance, surrendered. Now the first great 141 masterpiece of Irish book illumination, the Book of Durrow, was produced during this same period, towards the

end of the 7th century, when the national Church was collapsing. It seems probable that, defeated in the field of dogma, the Irish Church felt that its prestige could henceforth only be upheld by that of its art and its books. It was doubtless for this reason that it set about endowing them with that brilliance against which its ascetic spirit had hitherto rebelled. The great books, in which, as in goldsmiths' work, all the hitherto dormant possibilities were exploited, were evidently the outcome of this effort.

The Benedictines owing allegiance to Rome, their triumph henceforth secured, were, in turn, obliged to show far more tolerance towards the artistic productions of their defeated adversaries. As a result a sort of compromise came about, of which the Northumbrians, especially those at Lindisfarne, were the chief beneficiaries. Thus the Lindisfarne Gospels showed an amazing intensification of Celtic themes, reinforced by the Germanic 142 influence that came from the local Saxon goldsmiths' work, and, at the same time, introduced the representation of the Evangelists inspired by the Benedictine books. 147

It must have been these factors that determined the evolution of this Hiberno-Northumbrian style, in which the Celtic genius found its most perfect expression by adding a geometric rigour that curiously foreshadows certain characteristics of the English Perpendicular Gothic style. This, doubtless, was the contribution of English sensibility. At the same time, the abstract harshness softened, and attempts to produce 'figurative' art were made. With the Book of Kells, this art reached what 143 might be called its baroque or flamboyant phase, and was taken to Europe by the Hiberno-Saxon establishments.

In sculpture, also, after a period of irreconcilable opposition between the Irish and the Roman styles on 149

151 various Crosses, a compromise finally came about during
152 the 9th century in which the dominant Irish motifs were
fused with Carolingian ones. And so Lindisfarne, Jarrow
and Wearmouth finally associated in a common effort.

Local decline and influence on Europe

How this art, so boldly asserted during the 8th century,
would later have evolved, will never be known: within
a few years the Vikings had pillaged and destroyed the
great monasteries. Their first raids, which began in 793,
spelled the destruction of Lindisfarne; in 850, Olaf the
White settled at Dublin. Only a few late manuscripts,
such as the MacRegol Gospels, remained in Ireland, where,
deprived of the examples and technical skill of the great
schools, local artists attempted clumsy copies.

However, Irish art achieved a more ample posthumous
life. Through the monasteries on the continent and the
transport of manuscripts, it spread far and wide. Whereas
the Carolingian Renaissance steered the destiny of Euro-
pean art back on to the traditional Graeco-Latin course
and dedicated it anew to the truth and harmony of nature,
the Irish heritage kept alive the Celtic and Germanic
message, that of the 'barbarians', as the ancients called
them. Their more mystic art disregarded nature; when-
ever it accepted it, it did so only to twist it to its own
unconventional play of lines and colours; for it was in the
movement of a line or the brilliance of a colour that it
sought to give vivid expression to the intensity of life.

It has been possible to show the immense debt owed
by the Carolingian miniatures and Romanesque art to this
Celtic lesson, and how greatly it encouraged stylisation.
Its influence continued on Gothic art: the Celtic triskele
(three-branched figure) reappears, barely modified, in
many a rose window; above all, the forms in motion
which seem to undulate or twist, along the bays or in the
mobile centre of the rose windows, sometimes retain the
dynamism whose continuity and transmission were en-
sured by the example of the miniatures for generations to
come. The Irish miniature and its derivatives were among
the principal components of the medieval visual repertory.

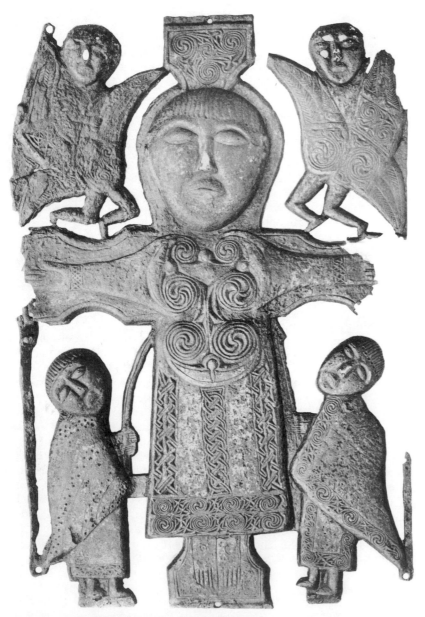

148. IRISH. Crucifixion. Gilt-bronze plaque from Athlone.
8th century. The triskele reappears on the still rather
schematic figures. *National Museum, Dublin.*

149. IRISH. Stele of Fahan Mura
(Donegal). Second half of the 7th
century. Interlace with two schematic
figures; an inscription in Greek
confirms the contact with the Eastern
Mediterranean, which was doubtless
established through the Copts. (*From
Fr Henry*, La Sculpture Irlandaise.)

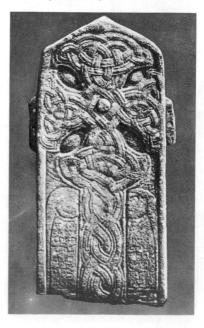

IRISH ART

History. The Irish who, during the Middle Ages, were known as Scoti (Scots), had been converted to Christianity in the 5th century. They maintained an important centre of monastic religious culture in north-western Europe. Their missionaries travelled far and wide over the continent and made a major contribution towards the conversion of Gaul, Germany, the Low Countries and Switzerland. St Columban founded (610) a monastery at Luxeuil in Burgundy (which gave rise to others at Jouarre, Chelles, Jumièges and Noirmoutier), and later one at Bobbio, in Italy (615). St Emmeran founded the Scots' church at Regensburg.

Sculpture and painting. The continuity of the Celtic style may be traced from late La Tène art (gold necklace of Broighter, 1st century A.D.) to Early Christian art, which began in the 5th century, and its goldsmiths' work (penannular brooches, clasps, small bronze bells, crosiers, and the Petrie crown in Dublin [**140**]). This art began to mature during the second half of the 7th century: first with the stelae and pillars (stelae of North Inishkea, Caher Island, Killaghtee and especially those of Carndonagh and Fahan Mura [**149**]), on which the braid pattern and interlace work were elaborated and sometimes associated with highly schematic human figures. This style is echoed in the art of illumination, in the Book of Durrow [**141**].

At the beginning of the 8th century, a fusion came about between Irish art and Northumbrian art, the result of which was the Lindisfarne Gospels [**142, 147**]. The influence of Germanic interlaced animal forms becomes clearly manifest (bronze plaques from vessels [**144**]), following a period of close contact with Scandinavian art, attested by the analogy of the carved Crosses and runic inscriptions in Scandinavia. This style was diffused by the missions on the continent (missals in the Bibliothèque Nationale, Paris, at Durham and at Lichfield, and the manuscripts at Echternach). The same style is displayed in goldsmiths' work: large penannular brooches (Tara brooch [**145**]), the Ardagh Chalice [**32**], enamels, etc., which inspired the Crosses with pierced circles (at first chiefly in the south of Ireland at Ahenny, Kilkirrane, Killamery, etc., and then at Clonmacnoise where the animal interlace predominated).

After 750, the interlace underwent a prodigious development in the manuscripts, in which highly stylised human forms appeared on certain pages: Gospels of St Gall [**150**]; MacRegol Gospels, Oxford, with its smaller imitations of Dimma and Mulling; Book of Kells [**143**]; and early in the 9th century, Book of Armagh. The Viking invasions cut short the development of this art.

ANGLO-SAXON ART

Anglo-Saxon art developed parallel to that of the Irish, but it combined more closely the Roman with the Celtic influence. The stone architecture is notable for the basilica at Canterbury, built by St Augustine, and for the abbeys at Ripon and Hexham, built by Wilfrid.

Illuminated manuscripts showed the same combination of influences, the Canterbury Psalter (c. 785) being a blend of Byzantine and classical styles with that of Ireland.

This art left its mark on the development of the West, notably on the Carolingian Renaissance.

*Josèphe Jacquiot
and René Huyghe*

150. IRISH. Crucifixion. Page from the St Gall Gospels. Middle of the 8th century. Here we see the interpretation of Eastern manuscripts in a decorative, abstract style. *Library of the Cathedral of St Gall, Switzerland.*

151. PICTISH. Stele of Hilton (Ross-shire, Scotland); late phase. Added to the Irish spiral and the interlace are hunting scenes reminiscent of the Scandinavian stelae. *(From Bain, Celtic Art.)*

152. IRISH. Muiredach's Cross, Monasterboice. c. 900. This cross, which is typical of the last phase, shows the evolution of the figure style under continental influence.

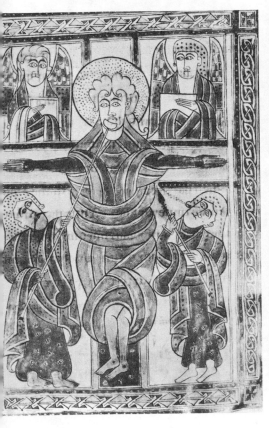

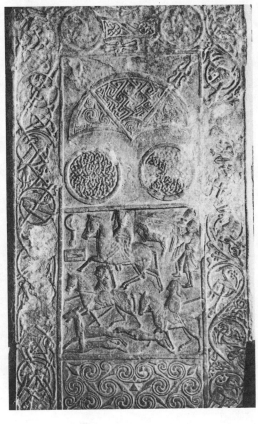

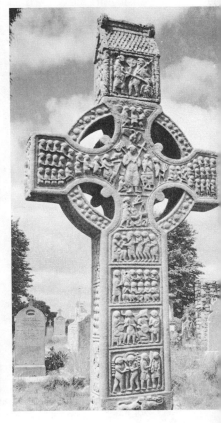

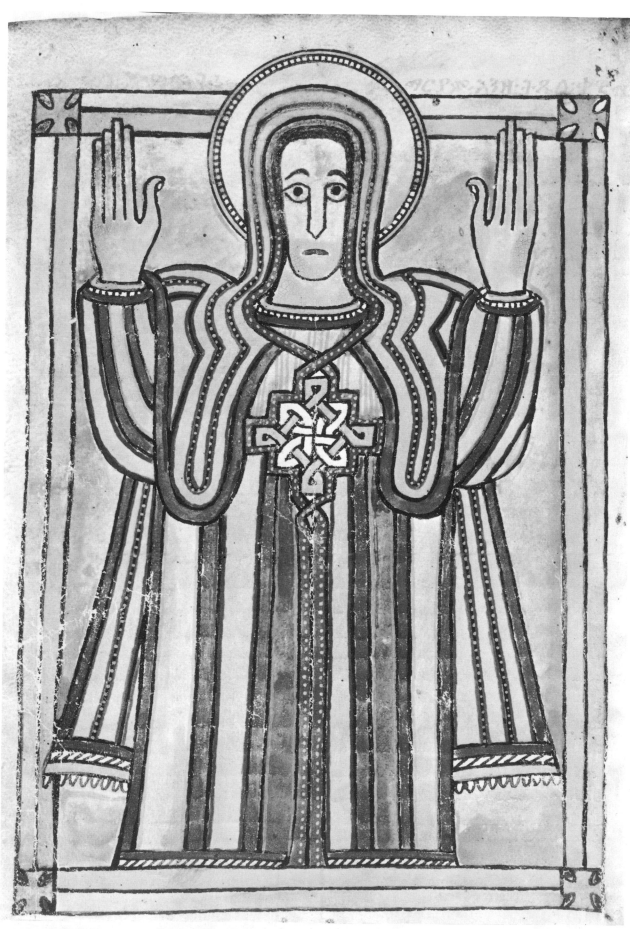

153. ETHIOPIAN. Miniature from a manuscript of the 15th century: the Virgin in prayer. MS. of the Abbadie Fund, No. 105. *Bibliothèque Nationale, Paris.*

154. *Right.* ETHIOPIAN. Monolithic church at Lalibela (northern Ethiopia). 12th–13th centuries.

A LATE SCHOOL: ETHIOPIA *Wilhelm Staude*

The art of the first centuries of the Christian era, having elsewhere either disappeared completely or taken on a new character between the 6th and 8th centuries, underwent an unexpected late flowering in Africa with Ethiopia, territory of the 'King of Kings', who traced his genealogy back to Solomon and the Queen of Sheba. It is thanks to Wilhelm Staude's intimate and locally acquired knowledge that it has been possible to present here this little known art.

Ethiopian art cannot be studied in accordance with the classical methods. Many monuments have disappeared without leaving any traces. This art was directly or indirectly influenced by a variety of extraneous elements operating successively or simultaneously. From the hybrid style of certain anonymous works, it is impossible to decide whether they were by Ethiopians working under the guidance of foreign masters or from foreign models.

One thing is certain—the arts served the Church from a very early date, since Ethiopia had been converted to Christianity at the beginning of the 4th century. Not a single work of art from this early period has survived; the first objects required for the cult and the first images offered to the faithful for veneration were doubtless imported from abroad.

The remains of churches dating from a later period, even to the group of monolithic churches at Lalibela, in the north, built during the 12th century, confirm the predominance of outside influence.

When, during the 12th century, the reformist Emperor Zar'a Ya'kub consolidated the foundations of Ethiopia, he also strengthened its ties with Jerusalem. It was in Jerusalem that the legendary Queen of Sheba bore King Solomon a son who, according to tradition, became the first

king of Ethiopia, under the name of Menelek I. In Jerusalem, too, stood the basilica of the Holy Sepulchre, in which the Ethiopian monks were privileged to reside and to celebrate their offices in the very shadow of Christ's tomb. However, Jerusalem was so far away that few pilgrims succeeded in overcoming the obstacles presented by man and nature along the road.

The Ethiopian Church was faced with the problem of how constantly to remind the faithful of the origins of their monarchs and, at the same time, to bring to them the mysteries of the Christian religion, relating either to Christ's life, His miracles, His sacrifice, His resurrection, or to the life of the Virgin, who was the subject of a very special veneration. How could they express the teachings of the Gospel by signs more eloquent than words? How could they best secure the protection of the particular saint to whom each church was dedicated, and that of all the other saints, of whom there are a considerable number in Ethiopia?

These problems of a religious order determined the specifically Ethiopian architecture and explain the fact that the same type of church was so frequently repeated: a church built on a circular plan, its interior either an open space or divided into several aisles, depending on the dimensions of the edifice, but always provided with a cubical cella, placed in the centre of the church and crowned with a drum. This cella, which has three doors, is the sanctuary containing the altar with the Ark and the sacred wood, the *tabut*, which are a reminder of the Ark and the Tables of the Law, transferred from Jerusalem to Axum by the son of Solomon and the Queen of Sheba, Menelek. It is here that mass is celebrated, hidden from the eyes of the uninitiated. The faithful participate through hymns, prayers

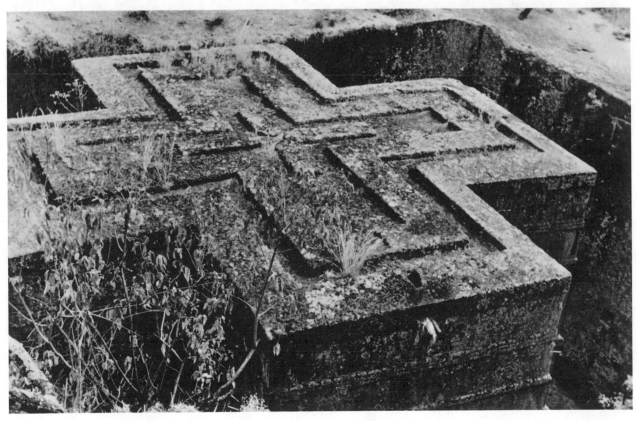

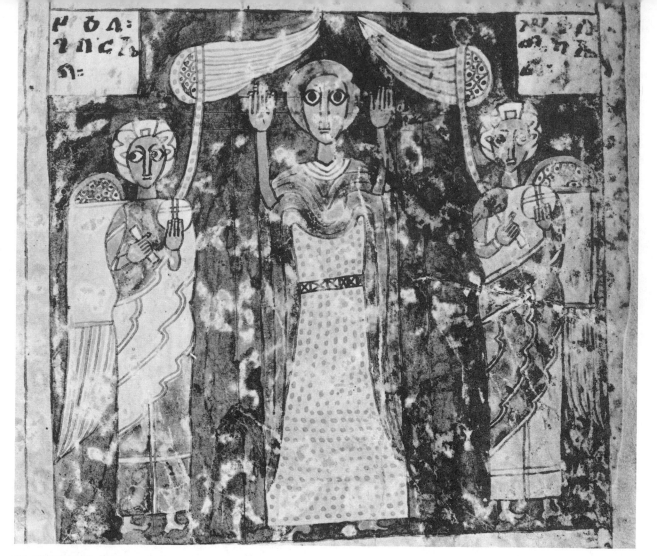

155. ETHIOPIAN. Miniature from a manuscript of the 14th
century: the Virgin between two archangels. Eth. MS. No. 32.
Bibliothèque Nationale, Paris.

and the communion; to them, it is as though the celestial
Jerusalem were come into their midst. Each church seeks
to be a reflection of this 'centre of the world', not only in
outward appearance, but also in spirit.

While the celebration of the Holy Sacrament is taking
place, the Ethiopian contemplates the images adorning
the church, which inspire his thoughts. These consist of
icons, and, in rich and important churches, paintings on
reinforced canvas cover the four walls of the sanctuary
and the drum surmounting it.

Some of these images offend by the awkwardness of
their forms, the discordance of their flat colours and the
realism with which certain of the religious scenes, often
taken from the apocryphal gospels or from legends, are
represented. Some, on the other hand, are striking for
their harmony of tone, their elegance of line and the
variety of subjects treated: more often than not, such
156 works derive from the Gondar school of painting, founded
in the 17th century, or else they are paintings done by
Ethiopians working under the direction of a foreign
master, perhaps a Greek or an Armenian.

The painters trained at this school worked according
to firmly established rules. Aesthetic problems seem to
have been considered less important than the observance
of rules and a feeling for symbolism, the colours which
were suitable for the Virgin's gown, or the appropriate
manner in which to represent a given personage or object.
Above all, it behoved the painter to follow, within the

limits of the space available, an iconographic programme
so vast that no church would be large enough to contain
it in its entirety.

Its essentials were as follows: God the Father or the
three Persons symbolising the Trinity, surrounded by the
'forty thousand priests of heaven', should figure on the
west side of the drum. The chief scene on the wall, on the
same side, should be the Crucifixion, with as a compulsory
adjunct Adam's skull upside down at the foot of the cross
to catch the blood of the Redeemer. The 'wicked Jews'
should be represented in profile. The north wall was
reserved for the so-called 'militant saints', who are partic-
ularly honoured in Ethiopia; the east wall was for the
kings of the Old Testament and the prophets; the south
wall for scenes from the life of the Virgin. The Archangel
Michael is represented on a panel of the central door, to
defend the sanctuary against evil spirits and especially
against the 'evil eye'. St George slaying the dragon should
likewise be assigned a place, on the west side. Because of
their protective power against the machinations of de-
mons, the same personages recur in manuscripts and on 153
icons. These rules, handed down from workshop to
workshop until a recent date, were recorded in 1932 by
Marcel Griaule, who got them in the region of Gondar
from the painter Qes Kasa.

Thus, something of the spirit which animated the first
centuries of Christian art lingered on until the 20th
century.

HISTORICAL SUMMARY: Ethiopian art

Geography. Ethiopia, whose territorial importance has varied with the centuries, is situated in the north-eastern part of the African continent. It was mainly in the northern provinces of the country (Shoa, Gojjam, Amhara and Tigré) that the arts flourished. The uneven countryside, where peaks rise to as high as 13,000 feet and expanses of high plateaux are cut by deep valleys, has made contact between the various peoples of the country difficult. The population is probably of Semitic origin but is mixed with outside elements, of Cushite race among others, from whom it derives its particular skin colour, which is darker than that of the Semites.

History and art. The Axumite kingdom (4th–7th centuries), strongly marked by Hellenistic culture, has left but few vestiges of its grandeur, apart from some colossal stelae in its ancient capital at Axum. Deprived of political importance, Axum has nevertheless remained a religious centre to this day.

Christianity, which penetrated to Ethiopia (between the years 330 and 350) by way of the northern provinces, soon gained the southern provinces and was imposed as the official religion. The Ethiopian Church is Monophysite, hence

its maintenance of close ties with the Coptic patriarchate at Alexandria (which formerly sent it a spiritual head, the Abuna) and, by the same token, with Coptic-Arab art, from which it derived its predilection for crosses and interlaced elements.

The almost total destruction of the artistic wealth Ethiopia had amassed over the centuries—up to the 16th century—a destruction due to the Moslem invasion led by Grañ (1528–1540), makes it virtually impossible to form an opinion on Ethiopian art produced prior to this date. However, a colossal group of a dozen monolithic churches, attesting to the artistic activity promoted, according to tradition, by the negus Lalibela (1182–1220), has survived at Lalibela, in the Lasta district. These monuments, of very varied plan and form [154], seem to have been built by Ethiopians with the collaboration of foreigners. Their only parallels are the temples at Ellura in India, though there can be no question of influence. They are noted for their relief carvings, a great rarity in Ethiopia where sculpture was not generally permitted.

Ethiopia had constantly to guard against hostile attacks, both from within and from without; moreover, to counteract

periods of decadence that took the form of magic practices which permeated even the royal palace, her rulers, beginning with Zar'a Ya'kub (1434–1468), endeavoured to restore the Church to its original purity by the use of all the means at their disposal, including that of art. Zar'a Ya'kub imposed a highly developed codification not only on his court and on the state, but also on the Church.

Painting. It was in painting that the Ethiopians excelled. Throughout numerous monasteries, the monks' chief occupation was to copy and illuminate manuscripts.

One of the oldest of these illuminated manuscripts (Ms. Eth. No. 32, in the Bibliothèque Nationale, Paris) is in the Armeno-Palestinian style of the 14th century [155].

Unhappily, not a single example has survived to give positive information on the arts practised during the time of the great reformer, Zar'a Ya'kub. However. the richly illustrated manuscript (No. 105 from the Abbadie Collection, Bibliothèque Nationale, Paris [153]), dates from the reign of his immediate successor, Baeda Maryam (1468–1478). These miniatures show a mixture of conventional forms and forms taken from life: the traditional subjects are expressed in a new language. It may well be that this style was peculiar to one particular centre; for Ethiopian art never again achieved such powerful expression.

Gondar, where Fasilidas II (1632–1667) founded a school of official painting, became a centre for mural paintings [156], icons and illuminated manuscripts (numerous miracles of the Virgin), all in the same style.

Ethiopian art remained accessible to outside influence: one of the most popular icons represented Christ in prayer, crowned with thorns. It was a copy of a Flemish primitive of about 1500. However, popular tradition gave rise to a variation showing two men driving nails into Christ's head.

In the second half of the 18th century, Ethiopian painting deteriorated; its colouring became poor and its drawing coarse. The technical formulas established by the Gondar school have nevertheless guaranteed it a certain continuity to this day.

The 20th century has witnessed the rise, parallel to the traditional art, of a popular art which has spontaneously returned to the representation of historical events, battles, the legends of the Queen of Sheba, of King Solomon and of the son born of this ephemeral union.

Wilhelm Staude

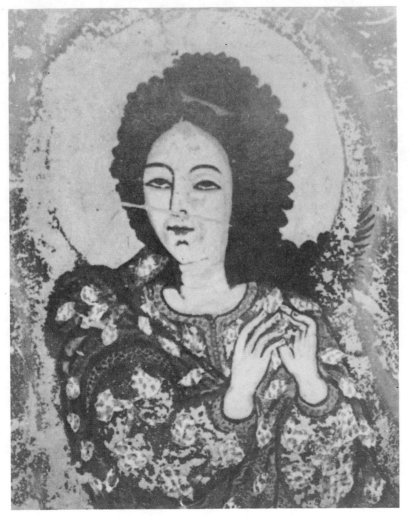

156. ETHIOPIAN. Painting in the Debra Berhan church, at Gondar. 17th–18th centuries. *Musée de l'Homme, Paris.*

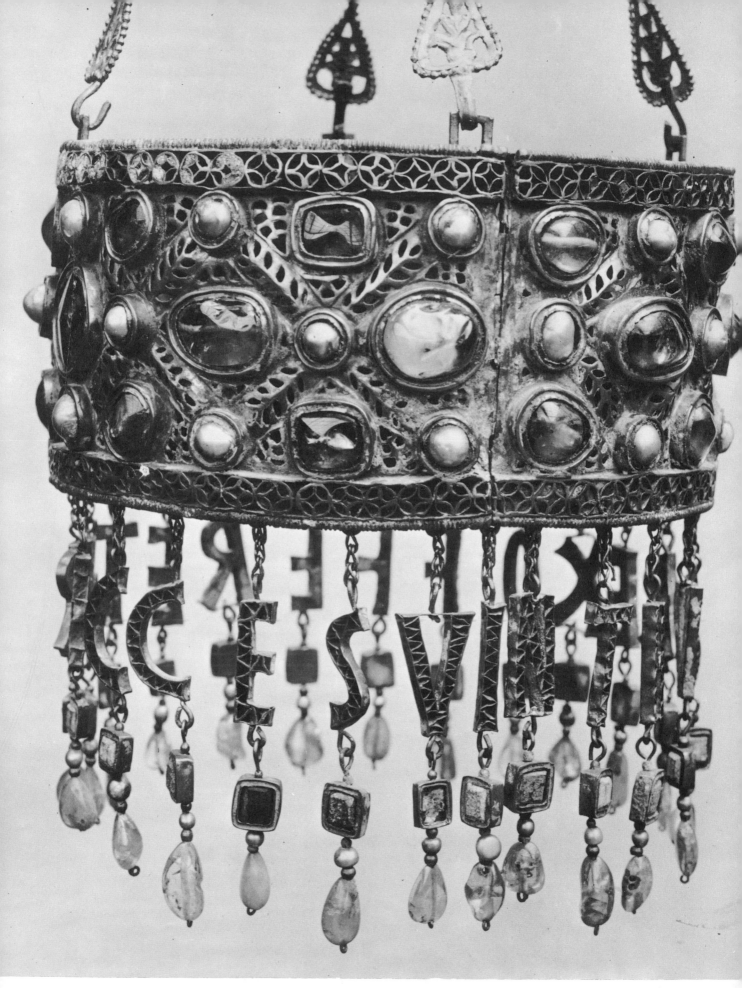

157. VISIGOTHIC. Gold crown of King Recceswinth.
Guarrazar treasure. 7th century. *Museo Arqueologico
National, Madrid.*

2 THE GREAT INVASIONS AND THE FALL OF BYZANTIUM

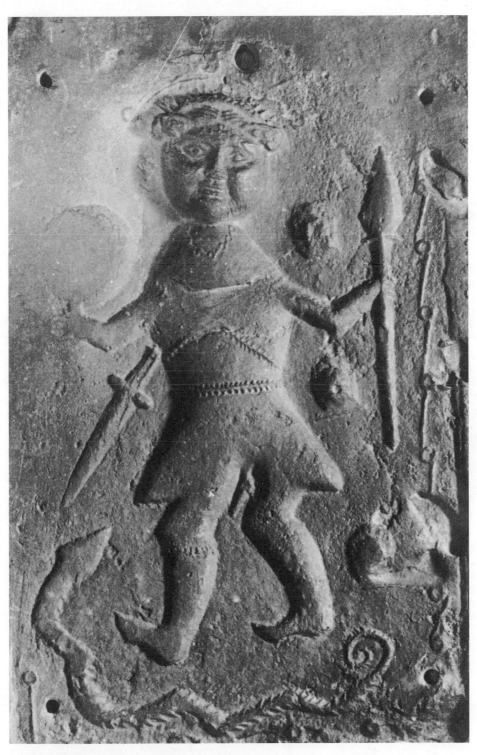

158. BARBARIAN. Terra-cotta plaque from Grésin (Puy-de-Dôme). *Musée de St Germain*.

ART FORMS AND SOCIETY *René Huyghe*

The empire of Alexander, followed by that of Rome, seemed to have thoroughly established the supremacy of the West over the East. Very gradually, however, Roman culture became impregnated by Eastern thought. Christianity and its new spiritual outlook precipitated this change, which became clearly evident when the Empire divided into two parts. In the West, the Roman civilisation was to be submerged from the 5th century onwards by the barbarian tides, which transmitted influences that originated in Asia. In the East, Byzantium was to become more and more Orientalised and as from the 7th century to sustain assaults from the Arabs, and then from the Turks, ultimately succumbing in the middle of the 15th century. In this turmoil the future destiny of the West was being played out, and when the situation became clear a completely different state of affairs had come into existence which was to lead on to the present day. Western culture had been overthrown from its ancient strongholds in the Orient; but in the West, where its collapse had appeared certain from the beginning, it gradually reasserted itself. A new equilibrium evolved, founded on the Roman heritage and absorbing a Germanic contribution. A new reality came into being— Europe. The centre of gravity which had moved eastwards now returned westwards further than ever before.

The onslaught of non-realistic art

With the first centuries of the Christian era the break-up of the Graeco-Roman world seemed probable. But the memory of its glory could not be obliterated, and it remained dormant and ready for revival at any moment. However, for the time being, a whole set of aesthetic traditions was laid aside—a repertoire of forms and a conception of art. Another conception was substituted in its place, in many ways a complete negation of everything for which it stood. The new art was calculated to appeal directly to the senses, relying for its effect on material, colour and light which took the place long held by line and sculptural form. It was not only the illusionism so much cultivated by the Romans that was abandoned, but also representational art itself, and its place was taken by what in other days had been thought of merely as decoration.

Between the 5th and 9th centuries figurative art, especially human representation, was attacked on all sides. The animal, which was of little importance in classical art, was alone in escaping the general prohibition. This onslaught on figurative art was particularly strong in Germanic barbarian art from the 5th century. In consequence it extended to the Vikings in Scandinavia, whose men-of-war later reached as far as the Bosphorus (A.D. 866), and also to Christian Ireland and England in the 8th century. The situation was very similar in the Arab world: in the 7th century its art was formed in Syria, and subsequently in Iran; its expansion was only brought to a halt in A.D. 732 at Poitiers. Simultaneously, in the 8th century, the iconoclastic crisis brought this antifigurative art to the Byzantine Empire. This Empire regarded itself as heir to the Roman tradition, which included Christianity. Indeed, if in that portentous year, A.D. 800, the crowning of Charlemagne had not demonstrated the

determination of the West to strengthen itself, the Western tradition would have been in danger of coming to nothing.

In exchange, an entirely new canon of art was established. It can be clearly seen in Arab art, and it was even more uncompromising in barbarian art and its successors. The artist no longer attempted to analyse, clarify and compose forms, which were more or less recognisable, by the combination of contour and modelling. Instead, the line acquired a purely dynamic character. Frequently such lines seem to have no beginning or end; they unfurl in the coils and knots of an arabesque; to increase the confusion, the line may seem to approximate to the silhouette of an animal appearing within the complexities of purely geometric linear windings. This was so, at least, in Germanic, Irish and Viking art. It was the revival and the triumph of dynamic art previously confined to the Polynesian islands, to the metalwork produced in a vast area between Crete and the steppes, and during the second Iron Age to the Scandinavian and Celtic countries. The Arabs and the horsemen of the steppes were nomads; the Scandinavians, the Cretans and the Polynesians were all seafaring peoples; and one wonders if this art expresses the spirit of a people who were continually on the move, who had no experience of, or else disliked, being settled in one place, and were therefore also opposed to settling an object into a definitive form.

The form of art characteristic of agricultural peoples was static and architectural, but this was already disturbed by the spirituality that Christianity was bringing to it. The new series of conquests carried this revolution right into the field of art. Limited forms with a sense of axis and core were replaced by a sense of infinity, expressed by a perpetual repetition of the same elements, or by an outline which has no reason to come to an end, but exists as an incessant metamorphosis. Arab decoration and Irish miniatures have the same effect on the imagination; they are both unreasoning and limitless. In this graphic imbroglio, the eye and the mind become lost.

The threat of barbarian infiltration materialised first. The barbarians were steadily admitted into the Roman legions, and then they were accepted as 'federates' and were installed in territories which were conceded to them. They had a strong influence on the course of Roman art, especially on the art of the goldsmith, which absorbed completely foreign characteristics during the last centuries of the Empire. But where did these innovations come from? They came from the heart of Asia. In order to grasp this, it is essential to understand the chain of artistic movements in this area which led up to it.

The Asiatic genealogy of barbarian art

Owing to the almost total absence of written documents and the paucity of archaeological finds, it is very difficult indeed to fix the point of origin and to follow the development of this art. It is characterised by a combination of two elements, representation almost exclusively confined to animals, and a curvilinear stylisation. The predominance of one or other element varies throughout the immense area covered, from the Black Sea to the Baltic Sea, and from the Great Wall of China to central Europe.

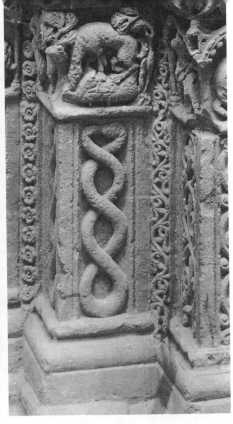

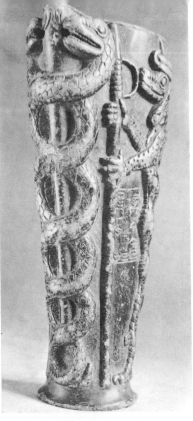

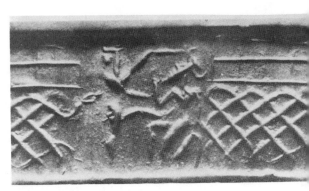

161. MESOPOTAMIAN. Imprint of a cylinder seal. Akkadian period. About 3000 B.C. Excavated at Tell Asmar. *Art Institute, Chicago.*

The snake god fighting with Ea and the gods of fertility.

159. ROMANESQUE. Detail from the right-hand doorway of St Lazare, Avalon. End of the 11th century.

160. SUMERIAN. Gudea vase. 3rd millennium B.C. *Louvre.*

162. MEROVINGIAN. Buckle from Bourogne (Belfort), decorated with interlace and the stylised heads and feet of animals. 7th century.

THE INTERLACE AND BARBARIAN ABSTRACT ART

The interlace, which had appeared at a very early period in Mesopotamia, was associated with the idea of two intertwining snakes [160, 161]. It was carried westwards by the barbarians [162], and survived into Romanesque art [159]. It was superbly suited to the semi-animal semi-abstract art of the barbarians [164]. In Nordic territories, it attained a lyrical power in the art of the Vikings [163] and continued into Christian art [164]; it had already been accepted into the art of the British Isles [165].

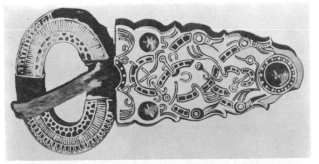

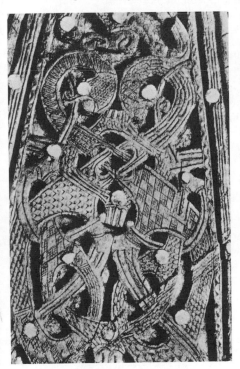

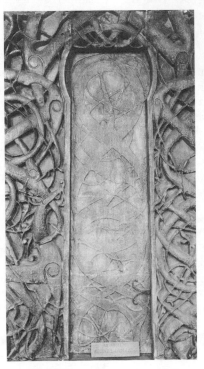

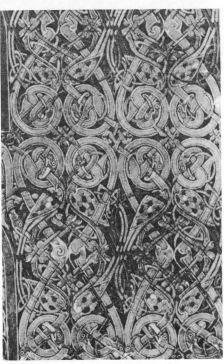

163. SCANDINAVIAN. VIKING. Detail from the Oseberg (Norway) funeral ship. Wood carving. First half of the 9th century.

164. SCANDINAVIAN. Detail of the doorway and its framework in the church of Urnes, Norway. About 1050. Plaster cast.

165. NORTHUMBRIAN. Detail of illumination from the Lindisfarne Gospels. 8th century. *British Museum.*

85

After the invasions it spread as far as the Atlantic.

The predominance of animal art was a sign of the survival of primitive cultures and was opposed by 'humanist' civilisations. The animal was all important in the art of the Old Stone Age. It was readily accepted into Egyptian art, and no doubt the same happened in the steppes. As the ice-cap receded after the last Ice Age, the reindeer found pasturage in the tundra of the northern sub-arctic regions of the continent. These regions were probably the last strongholds of the animal art that had flourished from the Magdalenian period of prehistory onwards, which had extended from Carelia, bordering on the White Sea, to the Urals, to Minussinsk and even to China. Recent excavations have shown that in the 14th century B.C. stonemasons of An-yang in Honan had inherited a long Neolithic tradition; sculpture on bone and on stone had continued the study, stylised over the centuries, of animal forms. In the steppes and Mesopotamia animals of the deer family and birds of prey remained the favourite themes for hundreds of years.

The coming of the Bronze Age, which began in mountainous regions bearing metallic ores, such as the Altai range, must have led to contacts that resulted in the fusion of the geometric and curvilinear style of the Bronze Age with the earlier and more northern animal art. Thus were found associated the two fundamental elements of an art that the nomads of the steppes were to carry throughout the length and breadth of the immense space in which they circulated. It appears that the nomads spread, rather than created, this art. It must often have been the work of craftsmen in annexed territories or from nearby centres of production, and must at all times have been open to the influences of neighbouring countries. These countries were submerged in the all-pervading style, so diverse yet so unique, of this animal art.

The influence of the art of China could be seen in the Altai region, towards the end of the Bronze Age, in the culture of Karasuk. This culture began about the 12th century B.C. and was for a long time considered as the starting point of the art of the steppes. But this art had a continual westerly drift. The Scythians made their way towards the Black Sea where they supplanted the ancient Cimmerians some time before 500 B.C. They made contact with the north of Iran and the Caucasus, and thus the art of the steppes that they carried became impregnated with one of the most ancient and most evolved of animal arts, that of Mesopotamia, which had been adopted by Persia. Earlier, in the 2nd millennium B.C., the art of Luristan had anticipated this union of the animal art of the steppes with that from Mesopotamia. Luristan art was the result of the fusion of the Kassites from the north and Akkad which they invaded, and was found between the Caspian Sea and the Tigris. After 1000 B.C. the goldsmiths of the Mannaean countries, situated a little further east in Azerbaijan, continued the art of Luristan and added elements taken from Assyrian art. The resultant aesthetic intermixture was then passed on to the Scythians.

So it was that, side by side with themes taken directly from Mesopotamia, there developed the prototypes of the griffon and of the deer lying down, which were to become classic motifs in Scythian art. Then certain types and forms became established in the steppes, some of which were to continue right into barbarian art. Examples include lions, ibexes, monsters such as winged lions, symmetrical arrangements such as an ibex on either side

of the Tree of Life, and a man between two ferocious rearing beasts, as well as technical details such as the use of incised pear-shaped muscles, especially at the shoulder.

A little later the Scythians made a close and lasting connection with the goldsmiths of the Greek colonies on the shores of the Black Sea, principally with those at the mouth of the Don, formerly known as the Tanais. These colonies were mainly Ionian, and the Hellenic art which they diffused was therefore based on the art of Asia Minor, where once again Assyrian influences were far from negligible. The ivories from Ephesus, as early as the 7th century, suggest a composite Graeco-Asiatic style, and already in a strange way resembled the art of the Scythians, who may only then have been carrying it into the West. In the following century the theme of fighting animals, deriving from Persia and Mesopotamia, became Hellenised. Such scenes as a lion leaping at the throat of a deer and devouring it, and a wild boar in flight, were typical. In textiles from the barrows at Pazyryk, dating undoubtedly from the 4th century, was added a fight between the eagle and the elk. These were to become the two essential animals in the bestiary of the steppes. This art showed an increasing assimilation, and was marked by violent movement, twisting and intertwining of line. This is seen, too, in Siberian reliefs carved in the last centuries B.C., and in the textiles of the Huns found in northern Mongolia at Noin-ula.

The 6th century seems to have been the crucial period in the formation of this art. The Mesopotamian and the Hellenic animal elements became definitely allied to those of the steppes and adapted themselves to that style, which was very strongly schematised, curvilinear and abstract. The great Scythian masterpieces date from this time, approximately between 550 B.C. and 450 B.C. In these, for instance the Vettersfelde fish and the Kul-Oba deer, there appeared new elements from the Graeco-Mesopotamian bestiary; these new elements contrasted strongly in their distinctive naturalism, but were also eventually assimilated.

The formation of barbarian art in Europe

As the Scythians pressed further to the west, so they brought with them their strongly developed art and diffused it over the territory that was to become Europe. Their forward march fanned out from south to north, covering Bulgaria, Hungary and Lusatia. To Bulgaria they brought the famous Garchinovo bronze plaque covered with gold leaf; Hungary has produced a rich haul of archaeological finds; and in Lusatia the Vettersfelde fish was found, just south of Berlin. Yet the links with the East were not broken; the steppes constituted an immense area for communication, and its art remained in contact with the art of China, by way of the Ordos. An enormous artistic contest was being played out; despite some superficial borrowings it had nothing to do with the struggle going on in the Mediterranean world.

Scythian art was firmly established between south Russia and Hungary. Scandinavian metalwork was a remarkable feature of northern Europe. It had been nourished at an early date by Creto-Mycenean forms. This Scandinavian art had also developed a dynamic curvilinear geometrical style, in this case with the emphasis on the spiral. In phases III and IV of the Bronze Age, there is proof of commercial relations existing, by way of the River Oder, with south Russia, the Volga and

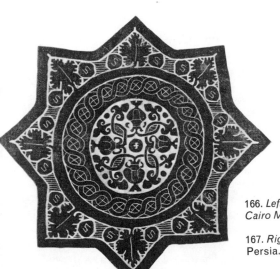

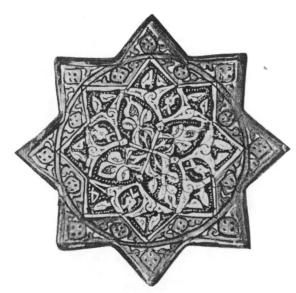

166. *Left.* COPTIC. 4th century. *Cairo Museum.*

167. *Right.* MOHAMMEDAN. Faience. Persia. 8th century. *Louvre.*

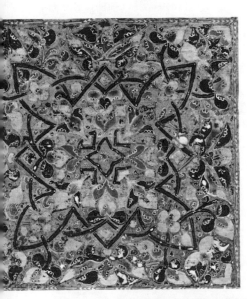

168. *Left.* BYZANTINE. Chapter heading from a Greek manuscript. 12th century. MS. No. 543, fo. 214. *Bibliothèque Nationale, Paris.*

169. *Right.* MOHAMMEDAN. Detail of a plate from Kutaiah, Turkey. 16th century. *Louvre.*

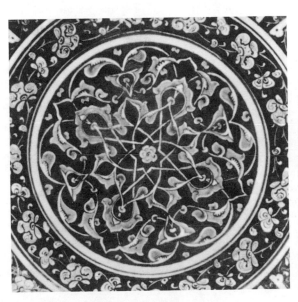

ISLAM'S DEBT TO HER PREDECESSORS

Islamic art was almost wholly made up of techniques and themes derived from invaded territories. It achieved a compromise, based on the arts of Persia, Byzantium and Egypt, which had already been suggested in Coptic decorative art, an art particularly instructive to Islam [166, 167]. The iconoclastic crisis was to facilitate relations with Byzantium, which was converted to abstract tendencies for a time [168, 169]. Also, numerous animal themes stemming from the furthest areas of Mesopotamia were to pass into Islamic art—for example the animals, often mythical, which stand facing one another on either side of the Tree of Life [172]. Lions had already been accepted into Byzantine art, and recurred in Persian textiles [171], which assured their survival as themes, as well as in Egyptian textiles [170].

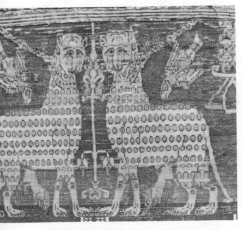

170. MOHAMMEDAN. Egyptian silk. Detail from the cope of St Mexme. 11th century. *Church of St Etienne, Chinon.*

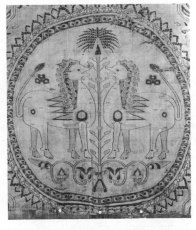

171. MOHAMMEDAN. Iranian silk from eastern Persia. Detail. 10th–11th centuries. *Musée Lorrain, Nancy.*

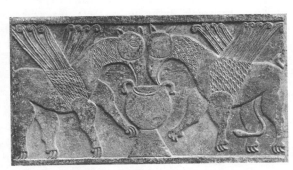

172. ITALIAN BYZANTINE. Marble screen. 8th–9th centuries. *Metropolitan Museum of Art.*

Siberia, and through these with the Caucasus and Persia! Evidence of this has been found at Gotland, the original country of the Goths. These Goths, in about 300 B.C., passed over to the northern shores of the Baltic Sea, and then in the middle of the 2nd century A.D. moved south along this ancient route to the Black Sea. In so doing they gave the barbarians one of their first setbacks. As a result, an important centre of the metal arts of the steppes was put in contact with Scandinavia, another great metal-working centre. It is true, however, that Scandinavian art was to be eclipsed with the coming of the Iron Age, when the Celts rose to power.

The first Iron Age developed a rectilinear style that was very different. This Hallstatt art had made contact with Scythian art about the year 500, as can be seen by a comparison of their swords. But suddenly with the arrival of the second Iron Age, that of La Tène, in the 5th century, the Celts began to develop their dynamic and curvilinear art which was to hold sway over Europe for centuries. This transformation seems to correspond to the Scythian advance up the Danube as far as the Hallstatt zone, and to the influx of new forms which must have resulted. Scytho-Persian buckles, found in the Oxus treasure, make it easier to understand the evolution of Celtic necklaces with their undulating decoration.

However, to the north of the Black Sea, in south Russia, where the Graeco-Mesopotamian influence had injected a strong naturalism, a new invasion resulted in a fresh domination of Oriental stylisation. The invaders, the Sarmatians, who seem to have been Aryans, pressed the Scythians westwards in the 3rd century B.C., occupied their territory, and crossed the River Don around 250 B.C. and the River Dnieper in 50 B.C. They brought yet another contribution of artistic ideas from the steppes. So in the last centuries B.C. the artistic zone of south Russia was established. This was to become a great reservoir in which was elaborated the art that was to be spread by the barbarians, whose successive waves eventually submerged Europe.

The part taken by Scandinavia should not be forgotten. It came about not only through long established commercial relations, but also through the fact that this was the original home of the Goths, the Visigoths and the Ostrogoths, whose multitudes were to play a decisive role in the great invasions, and who must have kept something of their original traditions. From these two extremities, the Black Sea and the Baltic Sea, and as a result of their interrelation, Germanic art was probably brought into being, and this was the art which was to be transported by the *Völkerwanderung* or 'migrations of peoples'. Hungary, too, was important in this elaboration. It had had commercial relations with Scandinavia from very remote times, and it also had contacts with the Scythians which, if rarely peaceful, were fertile.

The diffusion was due to the arrival of the Huns. These Tartars, in conflict with China from 800 B.C., had previously had close contact with the art of the Ordos, on the threshold of China, where there had been created a stylised animal art comparable to that of the Scythians further west. The Huns had become entirely nomadic by the 5th century. They began to migrate in the 4th century A.D., two centuries after the Avars, of Mongolian extraction. The human tidal waves arriving from the Far East and reaching as far as Hungary forced the barbarians yet further west and caused the irresistible surge of the 5th century. The Huns were the devastating climax of these tides. They were instrumental in the diffusion of the art which had been elaborated in south Russia, for they forced the Goths, from about A.D. 375, to leave the Black Sea for the extremities of Europe.

Barbarian art stressed the abstract qualities of the art of the steppes. The art that came to be known as the 'Germanic animal style' reveals no more than the vestiges of stereotyped beasts often absorbed into a network of lines. Here they survive as the heads of monsters, or sometimes paws may be discerned grafted on to the 162 swirling movement of the leading ribbon-like forms. The unchanging bird of prey with curved beak, shown in profile, can still be recognised. This bird had appeared in about the 7th century B.C., fashioned in gold, at Temri-Gora, and, even before that, on a gold cup acquired by the Louvre in 1956. This cup undoubtedly came from the north of Iran, which was probably where the motif originated. The motif spread over an area extending from the Ordos on the borders of China to the Ostrogoths of south Russia and the Visigoths in Spain. Both Ostrogoths and Visigoths used this bird of prey in their jewellery. There was another favourite form for a head, in which the jaw, straight and open, usually finished in two spirals, one to represent the nose and the other the chin. This idea was used about 500 B.C. to decorate objects in central Russia and even as far as Karelia, on the White Sea. It still existed in the Irish miniatures of the 8th century, and in the art of the Vikings even later.

Germanic art and the use of the interlace

There were two other factors in barbarian art even more important than the animal elements. The first was the interest in coloured materials. The second, more important still, was the combination, in a whirl of lines, of the arabesque with the interlace work, the two methods by which line may elude, rather than evoke, form.

The art of colour and the play of light on translucent stones, or on enamels which imitated them, appears to have originated in Iran, before passing to the steppes. Leaving out Sumeria and its contribution to the use of colour, Persia, a country rich in such gems as turquoises, garnets, lapis lazuli and mother-of-pearl, as well as many precious stones, had enriched still further the splendid effects previously sought in amber and practised the art of setting precious stones in gold as early as the 5th century B.C., in Achaemenid times. In Graeco-Scythian art this technique flourished during the following century. It was then spread by the Roman craftsmen from the Pontic region, and by the Goths as they trekked westwards. It was to be used simultaneously among all the barbarian groups. Sometimes they would mount single stones in gold. This was a favourite method among 157 the Franks. Sometimes they would make a continuous mosaic by the use of cloisonné. This method was espe- 188 cially in vogue during the 5th century, particularly in Scandinavia. Later, enamelling imitated this second technique.

What was the source of this linear exaltation, with its improvised and complex curves twisting and intertwining across the surface? From the end of the first Germanic style until the time of the Irish miniatures and the Vikings, it never ceased in the growing ecstasy of its baroque outbursts. Its base was the form known as the interlace which made a very early appearance in Egypt and especially in

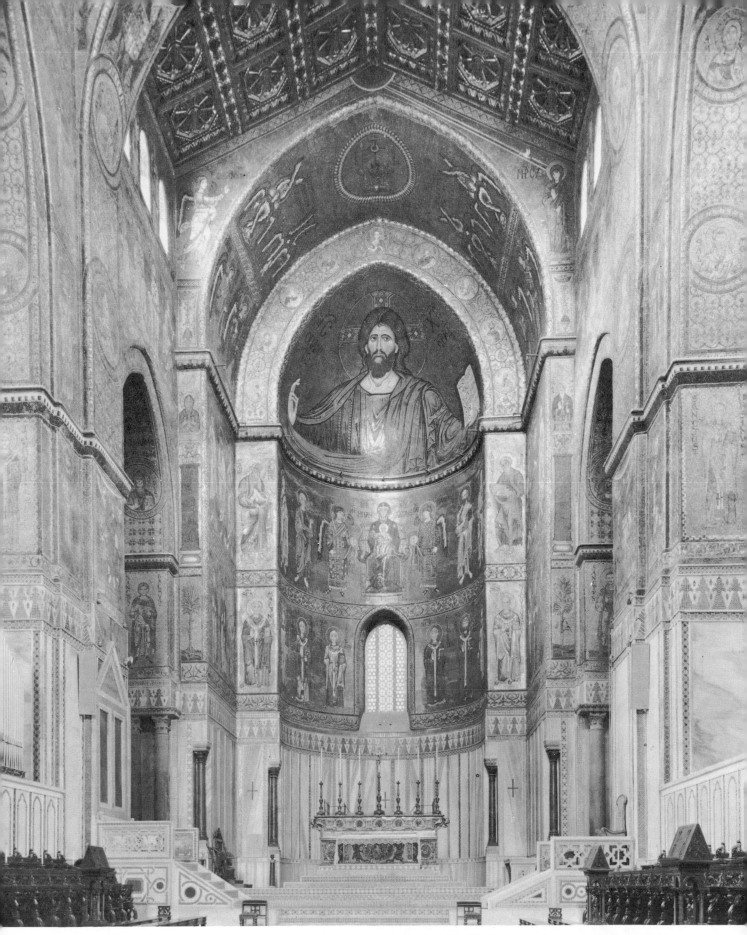

173. LATE BYZANTINE. Mosaic in the apse of the cathedral of Monreale. 1176.

The theme of the Church Triumphant is here developed, from bottom to top, according to its hierarchy. First come the saints, intercessors; then the Apostles who spread the Gospel; they frame the archangels and the Blessed Virgin who bears the Infant Jesus. Above all rises the enormous figure of the Christ Pantocrator.

89

Mesopotamia, and was derived from the twistings and knots in cord. It was one of the ideas that the Romans took from the East, and its importance became enhanced with time.

It has been the fashion for a number of years to stress what the barbarians and the Scandinavians derived from Roman art, especially that of the provinces. In these areas, Roman art had itself already been affected by the art of the barbarians who were their neighbours. In this way, technical and iconographical sources are easily explained, but not the style which was conferred on them. Now, it is in this, and in this only, that the personality of an art 201 is to be found. The bracteates (circular pendants of thin gold) of the Scandinavians were based on Roman coins, but what is more interesting is the transformation that took place and rendered the model scarcely recognisable in its new form. This clearly proves that fundamentally an imitating art has nothing to do with the art imitated. It is significant that when a bracteate imitated a Roman medallion the Mediterranean model became debased. The new design created was nothing but a free combination of graphic symbols. The same transmutation took place when Sassanian prototypes inspired the coins of eastern Iran, and also when Macedonian gold statues of Philip II inspired Gallic coins. In every case there is an underlying constant, and it is this constant which makes the personality and the reality of an artistic style.

Various forms of interlace—regular, symmetrical, cruciform and others—are to be found in late Roman mosaics and in Coptic art. These forms were used again, for example by the Lombards. In this case, a form belonging to one art passed directly into another art. In comparing the Mediterranean and Roman treatment of this theme with its Germanic equivalent, the incompatibility of spirit which separates these two civilisations stands out clearly. What had been static became dynamic; what had been clear and ordered became tenuously or naively asymmetrical and confused.

If this factor of transformation is accepted and borne in mind, then it throws some light on the source of the Nordic interlace. Hellenistic, Roman and Pontic goldsmiths drew much of their style from the technique in which they worked. This was filigree, which, as the name implies, was the decoration of the surface by means of a filament—usually gold. The nature of this material is to coil, and it lends itself admirably to the screw-like sinuosities, the spirals and the S-shapes that recurred from the beginnings of the art of metal, and for the same reason always sprang from the material itself. But the designs of the Mediterranean goldsmiths were always classical—that is to say, regular, intentionally symmetrical, easily seen and analysed. The themes passed to the Ostrogoths. With them, they were sometimes simplified by being replaced with a dotted line, which resulted from the technique of embossing or stamping, using a pointed instrument. It was customary to decorate not only borders but also the whole of a central space as well, as may be 196 seen for example in their brooches. As these models penetrated into the zones where the Mediterranean spirit had no meaning, so they became 'barbarised' and underwent the same sort of metamorphosis as the Greek and Roman coins. Barbarian goldsmiths had no feeling for symmetry of a kind that had nothing about it of the barbarian spirit. Instead they replaced it with the meandering of a serpentine line and elaborated its unexpectedness and its complexity. This was to become the typical Germanic interlace style, which was to redevelop the filigree technique, especially in the 6th century, and undoubtedly under the influence of south-east Europe. The goldsmith 162 had only to introduce the heads and feet of monsters from the usual bestiary, and the Germanic animal style had arrived.

It seems natural that this style was dominant in the parts of Europe furthest removed from Roman power, and especially in Scandinavia and in Britain. Since very early times there had been a strong link between these two areas, and this link had recently been reinforced. In the 4th and 5th centuries the Jutes, the Angles and the Saxons had replaced the departed Roman invaders and their predecessors, the Celts. All that had been inherited from the Celts came originally from the style of La Tène; and this heritage was now enthusiastically adapted to the style of the new invaders which encouraged its own ancestral tendencies. With the Lombards, and even with the Burgundians and the Franks, the position was entirely different. They had the problem of living with what had survived from Roman times, and of somehow absorbing this opposed culture. In art, this is revealed by the juxtaposition of the meandering interlace of the Germanic tribes with the regular form of the Mediterranean style. The bands on Merovingian sword belts show very clearly this division of influences. So, from the history of forms, we offer this explanation of the origin and evolution of a style, the history of which remains confused from the archaeologist's point of view.

There is one further characteristic feature of barbarian art. The interlace band would suddenly change its form in the course of its meanderings, first into the head of a bird and then into the foot of a dragon. This is only one particular example of a taste for metamorphoses which breaks out just as much in a Han bronze from China as in the Lindisfarne Gospels from Northumbria. Once again the same contrast is found—on the one hand the spirit of stability which is preferred in the art forms of agrarian peoples, and on the other hand the spirit of mobility that is natural to the art forms of the nomadic tribes of the steppes or of the sea.

Fabulous beasts, such as winged bulls with human heads, certainly seem to have originated in Mesopotamian art. Undoubtedly, it was from Mesopotamia that they spread to Egypt, and later to Greece, where such fantasies as sirens, centaurs and griffons appeared. These are found also in the art of the steppes, and correspond to a Graeco-Mesopotamian intrusion. But in this case, the unexpected juxtaposition of separate elements—assembled like stones in a building—was perhaps due to the need to represent divinities that were partly animal. These mythical creatures were essentially made up of separate forms. In the steppes the theme was treated quite differently: one beast modulated into the next, as part of the first suggested some similarity with its successor. The imagination seemed to run like a plastic dream, as in watching a dissolving cloud one's eye will recognise successive images. It was the same spirit of wandering as that which explains the unpredictable path of the interlace. The changing animal was an equally permanent theme, and was to recur in the Pontic 'grilles' of the 5th century, and in those of the Siberians in the 2nd century B.C., as well as in the fantasies of Ireland in the 8th century A.D. and 144 in the art of the Vikings in the 9th century. The Viking 163

LATE BYZANTINE ART

Far from being decadent, as has long been thought, Byzantine art, in its Second Golden Age, opened up new avenues. It constructed great works of theological exposition [173]. In its last phase, Byzantium seemed to attempt a renaissance which, without losing sight of the ancient world, for instance in the figure of the angel guiding the steps of the Virgin [174], approached it in observation, animation and intensity of life [174, 175].

174. LATE BYZANTINE. The first steps of the Virgin. Mosaic. 14th century. Narthex of the church of Kahriyeh Djami, Constantinople.

175. LATE BYZANTINE. St Eleutherius. Mosaic in the church of Daphni, Greece. About 1100.

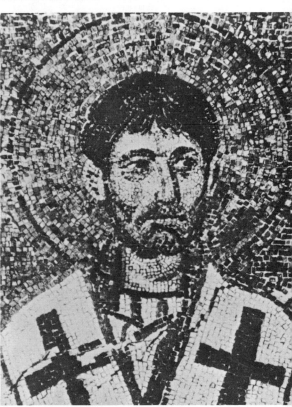

164 forms were even extended to the doorways of Norwegian churches as late as the 12th century.

Islam and its negation of Western ideals

The new power of the Franks was established and began to increase in the 6th century A.D. The barbarians were finally coming to rest, and the area in which the Franks settled became a permanent kingdom from which Europe was to grow. However, from the beginning of the 7th century, a new threat arose, that of the Arabs. They had given the Byzantine Empire a mortal blow by conquering, between 633 and 698, all its Oriental possessions from Syria to North Africa. The Arabs also attacked Europe through Spain, but were ultimately repulsed in 732 at Poitiers, by Charles Martel. This man was the founder of the Carolingian line. Twenty-four years later his son,

Pepin the Short, saved Rome from the assault of the Lombards, and in so doing marked the end of the barbarian attacks.

The redoubtable tide of the Mohammedans was a dangerous threat, but the influence of Islamic art did not penetrate into Europe, which was now in its formative period. Islam did not give any Oriental ideals to Europe. It was quite the reverse; when once halted in her advance, Islam raised a sort of screen separating Europe from Asia, and exchanges between the East and the West became more and more difficult. In fact, they were only maintained for a certain time, and then only in an indirect way, by means of the declining Byzantine Empire.

The only part of Europe to be impregnated by Arab traditions was Spain. Relatively permanent traces of these traditions remained, even after the reconquest. Mudejar

art (the art developed by Moslems working under Christian direction after the reconquest) reflects this clearly, but even these traces were effaced in their turn. Islam, nevertheless, was to put Europe in touch with its own most ancient cultural sources, and did this in two ways. Firstly, the Mohammedans gathered together, elaborated and transmitted to Europe the texts and commentaries of Greek thought, especially those of Aristotle. This powerfully influenced the return to certain ideas which were important in the formation of the Gothic aesthetic at the end of the 12th century. Secondly, in bringing about the downfall of Byzantium, they unwittingly caused the westward emigration of scholars who attempted to revive Hellenic philosophy in the West, this time with the emphasis on Plato. In this way they gave to the Renaissance and to the classical tradition a very clear direction, the aim of which was the attainment of ideal beauty.

166–172 The Mohammedans themselves were distributed over a vast area behind their own frontiers. They produced many fine works of art and even masterpieces, but there was no radical change of forms or of ideas. Their art consisted of a great many borrowings and adaptations, to which admittedly a new lustre was given. It did not, however, introduce any creative or revolutionary element capable of modifying to any marked extent the line of aesthetic development in the history of the art of mankind. Islam brought to an end the compromise achieved by Byzantium, in which a reverence for Greece and Rome acted as a strong bridle preventing the full release of a truly Oriental art. With Byzantium, one senses only the dim inspiration of such an art; but with Islam, it was brought to birth. The Mohammedans gained Syria and Asia Minor from the Byzantines. These territories had formerly been part of the Roman Empire, but they had played a large part in the progressive debasing of its classical culture, and in throwing off its purely Western character. Hellenistic domination had always been resented in the countries from Egypt to Mesopotamia. These countries manifested a strong tendency to develop heresies. They cultivated dissensions which led them, even though they were Christian, to receive the Mohammedans almost as liberators. The new masters were so few in number that they were like a net thrown over vast conquered areas. To begin with, they showed themselves shrewdly tolerant, and they allowed local organisations to continue. Like the Christian evangelists in the north they aimed at attaining their ends by slow degrees.

The terrifying expansion of Islam could have resulted in the Mohammedans stamping out earlier traditions, but they preferred not to do so. Instead, they adopted these traditions and gave them firm backing, provided only that they affirmed Eastern ideals. They remained impermeable to any heritage in which Western culture was perceptible. This attitude became very drastic in Spain, where the Arabs came out strongly against local traditions. European art, and in particular Romanesque architecture and decoration, was considerably influenced by Islam, but the flow of influences in the opposite direction was much less marked. Mohammedan art gathered up the whole tradition of the Middle East, to which it attempted to give new life. This tradition ranged from ancient Mesopotamia to Persia, whose art was inspired by a spirit which was diametrically opposed to that of the West, and it was from Persia that Islam was to draw its finest inspiration. The Mohammedans found these traditions everywhere diffused and degenerated. So they filtered them: they gave them a decided character, which is more recognisable in decoration than in architecture where the many different domes and arches, hitherto unknown, clearly reveal their Iranian or Armenian origin, even though they were ultimately derived from Constantinople. Massive and naturalist forms dominant in Greece and Rome had virtually disappeared and their place was taken by colour on the one hand and by line on the other. This led to the elimination of relief, and 177 flat decoration reigned supreme. In all this may be seen a deep-seated antagonism towards the spirit of Western art.

The surface became a vibrant area, as in barbarian art. The light was modulated either by glittering colour or by a linear pattern incised in the material. The underlying basis of the decoration was the ribbon, which constantly folded back on itself in its own meanderings and created by its myriad windings an excited agitation of highlights and shadows. The drawing did not aim to clarify the forms but to give life to every inch of the surface to be 235 decorated. In consequence, artists sought methods most suited to this aim. Their art, which was originally an art of nomads, had become established on lands which had been cultivated for centuries, and as a result artists tended to use a repertoire of forms based on plant life rather than on animal life. Artists would organise the surface by making use of definite shapes, and would then fill all the empty spaces with other forms, such as stems with 236 leaves, which fitted superbly into this sort of combination.

Furthermore, the technical problems involved were not the same as for the barbarian goldsmiths. There, the traditions of metalwork imposed the spiral forms of the filigree or of the incised line into which the clusters of cabochons were inserted. In Arab decoration, however, wood and stone were the principal materials in use. The 215 emphasis, therefore, was on a sculptural approach, and once again the plant form was more suitable for the decoration. The plant forms were perhaps the only derivations from Hellenistic naturalism that were acceptable to Islamic art. But these forms were, nevertheless, rapidly assimilated, 'digested' and given an abstract character. The large acanthus leaf was easily stylised and also it was 217 a convenient shape for filling spaces. The vine is the scroll form par excellence, for the branches end in elegant curling tendrils, while the leaves and grapes form useful shapes for covering areas. In the territory overrun by Islam acanthus and vine were associated on monuments of both antique and Christian tradition. The vine had been dear to the Phoenicians, it was familiar to Syrian and Coptic art, and it was used, though more moderately, in Persian art. This decorative theme was first assimilated and given a new spirit in the Umayyad castles of Syria, especially in the 8th century, at Qasr el Haïr and Mshatta. 18

In much the same way, the scroll—that fundamental shape in the repertory of forms—was to become extremely beautiful. It was perhaps born of the fusion of either the vine or the Dionysiac ivy, which the Greeks 19 loved, with the interlace which had already appeared in ancient Mesopotamian art. This fusion was already visible 161 in Etruscan art from the 7th to the 5th centuries B.C. It suggested the double origin of the Etruscan culture, Asiatic in source and Hellenic in its formation. The symbolic nature of the vine ensured its being used again in 21 Christian art. Thus the motif presented itself to Islamic

The assaults made on Europe first by the barbarians and then by the Arabs can be followed and compared. They coincided with an abstract and curvilinear stylisation which was to be found even in areas where there was little or no contact.

176. BARBARIAN. Fragment of buckle. Goldsmiths' work from the Danubian invasions. 6th century. *Budapest National Museum.*

177. *Below left.* MOHAMMEDAN. Wood panel, decorated with a bird; the beak, wings and chest develop into volutes of scrolls. Tulunid period, Egypt. End of the 9th century. *Louvre.*

178. *Above.* SCANDINAVIAN. Bronze sword-hilt decoration, animal style, from Gotland, Sweden. Vendel style. Beginning of the 9th century.

artists from all directions, and so they adopted it.

This decorative naturalism explains the success of the scroll, first in the Hellenistic and later in the Roman world, for its readymade decorative form required no alteration, but it must have offended the more abstract genius of Islam. Christian Rome had adopted the scroll to such an extent that missionaries sent by the Pope to England contrasted it with the fantastic interlaces of the Irish monks. But Islam, instead, forced it rapidly into a geometric mould quite opposed to the spirit of the Nordic world. The Persians, under the Abbasids, had already decorated surfaces with polygonal shapes, as for example at Samarra. The Mohammedan arabesque was to strengthen this geometric rigour. This was evolved about the end of the 9th century, especially in countries under the Fatimids. Under its apparent confusion there exists a rational order. The lines do not digress into windings and knots as in Scandinavian art. Instead, they close back again into a regular order, and with angular, as opposed to sinuous, contours. They form themselves into complex box-like arrangements, which still allow logical analysis. In some ways, Islamic art is quite as abstract as Nordic or Germanic art. Whereas the northern convolutions have the air of being projected into their unforeseeable adventures by some dynamic force, the Islamic complexities seem to be disciplined by mathematical calculation. They prefer rigid crossings to contortions. They are opposed to the whirling baroque forms of the Scandinavians.

This intellectual quality is even more evident in the use of decorative script, which goes back to the 9th century. Such ornament is, in fact, a religious text, ex-

149
169
234
228

93

tracted from the Koran. The writing itself, in particular
the ritual and angular Kufic script, forms the controlling
lines. The free spaces were filled, following the usual
custom, with floral decoration which varied according
to the period and place. This form of decoration directed
itself to the mind, both by its geometry and by its words.
It was to become more important as from the 11th and
12th centuries.

Islam and Greek thought

Islam was impenetrable from the religious point of view;
nevertheless, from the intellectual point of view it had
hidden but essential roots in Greek culture. Byzantium,
especially during its last centuries when under dangerous
threats, deliberately returned to its artistic sources, thereby
reinforcing the Hellenic tradition. This tradition showed
its influence in the thought given by Byzantine artists to
the coherent and sustained sense of the whole composi-
tion and of the iconography itself. The church with its
decoration thus became a theological exposition in pic-
torial form. In the Mohammedan world, the Hellenic
tradition was less obvious. It seems to have been visually
non-existent, but it was none the less effective in its
cultural influence.

Greek influences came by way of the Byzantine Em-
pire, especially through the Nestorian Christians who
spread eastwards as far as China in the 7th century. They
translated the Greek philosophers, in particular Aristotle,
who was the most 'Western' of them all by his positivism
and his logical rationalism. Versions in Syriac were
written in the coastal monasteries. To these may be
added the teaching in the schools, at Edessa in the heart
of Mesopotamia as early as the 5th century, at Nisibis,
and at Qennesrin two centuries later. The Koran brought
dogma, but not a philosophy. As a result, the Arabs based
their philosophy on the Greek texts which were known to
them. These nearly all included Aristotle, whose teachings
had also been spread through translations of the school of
Resaina, and also fragments from Plotinus which passed
under his name, and finally, extracts from Plato. To these
may be added the 'scientific' writers, such as Galen,
Ptolemy and Euclid. In A.D. 832 the caliph established
a department at Baghdad for the systematic translation
of these writers from Greek or Syriac into Arabic.

This resulted in a paradoxical mixture, under the name
of Aristotle, of his own thought and the very different
philosophy of the neo-Platonists. It encouraged the Arab
tendency, which was to transcend physical reality in an
attempt to join God by means of ascendant stages of the
soul and of the intelligence. It also led them to give their
philosophy a strong clarity and a logical framework,
which depended on demonstration of a mathematical or
geometric type. In the 8th century, a treatise on algebra
was written by Al-Khowarizmi at Baghdad, and it was
translated into Latin by Adelard of Bath in the 12th
century. From then on, a chain of great thinkers followed
one another, from Kindi and Faribi up to Avicenna and
Averroes; they were distributed geographically from
Baghdad and Bokhara as far as Cordova, and historically
from the 9th to the 12th centuries. Their theological
reasoning was related in many ways to medieval scholas-
ticism, and was ultimately to influence it, creating many
currents whose repercussions were soon to influence even
art and its evolution.

Mohammedan intellectuals delighted in surrendering

themselves to the most coherent and interwoven dialectics
that derived from Aristotle. They aspired also, as Plotinus
had done, to escape the positive and visible universe and
to attain fusion with God. It should be noted that these
tendencies correspond strangely to the Mohammedan
aesthetic. Islamic art was likewise hostile to concrete
appearances, and its artists preferred to construct and
assemble abstract forms as though for a geometric prob-
lem. Its taste was for unending repetition, with the
intentional monotony that is found in the litany or in
Arab music. Like them it seemed able to continue in-
definitely, and like them it succeeds in giving the appear-
ance of infinity, in which the human spirit is urged to
become absorbed in God.

The threat to Europe

From the time of the Greek and the Persian empires, an
unceasing struggle between East and West had continued,
in which the ascendancy alternated from one to the other,
and appeared finally to settle on the East. The West had
allowed itself to be penetrated by Oriental influences,
then to be invaded by military force, and finally to be
completely dismembered. During this time, Persia had
shown an increasing vitality and strength. It was the
Persian taste for coloured and translucent materials, and
the Persian motifs, often deriving from Mesopotamia,
that were passed into the art of the steppes. It was also
Persia that played the part of the leader at the source of
Islamic art, in its architectural and decorative forms as
well as in its colour.

Yet this triumph was more apparent than real. In the
first place, Rome, revived and allied to the Franks with
their temporal power, and under the aegis of the Church,
prepared the rise of Europe of the Middle Ages, and the
revival of classical traditions. In the second place, Greek
culture, which had seemed to be destroyed, had in fact
only been scattered. Hellenistic art passed a number of
its characteristics to Sassanian Persia, just as it did to
Islam, and attempts have been made to establish the term
'Iranian Hellenism'. Finally, Greek thought was all per-
vasive. It was with Chosroes in Persia that the last
Athenian philosophers took refuge when their schools
were closed by Justinian in A.D. 529. It was also in Persia
that the Nestorian Christians, so absorbed by the philo-
sophy of Aristotle, sought refuge. It was again in Persia,
at Baghdad or in the region of the Oxus, that Arab
philosophy was elaborated, a philosophy based on Greek
translations.

The transformation of ideas and art which was to take
place in the West during the 12th century was thus
prepared beforehand and far away by these currents of
thought. At the same time, it should not be forgotten
that in Byzantium during the 11th century Platonism was
given new life by Psellus. After him, a chain of disciples
continued these studies until the moment when from the
crumbling Byzantine Empire her last scholars fled to
Italy. These scholars, Gemistus Plethon and Cardinal
Bessarion among many others, were to play an important
part in the birth of the Renaissance and its aesthetic
outlook.

Never had Europe appeared so near to destruction as
in the centuries which preceded the Middle Ages. Yet it
was during this critical and troubled period, and in
secret, that all the elements of its future destiny were
gathered together.

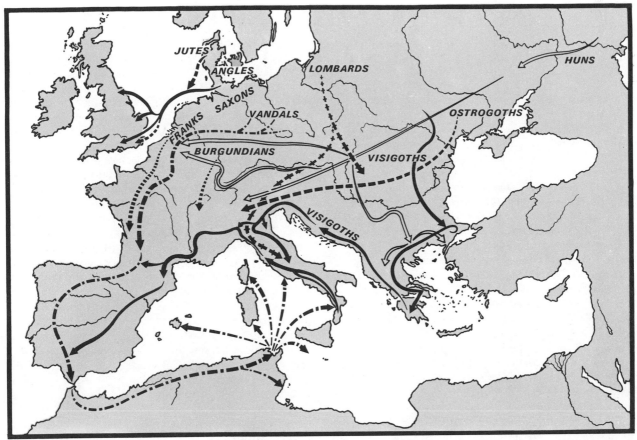

THE BARBARIAN INVASIONS

ISLAM AND THE VIKINGS

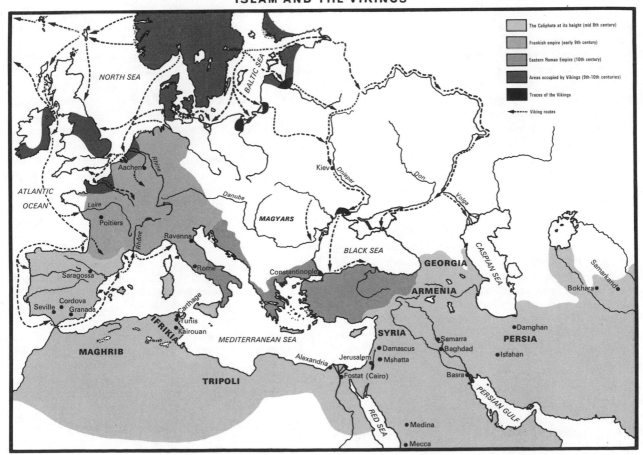

Legend:
- The Caliphate at its height (mid 8th century)
- Frankish empire (early 9th century)
- Eastern Roman Empire (10th century)
- Areas occupied by Vikings (9th–10th centuries)
- Traces of the Vikings
- ← Viking routes

THE BARBARIAN INVASIONS AND
THE EARLY MIDDLE AGES *Raymond Lantier*

The Western tradition was threatened by the collapse of its very foundation, the Roman Empire. This Empire had already been first split, and then deprived of that half which came under the rule of Byzantium. The West was profoundly disturbed by a total inner reorientation consequent on the introduction of Christianity. Finally, the Empire was completely submerged by the 'migration of peoples'. It was the last of these migrations from the East which caused such turmoil in the first periods of European history. The barbarians, after having first infiltrated the Empire, then invaded and ravaged it. With the classical heritage practically swept aside, indigenous traditions revived, and Europe came under the counter-influence of the Asiatic art of the steppes. As a result, an art of precious metal flowered, which echoed the art of the Bronze and Iron Ages. Throughout, there continued a period of political chaos in which the Middle Ages were evolving.

The study of the art of this troubled period of the early Middle Ages seems often only to reopen chapters of a very old story, suspended for a time by the Roman conquest of the Western world. The situation of the new invaders corresponded to some extent to that of Celtic groups in their contact with Mediterranean cultures. The barbarians, before overrunning the Roman Empire, had followed their own line of development, which takes one back to the protohistoric period in the Near East and central Asia. There had been migrations of peoples into western Europe ever since Neolithic times. Western Europe only received the final movements of this vast fanning out which had brought men from the steppes of Asia to the shores of the Atlantic.

In the lands they crossed, the barbarians benefited from contact with the culture of other peoples, especially when they penetrated an ancient civilisation. On the other hand, it was they who restored the East-West relations and spread the artistic traditions of Mesopotamia, Persia, and even India and China. Moreover, on freeing the countries within the Roman Empire the barbarians made it possible for their peoples to recapture ways of feeling and seeing which had lain dormant under the Roman veneer, and which were diametrically opposed to the classical tradition.

From the time of Constantine to the reign of Charlemagne this same art form left its mark right across central Europe as far as Britain, Gaul, and the Italian and Iberian peninsulas. A close solidarity always imposes a real unity on artistic forms—architecture, sculpture and the decorative arts. This is demonstrated in the new society, which seemed to be seeking a solid foundation and took its resources from where it could. In so doing, it endowed the West with a new conception of man and the world, and prepared the coming of the Middle Ages.

Survival and reawakening of indigenous arts

Although, in the 4th and 5th centuries, art in the West remained essentially Mediterranean in feeling, the years around A.D. 400 marked a distinct break that was historical and geographical. From the 3rd century the new era was foreshadowed by changes which had already appeared in the Roman world. There arose an increasing dissatisfaction with the underlying principles of Graeco-Roman aesthetics. In Rome, the Arch of Constantine shows clearly the stages of this decline, which appears to have gone hand in hand with the economic troubles of the 3rd century which followed the first barbarian invasions. But it was the same in the Near East, which was not overrun, and throughout the Empire's African provinces. One cannot avoid noticing the uniformity of this repetitive and banal art. Even the writings of Claudianus and of Apollinaris Sidonius did not escape the general paralysis of invention which struck a society overburdened with the weight of its past.

For several centuries the enormous area under Roman control had been subjected to incessant pressure by barbarian groups. From these enforced contacts, and also from trading relations, there arose a concept which was gradually to replace that of Graeco-Roman humanism. Another scene was being enacted in this ancient drama, in which since prehistoric times there had existed a fundamental conflict of ideas—on the one hand the Mediterranean artist with his bent towards the representation of man and nature, and on the other the metalworkers and goldsmiths of central Europe and of the steppes who favoured geometric patterns and for whom living forms were only raw material for design. This latter tendency was common to the people circulating over immense territories stretching without any real geographical barriers from the plains of Asia to the Romano-Germanic frontier.

In a province such as Gaul, the new artistic concepts only represented a revival of decorative processes which had, in fact, remained popular. These concepts included symmetry, stylisation, and a taste for materials which blazed with colour, such as garnets, multicoloured glass beads and enamels. In Gaul, too, the potteries continued to produce ceramics whose decoration was Celtic in feeling. When, following the 3rd-century invasion, the kilns of Argonne were relit, the decoration of their pots, done with a pricking wheel, reproduced the stylisation of the second Iron Age. From Great Britain, and from Belgium between the Sambre and the Meuse, the enamellers exported their wares as far as Hungary and the Caucasus. The old provincial ideas are seen in the decoration of their enamelled brooches, in which a strange collection of animals repeats the motifs of the potters—dogs, horses, cockerels, scenes representing the hunting of wild boars, stags and hares. At the end of the 3rd century, on the edges of the Empire, enamellers were working in Russia, and their industry was to grow in the following century. It is also known to have existed in Scotland (Traprain Law site), and probably in Ireland; its existence even in Persia may be suspected. There was enough of this work being done to prepare the way for the

ITALIAN. Christ in Majesty. Fresco of the Cassiciese school. Last quarter of the 11th century. S. Angelo in Formis. Formerly at Monte Cassino. *Photo: Scala.*

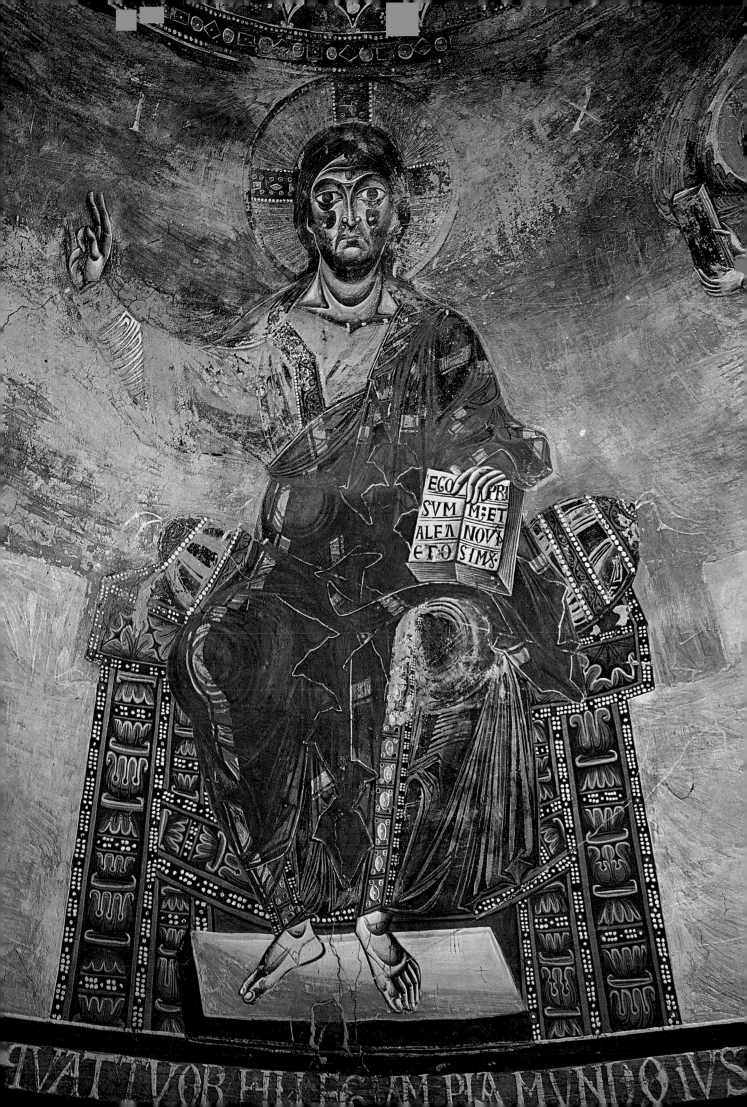

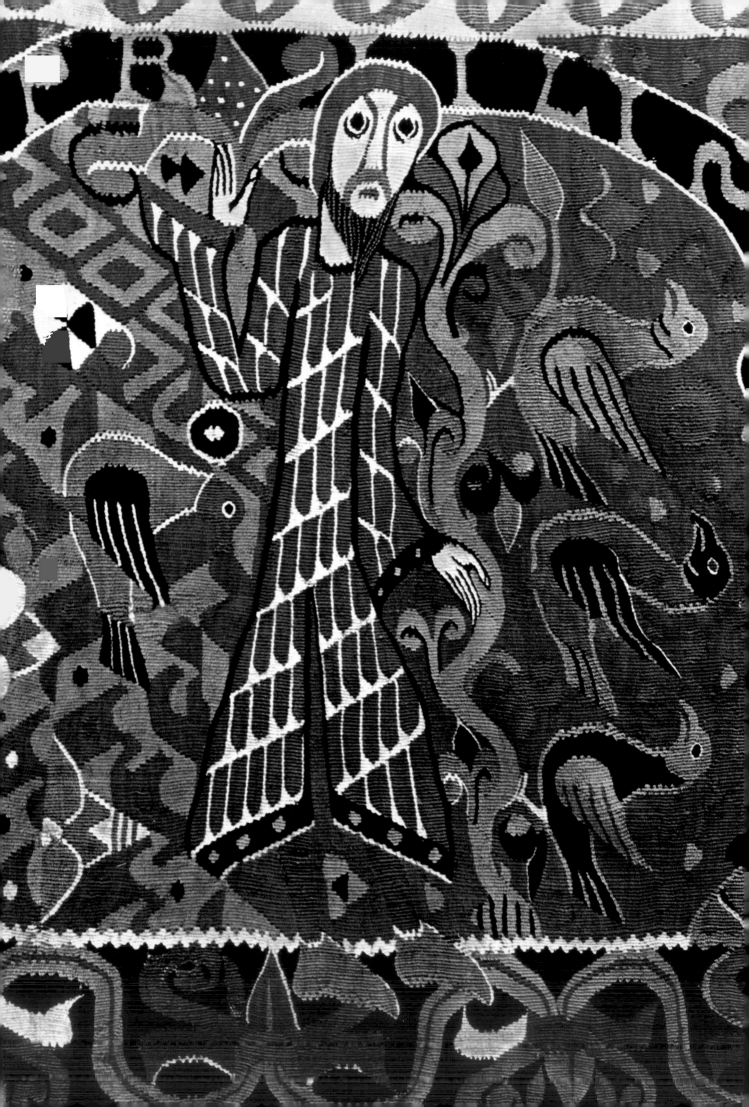

enamellers of barbarian times, and to explain the universal popularity of this form of decoration, which was in fact less novel than might appear at first sight.

The same thing applies also to certain other techniques whose centres of production were to be found in the provinces of the Empire. Ever since the Hallstatt period the metalworkers of the Danube basin had produced work of a high standard. In annexing Noricum, which bordered on the Danube, the Romans gained possession of their famous workshops, and so inherited their Celtic methods of work. This industry continued until the Vandal invasion, and it does not seem impossible that the craftsmen may then have emigrated westwards in the direction of the middle Rhine. Here one senses their importance in developing the industrial arts noticed in the 4th century. It seems certain, however, that their workshops, under 'state control', were placed in strongholds throughout the Empire rather than confined to any particular centre. The final development of Roman art in western Europe showed a profound alteration of taste. This was expressed by a striving for massive forms, by excessive use of linear decoration, sometimes pierced or deeply incised, and by the use of glittering colours. This baroque style did not arrive suddenly. Since the 3rd century the 'flamboyant' pierced work on harness and saddlery had, through its emphasis on tripartite forms, clearly shown a return to the ancient Celtic traditions. At the same time the use of a separately cast ornament partly sunk into a metal object reappeared, as in the beaded border of the medallion of the Emperor Probus. Then this form of decoration was drawn out in S-shapes, spirals, rosettes, loops and triskeles (three-legged symbol), which were already used on the belt buckles of the 4th century. These forms were also in use in the funerary workshops of the Comminges and Couseran districts.

Metal was not the only material to have deeply incised decoration. In the middle of the 3rd century, at a Cologne workshop where Greek craftsmen were working, glassware was engraved with mythological or genre scenes and geometric motifs were cut in, and these products spread through the districts of the Danube and Rhine valleys.

In this late period of the Roman Empire artistic tastes reappeared which, long before, had been those of the ancient tribes. These tribes found themselves, for a time, under a common authority and having the same general economy. Thus a climate of taste was created in advance, ready for the new productions of barbarian art.

The arrival of the barbarians

From the 4th century onwards, the barbarians became entrenched within the Roman Empire. The colonies of Gauls and Letts included many who were Germanic, and also Sarmatians from the Black Sea area, as well as some Theiphales and Scythians who came from the steppes of eastern Europe. These played their part in introducing bronzes with animal ornament in the Pontic style — originating from the Black Sea area — which had for a long time been exerting an influence over the German tribes. The funerary furniture of the Letts shows, in the use of these decorations, that, like their compatriots on

179. LATE ROMAN. Setting of inlaid silver, found at Vermand (Aisne). 4th century. *Metropolitan Museum of Art.*

180. LATE ROMAN. Christian vase with scenes from the Old Testament. Centre: Jonah and the whale. In the medallions: the sons of Constantine the Great. Middle of the 3rd century. *Roman Museum, Cologne.*

the right bank of the Rhine, they were inspired by the luxurious productions of Roman industry.

Already, in the 4th century, the role of the barbarians as intermediaries between East and West began to emerge. Germans served in the Roman army, side by side with the Roman officers, and these officers developed a taste for their heavy gold and silver ornaments and for weapons enriched with cloisonné glass beads (the statues of the Tetrarchs in the Piazzetta, Venice).

In the same way the Sarmatians, famous for their work in bronze and gold, spread their techniques towards the Danubian workshops, and thence further west. These techniques included bevelling and cloisonné. The foundation of Constantinople confirmed the compromise between classical civilisation and Eastern culture, whose prestige had steadily increased since the time of the first Syrian Emperors.

In the 5th century, after the collapse of Roman authority, classical art, now extremely decadent, survived, but in a Byzantine form, in Italy and North Africa. Elsewhere the door, which had been ajar to foreign influences, was now fully opened. As the Huns penetrated, so the people of the steppes exerted their influence over Europe.

The new forms which the Germanic tribes received are inseparable from the people who created them and from the type of life they lived. They were nomads from south Russia, Siberia and Turkestan, and included Scythians, Sarmatians, Huns and Turks. They were primarily concerned with ornamenting their clothes and tents, their

184

NORWEGIAN. Detail of a tapestry from the church of Baldishol. The Month of April. 12th century. *Museum of Antiquities, Oslo University. Photo: Giraudon.*

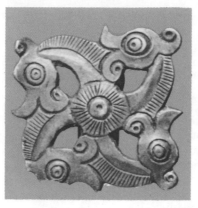
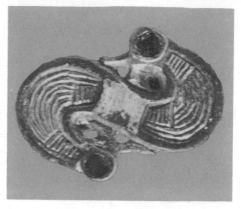

181. *Left*. FRANKISH. Jewellery in the form of a bronze triskele. 6th–7th centuries. *Musée de St Germain*.

182. *Centre*. SCYTHIAN. Silver ornament from the Craiova treasure. 6th century B.C. *National Museum of Antiquities, Bucharest*.

184. GALLO-ROMAN. Medallion of the Emperor Probus. 3rd century. *Bibliothèque Nationale, Paris*.

185. GALLO-ROMAN. Bronze bowl. Cloisonné enamel decoration. Middle of the 3rd century. *Musée de St Germain*.

183. *Right*. FRANKISH. Brooch in the form of a dragon, found in a tomb at Arcy Ste Restitue (Aisne). 6th–7th centuries. *Musée de St Germain*.

The triskele and the S-form, so frequent in Celtic art, recur in the form of animals in all barbarian art.

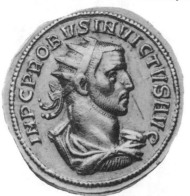

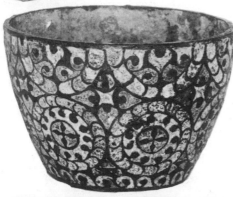

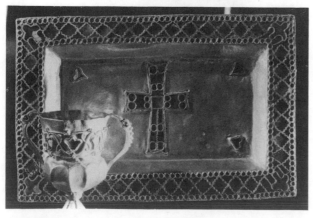

186. MEROVINGIAN. Gold chalice and paten from Gourdon (Lot). 6th century. *Bibliothèque Nationale, Paris*.

horse trappings and the equipment of their horsemen. Their art was essentially decorative, and was applied to textiles, metals and leather. All this nomadic equipment imposed a stylised, if not heraldic, treatment. The absence of permanent settlements accounts for the lack of architecture, sculpture and painting, essential elements in a naturalistic art. It is logical that from their Assyro-Babylonian models the huntsmen of the steppes retained only the themes familiar to them, such as animal combats.

Now, while the art of the Scythians still retained a memory of natural form, the art of the Sarmatians pursued a geometric stylisation, delighting in the play of polychrome enamels over gold. With these gold products, which the Sarmatians passed to the Goths and the Goths to the Germanic tribes, the art of the steppes extended over the plains of Eurasia, from Siberia to the Atlantic. In Hungary and Wallachia, territories occupied by the Huns, direct contact with Asia was continuous. The discoveries at Petrossa, Nagy-Szent-Miklos, Szilagy-Somylo, and Tirana (in Albania) all bear witness to the extraordinary richness of the treasures accumulated by the barbarian chieftains. These treasures included cups made of small panels of rock crystal linked together in a tracery of gold, with handles in the form of cheetahs whose eyes are garnets set in mother-of-pearl. There were brooches, enriched with pearls and garnets, in the form of birds; gold filigree brooches; Imperial medallions in a frame of cloisonné glass beads; and belt buckles depicting fighting animals or confronted griffons, in imitation of Sarmatian gold models. Golden cups glowed with coloured enamels; drinking vessels were decorated in relief with foliated scrolls, lozenges set in circles with a central cruciform design, or occasionally horsemen holding a captive by the hair, or the Sassanian motif of a horseman shooting an arrow at a lion. It was always imagination rather than reality which inspired this art. In the European versions of the styles of the Asiatic nomads, in Gaul, in Spain, in the Italy of the Ostrogoths and Lombards, as well as in Anglo-Saxon and Scandinavian countries, the craftsmen of the Great Invasions always used the same techniques and the same grammar of ornament.

The Mediterranean, gateway from the East

Though these invaders did not intend it, they ended by destroying the civilisation that they admired. If the provincial populations in the overrun territories had not maintained a strong social structure, and the aristocracy

had not held its position, the involuntary success of the invaders would have been less complete. But the invading Merovingian kings recruited their civil and military officers from among them, since they were more shrewd than the Germans. The bishop, the defender of the state, was usually chosen from this same class. So having been left with most of their wealth and power, the prelates proceeded to set up basilicas which were of astounding magnificence for such turbulent times. But contact with the barbarians changed the traditions; the old society, if not destroyed, became barbarised.

On the other hand, barbarian royalty allowed itself to be drawn by the lure of Mediterranean art. At this time, when Theodoric held court at Ravenna, a Gothic sovereign ruled at Toulouse, and the Frankish kings reigned to the north of the Loire. They built basilicas, those veritable storehouses of rare metals, brocades and ivories. Treasures such as the Gourdon chalice and paten, the reliquary of St Maurice of Agaune, and the Guarrazar crowns are outstanding works to have been produced in countries exhausted by invasion. But the external trade of the West was still hinged on the eastern Mediterranean. Greek, Jewish and Syrian merchants were established in the West and they kept up their contact with Byzantium, and the Near and Middle East. These merchants imported not only spices from India and oil and papyrus from Egypt, but in addition many Oriental works of art. There were Persian, Egyptian and Byzantine silks, with animal and hunting themes, ivories, including consular diptychs and pyxides of Byzantine, Coptic or Syrian origin. Gold- and silver-ware came from Antioch and included silver dishes decorated with mythological subjects in an Oriental embossing technique; these were heightened with filigree and probably gold cloisonné.

During the early Middle Ages there were many travellers, and after the triumph of the Church pilgrimages to the East increased considerably. The pilgrims travelled from Carthage to Alexandria, Byzantium, Judaea and Galilee, and even as far as Lyconia and Cappadocia. It seems likely that souvenirs of these journeys included the Ampulla of St Menas, the Coptic bronze clasp depicting St George slaying the Dragon with a Cross, and the Crucifix reliquary of Montcarret. These and others were probably brought home by devout pilgrims, and helped to spread in the West the marvels of Eastern art, including new decorative motifs and Eastern styles of building. If it had not been for the silver ampullae preserved mainly in the cathedral treasury of Monza and in the old church of St Columban at Bobbio, this commemorative art, represented in the mosaics of Jerusalem, now almost completely destroyed, would scarcely be known. In France this influence was to be felt throughout the Romanesque period. Kings and bishops sent pilgrims to search for and bring back relics from the East. The passion for relics became a cult: it drew crowds and caused much confusion. It also resulted in the building of new churches and gave birth to many works of art. Examples include the reliquary of the True Cross offered by Justinian II to St Radegund, decorated with gold cloisonné enamel, the reliquary casket of the hypogeum at Mellebaude with its Syrian decoration, and the wooden desk which is said to have been used by St Radegund, on which Christ's image is surrounded by the symbols of the Evangelists in a manner similar to the decoration of the

186
39, 157

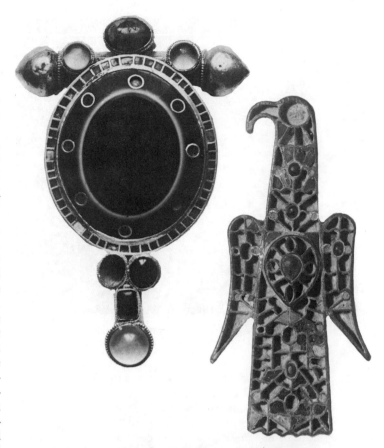

187. BARBARIAN DANUBIAN ART. Brooch from the Szilagy-Somlyo treasure (Hungary). *National Museum, Budapest.*

188. MEROVINGIAN. Bronze brooch in the form of an eagle. Cloisonné enamel decoration. End of the 5th century. *Musée de Cluny, Paris.*

lintels of 5th-century Syrian churches.

The Merovingian economy continued the Roman economy, but from the 5th century to the end of the 6th Western civilisation was declining. As a result of the invasions, the intercontinental routes became more important. These routes altered but remained open. Eastern trade came through the ports of the Adriatic and over the Alpine passes—Coptic bronze vases, belt buckles ornamented with Christian themes, and natron, which was a salt used in the manufacture of Syrio-Egyptian glassware and which was also used in the workshops of Cologne. Even though there were barbarians in the Danube valley, the route was kept open, and was used by traders and also by craftsmen. Bird-shaped brooches had originally appeared in the Crimea and in Moldavia about A.D. 400 but now the style spread along the river valley from Hungary, and extended to the middle Rhine and to the Somme. A similar correspondence is found between the ornamentation on the tomb of Childeric I, buried at Tournai in 481, and the princely sepulchres of the Rhineland and of Apahida, in Hungary. The ornamentation seems to be the product of the same workshop and may either have been imported by the Huns, or have been produced by Pontic goldsmiths working in the West or by goldsmiths working in Noricum, where the sword blade of Childeric may have been forged. Indeed, it is known that about 454 Queen Gisa, wife of Felethius, king of the Rugians, held barbarian, Sarmatian and Gothic goldsmiths in captivity.

Two main routes, the old roads of the amber trade, ran from the north to the Mediterranean through the Slavonic territories of the Oder and the Vistula. These were closed by the destruction of Aquileia by Attila, but the trade in

188

99

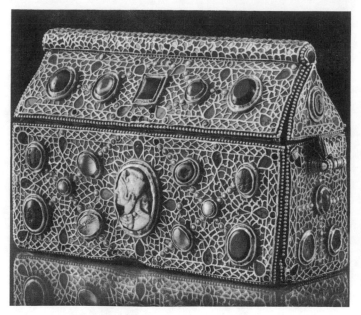

189. MEROVINGIAN. Cloisonné reliquary casket of Teudericus. 7th century. *Treasury of St Maurice, Agaune (Switzerland).*

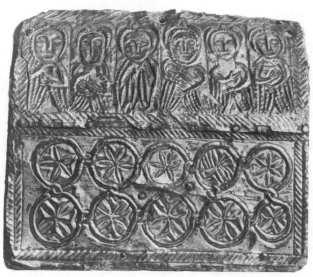

190. MEROVINGIAN. Reliquary of St Mommolinus, at St Benoît sur Loire. 7th century.
The decoration is characterised by the mixture of geometric ornament and schematised figures.

amber must have been reorganised in the 7th century, for amber reappeared on the sepulchral monuments of this period. The Rhine valley was the main route between Britain and Germany, and her brooches with cruciform heads and Anglo-Saxon money have been found. Through the Channel ports, in the 7th century, Northumbrian productions such as the whalebone casket from the St Julien at Brioude treasure were sent to central Gaul.

Court art and its goldsmiths

In the 5th century, the new forms and decoration brought to the West still remained an aristocratic prerogative. These magnificent collections of ornaments were, in fact, gathered into the princely tombs dating from the second half of the century, and they have no parallels in the sepulchres of ravished Gaul or central Europe. This contrast explains the formation of a 'court art' in which pieces of rare beauty are found side by side with pieces of the most mediocre quality. Several of these fabulous sets of ornaments may have been made in the Western workshops by Pontico-Danubian goldsmiths, who had arrived in the wake of the barbarians. Thus, the Constantine who came from Commagene practised the *ars barbarica* in Gaul. In the 5th century, the *Notitia Dignitatum* used the word *barbaricus* to describe the makers of damascened weapons, and it included the arts of damascene, filigree and cloisonné. It is also known that in Belgium and in the Rhine valley the pottery and glass workshops had employed Oriental and African craftsmen since the 3rd century.

During the 4th century, the industries of eastern Gaul received a boost from the presence of the Imperial court at Trier and of the armies stationed on the Rhine. All these industries could not have disappeared during the invasions. For example, there are the drinking vessels, and the wooden pails covered with thin bronze decorated with embossed scenes taken from the Old or the New Testament. Diverse industries flourished between the valleys of the Rhine and of the Seine, on the Channel coastline, and on the eastern shores of Britain. There must have been glass workshops in these districts; small spindle-shaped vases and conical goblets made their appearance in England. These industries successfully recaptured the traditions of the Kastel and Vermand casket-

makers and of the appliqué ornamentation in bronze and silver such as is seen on the Paulinus sarcophagus at Trier. Though the origins of this kind of art are to be found in the metal vessels imported from Egypt into Britain, the vessels of Lavoye, Miannay and Wisoppenheim clearly show Western characteristics in the barbarisation of the motifs and in the close relation with the themes treated by pottery and glass workers.

Similarly, British silver workshops are known to have survived in the regions later occupied by the Saxons. The Celtic tradition is clearly felt in the treatment of the forms. This tradition was already apparent on the Kastel casket and also influenced the ceramic ornamental grammar known as 'Visigothic'.

Certain traits were common to all these productions: conformity to the decorative repertoire and, frequently, poor execution. The country lying between the Seine and the middle and lower Rhine valley was best able to maintain the tradition of the minor arts deriving from the court style and was thus called upon to play a special role in the development and dispersion of the new forms. During the intermediate period between the end of the Roman world and the coming of the Merovingian kings, artistic tendencies appeared which, impelled by the force of events — the sack of Rome by Alaric and the upheavals throughout the Empire (410–420), the establishment of Visigothic supremacy in the Garonne valley and in Septimania, in south-west Gaul — definitely escaped being centralised.

Survival of the human figure and geometric abstractions

During the 4th century, remnants of classical humanism still survived in the sarcophagus workshops of Arles and Marseille. In the general impoverishment of the 5th and early 6th centuries, sculpture in the round and in high relief disappeared. This is strikingly revealed in the crypt of St Maximin (Var), which was the mausoleum of a rich family. Here is seen the lavishness of the Christian sarcophagi of the preceding century, alongside meagre wall decorations, awkwardly engraved marble plaques with representations of the Virgin and of Daniel in the Lions' Den. On sarcophagi, chancels and tombstones, even the most attenuated relief often gave way to a simple engraving, with the line picked out in red.

191. MEROVINGIAN. Scene representing a 'translation of relics'. Bas-relief at Vienne (Isère). 7th century.

The influence of the Gallo-Roman tradition can still be seen . . .

192. FRANKISH. Panel of a casket in whalebone, with inscriptions in Anglo-Saxon runes. 8th century. *Bargello Museum, Florence.*

Goldsmiths' work, embossing, ceramics, glass and sculpture were amazingly interdependent and followed the same development. On the sarcophagi, the simplified composition, the division into decorated niches, sometimes with curtain decoration, calls to mind the mosaics of S. Vitale at Ravenna. On the historiated altar panels the sculptural themes are the same as those on the mosaics and on the clay lamps. All made use of abstract animal forms, processions of stylised lambs and symbolic doves framing the Cross or the monogram of Christ. The abstract element was strengthened as a result of the renunciation of the human figure. This foreshadowed the time when sculpture became essentially a decorative technique making use of the same repertoire as textiles and goldsmiths' work. Sarcophagi, chancels and choir screens were covered in an embroidery of champlevé. Rosettes were scattered and honeycombed to receive paste cabochons; there were foliated scrolls, nests of interlacings, symmetrical whorls and leafy vines and palms.

Nevertheless, in the 7th century, the human figure was not completely abandoned. Craftsmen such as St Eloi translated the images of the Bible into gold. The gold statuette from Pontlieue-Le Mans shows that a workshop, continuing the Celtic and Gallo-Roman traditions, was capable of carrying out sculpture in the round. Even so, the living form was used almost exclusively in designs for church and tomb decoration. Scenes were rarely shown. But there were a few, as, for instance, the hunting scenes deriving from the funerary monuments of antiquity, a 'translation of relics' scene on a low relief at Vienne (Isère), which comes close to an ivory of Coptic origin from Trier, and the Last Judgment on the sarcophagus in the crypt of Jouarre (Seine-et-Marne). Frequently, the human figure appeared in the decoration. The images of Christ and of death were, with few exceptions, rudimentary in drawing. The head with its bristling hair was too large for the body, the features of the face were clumsy and slight.

On the panels of the chancel of the church of St Peter on the Citadel at Metz or on the terra-cotta plaque from Grésin (Puy-de-Dôme), even figures of Christ were modelled on those of Roman iconography, without being directly influenced by Oriental, Egyptian, Mesopotamian or Persian prototypes, which had served as models for

Roman Imperial images used by Christian artists, potters and lampmakers. There was, on the other hand, a direct link between the figure of the Christian Emperor triumphing over Satan and that of Christ victorious over evil. This theme, so roughly expressed in the Grésin plaque, had penetrated into the barbarian world by way of funerary iconography (the Niederdollendorf stele). This marks the reappearance of the human figure in the 7th and 8th centuries. The influence of antiquity was also apparent on the tomb of St Theodichildis at Jouarre, in the capitals and ornaments which included seashells. There is a close relationship between these decorations and those on the buckles on which Daniel is represented praying, which were also crude in workmanship.

Outline of a new civilisation

The artistic activities in the second half of the 6th century were one facet of the period; others included the revival of the general economy and of commercial relations, and also the spread of Christianity, which resulted in the building of churches and monasteries.

These monasteries played an important part in the

193. FRANKISH. Memorial stele from Niederdollendorf (Rhineland-Westphalia). 7th–8th centuries.

194. BARBARIAN. Head of an Ostrogothic king. 6th century.

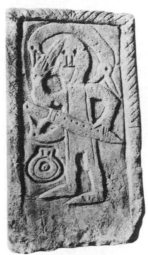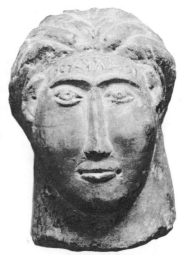

economic and spiritual revival. This revival, which can be dated from the 4th century, having started in the East and followed the shores of the Mediterranean in the wake of Syrian and Egyptian monks, only had its full effect with the arrival in Gaul of the Irish St Columban. He brought with him the concept of monastic life as it had been elaborated in Great Britain. The foundation of the abbey of Luxeuil in 599 marked an important turning point. It was to the credit of the Irish monks that they found a compromise between two disparate worlds, the Oriental and the Celtic. For two centuries they fused together the variety and exuberance of the geometric ornamentation of the one with the deliberate stylisation of living forms of the other. The monks were patronised by the prelates and the lay aristocracy, and their financial security was assured by their possession of land. So the monasteries were able to buy in the Mediterranean ports spices, papyrus, silks and ivories from the Orient.

At the same time, across central Europe, traders established liaisons between the northern regions and those of the Black Sea and the mouth of the Dnieper. Friesian merchants, profiting from the relative poverty of the East, brought the animal decorations of the steppes to Scandinavia and Saxon England. Owing to the Frankish expansion in the 6th century and the incursions of Islam in the 8th, trading activity moved northwards. As a result, the production of works of art was scattered in the northern areas, which were less affected than the countries south of the Loire by the critical phase of the first half of the 7th century.

The Norman invasions caused a break with the traditions of the previous centuries. Industries revived at the sources of the raw materials, and their goods were widely exported. The Pyrenean marble industry, which had contributed to the decoration of the Parisian basilicas of Clovis and of Childebert, sprang into new life. Sarcophagi and capitals were distributed throughout the Ile-de-France, Aquitaine, Septimania, Provence, the Rhône valley, the Auvergne, and on the Loire and lower Seine. Stone for sarcophagi in the district of the Marne and in Normandy came from Vergelé and St Leu. Workshops were busy in Burgundy, Champagne, Poitou, and in the valleys of the Loire and the Cher, in Sologne. The sculptors in the north of Gaul used Belgian limestone. There was now a reversal in aesthetic ideals: in the barbarian west—in continental Gaul, Lombardy, northern Spain, Great Britain and above all in Ireland—artists turned again to relief carving, whereas in the extreme south-west, under the influence of the Orient, the panels of sarcophagi are covered with stylised decorations.

In their masons' yards, the monasteries prepared the way for the arrival of a new humanism, whose influence was not confined to architecture and sculpture. The illuminators in their scriptoria elaborated a new form of illustration by entwining fishes and birds round letters.

The dispersal of minor arts throughout the West was another result of the revived economy. The quantity and quality imply that workshops existed in many districts with the necessary means of distribution. In Britain, for instance, there were workshops in Kent, and others that worked for King Redwald. Visigothic Spain, depending to some extent on Roman influences, preserved its traditions of craftsmanship in the cities of Toledo, Mérida and Tarragona. From these centres, the metalworkers exported their radiated fibulas or brooches, of a type then fashionable, to Roussillon and Languedoc. Damascened plaques were sent from other workshops by sea or river, or overland to Aquitaine and as far as the Ile-de-France and eastern Gaul. This type of work occurred throughout an area extending from the Atlantic Ocean to the plains of central Europe, and ignored national boundaries. Its dispersion was made easier by the great annual fairs held in Frankish territories, which were attended by many foreign merchants.

In many areas, barbarian art now took on a different character. It is necessary to make a distinction between, on the one hand, objects like the magnificent damascened belt-buckles and the brooches enriched with precious stones, cameos or gold filigree, and, on the other, the embossed or stamped industrial productions. The evolution of, and the changes in, the forms of this jewellery, reflect fluctuations in fashion rather than ethnographical characteristics. Otherwise it would be impossible to explain the vogue for damascening with its magnificent stylisations which recurred from the Seine and Saône to as far as the Rhine; nor would it be possible to explain the wide diffusion of the radiated fibula. Art ceased to be the privilege of the aristocracy and now reached all levels of society; it became universal throughout the West. Its contrasts, even, reflected a civilisation that was still unstable, with strongly marked oppositions. This art did not end with the Carolingian Renaissance. It is still perceptible in the illuminated manuscripts. And, in the 12th-century decoration in the churches of northern France, numerous themes were used, once more, that came from the animal art of the barbarians.

195. *Left*. BARBARIAN. Gold brooch. *National Museum, Budapest.*

196. *Right*. SCANDINAVIAN. Large brooch in silver gilt from Gummersmark. About 500. *National Museum, Copenhagen.*

197. *Left*. BARBARIAN. Brooch from Wittislingen (Germany). 6th century. *National Bavarian Museum, Munich.*

198. *Right*. BARBARIAN. Brooch from Tuscany. 6th century. *British Museum.*

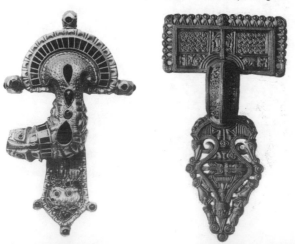

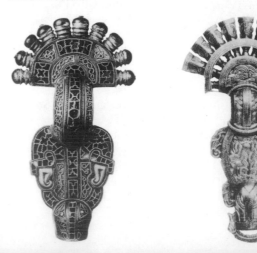

HISTORICAL SUMMARY: Barbarian art

HISTORY

In the middle of the 2nd century, the Goths moved south from the Baltic towards south Russia by way of the Vistula. Here the Sarmatians were established in the 2nd century B.C., pushing the Scythians even further westwards (in 250 B.C. they crossed the Don, in 50 B.C. the Dnieper).

First phase. The first thrust of the barbarians into the Roman Empire coincided with the military anarchism of the middle of the 3rd century A.D. Then the Germanic tribes, Franks and others, pushed as far as Byzantium and north Italy. The Saxons settled in Britain. The 4th century provided a breathing space for commercial relations. At this time, Bishop Ulfilas converted the Goths to Arian Christianity. The barbarians were welcomed into the Roman army, and even into the Empire itself, as confederates.

Second phase. The Huns were nomad Tartars. The Chinese had built the Great Wall to keep them at bay. The Mongols probably repulsed them and, after this, they surged westwards and overtook the Ostrogoths about the year A.D. 370. The barbarians fled before them. Alaric, with his Visigoths, attacked Greece in 395 and then Italy. He took Rome in 410. Later his troops went north into Provence, and had conquered Spain by the end of the century.

The last of the Roman legionaries had been recalled, and in 406 Vandals, Suevians (Tuetons), and Alani (Iranians) ravaged Gaul as far as the Pyrenees. They then passed into Spain and as far as North Africa with Gaiseric in 429, and came back to Rome, which they took in 455. The Burgundians (Scandinavian) and Alamanni (Germanic) settled in the east of Gaul; the Franks (Germanic), in the north, ceased to be loyal to the Empire and dispersed widely.

Third phase. The Huns were living in Hungary about 405, and had assimilated Iranian and Germanic tribes. Under their leader, Attila, in 443 they attacked Con-

stantinople. Then they invaded western Europe and reached Paris, but were defeated near Troyes in 451. They descended as far as Rome and then withdrew.

In 476, Romulus Augustulus, the last Emperor of the West, was overthrown by King Odoacer, king of the Heruli, who in his turn was overthrown by Theodoric and his Ostrogoths in 493. Byzantium rid herself of Theodoric by forcing him back from the Balkans on to Italy.

The Roman Empire collapsed and gave place to five states: Vandal (North Africa), Visigothic (from Gibraltar to the Loire), Ostrogothic, Burgundian and Frankish. Clovis, the convert king of the Franks, rapidly overcame his neighbours between 496 and 534. Byzantium destroyed the Vandal kingdom in 533 and the Ostrogothic kingdom in 555. But Italy fell again beneath the onslaught of the Lombards, probably of Baltic origin. These, driven from the Danube by the Avars, of Asiatic origin, arrived in 568 and captured Ravenna in 751.

The Merovingian kings expanded the Frankish kingdom across the Rhine. Now Carolingian, they made a fruitful alliance with the Church. St Gregory the Great (590–604) was at this time engaged in converting the Arian barbarians, from Spain to as far as Anglo-Saxon Britain.

ART

From the end of the 5th century, classical forms of art were gradually disappearing. Oriental and barbarian influences became intermingled, especially in Gaul.

I ORIENTAL INFLUENCES

The techniques and decorations of Asia were known in the Roman Empire long before the 5th century, when the barbarians became established. The Asiatic style first appeared in the eastern regions, notably in Syria. The praetorium of Mus Mieh (160–169) and the stelae and paintings of Doura Europos and Palmyra belong to the 2nd and 3rd centuries. This art was diffused through the movements of the legions, by merchants, and finally by monks and pilgrims. In the early Middle Ages, Gaul and even the British Isles were in contact with the Orient by way of the routes through Lombardy and the eastern Alps. St Fortunatus bears witness to this in 566.

The influences which affected sculpture, painting and goldsmiths' work are particularly marked in iconography. The theme of animals facing one another on either side of the Tree of Life derives from Mesopotamia by way of the Sassanians. This theme is found on the chancel of the church of St Peter on the Citadel at Metz, towards the end of the Merovingian period, on the cenotaph of Dizier at St Dizier near Belfort, in the 7th century, and on the reliquary casket of the cathedral of Chur, ascribed to the 8th century.

The theme of hybrid animals and plants is found on the tomb of the Abbess Theodata at Pavia in north Italy (720) and on the balustrade panels of the font (737) in the cathedral of Cividale.

II THE BARBARIANS

Barbarian goldsmiths' work became popular among the officers of the Roman army, which included in its ranks a number of Germans who had become 'federated'. From the 5th century, Gaul was the main centre of medieval art, where the marriage of two diverse elements, barbarian art and Mediterranean art, was gradually achieved, and to it, from the 6th to the 9th centuries, Germany, Lombardy, England and Spain all made contributions.

Origins. For a long time, the style of geometric ornamentation typical of the Bronze Age was the only style known to the Germanic tribes. This they had derived from the Scythians and Sarmatians, people of Iranian extraction, with whom the Germans had come in contact in south Russia during the 2nd century. The Scythians had specialised in an exquisite and stylised animal art which lost its purity under the influence of Greek art. It used the geometric and floral elements of classical art to enrich its own fantastic animals.

At that time, the style appeared in Sarmatian art and then spread in the 5th century over all the plains of Eurasia, from Siberia to the Atlantic Ocean. At the end of the 4th century the Germanic tribes were driven westwards by the Huns. They brought with them objects and jewellery originating from various places, including Sassanian jewels and Byzantine cups, like those in the treasure of the Gothic king Athanaric at Petrossa.

The minor arts. Barbarian art is known from objects found in the Frankish, Burgundian and Visigothic burial grounds. It was purely ornamental, characterised by the 'animal style' and cloisonné gold and silver work. The barbarians liked rich materials or those which gave the illusion of preciousness, and colour used with geometric decoration.

There were a great many brooches, sometimes round, sometimes elongated. They were decorated with cloisonné or filigree, sometimes with bevelled incisions; sometimes they were radiated (curved clasps, the heads of which terminated in radiating projections or were decorated with semicircular or square plaques, with the point in the form of a stylised animal). The radiated type was universal. Examples occurred from the primitive Goths to East Prussia, and from the Vandals of North Africa to the Anglo-Saxons and Scandinavians. In Historical Summary in Chapter 4 (p. 252) will be found the development of barbarian goldsmiths' work into the Merovingian, Lombard and Visigothic arts.

Josèphe Jacquiot

199. FRANKISH. Brooch found in the cemetery at Oyes (Marne). *Musée de St Germain.*

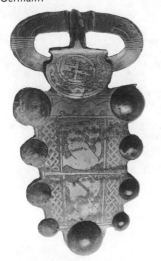

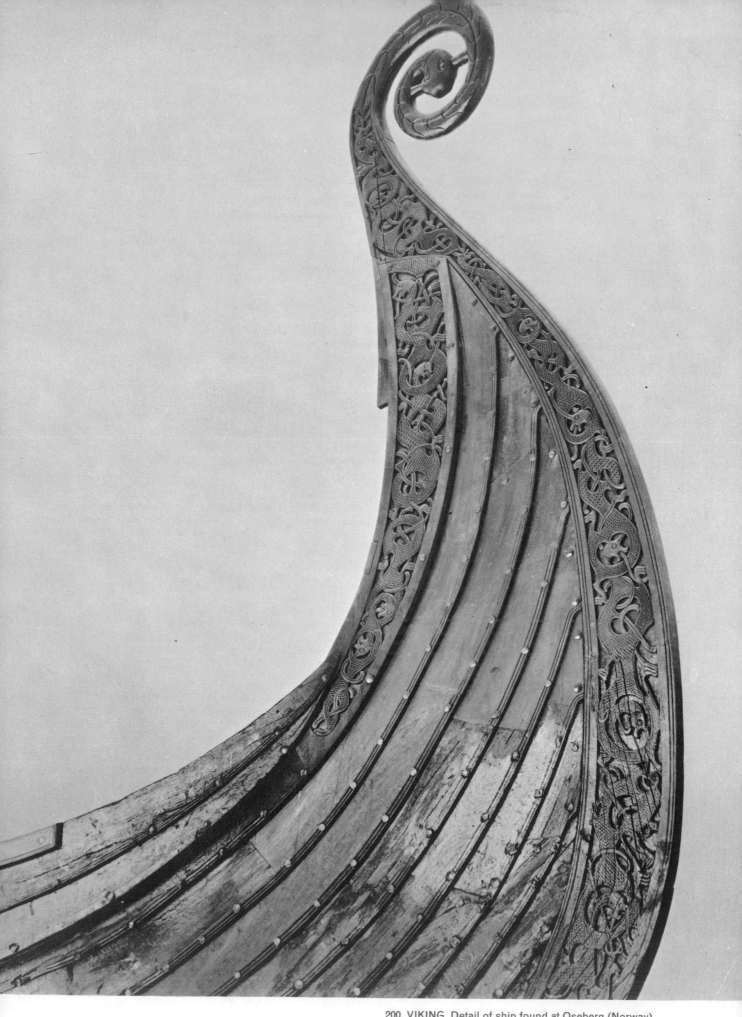

200. VIKING. Detail of ship found at Oseberg (Norway).
About 850. *University Museum of Antiquities, Oslo.*

THE VIKINGS *Ole Klindt-Jensen*

The great migrations of peoples had just drawn to a close when Viking sea raids, and sometimes invasions, marked the final barbarian offensive. Viking art, which no longer influenced a reawakening Europe, carried to extreme lengths the dynamic baroque characteristics already found in the arts of La Tène and of the steppes, and later in that of the barbarians, from whom Viking art sprang. It is not without some similarity to the Nordic art that was adapted to an early conversion to Christianity, which has been discussed in the previous chapter, that of Ireland and England.

The art of the Vikings is the expression of a fierce and adventurous people. The refined interlace enfolding fabulous mythological creatures reveals an imaginative, but cold, spirit. Although many Scandinavians lived by agriculture, their restless blood gave them a passion for seafaring and fighting, which became the highlights of their lives. Valhalla, the Norsemen's heaven, could only be attained by heroes.

Their tools, their weapons and their low, massive and sombre houses are known from excavations. Even more fascinating are their manuscripts which have come down to us, so that we can read their obscure poems and their laconic and dramatic sagas. It is essential to stress the fact that these were written in the Christian period.

The Scandinavian style, its originality and influence

During the Iron Age, an art using animal forms in an ornamental way was general in northern Europe; and influences from east, south and west may be noted. These foreign elements were assimilated by the Scandinavians, who even exaggerated the motifs.

The favourite theme was the animal, but the stylisation was carried so far that it is often difficult to identify it. At times, characteristic tusks seem to indicate a wild boar, or certain features lead one to recognise a horse. Usually, the beast is no more than a starting point for the imagination and, as in modern art, raw material for a visual language.

At first glance one might suppose that this approach indicated a delight in ornamentation. But the truth appears to be that these themes are not only freely stylised, but seek to translate a secret life, ideas, in fact a whole mystique. So, when this interlace style was taken over from the Near East, following the example of southern Christian Europe, the native genius stamped it with its own personality.

Foreign influences, especially from the Roman provinces, were added to the traditions and inventions of the native artists. The Scandinavians were in continual contact with other peoples, of whom the majority were Celtic, in the Rhine and Danube provinces. Many objects were imported, especially medallions; and so also were themes—spirals, croisillons and triskeles. On the large silver platter from Thorsbjerg, little bronze animals have been riveted to the original decoration, which testify to this Celto-Roman contact. Other evidence, such as the silver cups from Zeeland which are ornamented with friezes of animals and warriors, illustrates the same mixture of styles. This suggests the arrival of craftsmen from the south.

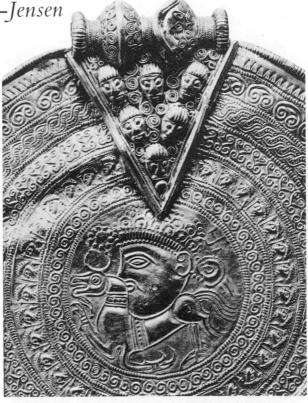

201. SCANDINAVIAN. Gold bracteate from Gotland (Sweden), obviously inspired directly by Roman medallions. Silver gilt. 5th century. *National Museum, Stockholm.*

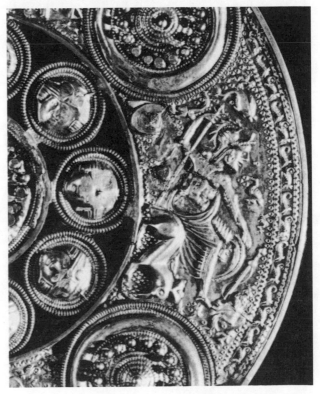

202. SCANDINAVIAN. Detail of platter from Thorsbjerg (Denmark). An animal motif is introduced with the classical figure of Mars (right). Probably Nordic. *Schleswig-Holsteinisches Landsmuseum.*

207

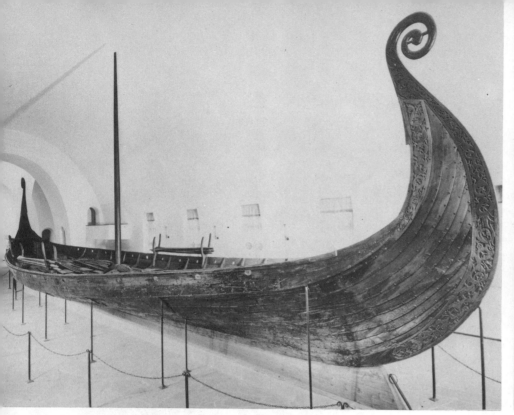

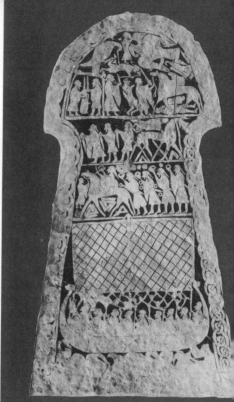

203. VIKING. Ship found at Oseberg (Norway). About 850. *University Museum of Antiquities, Oslo.*

204. VIKING. Picture stone from Tängelgårda, Gotland (Sweden). About 700. These stones can be regarded as memorials. *National Museum, Stockholm.*

Despite the cultural traditions that survived even after the end of Roman domination, Nordic art affirmed its own style. The influence of nomads from the east, though probable, has never been proved by reference to any imported feature with which we are familiar. The Nordic development is seen in the gold torques from Västergötland in Sweden; these are made in three rings, between which are a mass of little figured forms, including human masks and animal heads with large eyes seen from above. From the same period, about A.D. 400, date the two gold horns from Jutland (near Mögeltönder), of which only drawings remain, the originals having been stolen in 1806. The engraved forms of a three-headed god, a two-headed beast, and a horned god are similar to Celtic examples. There are centaurs, men with animal heads, numerous serpents, a woman in a long gown with floating hair, carrying a drinking horn, a hunter with a hind and its fawn; all these are depicted in bands round the horn, and there is also a runic inscription, now illegible, which indicated the artist.

The large relief brooches such as the silver-gilt one from Gummersmark (Zeeland) are typical of this style. The Roman influence still persists, for instance in the classical frieze similar to the ones at Ravenna; but Nordic taste is predominant in the two overlapping ferocious heads projecting above and below and in the drawing of the animals, etc. Some eastern Scandinavian brooches show an influence from the south-east, as in the sharp aquiline beaks of birds, stemming from Hungarian art.

The peoples of the north admired and envied the civilisation of Rome. From its alphabet they drew their own austere runes; and Roman coins inspired the northern bracteates, used with pendant rings as adornments. At first the subjects were imitated from Rome. After a while, the head, which had been inspired by that of the Emperor, was placed on a horse, and then bull's horns were added, symbolising power. Here, too, Hungary, where similar imitations were current, could have furnished the models

for these first medallions. The evolution of bracteates towards a more indigenous and abstract art may be followed again on the large brooches. Dismembered parts of animals were scattered and combined to suit the fancy of a wild and extravagant imagination. An example from Norway, with a richly decorated surface that scintillates in the light, shows the extent to which this art had become independent of nature.

In Sweden, at Vendel, and also at Valsgärde (Uppland), tombs of the Viking chiefs have been excavated. They were buried with their wives, their ships, their weapons and their ornaments—a succession of chieftains laid to rest on the hill.

In the style known as Vendel, the most outstanding characteristic is the use of the interlace. Though this, as has already been noted, was not an essentially Scandinavian treatment, it was, nevertheless, one which they used brilliantly, interweaving into the curves and countercurves their animal forms, of which only the heads are clearly distinguishable. Wings were soon added and the style became more abstract and unfathomable.

The representation of myths and sagas

The island of Gotland, a trading centre, contains curiously engraved commemorative stones. The oldest date from the period of the migrations, but they became far more numerous in Viking times. Their origin may be found in Roman mosaics and commemorative stones, but the myths and sagas of the Vikings gave them a new and dramatic life. The Tängelgårda stone, for example, recounts the story of a hero who has met his death in battle. He has fallen beneath his horse, and in the air above him hover winged maidens preparing to carry him away. In the lower part, the hero is sitting astride the eight-legged horse of Odin. He finally arrives in the land of the blessed, and is welcomed by a maiden holding a drinking horn and by warriors adorned, as he now is, with crowns. At the base of the stone is a Viking ship on

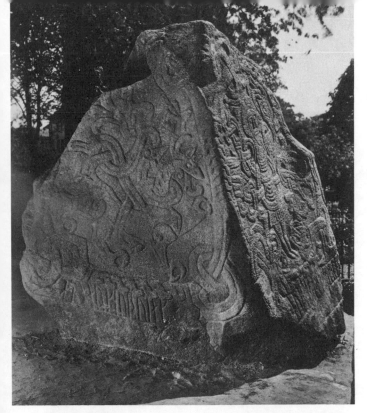

205. VIKING. The great stone from Jelling (Jutland). Northern Carolingian style. *National Museum, Copenhagen.*

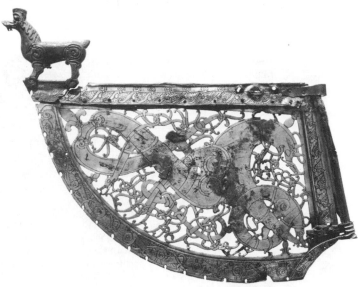

206. VIKING. Gilt-bronze weather vane. From the church of Söderala, Hälsingland (Sweden). 1025. At one time weather vanes like this may have been ships' ensigns. Later they came to be used on churches. *National Museum, Stockholm.*

207. SCANDINAVIAN. Detail of a gold horn from Mögeltönder (Denmark). Reconstruction. *National Museum, Copenhagen.*

the sea, and in this are Norsemen half hidden behind their shields. Another example, at Sanda, shows the everyday life of the Vikings and the layout of the house, etc. At Volundarkvida there is a theme from the *Edda*: the smith Volund (Wayland) is a prisoner of King Nidad, whom he is forced to serve; Volund lures the king's daughter and two sons into his forge; he violates her and kills the sons; he then escapes wearing the skin of a bird. The forge is drawn in minute detail.

Several Viking masterpieces have been found in the large tomb of a lady at Oseberg, in Norway. These include metal and wooden objects, textiles, and other items. 200, 203 A richly carved ship with its prow in the form of a serpent is carved with intertwining animals, in the Vendel style. Among the wooden articles found were beds, chariots sledges, etc. Haakon Shetelig, the Oseberg specialist, has distinguished the work of a number of different woodcarvers, to whom he has given the names 'the conservative academician', 'the careful eclectic', 'the baroque impressionist', etc.; these artists aimed at creating the third dimension. The masterpiece is the great richly carved bear's head.

At Oseberg the Scandinavian myths are to be seen: a textile designed with hog-headed women armed with lances, and men hanging from a tree; a wooden chariot carved with scenes such as Gunnar in the Pit of Vipers.

The latest works of art that belong to this period are the stones engraved with runes. These were frequently 205 decorated. The most beautiful is the great stone from Jelling (Jutland), placed by King Harald over the tomb of his parents. One of the three sides of this stele bears an inscription recording that Harald introduced Christianity into Denmark and united Denmark and Norway. Another shows a fight between a lion and a serpent, while the third shows Christ on the Cross, with eyes closed. This Christ is surrounded by native interlace work. It is an example of the birth of a new art that the Christian faith was to direct towards other ideals and different ends.

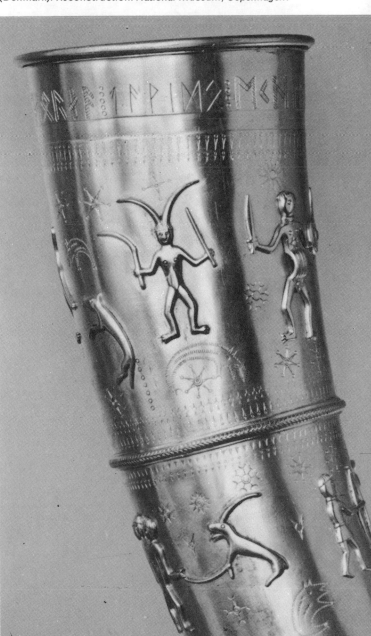

HISTORICAL SUMMARY: Scandinavian art

History. During the period of the early Middle Ages, Scandinavia was one of the principal centres of culture in northern Europe. The group of Germanic tribes in the north who inhabited Scandinavia was broken up into a cluster of tiny kingdoms whose dialects were very similar. A political triarchy came into being, consisting of Denmark, Sweden and Norway, countries which were to develop their individual languages in the 11th century.

The Scandinavian world was open to outside influences. Sweden traded with the East; Denmark was an intermediary between the Baltic and the North Sea; and Norway, well before the time of the Vikings, was open to seaborne influences which came in by way of the fjords of the western coast.

From 791 to 830, the Norsemen sent out reconnaissance expeditions; between 830 and 900 methodical invasions were launched; and then in the 10th and 11th centuries the invaders took possession of foreign soil. They gained territory in France in 911, in England at the beginning of the 10th century, in Italy at the beginning of the 11th century (1035) and in Sicily from 1016 to 1091. Their theatre of operations covered the whole of western Europe. Viking states were founded in the Orkneys and other islands, and the kingdoms of the Isle of Man, of Ireland and of England; and early in the 10th century the duchy of Normandy was established. Iceland and Greenland were colonised.

Art. Their art united the native traditions with influences from outside. The effects of Roman civilisation were followed by those of the Byzantine culture, the first through relations with France and England, the second from Constantinople by way of Novgorod and Kiev. In the 10th century Irish decorative art and Norwegian art were most successfully wedded.

First period. Style of the 'great invasions' (5th–7th centuries). Characteristic of the art of the northern pagans is their engraved or embossed decoration on cast metal, decoration consisting of a writhing mass of geometric patterns with animal themes. This animal style which sprang up at that time in the north followed a similar development to that of Anglo-Saxon art. It consisted of very beautiful filigree work, decorative silver-gilt buckles with elaborate animal patterns, ornamented scabbards and large silver brooches of which the most important were cruciform in shape [**196**].

Second period. Vendel or continental style. A new current developed in northern art, which began during the preceding style and predominated from the 7th century. The interlace, ubiquitous in Byzantium, Italy, central Europe, England and Ireland, was united with the animal forms. Among the Germanic peoples of the Merovingian civilisation, in central Europe and in the south of England, entirely new models appeared—round and egg-shaped brooches with birds and serpents. The elongated torsos of animals were arranged in borders of interlaced ribbons, or adorned the surfaces, following linear compositions of a most intricate geometry. The old forms disappeared. This break with local traditions prepared the way for the art of the Viking period.

Third period. Viking or Northern Carolingian style. On the threshold of the Christian Middle Ages, the Nordic tribes still embraced a deep-seated paganism. Their many masterpieces had a luxuriant decoration and used a combination of all the motifs set together with great clarity. They carved sledges and animal heads such as those found at Oseberg. The Gokstad ship, found at Borr, was carved with their savage animal heads. They wrought the golden spur and massive rings of the Varne treasure (Ostford)—necklaces, bracelets, buckles and brooches inlaid with silver and gold.

New ornamental motifs appear, such as the knot and bows of ribbons worked in high relief.

The Christian extension. It should be remembered that this style was maintained even in medieval religious art, especially in Norway. This is particularly noticeable in the art of wood carving, some fine examples being the portals of Urnes [**164**], 11th century, Aal and Stedje in the 12th century, and the carved timber gable ends which were still produced in the 14th century. The native style combined with the classical counter-influences which arrived from the continent, and reached its zenith in the 13th century with the work produced under King Haakon Haakonsson.

208. VIKING. Animal head by 'the baroque master', found at Oseberg (Norway). Northern Carolingian style. 9th century.

The real purpose of objects of this kind is not known, but they were probably used for worship. The decoration shows, in its profusion of detail, the high standard of wood carving of the period. The ornamentation seems to be in the Germanic animal style, consisting of interlace and barely recognisable animal motifs.

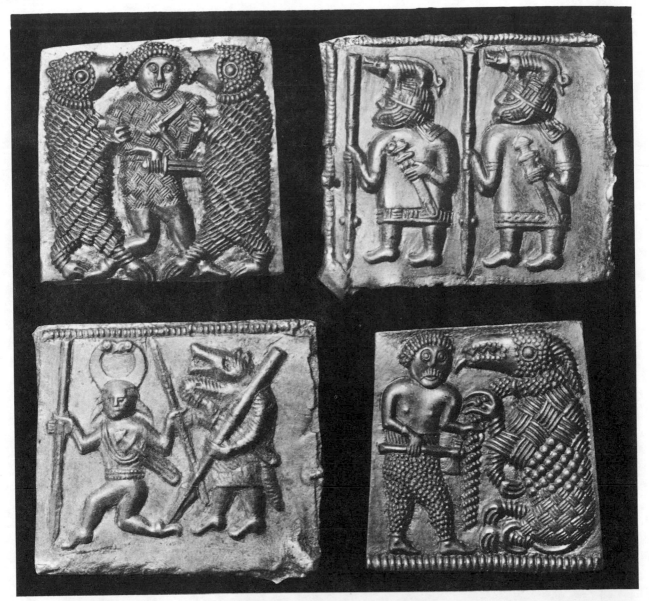

209–212. SCANDINAVIAN. Bronze matrices used for the decoration of special caskets. Vendel style. 7th century. *National Museum, Stockholm.*

213. VIKING. Viking head. Wood carving from Oseberg (Norway). About 850. *University Museum of Antiquities, Oslo.*

The indigenous style was submerged in popular art and disappeared in the acanthus volutes imported from the south.

The tombs reflected current beliefs, and their development varied in each country. The Norwegian tombs, from the third period, were the most remarkable: the royal tombs of the necropolis at Borr; the Rakmhang, which was the largest tomb in the whole of Europe; the Karm tumuli, near Haugesund and at Skien. The tomb chambers are sumptuously decorated.

The widespread custom of ship burial was started by the kings of Vestfold, who were the founders of a united Norway. The earliest known ship burials date from the 6th century. The tomb at Oseberg, in the district of Vestfold, was unearthed in 1904. In it were preserved both everyday things and works of the decorative arts.

Josèphe Jacquiot

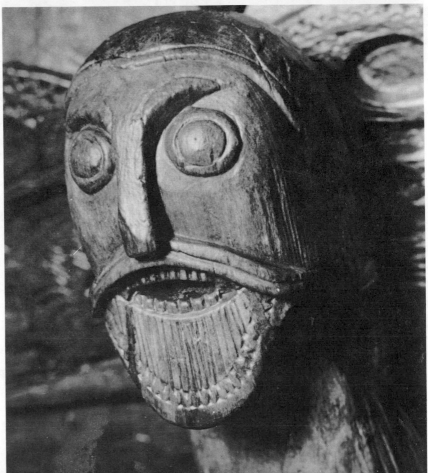

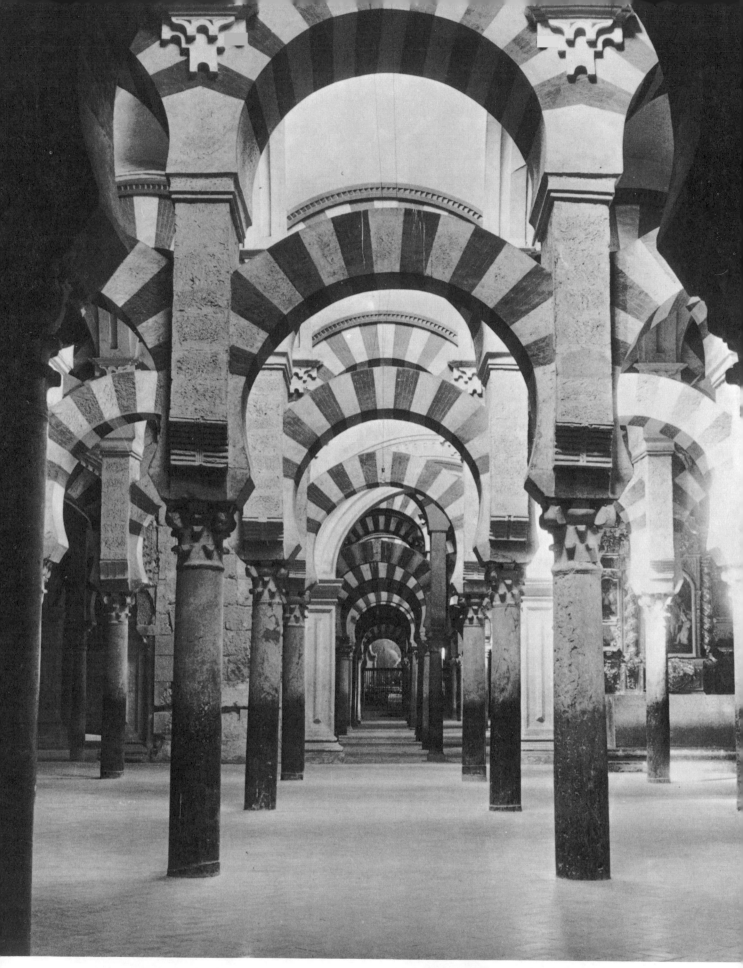

214. **MOHAMMEDAN.** Interior of the mosque at Cordova. Built in the Spanish capital of the Umayyads, this mosque was begun by Abd ar Rahman I in 756. It was enlarged in the three following reigns, during a period of more than two hundred years.

ISLAM AND MOHAMMEDAN ART

Gaston Wiet

Western Europe had barely recovered from the assaults of the barbarians in the north when a new menace appeared in the south. With irresistible force, the Arabs quickly forged an immense empire out of the empires that had preceded theirs. Persia and Byzantium were their principal victims, and soon they invaded Europe by way of Spain. In the art which they elaborated they seemed to unite, from the whole cultural heritage of the Near East, all the elements most opposed to the Graeco-Roman traditions.

Islam has been described as the greatest unifying power that has ever existed. Mohammedan art, then, may be considered as the whole ensemble of art produced in those countries which were subject to the law of Islam and ruled by Mohammedan princes. To this should be added the Spanish Mudejar art following the reconquest and the art of the Norman princes in Sicily. In both cases the Mohammedan traditions were maintained.

Naturally, in this immense area of the Mohammedan world, each region presented well defined characteristics, and national tendencies may be distinguished. Although it is certainly true that Islam dictated the plan of religious buildings, the monarchies created the visual language. This language was that of a court art dedicated to the glory of the sovereign, and was the visible sign of the capital which was the seat of the ruler. Political developments must also be considered. Some facts stand out—the introduction of the religious college, or madrasa, by the initiative of the Seljuks; the spiritual impact of Spain on the Berber tribes who defended the territory against the onslaughts of the Christians; and finally, the conquest of the Mediterranean area by the Ottomans.

The migration of artists is yet another factor to be reckoned with. Artists and craftsmen may have been attracted by high rates of pay or by the command or prestige of the sultans, as for example the Hafsids who surrounded themselves with Andalusians. Others may have been brought back as captives after an invasion, as was the case under Tamerlane, and also after the Ottoman victory over Persia.

Islam's retention of local traditions

The Arab conquest brought a religious creed and a way of life, but the ambition of the first statesmen was to govern. Everything else was subsidiary; the prefects of the caliphates allowed the national languages and administrative methods to continue. In Egypt, for example, we learn from a large collection of papyri that all the officials were Christian during the first hundred years. At the same time no efforts were made to increase the number of converts. This is proved by the fact that the first buildings consecrated to Mohammed were found in practice to be too small, even in Arabia. While numerous fire temples continued to exist in Persia, many districts still had no mosque as late as the middle of the 10th century.

In the Mediterranean area, the task of the victors was made easier by the hatred felt by the native populations towards the Byzantine overlords. The Arabs were so discreet in their demands that the vanquished peoples even had an illusion of liberty. Changes were introduced very gradually. The Arabs were not interested in setting up new methods. Their skill lay in giving the native populations full responsibility for everyday affairs.

With wonderful flexibility the conquerors respected local customs. Many lands were only Arab and Mohammedan in their exterior and official aspect. Islam brought a new way of life, with its own ritual, but lacking aesthetic tradition. Arabia had been inhabited by pagan tribes and their rudimentary religion had never consolidated its many gods. The primitive Arabs worshipped trees and especially stones of the most varied forms—random boulders, rocks, stelae and obelisks. There is no description of any idol made in man's image.

Little by little, the Mohammedan masters adopted the luxurious ways of the Byzantines and Iranians. It is to Muawiya, at that time sole governor of Syria, that Arab writers attribute the taste for Byzantine magnificence, and for the reason that he himself gave: 'We are at the frontier and I desire to rival the enemy in martial pomp, so that he may be witness to the prestige of Islam.' The caliphal courts at Damascus, then at Baghdad, drew from Byzantium and Sassanian Persia their love for luxurious dress, golden vessels, sumptuous festivals and royal display. It would be misrepresenting the facts of history to say that the first centuries of Islamic art were lacking in individuality; it would be evading the problem. The introduction of Islam was both a rupture and a continuation. In the realm of art there was an act of the will, or at least a disinterested conception, rather than any sort of parasitism. The perspicacity of the new masters consisted in changing nothing. In the art of the newly dominated countries they deliberately continued the old forms. The Umayyad and Abbasid caliphs called upon the services of Byzantine and Iranian artists, who continued to draw inspiration from well tried forms. The Mohammedans exploited Byzantine methods, but were happy to leave the religion alone. This explains in part why the organisation of techniques and crafts scarcely underwent any change.

If the first steps of the art of the Mohammedan era never faltered, it was because this art drew its inspiration from the traditional ways of expression. Among the peoples affected by Islamic doctrine, regional customs were covered as though by a veil by the new pervasive spirit. For over a hundred years the earlier arts survived and flourished so well that there was no trace of hesitation throughout the dawn of Mohammedan art. Daniel Schlumberger makes the point very clearly: 'The Umayyad baths seem to be the fruit of a civilisation whose art is ancient, but whose way of life is new.' Georges Marçais also comments: 'The art of the Aghlabid monuments appears for the most part as a prolongation of Christian art. The first Arab work in the West, the great mosque of Kairouan in Tunisia, ranks as one of the most beautiful creations of Islam. It fills us with wonder, but does not disconcert us. This is because we sense that it

215. MOHAMMEDAN. Wood carving. Umayyad period (Egypt). Beginning of the 8th century. *Arab Museum, Cairo.*

is impregnated with many traditions which are also our own. Somewhat Roman in feeling, or perhaps Romanesque, it is closer to us than any similar Mohammedan building later in date and more highly developed.'

Various wood carvings from Egypt show that it is difficult to distinguish between the 6th and 7th centuries, for they are decorated with the same Hellenistic or Sassanian motifs. There is a large panel in the Arab Museum, Cairo, with decoration arranged in almost square compartments. In three of these the ornament consists of balls framed between wing-shaped leaves which stand out against vine leaves. Alternating with these areas are others, which are filled by a cinquefoil arch which frames a slender tree, and on either side of this are palmettes growing from stalks arranged geometrically. Had it not been for two lines in Kufic, this apparently Sassanian panel would never have been ascribed to the beginning of the 8th century.

Similarly, it is not possible to be precise about the date of faience pottery excavated at Susa. It is enough to remember the learned discussions on the dating of the palace of Mshatta, when varying opinions placed it anywhere between A.D. 600 and 750.

And it is necessary to mention the recent discoveries at Qasr el Haïr. On the one hand there is a painted medallion bearing a fabulous beast in the most beautiful Sassanian style; on the other hand one finds frescoes which bear an undeniable relationship to the mosaics of the 4th and 5th centuries found at Antioch. According to Daniel Schlumberger, the archaeologist in charge of these excavations, the decoration of this palace is no more than a distorted reflection of past styles. He writes: 'The early art of Islam is an art of adaptation. It uses old forms in new ways. It transfers forms conceived in one material into another material, from one artistic domain to another. Using architectural forms, decorative themes and technical devices from various sources, it juxtaposes them all in the same construction. The explanation of this eclecticism is quite clear: it is that religion was made to serve the state.' So it is understandable that the dating of some pieces is vague, and may span nearly three centuries.

The adaptation of earlier cultures

Instead of destroying the earlier cultures, the Arabs adapted and made the most of them. The new converts little by little became incorporated into the spirit of

Islam. The same thing happened to religious art. Without diminishing the practical value of using again antique and Christian columns and capitals, one can imagine a sort of triumph for the glory of Islam in employing for their own ends the vestiges of abolished, or merely tolerated, religious cults. In any case, the first mosques founded by the Umayyad caliphs illustrate this fact. The mosaics of Kubbet es-Sakhrah (Dome of the Rock, Jerusalem) and of the Great Mosque at Damascus represent a Mohammedan selection from Byzantine and Sassanian forms. It should not be thought that images were forbidden; there was simply no call for them in the Mohammedan mosque. At Jerusalem there were magnificent floral decorations. An Arab geographer of the Middle Ages went into rhapsodies over the mosaics at Damascus: 'Trees, buildings and the inscriptions are of extreme beauty and finesse. Technically they are perfect. There can scarcely exist a species of tree or a known town which is not reproduced on these walls.'

It is not really accurate to speak of Byzantine influence. The artists who were commissioned to decorate the mosques were in fact Syrian specialists, who had been brought up on the art of Byzantium. The same problem occurs when one considers the Umayyad caliph of Cordova sending for craftsmen to come from Constantinople to work on the mosaics. Those who have examined them closely 'have not found in the execution, nor in the methods and materials used, nor in the arrangement of the more important designs, any difference between these mosaics and those at Ravenna, Venice and Monte Cassino.'

There is plenty of evidence of the persistence of the glories of the antique world. It was only after two centuries that the various elements began to merge and mingle sufficiently to form a cohesive aesthetic stream dominated by the spirit of Islam. Almost indiscernibly, there was born a special sensibility and a purpose that were new in the history of the world. So one may easily understand how it was that, with the inborn sense of abstraction and stylisation, the Mohammedan genius was successful in combining motifs it had not been necessary to invent. The force of this development varied according to the wealth and power of each succeeding dynasty. In order to achieve their imperialist ambitions, and art was included in these, the first caliphs turned their eyes to-

PERSIAN. Shapur surprising a Chinese woman at a well. Page from a copy of Firdousi's *Book of Kings.* 1341. *Fogg Art Museum, Cambridge. Museum photograph.*

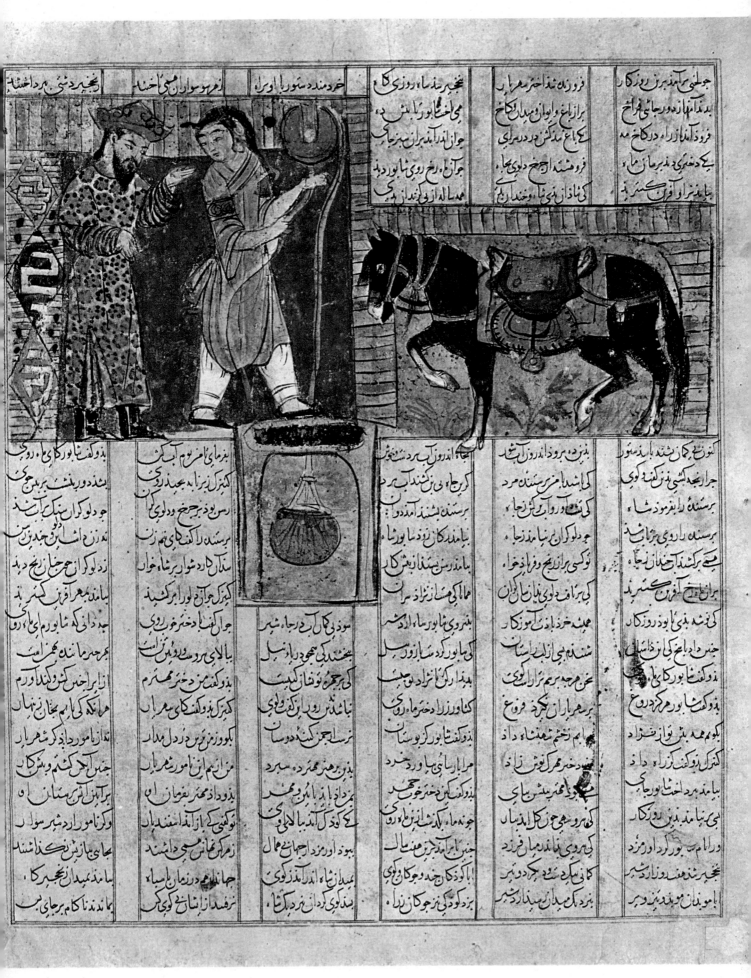

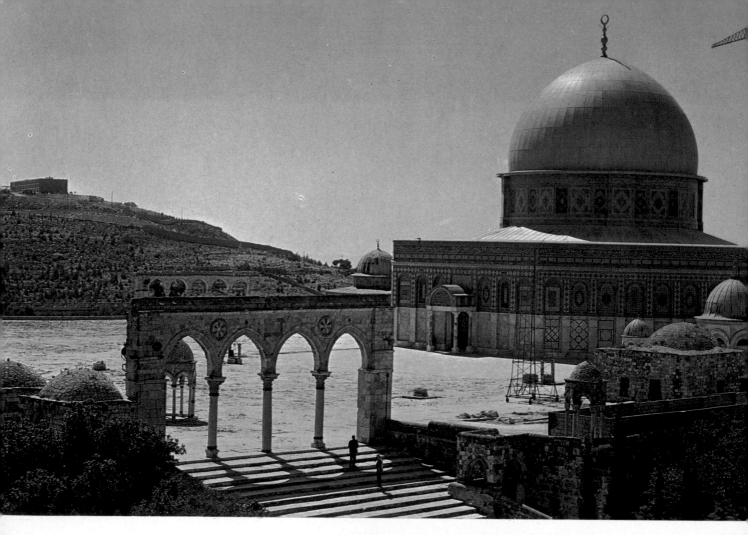

ISLAMIC. The Dome of the Rock,
Jerusalem. Late 7th century. *Photo:
J. E. Dayton*.

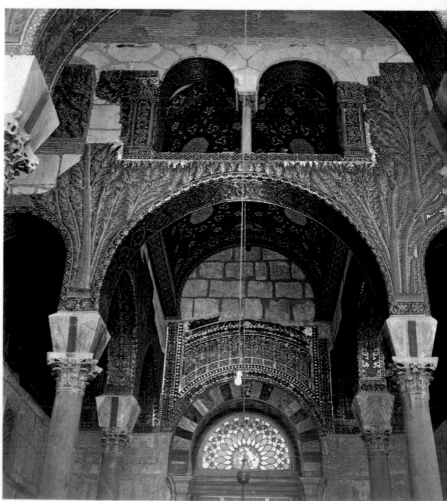

ISLAMIC. Interior of the Great
Mosque, Damascus. 7th century.
Photo: Picturepoint.

wards Byzantium and Iran. It is not surprising, then, that Mohammedan art in its early days was, with some re-adjustments, a reflection of Byzantine and Sassanian art. By this refocussing, Islam channelled decorative talents which might have followed quite a different line of development. The Mohammedans impregnated their works of art with the spirit of Islam. They found new combinations for old formulas, and they juggled with forms and proportions, always becoming more and more skilful and complicated, yet without ever ceasing to be harmonious. It is, then, quite correct to include this phase in the generic name 'Mohammedan art', since the whole movement took place within what is known as Islamic civilisation, made up of the ensemble of techniques, institutions and beliefs common to all the faithful of Islam.

From the Sassanians, the Mohammedans inherited a sense of proportion and a taste for nobility of design. From Byzantium, they drew the unrestrained exuberance of decoration and a love for sumptuous materials. At this period, ancient Arab poetry based its canons of beauty for the human countenance on the faces in the icons, or even on the images stamped on the gold coins of Heraclius. The tide of events delayed the birth of the new ideal and the change was slow in coming.

It is possible to see a similar, though later, development in reverse. The art of the Norman princes in Sicily was none other than a prolongation of Fatimid art; Mudejar art in Spain was a continuation of Spanish Mohammedan art. Finally, the Venetians perpetuated Oriental traditions of bookbinding and metalwork, but in an Italianised form.

The introduction of the Arab alphabet as a decorative element into Islamic art gave this art its characteristic stamp. At the beginning, the religious significance was to consecrate to God the buildings in which homage was given to Him, and also, with a wider gesture, to dedicate to Him all that constituted the beauty of life. The Arabic script lends itself, like the interlace and scroll, to the foundation of graceful patterns. One is charmed and beguiled by the sheer elegance of the characters, without having to make the intellectual effort or to have the knowledge to decipher their meaning. With great brilliance the calligraphers struck the happy balance between inflected curves and sturdy uprights. A dish from Turkestan (formerly in the collection of Alphonse Kahn and now in the Louvre) demonstrates this admirably: the exquisite characters which decorate the fillet (the raised border of the plate) are of an unequalled nobility.

Doctrine concerning images

The appearance of Arabic inscriptions was probably more spontaneous than considered. The Islamic community found itself obliged to analyse its own attitude towards this whole question.

Mohammedan doctrine came to forbid images, that is to say, the representation of any living being, human or animal. It is of the greatest importance to note that the Koran is silent on the subject, and the hair-splitting casuists, to support their prohibitions, never dreamed of quoting from the Koran a verse that is sometimes put forward. This verse only gives a ruling rejecting altars prepared for sacrifices. In other words, and it was quite natural, the writings of the Koran forbade any return to the old Arab paganism.

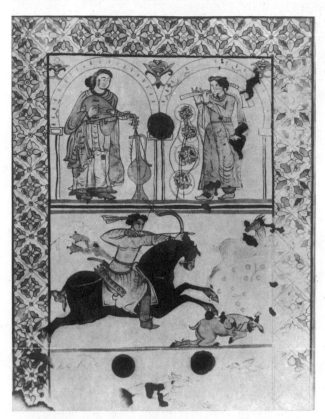

216. MOHAMMEDAN. Fresco discovered in 1936 in the castle of Qasr el Hair, in Palmyra. Umayyad period (Syria). 8th century. *Syrian National Museum, Damascus.*

The learned doctors, Sunnites as well as Shi'ites, founded their intransigent attitude on the sayings of Mohammed himself. His statement was that painters would undergo the most cruel of infernal punishments for daring to imitate and equal the creative act of the Almighty. It is probable that the Mohammedans were tempted to clarify their position rather late, under the Abbasid dynasty, just at the time when the discourses of the Prophet were being committed to writing. The only earlier solid historical fact was a decree of the Umayyad caliph Yazid II, promulgated in 722. This preceded by four years the first iconoclast edict of Leo III the Isaurian, and this synchronisation of events suggests that they were essentially measures following popular opinion in well determined Asiatic provinces. While considering the Umayyad caliphate, it is interesting to call to mind the fact that Hisham, a successor of Yazid, had a castle built for himself near Palmyra, which was ornamented with statues and low reliefs and decorated with frescoes.

The iconoclast tendency was not then an exclusive characteristic of Islam. In Syria, human representations had declined and realism in animal art had disappeared before the rise of iconoclasm. This problem has been very clearly put by Georges Contenau: 'A matter of religion, it is said: very good. But no religion would have considered similar restrictions in a country such as Greece, which was in love with form. In Assyria, Palestine and those territories of Islam where Jewish influence was strong, the ground was ready. Indeed, in Persia, an Indo-Iranian country, the prohibition did not meet with success.' It is interesting to find that Asterius of Amasia, a bishop of the same Asiatic district, should complain as early as the 4th century of the luxury of textiles covered with flowers and displaying images of lions, panthers, bears, bulls, dogs, 'in a word, everything that the work of the painter was able to produce in imitation of nature'.

113

217. MOHAMMEDAN. Detail from a mosaic with floral
decoration, from the Kubbet es-Sakhrah. Umayyad period
(Jerusalem). 7th century.

At this stage in the discussion, it is suitable to refer to
a text recently published, written by Abu Ali Farisi,
a celebrated Arab author from Persia who lived in the
10th century. He wrote: 'Whosoever fashions a calf,
whether it be in precious metal, or in wood, or made in
any manner whatsoever, he shall incur neither the wrath
of God nor the rebuke of Mohammedans.' If one objects
on the grounds that the tradition hinges on the utterance
of the Prophet that 'the makers of images will be chas-
tised on the Day of Judgment' and that, in some versions,
this is related to another saying, 'It will be said to them:
Give life now to those you have created,' then they will
be answered that the phrase 'the makers of images will
be chastised' refers to those who represent God in a cor-
poreal form. Any additions to this were individual as-
sertions and were not necessarily true. Moreover the con-
sensus of opinion among the ulemas (Mohammedan
divines) was not divided on this question.

This liberal thesis was not universally accepted. In fol-
lowing the Arab texts we may imagine that the doc-
trinaires were of two types. Firstly, the ascetic philoso-
phers stuck grimly to their uncompromising attitude,
which showed how much they shut themselves off from
life. Of course they forbade images, but they went much
further and sought to exclude such things as gilded ceilings
and cushions with flowered embroideries, and they would
have liked to decree that copyists should refrain from
transcribing stories, and even that singing should not be
allowed.

Secondly, there were those who might be called 'doc-
trinaires of action', like Savonarolas on a small scale. They
initiated movements against what they considered to be
the scandal of luxury. Their energetic protests occurred
at times of economic crisis, military reversal and social
disorder, when the sumptuous glitter of the courts con-
trasted painfully with the surrounding misery. They
argued that it was wrong for the wealth of a country to
be used, at one and the same time, to pay for the expenses

of war and also to meet the extravagant tastes of princes.
During times of peace and prosperity these doctrinaires
said nothing, or even approved. No one, as far as we
know, dreamed of protesting against the human repre-
sentations which ornamented the tent of Saif ud-Daula.
The poet Montanabbi sang their description: one of the
scenes represented was the Byzantine Emperor rendering
homage to the Hamdamid prince, champion of the war
against the infidel.

Men of letters were never hostile to the figurative arts.
As early as the 11th century one of them had compiled
a *Dictionary of Celebrated Painters*. The attitude of the
distinguished author, Ibn Khaldun, was equally clear. He
shows that the use of images was repugnant largely for
background reasons. 'The Mohammedans of Andalusia,
as a result of their relations with the Christians of Galicia,
resemble them in their style of dress and adornment. They
have adopted many other customs too, even going so far
as to decorate the walls of their houses and palaces with
pictures. With these facts before one, it is impossible for
any intelligent person to doubt the extent of their servi-
tude.'

The walls of a mosque were neither intended to il-
lustrate metaphysical concepts nor to set forth in a visual
way a commentary on a dogma. In this respect, the
Mohammedan community did not find itself in the same
position as the Christian Church. The latter, following
the guidance of St Gregory the Great, employed painters
'in order that the illiterate, looking at the walls, may read
what they are unable to read in books'. Islamic dogma is
clear and simple. Its precepts are formulated with preci-
sion, which makes them easy to understand.

It is true, however, that the Mohammedans have
venerated saints, even though their doctrine repudiates
the practice. It has been said that this was 'the veil beneath
which vestiges of vanquished religions perpetuated them-
selves under the rule of Islam'. It is interesting to note, in
view of the large number of sanctuaries dedicated to the
family of the Prophet, that this was originally a special
form of Iranian patriotism flouting the Arabian rules. It
was of little importance; the cult of saints existed, but it
never entered the head of any Mohammedan to com-
memorate them otherwise than by a simple cenotaph,
generally of white wood and covered with any cheap
material.

Thus the religious buildings have no illustrations, and
Islam has no devotional images. It was essential to avoid
the danger of idolatry under any pretext whatever. The
theologians brought to bear the full weight of their
austere feelings on the subject of the decoration of the
mosques. Nevertheless, as late as the 17th century in
Persia, there are scenes commemorating the martyrdom
of the son of Caliph Ali, painted in fresco on the walls of
a sanctuary in Isfahan, to say nothing of the miniatures
relating the outstanding events in the life of Mohammed.

Secular art and the human figure

In a visit to the Islamic section of a museum, or in reading
a book on Mohammedan art, it is impossible not to be
struck by the large numbers of representations of figures
and animals, and it is imperative to establish their relation-
ship. It is dangerous to consider Mohammedan art as a
single block, and to think of images as exceptions. These
were increasing in number every day. It is essential to
distinguish sacred from secular art, to separate the decora-

114

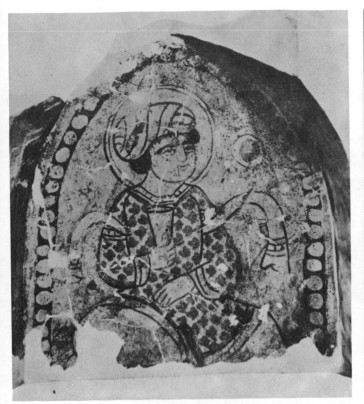

218. MOHAMMEDAN. Fragment of a fresco discovered in Old Cairo. Fatimid period (Egypt). 10th–11th centuries. *Arab Museum, Cairo.*

219. MOHAMMEDAN. Portrait of the Buyid ruler, Adud ad-Dawla. Gold medallion from Fars. Abbasid period (Persia). *Private collection, Teheran.*

tion of buildings consecrated for worship from the enrichments of daily life.

It is time we stopped thinking that figurative representations held an insignificant place in the art of Mohammedan peoples. At all times and in nearly all regions, one finds human beings and animals of many kinds depicted on all sorts of materials. This is not the only case where there is a wide divergence between theory and practice. And if one turns from fine art to popular art, one finds, among the lower classes as among the aristocracy, no taboo against the use of images. In spite of all the fulminations of puritanical philosophers, the custom of making sugar dolls as part of the celebrations on Mohammed's birthday continues even to this day in some countries. So, in secular art, there is to be found an almost universal taste for figurative representation. The Berber tribes were perhaps an exception; at a fairly recent date they were no longer under Andalusian influence, and became set in their ways.

For the moment, we leave aside the miniatures, which by their nature demand figures. From the earliest days of Islam, people and animals were represented in the frescoes on the walls of the Umayyad castles. Among these were Kuseir Amra and Qasr el Haïr. These recalled the Sassanid palaces of Ctesiphon, and also those of their Lakhmid protégés, at Khawarnaq in Mesopotamia. There is also documentary evidence relating to mural paintings in the first periods of Islam—at Medina as early as the 7th century, at Basra in the following century, and in the 11th century in Egypt and at Ghazna. We see, then, that fresco painting was not neglected by the artists of the Mohammedan empire. They preserved the tradition which derived from earlier civilisations. The caliphs decorated their palaces at Baghdad and Samarra with mural paintings. In Baghdad a later caliph, moved by a spirit of piety, had them effaced, but in Samarra the excavations have yielded sufficient information. In the throne room of the caliph's palace at Cairo were painted frescoes of hunting scenes and galloping horsemen.

There is an important document ascribed to Maqrisi in Cairo. He noted in the 11th century the presence in the Egyptian capital of painters who had come from Basra and who had been students in Egypt. Their work amazed their contemporaries, who were fascinated by the sheer technical skill with which they evoked the illusion of solidity and depth. The portraits of celebrated poets were painted in a tower in Old Cairo; they were commissioned by a Fatimid caliph. Frescoes painted in certain churches during the 11th and 12th centuries show that this school of painters was of some duration in Egypt.

These facts are sufficient for us to appreciate the importance of the frescoes discovered at Old Cairo, which are masterpieces of the Fatimid period and to this day arouse our enthusiasm. There is a complete figure measuring two feet in height. The subject is a young man, seated 218 with his legs folded under him. A red circle is drawn around his head, which is shown in three-quarter view facing to the right. The eyes have a faraway look and give his face a candid air of innocence and freshness, accentuated further by the soft plumpness of his cheeks. It may be that the painter wanted to show the sitter's importance, but it is more likely that the nimbus was placed there in order to emphasise the face. The beardless youth is wearing a dress decorated with red flowers. The ends of a stole billow out from under each armpit, recalling the Sassanian fashion.

There is no need to dwell on the paintings either of the palatine chapel or in the Alhambra palace. In Persia, Father Raphael du Mans reported having seen rooms 'painted in arabesques with birds, beasts and men, in two shades of blue; several were also gilded with gold leaf.' Later, Pietro della Valle described the mural paintings in the royal palace of Isfahan. One of these was 'the portrait of the King, represented in the middle of a troupe of

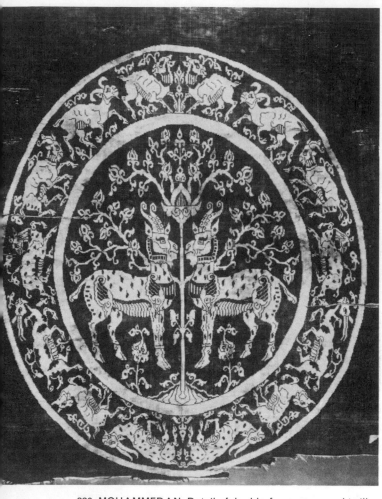

220. MOHAMMEDAN. Detail of double-face compound twill weave textile showing a procession of ibexes. Buyid period (Persia). 998. *Cleveland Museum of Art.*

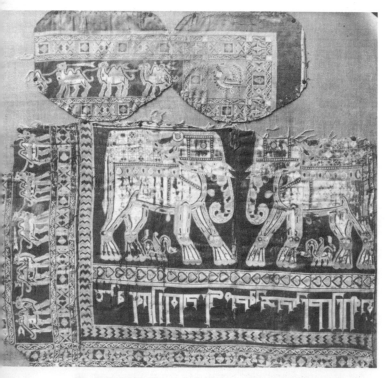

221. MOHAMMEDAN. Detail of elephant silk. Abbasid period (Persia). Second half of the 10th century. From the church of St Josse (Pas-de-Calais). *Louvre.*

young maidens, who sing and who play lightly on several instruments.'

The caliphs and princes had no qualms about having their likenesses portrayed on the coins of the realm. It is said that the first Umayyad caliph, Muawiya, was thus portrayed. Coins survive with the heads of three Abbasid caliphs, of the Ortokid princes of Mesopotamia, and even of Saladin. There is also a gold commemorative medallion on which is cut the bust of the Buyid ruler, Adud ad-Dawla. The hair style follows the Sassanian fashion.

In everything to do with works of art, the profusion of images is such that we may wonder if the sumptuous textiles, the iridescent ceramics and the voluptuous miniatures were not intended to set off the austere spirituality of the mosque.

Egyptian textiles were decorated with figures and animals in a vigorous style. At times the violent contrast of colours seems to echo the deeply undercut wood carving characteristic of the period. Motifs included tresses, twisted cords and spirals, treated with robustness and vigour and sometimes framing arabesques of birds or beasts not without a certain brutality of expression. These artists aimed not at grace, but at strength, and their textiles do reveal great strength and nobility. It is impossible to forget their austere grandeur and extreme clarity. This tendency of the Tulunid artists made them see things, to a certain extent, larger than life.

The Fatimid weavers had an entirely different style. They were exquisite miniaturists who drew their animals with a delicate and slender line, silhouetting their subjects, which appear to have no weight. Their themes included processions of little stylised birds and playful hares. Hundreds of examples have been found by archaeologists. There are far fewer pieces, however, to represent the following centuries, but a number of Mamluk textiles show that the earlier motifs continued to be used— groups of confronted birds, leopards, cheetahs and tigers chasing gazelles. There was, though, a tendency towards heraldic treatment.

One textile is inscribed with the name of Hisham II, the Umayyad caliph of Cordova. It represents animals and human busts surrounded by medallions, and follows the arrangement of the Fatimid textiles. The artistic value of Spanish silks is too well known to need emphasising. Their motifs consisted of wheels touching one another, and framed within these were the usual confronted birds or fighting animals. These were the ancient Sassanian themes which were transmitted from the East to European workshops, where they remained popular for a long time, not only in Spain, but also in Italy and at Regensburg.

Originality and importance of Iran

Persian Mohammedan art, including that of Mesopotamia, brings to mind a sense of exquisite perfection. It has far more boldness than that of Syria or Egypt and gains by its delicate clarity. All the artists, and especially the painters, drew much of their inspiration from the history of their own country, including the events which took place before Islamic times. This continuous use of the old formulas is a poignant aspect of their longing for independence.

One is attracted by the originality of the Iranians, all the more marked as the influence of Persia is shown also in other fields. It is important to bear in mind the extreme distances over which influences operated. Spanish ivories

219

can only be explained by reference to Mesopotamia; the mosque of Kairouan is decorated with faience tiles brought from Baghdad; and the prince Ibn Tulun spread the knowledge of Baghdad art to Egypt. In fact, it is impossible to arrive at a balanced knowledge of the artistic development of the other Mohammedan countries unless one studies the art of Iran. Islamists are not particularly astonished by this, as they know the important part played by Persian grammarians, historians, scholars and story-tellers in Arabic literature.

The general superiority of Persia, together with her geographical position, shielded her from counter-influences from the Islamic West. There were a few exceptions: some of the craftsmen from Mosul, after their town had fallen to the Mongols, fled to Persia. Their traditions are apparent in the Persian brasses of the 14th century. On the other hand, from the earliest times the Persians had greatly admired China. As a result of the Mongol invasions, Persia was strongly influenced by the Far East, a tendency that was to recur again and again, notably in carpets and miniatures.

Objects of immense historical value had been coming from Persia for a quarter of a century. One of the most gorgeous is the elephant silk in the Louvre, dating from the 10th century. This must be more or less contemporary with a considerable collection of perfectly preserved and fairly large fragments of silk fabrics. This was the phase that has been called the 'First Iranian Renaissance'. It is an art that was not unworthy of the genius of the national poet of Persia, Firdousi. Whether one considers the technical skill or the variety of motifs, mostly taken from the Sassanians, these silk fabrics bear witness to a supreme mastery. These painters, of outstanding skill, were endowed with much original talent. As they were working for princes, and for an aristocracy that had become conscious of its solidarity, the artists recast the old iconography, and with astonishing brilliance. It became minutely detailed, and this enhanced its decorative value.

The studios employed specialists whose subtlety was equal to rendering theatrically the forms of a great variety of animals, with careful observation of their natural stances and movements. This can be seen in the border decorated with ibexes drawn in a variety of attitudes as they bound along. Free of all restraint, they prance with an agility that makes the procession seem unending. This pastoral work is gay and full of verve. Another example shows a haloed figure, sitting on a throne as in a parade scene; he holds a falcon in each outstretched hand. He is a prince in all his majesty and this is reflected in his solemn bearing. The image is not really very animated, the features are regular and the gaze is fixed, but the face seems nevertheless to mirror the mood of the sitter. The satins and carpets of Safavid Persia abound in scenes of the chase and of people walking in flowered gardens. It was the reign of a languid and voluptuous grace.

One may object that these precious textiles were made only for princes, or at least for a very wealthy clientèle. In the Middle Ages, they must have been a most valuable, portable and easily disposable form of capital. So, through these works, it is only possible to see one aspect of Mohammedan art, an aspect restricted to the aristocracy. In the case of ceramics, the position is entirely different. Out of the thousands of pieces that have survived, there are very few which bear the name of a sovereign. In addition there is the recent extraordinary find at Gurgan

222. MOHAMMEDAN. Dish from the series known as Gabri ware. Abbasid period (Persia). 10th–12th centuries.

of what appears to have been the stock in trade of a merchant. This treasure had been placed in great jars and buried in the earth, before the menace of the Mongol invasion at the beginning of the 13th century. This prodigious discovery is made up of a collection of hundreds of plates of great beauty.

Ceramics with human or animal figures

It is impossible to review fully such a vast subject as Mohammedan ceramics, which is still very controversial. Here, we restrict ourselves to one aspect—the success achieved in human and animal representations.

Although it does not simplify the problem, the lustre pottery found in excavations at Rhages, Samarra and Fostat must be mentioned. This pottery was glazed in yellowish gold and olive shades. The work from Fostat (Old Cairo) was influenced by Samarra under the Tulunids. Samarra was for a short time a caliph's residence to which the caliph summoned craftsmen from far and wide. It seems reasonable to assume that potters came there from Persia, but the pieces found at Samarra are more easily dated than placed. This production covers the period from the 8th to the 10th centuries. Any later date is improbable because the inscriptions are always in archaic Kufic characters. Representations of animals and human beings in a barbaric style may be seen on nearly all of these plates. The eyes are treated strangely: in the

223. MOHAMMEDAN. Plate from Rhages with eagles, scrolls and inscriptions. Abbasid period (Persia). 12th century. *Staatliche Museen, Berlin.*

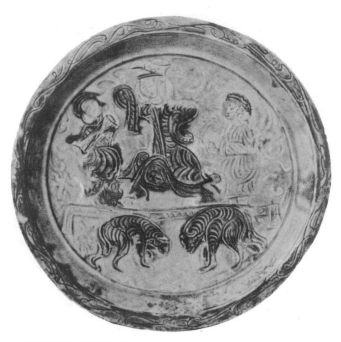

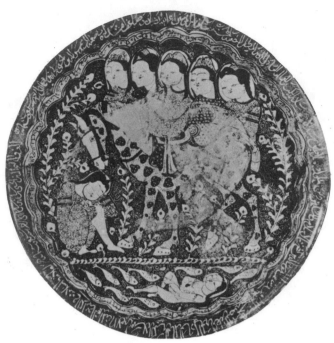

224. MOHAMMEDAN. Plate from Rhages with dancer. Abbasid period (Persia). 12th century. *Eumorfopoulos Collection.*

225. MOHAMMEDAN. Faience plate: Chirin bathing. Dated 1210. *Eumorfopoulos Collection.*

heads of animals the eye is shown by a black point in the centre of a white circle; human faces seem to wear spectacles owing to their broad almond-shaped or occasionally circular eyes.

222 In the series called Gabri ware, engraved decoration has been glazed with transparent enamel of a uniform green or brown tone. The themes are very characteristic. A prancing animal, full of life and sharply drawn, looms across the plate, the edges of which are decorated with floral scrolls.

Another group of Persian plates, whose decoration is engraved on a cream base, sets a more lofty tone. One, 223 in Berlin, shows an eagle in green, blue and aubergine. But already the painters are interested in genre scenes. On 224 a plate in the Eumorfopoulos Collection two musicians are seated on either side of a dancer who is performing on a stage; by the square head-dress and the long hanging sleeves we know that the dancer is Chinese; in front of the stage two hyenas feint at each other with angry snarls.

We must now consider the most characteristic types of Persian pottery. There are two techniques and both make full use of very lively decoration. Firstly there are the faiences in lustre with brown or golden-yellow backgrounds against which the scenes stand out in white (or very rarely they were incised). Secondly, there are bowls and plates decorated with many colours, principally blue, red and gold on a cream background, or black, red and gold on a background of turquoise. It is a sheer joy to contemplate these pieces, often exquisite in shape, with miniature people whose full rounded faces and gracious attitudes seem enchantingly naive. These works of art enable us to imagine a society in which life was sweet and unhampered by austerity. It is impossible to imagine that the restrictions of Islam had much effect either on the potters of Rhages and Kashan or on their clientèle. The Persian ceramists would certainly have produced their works even if the Arab conquest had not made them followers of Mohammed. They also encouraged the revival of Persian patriotism, for they sometimes illustrated themes from the *Book of Kings* by Firdousi.

What has been said of pottery applies to the square

faience tiles, too, and this may be demonstrated by comparing a plate and a tile. On the plate, the beautiful Shirin 225 bathes naked among fishes in a stream; a dappled horse fills the centre, and five spying heads appear from behind; Prince Chosroes, crouching by the head of his stallion, is deeply moved by the unexpected and delightful spectacle. On the turquoise faience tile is a reddish brown camel; on its back are a couple in brown and black robes flecked with gold; he draws a bow, and she, sitting cross-legged 226 behind him, is playing on a harp; this is an episode from the life of Bahram Gor, who is accompanied by his favourite, Azada. It should not be forgotten that in Persia the Khorremites, a sect without equivalent in any region of Islam, had a certain success. They were free-thinkers who opposed the severe puritanism of Islam; they wanted to preserve the right of indulging in the delights of the senses and linked themselves with the paganism of ancient Iran; they rejected all asceticism.

Some of the fantasies portrayed on ceramics are curious and humorous. On short pot-bellied vases are found handles in the shape of leopards that peer inside the pot. This idea was used by artists in ancient times. The necks of flasks were formed in the shape of cockerels' heads, or were arranged in lobes, decorated with masks, just like the jugs of more than a thousand years earlier that have been excavated at Tepe Sialk.

Fatimid art continued that of Persia, except that there was an increase in floral ornament and there were fewer genre scenes. Also the animal or figure, often painted by itself, covered the whole plate, or at least formed the centre and was surrounded by scrolls and interlaces. This was the heyday of ceramics glazed with metallic iridescence, shimmering with colour, that delighted a contemporary Persian traveller. The shape of the pieces always had a supple freedom. There were huge bulging vases and deep cups in the form of kraters. These were often painted with figures—dancers, musicians, drinkers and graceful girls. Like the wood carvers of the time, the painters were masters of their craft. Some of their frescoes still remain, and descriptions by contemporary writers survive. Look, for example, at the mandoline player who 227

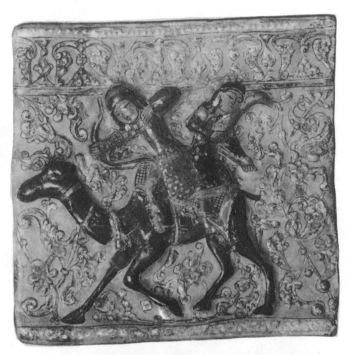

226. MOHAMMEDAN. Polychrome faience tile, representing King Bahram Gor drawing his bow, accompanied by Azada, his favourite. 13th century. *Arab Museum, Cairo.*

fits so perfectly into the shape of a plate; in order to take up less space he sits in a huddle, and the edge of the plate seems to have forced him to bend his head; his face is grave, with a melancholy and dreamy expression further enhanced by the shape of the mouth; he seems entranced by the melody escaping from his instrument as his fingers nonchalantly touch the strings.

In the 14th century 'Sultanabad' pottery made use of a background colour of blue or moleskin grey, decorated with broadly drawn foliage, and beasts with speckled coats are usually found standing out against this. These are skilful snapshots but are without expression. The gay floral decoration swirls ornamentally, but the principal merit of these pieces is in their colour. Eventually, the studios of Mamluk Egypt were to imitate this Sultanabad style, but they never equalled its colour, and the products were mediocre.

Mention must be made of the faiences from Daghestan and Kubatcha because, from the colour point of view, they appear to have been the origin of ceramics produced in Asia Minor. The tonality of the palette was quite unusual. The colour was soft and without any trace of crudity; it possessed a tender quality as though one were seeing it through a curtain of mist, or looking at a basket of fruit through muslin. These were like tentative essays, later to be taken up strongly in the Anatolian faiences. Many of these plates were decorated with leaves and sometimes with the heads and shoulders of youths and young maidens; their hair framed their handsome but sullen faces in its ringlets; and one thinks of a Persian poet who wrote: 'When my idol has rearranged the coils of her locks about her face, she has printed the mark of regret upon the hearts of Chinese painters.'

The forms of Safavid pottery show to what extent they were indebted to Chinese influence. This applies particularly to the long-necked bottles of lustred faience. The polychromed mural faiences, however, were more in harmony with the contemporary miniatures and with the spirit of the country. These large compositions mostly used colour schemes of white, blue and yellow. In these murals, sumptuous robes swathe tall and thin people like the elongated figures of Botticelli. The drawing is impeccable, the details are painted in with loving care for harmony and the colour is bright. These are indeed masterpieces of gentleness and precision.

Figure sculpture

Spanish textiles have already been mentioned, and it will now be seen that there were also talented sculptors in Spain. Henri Pérès has noted: 'The national poets have strikingly confirmed this by their frequent use of phrases describing sculpture and a miscellany of objects enriched with figurative designs.' Examples are the ivory caskets which were inscribed with the names of Umayyad princes, and two marble vessels of the 10th century. The spirit of the decoration has a Mesopotamian flavour, but they are also related to Fatimid wood carving in that the figure compositions recall court life.

These Fatimid caliphs lived in sumptuous luxury at Cairo, and the writers gave ecstatic descriptions of their palaces. A Persian traveller in the 11th century described the throne of the sovereign, with its three faces in gold, decorated with hunting scenes and riders galloping their horses. A hundred years later, it was the turn of William of Tyre to be amazed. The vast hall was partitioned by a large curtain of cloth-of-gold and silk of many colours, enriched with designs of beasts, birds and figures bedecked with rubies, emeralds and a thousand rich jewels.

The surviving panels of carved wood which come from these palaces are justly praised. They are the proof of a careful observation of visual truth. Divided into compartments, these scenes are juxtaposed in an original way —hunts, musical gatherings, dancing and drinking parties. The artists who imagined these scenes always maintained a delicate balance and an exact placing of the subject matter. Some medallions show groups of confronted beasts; a few of these are calm and stately, but most are full of vigorous movement. The general rhythm is regular, with the alternation of small multifoil medallions

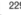

227. MOHAMMEDAN. Plate showing mandoline player. Fatimid period (Egypt). 11th–12th centuries. *Arab Museum, Cairo.*

228. MOHAMMEDAN. Plate with decorative inscription, from Samarkand, Turkestan. Abbasid period. 10th century. *Louvre*.

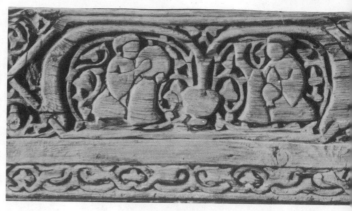

229. MOHAMMEDAN. Carved wood panel from a caliph's palace. Fatimid period (Egypt). 11th century. *Arab Museum, Cairo*.

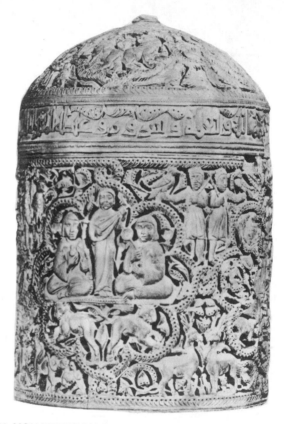

230. MOHAMMEDAN. Ivory jar bearing the name of El Mughirah, carved with figures and animals enclosed in polyfoil medallions. Andalusian school. 10th century. *Louvre*.

and extended hexagonal shapes. This layout is in keeping with the harmony of the figures that occur at regular intervals on either side of the central theme. The decoration is flat and on two planes; small figures, animals and birds stand out against scrolls and three-lobed leaves in lower relief. Each narrative scene is doubly isolated, by its frame and by the flanking animals. They are also charming in their variety. They probably represent collectively various incidents that would occur during a day in the life of the caliph.

These restrained panels are masterpieces of the art of the silhouette, and on these little figures drapery folds would be quite out of place. One cannot but admire the economy of means with which the sculptor has translated the steps of a lively dance. In one case, a girl gives herself up to the passion of her dance, to the point of frenzy; in another, a camel bends with its load while the driver, with his body tipped forward, shows by the spread of his legs that the camel is moving at a considerable pace.

The Ayyubid regime was founded by Saladin, and its spirit was quite opposed to the Fatimid way of life. The conqueror of Jerusalem was a man of war. He built colleges and fortresses, buildings in line with his religious conception of the state and the military defence of his kingdom. There is no surviving work of art from his reign. He sold the treasures of the Fatimid palaces. He was austere even to the point of never wearing silk robes. From all we know of his life, he was opposed to any form of display or luxury. Undoubtedly this attitude had repercussions, but one must not exaggerate the extent of its influence. It is useless to make comparisons between unlike examples. One cannot, for example, compare the delightful wood carvings of the Fatimid palaces with the splendid cenotaph which Saladin had built for the mausoleum of Shafii in Old Cairo. This work, bearing the artist's signature, is a masterpiece, with its small panels set in the most varied geometric forms; the fillings consist of fine floral decoration, with split stalks and veined leaves. Decoration with figures would have been quite unsuitable on this religious work.

The successors of Saladin, the Ayyubid rulers, were both liberal and eclectic in their aesthetic outlook. In their time, work in metal was especially important. A chandelier dated 1248 in the Musée des Arts Décoratifs, Paris, is decorated with medallions containing scenes from the life of Christ—the Adoration of the Magi, the Circumcision, the Baptism of Christ, and the Last Supper. On it there is only the signature of the artist, Dawoud ibn Salama, of Mosul; however, a bowl of the same period in the collection of the Duke of Arenberg is actually dedicated to the last Ayyubid sultan of Egypt, and this, too, portrays scenes from the Gospels—the Annunciation, the Virgin and Child, the Raising of Lazarus, Christ's Entry into Jerusalem and the Last Supper. These facts suggest that many artists of this splendid Mosul school were Chaldean Christians. The Ayyubid sultan encouraged the arts no matter what the religious contents. He modelled his views on a Mohammedan rhapsody on

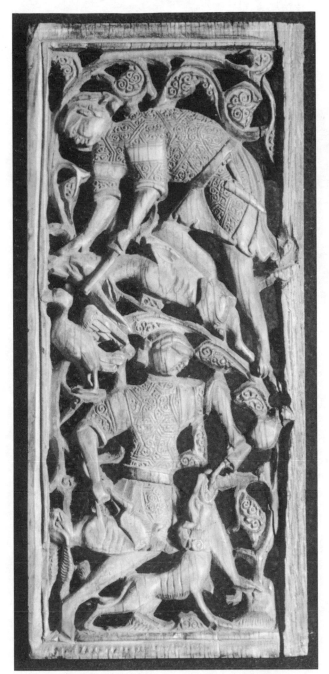

231. MOHAMMEDAN. Panel of a casket in pierced ivory: figures and animals among foliage. Fatimid period (Mesopotamia). 11th–12th centuries. *Bargello Museum, Florence.*

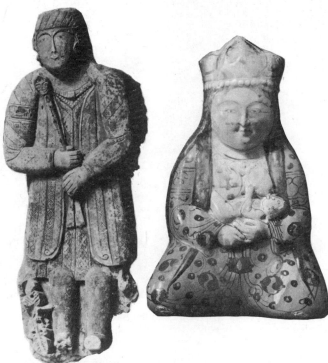

232. *Left.* MOHAMMEDAN. Figure in stucco from Rhages. Abbasid period (Persia). 12th–13th centuries. *Louvre.*

233. *Right.* MOHAMMEDAN. Ceramic figure from Rhages of a nursing mother. Abbasid period (Persia). 13th century. *Kaiser Friedrich Museum, Berlin.*

the subject of Akhtal: 'Do not talk to me of that man! he cried out, his verses have made me love Christianity.' Another great writer of the 10th century, who was a cadi or judge, affirmed that the poet remained great, even though he were atheist or libertine, provided that he possessed talent.

There is no need to consider the ducks and the friezes of fish engraved on Mamluk brassware. They seem like a sort of rhetorical duty lacking any conviction. The principal decoration consists of flowers in full bloom among delicate scrolls and geometric interlaces. They were designed in rectangular ribbons, sometimes with rounded angles, in circular and scalloped medallions. Briefly, it was an unoriginal, stereotyped ornamentation.

Statuary and the living model

It is necessary to consider one last aspect of the problem. The casuists had forbidden, above all, any images which cast a shadow, or in other words figure sculpture, which

is much closer to nature than is a line drawing. Various examples of statues in Mohammedan art, isolated though they are, prove that studios did exist for such work.

At the Umayyad castle of Qasr el Haïr several pieces of sculpture have been found—a bust of a woman in a medallion, young people carrying animals, a group including a prone figure with a seated woman beside it, and a large statue of a prince in Sassanian costume, who might be the caliph himself. A low relief found at Mahdia, now in the Bardo Museum, portrays a seated sovereign drinking and listening to a female musician; this may be ascribed to the Fatimid period. There is a large marble jar, dating from the 12th century and of Egyptian origin; four seated lions serve as feet; at each angle are two statuettes of women, their hands supporting their breasts, perhaps recalling unconsciously the Babylonian goddess or even the form of a statuette found in the excavations at Mari.

In Mohammedan Spain, at Cordova, a statue of the Virgin was allowed to remain over one of the doorways. This served as a model for a similar statue set up later over a doorway at Pechina. The Arab scholars who recorded these facts were not shocked by them, any more than they were when they related that the first Umayyad caliph had erected a statue of his favourite in the town of Medina az-Zahra. For the same city, the royal goldsmiths' workshops in Cordova received a commission to fashion twelve gold statues decorated with pearls, featuring a lion, a gazelle, an elephant, a dragon, a dove, a falcon, a peacock, a hen, a cock and a vulture.

On no account must the exquisite ceramic figurines of the Persian Middle Ages be omitted. There is the young mother nursing her baby; it has been suggested that this was a Madonna, intended for the Christians. In Western art the Virgin is shown looking tenderly at her Child, but here the mother's rounded puffy face has vacant eyes. Some bronze animals have also survived from this period

233

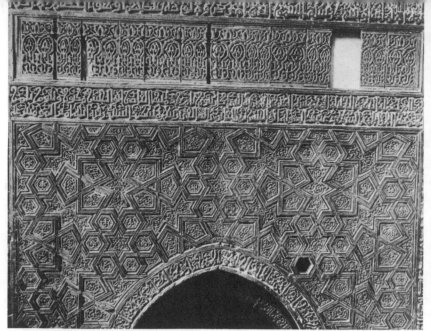

234. MOHAMMEDAN. Detail of the Saiyida Rokaiya mihrab. Fatimid period (Egypt). 1154–1160. *Arab Museum, Cairo.*

235. MOHAMMEDAN. Wood panel. Fatimid period (Egypt). 11th century. *Arab Museum, Cairo.*

of Persian art as well as from Egypt—stags, griffons, horses, hares and peacocks, not forgetting the huge griffon at Pisa, more than three feet high. These are the only remnants of the famous treasury of the Fatimid caliphs; the golden peacocks, gazelles and cockerels were certainly cast.

In upper Mesopotamia there are low reliefs of birds and of creatures belonging to the cat family, especially on doorways. The entrance of the Talisman Gate in Baghdad was decorated with such reliefs, and although these were destroyed in World War I, photography has made them familiar. They included a figure with a halo, richly dressed and wearing a diadem, who gripped with his outstretched hands the tongues of two winged dragons; their gaping jaws were threatening, and their tails were twisted into impressive knots.

Abstract design in decoration

The prohibition of images, even though theoretical, nevertheless influenced or underlined a certain trait in Mohammedan art. It caused artists to turn away from the copying of nature, and inclined them to emphasise geometric pattern. Their overflowing imagination was forced to obey a law of symmetry which dominated the natural curves of leaves and foliage. Their being forbidden to use the living model led to a whole system in which the draughtsman sought inspiration from within and no longer drew on the life around him. The Mohammedans cultivated a visionary art, and not an observed art. This gave rise to a heraldic or fantastic fauna, almost unrelated to anything in nature.

So the canon of beauty was developed uniformly from the same preferences. Realism gave way to stylisation. The patterns deriving from leaf and flower were intentionally deformed, and then became decoratively recombined in unfailing inventiveness. The floral scrolls degenerated into circles touching one another, containing one or more leaves pointed in carefully studied directions. Yet these infinitely delicate floral themes were always broad in conception and showed a quite remarkable nobility. Usually the Mohammedans were inspired by Byzantine subject matter—the acanthus, the vine and the vine branch.

There is a constant tension between the floral pattern

of harmonious curves which are continuous in movement and the stern geometrical patterns which are calm, even static, in feeling. This kind of ornamentation was not invented by Islam, but it was to be handled with unexpected results. With unremitting zest the Mohammedan artists searched for more and more exuberant and mysterious patterns, making use of unusual combinations and supplementary themes—interlaced bands or knots, spirals, wheels, zigzags and ribbons. The archivolts were decorated with serrated patterns, and niches were ribbed or fluted. There seems to have been, however, a preference for combinations based on the polygon. Polygons elaborated with extreme complexity were present everywhere, on walls, partitions, doorways, mihrabs (prayer niches), pulpits, on all the small objects, and in the illuminated designs of the Koran.

It seems that there was an irresistible urge for this form of decoration, as it was constant everywhere and throughout the dynastic changes. The Fatimid period made use of a variety of decorative motifs, which were carved in wood with great skill and were never again equalled. Pulpits in the mosques at Qus, in Upper Egypt, in Sinai, in the harem at Hebron and in the mihrab of Saiyida Rokaiya at Cairo are all worthy of admiration. The surfaces to be decorated were not continuous but presented a series of small panels of varied form. Each was carved lovingly, without consideration for the part it was to play in the ensemble. The squares, lozenges, trapeziums and star shapes are interlocked into one another, and could be arranged in different ways without upsetting the general effect. As one looks at them one may, according to one's fancy or the point on which one's eye happens to rest, combine forms from adjacent systems so as to make new patterns. In short, the groupings never create a synthesis. So, in order to enjoy them to the full, one must analyse the articulations and the most capricious meanderings to the point of becoming hypnotised into a quiet reverie.

It is, in fact, like a piece of orchestral music: first, the various instruments make themselves heard individually —the little compartments; then the theme is taken up by several of them together—as by new groups of patterns; and finally by the entire orchestra—as in the whole formation of a decorative panel. It is never finished; in

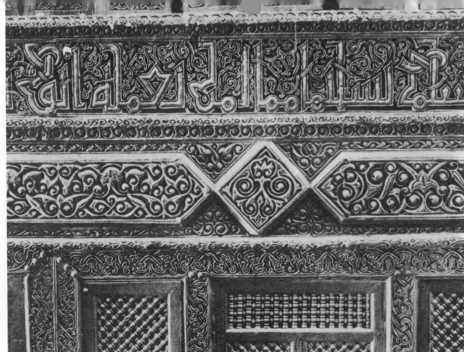

236. MOHAMMEDAN. Wood panel in the Umayyad style. 7th century. *Arab Museum, Cairo.*

237. MOHAMMEDAN. Maksurah from the great mosque at Kairouan (detail). This is undoubtedly one of the oldest known examples of a prayer enclosure reserved for the sovereign. Zeirid period (North Africa). 11th century.

the imagination we can see beyond the decorated surface the prolongation of this symphony. These works are fundamentally complicated. So, too, is Arab literature and music; one feels a need for long contemplation, to enjoy the modulations of an unending melody; often there is a harmonising from which springs a soft accompaniment, wanting to make itself heard. Such an air in Oriental music performs arabesques between the grave registers and the shrill impassioned ones, using accelerated scales and appoggiaturas. It stops suddenly, anywhere but on the tonic, and without any reason, judged by Western standards. In the same way, patterns will be cut abruptly, not because they have been resolved, but because they have reached the extremity of the panel. The imagination can extend song or pattern to infinity.

These orchestrations of pattern resemble the interminable stories which come suddenly to an end, as though the teller had become weary of the continuous repetition of adventures. It is easy to understand why some Arab writers so deeply admired the bees, which are so skilful in creating the hexagonal forms of the cells containing their honey, and the spiders who so cunningly contrive their star-shaped webs with concentric threads. Some patterns are impossible to analyse. These, like Arab poetry, should be appreciated for their music and their rhythm rather than for their substance; the syntax of this ornamentation which mingles the probable and the imaginary requires some preparation. In front of some arabesques, with their unrolling scrolls, one might think that Mohammedan art depended on the hazards of improvisation, while in reality the compass had never left the hand of the artist. It is a miracle of equilibrium and, in fact, the manifestation of a scientific precision: within the cadence of the star-shaped polygons, the artist remained a master of symmetry.

Such subtle ingenuity brought its own pitfalls: firstly, that of congestion, for Mohammedan art abhors a blank space. However, one could not delete anything from these compositions without spoiling the harmony of the pattern. Secondly, the countless repetitions and restatements of elaborate phrases seem to repeat the same ques-

tion. Again, it should be remembered that in Oriental music fatigue always comes before boredom. Finally, other dangers lay in wait for the mediocre craftsman, those of pedantry and finical affectation. As all artists were not geniuses, there were many mediocre ones: conscientious application can never replace real talent, and the work of these middling artists was like a series of copies made from a visual dictionary.

In order to appreciate the language of this art we must lay aside some of our preconceived aesthetic ideas. This is an abstract art based on plant symbols. It is always sincere and without deliberate mystification. The artists rarely observed the natural world, and seemed to notice the accidents rather than the underlying laws. Referring to this, Louis Massignon said that there were for them only 'processions of moments'.

Interaction of the real and the imaginary

This conclusion may be drawn: the Islamic artist describes his inner experiences far more than what takes place before his eyes. It may be argued that this defines the ideal of all great artists. The following examples will show how disconcerting to the Western mind is the intimate thought of the Oriental artist. There is a ceramic falcon with metallic iridescence, enriched with scrolls and oval and multifoil medallions which enclose tiny figures. In the Cairo Museum, a turquoise faience hoopoe has its breast ornamented with black foliage, and at the articulation of the wings there is a bird inscribed in a circle. Another graceful fantasy was popular at one time among the engravers on copper: they began to animate the inscriptions and to disguise the upright strokes as little people in various attitudes, rather like a set of charming marionettes. It was most certainly an art of visionaries.

The animal painters of Islam did not invent their monsters, griffons and winged quadrupeds. They adopted them from the Assyrian and Sassanian repertory, an adoption encouraged by their aversion to literal naturalism. Similarly, animal fights and hunting scenes were themes dear to ancient Iran. They were so rooted in their habits that a blind poet of the 8th century is said to have

123

commissioned a ceramic artist to create a hunting scene with a falcon. It is essential to note the sway of fashion: when a motif was in vogue, the artists repeated it to the point of satiety. It was the same with the theme of birds or hares nibbling a leaf.

Doubtless, many animals were decoratively treated, and were chosen for decorative reasons—the peacock, for instance, who attracted attention in order to 'have his new suit admired'. However, in the paintings as in the small bronzes, there is evidence of artists who have observed animals with a special understanding, full of humour and tenderness. There is the camel who half turns to caress her suckling calf. This scene was not original; one need only recall an Assyrian ivory from Arslan Tash. We read in a poem written before the period of Islam: 'Gracefully, the hinds glance over their shoulders, looking tenderly on their fawns.'

However, the Arab art critics had a sense of realism, as is proved in two anecdotes. The first is set in China: a man had drawn a bird perched on an ear of corn; the picture was thus judged: 'Everyone, without exception, will agree that an ear of corn must bend downwards if a sparrow perches on it; now, the artist has drawn the ear standing up stiffly and without drooping; he has drawn a sparrow perched thereon. This is a fault.' The second is even more significant: 'The Greeks, it is said, excel in

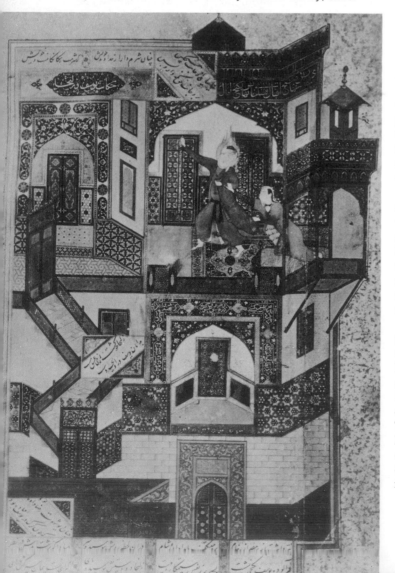

the figurative arts. They can represent the human figure without omitting the tiniest detail: they can represent the young, the adult, and the old, in quiet, amiable, gay or sad moods. They can even render successfully the most subtle forms of laughter: the sarcastic laugh, the hypocritical laugh, the hysterical laugh, the gay jovial laugh, and the crazy sniggering of the mad.'

The Oriental artists have rarely been affected by these criticisms. The theme of a bird perching on a stem was common, and nearly always the stem sticks up straight; moreover, if it should curve, it is probably intended for the general harmony rather than to obey any physical law. In Mohammedan art, visual accidents, or optical illusions, are corrected. A draughtsman would wilfully ignore refraction: he knows that a stick plunged into water remains, in fact, straight, even though in appearance it looks shortened and crooked.

It is true that in this art one does not find spontaneous inspiration, but this is not what one should expect; as in music, there is a quality of high nobility. Mohammedan art is never gauche, and it is always a direct manifestation of the will. The combination of animals and foliage, despite their suppleness, obeys mathematical laws and leaves nothing to chance. The artists display a complete grasp of rhythm, of tonality and of counterpoint. They arrange nature according to their vision, giving stems and leaves regular undulations, always with an eye on the circle or the spiral. It is a symphony of pattern with botanical variations, a transposition far removed from nature.

For decorative reasons also, enormous beasts, such as, for example, the elephant, were no longer made to seem dangerous. Scenes of animal fights, deriving from the Sassanians, were not intended to terrify, and violence was to give place to dignity. Mohammedan artists were not haunted by the hideousness of a carnage; they treated these scenes with a serene indifference that is without cruelty. On a marble slab in the Alhambra, lions clutching gazelles appear as though in play or enacting a routine from some ballet. On the mantle of Roger of Sicily, lions are crushing camels under their arched bodies. They are certainly in the Mohammedan style, as they produce only a theatrical effect.

These intentional distortions of animals and plants appear full of truth, because there is no clumsiness or vulgarity. These artists have succeeded in making us accept their vision, thanks to their absolute sincerity. It is greatly to their credit that, for an instant, they distract us from the realities of everyday life. We enjoy the unreality of their enchanted world, where, following the rules of the game, nature is reclothed in the most sumptuous adornments of art.

When, in some regions, the artists did set themselves to study nature their realism consisted in a sound observation of movement, but because of their affectionate humour it was never taken to extreme lengths. In any case, Islamic artists could never be asked to represent feelings of deep passion. There was an absolute exclusion of the pathetic, or of any form of suffering or anguish. They never set before us any gloomy and hidden feelings. It is known that in miniature painting the gesture of carrying the hand to the mouth symbolised astonishment or affliction: this convention was also used at one time in the Middle Ages in France.

Great Islamic artists skilfully exploited the dramatic

aspect of a situation. An example is the painter Bihzad; in the Bustan MS. in the National Library of Cairo, there is a seduction scene with Zulaikha, the wife of Potiphar. The miniature represents the interior of a villa on two floors. Zulaikha and Joseph are in a room at the top! Joseph makes an effort to escape, but Zulaikha tries to hold him by clutching the hem of his cloak. His cries are in vain, for there is not a soul on the stairways or in any of the rooms, the doors are closed, and it is quite clear that Zulaikha has taken every precaution.

An impersonal and repetitive art

In considering the distribution of decoration in Islamic art, two principles emerge. In general, pattern covers every surface and creates a sort of decorative fairyland; it would seem that the artists would have been ashamed to have left the least fragment without ornamentation. This richness was made up of the juxtaposition of tiny motifs, but we can see at once that the same floral scrolls are repeated uninterruptedly along an extended band to form a continuous series of spiral-like plants, or else geometric ornaments are repeated over a certain length. This process, intentionally repeating symmetrical motifs, irresistibly draws and fixes one's attention. Such combinations satisfy those who enjoy the mental pursuit of an ornamental system only limited by the contours of the decorated surface. For this constant quality it is essential to find an underlying reason: it is that the Oriental connoisseur finds great satisfaction in contemplating the patterns made up of repeating motifs.

In Arab literature, the great secret consisted in gathering together a series of reminiscences, or better still, in making veiled allusions to them. It was necessary to be learned in order to appreciate a poetic development only saved from

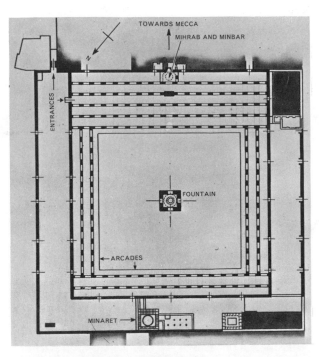

239. Plan of the mosque of Ibn Tulun, Cairo.

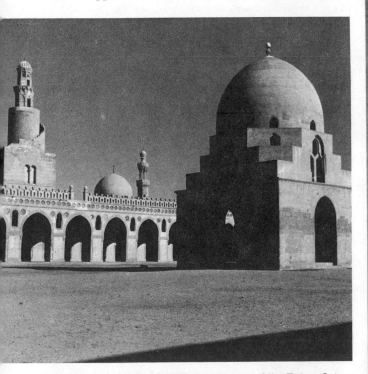

240. *Above.* MOHAMMEDAN. The mosque of Ibn Tulun, Cairo. 9th century. Abbasid period (Egypt). The courtyard, doorways and spiral minaret are inspired by those at Samarra. The cupola in the foreground dates from the 13th century.

241. *Right.* MOHAMMEDAN. Ruins of the mosque at Samarra. Abbasid period (Mesopotamia). 9th century.

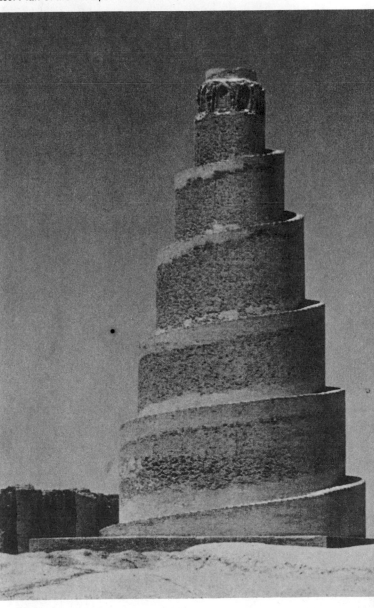

125

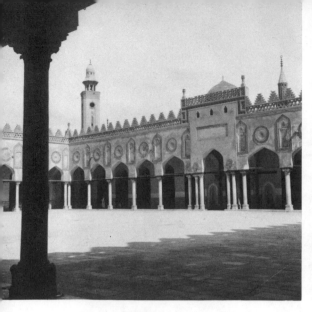
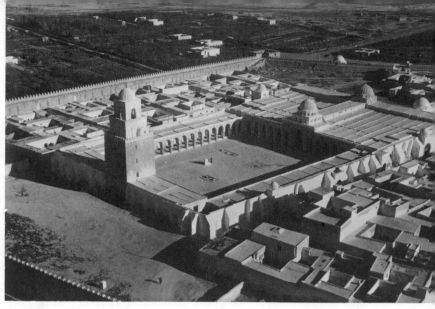

242. MOHAMMEDAN. The courtyard of the mosque of El Azhar at Cairo. Fatimid period (Egypt). 10th–11th centuries. The minarets are of a later date.

243. MOHAMMEDAN. Aerial view of the great mosque of Kairouan. Aghlabite period (Tunisia). 9th century.

banality by a breath of inspiration. It was sometimes the same in Mohammedan art: a mass of commonplaces was treated in a more or less successful or elegant manner, with nothing unexpected and everything conforming to a precise logic. Thus, Islamic artists, in the same way as the Arab writers, did not seek success by asserting their own originality. Both were content to show their understanding of the accepted conventions though sometimes they elaborated them. They were both scholars and virtuosi.

The Mohammedan spirit was suspicious of innovation, in which it saw a twofold danger—the break with tradition, and the flouting of society. This underlying outlook, almost instinctive, is the reverse of the present Western way of life and thought, in which the aim is for constant change.

Finally, the artists depended on a technique that had to be taught and was handed down through their studios. There were few violent changes, and when they did occur it was usually due to the sudden arrival of new artists or craftsmen.

It is more probable that artistic work reflected the surrounding taste rather than that there was any attempt on the part of the artist to impose new ideas. This desire to please must have paralysed all originality. In such an impersonal art it is not feasible to separate the artist from the patrons who gave him his livelihood. Official architecture, especially the mosque, was even more dependent on patronage; the wealthy princes who commissioned these buildings tried to attract the finest craftsmen to their courts. Of this there exists written proof in relation to architecture at Baghdad and at Samarra. Similarly, it is known that Tamerlane brought craftsmen, particularly glass workers, from Damascus to Samarkand, and as a result the wonderful enamelled glass in Syria and Egypt declined.

Thus, the personality of the artist is rarely expressed, and in architecture virtually never. The only variations are due to chronological or geographical differences. From these facts, migrations of craftsmen may be easily traced. The most striking example in Cairo are the walls of the Fatimid town, still partly standing, and including three monumental gates; the perfection and style of the general effect is in marked contrast to the mosques of the same period. It is almost certain that the builders came

from upper Mesopotamia. It is a masterpiece of precise workmanship, unique in the whole of Islamic art. The blocks of the arches and vaults have been most meticulously cut, and they are dovetailed into one another in such a way as to withstand the ravages of time. It is like a catalogue of vaults—semicircular, groined and barrel vaulting, domes on pendentives, arches with multiple mouldings. Some of the loopholes terminate in an elegant conically tapered stone; there is also a spiral staircase winding around a single pillar.

At the end of the 13th century, a Spanish school, ousted by the Christian reconquest, was established in Cairo, where it undertook additions to the mosque of Ibn Tulun; its work is identified in a carved bracket and in twin windows with horseshoe arches. Finally, several mosques in Cairo were redecorated with faience mosaics at some time during the 14th century. One historian attempted to explain all this by suggesting that the builder of a mausoleum at Tauris (Tabriz) stayed for some time in the Egyptian capital.

An original creation: the mosque

The description of one of the oldest mosques, completed all at one time, will make possible an analysis of the essential elements of a cult building. In the space available here it is impossible to give a detailed account of the subject, with its evolutions and its influences, so we will confine ourselves to referring to the penetrating studies of Georges Marçais, to whom we are so much indebted. We will concentrate on Egyptian buildings, with which we are personally most familiar.

It has been shown that Mohammedan art was a supple adaptation from earlier styles. The mosque, however, is a building of great distinction in its own right. It is through the organisation of the internal space that an architecture will generally make its claim to originality. In the case of the mosque there is a special arrangement which distinguishes it clearly from Western ecclesiastical buildings.

The court of the mosque may have had a double origin. It may recall the earlier meeting places for prayer, in the open air; in the early days of Islam the faithful met in front of the mihrab, generally outside the walls of the city. Secondly, it is necessary to remember the sunny climate of the East, which invites one to live out of doors;

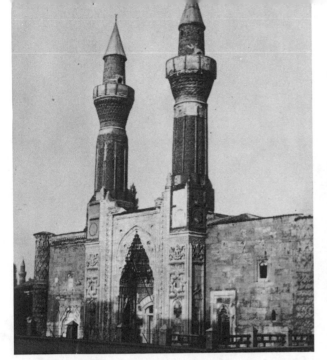

244. MOHAMMEDAN. Gök madrasa-mosque at Sivas. Seljuk period (Turkey). 13th century.

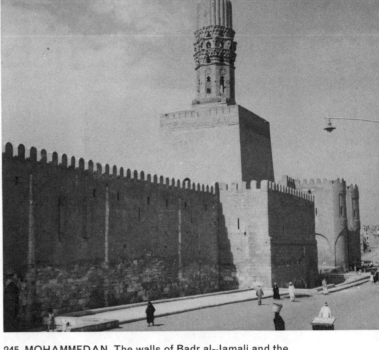

245. MOHAMMEDAN. The walls of Badr al-Jamali and the east minaret of the mosque of El Hakim at Cairo. Fatimid period (Egypt). 11th century.

so it is that in the well-to-do dwellings the courtyard played an important role, and there were large central courtyards in the Umayyad castles of Syria.

Thus, the original plan consisted of a courtyard surrounded by covered arcades, and, on the side facing Mecca, a deep-set sanctuary; the other three sides were less important. These arcaded mosques had flat roofs, occasionally resting on piers but usually on columns. Columns and capitals already existed in profusion in nearby classical or Christian buildings, and these were used haphazardly in the mosques.

Since the faithful grouped themselves in long rows for communal prayer, the mosque developed a rectangular plan, but with the entrance on the long side, that is, contrary to the direction in the Christian church. Another difference is that whereas the church pointed skywards with its soaring naves the mosque was riveted to the earth, as a symbol of serenity, faith and courage.

The minaret was probably an imitation of the bell tower. As the building of mosques followed in the wake of the Arab conquerors, so the square Syrian bell tower penetrated as far as Spain, and thence to Morocco. The cylindrical minaret was developed in Persia and influenced those 'candles of stone', each with a cap and extinguisher, which flank Ottoman mosques. A great variety of domes and minarets were built in Egypt, where many influences met. This variety continued until the architects of the mosque of Kait Bey re-erected, as it were, the lighthouse of Alexandria, a minaret in three stages, square, octagonal and cylindrical.

The mosque of Kairouan and the mosque of Cordova deserve special attention, the first for its clean-cut lines and its general severity, the second for its brilliant colour and the delicacy of its superimposed arcades.

The peace of Islam pervades the 9th-century mosque of Ibn Tulun. This was probably a direct copy of the building at Samarra, north of Baghdad. The moving and harmonious simplicity of the plan did not prevent the architect from contrasting the well lit court with the dark aisles, a contrast accentuated by the size of the piers. Inside, the space is so pure that it plunges the visitor into an atmosphere of meditation, and here he is struck by the

fine proportion of the lines, the height of the arcading, and the depth of the cloister surrounding the court. The contrast between the severity of the arcadings and the windows, which already compensate by their lightness, is further softened by the frieze of rosettes crowning the top of the walls. Several small portions of decoration in stucco remind one of artists who were wilfully awkward —but they created a linear repertoire so complete that following generations could do no more than enrich it. The minaret is unusual, with its spiral stairway; it echoes the primitive bell tower, such as the one at Samarra, with its stairway rising gently around an axis of brick. In this mosque, one is struck simultaneously by the implacable dazzle which falls on the court and by the deep mystery that seems to emerge from the aisles.

The Fatimid buildings also arouse our admiration. The mosque of El Azhar has maintained a universal reputation as a centre of religious teaching. With successive additions, this building has become virtually a museum of art. North Africa had some influence on the modified plan of this mosque: the aisle leading from the court to the mihrab became a sort of triumphal passage, which is distinguished by its direction, at right angles to the lateral aisles which are parallel to the mihrab. The mosque of El Hakim has an imposing entrance; and the little sanctuary of El Akmar possesses wonderful sculptured decoration whose motifs served as models to later artists.

Mohammedan art is intellectual, its decoration essentially refined and aristocratic. It has none of the meaningful sharpness and the intensity of life that constitute the merits of classical art. The compositions of Islam, in frescoe, in stucco, in miniatures, in glazed tiles and in wood carving, are often austere and abstract, always elegant and sometimes delicately gay. In Mohammedan art there is no portrayal of strong emotion or pathos, but instead a mysteriousness which reveals itself and an infinite virtuosity, in which we may unreservedly admire the richness and harmony. The Islamic artist has firmly preserved a serene harmony in his world. He has evoked this serenity in his sumptuous textiles, gracious miniatures, and, finally, on the glistening ceramics, as beautiful to contemplate as they are satisfying to touch.

241

242

245

256

243, 214

239, 240

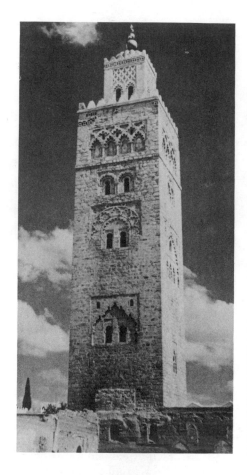

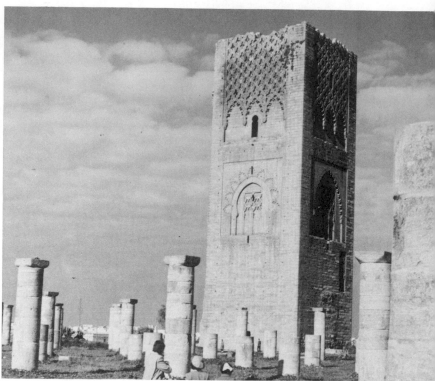

246. *Left*. MOHAMMEDAN. Minaret of Minaret of the mosque of Hasan, Marrakesh. Almohade period (Morocco). 12th century.

247. *Below*. MOHAMMEDAN. Minaret of the mosque of Hasan, Rabat. 12th century.

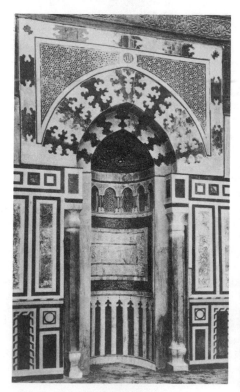

248. *Above*. MOHAMMEDAN. Mihrab of the madrasa of El Azhar, Cairo. Mamluk period (Egypt). 14th century.

249. *Right*. MOHAMMEDAN. Ribbed dome of the Hakam II oratory at Cordova. Umayyad period (Spain). 10th century.

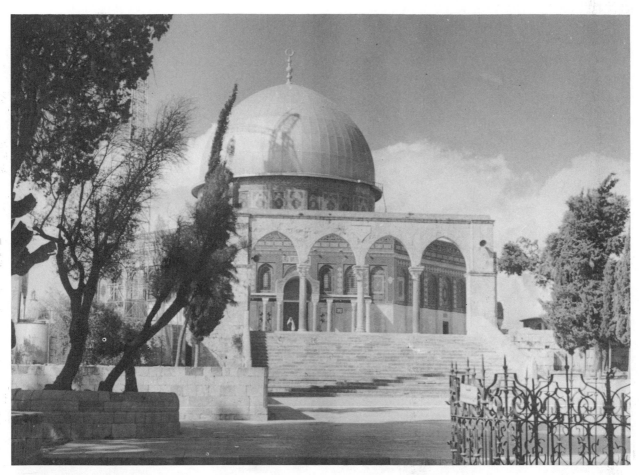

250. MOHAMMEDAN. The Kubbet
es-Sakhrah (Dome of the Rock), known
as the 'Mosque of Omar', at Jerusalem.
Umayyad period. 7th century.

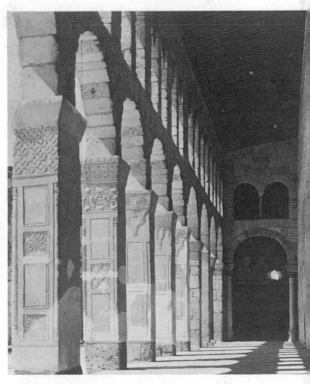

251. MOHAMMEDAN. The tower of
the Giralda at Seville. Almohade
period (Spain). 12th century.

252. MOHAMMEDAN. Minbar (pulpit)
of the mosque of Ibn Tulun at Cairo.
Mamluk period (Egypt). End of the
13th century.

253. MOHAMMEDAN. Colonnade of
the Great Mosque of Damascus.
Umayyad period (Syria). 7th century.

129

HISTORICAL SUMMARY: Islamic art

Archaeology. For a century before the publication of any textbook on Mohammedan art, there had been descriptions of travels, translations of Arab and Persian poetry, and also the analysis of documents written in Kufic script relating to the Islamic religion and governmental institutions. In addition, there had been some specialised monographs and inventories, one of the oldest, published by Reinaud, dating from 1828. The first essays on Arab architecture in Spain, Egypt and North Africa were written in 1841 (by Girault de Prangey), in 1875 (by Bourgoin), and in 1899 (by H. Saladin).

On the other hand, since the beginning of this century, specialists on the subject of Mohammedan art have done a considerable amount of work on the analysis of the various Islamic artistic techniques.

History. The Arab conquest with its resultant rapid diffusion of Mohammedanism in the Mediterranean world, which was at that time still subject to earlier influences, was the most important factor in the evolution of artistic forms. Shortly before the death of the Prophet (A.D. 632) the Arabs attacked with irresistible strength. They overcame Syria and Palestine which were insufficiently defended by Byzantium, and then after the

brilliant victory of the Yarmuk (636) they took Aleppo and Antioch. Damascus was conquered in 635 and Jerusalem, after two years of siege, in 638.

At the same time the attack on Sassanian Persia, which was so exhausted by wars with Rome and Byzantium that she was hardly able to resist, began in Mesopotamia, and all the frontiers were soon crossed. Ctesiphon, the capital, was pillaged in 637. King Yezdigerd III, the last of its kings, was obliged to flee. The Arabs crossed the Tigris, took Rayy (Rhages) in their stride, and then Qazvin in 643; Hamadan and Isfahan were taken by 644. In 711 they had reached the delta of the Indus.

In the west, the expedition to Egypt was commanded by Amr, general of the Caliph Omar. Amr forced the Byzantines to withdraw in 642. He founded Fostat, or Old Cairo, where in 643 he began to build the mosque which bears his name. From Fostat, the Arabs entered Tunisia in 647.

Byzantium resisted the invaders, sometimes successfully. However, in 670 Sidi Okba founded Kairouan, and in 709 North Africa succumbed. Spain was the next target and was overrun from Seville to Catalonia in 711. In 720 France was invaded; Narbonne, Toulouse and the valley of the Rhône fell, and the Arabs fought on as far as Tours under the Emir

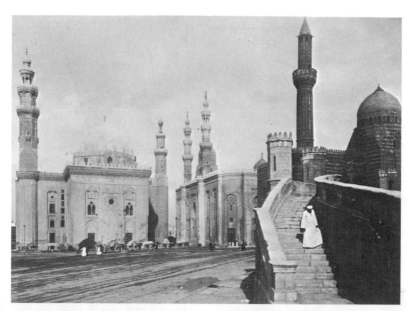

254. MOHAMMEDAN. Left: the mosque of Sultan Hasan at Cairo. Mamluk period (Egypt). 14th century. Right: the mosque of Mahmudieh. 16th century. Centre: the mosque of ar-Rifai. 20th century.

255. MOHAMMEDAN. Group of mausoleums known wrongly as the 'tombs of the caliphs', Cairo. Mamluk period (Egypt). 14th–15th centuries.

256. MOHAMMEDAN. Memorial mosque of Kait Bey. Mamluk period. 15th century.

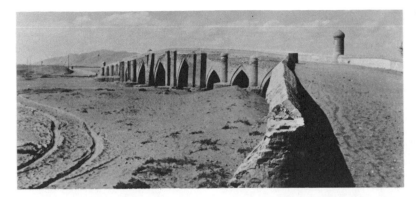

257. MOHAMMEDAN. Bridge to the north of Tabriz. Seljuk period (Persia). 12th–15th centuries.

258. MOHAMMEDAN. The Ince Minar at Konia. Seljuk period (Turkey). 13th century.

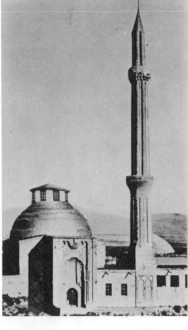

Abd ar Rahman. In 732, however, not far from Poitiers, Charles Martel halted the Mohammedan advance.

The Arab conquest, which was begun under the government of the first four caliphs, followed in the same rhythm under Muawiya. He was governor of Syria from 639, and he established the throne of the caliphate at Damascus in 661, which replaced Medina and became the capital of the empire. Muawiya was the remarkable founder of the Umayyad dynasty, named after Umayya, his grandfather. He broke with the fundamental Islamic custom of chiefs being elected by the whole community, and instead forced them to accept the designation of an heir presumptive.

Architecture. The Mohammedan style is distinguished, firstly, by the use of horseshoe arches and arcadings, and, secondly, by the frequent use of domes. The forms of arches included the semicircular arch, the broken arch, the stalactite or multifoil arch. Domes were shallow or high, sometimes bulbous, and in some districts ribbed.

The mosque was the building par excellence of Mohammedan architecture. In theory it consisted of two essential parts—the court with its portico, containing also a fountain for ritual ablution, and the covered sanctuary for prayer.

The orientation of the sanctuary was given by the wall (kiblah) in which was carved the mihrab (small niche) [234]. Not far from the mihrab was the minbar or mimbar (pulpit), in wood or stone [252].

The maksurah (a kind of enclosure round the site reserved for the use of the prince) was not obligatory.

One or several minarets (towers or campaniles for the call to prayer) were built near, or surrounding, the mosque [242, 245–247, 251].

THE UMAYYADS

History. The Umayyad caliphs governed Syria in a way that conciliated the nationalist elements, and without religious partiality. Like the Byzantine Emperors and the Sassanian kings, they were surrounded by an ostentatious court. They

259. MOHAMMEDAN. Miniature of the Baghdad school, dated 1222. *Louvre.*

set up lasting monuments—the Great Mosque of Damascus, the Kubbet es-Sakhrah (Dome of the Rock) of Jerusalem [250], as well as numerous castles, scattered over Syrian soil (Kuseir Amra, Qasr el Haïr, etc.).

This empire made up of such disparate elements inevitably split up. The Iranians, who had to endure the Arab supremacy, made use of all discontented elements, notably the Shi'ites (partisans of Ali, the son-in-law of the Prophet), who had never recognised the Umayyad caliphate, and the Abbasids (descendants of El-Abbas, uncle of the Prophet). The Umayyads were overthrown, then massacred. One alone escaped to Spain, and his dynasty continued at Cordova from 755 to 1009.

The Abbasids had themselves proclaimed caliphs in 750. At the same time, the Umayyads gave to Spain a measure of independence and developed in that country a splendid civilisation. The Umayyads in Spain were emirs and did not take the title of caliphs until 929, in the reign of Abd ar Rahman III.

Architecture. The Umayyad mosque was rectangular in plan. It included a court with a portico and a fountain, and also a sanctuary set transversely. There were numerous aisles; the axial one leading to the mihrab was the widest and highest. The roof was flat. The capitals were often Corinthian, salvaged from earlier buildings. The minarets were square. The Great Mosque of Damascus [253] was begun in 706 under Walid I. The sanctuary (16,000 sq. ft) lies in an east-west direction and is separated from

the court by a light colonnade of the Corinthian Order. Mosaics on a gold background cover the walls.

The Kubbet es-Sakrah was built in Jerusalem by the Caliph Abd al-Malik (668–691) on the site of the Temple of Solomon. It was exceptional in that the sanctuary did not extend the width of the mosque. It had a surrounding polygonal wall articulated with pilasters. This wall was pierced by four entrances facing the cardinal points of the compass. Within was a second octagon with eight square-section pillars with two columns between them and a circle of twelve columns around the rock. It recalls the mausoleum of Diocletian at Spalato (Dalmatia), and in some ways St Demetrius at Salonica.

Decoration. Multicoloured materials were employed (marble, porphyry, etc.); the walls and alternate voussoirs were decorated with mosaics with plant and architectural forms in the Byzantine technique [217]. This Hellenistic survival is explained by the presence of Byzantine artists.

THE ABBASIDS

History. The Abbasids were absolute masters of the Mohammedan world. They succeeded the Umayyads and styled themselves 'Commanders of the Faithful'.

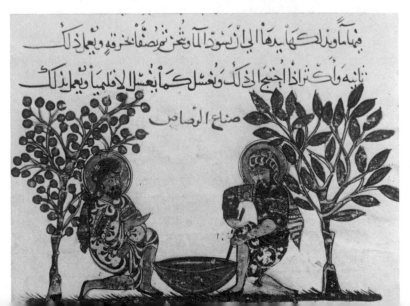

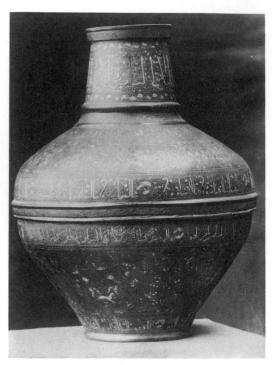

260. MOHAMMEDAN. Copper vessel inlaid with silver, known as the Barberini vase, from the name of an Ayyubid sultan of Aleppo or Damascus. About 1250. *Louvre.*

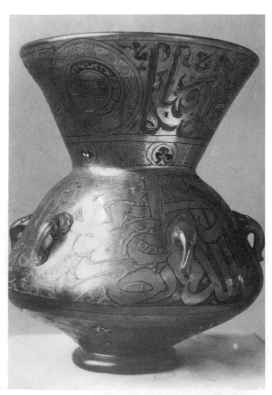

261. MOHAMMEDAN. Lamp from a mosque, in enamelled glass. Mamluk period (Egypt). 14th century. *Louvre.*

They ruled from 750 until the Mongol invasion of the 13th century, and saw first the unification and then the disruption of the Arab empire. Their capital was Baghdad. Samarra, the grandiose work of several caliphs, was important only for a short time, from 836 to 892. Relying less on the Syrians than on the Iranians, the Abbasids developed an administrative system analogous to that of the Sassanians. This system enhanced the power of the vizierate, a post which was often hereditary. The vizier would name his ministers according to his own judgment, and steadily the effective authority of the sovereign was eliminated. Nevertheless, there were great monarchs, among them Haroun al-Rashid, contemporary of Charlemagne, and also Mutawakkil (847–861), the real creator of Samarra, as well as other enlightened and refined princes.

The empire began to break up when the provincial governors shook off caliphal control, and often struck coins in their own name.

Among these provinces, Spain became entirely independent when its Umayyad sovereign took the title of caliph in 929. In North Africa, the Moroccans recognised Idris ibn Abdullah as their autonomous head. He was a descendant of Ali and of Fatima, and founded the dynasty of the Idrisids, centred in Fez, and also near Tlemcen, in 807. In Tunisia in 800 the Aghlabite dynasty was founded; they equipped a battle fleet which advanced on Italy, Corsica, Sardinia and Sicily.

In the 11th century, the growing anarchy in Spain forced the caliphs to appeal to the Berber tribes for help in resisting the Spanish reconquest. Power then passed to the Almoravides, in the beginning of the 12th century, and from them to the Almohades, from the 12th to 13th centuries. The Maghreb (Mohammedan North Africa) was penetrated by Andalusian culture and this resulted in an art generally known as Hispano-Moorish.

In Egypt the Abbasid mandatory, Ahmed ibn Tulun, reorganised the country, consolidated his power and passed it on to his descendants, known as the Tulunids. Their line continued until about the 10th century. They gave a new impetus to the arts. The mosque of Ibn Tulun bears witness to their vitality. They were independent of Baghdad, but acknowledged the caliph's authority on religion.

Their prestige, however, was threatened at the end of the 10th century by the Fatimids (Shi'ites) who pressed their demands by claiming descent from Fatima, the daughter of the Prophet. The success of the Fatimids was complete in the Maghreb, Yemen and Egypt, where many beautiful buildings recall their caliphate. Their success in these regions strengthened the latent hostility present in other parts of Islam. The unity of the Arabs, which had lasted a century, was on the point of disruption, for there was no real bond between the Arabs and the Iranians, nor between the Sunnites (orthodox) and the Shi'ites. A new threat now arose with the appearance in the Near East of the Seljuk Turks, strong supporters of Sunnism.

THE ABBASID SCHOOL (PERSIA AND MESOPOTAMIA)

Architecture. In spite of the great number of monuments that have been destroyed, the architecture, in addition to a taste for the colossal, recalling the apadana of the Achaemenids and the Sassanian palaces, can be characterised by the use of brick as a building material, and of ribbed and barrel vaults and domes. The iwan was also characteristic, and consisted of a hall closed in on three sides, and open on the fourth through a very high arch, generally giving on to a court.

At Samarra, the spiral minaret was derived from the Mesopotamian ziggurat and perhaps also from the Sassanian towers consecrated to fire worship [241]. This minaret and the plan of the large mosque, now destroyed, influenced the mosque of Ibn Tulun in Egypt [240]. Among the ruined palaces of Samarra, Jausaq el-Khaqani (c. 836) has been called 'the Arab Ctesiphon'.

Decoration. Stucco decoration was of three styles—the first called 'Samarra', which was Hellenistic in character, the second which became more geometric, and finally a more naturalistic style, with a marked taste for the repetition of a single motif. To this sculptured decoration was added painting on plaster.

The minor arts. Important productions included the works in copper and bronze (Sassanian-inspired fingerbowls), silk tiraz fabrics which came from official workshops [221], and enamelled earthenware of ancient tradition, which led to faience with a metallic lustre, at Samarra, Rakka, Rhages, Susa, etc. [228, 222–224, 233].

THE TULUNID SCHOOL (EGYPT) AND THE AGHLABITE SCHOOL (NORTH AFRICA)

Architecture. When Egypt recognised the authority of the Umayyads, Amr began to build the mosque of Fostat. This was remarkable for its two rows of columns, and was erected in 827, well before the founding of Samarra, the influence of which was later apparent in the mosque of Ibn Tulun (876–879). It was built of brick, even to the piers and arches; and it had five aisles on a rectangular plan [239].

The great mosque of Kairouan [237, 243] was built by the Aghlabites in Tunisia. Begun in 836, it had a vast court with entrances on four sides. On the side facing south-east was the sanctuary, with seventeen aisles. At each end of the central and largest aisle was a small dome, one ribbed, the other not. One of these domes was over the mihrab, the other over the narthex, towards the court. The massive minaret was square in plan and three storeys high; the first storey tapers slightly, while the other two storeys are narrower but do not taper.

Decoration. The Tulunids, influenced by Samarra, ornamented the surfaces of their buildings. Delicate niches, merlons, honeycombs and rosettes lightened the construction, while interlaced floral motifs were everywhere.

The Aghlabites, who had contact with Christian traditions, favoured the motif of the vine, which they interlaced into geometric decoration. This is seen in the oldest known minbar, dating from 863, which was made of teakwood.

The minor arts. The Abbasid influence seen in the minbar is also apparent in the faience. In the mihrab of Kairouan, its metallic glitter matches the marble to perfection. The Coptic tradition underlay Aghlabite and Tulunid leather bookbinding, and in Egypt this tradition was basic to wood carving and textiles produced in the official ateliers. Ceramics, however, were inspired by Iran.

THE FATIMID SCHOOL (IN IFRIKIA AND AT CAIRO)

Architecture. In Ifrikia (Tunisia), art was provincial, with derivations from Baghdad. As in Egypt, stone was used, for instance in the important entrance of the mosque of Mahdia, which was flanked by two storeys with recesses.

In Egypt, art was robust and prolific, and achieved greater perfection. It showed the influence of Syria and Mesopotamia.

In the 'New Town' at Cairo the mosque of El Azhar was built (962–972) [**242**]; this was soon transformed into a madrasa, or theological college. The T-shaped sanctuary recalls Kairouan; it carried two domes on drums, and used ogee arches over the court. Its decoration with many niches and rosettes still left plenty of room for ornamental bands of inscriptions. The influence of this mosque, together with that of the mosque of Ibn Tulun, made itself felt in the mosque of El Hakim (990–1003). On the other hand, the mashhad (or pilgrims' sanctuary) of El-Gouyuchi (1085), near the Mokattam hills, inaugurated a new type which was made up of three essential parts: the entrance, the court, and the sanctuary, formed by three aisles at right angles to the kiblah. A large slender dome adorned the oratory; the minaret rose in two square stages and one polygonal stage, and was topped by a dome.

There were also domed mausoleums— after 1100, those of Gafari and of Sayyida Atika, which derived the stalactite form from Iran.

Decoration. The decorative instinct expressed itself in broken arches, in horseshoe arches, in ogee arches and in the development of blind arcading. It also came out in the geometric arabesque, which was like a continuous braid that knotted itself and folded back on itself unendingly, while absorbing the floral element with which it intermingled. The highly embellished Kufic script was yet another manifestation of the same spirit.

The minor arts. The ancient native tradition influenced the expanding glass industry (and to this may be added the cutting of rock crystal [**262**]), the art of wood carving, which now included marquetry and elaborate joinery [**229, 235**], and ivory carving [**231**]. This tradition combined with Iranian influences in the arts of metalworking and ceramics, which continued to hold their place of honour [**227**].

SPANISH UMAYYAD ART AND HISPANO-MOORISH ART

Architecture. The mosque of Cordova, often altered and enlarged, was begun by Abd ar Rahman in 785. This mosque consisted of a court leading to the sanctuary with its numerous aisles and flat roof. In the interior, multifoil and horseshoe polychromed arches were superimposed; the capitals were Visigothic [**214**]. Domes on ribs were added in the 10th century. The influence of this mosque was to be felt in those built later by the Almoravides and the Almohades: the great mosque of Algiers (1096), the great mosque of Tlemcen (1136), and the mosque of the Kutubiya at Marrakesh (12th century), whose minaret was closely allied in form to the Giralda of Seville.

Umayyad domestic architecture is known from the important remains of Medina az-Zahra, a vast palace founded by Abd ar Rahman III. The decoration, which was exceedingly rich, was based on the vine leaf, the acanthus with long split leaves, and various geometric motifs.

Hispano-Moorish art is based largely on Cordova and Medina az-Zahra, and lasted from the 11th century to the beginning of the 12th. Hispano-Moorish architecture included fortresses with massive doorways, and brilliantly decorated palaces, such as the Abbadide palace of the Alcazar, Seville, and the Aljaferia, Saragossa.

Under the Almoravides and the Almohades, Hispano-Moorish art acquired a new style. Its purity of line is apparent in the Kutubiya [**246**], the mosque of Hasan, Rabat [**247**], and in general in the gigantic lavishly decorated minarets of the Almohades.

Decoration. In the mosque of Cordova, the mihrab was inlaid with precious marbles and ornamented with Byzantine mosaics. The beams of the ceiling were painted and gilded. At Medina az-Zahra, the walls were covered with a coating of red and yellow ochres or with relief sculptures.

Hispano-Moorish architects delighted in a profusion of domes, and also left

262. MOHAMMEDAN. Vessel of rock crystal from the St Denis treasure. Fatimid period (Egypt). 11th century. *Louvre.*

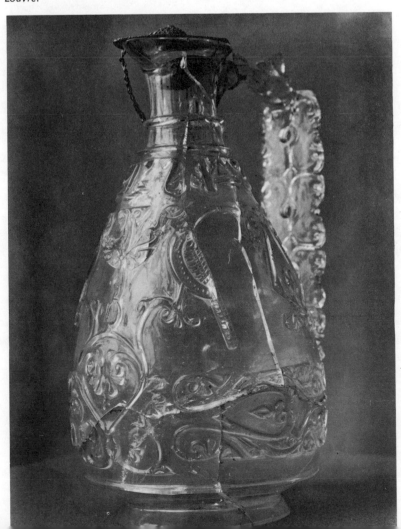

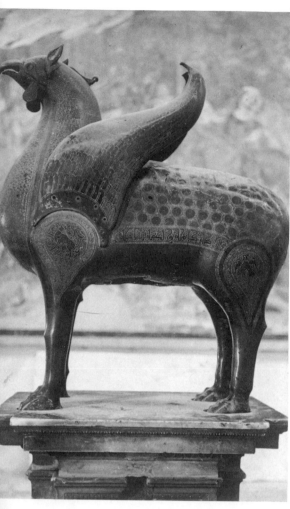

263. MOHAMMEDAN. Bronze griffon, probably brought back from Egypt by Amalric, king of Jerusalem. 10th–11th centuries. *Campo Santo, Pisa.*

264. MOHAMMEDAN. Lamp for a mosque, in pierced copper, originating from the Kubbet es-Sakhrah, Jerusalem. 12th century. *Louvre.*

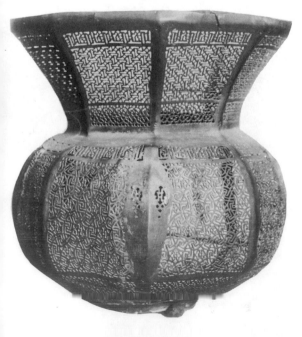

plenty of space for geometric and stylised floral decoration, but did not make use of the stalactite form until very late.

The minor arts. There were numerous ivories from Cordova and Cuenca. These were finely carved, and carried inscriptions; they have some resemblance to icons. The minbars were of wood, enriched with marquetry, and attained great technical perfection. Textiles, glass, and even the bronzes were sometimes very similar to Egyptian and Mesopotamian productions. Hispano-Moorish ceramics, with their blue and gold glazes, made at Valencia, Málaga and Manises, are incomparable. The last phase of this art is known as Mudejar art.

In the same way that the painted wood carvings of North Africa influenced Sicilian Norman art, for example in the churches of Palermo, so the ceramics of Mohammedan Spain contributed to the rise of Italian faience.

THE TURKS

THE SELJUKS

History. The Turks were first heard of before the Christian era. They played an important political role from the day that they were installed as governors of the Abbasid provinces, as for example Ibn Tulun in Egypt. About the same period, Turkish tribes infiltrated into Iran and Mesopotamia. In the 11th century one of these tribes, the Seljuk dynasty, named after their chief Seljuk, occupied Isfahan, Hamadan, then Kars in 1052, Lake Van in 1054, the Caucasus, and finally Baghdad in 1055. Here, the leader took on the new title of sultan, and became established as 'Sovereign of the Orient and the Occident', with full legislative authority. From then on he became the 'right hand of the caliph'.

The Seljuks clashed with the Byzantine forces at Malazgirt in 1071. The vanquished Byzantines saw the enemy instal themselves at Milet, at Trebizond, and at Isnik (formerly Nicaea). They made Konia (formerly Iconium) their Seljuk capital over Anatolia (1069). Syria and also Palestine were overpowered.

The West, realising the danger of the Turkish threat, increased the size of the first crusade, sent out by Pope Urban II.

Under Malik-shah (1072–1092), who was aided by his vizier Nizam ul-Mulk, Seljuk power reached its peak. After this reign, however, the Turkish principalities split; they were attacked by Byzantium and the crusaders, and at the same time by the Mongols under Genghis Khan. This man, proclaimed 'Universal Khan of the Mongols' in 1206, overran a vast territory before reaching the Islamic countries of Turkey, Iran and Arabia.

However, the Seljuks had given certain institutions an impetus that ensured their progress for centuries. They increased the number of madrasas, or theological colleges, they encouraged science and they formed a sort of graded civil service. The effect was especially felt at Konia, Kayseri, Erzerum, Karaman and Tokat.

Architecture. The first buildings of Iran, which were built of brick, have nearly all been destroyed. The Tarik Khaneh mosque at Damghan, dating from the end of the 8th century, is the oldest; it is of the basilican type, like the mosque at Nayin, near Isfahan: both were of the Abbasid type.

With the Seljuks, there appeared the madrasa with one or more iwans in place of the courts, and completed by an oratory for the teachers and students, corridors, passageways and so forth. One or four iwans could easily be inserted into the mosque, thus forming the madrasa-mosque type, such as the mosque of Zawara, dating from the years 1135–1136. Inside there was often a monumental maksurah, an enclosure for royalty, which became a veritable pavilion in wood or stone. The maksurah in the great mosque of Isfahan is forty feet in length.

Round minarets, decorated by the arrangement of the bricks, replaced the Syrian forms in which the corners were broken.

At the beginning of the Seljuk period, the mosque of Van, with its covered court, its slightly projecting mihrab and its gigantic maksurah, was covered with trefoil patterns, in the same style as the mosque of Kazvin in Persia. The Ince Minar at Konia, founded in 1262, consisted of a sanctuary covered by a high dome with a lantern [258]. The high doorway of this mosque was decorated in relief and with rich inscriptions, and is characteristic of Seljuk doorways, which are honeycombed and have more sculpture on them than the rest of the building. Other examples are to be found at Sivas and Divrigi.

Tombs were erected in the form of towers or as square chambers covered by a dome on pendentives, a trefoil dome, or sometimes by a pyramidal roof; these are known as gumbad, kunbed, and turbaned.

Decoration. Stylised floral ornament, geometric and epigraphic patterns, were carved in low relief or high relief, like lacework, and applied particularly to the doorways. Glazed turquoise-coloured bricks were inserted into a background of red bricks, and the pattern was sometimes emphasised by white plaster.

The minor arts. Ceramics, particularly at Rhages, continued to be produced in the Abbasid style. The bronzes have quite simple forms, ornamented with engraved or pierced patterns. Materials were sometimes woven in silk, such as the St Josse fabric in the Louvre. Textiles from Asia Minor were strictly geometric in pattern or were decorated with inscriptions.

THE MAMLUKS

History. Egypt was to enter a new phase with the Mamluk dynasty. Before this, the overthrow of the Fatimid caliphate in 1169 was followed by the dynasty of the Ayyubids (1169–1260), founded by Saladin, who were members of the Ortokid

family which was related to the Seljuks. The origin of the Mamluks was partly Circassian, partly Turkish; under the Ayyubid sultans they were firstly 'white slaves', and then personal guards to the sultan; ultimately they usurped the throne. In Cairo, their sovereigns erected many fine buildings—the mosque of Sultan Bibars, the mosque of Kala'un and the magnificent madrasa-mosque of Sultan Hasan. Their luxurious taste was displayed in the extravagant wealth of the architectural decoration and by the profusion of ornamental patterns in the minor arts.

The Mamluk sultans welcomed the artists fleeing from countries which the Mongol invaders had overrun. This resulted in the wide dispersion of Mohammedan techniques in metal, glass and ceramics during the 14th and 15th centuries. In 1516, with the rise of the Ottoman empire, the Mamluks' sovereignty came to an end.

Architecture. Stonemasonry developed and vaulting became popular—barrel vaulting, groined vaulting and stellar vaulting. Ogee arches, semicircular arches and horseshoe arches were used. Externally, domes were round or polygonal.

Minarets rose from a square base; their shafts were polygonal and decorated with corbellings and balconies; at the top there was placed a tiny dome.

The memorial madrasa-mosque of Sultan Hasan (1356–1362) [**254**], covered about 90,000 sq. ft. It had a central court with four iwans, giving a cruciform shape, which followed a type frequent in Persia. Accommodation was arranged on three storeys. The entrance decorated with honeycomb patterns reminds one of the Seljuk buildings in Anatolia. The memorial mosque of Kait Bey (1472) [**256**], was arranged more exclusively for worship.

The sultans also built tombs of the 'turban' type, covered by high domes which were bulbous or ribbed [**255**].

Decoration. Outside, walls were often banded horizontally in courses of red and white. Voussoirs were cunningly interlocked. Stalactites were used to excess. Inside, faience and inlaid marble appeared. Interlacing became greatly developed.

The minor arts. Works in the applied arts were as delicate as they were sumptuous. They included lamps of enamelled glass, copperware inlaid with gold and silver, weapons, and woven shot materials with 'kaleidoscopic' decoration. Wood carving made use of inlay and lattices of beadwork known as 'moucharaby'.

Sophie Essad-Arseven

265. MOHAMMEDAN. Ewer, engraved and inlaid. Mesopotamia. First half of the 13th century. *Louvre.*

135

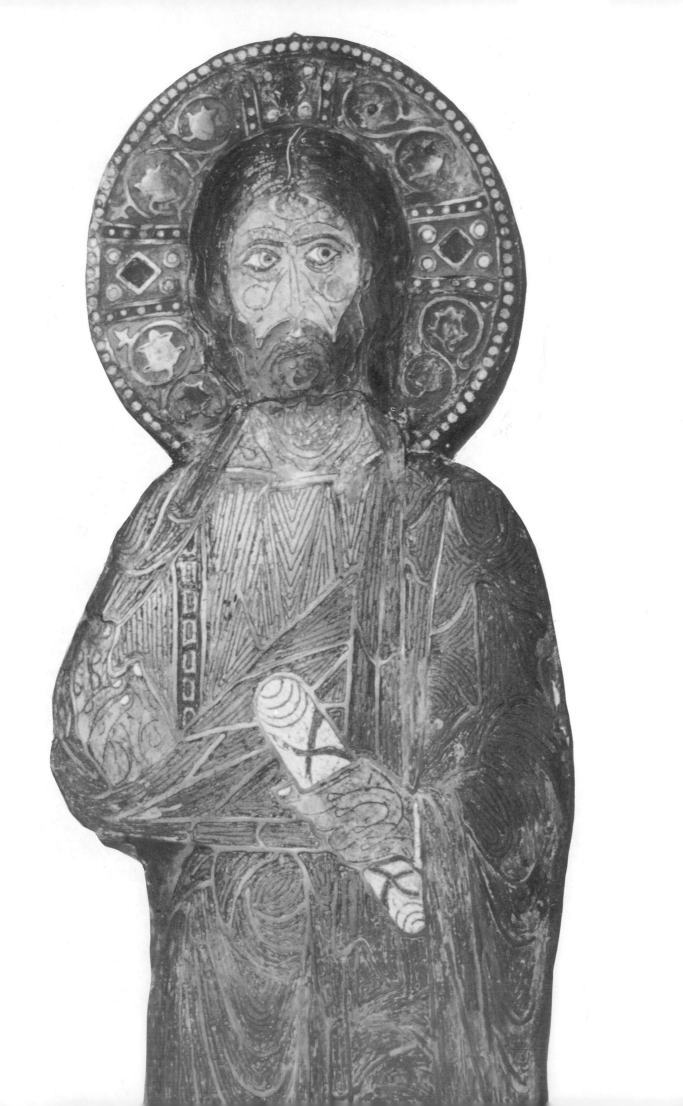

THE LATER BYZANTINE EMPIRE

Sirarpie der Nersessian

The Byzantine Empire, after recovering from the crisis of the 8th century, established a final artistic form, and this form was often codified by the Church. In spite of the efforts of scholars to give new life to the Graeco-Roman past, Oriental influences submerged its spirit as deeply as they did its outward appearance. Religious and political quarrels led to war and to a complete break between the West and the East. The defeated Byzantine Empire was soon absorbed into the Mohammedan world which had been surrounding it for so long a time.

The Byzantine Empire emerged victorious from grave political and religious crises in the middle of the 9th century. Emperors of the Isaurian, Armenian and Amorian dynasties had halted the Arab conquests which had dismembered the Empire and had threatened its very existence. These Emperors made the western frontier secure, and the other thread, that of the Bulgars, was turned aside for some time.

THE SECOND GOLDEN AGE

Byzantium, under Basil I and his successors, was soon to take the initiative, to regain some of the territory she had lost and to extend her sphere of action beyond her own frontiers. Her brilliance survived further territorial losses sustained at the end of the 11th century. In Italy, for example, Desiderius, abbot of Monte Cassino, sent for artists from Byzantium to decorate the church of his monastery. He and the merchants of Amalfi commissioned large bronze doors to be cast in Constantinople for their churches. Norman churches in Sicily were decorated with mosaics of Byzantine workmanship or inspiration. A new current of Byzantine influence appeared in the later mosaics at Ravenna, and in the buildings of Venetia, at Torcello, Murano, and in St Mark's, Venice. Christian missionaries in the Balkans converted the Slav peoples, gave them an alphabet, and laid the basis of a civilisation which was thoroughly permeated by Byzantine culture. Later, when they became independent of Byzantium, the Bulgars and Slavs continued to imitate the organisation and ceremonial of the Imperial court and, to a large degree, the artistic creations of the capital. The Russians were converted during the reign of Vladimir and came within the sphere of Byzantine influence, and their literature and artistic productions carried the strong imprint of Byzantine models for centuries. Finally, in the Caucasus, the influence of Byzantine religious painting is very clear in the Georgian works of the 11th and 12th centuries, for example, in the fine mosaics of the monastery of Gelati, and, to a rather lesser degree, in Armenian miniatures.

The return to antiquity and the use of images

The Byzantine Empire, whose influence spread far and wide even though its territory was very much smaller

274, 275

273
272

313

than in the past, had acquired a more homogeneous character. Non-Greek elements remained numerous, especially in the army. Several 9th- and 10th-century Emperors and most of the great generals came from Armenia. Though Constantinople had always been a cosmopolitan town, the Byzantine Empire considered as a whole was fundamentally a Greek empire, from the point of view of its traditions, its language and the ethnic origin of the majority of its population. It was a Greek empire united in the religion of the Orthodox faith.

Byzantine scholars had never entirely lost their contact with Greek antiquity. In the 9th century the works of classical antiquity became more and more widely known and appreciated. An intellectual renaissance took shape, and was referred to by contemporary writers as a 'second Hellenism'. The reconstruction of the university at Constantinople was undertaken by the Emperor Theophilus and completed by Bardas. Highly gifted men were teaching there, including Leo the Philosopher and, above all, the Patriarch Photius, whose erudition and brilliance have caused him to be considered as the most illustrious among the men of his time. These men contributed greatly to the developments whose impetus increased throughout the 10th century. Writers imitated both the classical language and the forms of the works of antiquity. For example, recent study has shown the profound contrast, from the literary and historical points of view, that exists between the *Life of Basil I*, written by Constantine Porphyrogenitus, and the *Chronicle of Theophanes*, which had been written a century earlier.

Under the influence and the direction of Constantine Porphyrogenitus, scholars and scientists prepared voluminous encyclopedias. These summaries of the knowledge of the past included historical and scientific works, treatises on strategy and tactics, and hagiographical collections. The Emperor himself took part in this literary activity and composed several works, notably the *Book of Ceremonies*. For these great works it was necessary to seek out and collate numerous ancient manuscripts. Other works were adding to the knowledge and dissemination of the writings of classical antiquity. From approximately 850 to 1000 the manuscripts written in uncials were recopied in minuscules. Most of the surviving classical texts were transcribed during this period. A contemporary interest in the study of philology resulted in some of the medieval copies being of a higher quality than the few surviving ancient examples.

Every category of ancient manuscript was studied; they included profane texts of classical antiquity and religious works of the first centuries of Christianity. Art and literature were profoundly affected by these works which were recopied completely or from which extracts were made. Illustrated manuscripts on science, such as the Theriaca of Nicander, the surgical treatise of Apollonius of Citium, and the Cynegetica of Oppian, which dealt with hunting, kept to the form of the ancient models. In art, manuscripts on mythography and other subjects were more and more frequently decorated with mythological scenes. These scenes were used to ornament luxury articles such as the

267

266. LATE BYZANTINE. Christ Pantocrator. Large figure enamelled on bronze. 13th century. *Palazzo Venezia, Rome.*

ivory caskets. They found their way into religious works as well, as for example the Homilies of St Gregory of Nazianzus. Miniaturists illustrating the Old and New Testaments found models among works dating from the early centuries of Christianity where pictorial compositions set allegorical figures against rich architectural and landscape backgrounds. These miniaturists also attempted, more or less successfully, to recapture the graceful and animated forms and the supple and delicate modelling that they found in those works. Among the finest examples of the manuscripts of this 'Macedonian renaissance' are the Psalter from the Bibliothèque Nationale, Paris, the Joshua Roll in the Vatican, and the Gospels belonging to the monastery of Stavronikita on Mount Athos.

Contact was made through the manuscripts with classical and Christian antiquity. This contact was enhanced when painters made direct copies, and it partly explains the difference in style between the miniatures of the 10th and 11th centuries, with their classicising form, and the monumental art of the same period. Other and more profound causes of this difference lie in the meaning and purpose of this monumental art.

The religious crisis that Byzantium had just passed through had been as grave as the political crisis. For more than a hundred years the iconoclastic quarrels had caused confusion in the capital and the provinces. Even after the final triumph of the supporters of images in 843, celebrated by the Church as the triumph of orthodoxy, feelings were still not entirely appeased. The opponents of images remained strong, and new measures were taken against them in 861. Religious painting, banished from the churches, only returned very gradually and at the beginning, it would seem, tentatively.

The long struggle which resulted between the opponents and the supporters of religious art caused those in favour of using the image to state very precisely its significance and its role within the Church. They held that scenes painted on the wall of a church would help those who were illiterate to understand what they could not read about, and that such pictures were just as useful to those who could read, for the sense of sight was swifter and more direct in comprehension, and the human mind would therefore arrive more readily at an understanding of 'what Jesus Christ had done and suffered for us'. These ideas had already been expressed in previous centuries. The fathers of the seventh council held at Nicaea in 787 had gone even further: they considered that the sight of images of Christ, the Virgin and the saints would contribute to the piety of the faithful, and that, by recalling those represented, these images 'could lead us to participate in some measure in their sanctity'. The sanctifying power resided in the resemblance which existed, and should exist, between the image and the person represented. The discussions which hinged on the veneration of images resulted in a further clarification of these ideas. 'The honour accorded to the image,' one reads in the decisions of the council, 'is accorded to that which the image represents. Whoever venerates an image venerates the person who is therein represented.' There is a mental identification of the image and its prototype, to which the image serves as a visible intermediary. This enables the faithful to grow in spiritual understanding, even though there can never be any identity of substance between image and prototype.

These ideas were spread within the Church and were defended by her, and they could not have failed to exercise an influence on the style and the character of religious art, especially when, in the form of icons, reliquaries and mural paintings, this art was directly exposed to the veneration and to the devotion of the faithful. This, in our opinion, must have been one of the principal causes of the stylistic differences to be seen between these representations and those of the manuscripts which were

267. LATE BYZANTINE. Miniature from the Therica of Nicander, a treatise on the healing of snake bites. 11th century. MS. Suppl. Gr. 247. *Bibliothèque Nationale, Paris.*

268. LATE BYZANTINE. St Mark the Evangelist. Miniature from the Four Gospels of the Stavronikita monastery on Mount Athos. 10th century. The return to the style of the earliest Christian miniatures is here particularly striking.

269. LATE BYZANTINE. The Martyrdom of St Boethazatus and his Companions. Miniature by the painter Simon for the Menologion of Basil II. 11th century. *Vatican Library*.

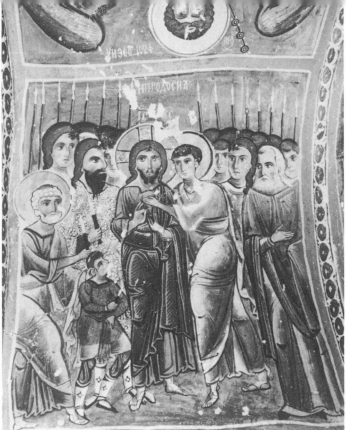

270. LATE BYZANTINE. The Betrayal. Fresco from the church of Qaranleq Kilisse (Cappadocia). Second half of the 11th century.

inspired by antiquity. Pagan allegories, picturesque land-scapes and domestic details enlivened the miniatures of the manuscripts intended for personal use and even for use in the churches, but such scenes would have been out of place on the walls of a church or on articles intended for use as aids to worship.

Architecture and official art

In this homogeneous Byzantine state that developed from the 9th century onwards, art too acquired a more homogeneous character. Regional differences still existed, and these were especially marked in the architecture of the Greek churches, which are clearly distinguishable from those of the capital. It is more difficult to discern and define the differences in painting during this period. Surviving examples in Constantinople are too few for valid conclusions to be drawn as a result of any comparison with works carried out in other towns within the Empire. Attempts have been made to classify the manuscript paintings, but the relatively limited number of which the provenance is known leaves too wide a margin for guesswork. The diffusion of art from the capital tended more and more towards creating a common artistic idiom. This applies to the cave churches in Cappadocia, where differences between paintings of an archaic character and later works may be explained less by the evolution of art forms in Cappadocia than by the penetration of models from Constantinople.

In attempting to analyse the characteristics of the Byzantine style, reference is made as often as possible to the productions of the capital, which have become far better known in recent years. When such works are lacking, then consideration must be given to those which seem best to reflect the official art of Byzantium.

Throughout the period discussed in this chapter the central space in a typical Byzantine church was covered by a dome. The plan of a cross in a square or rectangle is visible on the outside in the vaults that buttress the dome. The dome sometimes rests on angle squinches and nearly covers the full width of the church, as at Daphni and other Greek churches. In Constantinople itself, architects preferred the more scientific method of the dome on true pendentives which rise above the central square in front of the apse. Such a construction required fewer points of support and gave the fullest value to the internal space. The wish to give unity to the interior, and a marked preference for light forms and for slender proportions, were to become more and more characteristic in the work of the Byzantine architects. They led to the elegant churches of the 14th century, among which the Church of the Holy Apostles at Salonica is one of the finest examples.

This type was constant though it varied in certain details, such as the form of the apse, the number and position of secondary domes and the addition of one or two narthexes. This uniformity may be explained partly by the symbolic sense given to the architectural arrangement of the church. This symbolism, already set forth in a Syriac *sugitta* (canticle) of the 6th century, was augmented from century to century by Greek writers, who, it would appear, took pleasure in its repetition and in its amplification. As has been mentioned in Chapter 1, the church symbolises the visible world, which it reproduces in a cubical form, whereas the dome that covers it represents the vault of heaven.

The architects did not search for new forms, for the one they used corresponded to this symbolism and was moreover well suited to the requirements of the liturgical ceremonies. The modifications which they did introduce related to secondary elements and did not demand solutions to new structural problems. As a result, the Byzantine architecture which we are now considering differed profoundly from that of the period during which the innovations of architects had given birth to the masterpiece of Sta Sophia. It also differed from the art of other Christian countries in the East, such as Georgia and more especially Armenia. The architects of those countries continued to erect domed churches, but they employed a great variety of plans—trefoil, quatrefoil, octagonal and circular; and from about the end of the 10th century they began to explore new possibilities. They found new solutions to their architectural problems. In order to support the stone vaulting they found a means of transferring the weight by intersecting arches and by arches used in ways which anticipated the methods developed in western

139

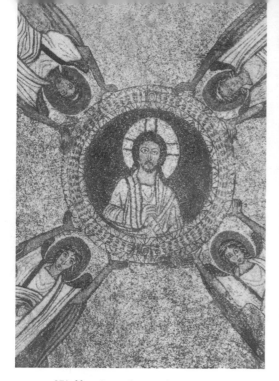

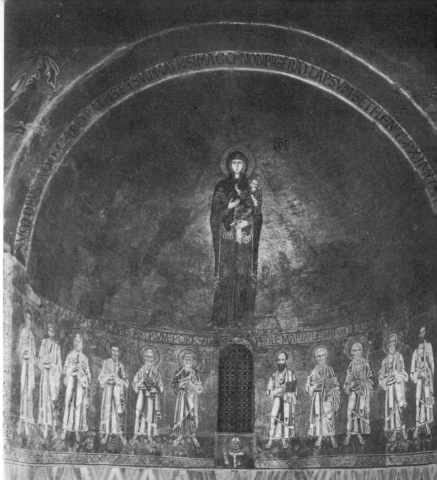

271. Mosaic on the pendentive of the chapel of St Zeno, at Sta Prasseda, Rome. Beginning of the 9th century.

273. St Barbatianus. Mosaic from the cathedral known as the Basilica Ursiana at Ravenna. Beginning of the 12th century. *Archiepiscopal Museum, Ravenna.*

272. Mosaic in the apse of Torcello cathedral, Venice. Beginning of the 11th century.

BYZANTINE ART IN ITALY

Byzantine art took the place of the classical tradition in Italy. In the capital, Rome, this classical tradition remained strongly resistant to the new aesthetic, and ultimately re-emerged in a 'renaissance'. The influence of Byzantine art was, however, very powerful in Ravenna, which was the capital of the Exarchate from 568 to 752, and also in Venice which, after Torcello had been abandoned, became the great maritime and commercial centre between West and East. Finally there was Sicily, which had been connected with Greece since antiquity, and which remained under the rule of Byzantium for three centuries after 535. Sicily became even more Orientalised by the Mohammedan conquest. Eventually the Norman kings overcame the Mohammedans and then continued the tradition of a composite style strongly coloured by Byzantium.

274. Mosaic in the dome of the chapel of the Martorana, Palermo. 1143.

275. The Seventh Day of the Creation: God resting. Mosaic in the nave of Monreale cathedral. Second half of the 12th century.

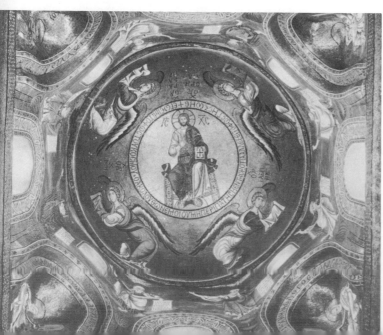

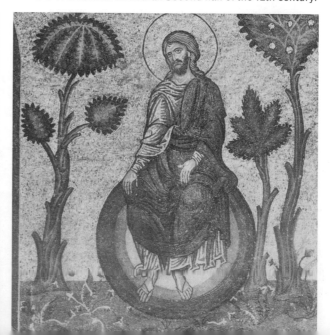

Europe during the Gothic period.

9, 280 The stone churches of Georgia and Armenia also differ in their external appearance from the buildings in the regions which were within the Byzantine Empire. In these churches sculpture occupied an important place. Rich bands of interlace or scrolls surrounded doors and windows, spread over the cornices, round the drum of the dome and round the blind arcades. Figure sculptures decorated the tympana and the walls of the façades. They were also introduced on the columns of the blind arcades. The early 10th-century Armenian church of Achthamar is unique in that the whole surface of the external walls was covered with a multitude of figures, biblical scenes, and animal and plant forms.

 On the other hand, on the façades of Byzantine churches built in brick and stone, figure sculpture was very exceptional. Where it did occur, in such rare examples as the
276 Little Metropole Cathedral in Athens, it was not related to the architecture, and consisted only of marble reliefs which were simply inserted into the façade. In place of sculptural decorations, the Byzantine architects preferred
281 effects of colour produced by alternating bands of brick and stone which were separated by a thick bed of mortar, or by using areas of stone surrounded by brick. They also designed geometric decoration across the flat surface or set the bricks at an angle so as to make stripes of serrated decoration along cornices and round windows. Marble, which heightened the polychrome effect, was often used as inlay, but most of this has disappeared. The decoration in general was restrained, and this intentional restraint contrasted with the richness and brilliance of the interiors.

 There again, the emphasis was on colour, and it was obtained by using precious materials. Slabs of marble and porphyry covered the walls as high as the springing of the arches, and they have survived in the church of St Luke of Stiris in Phocis, where their brilliance harmonises with the rich mosaics on a gold background. Multicoloured marbles covering the floor were arranged in geometric patterns, into which were sometimes set representations of animals or mythological scenes, as for example on the beautiful marble floor recently uncovered in the Church of the Pantocrator at Constantinople. Colour effects were even sought in some sculptural decoration. The technique that has been called 'champlevé sculpture' consisted in filling with crushed marble and wax the parts of the ground which had been cut away from the ornamental motifs. This technique, however, was not used on the slabs of the parapets nor on those of the chancel, which were decorated with animal, floral and geometric themes. Nor was it used in the low reliefs of figures, those large
304 stone icons on which the Virgin, the archangels and the saints were represented, and of which the best examples were modelled with superlative skill.

The symbolism of the iconography

Artists and those who determined the church decoration directed their attention particularly to the mosaics and frescoes on the dome, the vaults, the apse and the parts of the walls above the marble inlay. In those schemes which were formed or were already in use immediately after the iconoclastic period, the images did not have a specifically didactic purpose. Only the backward-looking and provincial painters, such as those in Cappadocia,
270 continued for some time to decorate church walls with scenes from the life of Christ. In Byzantium and the

276. LATE BYZANTINE. Little Metropole Cathedral, Athens. 12th century. The exterior decoration includes relief sculptures, which were sometimes taken from buildings of antiquity.

277. LATE BYZANTINE. St Nagoricavi (Yugoslavia).

278. LATE BYZANTINE. Church of the Holy Apostles, Salonica. 14th century. The small domes raised on drums contribute to the general feeling of elegance.

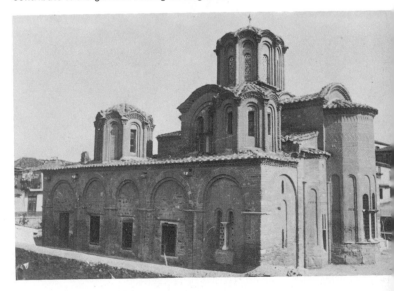

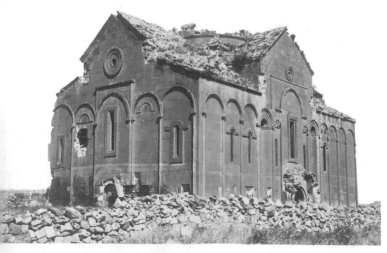

279. ARMENIAN. Ruins of the cathedral of Ani. 989–1001.

281. *Below*. LATE BYZANTINE. The church of the SS Theodore at Mistra (Peloponnese). End of the 13th century. The alternating bands of brick and of stone give a coloured decoration to the exterior of this church.

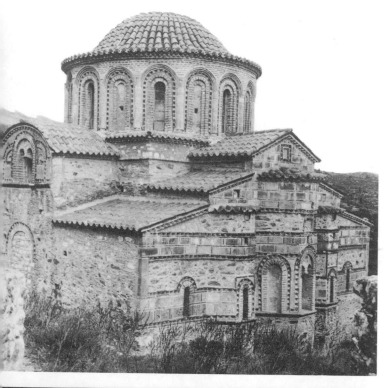

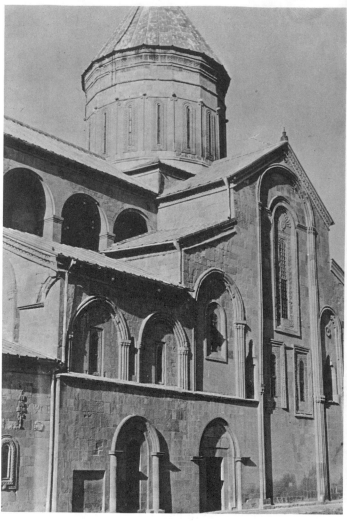

280. GEORGIAN. The cathedral of Mtskhet, the old capital of Georgia. 15th century.

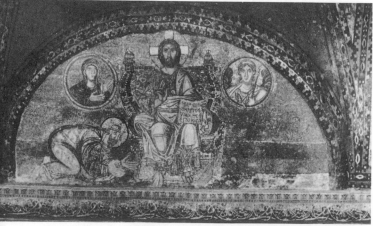

282. LATE BYZANTINE. Mosaic in the lunette above the entrance to the narthex, Sta Sophia, Constantinople: Leo VI prostrating himself at the feet of Christ. 9th century.

countries under her direct influence, images were to have another significance. They were to be an expression of the faith. In their selection and their placing they were to form a pictorial commentary on the liturgy and on the symbolism of the liturgy, and at the same time to rhyme with the symbolism of the architectural arrangement of the church itself.

According to one of these symbolic interpretations, the church, which is the temple of God, represents that heaven on earth where the God of heaven dwells and acts. It had been 'predicted by the patriarchs, announced by the prophets, founded by the Apostles, consummated by the martyrs and adorned by the bishops'. As far as it is possible to judge from literary sources, the Byzantines at first gave a concrete form to this symbolism by representing these specific groups of witnesses to the Church, but they did not incorporate them into scenes from the Gospels. In the central dome was shown Christ, the image of the invisible God, surrounded by the hosts of heaven. As early as the 4th century St Eusebius had described God as the 'Emperor of Heaven', to whom the arches of the world served as a throne around which the heavenly armies mounted guard. The groups of the prophets, Apostles, martyrs and bishops were depicted on the vaults and on the upper parts of the walls, and to these was added, in the apse, the figure of the Virgin, who was the instrument of the Incarnation, 'more venerated than the cherubim, more glorious than the seraphim, for it was she who had borne everlastingly the Word of God'.

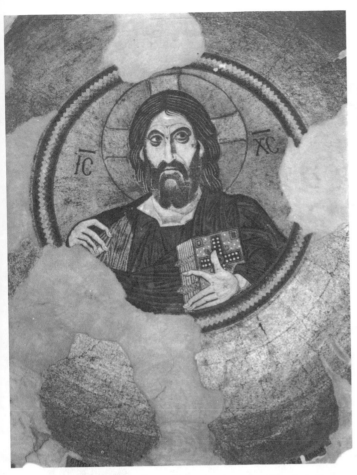

283. LATE BYZANTINE. Christ Pantocrator. Mosaic in the dome of the church at Daphni.

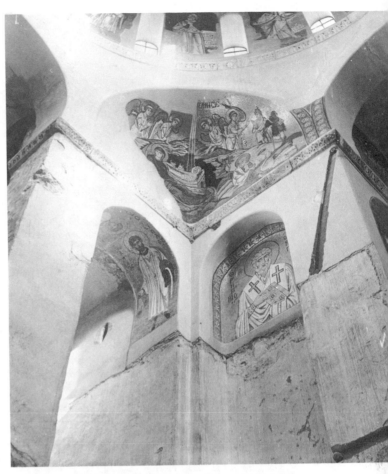

284. LATE BYZANTINE. Interior of the church at Daphni, showing the relation of the mosaic decoration to the architectural form. End of the 11th century.

Such was the decoration of the church described by the patriarch Photius, and which until very recently was erroneously thought to refer to the 'Nea' built by Basil I. Studies show that the sermon was preached in the reign of Basil's predecessor, Michael III, and that it related to a building he erected in the sacred palace.

This type of decoration was of a very restrained character. The scheme of salvation was expressed in a rather abstract manner, through the portraits of those who had prefigured, those who had announced, and those who had established the Church, and who, subordinate to the images of Christ in his Godhead, of the angels and of the Virgin, completed the representation of the Christian universe. Such a scheme was addressed above all to the intelligence. According to the supporters of images, these portraits were faithful replicas of their prototypes, and were therefore imprinted with the nobility and dignity inherent in their sacred character. This is the view that may be taken of the extant mosaics of the 9th and 10th centuries in the church of Sta Sophia. In a room above the south-west entrance Christ in Majesty is shown over the doorway with the Emperor prostrating himself at his feet; and in a tympanum on the north wall of the nave the bishops are portrayed. Comparing these, one may note the individualised features of the heads of the bishops, and the more generalised and idealised features which raise the sacred figures above ordinary humanity and make them the true heirs of Christ.

A second scheme of decoration, which was favoured by Byzantine artists and generally adopted by those who

followed their example, was to present the history of man's salvation in a more easily understood form. To the groups of figures which have just been described were added such scenes from the life of Christ and from the life of the Virgin as were especially closely connected with the Incarnation, the Passion and the Resurrection, as these were repeated and sacramentally renewed by each day's liturgy. The direct relation to the liturgy is clearly apparent in the scene showing the institution of the Eucharist which decorated the wall of the apse in a number of churches. Behind the altar where the priest celebrates and where the Eucharistic species are consecrated was the image of Christ, 'at one and the same time the priest and the victim of the sacrifice', who, accompanied by angels acting as his deacons, gives the bread and the wine of the Communion to his Apostles.

The existence of this 'liturgical cycle' in the 11th century is attested by a number of large groups of mural decorations—for example, in St Luke of Stiris in Phocis, in the Nea Moni on the island of Chios, and in the church of Daphni near Athens; it also occurred, outside the limits of the Empire, at Sta Sophia in Kiev. Some of the episodes were constantly repeated because they recalled events essential to the scheme of salvation, the Nativity, the Baptism, the Crucifixion and the Resurrection (the representation of which took the Byzantine form of Christ's Descent into Limbo). The system was not absolutely rigid, and there were variations both in the choice and in the placing of the subjects. For just as the architecture can be interpreted with different symbols attached

282

283, 284

286, 290

143

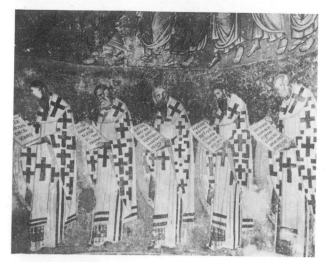

285. LATE BYZANTINE. Detail of fresco in the church at Sopoćani (Yugoslavia): Fathers of the Church. About 1260.

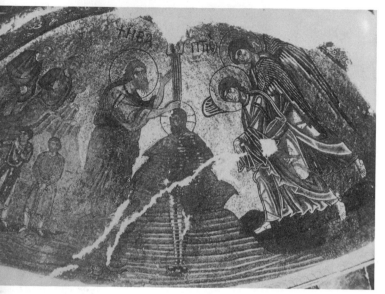

286. LATE BYZANTINE. Mosaic in the Nea Moni on the island of Chios: Baptism of Christ. 11th century.

287. BYZANTINE TRADITION. Mosaic from the doorway of the Umayyad mosque at Damascus. Beginning of the 8th century.

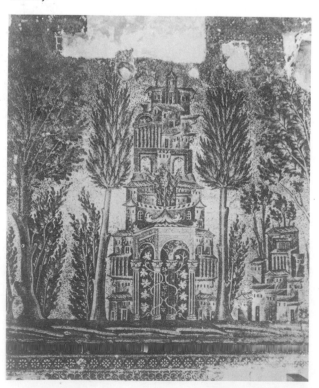

to each part of the building, so more than one episode from the life of Christ could be considered as the iconographic pendant to one or other part of the liturgy.

The style of the 11th-century mosaics

The mosaics of these churches reflect the characteristic features of the monumental art of the time and also the distinctive characteristics of each building. The taste and feeling for colour are clearly shown in these mosaics which scintillate in the light. The Byzantine artist aimed at rich colour rather than at rendering the exact shades of objects or of landscape elements. At St Luke the colour was reticent, at Daphni subtle, and at the Nea Moni it took on great expressive power. The mosaic artists of the Nea Moni delighted in daring effects, in contrasting vivid 286 colours and in using strong light and shade on the faces.

One may observe the skill, in different degrees, with which the mosaic artists adapted both single figures and groups to the architectural framework within which they worked. In the drum of the dome and on the arches were placed full-length standing figures, in the lunettes half-length figures, and in the spaces between the groins and on the summits of the arches busts enclosed in medallions. This sort of arrangement was carried furthest at Daphni. 284 In spite of the apparent simplicity of the compositions, which are for the most part symmetrical, the subtle arrangement of the figures is very skilfully handled, and so too are the balance of the masses and the relation of figures to the empty space; even the inscribed titles of the subjects are inserted in such a way that they unite and complete the lines of the composition. At St Luke the figures are aligned in almost identical poses, and there is no direct relationship between them even when they touch one another. At Daphni the poses are varied, and by the direction of the eyes, by the attitudes and by the general lines of the compositions a complete unity is achieved in each scene.

A grave detachment confers dignity on the heads of the 175 saints and on the whole evangelical cycle at Daphni. In St Luke, and to a lesser extent in the Nea Moni on the 286 island of Chios, the schematised draperies with their crisp folds create a rhythm, though at the same time they stress a severity, in the poses. Life is concentrated in the penetrating gaze of the characters in the Gospel narrative and of the visionary ascetics and monks, who are particularly numerous at St Luke. At Daphni, on the other hand, the forms have become more supple, and there is nothing that jars in the poses or expressions of these noble figures. For example, in the Crucifixion suffering and emotion are 290 discreetly indicated by the slightly frowning eyebrows of the Virgin and St John, by the scarcely emphasised gesture of their hands and by the slight flexing of the body of Christ. The dead Christ has replaced the open-eyed and erect figure of the Triumphant Christ of the early Church, but the Byzantine artist did not wish to convey the brutal image of anguish and death. The blood gushes forth in a graceful curve and recalls, rather than relates, the thrust of the spear which is not itself represented. All episodic detail was omitted from these compositions, with the exception of scenes of the childhood of Mary; they were placed in the undefined surroundings of the gold background, and exist outside time and space, as do the intelligible truths of which they are a visual representa- 283 tion.

The art of Daphni, which was an Imperial foundation

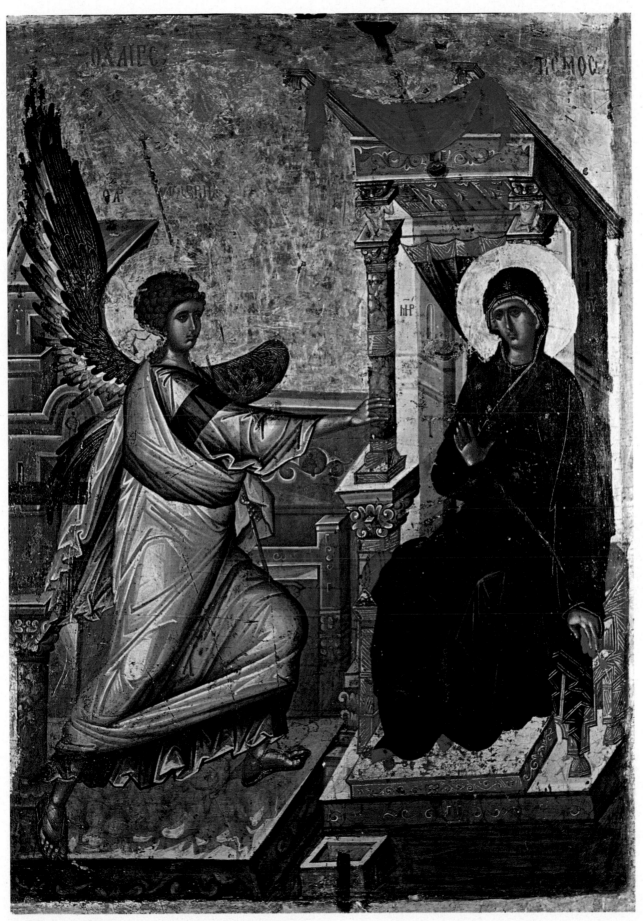

BYZANTINE. The Annunciation. Icon from the church of St
Clement, Ochrid. Early 14th century. *Macedonian State
Collections, Skopje. Photo: M. Hirmer.*

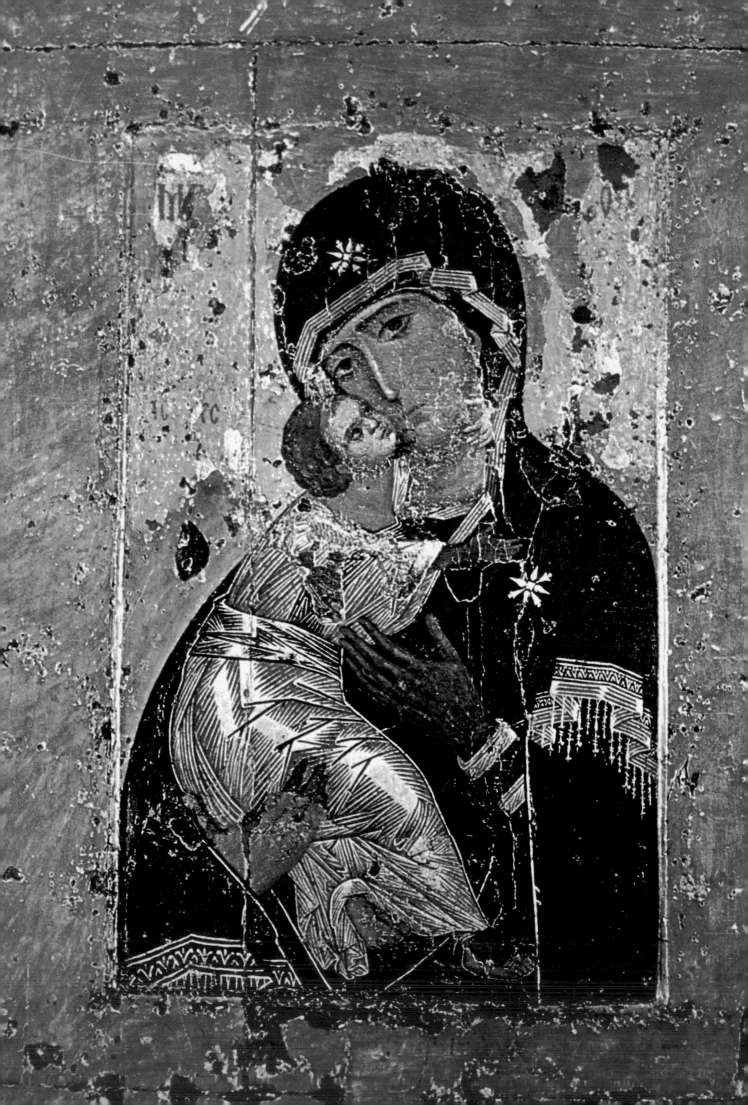

of the later 11th century, reflected the art of the capital. The image of the Virgin is in a direct line of descent from the Virgin who stands between Constantine and Justinian over the south entrance to Sta Sophia, where one Emperor offers her a model of the town of Constantinople and the other a model of the church of Sta Sophia. In spite of differences in material and technique, the tradition and inspiration of the mosaics at Daphni are closely linked to a whole series of small-scale works which are indisputably of Constantinopolitan origin.

The manuscripts of Constantinople

Many splendid works bear witness to the great activity of the studios in Constantinople throughout this period. There had been no break in this activity, for the iconoclastic Emperors, in particular Constantine V and Theophilus, had surrounded themselves with dazzling luxury. Profane subjects held an important place among the mosaics decorating palaces and churches, on the rich textiles and on the work of the goldsmiths. It was to be the same with the manuscripts, and examples of an iconic decoration have often been attributed to the iconoclastic period. After the triumph of orthodoxy decorations continued to enrich the manuscripts which were splendid and varied. Sometimes little scenes from everyday life, hunting and circus scenes, were added to the plant and animal patterns. These reflect the monumental examples of the pagan art of the period, which have entirely disappeared in Byzantium itself. Beyond the limits of the Empire, however, more important groups of princely art have been preserved, such as the frescoes over one of the staircases in Sta Sophia in Kiev which depict sports in the hippodrome taking place in the presence of the Imperial court.

The immense vogue for books was due mainly to the renewal of religious painting. Sacred and liturgical books, homilies, menologies (calendars with biographies of saints) and other didactic works were magnificently illustrated. Portraits of sovereigns, of the nobility and of the superiors of the monasteries decorated the lavish works which were written for them. Sometimes these portraits were the only illustration to a manuscript, as in the case of the Homilies of St John Chrysostom, written for the Emperor Nicephorus Botaniates.

It is scarcely possible, in the limited space at our disposal, to follow the many artistic currents which may be distinguished in the manuscripts. Even those from Constantinople itself reveal many trends, in consequence of the numerous artistic circles existing side by side in the cosmopolitan capital. These variations were particularly marked immediately after the iconoclastic period when, it would seem, models of different types and coming from different places were used, wherever examples could be found that had escaped the destructive fury of the iconoclasts. This may be seen in the copy of the Homilies of Gregory of Nazianzus which was illustrated for Basil I. Little by little, certain qualities became more clearly defined, in particular the antique character. Imitations were made, sometimes from picturesque compositions which stemmed from Hellenistic art, sometimes from more restrained compositions which go back even

RUSSIAN. The Virgin of Vladimir. Icon of the 14th century. *Tretiakoff Gallery, Moscow.*

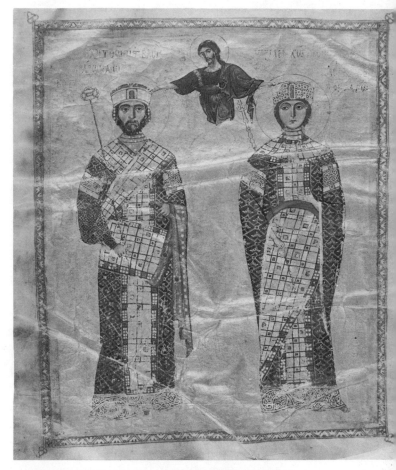

288. LATE BYZANTINE. Miniature from a manuscript of the Homilies of St John Chrysostom, written for the Emperor Nicephorus Botaniates (1078–1081). MS. Coislin 79. *Bibliothèque Nationale, Paris.*

289. LATE BYZANTINE. Fresco from the stairway of Sta Sophia, Kiev. 11th century. These scenes of sport give some idea of the great secular paintings of Byzantine times.

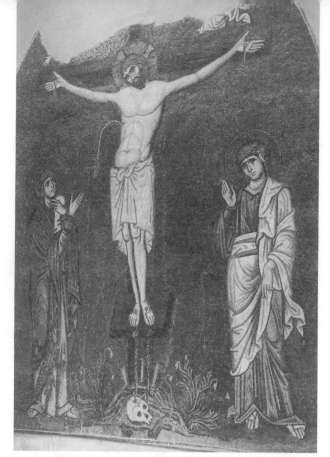

290. LATE BYZANTINE. The Crucifixion. Mosaic in the church at Daphni. End of the 11th century.

291. LATE BYZANTINE. The convent of Sta Sophia, Mistra.

further, and sometimes from the sculptural poses of philosophers and poets, which were to be repeated in the portraits of prophets and evangelists. All these works, 268 even including those which are on a very small scale, were monumental in conception. They were drawn on a gold background, frequently producing the same impression as the mosaics, and the brilliance of their colouring parallels that of the enamels.

The techniques of the goldsmiths and enamellers had 266, 30 reached perfection. In St Mark's, Venice, there are two icons of St Michael in gold and enamel which show the complete mastery of the goldsmiths who were able to combine the two techniques with brilliance and ease.

In the West their works were highly prized, and the finest surviving examples include, in addition to the two icons just mentioned, the Limburg reliquary, the Pala 307, 30 d'Oro of Venice and the crowns of Hungary. These and other objects were sent as presents by the Byzantine Emperors, or were bought in Constantinople, or were carried off by the crusaders after the fall and sack of the city. Enamels thus imported into western Europe were imitated there, especially in Germany and Italy, and these works, too, contributed to the brilliance of Byzantine art.

Other artistic activities of the period must not be ignored. There were icons which were either painted or made up of minute mosaic tesserae set in a foundation of wax; as well as carved ivories, engraved stones and figured 300–30 textiles. Oriental influences affected many of these objects, as well as the patterns on the textiles. Some themes were survivals from Sassanian art, while others came more 29, 30 directly from Mohammedan sources.

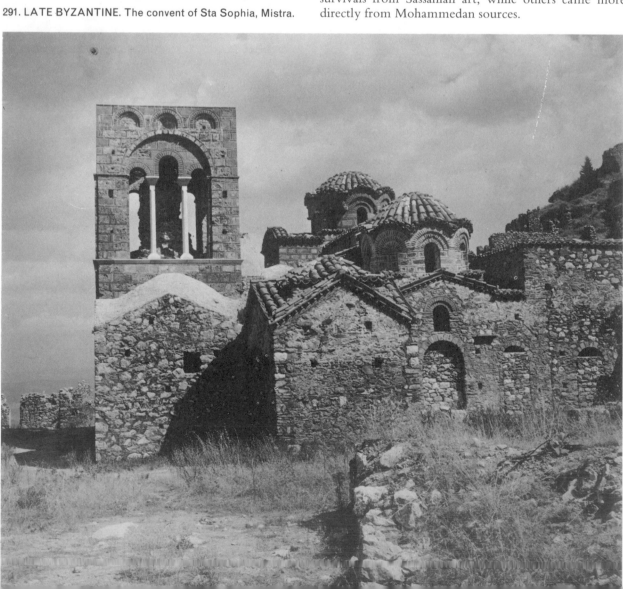

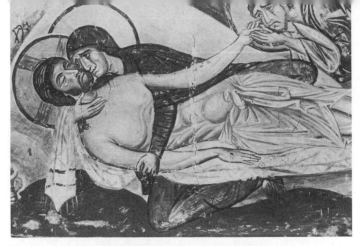

292. LATE BYZANTINE. Detail from a fresco (1164) in the church at Nerez: the Descent from the Cross.

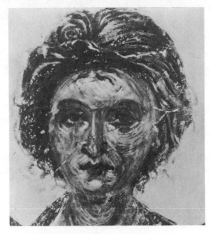

293. LATE BYZANTINE. Portrait of St Pantaleimon. Detail of a fresco (1164) in the church at Nerez, Macedonia (Yugoslavia).

THE END OF THE EMPIRE

Comnene art and the new spirit

The noble detachment of the mosaics at Daphni tended to disappear with the coming of the 12th century. The same tendency may be observed in many works belonging to the minor arts, but had disappeared earlier from those less subtle works intended for popular devotion. The writings of the time prepared the way. Earlier, hymns and liturgical chants had movingly described the sorrows of the Virgin; and sermons were composed that stressed her suffering 'which passed beyond words'. In the late 10th century and the early 11th, Symeon Metaphrastes, the great Byzantine mystic, considerably influenced religious thought by his writings. His hymns were filled with a deep personal love for Christ, and insisted on His humility in the face of suffering and on His charity; they help us to understand the images which were soon to be created of a compassionate Christ and of the Virgin who is shown full of tenderness and grief in such icons as the Virgin of Vladimir, sent from Byzantium to Russia early in the 12th century.

The writing of new commentaries on the liturgy may have given a further impetus to the extension of the evangelical cycle which began in the 12th century and achieved its full development in the time of the Palaeologues. Theodorus Studita and others had already taught that the Mass represented the whole scheme of salvation. In the 11th century Theodore of Andida took up this theme again, but with far more force, and he expressed it in a more precise manner. 'Those who exercise the priesthood,' he wrote, 'know and understand that what takes place in the liturgy is in the pattern of the Passion, of the Entombment and of the Resurrection of Christ. But I do not believe that they know that the liturgy also recalls the events subsidiary to the coming of the Saviour, and to the scheme of salvation—firstly, His Conception and Birth and the first thirty years of His life, then the ministry of His precursor and His manifestation at the Baptism, the Calling of the Apostles and the three years of miracles which prepared the way to the Cross.' Nicolaus Cabasilas developed this same thought later in the 14th century, and he examined the concordance between the Mass and the Gospel narrative.

As a result of these writings, and of technical changes such as the use of fresco which was less costly than mosaic, as well as the disappearance of marble inlay, the walls were entirely covered by an evangelical cycle which grew more and more extensive. Other scenes of a religious character were also added.

The new style may be seen in the Macedonian church of Nerez in Yugoslavia, founded in 1164 by a member of the Comnene family. Only a few scenes of the Passion were added to the liturgical cycle of the 10th and 11th centuries. These were charged with deep tenderness and poignant emotion. In the Descent from the Cross, the Virgin caresses Christ's cheek with her own, and St John kisses the lifeless hand of his Master. In the Lamentation over the Dead Christ, the tear-stained Virgin embraces the body of her Son. These scenes mark an important stage in the development of medieval painting. The painter was able to express realistically the difference between the face of the dead Christ, which had become hollow with suffering, and the grief-stricken face of the Virgin, which was swollen by tears. In some scenes, the unobtrusive inclusion of details from daily life shows the direct observation of the artist. This power of observation is to be seen too in the heads of the saints with their individualised features and their penetrating gazes. Highlights form ridges across the cheeks and pick out the cheekbones; deep shadows surround the eyes and accentuate the features, and this linear schematisation seems to strengthen the expressive quality of these paintings.

A desire to give individual character to the types which had been established by a long tradition can be seen in the beautiful heads of the Apostles which were painted in the church of St Demetrius at Vladimir by Greek masters who had come to Russia towards the end of the 12th century. A melancholy tenderness may be read in the features of these Apostles and of the angels who are included in the composition of the Last Judgment.

In Constantinople itself, the only extant examples of painting and mosaic which can be ascribed with certainty to this brilliant period of the Comnenes are the portraits in the south gallery of Sta Sophia. These show John II Comnenos and the Empress Irene standing on either side of the Virgin, and, in the neighbouring panel, their young son Alexis. Comparison with the mosaics of Zoë and of Constantine Monomachus shows clearly the features which distinguish the portraits of the 12th century from those of the 11th. However, the great importance of the Comnene period in the history of medieval painting is most clearly shown in the paintings at Nerez and at St Demetrius, to which should be added the mosaics at Cefalù in Sicily, which were also executed by Byzantine artists. In these works new tendencies revealed themselves at an earlier date than in the West. These included a closer observation of reality and of life, and a more personal

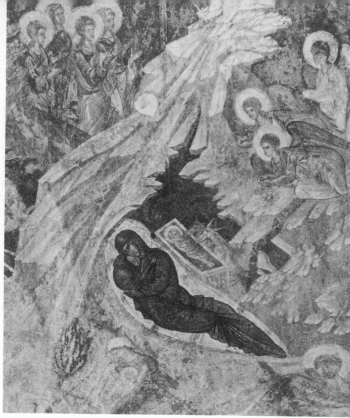

294. LATE BYZANTINE. Fresco in the Church of the Peribleptos, Mistra. The Incredulity of Thomas. Second half of the 14th century.

295. LATE BYZANTINE. Fresco in the Church of the Peribleptos, Mistra. The Nativity (detail). Second half of the 14th century.

interpretation which aimed at a greater emotional expression of sorrow and of tenderness.

Even now, very little is known about the art of this period, and it is to be hoped that further discoveries may add to the relatively few works at present known. Some paintings in the town of Kastoria, in Greece, appear to date from the 12th century and show that the art of the Comnenes had penetrated into the Byzantine provinces. Further research may, perhaps, define more clearly the relationship between this period and that of the Palaeologues. It seems, in fact, that what is called the 'Palaeologue Renaissance' was in many respects a continuation of the artistic movement begun in the 12th century, which was interrupted, or at least retarded, in the capital itself by the Latin conquest and occupation. This movement was to develop more broadly in the 13th century in the churches of Bulgaria and Yugoslavia. Perhaps one should recognise the influence of Serbian artists in the realism which sometimes characterises the scenes, as in the Crucifixion and the Descent into Limbo at Sopoćani. Perhaps, also, Western elements were not entirely absent from Balkan works. However, in general the frescoes of Bačkovo and Boiana in Bulgaria, and those of Milesevo, Sopoćani, Arilje and other 13th-century churches in Yugoslavia reveal the development of the Byzantine tradition. A comparison between these works and those of the 14th century will make two points clear. Firstly, there was a continuity of the artistic tradition which began in the Comnene period and ended in that of the Palaeologues; and secondly, there is a difference between the paintings of the 14th century, which introduced new elements into monumental art, and those which had preceded them.

The Palaeologue Renaissance

The Empire of the Palaeologues, though diminished in size and impoverished, and in spite of internal strife and dangerous outside threats from all directions, nevertheless still showed itself capable of brilliant feats in the intellectual field. The study of classical antiquity was again popular among scholars, and the scientific and philosophic writings of the Byzantines and the works of the philologists prepared the way for the humanism of the Italian Renaissance. Artistic developments were equally important. Fortunately it is possible with this period to study works of the first importance which have been preserved at Constantinople and Salonica, instead of merely following isolated examples on monuments in provincial and foreign centres. Conclusions usually drawn about Byzantine art would almost certainly be quite different were they founded on the buildings decorated for the Emperors and for the secular and ecclesiastical nobility, and if in addition to examples of religious art we could have seen and studied the sumptuous art of the Imperial palaces.

It has already been mentioned that from the 12th century onwards the evangelical cycle developed and new themes were introduced. The painters represented the life of Christ in great detail. They illustrated the parables and the childhood of the Virgin. They also related the legends of the saints, sometimes by depicting one by one the events in their lives, though more frequently by illustrating only their martyrdom. Sometimes there were portraits of all the saints in the order in which their feasts appeared in the calendar. The liturgy occupied an increasingly important place in the decoration. The psalms were illustrated, and so were the ecclesiastical canticles and the Akathistos hymn composed in honour of the Virgin. New iconographical formulas were added to, or took the place of, the old. In addition to the Communion of the Apostles, the solemn moment of the Processional Entry was shown, when the offerings were brought to the altar, but it was once more Christ who officiated at this divine liturgy, and He was surrounded by a great multitude of angels who carried the objects required for the Eucharistic sacrifice.

294, 295
174

The individual compositions grew ever richer. Subsidiary figures and accessories increased in number. A lively crowd portrayed against a background of landscape or architecture drawn from the artist's imagination took the place of the solemn figures standing out against a uniform background. The figures move swiftly, and this sense of movement is enhanced by the appearance of their garments and veils, which seem to be flying in the wind. Sometimes, however, this device of a flying garment became a simple decorative motif, as at Kahriyeh Djami, where the veil forms a graceful curve above the head of the young servant who gently guides the first steps of the Virgin. Landscape and architecture also took on a decorative character. The jagged contours of rocky mountains rise to sharp points. Draperies wind around columns, or hang on buildings which are complex in form but have no relation with actual constructions. Sometimes the landscape or architecture invades the scene and leaves little free space for the actors in the drama. Details from everyday life were also used to enliven the compositions. At Kahriyeh Djami, children play in the foreground of the scene representing the miracle of the Multiplication of the Loaves and Fishes. They dance on a bridge in the Baptism which is in the Church of the Protaton at Mount Athos. In the Pantanassa of Mistra, while a motley crowd runs in front of Christ to the gates of Jerusalem, the children squabble and throw stones.

From all this it may be seen that the art of the Palaeologues is more narrative than monumental in character. Both in the Church of the Holy Apostles at Salonica and at Kahriyeh Djami, each scene is separate and at the same time perfectly adapted to the architectural framework. In most of the churches decorated with frescoes, however, the scenes follow one another as on a scroll and are placed in rows one above the other, so as to cover the walls completely. This art of the 14th century is more human, and aims to touch us by an expression of love rather than to move us by depicting pain. Nevertheless, scenes of the Passion continued to be painted. Also, in pictures of the Last Judgment, the artists have enumerated the torments of hell, but dramatic emphasis tends to be lacking and the feeling is rather one of melancholy.

Tenderness is expressed in the series of the life of the Virgin, which became a favourite theme with the painters and mosaic artists of the Palaeologue period. It is most gracefully and touchingly interpreted in the mosaics of Kahriyeh Djami. This new expression of tenderness is also to be found in the faces of the saints, and especially in those of the Virgin and of Christ. The impassive and majestic Christ of the narthex of Sta Sophia and the severe Pantocrator in the dome at Daphni gave place to a merciful and compassionate Christ whose expression seems sad. This type had already appeared in the 13th-century church of Boiana in Bulgaria, on a portable icon, and in the crypt of St Demetrius at Salonica. Beautiful works of the Palaeologue period have been preserved at Kahriyeh Djami, at the Pammakaristos, and particularly in the Deesis in the south gallery at Sta Sophia, which in our view must be attributed to this period.

These images express a subtle yet profound religious feeling. It is to be seen again in the paintings of the *parecclesion* (side chapel) of Kahriyeh Djami, especially in the Descent into Limbo which decorates the apse. Few examples equal the beauty and nobility of the luminous figure of Christ, shining in the brilliance of His white

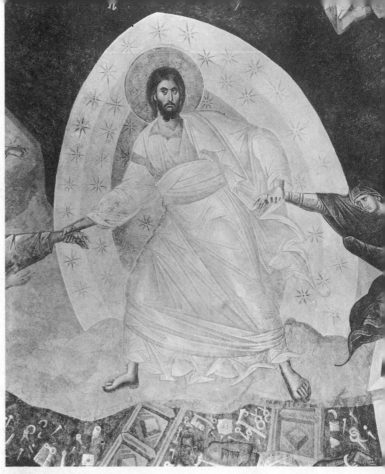

296. LATE BYZANTINE. Central part of the Descent into Limbo. Fresco in the apse of the *parecclesion* of Kariyeh Djami, Constantinople. 14th century.

297. LATE BYZANTINE. Head of Christ. Detail from the Descent into Limbo. Fresco in the *parecclesion* of Kariyeh Djami, Constantinople. 14th century.

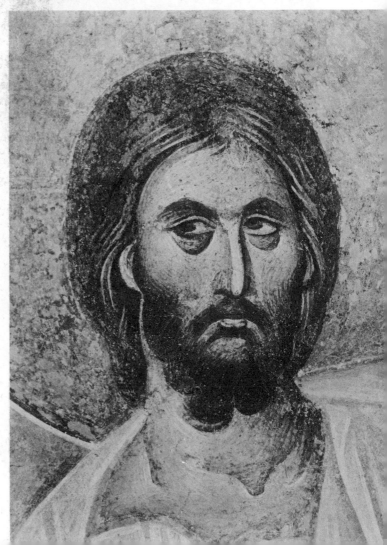

draperies, and surrounded by a blue star-studded aureole. The spirited treatment of Eve and especially of Adam, whom the Saviour raises by the hand from their tombs, the expression of the faces and the groups of the kings and the prophets arranged harmoniously on either side, make this composition one of the undisputed masterpieces of religious painting. At the time of writing, the frescoes in the *parecclesion* are still being cleaned, but a comparison between the parts that are now visible and the mosaics of the two narthexes would seem to suggest that they were executed by the same workshop. The artists who painted picturesque and familiar scenes with so much delicacy and grace were equally capable of creating religious scenes of real grandeur.

The limits of the revival

The art of the final phase of Byzantium, in spite of its beauty and its undeniable technical mastery, did not show the development that one might have expected after the experiences and successes of works produced in the 12th

298. LATE BYZANTINE. Interior of St Mark's, Venice. End of the 11th century.

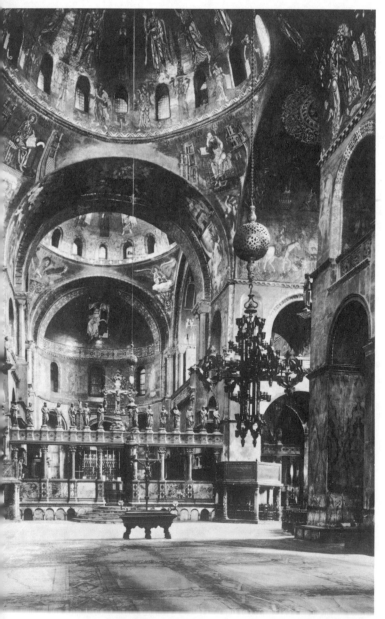

and 13th centuries. The triumph of the Hesychasts, a group of monastic mystics, probably did much to check any realistic tendencies which became apparent. Instead of becoming refreshed by contact with nature, as the artists of the Renaissance were to be, the Byzantine artists turned again towards the past, from which they had never been entirely able to break away.

The past weighed very heavily on the Byzantine artists. This fact should not be unduly exaggerated, nor should every innovation be explained simply by reference to pagan or Christian antiquity. Yet the new themes and compositions which came constantly to enrich the iconographical repertoire were, whenever possible, related by the painters and miniaturists to older themes similar in content. The portraits reveal direct observation of reality, and there are numerous examples in the extant works of the 14th century. Yet, even there, stylisation seems to have tended towards the creation of an ideal form.

The concept of the religious image, the idea of its relation to the person represented and the sacred character of the image itself, have given the finest examples of Byzantine work a permanent appearance deeply impregnated with a sense of noble dignity. As a result of their religious beliefs and their classical heritage, the Byzantines made the human figure the most important element in their compositions. In works that are purely Byzantine the human figure was never geometrically distorted to suit decorative or expressive ends, for it was the human figure which was the visual intermediary and which could raise the spirit above what was individual or immediate towards the supernatural life and the vision of God.

Constantinople fell and the Byzantine Empire was destroyed, but Greek painters continued its traditions in countries more or less distant from the capital. They worked in the monasteries of Mount Athos, where important series of pictures painted in the 16th and 17th centuries have been preserved. They worked, too, in Kastoria and other Greek cities, around Athens, in the Greek islands, in Cyprus and in Crete. Few innovations are to be seen in these works; the old formulas were repeated, and the artists found in *The Painters' Guide*, compiled by a 14th-century monk named Dionysios of Fourna, the principles for the general scheme of decoration and for the iconography of the individual scenes. Western themes made their appearance, but they were adapted to these formulas and to the taste of the Byzantines, as may be seen in such scenes as the Apocalypse, which was inspired by Western engravings.

Under the Palaeologues, and even in the period that followed, Byzantine art continued to shine. Its lessons and its models, which were sometimes carried by Greek artists, were followed in all the neighbouring countries. In Yugoslavia a new current of Byzantine art revived the traditional types, but here, too, realism was in retreat. Theophanes the Greek, a master gifted with a highly personal talent, worked in Russia during the late 14th century and executed powerful work which influenced painting in that country for centuries after his death. Roumanian art was also born during this last period of Byzantium. In the church at Curtea de Arges, the greater part of the series found in the narthex of Kahriyeh Djami was repeated. Painting in Wallachian and Moldavian churches of later centuries was all strongly influenced by the Byzantine tradition.

309

311

HISTORICAL SUMMARY: Late Byzantine art

THE ICONOCLASTIC CRISIS

In the Christian world a veiled hostility towards the use of images went back as far as the council of Elvira, which was held in 306. This hostility never ceased to exist in the East, in Asia, and especially in Syria, where it took on a definite shape in the 8th century. The excessive importance attached to images produced a reaction, which was accompanied by a general flood of superstition. Images were condemned by Leo III the Isaurian in 726 and again by councils held in 753 and 815. An implacable struggle led by the Emperors lasted for one hundred and twenty years.

Architecture. Several of the iconoclastic Emperors were also great builders; the Emperor Theophilus made alterations to the sacred palace, and there was also the palace of Bryos.

The trefoil plan had been formerly used in the Mohammedan East (Egypt and Syria). It was employed for the sacred palace, and in the palace of Bryos for the church consecrated to St Michael. The quatrefoil plan was used in Armenia. This influence persisted until the 12th century in the building of the Imperial palace.

Sculpture. Statues disappeared with the coming of the iconoclastic period; the figure of Christ in the entrance to the Great Palace was destroyed. Decorative sculpture tended towards abstraction and was used on ambos (raised pulpits), chancels and sarcophagi which were enriched with interlace, rosettes and Oriental elements which came from textiles, such as rampant beasts, heraldic eagles and griffons [172].

Painting. Decoration is characterised by a revival of the pictorial quality of antiquity and by genre scenes, but also by a predominance of ornamental motifs from the East. Only a few mosaic fragments remain which may be dated with certainty: at Salonica in St Demetrius, where three medallions, which were inserted when the building was restored, seem to belong to the period of Leo III. In the apse of Sta Sophia at Salonica the decoration is dated to the 8th century by the Monograms of the Emperor Constantine VI and of the Empress Irene, and by the name of the bishop Theophilus.

It was in the art of illumination that persecuted orthodoxy found new outlets. The 'monastic' psalters were remarkable works that first saw the light in the middle of the iconoclastic period, probably in the monastery of Studion during the first half of the 9th century. The Khludov Psalter belonging to the monastery of St Nicholas in Moscow was characterised by a study of expression, careful observation, and a sometimes amusing realism. It was full of verve, freedom and imagination. The

Physiologus was conceived in the same spirit by the monks of the 9th century. These manuscripts were intended for the instruction of the masses, and the works were infused with theological and mystical inspiration.

The minor arts. Certain groups of ivories decorated with secular themes seem to belong to this period. The Pirano casket in Rome is an example.

Consequences of the iconoclastic crisis. Profane art tended to return to the models of antiquity, and was concerned with reality and observation. Religious art, persecuted, acquired fresh creative force, and at the same time came under the influence of the new official art.

When the crisis came to an end, Byzantine art was ripe for the great renaissance of the 9th and 10th centuries.

THE SECOND GOLDEN AGE OF BYZANTINE ART

The renaissance of the Macedonian Emperors (867–1081) and of the Comnenes (1081–1185) followed the iconoclastic period. With the dynasty of the Angeli (1185–1204), the Empire moved towards another crisis caused by the taking of Constantinople by the crusaders, and also towards the coexistence, until 1261, of a Latin Empire and the Empire of Nicaea.

THE MACEDONIAN EMPERORS AND THE COMNENES
(9th-10th centuries)

Under the Macedonian Emperors there were two opposing trends in art—an Imperial art enamoured of classical traditions, fascinated by portraits, by the living model and by realism; and a monastic art more severe, more traditional and more theological. The confluence of these two streams resulted in a wonderful series of masterpieces.

Architecture. The form of the Justinian church was modified. As a result of Armenian and Georgian influence, the accepted plan was the Greek cross inscribed in a square. The idea of balance was reintroduced: piers became lighter and their place was often taken by columns; the interior space was more unified. In addition to the barrel vaults over the arms of the cross and to the four smaller domes over the angles of the square there was the hemispherical canopy of the central dome on a polygonal drum with eight, twelve or sixteen sides.

The appearance of the outside of the church had not been considered of importance during the reign of Justinian, but now architects strove to organise the masses, to arrange the building stone to give the effect of dressed stone [281] and to insert the stones to form patterns (lozenges; Greek ornament). Sometimes

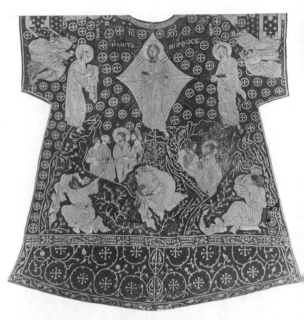

299. LATE BYZANTINE. The Transfiguration. Decoration on a liturgical vestment in silk embroidered with gold and silver, known as the 'Dalmatic of Charlemagne'. 12th–14th centuries. *Vatican Treasury*.

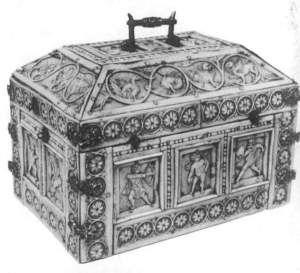

300. LATE BYZANTINE. Ivory casket decorated with rosettes and secular subjects. 10th–11th centuries. *Dumbarton Oaks Collection*.

faience was introduced to give a polychrome effect.

At Constantinople the New Church of Basil I formulated the type of the Greek cross inscribed in a square; the sanctuary had three apses and the narthex often had a pronaos in front of it. This form was used again in the churches of Bodrum Djami (920–941), Kilisse Djami (11th century) and of the Pantocrator (1124) in Constantinople; and in Salonica in the churches of the Theotokos (1028), the Isakie Djami (St Pantaleimon) (12th century) and the Holy Apostles (14th century) [278].

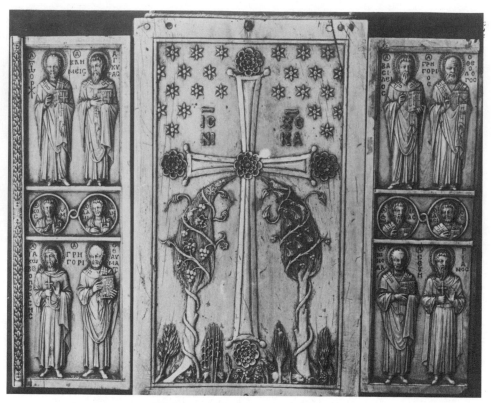

301. LATE BYZANTINE. Reverse of the Harbaville Triptych. Ivory. 10th–11th centuries. *Louvre.*

In Greece the building material was stone, and there were four types of church: 1. A vaulted type with three equal aisles (hall church): Sta Sophia at Ochrid (second quarter of the 11th century). 2. A vaulted type with three unequal aisles: at Kastoria in Macedonia, at Arta in Epirus, and in the monastery of the Blachernae. 3. A church with a single nave, and internally buttressed: frequent in Crete, it is the Tur Abdin type. 4. The inscribed Greek cross, similar to the Armenian types: at Athens, the Little Metropole Cathedral (12th century) [**276**], St Theodora (1049), and the Kapnikarea (12th century), and on Corfu, SS Jason and Josipater.

In Italy the Adriatic and southern regions, which were provinces of Byzantine art, represent the transition between East and West [**298**].

The Italian types were: 1. A single nave with buttresses projecting in the interior, which came from Crete and was used at S. Angelo al Raparo. 2. The inscribed Greek cross: St Mark's, Rossano (11th century), the Cattolica of Stilo (12th century), and St Andrew, Trani. 3. A mixture of Byzantine and Romanesque forms: St Victor, Chierse (inscribed cross with central dome), S. Claudio of Chienti in Ancona (where there was no dome).

The external decoration of these churches was in the earliest Romanesque style.

In Armenia and Georgia the Bagratid dynasty of the 10th and 11th centuries coincided with a brilliant aesthetic renaissance. A sculptural innovation was of the first importance: radiating arches of cut stone meeting at a central keystone support the vault. They were found in Armenia from the close of the 10th century to the 13th century: at Ani, in the Chapel of the Shepherd (second half of the 10th century), and in the entrance to the Church of the Holy Apostles (middle of the 11th century); at Khochavank, in the mausoleum (second half of the 11th century); and at Haghpat, north of Ani, in the entrance to the principal church (about 1180). All the arches of these churches were of considerable span; they were strong, were square or rectangular in section, and were not merely decorative elements. Somewhat similar were the cross-ribs of the cathedrals of Bayeux and Cormery, and the porch at Moissac.

Sculpture. The flat-surfaced champlevé technique, in which the design is worked into a base of dark mastic, again made use of colour, and was employed in architectural sculpture.

Painting. Iconoclasm had played havoc with the iconography. Henceforth the position of mosaics and frescoes was chosen, not for aesthetic reasons, but according to the symbolic meaning which theology gave to each part of the church. The Christ Pantocrator triumphed in the centre of the dome, which represented heaven, while the nave was reserved for scenes from His earthly life, of which the two most important were the Crucifixion and the Resurrection. Saints, monks and martyrs all had their own places allotted to them, even in hidden corners, according to a strict order of precedence, while scenes from the life of the Virgin and figures of the donors appeared in the narthex.

In Greece, the magnificent mosaics in the church of Daphni, near Athens, dating from the late 11th century, make an excellent example of this iconographical distribution [**175, 283, 284, 290**]. The art of St Luke of Stiris in Phocis (11th–12th centuries) is more Oriental in appearance. The Nea Moni on the island of Chios dates from the 11th century [**286**].

In Italy, the frescoes of Castelseprio in Lombardy (see p. 245) may belong to this period. The mosaics in St Mark's, Venice, were begun by Byzantine artists towards the end of the 11th century and were continued by Venetian craftsmen until the 14th century. The mosaics at Torcello date from the 12th century [**272**]. The Norman kings of Sicily, in particular Roger II, decorated the palatine and Martorana [**274**] chapels at Palermo with mosaics that rival those in the cathedral of Cefalù and in the cathedral of Monreale [**173, 275**].

In Yugoslavia, the frescoes in Sta Sophia at Ochrid are of the 11th century and those in the church at Nerez [**292, 293**] date from 1164.

Marginal miniatures of the 'monastic' psalters (11th-century psalter in the British Museum; the Barberini Psalter in the Vatican) and full-page illustrations in the luxurious 'aristocratic' psalters (Paris Psalter, Gr. 139, of the 10th century, in the Bibliothèque Nationale) bear witness to the beauty of Byzantine manuscripts, of which the masterpiece is the Menologion in the Vatican, written for Basil II [**269**].

The minor arts. The arts of the goldsmith and the enameller aimed at rich and colourful splendour.

THE PALAEOLOGUE RENAISSANCE (13th–15th centuries)

Architecture. As new inspiration was lacking there were only slight differences between churches of the 11th and 15th centuries. On the other hand, provincial differences became greater. The traditional centre, Constantinople, remained the model of Byzantine art. New centres were Trebizond on the Black Sea, and Mistra in the Peloponnese.

The domed basilica reappeared at Trebizond (the Chrysokephalos, St Eugene and Sta Sophia, all of the 13th century). At Mistra there were three types of church: the Latin cross (Evangelistria, 14th century); the Greek cross (church of SS Theodore of Brontochion, 1296); and the Greek cross inscribed in a square (the Aphendiko, early 14th century; the Metropolis (altered 15th century); the Pantanassa, early 15th century.

Painting. The great movement which revived classical antiquity began at Constantinople under the Palaeologues. It was to affect all Byzantine painting, including mosaics, frescoes and icons, during the 13th and 14th centuries.

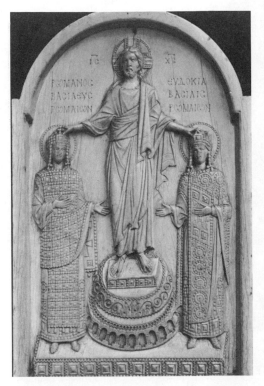

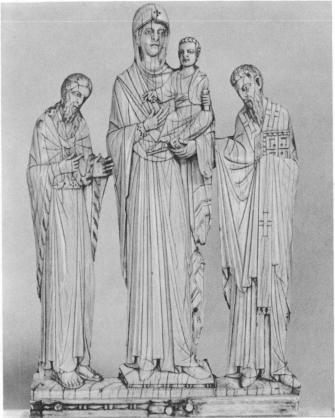

302. LATE BYZANTINE. Christ crowning Romanus and Eudoxia. Ivory panel. 10th century. *Cabinet des Médailles, Bibliothèque Nationale, Paris.*

303. LATE BYZANTINE. The Virgin and Child between two saints. Ivory statuette. Second half of the 10th century. *Dumbarton Oaks Collection.*

304. LATE BYZANTINE. The Virgin. Marble relief. 11th century. *Dumbarton Oaks Collection.*

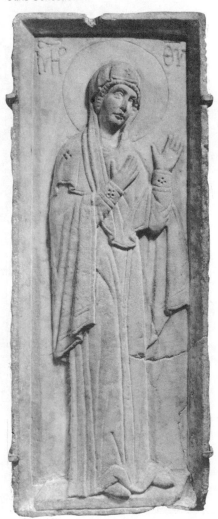

In Serbia, there were beautiful frescoes at Milesevo (1230), Sopoćani (*c.* 1265) [**285**], and at Nagoričino (14th century). In Greece further fine frescoes may be found in the churches of the Metropolis, the Brontochion, the Peribleptos [**294, 295**] and the Pantanassa at Mistra.

Icons gradually took the place of mosaics and frescoes. In Russia they were the principal decoration from the 15th century onwards. These icons helped to spread the knowledge of Byzantine art.

The minor arts. The most famous work produced by the Byzantine goldsmiths is the Pala d'Oro [**307, 308**], in St Mark's, Venice. It was commissioned in Constantinople during the 10th century; it was enriched after 1204 with enamels taken from the Monastery of the Pantocrator in Constantinople; and it was again altered during the 14th century.

THE SPREAD OF BYZANTINE ART

Byzantine art still survived for two or three centuries after the fall of Byzantium in 1453. With the Renaissance, the West was to follow other directions, but the Eastern Orthodox countries created a post-Byzantine art which developed in Turkey, Greece [**309**], Roumania [**311**] and Russia.

RUSSIA AND THE SLAVONIC COUNTRIES

History. Missionaries from Byzantium had converted the Slav countries and thus

opened new fields for the spread of Byzantine art. In these countries it was to survive long after the fall of the Empire. The brothers Cyril and Methodius from Salonica converted Moravia and Bohemia in 863. A year later the Bulgarian Tsar Boris was converted, and in 989 so was Prince Vladimir of Kiev.

Influences stemming from the Caucasus, the Balkans and Anatolia affected Russia as well as those influences that came from Constantinople. In the 14th century Serbia became a province of Byzantine art, and at the same time art in Bulgaria reached its greatest heights.

Architecture. Though Russia imitated Byzantium she never used the Greek cross plan for her churches. The oldest ones date from the 11th century and are at Kiev, such as Sta Sophia (1037), which was originally built as a basilica with a nave and four aisles with five apses, and which is unlike any within the Byzantine Empire itself. To the north, in Novgorod, Sta Sophia (1052) is smaller and has a nave and two aisles. The architecture of Novgorod in the 14th century was to be affected by local and popular influences which had their roots in earlier timber constructions: St Theodore Stratelites and the Church of the Transfiguration, both with a single dome and a single apse, are examples of this evolution.

In the churches further east, around Vladimir, the façades show Georgian influence. At Suzdal the façades were covered with sculpture in the Caucasian style, and they show similarities with the Western Romanesque rather than with

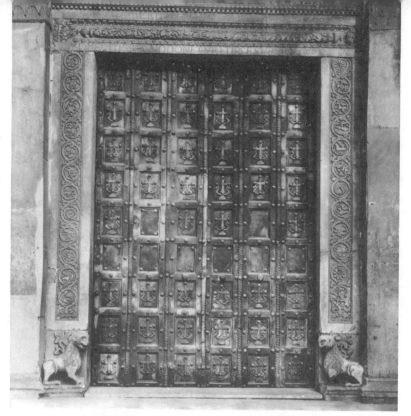

305. LATE BYZANTINE. Bronze door from Salerno cathedral, made in Constantinople. End of the 11th century.

306. LATE BYZANTINE. The Holy Women at the Sepulchre. Silver-gilt plaque with repoussé decoration. 11th century. *Louvre.*

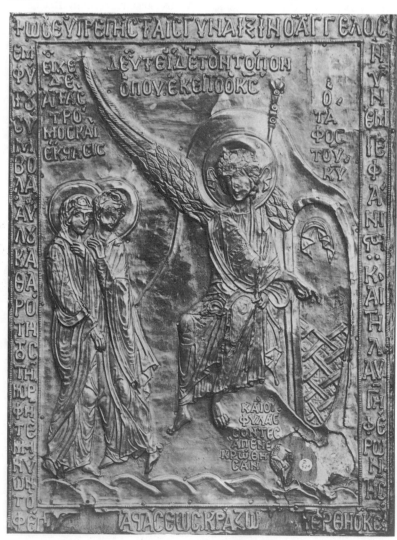

Constantinopolitan styles. Suzdalian churches were built of white stone, and had blind arcadings, etc. Their best buildings date from the second half of the 12th century, and include the Church of the Intercession of the Virgin on the River Nerl, and St Dimitrius at Vladimir. Later, the influence of peasant art made Suzdalian architecture more florid and decorative.

Towards the end of the 15th century, Moscow, the capital of the tsars, became the centre of a new aesthetic. The influx of Italian artists did not break the Byzantine tradition, as can be seen in the Cathedral of the Dormition, the coronation church which imitated the cathedral of Vladimir. The cathedral of St Michael, the tomb of the tsars, and the Kremlin remained Russian in character. The Cathedral of the Annunciation and the Cathedral of the Assumption, constructed in the 14th century and rebuilt in the 15th and 16th centuries, departed from Byzantine forms in their plans, in their structure, and in details such as their bulbous domes, but not in the luxurious interior decoration with paintings and panelling.

During the 16th century, timber architecture came to be the expression of a national style which was characterised by a pyramidal silhouette capped by a sort of polygonal belfry (*shater*) with the drum supported on corbelled arches (*kokoshniki*). The churches of St John the Baptist at Dyakova, of the Ascension at Kolomenskoe [**318**], and of the Transfiguration at Ostrovo, built between 1529 and approximately 1550 in the environs of Moscow, prepared the way for the famous Muscovite edifice of St Basil the Beatified which was erected in 1560. This work grouped together nine churches with *shaters* and bulbous domes. It was built by the architects Barma and Posnik and inaugurated a decadent and more baroque decorative tendency [**319**].

The influence of the West was growing, and Western architects worked in Russia, with the result that the national style became debased. However, the national style can still be seen in the church of Markovo (1690) and the Church of the Intercession at Fili near Moscow (1693).

In Moldavia and in Wallachia, Byzantine influence on national architecture survived the Turkish domination of the 16th and 17th centuries.

Painting. The influence of Byzantine painting was apparent from the 10th century in Bulgaria and affected important works at Bačkovo (12th century), Boiana (13th century) and Tirnovo (14th century). This influence reached western Russia, where many Greek artists emigrated [**289, 310**]. Theophanes the Greek painted the frescoes in the Church of the Transfiguration (1378), and also icons; he worked in Moscow, too, and contributed to the rise of the Novgorod school [**314**], which at the end of the 14th century produced frescoes true to Byzantine models. An original style came into being with the painting of icons and the development of the

154

iconostasis, which was a partition covered with icons separating the sanctuary from the main body of the church. This style culminated in the 15th century, with its more lively and freer use of colour and its subtle sense of arabesque.

The school of Pskov, which produced works in the Mizhorski monastery, grew out of that of Novgorod. The school of Moscow developed its own style in the 13th century. At the beginning of the 15th century, Andrei Rublev was to create the finest works of this school [315]. He was the pupil of Theophanes the Greek. He made use of sfumato (soft blending of light and shade) to envelop his elegant and tender forms. His influence was to last for a long time.

On the threshold of the 16th century, Dionysius filled the Therapont monastery, near Kirilov, with episodes from the life of the Virgin, painted with extreme refinement and spirituality.

The decline set in. The school of Moscow tended towards realistic narrative, whereas the Novgorod school stressed the richness of materials, and evinced a graphic skill which often drew inspiration from the East. These tendencies were still being opposed by Simon Ushakov in the 17th century, whose

icons have a solemn and backward-looking air. However, from then on the icons became heavier and more ornate; they united the arts of the painter and the goldsmith, and often became conventional or tended towards folk art.

EUROPE

Byzantine influence was weaker in France than in Italy. Nevertheless, Eastern art became known to the French through commercial relations, through pilgrimages to the Holy Land, and through the crusades. Eastern saints such as St Cosmas and St Damian, St Mamas and St Pantaleon were venerated. This influence can be seen in baptisteries and in some churches such as that of Germigny des Prés.

Christian and Mohammedan Spain were affected by Byzantine influence, especially in the north, in Catalonia, in the Romanesque altar panels.

The main centres of Byzantine influence in Germany were Reichenau and Aachen.

Even Scandinavia did not escape Byzantine influence.

Josèphe Jacquiot

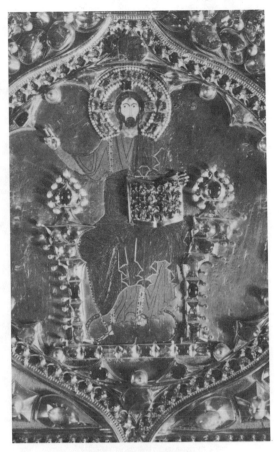

307. LATE BYZANTINE. Christ promulgating His Law. Detail (probably 12th century) from the Pala d'Oro. *Treasury of St Mark's, Venice.*

308. LATE BYZANTINE. The Pala d'Oro, a retable made up of enamels mounted in a gold and silver framework enriched with precious stones. 10th–14th centuries. *Treasury of St Mark's, Venice.*

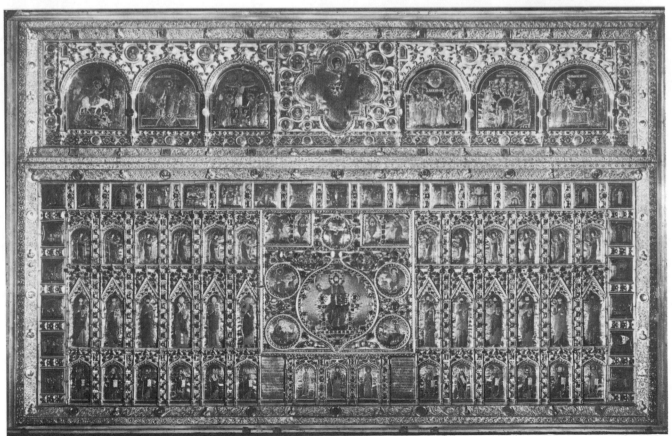

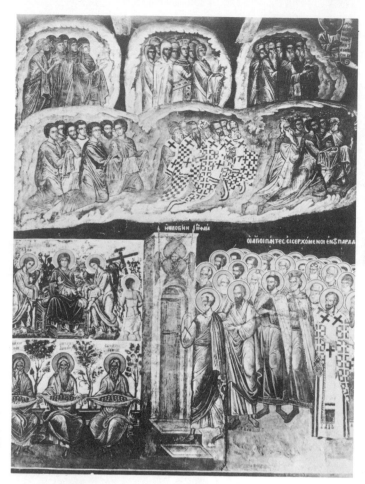

309. BYZANTINE TRADITION. Fresco in the monastery of the Lavra, Mount Athos. 1512.

311. ROUMANIAN. MOLDAVIA. Painted church of the monastery of St George, Voronets, Bucovina. 16th century.

310. BYZANTINE ART IN RUSSIA. Detail of a mosaic in the apse of Sta Sophia, Kiev; the Communion of the Apostles. Middle of the 11th century.

EXTENSIONS OF BYZANTINE ART

From the 6th to the 13th centuries Byzantine art spread not only in the West, but also triumphantly in Greece, Bulgaria and Serbia, though the latter were ruined too by the Turkish invasion. In Greece there were important survivals until as late as the 16th century.

With the establishment of Orthodoxy in Russia, new horizons were opened for Byzantine art. It penetrated by the ancient route of the Dnieper and extended as far as the Baltic, through the intermediary styles of the Caucasus and the brilliant schools of Armenia and Georgia.

It spread from Kiev and Novgorod to Moscow, and became gradually modified by Western influences. Russian art proper had evolved from it by the 16th century. Even then, in the monasteries founded by Stephen the Great and his successors in Moldavia, on the threshold of the Ukraine, the paintings inside, and often outside, the churches continued to follow Byzantine iconography.

312. RUSSIAN. Church of the Transfiguration at Kizhi, with multiple domes. Early 18th century.

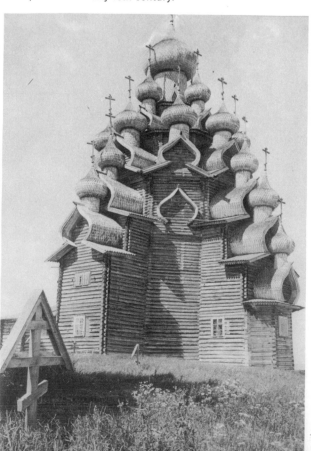

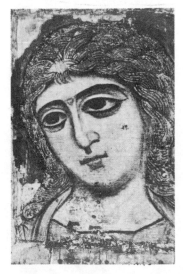

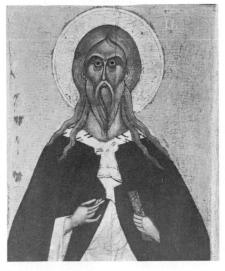

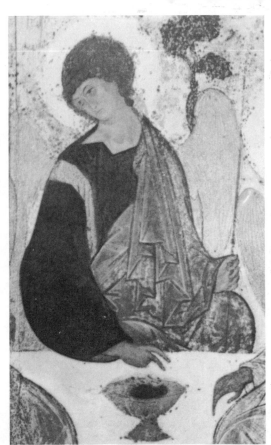

313. *Left*. RUSSIAN. Head of an archangel. Icon. End of the 12th century. *Russian Museum, Leningrad.*

314. *Right*. RUSSIAN. The Prophet Elijah. Icon of the Novgorod school. 14th–15th centuries. *Tretiakov Gallery, Moscow.*

315. RUSSIAN. Detail from an icon of the Trinity, painted by Andrei Rublev. Early 15th century. *Tretiakov Gallery, Moscow.*

316. *Left*. RUSSIAN. Jug in copper with repoussé decoration. 17th century. *Historical Museum, Moscow.*

317. *Right*. RUSSIAN. Canopy in carved wood. 16th–17th centuries. *Church of St Elijah, Yaroslavl.*

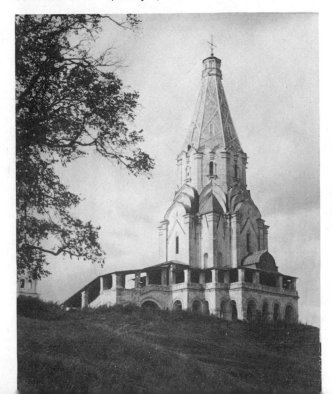

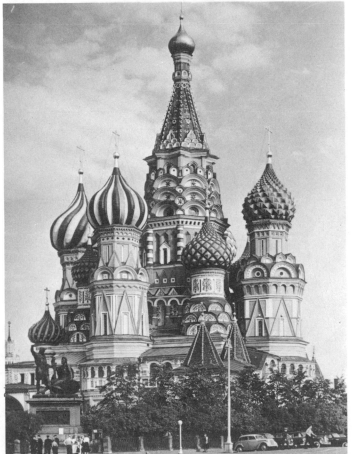

319. *Above*. RUSSIAN. St Basil the Beatified, Moscow. A church built with a central pyramid surrounded by multiple domes. Work of Barma and Posnik. 1555–1560.

318. *Left*. RUSSIAN. Church of the Ascension, of pyramidal form, in the village of Kolomenskoe, near Moscow. 1532.

157

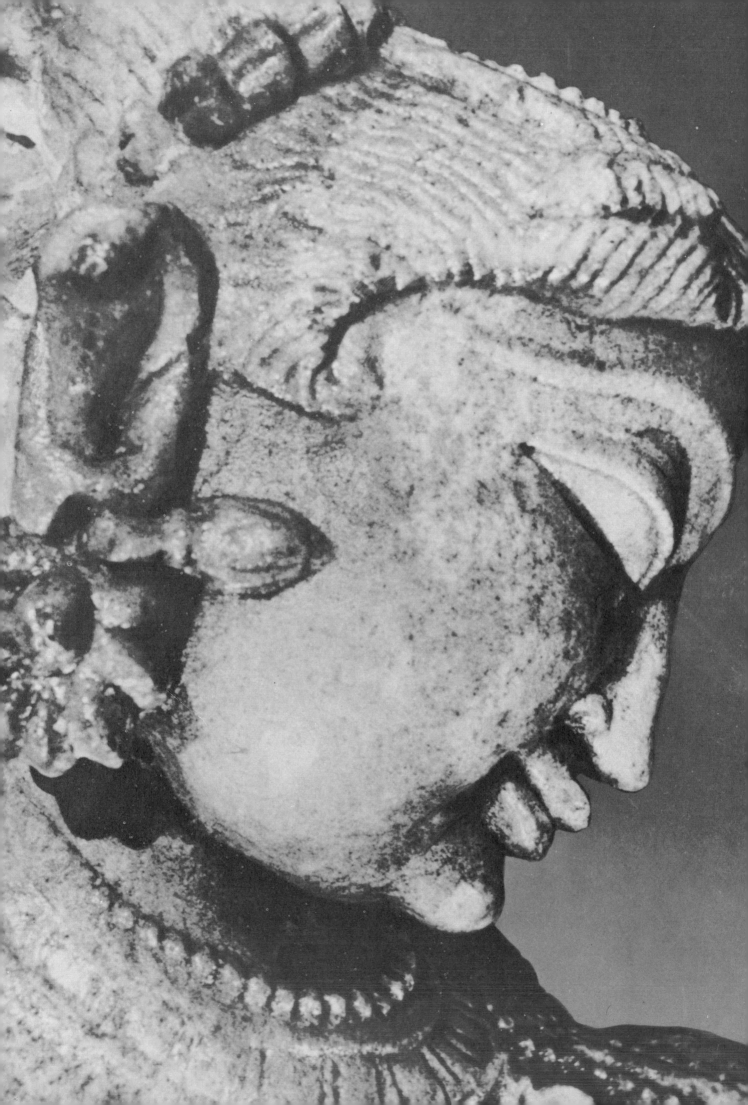

3 THE DEVELOPMENT OF ORIENTAL ART

320. INDIA. Head of an *apsaras* (nymph of the sky). Detail of a high relief from the temple of Parsvanatha at Khajuraho. 11th century. *(From R. Burnier,* Visages de l'Inde médiévale, *La Palme.)*

321. CHINA. An ascetic meditating. Painted in ink on paper, attributed to Shih K'o. 10th century. *Shohoji, Kyoto.*

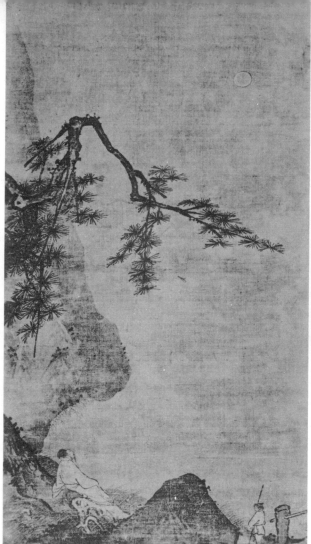

322. CHINA. A hermit under a twisted pine, by moonlight. Painting on silk attributed to Ma Yuan. 12th–13th centuries. *Collection of the Marquis Kurada. (From O. Sirén,* Histoire de la peinture chinoise, *Van Oest.)*

SUNG DYNASTY LANDSCAPES AND THEIR LITERARY ECHOES

Man lost in the immensity of nature, mountains and waters, mists, melancholy, great spaces, expressed in monochrome washes, sometimes with light touches of colour (see pp. 162, 170.)

323. CHINA. A fisherman in his boat. Painting on silk attributed to Ma Yuan. 12th–13th centuries. *(From O. Sirén,* Histoire de la peinture chinoise, *Van Oest.)*

324. CHINA. Valley, mountains and streams. Wash on paper, lightly touched with colour. Detail of a scroll attributed to Tung Yuan. 10th–11th centuries. *Museum of Fine Arts, Boston.*

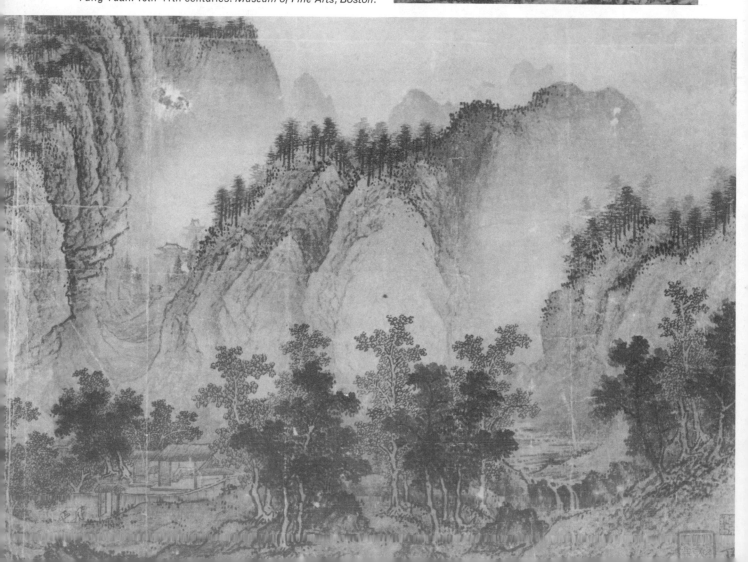

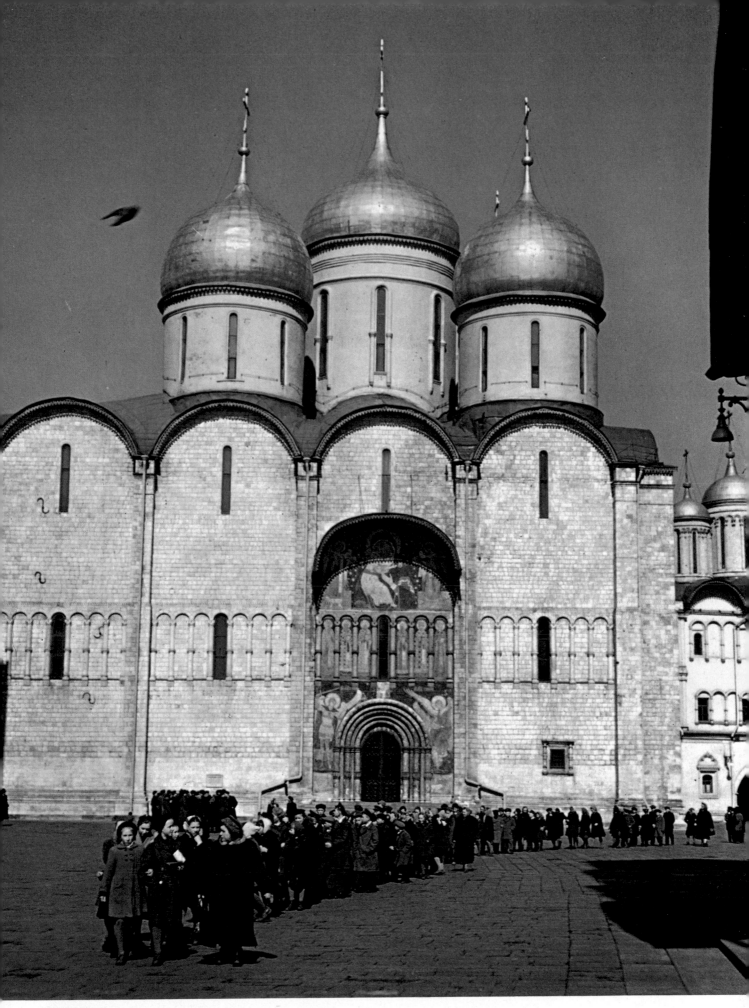

RUSSIAN. Cathedral of the Assumption, Kremlin, Moscow.
1474–1479. *Photo: Picturepoint*.

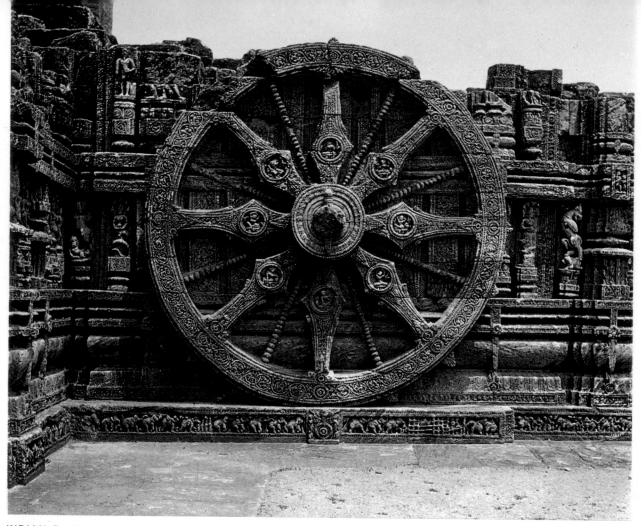

INDIAN. Detail of a wheel on the Surya temple, Konaraka. 13th century. *Photo: Josephine Powell.*

KHMER. Angkor Wat. First half of the 12th century. *Photo: Rapho.*

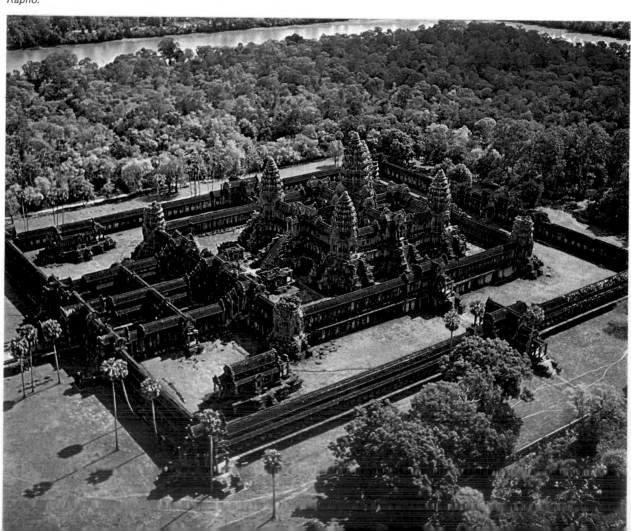

ART FORMS AND SOCIETY *Philippe Stern*

In outlining the art of the Far East, it becomes impossible not to oversimplify in view of the inextricable tangle of facts and tendencies. Oversimplification leads to deformation. Admittedly, a quick sketch may give a more truthful impression of a work than would a painstaking copy, but such summaries risk falsifying the proportions. In compensation, it is the aim of this work to multiply the number of viewpoints in an effort to catch the richness and complexity of the truth. One may, for example, consider in turn the various similarities and differences which are present at one and the same time in any comparison. These viewpoints or angles of vision are analogous to those which René Huyghe calls *'grilles'*. They are like a successive series of viewpoints from which a person or a sculpture may be seen. They vary greatly, and are true provided that the cone of vision and the angle of view succeed in bringing out fundamental qualities. On the other hand one must reject those viewpoints from which significant facets are either not visible or are distorted, though in some measure this will apply to every viewpoint.

In this chapter the art of India and China, from the 10th century onwards, will be considered. For Japan, and for those countries lying between India and China— Khmer, Champa (Vietnam) and Java, in particular—it is necessary to go back further, to the 6th century. The various angles of vision will be applied to the art of each of these countries in turn. They include 'the network of communication', 'evolution', 'constants', 'the arts and thought', 'tendencies and rhythms'.

The network of communication

It was along the great sea routes, perhaps in the wake of Roman commerce, that the first Indian expansion gave birth to the earliest Hindu kingdom in Indo-China during the 1st or 2nd centuries. Indian jewels were carried to Oc Eo, near Saigon, and a little later sculptures of Buddha in the Amaravati or Ceylon styles were distributed all along the seacoasts. These Buddhas have been discovered in Java, Thailand, Vietnam, and even as far away as Celebes beyond Borneo. Such works, either imported or copied, must have been very plentiful, for examples have usually only been found by chance. No trace remains of the wooden buildings in which they were housed, and so there are no archaeological clues to help research.

The arts of the great Hindu kingdoms appeared between the 6th and 8th centuries, doubtless following upon this first Indian expansion. Chinese pilgrims, important in cultural relations between China and India, travelled both by land and by sea. Those who followed the sea routes in the 7th century encountered along them— peacefully, it would seem—only Hindu kingdoms. These included Champa (now largely Vietnam), Khmer (now largely Cambodia), Dvaravati (the southern part of present-day Thailand), other kingdoms in the Malay peninsula, Sumatra and, a little later perhaps, Java. It would appear that the religious ban which forbade Brahmans to cross the sea was not strictly enforced. In order to grasp the curious yet harmonious intermingling of these kingdoms, it is useful to make a comparison with South and Central America at the present day. In these countries

the languages are Spanish and Portuguese, the religion is Catholic, the way of life often European, and yet continuously, even in the smallest details of living, memories of pre-Columbian times emerge. It was the same for the kingdoms on the sea route between India and China from the 6th century to about the 14th. They preserved their own languages, but adopted the rhetorical and flowery Sanskrit for literary and religious use. Their religions were Indian Hinduism and Buddhism, and they knew the myths, symbols and philosophies related to these religions, which were sometimes interwoven with their own local elements. In literature, Indian epics were added to the indigenous legends. The arts in these regions often made their appearance completely formed, having received both the technical knowledge and the spiritual outlook of the finest period of Indian art. But the Indian influence was usually rapidly assimilated. The arts became rapidly individualised and acquired an entirely new character, often even opposing the Indian matrix which gave birth to them. A century or so later, the art of these countries had usually developed an individual and original style. In Indo-China art degenerated after the 13th century, and in Java after the 15th century. Their way of life, usually almost unaltered, continues to the present day.

In these countries between India and China, Indian influence and the local undercurrents were compounded with slight Chinese and Vietnamese influences. The arts to be found in the countries along this maritime route also affected one another, and this interaction continued from the 9th century onward. Javanese art affected the art of Khmer and of Champa in the 9th and 10th centuries; the art of Champa affected that of Khmer in the first half of the 9th century, and later that of Vietnam; Khmer art influenced the art of Champa in the early 10th century and again in the early 13th century.

The great Chinese expansion corresponded to the great Indian seaborne expansion. The Chinese routes reached out not only towards central Asia and Tibet, but also to Japan, which was converted to Buddhism in the last quarter of the 6th century. She opened her doors to Chinese art and her traditionalism encouraged her to preserve ancient works of art. Indeed, in architecture, painting and sculpture one must turn to Japan in studying the art of the T'ang Dynasty, and even the mature work of the earlier Wei Dynasty. Later on, Chinese influences again crossed the sea and seeped into Japanese art, which, however, became more and more independent, as may be seen in their monochrome paintings of the 15th century.

The Indian and Chinese expansions were most powerful from the 6th to the 8th centuries. The Indian expansion across the continent extended beyond central Asia towards China and Japan, and also to Tibet, whose history begins at that time, in the 7th century; it also extended by sea towards the Hindu kingdoms which in their arts affected Khmer in the 6th century, and Champa and Java about the 7th and 8th centuries. The Chinese expansion spread towards central Asia and Tibet gathering strength until the 10th century; it moved in the direction of Japan after the end of the 6th century, and later towards Indo-China, with the rise of Vietnam.

On the subject of this 'network of communications'

one should remember the arrival of the Mohammedans in India in the 11th century, and the steadily increasing Mohammedan influence on the art of northern India, culminating with the Mogul Dynasty of the 16th century. Indo-Mohammedan art should be considered rather as a branch of Mohammedan art, and this is especially so of Mogul art which was a regional school of architecture and of miniature painting in which the Mohammedan style prevailed over the Indian. Elsewhere in Indian architecture and in other schools of more popular painting, the mixture is more balanced, and sometimes the Indian culture is barely touched by Islamic influence.

The evolutions and their diversity

A few remarks will show the variations of a constant art within the continuity of its development.

INDIA

In India, from the 10th century onwards, the tendencies of the post-Gupta style became more exaggerated and developed in various ways. Dravidian art in the southeast of India was isolated from the rest of India after the 9th and 10th centuries, and followed a separate evolution. Its architecture became geometric in style and led to vast 352 temple groups which cannot be fully appreciated at first glance. To begin with, the increased number of storeys 355 gave more height to the central sanctuary, then the 365 entrances or gopuras underwent the same development, and as late as the 17th century, in Madura, they still had a remarkably attenuated and concave appearance. In sculpture, the frenzy of the dynamic tension, strange as it may seem, is united with a certain coldness and dryness. It appears in architectural sculpture, for example in the rearing animals, and also in the bronzes and on the wooden framework of vehicles.

In the rest of India, especially in the east (Orissa) and near the centre (Khajuraho) as well as in some regional areas, the glories of Indian architecture took on another form. The main element is the grandiose and rather aloof 367 tower sanctuary, such as the Lingaraj temple at Bhuvanesvar, built about the year 1000. The sculpture on the 349 curvilinear tower sanctuary is quite different from the sculpture of Dravidian art. It has an exaggerated and rather distorted grace, and a precious and mannered vigour; and often jewellery was used to enhance the decorative lines. These tendencies spread to Nepal and 379 Tibet. It was in this sculpture that eroticism was to become so marked.

It should be remembered that in south-east Asia there existed neither the doctrine of Original Sin nor the Christian mistrust of the flesh. If Buddhism rejected physical love, it was only because it was a source of attachment to the illusions of this world. In Sivaism, the principal emblem was the linga, the erect and creative sexual organ. Siva found the completeness of his force in union with his sakti (consort). She perhaps represented created nature in relation to creative nature, or the active aspect reflecting the transcendental aspect. Eroticism, representing all possible forms of coupling, of caressings and of sexual groupings, came later, about the 12th or 13th centuries, a sign, if not of decadence, at least of an art that had become very exaggerated. This late arrival of eroticism is to be found in other periods and in other places. It surged up in the Graeco-Roman world shortly before its decline, in the art of Pompeii, and in Japan at a recent period in the woodcuts of the Ukiyo-e school. In the art of ancient India, sensuality was strong, but eroticism restrained. Even in the Amaravati style, the couples provoke and play with one another, as for example between the religious scenes at Nagarjunakonda, but they content themselves with these relatively innocent pleasures. At the height of Indian art, in painting as in Sanskrit drama, a deep and withdrawing modesty was united to a strong sexuality leading to an amorous lassitude. The sexual quality became stronger and there were excesses, as in the Kailasanath temple at Ellura probably belonging to the middle of the 8th century. Here the union of the sexes made its appearance, but it was not until later, after the point of equilibrium in Indian art had passed, that amorous sensuality became sheer exhibitionism, which incidentally coincided also with excesses of violence and horror. This exhibitionism was usually expressed through the somewhat distorted yet graceful charm of the period.

Indian art will not be followed into its decadence, where it became overloaded with decoration stereotyped into lacework, where realism was stressed together with contortions, horror and violence, which all intermingle, and often in spite of the survival of earlier traditions.

CHINA

In China, the predominance of two forms of art, painting and ceramics, began with the T'ang period which lasted from the 7th century to the 9th. Mme D. Lion-Goldschmidt and Mlle Madeleine Paul-David have very rightly emphasised how in China various arts came to the fore at different periods, and how these arts reflected the varying character of those periods. In this way, the pre-eminence of bronze passed to sculpture, and sculpture was superseded by painting on silk or paper, and ceramics. Both painting and pottery, especially during the Sung period from the 10th to the 13th centuries, attained the same refinement, the same reserve and the same use of monochrome.

Chinese painting goes back long before this period. In the Boston Museum there is a painting on a surface of brick belonging to the Han period (2nd century B.C. to 2nd century A.D.). Figures were drawn with calligraphic brush strokes of varying thickness, but the outlines were not filled in. Painting of the 4th century is known through the hand scroll either by Ku K'ai-chih, or more probably copied at an early date from a work by him. Though the texts praise the painting of the T'ang period, the attributions of works on silk or paper to this period are suspect. Monochrome paintings in ink reached their greatest heights during the Sung period (10th–13th centuries) and especially during the first half of the period. The technique was to use the brush charged to a greater or lesser degree with ink and water so as to give every tone from black to pale grey, and to modulate through this scale from the foreground to the background. This technique did not allow any repetition or correction. The brush, as in Chinese writing, had to move freely, giving emphasis and inflexion as necessary. The shapes of figures, animals, 321, 4 plants and mountains were simplified or accentuated, but 414, 4 were usually not precisely defined. The monochrome technique, which was so essentially Chinese, was frequently used for the typical Chinese theme of 'mountains

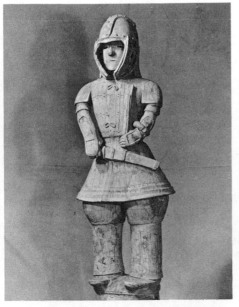

325. JAPAN. PROTOHISTORIC. Funerary statuette in terra cotta of a man in armour. 3rd–5th centuries (?).

326. *Centre*. JAPAN. PROTOHISTORIC. Head of a monkey; funerary sculpture in terra cotta. 3rd–5th centuries (?).

327. JAPAN. Gigaku mask. 8th century. *Todaiji, Nara.*

JAPANESE CARICATURE: A CONSTANT

The Japanese bent for caricature appeared some time before the 6th century. At first it was certainly unconscious, then through degrees of steadily increasing self-awareness became at last quite intentional, and continued up to the present day.

329. JAPAN. YAMATO-E SCHOOL. Old men; detail of a scroll, the Legends of Mount Shigi. 12th–13th centuries.

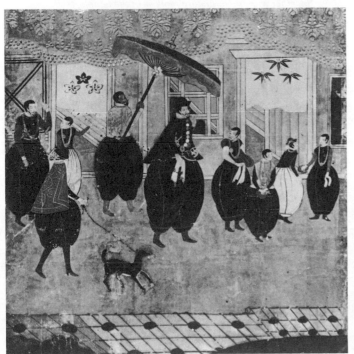

328. JAPAN. Detail of a folding screen showing Portuguese visitors. 16th century. *Musée Guimet, Paris.*

330. JAPAN. Foreigners' amusements; print (triptych). Second half of the 19th century. *Musée Guimet, Paris.*

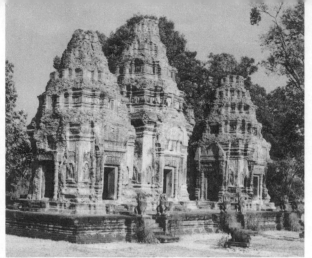

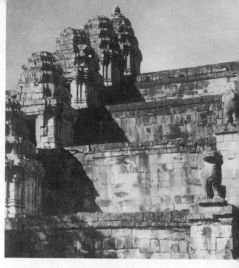

331. SAMBOR AND PREI KUK REGION. Isolated tower sanctuary. Beginning of the 7th century.

332. PRAH KO. Tower sanctuaries grouped on a terrace. 879.

333. ANGKOR. PHNOM BAKHENG. The early centre of the town of Angkor. Temple-mountain in the form of a stepped pyramid. About 900.

EVOLUTION OF KHMER ARCHITECTURE

Tower sanctuaries, first isolated [331], then in groups [332], rose on the pyramid of the temple-mountain [333] – which became more attenuated [334], and then more massive [335]. They were surrounded with galleries [336, 337] and finally overloaded with

transverse galleries and with various other additions [338]. These, together with the miniature replicas of the temple itself, were the basic elements in the logical evolution of Khmer architecture from the 7th to the 12th centuries (see p. 166).

and streams'. Though artists had already painted land-scape, as may be seen from the hand scroll of Ku K'ai-chih, they had not known the freedom of the Southern Sung school and of the new style of painting called 'painting without bones'. This style developed as far as the almost exaggerated pointillism of the 11th-century Mi Fei. Both in horizontal hand scrolls and in the later vertical strips, the mountains rise in stages, and are set with trees, often conifers, drawn in deep black. Here and there are villages, sometimes on hill tops, and below are the curving banks of the river which stretches back and becomes lost against the immensity of the sky. There are no limits to the view.

324 The untouched silk or paper represents space, water,
410 sky and mist. The mist creeps into the valleys, and engulfs the lower slopes of the mountains which are
424 now covered in a lightness which separates the planes and suggests the recession in space. An 11th-century treatise on landscape painting written by Kuo Hsi referred to mountains without mists being like a springtime with-out flowers.

These paintings have strong links with Chinese poetry and certain Chinese mystical tendencies. These mystical tendencies were especially important in poetry, and they

also pervade painting as will be seen later (see p. 170).

Varied and opposing qualities resulted from the mas-tery and improvisation essential to monochrome painting, where no correction nor pause in the brush stroke was possible. The direct brush stroke gave life and breadth to the work, which could not be overcharged with detail added at leisure. Yet, at the same time, when the brush stroke became too skilful and the theme too often repeated, it might degenerate into a stereotyped version of the same bit of nature, the same animal or the same plant.

Ceramics of the Sung period have similarities to the 389–398 wash technique of the painters. Like this technique they are often monochrome; they are also delicate without any insipidity, and they possess an elegant and disciplined purity. The colours are both deep and subdued; they are 'broken', as one says in painting—white without harsh-ness, celadon or willow green, bluish grey, and so on. The forms are of gently swelling shapes; the unobtrusive design is incised or is in a flat relief and covered by a monochrome glaze. This reticent refinement had evolved gradually during the first thousand years of our era. With the end of the Sung period this subtle art soon gave way

337. KHMER. ANGKOR. TAKEO. Here the arrangement was the same as at Pre Rup, but the encircling gallery became continuous. About 1000.

338, 339, KHMER. ANGKOR. ANGKOR WAT. *Below.* Aerial view. *Opposite.* View taken from the interior approach. First half of the 12th century.

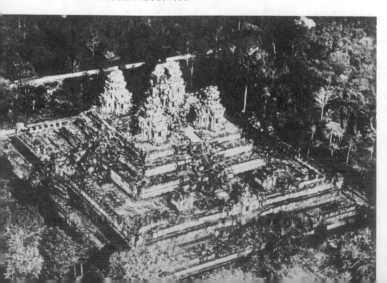

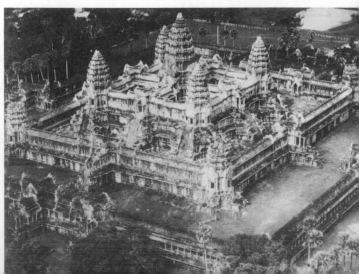

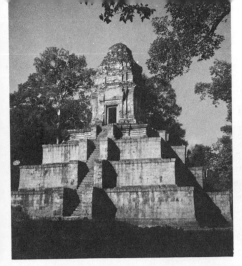

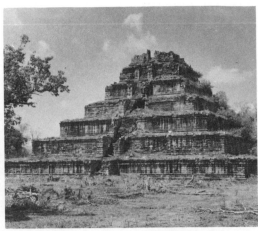

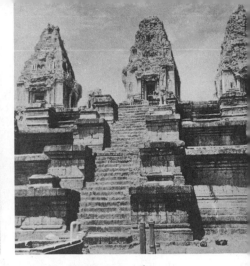

334. ANGKOR. BAKSEI CHAMKRONG. The small-scale temple-mountain became more attenuated. Beginning of the 10th century.

335. KOH KER. PRESAT THOM. The temple-mountain remained tall, but became more imposing. About 930.

336. ANGKOR. PRE RUP. The tower sanctuaries are at the summit of the pyramid on which independent galleries rise on all sides. 961.

420 to the 'blue and white', and then to the bright coloured 'families' and garish porcelains of great technical perfection, which, it is often thought today, is achieved at the expense of beauty.

421 In the Chinese sculpture of the Sung period there is a certain air of affectation about the poses and the ornaments. Decadence followed, in which the works only possess iconographical interest.

JAPAN

Japanese art followed a unique development. In this chapter it will be considered as a whole, even though it begins long before the 10th century. It alternated between Chinese influence and what was deeply Japanese; sometimes these two were completely fused, and sometimes Japan followed a direction parallel to Chinese evolution.

In the protohistoric period which existed until the last quarter of the 6th century, local styles produced work of a rough but very lively quality. There were astonishing 325, 326 funerary statuettes known as haniwa and bells of unusual form called dotaku. It is probably from about this time that edifices with curious roof structure were built on piles with unusual arrangements of columns, and strange covered staircases which were often oddly placed. Though this architecture was of timber and therefore impermanent, we probably have some idea of its style, as temples were regularly rebuilt, even several times in a single century, exactly as they were.

Then towards the close of the 6th century came Buddhism, accompanied by Chinese civilisation and art. Ancient Chinese architecture is known through Japan, for example at Horyuji. Separate buildings, including a sanctuary, a pagoda with superimposed roofs, and an entrance gateway, were regularly arranged within a spacious enclosure. The Chinese architectural forms, on reaching Japan, became lengthened or made more slender, and attained a rare beauty. The hieratic statues of divinities were subsequently affected by the Chinese sense of portraiture and T'ang naturalism. Even Indian influences, much altered during their passage through central Asia 450 and through China, reached Japan, as may be seen in the frescoes of the kondo (hall) at Horyuji. In some cases, it is not even possible to be certain whether a work is of Chinese or of Japanese origin.

Relations with China became strained, and little by little an essentially Japanese art came into existence; this phase has been studied recently by K. Akiyama. In the 12th-century hand scrolls of the Yamato-e certain charac- 438 teristics of Chinese painting are combined with an overall quality and details that are purely Japanese, and these predominate. The interior of a house is revealed by the double artifice of removing the roof and by the casual 452, 453 view. Faces have very special features, particularly the noses. The full robes and the positions of the figures are 444 clearly Japanese. These characteristics are found in pictures of a refined amorous life and of a caricatured daily life, but which are charged with human understanding. 320

Angkor Wat was the climax of the evolution of Khmer architecture. The preceding arrangements were repeated with the addition of tower sanctuaries, angle pavilions, encircling galleries and multiple crossings, access galleries, isolated kiosks and entrance doorways. In this way the Khmer temple simultaneously spread out horizontally and climbed towards the sky.

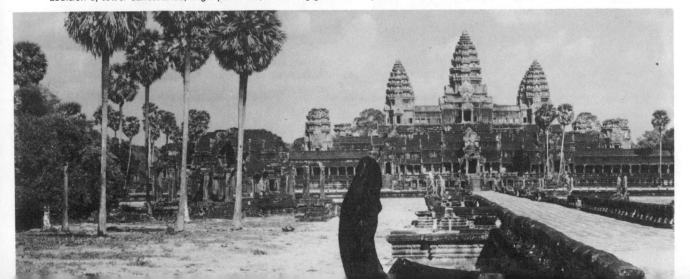

Japanese art progressed from the narrative painting of the Yamato-e to the recent style of the Ukiyo-e, best known through woodcuts, but the development is too long to be summarised here. Pictures in both styles depicted the current fashions, geishas and actors, places of recreation, and excursions into the country.

The production of masks was a characteristically Japanese art. Masks sometimes conveyed an introvert and concentrated expression; often they were purely caricatures, but also they frequently became merely stereotyped. There were specialists who produced particular types of mask for particular families, whose skill frequently degenerated into little more than a knack. Decoration was also important in Japanese art (Ogata Korin, 1658–1716); it was sometimes delicately and sometimes excessively naturalistic, as in plant forms which look as though they have been thrown across a composition (lacquerwork, sword hilts, etc.). Japanese architecture, even more than Chinese, renounced geometric construction in favour of complete integration with the natural landscape, with trees and often with water (the Hoodo or Phoenix Hall of the Byodoin temple at Uji, and Itsukushima Jinsha, 11th–12th centuries).

Other influences also came from China to affect this Japanese development. The art of monochrome painting, for example, arrived in the 15th century, and was to be very important.

KHMER

It will also be necessary to go back to the 6th century in order to study the Hindu countries along the sea route between India and China. Owing to lack of space, only the arts of Khmer (Cambodia), Champa and Java will be considered. Their developments were interrelated by the 'network of communication' (see p. 161).

Khmer architecture was an excellent example of a sustained and rational evolution, though before the correction of an erroneous chronology which was compiled between 1926 and 1936 it did not appear so. Angkor Wat, built during the first half of the 12th century, was the climax of this evolution and was the most perfect, complete and powerful realisation of Indian architectural technique, a technique which did not know how to construct vaults other than by corbelling, and was therefore only able to span narrow spaces. Tower sanctuaries, galleries, and the stump ends of galleries were built thus.

Khmer architecture, sometimes called pre-Khmer or Indo-Khmer until the 8th century, began with isolated tower sanctuaries dispersed within an enclosure, as at Sambor, which was built in the early 7th century. These tower sanctuaries were aligned on one platform, firstly in a single row (Kulen, first half of the 9th century), then in two rows (the six tower sanctuaries of Prah Ko, 879). About the middle of the 9th century the stepped pyramid was developed, and this symbolised the divine cosmic mountain which was the centre of the world of the gods. This arrangement soon became more imposing, with its sanctuary at the summit of the pyramid, and small temples on the steps (Bakong, 881, and Phnom Bakheng which was the earliest centre of the town of Angkor, and dated from about 900). The stepped pyramid became higher, attenuated at first, then more massive (Baksei Chamkrong at Angkor; pyramid of the Prasat Thom of Koh Ker, about 930). Galleries were built at ground level,

consisting of two walls and covered by timber vaults. These galleries, in broken form, were then built at different levels on the steps of the pyramid and were surmounted by five tower sanctuaries (eastern Mebon in 952, and Pre Rup, 961, a wonderful temple in its restrained grandeur). The galleries became continuous, and, at the level of one of the steps, completely encompassed the main building (Takeo, about 1000). Then the gallery was roofed first in brick, followed by sandstone, but was small in size (Phimeanakas). The temple became richer in its decoration, and the galleries on the steps larger (Baphuon, shortly after 1050).

This long evolution culminated in Angkor Wat, built in the early 12th century. Here there were continuous galleries on each of the steps and in some cases they rested only on pilasters along one of their sides. Everywhere, there was a profusion of angle towers, angle pavilions, entrance gateways, connecting galleries and separate kiosks. The substructures were made higher and these too became more richly elaborate. All the elements of an architecture which is familiar only with corbel vaulting seem to be brought together at Angkor Wat, the apogee of Khmer architecture. This temple mountain has balance, unity and grandeur. It extends lengthwise like Versailles, yet with its shell-shaped tower sanctuaries it also reaches towards the sky. Bayon, which was built early in the 13th century, and others of the same style, again made use of architectural sculpture. Bayon did not, however, add anything to the development of architecture, possibly because of the changes in the plan made while the construction was in progress.

The same rational evolution is found in the tiny columns which flank doorways and false doorways in Khmer architecture. They became progressively more complicated. The number of groups of mouldings, and both the number and size of their constituent elements, increased. As a result there were more uncovered parts on the shafts between these groups of mouldings, and a reduction in height. Similarly, the flat surface decorations on these otherwise uncovered passages diminished in size and increased in number from the 9th century onwards. They eventually became simple serrations and ended by completely disappearing.

That Khmer art frequently copied its own past was a discovery made by Gilberte de Coral Rémusat. Decoration alternated between rich and poor styles. Successive renewals were not restricted to transforming the elements in use at the time, nor to adding others from outside; but enrichment was achieved by adopting motifs derived from an earlier Khmer style, forgotten motifs from the last rich style, drawn in this way from the past and adapted to suit the taste of the time.

Other curious developments in Khmer decoration deserve consideration, in particular the lintels, and also pilasters and pediments, as well as the evolution of low relief sculpture.

Figure sculpture in the round was magnificent at the beginning and again at the end of Khmer evolution. In between, however, came a double period of opposing tendencies. A union, very rare in art, between non-idealised naturalism and hieraticism existed from the 6th century to the 9th. The sense of living flesh was communicated by a direct and restrained sculpture, which yet expressed the quality of noble and static grandeur. In our opinion, the only other place where these qualities were

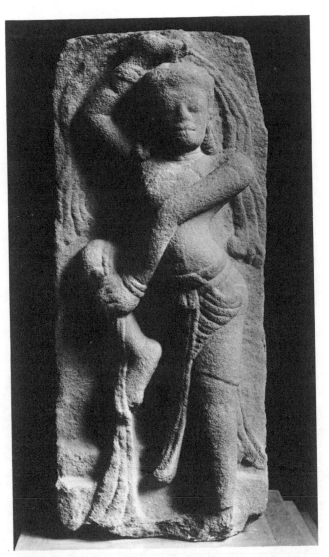

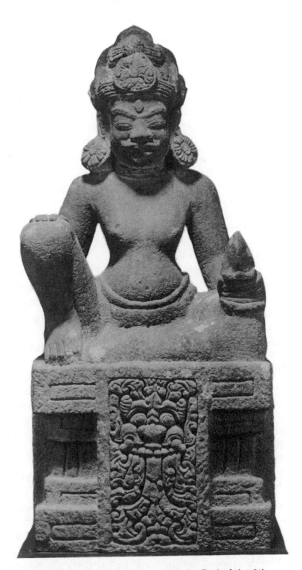

340. CHAMPA. Dancer with scarf, from Tra-kieu. Mi-son A 1 style. 10th century. *Musée Guimet, Paris.*

341. CHAMPA. Siva. Dong-duong style. End of the 9th century. *Rietberg Museum, Zürich.*

successfully combined was in Egypt under the Old Kingdom. Later, with the coming of the 10th century, the grandeur became dominant, but at the expense of the freshness, and the sculpture was at times cold in feeling. The hieraticism continued, extending into a new and lively taste for the trivial and charming which lasted for a considerable length of time (Banteai Srei, middle of the 10th century and following periods). Finally, with the Bayon style of about 1200, came the swan song of Khmer 383 art. To the continuing hieraticism was added the mystical and inward expression known as the 'Angkor smile' which seems to express a deep compassion. Throughout these developments there run curious 'constants' which will be considered later.

Only one example of animal sculpture in the round will be considered here. One of the most beautiful inventions of Khmer monumental sculpture are the long serpents flanking the access causeways. Their heads, aureoled with decorations, curved and reared at the extremities. But this form was not perfected until the first half of the 12th century, and was then followed by the more complicated theme of a fabulous bird represented with the serpent.

CHAMPA

Cham art developed alongside Khmer art, but in part of the territory that is now called Vietnam. In sculpture and in decoration it showed curious alternations. In turn, it would seem, there was a certain classicism influenced by India, and then Javanese and Khmer influences (early Cham art and Mi-son A 1 style) which alternated with 340 periods when the somewhat fantastic and exaggerated local tendencies predominated. These were further complicated by influences which came from China and other parts of Vietnam (Dong-duong and Thap Mam styles). 341 Between these various styles there was often a lively reaction. One can see a parallel case in Europe, when the Renaissance followed the Flamboyant Gothic style and opposed it.

Cham art, less than that of Khmer but more than that of India, may be studied by a method of reconstruction based on the evolution of the motifs. Hesitantly at first, characteristics are sought which, grouped together, determine the main styles or the periods within the same style. Overlapping which must have existed permits the establishment of contacts between these groups. The sense of sequence is found through these contiguities and through certain clues that must follow one another. By comparing the results thus obtained with data from written or other sources, it becomes possible to establish some fixed points in the vague nebulous idea of this development. If the results from the study of aesthetic evolution and from other sources confirm one another, then the degree of probability is increased. Sometimes results are contradictory; then one must take this as an alarm bell, and re-examine, without prejudice, all sources in order to locate the error. From the overlapping and from facts

which must be in sequence, as well as from the convergence of corroborating information from various sources, it becomes possible to test how well founded is the development already ascertained. So, little by little, the knowledge of an art and its history is brought to life.

JAVA

Seen in our simplified perspective, Javanese art evolved gradually from one great period to a second which had completely opposing tendencies.

346 The first period stretched from the 8th century into the early 10th century, and is known as the 'Middle Java' or 'Indo-Javanese' style. It remained close to Indian Gupta art and to the beginning of the post-Gupta style. It possessed, however, such individual characteristics as an almost over-placid gentleness, even in representations of the infernal regions. Rounded, sometimes swollen, forms expressed this tranquillity and innocence. The temple was usually a simple decorated cella standing on a raised stylobate. In general the taste was for harmony, and on a small scale. But there were also vast monuments such as Barabudur, a giant platform with stupa and Buddha figures of a complex symbolism with miles of low relief on the various stages. There was also the Hindu temple of Prambanam.

The second period, known as the 'East Java' style, lasted from the 13th to the 15th centuries, and was quite different. The point of equilibrium in Javanese art seems to have been passed, and the varied and numerous trends became strongly marked by indigenous elements. It was less beautiful and profound, but intensely vital and original. The divinities take on squat but realistic forms, and yet retain a hieratic mood; they were frequently laden with jewels. The result was generally mediocre, but occasionally remarkable as in the Ganesa of Bara, or the twisted grace of the bathing place of Majapahit. Realism, which is rare in religious art, was used in the representation of old age. In low reliefs, figures were set against a background of fantastic clouds which derived from China. Chinese influence also affected the low relief landscapes, shown without figures which is quite opposed to the Indian spirit. The decoration put the emphasis on the fantastic or *kala*, which was a mystical system of Buddhism.

Following this second phase of Javanese art, after the arrival of the Mohammedans, a curious native accent still continued, as was sometimes revealed in the decoration of the mosques. Then this art rapidly became decadent, and was prolonged, in this decadence, in the island of Bali.

The constants

In Japan may be found a permanent love for decoration which reaches back over a sufficiently long period to justify analysis. The strongest 'constant' is the continuous taste for the caricature, which is not without human sympathy. Even before the coming of Buddhism, and before the arrival of influences from China, the Japanese pro-
325 duced their crude but highly original funerary statues (haniwa) in terra cotta which reveal this sense of caricature in expressions and attitudes. Whether or not it was intentional must remain unknown, but conscious or not, the
326 tendency was already apparent. There is a monkey's head which shows strongly both this caricatural expression and

at the same time a compassion for suffering. In the 12th-century Yamato-e style, which was essentially Japanese, together with love scenes there appeared scenes from everyday life which were caricatured, sometimes to the point of satire, but always with a sympathy towards human misery—for example, old folk bent over their walking sticks. 329

Japanese caricature was given free play when the Europeans arrived and they depicted, with irony it seems, firstly the Portuguese lords and missionaries (there are 328 quite a number of 'Portuguese' screens), and then more recently the Dutch and other Europeans who are repre- 330 sented in woodcuts. The Japanese masks also have carica- 327 tural and human qualities.

Constants were very pronounced in Khmer art. In Khmer sculpture they were opposed to what was essentially Indian. Though technique and motifs originally came from India, the spirit of Khmer art was quite different. Whereas Indian art was sensual in the widest sense of the word, that of Khmer was not. The triple Indian flexion, or tribhanga pose, in Khmer first became stiffened or reduced, and was rapidly eliminated. The first ten centuries of Indian art were without the impassive and rigid hieratic poses which were constant in Khmer. This hieraticism existed together with naturalism from the beginning of Khmer art, and became intense early in the 10th century; it continued gracefully during the period of Banteai Srei, and ended by adding the mystical smile of the Bayon style. To this hieraticism or rigid static tension, there corresponded—an observation made by Mme S. Juillerat—the curve or dynamic tension, whether among the decorative and dancing figures or among the serpents of the access causeways.

In architecture, what corresponded to the hieraticism or the static tension of sculpture seems to be the austere grandeur of the naked monuments. This may be gathered from the pyramids of Phnom Bakheng and of Pre Rup, 336 provided they had the same appearance then as now. To this should be added the geometric impression of the cities that may be seen from the air—the square enclosure walls, the long ornamental lakes, and the long straight lines of the avenues that lead towards the central temple. In Khmer decoration there was the same tension. A dynamic effect was given by the thicket-like plant decoration, but this richness was enclosed by the rigid symmetry of a strict composition which appears to us to correspond to the static quality of this tension (for example, the lintels in the style of Prah Ko). In the large low reliefs of Angkor Wat, 347 there is a similar profusion in the figures in the battle scenes. The same order is found in the long horizontal lines of the historical sequence and in the representation of the legend of the churning of the sea of milk. So, in Khmer art, the emphasis was always on heightened tension, whether static or dynamic, rather than on relaxation.

In addition to these constants which mark deep tendencies, such as those just considered in Khmer art, there were also the constants which respond to the perennial appearance of traditional forms across the centuries. Examples of these constants will now be given.

In Cham art, the beautiful tower sanctuaries were ornamented by pilasters which frame the entrances and were used in a curious form of arcading, and then were also used along the walls. Though the decoration on these pilasters changed many times, and they multiplied in number, they continued from the time of the first extant

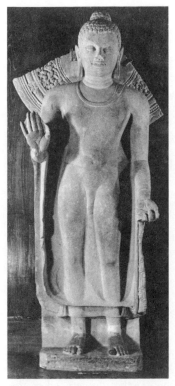
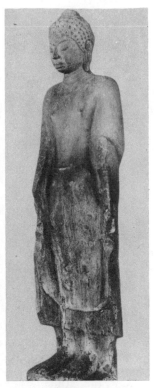
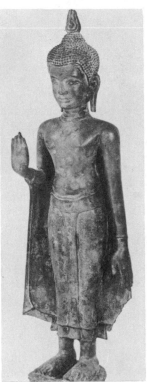

342. INDIA. Buddha. Gupta style. About the 5th century. *Sarnath Museum*.

343. THAILAND. Buddha. Dvaravati style. 6th–10th centuries. *Bangkok Museum*.

344. THAILAND. Buddha. U-Thong style. About 13th–14th centuries. *Musée Guimet, Paris*.

345. THAILAND. Buddha. Late Siamese or Thailand art. *Hanoi Museum*.

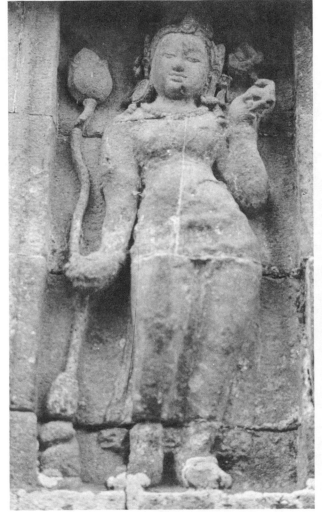

THE PERMANENCE OF THE BUDDHA TYPE: A CONSTANT

The same figure, although the treatment has become more and more stereotyped, recurs from the Indian Buddhas of the Gupta period (of about the 5th century) to the present-day productions in the Indo-Chinese peninsula.

346. CENTRAL JAVA. SARI. Female figure. 8th–9th centuries.

347. *Below.* KHMER. Lintel at Bakong, Angkor.

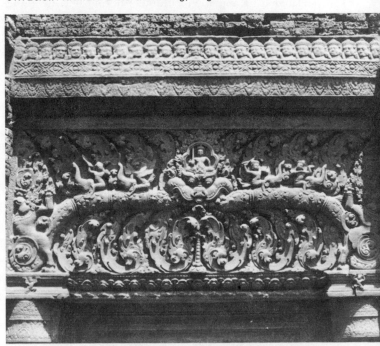

169

tower sanctuary, which belongs to the first half of the 9th century, until the last tower sanctuary, Po Rome, which was built during the final decadence in the 17th century, where they still occurred, but reduced in number and squat in shape.

342
343
344
Thailand adopted the Gupta Buddha from India during the early period, sometime between the 6th and 8th centuries, and then modified its form. The face, and even the attitude, were altered, and so too were the symbolic details. Yet, even today, in the Theravada Buddhist countries of Thailand, Cambodia and Laos (Theravada Buddhism was one of the sects of Hinayana or Southern Buddhism, as opposed to Mahayana or Northern Buddhism) the Buddha wears the same clothing as the ancient Gupta Buddha, clothing which frames the body and then hangs forward. Sometimes the form was not understood,
345
and was reduced to thin metallic plaques on each side, but it nevertheless continued.

The arts and thought

Indian eroticism in art is echoed in literature and religion. The amorous amusements of Krishna, Radha and the gopis may be given as an example. And there were religious overtones in the theme of the divine being drawing power from sexual union with his sakti, a theme which occurred frequently in Tibetan Buddhism. For further examples of these 'echoes' see pp. 190–191.

'Echoes' were also strong in China. There was close interrelation between the arts of monochrome painting, calligraphy and poetry. These were directly connected with the form of contemplative Buddhism which was influenced by Taoism—in China known as Ch'an Buddhism and in Japan as Zen Buddhism.

412
Calligraphy, regarded as a leading art, linked monochrome painting with poetry. A wash painting was often enriched with a poem composed by the artist, and the calligraphy formed part of the design. The contemplative religious sects directed attention back to nature, and landscape came to be considered as a reflection of the soul; vast spaces were created in which the spectator may imaginatively lose himself. These works were thus related to T'ang monochrome painting and to T'ang poetry.

In this painting and poetry especially the 'echoes' are 'constants'. The landscape often illustrated a poem, but as the poem was generally written before the work was painted—at least in the pictures that have survived— Chinese painting was probably strongly affected by the influence of the poetry written during the 7th and the 8th centuries.

T'ang poetry was charged with melancholy. It often echoed the time of twilight or of moonlight, the season of autumn or of winter, the migration of geese which evoked the passage of time. The landscape was hidden in mist or in rain, and in this silence the water became merged with the sky. It was a summons into that immensity in which the soul becomes dissolved. T'ang poetry is full of such images: 'Imperceptibly twilight falls—and the moun-
324
tains become lost in the light mist' (8th century); 'A light mist rises on the horizon—And the distant river becomes lost against the sky' (8th century); 'The lone wild duck flies with the lower clouds—The autumnal waters merge with the timeless sky' (7th century); 'The limpid water
323
sleeps—In an autumnal landscape—Bleak and melancholy' (8th century); 'Soon after, the moon rose above

the eastern mountain—The shimmering water merged with the sky—We let our boat drift with the current over
323
the immensity—As through space we sailed with the wind' (11th century); 'Then, in a floating dream, I know not where my thoughts stray—I lie beneath great trees
322
and I contemplate eternity' (7th century).

This, then, is the counterpart in poetry to the fisherman alone in his boat on a background of silk where sea and
323
sky become one, or the tiny hermit lost in contemplation
322
under a twisted pine, beneath the scudding clouds of winter and the migrating birds. The mist filters into the
408
valleys and hides the lower slopes of the mountains, which
324
stretch away, one behind the other, into the far distance. The mists, the vast surface of the water and the infinity of the sky unite to form this summons into the distance.

In Java there were echoes between the low reliefs of the second or Middle Javanese period (13th to 15th centuries) and the puppets cut out of leather used in the Wayang shadow plays, which are still popular today. It is unlikely that it was by pure chance that the figures in low relief of the second period, unlike those of the first, showed profile treatment similar to the Wayang puppets. However, it seems impossible to tell whether the puppets led to the change in the style of these low reliefs, or whether it was not rather the relief figures of this period which contributed to the birth of the Wayang shadow theatre.

Tendencies and universal rhythms

In conclusion, we come to the pan-human 'tendencies' and 'rhythms' which recur in the arts which lay so far apart that they were beyond all possibility of having an influence on one another. These resemblances which existed without any intermediary show, however, that the world of southern and eastern Asia was not so different from our own.

Has Chinese painting, at its most sublime, in its profundity, demonstrated this tendency towards a unity in art? It is difficult to know whether or not it has done so, for the convergence has revealed itself to us especially in the expression of the faces. Nevertheless, in the Chinese monochrome landscape, even though it was so different, there may be seen the same 'resemblances' that are to be found in the faces—that infinity in which one may lose oneself, that meditation, silence and melancholy which seem to be the very opposite of self-centredness.

In Java there are some exceptional Buddhist figures in which, to the childish and tranquil grace of the first Javanese period, there is added the triple flexion from India, symbolic of self-surrender, and sometimes an introvert expression in the face. Examples include a female figure
346
at Sari and also the figure of Sujata at Barabudur. These Javanese figures, though less intense, show 'echoes' of the Bodhisattvas at Ajanta and of the mysterious smile of Angkor.

This introduction may end with this mystical smile, the expression of infinite peace and recollection, of contemplation joined to an inner compassion for one's fellow beings. This meditation and sympathy were communicated by the closed eyes and the smile. It is an expression that corresponds to the sensibility of the times, and to the contemporary Jayavarman VII, the Khmer king and a fervent Buddhist, who had written on his hospital stele that 'he suffers from the ills of his subjects more than from his own, for it is the public suffering that is the malady of kings, and not their own suffering.'

170

THE CLIMAX OF INDIAN ART

Jeannine Auboyer

Indian traditions, despite political disruptions, but reinforced by Hindu conformity, survived. Art evolved on a basis of ancestral laws and reached its climax in majestic ensembles of Indian architecture. Simultaneously, Indianised overseas countries, benefiting from lessons received in the past, achieved masterpieces stamped by their own genius. They, too, reached a climax in the marvels of Angkor.

The period of Indian art covered by this chapter, though arbitrary, nevertheless corresponds to important historical facts. It represents the apogee—or, if preferred, a new flowering—of Indian styles. In order to understand its spirit to the full, it is essential to examine the mass of historical and cultural data that is available relating to the evolution of Indian civilisation.

In the 7th century, Harsha of Kanauj succeeded in almost completely reinstating the Gupta empire. In doing this, he assured the survival of the forms that the Gupta period had developed so splendidly in the plastic arts, and also in music, literature and philosophy, and this not only in India itself, but in those countries which were influenced by her. After the death of Harsha in 647, the rather precarious political unity of India was shattered. Nevertheless, thanks to the extreme slowness of Asiatic evolution, the whole of India continued to live on the memory of the Gupta grandeur, though little by little the various Indian regions were affected by the political fragmentation. A great diversity of styles grew up, both in the north and in the south, according to the tastes of the local rulers. Politics became more sharply defined, and their repercussions affected artistic creations. There was an essential difference between these 'Middle Ages' of Indian art and the ancient period. In the latter it is easy to distinguish several styles, or rather schools, but a fundamental unity underlies them all, and it is therefore difficult to attribute a work of unknown origin with any confidence to a particular country, without first examining carefully the material from which it is made. This unity reveals itself in a certain uniformity of fashion. Textiles and jewellery were similar from one school to another, and the difference lies mainly in style—in the composition, and in the treatment of the silhouette, etc. But from the moment when India became a mass of local kingdoms all striving to increase their own prestige, a notable change took place in the arts. Two great groups became established, one in the north and the other in the south, and local variations developed inside each.

The disappearance of Buddhism and the rise of Hindu art

This state of affairs was due to various causes. Not least among them was the disappearance of Buddhism from the very soil on which it had grown. In earlier periods Buddhism had given a unity to art, even if sometimes only in an iconographical sense. It had also spread Indian influence across Asia. But as it grew, so it suffered from this vast expansion. While in full ascendancy it became mixed with Hinduism; it lost its original ideals and also

its strength, though outwardly it continued to present the appearance of a universal and all-powerful religion. A double movement was unfolding: on one side there was the reaction of an excessive conservatism which attempted to confirm Buddhism within a tighter framework, but it became like a colossus with feet of clay, and its downfall was sealed when Islam unleashed its religious war over territories which had until then remained faithful to Buddhism. Art followed closely the graph-like curve of Buddhist power. It began with the dazzling productions of the ancient period, which were followed by the opulence of the classical period. Then came the period in which may be discerned the listlessness resulting from the overabundant production. Gradually, Buddhist art was throttled by the strictness of its rules: the contours became stereotyped, the animating spirit was extinguished, and in the Pala period it declined into a catalogue of iconographical themes executed according to formula. They remained varied, but the spiritual quality seemed to vanish. The final productions were confined to Bengal, which was the sacred ground of Buddhism. At the beginning of the 13th century the Mohammedans finally annihilated the artistic nucleus remaining in that region and the creative career of Buddhist art, on Indian soil, was definitely finished.

At the same time, Hindu art began to develop. Unlike Buddhist art, it had no period of radiant youth. Instead it entered smoothly into a phase of maturity which continued and flourished in southern India. It is important to remember that with thousands of miles of coastline, in many places inhospitable, and with the natural barrier of the Vindhya mountains, the Deccan was nearly always

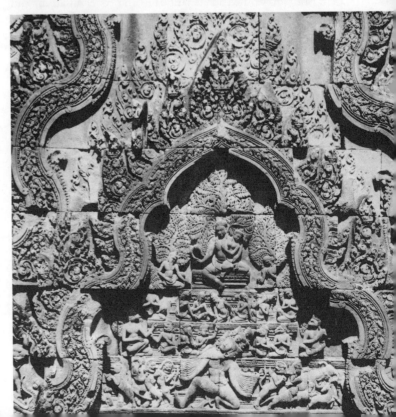

348. KHMER. Representation of Mount Kailasa, at the top of which is the abode of the god Siva. Low relief on a tympanum of the temple of Banteai Srei. Third quarter of the 10th century.

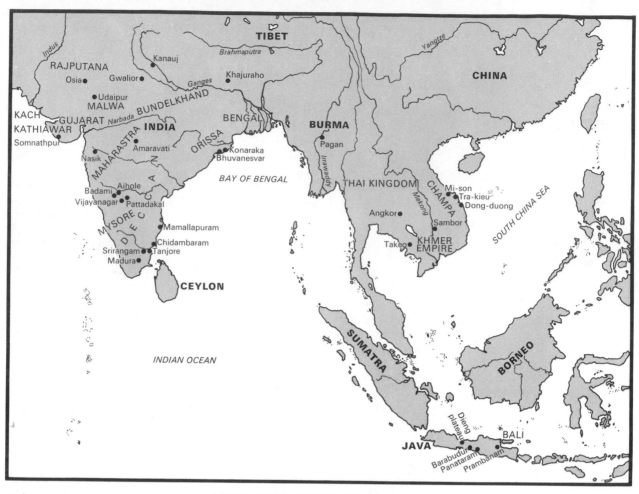

INDIA AND SOUTH-EAST ASIA

able to maintain its independence and its own government, whilst the north, open by way of the Indus valley, was the theatre of many invasions. Foreign elements penetrated by way of the north, where they became more or less established. Indigenous elements were able to survive with much greater purity in the south.

Before the menace of invasions, the southern provinces remained not only a bulwark and a refuge, but also not unlike an art museum. The countries of the south included Maharastra, which was of Dravidian origin though entirely Aryanised in its language and its civilisation, and the Deccan, which accepted the Indian religions but preserved its own languages, Telugu and Tamil, and its own culture together with its originality. These countries had received Aryan immigrants more as a civilising influence than as conquerors. In this respect they also bore similarities to countries in the Indo-China peninsula and to the Sunda Islands, of which Java is the most important. In southern India, a whole civilisation was founded on the Dravidian traditions; it flourished and gradually became so important that it ended by influencing the north, which enabled it to resist the Mohammedan persecutions with more vigour. Its cultural roots were embedded deeply in the *Vedas*, and even earlier, allowing it to become the champion of Hindu purism. As a result of this civilisation, the most characteristic Indian qualities flourished and were maintained even in the more exposed regions. A Dravidian style emerged which was to remain a dominant element for several centuries.

Hindu conservatism

Hinduism, from then on, impregnated all 'Indian' India. But like Buddhism, it was forced to be extremely conservative in order to preserve its ideals which seemed to

be jeopardised by the presence of foreigners living in the same territory. The Mohammedans first, and then the Europeans, established themselves in the north. They were to have no peace, however, until they had conquered the south, and this they had to do, without being crushed, deep inside a country whose resistance sometimes threatened their mighty power. It was not until 1565 that the last independent kingdom, that of Vijayanagar, finally succumbed to the tremendous weight of the Mogul invaders. As each region was successively conquered, so they were reduced to a weakness which was emphasised by the unremitting conservatism that paralysed and stifled them. The same phenomenon continued to recur in many areas right into the present century, when they were opposed to the application of the 1949 constitution which touched their religion in all the essentials of its orthodoxy. Up till then their religion was closed in on itself by the inviolability of the caste system and by its insistence on the identity of the divine and the human. These times are now fundamentally in the past. Nevertheless, history makes clear both the cause of the underlying permanence of the Indian civilisation and the cause of its weakening. This last made Indian civilisation the prey of successive invaders and could have led to total annihilation.

The Mohammedan invasion reached a point from which it appeared ready to launch upon the creation of a vast Indian empire. The problem of India here stands out clearly, for the political conditions there were such that for several centuries it could not ensure its independence by the concerted action of its forces. The local kingdoms fought courageously but in isolation. The crumbling of power and the splitting up of territories could have had no other result. Yet in the intellectual and religious spheres, Greater India remained what she had never

172

ceased to be—an enormous mass of peoples solidly cemented by a single form of thought and tradition. Throughout centuries, Islam scarcely spread except in the north, and Hindu India continued to develop its fundamental heritage, and to maintain overseas the influence that it had implanted there in the past.

Religion, the warp of Indian life

Indian culture was outstanding throughout a series of dynasties both in Maharastra and in the Deccan, and it was unequalled in its ostentation. These dynasties included the Rashtrakuta, the Chalukya and the Yadava in Maharastra, and the Pallava, the Pandya, the Chola and the Hoysala in the Deccan. It was the Chola Dynasty that conquered Ceylon. All these dynasties had a glorious past. Art flourished during their reigns despite incessant military conflict. Similarly, the heights of philosophy were reached by scholars whose personalities still survive. A number of trends stand out in this period following the year 1000, and these must now be considered. Emphasis must be put on the religious development, for religion was the veritable warp of Indian life. Six orthodox 'theories' or *darsanas* were based on ancient roots drawn from the *Vedas*. Some had already been formulated in an earlier period, and the others were defined immediately after the year 1000. These took the form of fundamental texts or *Sutras* and commentaries or *Bhashyas*, and they covered the subjects of religious ethics, logic, physics, metaphysics, philosophy and theology. From the 10th to the 16th centuries, the philosophical masters added important modifications to each of the 'theories'. They also proposed several solutions to the problem of salvation.

A strong emotional pressure runs through the enormous mass of these texts, and this gradually turned the philosophers from quite speculative conceptions towards a belief in theism and to mysticism, in which the *Vedanta* played the most important part. Spread out over more than seven hundred years of the evolution of Hinduism, its great philosophers affected the popular poets, to whom we are indebted for the *Puranas* or 'Antiquities'.

Mysticism and syncretism

As a result of the *Puranas*, a syncretism was evolved which was to become characteristic from the medieval period to the present day. This movement towards the union of the various strands in Hinduism was founded on a theism which was to become more and more exalted, and resulted in repeated endeavours to establish a universal religion. Mystical theology took precedence over other forms from the 13th century onwards. It was the result of a long evolution of *bhakti* (love or devotion), one of the three paths to God. As a result the religion of the people triumphed at the very heart of Brahmanic orthodoxy. This spirit of religious compromise also tried to unite all the mystics of the world. It was to play an important part in relations between India and her Mohammedan invaders, when she found among these invaders a mysticism analogous to her own, preached by the Sufis.

Syncretism also caused a spirit of tolerance to develop, which has meant a great deal to all religious teachers both in medieval and contemporary India. It was not, however, universally accepted, because it was firmly counterbalanced by orthodox conservatism, which was jealous of preserving the purity of the moral laws or *dharma* representing the Aryan tradition.

From all this a religious environment of exceptional quality emerged which impregnated all facets of Indian culture and the life of the individual. More than ever before, the human and the divine became intermingled. The emperors identified themselves with their favourite divinity. Temples imitated the *mandalas* which were magic diagrams of the cosmic system. The terrestrial world was ordered in the image of a residence for the gods. All concurred in an outburst of spiritual well-being.

The expansion of India and south-east Asia

Furthermore, this period saw an overseas expansion based on Indian culture. Earlier, from about the 2nd to the 4th centuries, because of the barrier raised by Iran between eastern Asia and the West, India had transferred much of her commercial activity to south-east Asia. It seems, then, that Indian interest in these countries was due to economic factors, but she did not restrict herself to trade, as so often happens when a rich country has dealings with underdeveloped peoples. Without fully realising it, she played the role of an exemplary coloniser. Her merchants, colonial settlers and travellers all represented the refined culture of their homeland. The language used for official and religious acts was Sanskrit. Indian literature was rooted in folklore, and many traces of this survived. The

349. INDIA. Example of the myriads of sculptures on a temple at Khajuraho. 11th century.

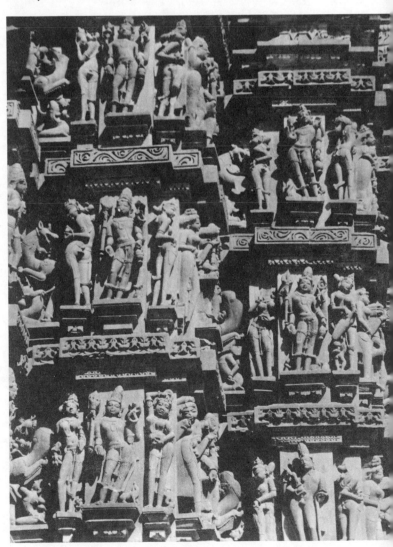

local rulers were so impressed by the political structure that they did their best to imitate it. In short, all that was most characteristic of Indian culture was grafted on to nations whose simplicity of life had astonished earlier travellers. Nothing was imposed by force, only by example and also by helping them to acquire the necessary intellectual development.

This deeply pervasive influence was nourished by repeated contacts which took place over centuries, especially through pilgrims and religious teachers. During the 10th and 11th centuries, while India was achieving some of her finest and most characteristic productions, the countries of south-east Asia, infused with the fundamental elements of her spiritual and artistic culture, experienced a similar period of fertility. From now on, these states became consciously organised, and they scarcely noticed the gradual withdrawal of Indian power, which had been so discreetly administered. The kingdoms which shared the Indo-China peninsula, as well as those in the Sunda Islands, became independent. Their political structure was firmly laid and Indian culture had been completely assimilated. They had now reached maturity and a splendid period was about to begin. The unique permanence of the Indian spirit was more suggested than defined, but it underlay their whole culture and especially their artistic activities. It gave them the foundation for the most daring creations in which their local genius shone out, a genius stimulated by this influence and not paralysed by it.

Khmer

The civilisation of Khmer was far and away the most brilliant in the Indo-China peninsula. It has left incredibly magnificent remains of its glorious past and also extremely valuable information on the political and religious life of that part of Asia. It is very instructive to examine the principles relating to that culture, because in them it is possible to see the harmonious intermingling of Indian traditions and local customs with creations that are essentially Khmer, and how this intermingling achieved such a perfectly coherent climax.

Without any doubt at all, the Khmer empire owed its power and brilliance to this harmony and coherence. The Khmers achieved a political unity founded on royal authority and supported by a ritual that henceforth became rigid, in which the god-king or Devaraja played the essential part. The Khmer capital was at Angkor where a growing number of religious buildings was constructed. The Khmer civilisation had taken on its own character which was to survive until the decadence of the 14th century. The king was the pivot of the whole political organisation of the state. He was the guardian of religious law and of the established order; he was the protector of religion itself and the preserver of pious foundations; he was pre-eminently the sacrificing priest, the defender of the kingdom and the supreme administrator. His capital was enclosed by a surrounding wall and a vast moat, which represented in microcosm the universe surrounded by mountains and oceans. The centre of the universe contained the cosmic mountain, Meru, which was symbolised by a stepped pyramid. At the summit of this pyramid was the sanctuary of the god Siva, represented under the aspect of his phallus or *linga*. The ritual which took place at its consecration associated the name of the king with that of the god. The safety of the kingdom resided in the *linga* which had to be carried after the king in all his official movements.

The temple-mountain

Each king built one of these temple-mountains if he had the time and the means. They were a type of sanctuary and they reached their most spectacular form among the Khmers. They were part of the conceptions held in all countries of Asia affected by the monsoon. As in India, but in a more systematic form, the kingdom, the palace and the temple were considered as microcosms or miniature replicas of the cosmic order, into which were integrated the court, the administration, the provinces, etc. The divine world and the human world corresponded closely and harmoniously, but though this conception was inspired by India, its translation into architecture was different in Khmer, and this difference will be discussed later.

The temple-mountain, where the god-king was worshipped, was at one and the same time the centre of the royal town and the centre of the universe. It became the mausoleum of the king, and his ashes were probably placed there after his death. The king, as he was identified with the god who resided on the summit of this mountain, was assured of his survival there after death. The princes, dignitaries and gallant warriors likewise became identified with the statue of a god or goddess or with a *linga* which carried their name. In this way they underwent a sort of canonisation, sometimes even during their lifetime. They then took on the title 'Lord of the Universe', and the statue was substituted in place of their mortal remains to serve them as a glorified body. This funerary worship was essentially personal and gave rise to the erection of numerous statues, many of which were set up by private individuals within the royal foundations. There was considerable religious syncretism as Buddhist effigies became included in the Hindu pantheon. The areas allotted to personal veneration were numerous and often very large. It is highly probable that they retained a degree of privacy, except during some festivals when the people had to be admitted so that they could bow down before the images of the gods which were incarnated in the king and his dignitaries. It was an administrative hierarchy modelled exactly on the divine world, which from the summit of the pyramid, in the heart of the sanctuaries, imitated the equilibrium of the universe.

These beliefs were not limited to ancient Cambodia, but were also to be found in Champa, and especially in Java and Bali. They explain the particular form taken by religious art in these various regions, and they confirm that the temple and the image were regarded as the dwelling place of the god, just as in India. The sanctuary, then, could not have been a place of assembly, but must have remained a sacred cella. The structure and the decoration marked it as first and foremost the cosmic mountain, the divine abode, or the microcosm of the universe. In spite of local variations, all the characteristics were inspired by Indian models.

The predominant role of architecture in Hindu India

There was a crescendo of artistic activity during this period, as a result of the effervescent vitality of religious life. Architecture clearly took first place. Sculpture was relegated to the role of architectural decoration, which became prolific later on. Only the images persisted inside

the sanctuaries and chapels. There were no more of the narrative low reliefs which had been so important in the previous period.

Indian architecture entered into a new phase, which coincided with the flowering of Indian philosophy and with the increased needs of the Brahmanic religion. Architecture also entered a new phase and abandoned the ancient formula of copying exactly a timber structure in rock. This had been the method used firstly in the subterranean sanctuaries and monasteries, and later above ground, as at Mamallapuram in the 7th century, and in the Kailasanath temple at Ellura in the 8th century. Indian architects ceased to be tied to a monolithic form of construction and henceforth worked in brick or dressed stone. This tremendous innovation transformed the whole spirit of architecture. Earlier, architecture had been treated as a colossal sculpture, and gave more importance to the sculptural decoration than to the structure itself, which remained very simple. Architecture now took precedence over sculpture. The problems involved were entirely different. No longer was it a case of reproducing a timber building in stone, but of raising an edifice by the piling up of stone blocks, of screening the spaces that were left and covering it solidly. The decorative features remained interesting, but only as decorative features. The change from a timber technique to a technique in brick or stone necessitated a completely different treatment. It was also necessary to reconcile new building methods to a whole collection of traditions which could not be abandoned owing to their ritual significance.

This transition from the use of one building material to another seems to have been effected gradually from the 7th century to the 9th. Perhaps the monolithic buildings erected above ground during the 7th and 8th centuries served as the intermediate stage. The fact remains that buildings constructed in stone, such as those at Sanchi, had appeared in the Gupta period, about the 5th century. There followed an obscure period in which architects seem to have groped for their forms. Then, in the 8th and 9th centuries, more important edifices were erected, which were to develop, around the year 1000, into gigantic architectural groups, as impressive in their proportions as in the majesty of their style. The only revolutionary facets of this new emphasis on giant forms—it had first appeared in sculpture—were in the sheer size of the works, and from this, though less obvious, the means employed to realise them. The style itself had already been used in the buildings of the 7th and 8th centuries, where the new type of sanctuary had emerged from the timber tradition of architecture, and where the problem of roofing was resolved in various ways. The various solutions to this problem were to be fully explored by the medieval Indian architects.

Architectural innovations

The major innovations of the medieval period were in the plan and in the treatment of the roof. Both were to alter profoundly the appearance of the temples. In the Shore temple at Mamallapuram and the Kailasanath temple at Kancipuram, of the 8th century, several buildings were grouped in alignment inside a rectangular enclosure. In addition to the sanctuary, there was an antechamber or

350. INDIA. Hypostyle hall or mandapa at the Vaikuntha Perumal of Kancipuram. 8th century (?).

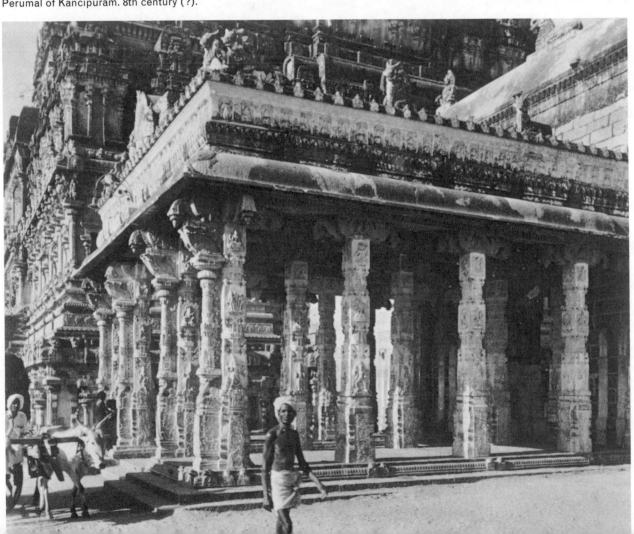

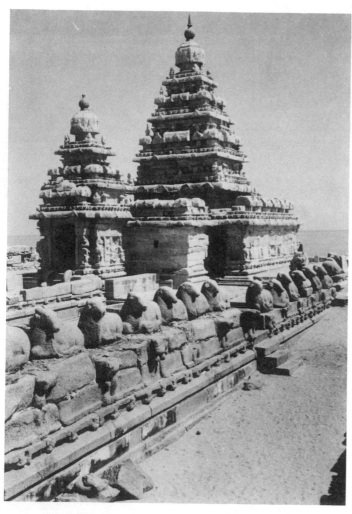

351. INDIA. Shore temple at Mamallapuram. 8th century.

Badami, one of the oldest temples of this type, is over 160 yards by 80 yards in area, and it has in front of it a first court measuring more than 80 yards square. The temple of Lingaraj at Bhuvanesvar, dating from about the year 1000, is in an enclosure measuring 180 yards by 145 yards. The exterior walls of the temple of Jagannath, at Puri, are 225 yards by 215 yards. One of the largest temples in southern India, that of Srirangam, is enclosed 354 by five concentric walls, of which the outer one measures 955 yards in length and 840 yards in width. These colossal dimensions were repeated and even exceeded in southeast Asia, at the time when the religious foundations were being developed to the maximum. The famous temple of Angkor Wat built by Suryavarman II (1112– 338 1152) is enclosed by a moat nearly two and a half miles in circumference. Angkor Thom, built by the great king Jayavarman VII (1181–1201), which contains in its centre the colossal temple of Bayon, is enclosed by a wall which is nearly two miles long on each of its four sides. The temples of Prah Khan and of Ta Prohm, raised by the same king, measure respectively 875 yards by 655 yards, and 1095 yards by 765 yards. Similarly, in Java, the Brahmanic group at Prambanam, built in the 9th century, has an interior enclosure of 230 by 250 yards.

The plan of the temples

The interior of Hindu temples of this period will be considered later on; for the moment, it is necessary to examine the plan of the sanctuary itself.

It has already been said that the central kernel of the temple consists of the sanctuary, an antechamber or antarala and a pillared hall or mandapa. On these basic elements the Indian architects were to elaborate their types of plans, which were to be numerous and very varied. It is difficult to classify them; attempts at geographical or religious grouping have never been entirely satisfactory. A classification by type or shape, however, appears feasible, for in this way they can be divided into two large groups—those with a pyramidal roof and those with a curved roof. The temples with pyramidal roofs were usually built on a square or nearly square plan. These temples are known as vimanas (sanctuaries), and 355–361 they were localised especially in the Deccan, in Dravidian country. An antechamber was added to the front face of the square plan, which henceforth was incorporated in the temple. The temples with curved roofs in the form of a beehive were distributed throughout the north and were found in the south as far as Madras. This form of roof was known as a sikhara. These temples were based on a plan 369–374 which was originally lozenge-shaped but which tended to become cruciform as a result of the indentations—the alternating convex and concave lines of the tower.

Innumerable variations developed from both the square and cruciform plans. In some regions, as a result of multiple indentations, the cruciform plan became octagonal, star-shaped, or even more or less circular. But whatever the form or the size of the building, the sanctuary was invariably tiny. This sanctuary, that is to say the abode of the god, was usually square, and had in front of it a projecting part containing a hall, vestibule or simple corridor, which served as entrance. Even in the largest temples, it was rare for the walls of the sanctuary to exceed five yards in any direction. Throughout the ages this sacred spot was reserved exclusively for the image and the officiating priest. It was the veritable abode

350 antarala, and a pillared hall or mandapa, which were close to the principal entrance and within the enclosure. The essential parts of the Hindu temple consisted of the 351 sanctuary, or small cella, containing the god, into which only the officiating priest was permitted to penetrate; the antechamber, in which this priest would make the preparations for the ceremony; and finally, a columned hall, in which some ceremonies would be carried out in full view of the faithful, who had been allowed into the enclosure. Dances, offered as entertainments to the god, would be held in this space. Numerous buildings of light construction were certainly grouped round this central area, and these were used to accommodate the temple personnel and to store provisions for them as well as material needed for ritual purposes. These utilitarian buildings within the immediate vicinity of the temple have disappeared, but gradually they were replaced by stone or brick buildings erected in a second and concentric enclosure. They then overflowed into a third enclosure, and into even further enclosures, until they covered a very large area. Buildings of diverse types were also erected for various other purposes such as the chapels of secondary gods, cloisters and lustral baths. The whole agglomeration became more and more vast and developed into a sort of religious city 354 enclosed within its own walls. The dimensions of these 352 walls reflect the ceaseless growth of Hinduism over several centuries.

A few measurements will give some idea of these temples. The Virupaksha temple at Pattadakal, near

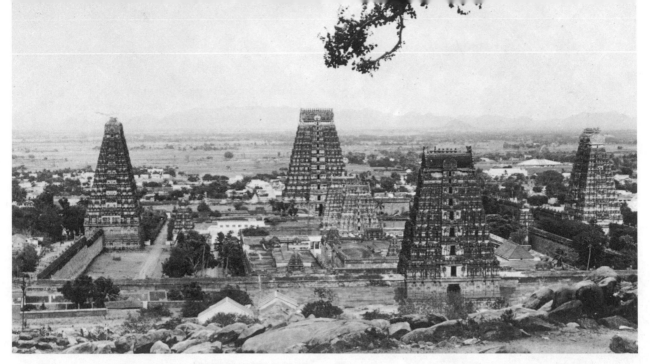

352. INDIA. View of the temple group at Tiruvannamalai (south India), with its quadruple enclosure and gopuras. 17th century.

of the god; it was the womb containing the 'embryo of the world' mentioned in the sacred texts.

This notion was passed on to the countries of southeast Asia. Except in Burma, which came under Chinese influence, the idea was always accepted, in spite of the colossal and ostentatious proportions of the temple. Everywhere, in Khmer, Champa, Siam, Java and Bali, the sanctuary remained tiny, and was enclosed beneath a massive weight of masonry. In these countries as in India, it was not accessible to the crowd of pilgrims. It likewise had an antechamber in front of it joined to the sanctuary by a corridor. This arrangement, which was adopted about the 7th century, was based on earlier arrangements. It came about because of the needs of the religion; it continued and was perpetuated.

Though these principles spread everywhere, there were nevertheless variations. At Mysore, for example, three semicircular chapels were linked to the principal sanctuary, which was thus given a cruciform appearance in spite of the basically square plan. It did not, however, belong to the cruciform type, which was derived from the lozenge plan. Architecture of the Chalukya and Hoysala Dynasties frequently employed the plan used at Mysore—for example, at Somnathpur. It was never used in Java, though, nor in Cambodia. Nevertheless, a somewhat similar combination occurred in these two countries. At Candi Kalasan, built in the 8th century in Java, and at the temple of Banteai Samre built in the 12th century in Cambodia, chapels were attached to the central sanctuary, but did not communicate with it, and only opened on to the exterior. The star-shaped plan, which resulted from an accumulation of indentations and of projections, existed only in the architecture of the Chalukya Dynasty. The octagonal plan was quite rare in India, and was exceptional in the architecture of southeast Asia. It occurred, however, at Sambor and Prei Kuk, built in the 7th century in Cambodia, at Chanh-lo and at Bang-an in Champa, and at the Candi Jabung in Java.

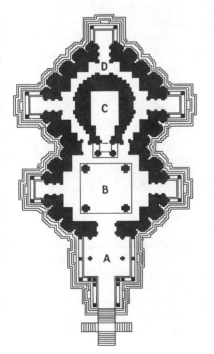

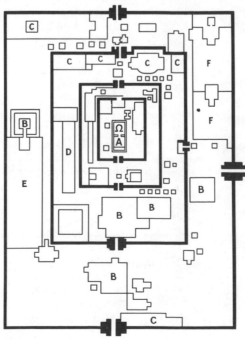

353. Plan of the temple of Kandariya Mahadeo, at Khajuraho in north-east India (beginning of the 11th century). A. Hypostyle hall (ardhamandapa); B. Porch (mandapa); C. Sanctuary (garbha griha); D. Ambulatory for the pradakshina (circumambulation of a sacred site), and secondary chapels.

354. Plan of the temple of Srirangam, south India (16th century). A. Sanctuary; B. Hypostyle hall (mandapa); C. Secondary temples; D. Stores; E. Stables for the sacred elephants; F. Hall of the Thousand Pillars.

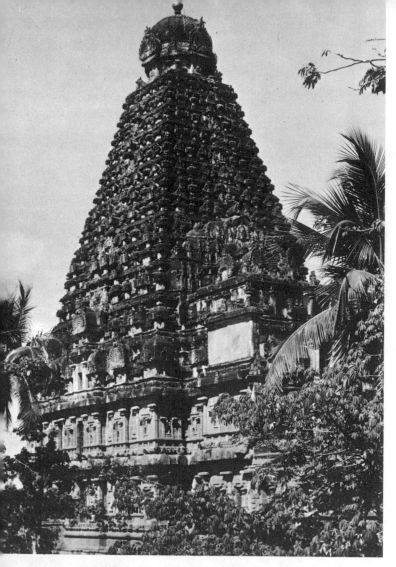

355. INDIA. The vimana of Tanjore. Beginning of the 11th century.

356. INDIA. The Dharmaraja rath, at Mamallapuram. 7th century. The simplest type of sanctuary, consisting of a pyramidal roof on a square plan, whose development culminated in such works as the vimana of Tanjore.

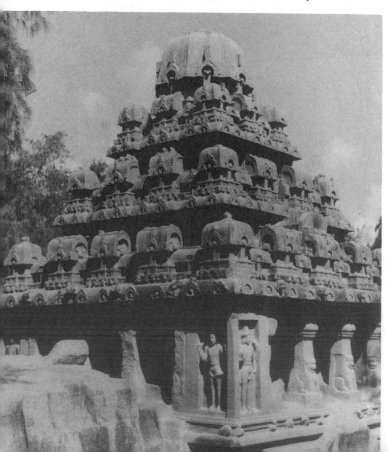

Another peculiarity common to architecture in India and in south-east Asia was the curious habit of superimposing hollowed out areas in the solid mass of the masonry. These hollows were like small rooms and in Indian examples their ceilings were flat stone slabs, though in Java they were covered by vaulting. Very rarely did any staircase lead up to these openings. They did not exist in Burmese architecture, where the masonry was solid. It is possible that this arrangement corresponded to a ritual tradition, for it recalls the solid masonry of the stupas, where a small chamber entirely walled in served as a receptacle for the sacred relics. It may also be supposed that these hollowed out spaces contrived by the Hindu architects and their emulators were a means of lightening the weight of the masonry surmounting the sanctuary. Yet it is very possible that some symbolism entered into this form of construction, just as the whole composition of the building was controlled by its sacred character.

The roof of the temple

The methods of arranging the roof should be considered before a study is made of the exterior in general. Very important is the almost constant use made of vaulting arrived at by allowing each successive horizontal course of masonry to project slightly beyond the one below until the opening becomes small enough to be covered by a flat stone or small cupola. Indian architects knew how to construct the true arch, but generally did not use it. There were rare examples, especially in the provinces of the north-west. In Burma, on the other hand, arches were continuously used, probably as a result of Chinese influence, for in China the arch form was basic to architecture in stone and brick. In India, the corbelled vault was the most usual, and it was the only one that was passed on to south-east Asia. There it appeared more or less crudely, and in Khmer where the execution was the least skilfully carried out it was often concealed by a wooden ceiling, which recalls the viharas (cave monasteries) of Ajanta.

It is from the shape of the exterior that the characteristic difference of each style or each region can best be distinguished. These shapes were used in many different combinations, but always remained true to the basic form of the group. The two types, the pyramidal roof and the curved roof, even though very different in their appearance, obey the same fundamental laws which render them so essentially Indian. Each evolved by using the same elements endlessly repeated. The final results were extraordinary. They began from prototypes of very average size, and steadily developed into gigantic buildings, whose harmony arose from the coherence of the system from which they were born.

The pyramidal roof and the role of the kudu

The temple based on a square or rectangular plan and supporting a pyramidal roof was clearly descended from prototypes which were themselves the final results of an even earlier evolution. These prototypes may have existed either as temples which were actually built or perhaps as temples represented in paintings and sculptures. They include the small temple depicted in one of the Ajanta frescoes of the 6th century, Draupadi's rath built in the 7th century at Mamallapuram, and the sanctuary included in the immense low relief illustrating the Descent of the Ganges carved in the 7th century, also at Mamalla-

puram. From this series of archetypes there is a gradual progression, step by step, and century by century, which ends in the great achievements of the medieval period.

Numerous variations occurred together, and it would be impossible to examine all of them in this work. However, it is interesting to make some comments on them, for these 'variations on a theme' were typical of the Indian spirit, and later were to be magnificently echoed in south-east Asia.

One type may be easily isolated from the many that existed. The essential characteristics of this type are a square plan, exterior walls decorated by pilasters, and a pyramidal roof. The pyramidal roof appeared to be in stages, and each stage contained an alignment of miniature replicas of the whole building. The pyramid was crowned by a square or polygonal finial. Until about the 11th century, each stage of the roof contained three or four of 356 these miniature replicas, which were square at the angles and rectangular on the centre of the roof. They were arranged regularly, diminishing in size, one above the other. These miniature replicas, known as pancharams, repeated the form of the whole construction with miniature pilasters and miniature roof pierced by blind windows. In the oldest of these temples, dating from the 6th and 7th centuries, the false windows could still be recognised as deriving from the bays with sloping roofs of ancient timber architecture. They became more stylised and ended as a decorative motif. This evolution was already clearly apparent in Gupta and post-Gupta times, from the 4th to the 8th centuries, and it became steadily accentuated until these motifs bore only a very distant relationship to the original feature.

These false windows, once they had become part of the decorative repertoire, were known as kudus. The term kudu is from the Tamil language, and was adopted by G. Jouveau-Dubreuil in his study of the architecture of southern India. The kudus were important in the evolution of the pyramidal roof. They also decorated 356 each face of the pyramidal roof of the miniature replica, and ornamented the cupola crowning the shrine. More important still, a kudu, usually of great size, marked the centre of the miniature placed at the middle point of each 355 stage of the roof. As these large kudus were placed one above the other, so together they gave a centre of interest to each face of the roof, by making a sort of vertical salient, and from this arrangement were elaborated the 358 great kudus of the rectangular pancharams, whose forms were to become more and more changed. Gradually, they 357 took on the appearance of pediments, and in this form they were to be adopted and yet further exploited by the architects of 'Indianised' Indo-China.

355 The great vimana of Tanjore was the most representative and at the same time the finest temple of this type and was built about the year 1000. It was essentially the climax of an evolutionary process, and it is only necessary to compare this temple with others in the same group, of which there are a very great number, in order to realise its magnificence. Such comparable temples include the temple of Narthamalai, the temple of Siva at Panamalai, the temple of Agastyesvara at Melappaluvur, the small temple erected in front of the Indra Sabha cave at Ellura, the Kalagamalai rath, the Arjuna rath at Mamallapuram, the Kailasanath temple at Ellura, the temples of Badami (Malegitti Sivalaya) and of Pattadakal (Sanganesvara, Malikarjuna, Virupaksha), as well as many others.

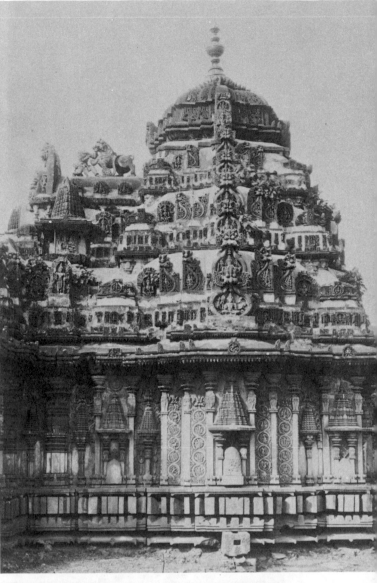

357. INDIA. Temple of Siva at Amritapura. 13th century (?). The kudus, transformed into exuberant decorative motifs, have here invaded the entire roof.

358. INDIA. The temple of Ittagi (Raichur district). 12th century. The development of the central kudus on each face gives a new rhythm to the pyramidal roof.

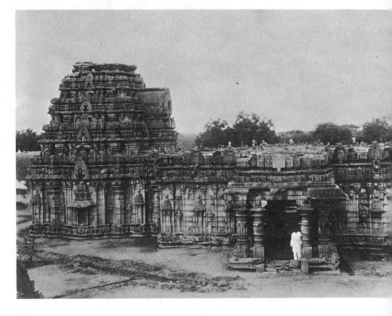

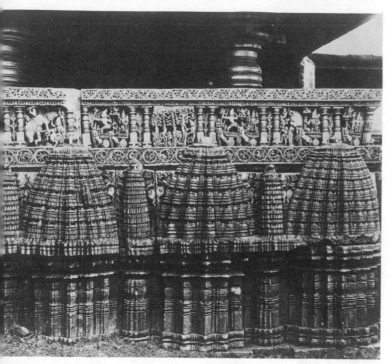

359. INDIA. Miniature replicas of temples at the foot of the temple of Siva at Amritapura. 13th century (?). The final stage of an architectural development [360, 361] which, by multiplying the projecting vertical courses, tends to give a beehive-shaped silhouette to the pyramidal roof and to transform the polygonal plan into a circular one.

It is necessary, though, to pause in order to consider the most typical temple of this group, which began about the 7th and 8th centuries. This is the Dharmaraja rath at Mamallapuram built in the 7th century. In size, the Dharmaraja rath is small; it is only thirty-six feet in height, whereas the vimana of Tanjore is about two hundred feet in height, which is scarcely less than the height of the towers of Notre Dame in Paris. Both the vimana of Tanjore and the Dharmaraja rath were made up of the same component parts. The only difference, apart from the styles of the two buildings, was in the number of the component parts each employed. In the vimana of Tanjore the body of the temple was built in two stages, one superimposed above the other; and the stages of the roof number thirteen as against three in the Dharmaraja rath. The silhouette of the roof of the vimana of Tanjore is a more clear cut and continuous slope by reason of the progressive diminution in size of each successive storey. This silhouette was already the same as that of the Shore temple at Mamallapuram, which dates from the 8th century. At Tanjore, the part played by the central kudus can be seen on each face of the roof. They had become decorative motifs like pediments and broke the monotony of the repetitive decoration. The development may be followed through its successive stages in the temples of southern and western India. There was the temple of Lakkundi Jain Basti in the district of Dharwar, where the form was still very simple. Following this there was the temple consecrated to Somesvara at Harahalli, in the same region, which has a more elaborate form, repeated at each stage, which gave a vertical accent to a roof built up in a stratified form. This arrangement was more strongly marked in the temple of Ittagi, in the district of Raichur, and in the temple of Amritesvara at Annegeri, in the district of Dharwar. In these the kudu became intermingled in a more heavily laden architecture. Its origins were henceforth forgotten, and it passed completely into the realm of decoration. It became more

and more transformed; it ultimately invaded the cornices, and the pancharams were no longer distinguishable. This was to be seen in the temple of Narayandeva at Lakkundi, the temple of Vira Narayana at Belavadi, the temple of Lakshmi Narasimha at Vighna Sante, and the temple of Siva at Amritapura.

The slow transformation from the kudu to the decorative pediment, together with the use of these to accentuate the central ridge on each face of the roof, was accompanied by another development. This began from the plan itself and was to affect the whole appearance of the roof, particularly in the temples of Mysore. There was a tendency, more or less regional, of complicating the plan by so great a number of curves that it could finally be inscribed in a circle. The indentations themselves were rounded and were extended upwards into the roof, giving a ribbed effect to the whole, which sometimes resembled the temples with curved roofs which will be analysed later in the chapter. In the present type which derived quite definitely from the temples with pyramidal roofs, one can still perceive the superimposed stages of pilasters and the pancharams ornamented with kudus, but the stylisation became so strong that a very attentive analysis is required to differentiate the various elements.

One of the most typical shrines in this respect is the Kesava temple at Somnathpur, and it may be compared with the temple of Siva at Arsikere. This form of composition reached a sort of climax, or exaggeration, in the temple of Vidyasankara at Sringeri where the arrangement of the indentations and the pilasters became so systematic that it looked completely stereotyped and dry. The circular appearance had become very marked. Only one further step was needed in order to obtain a new silhouette, found in some of the miniature replicas that ornamented the base of the temple of Siva at Amritapura. On an indented rectangular plan, the roof rose in beehive-shape, and was ornamented by motifs derived from the kudus. This silhouette was to be found again in the architecture of Cambodia and of Siam.

Emphasis has been placed on the variations of the temple with pyramidal roof as found in India, for one also finds numerous repercussions of this form in south-east Asia.

From these Indian examples, it is possible to sum up the main characteristics of this type of temple. The stages were ornamented by pilasters which supported miniature replicas of the whole building. These replicas were of square plan at the angles of the roof, and of rectangular plan midway between the angles. The kudus of these midway pavilions, superimposed one above the other at each stage of the roof, became increasingly important, and finally resembled decorated pediments. The plan of the temple became more and more indented, and the indentations were extended into the roof, which however retained its storeyed effect. Finally, in some cases, accented motifs replaced the kudus and the pancharams. These same characteristics occurred again in the countries permeated by Indian influence in Indo-China, and also in Java. The arrangement varied to a greater or lesser extent, but clearly arose from a common inspiration.

The pyramidal roof in south-east Asia

The influence of Indian architecture in that of south-east Asia would most probably not have had the same force if it had merely been a question of transmitting forms.

356

351

358

357

361

360

359

364

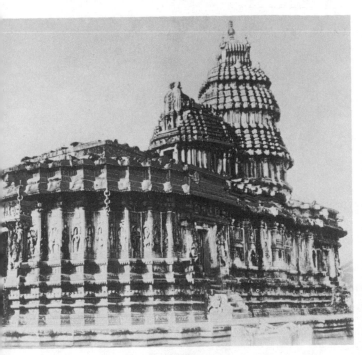

360. INDIA. The temple of Vidyasankara at Sringeri. 12th century (?).

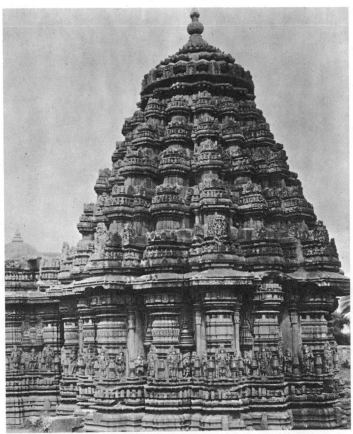

361. INDIA. The temple of Siva at Arsikere. 12th–13th centuries (?).

362. KHMER. Angle kiosk on the pyramid of Phnom Bakheng. End of the 9th century.

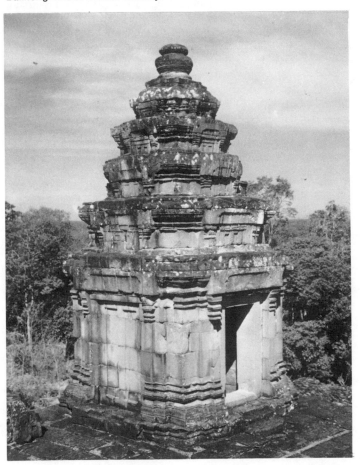

These forms, however, were closely tied to a symbolism which surrounded the sanctuaries, and which had originally come from Mesopotamia, though this source had been entirely forgotten. The clear fact is that the temple represented a very precise image, that of the cosmic mountain. The pyramidal roof, conceived by India, was adopted by the countries of south-east Asia for this reason; and for this reason also, it not only continued and spread, but also preserved all its principles.

It even seems that in some respects these countries interpreted the mountain into architectural form far more rigorously than had India. The stages of the pyramid were more marked or frequently even accentuated. Each stage in itself became a repetition of the whole building, complete with pilasters and doorways surmounted by a pediment. A good example is the temple of Phnom Bakheng, which was built late in the 9th century or early in the 10th, and has virtually no decoration to complicate the analysis. Each successive stage of the roof repeated the main body of the temple but in reduced dimensions, and the whole impression is that of a 'telescopic' temple. It had very simple indentations, and the superimposed pediments together formed a salient on each face. This temple represented the perfect type of the Khmer prasada. This same arrangement, coming obviously from India, is found again in the temple of Banteai Srei, which was built in the second half of the 10th century. Similar characteristics were preserved together with the decoration general to this style. Further, a miniature replica of the whole building occurred at each angle of the well defined stages of the roof. This replica was of square plan, just as in India.

There are numerous examples, but these two are among the most clear-cut. The miniature replicas at the angles and the vertical alignment of the pediments suggest a direct descent from Indian temples. However, we do not believe that the pediments in Khmer temples came about through the same evolution as those in India. In India, the pediments were descended from a transformation and alteration of the pancharams, whereas in Khmer they appear to have developed from the porches surmounted by a stub of vaulting that terminated in a

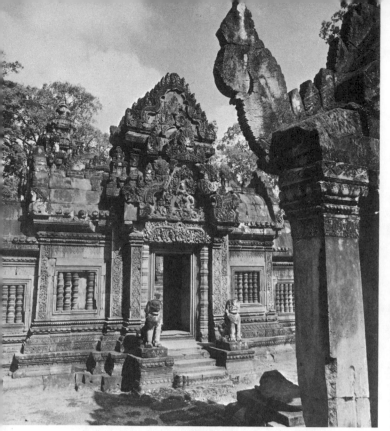

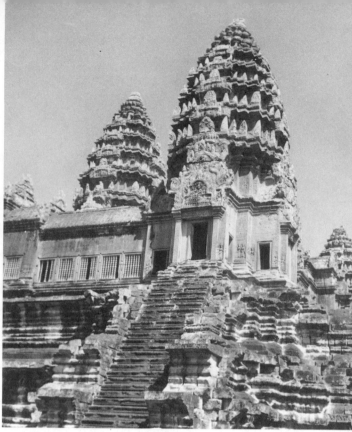

363. KHMER. Southern sanctuary of Banteai Srei. Third quarter of the 10th century.

364. KHMER. Central tower of Angkor Wat. First half of the 12th century.

large kudu. The idea of a central salient which vertically punctuated the horizontally stratified pyramid certainly resembled the Indian types. It may even be asked if it was not the Khmer interpretation that influenced Indian architecture rather than the other way round.

The architecture of Champa corresponded to this Khmer interpretation. In Champa, all these characteristics became exaggerated and heavy, but they preserved intact the original arrangement. The Cham kalans were square in plan and the indentations were slight. They had a principal entrance and three false doors, each surmounted by a pediment, the shape of which was repeated at each stage of the roof in a vertical alignment. Miniature replicas marked the angles of each of the very accentuated stages. These replicas became larger and more detached as the architectural evolution reached its later periods. An excellent example of one of the final stages is the principal tower of Po Klaung Garai built in the 14th century in the province of Phan-rang in south Vietnam.

This type was still very near to Indian examples, and from this one may pass to a more evolved type, which also followed the same progression as in India. The indentations were multiplied, the contour could be inscribed in a circle, the silhouette and the pancharams were replaced by pieces more or less triangular in shape. The most 364 perfect example of this is the central tower of Angkor Wat, built in the first half of the 12th century. It presented all the principles of this evolution whilst still preserving the vertical alignment of the pediments on each face. This arrangement was passed on to Thailand, where Wat Mahadhatu reached the same result, but it seems more systematic and came nearer to the miniature replicas that 359 adorned the base of the temple of Siva at Amritapura.

Thus, it would certainly appear that the influence of Indian architecture on the countries of south-east Asia was not only manifest at the beginning, but was renewed from time to time, and gave these countries repeated inspiration. It was originally thought that the influence of

India had served as a point of departure, that on this initial basis a stylistic evolution had been independently elaborated and that derivations were made only occasionally and then as often from other neighbours as from India itself. In actual fact, the development of architecture in south-east Asia, and especially in Khmer, ran parallel to that of India. Information passed which permitted these countries to follow the progression of the Indian style. Iconography and writings prove that the same was happening in the intellectual and religious domain. In short, these countries all possessed full knowledge of the developments in Indian thought.

Further still, the temple with pyramidal roof influenced all of the Sunda Islands, which had been strongly affected by India. It showed itself in various aspects, more or less near to Indian prototypes, but always translating the cosmic mountain into the form of a stepped pyramid. In Brahmanic as well as in Buddhist temples, miniature stupas replaced the pancharams of Indian architecture, even though the stupa was essentially a Buddhist or Jain form. In this, the collusion of Buddhism and Brahmanism is clearly visible and in Java it appeared in various other ways as well. There is little doubt that at least during the whole of the important period of Middle Java, that is, from the 6th century to the 10th century, direct contacts were maintained with India. These contacts were both on official levels and in the popular traditions, which is proved by the Javanese versions of the *Ramayana*, which have strong similarities to some local Indian versions. The temple of Siva at Prambanam was the last great temple constructed in Middle Java and dates from the end of the 9th century. In this shrine there were close echoes of developments in Indian architecture. As in the vimana of Tanjore, the main body of the temple consisted of two storeys instead of one; similarly the silhouette of the pyramidal roof, in this case ornamented with miniature stupas, was more attenuated than in the earlier candis. The process was identical in both cases.

365. INDIA. One of the gopuras (towers over the entrances to the enclosure) of the temple of Srirangam. 16th century.

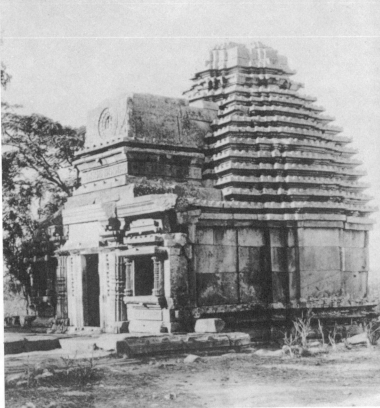

366. INDIA. The temple of Konnur (district of Belgaum). 11th century. Example of a pyramidal roof of the Kadamba type.

Another type of pyramidal roof, also originating from India, is called a Kadamba roof by some authors. It followed the same rules, but in India was generally used for secondary shrines or for miniature replicas. It was used to cover the anterior halls joining the principal sanctuaries. Its form was somewhat similar, being based on a square plan, and having a pyramidal roof crowned by a pseudo-dome. The essential difference was in the arrangement of the stages of the roof, which were in the form of narrow cornices placed immediately above one another and always devoid of miniature replicas. The absence of ornamentation gave the pyramid a poorer, more systematic and in some ways more abstract appearance, which contrasted with the size and richness of the roof of the principal sanctuary. It seems that these were like an abridged version or a simplification of the symbolism of the cosmic mountain, yet this is only logical for they were restricted to secondary buildings. This form was used in both the north and the south of India. It was employed, for example, at Bhuvanesvar near the great temples with curved roofs, in the region of Khandagiri, and at Dodda Gaddavalli. It also passed into the countries of south-east Asia, but there it was also used for some principal sanctuaries. In Khmer it is found at Asram Maha Rosei, built in the 7th century; in Java it figured in the large temple group of Panataram built between the 12th and the 14th centuries; and in Burma this form was very frequently employed.

The gopura or entrance to the enclosure

Another group of buildings, connected in principle to the temple with pyramidal roof, must also be briefly considered. These are the monumental gateway towers known by the name of gopura, which were important in the great architectural groups of southern India. They looked like huge accumulations of stone, piled up on a rectangular plan, and surmounted by a covering in which, to one's astonishment, may easily be seen the hull-shaped roof used in the timber sanctuaries of the earliest Indian architecture. The purpose of the gopura may best be explained by the fact that this form was employed from the 2nd century B.C. in civil and in military architecture, and that it was particularly used in the buildings that served as a sort of customs' house at the entrance to a town. The gopura is thus a type that existed throughout the whole period of Indian architectural evolution. The Dravidian gopura, the climax of this form, is a supplementary proof of the way in which, over a long period of time, a very simple timber building became transformed into an astonishing edifice of stone. These gopuras reached incredible heights—150 feet at Madura—and they served to draw attention to the sacred shrine whose guardians they seemed to be. On them the stages of the roof were daringly multiplied, and they rose with a breathtaking accumulation of stone. These giants were, from about the 11th century, one of the most original creations of southern India.

It is strange that the gopura never passed into the architecture of south-east Asia, at least not in this form. In those countries the entrances to the enclosures never attained such dimensions, nor were they conceived in the same style. When the hull-shaped roof was used, it was for the sanctuary itself, as had occurred at Mamallapuram. A good example in Khmer is the Prasat Andet.

The curved roof and its variants

The temple with curved roof had a parallel evolution to the temple with pyramidal roof. It was just as important, but there were fewer variants. Both attained a majestic development about the year 1000. The temple of Lingaraj at Bhuvanesvar in Orissa is an excellent example of the curvilinear type of this period. The origin of the curvilinear sanctuary is very much more obscure than that of the pyramidal. At best, one can recognise in the temple of Lakshmana at Sirpur, built in the 6th or 7th century, one of the earliest attempts at curved roofing.

183

Its symbolism was also different. Instead of representing the mountain residence of the god, it was rather the representation of the divine and cosmic body, which the *Vedas* call *purusa*. The names given to the principal parts of the building corresponded to this cosmic body. The roof itself was called *gandi*, which literally means 'the trunk of the body'. Its summit or mastaka included the *beki* or 'throat' and the *khapuri* or 'skull'. These terms are confirmed by a tradition of Orissa handed down by word of mouth, which even attributed a masculine and feminine sex to different categories of buildings. This distinction is also met in Burma, where it is confirmed by inscriptions carved in stone. When a 'masculine' temple was to be linked to a 'feminine' one, their point of contact was known as *ganthiala*, a word used for the symbolic knot which joined the clothes of the bride and groom during the marriage ceremony. Finally, some shrines in Gujarat, such as those of Sunak and of Ruhavi belonging to the 12th and 13th centuries, had four human faces carved near the top and in the middle of each side of the roof. There is a local tradition that these faces were talismans against demons, but their presence agrees with the idea of the representation of the cosmic giant. They also recall other temples with human faces, in particular that of Bayon dating from around the year 1200. In this case the symbolism is known, thanks to the studies made by Paul Mus and G. Coedes and by Jean Przyluski. Though practically nothing is known of the symbolism of the temples of Gujarat, at Bayon on the other hand it is known that these heads represented King Jayavarman VII as Lokesvara or the Lord of the World. In short, it was the expression in material terms of the identity of the king and of the god. It cannot be assumed that there was a close relation between the sikharas of Gujarat and the extraordinary towers with human faces at Bayon, but in their similarity may be seen the trace of a common tradition, which had been born in India.

368

Two main types may be distinguished among the temples with curved roofs, depending on whether or not they had miniature replicas. The oldest group did not use them. The roof was made up of stages, just as in the pyramidal type, but the stages were much closer together and gave a stratified appearance which became more marked as the type developed. At the angles of alternate stages, superimposed vertically, were cornices ornamented with kudus, which were derived from the degenerate tradition of the pancharams. Alternating with these were ribbed cushions called amalakas after the name of a fruit and these formed a sort of bulky pad which had the effect of softening the angles. They may have been derived from the capitals of ancient Persepolis. In the centre of each face, a vertical salient became more and more marked, and was ornamented at the base by a large kudu which acted as a decorative pediment. The roof curved inwards towards the top and tended to become rounded into the shape of a beehive.

369

There are innumerable examples of this relatively simple type. Among the oldest (7th–8th centuries) are the temple of Durga at Aihole, the temple of Jambulinga at Pattadakal and that at Bhuvanesvar which date from about 750, as well as temple IV at Begunia (Burdwan, Barakar, Bengal) and the little brick temple at Kharod (Bilaspur). Then everything became more systematised and the kudus of the cornices, arranged more and more regularly, formed a pattern rather like a decorative net-

369

370

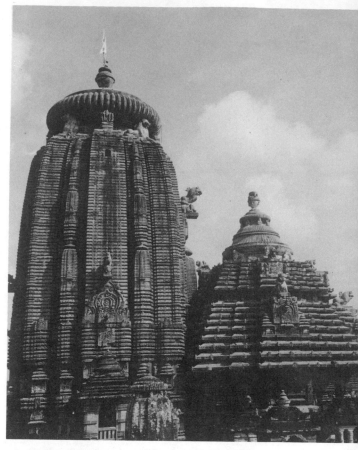

367. INDIA. Temple of Lingaraj at Bhuvanesvar, dominating the small temples with its immense sikhara. 10th–11th centuries.

work, which was only faintly reminiscent of the original appearance. Examples include the temple of Kashivisvanatha at Pattadakal, the temple of Muktesvara at Bhuvanesvar of about 975, the large temple of Siva at Pattadakal, the temple of Surya at Osia, the temple of Mahadeva at Nilkantha (Alwar), the temple of Bajramatha at Gyaraspur (Gwalior). The outcome of this type is well represented in the temple of Parsvanatha at Khajuraho, after which it gave place to the heavy stratified roofs of the temples of Begunia, of a special type which appears to have been restricted to Bengal.

371

A second type originated in about the 10th century. Miniature replicas made their appearance, this time, as miniature sikharas and not as pancharams as they did on the temples with pyramidal roofs. They were arranged in a number of ways which gave birth to various forms of roof, all more or less tapered. Three main categories may be distinguished within this second type, though there were many other variations. One of these categories may be illustrated by the temple of Lingaraj at Bhuvanesvar built about the year 1000. There, the miniature sikharas were superimposed, from the base to the summit of the roof, between the salients of each face and the cushionings that softened the angles. Other shrines resembled this one, and among them may be cited the temple of Maitresvara and the temple of Ananta Vasudeva, probably built about 1100, on the same site.

By comparing the temples of the 7th and 8th centuries with the sikharas, it is possible to realise the full extent of the development that had been made in architecture. There were as many differences among the sikharas as there were among the temples with pyramidal roofs, which evolved from the Dharmaraja of Mamallapuram to the vimana of Tanjore. The sikhara of Lingaraj rose to 180 feet. Under the ridges of its immense roof it would

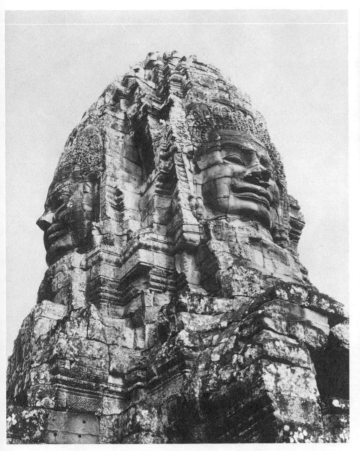

368. KHMER. Temple of Bayon. Tower with the face of the Bodhisattva Lokesvara. Late 12th or early 13th centuries.

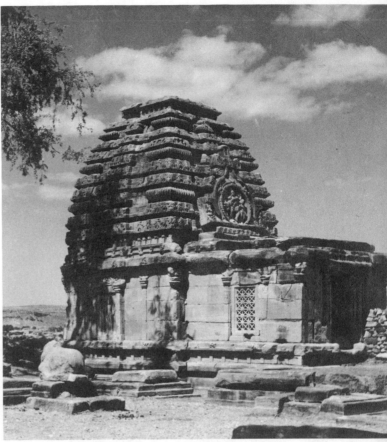

369. INDIA. The temple of Jambulinga at Pattadakal. 8th century. Ancient example of a curved roof.

be difficult to make out the cornices of the original stages if one did not know the evolutionary progression that led up to this climax. At the same time it becomes possible to grasp the magnificent success of Indian architecture, which, both in the temples with pyramidal roofs and in those with curved roofs, achieved effects so grandiose and so original, whilst always holding to the traditional scheme of arrangement. It would seem, however, that the temple of Lingaraj, representative as it may be of the medieval period, was none the less the most perfect example of a local form of the sikhara, for it did not recur, save in a degenerate form, except in Bengal which was the neighbouring province to Orissa.

Another category of sikhara, probably belonging to the 12th century, made use of miniature replicas in a more 72, 373 systematic way. Their regularly aligned forms completely filled the intervals between the salients. The curvilinear shape became less pronounced and the cruciform plan became more clear-cut. The following are examples of this category: temple I at Balsane; the temples of Jogdha, of Jagambabedi at Kokamthan, of Amritesvara at Ratanvadi, of Udayesvara at Udaipur, of Sakegaon, etc; the temples at Ambarnatha, of Gondesvara at Sinnar, of Amritesvara at Singhanapur, etc.

Finally, the third category appears to have prevailed mainly in the western provinces of Gujarat, Kathiawad and Kach, but it also occurred at Bhuvanesvar and at 374 Khajuraho where it was used in a masterly fashion. These temples have miniature replicas which vary greatly in size, and which build up along the median band forming the salient of each face of the roof, while others are set symmetrically between the salient and the cushionings of the angle. This arrangement was capable of varied combinations. The earliest were still heavy and somewhat clumsy, but the most audacious displayed a magnificent

upward surge of lines curving inwards towards the top.

These temples probably made their appearance in the 9th century. Their decoration consisting of kudus within a network pattern connected them to the earlier types which were built without miniature replicas. They evolved slowly, and to begin with had only a few miniature sikharas decorating their roofs, as in the temples of Dilmal, of Lakshmi Narayana at Dhinoj in Gujarat, and the temple of Surya at Babriowad, in Kathiawad. The miniature sikharas increased in number and became progressively taller. At first, there were two principal ones which partly concealed the salient as in the temples of Kasera, of Sandera, and of Gorad in Gujarat, and in the temple of Raja Rani at Bhuvanesvar. Then the number increased, and in the temple of Nilakantha Mahadeva at Ruhavi, in Gujarat, there were three. Finally four miniature sikharas of considerable size mount one on top of the other like gigantic buttresses rising upon the salient, while smaller ones ornament the base of the roof, giving by their very arrangement a tapered but powerful silhouette to the whole building. Of this final type are the great creations of the Khajuraho style: the temples of Bhadresvara in Kach, of Sundara Narayana at Nasik and the Jain temple at Taringa, belonging to the 11th and 12th centuries and later. The roof became narrower as it rose clear of each successive group of miniature sikharas, and this silhouette became more frequent in later examples. In temples of the present day, this evolution has resulted 376 in a complete stylisation of the miniature sikharas, which surround and almost fold on to the principal sikhara like giant leaves, as for example at Palitana and Catrunjaya.

Unlike the temple with pyramidal roof, the temple with curved roof seems to have had only a slight influence on the architecture of the countries of south-east Asia. Only in Burma does it appear to have been fully adopted, and

185

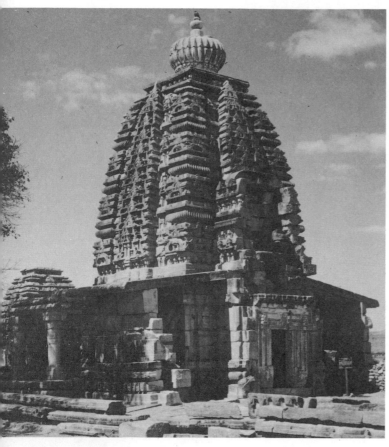

370. INDIA. The temple of Galaganatha, at Pattadakal. 8th century. The curved roof begins to develop.

A development similar to that of the pyramidal roof is seen in the temples with curved roofs: the kudus gradually invade the cornices, making a vertical projection in the middle of each face [370], and end by becoming a sort of decorative web [371].

371. INDIA. The temple of Parsvanatha at Khajuraho. 11th century. The final stage in the development of the curved roof without ornamentation by miniature replicas of the building.

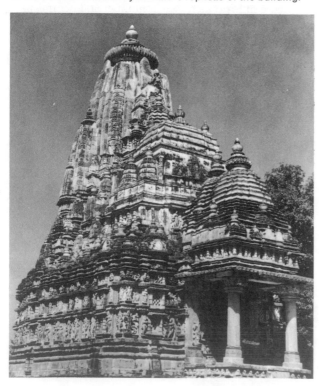

there it was to be richly developed. Burmese architecture used the curved roof with two other features in a curious 375 combination. There was a stepped base, analogous in principle to the Khmer temple-mountains, from the top of which rose the curved roof or sikhara, and crowning the sikhara a tall flèche or spire. This flèche was similar to the chatravala, resembling the shaft of an umbrella, which ornamented the Buddhist stupas in the Indo-Chinese peninsula. Its occurrence in Burma was due to the proximity of Bengal and to the close relations that Burma kept up with India. The same reasons caused the architects of Pagan not only to copy the famous shrine of Mahabodhi, but also to put to Buddhist uses the essentially Hindu form of the sikhara. Its typical curved silhouette was retained and it was only stylised in the detail. In Burma, the sikharas developed with the filleted strata of the cornices and the smooth projecting strips which were sometimes ornamented by superimposed kudus. These latter stood out clearly against the horizontal layers of the rest of the roof. The temple of Ananda at Pagan, dating from 1091, is one of the most typical, as well as 521 one of the best preserved, of the numerous Burmese temples which were built with a sikhara—a form especially current from the 11th to the 13th centuries.

The sikhara was not adopted anywhere else, though there was a hint of it in Middle Java, on the Dieng plateau, in the construction of the Candi Bhima. In some details, it was close to the temple of Lakshmana at Sirpur, which, as already mentioned, could have been one of the prototypes of the temple with curved roof. In Middle Java it was an exception, and no more like it were built.

From all the foregoing, it becomes possible to grasp the manner in which Indian architecture evolved. It was fundamentally the same as the development of Indian civilisation in other fields. Also, it explains objectively the logical sequence by which the cultural and artistic influence of India penetrated and became established in overseas countries to which she had been drawn by commercial interests. The study of the plan of Indian temple groups, and their comparison with those in the countries influenced by her, permit an even more precise summary of these ideas to be made.

Temple groups in India and Indianised countries

The great temples of India, then, were composed of a large number of buildings grouped within one or several 352 enclosures. They have two distinctive characteristics. Firstly, they were all on one level, and the base of one building was only rarely shared with another. The base was sometimes just a fairly low pedestal from which the structure rose directly, and it was never in the form of a stepped pyramid. Secondly, the various buildings were not always aligned symmetrically, and the orientation of the whole group, though generally to the east, was not always so. As a result, these vast religious cities lacked cohesion. The absence of an overall conception resulted largely from the fact that these groups were built piecemeal over centuries, and the scheme was modified from time to time to suit the needs of the moment.

This shows up even more the divergences recorded between the canonical texts and the technical realisations. A whole cosmic symbolism was expressed in the texts, not only Hindu but also Buddhist. The underlying idea was the comparison of the temple to the universe, and of making the temple a microcosm of this universe. As a

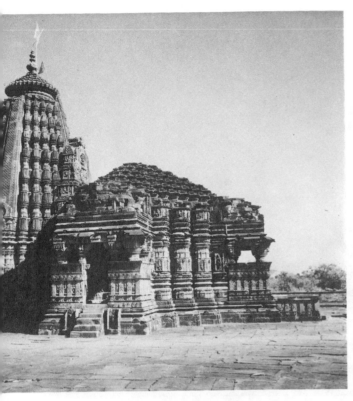

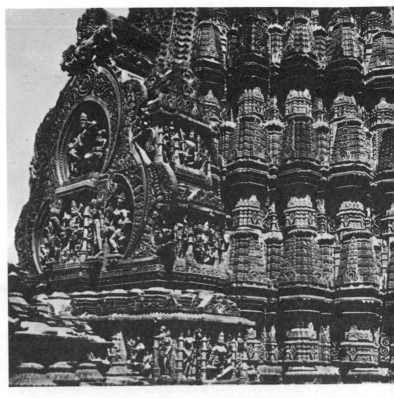

372, 373. INDIA. The temple of Nilakantesvara at Udaipur, and detail of the sikhara. Middle of the 11th century. The miniature replica motif, which was used more hesitantly in other curvilinear temples such as Lingaraj, here plays a very important decorative role.

374. *Below*. INDIA. The temple of Kandariya Mahadeo at Khajuraho. Beginning of the 11th century. Grouped one above the other at the middle of each face of the sikhara, imposing miniature replicas of the temples give a remarkable impression of power and upsurge.

result the whole temple group followed a precise pattern, so that a magic correspondence should exist between the world and its representation in miniature. In the centre, the sanctuary corresponded to the cosmic mountain or world of the gods. This was encircled by the continents or by concentric chains of mountains, and by oceans which separated these continents or mountains. The cosmic mountain rose as far above the ground as it plunged deeply into the ground. These fundamental ideas were so current in Indian literature that they became conventionalised, and the Indian architectural planners did not need to reproduce this system detail by detail. It was sufficient to give the sanctuary of each temple the essential features that symbolically represented the central mountain. Of importance was the roof formed in the shape of a stepped pyramid, which corresponded to the image of the divine mountain. It did not matter if the sanctuary was not in the precise centre of the enclosure, and in fact it never was; the sanctuary *was* the central mountain and the abode of the divinity. Since the magic was more or less satisfied with an approximation, it also did not matter if the other buildings were not arranged in a perfect order.

The countries of south-east Asia inherited from India the same cosmological conception, but were very much more conscientious in its architectural realisation. Perhaps this was due to the fact that they received this cosmology mainly through sacred texts, and they would naturally translate these texts as closely as possible, especially as this rigorous interpretation accorded perfectly with their own traditions. For this reason, one finds architectural representations conforming most closely to the Indian conception of the cosmos, not in India itself, but in those countries overseas where she had implanted her culture.

The most brilliant material realisations of this cosmic order were constructed by the Khmers, which is quite

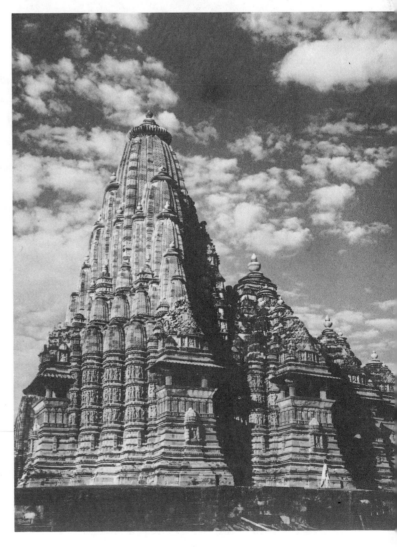

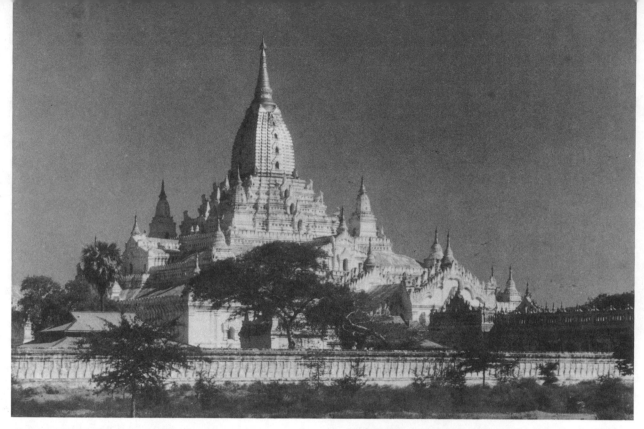

375. BURMA. The Buddhist temple of Ananda at Pagan. End of the 11th century. Combination of elements derived from various sources: stepped podium from Khmer architecture; curved roof from Hindu architecture; and spires comparable to the parasol-like spires of the stupas, from Buddhist architecture.

astonishing if one does not know the intermediate stages of the development. Khmer architecture, across the ocean, was to exploit in the most explicit manner the cosmology that India had derived from Babylonia. In Khmer architecture one cannot fail to establish the relations which existed between the Khmer temple-mountain and the Mesopotamian ziggurat. Both were in the form of a stepped pyramid and had many symbolic similarities, such as a secret part which plunged below the ground, or, failing this, was at least concealed by a contrivance of masonry.

The carved stone inscriptions of Cambodia recall precisely that the various parts of the temple corresponded to the scheme of the world: the central mountain became the sanctuary; the continents or concentric chains of mountains became the enclosing walls; and the oceans became moats or ornamental lakes; it is only in regard to the access causeways that one cannot now be sure whether they were analogous to the rainbow in forming a bridge between the world of the gods and that of men. The iconography itself, often on a monumental scale, corroborated these interpretations. The whole ensemble was perfectly coherent, and showed to what extent the temple was a true reproduction of the divine world and with what profound comprehension the Khmers were able to conceive it.

In south-east Asia, the form of the sanctuary was based on Indian buildings from the moment when brick and stone began to be used for architecture. Even the methods of construction were based on those current in India. The use of corbelling, the use of solid masonry with a space contrived above the sanctuary itself, the proportions and composition of the sanctuary with its vestibule and antechamber, the materials themselves—all were based on Indian temples. In Khmer the buildings which made up the temple group were arranged with a symmetry

376. INDIA. The temple of Mahadeva at Kanki (district of Bilaspur). A modern development of the type in 372–374: the miniature replicas of the temple are here stylised and flattened and almost completely cover the sikhara.

188

which was more apparent than real. They became smaller in proportion as they were further away from the sanctuary or central part, thus giving more grandeur to the centre by its relatively greater dimensions. The temple-mountain evolved slowly because of technical problems. Tentative attempts using brick were made at the Prasat Ak Yom and at Rong Chen on the Kulen. At Bakong, the temple-mountain was fully realised for the first time. It was built in 881 to mark the centre of the town of Hariharalaya, then capital of the Khmer kingdom. Gradually, the temple-mountain form developed, grew and flourished during successive reigns with an increasingly imposing mass. The pyramid of the temple-mountain reached 70 feet at Takeo, built late in the 10th century, and about 80 feet at Angkor Wat, built in the first half of the 12th century. At the summit of Angkor Wat were built several prasats. These were usually five in number, representing the five peaks of the cosmic mountain, and were generally arranged so that the one in the centre was surrounded by the other four. The central prasat, though not necessarily larger, was higher than the others. Galleries, which had at first been tentatively used, now joined the various buildings erected on the pyramid itself. Angkor Wat, the apogee of the Khmer evolution, resulted in the majestic success of a temple-mountain complete with its high pyramid supporting five prasats linked by galleries, and surrounded by successive enclosing walls. It was the perfect microcosm, executed with a total grasp of the architectural effect that was to be produced.

The architects of Java, like the Khmers, were more strictly orthodox in their observation of the technical treatises than were the Hindus, though they did not achieve works as complete in their conception as the Khmers. It also seems that they were more inspired by the Buddhist layout or *mandala* than by the symbolism of the Hindu cosmology. The extraordinary monument of Barabudur (built between 800 and 850), the layout of the Candi Sewu (about 850) that Dutch archaeologists associate with the Kongokai *mandara* paintings of Japan, and the layout of the central group of Prambanam do indeed reflect the highly systematised organisation of the magical diagrams transmitted throughout the Buddhist world by the Tantric Buddhists in India. Java did not make use of galleries like those found in Khmer, nor of the entrances to the temple enclosures like the gopuras found in India, nor of the hypostyle halls or mandapas. Platforms were shallow and flat, and were shared by several buildings.

The emancipation of art in south-east Asia

A number of changes took place, in architecture as well as in decoration, when power was transferred from central Java to eastern Java. The Indian influence was much weaker and less direct. Developments from then on continued independently. There was an aesthetic change which showed clearly in both architecture and sculpture. Ancient native elements made themselves felt, and these grew stronger with time.

In every country influenced by India the following development took place. Firstly there was a very 'Indianised' period when faithful copies of Indian models were the only works created. Secondly came the highly creative period when local artists assimilated and made use of the Indian formulas, which led to 'classical' realisations. Thirdly, the indigenous elements gradually reasserted

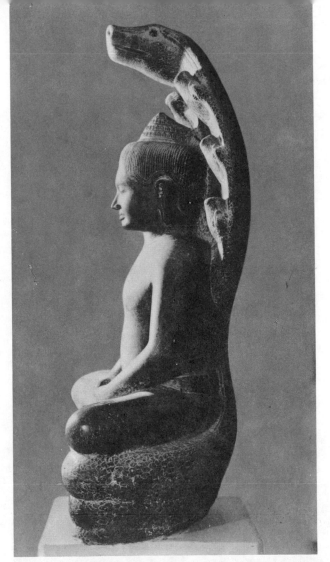

377, 378. KHMER. Buddha sitting on the serpent (*naga*) and detail of the head of Buddha. Angkor Wat style. Beginning of the 12th century. *Musée Guimet, Paris.*

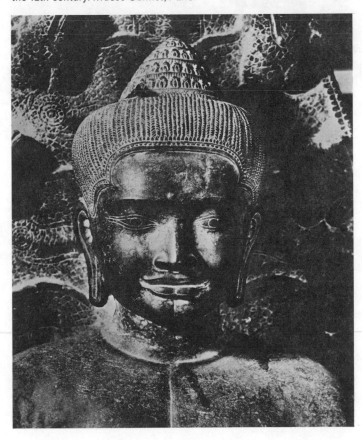

189

themselves and gave a new character to architecture and sculpture, preserving the same themes, but transforming them more and more boldly.

This phenomenon appeared more clearly in sculpture, where the personality of the artist strikes through more directly than in architecture.

Eroticism and the culmination of medieval sculpture

In India itself, medieval sculpture took on a clearly defined form. It became divorced from philosophy, which soars on the highest intellectual plane. Instead, sculpture confined itself more and more to the gloomy enjoyment of pure iconography. It would, however, be wrong to judge Indian sculpture only from this viewpoint. Whereas religious literature was the product of men who, besides being dedicated to an intellectual life, were often recluses and were perpetually in quest of the Absolute, art was the product of specialised lay craftsmen. The sculptors lived in the world, and they observed nature with love and with wonder. Collaborating with Brahmans, ascetics and monks, they were forced to keep strictly to the aesthetic canons imposed by religious tradition. Yet, beyond these rules, which they scrupulously respected, their temperament made itself felt with an intensity that was often quite remarkable, even though this temperament was expressed through traditional formulas. Their work exuded their love of life, of healthy and fertile youth, and of the whole human exuberance under an excessively hot climate. They preferred the world as seen by the artist. Theirs was a feeling for creative power, and for sensual vitality in perfect accord with the sheer abundance 320 of nature.

The most typical expression of these medieval sculptors —at least to Western eyes— is in the amorous couples or mithunas. These existed in earlier periods, but from 379 about the 8th century became the *leitmotiv* of decorative sculpture. Their exceptional abundance, on the walls of the temples that have just been considered, confirmed earlier tendencies in literature. Indian writings, whether religious or not, were full of sexual allusions or symbols, and of passages impregnated with eroticism. This sexual paroxysm corresponds in many ways to the concept of the cosmic creation. The union of the sexes corresponds on the human level to the masculine and feminine principles of the divine union.

The medieval sculptors reproduced the different positions of the sexual union in the same way as the mystics made use in their vocabulary of terms borrowed from

379. INDIA. Divine couple or mithuna. Sculpture from the temple of Konaraka. 13th century.

380. INDIA. Siva as Nataraja, Lord of the Dance. Bronze from south India. *Museum of Asiatic Art, Amsterdam.*

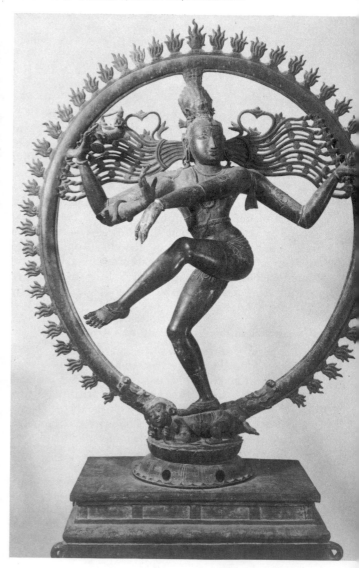

amorous passion. The artists treated the subject with candour and without obscenity. As lovers of human life in all its aspects and as conscious adepts of certain sectarian cults which even went as far as introducing the sexual act itself into its ritual, these artists kept a sense of beauty which gave a glorious quality to all their works. These were perfectly natural to the Indians of the time, for the legitimate union of the sexes was a powerful means of attaining salvation. It was the imitation of the divine union, and a reflection of nature herself. Man and woman thus became integrated in the colossal work of Life. Sexual activity was positively a religious duty, and was codified like the others by the sacred texts, of which the best known is the *Kama sutra*. This quasi-ritualistic approach, with aesthetic recipes and even aphrodisiac charms, does not appear to reach further back than the 7th century; commentaries were added in the 13th century. It was only part of a whole encyclopedic science fully characteristic of Indian thought, in which many studies were grouped close together. These included law and custom, medicine and magic, astrology, drama and rhetoric, diplomacy and strategy.

Besides this eroticism of medieval sculpture there is another and more general characteristic. Parallel with the vast size reached in architecture, there was a proliferation of sculpture to the point of overloading; it was not always in the best taste but it did make the walls appear vibrant with life. The pillars were enlivened with astonishing animals that reared up along the whole height of the shaft. The multitude of carved divinities silhouetted against the sky on the gopura roof visually echoed the pilgrims teeming in the precincts of the temple below. This sheer abounding exuberance reflected the religious effervescence of the period, and gives a good idea of the tremendous amount of work required in erecting such monuments.

Sculpture in the round was henceforth completely integrated with architecture. Even when the works were individual pieces, their functional role was preserved and can be seen without difficulty. They were none the less masterpieces, and the most remarkable were the bronzes produced in the south, which were cast by the cire perdue technique. The purity of their form is brilliantly related to the balance of their movement.

Sculpture in south-east Asia

The character of sculpture in south-east Asia was entirely different from that of India. It was iconographically related, but it scarcely ever experienced the lively movement of contour and mass that is seen in Indian sculpture, nor did it make use of eroticism. The sculpture of south-east Asia may be divided into two main categories— sculpture in the round or the high relief, and the low relief.

Sculpture in the round was static in quality; occasional attempts at more dynamic poses were generally fruitless.

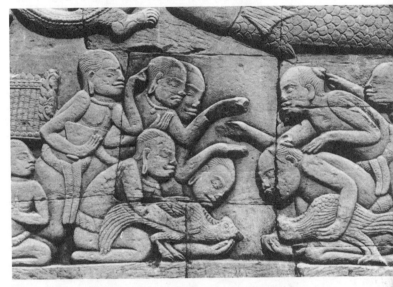

381. KHMER. Detail of a low relief from the temple of Bayon. End of the 12th century or beginning of the 13th century.

382. KHMER. An episode from the *Mahabharata*: the brothers Sunda and Upasunda fighting over the *apsaras*. Tilottama. Detail from a tympanum of the pediment of Banteai Srei. Third quarter of the 10th century. *Musée Guimet, Paris.*

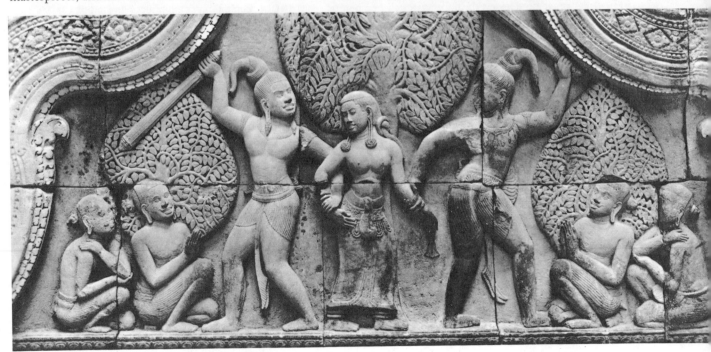

349

380

191

This rigorous and persistent static mood was not devoid of grandeur, whether in Khmer, Champa or Java, even though it is clearly the result of technical incapacity.

In the low reliefs, however, there is a strong sense of composition, a taste for sculptural settings and a stylisation which is sometimes amazingly postured. As this art developed, especially in Cambodia, the taste for picturesque episodes increased. These came from Indian legends and were the pretext for many amusing and moving descriptions, which show clearly the artists' sense of humour and of drama. The immense sculptured frescoes of Angkor Wat sometimes revealed an intentional uniformity that was truly monumental, and sometimes an epic vehemence. The low reliefs of the Bayon were quite different; more interest was shown in the details of the figures. Also they were more hastily executed, which seems to reflect the unquietness, almost instability, of the times. The kingdom was at the very height of its glory, but also on the verge of its downfall.

The very classical period of Indo-Javanese sculpture in central Java lasted from the 8th to the 10th centuries. Then, the indigenous qualities arose again and strongly affected low relief sculpture. It became more primitive in appearance and less sophisticated, but at the same time more truly original. Indian sculptural traditions were submerged under a series of completely different characteristics as the Malayo-Polynesian forms eventually triumphed. The latent animism that lay deep in the sculptors' spirit shows through in their work. In their curious low relief landscapes there were sometimes disturbing monsters hiding beneath rocks or clouds. Such works, which were created in the 15th century, distinguish eastern Java from all the other countries of south-east Asia, and also from India. One may guess the extent to which this mysteriously animated nature could leave a terrifying impression in the spirit of the Javanese of that period.

Conclusion

An attempt has been made to show the reflection of Indian civilisation in its art. The dynamic quality of this civilisation must be stressed. India manifested her genius in art as in other domains, and this in spite of the political fragmentation which was further aggravated by the Mohammedan invasion, and in spite of religious and racial differences. Her power of expansion was great, and all the countries of south-east Asia are greatly in her debt for the possession of an artistic and cultural past that they could never have known without her.

To the beauty and to the grandeur of the Indian civilisation, it is necessary to add the rare quality of having been able to carry out a 'colonisation' in the noblest sense of the word, and of having thus influenced vast overseas territories. It is also necessary to recognise in the peoples who lived in these territories the equally rare quality of allowing themselves to absorb the benefits of this civilisation. In pursuing Indian thought to its conclusion they formed a prolongation of Indian civilisation. However, and this is perhaps even more remarkable, this influence which so profoundly impressed them did not in any way paralyse their own genius. It is sufficient to contemplate the wonderful statues in the Bayon style to realise to what point the spirituality of India had been able to blossom at so great a distance and there to be translated with a genius equal to her own.

382
381
346

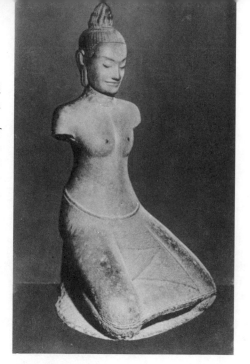

383. KHMER. Statue of the goddess Tara. Bayon style. End of the 12th century. *Musée Guimet, Paris.*

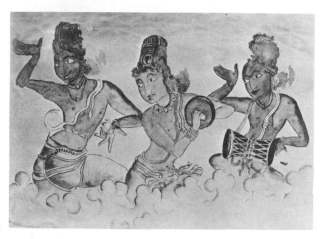

384. INDIA. Celestial musicians. Fresco in the vimana of Tanjore (copy). Beginning of the 11th century.

385. INDIA. Comb from south India. 16th century (?). *Musée Guimet, Paris.*

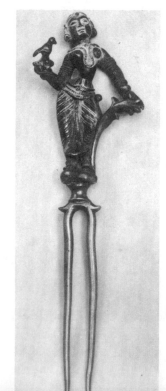

192

HISTORICAL SUMMARY: Indian art

INDIA

History. Indian unity was shattered after the death of Harsha of Kanauj in A.D. 647. From then on it is only possible to study Indian history region by region. The north fell before the Mohammedan conquest, which took effect gradually in successive waves. The first sultanate was founded about the year 1000 at Lahore, and it was two hundred years before the sultanate of Delhi reunited the Ganges and the Indus valleys. The Deccan retained its independence longer and preserved its own dynasties until about 1300.

In both the north and the south, the limelight passed from one state to another, and as it did so, their prosperity was reflected by the erection of numerous temples. In the north, the Utpalas in Kashmir, the Solankis in Gujarat, and the Paramaras in Malwa under the poet king Bhoja (about 1010–1065) were followed by the Chandellas in Bundelkhand who raised the majestic shrines at Khajuraho at about the year 1000. In Bengal the rule of the Palas and of the Senas was broken up at the beginning of the 13th century. In southern India the second Chalukya Dynasty flourished until about 1190. The Hoysalas and the Yadavas built the most beautiful temples of the 12th century in Mysore. The Cholas constructed the famous vimana of Tanjore and the Pandyas made themselves masters of the Carnatic between 1216 and 1238.

With the opening of the 14th century, these states fell one by one under the Mohammedan attacks. The last of them was defeated in 1565 at the battle of Talikota. The Moguls were in full power under their emperor, Akbar.

Architecture. The use of stone and brick extended the range of architectural forms, and enabled temples to soar higher and higher and to increase in all their proportions. The old ideas were not abandoned but were gradually adapted to more grandiose conceptions. New forms emerged, and though traditional in principle were to transform the silhouette of the buildings. These became more varied in form and often reached a gigantic size.

The more clearly defined types characteristic of this period are: 1. A square plan with a curved or beehive-shaped roof called a sikhara, which was mainly to be found in the north; 2. A pyramidal roof covered by a cupola; and 3. A rectangular plan, with a barrel roof crowning a pyramid. In all cases, construction was based on a system of corbelling.

There are vast groups of temples and large individual temples that illustrate each of these different types. The temple of Lingaraj at Bhuvanesvar, built about the year 1000, and the temples at Khajuraho, built from the 11th to the 14th centuries, are good examples of the curvilinear type [**369-373**]. The vimana of

Tanjore, of about the year 1000, is a superb example of the pyramidal type [**355-361**]. The type which is based on a rectangular plan and surmounted by a hull-shaped roof is represented by the Teli-ka-Mandir at Gwalior erected late in the 11th century. This last type was used especially for the monumental entrances to the enclosures of large temples [**352, 365**], as at Chidambaram, which belongs to the 13th century. This type has been popular from the 14th century to today. Other examples of it include Srirangam and Madura.

A great variety exists, which combine the characteristics of more than one type to form regional styles. Plans often became complex, using polygonal and even star shapes.

Sculpture. Sculpture became completely integrated with architecture [**439**], except in the case of the image in the sanctuary. The division between northern and southern styles is more clear cut in sculpture than in architecture. All works were anonymous, but there are masterpieces, both in the north and in the south, which reveal the highly skilled hand of a master. In the north the finest were in stone, decorating temple walls, for example at Khajuraho [**320, 379**]; in the south the most beautiful were in bronze, such as those of Siva as Lord of the Dance [**380**]. Alongside these magnificent works, however, there was a certain decadence, shown in the heavy forms and harsh contours.

Painting. Mural painting lost most of the qualities which carried it to such heights in the preceding period. Some works, however, preserve a purity of line and a feeling for movement, as in those of the vimana of Tanjore [**384**], but the colours have lost their richness, and the beautiful backgrounds of architecture and landscape have disappeared.

Miniature painting, however, was to grow in excellence from the 11th or 12th centuries, especially in the western provinces, such as Gujarat and Rajputana. It was to reach its most brilliant period under the Moguls in the 16th and 17th centuries.

The minor arts. Advances were made in all the minor arts, which were to reach their full development under Mohammedan rule. The Mohammedans were adept at making the best use of the skill of local craftsmen and they also brought valuable technical knowledge. Among the crafts, textiles retained a purely Indian quality for the longest time.

SOUTH-EAST ASIA

History. This period saw the blossoming of culture in the 'Indianised' states of south-east Asia. For centuries, the seed sown by India germinated in these countries, and now a new culture burst

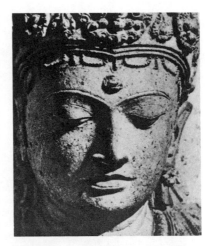

386. JAVA. Head of Prajnaparamita, from Singasari (eastern Java). 13th century. *Leyden Museum.*

forth in those regions that were the best organised. Power in the Indo-Chinese peninsula was shared by Khmer, the future Thailand, and Champa. The Indo-Javanese period of Middle Java was followed by native dynasties in Java and also in Bali.

Everywhere the civilisation was based on Indian culture, and Sanskrit was the language of religion. But the time was past when inspiration was drawn directly from Indian sources. Having assimilated the Indian formulas each of these kingdoms followed its own path, and became capable of its own original creations.

Architecture and sculpture. Architecture was characterised by the brilliant efflorescence of the Khmer style in the famous temple of Angkor Wat, constructed in the first half of the 12th century, and in the temple of the Bayon, erected at the turn of the 12th and 13th centuries. This style was due to the personalities of the last great Khmer kings, of whom Jayavarman VII (1181–1201) was the most illustrious [**331–339, 362, 363, 364, 368**].

In Champa, sculpture reached its heights with the Mi-son A 1 and the Tra-kieu styles. In these, naturalism became allied to a hieraticism that was becoming more and more noble. In Thailand, a multiplicity of styles continued for a longer time. From the 12th century bronze sculpture became prolific, in a distinctive style that has lasted until the present day [**344, 345**]. Finally, in eastern Java, the Indonesian background made itself felt more strongly. It gave to sculpture a pronounced decorative effect, the figures became squat and the features caricatured, but the works created in this style [**341**] had a very personal quality. Islamic influence intervened in the 15th century, but the Mohammedan aesthetic was also adapted to local conceptions.

Jeannine Auboyer

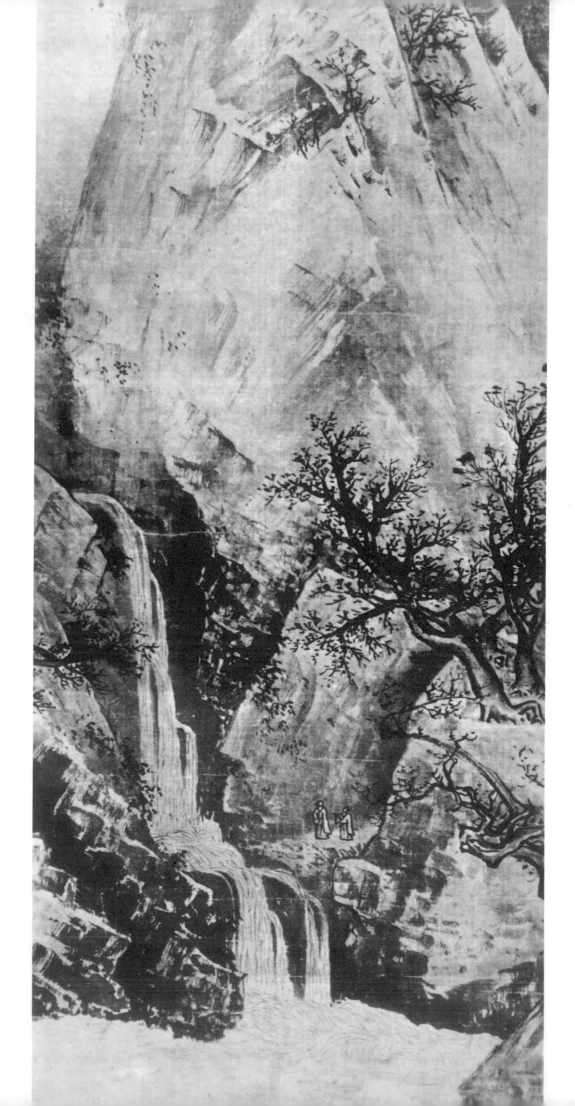

CHINA DURING THE SUNG AND YUAN DYNASTIES *Madeleine Paul-David*

The creative spirit of China reached its climax with the classical art of the Sung Dynasty, which was one of the noblest periods in the whole history of art. Technical perfection served a high spirituality, and the Sung period became the foundation of Chinese art right up till the end of the 19th century.

The aristocratic art of the T'ang period flourished during the 7th and 8th centuries. Interior stability, the development of trade and influences from abroad contributed to its rise. The greatest years were during the reign of Ming Huang (710–755) who was surrounded by a brilliant group of poets and painters. The development of this art was rudely interrupted by the revolt of An Lu-shan in 755. Though the troubles were suppressed for a time, the aristocracy had been shaken and weakened, and while life at court continued, it was only a shadow of its former glory, and art plunged into traditionalism.

The spiritual sources of Sung art

The Confucians were conscious of the dangers that threatened the dynasty in these unfortunate times, and they ventured to do something about it. In 845 there was a religious persecution of which Buddhism was the principal victim. Although it only lasted for a short time, this persecution put an end to the progress of the foreign religion. Buddhism no longer held its place as the official religion, though it was not stamped out, for the Buddhist deity, Amida, still attracted souls in distress. It also persisted in small groups at a more intellectual level — with the T'ien-t'ai and Chen-yen sects in a form which laid stress on ritual and mystery, and with the Ch'an sect in a mystical and intuitive form.

With the arrival of the Sung Dynasty, Buddhism ceased to exist among the cultivated classes. This religion had dominated the life of the individual for centuries and as a result had completely pervaded Chinese thought and sensibility. In the lyrical effusions of the poets of the 8th century, it was already difficult to distinguish the part played by Buddhism from that resulting from Taoism.

The ideal preached by the Ch'an sect, who despised the sacred texts, was that each person should attempt to attain, by meditation or by arriving at spontaneous illumination, the Buddha that each being carried within himself. This symbolised the intimate union of Chinese thought, in its Taoist form, with the thought which had come from India.

Further, one of the foundations for the renewal of Confucianism which characterised the Sung period was logic, which had been introduced into China by Hsuan-tsang in the 7th century. The critical examination of texts composed under the Han Dynasty resulted, in the 12th century, in the work of Chu Hsi. His work was undoubtedly influenced by the numerous streams which had come to enrich Chinese thought from the beginning of our era. It was claimed that the true thought of Confucius

387. CHINA. Li T'ang (first half of the 12th century). Waterfall; painted in ink on paper. *Kotoin, Kyoto.*

had been found again through the Han commentaries. The Chinese could not isolate themselves from contemporary currents, and their interpretation was perfectly adapted to the needs of the time. It had become necessary to fill the gap in spiritual life left by the decline of Buddhism, and to lay down a political and social system which suited individual requirements. Neo-Confucianism, far from being a return to the sources, was in fact a religious synthesis of the three great systems of thought which had prevailed in China during the preceding thousand years. This fusion marked the start of modern times in China.

The art of the Sung Dynasty was also a synthesis. All the developments from the period of the T'ang Dynasty onwards were brought together. The art which resulted has served as a model to all that came later.

Historical events account for the slow development over the 10th and 11th centuries of experiments begun as early as the 8th century. It was then that Ch'ang-an had ceased to be the artistic capital of an empire which now was united only in appearance. Experiments undertaken by the court followed one another, but outside the court itself. They were carried on by retired officials, and by Buddhist priests of the esoteric and Ch'an sects. The monasteries of these Buddhist priests were far from the big cities. It was there that techniques were perfected which made possible the efflorescence of Sung painting.

Influence of the brush on Sung painting

With the invention of the brush and of ink, calligraphy, the art of writing, became steadily more important from the last phase of the Han period. By about the 4th century, it took the first position among the arts, which in antiquity had been held by music.

The art of writing demanded the fullest concentration on the part of the writer, both morally and physically. It required perfect self-discipline. The whole arm had to move freely and without support as the calligrapher shaped his characters.

The T'ang period still remains the golden age of this difficult art. The calligraphers of those times modelled themselves on Wang Hsi-chih who lived in the 4th century. He created the pattern for this style which aimed at harmonising each character by the equilibrium of its parts, and by the elegant and supple precision of the brush drawing. This elegance and suppleness are found again in the fine unstressed outlines which delineated the figures in the paintings of Yen Li-pen. His pictures show the very close bond which already united the arts of calligraphy and of painting.

Coming at the end of the imperial power of the T'ang Dynasty, the reign of Ming Huang marked the beginning of a long series of fertile experiments in art. In the lost works of Wu Tao-tzu it seems that the outline, though still present, became more subtle and varied, and altogether more lively.

It is said that his contemporary, Wang Wei, broke from the traditional technique, and used ink by itself to render the variations of light and atmosphere in a landscape. He too continued to use the outline in developing

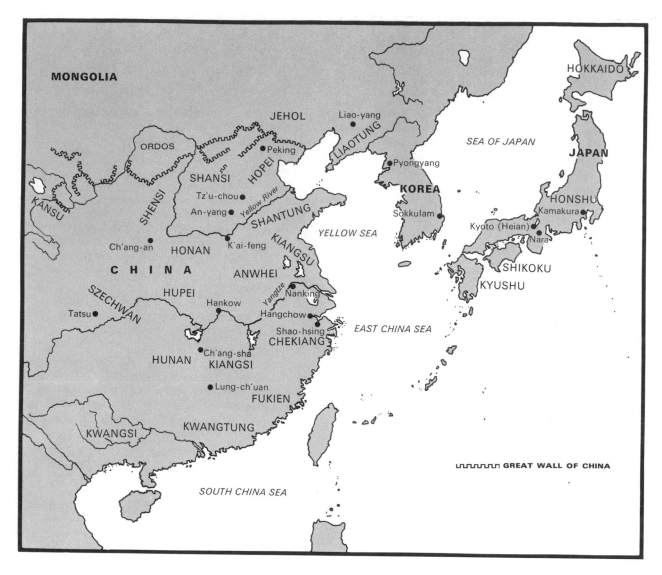

CHINA AND JAPAN

the pai-maio technique of monochrome painting.

The new style of writing must have been born among this group of painters and poets. Tu Fu dedicated a poem to the event, and related that his friend Chang Hiu conceived the idea while watching the sabre dance. He then created the cursive script which was more rapid and supple than the official form. It was strongly criticised by the traditionalists. This 'extravagant' or 'coarse' cursive script was none the less adopted by the poets who were the friends of Tu Fu. Yen Chen-k'ing, the disciple of Chang Hiu, was to carry it to its full maturity. Yen Chen-k'ing was a state official; he fought for Ming Huang against the armies of An Lu-shan and successfully held Shantung. In his writing, which was a model to generations of scholars, his bold character and his integrity are clearly revealed. Each stroke possessed an individual character. Some were likened to summer clouds, others to twisted golden hooks, and others again to bowed arches whose points bore the weight of a falling stone. This style was immensely successful from the 9th century onwards. Critics began to discuss the 'bones' and the 'muscles' of a writing, and in this way distinguished the places where the brush attacked the surface with vigour from those where it glided softly throughout the length of its course.

We do not know whether or not the innovations of the painters bore any relation to the newly found freedom of the brush in the art of calligraphy. However, from the middle of the 8th century, a new painting technique was developed in the southern provinces. This was the use of wash. Chinese treatises refer to some artists, such as Wang Mo, as heterodox. Others who worked with the poet Lu Hong-tsien in retirement in Chekiang practised the p'o-mo, a technique of splashed ink. Some used their hair dipped in ink, some used the palm of their hand, and others used the pressed stems of sugar cane soaked in ink. With the blots thus formed they evoked the landscape in front of them. This was the landscape of the Yangtze valley, where the whiteness of the sheets of mist produced by the damp atmosphere contrasted with the mountain peaks covered with the dark shapes of pine and fir. The classic Sung compositions suggest a dream world, but comparison with a photograph taken in the same region will prove how amazingly close the dream was to reality.

This new technique became known in Ch'ang-an from the second half of the 8th century, and it was popularised

196

by Chang Tsao. The method became normal, the brush was used, the contour line disappeared, though lines of varied thickness remained. Its name, p'o-mo, means the 'broken ink' technique.

The p'o-mo technique continued through the course of the Five Dynasties, from 906 to 960, both in Chekiang and in Szechwan. Unfortunately, as in the case of the T'ang period, not one of these works has survived. There is an old Japanese tradition that the Two Hermits Lost in Ecstasy, belonging to the Shohoji of Kyoto, was by Shih K'o, a scholar of Szechwan. The inscription points to the Yuan period, and the painting would then date from 963. But recent study by Japanese experts suggest that these two hermits are later copies. This view is supported by the fact that they are painted on paper, which did not take the place of silk until about the 12th century. Nevertheless, they admirably represent the free handling of the brush belonging to the Sung period, and the Sung richness of treatment is also to be found in them—the lines of varying emphasis, the contrast of light greys and intense blacks.

The Five Dynasties (906-960)

With the crumbling of the T'ang empire in 906 the north and south of China became separated, and once again their destinies followed different paths. The northern provinces had surrendered to rival military factions and they were partly occupied by barbarian populations. They had little chance for artistic expression. The southern provinces were in a more favourable position. They became the refuge for the aristocracy. The traditions of the past were continued in the small local courts, and new forms, too, were born.

The last T'ang emperor sought shelter in Szechwan in 880 and the court painters went with him. It was a remote province, isolated by mountain barriers. Under the T'ang Dynasty it had been an important centre for the production of imperial silks, to which the court must have sent specimens of decoration. The T'ang tradition was strong in this region, and was to continue in the kingdom of Chou, which took over the empire from Szechwan. This tradition was at the root of the art of the flower painter Huang Ch'uan (920–965?) who continued to use the outline and the lively colours of the artists before him.

The court of Nanking was that of the Southern T'ang Dynasty. It had a refined air and, in imitation of the T'ang emperors, the sovereigns created a Painting Academy which they protected and patronised. The art of painting reached great heights with the work of Chu-jan and Tung Yuan. Their landscapes were to become one of the most fertile sources of inspiration for later artists. It was the same in the case of the flower painter Hsu Hsi, whose works are often contrasted with those of Huang Ch'uan. Hsu Hsi, an artist in the purely decorative tradition, attempted to render the intrinsic character of the plant he was depicting, observing each part with great care, and drawing them in ink with the addition of a little colour.

Other techniques were also developed in the southern provinces, which were to attain distinction under the Sung Dynasty. These techniques were a result of the economic prosperity which prevailed, and of maritime trade. The princes of Wou Yueh in the province of Chekiang patronised the kilns of Shaohsing. These produced vases with decoration finely engraved beneath a thick olive-green or greyish glaze. These ceramics already had the elegance of those produced later during the Sung period. They were in fact a prelude to the Sung willow-green celadons which were to be manufactured at Hang-chow and Lung-ch'uan. The celadons already being made at Wou Yueh were exported far and wide. The proof of this is to be found in the numerous traces discovered in Japan, the Philippines, and as far away as Fostat (Old Cairo) where they were carried by Arab merchants.

These merchants traded in Canton as early as the 8th century, and now carried on a considerable business. Their ships plied between southern China and Basra, which formed the link with the Near East. Chinese silks and ceramics were highly valued in the Mohammedan world. Some Japanese specialists go so far as to believe that Persian influences are to be found in the architecture of the southern provinces from the 10th century, for

388. CHINA. K'o-ssu (tapestry in petit point). Northern Sung period (960–1127).

example in the arcades of flattened arches which were to become characteristic of Sung buildings. This attribution of influence is very plausible, for in Canton there were a number of mosques.

Sung art

The Sung Dynasty was founded by T'ai-tsu, who re-established political unity. His new capital was Pein-ching, which is now known as K'ai-feng. To this town he drew the most renowned artists from various parts of the empire. He set up the Academy once more, and it continued to grow in importance under his successors. The life of the court was resumed but its atmosphere had changed, for its members came from a different background. Most of the aristocratic families had disappeared during the recent wars. A new social class was called upon

197

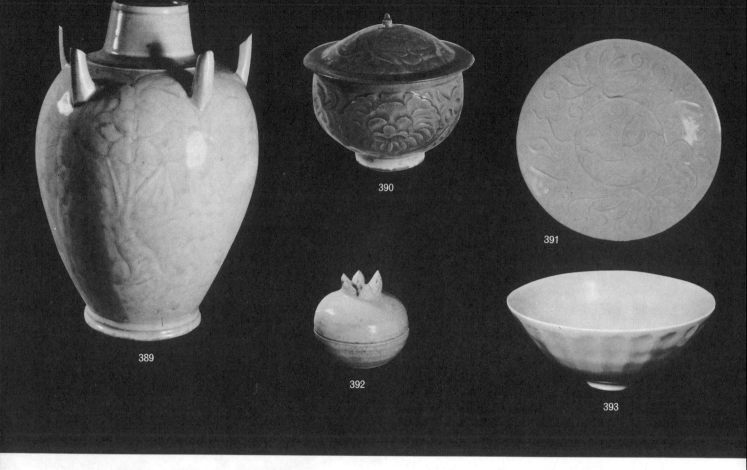

389

390

391

392

393

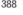

to take part in the government. It came from the towns, and included the sons of merchants who had become rich and who had therefore been able to afford a good education for their children. They now enjoyed the culture which had previously been restricted to the Chinese aristocracy. This new class of *literati* were able to attain positions of state through a reform of the examination system.

The spread of printing resulted in a wider diffusion of culture. Buddhists had used printing for propaganda under the T'ang dynasty. It was rejected, however, by the literate classes, who thought it vulgar and preferred manuscripts. But the Sung emperors were in favour of printing, and they extended their patronage to large editions of the classics. Many printing and publishing houses sprang up in the towns, which now became prosperous, especially Pien-ching, which was made very beautiful by the sovereigns of the second half of the 11th century. This city was the model used by the Liao and the Chin Dynasties when building their towns in Manchuria, Jehol and in the region of Peking.

Important technical improvements contributed to a prosperity unprecedented in China. As a result of the growing number of well-to-do people the demand for luxury products steadily increased, and a great number of orders also flowed in from abroad. The invention of the compass made long-distance navigation much easier, and it became possible for the Chinese junks, laden with silks and ceramics, to sail regularly to south Asia, India, and even to the shores of the Persian Gulf.

Great progress was made in textiles. In the T'ang period, under the influence of Iran, methods of weaving used in the West had been adopted, in particular the decoration worked on the weft instead of on the warp, as it had previously been ever since ancient times. This resulted in a flowering of materials of astonishing di-

versity, which enchanted Marco Polo three centuries later. Brocades of gold and silver thread were introduced from central Asia about the 10th century. Tapestry in petit point or k'o-ssu also achieved great beauty.

388

The ceramic arts, too, developed magnificently as a result of two main causes, the improved methods of production, and the increased demand that was a consequence of the more general drinking of tea. Improvements in technique included the faster speed of the potter's wheel, the greater refinement of the materials used, higher kiln temperatures and better control of firing.

For many centuries the Chinese had made a careful study of the qualities and reactions of clay, and they had discovered original solutions to a number of technical problems. These led gradually to the invention of porcelain. The excavations at An-yang have revealed that as early as 1300 B.C. the Chinese had used glazes in order to counteract the porosity of baked clay vessels. Shortly before our era they began to use lead glazes coloured by the addition of metallic oxides, a method invented in the West. The potters in the T'ang period used the play of iridescent colours with great skill. This foreign technique, however, did not hamper the evolution of essentially Chinese methods. During the T'ang period white porcelain was created. It was delicate and translucent, and it was toughened by being fired at a high temperature. Porcelain was admired by Arab travellers who wrote about it enthusiastically.

In the 11th century kilns increased in number in many provinces. In spite of distinct local characteristics, such as the willow-green celadons of Chekiang, the bluish Ju, the Kuan of Honan, the creamy Ting of Hopei and the temmoku with dark iris glazes of a metallic lustre from Fukien, pieces everywhere were of an elegantly unified form. Bowls with narrow bases, the walls widening extensively and with harmonious lines, produced during

389–398

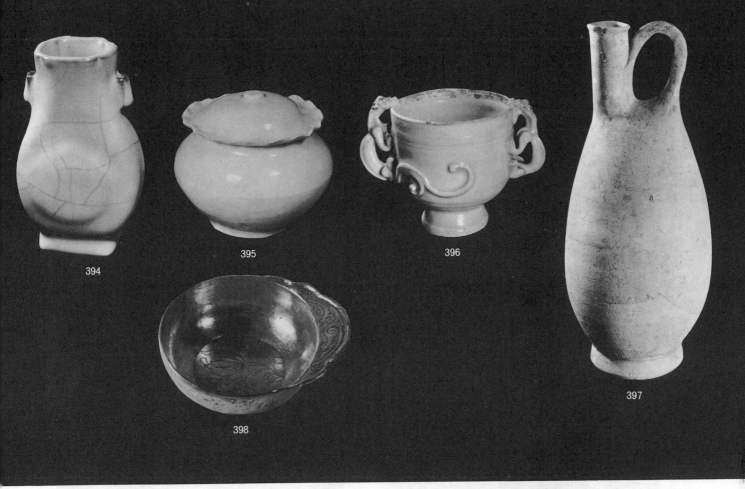

SUNG CERAMICS

389. Vase; celadon from Yueh (Chekiang). Beginning of Northern Sung period; end of the 10th century. *Frank Caro Collection, New York.* 390. Pot with lid; Northern celadon. Sung period (960–1279). *Sir Alan and Lady Barlow Collection, Wendover.* 391. Dish; Ting-yao. Northern Sung period (960–1127). *Mrs Alfred Clark Collection, Fulmer.* 392. Small pot in the form of a pomegranate. Sung period. *Cheng Te-K'un Collection, Cambridge.* 393. Bowl; celadon from Lung-ch'uan (Chekiang). Southern Sung period (1127–1279). *J. Coiffard Collection, Paris.* 394. Small vase; Kuan group, Hangchow (Chekiang). Southern Sung period. *Mrs Alfred Clark Collection, Fulmer.* 395. Pot with lid; white porcelain. Northern Sung period. *Carl Kempe Collection, Ekolsung.* 396. Cup; Ts'ing-pai. Sung period. *Mrs Alfred Clark Collection, Fulmer.* 397. Flask glazed with white lead glaze. Liao period (936–1125). *Bernard Groslier Collection, Paris.* 398. Small silver cup. Sung period. *Carl Kempe Collection, Ekolsund.*

399. Bowl; Ki-ngan group (Kiangsi). Sung period. *Lord Cunliffe Collection, London.*

400. *Mei-p'ing* vase; Tz'u-Chou group. Sung period. *Michel Bréal Collection, Paris.*

the Sung period contrast with the abrupt profiles and wide bases of the T'ang pieces, which had often been inspired by Sassanian silverware, the shapes of which were not really suited to the plastic possibilities of clay.

Against the motifs and colour contrasts of the preceding period, the form was now covered by a glaze of a single colour, which was sufficient by itself, and decoration was reduced to delicate engraving. At Tz'u Chou, in the north, use was made of floral motifs, engraved, painted or cut into the clay, and their broad and balanced style reminds one of the paintings of Huang Ch'uan and his numerous disciples, which were then so popular.

Precious objects were made from lacquer and jade, but unfortunately very few have survived. From the 12th century the minor arts were often influenced by a return to archaic forms and motifs which were being rediscovered in the course of excavations carried out at Anyang for the emperor Hui-tsung, and which were among

400

199

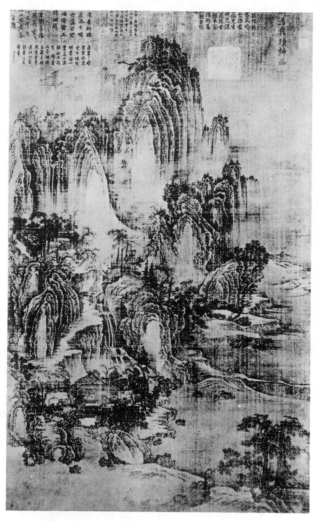

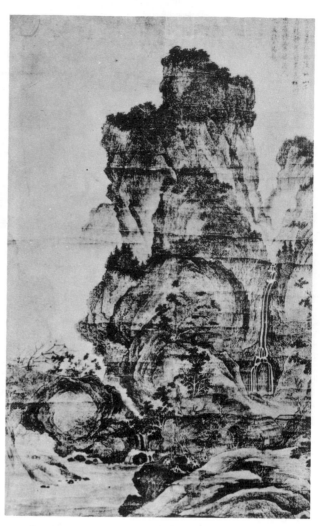

401. CHINA. Ching Hao (beginning of the 10th century). Landscape; painting on silk. *Collections of the Chinese People's Republic*.

402. CHINA. Kuan T'ung (early 10th century). Awaiting a Crossing; painting on silk. *National Palace Museum, Peking*.

the earliest archaeological studies. Antique bronzes and jades were more or less faithfully copied and their forms inspired the potters in the imperial workshops at Pien-ching and later at Hangchow.

Sculpture, however, had fallen to the level of mere craftsmanship. The decay of Buddhism was the primary cause of this decadence. Pagodas and monasteries continued to be built and they were ornamented with sculptures of the divinities cast in iron or bronze, or carved in stone or wood. Certain statues of Kuan-yin who had become a Chinese goddess—as a Boddhisattva in India she had been known as Avalokitesvara—were given elegant poses, and a grace not entirely without mannerism. But the fervour had disappeared from sculpture, and with it the intellectual and spiritual support which gives birth to great works also disappeared. Further, the funerary statuettes or ming-ch'i were now scarcely ever used, their place being taken by cut paper silhouettes which were burnt in the course of the funeral ceremony. These, too, rapidly deteriorated in an art which had been reduced to a trade and where the only skill that remained was in the execution.

Landscape painting

As sculpture went into decline, so painting began to play a leading role in Chinese art. There were two main reasons for this. Firstly, the Academy was now in an

important position and was protected by the patronage of the emperors. Secondly, cultivated amateur artists became attracted to painting in ink, which was far easier to handle than pigment. Though painting was not essential to a good Confucian education, it became an accomplishment on which a cultured man could pride himself.

It is customary to distinguish between academic or official painting and painting by cultivated amateurs. The academic painters abandoned the decorative style of the T'ang Dynasty in favour of realism. The amateurs anticipated the idealist tendencies of their successors in the Ming and Ch'ing Dynasties. The two currents frequently crossed one another. Though academic painters preferred to do coloured compositions, they occasionally worked in monochrome. It would seem better instead to make a distinction between landscape on the one hand, and the painting of flowers and birds on the other. At this moment landscape was the means of pictorial expression par excellence. The painting of flowers and birds was strongest in the Academy, but was also adopted by the amateurs.

For centuries, artists and theoreticians had been searching for a pictorial language capable of expressing the relation of man to nature. The freer brushwork and the use of ink allowed the painters to reproduce effects of atmosphere and space by means of the varying strength of the diluted ink. This made it possible for artists to express visually what the great lyric poets of the T'ang dynasty

had evoked in words. A whole symbolic language was created, in which large clouds, light, mist and vast horizons held an important place.

Sung philosophy was all synthesis and harmonisation. This tendency towards unity is also found in the landscape painting of the time. It is, in fact, the spiritual life of man projected into nature which emerges in these works. Among the cultivated amateurs, who were essentially individualist, this spiritual life is vividly affected by their personal sensitivity.

It would be wrong, however, to think of the Sung landscape as a simple impression. Reality always pervades it. It was rendered with more or less detail according to the temperament of the artist, and this temperament is revealed in the composition, the handling of the brush, the strength of the ink, and in the spatial organisation. The rendering of space was in no way connected with our linear or geometric perspective. Space was limited to the picture area itself and in it the forms were related to each other as the artist wished. They were an expression of his inner life which is communicated to us through his painting.

A Chinese landscape is completely absorbing; it does not impose itself but invites one to penetrate into it. Mentally one follows the roads, the valleys and the rivers, tracing the routes drawn by the painter, which lead us towards the summits or towards the light. The experience corresponds to the wanderings of those Taoist mystics who lost themselves in vast solitudes, or if unable to do this, lost themselves in the imagination in their miniature gardens composed of pebbles and dwarf trees, which they kept on their work-tables.

This development towards unity first appeared at the beginning of the 10th century in the works of Ching Hao. Tradition makes him the author of an essay on landscape painting, and contemporary documents support this attribution. The aim of this work was to unite the linear drawing of Wu Tao-tzu to the ink wash techniques fashionable among the 'heterodox' artists of the T'ang Dynasty. Ching Hao was a refugee scholar working in the mountainous region of northern China, and he was also preoccupied with the spiritual content of landscape. 'It is essential,' he said, 'to go further than mere resemblance and in everything to search, beyond the accidental, for that which is permanent.' However, this approach had not really shaken itself free of the earlier traditions which still held sway. Though technical progress is apparent in the only surviving landscape by Ching Hao, which is in the collections of the Chinese Peoples' Republic, spatial unity is not yet fully realised. It is an upright composition, and portrays mountains cut by vertical crevasses which have a foliated appearance. Mists partly envelop them and give a certain feeling of distance. In the foreground, or lower part of the painting, there is a gnarled pine which is drawn in more strongly. The linking up of the various planes, which rise one above the other, is not fully realised. Apart from colour, one is still very close to the enchanting compositions of Li Chao-tao.

The result of these many different trends became apparent in the second half of the 10th century. A pattern for landscape painting was created by artists of various origins becoming the source of inspiration for centuries.

404. CHINA. Chu-jan (end of the 10th century). Seeking Instruction in the Autumnal Mountains; painted in ink on silk. *National Palace Museum, Peking.*

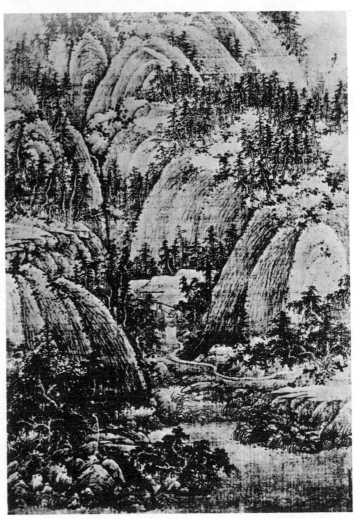

403. CHINA. Tung Yuan (end of the 10th century). Landscape; painted in ink on silk. *Collections of the Chinese People's Republic.*

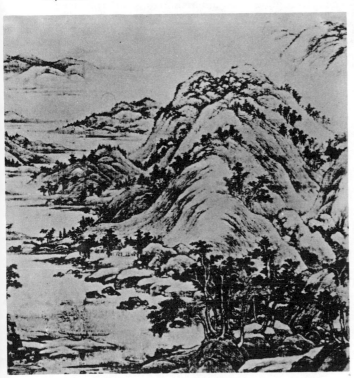

201

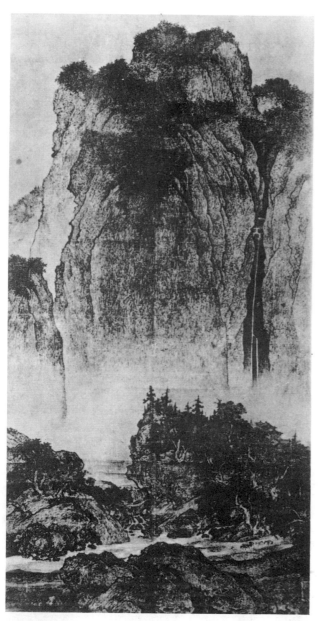

405. CHINA. Fan K'uan (beginning of the 11th century). Travelling among Mountains and Streams; painted in ink on silk. *National Palace Museum, Peking.*

Chinese tradition attributes the origin of the monumental style to Li Ch'eng, a Confucian scholar and a descendant of the imperial family of T'ang. He drew inspiration from the great stretches of the northern plains; he was the painter of the p'ing yuan or vast flat expanses. He gave more importance to the foreground than his predecessors had done. He made it more interesting by including rivers with sinuous banks, and great conifers writhing upwards with knotted trunks and hooked needles. All these were drawn with great spirit and verve. A plain stretched away in the distance, and in the middle were mountains, rendered by a light wash and fine outlines. The *Secret of Landscape Painting* is traditionally attributed to Li Ch'eng. This treatise gives us a glimpse of the aims which he set himself. These were to suggest the relative distances between the different parts of the composition, to achieve a balance in the distribution of mists and clouds, and to alternate harmoniously between strong accents and delicate touches. All these ideas, even if they did not come directly from Li Ch'eng, certainly are perfectly in accord with his work.

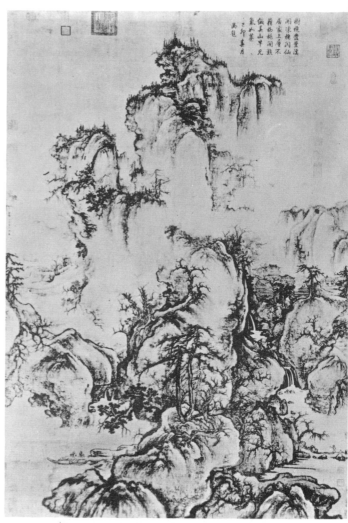

406. CHINA. Kuo Hsi (middle of the 11th century). Landscape; painted in ink on silk. *Collections of the Chinese People's Republic.*

Tung Yuan and his pupil Chu-jan worked in the southern provinces at the same time as Li Ch'eng in the north. They arrived at similar results but by different means. Theirs were not the vast distant horizons of the north with their denuded heights, but the hills of the Yangtze valley, softened by mists and dotted with clumps of trees. Their lines were softer, and they used little parallel touches; the trees would be drawn strongly, and the thick mists often gave their landscapes a dramatic quality.

When the Southern T'ang submitted to the Sung Dynasty in 975, the painter Chu-jan was called to Pien-ching. Even so, the dominant style during most of the 11th century was that established by Li Ch'eng, which was continued in the works of Fan K'uan, Yen Wen-kuei and Hsu Tao-ning. They all remained true to the logically constructed composition, though their handling of rocks and trees reveals their differing personalities. In their very few surviving works may be seen a similar emphasis on the foreground and the same treatment of the rocks, which were delicately rendered in sharp lines. In Travelling among Mountains and Streams by Fan K'uan (National Palace Museum, Peking), the tiny people are scarcely more than indicated. They pass in single file along a path which disappears behind a darkly drawn rocky mass, and then they reach a bridge spanning the river, which is also lost in the gorge dominated by tree-capped crags. The three receding planes are thus united, while the unity in height is achieved by means of a waterfall. The mist lying over the pass gives a sense of distance.

403, 4

405

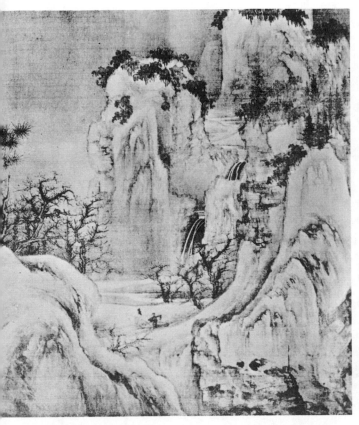

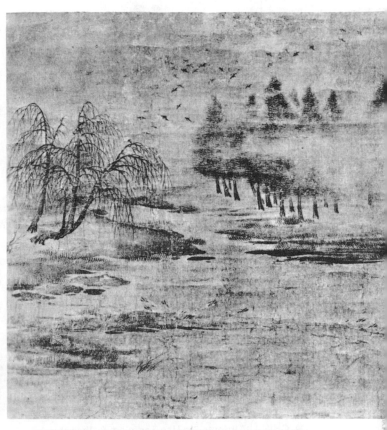

407. CHINA. Wang Chien (second half of the 11th century). Fishing Village under Light Snow; detail of a hanging scroll painted in ink on silk. *Shanghai Museum.*

408. CHINA. Chao Ta-nien (end of the 11th century). Crows in the Forest in Winter; painted in ink on paper. *T. Hara Collection, Yokohama.*

406 Kuo Hsi was to carry this logic to extreme lengths. His son has passed his theories on to us. He insisted on the necessity for concentration, for emptying one's soul of all extraneous cares before beginning to paint, for being complete master of the brush and the ink, and not their slave, and for coordinating the work in its three dimensions—from bottom to top, from side to side, and from the foreground to the distance. The only authenticated painting by Kuo Hsi, Pilgrims on their way to the Monastery, is a fine example of his deliberate and minute approach. In it the people and the buildings are only landmarks which lead one, by a path which twice runs the whole width of the hand scroll, towards the top of the composition, and towards the last summits which are lost in mists. The same care for detail is expressed in the foreground pines with their jagged branches.

This great classical master had proclaimed himself a fervent disciple of Li Ch'eng. With him the monumental form of landscape reached its most perfect development. The same principles were used by the 11th-century masters of the long hand scrolls. The transformation in the aims and methods of the painters of these scrolls would seem to place them in this period. Previously, during the T'ang period, long narrow rolls had been painted with various scenes, often separated into distinct scenes by mountains enclosing each little picture. This was the same method used in the mural paintings at Tun-huang, and on banners which showed scenes from the *jataka* tales or from the life of Buddha.

There is a scroll in the William Rockhill Nelson Gallery, Kansas City, which has been incorrectly attributed to Hsu Tao-ning, in which man has completely disappeared from the scene. Only the landscape remains, a landscape of strongly drawn mountains alternating with deep valleys bathed in light. Everything is harmonious, and the skilful arrangement leads the eye across the scroll as it is gradually unrolled. Unfortunately such a scroll, depending for its effect on the gradual unrolling, cannot be effectively reproduced on the page of a book, because the eye would then take it in at a single glance. The hand scroll may be compared to music. Areas painted in strong tones (vigorously inked mountains) correspond to loud passages, and alternate with luminous areas in the same way that the music modulates from loud to soft and back again. From then on a musical rhythm vibrates through most of these scrolls. Just as in a symphony the mood will vary according to the proportion of loud and soft passages, so in the scrolls the same variation is effected by strong tones and dilute washes, by strong brush strokes and light touches. This resemblance to music is not accidental. In both cases the art form is essentially intellectual. There is no need to add that the multiple variations cannot be fully appreciated at the first glance. The ear must be accustomed to music to appreciate all the nuances of a set of Bach variations. The same sort of preparation is necessary in order to appreciate the Chinese scroll.

The hand scroll belonging to Kansas City still follows the rules for upright compositions, and the eye is often led to the top of the picture instead of following a horizontal path. The Fishing Village under Light Snow by Wang 407 Chien, which has been published recently in China, is free from this tendency. The foregrounds rise up very high close to the picture plane; jagged rocks bristle with

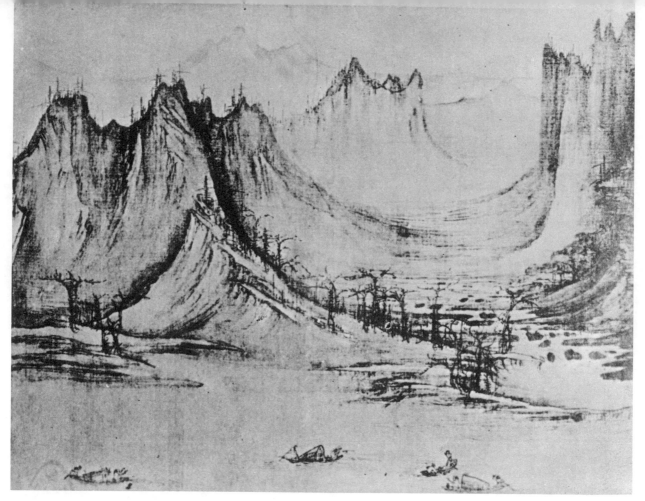

409. CHINA. Attributed to Hsu Tao-ning (11th century). Fishing in a mountain torrent; detail of a hanging scroll painted in ink on silk. *William Rockhill Nelson Gallery of Art, Kansas City.*

pines which throw their twisted branches into space above a sheet of water enveloped in mist. Distances are laid in with light washes and delicate outlines. Importance is given to the empty spaces which are broken up by the foreground trees. New developments are suggested in this painting of the second half of the 11th century.

The transition towards the lyrical landscape

About 1060 the style of Li Ch'eng and Kuo Hsi was tending to become a formula devoid of spiritual meaning. It appears that the emphasis on a logical composition was unsuitable to the new sensitivity. The painters of the end of the 11th century looked for new means of expression.

The circle surrounding Su Tung-p'o and Mi Fei, who were great scholars and statesmen, was extremely interested in the arts related to painting. They were excellent calligraphers and poets. They strove to express their personal reactions through their representations of nature, Su Tung-p'o through his paintings of bamboos and Mi Fei through his landscapes. Mi Fei was a learned connoisseur of earlier styles of painting; he had studied the p'o-mo technique which made use of the wash without outline. In his *Hua Shih* ('An Account of Painting') he expressed a preference for the works of Tung Yuan and Chu-jan, who were painters from the south. Their landscapes were less constructed than those of Li Ch'eng and they gave more importance to the rendering of atmosphere and light. Unfortunately no paintings have survived by this great patriarch, Mi Fei, whose art was a starting point for so many later landscape painters. But he seems to have introduced a freer approach to composition, and a more atmospheric and wider use of wash.

About the same time, Chao Ta-nien (Chao Ling-jan) 408 returned to the tradition of Wang Wei, whose works he copied excellently. There is a tendency to regard him as retardative, but his landscapes really seem very original; he broke with the tradition of strong foregrounds and mountainous distances. Unity was achieved by sheets of horizontal mist, through which trees appeared more or less distinctly. The contrasts of mists and light gave these works a simplicity and a personal quality. Chao Ta-nien was one of the first artists to make use of a smaller format, that of an album leaf in the shape of a Chinese fan (a screen with rounded corners).

Li T'ang was a member of the Imperial Academy, and he developed a monumental style which also made use of simplified compositions, rapid execution and a keen perception for the qualities of light. His signature has recently been deciphered by S. Shimada on a painting of the waterfall of Kotoin at Kyoto. This picture is still a classical upright composition, but the treatment is more varied, making use of rough touches and blobs in addition to line.

It is not known whether or not Mi Fei, Chao Ta-nien and Li T'ang knew of each other's work. They lived in different parts, and it is possible that their parallel developments were quite independent of one another. However, the fact that these developments took place simultaneously proves that they were necessary. The emperor Hui-tsung exercised a dictatorship over the Academy and imposed a scrupulous realism, which does not seem to have favoured the lyrical style. After 1126, when the Jurchen destroyed the enchanted world of Pien-ching, they carried off the emperor and his eldest son to distant Manchuria. Their successor took refuge in the region

south of the Yangtze, and settled in Hangchow. The Sung Dynasty remained masters of the most fertile and the most civilised parts of the empire. Hangchow enjoyed peace and prosperity. The pleasantness of life there was heightened by the threat of danger outside. The Jurchen Chin empire was near, and behind it the Mongolian menace was beginning to unfold itself.

Li T'ang took his place again in the new Academy set up at Hangchow. The lyrical style triumphed with him and with Chiang Ts'an, Liu Sung-nien, Li Sung and Ma Ho-chih. Wide pictures took the place of upright ones. Mountains often became reduced to a simple rocky shore and were more closely related to the water. Drawing became more calligraphic and was unified by washes. The eye was no longer guided firmly along an exact and detailed route dictated by the artist. These subjective compositions were not symmetrical; empty spaces took up large areas and were often balanced by a rocky mass in one corner.

With the opening of the 13th century, Ma Yuan and Hsia Kuei, who were both members of the Academy, continued to derive inspiration from Li T'ang, but their works lacked the earlier spontaneity and freshness. They were more systematic and methodical in their approach. Many works have been attributed to Ma Yuan but none with certainty. Through his followers it is known that he preferred wide compositions and that he liked to arrange the masses in a corner and extend them towards the centre by way of strongly drawn branches of trees silhouetted in space. Hsia Kuei, whose drawing was very calligraphic, used similar methods, but he also used wash by itself.

The use of wash, now fully accepted by the Academy, continued also to be in fashion with the amateur painters, who were principally Taoist, Buddhist priests of the Ch'an sect and retired officials. These were less hampered by rules, and were freer to express their intimate feelings. Forms rendered by blobs of ink of varying strength tended to lose themselves in light. All was suggestion. The landscapes of the Hsiao and Hsiang lakes, traditionally attributed to Mu-ch'i and to Ying Yu-chien, reveal nature transformed, transmuted by the ecstatic vision of a Taoist or of a Ch'an monk.

The painting of flowers, birds and figures

An official style for landscape painting was not created immediately in the Academy, because the painters coming to Pien-ching came from so many different schools. But it was not the same for the painting of flowers and birds. The decorative compositions of Huang Ch'uan set the style for this subject. An echo of this art is to be found in the floral decorations on the walls of the tomb of Chen Tsung, who was a Liao sovereign of the middle of the 11th century. The Sung court valued this rich 'official' style, and remained faithful to it for a long time. Ts'ui Po, in the second half of the 11th century, followed with a more realistic and monumental style, which fascinated the emperor Hui-tsung (1082–1125) who was also a painter. He made this style his own, but reduced the scale, insisted on detail, on the delicacy of the lines, and also on rather precious colour. He imposed this style on the court painters and this delicate and precise art was transplanted to Hangchow, where it became the academic style par excellence.

From the middle of the 11th century the literary circle,

hostile to the realist aims of painters such as Ts'ui Po, concentrated on the study of flowers and plants, and used ink in place of colour, a far more difficult medium. Plum blossom, orchids and bare trees were used endlessly by these amateurs whose aims differed widely from those of the court painters as expressed by Su Tung-p'o: 'To aim at resemblance is infantile.' These floral paintings became the symbols through which the cultivated man could reveal his spirituality and his sensitivity. The same themes recurred continuously, and their authors enjoyed creating them in the same way in which they enjoyed the practice of their calligraphy. From this constant repetition

410. CHINA. Ying Yu-chien (middle of the 13th century). Mountain Village in Mist; painted in ink on paper. *Yoshikawa Collection.*

they created their personal style, and the form of the plant became only the means by which they expressed, from day to day, the state of their souls. This genre continues to the present day. Excellent examples include the bamboos of Wen T'ung (National Palace Museum, Peking) who was a rival of Su T'ung-po, and the orchids and narcissi of Chao Meng-chien (Freer Gallery, Washington).

The painting of figures continued in the T'ang tradition for a long time. Proof of this may be found in the Preparation of Silk by the Ladies of the Court which is a famous hand scroll in the Museum of Fine Arts, Boston. It is a copy of an 8th-century work, attributed to Hui-tsung.

At Hangchow, in the middle of the 12th century, Chao Po-chu reverted to the tradition of the coloured landscapes of Li Ssu-hsun and of Li Chao-tao, and he peopled these landscapes with figures of reduced size. Meanwhile Li Kung-lin (or Li Lung-mien), a high official and great connoisseur of paintings by the old masters, returned to the pai-miao technique of painting in ink with a continuous outline. He was a contemporary of Mi Fei and of Su Tung-p'o. Li Kung-lin drew openly from the style of Yen Li-pen in his pictures of horses and grooms, but he achieved greater suppleness of line.

The return to a distant past was to have an unexpected echo in the works of independent artists of the 13th century, such as Liang K'ai, a Taoist and deserter from the Academy, or Mu-ch'i, who was a Ch'an priest. Liang K'ai painted an imaginary portrait of the famous 8th-century poet Li T'ai-po, in which he aimed to portray the essence of the poetry rather than any likeness to the poet's physical appearance. He drew lightly a delicate silhouette enhanced with heavily inked lines, which tends to make the form stand out from the wall and move in space. The same artist painted the Sakyamuni Buddha, enveloped in a mantle, the delicate and parallel folds of which undulate in the wind. The figure stands out against a broadly washed landscape and is balanced by jagged wintry trees. The Kuan-yin by Mu-ch'i, preserved in Daitokuji, Kyoto, is carefully drawn among rocks darkened by repeated washes, using the same technique. The use of these two dissimilar techniques within the same work is fascinating. These examples from the 13th century show how great artists can blend the methods of very different traditions and from them create masterpieces.

The separation of north and south China

The barbarians had occupied a part of northern China from the 10th century onwards. In 936 the Khitans (who later founded the Liao Dynasty) had installed themselves in the north of the Hopei and Shansi provinces. In 1028 the Hsi Hsia took Kansu. By 1125 the Jurchen (who founded the Chin Dynasty) had dominated all the provinces of the upper Yangtze. These rough nomads had no artistic traditions, and they took over what they could from Chinese civilisation. They employed local craftsmen but, being incapable of inspiring them to original creation, encouraged them to imitate Sung productions. Their work may be distinguished, however, by a taste for large forms and for bright colours.

So, from the 12th century onwards, the whole civilisation of northern China was prevented from following the natural path of Chinese evolution. The Mongols invaded in the middle of the 13th century, and they only accentuated the rift between the north and the south of the empire. It was through the works of the Chin and the Hsi Hsia that the Yuan Dynasty was to know the art of China and it was from the Hsi Hsia that they drew their inspiration. The northern provinces gradually lost their creative ability and, even when the Ming Dynasty ultimately came to power, it was unable to restore their inventiveness.

The Yuan Dynasty

A terrible menace hovered over the Sung Dynasty after the middle of the 13th century, and a tidal wave was to submerge their enchanted world. The reverberation of the marching feet of warriors was borne into their pleasure-seeking cities. North of the Yangtze everything was on the move. The Mongol hordes swept aside the Chin and the Hsi Hsia as they penetrated deep into northern China. The echo of their advance in the west, through central Asia to Iran, soon reached as far as the rich southern provinces. Henceforth they were isolated from the rest of Asia by the barbarian multitudes. Soon, in 1260, Kublai was proclaimed Great Khan and set up his capital close to that of the vanquished Chin. In addition, the very plan of Khanbaliq (the present-day Peking) was based on that of Pien-ching. However, the fact which

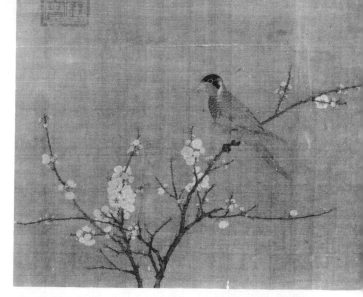

411. CHINA. Emperor Hui-tsung (1082–1135). Five-coloured Parakeet; painted in colour on silk. *Museum of Fine Arts, Boston.*

412. CHINA. Mi Fei (1051–1107). Calligraphy.

413. CHINA. Li Kung-lin, sometimes called Li Lung-mien (about 1040–1106). Detail from a hand scroll representing horses brought in tribute from Khotan; painting in ink on paper. *Collections of the Chinese People's Republic.*

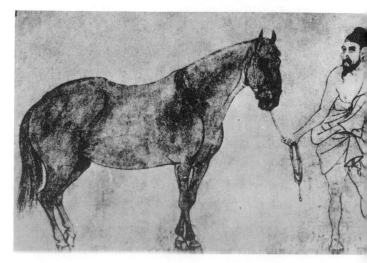

most clearly reveals the eclecticism of the new masters of China was that the work of construction was entrusted to the direction of an Arab.

The Mongols crossed the Hsiang River in 1276 and occupied Hangchow. They reached Canton three years later. A new China was born, which looked down on the achievements of the previous dynasty, even though it retained their records. Kublai, who had been brought up in China, was cosmopolitan in his outlook; his grandfather, Genghis Khan, had made the world tremble. In the great summer camps on the banks of the Orkhon he habitually gathered together men from all over the known world. There, Master Guillaume, a Paris goldsmith, was astonished to meet William of Rubruquis, sent by St Louis to the Mongol court. For political ends, Kublai favoured Confucianism, for he realised, as had the Liao and the Chin Dynasties before him, that China could not be dominated if this age-old force were neglected. He hesitated for some time over the choice of the official religion. He considered Nestorian Christianity as well as Buddhism, but finally decided on a heterodoxical branch of Buddhism, that of Tibetan Lamaism. As a result, new forms of sanctuary were introduced into religious architecture, and also a more complex iconography of images into painting and sculpture.

The essential spirit of Chinese culture remained foreign to the Mongol rulers. This is shown clearly by two facts: Kublai did away with the examination system; and he abolished the Academy of Painting. The *literati* were denied the political and administrative offices which had so long been their prerogative, and they were no longer predominant in intellectual and artistic life. This break with the tradition of a thousand years and the neglect of the educated elite were a severe handicap to the revival under the Ming Dynasty. The natural evolution of Chinese art was thwarted and it never again resumed its normal course. The Yuan Dynasty, however, did not ignore a production whose brilliance, beyond the frontiers of the empire, had so great a part in its economic well-being. Trade was encouraged, and grew rapidly with the reopening of the transcontinental routes which the 'Mongol Peace' made secure. Some of the arts flourished, such as ceramics, silks and lacquerwork, and they experienced great prosperity, but though the quantity increased the quality suffered. The celadons of Lung-ch'uan show this clearly; the forms grew heavy and the colours lost their subtlety.

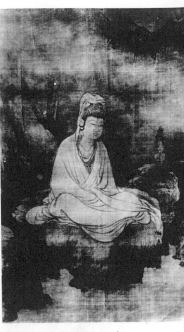

414, 415. CHINA. Mu-ch'i, sometimes called Fa-ch'ang (13th century). *Left*. Monkeys. *Right*. Kuan-yin. Wings of the triptych of the Daitokuji of Kyoto; painted in ink on silk.

Changes, however, seem to have been slow. The same craftsmen continued to work and they preserved their technical mastery, but the taste of their clientèle had deteriorated. Neither the court, nor the bourgeoisie who had become rich through commerce, had any fresh demands to make on the craftsmen, nor did their patronage show any signs of enlightened guidance. This same clientèle was enthusiastic about the opening of the theatre, and about stories written in the spoken language, which resulted in some of the more highly flavoured chapters of Chinese literature. It is significant that neither the theatre nor the literature was ever intended for the enjoyment of a cultivated class.

Nevertheless, imperial workshops were set up, where painting, goldsmiths' work, carpet weaving, lacquerwork and brocades were produced by craftsmen, who were, it would seem, all treated very much as artisans. They were employed by a court that was more in love with glitter than with refinement, and that preferred richness to purity of form. Among the few examples which have survived are some of carved lacquerwork embellished 419

417. CHINA. Jen Jen-fa (beginning of the 14th century). Horses and Grooms; detail of a hand scroll painted in colour on silk. *Victoria and Albert Museum, London*.

416. CHINA. Wen T'ung (11th century). Bamboo; painted in ink on silk. *National Palace Museum, Peking*.

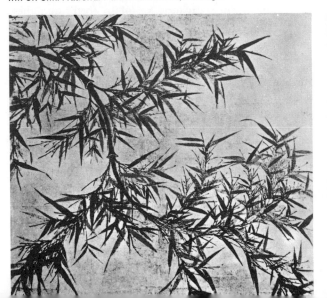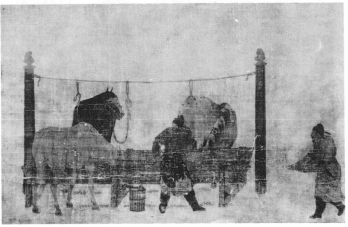

with vigorous floral decoration. It is beautifully balanced and reveals great skill, but unfortunately it is not possible to compare it with the Sung models, as these are only known to us through the descriptions of writers.

Though official writings remain silent on the subject, it would seem that other techniques were developed outside the court. The silence may have been intentional. The *Annals of the Yuan Dynasty* were written during the Ming period, and they would probably have minimised any influence of the detested conquerors. It is possible, for example, that the Mongols may have introduced the making of 'blue and white' ceramics into China, but this has not yet been proved. This style seems to have come from Iran, and was to be very popular in the following centuries. It involved a decoration painted in cobalt blue under a glaze, and the pieces were fired at high temperatures. The large vases of 1351 belonging to the Percival David Foundation confirm that in the middle of the 14th century the Chinese had mastered this material and could handle it with extreme delicacy. By reference to these masterpieces John Pope has recently shown that a number of vases and plates of the famous collection of the Turkish sultans at Istanbul belong to the 14th century. The series from the mosque of Ardebil now in the Teheran Museum also seem to belong to this period. Despite their beautiful deep blues, and the fullness and variety of their decoration, these first examples of 'blue and white' ware were less pure and elegant in form than the ceramics of the Sung period, and already reveal a certain decadence. The multiplication of the motifs, divided in bands one above the other, left little free space, and was the first foreshadowing of the crammed decoration so often preferred in the 17th and 18th centuries.

In this way the intimate union began between ceramics and painting, a union which the Chinese could not resist and which continues unweakened even today.

The 'reactionary' painting of the Yuan Dynasty

Any tendency in the art of painting corresponding to this ceramic decadence is not easy to unravel. Authentic works are relatively few, and contemporary writings were biased. The scholars who wrote them would probably have run down official productions whatever their merits. They also ignored some independent currents known through surviving examples in Japan. The *literati* evolved an aesthetic which reached its most perfect expression in the writings of Tun Ch'i-ch'ang and Mo Shih-lung at the beginning of the 17th century. But this aesthetic may have helped to falsify all the perspectives.

The court seems to have preferred colourful pictures of hunting scenes, cavalcades and so forth, and these would have been painted to their satisfaction by the official artist, Chao Meng-fu. Although many pictures supposed to be by him have reached the West, not one has been authenticated. Most of them do not belong further back than the Ming Dynasty, or even the Ch'ing. The works of Jen Jen-fa, his disciple, are better known. They are sure in drawing, and sensitively outlined according to the oldest Chinese traditions, but they reveal the retrograde aspect of Yuan art.

Some flower pictures drawn with thick outlines and painted with opaque colours show the decorative tendency which was already apparent in academic art about the end of the Southern Sung period. In general, however, Yuan painting opposed the methods of this technique.

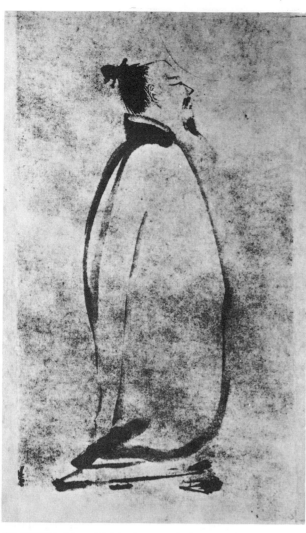

418. CHINA. Liang K'ai (13th century). Portrait of Li T'ai-po, 8th-century poet; painted in ink on paper. *National Museum, Tokyo.*

419. CHINA. Plate in carved lacquer. Yuan period (1279–1368). *Sir Percival and Lady David Collection, London.*

420. CHINA. Vase; porcelain with decoration painted in cobalt blue under glaze. 1351. *Percival David Foundation of Chinese Art, London.*

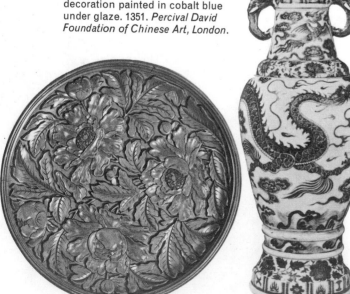

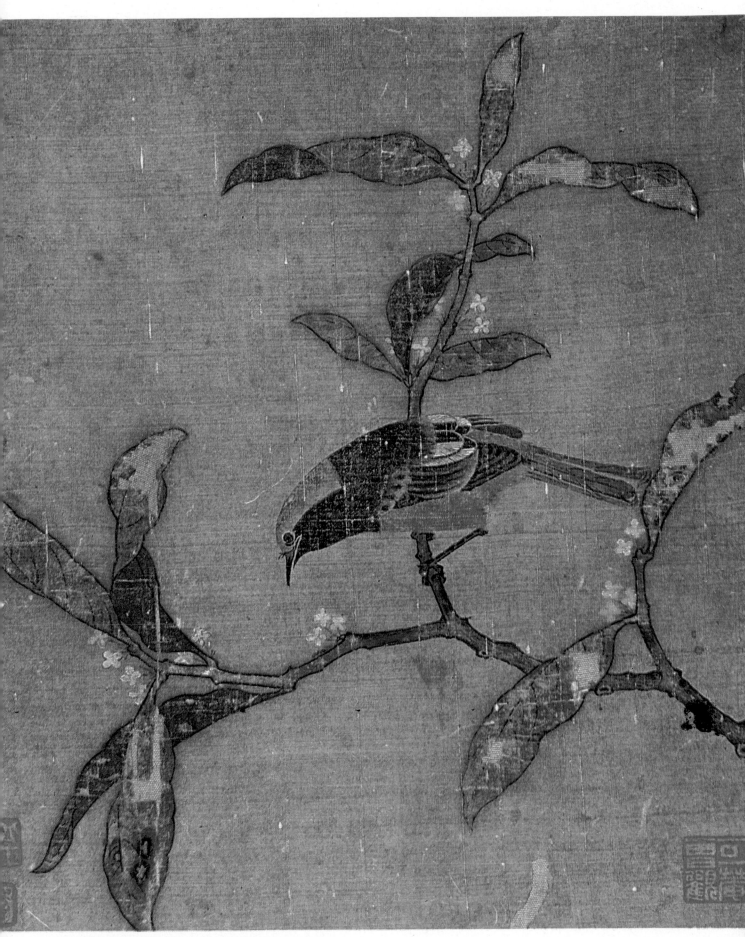

CHINESE. Bird on a branch. Attributed to the Emperor Hui-
tsung (1082–1135). *British Museum. Photo: David Swann.*

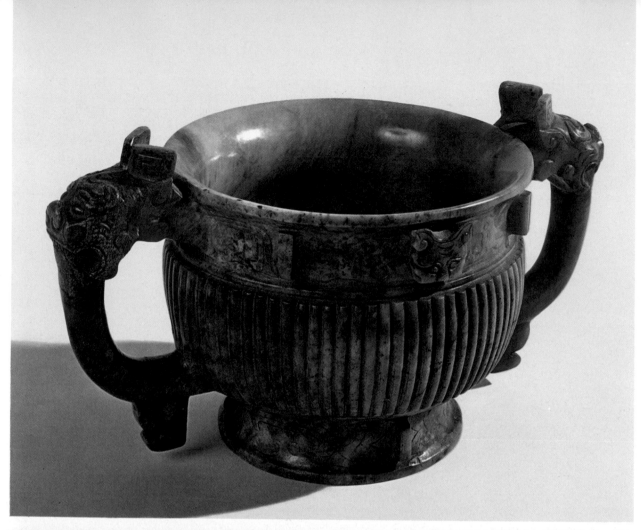

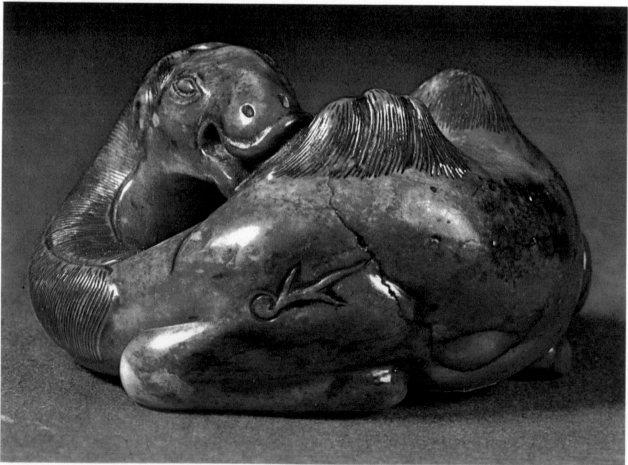

CHINESE. Jade vessel in the form of a kuei type bronze. Sung dynasty. Collection of Sir Alan and Lady Barlow, Wendover. *Photo: Michael Holford.*

CHINESE. Jade figure of a camel. Sung dynasty or earlier. *Victoria and Albert Museum. Photo: Michael Holford.*

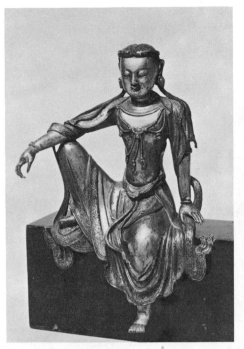

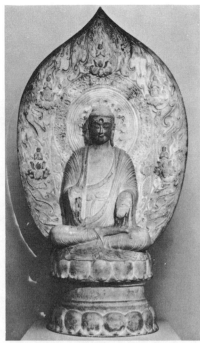

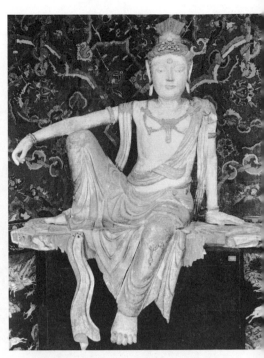

421. CHINA. Kuan-yin (Avalokitesvara), Bodhisattva of mercy; bronze gilt. Sung period (960–1279). *Department of Eastern Art, Ashmolean Museum, Oxford.*

422. CHINA. Buddha; white marble from Hopei, in the Northern Ch'i style (6th century). Liao period (936–1125). *Musée Cernuschi, Paris.*

423. CHINA. Kuan-yin in the 'Royal Ease' pose; painted wood. Chin period (1125–1234). *Collection of the Compagnie de la Chine et des Indes, Paris.*

Only the painters of the Ch'an sect continued to make use of wash and they passed it on to the great masters of the 17th century. Under Mongol domination the art of painting was essentially calligraphic, and great importance was attached to the brush stroke. Even Ch'ien Hsuan, one of the last artists admitted to the Academy before 1276, and who continued to work in private, revealed an archaic approach in his flower paintings by returning to the very fine line used by Hui-tsung.

In landscape, lyricism and suggestion were abandoned. The asymmetrical compositions of Ma Yuan and Hsia Kuei gave place to a revival of the monumental style of the 10th and 11th centuries. Some artists looked back to Kuo Hsi, whose works were the most complete expression of this style; others, such as Kao K'o-kung, drew their inspiration from Mi Fei, and their simpler and freer compositions showed mountains drawn with fine lines, and dotted with trees summarily indicated by little parallel touches. This 'pointilliste' technique was Mi Fei's own invention. The posthumous fame of this master of the Northern Sung, who was so little noticed in his own lifetime, never ceased to grow. Unfortunately, as we have no authenticated works, it is difficult to make out whether the influence of Mi Fei was on a technical plane, or

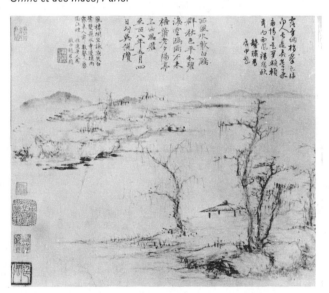

424. CHINA. Ni Tsan (1301–1374). Landscape; painted in ink on paper. *Collections of the Chinese People's Republic.*

425. CHINA. Huang Kung-wang (1269–1354). Landscape; painted in ink on paper. *Collections of the Chinese People's Republic.*

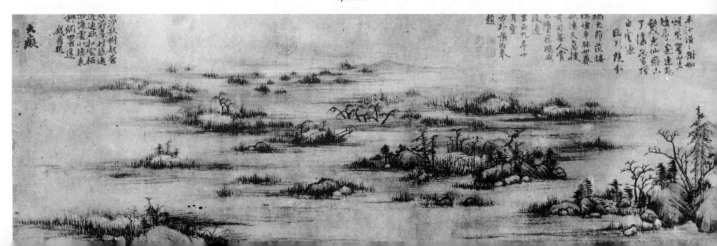

426. CHINA. Chao Meng-fu (1254–1322). Autumn Colours on the Ch'iao and Hua Mountains; detail from a hand scroll painted in ink and light colours on paper. *National Palace Museum, Peking.*

427. CHINA. Wu Chen (1280–1354). Landscape; ink on silk. *National Palace Museum, Peking.*

whether his name had not rather become a symbol, among the Sung scholars, of protest against foreign rule, and therefore to be praised as much as possible. The same protest may have affected the position of Chao Meng-fu, and this in spite of the fact that it would also have aimed at the official position which he held in the Yuan court. Without any doubt his work dominated his period. He came from the fallen imperial family, but from 1284 had accepted the invitation of Kublai, for whom he worked thenceforth. He was a Confucian, and in his calligraphy as in his painting he showed himself a representative of his own national culture in its purest essence. In some works he reverted to the aristocratic style of which he is considered one of the finest practitioners. In other works he showed himself a disciple of Tung Yuan and of Chu-jan, who were 10th-century painters in southern China. There is a landscape by Chao Meng-fu (National Palace Museum, Peking) in which it may be seen that he no longer made harsh contrasts between the planes or in the strength of the ink. In the background of this picture, vast expanses of water are barred by long bands of flat banks treated with light touches. The trees are drawn delicately, and their species are clearly distinguished. The trees unite with the background which is charged with mists in which mountain humps are flecked with dark woods. This is a spontaneous and balanced art, in which the essential characteristics are the return to line used with varying degrees of accent, the small amount of wash, and the economy of ink.

These characteristics are met again in the work of Sheng Mou, a contemporary of Chao Meng-fu, and also in the work of four great painters who brought new life into landscape painting about the middle of the 14th century. Though all were influenced by Sheng Mou— Huang Kung-wang was his pupil and Wang Meng a descendant—they seem only to have used his work as a point of departure. From him they inherited technical knowledge and his preference for the 10th-century monumental compositions, and they made use of these in arriving at a new conception of space. They were far from repeating the logical universe of their early predecessors, but transformed it into heroic and revolutionary compositions which have something of the upsurge of national feeling that led to the liberation of China from foreign domination in 1386.

There are no better works from which to understand what was, for the *literati*, the symbolic language of landscape, a language which had been evolved over centuries. Those who had fled for refuge to the south had worked in solitude and made use of the brush to express their refusal to play a part in a world that they held in contempt; instead they translated into pictures the world of which they dreamed. Their landscapes were not purely imaginary, for we know that Huang Kung-wang, who lived in Chekiang, made numerous sketches directly from nature as preparation for his paintings of the rich and humid atmosphere of that district. Wu Chen was a fervent Taoist who is distinguished by his calligraphic line and by his economy of ink. The long narrow compositions of Wang Meng tend to be oppressive because their skyline was overfilled with mountains.

With these three painters of grandiose and austere space, it is customary to associate another solitary, Ni Tsan. He came late to painting, but brought to it the sensibility of a poet. During the course of the travels that he made in his declining years, he painted simple compositions in which space was especially stressed. These are more calligraphic in style than the lyrical works of the Sung period. They are more balanced and are bathed in a delicate light rendered through graduated silvery greys.

These four Yuan masters, reactionaries who became revolutionaries, gave a new life to the art of landscape. Most later painters have followed in their path, but few have equalled them, and even fewer surpassed them.

426

425

427

429

424

HISTORICAL SUMMARY : Chinese art

THE FIVE DYNASTIES (906–960) AND THE SUNG PERIOD (960–1279)

History. In 906 the T'ang Dynasty, which had been undermined by 150 years of internal anarchy, ended in collapse. The Chinese empire became utterly disrupted. In the wide north China plain five dynasties succeeded one another until 960. While the military leaders were fully occupied quarrelling over their disputed power, the Khitan barbarians, of Tungusic origin, were 'left free to descend from their native Jehol and to occupy the northern part of the Hopei and Shansi provinces. In the west and in the south of China there were ten kingdoms that shared rich provinces and that, remaining in relative security, were able to follow their economic, cultural and artistic development.

In 960 a military leader, proclaimed emperor by his troops, founded the Sung Dynasty at K'ai-feng in the Honan province, and undertook the unification of China. His brother T'ai-tsung, who succeeded him in 976, continued the work that he had begun. These two first emperors of the new dynasty carried out many administrative reforms. The military forces became subservient to the civil government. Statesmen were more widely recruited, and official patronage of printing resulted in a broader dispersion of culture.

Confucianism triumphed over the declining Buddhism. The classics were revised, and in the 13th century Chu Hsi inaugurated Neo-Confucianism. This philosophy was to remain the intellectual framework of China until as late as 1911.

Methods in agriculture and in industry were improved as a result of developments in science and the discovery of new techniques. As a consequence trade expanded both at home and abroad. A rich middle class came into being, and their sons were given a good education and eventually filled important positions in the government.

Nevertheless, the Sung forces failed to push back the Khitans behind the old frontiers, and they continued to reign in the northern provinces under the name of the Liao Dynasty. The Sung were even forced to pay tribute to the Liao as well as to the Hsi Hsia. The latter, of Tangut origin, had occupied Kansu in 1031, and sealed off the Silk Route, thus barring intercontinental traffic.

In 1125 new barbarians, this time the Jurchen, repulsed the Liao and occupied their territory inside the Great Wall of China. They crossed the Sung frontier and invaded the whole of northern China. Under the name of Chin, they established their capital on the site of present-day Peking. The Sung emperors, who took refuge at Hangchow in Chekiang, found their power restricted to the southern provinces, which fortun-

ately were very prosperous. A new and dangerous threat was soon to develop. Genghis Khan had eliminated the Hsi Hsia and the Chin in 1234. His death caused a temporary diversion of Mongol interest from China. His grandson, Kublai, resumed the invasion, and in 1276 had occupied Hangchow. Three years later Canton fell, and so the Sung Dynasty came to an end with the year 1279.

Architecture and sculpture. New architectural forms which had been created in southern China in the 10th century were introduced in Honan at the time of the rebuilding of Pien-ching (K'ai-feng), which was the new capital of the empire. This was to be in the official Sung style, with roofs that were turned up at the angles, with a more complicated timber framework, with more varied plans, with its elegant if somewhat fragile lines, and its use of the flattened arch. It was less spacious than that of the T'ang period and more covered with detail, such as painted and carved ornamentation. The accent was on verticality. Pien-ching, which was reconstructed in the middle of the 11th century during the reign of Jen-tsung, became the model for the Liao and Chin capitals, as well as for Pyongyang, the capital of the new Korean dynasty called the Koryo.

Buddhism continued among the people but was neglected by the aristocracy, and consequently was not strong enough to sustain a revival in sculpture, which rapidly degenerated. This degeneration was aggravated by the emphasis on painting and the increasing trend towards realism. The sculpture decorating many sanctuaries was very skilful, but it lacked grandeur [421]. Examples of temples include Tatsu in Szechwan, and a number of temples in the neighbourhood of Hangchow and Ning-po.

Painting. As the Sung rulers were themselves amateur painters, this naturally gave an added incentive to the art of painting. However, their taste was for earlier styles, and they therefore patronised the artists who specialised in the floral compositions belonging to the decorative tradition of the T'ang Dynasty. At the end of the 11th century the emperor Hui-tsung (1082–1125) imposed on the artists of the Academy his own delicate and precise style with its bright and transparent colours, which may be seen in his numerous pictures of flowers and birds [411]. This style retained its importance under the Southern Sung Dynasty. At the same time, but apart from official patronage, a landscape style developed making use of Indian ink. During the 10th century this style was developed by Ching Hao [401] and Li Ch'eng in the north, and by Tung Yuan [404] and Chu-jan [403] in the south. In the following century Fan K'uan [405], Hsu Tao-ning [409], Yen

428. CHINA. Secular figure; sculpture from Pao-ting (Tatsu, Szechwan). Sung period (960–1279).

429. CHINA. Wang Meng (about 1320–1385). Landscape; painted in ink heightened with colour on paper. *The Bamboo Studio, New York.*

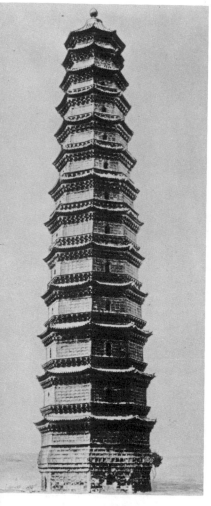

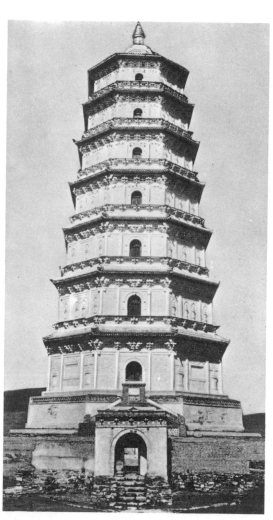

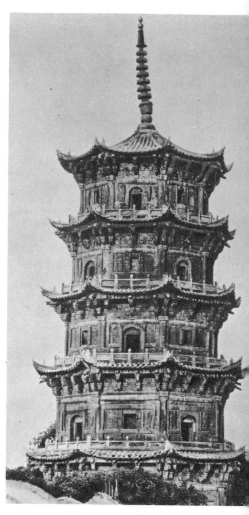

430. CHINA. The 'iron-coloured' pagoda at K'ai-feng (Honan), built after 1044. Northern Sung period.

431. CHINA. 'White pagoda' of Pai-t'assu north of Ching-chou (Inner Mongolia) built after 1031. Liao period.

432. CHINA. One of the twin pagodas at Ch'uan-chou (Fukien) built between 1228 and 1256. Southern Sung period.

Wen-kuei and Kuo Hsi [406] were disciples of Li Ch'eng as may be seen in their highly constructed compositions, which put the accent on spatial values.

In the middle of the 11th century, the ruling classes were captivated by the charm of ink, and found in calligraphy [412], poetry and painting a means of expressing their own individualities. Li Kung-lin (Li Lung-mien, 1040–1106), in paintings of men and horses [413], returned to the continuous outline which had been traditional in China since the 4th century. Su Tung-p'o (Su Shih, 1031–1101) and Wen T'ung (died 1079) [416] in their paintings of bamboos, and Mi Fei (1051–1107) in his landscapes, made more use both of wash and of drawing in small strokes. In the Southern Sung period, Li T'ang [387] adapted this new technique to the style of Kuo Hsi, and in this he was followed by Li Sung and Liu Sung-nien, who were important for their improvisation of more varied compositions. In the 13th century their various methods were developed into conventions by Ma Yuan [430, 432] and Hsia Kuei.

During the same period, in the monasteries of the contemplative Ch'an sect, the wash technique was predominant, as

for example in the visionary art of Liang K'ai [418] and of Mu-ch'i [414, 415].

The minor arts. The writings of the period show that a number of artistic techniques were prospering. These included silks, k'o-ssu or petit point tapestries [388], glass, gold and silver work, jade [433] and lacquer. Carved lacquer and brocades with gold and silver thread appeared about this time. Unfortunately, very few specimens have survived.

The ceramics of the period are better known and are aesthetically unequalled. Their harmonious and restrained forms were covered with glazes of a single colour, over an incised floral decoration. Technical improvements together with the spread of the tea ceremony led to a greatly increased output [389-400].

FURTHER DEVELOPMENT

The Liao, who had come as barbarians from the north, had been settled on territory inside the Great Wall of China since the beginning of the 10th century. At first they imitated the forms of T'ang architecture and sculpture. In Mongolia and in Jehol there are many pagodas built on a square plan. However, in China

itself, Sung art soon influenced the Liao, whose buildings followed the new Chinese style, with slight modifications in detail, from the middle of the 11th century onwards. The mural paintings in the tomb of Chen Tsung, who died in 1032, remained true to the T'ang tradition. The great number of ceramics produced were also inspired by the three-coloured T'ang ware. There was a return to the 6th-century style of the Northern Ch'i in the sanctuaries of those parts of China which were occupied by the Liao [422].

The Chin, who reigned from 1125 to 1234, adopted the art of the Liao. They were fervent Buddhists, and in Shansi province they founded many monasteries which were decorated with mural paintings and polychromed woodcarvings [423].

THE MONGOL YUAN DYNASTY (1279-1368)

History. With the beginning of the 13th century, Timurjin (1167–1227) formed a confederation among the barbarian populations of Outer Mongolia, which rapidly extended to include the rest of Mongolia. Timurjin took on the title of Genghis Khan or Universal Emperor in 1206. His

hordes lost no time in penetrating into China. He overcame the Hsi Hsia, and in 1215 took the capital of the Chin, which stood on the site of present-day Peking. He then turned on central Asia and began the series of successful attacks which led his armies as far as the Danube. It was not long before the conquest of China was resumed. In 1233 K'ai-feng fell and the Chin were annihilated. In 1276 Hang-chow was captured, and the ravaged Sung were finally eliminated three years later when Canton fell in 1279. These last campaigns were led by Kublai, the grand-son of Genghis Khan. He had been brought up in China, where he now founded the dynasty which took the Chinese name of Yuan and lasted from 1279 until 1368.

Kublai continued the traditional political methods of the Chinese sovereigns, but he left the *literati* out of his government, and they never forgave him for their elimination from political life. The Mongol conquest made a complete and permanent break in Chinese history and culture. The Yuan period was nevertheless brilliant, especially in its opening phase, and Marco Polo, who lived in China from 1276 to 1292, was dazzled by its luxury.

In an Asia almost entirely dominated by the Mongols, the trade routes were safe and so Chinese production grew. The Mongol princes became degenerate, their army lost its fighting value, the financial administration was unsound, and so the dynasty gradually became weak. The Yuan were unable to counter a revolt, which rapidly spread and flared up into a national insurrection. The Mongols were thrown back behind the Great Wall in 1368, when a new Chinese dynasty, that of the Ming, was founded by the victorious Hung-wu.

Architecture and sculpture. There were not very many new influences in architecture. The Sung architectural forms became crystallised and lost their suppleness. The only innovations, such as the bottle-shaped stupa type of temple, were a result of the patronage of Tibetan Lamaism by the Mongol sovereigns.

In sculpture, the large forms of the Chin Buddhist images were modified by the intrusion of Tibetan iconography. In the 14th century sculpture became duller owing to the influence of Nepalese sculpture.

Painting. At the Yuan court, painting was reduced to a trade. Tradition required that the Mongol rulers should show a preference for scenes of hunting and horsemen. Jen Jen-fa excelled in these subjects [417].

Chao Meng-fu worked for the foreign rulers from 1294 onwards. He showed a retrograde spirit by declaring himself in favour of the old calligraphic methods of Wang Hsi-chih, who had lived in the 4th century. His landscapes [426] were a reaction from the subjective style of the Southern Sung artists. He made use of stipple in place of the wash technique.

Ch'ien Hsuan, a former Academician, became a refugee in the south. He was a flower painter, and infused new life into the flower compositions which had deteriorated during the 13th century.

Four great landscape painters living towards the end of the period revealed in their works their spirit of revolt against the Mongol domination. They lived in isolation and based their style on the works of Tung Yuan and Chu-jan, who had made landscape painting an illustrious art at the court of Nanking in the 10th century. The works of Huang King-wang (1269–1354) [425], of Wu Chen (1280–1354) [427], and of Wang Meng (1310–1385) [429], are distinguished by their well knit composition, by a sense of spatial values, and by their use of small brush strokes inspired by calligraphy. With them it is customary to associate Ni Tsan (1301–1374). He was a poet of greys and silvers which illuminate his simple and clear compositions [424]. These four artists set the style which was to be followed by all later painters.

The minor arts. The Sung craftsmen worked for their new masters, but as there was no fresh nourishment for their art their technique gradually declined. The art of carpet weaving was introduced into China by the Mongols. Probably the earliest cloisonné enamels belong to this period, but no examples remain. Silks and ceramics were produced in great quantity and formed a most important item in China's foreign trade.

The quality of craftsmanship became poorer during the course of the 14th century. Porcelain decorated in cobalt blue and glazed made its appearance [420]. Later, with the Ming Dynasty, this type of porcelain was to develop magnificently.

Madeleine Paul-David

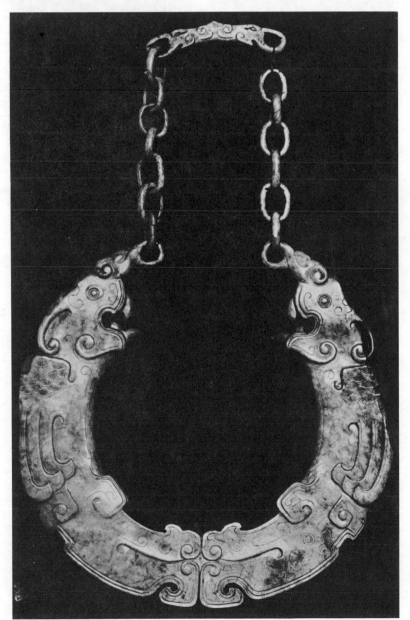

433. CHINA. Jade pendant. Sung period (960–1279). *Musée Guimet, Paris.*

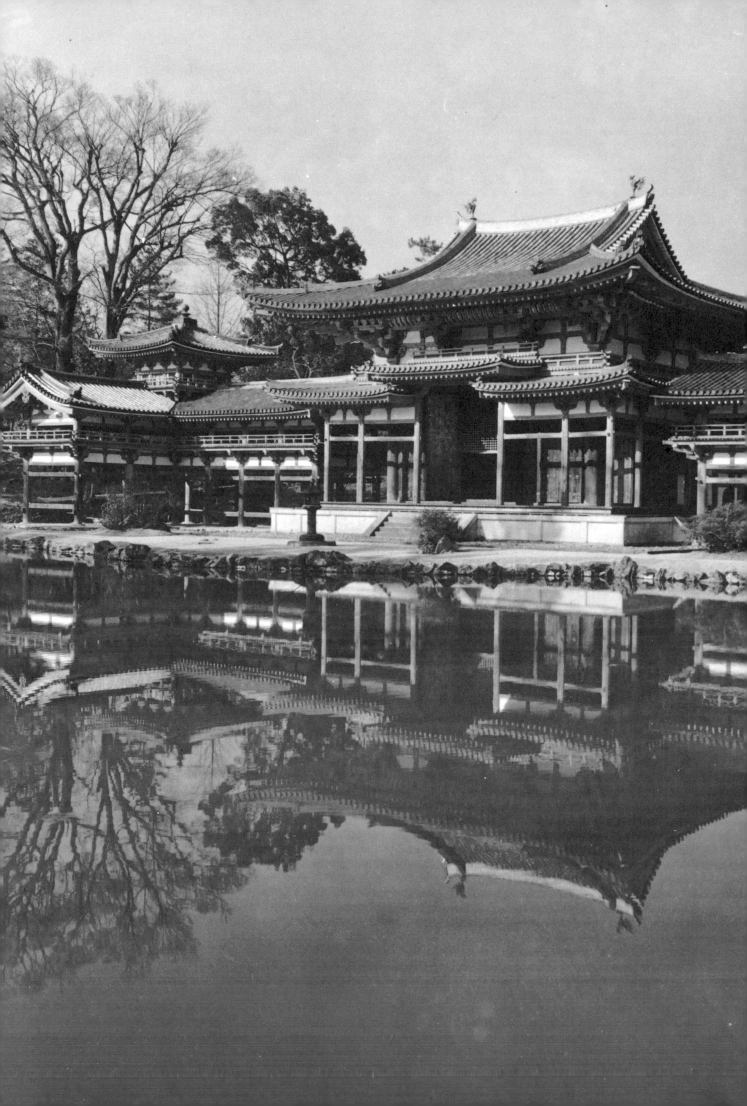

KOREA AND JAPAN *Madeleine Paul-David*

Japanese art has its roots in China. Chinese influence came by way of Korea, where Chinese traditions became completely transformed by contact with barbarian populations. As a result, a new vocabulary of form emerged, which was to serve as the basis for the sensitive, aristocratic and essentially national art of Japan.

CHINESE ART IN KOREA

At the beginning of our era, Korea had been of primary importance as an intermediary between the civilisation of China and that of the Japanese archipelago. By the middle of the 7th century, however, when close relations had been established between the courts of Yamato and of China, Korea became of only secondary importance.

The Korean kingdom of Silla, known in Japan as Shiragi, was founded in the 3rd century A.D. in the south-east coastal area. In 668 it achieved the unification of the peninsula with the support of the T'ang rulers, whose sovereignty it recognised. Korea, like the rest of the Far East, was dominated by Chinese art and culture. The mastery attained by the Korean emulators of the Chinese architects and sculptors is shown in the Buddhist temples of Pul-kuk-sa (Bukkokuji) and of Sokkulam (Sokokuji), and in the remains discovered at Kyongju, which was the capital of the new Korean kingdom.

Korea in the Koryo period (936-1392)

The weakening, and eventual submergence in 906, of the T'ang Dynasty had repercussions in Korea. In 936 Silla, deprived of her powerful protectors, was replaced by a dynasty from the north which took the name of Koryo and reigned in the peninsula until 1392. The Koryo accepted subservience to the Sung Dynasty when the latter came to power in China, but the political influence of the Chinese dynasty was short lived. The Liao, after occupying Manchuria and taking northern China, dominated Korea. They were followed by the Chin, and in due course by the Mongols. Politically, Korea became included within the barbarian group of kingdoms which dominated northern China from the 10th century to the 14th century, and the whole of the Chinese empire after 1278.

The geographical position of Korea, however, enabled it to keep its thousand-year-old sea contacts with the coastal provinces of central China.

Koryo art reflects this intermediate position between China proper and the barbarian kingdoms. Its history has still to be written. Japanese archaeologists, suddenly interrupted in 1945, appear, as regards this period, only to have made a sort of inventory of sites and monuments. It is known that Pyongyang, the residence of the dynasty on the shores of the river Ta-t'ong, not far from the ancient Chinese district of Lo-lang, was built on a plan inspired by Pien-ching, which was the capital of the Northern Sung. But there was nothing unusual in this, for the Liao and the Chin had adopted the same model. Some Buddhist temples resembled those of the Liao.

434. JAPAN. The Hoodo (Phoenix Hall) of Byodoin, near Kyoto. 1053.

In others, there was an influence from southern China, which was also to affect buildings in Japan at the end of the 12th century. It will only be possible to give a complete picture of Koryo art when more is known about the arts of the Liao and the Chin, and also of the Yuan. All are branches of Chinese art, and are distinguished by the varying amount of T'ang influence, by the specific features of the different barbarian populations, and by later Sung influence. Koryo art, then, belongs to a marginal chapter of the history of Chinese art.

The minor arts of the period are better known and reveal a number of local characteristics. The old technique of lacquer inset with mother-of-pearl, which had flourished under the T'ang Dynasty, continued both in Korea and in Japan. The Koryo craftsmen excelled in this work which they carried to a high degree of complexity. In the 12th and 13th centuries they adapted it to new decorative themes, as, for example, that of the willows shading small rivers dotted with tiny islands, and filled with little people and aquatic birds. The same direction was followed in the ceramic arts, again dominated by Chinese influence. The Korean potters copied 435 in detail the famous celadons which in the 10th century were the glory of the Wou Yueh kingdom in Chekiang. An ambassador of the emperor Hui-tsung who visited Pyongyang in 1124 drew attention to their skill. Later, these pieces were decorated with floral motifs painted in rust colours under glaze and fired at a high temperature. Finally, in the 13th century, they drew inspiration from the inlaid work of the lacquer craftsmen, and imitated 436 their decoration by using barbotine, a pottery paste, heightened with black and red.

It is probable that further study of the remains of buildings and painting will reveal other local features.

CHINESE CULTURE TRANSFORMED IN JAPAN

While Korean art remained subordinate to the Chinese, in Japan, where continental influence had held sway during the 7th and 8th centuries, national styles began to develop. It was a slow process which began at the same time that the court was transferred to the new capital of Heian, which is now known as Kyoto. This transfer was made in 794 by the emperor Kammu and marked the disruption between the Buddhist sects of Nara and the rulers of Yamato. It was a move of the greatest importance in the history and art of Japan. The rationalist sects who had unsuccessfully attempted to instal a theocracy at Nara were henceforth relegated to the background. The court aristocracy took over their power. During the course of the 9th century the clan of the Fujiwara gradually acquired a dominant position. They reserved to themselves the privilege of marrying their daughters to the sovereigns and in this way the elders of the Fujiwara family were able to rule in the names of their imperial sons-in-law for nearly two hundred years, from the 10th to the 12th centuries. Allied to, or under the protection of, the masters of the day, the members of the aristocracy took part in their fortune, and were given important positions in the government.

435. KOREA. Ewer; celadon. Koryo period; 12th–13th centuries. *Musée Guimet, Paris.*

436. KOREA. Ewer; inlaid celadon. Koryo period; 13th century. *Mme Henri Maspero Collection.*

437. JAPAN. Bodhisattva. Statue in wood. End of the 8th century. Style of the Toshodaiji workshop. *Musée Guimet, Paris.*

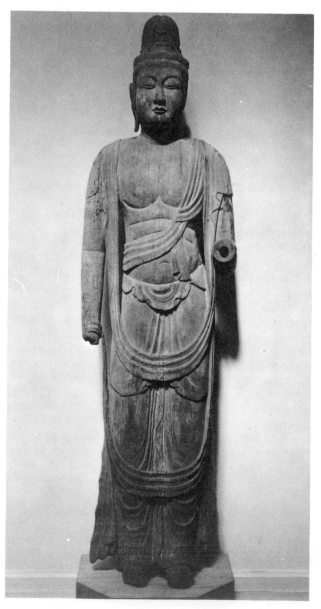

At first, Chinese culture was all pervasive. Heian, as had been the case with Nara, was laid out on the chequered plan of Ch'ang-an, which was the great continental metropolis. The aristocracy of Japan were desirous of equalling the ruling class of China in everything, and so they took up poetry, calligraphy and all the diversions of the Chinese *literati*. This zeal for Chinese fashion (Karayo) showed itself in every direction, and throughout the 9th century the Japanese scrupulously imitated the literature and the art of China.

The court aristocracy regarded with favour the new sects introduced from China at the beginning of the 9th century. Their mystic and esoteric tendencies, their sumptuous ceremonies and their complicated ritual appealed to the Japanese taste for luxury and mystery. The Tendai sect was founded by Dengyo Daishi (Saicho), and in imitation of the Chinese Buddhist priests he established his monastery away from the capital on the side of Mount Hiei. When Kobo Daishi (Kukai) returned from China, he installed the first Shingon sanctuary on the slopes of Mount Koya, in a region which was difficult to reach from Yamato. From then on, the symmetrical plan which had been preferred in the temples at Nara was no longer used. This was due to the necessity of adapting the architecture to difficult terrain, which was to mark the beginning of the intimate union between architecture and landscape. This became one of the essential characteristics of Japanese traditional architecture.

Iconography had been enriched by numerous themes deriving from China. The Shingon cult increased the number of its images, which represented metaphysical entities emanating from the supreme divinity, Vairocana, the Great Illuminator. From the end of the 8th century

438. JAPAN. Detail of a hand scroll, the *Nezame Monogatari.* About 1160.

images carved in wood (ichiboku) replaced those in bronze, plaster and dry lacquer. Statues rich in form and with resplendent draperies were made in the workshops of Toshodaiji at this period, and they reflected the realist T'ang style then at its height. During the 9th century this technique was used to express the power of the Shingon gods battling against evil. Elegance gave way to massive form, and movement to rigidity. These gods sit with legs crossed, in one hand brandishing the chastising sword and in the other holding the cord with which to tie up the demons. The Fudo of Toji is a fine example of this austere art; once having seen him, it is impossible to forget his strongly marked features, his fixed and piercing eyes, his draperies with their deeply hollowed folds which resemble the flutings on a column. This work shows more clearly than any others the mastery of the Japanese sculptors; the nervous tension and the concentrated power which springs from it do not appear to have been found in any Chinese works of the same period.

The painters, however, were less skilful. In Japanese monasteries there are still piously preserved the portraits of patriarchs of the Shingon sect, which were conscientious imitations of continental images of the divinities. But both the tendency to monumentality and the study of mass and volume which characterised Chinese painting seem to have remained foreign to the Japanese spirit. The monks who copied them strove vainly to render their imposing fullness, and their attempts were not happy. The Yellow Fudo of the Miidera temple remained awkward and static. It was not an accident that Japanese artists showed much more competence in their reproductions of the *mandara* which were translations into a pictorial form of the world of spirit and of matter grouped in a complex pantheon around the supreme divinity, Vairocana. These compositions, painted in lines of gold and silver on purple, red or deep blue paper, harmonised more readily with the Japanese spirit, which was always more sensitive to linear art. This tendency dominated in both painting and sculpture during the 10th century, which saw the 'Japanisation' of foreign forms.

Formation of an aristocratic culture

Political conditions were favourable for the blossoming of a national art. From the middle of the 9th century contacts with China had become less frequent. The last official ambassador left for Ch'ang-an in 838, and in 894 the government put an end to this age-old custom. The Chinese world was in jeopardy, and the anarchy which was a prelude to the overthrow of the T'ang Dynasty made travel dangerous. Priests were unwilling to go to the continental monasteries ruined in the persecutions of 845. The Fujiwara were proud of their newly found power and wished to assert it, so they no longer felt the need to follow foreign examples as had always been done in the past.

From this time onwards, everything was changed. The aristocracy of Heian were sensitive if superficial, but Chinese culture had little effect on them. They fell in love with anything that to them seemed new, adventurous or modern. They developed their own means of expression, having replaced Chinese writing with their own *hiragana* or spelling book, which was more suitable to the Japanese language. Their choice of the most cursive forms for its characters betrayed their preference for suppleness of line and for movement. They soon had

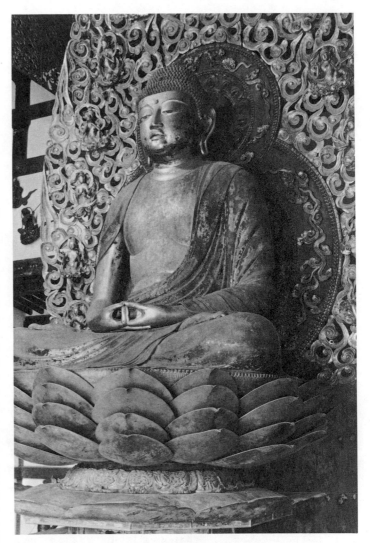

439. JAPAN. Amida. Statue by Jocho in carved and gilded wood. 11th century. *Hoodo of Byodoin, near Kyoto.*

their own terse and rapid calligraphy, which was not so balanced or so robust as that of the Chinese. They wrote with refined elegance on tinted and sometimes decorated paper. They preferred short poems with allusive images to the T'ang forms which had for so long inspired Japanese poetry. Themes of local inspiration replaced those of the *literati* of Ch'ang-an. Their quivering sensitivity was infused with the beauties of Heian, which was surrounded by undulating and thickly wooded hills. They invoked the simple and delicate pleasures to be enjoyed in the countryside around the capital, the sparkle of a waterfall, the song of a bird, cherry trees flowering in the spring, and maples turning red in autumn.

It would appear from the novels and intimate diaries of the period that the nobility of the court were quick to anger or joy and passed rapidly from gaiety to melancholy; they were avid for any novelty, and enslaved by the latest fashion; they were inclined both to sentiment and to mystery, but were hedged in by religious prohibitions and by the rules and requirements of a very strict etiquette. The *Genji Monogatari*, their undisputed masterpiece, was written by Murasaki Shikibu, who held a high position in court as lady of honour to the empress. Everywhere the Japanese spirit reappeared from under the veneer of Chinese culture which had covered it for three centuries.

Official architecture, as in the case of Nara, imitated the style of Ch'ang-an. Meanwhile, a new style called shinden-zukuri was used for the private apartments of

217

the rulers and for princely dwellings. It was a harmonious blend of foreign idioms and local traditions of architecture. The roofs were covered with cedar bark in place of tiles. Instead of stone terraces, a veranda surrounded these new dwellings. Piles supported a raised floor which projected considerably beyond the partition, thus forming a veranda or engawa. This engawa later became a regular feature in Japanese houses. From it one could contemplate the landscape, see the sun rising or setting on the far horizon, watch the moon drench the trees in silver and enjoy the winding streams dotted with tiny islands, joined to the mainland by bridges.

The gardens of Heian reflected the new beliefs. The Fujiwara were especially devoted to Amida. The worship of Amida was more human and less complex than the esoteric sects. Its doctrine was spread in the 10th century by the priest Genshin. It promised to every living being who invoked the Lord of Compassion (Kwannon), even if in his last hour, entry into the Land of Purity, the Paradise of Amida. This cult was popular in China for a long time and there is a banner from Tun-huang, preserved in the Musée Guimet, which represents this enchanted world. It shows us a palace composed of symmetrically arranged pavilions linked together by covered galleries, and surrounded by terraces where the gods are resting. In front of this palace is a lake, in which the floating lotus flowers carry the souls of the Blessed.

A similar lake is found again at Uji, where it reflects the Hoodo (Phoenix Hall) of the Byodoin temple. This was the pleasure villa of Fujiwara no Michinaga, consecrated by his son to the worship of Amida in 1053. The central pavilion is connected by covered galleries to two side pavilions over which rises a sham storey. The painted palaces of Tun-huang may have had fuller proportions, but here at Uji the restrained dimensions reveal the refinement of the period, and the skill of the architects, sculptors, painters, metalworkers and lacquerworkers. The interior of the sanctuary is square in form, and the walls are covered with red lacquer heightened with gold and decorated with paintings. These surround a central dais, flanked by four columns which support a coffered ceiling. The statue of Amida is in gilded wood and stands out from a splendid tooled and fretted aureole.

The statue is of rare elegance, and its rounded and slightly heavy forms contrast with the massive power of the Shingon divinities of the 9th century. The face is expressionless. Jocho was the sculptor, and the Fujiwara were his patrons. In this work may be seen a new technique in which Jocho, instead of carving from a single block of wood, assembled a number of wooden blocks. This method made it possible for several craftsmen to share in one work. Jocho's studio was at Kyoto and he trained many pupils who followed his teaching faithfully, and were to copy this work many times, eventually making of it a stereotyped convention. The influence of painting tended to draw their study away from volume and to put the accent on line, and so to treat their works in a two-dimensional manner.

Birth of the Yamato-e style

Painting became more and more popular. It had become fashionable. The writings of the 11th century begin to contrast the Karayo or Chinese style with the Wayo or national style, which in the 13th century was to take the name of Yamato-e, covering a whole range of Japanese

subject matter to which techniques became adapted.

For their subject matter the artists chose well known Japanese scenery, and on these themes produced a whole series called meisho. These scenes recurred very much later in the work of the Japanese woodcut artists. In the representations of the four seasons, which decorated the imperial and aristocratic folding screens, they replaced the Chinese landscapes that had been faithfully copied since the Nara period.

As regards the change in technique, in a passage in the *Genji Monogatari* Murasaki Shikibu writes with a certain amount of disdain about the mountains rising in fifteen superimposed planes, painted by Kose no Kanaoka, one of the masters of the early 10th century. She compares these mountains with the more simple and horizontal pictures by this artist's grandson, Kose Hirotaka. The Chinese sense of space had never been really understood in Japan and for a long time Japanese painters had imitated Chinese landscapes quite superficially. The Japanese approach to nature was entirely different; their reactions were emotional rather than intellectual. The Chinese found in landscape the relation of man to the universe. But, for the artists of Heian and their aristocratic patrons, nature was the familiar setting in which the actions of everyday life took place. They enjoyed its charm and even made it a symbol, and into this symbol projected their keen sensibility, but never with any profound feeling. This was partly due to the difference of the Japanese scenery which was less grandiose than that of China; and partly due to the Japanese mentality, which was less highly intellectual than that of the Chinese *literati* and was more drawn to what was concrete and particular. Further, the Japanese gave much more importance to line, and consequently their pictures appear flatter and more decorative. Finally, landscape was very rarely drawn for its own sake, but rather as a backcloth to anecdotal subjects.

Very few works have survived, and it is therefore extremely difficult to follow the development of the Yamato-e style from its beginnings in the 10th century. There is a poorly preserved landscape over one of the doors of the Hoodo of the Byodoin temple which dates from the 11th century. Merciful Amida, followed by a whole group of divinities, descends from the sky to come to the bedside of the dying who have invoked him in their last hour. The dazzling cohort crosses valleys and undulating hills, among which are winding streams speckled with waterfowl and fishing boats. In this religious work may be seen a thousand familiar details which must have come from pictures on the folding screens painted for the court. Not one of these screens survives, but they are known through their inclusion in scenes that illustrate the texts of the *Genji Monogatari*, of which fragments remain. Today this work is attributed to the 12th century, and the decoration of the screens represented in it show that the theme of the seasons interpreted in the form of landscapes was already a convention. It is not surprising, then, that from as early as 1056 when the Hoodo paintings were carried out, the influence of the secular Yamato-e style was already affecting religious art. The rounded hills were tending to be detached as flat and isolated silhouettes without any attempt at recession.

The earliest extant examples of this secular art are later in date. They are the hand scrolls illustrating the

440. JAPAN. Detail of a hand scroll of animal caricatures. End of the 12th century. *Kozanji, Kyoto*.

441. JAPAN. Detail of a hand scroll, the *Story of Ban Dainagon*; people rushing towards the burning door of the imperial palace. End of the 12th century.

442. JAPAN. Detail of a hand scroll, the *Legends of Mount Shigi*; painted in ink and heightened with colour. 12th century. *Chogosonshiji, near Nara*.

novels of the period, and in them the scenes alternate with the text, which is copied in the beautiful calligraphy of the times. Though the origin of this form was Chinese, the Japanese chose from among the foreign elements a number of stylised themes which soon became classical.

452, 453 In the illustrations for the *Genji Monogatari*, as the reader slowly unrolls the text from right to left, so the illustrations follow, beginning from the upper right-hand corner and finishing in the lower left-hand corner. The views are panoramic, and interior scenes are made visible by the device of removing the roof. The story of Genji takes place in the court of Heian: a concert is given by the young lords who are sitting on the engawa which is bathed in moonlight; the ladies of the court are looking at pictures, their long loose hair falling about their shoulders and their numerous garments spreading out in a way that makes them look like so many flowers. The scene of the last visit of Genji to the beautiful Murasaki takes place in a room that opens on to a melancholy garden where the

autumn wind bends the trees and shakes the tall grass. There is no movement, no expression in the faces; the nose is drawn with a single hook and the eyes are indicated by an oblique stroke. The lines drawn in ink are covered by opaque and brilliant colour which gives the work a glittering and precious appearance. It is a delicate art and Japanese specialists see in it the work of court painters who aimed at pleasing a feminine clientèle. The same artists, using the same style, also decorated the kimonos and the fans of the aristocracy. At the end of the 12th century, the *Sutras* were carefully copied by devout lords on to fans ornamented with secular scenes.

The *Story of Ban Dainagon*, attributed to the end of the 12th century, is more elaborate and less static. A succession of continuous scenes is used to relate a 9th-century court story in which everyone in the capital takes part. There is an outbreak of fire at the entrance to the imperial palace; a thick cloud of smoke in the distance draws the attention to the people, who run as fast as possible towards

the scene with the lords on horseback riding ahead of them; flames are painted in brilliant red. There are children quarrelling in the roadway and the parents soon become involved in the disturbance as they take sides with their offspring. Everything is drawn with the lively exaggeration of a caricature. The scenes are heightened with light and transparent colour; all is movement, faces have become expressive, and there is a skilful balance between areas full of activity and the interval spaces which give unity to the long composition.

The temples soon began to make use of the new style for their own purposes. Numerous hand scrolls relate the miraculous founding of various sanctuaries. The *Legends of Mount Shigi* is the first of this series and also the masterpiece of the period. It was painted in Indian ink and lightly heightened with colour. Among other episodes, the supernatural story of a flying granary is depicted. It rises from the ground amid the astonished peasants, it flies over mountains and valleys filled with deer, and eventually comes to rest close beside a saintly hermit living in solitude.

The two well known and exceptional hand scrolls of the Kozanji temple of Kyoto, which date from the close of the 12th century, do not tell a continuous story. The monks of this temple possessed an important painting studio, and they enjoyed producing humorous burlesque scenes with an incredible suppleness of line. They represented frogs mimicking nuns, monkeys and foxes as

443. JAPAN. One of the guardian kings of the nandaimon (south entrance) of the Todaiji of Nara; statue in wood carved by Unkei. About 1195.

pilgrims, and hares as priests. Inevitably the weak always triumphed over the wicked. Some Japanese scholars have found in these scrolls a reflection of the troubled times that saw the end of the enchanted world of Heian.

THE BAKUFU AND THE NEW REALISM

The Fujiwara had been weakened by their love of luxury, and now two factions disputed the power which the Fujiwara were incapable of recapturing. The Taira and the Minamoto engaged in a cruel struggle that put an end to the dream world of the aristocracy, which in its elegant dwellings and sumptuous sanctuaries had virtually realised in this world the paradise of the Land of Purity. When Minamoto no Yoritomo triumphed in 1185, the court nobility lost its power and riches for ever. Yoritomo created the Bakufu, a military government, and took the title of Shogun or Commander-in-Chief. He assumed power in the name of the emperor, but he removed from the court to Kamakura, near present-day Tokyo, where he founded a new capital. Japanese civilisation did not, however, experience a sudden change, for Heian remained the cultural centre of the empire.

The new rulers of Japan were warriors and they came from the provinces. They were less civilised than the aristocracy of Heian, they were more brutal and austere in their habits, and their realist vision of the world was to affect the artists. The portraits of these soldiers in sculpture and in painting reveal a new tension and a direct if nervous treatment. The effigy of Uesugi Shigefusa is carved in broad planes in a dark wood, and the face has a stern expression. Fujiwara no Takanobu painted the

444. JAPAN. Portrait of Minamoto no Yoritomo, by Fujiwara no Takanobu. *Jingoji, Kyoto*.

444 portrait of Yoritomo, who is shown wearing a severe
black garment, delicately drawn and with angular con-
tours; this black shape gives a magnificent foundation on
which is poised the pale and expressive face of the
warrior.

The heightened sense of reality, strongly felt by a
people so recently the prey to civil war, was reinforced
by Chinese influences. It also led to a return to the past,
which had been treated with contempt by the lords of the
Fujiwara period. The tastes, and also the political methods,
of Yoritomo favoured this return. The Shogun restored
the old poetic anthology of the *Manyoshu* to its former
place of honour. It had been forgotten since the 8th
century. Yoritomo's successors confirmed their power
by resuming the programme of the emperor Shomu. At
445 Kamakura they erected a monumental Daibutsu which
was intended to rival the Great Buddha of antiquity,
which in 755 had been consecrated at Todaiji.

Recent events made Yoritomo look towards the old
city of Nara, where he had to restore the two most
important monasteries which had been burnt down by
the Taira in 1180. Yoritomo was helped in this work by
Shunjobo Chogen, a monk who had studied the new
methods employed in the Buddhist architecture of China.
448 The nandaimon or south entrance and the kondo or
Golden Hall of Todaiji were rebuilt in a new style known
as the Tenjikuyo. Though its name would appear to
suggest an Indian origin, this style had been evolved in
southern China. The framework of the building was
different in style. In place of columns superimposed at
each stage by means of consoles, continuous pillars were
employed which ran through the whole height of the
building, though purely decorative consoles were never-
theless inserted. It was a severe style of architecture,
without any ornament, and was not continued in Japan.

The Great Buddha of Todaiji had been damaged dur-
ing the disorders and two Chinese craftsmen were en-
gaged to carry out repairs. At Nara they must have met
a whole group of sculptors who were busy replacing
Buddhist works that had disappeared during the troubles.
Kokei, who was a descendant of Jocho, together with his
son Unkei and his disciple Kaikei, attempted to revive
the beautiful style of the 8th century. Their realism,
443 however, led them towards a more acute and more
nervous realisation, which may be attributed to the influ-
ence of contemporary Chinese work. The two large
449 disciples of Buddha at Kofukuji were made by Unkei to
complete an old series which had been dispersed during
earlier centuries. A study of these two works reveals that
in spite of the great fidelity to the ancient prototypes,
their faces are much nearer to the living model and
betray an inspiration comparable to that found in the
official portraits of the time.

After the close of the Heian period, Japanese priests
had again made their journeys to the continent. They
made their way especially to southern China, and brought
back new ideas and new forms. These were to be the
more successful as they coincided with a revival of reli-
gious fervour quickened by the recent strife. The old
sects of the Nara period became active again. The monks
of the Shingon and Tendai sects no longer had the sup-
port of the nobles, who had become impoverished, so
they tried to make their rigid doctrines acceptable to the
people. They increased the number of statues of their
divinities in human form and bedecked them with orna-

445. JAPAN. The Amida of Kamakura; bronze, 13th century.

446. JAPAN. Detail of a hand scroll illustrating the *Heiji
Monogatari*; the burning of the Sanjo palace. Attributed to
Sumiyoshi Keion, 13th century. *Museum of Fine Arts, Boston.*

447. JAPAN. Detail of a Mongol scroll. 13th century. *Imperial
Household Collection.*

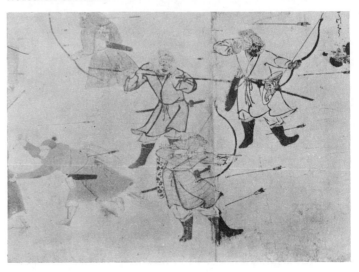

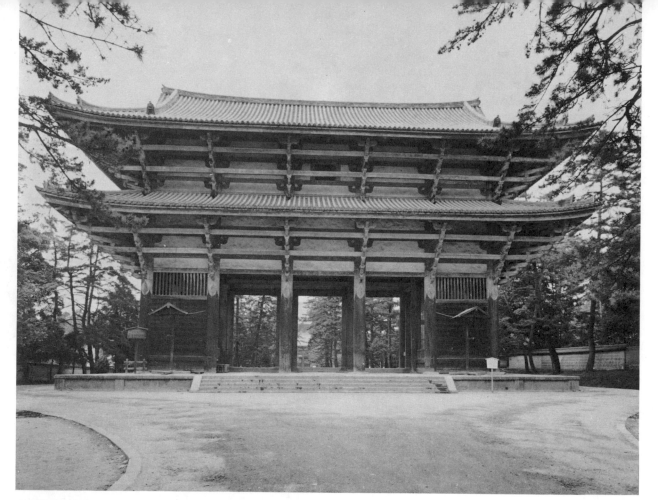

448. JAPAN. The nandaimon (south entrance) of the Todaiji of Nara. About 1199.

ments of precious stones and metals in order to attract the crowds. But, for the people, Amida remained the favourite deity. Many Raigo-zu were painted, in which Amida is shown descending to this earth with his cortège of divinities borne rapidly through the air on clouds of a Chinese style, often enriched with gold. Amidism, besides relating the splendours of Paradise, also threatened the horrors of the infernal regions, and depicted the misery of humanity on this earth. The form of the hand scroll or emakimono was used to represent hell with its demons, and the disorders and calamities of this world. Japanese caricature had free scope and became allied to the inherent realism of the period. So the Yamato-e style affected both religious and secular art. Even though Japanese scholars have not yet taken it into account, it is probable that certain Sung works, less sought after and less well known than the landscapes, played an important part in the new orientation of the Yamato-e style.

A great series of didactic hand scrolls was created relating the lives of heroes who were accepted into the Shintoist pantheon. Examples are the famous Sugawara no Michizane, who was a 9th-century politician and poet, and the Buddhist monk Ippen, whose wonderful story unfolds against a background of Japanese scenery which reveals a consummate knowledge of landscape. Painters continued to illustrate novels for the court and there were new romantic histories recalling the epic struggles of the Taira and the Minamoto. These were depicted in the *Heiji Monogatari*, the fragments of which are preserved in the Boston Museum. They were drawn with skilful grouping and an admirable sense of movement. Finally, there were the scenes from contemporary life, including the hand scrolls which illustrate the most important event

of the 13th century—the unsuccessful Mongol assault upon south Japan.

The appearance of Zen

One of the most important facts of this period was the adoption of Ch'an Buddhism by the military class. In Japan it was known as Zen Buddhism. It had come recently from China and as the centuries passed it was to transform Japanese life and culture. To begin with, its influence did not have spectacular results. Even though the sect was spiritual and contemplative, and demanded concentration and self-knowledge above all else, yet in some ways it attracted men of action. The Zen monks dispensed with books, their approach was metaphysical, proceeding by suggestion towards the mastery of self. This appealed to soldiers. So, too, did the simplicity of their sanctuaries and the austerity of their lives, which had some likeness to the frugal lives of the warriors and their rough and simple dwellings. Many monasteries were built using the square plan which this sect preferred. The architects appointed to erect the Engakuji monastery at Kamakura were first sent to China. All that remains of this temple is the relic hall or shariden, one of the very few examples of the Karayo or Chinese style of the period. It is restrained in dimensions but has unfortunately been disfigured by a thatched roof added at a later date, which is completely out of keeping with the proportions of the building. The style follows the Buddhist temples of the Sung period and is distinguished by the multiplication of brackets and by windows under 'basket handle' arches.

Many Zen practices soon seeped into Japanese life, and in the 14th century it became completely accepted,

HISTORICAL SUMMARY: Korean and Japanese art

KOREA

In the first quarter of the 10th century the Silla Dynasty gave place to the Koryo, which in 936 succeeded in uniting the peninsula. The Koryo Dynasty continued until 1392, but after 1018 only as vassals of the Liao, and then under the domination of the Chin, finally coming under Mongol rule.

As a result of these political circumstances Korean art was of a hybrid form, made up of remnants from the T'ang tradition, direct influences from the Five Dynasties and from the Sung Dynasty, and also affected by the art of the barbarian kingdoms. A Chinese ambassador visited Pyongyang, the residence of the Koryo sovereigns, in 1124 and noted that the plan of the town and its monuments copied those of Piencheng, which was the capital of the Northern Sung. Korean painting and sculpture have scarcely been studied at all as yet, but are certainly related to Chinese art.

Ceramics enjoyed a magnificent development. They were influenced by the Yueh celadons from Chekiang [435]. To this influence painted and inlaid decoration was added in the 12th and 13th centuries [436].

JAPAN

THE HEIAN PERIOD (794–1185) AND THE KAMAKURA PERIOD (1185–1333)

History. In 794 the court of the Yamato was moved from Nara to the new capital of Heian, present-day Kyoto. The period opened under the rule of an aristocracy which was intimately acquainted with Chinese culture, and which took the place of the Buddhist priests who had hitherto directed cultural and political life. With the coming of the 11th century the Tendai and Shingon sects were introduced from China. They were esoteric sects with a complicated ritual, and they brought with them new styles of architecture and a complex iconography.

The power of the Fujiwara was consolidated at the end of the 9th century, and they then became the rulers of Japan in all but name. They broke off official relations with China, which had become more and more difficult in consequence of the state of anarchy existing on the continent. As a result, Japan was cut off from the Chinese influences which had been so powerful over many centuries, and she thereupon created a civilisation which was essentially her own. This art and culture were aristocratic and largely secular in nature. The development of Japanese writing, evolved from the Chinese cursive script, made Japanese literature possible. Poetry and stories reflected the sensibility of the period, together with its enjoyment of nature and its refinement. The Fujiwara were fervent worshippers

of Amida, Lord of the paradisal Land of Purity, where were gathered the souls of all those who invoked him in their last hour. Numerous sanctuaries were raised to him.

The luxury of the court led to heavy expenditure which weakened the power of the Fujiwara. They were envied by the lesser nobility, who lived in the provinces in relative poverty. Being stronger, they eventually wrested power from the Fujiwara. The Taira dominated the court for a quarter of a century from 1160, but after bloody battles they were supplanted by the Minamoto in 1185. Minamoto no Yoritomo was now in the leading role. He created at Kamakura a military government known as the Baku-fu, which ruled from 1185 to 1333. Under the title of Shogun or Commander-in-Chief he wielded all the delegated power of the emperor. This method of government was to continue until the reforms of Meiji Tenno in 1868. The court aristocracy were followed by an austere and realist warrior caste. Its turbulent chiefs were soon squabbling over power. They were supported by their clans, to which they were united by ties of personal allegiance which were to develop into a feudal system. In 1276 the Hojo succeeded the Minamoto. They twice repulsed attempted Mongol landings but they failed to re-establish internal order.

During the 12th century the Japanese reopened relations with China. There they discovered Sung art, which was to have its influence in Japan. They also made contact with the sect of contemplative monks known as the Ch'an Buddhists. This sect found wide support among the military ranks, and in Japan went by the name of Zen Buddhism. In the centuries which followed it was to have a most important position in the evolution of Japanese aesthetics.

Architecture. In the esoteric sects there were many deities and the number of sanctuaries was correspondingly increased. The plans of the temples consequently became more complex and less symmetrical. As a result of the increased number of the buildings their scale was reduced and their architectural form simplified, but this was offset by the more lavish use of decoration.

A large number of Amidado were built because of the growing enthusiasm of the followers of Amida. They were small square buildings marked by certain local characteristics, such as the use of roofs made from cedar bark. The only extant examples are the Amidado of Hokaiji near Kyoto and the Amidado Shiramizu to the north of Tokyo. To these may be added the Byodoin temple [434], but this was originally a secular building turned into a sanctuary in the mid 11th century.

The Konjikido Chusonji was the

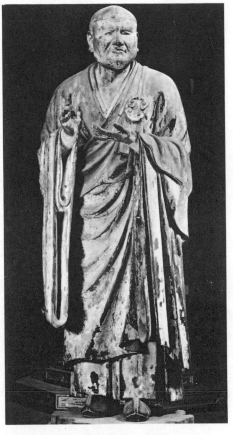

449. JAPAN. Vasubandhu, disciple of Buddha; statue in wood carved by Unkei. 12th–13th centuries. *Kofukuji, Nara.*

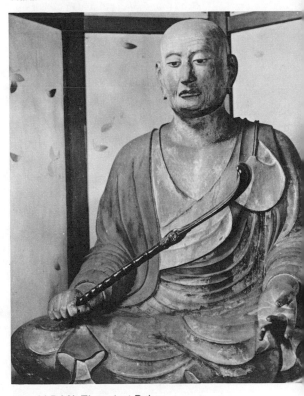

450. JAPAN. The priest Roben. Statue in wood. 10th century. *Todaiji, Nara.*

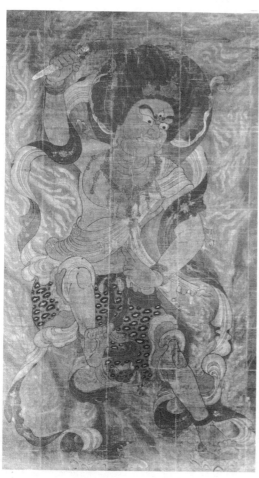

451. JAPAN. One of the Godairiki. 9th century. *Koyasan Monastery.*

452, 453. JAPAN. Illustrations for the *Genji Monogatari* painted in colour on paper. 12th century. *Right.* The hero, Prince Genji. *Masuda Collection, Tokyo.*

mausoleum of a clan which claimed descent from the Fujiwara and predominated in Mutsu, a northern province of Honshu. The building remains a symbol of the architecture of the time. The small sanctuary was entirely covered in black lacquer and ornamented with powdered gold decoration or with gold leaf inlaid with mother-of-pearl.

Shinto architecture remained unaffected by Chinese traditions for a long time, but ultimately came under the influence of Buddhist styles. The Itsukushima Jinsha is the finest example of this change, and its arrangement is harmoniously suited to the beautiful landscape.

Secular architecture was originally in the Chinese style, but the shindenzukuri style soon developed in which there is a compromise between national and continental qualities. The memory of this style is preserved in some old gardens at Kyoto and in the imperial palace of Kyoto which was restored at the end of the 19th century. The Wayo or Sino-Japanese style became traditional. New fashions were introduced from China alongside this style during the Kamakura period. The Tenjikuyo style, simple but grandiose, was used for the reconstruction at Nara of the nandaimon of Todaiji between 1158 and 1199 [448]. This style derived from the local style of Fukien, but it proved to have no future in Japan. The Zen monks introduced the official Sung style, which became known as the Karayo or Chinese style, and this was to be widely used. In addition to the classical example of the relic hall at the Engakuji monastery, near Kamakura [455], there is also the Butsuden of Sofukuji still to be seen near Tokyo.

It was not long before hybrid forms appeared which mixed together the Wayo and Karayo styles; these became characteristic of later Buddhist architecture in Japan.

Sculpture. During the 9th century Japanese sculpture still drew its inspiration from T'ang sources [437]. Terrifying gods intended to frighten away the forces of evil were carved in solid wood and were of an impressive grandeur. But Japanese sculpture soon lost its plastic qualities. The great increase in the demand for sacred images resulted in the setting up of workshops where the work was divided among numerous craftsmen under the direction of a master. The most famous of these was Jocho. A graphic treatment more in keeping with the Japanese temperament took the place of solidity. Images were covered with rich polychrome decoration heightened with gilt [439, 450]. One of the most characteristic works of this refined though less vigorous art is the little Joruriji Kichijoten; Srideva the goddess of good luck, of Indian origin, here takes on the guise of an elegant lady of the Japanese court.

In many works the Kamakura period continued the style of the preceding period. There was, however, a steady increase in realism, and clothes and jewels became more and more magnificent.

A new trend was developed at Nara by the great sculptors, Unkei and his sons. One may observe in it a return to the style of the 8th-century Tempyo period, which henceforth remained a classical style, together with a sharpened sense of realism and some influence from Sung sculpture [443, 449].

Painting. Many Buddhist paintings were brought from China in the 9th century. They became models which the Japanese monks copied, but they always

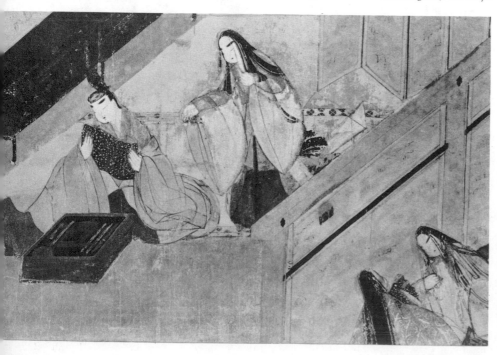

JAPANESE. The Golden Pavilion, Kyoto. Muromachi period (built 1397, reconstructed). *Photo: Orion Press, Tokyo.*

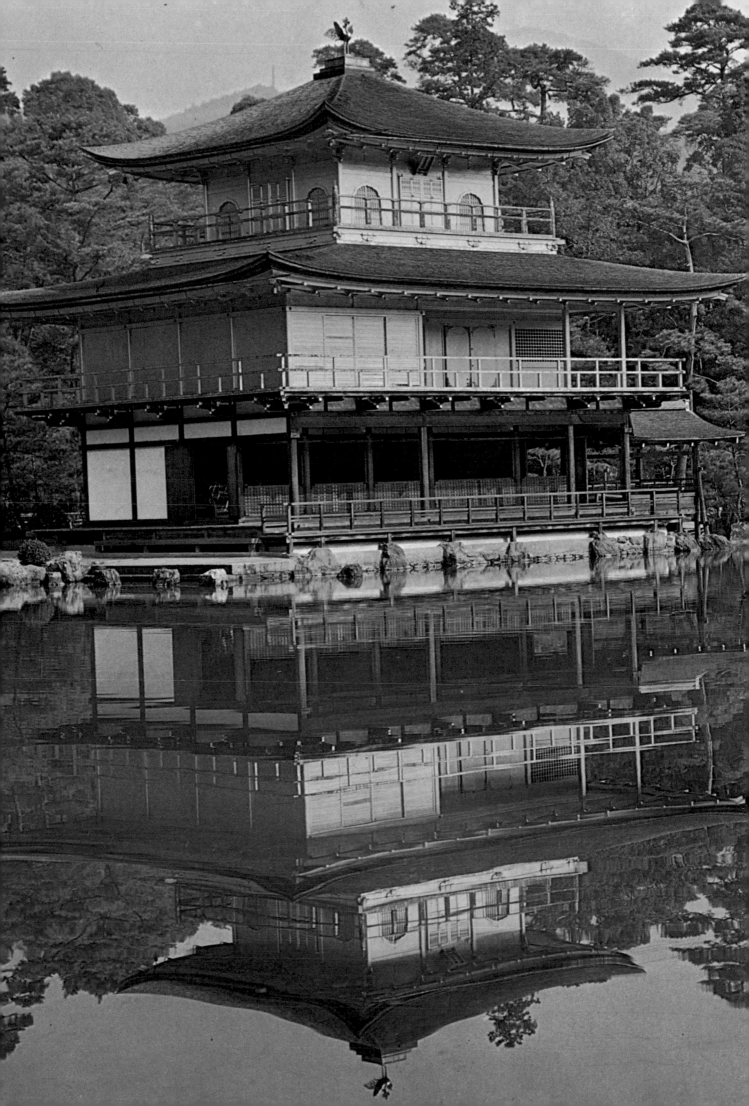

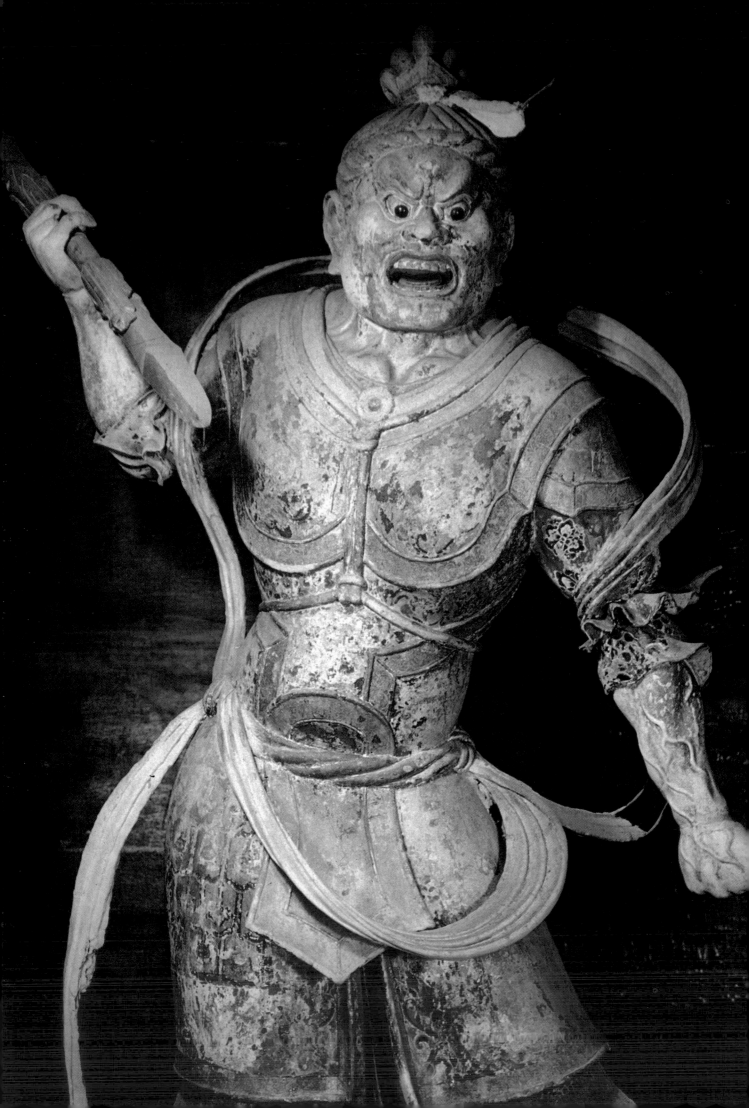

stressed graphic qualities and movement rather than the Chinese feeling for volume [**451**]. During the 11th and 12th centuries this linear treatment became much clearer in extremely elegant representations of the gods which were painted in light colours and often enriched with gold. Gold was used for lines emphasising the folds of the garments, and in the form of applied gold leaf.

The cult of Amida made the Raigo-zu fashionable. This showed Amida coming down to earth against a landscape background reminiscent of the pleasant hilly countryside around the capital.

In secular painting, the Chinese or Karayo style favoured at the court during the 9th and 10th centuries became transformed into the more original Yamato-e or national style. Characteristic of this style was the use of Japanese picturesque scenery and themes, as well as a general simplification in the treatment of both landscape and figures. The Yamato-e was used first for mural decorations and on the folding screens of the imperial palaces. It was then adapted for the illustration of contemporary literary works, and only in this form have examples survived. In the illustrations for the *Genji Monogatari* [**452**] the feeling is static, but the style quickly developed a narrative form full of movement [**440, 441**]. It gave more individuality to the people and animals represented.

The Kamakura period brought few innovations into the traditional style of religious painting, but to the Yamato-e it brought a steadily increasing realism. Many fine portraits were also produced in this period.

The minor arts. The refined taste of the Heian period gave rise to a flowering of the minor arts. The court painters who worked in the imperial palaces also decorated the dresses and the fans of the aristocracy, as well as the tinted paper on which they wrote their poems and love letters. Scarcely any of these fragile works have survived.

Various objects worked in lacquer were enriched with precious metals and mother-of-pearl, and these were also found in architectural decoration. Bronze was used, as in the mirrors inspired by Chinese examples, although their asymmetrical decoration displayed the greater freedom of Japanese taste.

The Kamakura period was dominated by the warrior classes and was less concerned with luxury. There were, however, new techniques introduced from China, such as the art of carved lacquer inspired by works of the Sung period, and also the ceramics known as Seto ware which more or less skilfully imitated the continental celadons.

Madeleine Paul-David

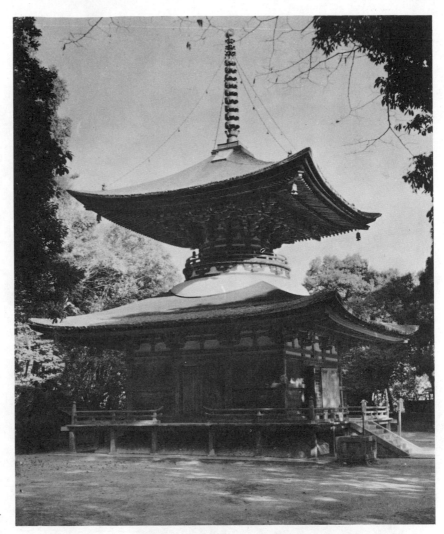

454. JAPAN. Pagoda of Ishiyamadera. 1194.

455. JAPAN. The Shariden (relic hall) of the Engakuji monastery, at Kamakura. Built in 1285.

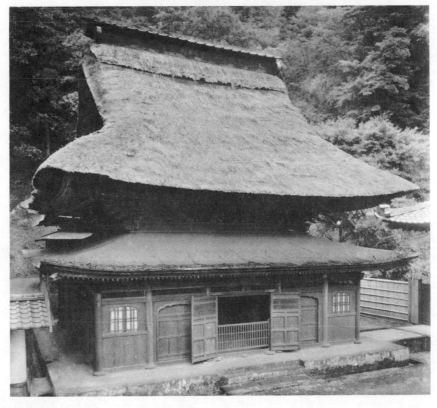

JAPANESE. Shukongojin in the Hokkedo. Late Nara period. Wood. *Todaiji, Nara. Photo: Orion Press, Tokyo.*

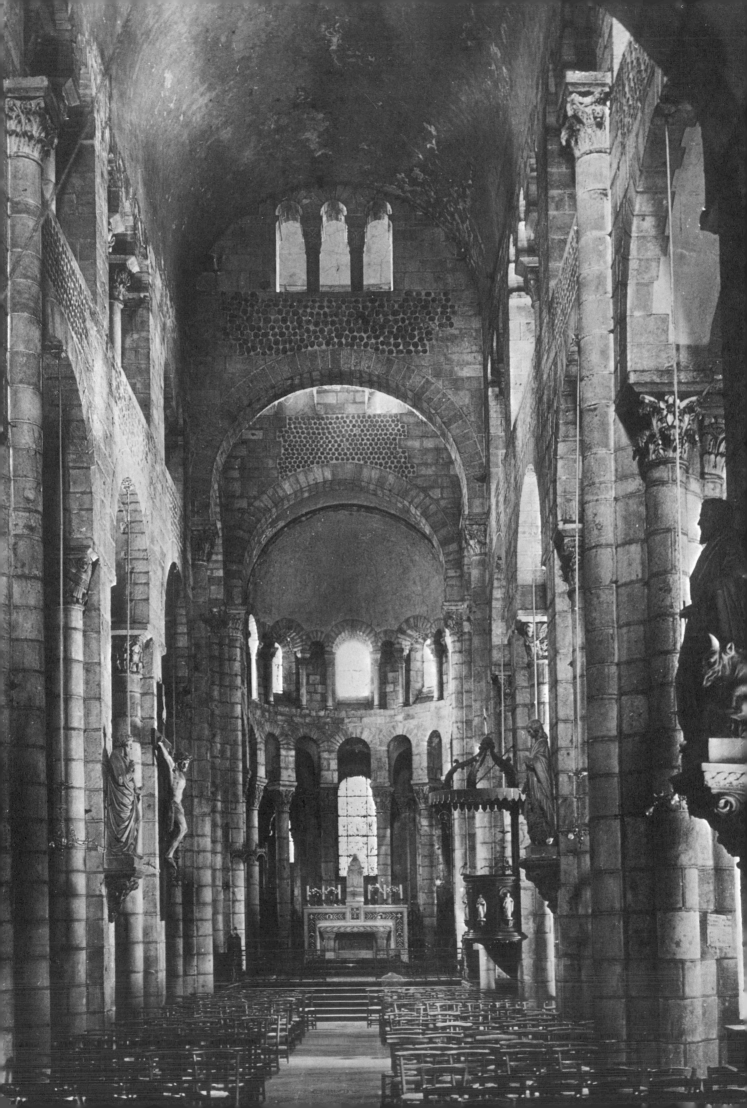

4 THE FLOWERING OF MEDIEVAL ART IN THE WEST

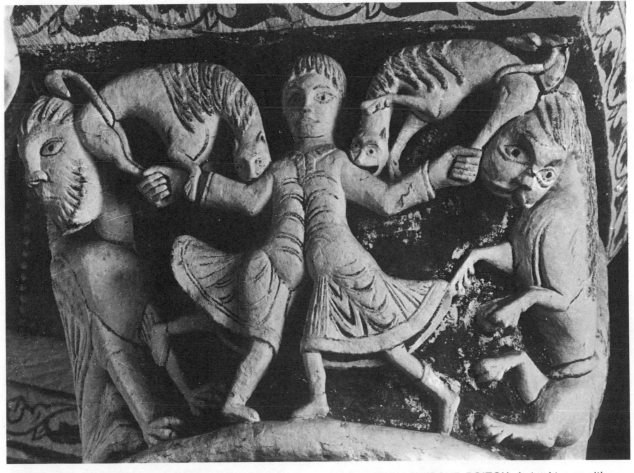

456. *Opposite*. ROMANESQUE. AUVERGNE. Notre Dame du Port, Clermont-Ferrand. Nave, looking towards the apse. 12th century.

457. *Above*. ROMANESQUE. POITOU. Animal tamer with double body. Capital at Chauvigny.

ART FORMS AND SOCIETY *René Huyghe*

The historical background

From the 6th to the 8th centuries the decline of the West seemed to reach its lowest point. Had it not been for Christianity, which stood its ground tenaciously and even expanded, despite all the difficulties created by the Arianism of the barbarians (converted very early by Ulfilas, in the 4th century) one might have thought that the West was regressing to a protohistoric stage. Urban civilisation was gradually abandoned and was replaced by a rural society. This does not mean that the Latin element, however strongly opposed, did not keep a very firm hold, thus making possible its later reassertion. Latin remained the language of everyday life, of the Church and of the men of letters, among them, around the 6th century, men like Boethius and Cassiodorus in Italy, Isidore of Seville in Spain and Fortunatus and Gregory of Tours in Gaul. The administrative structure retained its foundations. The trade routes of the Mediterranean—though no longer serving to spread the Roman spirit but, on the contrary, transmitting the examples and the lessons of the Orient—continued to function.

In the divided Empire Byzantium alone prospered and, under Justinian and Belisarius, attempted to reconstruct the former Roman realm or, at least, to gain the upper hand over the barbarians. But for all that the centre of the Mediterranean shifted towards the East, to the threshold of Persia and even of Asia, whose presence and activity were increasingly felt. In 529 the same Justinian, more concerned with military and juridical than with intellectual traditions, closed the still flourishing schools of Athens, forcing their last philosophers to seek refuge at the Sassanid court—a paradoxical situation.

It was left to the Church to preserve the continuity of the West to which it had first dealt such a mortal blow. Her only effective cultural weapon was the monasteries. But monastic life, offering retreat from the secular world and refuge from it, drew its inspiration in the 5th century from the already Orientalised Egyptian example, as could be seen in the south of France (Lérins) with St Honorat, or at Arles with St Césaire or in Ireland with St Patrick. In 534 St Benedict founded his Order which was soon to play an important role. But it must be admitted that up to the moment when, supported by Rome, he put a final stop to their activity, it was the Irish missionaries who spread the Gospel in Europe. But they were total strangers to the Latin tradition. Indeed, they embodied the adaptation of the northern barbarian spirit to Christianity, as is evident from the art which they were soon to create and in which Celtic and Germanic traditions were linked to Coptic examples.

At the end of the 6th century a Pope of genius, Gregory the Great, determined that Catholicism was to be Roman or nothing at all, tried to recreate a Latin liturgy and a Latin art. Making use of the Benedictines, he boldly launched their missions in the heart of the northern barbarians' territory, to win these people over to Christianity, and among the Anglo-Saxons, to supplant the influence of the Irish; he fully deserves the title of 'Father of the Occident'. But hardly had he thus opened the road to a Europe Christianised 'in the Roman fashion', when the people of the new religion, both in the East

and in the West, were threatened by the irresistible impact of Islam which from 622 to 755 extended its empire from the Caucasus to Saragossa. At the same time, Italy was gradually conquered by the last wave of barbarian invaders, the Lombards. The fragile vestiges of the Graeco-Latin culture seemed on the point of being submerged.

The shaken Occident seems to have recovered again in the 8th century. The barbarians continued to embrace Christianity. The Franks, some of whom had been Roman subjects since the middle of the 4th century, associated themselves more and more closely with the Empire, first as mercenaries, then as federates and, from the time of Constantine, as administrative and military leaders. Only in its final defeat did they betray the Empire. Christianised under Clovis (who was baptised in 496), they were destined to form the nucleus of the future Europe. So well integrated were they into Roman Gaul that their frontiers remained the dividing line between the Romance and the Germanic languages. As early as the end of the 6th century they resisted and eventually halted the invasion of Italy by the Lombards. At the beginning of the 8th century, when the Merovingians gave way to the Carolingians, it was Charles Martel who drove the Arabs back to the other side of the Pyrenees, breaking their onslaught once and for all. And his son Pepin, five years after becoming king, presented 'St Peter' with the gift of

458. MOZARABIC. The Two Witnesses. From the illuminated manuscript of the Apocalypse of Beatus. 975. *Gerona Cathedral.*

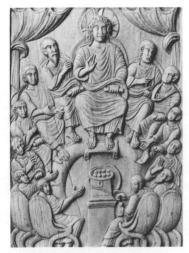

459. BYZANTINE. The Sacred College. Ivory plaque. Middle of the 5th century. *Dijon Museum*.

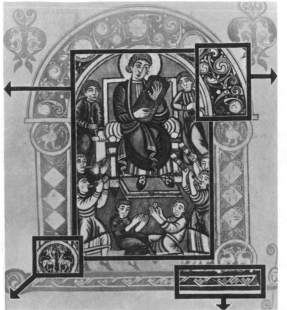

461. ANGLO-SAXON. David composing Psalms. Frontispiece of the Canterbury Psalter. *c. 700. British Museum*.

462. *Above right*. IRISH. Detail of a gilt-bronze object. Late 8th–early 9th centuries. *Musée de St Germain*.

460. SASSANIAN. Ibexes and Sacred Tree. Stucco. *Louvre*.

463. IRISH. Detail from an ornamental page of the Gospels of St Gall. 8th century. *Library of the Cathedral of St Gall (Switzerland)*.

THE HERITAGE OF ROMANESQUE ART

In its formative stage medieval art appeared as a confluence of a wide variety of contributions. An analysis of an early 8th-century miniature [461] reveals the diversity of the combining elements: themes that went back thousands of years, to Mesopotamia—transmitted via northern Iran [460] to the steppes and carried further by the barbarian invasions—took on the form in which Romanesque art would inherit them. Celtic art, then still flourishing in Ireland and Northumbria, contributed its spiral forms [462] and interlaced patterns [463]. Lastly Byzantium, the most important centre of contemporary civilisation, transmitted its figurative motifs, which were, however, subordinated to purely rational laws [459]. Metalwork showed the same diversity of influences; the so-called key of St Hubert [466] is said to have been sent by Pope Sergius to the Bishop of Tongeren-Maastricht. Juxtaposed on the bow of the key are draped figures of classical origin, such as the Christ, and the theme of animals on either side of the Tree of Life, which we have encountered in the Asiatic tradition and which was transmitted directly to Italy by popes of Eastern origin. But side by side with the Christian Orient the Mohammedan Orient took root in Spain and spread its influence by way of its Mozarabic manuscripts [458]. However, the strong tradition of classical sculpture was not submerged. It was to be reborn in the sculpture of the churches. The theme of Mithras [464], carried over the whole Empire by the legions, furnished models which would be copied and adapted to the Christian iconography [465].

466. PRE-ROMANESQUE. Key of St Hubert. Cast and pierced brass. *c. early 8th century. Church of the Holy Cross, Liège*.

464. *Above*. ROMAN. The god Mithras sacrificing a bull. Detail from a bas-relief. 2nd century A.D. *Louvre*.

465. *Right*. ROMANESQUE. LANGUEDOC. Sampson killing the lion. Capital from the narthex of St Pierre at Moissac. 12th century.

the first pontifical state. The event is symbolic: threatened by the Lombards, the papacy renounced the support of Byzantium—the schism was to become irreparable in 1054—and turned to the Franks who were designated the protectors of the West. The religious and the civil powers thus sealed an alliance which formed the foundation of Europe and was to be the basis of future attempts to resurrect the Empire, which had by that time become the Germanic Holy Roman Empire. It is symptomatic that at the same period, i.e. in the 7th and 8th centuries, the Romance languages established themselves, marking the beginning of a new civilisation, related to Rome but superseding it.

This civilisation lacked an art. But it is easier to make a political decision than it is to achieve the slow travail of the spirit. In this 8th century, when the foundations on which Europe was to be built were clearly defined, the position of art was considerably more confused.

The position of art

It seems evident that Europe was seeking to establish itself by the association of the religious with the civil power. But the one was the heir of Rome and the other of the barbarians. And the struggle between these two antagonists terminated in this combination. It was a difficult one. The papacy, in order to assert itself, intended to give the Eternal City all the prestige it had inherited from its past. When the Empire collapsed, the papacy believed it would be engulfed in that collapse. It did not anticipate the revival it was to achieve with the help of a victorious and consolidated barbarian rule. Regarding the collapse of Rome as a sign of the coming of the Anti-Christ, the papacy took courage and succeeded in asserting itself in the face of these two foreign powers —the barbarians in the north and Byzantium in the east.

The situation in art was similar. The Roman tradition had nearly disappeared and it was growing increasingly difficult to recapture it. Even before the catastrophes occurred which were to reveal the decline that, unnoticed, had already set in, art, that subtle indicator of as yet unconscious developments, had shown signs of the infiltration of these two dissolving elements; it became increasingly barbarian and Orientalised. The barbarian impact and the establishment of an independent Byzantium only brought into the open the slow forces that were at work. From the 4th to the 8th centuries, in Italy itself, i.e. in Rome and Ravenna, the mosaics show, like a changing light, the irresistible and progressive transition from Roman plasticity to the hieratic Byzantine style. The Lombard floors and chancels display the variety of interlaced patterns which had adorned the floors of Roman houses. But their style expresses a barbarian spirit. Where is the dividing line? Where does Rome end and where does the reign of its antagonists begin? Even the most perspicacious Roman would have found it difficult to recognise the Roman tradition in its purity and to distinguish it in its details from the constant influences coming from Byzantium by way of the Exarchate of Ravenna and the south of Italy, through Greek patriarchs and through religious, political and commercial contacts. This penetration affected architecture as well as the plastic arts. The full force of the Renaissance was needed to purify the Roman tradition.

But just as Italy was pervaded with the spirit of Byzantium so Byzantium was pervaded with the tradi-

tions of Persia and the Orient. The most precious, and therefore the most coveted, objects are often the easiest to transport. With the ivory works and textiles the themes of the Orient and its forms and styles invaded an impoverished Occident incapable of such sumptuous creations and therefore tempted to imitate the highly prized examples. When Charlemagne, and later the Ottonians, with their dream of a Holy Roman Empire, tried to give to the Oriental influence a classical and traditional direction, it was no longer possible to tell the authentic heritage of Rome from the heritage of the Byzantine-Sassanian Orient. And what would be the effect of the proto-Islamic and then the Islamic art of Spain, which affirmed 458 the lesson of the Orient with even greater authority? How, in this mixture of diverse influences, was Europe to distinguish, there and then, the true line of descent which it was called upon to follow?

So far we have discussed only the first of the two great 'adversaries' of the Latin tradition, the Orient. What about the other, the barbarian north? We have seen the sustained effort of Rome to resist Anglo-Saxon Christianity and to set against its miniatures and decorated Crosses (in which the Celtic tradition modified by the Germanic contribution is continued) a Benedictine and Roman art, replacing the interlaced abstract patterns by naturalistic scrolls, and the fantastic and imaginary animal ornamentation by the human figure. Because of this effort, the only refuge left to Celtic Germanic art was with the last great barbarian group—the Scandinavian Vikings who clung tenaciously to this art even after their 164 conversion to Christianity in the year 1000.

But here, although the intentions are clear, the facts are more complex. The Roman Benedictines were particularly satisfied to see the introduction of the human figure, which seemed to counteract the abhorred iconoclasm triumphant in Byzantium and the Arab world. They abandoned their exclusiveness and tolerated interlaced patterns and Irish monsters in the decorative parts of manuscripts. The Canterbury Psalter of the early 8th 461 century combines figurative scenes in the 'classical' tradition (strongly modified by Byzantine style) with borders of whirling triskeles, interlaced patterns and symmetrically confronted monsters which go back as much to the Germanic bestiary as to influences from early Mesopotamia transmitted via Persia. They remind us of the 460 important role of the Anglo-Saxon monks of the Benedictine Order, who were the successors of the Irish missionaries and travelling monks. In the 8th century they, and particularly their disciple Alcuin, constituted the nucleus of the Carolingian élite. This explains why, in the limited field allotted to them, Celtic themes continued to exist and even to spread, inspiring the art of many generations of monks. Considered as palliatives because of their purely decorative and auxiliary function, their influence was felt up to Romanesque and even Gothic art. In fact, a compromise was achieved with both Ireland and Byzantium.

The awakening of Rome

However, the 'Roman' current continued to swell, subordinating everything to its directing impulse. But in the river bed through which it ran there flowed the flotsam of all the tributaries dissolving in its stream. While in the Merovingian and the Visigothic art of the 7th century the barbarian influence reigned supreme in the goldsmiths'

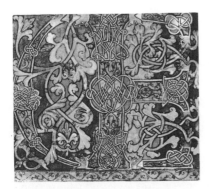

467. ROMANESQUE. Beginning of the Canon Tables of the Limoges Sacramentary (detail). *c.* 1100. MS. Lat. 9438, fo. 57. *Bibliothèque Nationale, Paris.*

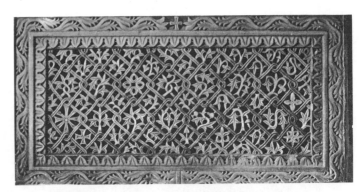

468. BYZANTINE. Pierced marble slab. 6th century. *S. Vitale, Ravenna.*

THE FUSION OF DECORATIVE MOTIFS

From the diversity of its sources Romanesque art drew an extraordinary decorative wealth. On a single page of ornamental letters in a French manuscript [467] the entire repertory of interlacing patterns and of scrollwork may be combined. The interlace designs, regular and symmetrical in the Byzantine tradition [468], complex and dynamic in the barbarian tradition, bear witness to the lesson learned from Irish manuscripts. The scroll multiplies to form fanciful plant designs whose intertwining lines join the interlace pattern. This does not apply to the Germanic style animals in 'flowing ribbons', devouring each other, which do not mix with the rest of the design. In the Mediterranean region the Sicilian miniatures [469] show the same complexity, but without the more Nordic elements. On the other hand the human and animal forms which, coming via Byzantium, derive from their double source— the classical and the Oriental—some of their original sculptural power, take on an importance which they will retain in Romanesque sculpture. Spain [472] and south-western France [470, 471] seem to be the routes through which this figurative art, in which mythological and Oriental figures and monsters combine to form interlaces and scrolls, was transmitted.

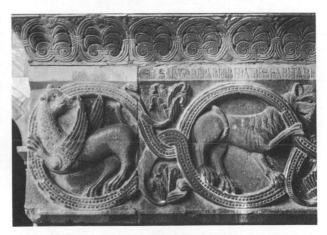

470. ROMANESQUE. LANGUEDOC. Capital in the cloister of Elne cathedral. 12th century.

469. ROMANESQUE. SICILY. Illuminated initial from a Palermo manuscript of the 12th century. *Biblioteca Painiana, Messina.*

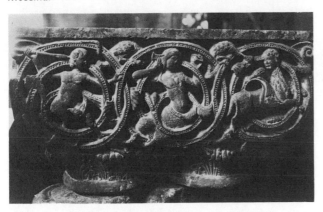

471. ROMANESQUE. LANGUEDOC. Capital, originally part of the abbey of La Daurade at Toulouse. End of the 12th century. *Musée des Augustins, Toulouse.*

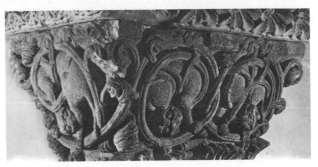

472. ROMANESQUE. SPAIN. Capital, originally part of the cloister of Aguilar de Campoo (Palencia). 12th–13th centuries. *Museo Arqueologico Nacional, Madrid.*

art, which had been its domain from time immemorial, this was no longer the case with architecture, which therefore had to go back to the only tradition, that of Rome, in which were fused additional Oriental influences deriving from Asia Minor and from Armenia. Through the basilicas and the baptisteries of the 4th and 5th centuries, the lesson of the past had been handed on to buildings where the classical column, however degenerate, always combined with the arch which Rome had received from the Orient.

Carolingian art marks a further step. It was no longer satisfied with things as they were. It made a conscious attempt to re-establish the Roman tradition not only in the art of building but also in the decorative arts—books, ivory carvings, goldsmiths' work. Charlemagne, using the alliance of the Frankish temporal power with the Roman spiritual power, applied with force and with new authority the programme which was sketched out at the end of the 6th century by Pope Gregory the Great and his Benedictine missionaries. Significantly, it was he who imposed the Benedictine rule on all the great abbeys. For him art and culture in general had to be expressions of the only way in which a revival, continuation and strengthening of the Occident would be possible. For him the following were all part of a whole event: the final annihilation of the Lombards; the submission of the Saxons and the Avars; the establishment of a Spanish frontier province against the Moslems; the replacing of the uncial by the Carolingian script and of the Gallic by the Roman liturgy; the return to Roman culture which had been abandoned almost since the time of Isidore of Seville, and the restoration of its realist and humanist art which from then on found its way back into architecture, manuscripts and ornamentation. Even in the decoration of manuscripts the interlaced patterns and the monsters were gradually supplanted by elements derived from the acanthus leaf and the vine scroll.

Charlemagne's grandiose enterprise was premature. But it showed Europe the way it was to take from then on, forging ahead untiringly to create an art which would be expressive of its spirit. The same general trends occur from the Middle Ages to the Renaissance and the Neo-Classical period: the revival of a vision which is in harmony with nature and in which the human figure predominates; the elimination of the dynamic linear style in favour of form, mass and static composition; the imposition of a directing order consistent with rational rules. And, as from 888 onwards the immense Empire which extended from the Elbe to Barcelona and from Denmark to Monte Cassino was soon to break up and be dismembered, so its art was only a passing expression, a sign of things to come, for it was an arbitrary rather than an organic attempt. It was in the face of this mixture of often incompatible influences which had left their mark on the melting-pot that was Europe that Carolingian art selected, proscribed and eliminated. It did not achieve a synthesis. It wanted to be classical and believed itself classical because it set itself certain examples. But it was not aware of all that was still present of the Byzantine Orient and the barbarian tradition which it wished to replace by a return to classical antiquity. The intention is evident, but the actual result was mixed.

Soon after the iconoclastic crisis, under the Macedonian Emperors in the late 9th century, Byzantium had a classical renaissance—with equally mitigated results.

The importance of Byzantium and of the Germanic peoples

It is a fact that antiquity, modified by so many centuries of Byzantine evolution, was no longer very much in evidence. It was above all in its aspect as shaped by Byzantium that we can recognise it. Did not Charlemagne consider marrying the Greek Empress Irene? Was he not the first Carolingian to receive from the Emperors of Constantinople and even from the Moslem caliphs gifts of precious Oriental textiles whose style and iconography continued to haunt the eye? Moreover, were these not, though on a more modest scale, transported to the north by Jewish and Syrian merchants using the land route from the Mediterranean to the Channel or the river route along the Rhine and the Meuse? Nor should the first pilgrimages be forgotten; in the 9th century a Frankish nobleman, Fromond, is mentioned as having departed on a pilgrimage with his two brothers to atone for his sins, traversing the Orient from Carthage and Egypt to Galilee, Anatolia and Armenia . . .

A strange example of the resulting mixture of styles is the knob of the so-called key of St Hubert which was no **466** doubt executed about the year 700 and which is preserved in the Church of the Holy Cross at Liège, where it is said to have been sent by Pope Sergius. Splendidly executed, it shows Christ in Majesty and two monsters symmetrically placed on either side of the Tree of Life, a theme which Persia had taken over from ancient Mesopotamia. **460** The example came from Liège whose diocese included Aachen (Aix la Chapelle) itself, the region from which (together with Nivelles) the Carolingian stock came. In other words, the new trends became active very quickly. Such was the strange complexity in which the rising European art sought for a way.

Charlemagne made Aachen, outside the Frankish kingdom and within the territory of the Germanic language, the capital of his empire. He expanded his empire not only in the direction of Italy but in particular towards the Elbe, into Germania which had only recently become converted to Christianity, or which Charlemagne himself Christianised by force. He thereby shifted the centre away from the West, to the advantage of the barbarian world. What had occurred when, after the establishment of the Eastern Empire, the Roman Empire moved towards the Orient, now happened again to a more limited extent. Europe, newly formed and claiming so intensely the authority of Rome, became nevertheless Germanised. Indeed, fate had ordained that after Charlemagne and the partitioning of his empire, and from the time when Charles the Fat was deposed and died in 888, the Frankish part of the empire should rapidly fall into decline and anarchy, from which it did not rise again until the end of the 10th century under Hugh Capet. In Germanic Lotharingia, on the other hand, the eclipse of the Carolingians from 911 onwards soon brought Otto I to power. The devastating invasions of the Vikings, which struck in particular what was to be the future France right down to the Bay of Biscay and deep into its territories, caused the cultural centres to recede into the very heart of the Germanic empire, to Reichenau on Lake Constance, to the threshold of Italy, but also to Regensburg and Fulda. While the Vikings succeeded in creating a duchy of Normandy (Nordmen: the men from the north) in France, the Germanic empire was itself attacked in the East by a last barbarian wave, that of the Magyars whose raids continued sporadically from 862 to 970,

476. ROMANESQUE. BURGUNDY. Detail from the Virgin in Majesty with the infant Christ. Wood. 12th century. *Old Abbey of St Philibert at Tournus.*

473. *Above left.* ROMANESQUE. BURGUNDY. Christ. Detail from the tympanum of the inner portal at Vézelay. *c.* 1125–1130.

474. *Above centre.* BYZANTINE. Detail from the Taking of Christ. Mosaic in St Mark's, Venice. End of the 11th century.

475. *Above right.* ROMANESQUE. DENMARK. Metal statuette of the Virgin, discovered at Randers Fjord. 12th century. *National Museum, Copenhagen.*

THE TWO CURRENTS IN SCULPTURE

Romanesque sculpture vacillated between two tendencies: the ornamental one in which the linear element and the plane predominated, and the sculptural one of mass and relief. The northern Middle Ages [475] added its own forms to those of Byzantium. Certain conventional stylisations such as the spiral [474] were faithful imitations of Byzantine models, often inspired by miniatures which stressed the linear element, thus preserving the linear tradition with its characteristic designs of waves and eddies [473, 477]. But the latent influence of antiquity caused them to be mere surface coverings for the revived sculptural forms [476, 178].

478. ROMANESQUE. SPAIN. Virgin and Child. Ivory. 12th century. *Lázaro Museum, Madrid.*

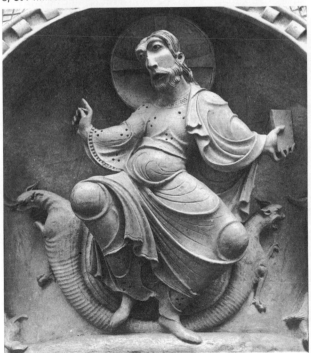

477. ROMANESQUE. LOIRE VALLEY. Christ, from the church of Plaimpied (Cher). 12th century.

Everything conspired to create increasing confusion. The alliance of the Franks (long since Romanised) with the papacy was replaced by an alliance with a Germany still close to its barbaric sources. The Ottonians, on their part, revived the ideas of Charlemagne whose remains the young and sympathetic Otto III ordered disinterred; he went to pray before them at Whitsun in the year 1000, after having been crowned, like his father and his grandfather, in Rome.

This restoration of the Empire was achieved with Otto III who has an almost symbolic significance. A descendant of the house of Saxony (so recently pagan) and son of the Empress Theophano of Constantinople, this youth, in whose veins barbarian and Greek blood were combined, took up his abode in Rome and there ordered seals to be struck proclaiming his credo: *Renovatio Imperii Romani*: the restoration of the Roman Empire.

534, 538 The complexity of the period and its art can be seen once again in a few characteristics: in its desire for a revival of antiquity Ottonian art combined the intensity and forcefulness of the Germanic with the highly developed Orientalisation of the Byzantine world. Again Europe was but a crossroads of discordant influences which prevented Ottonian art from having that personal expression to which it aspired. Once more the goldsmiths' work and other metal arts strove to represent the human form, to express its mass but also to animate it. In the manuscripts too the human form is rendered with expressive force. It appears in other forms, in other contemporary schools of illumination in England and in Spain. Yet another attempt, partly artificial because lacking a new unifying principle, consumed itself without attaining its ambition.

The role of France in synthesis

From what source was the awaited solution to come? All eyes were turned to Rome. It was from its past that the answer was expected—but in vain. And between 860 and 1000 not a single building was erected in Rome and not a single monument was restored. In striking contrast to this there arose a new power in Christendom—the Order of Cluny, which St Odo founded in 930 following a reform of the Benedictine Order. It was to group thousands of monasteries in France and other countries
568, 569 around 'the mother house of Cluny which came to be known as the 'second Rome'. The first church of the Order was consecrated in 985, and the American excavations of 1936 have revealed its importance. But it is the church of St Hugh—begun in 1088 and the greatest of the churches in Christendom—which marks the beginning and the success of the new art. It was preceded by numerous church buildings in Catalonia and Lombardy. Nor should the mission of Italian monks called to Burgundy by St Mayeul towards the end of the 10th century be forgotten. From Cluny would spread that Romanesque art which would bring to Europe the awaited solution by resolving the inner contradictions with which the Merovingians, Carolingians and Ottonians had struggled.

When the renewed barbarian invasions, then the Norman invasions in the 9th century, and, finally, the Hungarian invasions (which in the 10th century had swept as far as Champagne and the Languedoc), came to an end, it was France which, with the rise of the Capets, established a balance and an economic prosperity that were models for the whole of Christendom. The Vikings had been converted, the Slavs had been won over to the Greek Church and the barbarians had been stopped by the Christianisation of Hungary where the future St Stephen was baptised in 985. The pilgrimages to Santiago de Compostela paved the way for the Spanish reconquest. Then followed the crusades which began towards the end of the 11th century. These were the events which marked the stabilisation and the expansion of European civilisation. But this expansion, whether in Spain or in the Holy Land, in no way slowed down the interchange with the Orient whose influence was spread more than ever by trade, the pilgrimages and the crusades. At the same time there arose the literature of the epics of heroic exploits, the ideas of the theologians of the schools of Tours, Chartres and Paris, and, finally, Romanesque art. Europe became conscious of its strength and of its reality. From this time on, its art lived and made its influence felt.

It lived from the time it succeeded in linking and combining the two divergent trends which, as we have seen, were until then in opposition, particularly in the conflict between abstract Irish art and the figurative Benedictine and Roman art. We must therefore have a clear understanding of what these two currents represent —and they have never ceased to make contradictory claims on art—before we can analyse how their synthesis was effected.

This contrast may be observed from the earliest prehistoric times, when two approaches to art developed side by side. The one aspired to rendering visible experience. It found its culmination in the plastic quality of sculpture, which from the time of Egypt and Greece up to the Middle Ages was made even more realistic by the addition of colour. In contrast to this, the other approach seems to ignore visual reality except where this is absorbed and integrated within its own stylistic conventions. In fact, this approach concentrates on combining the lines and then the colours so as to apply and satisfy the basic laws of the rational function of the mind. And so were created symmetry, the rhythm of repetition, alternation and inversion, and in general all the geometric and abstract combinations. Thus pure ornament was born. Between these two extremes, present from the very beginning, there will always exist a series of intermediate combinations in which the realistic element is formalised, while at the opposite pole geometry adopts elements taken from nature. This purely theoretical distinction became a historical fact when the early Middle Ages brought about the confrontation of the Graeco-Latin with the barbarian tradition.

The clash of the two traditions, sculpture and decoration

From Egypt to Greece and thence to Rome the Mediterranean world had evolved an art which was its task in the rendering of reality. This was defined in the most unequivocal manner by Vitruvius. Painting, he said, 'gives the image of what is or can be,' but excludes 'that which, being only a product of the imagination, does not exist, cannot exist and never will exist.' Whether its aim is commemorative, religious, or 'aesthetic' to express beauty, this art is based on the illusion of an identity with things which exist or may exist in reality. Consequently, from goldsmiths' work to painting, everything strives for the sculptured form which alone conforms to reality or, at any rate, to the illusion of the sculptured

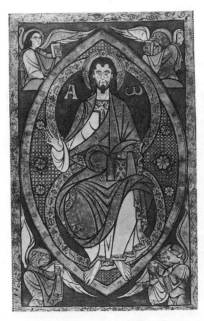

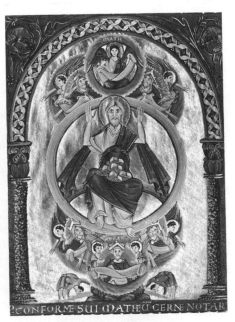

479. ROMANESQUE. FRANCE. Christ in Majesty. Limoges Sacramentary. *c.* 1100. *Bibliothèque Nationale, Paris.*

480. ROMANESQUE. ENGLAND. Virgin and Child. Coloured drawing. 12th century. *Bodleian Library, Oxford.*

481. OTTONIAN. St Matthew, from the Gospels of Otto III. *c.* 1000. *Bayerische Staatsbibliothek, Munich.*

THE MANDORLA

A new form appeared in Christian art: the circular nimbus which had already appeared in the frescoes at Baouit [135] became elongated, perhaps to correspond to the perspective of the half-dome, and took on an almond shape (Italian: mandorla). The mandorla adapted itself remarkably well to the human figure [485]. The Nordic linear sense and the Mediterranean sense for geometrical forms united in Romanesque art to achieve a decorative arrangement of the surface. In this way the theme of Christ in Majesty supported by two angels, which was essentially the theme of the Ascension, gave rise to a complex play of lines formed by the angels and their wings. The lines become the pretext for a linking up with the form of the mandorla in the most varied ways and for relating it to the architectural frame of the capital [483] or the tympanum [482, 484]. In the manuscripts the miniaturist displayed all his plastic imagination, taking the simple mandorla as his starting point; the throne serves to resolve the mandorla into two intersecting circles [480], to connect it by the suggestion of the S-shape [479], or to multiply it in a combination of circles [481].

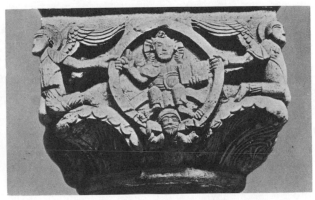

482. ROMANESQUE. BURGUNDY. Christ in Majesty. Detail from the tympanum of St Julien at Jonzy (Saône-et-Loire). *c.* middle of the 12th century.

483. OTTONIAN. Capital representing Christ in Majesty, in a mandorla. Church of St Michael at Hildesheim. 11th century.

484. ROMANESQUE. BURGUNDY. Christ in Majesty, supported by two angels placed back to back. Detail from the tympanum originally at Anzy le Duc (Saône-et-Loire). Late 11th century. *Paray le Monial Museum.*

485. ROMANESQUE. ENGLAND. Christ in Majesty. Ivory plaque. 2nd quarter of the 11th century. *Victoria and Albert Museum.*

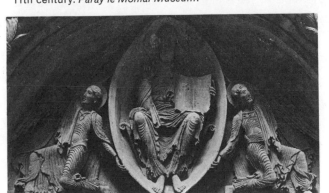

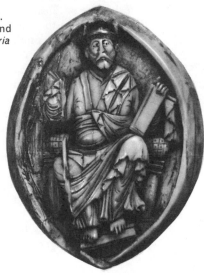

form, which is expressed by the relief carving, where the chosen technique is confined to a flat surface. Being static by its very nature and scarcely seeking movement except by perfect rendering, and having relegated the figure of the animal — predominant in prehistoric times — to second place, this art finds it favourite model in the human body. This then is the source of that Graeco-Roman art to which the Carolingians and the Ottonians aspired as to a lost ideal.

Lost — but how? By the encroachment of the opposite concept as displayed in barbarian art, from the steppes to Scandinavia and as far as Christian Ireland. It finds its accomplishment not in statuary but in the ornament. It is no longer concerned with space as such nor does it seek to suggest it in order to isolate itself in the form. Its aim is to cover a given surface and to become one with it. It adheres to this as rigidly as possible by confining itself to the linear element. With what has been called a *horror vacui* it overlays this surface copiously, if not entirely.

To understand this conflict we need only follow the transformation of a Graeco-Roman model when it submits to the attraction of the opposite pole. This was the case towards the end of the Roman Empire as it was gradually engulfed by the barbarian flood, when the capital with its naturalistic element, the acanthus leaf unfolding into full relief skilfully modelled with the chisel, is transformed into a Byzantine capital: the mass, once airy and complex, is now confined to four planes; the ornamentation, cut with the drill, is reduced to flat surfaces with linear contours; lifted from the background as it were, in the form of a relief, the surfaces are carved like lace until in the end sculpture becomes a pierced surface. A similar process is operative in the transition from Greek to Persian — Parthian and Sassanian — art. The sculptured bas-relief is replaced by neatly cut planes which have no transitions but on which the details, designed like goldsmiths' work, spontaneously multiply. To be sure, we should avoid generalisations which serve only as labels. But it is clear that the latter conception appears in Asia, in the steppes and the Middle East, and the former in the Mediterranean countries.

As the sculptural quality vanishes the linear element is accentuated. It has been possible to verify this from the imitations made of Greek and Roman coins by the Celts and the Scandinavians and even by the peoples of the Near East. From the technique of modelling (not, as Delacroix has so brilliantly demonstrated, starting from drawn contours but from a moulded relief) we pass to a technique of linear design, a play of curves, circles and points, while at the same time likeness disappears to lose itself in abstract combinations. Geometry thus replaces the naturalism of observed reality. Line supplants volume. The dynamic principle underlying every drawn line and bound up with the progressive swing of the hand replaces the static principle to which all voluminous mass inclines, arresting it in a position of equilibrium.

As Louis Bréhier has pointed out, all art implies the predominance of the technique which most clearly embodies the aspirations of that art. In Mediterranean art it was sculpture, that replica of the human body for which even architecture preserved a certain nostalgia, since it borrowed from sculpture its laws of proportions and sometimes even its forms, such as the caryatids. In the art of the barbarians and the art of the steppes this predominance is given to decorative art — to goldsmiths'

work and to textiles, where the line has free and unrestricted play. The intermediary arts are attracted to both poles. Where the barbarian-Asian 'complex' predominates, painting and sculpture tend to be absorbed into the ornamental pattern by the rule of line and plane. Where the Graeco-Roman tradition prevails, decoration and painting seek to evoke the art of sculpture. Carolingian goldsmiths' work is proof of this. It restrains geometric design in favour of sculptured high relief, anticipating the admirable work of the Romanesque artists in bronze. The Graeco-Latin conception is almost revived in the bronze doors of the cathedral of Hildesheim (1008–1015), in the font of St Barthélemy in Liège (1112) — which in turn is the forerunner of the portals of the cathedrals of Pisa and Monreale (by Bonannus, in 1180 and 1186 respectively). The naturalism of the human figure modelled fully in the round recalls the graceful ease of the living form. A comparison is indicative: in Ireland, where the Celtic and the Germanic traditions converged, the sculptured ornamentation of the high Crosses and especially the painting in the remarkable manuscripts kept strictly to the models of the goldsmiths' art. In Romanesque art the current flows in the opposite direction — the goldsmiths' art, far from predominating, is sometimes no more than an extension of the work of the sculptor-architect promoted to 'foreman'. This is so in the case of Aléaume who in the 10th century built the cathedral of Clermont-Ferrand and executed a reliquary statue of the Virgin, and with Theudon who during the same period rebuilt the upper parts of Chartres cathedral and also created the shrine of the Veil of the Virgin.

The Romanesque solution — a synthesis of ornament and

It was the great achievement of Romanesque art that it did not give preference to one or the other of the discordant tendencies which divided the Western world of art but coordinated them in a unifying spirit. This spirit remained faithful to the Christian tenets of the first centuries; that is to say, thought preceded, dominated and explained the physical world which was no more than its visible and symbolic garment and the gateway to the world of the spirit. In the following chapter we shall define this spirit more closely in a comparison with the spirit of the Gothic period. The same approach prevailed in Byzantium. The predominant role of architecture in Romanesque art did not conflict with it. In fact, architecture was traditionally concerned with pure and theoretical forms, taking as its basis the parallelogram, the triangle and the circle, and therefore was the only Graeco-Latin art which could be qualified as abstract; it made it possible to respect the supremacy of mind over matter and to combine harmoniously Roman and Byzantine patterns.

The difficulty arose with sculpture; it was given more and more prominence by the Romanesque artist and pushed, though very often timidly, towards high relief and a naturalistic presentation of the human figure through a voluntary return to Roman traditions, to which tendency Carolingian art had given the first impulse. But would not its development lead to the abandonment of earlier aesthetic values, or at least to counteracting them? There was the danger of a rift. Romanesque art escaped it by not allowing sculpture — which it regarded as no more than an ornament of architecture — to develop

119, 120

99

534

496, 49

498

486. ROMANESQUE. FRANCE.
Historiated initial from an illuminated
manuscript of Citeaux, Moralia in Job.
Completed 1111. *Dijon Library*.

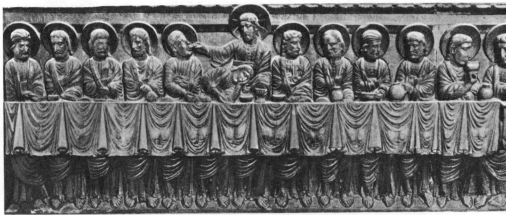

487. ROMANESQUE. ITALY. The Last Supper, by Antelami.
Detail from a portal in the presbytery of the cathedral of
Modena. 12th century.

488. ROMANESQUE. LANGUEDOC.
Capital in the cloisters of St Bertrand
de Comminges. End of the 12th
century.

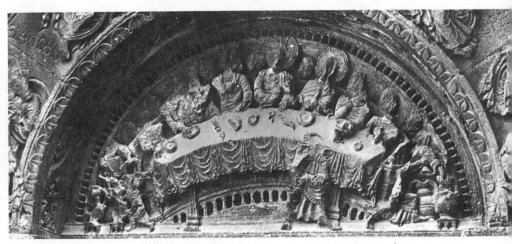

489. ROMANESQUE. BURGUNDY. The Marriage at Cana.
Main portal of the porch of St Fortunat at Charlieu. *c.* middle
of the 12th century.

THE LAWS OF THE FRAME AND OF THE GEOMETRICAL DIAGRAM

*Focillon has shown that two laws govern Romanesque sculpture.
According to the first, the scenes represented (for instance a
banquet, the Last Supper or the Marriage at Cana) are subordinated
in composition to the form of the frame (isocephalic arrangement
within a rectangular frame [487], grading of the heads in pyramidal
form [490] or curving of the table within a semicircular frame
[489]). The second law compels the figures to assume a geo-
metrical form of a highly decorative character [486] which
determines their structure: the figures in 488 and 493 show the
rigid arrangement imposed by the shape of the capital [492]. The
notebook of Villard de Honnecourt is a further proof of somewhat
later date that the artists trained themselves to base their work on
these simple abstract diagrams [491].*

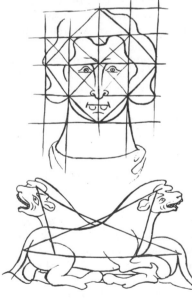

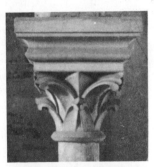

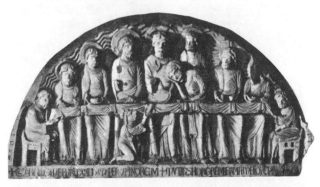

490. ROMANESQUE. BURGUNDY. The Last Supper.
Tympanum from St Bénigne at Dijon. Middle of the 12th
century. *Musée Départmental des Antiquités, Dijon*.

491. *Above*. Diagrams from the note-
book of Villard de Honnecourt. 13th
century. *Bibliothèque Nationale, Paris*.

492. *Above right*. ROMANESQUE.
form of capital in the gallery at
Montierender (Haute-Marne).

493. *Right*. ROMANESQUE.
BURGUNDY. Capital from Autun: St
Vincent being carried away by eagles.
Second quarter of the 12th century.

independently, that is to say, inconsistent with the rest of contemporary art. To achieve this, the geometrical and rational laws which hitherto had prevailed only in decoration were now applied to sculpture. Byzantium had done the same with painting and with mosaics. But these lent themselves easily to such a style because of their two-dimensional nature and the role played by the design, which favoured the linear pattern. To submit to the discipline of the ornament seemed more difficult in the case of sculpture which exteriorises and projects from a flat plane into three-dimensional space. It ceases to be almost exclusively a series of images covering the interior walls, as is the case in Byzantium, but serves as relief projecting into the open air to enliven the outside of the building. It therefore had to be based on the play of volumes thrusting into the light of day instead of, as before, on the combination of design and colour.

Thus Romanesque sculpture was finally to satisfy both the law of figure sculpture, which is representational, and that of decoration, which is an application of rational rules. In about 1930 H. Focillon and J. Baltrusaïtis, using different approaches but arriving at the same conclusion, explained the process by which this was achieved. Baltrusaïtis gave more detail; Focillon supplied the general idea. Both succeeded in formulating the two laws which have transformed our understanding of Romanesque art or, more correctly, the relationship between sculpture and architecture. Though an art concerned with volume, sculpture from then on was conceived as a functional part of the wall which hitherto had been considered as the domain of ornament. True, the high relief and sometimes also the bas-relief had long since been used to place and bring to the fore sculptural forms on a plane serving only as background; but they seldom submitted to the strict rules which determine the ornamental plan. That is precisely what Romanesque art does, and this is what the two laws defined by Focillon and Baltrusaïtis express: the frame without and the design within.

Following the law of the frame, forms are conceived as a function of the external structure of the surface on which they are grouped. The forms establish as many points of contact as possible with the surface and submit to the general arrangement. For instance, on a lintel the
487 table in the Last Supper may be rectangular and horizontal and the figures in a line. But in the semicircle of
489 a tympanum it will be curved, resulting in a curvilinear arrangement of the heads. Following the law of the design as such, the figurative forms are closely joined, if necessary by arbitrary deformations, with the geometrical pattern provided by the space enclosed within the frame; and these patterns and these lines will almost always correspond to regular ornamental figurations. In this way figures and scene, while still reminiscent of naturalistic presentation, are no longer organised according to the laws of life but according to the laws governing abstract decoration—repetition, alternation, parallels, symmetry, intersecting diagonals, the rhythm of curves, etc. The ornamental concept precedes and so far dominates the seemingly figurative concept that what at first
488 glance appears to represent a human figure or an animal
493 has only been used by the sculptor to 'feed' a purely linear outline which he obtains by the use of the compass, for instance. This is shown in the notebook of the archi-
491 tect Villard de Honnecourt who, at a later date, proved

the continuity of these traditions by revealing the purely geometrical forms underlying the images; they are entirely geometrical constructions of rule and compass which so far in the history of art had only been instruments for the elaboration of abstract decoration.

Romanesque art thus found a compromise between the two extreme positions: the position of Rome which treated sculpture as a major and autonomous art and that of the barbarians who eliminated it completely and were content to let sculpture develop in subordination to the laws of decoration.

The manifold aspects of Romanesque art

This new solution moreover enabled Romanesque art to adopt two elements cultivated in barbarian and Oriental art which it seems difficult to reconcile with the effort to revive Roman sculpture. One is linear dynamism, the other the invention of imaginary monsters. Focillon has shown that movement, sometimes forced and exaggerated, makes it possible to increase the points of contact with the frame by projecting the limbs. We should add that movement, by vitalising the contours or the drapery folds, permitted great linear inventiveness. In static sculpture the line is limited, controlled by the solid masses to which it adheres; in Romanesque art it represents the continuation of the linear contortions and the interlace of the barbarian style. As for the monster, it put 606 an end to the paucity of known human and animal forms, which were too limited to admit of the many combinations a decorative art demands. It made an unlimited number of combinations possible by bringing together

THE WORKERS IN BRONZE AND THE REVIVAL OF SCULPTURE

In the early Middle Ages, as a result of the decline of classical influence and the advance of the barbarian spirit, sculpture was reduced to linear rather than sculptural ornamentation, even in scenes with figures [494]. But the statues of antiquity were not forgotten and Charlemagne had already called for their revival. His bronze statuette recalls the equestrian figures of the Romans [498]. It was the workers in bronze who effected this return to the sculptural tradition of the Roman period. Bronze doors imported from Byzantium inspired Italian works of art [495]. In the Meuse region—the home of Charlemagne—the Carolingian Renaissance led, in the 12th century, to further developments [496, 497] which paved the way for the artistic achievements of the 13th century [499–501].

494. PRE-ROMANESQUE. ITALY. Adoration of the Magi. Fragment from the altar in S. Martino at Cividale (Friuli). 8th century.

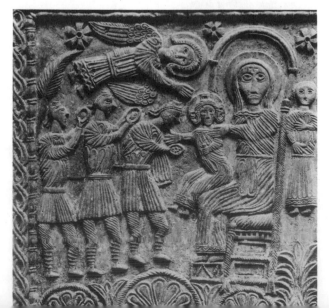

incompatible forms. Romanesque art took its examples from two sources. On the one hand, from the Oriental textiles with their Persian ornaments which continued the Mesopotamian contribution it was introduced to a series of static figures based on heraldic symmetry; and on the other hand it took over the legendary beasts which the barbarians, from the steppes to Scandinavia and Ireland, had incorporated into the whirling dynamism of their interlace designs. This strange bestiary adopted by Romanesque art was to invade the Middle Ages, not without arousing, from Alcuin to St Bernard, indignant opposition because it remained the most provocative symbol of the anti-Roman and anti-Christian world.

This general outline of Romanesque art has to be qualified. We shall see that this balanced and almost autonomous sculpture appears much earlier and to a much greater extent in the south of France, in the old Provincia, now Provence. It was there, we remember, that the Mediterreanean feeling for sculptural expression had already commenced to bend the art of the Gauls to its tradition, however resistant it may have been to this influence. In this region of France the proportions of the figures, voluminous and stocky, are more reminiscent of Rome. By contrast in Languedoc, and in Burgundy especially, they are finely drawn, spiritualised, lending themselves with greater flexibility to calligraphic inventions, which brings them closer to the pure ornament of the northern countries. There can be no doubt that here the more deeply instilled barbarian ideas produced different artistic styles.

Thus the threefold and contradictory heritage—that of Rome, increasingly assertive; that of Byzantium and the Near East, ever more deeply instilled; and that of the barbarians, not yet completely eliminated—resulted in an unexpected and new balance. It was rapidly adopted in the different countries which made up the newly born Europe, and from that point on one may indeed speak of a European art.

In any event, with the emergence of Romanesque art the West achieved at last an organic synthesis of its constituent elements. One further step forward remained to be taken for it to assert itself even more forcefully by creating an art based this time on principles as yet unknown, an art which was to usher in a new phase of artistic creation by rejecting as archaic its Roman as well as its Byzantine forerunners. That would be the task of Gothic art. Like Romanesque art, it too would be developed mainly in France, spreading from there and confirming the central place France was from then on destined to occupy in the culture and art of Europe; Italy alone challenged it successfully for two centuries.

In La Charité sur Loire and at St Denis, as early as the first half of the 12th century we can observe the sculptured figures breaking through the boundaries imposed upon them by the architectural plan which ceases to dominate them. They gain their independence, at the same time doing homage to naturalism. Simultaneously a hitherto unknown style of architecture evolved, displaying not so much a combination of mass and regular forms as an unexpected organisation of forces brought into play by their weight: Gothic art was preparing to supplant Romanesque art.

495. ROMANESQUE. ITALY. The Healing of the Woman Possessed by a Devil. Detail from a bronze portal at S. Zeno, Verona. 11th century.

496. *Above right.* ROMANESQUE. BELGIUM. Baptismal font in St Barthélemy, Liège. Work of Renier de Huy. 1111–1118.

497. *Right.* Detail from baptismal font in St Barthélemy, Liège, showing angels.

498. CAROLINGIAN. Equestrian statuette of Charlemagne, from the treasure of Metz. *Louvre.*

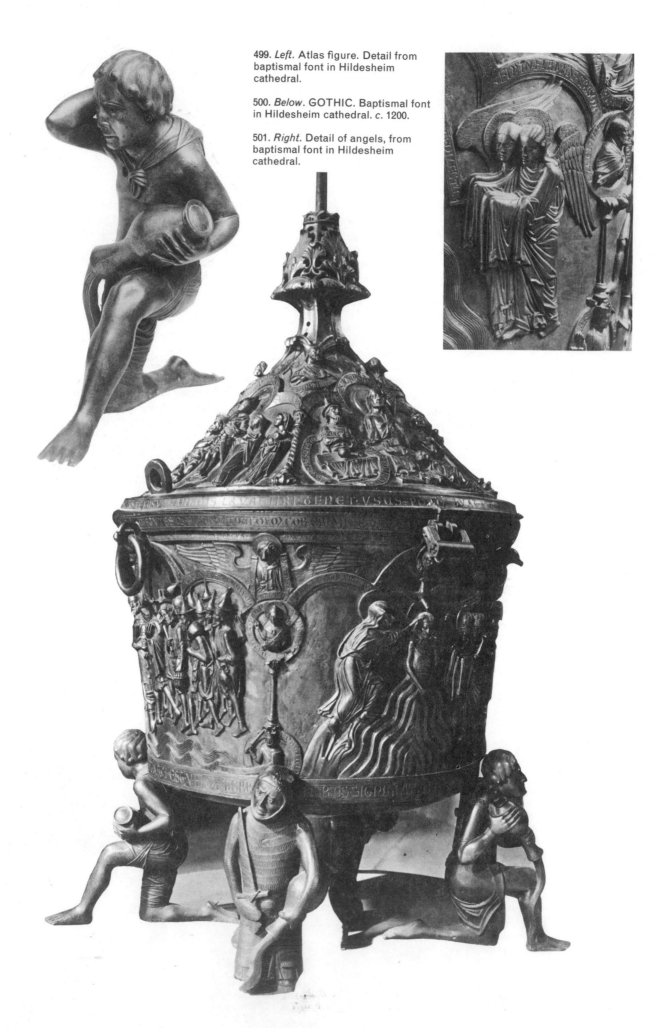

499. *Left*. Atlas figure. Detail from baptismal font in Hildesheim cathedral.

500. *Below*. GOTHIC. Baptismal font in Hildesheim cathedral. *c.* 1200.

501. *Right*. Detail of angels, from baptismal font in Hildesheim cathedral.

THE ART OF THE EARLY MIDDLE AGES

Jean Hubert

*With the early Middle Ages the Occident again came into
its own. It was no longer Mediterranean in character, as in
antiquity, but European and greatly mixed. As discussed
in connection with the barbarian invaders, the portable
products of the decorative arts were peculiar to the nomads.
Once they settled, however, there was a revival, timid at
first, of that most stable of all arts, architecture. It had
of necessity to be based on the example of classical art, so
brutally interrupted, which had left its influence, especially
in the Latin regions, in the continuity of the techniques
employed in the artisans' workshops.*

THE MEROVINGIAN PERIOD

The art which evolved in the Occident during the early
Middle Ages was little known at the end of the 19th
century. Some saw in it but a slow and irretrievable
decline of Roman art. Others, noting that the Merovin-
gian basilicas were described with enthusiastic admiration
by contemporary authors, thought that these lost monu-
ments had been sumptuous creations of the Germanic
barbarians, imparting new life to the decaying Roman
world. Still others believed that the introduction into
Gaul of textiles, ivories and precious objects by 'Syrian
merchants', as mentioned by Gregory of Tours, sufficed
to assure the triumph in the West not only of the decora-
tive arts of the Middle Eastern countries but of the
architecture as well.

None of these theories has proved to be accurate.
Methodical research carried on throughout Europe has,
however, made great strides. Excavations, helped by the
destruction wrought by the last war, have led to amazing
discoveries. The overall picture which can now be
sketched out suggests a far more complex answer. The
great variety of artistic activity which these monuments
reveal is in fact but a faithful mirror of the history of
a troubled period, alternating between the decline of the
Occident and the rise of the Orient.

The Roman precursors of the new architecture

In Italy the structure of the old Roman administration
showed many signs of deterioration. To economic crises
and internal difficulties was added the threat of invasion
by the barbarians who menaced the northern frontier.
This resulted in a gradual shift of the great centres of
communication to the Eastern provinces and with them
of the life force of the immense Empire. When the bar-
barian invaders threatened Rome herself, the Orient
became a refuge. During the reconquest of southern Italy
and part of North Africa by Justinian from 533 onwards,
the hub of the Empire lay between Greece and Asia
Minor. Rome, five times conquered, was no more than
a large city of ruins, its aqueducts in disrepair, its country-
side a wasteland. The real capital was Byzantium, the
only cultural centre of the Orient which had preserved
the schools and the workshops as well as the trading
centres from which luxury products were exported.

Another factor determined the history of this period.
At the beginning of the 4th century, at the very time

when in the West the Roman administration had to
abandon its policy of erecting magnificent buildings, an
important event changed the course of European history
and art. The recognition, in 313, of Christianity as a state
religion led in effect to the Imperial government's direct
participation in the construction of new places of wor-
ship. During the persecution of the Early Christians, the
houses where the faithful assembled and the catacombs
where they buried their dead were unpretentious and had
only very simple ornaments. But a Christian art worthy
of its name and capable of setting an example was to
burst into flower. It benefited from the official benevo-
lence previously reserved for pagan monuments.

Thanks to the Emperor Constantine (see Chapter 1)
the Christian religion now had its Imperial places of
worship in Rome as well as in Jerusalem and in Byzan-
tium—the Lateran church and the two basilicas conse-
crated to St Peter and to St Paul. These three buildings
were of huge dimensions. They measured about 160 feet
in width and 320 feet in length. The interior, which was
covered by a timber roof, was divided into a nave and
four aisles by rows of marble columns. There were no
arcades or galleries in the nave. As in ancient Roman
architecture, the architrave rested on the columns in the
manner of stone beams. On a series of large rectangular
panels on either side of the nave between architrave and
high windows were depicted the most striking episodes
from the Holy Scriptures. A large quadrangular court
surrounded by porticoes, the atrium, lay in front of the
entrance. This was the type of church that was adopted
as a model in the Occident up to the Carolingian period,
and in Rome itself until the end of the Middle Ages.

The Lateran church and its baptistery were built
within the walls of the town, replacing an old palace.
The basilica of Old St Peter's was built outside the walls
on the site of a cemetery where the remains of the first
Apostle were buried. Evoking the memory of the martyrs,
the witnesses of Christ, it symbolised what was later
called 'the communion of the saints', i.e. the close union
in one faith and one hope shared by the faithful, the
dead and the living alike. The relics of St Peter were
buried under the altar and early in the morning people
began to arrive from long distances away to worship
there. Next to the Holy Places in Jerusalem, St Peter's
was the foremost centre of Christian pilgrimages. Follow-
ing the example of Rome all the large towns in the West
were soon to build their cathedrals *intra muros* and their
sepulchral basilicas outside the walls, surrounded by
cemeteries for the chosen. But only in exceptional cases—
as for instance in Trier—did these buildings have the
grandiose dimensions of the Constantinian churches in
Rome.

In Trier the substructure of a twin church, one dedi-
cated to the Virgin, the other to the Apostles, was dis-
covered in 1943. In the 4th century these structures
served as the cathedral of this great Rhenish town
elevated to the rank of an Imperial residence at the end
of the 3rd century. The total surface area of these two
buildings surpassed that of the cathedral in Rome. The

funds for this imposing unit came no doubt from the Imperial coffers because it was built near the Emperor's palace. Its twin structure was due to religious and not to aesthetic considerations. Today we know of some fifteen cathedrals from the 4th and 5th centuries, situated in towns along the eastern bank of the Adriatic, in northern Italy, and in southern Gaul, which, like the cathedral at Trier, comprised a church dedicated to the Holy Virgin, with a baptistery attached to it, and another church dedicated to a martyr. This type of double cathedral originated not in Rome but in Jerusalem. On the site of the ancient forum of the Holy City Constantine built a huge church open to all, the initiated and the catechumen. It stood next to the Anastasis—the Holy Sepulchre—where only the initiated were permitted to participate in the solemn celebration of the rites. Places of worship consisting of two rooms existed in the East well before the time when peace between Church and state was established. From the 4th century onwards this type of construction spread throughout the Christian world. In the West it was preserved by tradition until the Carolingian period.

Development of the first Christian architecture

Following the establishment of the peace of the Church, Provence was soon organised into ecclesiastical dioceses. Nothing has remained of the cathedral churches erected at the beginning of the 5th century in Marseille, in Aix, in Fréjus or in Riez. But we know the original arrangement of their baptisteries: a square plan, angle niches and a central dome. In Aquileia, not far from Venice, a similar arrangement of parts has been found modelled on the villas and Roman baths from the end of the classical period. The cult buildings with angle niches which later made their appearance in Syria should not be looked upon as imitations of the baptisteries in Provence. We must assume the existence of a common prototype which spread as the result of the Church councils.

503, 506

The speed with which this type of architecture, adapted to certain religious usages, spread across the immense Empire is even more evident from three churches of the 4th and 5th centuries. Their original arrangement has only recently become known. The first is the rather large basilica of St Peter on the Citadel at Metz. Excavations have revealed that the eastern part of the church ended in an apse forming a semicircular interior and a polygonal exterior. St Gereon in Cologne —Gregory of Tours called it the 'church of the Golden Saints' because of its rich mosaics—was a martyrium of oval plan surrounded by niches. Finally, another famous martyrium of the 5th century, that of S. Lorenzo at Milan, was discovered almost intact beneath the Renaissance plasterwork. This vast building on a quatrefoil plan was very skilfully constructed; a raised dome covers the central part, there are large galleries above the aisles, and four square towers more than 90 feet high are at the corners.

The architectural characteristics of the three buildings reappear in a large number of churches in Asia Minor which were built at the beginning of the 6th century. Their earliest examples are found in the western provinces, but they are found more often in the east. It is therefore impossible to say where they originated. In the 4th century travel and communications throughout the Empire were still so easy that it is difficult to establish the relative

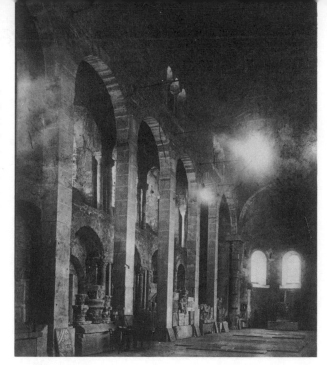

502. PRE-ROMANESQUE. Interior of St Pierre at Vienne (Isère), dating back to the 5th century; partly rebuilt in the 9th century and in the Romanesque period. From the original building two superimposed Orders of marble columns placed against the lateral wall survive.

share of the Occident and the Orient in the evolution of the first Christian architecture. After the barbarian occupation, the West faded into the background, leaving to the East the creative activity in architecture and decoration—to the benefit of the whole Christian world —until its own independence was threatened.

The reawakening of Gaul

Undermined by the invasions, Gaul's brilliant urban civilisation of the 2nd and 3rd centuries was but a memory by the end of the 6th century. From the end of the 3rd century—the time of the first Germanic invasions—the towns of most of the provinces went into a deep decline. It was a general rule for every town to be surrounded by a fortress wall, but people became content to build a high wall around the quarters that were easiest to defend. The vast expanse of the Gallo-Roman towns was replaced by the narrow confines of the citadel.

The only public buildings erected during the 5th and 6th centuries were churches of modest dimensions. The oldest Christian communities established themselves outside the citadel and sometimes, as at Tours, Clermont-Ferrand and Paris, at a considerable distance from it. The bishops who built their cathedrals within the walls of the crowded citadel of their cathedral towns probably did so less for reasons of prestige than of security. This was the period when, under the immediate or distant threat of the barbarian hordes, the big landowners surrounded their dwellings with high walls and towers. Confined by the narrow limits of the citadel, the two sanctuaries composing the cathedral could be no larger than a village church. The decoration does not show much refinement. The marble architrave above the entrance to the cathedral of Narbonne, consecrated in 445, is embellished with a simple moulding. The inscription indicates that priests and deacons were in charge of the building work. If this work was executed by artists, it was closely supervised by the clergy. Sulpicius Severus, writing his praise of Narbonne around 462, speaks enthusiastically of its ancient monuments but is not concerned with its churches.

503. PRE-ROMANESQUE. Baptistery at Riez (Basses-Alpes). 5th century.

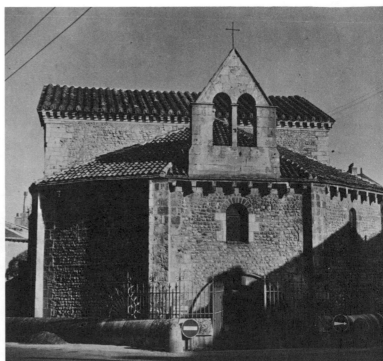

504. PRE-ROMANESQUE. View of the exterior of the baptistery of St Jean at Poitiers, dating partly from the 7th century.

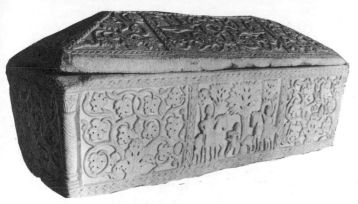

505. PRE-ROMANESQUE. Marble sarcophagus, from the cemetery of St Sernin, Toulouse. 7th century. The motif in the centre is a classical funereal symbol. *Toulouse Museum*.

506. PRE-ROMANESQUE. Interior of the baptistery at Fréjus. 5th century.

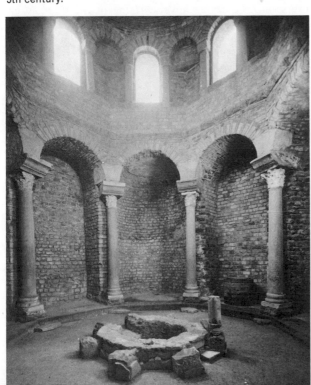

Greater attention was paid to the sepulchral basilicas which, following the example of St Peter's in Rome, were built outside the walls. The famous sanctuary built in this way outside Tours above the tomb of St Martin was of the same modest size as the church of St Pierre in Montmartre. But Gregory of Tours praised its marble decoration and its paintings. In Vienne, the town's bishops had been buried in the basilica of St Pierre since the 5th century. Though partly reconstructed in the 9th century and in the Romanesque period, the two super-imposed Orders of marble columns placed against the lateral walls have survived from the original structure. The interior of the basilica with its simple timbered roof thus recalls the beautiful Orders of classical buildings. The same is true of St Martin at Tours, in fact according to Gregory of Tours the number of columns adorning this basilica corresponded to that of St Pierre at Vienne. Thus the lasting influence of the building practice of the late Roman Empire made itself felt in Gaul.

This fidelity to old traditions did not make for progress. But we owe to it the marble workshops of Aquitania (Aquitaine), whose products were exported all over Gaul until the middle of the 8th century, when Aquitania was destroyed by the barbarian invasions and during the brutal reconquest by the Franks. Recent inventories have revealed the amazing number of sarcophagi and capitals carved by the marble-workers of the south-west in the course of two centuries. The sarcophagi of the 6th century are rather clumsy imitations of the beautiful models with scenes carved on the sides which by an accident of history—the transfer of the seat of the praetorium from Trier to Arles—were made in Arles and Marseille, commissioned by the high officials who had taken refuge in Provence. At the turn of the 6th century the sepulchral decorations prevailing in Aquitania underwent a change and became purely ornamental. This marked the triumph of deep-cut sculpture, a process originating in the Orient and by which a somewhat dull decorative pattern of fluted pilasters, rosettes and stylised leaves could be quickly carved out from the marble. The capitals, on the

243

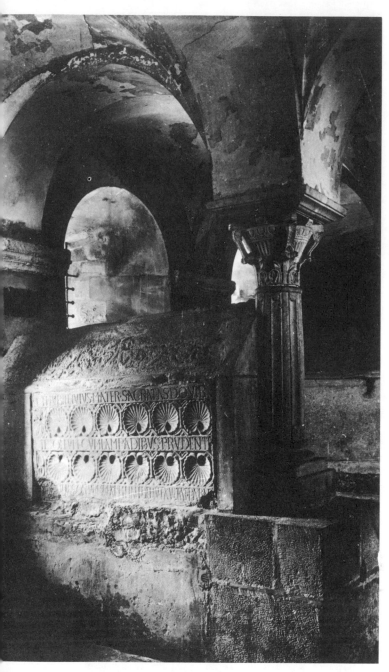

507, 508. PRE-ROMANESQUE. Jouarre abbey (Seine-et-Marne). *Above.* Crypt of St Paul and cenotaph of Theodichildis. *Below.* Sarcophagus of St Agilbert. End of the 7th century.

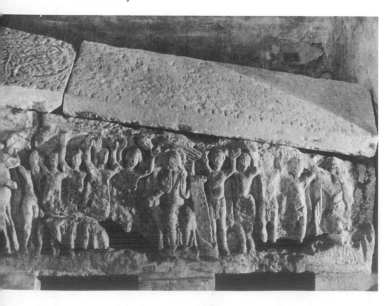

other hand, show variety, elegance and often great originality which reflect the virtuosity of the last workshops of the Roman period. There can be no doubt that the people of Aquitania had studied the technique of the classical capital—it has often, but wrongly, been believed that these sculptures actually date from the classical period—but they did not stop at imitation. The first lesson which they learned from their predecessors was the return to the study of nature. Classical sculpture itself offers few examples showing such a spontaneous rendering of flowers and foliage. Sometimes, then, the Aquitanian artisan attained the stature of an artist.

The 7th century: Poitiers and Jouarre

The trends which reveal themselves in Gaul in the 7th century take on a striking diversity as soon as we leave the region of Toulouse for Poitiers and Jouarre.

The baptistery of St Jean at Poitiers is the only building above ground in France which still shows the architec- 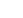 504 tural elements dating from the end of the Merovingian period. Seen from a distance its pediments, accentuated by a large cornice, and the blind arcades which break the monotony of the walls built of small stones, recall certain Mediterranean works of art of the 5th century. The sculpture is clumsy, but the attempt to soften the severity of the external façades is well worth noting. Perhaps it is here that we should look for the distant origin of this taste for ornate façades which was so much alive in the nearby valley of the Loire from the end of the 10th century onwards.

In an ancient cemetery south-west of Poitiers a small sepulchral chapel was discovered at the end of the last century. It soon became famous as the 'Crypt of the Dunes'. Here we encounter the art and the spirit of a little known period when we read the engraved and painted inscriptions profusely displayed by the builder, the Abbot Mellebaude, in his desire to secure the highest protection for his future tomb against the forces of evil and the robbers of cemeteries. Ten steps lead down to the crypt which lies half underground. The three steps nearest to the entrance of the burial chamber are decorated with deeply carved motifs. The decoration is unusual— three intertwined serpents, fishes, and an ivy scroll. Other ivy scrolls are carved on the frame of the door. Were these symbols of immortality, as in the classical period? Far from it. In juxtaposition to the intertwined serpents —a theme of Germanic origin—the dolphin and the ivy seen here have a prophylactic purpose. This is confirmed by the cabalistic formula *Grama Grumo*, engraved upon the step which forms the threshold. It is designed to stop those who try to rob the tomb. The carvings on the steps and on the door jambs are therefore not simple ornaments but fulfil a definite function. In the interior of the building, next to the stone shrine with carvings of roughly hewn figures, we can see a stele depicting with harsh realism two martyrs chained to Crosses. The semi-magical character of such representations was, 509 under other skies, to provoke the famous iconoclastic dispute.

In Jouarre, near Meaux, there is a very different hypogeum of the same period. Let us step over the 507 threshold of this building whose admirably sculptured capitals and tombs display a consummate art. Jouarre was one of the seven abbeys in the Marne valley founded as a result of the monastic rule of the Irish St Columban.

The crypt shelters the tombs of the first abbesses and that of its own builder, Agilbert, one of the greatest prelates of the 7th century, who for ten years studied the Holy Scriptures in a monastery in Ireland. He was Bishop of Dorchester before being placed at the head of the Church of Paris. On his tomb is portrayed the Last Judgment. The admirable technique is reminiscent of the English stone Crosses of that period, especially at Ruthwell and Reculver, and even more of the Coptic stelae of the 7th century.

Threatened by the Arabs, large numbers of Egyptian monks sought refuge in Italy, Gaul and Britain. This was no doubt how a religious sculpture which still fills us with admiration made its appearance in northern Europe. It was used only on tombs, shrines and stone Crosses and is in no way related to the art of classical antiquity, nor did it influence the advent of Romanesque monumental decoration. But it paved the way for the figurative art of the 8th and the 9th centuries. The Carolingian Renaissance, let us remember, was above all an effort to extend to the whole Church a culture which in the 7th century was still the privilege of a few monasteries in Ireland, Britain and north-eastern Gaul. In Jouarre it is made manifest by an inscription in Latin verse carved upon the grave of the first abbess with a skill equalling that of antiquity: 'Here rests the blessed Theodichildis, of noble birth and radiant worth. Mother of this convent, she calls upon her daughters, the Wise Virgins dedicated to God and carrying their lamps, to join the Bridegroom. Departed, she now dwells in the heights of Paradise.'

THE CAROLINGIAN PERIOD

A century later the efforts of the 7th century culminated in the Carolingian Renaissance. To the heritage of the past were now added further contributions, particularly that of northern Italy.

The contribution of northern Italy

The provinces of northern Italy had suffered sorely under the Lombard invasion and occupation. Their recovery

509. PRE-ROMANESQUE. Martyrs chained to the Cross. Stele from the crypt of Mellebaude at Poitiers. End of the 7th century.

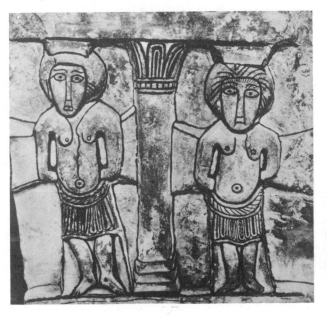

510. PRE-ROMANESQUE. The chapel of Castelseprio (Lombardy). The walls are covered with frescoes. 8th century (?).

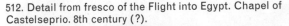

511. Detail from fresco of the Nativity. Chapel of Castelseprio. 8th century (?).

512. Detail from fresco of the Flight into Egypt. Chapel of Castelseprio. 8th century (?).

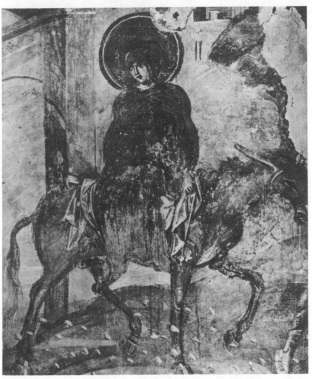

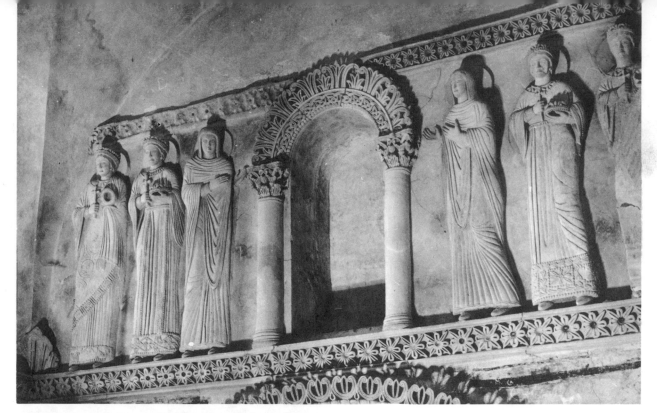

513. PRE-ROMANESQUE. ITALY. Stucco statues of a procession of holy women. 8th century. Oratory in the palace of Cividale (Friuli).

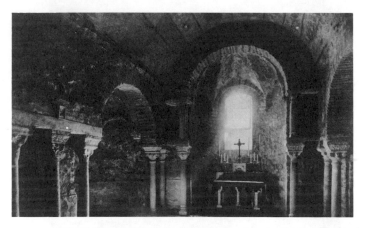

514. PRE-ROMANESQUE. Crypt of the church of St Laurent at Grenoble. End of the 8th century.

515. PRE-ROMANESQUE. GERMANY. The great arcades of Charlemagne's Palatine Chapel (796–814), now the cathedral of Aachen. A striking example, in spite of its later alterations, of Carolingian architecture.

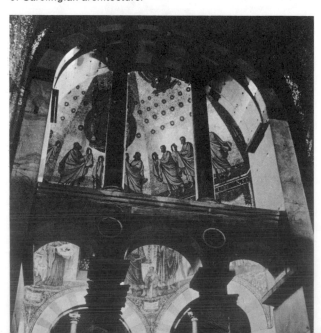

during the second half of the 7th century and in the 8th century resulted in the construction of many churches, among them that in Castelseprio, the ancient seat of the 510 Archbishop of Milan. The frescoes (accidentally discovered during World War II) on the walls of its sanctuary represent scenes from the childhood of Christ. The 511, 512 technique is Byzantine but the arrangement follows Western iconography. The painter had no doubt been trained in a Byzantine workshop in southern Italy or in Rome, probably at the beginning of the 8th century when a Greek Pope, John III, occupied the papal see. The Archbishop of Milan, a powerful prelate, could afford to commission famous painters from distant places. A similar origin may be assumed for the famous stucco figures 513 and paintings in the palace oratory of Cividale in Friuli. There are clear indications that they date from the 8th century. The decoration of the nave of this small building leaves an overwhelming impression. A procession of holy women carved in high relief into the plaster extends along the wall; it is a theme which we shall encounter again in the mosaics of the early 9th century.

These two examples are proof that all over Italy there were workshops which, though situated outside the sphere of influence of the Byzantine studios, nevertheless inherited their tried and tested techniques. The consistent evidence of the Oriental element may indicate one of the sources of the development of illumination and ivory carving in north-east Gaul at the end of the 8th century.

The distribution of screen panels with interlaced ornaments is striking proof of the existence of currents of influence which originated north-west of the Adriatic and were transmitted to Gaul either via the Alpine passes or along the Mediterranean coast and the Rhône valley. The screen was the stone parapet separating the sanctuary from the nave of the church. In many churches it constituted the only sculptural decoration apart from the ciborium, a stone baldachino rising above the altar, and the ambo, a pulpit for sermons and the reading of certain liturgical texts. The modest art of the screen panels

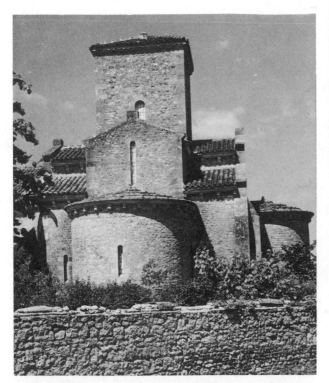

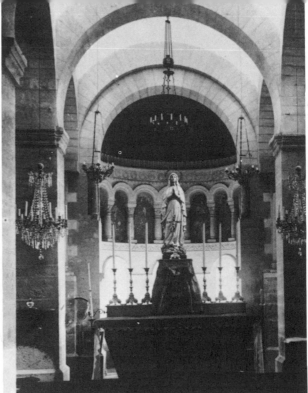

516. PRE-ROMANESQUE. The oratory of Germigny des Prés (Loiret). Built at the beginning of the 9th century by Theodulph, friend of Charlemagne, and rebuilt in the 19th century.

517. Interior of the oratory of Germigny des Prés.

518. The oratory of Germigny des Prés. Mosaic on the half-dome of the apse, representing the Ark of the Covenant according to the Bible.

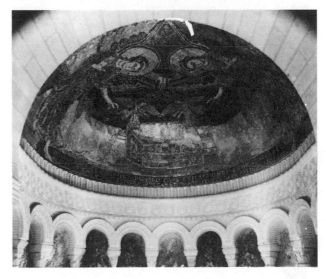

developed towards the middle of the 8th century in this region, rich in quarries, where the frontiers of Italy, Switzerland and Austria meet today. From here this art gradually spread westward and northward. The numerous Lombard churches built from the end of the 7th century account for the establishment of important workshops whose products were the objects of a lively export.

In Gaul the workshops of the marble cutters near Toulouse were destroyed during the Aquitanian wars. This region was therefore ready for imports of Lombard panels, examples of which have been found as far away as Bordeaux. But little by little local workshops came into being which copied the Lombard products. This explains the source of many of the panels with interlaced patterns which have been found in France and Switzerland. The very skilful curves systematising motifs of Syrian and Coptic origin had a lasting influence, and the Romanesque sculptors still used the interlace in their capitals.

At the time when the style of the Lombard screen decoration was spreading, the Alpine regions adjoining the Rhône valley experienced a period of intense building activity. This is evident from several buildings which have been discovered through excavation or which still survive in Switzerland and from the church of St Laurent at Grenoble in France. The churches in Switzerland belonged to monasteries famous at the beginning of the 9th century. The east end of the church terminated in three adjacent, projecting semicircular apses. The church of Germigny des Prés, built during the Carolingian Renaissance, is a fairly faithful replica. The 'crypt' of St Laurent at Grenoble, which was built towards the end of the 8th century, is an unusual mausoleum placed at the end of the sepulchral basilica. Its apses give this small structure, half buried in the ground, a trefoil plan. In the interior each decorative element contributes to the total effect; the barrel vault rises from an architrave supported by columns with carved capitals. At the entrances to the eastern and western apses small coupled colonnettes stand on the architraves to support a trium-

phal arch. This arrangement, which creates the illusion of a second superimposed Order, at the two furthest points of the small basilica, is similar to that of Germigny des Prés. And as in Germigny, a stucco decoration conceals the interior stone-facing of the main apse. In the centre of the vault a Cross carved between scrolls betrays a distinctly Mediterranean style. Where the stucco is not decorated in relief, the illusion of decorative stone-work is obtained by a fine trellis-like design. The small colonnettes of the arches were also of plaster.

This small but important building, miraculously preserved, represents different influences characteristic of this period; the rows of columns which support the architrave and reinforce the lateral walls resemble the Orders simulating a classical design in the interior of the Merovingian basilicas. The ribbed vaults and the stucco decoration indicate Mediterranean influences. The severe geometric arrangement based on two opposite equilateral triangles and the highly skilled building technique in which brick alternates with stone show that a real

247

architecture existed in south-eastern Gaul at the time Charlemagne, according to his biographer Einhard, executed 'a large number of works for the glory and the benefit of the kingdom'.

The impact of Charlemagne

In the eyes of his contemporaries the two outstanding structures built by Charlemagne were the Palatine Chapel at Aachen and the wooden bridge over the Rhine at Mainz. The latter serves as a reminder that wood construction—which had its masters and its admirers—was long in use in northern and eastern Europe.

Charlemagne also built the palaces at Ingelheim and Nijmegen. 'Above all,' states Einhard, 'he ordered the bishops and the prelates to restore throughout his realm the churches that were falling into decay, and he made sure through his officials that his orders were faithfully carried out.' The *Libri Carolini* praise Charlemagne for the fine condition of his churches, 'decorated with precious stones, silver and gold, while the churches of the Byzantine Empire, miserably neglected, fall into ruin.' But the *Libri Carolini* were propaganda, and this statement must therefore not be taken too literally. We must be especially wary of the confusion caused by eager amateur archaeologists who attributed to the 9th century village churches which were actually built at the beginning of the Romanesque period. For in the Carolingian and the Merovingian periods the stonemasons' workshops were in the service of the princes, the great bishops, the abbots and the nobility, whereas the rural churches were built of clay and timber.

To judge from the palace at Aachen, built during the first few years of the 9th century, Charlemagne's builders must have been extremely competent. The substructure of this edifice, most of which was discovered in the 19th century, was on a huge rectangular plan, 590 feet long. The buildings were arranged around an oblong court with a gallery formed by arcades in the manner of the cloisters of the contemporary monasteries. In the northern part, facing the chapel, rose the *sala regalis*, its ends rounded like an apse. The proportions and dimensions were determined by an accurately drawn system of squares, a practice in general use at that time. Careful planning and study went into this type of construction which had to conform to fixed rules. It is known that when Conrad, the uncle of Charles the Bald, decided to build the basilica of St Germain at Auxerre, the site was examined by the builders down to the minutest detail and a wax model was made of the edifice.

515 The Palatine Chapel is today the cathedral of Aachen. Despite the architectural additions in the Gothic period, one can easily recognise the original arrangement. The Chapel was built by a Frankish master builder, Odo of Metz. An octagonal building with galleries and rising to a height of 130 feet, it reveals an astonishing knowledge of architecture. No one has yet been able to explain its origin. It is entirely different from Byzantine architecture. But it anticipates the French solution of the problem of roofing which was to become so acute in the 12th century. At Aachen the rampant triangular vaults above the gallery rest on diaphragm arches surrounding the octagonal central space. Perfect stability of the dome is achieved with only few supports and struts. Large windows between them let in a flood of light. A mosaic about 12 feet high once adorned the interior of the dome. We know it

from descriptions and drawings. It depicted, on a star-studded azure background, high above the altar at the east end, the figure of Christ clothed in a purple mantle. The right hand was raised in a gesture of blessing; at His feet the life size figures of the twenty-four Elders of the Apocalypse rose from their seats to offer Him their jewel-incrusted golden crowns.

Facing this mosaic but at the gallery level is the Imperial pew. Here, seated on a throne of stone which is still extant, the Emperor 'could see all and was seen by all'. Made of bronze like the portals of the basilica, the ornamented grille which forms the balustrade is admirable in design and execution. Each one of the pierced panels is framed by fluted pilasters crowned by capitals. Because of the perfection of the classical scrolls carved in delicate relief on the upper part of several panels, these were formerly thought to date from the Roman period. But the capitals on the pilasters show the same ornamentation as the stone capitals carved in Gaul at this period. This proves that the grille was executed by a local workshop. A similar error was made with regard to the Carolingian throne from St Denis, which was for a long time erroneously referred to as the 'throne of Dagobert'.

The oratory in Theodulph's villa in Germigny des Prés also gives an idea of the aristocratic art of the period. Theodulph, abbot of St Benoît sur Loire and Bishop of Orléans, an intimate friend of Charlemagne and *missus dominicus*, was one of the most cultured prelates of his time. His chapel has a central plan with five domes. The stucco panels that frame the windows and cover the walls of the apse are of rather mediocre artistic quality. But the mosaic on the vault of the principal apse, which as we know from ancient documents at one time extended over 518 the walls and the neighbouring dome, is exquisite and is far superior to the mosaics of the same period in the churches at Rome. That the artist who executed the mosaic in Germigny was not a Byzantine has been established by recent research which has also revealed the significance of the iconography. Theodulph had ordered a representation of the Ark of the Covenant surrounded by angels, palm trees and flowers similar to those on the walls of Solomon's Temple. 'Behold the splendour of the Ark of the Lord, and beholding it attempt to move with your prayers the God of thunder and include, I beseech thee, the name of Theodulph in thy prayers.' This was the inscription running along the base of the mosaic. The 'God of thunder', that is to say God Himself, is represented by a hand extending from a cloud. This is not a narrative or historical but a mystical representation derived from the development of biblical exegesis and the symbolist tendencies at the time of the Carolingian Renaissance. This was also how the New Jerusalem, the hope of Christendom, was pictured in the Temple of Solomon. The chapel of Theodulph, today a simple village church, is the only structure which conveys some of the ideas of the scholars surrounding Charlemagne.

The effects of the Carolingian Renaissance

There is nothing more ephemeral than a learning and culture shared only by a small élite. Fifty years of turmoil sufficed to destroy completely the intellectual accomplishments of the Carolingian Renaissance. But this Renaissance had also created a temporal order and had achieved a corpus of architecture and town planning

which had permanency and whose main features continued to be used.

In the 9th century there was great building activity as a result of the reform of the cathedral clergy. This was an important event in contemporary church history. A few examples will show the considerable effect of this reform on the topography of the cathedrals and their annexes and, indirectly, on the plan of medieval cities in general.

At Metz, Bishop Chrodegang issued an order about 754 which imposed a monastic discipline on the clergy of his diocese. A short time later this reform was extended to the whole Empire by Conciliatory and Capitulary edicts. To enable the canons to live and pray together, they had to be provided with a chapter house consisting of a refectory, lodgings and oratories arranged like those of the contemporary monasteries. This is how buildings, oratories and a cloister came to be constructed round the cathedral at Metz. In Lyon, where a small group of canons lived close to the cathedral of St Stephen, Bishop Leidrade built a cloister and a large church in accordance with his own plans. The apse of the church was discovered by excavations. It was here that Bishop Leidrade established the *ordo psallendi* (order for psalm singing), which corresponded to the rites of the Imperial chapel. An official from Metz was specially sent for that purpose by the Emperor. At Vienne, on the Rhône, a canonical

church modelled on the one at Lyon was founded and dedicated to the Saviour. And at Le Mans, a church for the cathedral's clergy, who had been organised into a chapter, was consecrated by Bishop Alderic in 834. While at Metz the old practice of the Merovingian monasteries of building separate oratories, each having only one altar, was still adhered to, this tradition was abandoned at Le Mans in the light of the exigencies of the new situation. Here the altars, fourteen in number, were placed inside the church, several of them on the galleries.

In many places schools and hospitals were built near the chapter houses. From the 11th century on, in most of the episcopal towns in the north of France imposing religious buildings arose round the cathedrals. And on the sites occupied by the churches, the chapter houses and the adjoining buildings, the huge Romanesque and Gothic cathedrals, which were so radically to transform the face of the towns, could later arise.

The Carolingian rule imposed its imprint on the towns. It imposed its imprint also on the cities of the dead. There were a number of sepulchral basilicas on the outskirts of the towns, but they had no crypts. The holy body rested there close to the altar in a stone or precious metal tomb surmounted by a ciborium. In Carolingian times the bishop would erect at the east end of the major basilica outside the town a building which would contain all the

519. PRE-ROMANESQUE. ITALY. Detail from the frontal (paliotto) of the high altar, S. Ambrogio, Milan. Presented by Angilbert about 835. Made by the goldsmith Wolvinus from silver-gilt plaques enriched with precious stones and enamel.

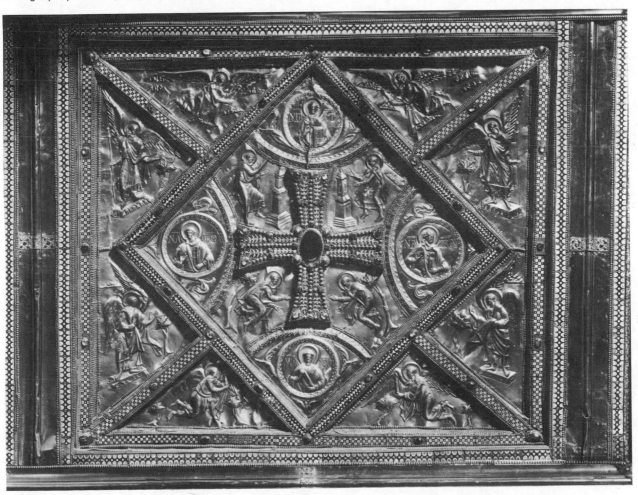

tombs of his predecessors. This was done at Auxerre, Reims, Sens, Dijon, Lyon, Vienne and probably also at Grenoble. It gave rise to a new architecture which was to last for a long time. It consisted of vast vaulted crypts with narrow passages and dark chambers radiating around the tomb of the patron of the basilica; these received the mortal remains of the prelates and the great men. We should also mention the use made by the Carolingian builders of the *confessionale*. Originating in Rome at the beginning of the 8th century, the place of confession was to begin with a narrow subterranean space formed like an apse, intended to receive the bodies of the saints, which in these troubled times were no longer safe in the cemeteries on the outskirts. In Gaul the Romanesque *confessionale* evolved into a kind of underground church situated at the east end of the basilica.

520 At Auxerre, between 841 and 859, to quote a contemporary historian an 'admirable unit of crypts' was constructed at the east end of the basilica of St Germain. In contrast to most Romanesque crypts, the completely vaulted building was not underground. Side entrances connected it with the aisles of the church. In the centre, the Holy of Holies, was the tomb of St Germain. A surrounding ambulatory provided space for the pilgrims to circulate. In the oratories opening on to this ambulatory were the tombs of those on whom had been conferred the honour of burial in this sanctified place. Narrow windows let in little light. Divine services and vigils were conducted by the light of candles and lamps. A small opening allowed a glimpse of the tomb which was concealed like a treasure under the vault of the Holy of Holies. Painted inscriptions enjoined pilgrims to approach with awe. Occasionally an oratory would be attached to the head end of the Holy of Holies, as at Auxerre, Flavigny, Dijon and Sens. The circular or square oratory was surmounted by several stories which formed a kind of tower, and one of these was connected with the upper church.

 Another innovation of the Carolingian period was also to survive for a long time—the nave at the west end was preceded by a vast westwork with a gallery. From this raised level one could, as from the Imperial pew in the Palatine Chapel, look down into the interior of the church. The only knowledge we have of this feature is 523 from a drawing of the westwork of the abbey of St Riquier, built by Angilbert, a friend of Charlemagne. The comparatively large gallery could hold a choir of a hundred monks, whose chants alternated with those of the choirs assembled in the nave and the sanctuary.

 We have but scant knowledge of the interior structure of the great Carolingian churches. There was doubtless little difference between the basilica of St Denis, built towards the end of the 8th century, and the basilicas of the churches built in the preceding centuries. Two rows of slender marble columns supported the arcades of the nave. The roof and bell tower were built of timber. Later more intricate methods of construction were employed. Thus from the 9th century onwards the architects must have used the method of transverse arches, that is, arches supporting an upper wall. This architectural device served to link the side walls and to support the whole structure. All the types of vaults which were employed in the Romanesque period were moreover in use already in the 9th century, though generally as yet only to cover small spaces in the oratories and the crypts.

 The exterior of the Carolingian church is severe in appearance. In the Germanic countries it preserved this character up to the Gothic period. Was this due to lack of skill or to enforced austerity? The old portals of the monastery of Lorsch (end of the 8th century) prove that artists were well able to endow a façade with rich decoration. The portals of the palaces were no doubt equal in splendour to the portals of the abbeys. The severe appearance of the church façades was therefore deliberate. It was a starkness imposed by a bias in favour of austerity, which derived from religious tradition.

The splendour and classicism of the decoration

It was in the interior of the churches that a rich decoration was displayed for the delight of God and man. We have already mentioned the important role of marble and bronze. In the monastic churches and the cathedrals of the Carolingian period the goldsmiths' work over a wooden core, executed with consummate artistry, served to enhance the splendour of the sanctuary. We get an idea of this from the altar frontal (paliotto) in the church 519 of S. Ambrogio in Milan, executed between 824 and 835, and from the portable altar of the Royal Chapel in Munich.

 Two works which have not survived—the gold altar which Charles the Bald presented to the abbey of St Denis and the silver reliquary commissioned by Einhard for the church of St Servaas in Maastricht—are known from old drawings. These works show that the artists had rediscovered the secret of the ancient classical art of monumental sculpture. The gold table of the altar of St Denis, with its three compartments and arcades, and the representation of the Apostles raising their eyes to the high figure of God seated on a throne, anticipated the Romanesque and Gothic bas-reliefs. The reliquary of Maastricht had the form of a Roman triumphal arch. The surfaces, divided into several vertical areas, were decorated with figures and scenes. Early Christian art supplied the venerable themes, and the still earlier pagan art the technique of monumental decoration. In art as in literature the Carolingian Renaissance owes much to classical antiquity. In many places Gallo-Roman buildings, which were still numerous in the 9th century, were the source of decoration used in everyday life. This decoration deteriorated more and more, but among the clergy and the aristocracy there remained enough curiosity and culture to enable good artists to draw their inspiration from these examples.

520. PRE-ROMANESQUE. FRANCE. One of the frescoes of the life of St Stephen. Crypt of St Germain at Auxerre. Before 859.

In its painting, too, Carolingian art is like a last extension of classical civilisation. The sham marbles painted on the walls of the *confessionale* of the Carolingian church of St Denis recall those of the villas of the Roman period. The naturalism of bearing and of gestures and faces in the frescoes of the Carolingian crypt of St Germain at Auxerre and in the paintings of contemporary manuscripts brings these works very close to those of the 2nd and 3rd centuries. There are no paintings of the Romanesque period to equal them, and we shall have to wait until the 14th century for the reappearance of a draughtsman comparable to the artist who in the opening years of the 9th century illustrated the extraordinary Psalter of Reims which is today preserved in the Library at Utrecht.

There was one part of Europe which preceded Gaul in the art of illustrated sacred texts—the British Isles. The manuscripts painted in the monasteries of Ireland and Britain are masterpieces of skill and perseverance (see Chapter 1). But Carolingian painting, even though it originated in the north, was the highest expression of classical humanism manifest in the Occident since the end of antiquity. The lessons, the ideas and perhaps even the models came from northern Italy, where they had derived from Byzantium. But Carolingian art was able to create a style of its own. The origin of the style remains a mystery. The discipline introduced into religious and social life through the new Carolingian institutions is also to be found in the calligraphy of the beautiful manuscripts of the time, bound in ivory and silver. From the 8th century onwards the cursives of barbarian times were replaced by the Carolingian minuscule, drawn with a disciplined hand. This script is of such perfection that the humanists of the Renaissance believed it to be a classical script, and they chose it as the model for our printing types.

The wealth of art of the later Middle Ages should not make us underestimate Carolingian art. We are only now beginning to discover its variety. At the end of the 9th century Abbo, a monk from St Germain des Prés, composed an epic poem on Paris besieged by the Normans in 885. He concluded his Latin poem with a curious reproach. He blamed his compatriots for having deserved the scourge of the invasion as a result of their unrestrained worship of luxury: 'Your stately gowns are fastened by golden jewels. Precious purple stuffs keep you warm. Your shoulders are covered by none but the finest cloaks, woven with gold thread. A belt studded with precious stones girds your loins. And your shoes are tied with laces of gold.' Charlemagne's empire did indeed perish though its love of luxury, for the Normans whose invasions brought about its downfall were hardy pirates, lured by the treasures accumulated in the monasteries and the palaces.

521. PRE-ROMANESQUE. Gospel of St Médard of Soissons. Palace School of Charlemagne. Beginning of the 9th century. MS. Lat. 8850. *Bibliothèque Nationale, Paris.*

522. PRE-ROMANESQUE. The Church of Sta María de Naranco. *c.* 848.

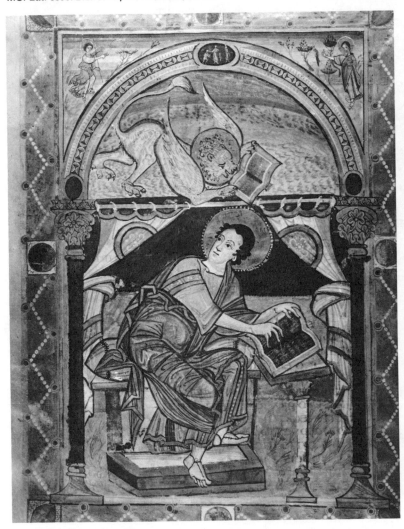

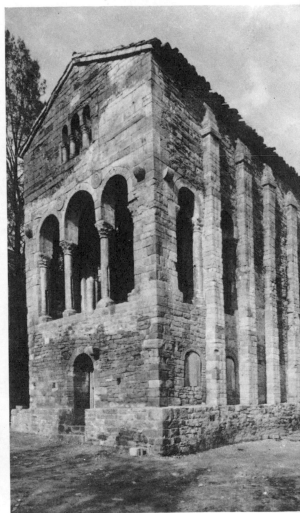

HISTORICAL SUMMARY: Pre-Romanesque art

MEROVINGIAN GAUL

(For **History** *see Chapter 2)*

Architecture. The importance of Gaul from early times in the history of Christian architecture enables us to understand the works of art created from the beginning of the 8th century. There are three types of churches:

Episcopal churches. As in many other regions of the Christian world at this time, the episcopal church frequently consisted of two churches and a baptistry. South of the Loire and in Burgundy the three structures are placed parallel in a north–south direction (Fréjus, Avignon, Nîmes, Vienne [**502**], Auxerre, Sens, Geneva). This pattern was also adopted in Trier from the end of the 4th century.

Monastic churches. Monasticism, originating in the East, was introduced into Gaul in the second half of the 4th century. By the 7th and 8th centuries close to two hundred monasteries had been built, especially in northern and eastern Gaul. These varied in plan and had at least two churches. The general design recalls Oriental monasteries, but differences appear from the beginning of the 7th century.

Basilicas. The basilicas, goals of the pilgrims, were usually built on the outskirts of towns or in the countryside, over the tomb of a revered saint. Examples are St Germain at Auxerre, St Bénigne at Dijon and St Remi at Reims. They were built from the 4th to the 6th centuries and resembled the basilicas found throughout the Christian world. Their plan showed several variations:

1. In Gaul from the 4th century onwards we find churches with only one apse. Two very old churches in southern Gaul were built as basilicas: St Bertrand de Comminges, before the second half of the 5th century; SS Apôtres in Vienne (5th century).

2. The basilica with three apses appeared at the beginning of the 6th century, the two lateral apses ending in a straight wall. Examples are: the basilica at Autun built by Queen Brunehaut around 590; the plan of the basilica at Parenzo (550) in Istria; possibly the apse of the episcopal church of St Pierre et St Paul at Nantes (built before 548 and consecrated about 567).

3. Vaulted oratories were built from the 5th and 6th centuries (the oratory of St Victor of Marseille and that of Glanfeuil). They are similar to the vaulted churches of Bin Bir Kilisse (Asia Minor).

4. From the 5th century onwards the introduction of the transept gave rise to the cruciform plan. Many texts of the 4th and 5th centuries attribute symbolic significance to it. It had early been adopted by the architects of Gaul. According to Gregory of Tours, the episcopal church of Clermont had a circular apse added to a transept (5th century), like the two churches, whose substructures have been found, which were built before the 9th century at Romainmôtier (Vaud, Switzerland) and at St Denis. Cruciform basilicas were: Ste Croix et St Vincent in Paris (consecrated in 599), and the church of Notre Dame at Jumièges (built after 654).

5. Finally, certain monastic and rural churches could only be built as simple rectangular halls facing east, such as the church and churchyard at Jouarre (7th century) [**507**] and Ste Reine d'Alise (before 721).

The bell tower is the most original feature of the Merovingian church. It was not until the 5th century that the bell, invented long before our era, was added to the sacred building in a special tower. The tower was placed either in front of the sanctuary (basilica of St Germain at Brioude) or in front of the main body of the church (St Martin at Tours; episcopal church of St Etienne in Paris).

Baptisteries were built in Gaul at an early period. Some complete buildings and some with only the foundations surviving are to be found in Marseille (314–614), Fréjus (374–636) [**506**], Aix (412–596), Riez (439–650) [**503**] and Venasque (541–650).

The plan of the baptisteries in Provence shows striking similarities to the religious buildings in Asia Minor, in Syria and on the Adriatic coast; four niches in the corners of a square hall serve as a transition to an octagonal plan. This device first appeared in the Orient. There as in Provence it was used in the building of baptisteries and small basilicas. The baptisteries in Italy are similar but are octagonal instead of square on the outside. They were covered by a dome.

Sculpture and painting. Monumental sculpture lost its relief-like quality and shunned the realism of classical art in favour of an increasing stylisation.

The decoration of manuscripts, too, was reduced to stylised motifs: zigzags, circles, spirals, interlaced braided patterns and plait-work. Figures were rare and barbaric in appearance, but they were expressive: Frédégaire in the Bibliothèque Nationale, MS. Lat. 10910 (7th century). Colouring was restricted to a few flat tones: green, yellow, red and brown.

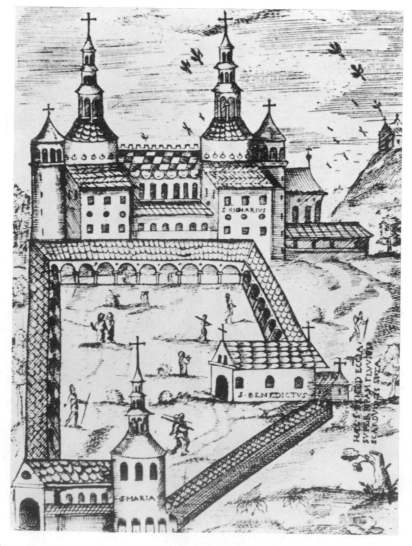

523. CAROLINGIAN. FRANCE. Monastic church of St Riquier (Somme). Old miniature known from an engraving by Petau. *Bibliothèque Nationale, Paris.*

The minor arts. In the basilicas of Gaul the decoration of precious metals assumed an importance similar to that in Byzantium and in St Peter's in Rome. Decorative art had been executed in rich colours since the beginning of the 7th century and was used in eastern Gaul to adorn the altars. The subjects represented were holy personages, and clouds chased on silver tablets (altar of the Virgin of Notre Dame at Stavelot, about 660). Although the presentation of the human figure shows a certain lack of skill, it was mainly the goldsmiths' work which pioneered the development of monumental sculpture. Two processes were used:

1. *Cloisonné work*: treasure of Tournai (tomb of Childeric, 481, Cabinet des Médailles, Bibliothèque Nationale); tombs of the Catalonian Fields (treasure of Pouan, 451, Troyes Museum); treasure of Gourdon (after 527, Bibliothèque Nationale [**186**]); Cross of St Eloi at St Denis.

2. *Repoussé work*: shrines of St Bonnet Avalouze (Corrèze) and of St Benoît sur Loire [**190**] (7th–8th centuries).

The most famous goldsmith was St Eloi (588–665). The reliquary casket decorated with antique gems and precious stones in the treasury of St Maurice of Agaune (Switzerland) [**189**] was left by Dadillo and Ello (*c.* 760).

LOMBARD ITALY

History. After the deposition of Romulus Augustulus by Odoacer in 476, Italy succumbed to the barbarians. It was Byzantium that drove the Ostrogoths there. Theodoric eliminated Odoacer (493) and set up an Imperial court at Ravenna. He was succeeded (540), though only for a short time, by the Byzantines under Justinian. From 568 onwards, following Totila and the Goths, the Lombards invaded Italy, hemming in the Greeks in Ravenna and its dependencies and threatening (593) and encircling Rome. Their power was consolidated and expanded, to the detriment of Byzantium especially (Ravenna taken in 751). Rome, on the brink of disaster, was saved by the alliance between the Pope and the Franks, and Charlemagne became 'King of the Lombards' in 774.

Architecture and sculpture. If we exclude the mausoleum of Theodoric at Ravenna, with its enormous monolithic dome, Ostrogoth and Lombard art is scarcely more than a decorative art. Stone sculpture of parapets, transennas and ciboria, very often with pierced decoration, was worked like an embroidery of interlacing plaits, etc. (St George at Valpolicella; works at Perugia and Ravenna, 8th and 9th centuries). The human figure was very rare and rather clumsy (sculptures in S. Martino at Cividale, in Friuli, 8th century [**494, 513**]).

The minor arts. From the Ostrogoth period only the ornate armour which allegedly belonged to Theodoric (Ravenna Museum) is left. It shows the same decoration as the frieze on his tomb.

The contents of the tombs, especially from the 7th and 8th centuries (Nocera Umbra near Assisi; Castel Trosino near Ascoli) show that the spiral pattern of the Bronze Age was continued in the decoration of arms, and the filigree work on the brooches recalls the motifs of the Iron Age. On the pectoral Crosses, the interlaced pattern predominates. In the treasure of King Agilulf (591–625) and that of Theodelinda in the cathedral of Monza, precious stones and antique cameos mingle with the gold cloisonné ornaments.

VISIGOTHIC SPAIN

History. The Visigoths, established in Spain, founded a stable monarchy with the accession of Euric (466), who often held court at Toulouse, his Aquitanian dependency. Threatened by the Franks after the battle of Vouillé (507) and pushed back to the Pyrenees, the kingdom was saved by the protective intervention of Theodoric, and Justinian soon established a foothold there (554). Reccared, abandoning the Roman Church (589), which took over effective control. In spite of continued troubles, the arts developed rapidly and flourished until the definitive Arab conquest in 713.

Their art reminds us that the Visigoths, in contrast to the Franks, passed through the Byzantine Orient and Italy before establishing themselves in the south of Gaul and in Spain. They continued to maintain contact with the Ostrogoths who had remained in Italy, and they encouraged local workshops by their commissions.

Architecture. We must distinguish between the following:

1. In north-western Spain a group of basilican type churches were built (S. Juan at Baños, Sta Comba at Bande, S. Pedro de la Nave) in the form of a Greek cross with groined vaults (7th century).

2. Another group, in Catalonia, comprised in particular the three churches of Tarrasa (S. Pedro, which was only a chapel, S. Miguel and Sta María) and the cathedral of Egara and its baptistery. Sta María was no doubt a basilica having a nave and two aisles, with a timber roof. S. Miguel is a small building; the plan is a Greek cross inscribed in a square, with an apse at the east end. The arms of the cross are groin vaulted, while the central part is covered by a dome on squinches. In the corners are chapels with quadrant vaults. The influence of the Orient is evident.

3. In France there were a few buildings constructed through the initiative of the Visigoths, foremost among them the church of La Daurade in Toulouse.

What is called Visigothic architecture is characterised by a horseshoe design of the apse or of some of the arches. As in Gaul, there was a panelled decoration.

Sculpture and painting. There are two types of capitals:

1. The Roman Corinthian (Composite)

524, 525, 526. *From top to bottom.* Plans of St Pierre at Vienne, Aachen and Germigny des Prés. (*After E. Rey and R. de Lasteyrie.*)

CAROLINGIAN ART

527. CAROLINGIAN. Chased and gilded chalice presented by Tassilo, Duke of Bavaria, to the abbey of Kremsmünster, between 777 and 788. (After J. Baum.)

528. CAROLINGIAN. St Matthew, from Gospels commissioned from the scribe Godescalc, c. 781. *Bibliothèque Nationale, Paris.*

529. CAROLINGIAN. Allegorical illustration of a Psalm. Pen drawing. Utrecht Psalter, Reims. c. 820. *Library of the University of Utrecht.*

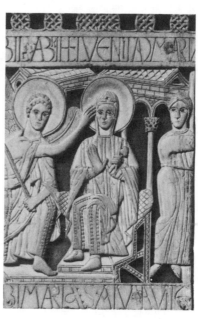

532. CAROLINGIAN. Ornamented letter 'L'. Gospels in the library of Laon. Middle of the 9th century.

530. CAROLINGIAN. Carolingian soldiers. Psalterium Aureum. 841–872. *Library of the Chapter of St Gall (Switzerland).*

531. CAROLINGIAN. Leaf of a diptych known as Genoels Elderen. The Annunciation. Ivory. 8th century. *Musées Royaux d'Art et d'Histoire, Brussels.*

533. CAROLINGIAN. Crowning of a prince standing between two Church dignitaries. Sacramentary. MS. Lat. 1141. Second half of the 9th century. *Bibliothèque Nationale, Paris.*

THE CAROLINGIAN EMPIRE AT THE BEGINNING OF THE 9TH CENTURY

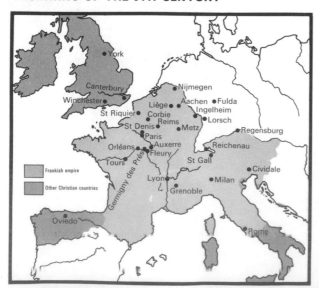

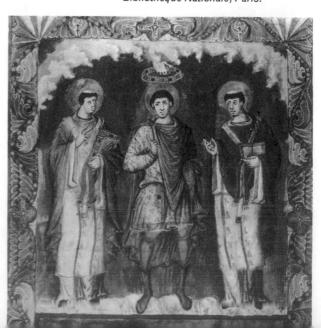

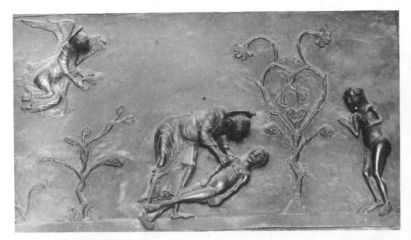

534. OTTONIAN. The Creation of Eve. Detail from the bronze doors of the cathedral of Hildesheim. 1015.

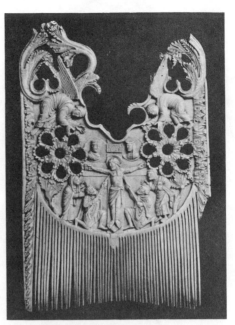

535. OTTONIAN. Liturgical comb (from Metz). Ivory. Beginning of the 10th century. *Stadtmuseum, Cologne.*

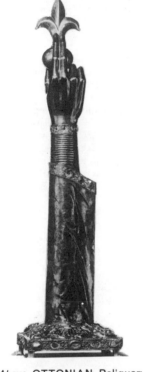

536. *Above.* **OTTONIAN.** Reliquary arm of St Sigismund. 11th century. *Schlossmuseum, Berlin.*

537. *Above.* **OTTONIAN.** The Raising of Lazarus. Detail from the Miracles of Christ. Fresco in the nave of St George at Oberzell, Island of Reichenau. Second half of the 10th century.

538. *Below.* **OTTONIAN.** Gold altar frontal presented by the Emperor Henry II to Basle cathedral. *c.* 1020. Probably executed by a workshop at Reichenau. *Musée de Cluny, Paris.*

THE OTTONIAN EMPIRE IN THE 10TH CENTURY

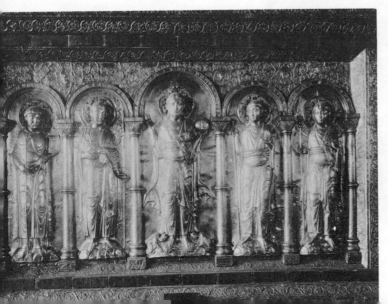

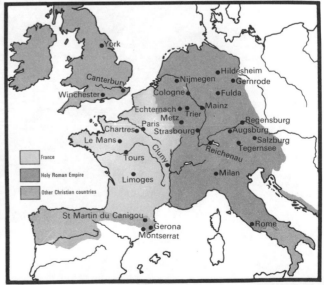

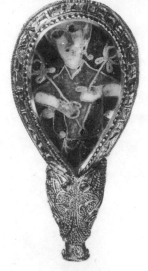

capital is the most frequently found.

2. The other type consists of human figures and animals inscribed in medallions and carved in very low relief.

Our knowledge of the wall paintings of this time comes from written records. The Apocalyptic Vision, in the vault of S. Miguel at Tarrasa, has been related to the frescoes of Baouit.

The minor arts. The famous treasure of Guarazzar (near Toledo) contains the devotional crowns of the Kings Swintila (621–631) and Recceswinth (649–672) [**157**]. The technique is Byzantine, but they are barbarian in spirit, both as regards the form and in the association of stones cut en cabochon and filigree cloisons.

CAROLINGIAN ART

Carolingian art represents a synthesis of different cultures in western Europe and at the same time a rebirth of classical antiquity, a revival of Roman traditions.

Charlemagne had some remarkable predecessors: Pepin of Heristal (687–714); Charles Martel (714–741); Pepin the Short (741–768). Charles Martel saved Gaul from Arab invasion at Poitiers (732). He prepared the way for Charlemagne's empire by his support of St Boniface, who won Germany over to Christianity and consolidated the Church. Pepin the Short completed the conquest of Gaul and defended the Pope in Italy against the

Lombards by presenting him in 756 with the territory which formed the basis of the pontifical state. Their reigns laid the foundations of the Carolingian dynasty and of the entente between the Church and the Frankish state, who lent each other their support.

Charlemagne (768–814), crowned Emperor at Rome by the Pope (*a Deo coronatus*) in 800, created a European civilisation. From Holstein to Barcelona and Benevento, from the Elbe to the Atlantic, there was only one Empire. Laws based on uniform principles were established for all the peoples in the Empire by the Capitularies. These laws were motivated by aspirations for a renaissance and a new culture under one religion. Their impact continued to make itself felt long after Charlemagne's death and in spite of the Norman invasions and the dismemberment of the Empire.

Charlemagne's descendants, Louis the Pious (814–840), Charles the Bald (840–877), Louis the Stammerer, Louis III and Carloman, and Charles the Fat (880–887), could not preserve the unity of the Empire. The advance of the feudal system which started under the Merovingians and was intensified by the Capitularies of Mersen (847), of Pitres (862) and of Quierzy (877), the ambition of the Church to control the civil power and the Norman, Hungarian and Arab invasions were the main causes for the break-up of the unity of the Carolingian Empire (888). From its ruins rose the nations France, Germany and Italy.

539, 540. ANGLO-SAXON. The jewel of Alfred the Great. Cloisonné enamel, mounted in crystal. 871–901. *Ashmolean Museum, Oxford.*

541. ANGLO-SAXON. The Ormside bowl. Silver and copper gilt, studded with enamelled bosses. c. 750. *York Museum.*

Architecture. Important remnants of palaces have been found at Aachen and Ingelheim. The architecture of this period is, however, essentially religious. A plan of the monastery of St Gall, dating from 830, conveys an idea of the vast dimensions of monastic buildings during the Carolingian period. But we have more knowledge about the churches.

Most of the churches have a basilican plan. Exceptions are Aachen (796–814), which is octagonal [**515, 525**], and Germigny des Prés (799–818), built by Bishop Theodulph [**516-518, 526**], which is a Greek cross inscribed in a square, with barrel-vaulted arms supporting a central tower over the sanctuary and domes resting on squinches over the angles of the square. There are some arrangements which are new:

1. Porch churches, with a raised western sanctuary allowing for easy passage into the nave.

2. Crypts built under the raised eastern sanctuary and projecting beyond it to make room for the worship of saints and for the tombs of the privileged.

3. Later, three parallel apses gave rise to the so-called Benedictine apse, as at St Philibert de Grandlieu (819), or in the crypts of Flavigny (807–864) and of St Germain at Auxerre.

4. The ambulatory (cathedral of Clermont-Ferrand; the abbey church of St Maurice at Agaune).

These new features created in the Carolingian epoch led to Romanesque art.

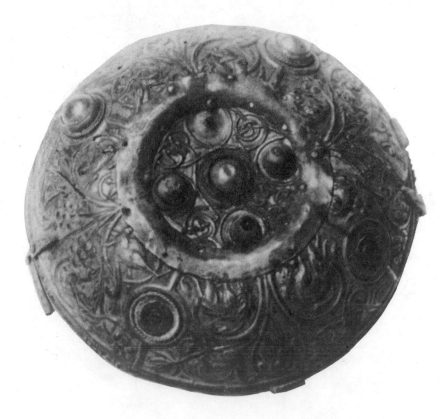

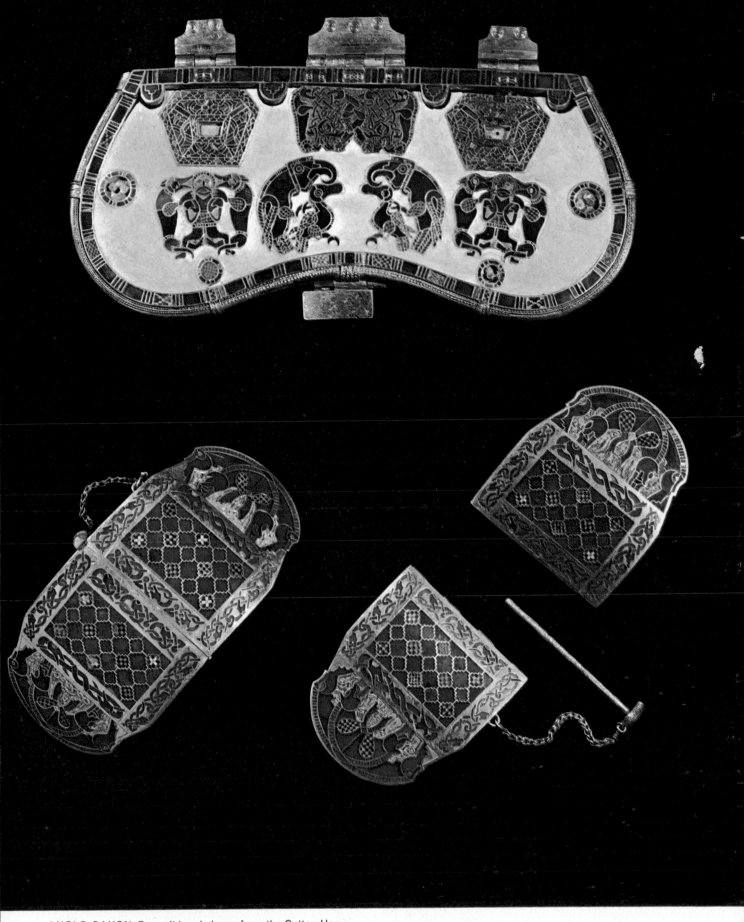

ANGLO-SAXON. Purse lid and clasps from the Sutton Hoo
ship burial. Gold, garnets and mosaic glass. Before *c.* 655.
British Museum. Photo: Thames and Hudson.

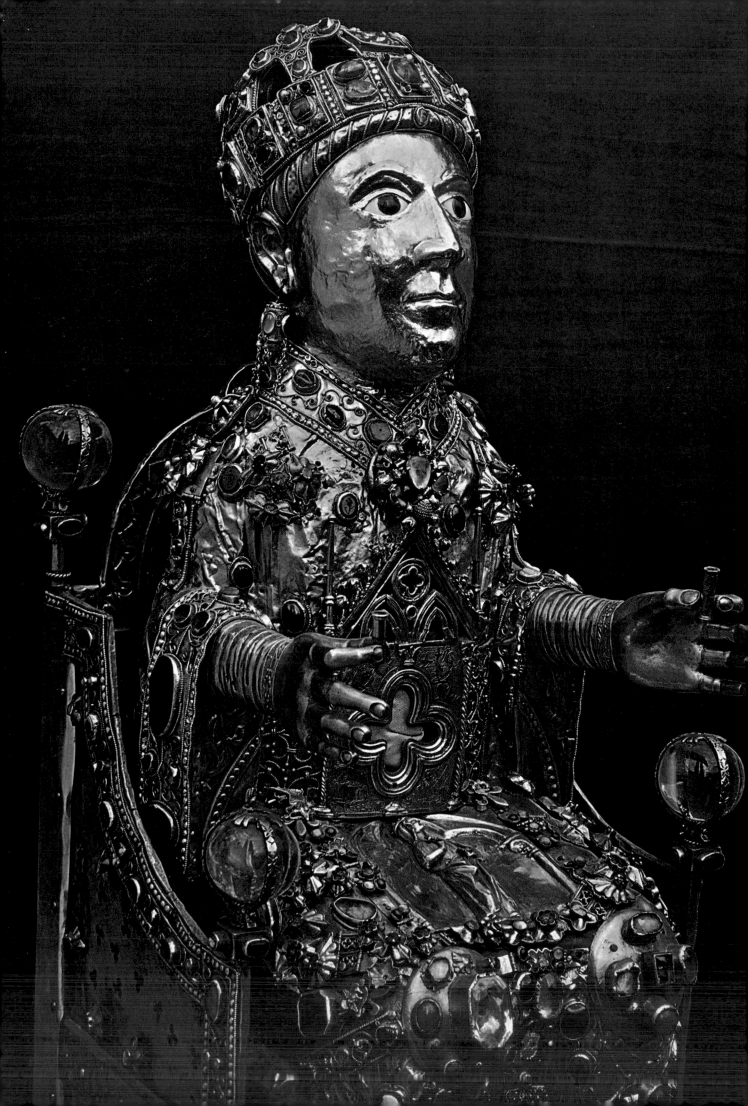

The structure of the buildings presents two innovations:

1. A new architectural system based on the wider distribution of stresses. Almost all the churches continued to be covered with a timber roof, with the exception of the apse; but the square pillars and the simple columns of the Merovingian and the Constantinian churches were replaced by cruciform piers (Aachen and St Germain at Auxerre).

2. Tower-framed façades made their appearance in Gaul in the 9th century (St Martin at Autun; St Germain at Auxerre).

Decoration was most important. It was not so much sculpture proper as a decoration of surfaces with painting, mosaic and goldsmiths' work.

Sculpture. Examples of stone sculpture found at Lorsch and Aachen show a skilful imitation of classical works.

There are beautiful examples of ivory carving [531]. From this small-scale sculpture and from the decorative goldsmiths' work the great monumental Romanesque sculpture was to develop. The Benedictine monk Tuotilo, painter, sculptor, poet and musician, is famous for his ivory carvings on the book covers of the Evangelium Longum of St Gall.

Painting. Mosaics were so numerous that they were placed *ex voto* at the entrance to the churches in thanksgiving for favours granted by saints. (It should be mentioned in passing that the mosaics at Germigny des Prés show many iconographic features which are not derived from the art of Rome, Ravenna or Byzantium [518]).

Especially noteworthy are the mosaics of the dome of Aachen (Christ surrounded by the twenty-four Elders).

The frescoes at Aachen no longer exist; but in St Germain at Auxerre (the life of St Stephen, 9th century [520]) the paintings of the crypt, discovered in 1927, show a remarkable mastery of monumental ornamentation in which only four colours were used: red ochre, white, yellow ochre and pale green. These frescoes, in which correctly proportioned figures move with ease, show, as do the frescoes at St George in Oberzell (see Ottonian Art), the influence of Italy in the scenes from the life of Christ and the Last Judgment. The recently discovered frescoes at Sta Maria del Castelseprio are closer to both Byzantine and classical art [510–512].

Illuminated manuscripts were the finest achievement of the Carolingian Renaissance. Conscious classicising was tempered by Celtic and Near Eastern influences. Favourite themes included figures of the Evangelists, royal portraits, historiated initials [532] and ornamental borders.

The two chief stylistically opposed groups were the Palace School and the Ada School. The Palace group inclined to linear impressionism and colour-washed pen drawing. Major examples are: the Vienna Gospels (early 9th century, Vienna); the Gospels of Aix (*c.* 800, treasury of Aachen); the Gospels of Bishop Ebbo of Reims (816–833, Epernay). The style of the Ada group, even more important for the Romanesque artistic ideal, shows a more monumental figure style and a use of more solid colours and of gold. Works of this group include: the Gospel for Charlemagne written by Godescalc (*c.* 781, Bibliothèque Nationale, Paris [528]); the Ada Gospels by Godescalc (*c.* 800, Trier cathedral); the Gospels Charlemagne gave to Abbot Angilbert of St Riquier (*c.* 800, Abbeville).

Notable scriptoria were at: (1) Tours: the Bible of Fleury (*c.* 818, Bibliothèque Nationale, Paris); the Bible of Charles the Bald (*c.* 850, Bibliothèque Nationale, Paris); (2) Reims: the Utrecht Psalter (*c.* 820, Utrecht [529]); (3) Metz: Gospel of St Médard of Soissons (early 9th century, Bibliothèque Nationale, Paris [521]); (4) St Gall: Psalterium Aureum (841–872, St Gall [530]).

The minor arts. The metalwork certainly indicated a revival of the Roman style (the bronze statuette of Charlemagne; the classical style of the lions' heads on the portal of Aachen, *c.* 800). Goldsmiths' work developed; the cloisonné technique was a tradition derived from the past (chalice of Tassilo, *c.* 780 [527]). The most outstanding work of the early 9th century is the paliotto of S. Ambrogio, Milan (824–835), by Wolvinus, given by Archbishop Angilbert of St Riquier, *c.* 835. In the second half of the 9th century St Denis was the centre of the technique in which the ornament is applied in high relief, combined with the technique of repoussé work. The cover of the Codex Aureus of Regensburg (Munich, *c.* 880) and the reliquary statue of Ste Foy at Conques (*c.* 960) in repoussé metal on a wooden base illustrate this. (See colour plate opposite p. 257.)

*Josèphe Jacquiot and
Evelyn King*

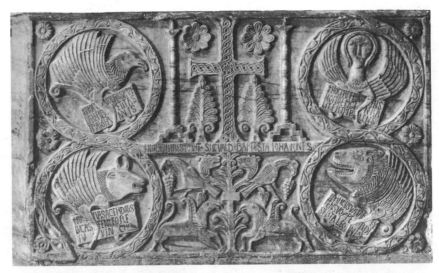

542. CAROLINGIAN. ITALY. Sigwald relief. The symbols of the Four Evangelists. Part of canopy over the font. 762–776. *Baptistery, Cividale.*

543. OTTONIAN. Registrum Gregorii, Trier. The Emperor Otto II (or III) with the symbols of the four parts of his Empire. *c.* 10th–11th centuries. *Musée Condé, Chantilly.*

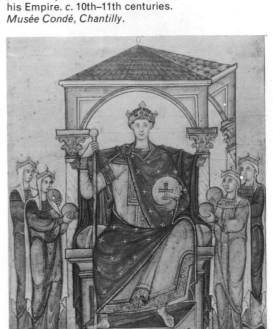

CAROLINGIAN. Reliquary statue of Ste Foy. End of the 10th century. *Church of Ste Foy, Conques. Photo: Réalités, Paris.*

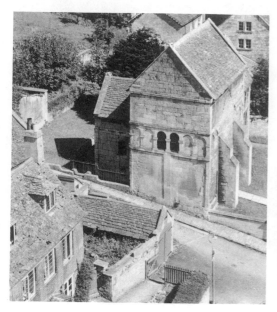

544. ANGLO-SAXON. The exterior of the church of St Lawrence, Bradford-on-Avon.

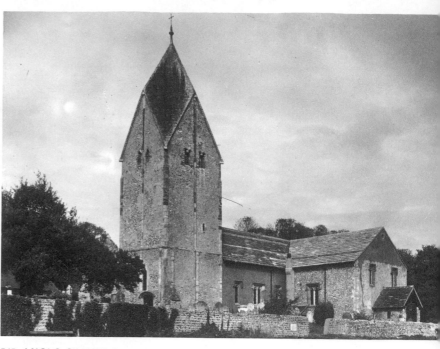

545. ANGLO-SAXON. Sompting church, Sussex, showing the Saxon tower from the south-west.

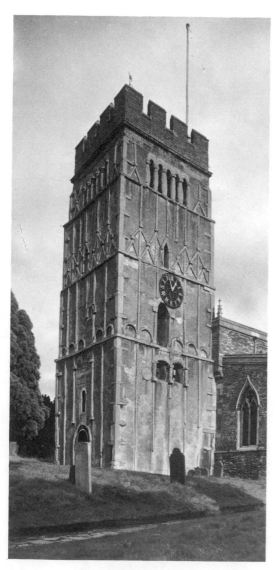

546. ANGLO-SAXON. The western tower of All Saints, Earls Barton. c. 935.

OTTONIAN ART

History. The 'Ottonian Renaissance' merges into Romanesque art and will be mentioned in that context. But we shall examine it here as an extension of the tentative aims of Carolingian art. It came to flower under the Ottonian dynasty, founded in 919 by Henry I the Fowler, of Lower Saxony (876–936), and continued until the Salian Emperors in 1024. Germany's great problems were the orgnisation of the feudal system, the struggle against the barbarians (the Slavs, the Scandinavians and the Hungarians), the formation of a dynasty, and, finally, the restoration, if possible, of the Empire for the king of Germany. It was Otto I, called the Great (912–973), who re-established the Empire by having himself crowned Emperor in Rome in 962.

Ottonian art was one of the results of this restoration. Taking up the political ideas of the Carolingians, the Ottonian rulers established close bonds with Italy and took an interest in artistic and intellectual activities. The Byzantine influence predominated during the reign of Otto II (955–983), who married a Byzantine Empress, Theophano, and during the reign of their son Otto III (980–1002). The latter's counsellors in Rome were the artist-bishop Bernward of Hildesheim and Gerbert of Aurillac, later Pope Sylvester II, a universalist, philosopher, theologian, mathematician and astronomer.

The great cultural centres were situated in the heart of the Holy Roman Empire, far from the coast ravaged by the Vikings and the Arabs. The most important of these centres was the Benedictine abbey of Reichenau, an island off the shores of the Lake of Constance, on the road to Italy. St Gall, Trier, Echternach, Cologne, Augsburg, Regensburg, Tegernsee and Salzburg were also important cultural centres.

Architecture and sculpture. Among the churches that have survived are the palatine chapel of Valkhof, Nijmegen, and St Cyriakus, Gernrode.

At the beginning of the 11th century the outstanding works of Ottonian sculpture were the bronze doors of the cathedral of Hildesheim, created by Bishop Bernward [534]. In 1060, biblical and mythological subjects were combined in the portals of the cathedral of Augsburg. The only surviving wooden doors of this period, with scenes from the New Testament, are at Sta Maria im Capitol, Cologne (c. 1050).

Painting. The important discoveries which brought to light a part of the paintings in the church of St George at Oberzell (before 997) [537] and the chapel of St Sylvester, Goldbach (late 10th century), testify to the major role played by Reichenau. Otherwise almost nothing remains of monumental painting from the period 950–1100, and only the illuminated manuscripts help us to form an idea of this. This style of painting was dominated by the concept of political power made manifest:

1. By portraits of emperors, kings and princes and their wives, representations of royal personages enjoying divine protection. They were perhaps inspired by the spirit of Byzantine paintings [543]. In the manuscript at Aachen Otto III (?) is shown in a mandorla, seated on a throne amidst symbols from the Gospels, as God's vicar on earth.

2. By the introduction of allegorical female figures representing the countries under the domination of the sovereign, as in the sacramentary (Munich) showing Henry II amidst provinces paying homage.

The most influential scriptorium was at Reichenau, on the Lake of Constance; outstanding manuscripts include the Codex Egberti, by Kerald and Heribert for

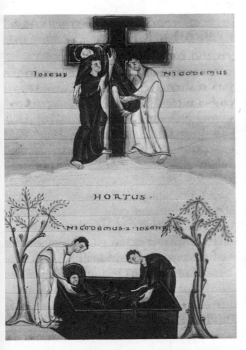

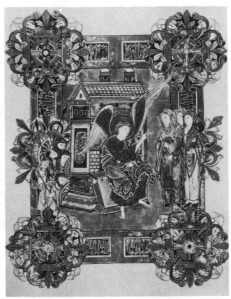

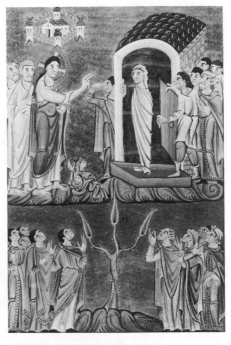

547. OTTONIAN. The Deposition and the Entombment. Codex Egberti. *c.* 980, for the Archbishop Egbert of Trier. *State Library, Trier.*

548. ANGLO-SAXON. The Three Marys at the Sepulchre. Benedictional of St Aethelwold. School of Winchester. *c.* 975–980. *British Museum.*

549. OTTONIAN. The Raising of Lazarus. Gospels of Otto III, *c.* 1000. *Bayerische Staatsbibliothek, Munich.*

Archbishop Egbert of Trier (*c.* 980, Trier [**547**]); the Sacramentary of Gero, Archbishop of Cologne (before 969, Darmstadt); the Gospels of Henry II, from Bamberg (1002–1014, Munich).

The influence of Reichenau radiated to other centres, through both its manuscripts and its scribes, although other influences are also apparent at: (1) Echternach: Gospels of Otto III (983–991, Munich [**549**]); (2) Cologne: Gospels of Abbess Hitda of Meschede (*c.* 1030, Darmstadt [**550**]); (3) Regensburg: Gospels of Abbess Uota of Niedermünster, showing the abbess presenting the manuscript to the Virgin (1002–1025, Munich).

The minor arts. Ivories continued the Carolingian tradition. The great centre remained at Metz [**535**]. But it was the goldsmiths' craft which produced the major works of art: the altar frontal from Basle (Musée de Cluny [**538**]), a relief in wood plated with gold, probably made at Reichenau about 1020; the Codex Aureus of Echternach (*c.* 990, Koburg); and the works of a remarkable school of goldsmiths at Essen—a Crucifix, a bronze candelabrum and a gold high-relief Virgin and Child, one of the oldest cult statues (treasury of Essen cathedral, 971–1011).

Lydie Huyghe and Evelyn King

ANGLO-SAXON ENGLAND

History. In the 9th century Wessex, with its capital at Winchester, succeeded to the supremacy of Mercia and Northumbria. Viking raids began in 835. Under Alfred the Great (871–899), whose mother Judith was the daughter of the Emperor Charles the Bald, there was renewed contact with the continent. In the 10th century there was a revival of monasticism under the influence of three great prelates: St

Dunstan, Archbishop of Canterbury 958–988, St Oswald, Archbishop of York 972–992 and St Aethelwold, Bishop of Winchester 963–984. There was a new spirit under the inspiration of Cluny and Fleury, and new monasteries were founded: Westminster abbey by St Dunstan, 960; the new minster, Winchester, by Edgar, 966.

Architecture. Until the Norman conquest architecture was largely an offshoot of Carolingian. Many of the earliest Saxon churches were probably of timber, like the log church of St Andrew, Greensted, Essex (*c.* 1013). The greater churches, at Canterbury, Durham, Ely and Sherborne, influenced by certain French monasteries such as St Riquier, have perished. Of smaller churches, the most complete is St Lawrence, Bradford-on-Avon (remodelled in the early 10th

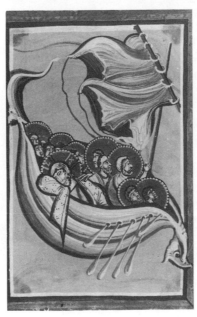

century [**544**]). Among the most important remaining features are towers: Earl's Barton [**546**]; Barnack; St Benet's Cambridge; Sompting (the last showing Rhenish influence in the original capping of its 'helmturm' [**545**]). The most important motifs are pilaster strips, blind arcading, baluster shafts and triangular-headed openings.

Painting. Illumination showed the influence of both the Palace and Ada groups, together with Irish calligraphy and Scandinavian animal ornament. The Utrecht Psalter was at Canterbury by 1000 (copy, *c.* 1000, Harley MS, British Museum) and contributed to the Winchester style (so-called though Winchester was probably not the only scriptorium). Examples include: the Sacramentary of Robert of Jumièges (*c.* 1008, Rouen); the New Minster Gospels (1016–1020, British Museum) and the masterpiece of the style, the Benedictional of St Aethelwold, by Godeman (975–980, British Museum [**548**]).

The minor arts. Both goldsmiths' work and ivories continued the Carolingian tradition: the Alfred jewel (871–901, Ashmolean Museum, Oxford [**539, 540**]); the Godwin seal (*c.* 1000, British Museum). Textiles included the embroidered stole and maniple of Bishop Frithestan of Winchester, found in St Cuthbert's tomb at Durham (909–916, Durham Museum).

Evelyn King

550. OTTONIAN. GERMANY. The Storm on Lake Genazareth. Gospels of Abbess Hitda of Meschede. Cologne. *c.* 1030. *Darmstadt Library.*

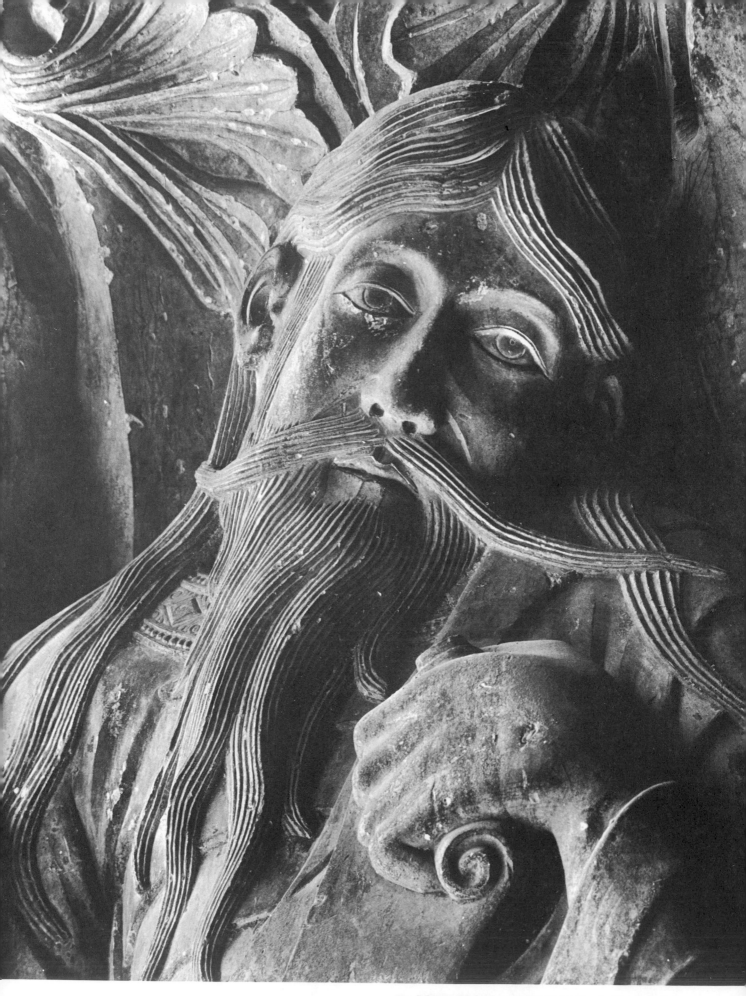

551. ROMANESQUE. LANGUEDOC. Head of the Prophet
Jeremiah, from a pillar on the portal of St Pierre at Moissac.
1130–1135.

ROMANESQUE ART *Jean Hubert*

*The new society was essentially based on the teachings
of Christianity. The collective life of the community required
ever larger buildings for worship. Architectural problems
assumed a specific importance; they became the predominant
factor in medieval art. To begin with, they increased the
interest in the example of antiquity. What remained of
barbarian art and Byzantine and Oriental influences was
integrated into the decoration of the new buildings, to whose
structural exigencies they were rigorously subordinated. Hand
in hand with the birth of the new architecture went the
revival of monumental sculpture.*

The term Romanesque art was invented by Charles de
Gerville, a Norman archaeologist, in order to define
Western architecture from the 5th to the 13th centuries.
Romanesque art was held to have succeeded classical art
in the same way in which the Romance languages re-
placed classical Latin. It was assumed that the arts had
progressed without interruption from the time of the
barbarians. Only later was it realised that with the
re-establishment of society and institutions after their
breakdown during the Norman and Magyar invasions
of the 9th and 10th centuries, architecture had taken on a
new character. As the term Romanesque art had become
established, it was then, as it is today, applied in a more
restricted sense to define the type of architecture and the
decorative arts which evolved in western Europe during
the reign of the Capetian kings in the 11th and 12th
centuries.

In the 17th century it was thought that the cathedral
of Chartres, with its statues and marvellous stained glass
windows, dated from the year 1000. It was long believed
that the oldest Romanesque churches in France went
back to the time of Charlemagne. Nobody considered the

552. ROMANESQUE. Interior of St Martin du Canigou
(Roussillon). Consecrated in 1026. Restored at the beginning
of the 20th century.

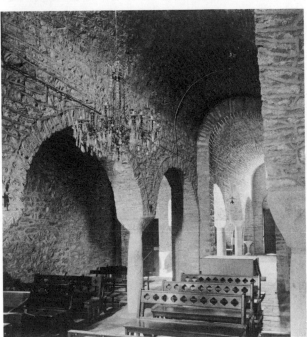

fact that a number of reliable documents gave as their
date of origin the 11th century, when the religious com-
munities which built these churches were founded.
National vanity and regional pride were responsible for
increasing their age. Uncertainty and pretence in this
matter are now being corrected. Our knowledge is suffi-
ciently advanced to show the close relationship between
social happenings and artistic creation. Nowhere did the
development of architecture precede the rebirth of cul-
tural life, which took place only after the Norman
invasions. The two were simultaneous.

The suddenness and breadth of this development dur-
ing the last third of the 11th century is startling. Two
stages can be distinguished in Romanesque art—infancy
and maturity. During the first, material resources were
limited and construction was poor and lacking in imagina-
tion. We call it the First Romanesque style, and it began
towards the end of the 10th century. Shortly after the
middle of the 11th century a new type of church build-
ing made its appearance, spreading over western and
southern Europe; these buildings had carefully dressed
masonry, were completely vaulted and were decorated
both inside and out. This was the Second Romanesque
style.

THE FIRST ROMANESQUE STYLE

In a chronicle written about 1048 in poor but expressive
Latin, the monk Raoul Glaber recalled a childhood
memory: 'In the years that followed the year 1000 we
witnessed the rebuilding of churches all over the universe,
but especially in Italy and Gaul. Even if there was no
need for it, each Christian community resolved to build
sanctuaries more sumptuous than those of its neighbours,
as if the world, anxious to cast away its rags, wished to
dress in a beautiful white robe of churches.' This fever
of building, attested by many texts, began during the last
years of the 10th century, shortly after the Norman and
Magyar invasions had laid waste the greater part of
France and northern Italy. The general state of insecurity
had been even more harmful to the arts than arson and
plunder. Schools, which had been restored or newly
established during the Carolingian period in the precincts
of monasteries and cathedrals, had ceased to teach; the
old workshops were scattered. In Paris in 1050 the abbey
of St Martin des Champs was still in ruins, and in the
Cité, close to the royal palace, the old cathedral of St
Etienne had a vineyard within its broken-down walls.

Only in the Germanic countries that escaped Norman
invasions did Carolingian art survive without interrup-
tion. Everywhere else throughout the old Empire the art
of building ceased to be practised for a long time, and
this had serious consequences. The abbey founded in
Aurillac about 900 by Count Géraud, the second church
of Cluny, begun in 955, and the crypt of the royal col-
legiate church at Etampes, erected in 1016 by Robert the
Pious, all show an alarming decline in technical skill and
decoration compared with the workmanship and beauty
of the Carolingian buildings. Although the lesson of the
past was not altogether lost in the north of France and in
the Germanic countries, the break was most decisive

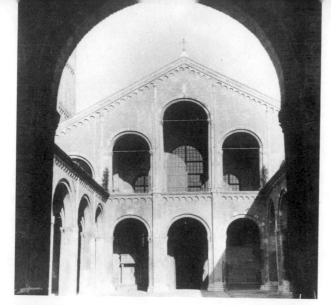

553. ROMANESQUE. LOMBARDY. S. Ambrogio at Milan. 850–c.1180

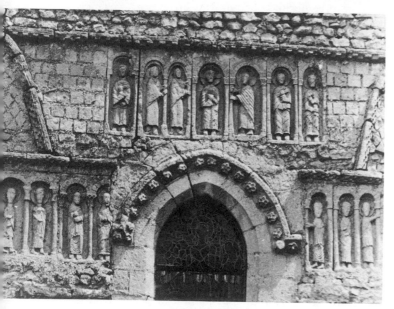

554. ROMANESQUE. LOIRE VALLEY. Figures in arcade. Bas-relief. Façade of the church at Azay le Rideau. Beginning of the 11th century. The dressed stones form a decorative ensemble with the ornamentation.

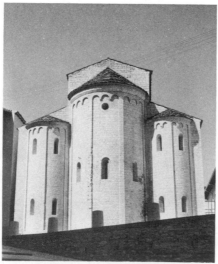

555. *Left.* ROMANESQUE. Plan of S. Pietro at Agliate. Prototype of a Lombard church with three apses.

556. *Right.* ROMANESQUE. ITALY. Sta Eufemia at Spoleto, showing Lombard bands.

precisely in those parts where later, in the Second Romanesque period, architecture developed most vigorously. In France this later development was the result of a continuous creative effort which owed its specific character to the fact that from the outset the masons had to rediscover the basic principles of their craft and adapt the sacred building to the growing needs of social and religious life. It was in religious architecture that Romanesque art reached perfection. Only later, in the 12th century, did castles, palaces and town halls reflect some of its splendour. In town and country there existed only one public building—the house of God. To build it and to adorn it, the offerings of the great and the faithful were added to the enormous sums the abbeys raised from their large estates, which at the end of the 11th century comprised almost one third of France.

The earliest Romanesque buildings

In northern Italy the churches were soon rebuilt, though the country had suffered severely from the Magyar invasions. From antiquity onwards the masons of Lombardy had a well-deserved reputation as skilful builders. Accustomed to working abroad during almost the whole of the 11th century, their workshops moving from place to place, they helped to rebuild churches all over Europe. This is proved both by documentary evidence and by the buildings themselves, all of which show similar features. Their plan, of great simplicity, consists of nave and aisles covered with an open timber roof. The arcades of the nave are supported by square or round pillars with plain block capitals. Three apses in echelon, vaulted with half- 555 domes, form the east end. The bays preceding them are sometimes vaulted. The walls, constructed with great economy, are composed of split small stones, carefully dressed to resemble Roman bricks. The outer walls, especially at the east end, are decorated in the same manner as the brick buildings of the 5th–8th centuries at Ravenna, with a corbel table on flat pilasters in flat 553, 556 relief, made of the same rustic stonework, running along the top of the wall below the eaves. With the larger buildings, this corbel table round the apse framed a series of niches which enlivened the surface of the upper wall. A bell tower of moderate height but good proportions rose usually at the side of the building, especially in northern Italy.

Lombard masons were active from Catalonia, Roussillon, Languedoc and Provence to as far as the north of Burgundy and the Rhine valley. A map of the regions 693–696 where their activity can be traced would indicate the magnitude of the damage inflicted on a large part of Europe during the upheavals in the 10th century; it would also show the extent to which local workshops were scattered, and the creative efforts of man stifled. In some of these regions, however, a few signs of independent initiative can be found. One example is the monastery of St Martin du Canigou, in the foothills of the Pyrenees, founded by Count Guifre de Cerdagne, the church of which was consecrated in 1026. The church has two storeys with semicircular vaults. They are of modest span and are supported on columns similar to 552 those supporting the walls of a timber-roofed basilica. The capitals have a sketchy floral decoration in flat relief. Both vaults and capitals point on the one hand to neighbouring Catalonia, the border province of Carolingian Spain, where vaults over small spaces were the general

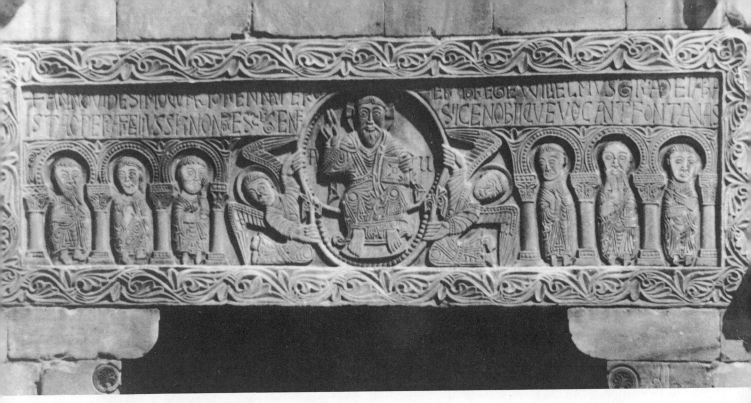

557. ROMANESQUE. LANGUEDOC. Bas-relief in marble (1019–1020) at St Genis des Fontaines. Christ in Majesty, in a mandorla carried by two angels between Apostles. Example of undercut sculpture imitating the technique of goldsmith's work.

practice, and on the other hand to the proximity of the Mozarabic countries, which benefited from the brilliant Arab civilisation of the late 10th century.

The revival of sculpture on marble altars, which made its first appearance at this time in Roussillon, must have been due to the same cause. The most remarkable works are two retables in bas-relief at St Genis des Fontaines and at St André de Sorède. The first, according to an inscription, dates from 1019–1020. Both represent Christ and the Apostles and are obviously copies of Carolingian goldsmiths' altars. Though clumsy in execution, they have such a pronounced character that they were used in the 12th century as door lintels on the façades of the two churches. In Roussillon, as in Burgundy, churches were built in the technique of the Lombard masons. Typical examples are the collegiate church at Châtillon sur Seine, founded about 1015, and the abbey of St Philibert at Tournus, rebuilt in the 11th century after the fire in 1019. At Tournus the two towers of the façade rise in front of a large two-storeyed vaulted porch. Although piers and walls were constructed in the Lombard manner, the porch is typical of Burgundy, being a Carolingian survival like the large oratory of circular plan built by Abbot William of Volpiano about 1015 at the east end of St Bénigne at Dijon. There can be no doubt that Carolingian works of architecture survived in Burgundy, which was relatively safe from the impact of Norman incursions.

On the other hand destruction was great in the valley of the middle Loire. But the people of the Touraine enjoyed a measure of peace long before the inhabitants of the Seine valley did. Their abbeys were rebuilt a quarter of a century before those of the Ile-de-France. In the 11th century, buildings of the First Romanesque style in the Loire valley showed more original features than did those in regions which had been subjected to a strong Lombard influence. The ground plans are extremely simple. The abbey church at Beaulieu, near

Loches, founded about the year 1000 by Fulk Nerra, one of the most turbulent men of his time, consists only of one large rectangular hall covered with an open timber roof. As the century advanced, church plans became more complicated. A square chancel divided into three bays by small piers supporting vaults of narrow span was added to the timber-roofed aiseless nave. In some cases the bays preceding the chancel were also covered with vaults.

The limestone found in the Loire valley, light in weight and easy to cut, facilitated the construction of vaults which posed no particular structural problems and also replaced the rusticated walls of broken stones by walls built of regular courses. Furthermore, before the end of the First Romanesque period the Loire country became known for its decorative dressed stone and its sculptural friezes. The technique of ornamental dressed stone, which goes back to antiquity, was perfected in the 11th century. The outer surface of the wall presented a kind of stone mosaic displaying motifs comparable to, but more varied than, those of terra-cotta tiles. The smaller elements were cut in series in the quarries and transported by water along the Loire to the building site. The sculptured friezes followed the same principles of an industrialised art. The interchangeable rectangular slabs, having various scenes and motifs on their carved surfaces, were generally displayed on the upper part of the walls. Though the artistic quality of the single slabs was rather mediocre, as a whole, in combination with the patterned stonework, they gave the façade of the building a new formal expression. Were these friezes of the Loire valley the forerunners of monumental sculpture? Although we cannot trace any direct connection between the friezes on the façade of St Mexme at Chinon and the portal at Moissac, they do present the first tentative efforts to transfer to the exterior of the churches decoration in stone hitherto reserved for the altar and the tomb of the saint, within the sanctuary. The decorated fonts and the carved

263

façades of the churches in the south-west of France of the Second Romanesque style were no doubt their descendants.

Architecture in the north of the Loire is simpler in style and more severe. The ruins of the old cathedral of Alet, St Servan, the collegiate church of Notre Dame at Melun (founded by Robert the Pious), Notre Dame de la Basse Oeuvre at Beauvais, the walls of the old cathedral of Verdun (discovered during excavations of the present building), all testify to the survival but also to the decline of Carolingian construction. Characteristic of this decline is the disappearance of moulded cornices. Notre Dame de la Basse Oeuvre at Beauvais, rebuilt in the second half of the 10th century, is of a depressing monotony, with its bare walls and its arcades devoid of mouldings.

The Germanic Kingdom and Ottonian art

The main centres of Carolingian civilisation extended over Franconia north of the Loire and the Germanic countries. But during the second half of the 9th century the activities of the great monastic workshops at Tours, St Denis, Reims, Metz and Corbie declined and then died out. Other centres came into being further to the east and prepared the way for the Ottonian Renaissance.

Founded in 887, the Germanic kingdom included from the beginning of the 10th century Saxony, Franconia, Allemania and Bavaria. The Holy Roman Empire, established in 962 when Otto I was crowned Emperor by Pope John XII, extended its frontiers from the North Sea to the Adriatic and the Mediterranean. Here, as in France, the influence of Lombard masons was evident. But the real impulse for the rebirth of the arts—an imposing offshoot of the Carolingian civilisation—came from the Imperial court and the important episcopal seats.

The palace at Aachen remained from the beginning of the 9th century the symbol of the power and splendour of Imperial institutions. In the Ottonian epoch the famous polygonal Palatine Chapel commissioned by Charle-
515 magne served as a model for other palatine chapels built by the Emperor and patrons of high rank at Nijmegen, Sélestat, Liège, Muizen, Ottmarsheim in Alsace, Essen, Groningen and Mettlach. The remains of the cathedrals of Mainz, Worms, Strasbourg, Paderborn and Regensburg, still visible among later reconstructions or traceable from excavations, are of remarkable size. Following Carolingian tradition, equal emphasis was placed on the east and west ends of the church. The most impressive example of German architecture of this period is the ruin of the abbey of Limburg in the Hardt Mountains. Truly Imperial in proportion and size, this church was built between 1025 and 1042 for a monastery founded by Conrad II. The chancel terminates in a straight wall. Both chancel and transept have a series of blind arcades which serve both as decoration and to strengthen the masonry. An impressive row of columns divides the nave
559 from the aisles; the plan is that of a timber-roofed basilica of the early period. In St Michael at Hildesheim, a contemporary building, there is the same division of the nave into regular bays, but columns alternate with rectangular piers. The stonework of the German churches was executed with greater care than that of the French churches, and we occasionally find interesting moulded profiles which are somewhat heavy but of good proportions.

Adherence to Carolingian tradition was even more pronounced in metalwork. A remarkable school of goldsmiths and metalworkers flourished in the abbey of Essen around the year 1000. There can be no doubt that the two golden Crosses embellished with filigree work, precious stones, cameos and small enamel plaques, and the beautiful seven-branched bronze candelabrum, all in the treasury of the cathedral of Essen, date from this period, as they bear the name of the Abbess Matilda (971–1011), sister of Duke Otto. Some decorative details, especially the cameos, show Byzantine influence, but they are treated with great freedom. No date is available for the strikingly realistic Virgin and Child, a small wooden statue covered with gold leaf, but the filigree work of the small sphere, symbol of the world, that the Virgin is holding in her right hand points to the first half of the 11th century. The high reliefs on the bronze doors of the cathedral of Hildesheim (origi- 534 nally made for St Michael's and transferred to the cathedral), representing scenes from the Old and New Testaments, with their sensitive human figures in correct proportion, are among the masterpieces of the religious art of all times. From the same period we have the gold altar frontal from Basle cathedral (Musée de Cluny, Paris) 538 and the ambo of Aachen, both gifts of the Emperor Henry II, the last ruler of the Saxon dynasty, who died in 1024. This altar frontal, like the gold altar of St Denis, is an unmistakable offspring of Carolingian goldsmiths' work and directly anticipates Romanesque sculpture. Ottonian art owed its origin to the patronage of a few great Emperors who had the ambition to rival the sumptuous arts of the Byzantine court. What they achieved in goldsmiths' work was a kind of short-lived miracle, whereas bronze work, deeply rooted in local tradition, especially in the Meuse valley, continued to develop. The German achievements during the Ottonian period in metalwork and ivory carving taught a lesson which was not lost on the rest of Europe. Cluniac Burgundy was close to the Germanic Empire. It is likely that monumental sculpture in the Second Romanesque period was inspired by these examples.

THE SECOND ROMANESQUE STYLE

During the First Romanesque period Europe was mainly concerned with rebuilding and repairing the ruins which had accumulated during the Norman and Magyar invasions. Frequently foreign craftsmen had to be called in to do this work. When peace had returned it was still a long time before a social organisation worthy of the name was established. Poverty, ignorance and anarchy retarded the development of the arts. The coming of the artist was preceded by that of the craftsman. The many new masons' yards had the effect first of gradually training a number of masons in the technique of construction and then of bringing forth real architects. What these men lacked in experience (having been, for a century, without schools and workshops) they supplied in invention.

A new problem, the vault

During the First Romanesque period nobody in Europe who built a church consisting of an elongated nave preceding a sanctuary would have thought of covering this large space with a vault. Moreover, a wall built of Lombard stone did not lend itself to vaulting. Having decided, towards the beginning of the 12th century, to vault the nave of their church, the builders of St Philibert at Tournus had to resort to the device of covering the nave

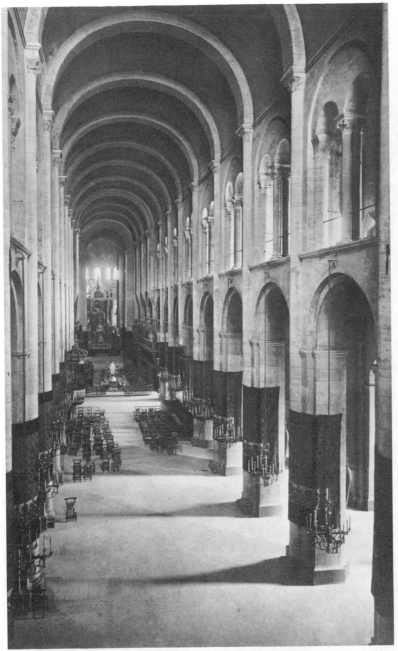

558. ROMANESQUE. LANGUEDOC. Barrel vault with transverse arches. St Sernin at Toulouse. 11th century.

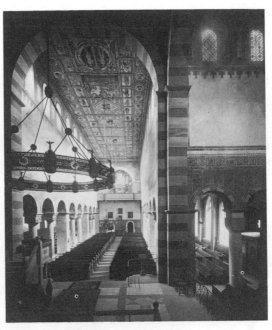

559. ROMANESQUE. GERMANY. St Michael, Hildesheim. 1001–1033. Timber ceiling *c.* 1200.

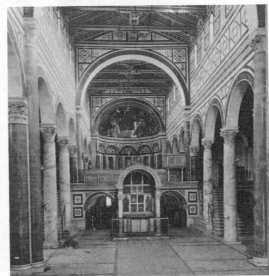

560. ROMANESQUE. ITALY. Nave, S. Miniato, Florence. 1013.

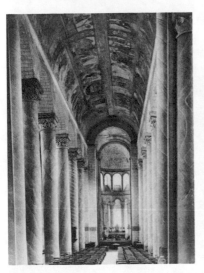

561. ROMANESQUE. LOIRE VALLEY. Barrel vault. St Savin sur Gartempe (Vienne). *c.* 1100.

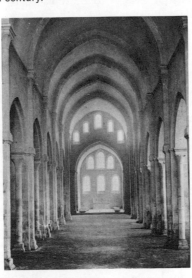

562. ROMANESQUE. BURGUNDY. Barrel vault with pointed arch. Abbey church at Fontenay. Cistercian. 1139–1147.

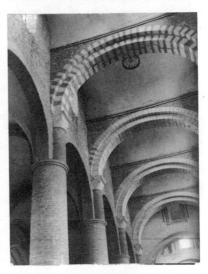

563. ROMANESQUE. BURGUNDY. Nave covered with transverse barrel-vaults. St Philibert at Tournus.

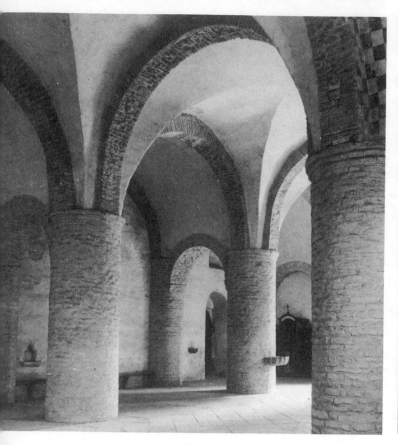

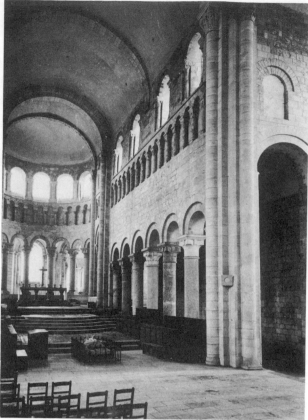

564. ROMANESQUE. BURGUNDY. Groined vault. Nave of narthex (*c.* 980–1000), St Philibert at Tournus. (Transverse barrel-vault over aisles.)

565. ROMANESQUE. LOIRE VALLEY. St Benoît sur Loire. 11th–12th centuries. Choir showing windows above the blind arcades at the springing of the vault.

563 with a series of transverse barrel-vaults (barrel vaults going across the width of the nave) to avoid undue stress on the lateral walls. In the region of the middle Loire the lightness of the local stone made it possible to cover the sanctuary with narrow vaults, but the use of dressed stone, a surface decoration that tends to weaken rather than strengthen the wall, is sufficient proof that there was as yet no intention of extending the vault along the entire building.

559, 560 Towards the second quarter of the 11th century the nave of the larger churches was still covered with a timber roof and wooden ceiling. The vaulting of the entire building was the achievement of the Second Romanesque style. However, the replacement of a light wooden ceiling by a heavy stone covering—a simple problem today—presented at that time great difficulties, implying a readjustment of the entire structure of the building.

A few preliminary technical explanations are necessary: to cover a hall with a wooden ceiling and timber roof, a number of wooden beams placed at regular intervals above the space to be spanned will offer enough support for the covering. Large trees, numerous in the medieval forests, provided beams up to a length of nearly 60 feet. Even poorly built walls could support the extremities. If the ceiling is to be replaced by a vault, the space has to be bridged by a number of small units instead of a large single unit. The vault is formed by a succession of juxtaposed arches. To build an arch a projecting moulding called the impost is placed on top of the supporting wall or pillar (the part bearing the arch); on this the mason fixes a provisional wooden casing called centring on which he arranges the voussoirs, which are wedge-shaped stones. Under the pressure of weight the voussoir tends to push the neighbouring stones to the left and right; whereas the beam transmits a simple vertical thrust, the arch

exerts an oblique one upon its support. The larger the span to be bridged or the higher the support, the more difficult it becomes to counterbalance the oblique thrust. This thrust can be reduced if the fully semicircular form is pointed in the upper part, thus eliminating the keystone 562 which exerts the greatest pressure. Almost the whole story of building during the Second Romanesque style is that of a stubborn struggle against the problem of the oblique thrust of the arch and the vault.

The chronicles of the 10th and 11th centuries frequently report fires destroying within a few hours churches with wooden ceilings. To prevent these accidents, wood had to be replaced by stone. But this is not the complete

566. St Benoît sur Loire. Interior of porch below the bell tower. After 1067.

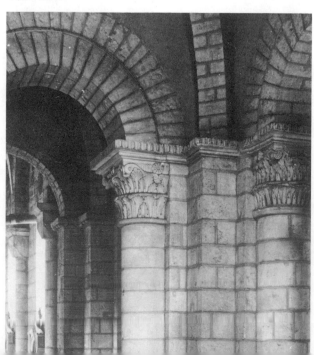

explanation for the prodigious development of Romanesque art. The Germanic countries and a great part of Italy continued for a long time to cover the large naves of their churches with wood roofs without suffering serious damage. To successfully vault not only the sanctuary which sheltered the altar and the choir where the clergy had its place but the entire body of the sacred building, was an ideal for religious architecture to execute whenever material conditions and the advance of technique permitted it. The temple is the palace of God; it must be stronger in construction, more impressive and more beautiful than any other building. When at the end of the 11th century the wooden ceiling of the nave of St Hilaire at Poitiers was replaced by a stone vault, a contemporary witness wrote that this was done 'to protect the building from fire and to give greater perfection to its structure'.

For the history of vaulting in the Second Romanesque period we rely mainly on the evidence of buildings which have been preserved or on documentation that has come to light concerning many buildings which no longer exist. Although many links in the chain of our knowledge are missing, there is enough material available to describe the general characteristics and the important stages in the evolution of technical problems as they have taken place over a large area.

The rise of a new architecture

During the Carolingian period the barrel vault and the groined vault were used to cover both ends of the great monastic churches—the two-storeyed sanctuary and the narthex, or porch. The church of St Martin du Canigou possessed in 1020 a fully vaulted nave and aisles, but of very modest dimensions, not exceeding those of the crypt of the cathedral of Auxerre, a much more skilful building completed about 1050 which foreshadowed the future solutions. In St Martin du Canigou the barrel vaults of the nave are supported by simple monolithic columns, and they have stood firm only because their span did not exceed 9 feet. The crypt of Auxerre on the other hand, which is 39 feet wide, is divided into a nave and two aisles by two rows of well-cut stone piers of quatrefoil plan. This was the Romanesque compound pier, which shows a notable progress compared with the Carolingian pier of cruciform section with only very slight projection. The half columns engaged to the masonry of the piers, with which they form a structural unit, face the nave and the aisles and continue vertically to support a succession of solid transverse ashlar ribs which reduce the thrust of the vaults and prop up the whole structure. The mouldings are summary; the workmanship of the capitals is poor. Nevertheless, the crypt of Auxerre is the starting point of a new architecture. The walls, built of hard dressed stone, and the replacement of simple piers by ｎd piers mark a step forward of great consｅ ｆ which, according to texts of the time, conｅｓ were fully aware.

ｉr of Vignory (Haute-Marne) is, like Auxerre, ｎument of ancient Burgundy (the church, a ｂey of St Bénigne at Dijon, was built 1059). The timber-roofed nave is a few rustic appearance of the outer walls of es no indication of the skilfully executed vering the interior of the sanctuary and tory and radiating chapels. The arcades of

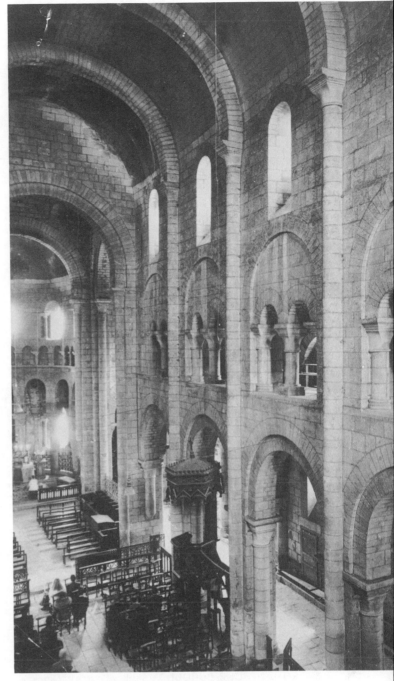

567. ROMANESQUE. Interior of St Etienne at Nevers. 1083–1097.

the ambulatory are supported by columns alternating with piers. Two capitals are decorated with lions facing each other and with floral palmettes. The same lions recur on a bas-relief of the ancient priory of Salaise (Isère), which proves that workshop models supplied the masons with the elements of the sacred imagery for the decoration of churches and, moreover, that distance counted for little in an incipient France whose feudal divisions rarely presented obstacles to the widespread exchanges encouraged by the growing size and importance of the monastic domains.

The first naves with barrel vaults supported by transverse arches which can be dated with certainty are those of Quarante (c. 1063) and St Guilhem le Désert, in Hérault. The vaults are supported by simple piers of early cruciform shape; the upper walls of the nave are not pierced by windows; the span of the nave is of modest dimensions. The vaulted choir of St Savinien at Sens (c. 1070) shows some new arrangements, but these are

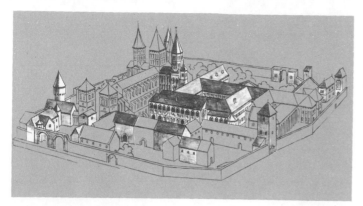

568. ROMANESQUE. BURGUNDY. Abbey church of Cluny (Saône-et-Loire). From an 18th-century drawing. The shaded parts show the present buildings. (*After Michelin.*)

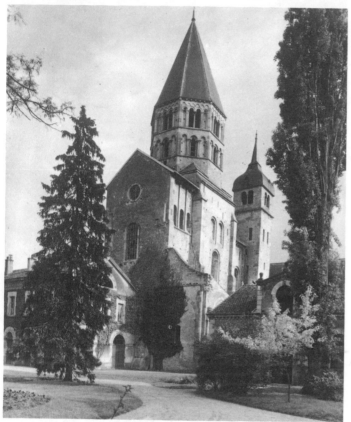

569. ROMANESQUE. BURGUNDY. Abbey church of Cluny. Begun in 1088; completed before 1118; the greater part of the building was demolished between 1811 and 1823.

of more interest for the elevation than for the plan. The carving of the capitals is still very primitive; a string course runs along the foot of the abacus. This very simple decoration adorns the imposts and piers in churches of rustic appearance; these churches formed a homogeneous school between the Loire and the Seine towards the end of the 11th century.

The most important building in the region of the middle Loire was the new abbey church of St Benoît sur Loire. Reconstruction began at both ends about 1068. The new choir was laid out on a large plan in the form of a cross of Lorraine, with two transepts. After the completion of the arcades, contrary to the original plan it was decided to put a barrel vault supported by transverse arches over the nave, which had a span of $32\frac{1}{2}$ feet. The summit of the vault had to be raised 65 feet above the ground. This was a new and rather daring experiment. The windows on both walls just below the springing of the vault permitted a flood of light to enter but weakened

565, 566

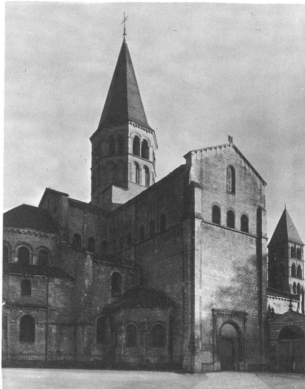

570. ROMANESQUE. BURGUNDY. Paray le Monial (Saône-et-Loire). Begun in 1109 under the patronage of St Hugh, abbot of Cluny. Restored in the 19th and 20th centuries.

the supporting walls. A row of blind arcades was therefore inserted into the wall between the base of the windows and the arcades — an ingenious device for strengthening the masonry and at the same time decorating the walls. The arcades were completely integrated into the face of the wall in such a manner that each capital and base was shaped by a stone which formed at the same time a part of the wall masonry. The close bond between the two stiffened the latter from the inside, effectively counteracting the thrust of the vault. The blind arcades became a characteristic of Romanesque architecture in Berry, Burgundy and other provinces.

Another characteristic of the Second Romanesque style is the dome of carefully dressed stone mounted over the crossing. In St Benoît sur Loire the transition from the square to the circular plan was obtained by squinches at each corner. This rather clumsy device should remind us that St Benoît was one of the earliest of the large Romanesque domes which has survived in France. Several of the figured capitals surmounting the enormous piers of the crossing of the main transept, strangely barbaric in appearance, are older than those of the choir, dating probably from 1068 when the building was begun. The capitals of the porch on the other hand, dating from some twenty years later, are admirably executed. The skilful order in which the piers of this porch are arranged, their accomplished mouldings, the combination of expressiveness and restraint in the figurative display and, above all, the perfect harmony between structure and ornament, show the strides made in the half century since the crypt of the cathedral of Auxerre had been erected. The narthex of St Benoît sur Loire produces the illusion of a forest in stone penetrated by light from three sides, a kind of exalted anteroom of prayer which the monks had placed at the threshold of the temple, facing the Loire from which the masses of the faithful went ashore in the days of pilgrimage. Its powerful architecture is of great perfection, a masterpiece, but the last of its

566

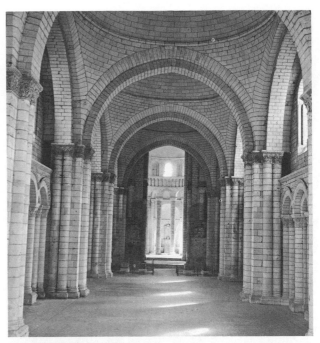

572. ROMANESQUE. LOIRE VALLEY. Nave of the abbey church at Fontevrault (Maine-et-Loire). Consecrated in 1119. Note the domes of the vault.

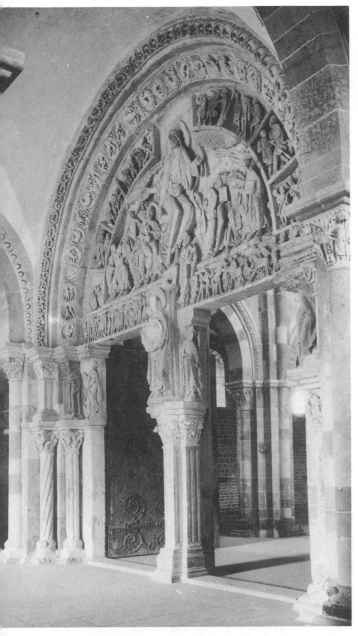

571. ROMANESQUE. BURGUNDY. Central portal of the narthex of La Madeleine at Vézelay. *c.* 1125–1130. Completed in 1140.

kind. Its completion preceded by only a few years the creation of the monumental portal of the façade where not a single column was permitted to obstruct the view of the whole.

St Etienne at Nevers, the first church to be completely vaulted

The stones of which St Benoît sur Loire was built came from the excellent quarries around Nevers. In Nevers itself, the abbey church of St Etienne is the oldest building preserved which combines harmoniously and skilfully all the characteristics of a Romanesque church entirely covered with vaults.

St Etienne, the church of a monastery which came under the rule of Cluny in 1068, was rebuilt between 1083 and 1097 under the patronage of Guillaume, the powerful count of Nevers. Though erected twenty-five years later than St Benoît sur Loire, this church, being of smaller size, was completed in fifteen years. Its total width

567

including nave and aisles is 49 feet, the nave not exceeding 23 feet. The spanning of so reduced a space encouraged a daring architect to apply to the whole of the nave a construction attempted a few years earlier in a modest way over the west end of Tournus which preserved two outstanding qualities of the pre-Romanesque basilica — spaciousness and light. This was achieved by placing a gallery above the aisles and by direct lighting through high windows in the nave. In section the vault over the galleries is a quarter of a circle, its summit propped like a buttress against the upper part of the nave wall at the point just below the base of the window; this counteracted effectively the oblique thrust which the great barrel vault exerted on a wall weakened by the pierced opening of the windows. The first instance which has survived of an overall uniform structure which has been fully carried out, is St Etienne. It coped effectively with the serious difficulties resulting from insufficient resistance to the lateral thrust of the central vault. If the barrel vault is supported by a simple wall or by supports such as the ones in the timber-roofed basilicas, as was the case in St Benoît sur Loire, the thrust is diffused and is therefore more difficult to control. It was thus desirable to canalise it. This was achieved by linking the transverse arches or ribs so closely with the piers that the one was but a continuation of the other, with the result that the arch or rib became the framework of the vault and the pier the skeleton of the wall. External buttresses placed exactly along their axes sufficed to combat and to neutralise the thrust.

565

664

A new decorative principle was introduced simultaneously with these structural innovations. From the compound piers, the arches of the great arcades branch off lengthwise in succession; crosswise and higher up are the transverse arches of the vault. The succession of the compound piers and the arches which prolong them creates the rhythm of the bays, a harmonious order introduced into the interior of the church by the relief of the vertical lines and by the distribution of light and shade.

269

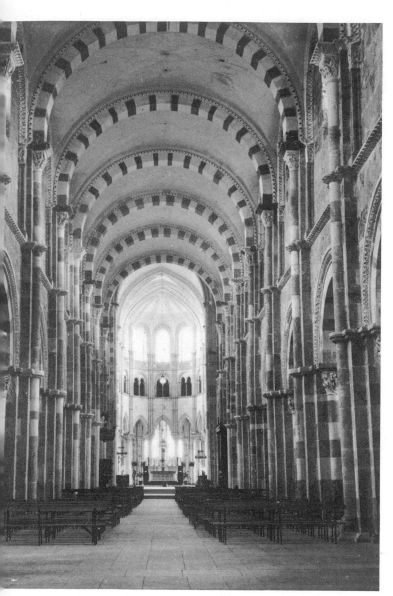

573. ROMANESQUE. BURGUNDY. Nave, La Madeleine, Vézelay. 1120–1140.

As regards the arrangement of the supports and bays, Gothic construction derives directly from these structural innovations of the Romanesque buildings of the end of the 11th century. Making their first appearance in St Etienne at Nevers, these innovations indicate a definite break with the system of the pre-Romanesque basilica, with its fragile columns and its flattened walls clearly set off against the ceiling. They present one of the most decisive steps in the evolution of medieval architecture.

Cluny, capital of a new empire

The end of the 11th century, which witnessed the first crusade, was a time of great enterprise. On his journey through France in 1059, Pope Urban II consecrated twenty abbey churches which were being rebuilt, most of them on greatly enlarged plans. They bear witness to the power the monastic orders had obtained after a century's effort of restoring and then increasing their temporal possessions by new foundations in and outside France.

Of all the monastic orders in France the most prominent was Cluny, under whose rule were two thousand monasteries served by over ten thousand monks. In Cluny itself there were three hundred choir monks, and it was for them that the new church, stupidly demolished in 1811, had been erected between 1088 and 1118. We know from remains and excavations the general layout of this immense and admirable building which in the 12th century served as a model for Paray le Monial, a priory of Cluny, for the collegiate church of Notre Dame at Beaune and for the cathedrals of Autun and Langres. Under direct patronage of Rome, the mother church of Cluny was frequently described as a second Rome. Replacing an older church, St Pierre le Vieux (Cluny II), 164 feet long and built at the end of the 10th century, the new building, 426 feet long, had the exact length of Old St Peter's in Rome, the symbol of the 'first' Rome. At its west end there was a huge narthex as large as another church—a northern version of the atrium with porticoes of the Constantinian basilica. St Pierre at Cluny and St Peter's at Rome had both the same length and the same nave flanked by a double row of aisles. But the resemblance goes no further. The Constantinian basilica surpassed Cluny in its immense interior space which could only be spanned by a timber roof, whereas the builders of Cluny had the ambition of attaining the highest possible elevation by using the most advanced techniques of the time. The vaults and arches which were adopted to

568, 569

574

570

574. Plan of the abbey church of Cluny.

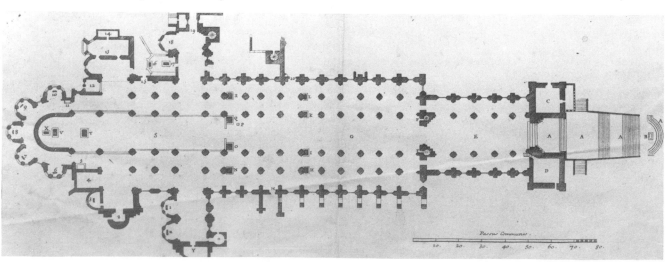

cover the building were pointed to reduce the thrust which would have come from semicircular vaults. But it was imprudent to raise them to a height of 91 feet in the nave, with its lateral walls already weakened by windows, and in spite of the support of the double row of vaults over the aisles and the massiveness of the piers, the vaults collapsed in 1125. The ambition of the medieval architect to repeat the dimensions of ancient classical edifices was frustrated by the laws of statics.

573 The nave of the abbey church of Vézelay, begun in 1120 and completed in 1140, marked a further step in the evolution of medieval architecture from Cluny to the Gothic cathedrals. After Cluny, Vézelay was the richest abbey in Burgundy. Her monks wanted their new church to equal Cluny, if not in width at least in length. The collapse of the great vaults at Cluny taught the architect of Vézelay a lesson. He preferred to span the nave with 575 a groined vault, which with its four sections produced a better distribution of the thrusts. It also made it possible to pierce the windows in the upper part of the nave wall without endangering its stability. A careful tapering of the piers and the strength of the transverse arches assured the solidity of the whole structure. This arrangement was another of the various experiments leading directly to the rise of Gothic architecture. For the cross-ribbed vault is in effect a groined vault having ribs to emphasise and strengthen the four groins.

We must go back a few years to summarise the great number of innovations made by architects towards the end of the 11th century in order to solve the problem of vaulting entire church buildings. The most usual method of buttressing the nave was to cover the aisles, which were either one- or two-storeyed, with quadrant vaults. Churches of this type occur from the Loire down to Provence. A few buildings in Provence and in the Auvergne date only from the second half of the 12th 8, 589 century, but the larger ones, the great abbeys of Ste Foy 582 at Conques, St Martial at Limoges and St Sernin at Toulouse, and the famous collegiate church at Santiago de Compostela in Spain, post-date St Etienne at Nevers by only a few years. At St Etienne the architect, in view of the modest span of the nave, could raise the walls of the main arcade from the abutment of the lateral arches up to the springing of the main vault, a fairly good height, in order to provide space for the top windows. Unfortunate experiences no doubt brought home the danger of such an arrangement, and for this reason it was only rarely repeated. At the end of the 11th and during the 12th centuries the most usual solution was the use of quadrant vaults to support the springing of the barrel vault over the nave. This arrangement gave the building an unfailing stability, but it submerged it in a sort of twilight — as very little light passes through the windows of the aisles and the galleries — which spread over the whole interior an atmosphere of mystery and contemplation hitherto restricted to the crypt under the apse, built round the tomb of a saint.

In the west of France, especially in Poitou, a simpler solution was adopted which also deprived the nave of direct light. The quadrant vault of the aisles was replaced by a fully semicircular one, raised almost to the level of the main vault. The latter, solidly secured by the lateral vaults, did not need to be strengthened by transverse arches and could rest on simple supports. In the interior the vault presented a long, smooth surface, running with-

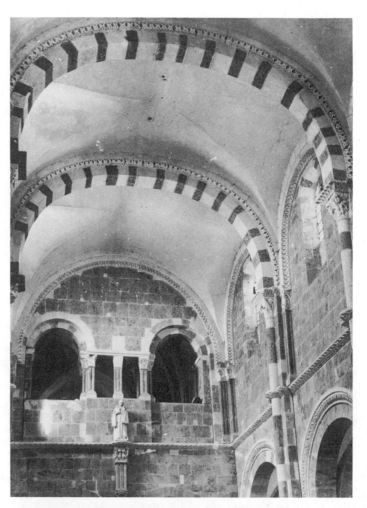

575. ROMANESQUE. BURGUNDY. Groined vault with transverse arches. La Madeleine at Vézelay (Yonne).

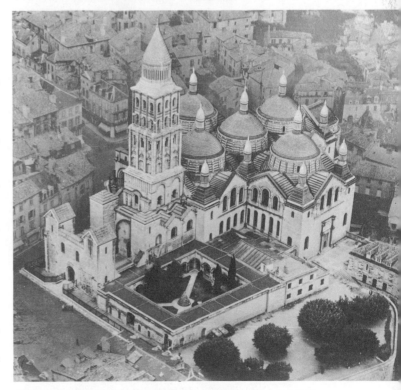

576. ROMANESQUE. PERIGORD. Aerial view of St Front at Périgueux. Church covered with domes, arranged in form of a Greek cross. 1120–1160. Restored in the 19th century.

271

561, 585

out interruption from the entrance to the choir, like the flat ceiling, an ideal ground for painting. The church of St Savin sur Gartempe is an outstanding example, among others, of the force of tradition prevailing over the desire to apply the structural changes implicit in the new construction of a vaulted edifice.

The south-west: churches with a sequence of domes

Churches covered with a succession of domes, of great originality, are typical of the south-west of France. About sixty buildings of this type were erected in the first half of the 12th century, on a fairly narrow stretch of territory extending from Cahors to Saintes and passing through Périgueux and Angoulême. Their domes with their sturdy forms silhouetted against the western plains conjure up a vision of the East. What is their origin? No problem has been discussed more by archaeologists. By some they were thought to derive directly from Byzantine architecture; others considered them to be an original product of a local tradition whose artists had by chance found a similar solution to that of the builders of the eastern Mediterranean. Here, too, we should ignore the early dates which regional vanity attributed to some of these buildings in order to explain their origin and the part imitation and invention might have played in the interchange of forms throughout the Christian world.

It should be noted that the structure of the domes of Aquitanian churches differs from that of the domes over the crossings of Romanesque churches in the rest of France. The passing from the square to the circular plan is not effected by squinches, i.e. small arches thrown crosswise over the corners, but by pendentives, i.e. triangular segments thrown point downwards into the corners. Each dome resting upon a pendentive, instead of pressing upon the whole length of a wall, localises the thrust upon the four corners, as does the groined vault. A succession of domes further neutralises part of the thrust. An opening can be pierced in the apex of the dome to improve the lighting of the interior.

576
298

This ingenious method of vaulting was used for the large choir of St Front at Périgueux after a fire in 1120. The succession of domes and their arrangement in form of a Greek cross was, even in its dimensions, a replica of St Mark's, the chapel of the Doge's palace in Venice, begun in 1063 and completed about 1111. So striking is the similarity to St Mark's, a rather independent western version of earlier Byzantine examples, that imitation is obvious, although there is no documentary evidence of this. St Front, with its succession of domes, has been imitated in turn; a famous sanctuary and one of the most popular places of pilgrimage in the south-west of France, it stood out as an example in a period when the desire to build vaulted edifices was an aim in all the provinces.

The quarries supplying stones from Upper Cretaceous levels, abundantly present in the region of Cahors, provided a stone which splits naturally into flat layers, greatly facilitating the laying of horizontal courses. This very resistant stone, almost impervious to erosion, avoided the expense of a timber frame and a roof to protect the exterior of the dome—an obvious advantage in a region where timber is rare. All the churches with a series of domes were erected in the neighbourhood of such quarries, or along old Roman roads which obviously facilitated the transport of loads of stone. In this way the

572

cathedral of Angoulême and the great abbey at Fonte-

vrault were roofed by a series of domes. The same process was repeated in a rather original fashion in St Ours at Loches. Each dome has a pyramidal shape; the stone is dressed like that of the spire of a church tower.

The ground plan of the cathedral of Angers, erected in the middle of the 12th century, gives a clear indication that the building was originally intended to be covered by domes. But the progress achieved north of the Loire offered the architect a structural solution technically far in advance of that of the domes of Aquitaine. Covered with rib vaults, the building, though not wider than the cathedral of Angoulême, was 26 feet higher inside.

The influence of the pilgrimages

The most outstanding feature in the evolution of Romanesque architecture was the transformation within half a century of the timber-roofed basilica into an edifice entirely covered with vaults. At the same time, the great churches adopted new arrangements in the interior to facilitate the performance of divine service in the presence of large crowds, who were no longer expected to attend Mass or listen to sermons in the open air.

A too literal interpretation of the *Book of St James*, a curious text written in 1137, led to the belief that great Romanesque churches existed in France only on the routes leading to Santiago de Compostela, one of the

582, 65

most celebrated places of pilgrimage in the western world. This theory of pilgrimage roads explained conveniently why churches separated by great distances showed such similarity in plan and appearance at a period when France was believed to be so deeply divided as a result of its feudal structure that each province would have developed its own art from the 10th century onwards. The theory of pilgrimage roads, however useful as a working principle, contained as much error and as much truth as did the theory of the Romanesque schools. No frontiers between the feudal domains and the kingdoms existed for members of monastic orders, and all routes were open.

Although the monastic world was very close to the secular one and had to make compromises as the occasion arose, it enjoyed in the 11th century a privileged position; it knew how to set up a powerful organisation, able to revive the arts and letters and to restore economic life in many places. Its material resources were considerable. But the extraordinary impulse given to the cult of saints during the 11th century was not entirely disinterested. Almost all the great abbeys had the ambition to become centres of mass pilgrimage, and many succeeded in doing so. The church, the temple of God, became equally the house of the saint whose tomb it sheltered. In the course of the Middle Ages in episcopal towns and abbeys the distinction disappeared between the church destined for the mysteries of the Sacrament and the martyrium. One building united the two sanctuaries under one roof. The largest sanctuary adopted in the 11th century to receive pilgrims was the crypt of the cathedral of Chartres.

In the abbey church the choir reserved for the monks occupied the centre of the building, whereas the tomb of the saint was placed in the apse, east of the main altar. A fairly wide passage had to be left open on both sides of the monks' choir for the faithful proceeding to the tomb

CAROLINGIAN. The Gospel cover of St Gaucelin. 9th century. *Nancy cathedral. Photo: Giraudon.*

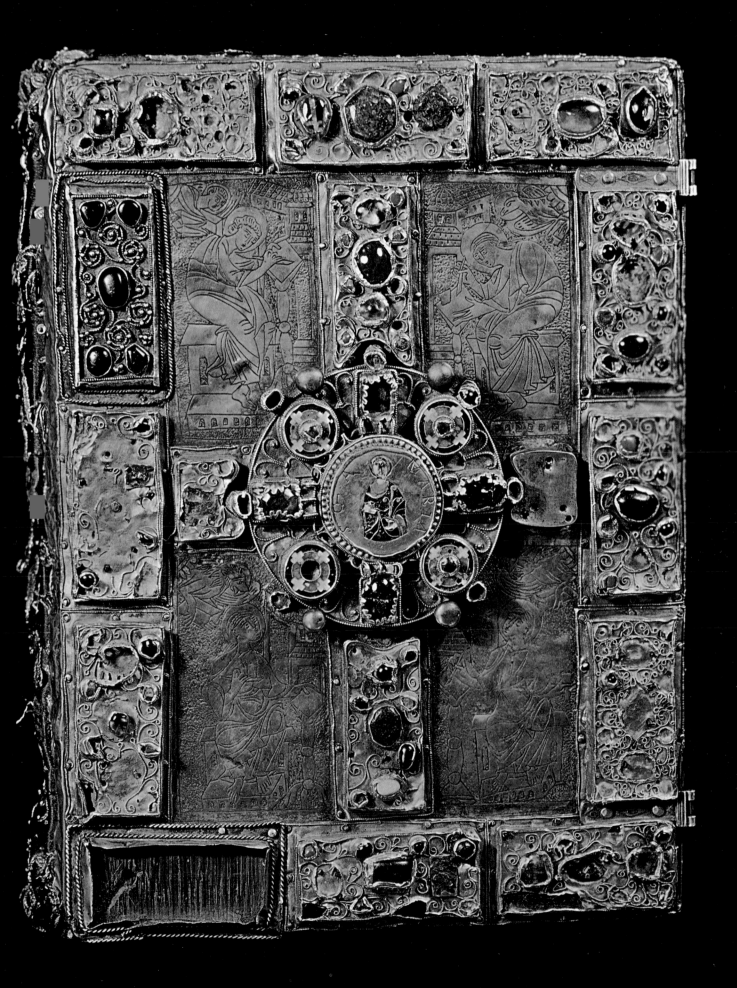

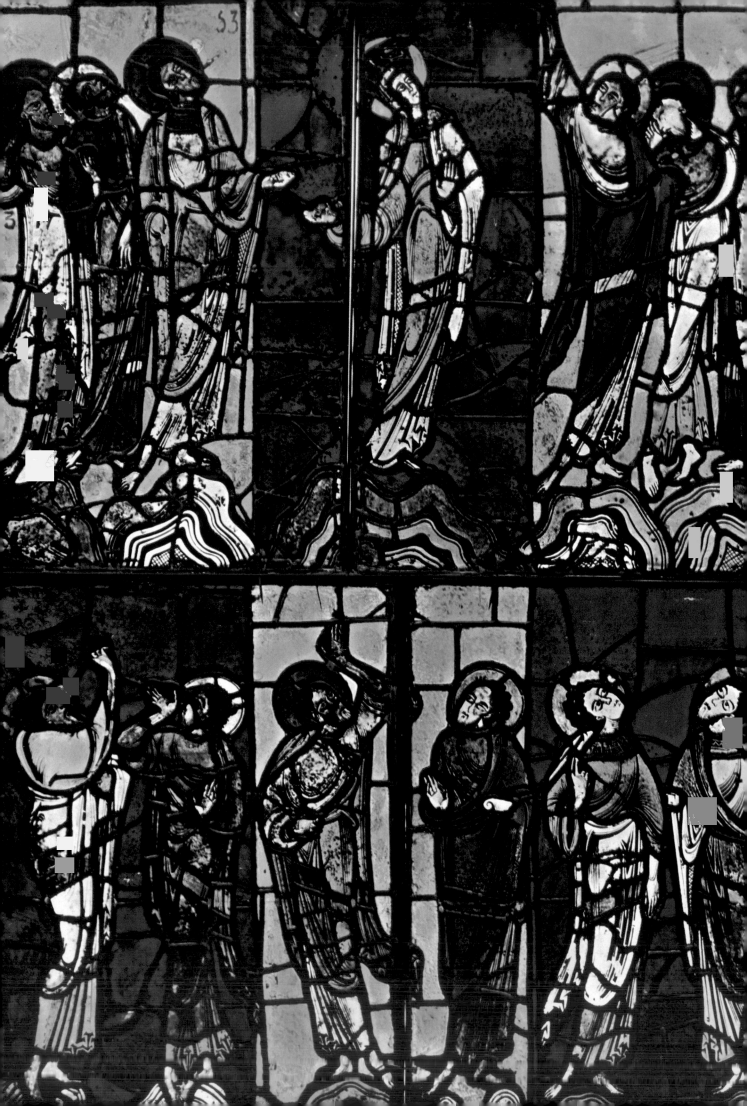

of the saint. This is the reason for the immense development of the part of the church building east of the nave; this tendency culminated in the Gothic period, when the choir attained the same length as the rest of the building. From the 11th century onwards, as is shown by excavations undertaken at the cathedral of Orléans, the Romanesque architects facilitated the passage of the crowds who wanted to proceed to the apse or to assemble round the choir reserved for the clergy by enlarging the interior of the transept and by carrying the aisles, with their galleries, round the whole choir.

The new arrangement had come into existence at the beginning of the 12th century in the north at St Remi at Reims, at Notre Dame at Soissons and in Lille, in St Sernin at Toulouse in the south and in Spain at Santiago de Compostela. In St Martial at Limoges it was added to the original much simpler plan, as was the vast choir in form of a Greek cross in St Front at Périgueux and the choir of the abbey at St Gilles du Gard, erected to the east of the previous church and crypt. Of St Martin at Tours, consecrated in 1014, only the plan of the ambulatory and radiating chapels is known from the excavations of 1886. The very large transept, slightly modified in the Gothic period, still extant in 1789, was built after the basilica had been destroyed by fire in 1096. The 12th-century author of the *Book of St James* described the spirit of emulation inspiring the founders of the great sanctuaries by saying: 'As in Compostela for the tomb of St James an immense basilica has been erected in Tours over the tomb of St Martin that will become an object of veneration in honour of this saint.'

Generally, the apse was laid out to accommodate a number of secondary altars. The adjoining chapels were either arranged in a semicircle round the ambulatory, hence their name of radiating chapels, or they were staggered on either side of the main apse, decreasing in depth in proportion to their distance from the chapel placed on the central axis. Abbey churches showing the latter arrangement divide into groups, radiating from the neighbourhood of Cluny. In the Norman group the ground plan was based on a system of squares and in Berry on equilateral triangles. Geometry was also used to determine the elevation and to secure good proportions. The exterior structure underlined and crystallised that of the interior by means of a skilful arrangement of arcades and columned supports. The two types of east end existed in France from the beginning of the 10th century, but progress made in the art of construction and the application of stereometry during the Romanesque period conferred on them a consistent and well designed order, evident both inside and outside the building, which gave them a formal beauty unknown in the preceding period.

Monumental decoration

The structural improvements of the buildings brought about the rebirth of monumental sculpture. This developed into as great a decorative art during the Romanesque period as painting, mosaics and goldsmiths' and bronze work had been in Carolingian times.

ROMANESQUE. Stained glass window showing the Ascension. Le Mans cathedral. End of the 11th century – beginning of the 12th century. *Photo: Giraudon*.

Mural painting reappeared in churches of the First Romanesque style in France, Italy, Catalonia and Germany, but, with the exception of the works produced at the Ottonian courts, the classical naturalistic tradition that had been revived in Carolingian painting was virtually lost in mural paintings as well as in illuminated manuscripts. Wall paintings like those in the choir of the church at Vicq in Berry are valuable because they show the survival of a decorative composition which attempts to apply unity of form to a great number of juxtaposed scenes. They also illustrate the development of iconography which was due to the growing cult of saints and to the efforts made by the clergy to bring within the grasp of even the simplest of the faithful the sacred history, the teachings of the Church and the mystery of the Judgment Day.

At the beginning of the 12th century there were in France excellent painters' workshops, of which the frescoes of the church at Berzé la Ville and the beautiful murals of scenes from the Old and New Testaments, on the vault and walls of St Savin sur Gartempe are striking examples. But the development of wall painting was arrested by the progress of the art of building itself. Wall and vault were increasingly partitioned into narrow compartments by the massive bodies of the compound piers supporting transverse and lateral arches; naves provided with galleries were deprived of light. Monumental wall painting no longer had any place in the vaulted church of the 12th century, but a taste for polychromy lived on. The ancient technique of the decorated mosaic pavements, greatly cherished in the Orient during the earlier Middle Ages, was revived in many districts. The mosaics of St Genès at Thiers, of the baptistery at Valence and of the cathedral of Lyon, formerly believed to be Merovingian, actually date from the Romanesque period, as do similar pavements in Italy, eastern France and the Rhenish provinces. Of the mural mosaics mentioned in texts, none has survived.

Very little is known of stained glass windows before the middle of the 12th century, although in view of the perfection of windows executed at this period we may draw conclusions as to the quality of preceding works. 'Stained glass has been France's art par excellence,' said the monk Theophilus in his treatise *Diversarum Artium Schedula*. The coloured daylight filtering through the transparent mosaic produced the right effect in the interior where capitals, columns and arches were enhanced by paint and where all sculpture was polychrome. The embroidery in the cathedral of Gerona and the famous Bayeux Tapestry give an idea of the decoration, permanent or temporary, which was used to embellish bare walls or to create a festive atmosphere in church and castle. Like murals and stained glass windows embroidery in wool was executed in bright colours. As a handicraft it was the forerunner of the more sophisticated art of tapestry, which was probably practised from the end of the Romanesque period.

The great works of Romanesque sculpture made their appearance at the very end of the 11th century and the first years of the 12th century, at the time when the art of vaulting large churches had reached its full development. The sculptured capital is to the compound pier what the fruit is to the tree. The carved portal is essentially an architectural element; its decorative function is secondary.

273

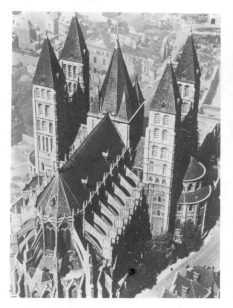

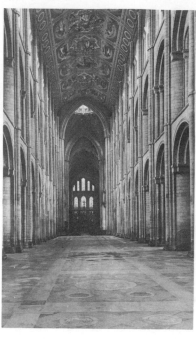

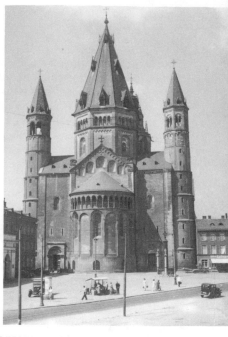

577. BELGIUM. Aerial view, cathedral of Tournai. 1110–1171.

578. ENGLAND. Ely cathedral, view of nave. 1083–1190.

579. GERMANY. Cathedral of Mainz. 1085–1239.

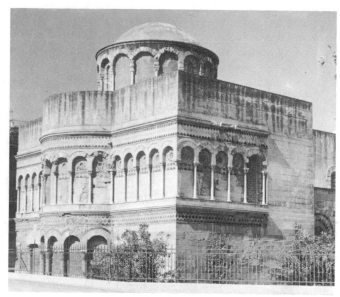

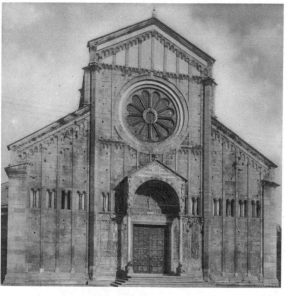

580. SICILY. L'Annunziata dei Catalani at Messina. Norman church of the 12th century.

581. ROMANESQUE. ITALY. West front, S. Zeno, Verona. 1139.

582. SPAIN. Santiago de Compostela. c. 1077–1124.

583. ITALY. Cathedral of Pisa. Begun in 1063 by Boschetto; consecrated in 1118.

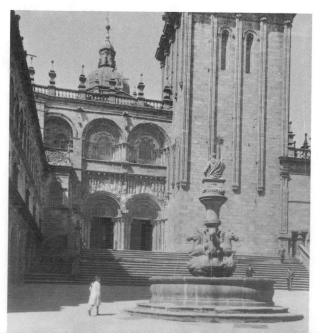

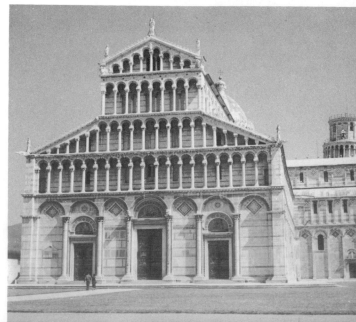

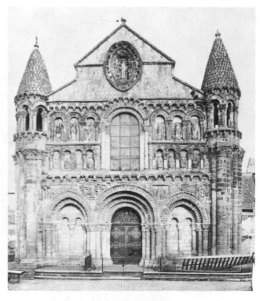

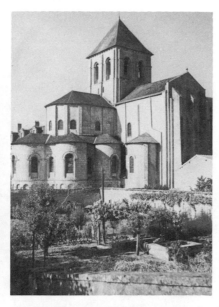

584. NORMANDY. Church of St Georges, at St Martin de Boscherville (Seine-Maritime). Begun c. 1125.

585. LOIRE VALLEY. Abbey church of St Savin sur Gartempe. End of the 11th century–12th century.

586. POITOU. Façade of Notre Dame la Grande at Poitiers. First half of the 12th century.

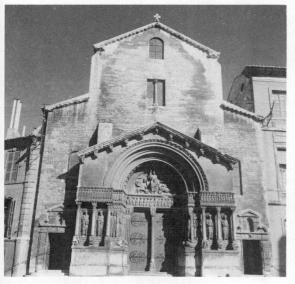

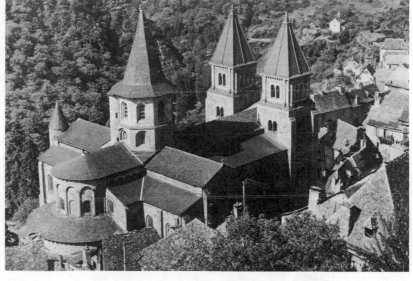

587. PROVENCE. Façade, St Trophime at Arles. End of the 12th century.

589. LANGUEDOC. Five-storeyed octagonal bell tower of St Sernin at Toulouse. 12th century.

588. Conques (Aveyron). Church of Ste Foy. 11th century.

590. AUVERGNE. Façade of the cathedral of Le Puy. 12th century.

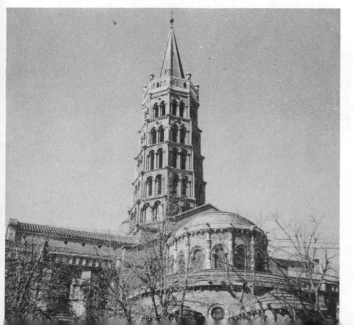

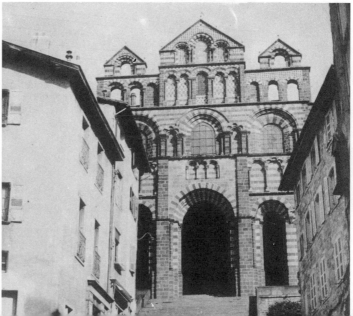

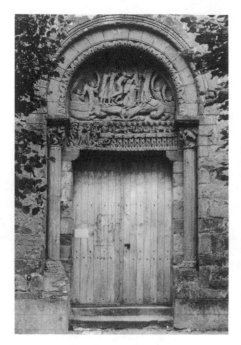

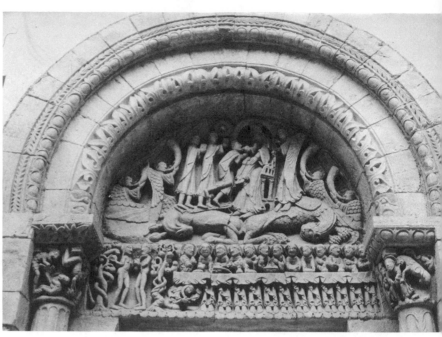

591. ROMANESQUE. BURGUNDY. Portal of the church at Neuilly en Donjon (Allier). *c.* 1130.

592. Neuilly en Donjon. Tympanum: Adoration of the Magi; on the lintel, the Temptation of Adam and Eve and the Supper in the House of Simon. Beginning of the 12th century.

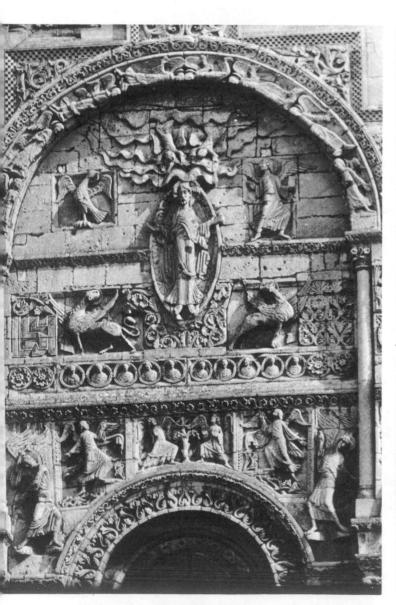

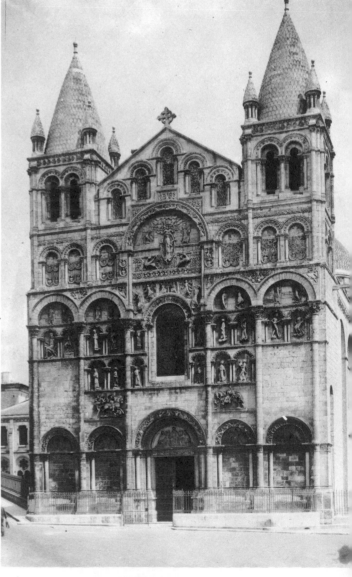

593. Façade of Angoulême. Detail of the Ascension showing Christ in Glory with symbols of the four Evangelists.

594. ROMANESQUE. ANGOUMOIS. Façade of the cathedral of Angoulême. Begun 1125. Completed about 1150.

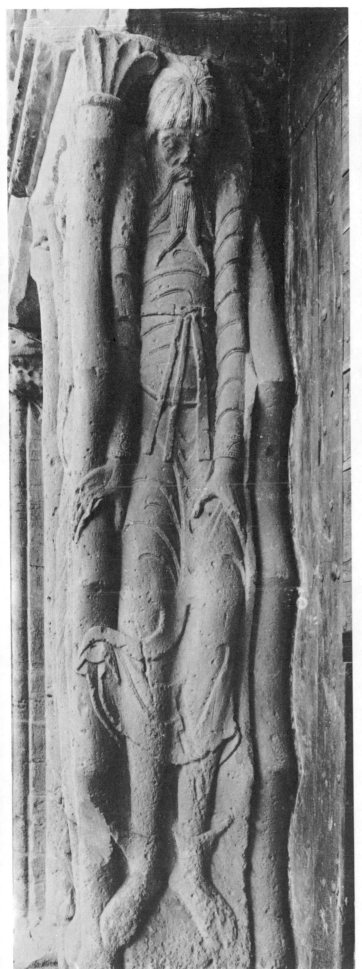

595. Decorative figure on the portal of the church at Beaulieu (Corrèze). 12th century.

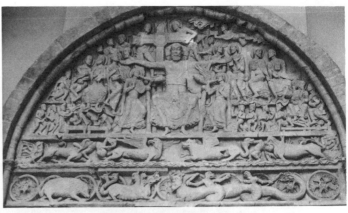

596. ROMANESQUE. LANGUEDOC. Last Judgment, tympanum of Beaulieu (Corrèze). c. 1130–1140.

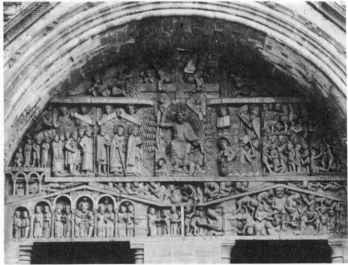

597. ROMANESQUE. AUVERGNE. Last Judgment, on the tympanum of Ste Foy at Conques. 1115–1125.

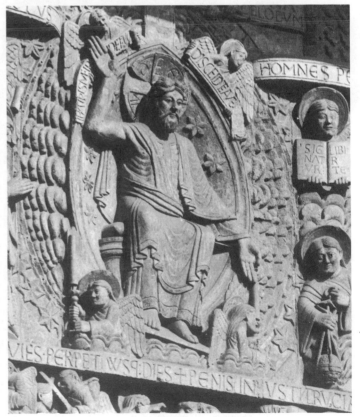

598. Tympanum of Conques. Detail of Christ.

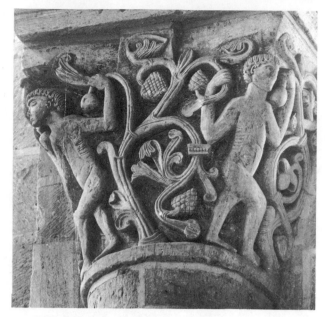

599. ROMANESQUE. LOIRE VALLEY. The Earthly Paradise. Capital in the south aisle of St Benoît sur Loire. 11th century.

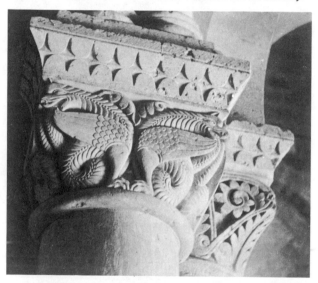

600. ROMANESQUE. SAINTONGE. Capital from the church at Aulnay (Charente-Maritime). 11th century. Oriental influence is evident in the carving of the fantastic beasts.

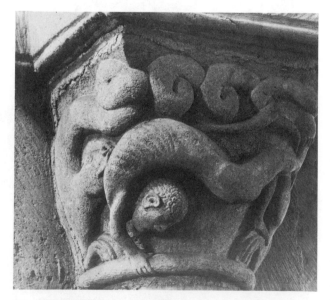

601. ROMANESQUE. BURGUNDY. Acrobat or snake-man surrounded by a serpent. Capital from the church at Anzy le Duc (Saône-et-Loire). 11th century.

The rise of Romanesque sculpture was an event of the first magnitude in European art. Scholars have tried to discover forerunners from Ireland to Armenia, and it has been possible to prove that the new sculpture, as regards iconography, was greatly indebted to painting; a comparison of the capitals of the choir of Cluny with Ottonian bronzes has revealed a certain affinity in the execution of the relief. However valuable these observations may be as a proof that an artist, being equipped with memory and power of observation, relies in his creations more on experience than on imagination, the fact remains that the great Romanesque portal of the beginning of the 12th century showed no resemblance whatsoever to anything preceding it. It is a door opening into a two-dimensional world far removed from reality, but where the figure of God appears in human proportions. The beauty of these portals derives mainly from the consistency of the composition as a whole, which is due not only to a system of simple geometrical proportions and designs based on squares and circles enclosed in squares, but also to the extraordinarily subtle treatment of the relief that the artists had acquired by mastering the most difficult of the arts—the carving of animated scenes on the curved surface of a capital.

There is no justification for regarding the elongated bodies, the faulty anatomy and the strange perspective as conscious and intentional deformations. The sculptor expressed himself in the same primitive language the contemporary painter used in his murals and illuminations. When, after the collapse of the Carolingian civilisation, the elements of the classical humanist tradition were lost and instincts were no longer controlled or directed into cultural channels, man, for a time, resumed the naive attitude of the child to express his inner vision. But the revival of schools soon had its effect on the arts and on literature. In the second half of the 12th century the Romanesque sculptors in Provence and the Gothic sculptors in the north of France rediscovered the natural beauty of classical art—the Provençal artist by direct contact 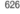 626 with models of antiquity, the Gothic artist by a methodical study of nature. The decorative sculpture of the French Romanesque churches at the end of the 11th century remains a unique evidence of a primitive art brought to the highest perfection by the impact of a single discipline, that of architecture.

Artistic activity of the religious orders

A map showing the distribution of churches with large sculptured portals executed during the first forty years of the 12th century would be almost identical with a map showing the possessions of Cluny. These churches spread over a fairly narrow zone from the north-east of Burgundy to the south of Languedoc with Cluny as the centre. Although developing simultaneously in Languedoc and Burgundy the sculpture in the two regions is not of exactly the same character. This was due as much to the nature of the stone as to the temperament of the artist. Even within each of the two schools the diversity of the works suggests several local workshops. Cluny obviously did not train the artists directly, but as the map on p. 364 suggests it was from this masterpiece of the Order that within its domains the idea took root of setting a stone image over the entrance to the church. The abbey's immense sculptured portal, over 50 feet high, served as an outstanding model.

The violent denunciations uttered by Bernard of Clairvaux were aimed particularly at this Clunaic practice: 'Why place these ridiculous monsters, these beautiful horrors and horrible beauties, under the eyes of monks who should read and meditate? What is the use of these unclean monkeys, these ferocious lions and monstrous centaurs? Will it be more profitable to study these marbles than to read the sacred books, to pass days in successive contemplation of these sculptures instead of meditating the law of the Lord?' Bernard obviously had in mind the sculptured decorations of the cloisters which in many Cluniac monasteries were a delightful retreat laid out with greater art than the interior of the richest palaces of the time. The monastic reformers of the 12th century did not condemn in principle an art which adorned the church visited by the faithful, but they spurned its excess, proclaiming, not without reason, that whoever takes the vow of poverty should live as simply as he should dress.

In this way France gave to Christian Europe in one century examples both of the most luxurious and the most austere art. Founded at Cîteaux in 1112, the Cistercian Order comprised over five hundred monasteries by about 1200. All were established in secluded and often inhospitable places. Their statutes did not permit the buildings to be adorned with sculptures, paintings or stained glass. Even bell towers of stone were not tolerated. The Cistercians, by carrying out the construction of buildings themselves, introduced everywhere a spirit of order and simplicity. The church with its white walls and the adjoining buildings owed their beauty to the excellence of their proportions and a perfection of workmanship which we admire to this day where we see the ruins. From Cîteaux to the most distant monasteries the Cistercian monks made use of the technical achievements of the builders of their home provinces and spread them far over the world. Obedient to a discipline stricter than that of soldiers they put into practice the principles of an art reduced to its pure essence, and adopted much earlier than any lay builder rational methods of construction

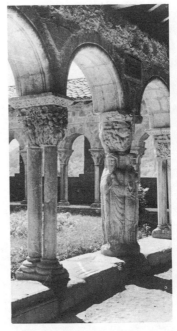
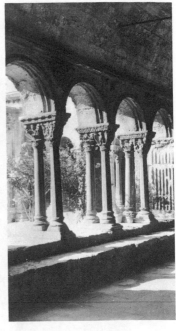

602. *Left*. ROMANESQUE. PYRENEES. Cloister, St Bertrand de Comminges.

603. *Right*. LATE ROMANESQUE. PROVENCE. Cloister of St Trophime at Arles. Built in the second half of the 12th century. Restored at the end of the 14th century.

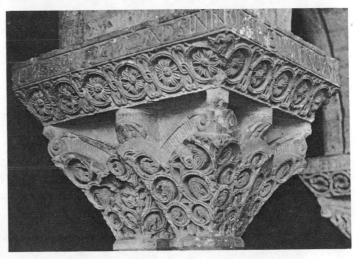

604. ROMANESQUE. LANGUEDOC. Capital in the cloisters at Moissac. *c.* 1100. The stylised floral pattern is reminiscent of Arabic models.

606. ROMANESQUE. POITOU. Capital from Chauvigny (Vienne). Winged monster. First half of the 12th century.

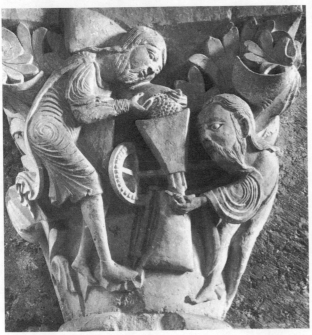

605. ROMANESQUE. BURGUNDY. Capital from La Madeleine at Vézelay. The Mystic Mill of St Paul. *c.* 1130–1135.

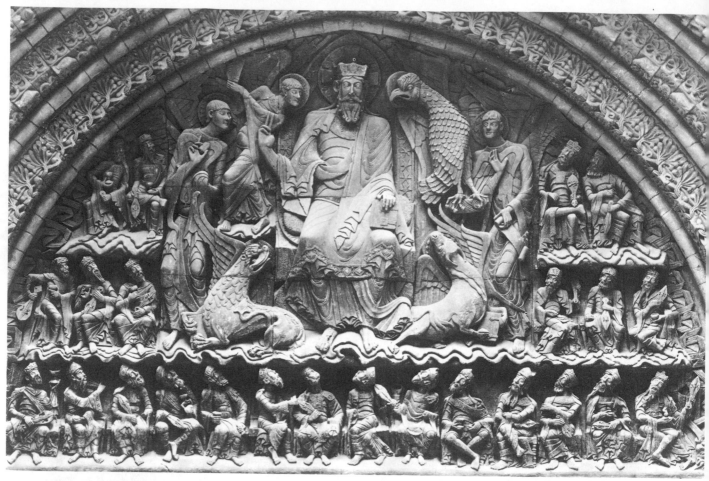

607. *Above*. ROMANESQUE. LANGUEDOC. St Pierre at
Moissac. Tympanum showing the Christ of the Apocalypse,
with the symbols of the Evangelists. *c*. 1115–1136.

610. *Below*. Detail from the Weighing of the Souls, tympanum
of Autun cathedral.

608. Figures from the tympanum of St Pierre at Moissac.

609. ROMANESQUE. BURGUNDY. The Last Judgment.
Tympanum of Autun cathedral. 1130–1140.

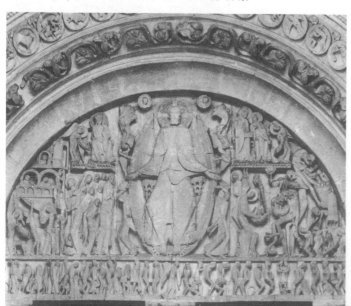

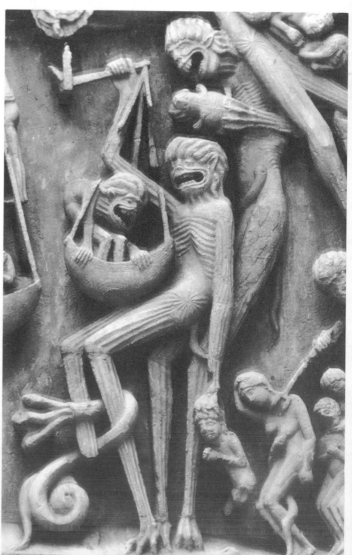

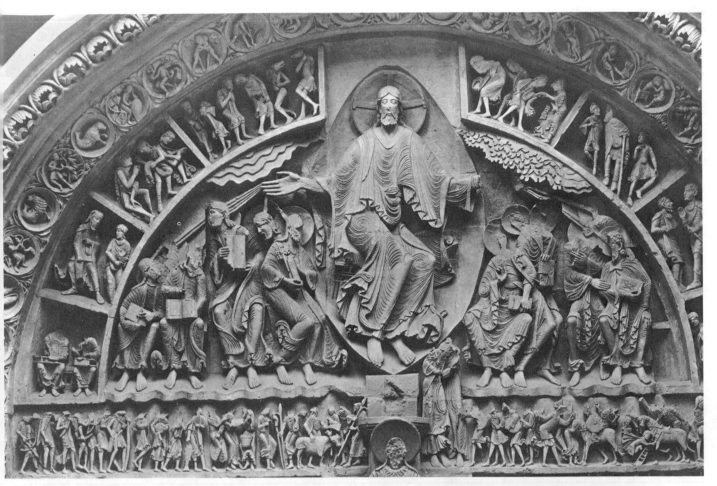

611. ROMANESQUE. BURGUNDY. Tympanum in the narthex of La Madeleine at Vézeley, showing the Pentecost. *c.* 1125–1130.

612. Atlas figure beneath column, from the portal of Oloron Ste Marie.

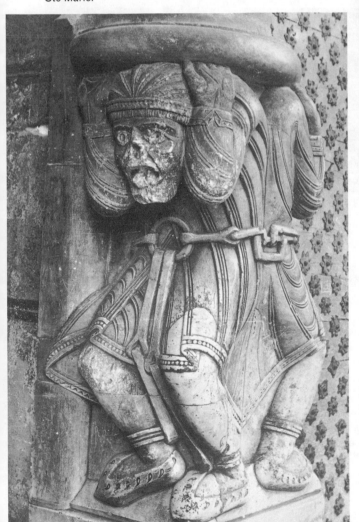

613. Joseph accused by Potiphar's Wife. Capital from Vézelay. *c.* 1130–1140.

614. ROMANESQUE. PYRENEES. Tympanum of Oloron Ste Marie: the Descent from the Cross. Marble. 12th century.

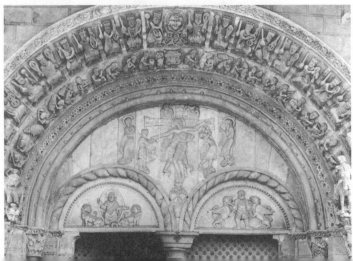

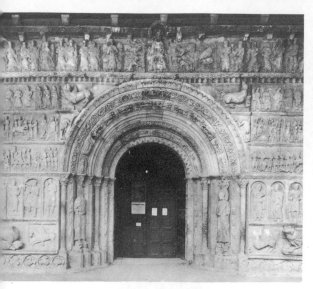

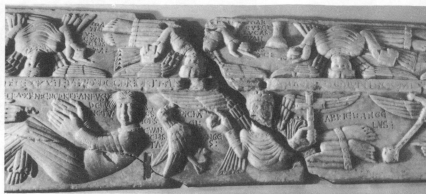

616. SPAIN. Tombstone of Alfonso, son of Count Pedro Ansurez. End of the 11th century. *Museo Arqueologico Nacional, Madrid.*

615. SPAIN. Portal of the church of the monastery of Sta Maria at Ripoll. 12th century. The various panels have the following themes: the struggle between Good and Evil; rewards and punishments; scenes from the Bible; the Triumph of Christ.

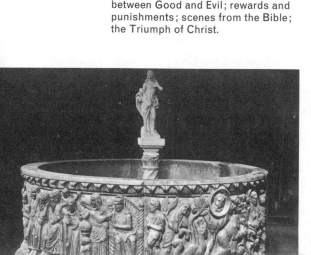

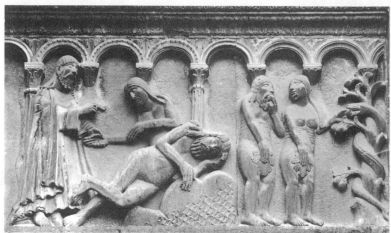

618. ITALY. Modena cathedral. The Fall of Adam and Eve. Relief by Guglielmo. 12th century.

617. ITALY. Baptismal font of S. Frediano at Lucca. 12th century.

619. ITALY. Metope from the cathedral of Modena. *c.* 1099.

620. ITALY. 'Spring'. Formerly attributed to Benedetto Antelami. (1178–1233). *Baptistery, Parma.*

621. SPAIN. King David, from the Puerta de las Platerias, Santiago de Compostela.

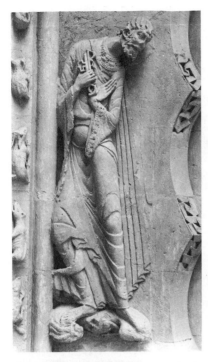

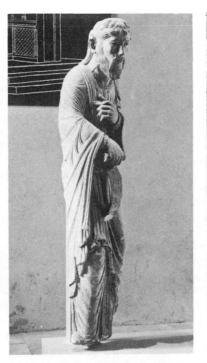

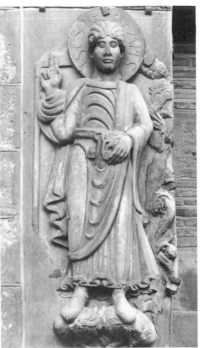

622. LANGUEDOC. St Peter. Jamb of the portal at Moissac. *c.* 1110–1120.

623. BURGUNDY. Statue from the tomb of St Lazare, at Autun. Work of the monk Martin. 1170–1189. *Musée Rolin, Autun.*

624. LANGUEDOC. St Peter. Porte de Miègeville, St Sernin at Toulouse. *c.* 1115–1118.

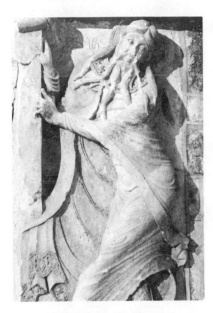

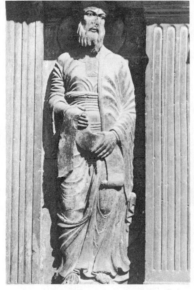

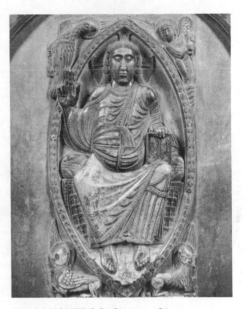

625. LANGUEDOC. The Prophet Isaiah, from Souillac. Middle of the 12th century.

626. PROVENCE. Statue from the façade of St Gilles du Gard.

627. LANGUEDOC. Christ in Glory. Marble relief from St Sernin at Toulouse. End of the 11th century.

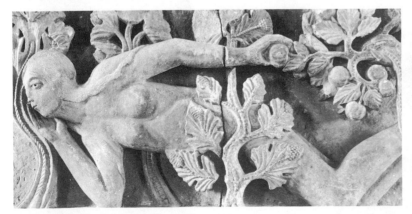

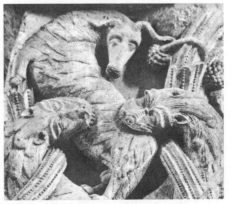

628. BURGUNDY. Eve. Fragment from the north portal of Autun cathedral. *c.* 1135–1140. *Musée Rolin, Autun.*

629. LANGUEDOC. Monsters from the trumeau of the portal at Souillac. *c.* 1130–1140.

which enabled them to build with competence and economy. The plan of a Cistercian church of the beginning of the 12th century, with its chapels terminating in a straight wall to permit the simplest method of covering, gives a foretaste of the architecture of the time of St Louis. The organised workshops and 'barns' of the lay brothers were the forerunners of the factories and large estates of modern times, with the difference that a forge or a hospice was built with the care accorded to a church.

By the end of the 11th century architects had gained all the experience indispensable to the construction of large churches which were completely covered by vaults, were flanked or dominated by several bell towers and were decorated with sculptures inside and out. In the first half of the following century regional styles gradually made their appearance and church buildings differed more in decoration than in structure. They enriched French Romanesque art with an admirable variety of expression. This final stage, like the preceding one, owed its vigour to the growth of monastic institutions. Each monastery

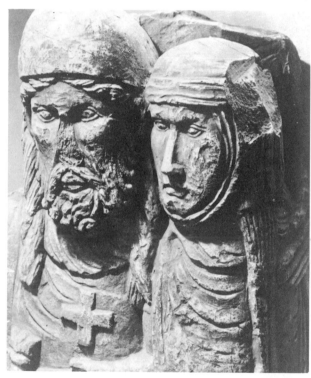

630. ROMANESQUE. FRANCE. Crusader and his wife. 12th century. From the Franciscan church, Nancy.

631. ROMANESQUE. FRANCE. The keep at Falaise (Calvados). 12th century.

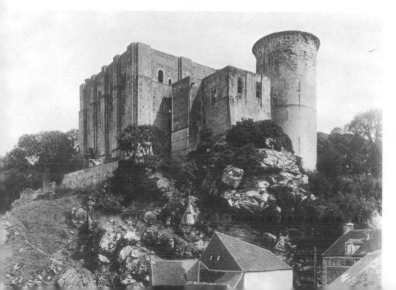

held a large number of domains spread over distances too great to assure direct surveillance and administrative control. Through the establishment of priories these functions were delegated to priors and provosts. Though in parochial matters the prior was usually assisted by a curate appointed by the bishop, the construction and maintenance of buildings of the priory remained in the hands of the abbey. The large and beautiful Romanesque churches to be found all over the country owe their origin to these institutions. Moreover, bishops and lords in a spirit of emulation commissioned many rural churches which imitated in decoration and structure the monastic and urban edifices. The expansion of artistic activity resulted in a profusion of workshops and building centres. This is one of the striking differences between the Second Romanesque style and the Carolingian period.

Among the regional schools those of the west, of the Auvergne and of Provence show the most distinctive characteristics. As they were also the latest, they were able to profit, with greater or less skill according to region, by progress made elsewhere during the previous period. The provinces south of the Loire stuck tenaciously to the Burgundian tradition. Notre Dame du Port at Clermont-Ferrand, the most typical example of Romanesque architecture in the Auvergne, was still under construction in 1185, at a time when the great Gothic cathedrals at Sens, Noyon, Senlis, Laon and Paris were approaching completion. In the south-west, capitals of great perfection were being carved in the Romanesque style up to the 14th century. In Alpine villages Romanesque churches were erected up to the beginning of the 17th century.

456, 66
667, 6
738, 83
839, 84

Illuminated manuscripts

The artistic activities of the religious orders were not limited to the building and decoration of churches and cloisters. They were also responsible for a great number of manuscripts illuminated with ornamented letters and pictures which were executed in the workshops of the scribes (scriptoria). Their contribution in the 11th and 12th centuries was an important one for the revival of culture and the creation of new aesthetic values. The art of illumination had a future which was denied to wall painting. It was an art of scribes and scholars, and the growing demand for manuscripts brought with it increased opportunities of practising this art. So did the range of subjects; originally limited to the Bible, the writings of the Fathers of the Church, the Gospels and other holy books, it expanded during the Romanesque period to include commentaries on sacred texts and the lives of the saints. At the same time the conventional and rather primitive design of the early Romanesque period evolved towards a naturalism of delightful originality. Facial expressions became more alive, the lines more assured and subtle, the colours richer and of greater variety. Harmony of tone and balance of design make some of these works masterpieces of decorative art.

In the initial phase there was a striking difference between the illumination produced in northern France and that of the south. The southern schools drew their inspiration from Spanish and Italian sources; they frequently illustrated the Commentary on the Apocalypse written by Beatus, abbot of Liébana in Asturias, whereas the northern schools were so deeply permeated with English influence that it is difficult to distinguish between works of French and English origin. Contacts between

486

458, 63

France and England were numerous and frequent at this period. Abbon, abbot of Fleury from 988 to 1025, spent two years at the abbey of Romsey; St Aethelwold, Bishop of Winchester (963–984), had connections with the monasteries of Corbie and Fleury; at a later date Stephen Harding, an Englishman, became abbot of Cîteaux (1109–1133) after he had been a monk at Sherborne. The interpenetration of Anglo-French schools continued throughout the Romanesque period, without excluding influences coming from other countries.

These diverse influences, which were due to contacts and interchanges all over France and to certain outstanding artists working in the scriptoria, led to the production of works of a fascinating originality. Thus from the beginning of the 12th century the scriptorium of Cîteaux produced illuminated manuscripts of consummate art, such as the admirable frontispiece to the Explanatio in Isaiam by St Jerome, in the Dijon Library (MS. 129), representing the Virgin and Child above Jesse sleeping. The solemn majesty in the composition of the miniatures did not impair the imaginative side; we only need to turn 486 a few pages of the Bible of St Bénigne or the Moralia in Job of St Gregory (both manuscripts are preserved in the Dijon Library) to realise the freedom and humour with which the artists treated the many small figures and animals which enlivened the initials.

Stone castles

The castle built of stone, in addition to the vaulted church with its soaring towers, made its appearance during the Romanesque period. The only military defences known in the early Middle Ages were the walled redoubts of the ancient cities of Roman Gaul, which had been erected at the end of the 3rd century round the most easily defensible parts after the first wave of Germanic invasions. These walls, used as quarries during the peaceful Carolingian times, had to be repaired and rebuilt to stave off the Norman raids. The countryside, too, needed protection against the Normans; monasteries were surrounded by a castellum, a parapet consisting of a trench and strong wooden fences. At county frontiers and strategic points enjoying a natural protection mottes and baileys were erected with a simple wooden tower as redoubt. Many of these light defences, secured by ingenious entrenchments but easily set on fire, became obsolete during the 10th century. The most favourable sites were turned into the medieval fortified castles.

There is documentary evidence to show that as late as the early 12th century nothing but wood was used for fortification works in the Paris region. The first castles built of stone made their appearance in the 11th century on the middle Loire, a region of great building activity during the First Romanesque style. They were rectangular 631 structures with very thick walls, divided into several storeys by wooden planks. The oldest keep is to be found at Langeais, attributed (without proof) to Fulk Nerra, though the rubble walls date from a period prior to the end of the 11th century. From the Loire, the keep spread north and south. A flanking fortification in form of a strong stone wall was added to the castle of Arques, built in 1123 by Henry I, king of England. It was only towards the end of the 12th century that military architecture made any noticeable progress, especially in the Ile-de-France. The age of the Gothic cathedrals became also the age of the fortified places.

632. ROMANESQUE. FRANCE. Commentary of Beatus. The Fifth Plague, from the Apocalypse of St Sever. Middle of the 11th century. Although the manuscript is very French, the proximity of Spain and the influence of Arab motifs are much in evidence. *Bibliothèque Nationale, Paris.*

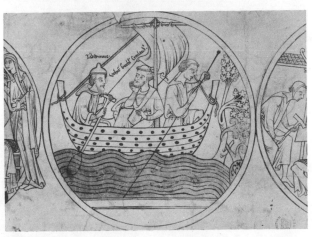

633. ROMANESQUE. ENGLAND. St Guthlac sailing in a fishing boat to the island of Crowland. Drawing on parchment from the Scroll of Guthlac. End of the 12th century. *British Museum.*

634. ROMANESQUE. FRANCE. Decorated initial. Bible of the Grande Chartreuse. Beginning of the 12th century. MS. 17, fo. 175. *Grenoble Library.*

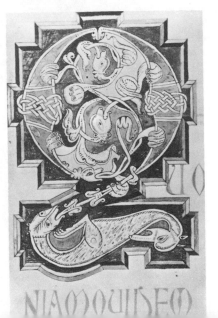

NIAMOUIICO

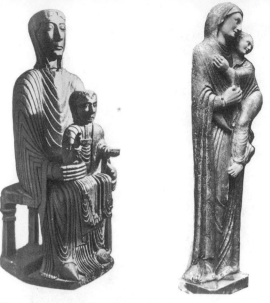

635. *Left*. AUVERGNE. Virgin of St Gervazy (Puy-de-Dôme). 12th century.

636. *Right*. GERMANY. Virgin from the church of Sta Maria im Capitol, Cologne. 12th century.

638. FRANCE. Crucifixion. Painted and gilded wood. Second quarter of the 12th century. *Courajod Bequest, Louvre, Paris*.

637. ROMANESQUE. NORMANDY. Halley's Comet, from the Bayeux Tapestry. 11th century.

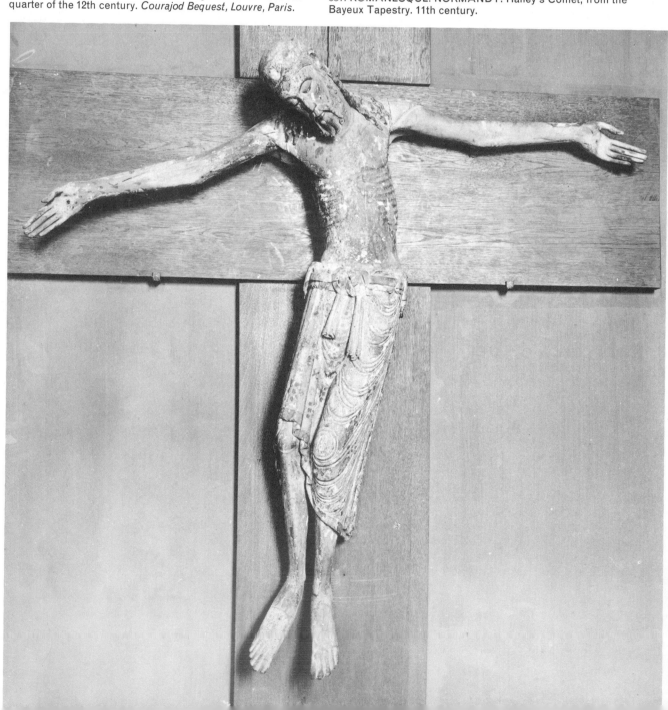

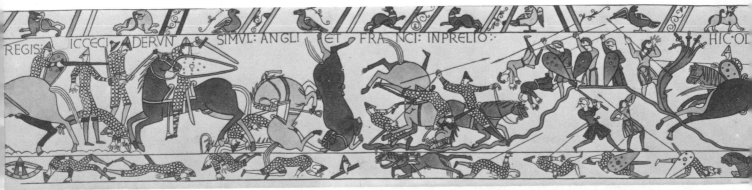

639. ROMANESQUE. NORMANDY. The Battle of Hastings, from the Bayeux Tapestry. 11th century.

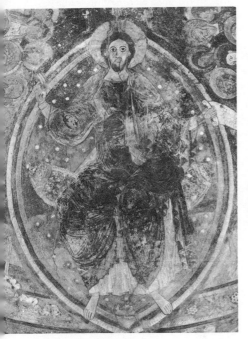

640. ROMANESQUE. Christ in Glory. Wall painting from the chapel at Berzé la Ville. 12th century.

641. ROMANESQUE. The Martyrdom of St Lawrence. 12th century. Wall painting in the chapel of the old Cluniac priory at Berzé la Ville (Saône-et-Loire).

642. ROMANESQUE. The Magi on horseback. 1150–1160. Wall painting in the church at Brinay (Cher).

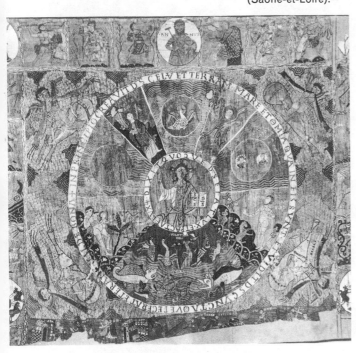

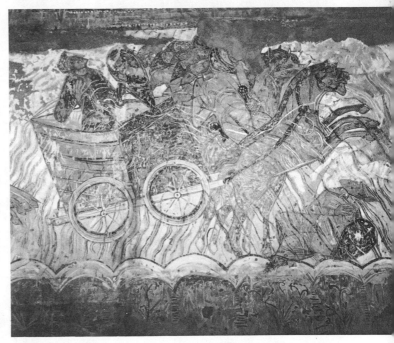

643. ROMANESQUE. SPAIN. Genesis. Wool embroidered on linen cloth. Beginning of the 12th century. *Cathedral of Gerona*.

644. ROMANESQUE. Pharaoh's chariot engulfed by the waters of the Red Sea. Painting from the vault of St Savin sur Gartempe. c. 1100.

287

HISTORICAL SUMMARY: Romanesque art

Archaeology. The study of Romanesque art, especially the question of its origin, has raised many problems. The problem of its connection with the Orient has been dealt with by Emile Mâle, Marcel Aubert, J. Baltrusaïtis and J. Puig i Cadaflach but is far from being solved. The theory of regional schools of Romanesque architecture, first set forth in 1840 by Caumont and expanded by E. Viollet-le-Duc, A. Choisy, R. de Lasteyrie, C. Enlart, J. A. Brutails, E. Lefèvre-Pontalis and Louis Bréhier, cannot any longer be maintained in its entirety. The influence of pilgrimages on art, emphasised especially by Mâle, led to a search for the prototypes of the churches which mark the routes of the pilgrims. (Abbé Bouillet was the first to point out the similarity between Ste Foy at Conques, St Sernin at Toulouse, St Martial at Limoges and Santiago de Compostela.) Henri Focillon devoted himself to the task of re-evaluating Romanesque sculpture, whose chronology, established by A. Michel, has been questioned mainly by Kingsley Porter and Marcel Aubert.

ROMANESQUE ART OF THE 11TH CENTURY

History. Three important factors contributed to the formation and expansion of Romanesque art.

1. Strong personalities among the politician-prelates who from the beginning of the 11th century built the churches and reformed the religious orders: St Bernard at Hildesheim; William of Volpiano at Dijon; Abbot Oliva at Ripoll; Gaucelin at Fleury sur Loire; Odilo, abbot of Cluny; St Hugh of Semur, abbot of Cluny; Lanfranc, abbot of St Etienne at Caen.

2. The foundation and subsequent influence of monastic orders subjecting their members to rule and subordinating the priories to the mother house. They became increasingly influential and wealthy. The Cluniac Order was founded in 909 and spread over the whole of France and northern Spain and Italy; then followed Cîteaux, founded in 1098, which received a powerful impulse through Bernard of Clairvaux, the most notable personality of the 12th century. He opposed the Benedictine spirit of Cluny with the Cistercian spirit of sobriety and purity. Cistercian buildings spread from Sweden to Sicily, Spain and Palestine, showing everywhere the same simplicity of plan.

3. Pilgrimages to Rome, Jerusalem and above all to Santiago de Compostela contributed to the diffusion of certain types of church buildings and of decoration.

Political events were of great influence on the development of the arts:

1. The conquest of England by William of Normandy (1066, battle of Hastings [**639**]). A Franco-Norman civilisation developed on both sides of the Channel.

2. The conquest of Sicily by the Normans in the middle of the 11th century. The Kingdom of the Two Sicilies became a crossroads for Byzantine, Arabic and Franco-Norman influences.

Another cause of artistic development was a growing national consciousness which was finding expression through poems in the vernacular. The first poetical works were epics: *Chanson de Roland* in French; *Der Nibelunge Nôt* in German.

Architecture. Characteristics of the earliest Romanesque architecture in the Mediterranean area were, according to Puig i Cadafalch: masonry of rough-hewn stones and the regular use of small blind arcades and of flat pilaster strips. This system of decoration gradually spread over apses, side walls and façades [**553, 556**]. Basilicas adopting this decoration were still covered with wooden roofs. Later, the dome and the groined vault covering the nave appeared simultaneously.

The new Romanesque architecture was adopted in southern and northern Italy, in Catalonia, in the lower Languedoc, in Provence and in the valleys of the Rhône, the Saône (Jura and Burgundy) and the Rhine including Holland and Switzerland.

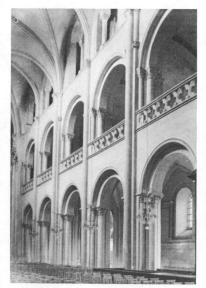

646. ROMANESQUE. NORMANDY. View of the nave, St Etienne at Caen. Begun 1062.

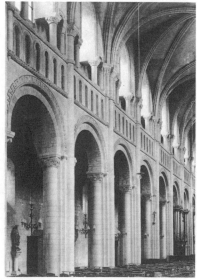

647. ROMANESQUE. NORMANDY. View of the nave, La Trinité at Caen. 1062–1066.

645. ROMANESQUE. FRANCE. Interior, looking east, Ste Foy at Conques. 11th century.

ENGLISH. Frontispiece to the Book of Numbers in the Bury Bible, showing (*above*) Moses and Aaron, and (*below*) Moses and Aaron numbering the people. Mid 12th century. *Corpus Christi College, Cambridge. Photo: Michael Holford.*

288

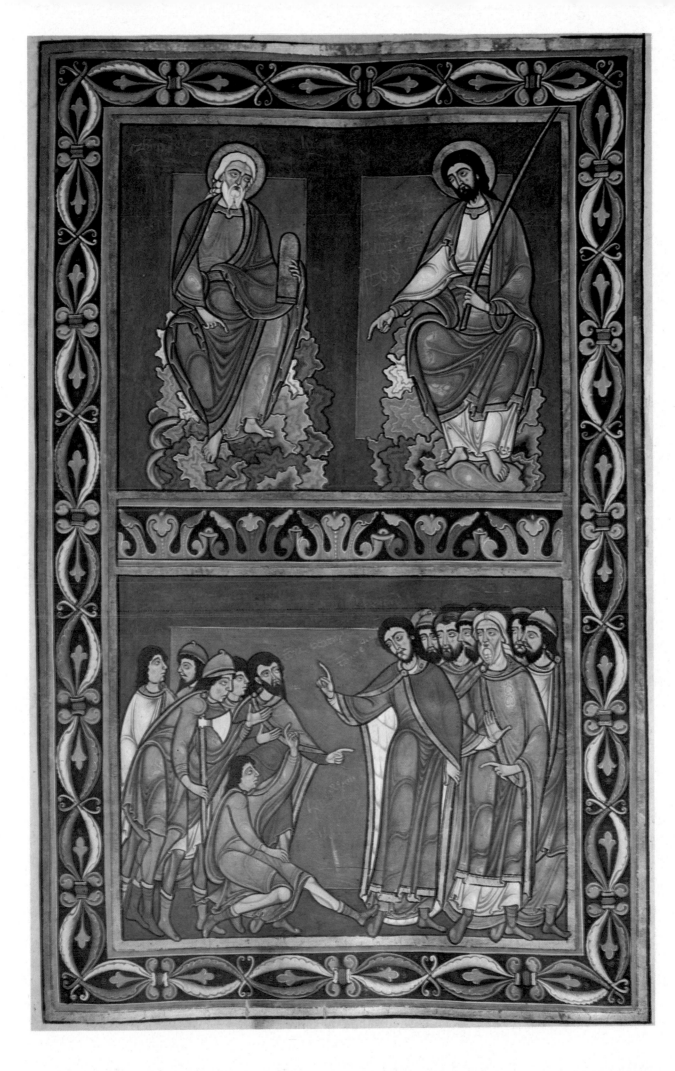

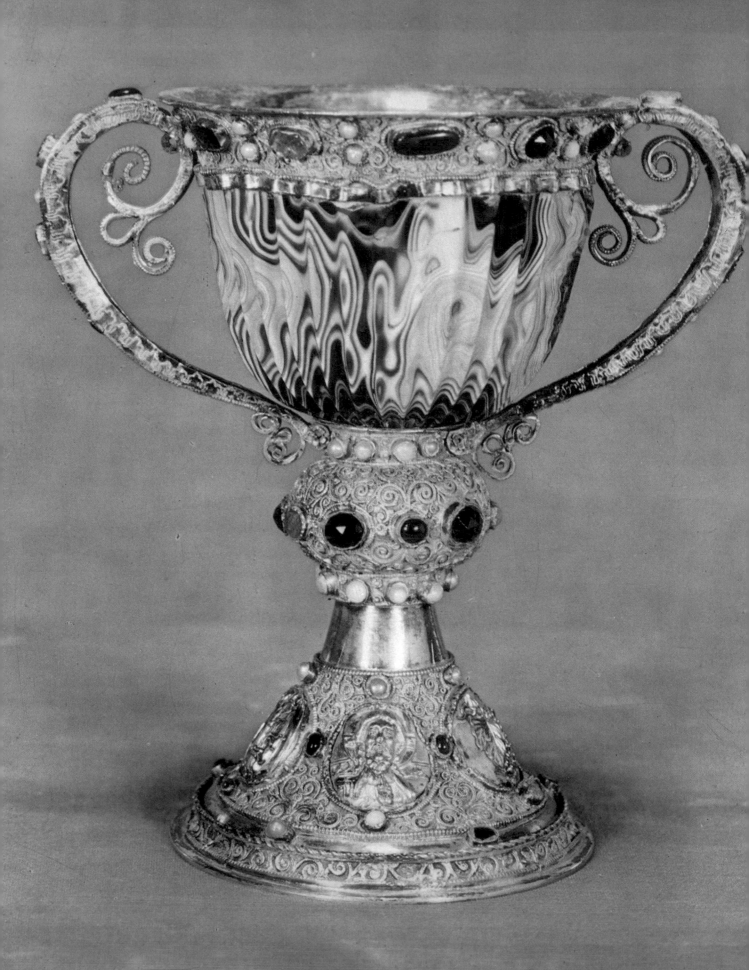

Towards the end of the Middle Ages it was found in Byzantine territory in churches built by the princes of Moldavia.

In certain regions the construction of basilicas in the Carolingian tradition was continued, especially in Switzerland, Germany, Holland (St Peter and St John at Utrecht in 1050) and northern and eastern France (at Montierender, Vignory, 1050, and St Germain des Prés in Paris, which still had a timber-roofed nave in the middle of the 17th century).

Romanesque art developed most favourably in regions which were least open to Byzantine influences: France, Spain and England. In Italy the name neo-Latin was adopted, especially in parts untouched by French influences. In Germany Romanesque art continued and completed the Carolingian and Ottonian efforts.

The countries of innovation in Romanesque architecture were Catalonia, Burgundy, Normandy and the region of the middle Loire.

The northern Mediterranean and Catalonia. The first structural innovations which made their appearance were:

(a) Extension of the vault over the whole nave. The first basilicas in western Europe which were completely vaulted were: Sta María de Naranco, Oviedo (c. 848) [**522**]; Sta María at Amer, consecrated 949; Sta Cecilia at Montserrat (957); St Martin du Canigou (1009 and 1026) [**552**]; St Guilhem le Désert (1076).

(b) A dome either over a cruciform plan (St Cugat at Salon, 1012) or on a basilica: S. Vicente de Cardona (1020–1040); abbey church of Sta María at Ripoll (1020–1032) [**615**].

Burgundy. Burgundian Romanesque art spread over the area under Cluniac rule. Cluny had three successive abbeys: Cluny I (916); Cluny II (second half of the 10th century); Cluny III (begun by St Hugh in 1088 [**568, 569, 574**]). This was the largest church in Christendom before the reconstruction of St Peter's in Rome. Other important Cluniac buildings were: St Bénigne at Dijon, consecrated before completion in 1018; St Philibert at Tournus (nave and apse, 1066–1119 [**563, 564**]); Paray le Monial, begun at the end of the 11th century [**570**].

Normandy. Romanesque art was almost completely developed by the beginning of the 11th century, and original forms characteristic of the Norman style had made their appearance. Prosperity and Norman dynamism at the time of William the Conqueror penetrated not only England, in 1066, but also Brittany, Maine and the Ile-de-France. Important abbeys were: Jumièges (1037–1067); Fécamp (1082–1099); St Ouen at Rouen (1060); Bernay (1017–1060); St Etienne (Abbaye aux Hommes, c. 1064, consecrated in 1077) and La Trinité (Abbaye aux Dames, begun 1062), both at Caen [**646, 647**]; Mont St Michel (1023).

The most important cathedrals are at Coutances (nave consecrated in 1056; the whole church in 1061), Bayeux (1077, the old choir) and Evreux (1076).

The arrangement of these churches is extremely varied. Generally they have three storeys, large arcades, galleries (St Etienne at Caen; Cerisy la Forêt; Fécamp), and a triforium (Bernay; Mont St Michel; Lessay; La Trinité at Caen).

In many of the 11th-century churches the roofing was of the open timber type, sometimes supported by diaphragm arches (St Vigor at Bayeux). About the middle of the 11th century the groined vault prevailed, leading eventually to the rib vault; in La Trinité at Caen the groined vaults retain their original form; in St Etienne at Caen and in La Trinité at Fécamp they were replaced by cross-ribbed vaults. Noteworthy is the application of the massive wall (Coutances, c. 1050) and the special disposition of the masses, façade towers and lantern tower.

Decoration, comparable to Irish and Viking ornamentation, retained a sober character based on geometrical patterns — tangent or intersecting circles, toothed fretwork and zigzag mouldings.

The valley of the middle Loire. In the 11th century Touraine and the valley of the middle Loire were the scene of great building activity. Examples are: St Martin at Tours; St Savin sur Gartempe [**561, 585**]; Montierneuf at Poitiers; the choir of St Benoît sur Loire, influenced by Cluny, its double transept a forerunner of Cluny III [**565**].

Experiments in stone vaulting began early at Reignac and at St Jean Baptiste at Langeais, and were first applied to parts of the building, i.e. the choir, the crossing and the narthex (St Mexme at Chinon). St Gildéric at Lavardin (Loir-et-Cher) is one of the earliest churches completely covered by a stone vault; the vault is supported by cross-ribs, the forerunners of the rib vault; the same is the case in the church of St Ours at Loches, and at Cormery.

The so-called pilgrimage churches were the most accomplished of the Romanesque buildings. The type occurs in the heart of France (Ste Foy at Conques, in Aveyron, 1039–1065, which can be considered a prototype [**588**], St Martial at Limoges, rebuilt 1063–1096, and St Etienne at Nevers, completed in 1097 [**567**], which had direct lighting from the clerestory). A barrel vault supported by transverse arches, galleries above the aisles and an ambulatory with radiating chapels are the characteristics of this type of church which were fully developed from the 3rd quarter of the 11th century [**645, 649**].

Developments outside France were as follows:

Spain. The crusade for the reconquest of Spain and the pilgrimages to Santiago de Compostela established continuous contacts with France. A complete replica of a Poitevin church is S. Martín at Frómista, erected in the second half of the 11th century. The abbey of Sahagún is the mother house of Cluny in Spain. The great monuments of the 11th century are closely related to the buildings of Languedoc: cathedral of Jaca (begun 1054); narthex of S. Isidoro at León (1063); Santiago de Compostela (begun c. 1077), closely related to French churches on the pilgrimage route, especially St Sernin at Toulouse, in its barrel vault, galleries, tower over the crossing, ambulatory and radiating chapels [**582, 653**].

England. The first of the great churches built in the Norman style was Westminster abbey, founded by Edward the Confessor c. 1049 and consecrated in 1065 (only the undercroft remains). For nearly a century after the Norman conquest architecture, with continental master masons, proceeded on almost the same lines as in Normandy (verticals, massive volumes, squat proportions, marked transepts, a lantern tower over the crossing and elongated naves with columns or piers, galleries and a timber roof).

From c. 1070 many Anglo-Saxon churches were destroyed and rebuilt on a more magnificent scale. The principal buildings were: St John's chapel in the Tower of London (1087), constructed by William the Conqueror, and the cathedrals of Canterbury, begun by Abbot Lanfranc of Caen in 1070 (only the crypt remains); St Albans, from 1077, by Paul of Caen, using Roman brick [**651**]; Winchester (transepts and crypt, 1079–1093); Lincoln (1074–1093); Ely (1083) [**578, 697**]; Gloucester (1089; only the crypt remains); Norwich (1096).

Italy. It was in Lombardy that Italian Romanesque architecture first developed. It included the introduction of piers into the column arcade (S. Eustorgio, Milan, 10th century) and the beginning of the substitution of a stone vault for the timber roof (Mazzone, c. 1030). Travelling ateliers of Lombard masons carried the style as far as Catalonia and the Rhineland. Externally, pilaster strips support dwarf arcading, especially round the apses of the short parallel-apsed presbytery (Sta Eufemia, Spoleto, 10th century). S. Ambrogio, Milan (though the dating is still controversial) contains all the distinguishing Lombard features (built c. 850 on present plan; reconstructed from 1128; narthex c. 1140; rib vault c. 1180 [**553**]). S. Abbondio, Como (1063–1095) embodies Cluniac architectural ideas.

In Tuscany the influential cathedral of Pisa was commenced in 1063 by a Greek, Boschetto, on a cruciform plan with oval dome [**583**]. Florence adhered more closely to Early Christian forms. S. Miniato (c. 1013; rebuilt 1140–1150 [**560**]) is a basilica with a timber roof but with piers at every third bay, carrying transverse arches. The decoration in veneers of patterned marble is similar to that on the façade of the Badia, Fiesole (c. 1090) [**650, 652**].

One of the most famous medieval buildings in Italy, the church at Monte Cassino, was destroyed in the Second World War.

The Rhineland and the Franco-German frontier region. Under the Salian

FRENCH. The Abbot Suger cup. Sardonyx. c. 1140. *National Gallery of Art, Washington.*

Emperors (1024–1125) Germany played a leading role. An important development was the double apse, east and west. The earliest instance is probably at Gernrode abbey (958–1050) and it becomes a prominent feature at St Michael, Hildesheim (1001–1033) [**559, 648**]. With its two apses, two chancels, two transepts and towers over both crossings, it is the earliest surviving example of this type of exterior. It also marks an important stage in the development of the Romanesque interior in the elementary articulation of its alternating piers and columns. Aquileia cathedral (rebuilding from 1031) derives from Hildesheim.

The Rhineland became the centre of a school of builders whose greatest creations (in their original form) included the cathedrals of Speyer, Trier and Sta Maria im Capitol. At Speyer (1030–1060) [**694**] the shafts of the nave piers ran right up to the flat timber ceiling. The latter was replaced *c.* 1080 by one of the earliest large-scale groined vaults in Europe. (Of this cathedral only the aisled groin-vaulted crypt survives [**654**]).

Trier cathedral (1017–1047), a rebuilding of an older church by Archbishop Poppo on a cross-in-square plan, remains almost unaltered. It is the only extant example of an early Salian façade, whose arcaded galleries, pilaster strips and arched string courses derive ultimately from Lombardy [**655**].

In Switzerland buildings of the Tessin valley region are closely related to those of Lombardy. Cluniac influence, how-

ever, is marked in the abbey at Payerne and at Romainmôtier (analogies with Tournus). Germanic influence prevailed at All Saints in Schaffhausen, one of the most beautiful German monuments of the period.

Sculpture. At the outset sculpture of the 11th century followed the technique of inlaid work, taking its inspiration from manuscripts, frescoes, ivories, metalwork and even textiles. It was still in the stage of experiment. The enormous capitals of St Germain des Prés (Musée de Cluny, Paris), dating from the second half of the 11th century, conclude these experiments.

In the 11th century the elements of decoration were of great variety, consisting of geometrical and plant motifs, animals, human figures and monsters. During the Carolingian period (owing to the absence of monumental sculpture) the minor arts showed a preference for human figures. The inexhaustible imagination of the Romanesque period avoided realistic presentation at first. Its principal aim was perfect adjustment of the sculpture to the architectural frame, together with realisation of its decorative function within this frame. Henri Focillon defined Romanesque sculpture as the 'plastic expression of architecture'.

Capitals were the first parts to be decorated with sculpture. These enhanced the rhythm of the structure by stressing the articulation of column or pillar and the springing of the arch. Human figures were rare; plant and geometric patterns prevailed.

The sculpture projected only slightly; the stone was treated as an engraving. Composition was either adapted to the architectural frame, underlining the function of the capital, or it was adapted to the geometrical form of the capital — trapezoidal, cubic, or hemispheric. Examples of functional adaptation are as follows: Atlas figures occur in southern France as far north as the Loire (St Benoît sur Loire) and in Spain (cathedral of Jaca; Sto Domingo de Silos).

The tympanum carved in low relief is a French invention of the end of the 11th century. The oldest example known is to be found on the church of St Fortunat at Charlieu (Loire), probably executed before the consecration of the church in 1094, representing the Ascension of Christ in the presence of the Apostles. The rather clumsy execution resembles that of the tympana of Anzy le Duc (Saône-et-Loire) and Neuilly en Donjon (Allier), representing the Fall (Temptation of Adam and Eve) and the Redemption (symbolised by the Adoration of the Magi). An early date has been attributed also to the tympanum of the cathedral of Jaca (Huesca), representing a labarum (Constantine's Christian standard) between two symmetrical lions, which served as a model for tympana in Aragon at Sta Cruz de la Serós and at S. Pedro at Huesca.

Painting. Romanesque churches were not as bare as has often been assumed. On the contrary, colour played a great part

648. ROMANESQUE. GERMANY. St Michael, Hildesheim. 1001–1033.

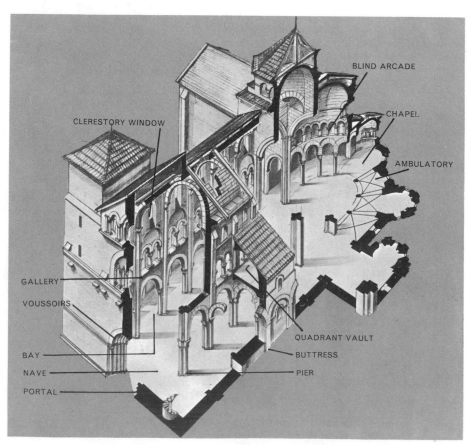

BLIND ARCADE

CHAPEL

AMBULATORY

CLERESTORY WINDOW

QUADRANT VAULT

GALLERY

VOUSSOIRS

BUTTRESS

BAY

NAVE

PIER

PORTAL

649. ROMANESQUE. Analytical perspective of St Etienne at Nevers.

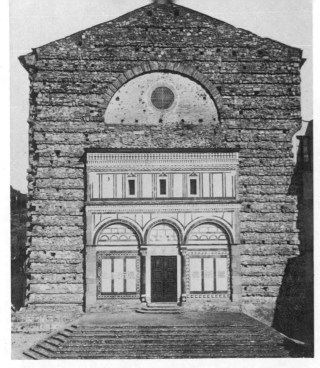

650. ROMANESQUE. ITALY. Badia, Fiesole. Façade. *c.* 1090.

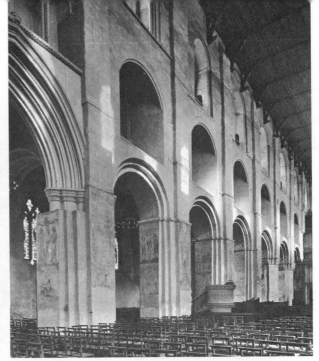

651. ROMANESQUE. ENGLAND. St Albans. North side of the nave, showing the original frescoes.

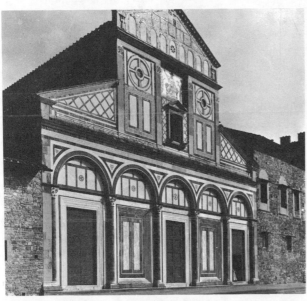

652. ROMANESQUE. ITALY. S. Miniato, Florence. The west front.

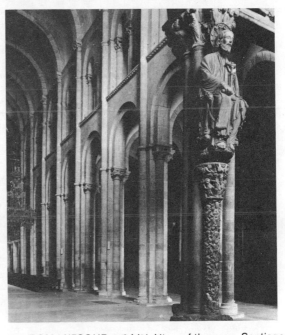

653. ROMANESQUE. SPAIN. View of the nave, Santiago de Compostela. End of the 11th century – beginning of the 12th century.

654. ROMANESQUE. GERMANY. Speyer cathedral. The crypt. 1004–1039.

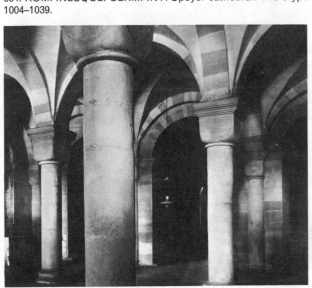

655. ROMANESQUE. GERMANY. Trier cathedral. West front. 1017–1047.

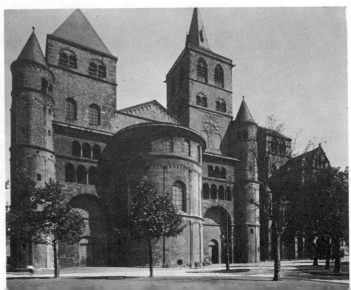

in the wall paintings, mosaic floors, stained glass windows, painted capitals (traces remain at St Nectaire and Mozac) and porches (traces are still visible at Conques and Vézelay).

Many murals, virtually unknown a century ago, have been rediscovered throughout Europe. These paintings covering walls, piers and vaults served the double purpose of decoration and instruction (for they illustrated the Bible in simple images). The different iconographical subjects had their place within the Church according to a kind of symbolic topography, reminding us of the teachings of the Eastern Church. Christ in Majesty has His sacred place in the apse, narrative scenes, on the vaults, etc. Secular subjects were rare. (On a gallery at Ebreuil [Allier] a hunting scene is interwoven with the scrollwork.)

Although it was an offspring of Carolingian painting (a good example of which, the Martyrdom of St Stephen, has been preserved in the crypt of St Germain at Auxerre [**520**]), Romanesque painting is more schematic and has moved far away from the naturalism of ancient classical painting.

Italian wall paintings were often inspired by Byzantine models, especially in southern Italy through the influence of Monte Cassino: S. Angelo in Formis (c. 1080) [**660**], a complete mural decoration, possibly deriving from a similar cycle at nearby Monte Cassino. Also drawing inspiration from Byzantine art is one of the masterpieces of Romanesque fresco painting—the scenes from the legend of St Clement in the lower church, S. Clemente, Rome (before 1084) [**659**]. The Ottonian influence can be seen in Lombardy in the painting of the Virgin and Child with the Emperor Conrad II, in the apse of Aquileia cathedral (1024–1039).

A major influence on the formation of Romanesque painting and sculpture came from manuscript illumination. Four groups can be distinguished:

1. *Ottonian.*
2. *Anglo-Saxon.* The Gospels of Amiens (1030) and the Life of St Omer (1050) are typical of the northern French school of illumination, known as the Franco-Saxon school.
3. *Mozarabic Spanish and southern French* (region of Albi and Toulouse). In Catalonia and Asturias, Christianity persisted but absorbed many Islamic elements. The anti-classical results are seen in the famous so-called Beatus MSS., illustrated editions of a Commentary on the Apocalypse written by Beatus of Liébana (786): Beatus MS. 975, Gerona cathedral; Beatus MS. for Sto Domingo de Silos (1091–1109, British Museum [**657**]). A masterpiece of the southern French school is the Apocalypse of St Sever, signed by Stephanus Carsia (middle of the 11th century), showing distinctly Mozarabic influence [**632**].
4. *Italian.* Monte Cassino abbey, which under Abbot Desiderius (1058–1087) played a great part in the shaping of late 11th-century Italian art, produced a number of important exultet rolls [**030**].

Exultet Roll of Benevento (1045); the Life of St Benedict (1070). In Lombardy the Ottonian influence was predominant: Sacramentary of Ivrea (1010). The large 'Atlas' Bibles produced in Rome during the second half of the century laid the foundation for later Romanesque miniature painting in central Italy.

ROMANESQUE ART OF THE 12TH CENTURY

History. In the 12th century western Europe assumed the leadership of Christian civilisation. The crusades bore witness to its expansive force.

1. *The rise of national monarchies.* In France the Capetian dynasty began the unification of the country under the French crown with Louis VI (1108–1137), Louis VII (1137–1180)—both kings being assisted by the wisdom of Suger, abbot of St Denis (1081–1151), a great minister and astute politician—and Philip Augustus (1180–1223).

In England after the death of the sons of William the Conqueror the partly French Plantagenet dynasty was installed under Henry II in 1154.

In Spain the arduous crusade of the reconquest promoted national feeling. Its symbol was the Cid Campeador (d. 1099).

2. *The rise of urban communities.* The rise of urban communities as an expression of the growing wealth of citizens in great commercial regions, especially in ports, had its origin in northern Italy in the early 11th century, and spread over the peninsula. Self-governing communities like Venice, Genoa, Pisa and Lucca grew into independent states. In the north communities and free cities supported by the power of the Hanseatic League (in Flanders and Germany) competed with the most powerful princes and gave birth to a class of merchant patrons of ever increasing prosperity.

The classical Romanesque style evolved in the first third of the 12th century was a complete realisation of religious and social functions and had an architectural programme with a wealth of sculptural decoration subordinated to the architectural frame.

The influence which a few great monuments exerted within a limited area led scholars to assume the existence of 're-gional schools'. However, the fact that monuments of a general type and of common characteristics are found both inside and outside France regardless of provinces and frontiers confutes this theory.

Religious architecture in France. Apart from churches continuing the use of the open timber roof (Dugny [Meuse]; St Martin de Boscherville, c. 1125 [**584**]) and buildings which already belong to Gothic architecture, we can distinguish three groups:

1. *Churches with pointed barrel vaults and without galleries above the aisles.* These are found mostly in Burgundy, Poitou and Provence.

a. *Burgundy.* Distinctive traits of the churches in Burgundy are: the peculiar shape of profiles and mouldings, with numerous decorative patterns borrowed from ancient Roman models (e.g. Cluny III); the wealth of the sculpture, with the exception of the Cistercian buildings. Apart from these general characteristics great variety prevails in structural design. Three types stand out, each of them represented by a great building.

(i) The Cluny group. The outstanding model was the grandiose church of Cluny III, begun by St Hugh (consecrated in 1095 and in 1131 [**568, 569**]). Certain details of the plan were peculiar to Cluny. The nave had direct lighting. The barrel vault was pointed, which meant that the semicircular arches were replaced by pointed ones. Similar buildings are: Paray le Monial [**570**]; St Andoche at Saulieu (1119); the cathedral of Autun (c. 1120) [**658**]; Notre Dame at Beaune; the cathedral of Langres.

(ii) The Vézelay group. In the church of La Madeleine at Vézelay (1096, consecrated in 1104 and 1132 [**573**]) the pointed barrel vault gave way to the groined vault divided by semicircular transverse arches [**575**]. The choir was rebuilt in the second half of the 12th century, with rib vaults. The groined vault exerted less pressure than the barrel vault. Similar buildings are: St Lazare at Avallon; St Philibert at Dijon; the priory church at Anzy le Duc. A little later Maria Laach, the first entirely vaulted basilica in the Rhineland, was constructed in the same way.

(iii) The group without clerestory. Nave and aisles are of almost the same height, so that direct lighting of the nave becomes impossible (Cistercian church at Fontenay, 1139–1147). The nave is covered by a pointed barrel vault supported by transverse arches [**562**].

b. *Poitou.* The bell towers of the churches of this region have a peculiar form: they are conical and are covered with overlapping stone scales; the façades bear an extraordinary wealth of decoration. This is true of Notre Dame la Grande at Poitiers [**586**]. The structure of these churches varies. The type most frequently encountered is the hall church (*Hallenkirche*), very common in Germany, in Spain and in France between the Garonne and the Loire. Other churches are aiseless or have a nave and two aisles, the aisles having groined vaults as at Notre Dame la Grande, Poitiers, and Chauvigny; at Preuilly and in St Eutrope at Saintes the aisles have quadrant (half-barrel) vaults, at Le Blanc and St Gaultier (Indre), transverse barrel vaults.

c. *Provence.* Simplicity of plan (aiseless nave or nave and two aisles and no ambulatory) and of line are the main characteristics of Romanesque churches in Provence. The bell towers are robust and square [**661**]. The decoration is reminiscent of that of Roman times, with egg-and-tongue, meander, and bead-and-reel motifs; so is the architectural arrangement, with its triangular pediments (St Restitut, St Gabriel; Notre Dame des

656. ROMANESQUE. ITALY. Adam and Eve: Exultet Roll from the Benedictine monastery of Monte Cassino. 1057–1058. Add. MSS. 30337. *British Museum.*

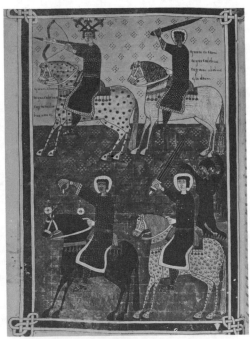

657. ROMANESQUE. SPAIN. The Four Horsemen of the Apocalypse, from Beatus' Commentary on the Apocalypse, written for the abbey of Sto Domingo de Silos. 1091–1109. Add. MSS. 11695. *British Museum.*

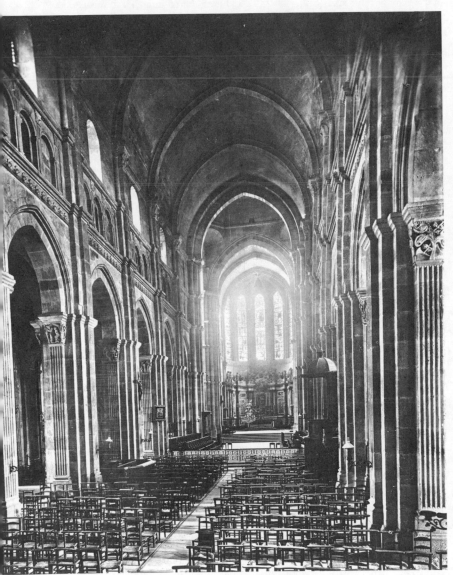

658. ROMANESQUE. BURGUNDY. Nave of Autun cathedral, showing pointed barrel vault and arches.

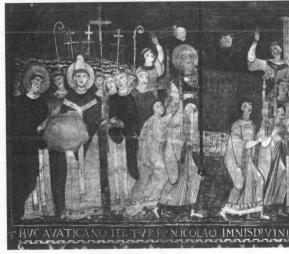

659. ROMANESQUE. ITALY. S. Clemente, Rome. Fresco showing the Carrying of the Body of St Clement. 11th century.

660. ROMANESQUE. ITALY. S. Angelo in Formis. Fresco of Christ healing the Blind Man. 11th century.

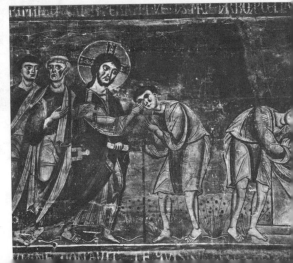

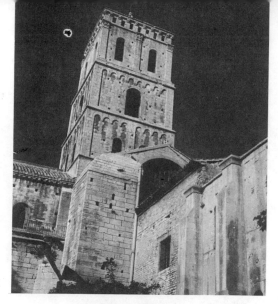

661. ROMANESQUE. PROVENCE.
Bell tower of St Trophime at Arles.

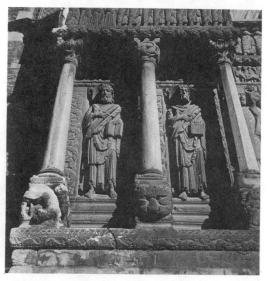

662. ROMANESQUE. PROVENCE.
St Trophime at Arles. Detail from the façade, showing frieze and columns.

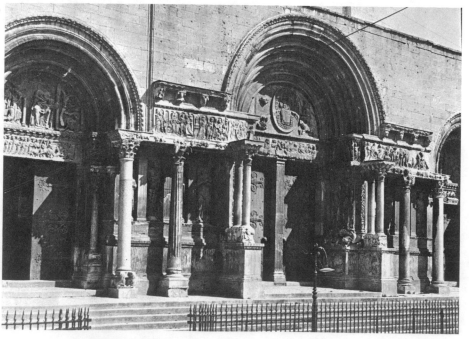

663. ROMANESQUE. PROVENCE.
St Gilles du Gard. Detail of the façade.

Doms at Avignon) and its friezes supported by columns (St Trophime at Arles; St Gilles du Gard in Languedoc [**662, 663**]).

2. *Churches with galleries over the aisles.* This type, known as the pilgrimage church, existed from the end of the 11th century: Ste Foy at Conques; [**588, 645, 665, 666**]; St Etienne at Nevers [**567, 664**]; Santiago de Compostela [**653**]. In the 12th century a number of these churches were erected in southern and central France: St Sernin at Toulouse (choir consecrated in 1095 [**558, 589**]); St Gaudens; Notre Dame du Port at Clermont-Ferrand [**456, 668**]; Orcival; St Nectaire; Issoire [**667, 669**]; Figeac. All have an ambulatory and radiating chapels and, over the crossing, a bell tower on domical vaults.

3. *Churches with a sequence of domes.* These form a homogeneous group and are found in Périgord (St Front at Périgueux [**576**]), Angoulême, the Quercy (Cahors; Souillac), and even the Limousin (Solignac), the Auvergne (cathedral of Le Puy, with six domes resting on squinches), and Poitou (St Hilaire at Poitiers). None of these churches has aisles [**572**].

Religious architecture in England.
In this century English architecture developed a personal style. Individual characteristics included: (1) A tendency to increased length of nave: Peterborough; Ely [**578**]. (2) The combination of a central tower with two western towers, all surmounted by spires. All three original towers remain only at Southwell (1108). Tewkesbury [**703**], St Albans, Winchester and Norwich retain central towers. The unique towers of the transepts at Exeter (1130) reveal Rhenish influence. (3) Little emphasis on the west front. The exception is Lincoln with its three deep recesses (the only surviving part of the church begun in 1074). The

finest west front is at Tewkesbury (*c.* 1130–1140; window, 15th century) [**702**].

Nearly all the cathedrals have been extensively altered, but Durham [**706**], Gloucester [**700**], Norwich, Peterborough, Ely [**578, 697**], St Albans [**651**] and Rochester are mainly or largely Norman structures.

There were two main types of East end: (1) Parallel apsed (like Bernay): St Albans, Canterbury, Ely and Durham. Peterborough (begun 1118) has the only surviving one. At St Albans [**651**], Peterborough and Norwich, there are compound piers with tall shafts running through from floor to ceiling, giving bay articulation. (2) Ambulatory type (like Jumièges): Winchester, Worcester, Chichester, Norwich. The last (1096–1150) alone retains the main apse and ambulatory. (3) In the south-west, at Gloucester, Tewkesbury and Pershore, the main apse was three sided, not semicircular, and the nave had tall cylindrical columns, no vaulting shafts, and diminutive triforium arches.

Durham (1093–1133 [**707**]) is the finest and least altered cathedral of this period, retaining its choir, transepts, nave and western towers: (the parallel-apsed east end was replaced in the 13th century by the Chapel of the Nine Altars). It was the first building in Europe to have ribbed stone vaults throughout: choir, by 1104; nave, 1128–1133. The nave has compound piers alternating with cylindrical columns, and pointed transverse arches, but the building is still Romanesque in feeling.

The pointed arch and the square east end, together with an absence of towers, appear in the first austere Cistercian churches: Rievaulx abbey (founded 1132); Fountains abbey (begun *c.* 1135).

Religious architecture in Spain. A
marked difference exists between buildings of western and eastern provinces. Catalonia in the east remained faithful to the forms of the 11th century: no galleries; ambulatories rare and without radiating chapels (Benedictine monastery of S. Pedro at Roda). On the other hand the structure is varied. The most outstanding buildings are the cathedral of Urgel and S. Pedro at Galligans. The cloisters are of remarkable beauty, as at Gerona, S. Cugat del Vallés, Ripoll, Estany and Elne. The rib vault made its first appearance in Cistercian buildings.

In the West there is a striking difference between the official art, showing French influence, and a popular current inspired by Moslem art. To the official type belong: S. Vicente at Ávila (1100); the Salamanca group with the old cathedral of Salamanca; the collegiate church at Toro, recalling Vézelay; the cathedral of Zamora; the region of Sahagún, where Spain's most important Cluniac foundation was established.

The Moslem influence is most evident in the region of Sahagún at S. Tirso, S. Lorenzo, S. Jago, La Lugareja at Arévalo and S. Andrés at Cuellar. The naves of these churches are decorated with horse-

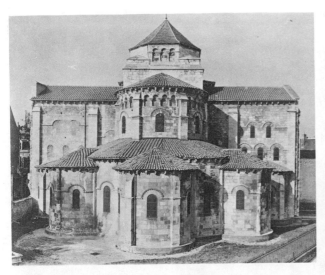

664. View of the apse, St Etienne at Nevers. 1083–1097.

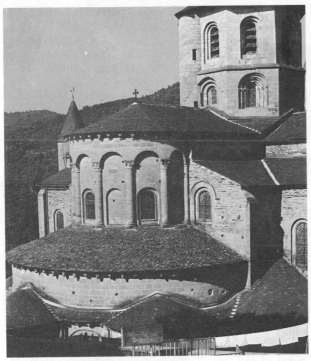

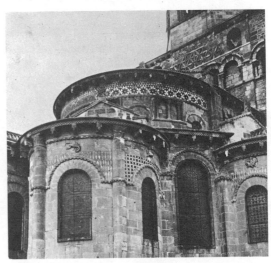

666. *Above*. Ste Foy at Conques. View of the crossing.

665. *Left*. View of the apse, Ste Foy at Conques. 11th century.

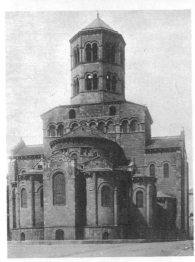

667. ROMANESQUE. AUVERGNE.
Issoire. View of the apse, showing
characteristic Auvergnat bell tower.

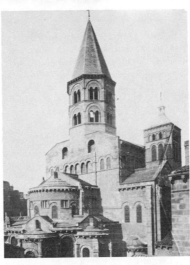

668. ROMANESQUE. AUVERGNE.
Notre Dame du Port, Clermont-
Ferrand. View of the apse, showing
characteristic Auvergnat bell tower.

669. ROMANESQUE. AUVERGNE.
Issoire. Detail of the apse, showing
characteristic Auvergnat decoration.

shoe arches in the Moorish style, the apses with superimposed arcades; in the region of Segovia, rib vaults are found side by side with wooden ceilings supported by arches.

Religious architecture in Italy. The unsettled state of affairs in Italy was reflected in the regional nature of its architecture.

1. *Lombardy.* Northern Romanesque made little headway except in Lombardy where the substitution of clustered piers for the column arcade continued (S. Zeno, Verona, 1125–1139); rib vaults became more general (S. Michele, Pavia, after 1143 [**709**]) and the crossing was covered by a polygonal dome on squinches (Parma cathedral, after 1117). The west front was treated as a flat, low-pitched gable-end extending across the whole building (S. Michele, Pavia, *c.* 1160–1180 [**708**]), relieved by stepped arcading under the eaves and by projecting porches on detached columns (Ferrara cathedral *c.* 1135). The upper part of the apsidal east end was treated as an open-arcaded gallery [**710**].

2. *Tuscany.* Tuscan architecture differs from other schools in: (a) the adoption of marble casing, either in alternating bands of light and dark (Pisa cathedral, 1063–1125 [**583**]) or in thin veneers of coloured patterns (S. Miniato, Florence [**652**]); (b) the widespread use of arcading on façades, with galleries in tiers above the ground floor (S. Michele, Lucca, from 1143 [**716**]); (c) the retention of the timber ceiling, allowing a columned arcade (Pisa cathedral [**717**]). This building (begun 1063, enlarged in the 12th century), with its baptistery (begun 1153) [**719**] and campanile (from 1174) [**718**], had a wide influence, not only in Tuscany (Lucca [**714**, **716**], Pistoia, Arezzo) and Apulia (façade of Troia cathedral, begun 1093) but as far afield as Dalmatia (S. Grisogono, Zadar, 1175).

3. *Rome.* In Rome the basilica form remained supreme and building was restricted chiefly to the addition of porticoes, cloisters (S. Paolo fuori le Mura) and campanili (S. Girorgio in Velabrio).

4. *Southern Italy.* The conquest of Sicily by the Normans in the middle of the 11th century brought about an intermingling of Norman, Islamic and Byzantine influences. Architecture was concentrated chiefly in Apulia with its centre at Bari and in Sicily with its centre at Palermo. Norman influence is strong in Cefalù cathedral (choir begun 1131), built by Roger II as his tomb [**713**]. Byzantine influence is seen in a series of domed churches (Molfetta cathedral, after 1150) and in the lavish use of mosaics (Cefalù, Monreale, Palermo). To Islamic influence is due the interlaced arcading of the apse of Monreale cathedral (1174–1182) [**712**] and the pointed arches of its cloisters (pre-1200) [**711**]. The outstanding example of this mingling of styles is the palatine chapel, Palermo (1132–1140), built as part of the Norman royal palace, which has a European plan, Byzantine mosaics and Moorish stalactite vaulting

Religious architecture in Germany and Belgium. The Rhineland continued its lead; nearly all the important buildings were in a relatively small area in the lower Rhine. The most effective feature externally is the skyline, with fine grouping of two pairs of towers (often circular [**696**]) at each end and the crossing of both apses covered by an octagonal cupola or lantern on squinch arches (abbey church of Maria Laach, 1093–1156, with its three east apses and six towers and, inside, its transverse arches separating cross-vaults).

Ornament is virtually restricted to arcaded galleries round the apses, pilaster strips and arched string courses under the eaves. The internal effect is simple and severe and can be seen to advantage in the three large Imperial cathedrals of Speyer, Worms (1170–1230) and Mainz (1085–1239) [**579, 689, 691**]. There are alternating large and small piers in the nave arcade; there is no triforium, and a desire for verticality is implicit in the continuation of the inner members of the piers to the full height of the wall even where vaulting was not intended.

At Cologne (severely damaged in the Second World War) was a group of churches attempting a synthesis of basilican and central plan through a triapsidal choir: Sta Maria im Capitol (*c.* 1050); S. Martin's (after 1185); Church of the Apostles (from *c.* 1190). Their influence is seen in the east end of Tournai cathedral (1110–1171) in Belgium, where the apsidal transepts remain almost unaltered [**690**]. The nave (dedicated 1066), with a large open-arched triforium, is northern French in style [**577**]. The influence of Rhenish Romanesque is also seen at Lund cathedral in Sweden [**692**] (begun 1080 on the model of Speyer [**654, 694**]).

Compared to the Rhineland the rest of Germany is of less importance, with exceptions such as the Chapel of All Saints, Regensburg cathedral (*c.* 1150), and the abbey church, Königslutter (begun 1135), which followed Speyer in cross-vaulting; its double-aisled cloisters are famous for their lavishly decorated piers.

Religious architecture in the Middle East. The conquest of Jerusalem acquainted Palestine and Syria with French Romanesque architecture, especially with the Burgundian style. Gaza, St Anne in Jerusalem, Tortosa and Beirut remind us of Vézelay and Cluny.

Military and civil architecture. During the 11th and 12th centuries wooden keeps gave way to quadrangular stone fortresses (Beaugency, for example). In England William the Conqueror built a chain of castles (eighty-five, by 1100). With the exception of the Tower of London (White Tower, 1078–1087 [**670**]) and Colchester, the majority were of the motte and bailey type, with timber palisade. In the 12th century there was a striking change from the stronghold of earthworks and timber to the fortress of stone—either the shell keep, a ring of masonry round the plateau (Windsor,

Alnwick, Berkeley, Arundel), or the rectangular tower keep (Hedingham, Rochester, Dover, Norwich [**671**]). In the bailey the most important building and the centre of domestic life was the hall (Oakham, Winchester).

During the crusades military architects learned in Syria from Byzantine and Arab engineers how to construct skilful fortifications which were indispensable to the crusaders in maintaining strategic positions in hostile countries. The military orders were extremely active: the Templars at Chastel Blanc and Tortosa, the Knights Hospitallers at Margat and at Krak des Chevaliers (rebuilt after 1170 and completed in the 13th century [**933**]); the style of the last is reflected in the ruins of Château Gaillard, built by Richard I of England, in 1197. These castles are an indication of the accomplished skill reached at that period in the art of fortification.

The bridge over the Rhône at Avignon (end of the 12th century), of which four arches have survived, the town hall of La Réole (Gironde) and the large hall of the hospital at Angers with its cloisters are the major examples of the civil architecture of the Romanesque period which have remained.

Sculpture. Romanesque sculpture of the 12th century is unrealistic in character and is subordinated to the architectural setting.

Iconography. The subjects on the portals are usually taken from the Apocalypse. The most outstanding work, the portal of St Pierre at Moissac, shows Christ surrounded by the symbols of the four Evangelists in the presence of the twenty-four Elders in contemplation [**607, 608**]. Frequently this subject is confined to a presentation of Christ in Majesty (in a mandorla), a form easily adaptable to the tympanum. Other subjects are the Ascension (Cahors) and the Last Judgment (Conques and Autun), giving occasion to a picturesque description of the punishments of man. The God of the Romanesque sculptors was a formidable, majestic and just God [**597, 598, 609, 610**].

The subjects of the capitals are either purely decorative (foliage, animals, monsters of an inexhaustible variety) or are narrative (Virgin and Child, the life of Christ, scenes from the Old Testament, the seasons, the Labours of the Months and allegories, i.e. the Virtues and the Vices). The treble series of capitals from the cloisters and the statues from the portal of La Daurade, preserved in the Musée des Augustins at Toulouse, illustrate the evolution of Romanesque sculpture in Languedoc from its beginnings until it came into contact with the art of Chartres and of St Denis.

The sculptured altars such as the altar of St Sernin, a work of Gilduin, reveal the same spirit as the monumental statues of the churches [**624**]. Sometimes these sculptures were a translation of goldsmiths' work into stone, e.g. the altar of Avenas (Rhône); others, less deeply carved, have the effect of inlays on

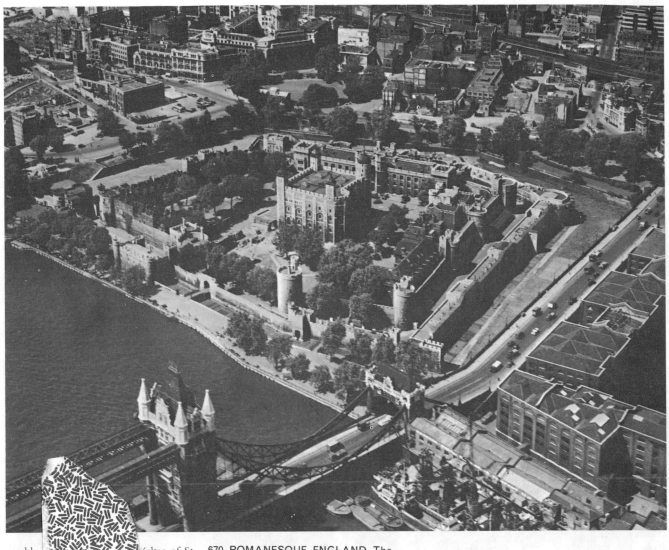

670. ROMANESQUE. ENGLAND. The Tower of London. Aerial view showing the keep. 1078–1087.

marble, [...] (altar of St Guilhem [...])

Franc[...] [...]onumental sculptur[...] [...]oc, Burgundy, [...]ne and Poitou, [...] and southern France. In the north, sculpture was already becoming Gothic in style.

a. *Languedoc.* The proximity of Spain, the road to Santiago de Compostela and the marble quarries in the Pyrenees were all influential.

Capitals: At St Sernin the decoration consists of foliage and animal motifs (1095–1130); in the great cloisters at Moissac are scenes from the lives of the saints (1100). Similar works from the same school were found in the cloisters of the cathedral and of La Daurade in Toulouse [471].

Portals: Characteristic of the monumental sculpture in Languedoc are the elongated proportions of human figures, their crossed legs and dancing postures [551], the intense life animating them with a keen sense of rhythm, e.g. the great statues of Apostles from the portals of the chapter house of La Daurade and the cathedral, Toulouse, signed: Gilabertus (1121–1130).

On the tympanum of the great portal of St Pierre at Moissac is the Apocalyptic Vision (1115–1136); on the jambs are narrative scenes (closely related to those on the great portal at Beaulieu, in Corrèze) and episodes with a moral lesson, e.g. the chastisement in hell [720, 724]. The

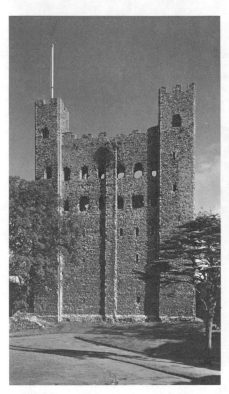

671. ROMANESQUE. ENGLAND. The keep at Rochester castle. c. 1130.

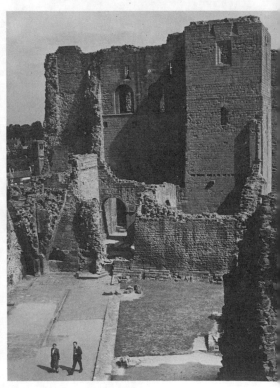

672. ROMANESQUE. ENGLAND. Kenilworth castle, the keep. 1120.

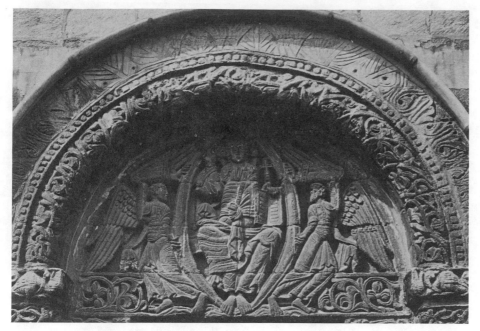

673. ROMANESQUE. ENGLAND. Ely cathedral. The Prior's Door.

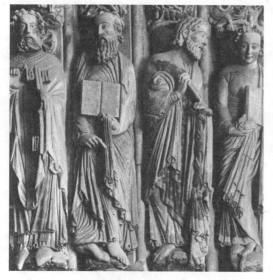

674. ROMANESQUE. SPAIN. Detail of the Portico de la Gloria. Santiago de Compostela. By Master Matthew. Completed 1188.

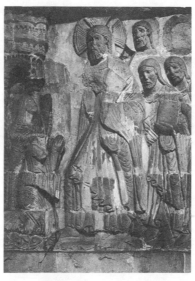

675. ROMANESQUE. ENGLAND. Chichester cathedral. Relief showing Christ in the house of Martha and Mary. c. 1140.

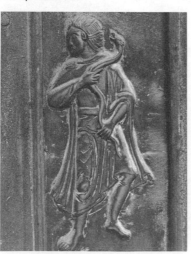

676. ROMANESQUE. GERMANY. Moses with the Serpent, from the bronze doors at Augsburg cathedral. 1060.

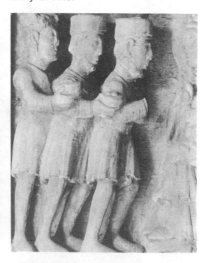

677. ROMANESQUE. GERMANY. The Adoration of the Magi, from the doors, Sta Maria im Capitol, Cologne. c. 1050

influence of this sculpture is evident in Corrèze and in the Cantal; its workshops were active far to the north in the 12th century (the Royal Portal at Chartres [**797**]).

b. *Burgundy*. The capitals of Vézelay (1120–1140) are carved with profane allegories, biblical subjects and the lives of the saints [**605, 613**]. They are closely related to the capitals of St Andoche at Saulieu and St Lazare at Autun, probably products of the same workshop, about 1120 [**493, 725–727**]. The famous Last Judgment at Autun shows a particular elongation of proportions [**609, 610**].

c. *Provence*. The influence of Graeco-Roman entablatures can be detected in the great frieze of the life of Christ at St Trophime, Arles, and at St Gilles du Gard [**626, 723**].

d. *Auvergne*. The series of capitals at, for example, Notre Dame du Port in Clermont-Ferrand, Mozac and St Nectaire, of soft limestone cut coarsely in thickset masses, forms a striking contrast to the slender forms found in the Languedoc [**728–730**].

e. *Poitou and the south-west*. The sculptures cover the entire façade (cathedral of Angoulême [**593**]; Notre Dame la Grande, Poitiers). On the portals most of the decoration is limited to the voussoirs of the arches, each designed independently (Blazimont in Gironde; Ste Marie at Oloron, Basses-Pyrénées [**612, 614**]).

Outside France Romanesque sculpture continued into the 13th century.

Spain. Together with France, Spain has produced the most beautiful sculptured capitals, e.g. the large buildings in Catalonia (Barcelona, Gerona, Tarragona, Ripoll, Estany); in Aragon the cloisters of Huesca and S. Juan de la Peña; in Navarre, Pamplona; in Castile, Sto Domingo de Silos. The portals at Ripoll [**615**] and at Santiago de Compostela (Puerta de las Platerías; Portico de la Gloria, completed in 1188 by Master Matthew), as well as tympana such as that of S. Isidoro at León, show a close relationship to the sculptures of Languedoc [**621, 674, 679**].

Italy. The tradition of Roman sculpture remained everywhere. Rome, though accepting Romanesque architecture for its cloisters, remained indifferent to the dynamic and revolutionary spirit of this style.

Lombard sculpture was in the hands of Guglielmo de Modena and Benedetto Antelami, one of the earliest individual personalities among the medieval artists, who worked mostly in Parma from 1178 to 1223 (ambo and portal of the cathedral; decoration of the baptistery [**620**]).

In Sicily the beautiful capitals of the cloisters of Monreale near Palermo (1174–1182) [**681**] are French in influence, transmitted by the Norman rulers. The bronze doors of the basilica at Monreale, on the other hand, were signed by Bonannus of Pisa in 1186.

Germany. The decoration of Romanesque buildings is restrained. There were few sculptors but excellent founders and goldsmiths, (Riquin of Magdeburg

worked on the bronze doors of the cathedral of Novgorod.) The north portal of St James, Regensburg ('Schotten-kirche', c. 1185) recalls Notre Dame la Grande, Poitiers. The stucco choir-screen reliefs in St Michael, Hildesheim (c. 1186) herald the classical period of German medieval sculpture.

England. In England architectural sculpture was strongly influenced by France, though in the works of the Herefordshire school there was a revival of the Anglo-Saxon 'beak-head' ornament: Kilpeck (c. 1140); Leominster priory (after 1141); Iffley (c. 1175) [**678, 705**].

The most ambitious west fronts were Lincoln (after 1141), having three door-ways showing analogies with St Denis and a frieze inspired possibly by Modena, and Rochester (c. 1160), whose main door-way derives from Poitiers. Influence from western France, especially the Saintonge region, is also seen in the south porch of Malmesbury abbey (1160–1170) and the west door of Barfreston (c. 1180).

Painting. *Frescoes.* A number of wall paintings were executed in the 12th century. Wall paintings in France used to be somewhat arbitrarily divided into two groups:

(1) Paintings on a light ground are found in Poitou, in the Loire region, in Anjou, in the Touraine and in Berry. The most famous are at St Savin sur Gartempe (Vienne) [**561, 644**] and at Tavant (Indre-et-Loire). Those at Liget (Indre-et-Loire), Vicq (Indre) and Brinay (Cher) [**642**] are striking in their power of expression and their majestic quality.

(2) Paintings on a dark ground of azure or dark blue, executed in bright tones, occur in Burgundy and central France and extend to Velay, Provence, Languedoc and Catalonia. In some of them Byzantine influence transmitted by Italian painting is predominant. The chapel of the Cluniac priory at Berzé la Ville is decorated in this style [**640, 641**].

Outside France Romanesque wall paintings of great originality have survived in Catalonia (Sta María at Bohi, S. Clemente at Tahull [**680**] and Pedret). Many of these paintings are in the museums of Barcelona and Vich. The frescoes in the Panteón de los Reyes, S. Isidoro, León (1157–1181), show a new style strongly influenced by French miniatures.

Illumination. In France the centre showing the greatest originality in the 12th century was Cîteaux in Burgundy (Bible of St Stephen Harding in the Dijon Library; in a similar style was the Moralia in Job of Cambrai, Bibliothèque Nationale, Paris [**486**]). The order of Cîteaux, before it prohibited the use of decorated manuscripts in 1134, gave French illumination a tendency towards a stylised form of naturalism.

Aquitanian manuscripts show similarities of style with the sculptures of Moissac and Toulouse. Influences coming from outside France were considerable (English in Normandy and northern France). Close contact between England and northern France gave rise to a

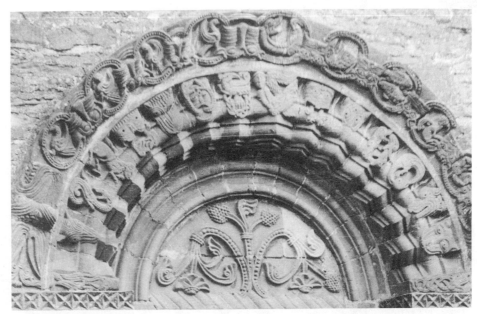

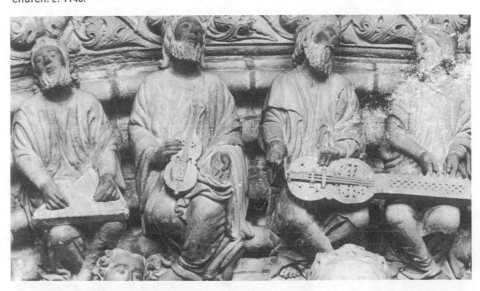

678. *Above.* ROMANESQUE. ENGLAND· Tympanum, Kilpeck church. c. 1140.

679. ROMANESQUE. SPAIN. Detail from the Portico de la Gloria, Santiago de Compostela.

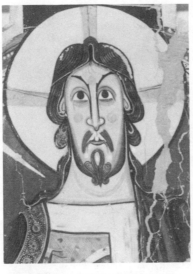

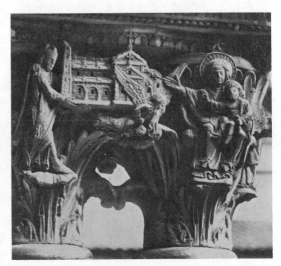

680. ROMANESQUE. SPAIN. Fresco from the apse of S. Clemente at Tahull (Catalonia). 1123. *Barcelona Museum.*

681. ROMANESQUE. SICILY. Monreale cathedral. Joined capitals in the cloisters, showing William I offering the Church to the Virgin. Last quarter of the 12th century.

'Franco-insular' style. Byzantine influence penetrated by way of Ottonian manuscripts, particularly to Cluny. One of the most sumptuous among the great Bibles of the 12th century is that of Souvigny (Allier).

German illumination, strongly influenced by Byzantium, lost the predominant position it had held during the Ottonian period.

In England a renewed wave of Byzantine influence from Norman Sicily resulted in a monumental style of large-scale magnificence. The chief scriptoria were in the south, at Canterbury, Winchester, Bury St Edmunds and St Albans. The new elements of thick body colour, patterned borders, strong contours and rigid attitudes appeared first in the St Albans Psalter by Roger of St Albans (1119–1146, St Godehard, Hildesheim). The finest works of the style are a series of large Bibles: Bury Bible (1121–1148, Corpus Christi College, Cambridge); Lambeth Bible (mid-12th century, Lambeth Palace); Winchester Bible (c. 1160–1170, library, Winchester cathedral), which surpasses the others in boldness of decoration and vigour of figure painting [683–686].

Mosaics. In France mosaic floors (Ganagobie, Basses-Alpes) received inspiration from Oriental textiles.

In Italy where there is an abundance of coloured marble the Cosmati, a family of Roman architects and sculptors working in the 12th and 13th centuries, revived the craft of Roman marble-work and decorated façades, floors, ciboria, thrones, ambos, tombs, etc., with mosaics in geometrical designs, rich in colour and full of imagination. In Latium and Tuscany this art assumed classical forms. The finest work of the school was the cloister of S. Paolo fuori le Mura, Rome (1193–1241). In the Campagna and southern Italy and Sicily mosaic was enriched by Moslem motifs (decorations in the cathedrals of Salerno, Ravello and Amalfi).

Stained glass. Texts tell us that at the end of the 10th century Bishop Adalberon ordered for the cathedral of Reims stained glass windows which are now lost.

Although the technique used by the workers in stained glass of the Romanesque period is well known from Theophilus' treatise, very little is known of the actual works. Only a few windows of the second half of the 12th century have survived (prophets in the cathedral of Augsburg; Ascension in the cathedral of Le Mans).

In the rather sombre Romanesque churches stained glass was, to begin with, thick and light, with only a few colours. The iconography was that of wall paintings and sculpture; the composition was simple and the designs were heavily stylised.

Suger, under whose direction the windows of St Denis were executed, gave a great stimulus to the rise of the Gothic stained glass window.

The minor arts. *Ivories.* In Germany the Carolingian and Ottonian tradition crystallised into a solemn and meticulous style (Bamberg shrine, Munich Museum).

In France ivory sculpture was insignificant, generally influenced by Oriental or Mozarabic models (ivory horn at Toulouse; reliquary of St Cassien at Marseille).

In Spain the most original works are the Mozarabic ivories, owing to their combination of Christian subjects and Moorish ornaments (Crucifix of S. Isidoro at León, Madrid [687]).

England produced a small group of unrivalled quality, which includes the crozier (11th–12th centuries) in the Victoria and Albert Museum and the whalebone relief of the Adoration of the Magi (early 12th century, Victoria and Albert Museum), which has stylistic affinities with French and northern Spanish work [688].

Metalwork and enamels. Goldsmiths' work developed rapidly and played an influential role. The lavish use of cloisonné enamel and embossed gold relief was abandoned for champlevé enamel and solid bronze casting. At Stavelot and Liège a style of sombre monumentality developed (silver altar by Roger of Helmarshausen for Henry, Bishop of Paderborn, 1100, Paderborn cathedral).

Mosan art [739], originating in the Walloon provinces and developed in Lorraine, penetrated into Austria, Poland, Switzerland and Scandinavia. The three greatest personalities were: (1) Renier de Huy (bronze font in St Barthélemy, Liège, 1107–1118), has a nobility of style influenced by Liège ivory carvings and the Stavelot Bible (1097–1098, British Museum). (2) Godefroid de Claire (reliquary head of St Alexander from Stavelot abbey, 1146, Brussels). The Crucifix of St Bertin (1160–1175, St Omer Museum) also reflects his style. (3) Nicolas of Verdun: the finest work of the period is his Altar of Verdun (1181) [735, 736]. Other works of his include the Shrine of the Virgin (1205, Tournai cathedral) and the Shrine of the Three Kings (1190–1230, Cologne cathedral).

Rhenish art, after initial influence from Ottonian goldsmiths' work, developed an individual character. The chief centres were at Cologne, Trier and Aachen. Outstanding works include a reliquary (c. 1150–1160, Darmstadt), an altar by Cologne goldsmith Eibert at Welfenschatz (1170) and the domed Eltenberg Reliquary (c. 1180, Victoria and Albert Museum [740]).

In France Abbot Suger (1122–1151) imported 'lorrain' goldsmiths in 1140 to work on a gold crucifix 23 feet high for the choir of St Denis. It may have been they who mounted the famous antique vases (e.g. Eagle porphyry vase, treasure of St Denis, Louvre) and the sardonyx chalice of Suger (Kress Collection, National Gallery, Washington). In the Li-mousin was developed the extensive use of champlevé enamel, which differs from cloisonné in that the metal is hollowed out into cells in which the enamel is fused. The abbey of Solignac and that of St Martial, Limoges, produced large numbers of copper shrines in basilica form ornamented with figures enamelled in blue, red and turquoise (casket of Ste Valerie, the patron saint of Limoges, c. 1170, British Museum [734]). Towards the end of the century grounds were enlivened with foliage scrolls and flowerets in yellow, white and green (shrine from the treasure of Mozac, Puy-de-Dôme). The use of enamel extended even to royal tombs (plaque of Geoffrey Plantagenet, Duke of Anjou, Le Mans Museum [733]).

In Italy the masterpiece is the silver paliotto of Città di Castello (1144), already proto-Renaissance in feeling. There are bronze doors at Troia cathedral (1119) and Ravello (1179) by Barisanus of Trani; at Pisa (1180) and Monreale (1186), by Bonannus of Pisa.

In England an exceptional work is the Gloucester candlestick, given to the church by Peter, abbot of Gloucester, 1104–1113 (Victoria and Albert Museum). The treatment of men, monsters and foliage relates it stylistically to Hildesheim rather than to Mosan work.

Textiles, hangings, embroidery. Luxurious and precious textiles for display at divine services were brought from the Orient by Italian merchants (Genoa and Venice) and pilgrims, or found their way into Europe from Arab Spain. The Oriental textiles played an important part in the development of style and design in Romanesque art. Local workshops also produced hangings and embroideries such as the tapestry of St Gereon, Cologne, that of the cathedral of Gerona, Catalonia and that of Quedlinburg castle in Prussia. The Bayeux Tapestry [637, 639] is an embroidery ordered in England by William the Conqueror's brother, Bishop Odo, for his cathedral of Bayeux (consecrated 1079). Though questioned, an English provenance remains the most plausible.

Josèphe Jacquiot and Evelyn King

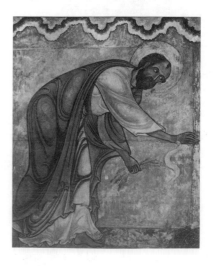

682. ROMANESQUE. ENGLAND. Canterbury cathedral. Fresco of St Paul at Melita, shaking the viper off his hand. Early 12th century. Reconstruction by Dr E. W. Tristram,

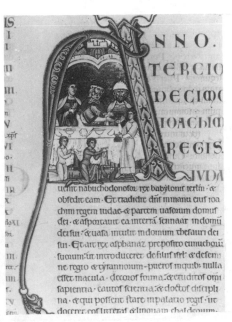

684. The Winchester Bible. Initial to Daniel.

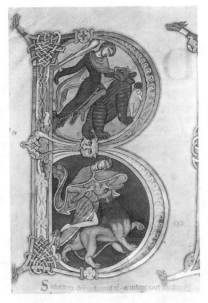

683. *Above*. ROMANESQUE. ENGLAND. The Winchester Bible. Begun *c*. 1160–1170. Elijah and the Chariot of Fire. *Winchester Cathedral Library*.

686. *Below*. The Winchester Bible Moses and the Egyptian.

685. The Winchester Bible. Initial including David delivering the Lamb from the mouth of the Lion.

687. ROMANESQUE. SPAIN. Ivory Crucifix. 11th century. *Museo Árqueologico Nacional, Madrid*.

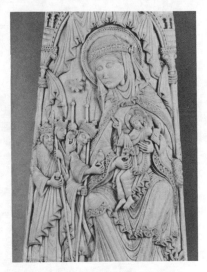

688. ROMANESQUE. ENGLAND. Adoration of the Magi. Whalebone. 12th century. *Victoria and Albert Museum*.

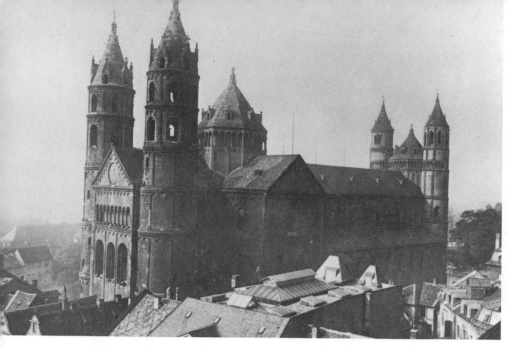

689. ROMANESQUE. GERMANY. Worms cathedral. 1170–1230.

690. ROMANESQUE. BELGIUM. Tournai cathedral. Interior of apsidal transept.

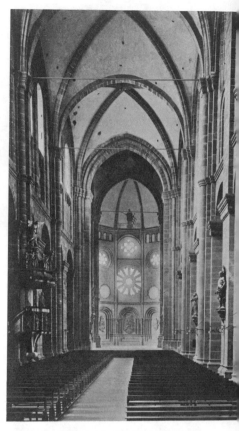

691. ROMANESQUE. GERMANY. Worms cathedral. View of the nave.

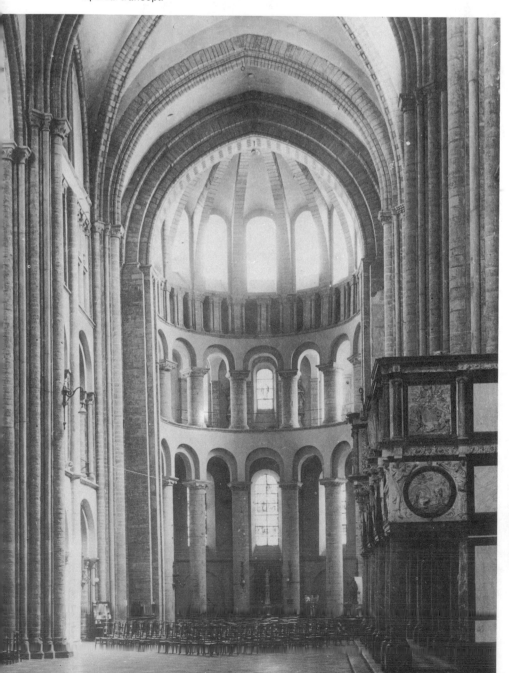

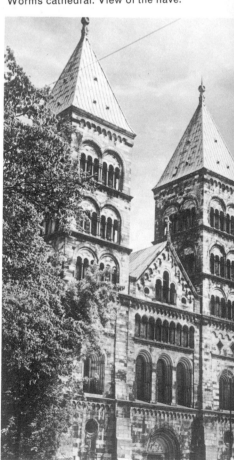

692. ROMANESQUE. SWEDEN. Lund cathedral. View of the west front. 12th century.

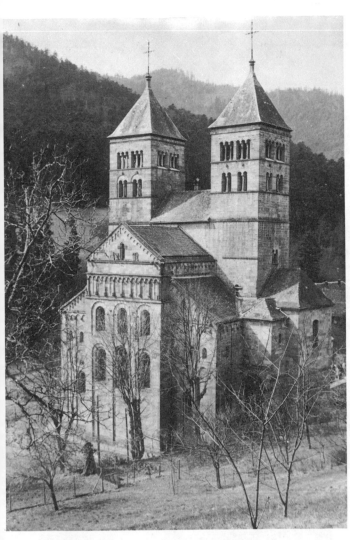

693. ROMANESQUE. FRANCE. RHENISH. View of the abbey church of Murbach, which shows stylistic affinities with Lombardy. 12th century.

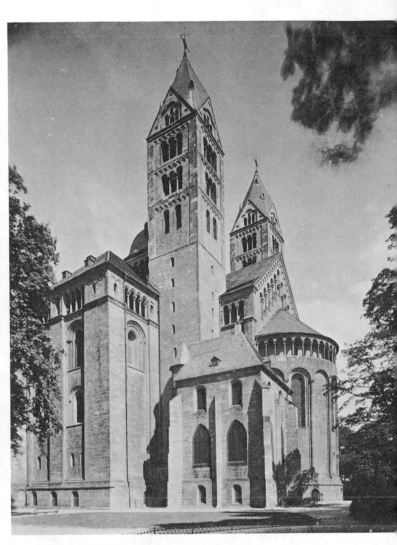

694. ROMANESQUE. GERMANY. Speyer cathedral.

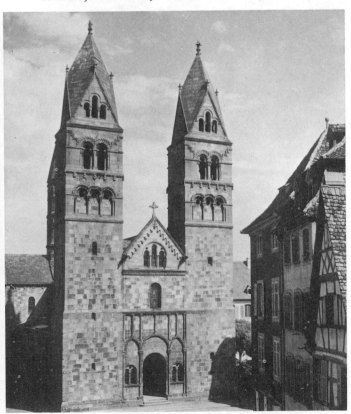

695. ROMANESQUE. FRANCE. RHENISH. The façade, Sélestat, showing affinities with German Romanesque.

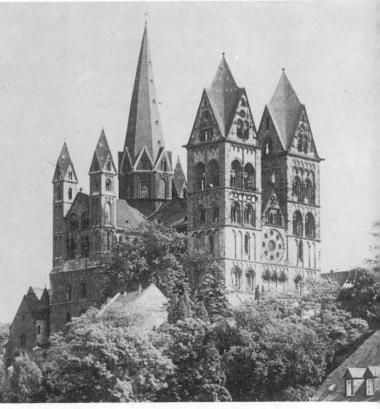

696. ROMANESQUE. GERMANY. The cathedral, Limburg on the Lahn.

303

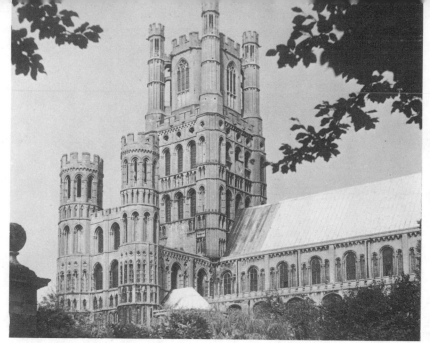

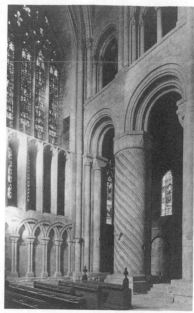

697. LATE ROMANESQUE.
ENGLAND. Ely cathedral.

698. ROMANESQUE. ENGLAND.
Durham cathedral. Detail of the
south-west transept.

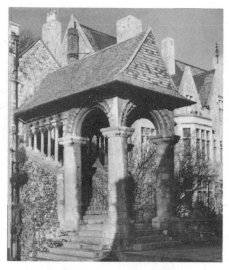

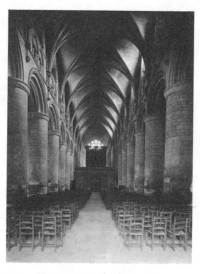

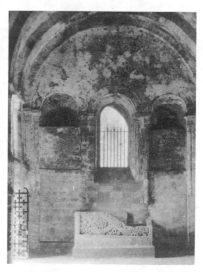

699. ROMANESQUE. ENGLAND.
King's School, Canterbury. View of
the Norman staircase. c. 1150.

700. ROMANESQUE. ENGLAND.
Gloucester cathedral. Nave showing
the massive Norman pillars. c. 1100.

701. ROMANESQUE. IRELAND. King
Cormac's chapel, Cashel, County
Tipperary. 1127.

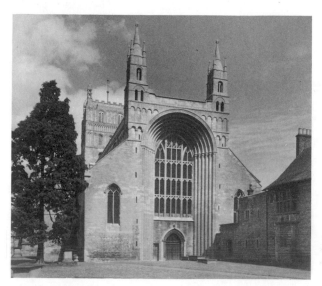

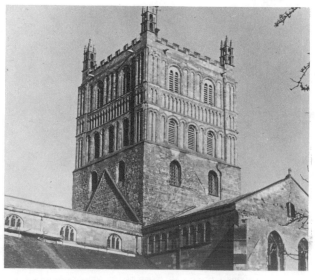

702. ROMANESQUE. ENGLAND. West front of Tewkesbury
abbey. Second quarter of the 12th century.

703. ROMANESQUE. ENGLAND. The central tower,
Tewkesbury abbey.

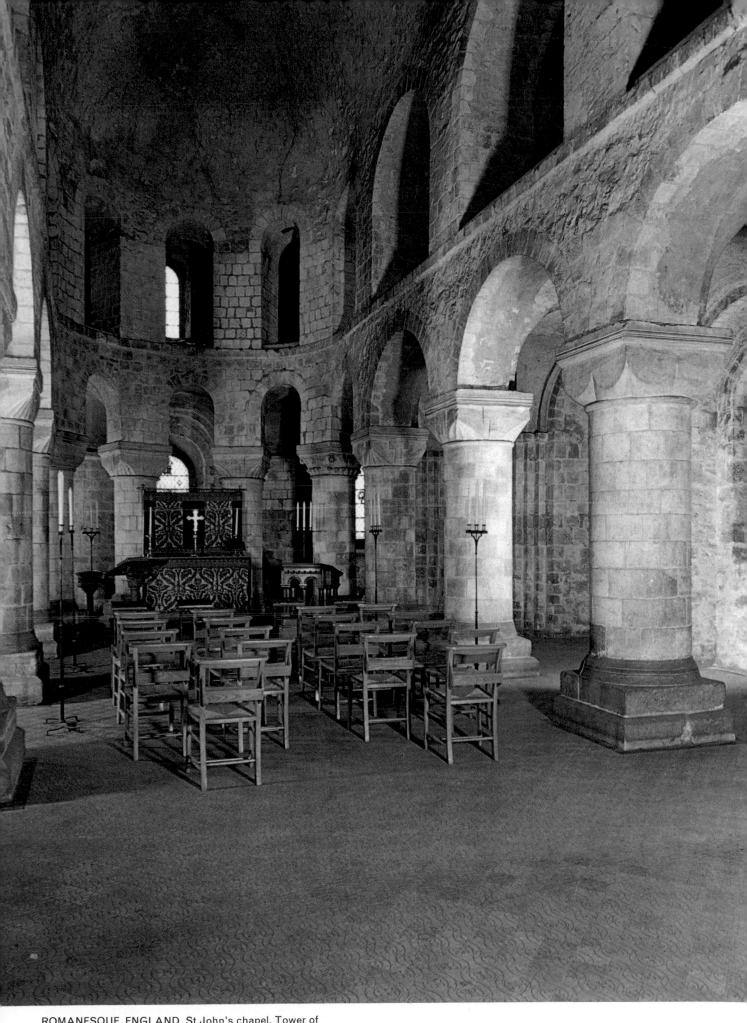

ROMANESQUE. ENGLAND. St John's chapel, Tower of
London. Late 11th century. *Photo: British Travel Association.*

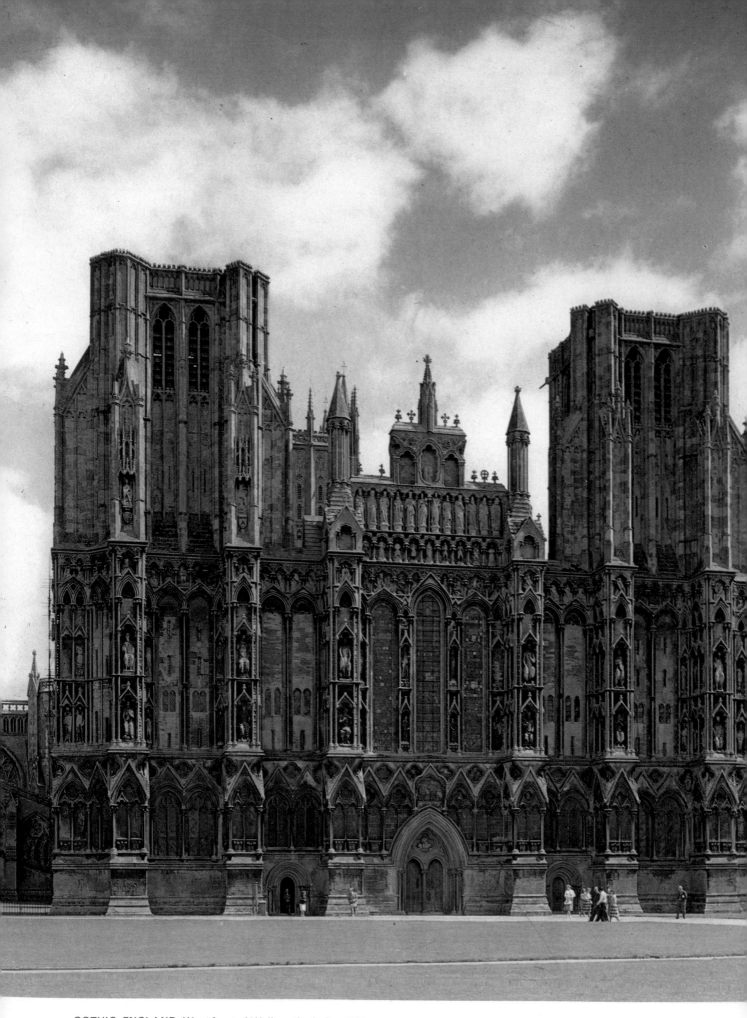

GOTHIC. ENGLAND. West front of Wells cathedral. c. 1220–
1240. Photo: Picturepoint.

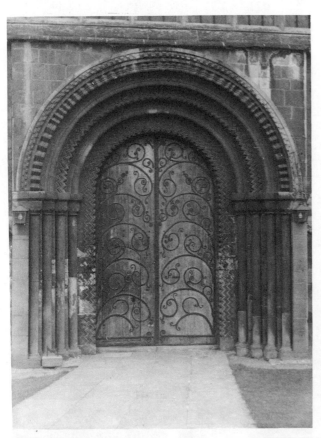

704. ROMANESQUE. ENGLAND. Southwell minster. West door. First half of the 12th century.

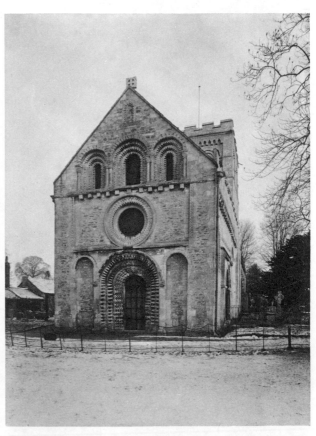

705. ROMANESQUE. ENGLAND. Iffley church, Oxfordshire. West front. *c.* 1175.

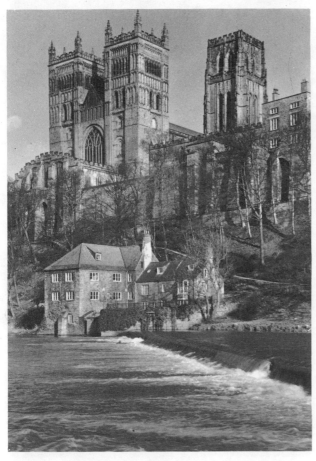

706. ROMANESQUE. ENGLAND. Durham cathedral. View from the River Wear. 1093–1133.

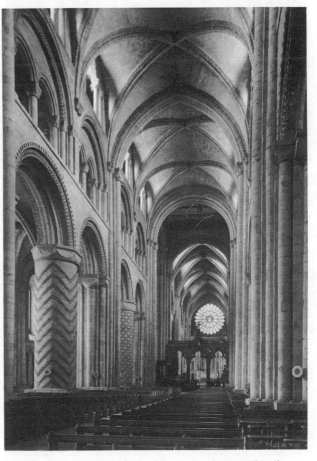

707. Durham cathedral. View of the nave, showing the rib vaulting, which is not Gothic but Norman Romanesque.

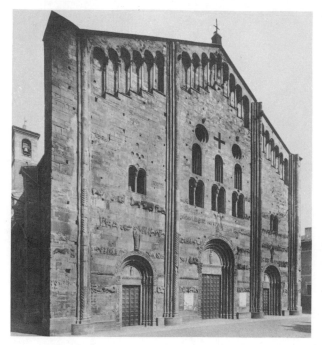

708. ROMANESQUE. ITALY. West front, S. Michele. Pavia.

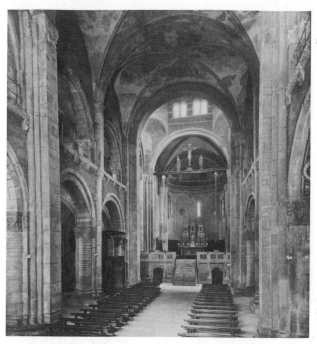

709. ROMANESQUE. ITALY. Nave, S. Michele, Pavia.

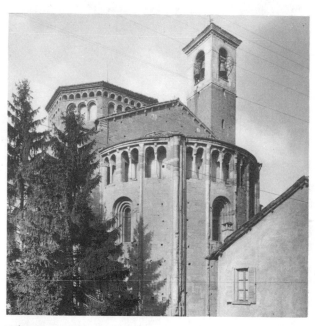

710. ROMANESQUE. ITALY. Apse, S. Michele, Pavia.

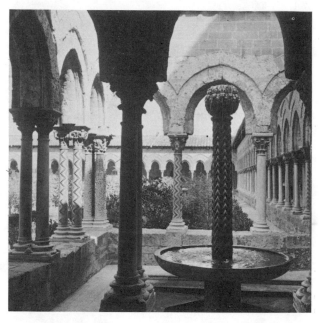

711. ROMANESQUE. SICILY. Monreale cathedral. The cloister. 12th century.

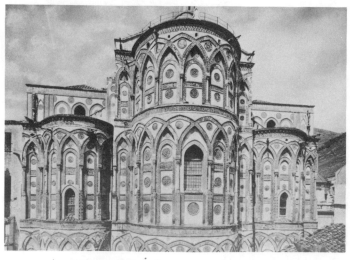

712. ROMANESQUE. SICILY. Apse, Monreale cathedral. Begun 1174. The arcading shows Islamic influence.

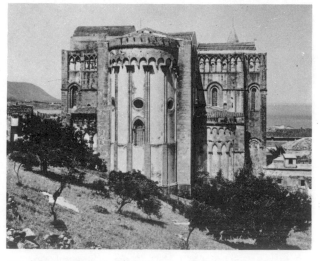

713. ROMANESQUE. SICILY. Apse, Cefalù cathedral. 12th century.

306

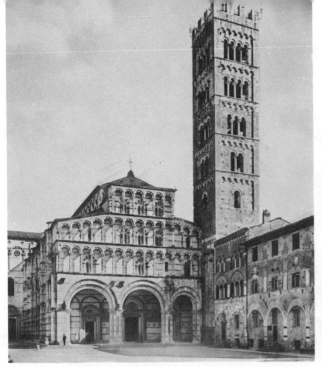

714. ROMANESQUE. ITALY. View of Lucca cathedral.

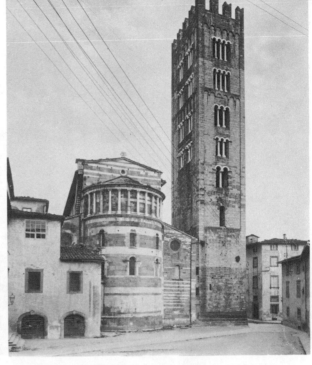

715. ROMANESQUE. ITALY. S. Frediano, Lucca. Apse and campanile. 12th century.

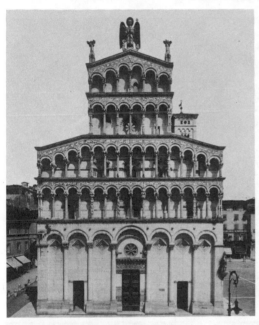

716. ROMANESQUE. ITALY. S. Michele, Lucca. From 1143.

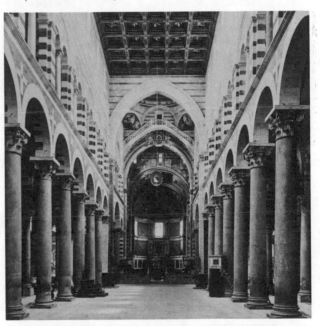

717. ROMANESQUE. ITALY. The nave, Pisa cathedral.

718. ROMANESQUE. ITALY. Pisa, the campanile. Begun 1174.

719. ROMANESQUE. ITALY. Pisa, the baptistery. 1153–1278.

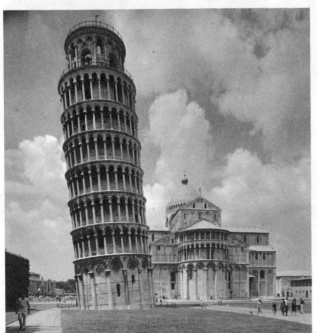

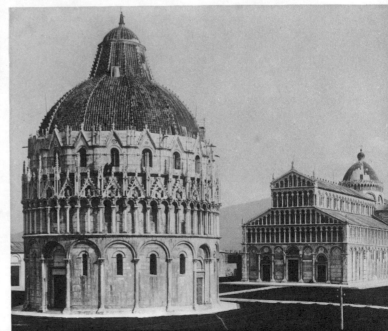

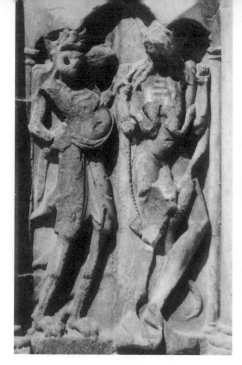

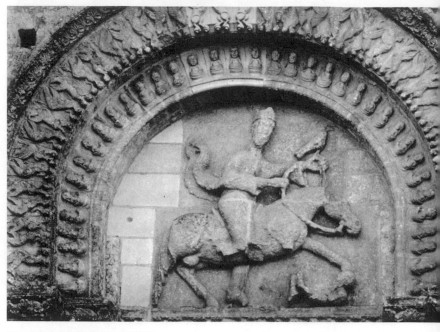

720. ROMANESQUE. LANGUEDOC. The sin of Luxury, from the jamb of the left portal, Moissac.

721. ROMANESQUE. POITOU. Equestrian figure from the façade of the church of Parthenay le Vieux.

722. ROMANESQUE. POITOU. The The Crucifixion of St Peter, from the façade of St Pierre at Aulnay.

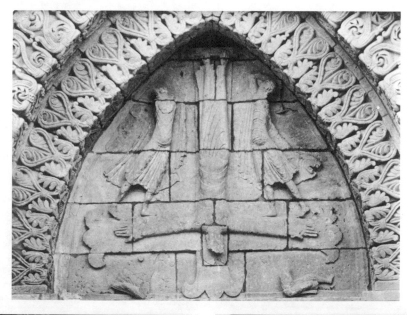

723. *Below*. ROMANESQUE. PROVENCE. Cain and Abel: God accepting Abel's offering. Façade, St Gilles du Gard.

724. *Below right*. ROMANESQUE. LANGUEDOC. The Death of the Miser, from the jamb of the left portal, Moissac.

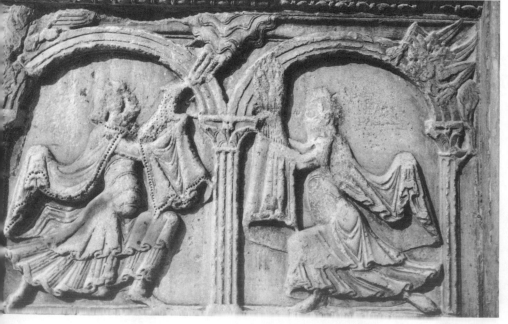

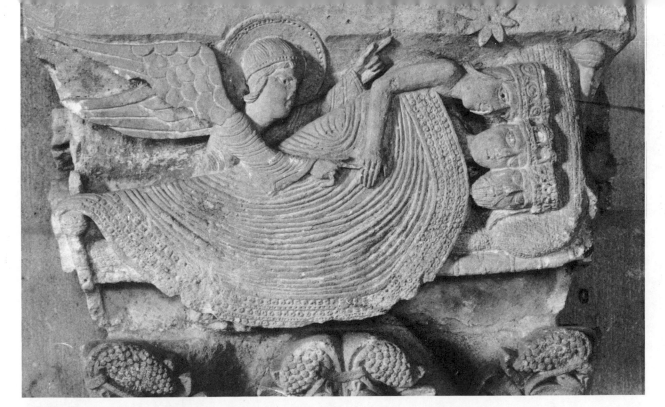

725. ROMANESQUE. BURGUNDY. Capital from Autun cathedral. Angel appearing to the Magi. *c.* 1120–1130.

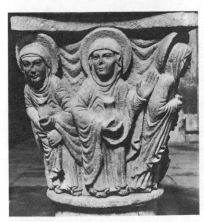

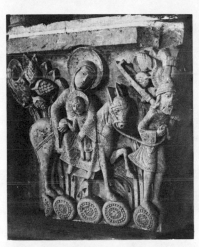

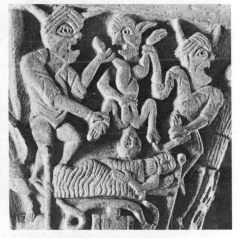

726. ROMANESQUE. BURGUNDY. Capital from Autun cathedral. The Temptation of Christ. *c.* 1120–1130.

727. ROMANESQUE. BURGUNDY. Capital from Autun cathedral. The Flight into Egypt. *c.* 1120–1130.

728. ROMANESQUE. AUVERGNE. The Death of the Miser. Capital in Besse en Chandesse.

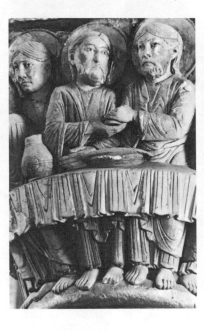

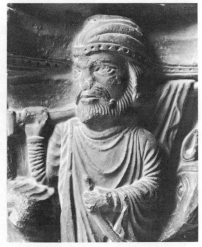

729. *Above.* ROMANESQUE. AUVERGNE. The Holy Women at the Sepulchre. Detail of a capital, Mozac.

730. *Right.* ROMANESQUE. AUVERGNE. The Last Supper. Detail from a capital at Issoire.

731. ROMANESQUE. PROVENCE. Detail from the Massacre of the Innocents. Capital from the cloister of St Trophime at Arles.

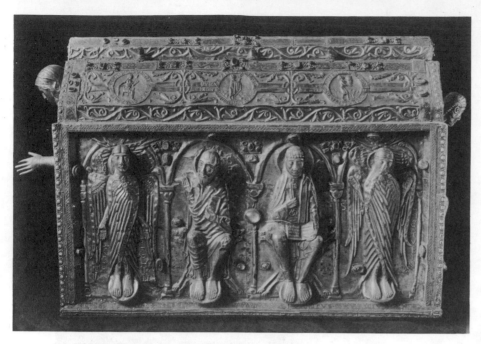

732. ROMANESQUE. Shrine of St Maurice. 11th century.
Treasury of St Maurice, Agaune (Switzerland).

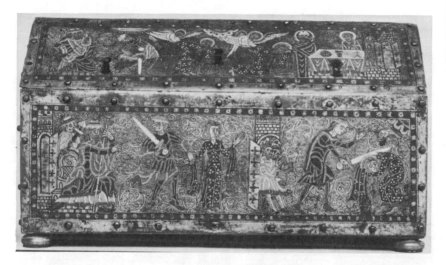

733. *Above.* ROMANESQUE. Enamel
plaque on the tomb of Geoffrey
Plantagenet. 12th century. *Le Mans
Museum.*

734. *Left.* ROMANESQUE. Casket of
Ste Valerie. Champlevé enamel.
Scenes of her martyrdom on the front
and the lid of the casket. *c.* 1170.
British Museum.

736. *Below.* ROMANESQUE. The Altar
of Verdun (at Klosterneuberg), by
Nicolas of Verdun, consisting of 59
plaques of gilt bronze and niello. 1181.

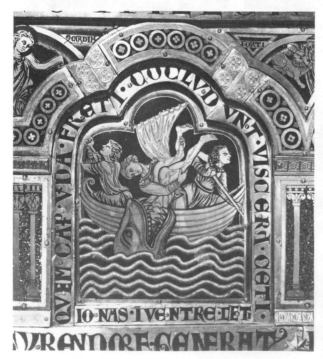

735. Jonah and the Whale. Detail from the Altar of Verdun.

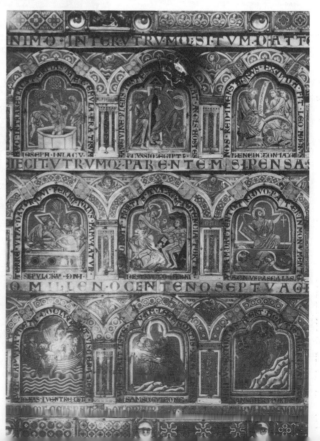

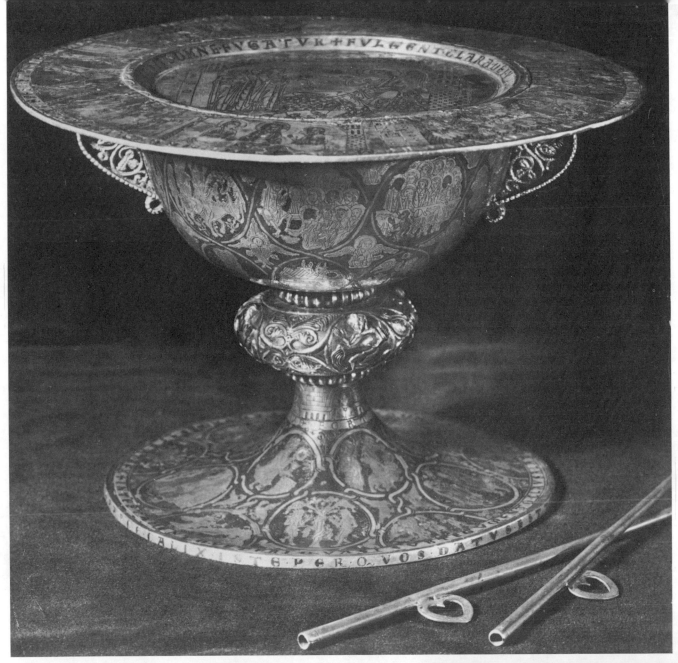

737. ROMANESQUE. SOUTH-WEST GERMAN. The Wilten chalice. Silver. Gift to Abbot Heinrich von Wilten from Count Berthold. *c.* 1160. *Kunsthistorisches Museum, Vienna.*

738. ROMANESQUE. SPAIN. Silk tissue with peacock design. 12th century. *Victoria and Albert Museum.*

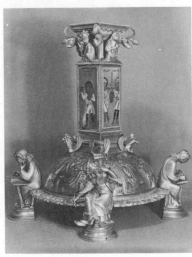

739. ROMANESQUE. MOSAN. Base of a Cross. Copper with champlevé enamel. *c.* 1160–1175. *St Omer Museum.*

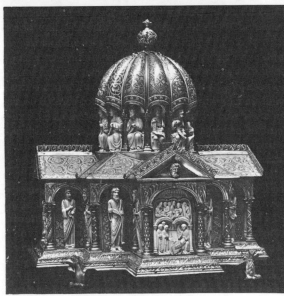

740. ROMANESQUE. The Eltenberg Reliquary. Copper and bronze gilt on oak foundation with champlevé enamel and walrus ivory carvings. Rhenish. *c.* 1180. *Victoria and Albert Museum.*

311

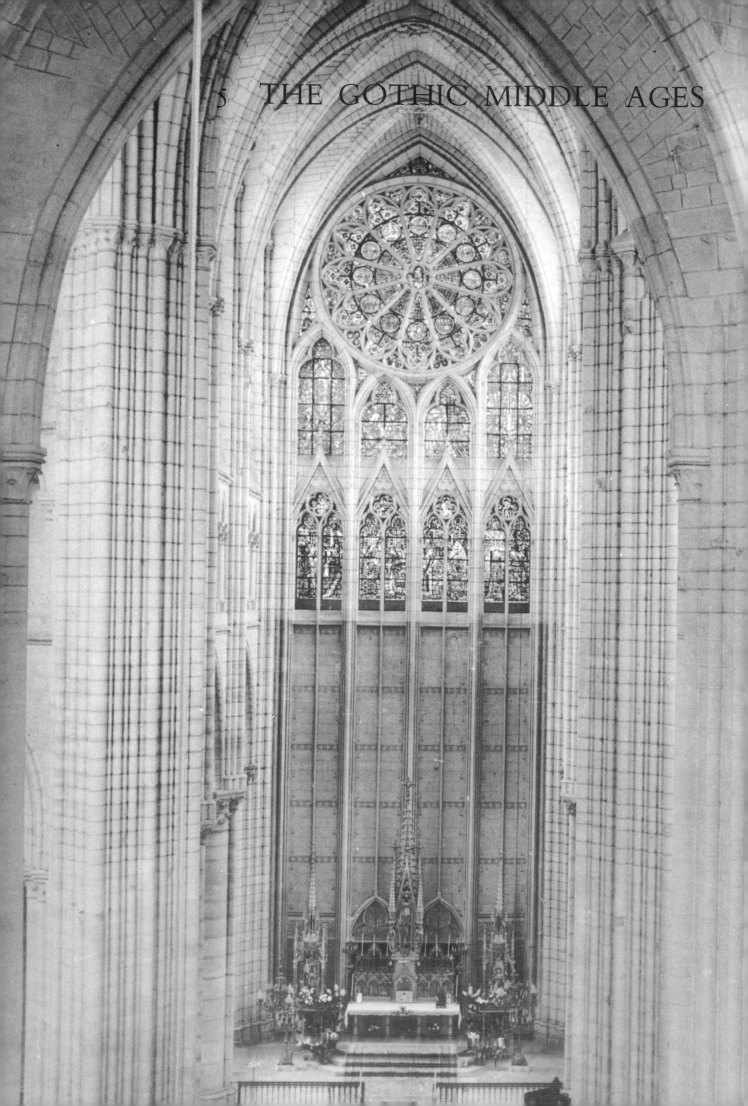

ART FORMS AND SOCIETY *René Huyghe*

Great efforts have been made to define Gothic art. The first and rather superficial attempt was by means of a formal characteristic, the pointed arch, but when it was discovered that the pointed arch had been of much wider use, apart from and even prior to Gothic architecture, a structural element, the rib vault, was put forward as a basic characteristic. This alone, however, important though it is, cannot explain so complex a phenomenon. With the advent of Gothic art we are in fact faced with an altogether new concept of art and a new outlook on life in general.

Is Gothic art an expression of the Nordic spirit?

The historians of the 19th century, in their rehabilitation of the Middle Ages and of what seemed to them its very embodiment, Gothic art, felt this instinctively. In choosing the term 'Gothic' (an arbitrary choice since Gothic art is essentially a French invention) they wished to give expression to ideas and values diametrically opposed to those we generally call 'classical', against which they were in any case beginning to react. They looked for their origin in the opposite direction, that is in the camp of the barbarians, the 'Goths'.

Historically speaking, Gothic art was not of Germanic origin but had its beginnings in the Ile-de-France. This, however, does not answer the whole question. Certainly it was elaborated in France in particularly favourable circumstances, but was its sudden rise not a triumphant return of the same dynamic forces that had stirred Europe during the barbarian invasions, forces against which Graeco-Roman culture had reacted in an attempt to contain and even to eliminate them so as to replace them with the measured and rational forms of antiquity? And was it not these forces which at a later date the Carolingian and Romanesque masters tried to counter by discipline and organisation? This view was cherished by German scholars, beginning with Josef Strzygowski who thought the Gothic cathedrals to be descendants of Scandinavian wood architecture. Wilhelm Worringer, an exponent of the 'psychology of style', saw in the Gothic the outcome of a specifically northern form of expression which began as early as or earlier than the Hallstatt and La Tène periods and which re-emerged in the northern Baroque.

There is, no doubt, a good deal of truth in this theory, as there is in all theories conceived by brilliant minds, though applied partially and with bias it loses much of its validity. Truth resides in the sum total of established facts rather than in generalisations.

It is an incontestable fact that Romanesque art developed its most classical forms and survived longest in southern France where the impact of Roman art was strong. It is equally true that Gothic art was born and reached its greatest perfection in the north, and that the Normans—the men of the north—in France as well as in England, greatly influenced its early development. This geographical predisposition corroborates the fact that deep affinities existed on the one hand between

741. GOTHIC. FRANCE. North transept of the cathedral of Soissons. 1180–1225.

Romanesque art and the Mediterranean spirit, of which it was to some extent a revival, and on the other hand between Gothic art and the northern spirit.

The principles of construction and balance in Romanesque architecture were basically static and in this sense descended from the Mediterranean and ancient classical civilisations of agrarian origin, whereas those of Gothic architecture, based on the play of stresses and strains, were essentially dynamic. Here we meet again the dominant trend that we saw develop in barbarian Europe, from the steppes to Ireland. This tendency is even more visible in the techniques stemming from graphic art, above all in decoration, with its thrusting and undulating lines avoiding the symmetry of geometrical figures.

The basic character of a style, like the character of a human being, becomes more pronounced with the passage of time, and this is abundantly true of the Gothic style which culminated, at the end of the 14th century and in the 15th, in 'Flamboyant' architecture and the curvilinear arabesques of 'International' Gothic painting. The Romanesque style, so different in spirit, culminated in nothing comparable. The Flamboyant style even revived certain asymmetrical, whirling and undulating forms strikingly reminiscent of the ancient Celtic repertoire and its most extravagant outbursts. Was their recurrence due to actual influence or is it merely a case of analogy? Probably a similar mentality produced in Gothic artists a taste for these forms which was satisfied partly by the discovery of examples wherever they existed and partly by the revival of their dynamism. Furthermore, it should not be forgotten that many of these forms lived on in illuminated manuscripts, which were long influenced by Irish models and their offshoots.

In Gothic art a static geometrical form such as a circle, which is essentially a classical form, was rendered dynamic first of all by emphasising its radius: it 'radiates'. The great 'centrifugal' rose windows are admirable examples. From the end of the 13th century this style is known as 'Radiating'. The Flamboyant style in the 15th century went a step further; with its curved radii the circle appears to rotate, and we see here a revival of the ancient triskele and its derivations. Is it pure coincidence that the masterpieces of this style appear most frequently in those regions of France where the settlement of Germanic races had been most pronounced, for instance in Normandy and in eastern France?

However, if we were to over-emphasise these factors we should narrow our field of view, as many historians have done, to cover only one aspect of the problem. For how can we explain that in other ways there is in Gothic art an equally marked revival of a trait peculiar to classical civilisation—the careful imitation of nature? It is a characteristic that found its way not only into sculpture in the round but even into decoration, the time-honoured domain of abstract patterns. Here is a new assertion of that realism characteristic of the Mediterranean world which the barbarians, from the Germanic peoples to Ireland, so persistently rejected. Although Gothic art has undeniable affinities with the north and with anti-classicism, one is forced to admit, without splitting hairs, that it cannot altogether be explained by them.

752

800, 827

924, 929

744–748

461

787

748

803

762

One can no longer look to dubious racial theories to solve the problem of the origin of Gothic art. It can only be solved by studying the changing spiritual climate of the time, which affected simultaneously the evolution of thought and of art, and at the same time reflected a fundamental cultural change. It is vital to understand that this change is the very core of a complex situation in which medieval man struggled to find stability and harmony.

The spiritual character of the Middle Ages

The medieval world rose among the ruins of the ancient classical civilisation, the result of the assimilation of the two elements which had worked to destroy it, the invading Celtic, Germanic and Scandinavian barbarians on the one hand, and the Orient on the other. This led to an enormous but confused widening of man's scope and to the more or less violent interaction, over a long period, of contradictory forces.

In the centre remained the positive and rational dynamo of the Graeco-Roman tradition, forming the backbone of the new civilisation. At its base a direct experience of life supplanted the traditional precise imitation of reality. This was based on the physical pleasures derived from direct contact with material things—from the enjoyment of their riches, their dazzling surfaces, their colours or transparency and the mysterious effects of the play of light. Hence the liking for precious stones, glass and enamels that persisted from the time of the Gauls and the barbarians to the stained glass windows of the Gothic cathedrals which seem like remote descendants of them.

But above all, a disdain for physical likeness, first manifest in a daring stylisation of forms, allowed imagination to soar towards a superhuman world transcending reason and the senses; Christianity made of it an approach to the divine that the Fathers of the Church had sought along roads opened by Plotinus. Through all the various and even opposing aspects of Romanesque and Gothic art, this dominant spirituality remained the keystone of the Middle Ages. It enlisted into its exclusive service not only all the splendours that appeal to the senses—the gleam of goldsmiths' work, the rich colours of stained glass, the scent of incense—but also everything that could satisfy the intelligence. The former enriched, above all, the arts, the latter theology, but they were to remain united and complementary. This medieval spirituality explains, even in respect of Gothic realism, the continuity of the symbolic approach that allowed Romanesque artists to disregard the reality of nature, and Gothic artists to find a place for this reality in the splendid logic of their cathedrals.

Although this spirituality remained the lasting basis of Christianity, Romanesque and Gothic artists had a profoundly different attitude towards the visible world and how to represent it. The fact is that the concept of man, of the world and of their relation to each other underwent a profound transformation in the course of the Middle Ages.

For a long time medieval thought was dominated by St Augustine who, in the 4th century, had succeeded in reconciling neo-Platonism and Christianity. He played in the West a part comparable to that of St Basil and other Church Fathers in the Eastern Church, where Augustine was little known. The Augustinian doctrine dominated the Middle Ages for eight centuries—that is, during the period culminating in the Romanesque—and was the main source of neo-Platonic thought. Macrobius followed him in the 5th century and Johannes Scotus Erigena in the 9th century; the latter is best known for his translations of Dionysius the Areopagite, believed to have been a companion of St Paul though he was in reality a philosopher of the 5th century imbued with neo-Platonic thought and following Plotinus, Porphyry, Proclus, etc.

These ideas, universally accepted in the West, run parallel to those we found, in the East, underlying Byzantine art. Disdaining physical appearances, questioning their accuracy, medieval man accepted them only as pictorial symbols which could be read even by the uneducated; their meaning and their symbolic arrangement were intended to direct and summon the mind to the presence of God. 'Shame on those who love His outward signs instead of loving Him,' said Augustine. Like Plotinus he disapproved of the partiality of observation and preferred the 'eye of contemplation', or the 'mind's eye', which alone is able to penetrate the surface of appearances in order to grasp the spiritual reality, which reflects God, hidden behind it. 'My desire is to experience God and the soul of man'—such was the exclusive goal that man and art should pursue. For this very reason Augustine preferred architecture and music to the figurative arts, as neither presented visible things. Images from the world of the senses were only admitted in so far as they served as vehicles to or symbols for the world of ideas.

In 1130, at the time when scholasticism was becoming important, the school of Chartres was still imbued with this symbolic interpretation of reality, drawing its inspiration from the original writings of Plato. John of Salisbury described Bernard of Chartres as 'the most perfect Platonist of our time'.

But by the end of the first third of the 12th century, when the first buildings foreshadowing the Gothic period were under construction, the powerful influence of St Bernard, abbot of Clairvaux, was rising, and the first buildings were being planned in the transitional period which was to open the Gothic age. A decisive revolution was beginning to take effect. Cluny's power and influence, closely connected with the expansion of Romanesque art, was discredited and superseded by the new spirit preached by the Cistercians. St Bernard hardly differed from Augustine in his contempt of the physical world; rather he intensified it. He made it a pretext for a violent onslaught on the art of the time. 'Naves high beyond measure, of interminable length and impractical width, sumptuous decoration and elaborate paintings—that all this is done for the glory of God, well and good.' But 'why place these ridiculous monsters, these beautiful horrors and horrible beauties, under the eyes of monks who should read and meditate?'

So St Bernard proscribed the hallowed forms of Romanesque art and insisted that they should not be used. This return to the simple life that he advised, while at the same time he urged men to love God and the Virgin instead of resorting to the subtleties of philosophy, led to a rebirth of sensitivity and perception that became increasingly direct. Man was to reach 'the face of God' by stripping away everything between himself and the divine.

At the beginning of the 13th century St Francis of Assisi, in his mystic love, recognised the world of concrete

187

756

606

742. *Above.* GALLO-ROMAN. Ornament from a chariot. Horseman fighting a pantheress. *Musée de St Germain.*

743. *Top right.* ROMANESQUE. ENGLAND. Pastoral staff. Ivory. 11th–12th centuries. *Victoria and Albert Museum.*

THE CONTRIBUTION OF THE NORTH

In the same way that Romanesque art had affinities with the repertory of Mediterranean art, Gothic art in the course of its development evoked the oldest forms of the art of northern Europe [742, 743]. The same whorls that were known in Europe since the Bronze Age, especially among the Celts [744–748], recur in the 15th century, at a period when Gothic art had evolved its most characteristic features; we observe the revival of the triskele [746, 748], the whirling wheel [744, 747] and the spiral [745, 747], as well as linear designs transmitted by illuminated manuscripts, especially of Irish origin or influence. It is possible that Gothic artists in their desire to observe and imitate nature (to the point where, at the beginning of the 19th century, it was imagined, poetically, that their architecture copied the forest and its vegetation [751]) were irresistibly attracted by these undulating and whirling forms and soaring columns which remind us of trees [749, 750].

745. *Above left.* CELTIC. SPAIN. Motif from a torque (Lanhoso, Galicia).

746. *Above right.* EARLY CHRISTIAN. IRISH. Bronze disc. *Dublin Museum.*

744. *Left.* SCANDINAVIAN. Engraved tombstone. *c.* 500.

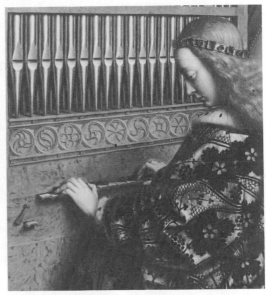

747. GOTHIC. Detail of a wooden door panel. 15th century. *Museo Civico, Padua.*

748. FLEMISH. JAN VAN EYCK. Angel musician. Detail of the Ghent Altarpiece. 1432. *Cathedral of St Bavon, Ghent.*

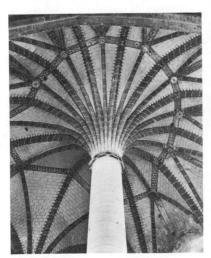

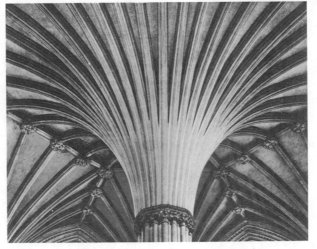

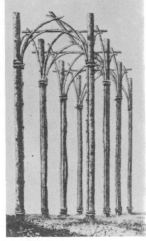

749. GOTHIC. Pillar and vault, nave of the Church of the Jacobins, Toulouse. Begun 1230; vaulted 14th century.

750. GOTHIC. ENGLAND. Pillar and vault of the chapter house, Wells cathedral. 1293–1319.

751. Reconstruction of a Gothic nave by means of ash-tree poles and willow branches. Experiment by J. Hall, 1798.

reality. If he gave a prodigious new impetus to the yearning of the soul of man, it was because he taught man to love God through His work, Creation in all its forms, the stars, the birds, the trees, where he most felt the presence of God's love.

Just as sensibility was deeply affected, so intellectual concepts underwent an equally important transformation on parallel lines. The traditional neo-Platonic and Augustinian ideas had led medieval scholars to form the school of 'realists' to whom, contrary to the modern sense of the word, ideas rather than impressions of the senses had the attribute of reality. To the 'nominalists', on the other hand, abstract ideas were nothing but words, by which the mind generalises the experience of material objects. Severely assailed as early as the end of the 11th century by Roscellinus, the realists, by the end of the 13th century, had given ground to their adversaries the nominalists, and were utterly routed in the following century by William of Occam.

The rediscovery of nature

The conflict between the realists and the nominalists was in a way a new episode in the old controversy which had been raging since ancient Greek times between the philosophies of Plato and Aristotle. Now, at the beginning of the 12th century, Aristotle's work, transmitted by the Arabs and translated by Dominicus Gundisalvi of Segovia, began to exert a steadily growing influence upon medieval thought. And it was in the middle of this same 12th century that Gothic art began. It was born at St Denis in the abbey built for Suger. Nevertheless, Augustinian influence was still strong enough to make the abbot say that, in art, material things should be used only as a consequence of the incapacity and infirmity of man and his spirit which were forced to make use of them in their search for the divine truth: '*Mens hebes ad verum per materialia surgit.*'

Gradually Aristotelian thought influenced such different thinkers as John of Salisbury and Hugh of St Victor. St Anselm, the champion of universal ideas, died in 1109. Adelard of Bath, who used to refer to Plato as his 'friend', was his contemporary. Chartres, a stronghold of Platonism, was being eclipsed by the university of Paris. Established by statute in 1215, Paris became the centre of the new (Aristotelian) theory of knowledge, although Robert de Courçon, following the ban passed by a provincial council five years previously, had, in the statute, prohibited the reading of Aristotle's works on metaphysics and on the philosophy of nature. Successive attempts of the Pope between 1231 and 1261 to proscribe Aristotle's *Physics* were but a sign of the philosopher's growing authority. Within a century his triumph was complete; in 1366 the study of his works became compulsory for obtaining a university degree. Many years had already passed since Albertus Magnus (1193–1280) and his illustrious pupil St Thomas Aquinas (1224–1274) had integrated Aristotelian philosophy with Christian doctrine, in the face of strong opposition from the Augustinian thinkers.

Henceforth perception by means of the senses held a predominant place in philosophic speculation as a source of ideas and the imagination. It and experiment were regarded as the bases upon which knowledge of the physical world should be founded. Although faith would, to some extent, always be mysterious, reason could explain beliefs. *A priori* idealism was completely discredited; the evidence of the senses, backed by reason, regained full authority. Albertus Magnus admired Aristotle and praised him as one 'who best understood nature'. He commended him for extracting the truth from nature by empirical means. He maintained that only experiments were valid in concrete cases and that it was from them that the mind should gain understanding. St Thomas echoed him by saying that the soul must 'draw all understanding from the senses'.

The Franciscans of the university of Oxford thought likewise, though paradoxically they claimed to be faithful to the Augustinian tradition and to challenge Aristotle. Rivals of the Dominicans because they were Franciscans and therefore of the Order of Albertus and St Thomas, rivals also of the university of Paris, because they belonged to Oxford, they were forced to claim kinship with the Augustinian thinkers and to attack the philosopher who had been carried to such heights by the 'moderns'. But they quarrelled only with the letter of his works and with his influence. Though they challenged the dialectics of the scholastics, inspired by his rules of logic, though they challenged the conclusions of his *Physics*, this did not prevent them from adopting the important new view of the world offered by Aristotelian thought, which has been summed up as follows: 'Nothing exists except tangible and extended forms.' St Bonaventura, whose thinking dominated the Franciscan Order, admitted that, though the senses may not enlighten us about God or ourselves, they are in fact the key to our knowledge of things; he even added: 'Aristotle is right on this point, not Plato.' This was also the opinion of Roger Bacon, the 'admirable doctor', who was the most brilliant of the Oxford Franciscans. In contrast to the view of his master Robert Grosseteste that all knowledge could be gained without recourse to the senses, Bacon affirmed that abstract reasoning cannot replace visual or tangible experience, adding further that pure theory does not offer that absolute certainty provided by a conclusion arrived at by means of experiment. He was the first to use the expression 'experimental science' (*scientia experimentalis*). In the following century William of Occam clearly referred to 'experimental knowledge' (*notitia experimentalis*).

Henceforth observation and calculation were to take pride of place in contemporary culture over grammar and logic. In the same way the art of the time could only be one in which the realist and the engineer worked towards a spiritual goal. This is almost a definition of Gothic art. Significant, too, was the growing interest in the problem of vision. In the 12th century the *Optics* of Ptolemy was translated into Latin, followed by a translation of the *Optics* of Alhazan, the Arab astronomer of the 11th century, which was greatly in favour with the Franciscan scholars of Oxford. Roger Bacon in the 13th century developed a new theory of vision, and the treatise on optics or perspective by the Silesian monk Vitello, who lived in Italy, had a lasting influence on later generations; though steeped in neo-Platonic ideas his work opened the way for the scientific approach, so that he has even been cited as one of Leonardo da Vinci's sources.

The conflict of ideas reflected in the arts

One has only to turn to art to realise that here, too, there was a similar transition from abstraction to reality and

755, 780

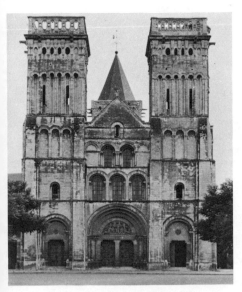

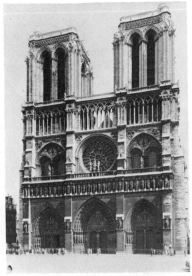

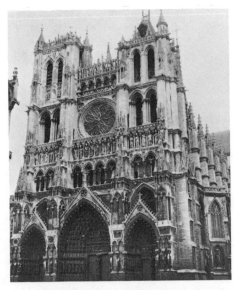

752. ROMANESQUE. West front of La Trinité at Caen. Begun in 1062; completed in the 12th century. Restored in the 19th century.

753. GOTHIC. West front of Notre Dame in Paris. First half of the 13th century; completed in 1245. Restored in the 19th century.

754. GOTHIC. West front of Amiens cathedral. Begun in 1220; completed in 1236 (except for the gable ends).

THE ROMANESQUE HERITAGE

Stylistically Gothic art presented a visible contrast to Romanesque art, although it followed it historically and to some degree evolved from it. A powerful effort was needed to make the Gothic façade [754] break the law of symmetry of the Romanesque façade [752]. At an early stage the tension of this threatened symmetry that was soon to be destroyed can be sensed [753].
The rational and geometrical method by which Christian symbolism was demonstrated during the Romanesque period continued to be valid for some time during the Gothic period [755, 756]. Gothic architects still believed in the theoretical rules of numbers and geometrical proportions, although they approached the practical problems of mass in the spirit of engineers [757, 758].

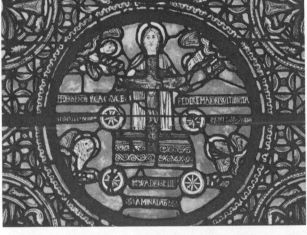

756. *Below left*. LATE ROMANESQUE. Page of the Hortus Deliciarum of the Abbess Herrad of Landsberg. End of the 12th century. Formerly in the Library of Strasbourg; destroyed by fire in 1870.
The liberal arts are represented here. In the centre is Philosophy, inspired by God; seven rivers spring from her bosom, the seven arts, which appear in the lobes surrounding the circle, in the form of seven young women.

755. EARLY GOTHIC. The Ark of the Covenant. Stained glass window in the abbey church of St Denis. Middle of the 12th century.
This window demonstrates the concordances between the Old and the New Testaments: the quadriga of Aminadab, the triumphal chariot of the Song of Songs, carries Christ on the Cross held by God the Father; the four wheels correspond to the symbols of the four Evangelists who draw the chariot to the four ends of the earth.

758. Plan of a Cistercian church, by Villard de Honnecourt, based on squares and double squares (*ad quadratum*). 13th century.

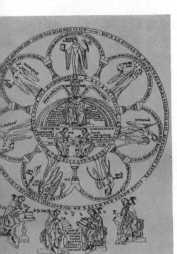

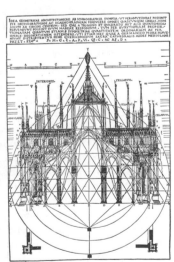

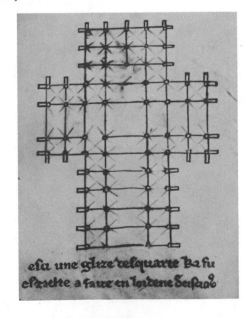

757. *Above right*. Elevation and cross-section of the cathedral of Milan. (*After Cesare Caesariano's Vitruvius, Como*, 1521.)
The proportions are arranged more Germanico *by means of equilateral triangles. The archives of the cathedral preserve a similar drawing of 1391, but without the drawings of the circles which reveal the secret of the proportions.*

317

nature. In order to understand it we must empty our minds of the ideas of our time, which we regard as natural but which are characteristic only of the age in which we live. Our present-day notion of visible reality is that it is immediate, that is to say, that it is accessible to our senses, that it can be explored by them, and that such exploration needs only the guidance of rational methods. This notion is a creation of the intellectual impulse we call Gothic, using the term in its widest connotation. From that time art started to become 'realistic', no longer in the medieval sense but in the modern sense (exactly the opposite, as we have seen) which involved a belief in the fundamental reality of tangible, visible appearances.

For medieval man, before the Gothic revolution, visible reality was only mediate; it was an intermediary, a middle term between man and the true reality, inaccessible to the senses and hardly accessible to the mind, which is God. God reveals Himself to us in two ways: we perceive His presence, as Marie Magdeleine Davy wrote, 'not only through revelation, but also, as it were, in the mirror of His Creation'. To men of the Gothic period the first way obviously remained open, so much so that medieval symbolism continued during that time; but the second became more and more important and increasingly tempting—to the point where the divine goal was forgotten. Limited henceforth to a simple positivism, this second way led only back to itself, that is to say, to realism, and turned out to be, as our own age knows, an impasse.

For man and for the artist during the early Middle Ages, and especially during the Romanesque period, the universe was a perfectly logical and comprehensible world as long as he realised that its truth could be revealed not by experimental research but by the sacred texts. So the philosopher's task was to relate the material world to these texts and to interpret it through them, so as to recognise in it the divine order they laid down. It was not yet a question of discovering nature but of deciphering it. Art was the image of nature only to the extent necessary to help man perceive the image of God hidden behind it.

Art forms, as a result of this attitude, showed a tendency towards stylisation, geometric design and symmetry, which, after all, only restored to the outward appearance of things the hidden order that governs them. This tendency dominated Romanesque art. Of course it still persisted in Gothic art in that the symbolism of numbers continued and that the master masons' drawings correspond to 'ideal' proportions such as the 'golden section' or the 'double square', according to the Norwegian architect F. M. Lund (*Ad Quadratum*, 1921). His controversial theory has led to much argument among art historians; without accepting it in its entirety, let us just notice that at the end of the 14th century, for example, a discussion concerning Milan cathedral took place to decide whether the new building under construction should be erected according to the double square method (*ad quadratum*) favoured by Master Jean Vignot of Paris or to the equilateral triangle method (*ad triangulum*) of the German builders. This shows how abstract methods had retained their importance.

But, though it is important to take into consideration the inevitable continuation of the earlier spirit into the Gothic period, it should be realised that Gothic art was essentially based on a new spirit in which realism prevailed over abstraction. This was particularly the case in sculpture where practical considerations replaced the traditional doctrinal approach that lingered on, as we have seen, in architecture. When Villard de Honnecourt in the 13th century drew a lion in the notebook he carried with him on his journeys, he made the explicit comment that he 'copied this lion from life', showing that he was anxious to rely on nature and observation.

In every field, as in the contemporary transformation of philosophical thought, it is a return to physical reality that appears as the distinctive imprint of the new age. At first conforming to the tenets of faith and the teachings of the Church, the new ideas prepared and eventually caused their downfall in the course of the following centuries and gave birth to the spirit of positivism.

The triumph of the new ideas in art

Art historians often point to the rib vault as the distinctive element of the Gothic style. But this new device, introduced in response to the laws of statics, was purely 'functional', as we should say today. The architect, bowing to the practical aspects of the problem of balance and weight, became the forerunner of the modern structural engineer. The problems of the Romanesque architect were of an altogether different order. He had no idea of looking beyond a range of forms derived from basic geometrical figures—squares, rectangles, triangles, semicircles for the organisation of the plan, parallelograms, hemispheres and semicylindrical forms for the organisation of volumes. For instance, in Notre Dame la Grande at Poitiers (first half of the 12th century) surfaces and volumes were organised in a combination of regular and symmetrical forms of a fundamentally cerebral kind far removed from anything that might result from the accidents of nature—simple combinations of straight lines, planes, right angles and segments of a circle, all drawn with rule and compass. The architect constructed in a finite space forms that were almost bred into his mind; his whole art consisted in moulding his materials to these forms in so far as the weight and strength of the materials permitted.

The Gothic architect seems like a being from another planet. He turned the problem upside down. He took as his point of departure the demands of gravity and allowed this force to dictate the solutions which best suited it; he collaborated with it, allowed it to inspire him and let it decide the forms to be used, reserving only the right to organise them so as to achieve beauty. Thus beauty was the end product of the building, whereas for the Romanesque architect it depended on the preliminary choice of forms.

The rib vault was a device to disperse the stresses and to conduct them to the ground like rainwater running down drainpipes from a sloping roof. The flying buttresses, 'crutches' as they were called, were introduced to receive and eliminate the forces of gravity. The pinnacles were merely heavy weights to help various parts of the building to neutralise gravity. All these were purely functional elements that developed into an array of forms hitherto unknown, inconceivable (except in Arab art, where certain features such as the pointed arch foreshadow them) in terms of an abstract geometrical order; they are no less surprising, in fact, than the forms invented by the modern engineer, also dictated by the very forces they have to control. These buildings have a sort of flat, pragmatic beauty. Surfaces were discounted; they bristled with points, portions cut out and projections, and were

776

586

759

758

757

865

800, 82

899

THE CONTRAST BETWEEN ROMANESQUE AND GOTHIC

In spite of the element of continuity which during the Romanesque and Gothic periods formed the thread linking the medieval world together, the later style appeared to be founded on principles which were opposed to those of the earlier style. Thus while Romanesque artists responded to the ordered and symbolic contemporary thought by creating stylised, geometric works of architecture [759] and figurative art [763], the Gothic artists rejected this theoretic logic in favour of the incalculable logic of nature. Gothic façades seem to grow spontaneously, like living organisms [760]. Figures and decoration have the air of being placed at random [764]. Where the Romanesque capital crystallised plant forms into abstract patterns [761], the Gothic rendered them with a freedom that recalled nature [762]. While the Romanesque column-statues remained cylindrical [765], the Gothic ones assumed increasingly natural postures [766] and were eventually freed from any formal restriction [767].

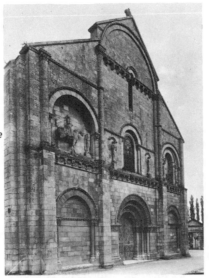

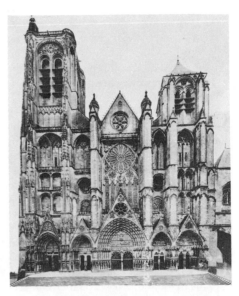

759. ROMANESQUE. Façade of the church of Chateauneuf sur Charente. First half of the 12th century.

760. GOTHIC. West front of Bourges cathedral. Middle of the 13th century.

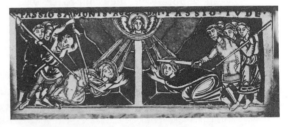

763. MOSAN. Detail, portable altar from Stavelot. 12th century. *Brussels Museum.*

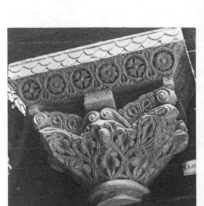

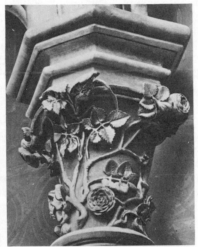

761. ROMANESQUE. Capital with stylised floral pattern, in the cloisters at Moissac.

762. GOTHIC. Floral capital in the Sainte Chapelle (upper chapel). Paris. Second half of the 13th century.

764. GOTHIC. Enamelled casket from Limoges (detail). End of the 13th century. *British Museum.*

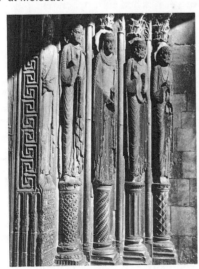

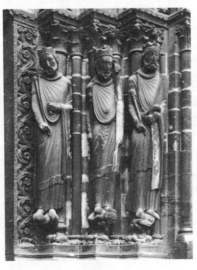

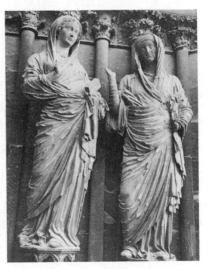

765. TRANSITIONAL. South portal of Le Mans cathedral. 1150–1155.

766. GOTHIC. Statues of kings. North portal of the abbey church of St Denis. *c.* 1170–1180.

767. GOTHIC. The Visitation. Central portal of the west front of Reims cathedral. Middle of the 13th century.

broken up by the complex play of salients and openings. The clashing lines break or cut into each other, so that one is continually surprised by the unexpected over-riding demands of the structure.

Even on the façades of the cathedrals, where the traditional perfectly balanced arrangement deriving from Romanesque art—two towers flanking the central porch 752 (e.g. the famous churches of Caen)—was often main-tained, the original quadrilateral order was soon upset by the new forms, and the old law of symmetry was frequently broken, as at Chartres, for instance, in the 796 striking dissimilarity between the two towers. The empiricism of the Gothic architect also took the form of an increasing freedom in the final execution of the original plan. A building was often altered and new plans made while it was under construction; a cathedral, 760 in the course of its building, developed in unexpected ways, much as a plant does.

In sculpture the new approach was even more pro-nounced. Soon the human body was no longer distorted to fit into a predesigned geometrical frame. To mention only one typical feature, already at the entrances to churches the statues on the jambs of the portal replaced the columns that would normally support the archivolt. 765 At Le Mans and Corbeil in the 12th century, just before the beginning of Gothic art, and even just after it started, 807 on the west front of Chartres, they still assumed the form of the shafts they supplanted, looking like cylinders crowned with heads like a second capital. These figures are as rigid as primitive statues not yet fully carved out of the tree trunk, their drapery imitates the fluting of a pillar, and their arbitrary elongation shows that natural appearances are subordinated to the use to which they are put, this use being that of a cylindrical column. But, 766 with Gothic art, statues regained their natural appearance, at the expense of preconceived and arbitrary forms. At Chartres itself, fifty years later the figures of the saints on the south front have the fullness and flexibility of life. 767 At the end of the century at Reims the statuary seems to consist of real persons in lifelike attitudes, conversing in animated groups and wearing naturalistic clothes as if they had casually mounted the empty plinths. Clearly, reality was now paramount, not abstraction.

Even more telling is the carved decoration. In Roma-761 nesque art everything was dominated by arbitrary forms derived from geometry. The decorative artists played with Greek borders, meanders, rope mouldings, herring-bone patterns, etc.; or as Baltrusaïtis has shown, they crammed into the same mould such heterogeneous sub-jects as a siren with two tails and a Daniel surrounded by lions. The Gothic artist drew his inspiration from the 762 woods and fields, swamping the forms of his capitals and friezes with ivy, columbine, ferns, chicory and strawberry plants. Each successive phase of this style increased in extravagance, like a plant bursting forth from a timid bud to the luxuriance of flowers and leaves.

923 Painting changed less radically. The conventional forms of Romanesque wall painting disappeared only gradually. Illumination remained for a long time under the influence of stained glass with its strong outlines and flat but striking tones, as did enamelling, then at its height.

Though the speed of this revolution depended upon material considerations, the major impulse in every artistic field came from the growing desire to express things seen rather than things thought. Everything was based on data derived from the world of the senses. Although religious fervour was as intense as ever, making the upward surging lines a visible expression of its force, reality dictated the artistic 'language'. We may see in this development a sign of the growing consciousness of a Europe establishing itself in the West, detached from the Orient and turning again towards the aesthetic values of Mediterranean antiquity shortly to triumph in the Renaissance. It may also be due to the growing impor-tance of the new social class of the bourgeoisie who through their commercial interests had formed new realistic and practical attitudes. The symbolic and mystical interpretation of the visible world receded 768–7 steadily. The iconography of the 15th century became more and more narrative and emotional and was markedly influenced by stage plays which also reflected the growing taste for realistic presentation.

The primacy of faith and love

This trend towards naturalism which blossomed in the 15th century was still in its infancy in the 13th century, though its presence can be distinctly felt. It infiltrated gently into a world still dominated by the central idea of God towards which everything converged and by which everything could be explained. Nature and the visible world were being discovered, but they remained a crea-tion and image of God, shrouded in mystery, where reason could only penetrate with humility, and they did not yet turn men's thoughts away from God. We have to wait until the 15th century before the universe seemed more and more like a neutral, passive object, placed before man and at his disposal, which he could grasp and plunder by explaining and making use of it. Then he was to need only his intelligence to help him understand its workings and appropriate them. In this relationship between man and his powers on one hand, and the universe and its resources on the other, God was to seem almost unnecessary, if not awkward, and man, in his vanity undertook to do without Him. This new attitude was linked again quite naturally to the enlightened rationalism of the Graeco-Roman period which had itself superseded an age of religious faith.

Rational thought was gaining a new status in the 13th century, especially among the scholastics of the uni-versities; but it had not yet reached an independent posi-tion; neither had the discovery of empirical reality based on experiment. Both still took second place to faith, which was founded upon Christian love. Our idea of realism as evolved during the Gothic age would be erroneous if we forgot that, like everything else, it was sustained and uplifted by the absolute power of love.

The Middle Ages were essentially Christian. For Christ the greatest commandment was: 'Thou shalt love the Lord thy God with all thy heart, and with all thy soul and with all thy mind.' The second was: 'Thou shalt love they neighbour as thyself.' Or as St John put it: 'He that loveth not knoweth not God; for God is love.' Even during the early Middle Ages, which had been dominated by Augustinian thought re-established in the 9th century by Johannes Scotus Erigena, the latter, although, like Plato, he attributed supreme reality to Ideas, which are an aspect of God, nevertheless insisted on an approach both to God and to Ideas through love. When, early in the 12th century, the scholastics began to be tempted by pure reason, St Bernard erected the idea of love as a barrier

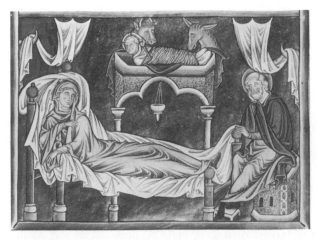

768. The Nativity. Illumination from the Psalter of Ingeburg. *c.* 1200. *Musée Condé, Chantilly.*
In the late Romanesque illuminations the Child is shown symbolically in a cradle which takes the form of an altar (the curtains are drawn, the altar lamp suspended below); the disembodied heads suffice to conjure up the animals of the sacred story.

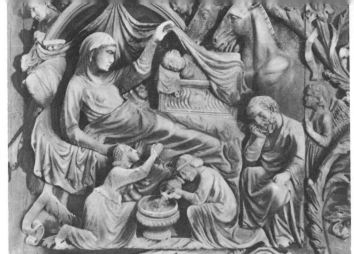

769. GOTHIC. ITALY. The Nativity. Bas-relief on the façade of the cathedral of Orvieto (1320–1330), by Lorenzo Maitani and pupils of the Pisani.
In this Italian bas-relief the Nativity is taking place in an atmosphere of reality emphasised by such details as the servants pouring out water and the tender gesture of the Mother drawing aside the curtains which hide the Baby from her.

REALISM VERSUS SPIRITUALITY

The unity of the medieval world rested essentially on man's spiritual outlook. In Romanesque art this spirituality was expressed in an almost abstract way, by symbols [768] in which religious doctrine was embodied. In Gothic art it emanated from real life itself, through which the transcendental world was truly felt [769]. In the end man's preoccupation with physical detail stifled the spiritual impulse that prompted it [770].
The Middle Ages (and Gothic art) came to an end at the moment when interest in material reality became mere curiosity or descriptive skill and was no longer a means of expressing God's love of His creation. Man's religious fervour [771] subsided and with it the form of spiritual love that united Adam and his Creator in the Old Testament [773] and the Saviour and His Disciples in the New Testament [772].

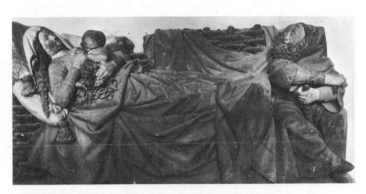

770. GOTHIC. The Nativity. 15th century. *Dijon Museum.*
In the 15th century the scene is burdened with realistic detail—the drapery, the trellis, the laces of the pillow-case and the wavy hair of the Madonna. The Child is seen taking the breast.

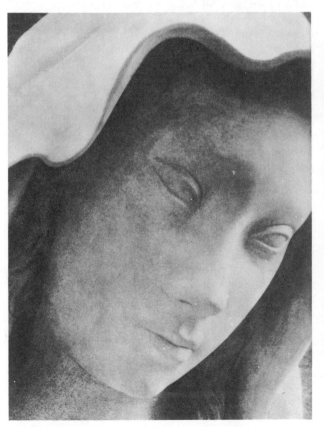

771. FRENCH. Head of the Magdalene. Wood. End of the 15th century. *Church of St Pierre, Montluçon.*

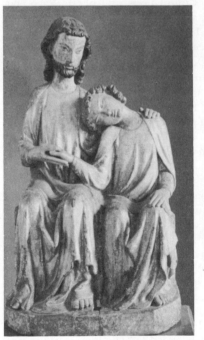

772. *Above left.* GOTHIC. GERMANY. Christ and St John. Wood. Beginning of the 14th century. *Deutsches Museum, Berlin.*

773. *Above right.* GOTHIC. The Creation of Man. From a voussoir on the north portal of Chartres cathedral. 13th century.

against the aridity of reasoning. He said that charity (that is, love) 'is God and is God's gift'. Divine mysteries could not be approached through reason alone. The new rule proclaimed in 1109 by the abbot of Cîteaux, St Stephen Harding, was called the 'Charter of Charity'. The cult of the Virgin, so dear to St Bernard and the Cistercians, coloured the Christian faith with a feminine tenderness. Soon, for the first time in Cistercian Burgundy, the Mother of God was to replace the Son on the central portals of churches. Cathedrals were dedicated to her, and she became the patroness of cities and countries. Siena, after the victory over Florence, was called the 'City of the Virgin', and Bavaria adopted her as patroness. St Bernard, like many mystics, was drawn to God with such intensity that to describe his feelings he borrowed his vocabulary from human love. The tender feelings between God and the soul could only be expressed by 'such affectionate names as Bridegroom and Bride'. 'They are but one flesh . . . Let him kiss me with a kiss of his mouth.'

Religion had been enriched by the same impulse that inspired courtly love, just as religion infused the latter with Christian purity. Cultivated from the days of William IX of Aquitaine (d. 1127) down to those of his grand-daughter Eleanor and his great-grandchildren, Mary, wife of the Duke of Champagne, and Adela, wife of the Count of Blois, who were the founders of the famous courts of love, this secular love cult was gradually spiritualised and eventually gave way to divine love in Guirant Riquier's *Trois Amours* (1280). In the 13th century both seem to blend in Dante's mystical passion for Beatrice and, a century later, in Petrarch's love for Laura. It is significant that André le Chapelain, the author of a treatise on the art of love published in about 1200, was a priest. Even the Celtic contribution of the 9th-century Breton lays and of the legends of King Arthur, Tristan and Iseult, and Sir Lancelot was Christianised during the 12th century by the translations of Robert Wace and Chrétien de Troyes, a protégé of Mary of Aquitaine. At the beginning of the 13th century this twofold stream was diverted towards the divine by St Francis of Assisi. From his French mother, Domina Pica, he heard the troubadour songs of Provence and the heroic legends of the Knights of the Round Table. His father, Pietro Bernardone, whose business interests led him to the fairs of Champagne, was familiar with the atmosphere of the court of the Countess Mary. Its warmth of heart and fervour of soul found their way into Italian art. We see them in the 13th century in the transformation of the images of Christ from Berlinghieri's workshop at Lucca, and again in the 15th century in the paradisial visions of Fra Angelico.

It was the final effusion. The impetus of love and faith, symbolised by the cathedrals soaring to heaven with their towering spires, began to subside in the 14th century; by 1300 the great period of cathedral building was practically over. Love and faith gave way, in the 15th century, to the hair-splitting dialectics of the universities, which infiltrated the *Roman de la Rose*, the famous poem by Guillaume de Lorris. (A letter from Heinrich Glareanus to his teacher Erasmus thus describes the situation at the Sorbonne as late as 1517: 'The hordes of sophists hinder all progress.') Instead of love and faith we also find the earthbound piety of the bourgeoisie, and even scepticism and unbelief. In about 1350 Boccaccio revealed a licentious world in his *Decameron*. A dry intellectualism on the one hand and a kind of materialistic positivism on the other occupied the stage, leaving man to face the world alone.

The Church's loss of prestige accelerated by the Great Schism in the West (1378–1415) further contributed to this sterility. Papal authority was destroyed by the councils convened to end the schism; that of Pisa in 1409 deposed two rival popes, the councils of Constance (1414–1418) and especially of Basle (1433) aimed to reduce the Vicar of Christ to the role of an administrator. Even the Church itself was on trial; the abortive attempt of Wycliffe and his disciples, the Lollards, at Oxford in the 14th century, and in the following century the revolt of Huss, burned alive in 1415, opened the way to the Reformation, which was helped on by the struggles of the secular powers in England, France and Germany to gain their independence and predominance.

This decline of the secular power of the Church was mainly caused by the even more serious decline of its moral authority. In his *In Praise of Folly* Erasmus denounced the evils to which Rome had succumbed: 'Such wealth, honours, power, triumphs, offices, dispensations, taxes, indulgences, horses, mules, guards and luxuries— all should be renounced, and life should be devoted to watching, fasting, tears, prayer, preaching, study and penitence.' Warnings were voiced throughout the 15th century by ardent predicants such as the Spanish Dominican St Vincent Ferrer, who died in 1419 and whose influence spread to France and Ireland, the Franciscan St Bernardin of Siena, who preached at the time of the plague in 1400 and precipitated the reform of the Observants branch of the Franciscans, St John of Capistrano who preached in Bohemia and Carinthia where he died in 1456, and lastly the Dominican Savonarola, who at the end of the century imposed austerity on Florence and on Florentine art before he was burnt alive.

They were the last desperate witnesses of religious fervour. From the end of the 12th century the new bourgeoisie, with their pragmatism and rationalism, penetrated the universities. This class provided the professional lawyers who deliberately set the independent rights of the secular national state against the spiritual power of Rome. In the same way, in the sphere of thought, the nominalists contributed to the decline in religious fervour by denying that the soul could reach God through love; they limited themselves to what they could learn through direct experiment backed by logical thought. Nicolas of Autrecourt at the beginning of the 14th century proclaimed: 'Nothing entitles me to believe that there exists anything which does not come to us through our five senses and through our experiments.'

A civilisation only progresses or even remains positive as long as it has that expansive energy which gives self-confidence, a certainty deeply rooted in the emotions that involves a spontaneous, total, ungovernable and blind faith in its way of life and its ideals. It is only too easy to demonstrate the truth of this in our own day and age. From the 14th century onwards this faith declined, to disappear altogether in the 15th century. Certainly in its outward appearance Gothic art continued. It even seemed to find a new vitality in new forms like the Flamboyant style, but in fact its death warrant was signed. A new age was opening for art and for civilisation; at first vague and hesitant, it was to take definite shape in the course of the 15th century, when it would constitute the Renaissance.

THE ORIGINS AND DEVELOPMENT OF GOTHIC ART *Marcel Aubert*

In order to create the first genuine medieval style, the Romanesque, the builders of Europe made an effective synthesis of the various elements which preceded it. The next step in a highly original creative process was the development of a fundamentally new style, the Gothic. The birth and development of Gothic art, in which the Capetian monarchy played a decisive role, are traced by the scholar who has taught an entire generation of archaeologists.

During the 11th and the first half of the 12th centuries great abbeys literally covered the whole of France. These were immense churches, answering the needs of the time and expressing the drive and the wealth of the older religious Orders such as the Augustinians, Benedictines and Cluniacs, and bearing witness to the religious and missionary fervour of the new Orders, such as the Premonstratensians, Cistercians and Grandmontines, that made poverty a supreme rule. They responded also to the

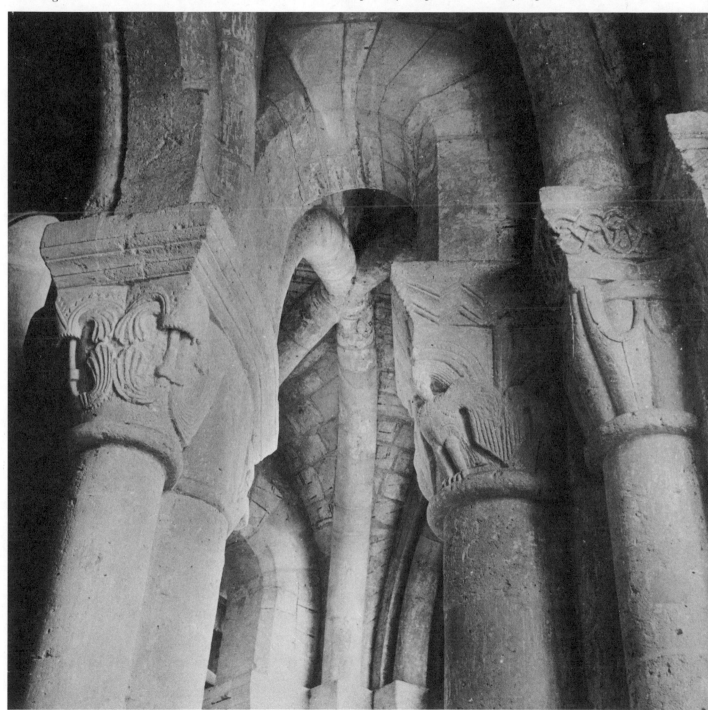

774. GOTHIC. Rib vault in the ambulatory, Morienval. *c.* 1125.

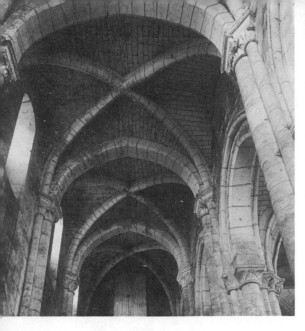

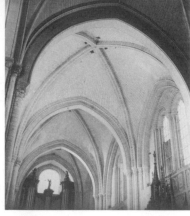

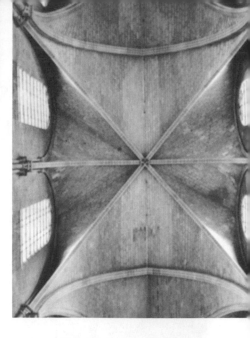

775. GOTHIC. Cross-ribs in the church at Cambronne. c. 1150.

776. GOTHIC. Rib vault in Angers cathedral. Middle of the 12th century.

777. GOTHIC. Sexpartite rib vault in Notre Dame at Mantes. End of the 12th century—beginning of the 13th century.

growing cult of relics that drew the faithful along the pilgrimage routes to Santiago de Compostela—the edge of the known world.

Architectural problems

785, 794, 813, 824

During these centuries of experiment and invention the plan of buildings had been considerably enlarged and became fixed. In general it consisted of a long nave flanked by aisles—sometimes by double ones—a large transept, and an elongated choir surrounded by an ambulatory and radiating chapels. Under the choir there was frequently a large crypt; central bell towers and, especially, the two towers at the façade became increasingly important. Sometimes a narthex was placed at the front of the building. To protect these large buildings against fire and weather the nave was covered with a

941

barrel vault resting on thick walls and buttressed on either side by barrel or groined vaults covering the aisles or galleries. The weight of the main vault exerted considerable thrust and threatened the equilibrium of the building. Many accidents happened and are recorded in the chronicles or are traceable on the buildings themselves. Since the walls were exposed to the heavy pressure of the vaults,

windows could only be put in at great risk; the building therefore usually remained submerged in semi-darkness, receiving light only through the windows of the façade and of the choir and aisles.

Enterprising architects in Burgundy attempted to mount groined vaults over the nave, a device which made the piercing of large windows in the clerestory possible, thus providing ample light; but these openings endangered the stability of the building—for example, at Vézelay. In Périgord a succession of domes over an aisleless nave enabled the builders to cover large spaces without danger, though at great expense as their construction required large blocks of masonry. Everywhere, however, efforts were made to construct light but sufficiently solid vaults which were easy to stabilise.

941

575, 5|

For centuries many attempts were made in various regions to strengthen or to support a stone vault by the use of intersecting ribs.

A. Choisy has shown how the Romans reinforced the groins of the vault by arches which were embedded in the vault, sometimes projecting slightly as ledges beneath the groins. G. T. Rivoira, Kingsley Porter and Paolo Verzone discovered that the same procedure was followed in

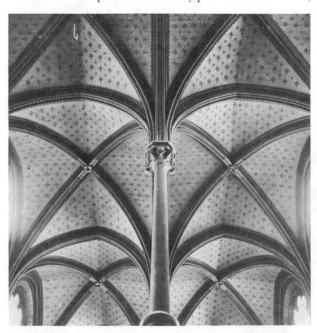

778. GOTHIC. Vault of the refectory at St Martin des Champs. Work of Pierre de Montreuil. 13th century.

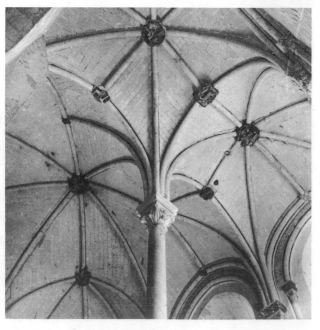

779. GOTHIC. Vault of the Angevin type. Choir of the abbey church of Asnières. First quarter of the 13th century.

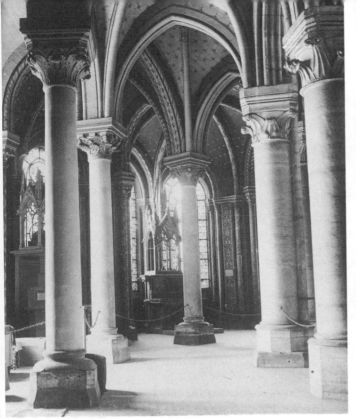

780. GOTHIC. Ambulatory of the abbey church of St Denis. 1140–1144.

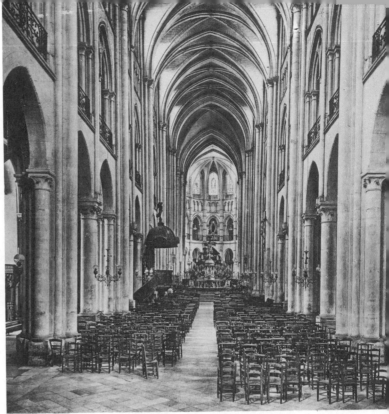

781. GOTHIC. Nave, Noyon cathedral (four-storey elevation). The rib vaulting is sexpartite. Middle of the 12th century.

Lombardy and central Italy during the 11th and the early 12th centuries. The groins were strengthened by large thick ribs, massively constructed with small units of masonry, mostly of brick, which were embedded in the stilted groined vaults and which abutted together at the summit without a keystone. These attempts, like many others, were abandoned when at the end of the 11th century the Cistercians introduced in their churches the true rib vault which had been used in the Ile-de-France and in Burgundy. The influence of the Lombard rib vault is found up to the 12th century in the Alps and the south of France where certain features of Roman buildings had survived.

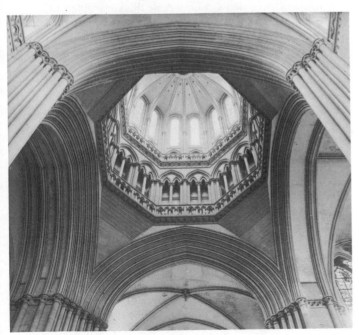

782. GOTHIC. Lantern tower at Coutances cathedral. Of very pure Norman style. First half of the 13th century.

Ribbed domes had been constructed in the Orient. J. Hackin found examples in India, M. Dieulafoy and A. U. Pope in Persia; A. Choisy and J. Strzygowski, and more recently Baltrusaïtis, rediscovered various combinations of intersecting ribs in Armenia. Transcaucasia and Georgia. These ribs lined a vault or rested on a low wall to support a stone ceiling. M. Gómez-Moreno, L. Torres Balbás, H. Terrasse and Elie Lambert made special studies of the development of many types of ribbed domes in Africa and in Moslem Spain of the 9th and 10th centuries. These varied from simple cross-shaped ribs to the decorative stellar vaults of the mosques at Kairouan, Tunis, Cordova and Toledo. They also examined the rib vaults of several Romanesque churches in northern Spain and of two churches in the Basses-Pyrénées: Ste Croix at Oloron and L'Hôpital St Blaise. The ribbed domes in Aquitaine, placed under the bell towers at Cormery and in St Ours at Loches or over the crossing as at Montagne (Gironde), are similar to those in Moslem Spain, Armenia and Georgia. But these attempts at building ribbed domes did not provide a very satisfactory solution, as the constructions of a dome and of a rib vault are based on different principles.

From the middle of the 12th century the builders of Anjou and Poitou understood this and constructed, instead of a dome, a true cross-ribbed vault, but much stilted, as for example over the nave of the cathedral of Angers and over the two easternmost bays of the cathedral of Poitiers. At the end of the century the Angevin masters brought this problem to its logical conclusion by transforming the cross-ribs, which were supplemented by liernes and tiercerons, into simple ribs embedded in the masonry of the vault, with no projecting edge to support the compartments and showing at the intrados (inner curve) only as a fine torus (convex) moulding.

These ribs formed a kind of skeleton facilitating the actual task of construction but not supporting the vault itself during or after the setting of the mortar. This

766

941

self-supporting vault rested on powerful transverse arches and wide longitudinal arches which were supported by thickset walls pierced by narrow windows. The transverse and longitudinal arches canalised the entire thrust into the angles of the bay which was usually square. Typical examples are at St Jean at Angers (end of the 12th century), in the transept and choir of the cathedral of Angers, in the nave and aisles of the cathedral of Poitiers (both of the 13th century) and in many other church buildings in western France and in Italy, Spain, Portugal, England, Germany, Flanders, Holland and the Scandinavian countries. In all these churches it is not a question of vaults resting on cross-ribs but rather of vaults of cross-ribs.

707
Other experiments in vaulting were made in England at the end of the 11th century and at the beginning of the 12th century. Their importance has been shown by J. Bilson. The cathedral of Durham is one of the oldest examples. Similar attempts were made in the transept aisles of the cathedrals of Winchester and Peterborough and in the north aisle of the cathedral of Gloucester, and,

646,647
in Normandy, at Evreux, Lessay, St Paul lès Rouen and somewhat later at St Etienne and La Trinité at Caen. By the end of the 12th century the Ile-de-France type of vault, only slightly depressed, with its pointed arches raised on semicircular groined ribs that were soon to be

941
pointed, and with a four-armed boss at the intersection, gradually replaced the Anglo-Norman vault. This vault, framed by semicircular arches, depressed in spite of the segmental groined ribs, exerted a considerable thrust which could only be absorbed by thick lateral walls which hindered the architect from raising the vault higher and from opening up the lateral walls with larger windows. In its essence the Anglo-Norman and Lombard vault was a highly improved groined vault having the same shortcomings as in Romanesque buildings.

The rib vault

The Ile-de-France and the Royal Domain enjoyed a long period of peace, good government and prosperity. It was an area rich in beautiful stone, the royal lime and lias, resistant and easy to work; here the cross-rib became an enduring element in a type of vault that gave birth to Gothic art. The rib vault like the groin vault canalises the thrust to the four angles but has the advantage of being lighter, and easier to construct and to stabilise. It can cover any space and offers greater resistance to deformation and weather. There is plenty of evidence that the architects of Lombardy, Spain, England and Normandy used it before it was adopted by the master builders of the Ile-de-France, but the latter made the fullest use of its structural possibilities and brought it to the highest perfection. The vaults they constructed were of extreme lightness and solidity. Divided into independent compartments they resisted deformation, fire and weather; built high over walls completely open between the supports, buttressed from within by wall props, from without by flying buttresses, they helped to carry out the dream of the medieval builders to erect a huge shrine enclosed in glass screens.

In the first half of the 12th century the peace of the king extended over the Ile-de-France, and with it went that prosperity under which art flourishes. In addition the close union of the reformed clergy with the Capetian kings, who were religious by temperament and politics,

made it possible to give expression to the religious fervour rising at this time. This fervour reached its height under St Louis, and under the king's protection these immense cathedrals were erected in honour of God and Our Lady. At the beginning of the 13th century the major cathedrals of the kingdom had been built or were in the process of being built. As fast as the Royal Domain grew new building sites were opened within this favoured territory which eventually gave France its laws, its political unity and above all a literary language of unusual lucidity and a highly original form of art.

About the second quarter of the 12th century the master builders of the Ile-de-France had learnt to construct cylindrical rib vaults, which exerted less thrust than the Anglo-Norman vaults. They were formed of voussoirs and were keyed at their intersection by a four-armed boss which strengthened the cross-vault and prevented the structure from slipping, a danger inherent in the Lombard vault. Very soon these semicircular rib arches were pointed at the crown, a device which gave greater solidity to the vault and diminished its thrust. This treatment of the arches, in use in Burgundy from the beginning of the 12th century, was also applied to the transverse arches and the wall arches framing the vault. By raising their crowns a less depressed profile of the vault was obtained.

941

The adoption of the flying buttress at the end of the 12th century enabled the rib vault to be raised to a greater height. The fact that the thrust was localised entirely at the four springing points of the arches made it possible to reduce and even to eliminate the part of the wall carrying the gutter, which was replaced by large open bays containing stained glass windows. As for the vault, it was narrowed from square to rectangular shape so that the profile of the rib arches and that of the transverse arches had nearly the same curve. This measure increased at the same time the number of supports on which the arches rested, thus improving the system of buttressing.

The groined vault led to the development of the rib vault, though the latter did not adopt the same form. The former demanded a considerable thickness along the entire length of the groins. Its construction therefore necessitated an elaborate scaffolding, and its stability remained precarious so that it was rarely used to span a nave. Originating from the intersection of two barrel vaults of the same cross-section at the base and of the same tangential plan at the summit, the groined vault could only be erected over a square space. It was much less trouble to construct a rib vault. The centring of the vaults was easier and the use of complicated scaffolding unnecessary. It could readily be adapted to covering the most irregular spaces. It hid defective stone-cutting, and remained secure during the setting of the mortar. Moreover, it strengthened the vault at its two weakest points, along the groins and at the plane of the summit; this was a matter of importance when the stone was friable and inclined to crack when exposed to frost or accidents. The rib vault made it possible to reduce the thickness of the single panels of the vault, whose width was cut down to one foot or less in the vaults of the great cathedrals. The web of the vault could be built of very light materials: chalk from Champagne, tufa from Anjou, limestone from the Ile-de-France and other stone of feeble density. In this way large vaults of negligible thrust, composed of small and light panels, were erected with the aid of ribs.

941

It is certain, however, that the ribs do not carry the whole weight of the vault, as has been suggested, nor do they alone transmit the thrust. Their resistance to deformation is not unlimited, and if the system of buttressing is insufficient the ribs will collapse with the vault. If, however, a deformation which has just begun is arrested, the ribs are able to save the vault. It is certain that from the end of the 12th century onward in Anjou and other parts of western France the ribs did not entirely support the web of the vault; they simply stiffened the structure and served as a guide for the builders. In several churches at Reims, for example, the ribs and transverse arches have a rather weak cross-section in relation to the considerable mass of the masonry forming the vault, but such cases are rather exceptional.

It is an undeniable fact that the rise of Gothic architecture coincided with the use of the rib vault and the flying buttress. Wherever the risk of vaulting large naves had previously been avoided, as in Normandy for example, the rib vault offered a solution. In eastern France it supported the bell towers and strengthened their masonry; in Burgundy it covered the nave whereas over the aisles groined vaults remained in use. But soon the rib vault replaced all other types of vaulting, even covering cellars, rooms with low ceilings, corridors and military and domestic buildings. Above all it was adopted by the Cistercians who were averse to decoration and adopted the strictest form of austerity in their buildings.

During the 12th and 13th centuries the rib vault was never considered a decorative element, though it was instrumental in giving the Gothic cathedral its daring proportions and sublime height. It accentuated the upward movement of these high and narrow naves, where the dominant verticals, rising in long, finely carved pillars attached to the piers and walls, gave expression to the dreams of great height which haunted the Gothic builder even beyond the limits of prudence, as at Beauvais.

The beginnings of Gothic art

In the beginning the Gothic builders tried to feel their way. In an area of which the Ile-de-France formed the centre and Reims, Provins, Etampes, Mantes, Gournay, Amiens and St Quentin the outer limits, we witness during the middle of the 12th century the emergence and then the rapid development of the rib vault. This area comprised roughly the Royal Domain of that period.

In several of the older rib vaults of this region, as for instance those of the ambulatory of Morienval (*c.* 1125), of the aisles of St Etienne at Beauvais and of several churches of the Aisne valley, the ribs were embedded in the vault and at the same time supported the panels on two grooves cut along the lateral faces of the voussoirs. This arrangement differs entirely from the ribs of the Angevin churches which, it will be remembered, lacked all reinforcement. This made them prone to the same accidents as the vault. The builders of the Ile-de-France

774

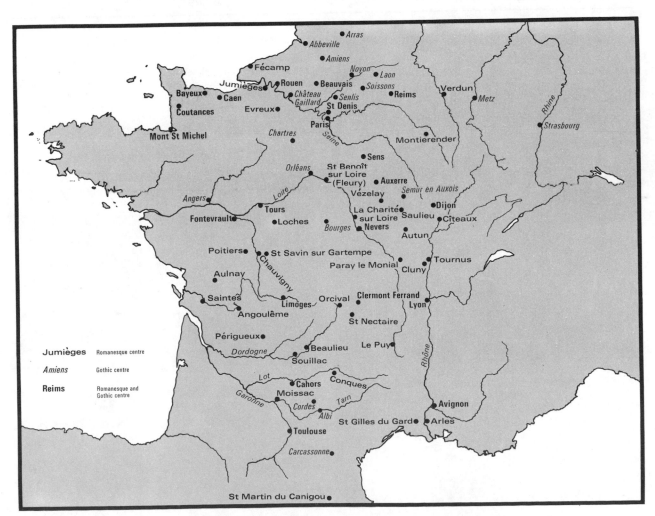

ROMANESQUE AND GOTHIC FRANCE

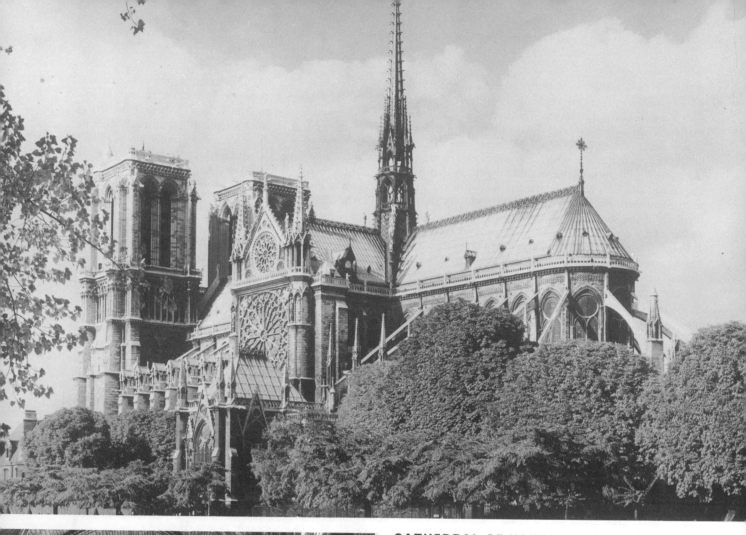

CATHEDRAL OF NOTRE DAME, PARIS

783. *Above.* GOTHIC. Notre Dame, Paris. Begun 1163 by
Maurice de Sully. Choir consecrated 1182; nave completed
c. 1200. The apse chapels were built in the first quarter of the
14th century by Pierre de Chelles and continued by Jean Ravy.

784. *Left.* The nave, Notre Dame, Paris.

785. *Below left.* Plan, cathedral of Notre Dame, Paris.

786. *Below right.* Virgin on the portal leading to the cloisters of
Notre Dame. End of the 13th century.

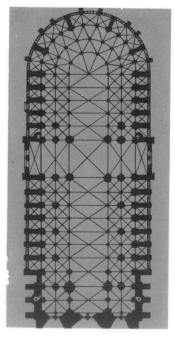

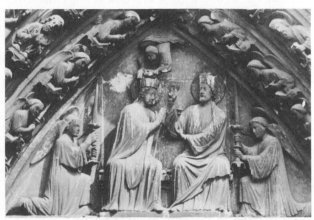

789. The Dormition of the Virgin. Detail from the portal of the Virgin, Notre Dame. 1210–1220. Two angels in the presence of Christ and the Apostles lift the Virgin to carry her to heaven.

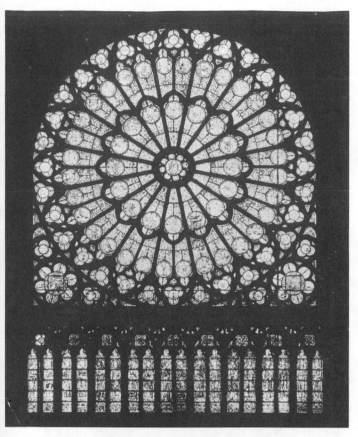

787. Rose window in the north transept of Notre Dame, containing 80 subjects of the Old Testament. c. 1270.

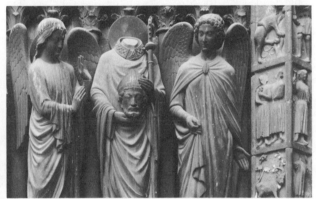

790. The Coronation of the Virgin. Detail from the portal of the Virgin, Notre Dame. Originally gilded. 1210–1220.

788. South portal of Notre Dame. On the tympanum is the Martyrdom of St Stephen. Middle of the 13th century.

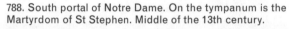

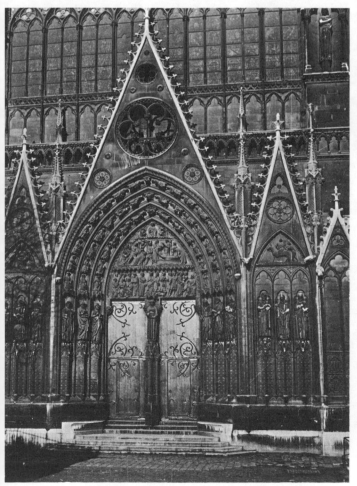

791. St Denis between two angels. From the portal of the Virgin, Notre Dame.

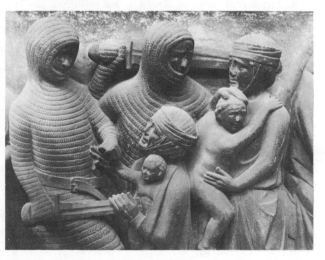

792. The Massacre of the Innocents. Detail from the portal of the north cloister, Notre Dame. Second half of the 13th century.

were quick to realise this danger and constructed ribs independent of the vaults, as over the choir of Morienval (where the vault was built shortly after the one over the ambulatory), at St Martin des Champs in Paris, at Foulangues, at Cambronne and in the majority of the smaller churches built in the years preceding or following the construction of the narthex (1140) and the choir (completed 1144) of St Denis.

775

Most of these vaults are quadripartite spanning a square bay, sometimes slightly elongated. The sexpartite vault, in which an intermediary rib was added, appeared only in the second half of the 12th century, in larger buildings such as the cathedrals of Senlis, Noyon, Laon and Paris.

777

781,839
784

Until the end of the 12th century the vaults were more or less stilted so as to divide the thrusts more evenly and to reduce the pressure exerted on the angles which were insufficiently propped by buttresses, spurs or wall arches hidden under the roofs of the galleries or the aisles. From the middle of the 12th century it became general practice in the Ile-de-France to point the arches of the ribs at the bosses so as to lower the points of pressure, and, especially in Champagne, this pointing of the arches was accentuated until the end of the century. The flying buttresses, large stone arms to counterbalance at great height the lateral thrust of the main vault, came into general use at the beginning of the 13th century. Towards 1180 they were used conspicuously in the nave of Notre Dame at Paris. At the time of the rebuilding of the cathedral of Chartres (1194), the architects of the Ile-de-France had learned to span large spaces with vaults flattened at the top, in which the bosses of the ribs of the transverse arches and of the wall arches (all of which were pointed) were at approximately the same level. The thrusts were now largely concentrated at the four corners and were effectively counterbalanced. With the help of independent supports separated from each other by large bays, the architects were able to raise the building to hitherto impossible heights.

783

The first important building constructed in the new style, with the combined efforts of the master builders of the valleys of the Seine, the Marne, the Aisne and the Oise, was the abbey of St Denis, which enjoyed the special affection of the kings of France and which was their favourite burial place.

780

Suger, a great man of action and a profound mystic, after having become abbot of St Denis in 1122, decided to rebuild his abbey. Work was started about 1132. On the 9th June 1140, the western portal and the adjacent bays were consecrated. The choir, begun in the same year, was completed in June 1144. At the consecration Louis VII, the queen, the lords of the realm and a great many archbishops, bishops and abbots gathered in the old Carolingian basilica that had been enlarged by a portal and a choir in the new style. They all wished to have in their diocese a church of comparable height, light and beauty.

781, 848

The cathedral of Noyon is of almost the same date. Not far from there, at Senlis, Bishop Thibaud, a friend of Louis VII and of Suger, built his new cathedral which was consecrated on the 16th June 1191. Also dating from the second half of the 12th century are Notre Dame en Vaux at Châlons sur Marne, the choir of St Remi at Reims, the south transept of the cathedral of Soissons, the cathedral of Laon and the two large cathedrals of

858
839

Cambrai and Arras which were destroyed during the Revolution. Motifs from the cathedral of Laon (which rises on top of a hill, visible from afar) recur in northern and eastern France as far as the Rhineland and Normandy. They inspired the master builder of the cathedral of Lisieux and served also as a model to the builders of Notre Dame in Paris (built between 1163 and c. 1245), which, in its turn, influenced the builders of Bourges cathedral in the 13th century, and of many churches in the Ile-de-France. Bishop Maurice de Sully devoted all his energy to the new cathedral of Notre Dame, for which he laid the foundation stone in 1163. Building began in the choir, was well advanced in 1177 and terminated on the 19th May 1182. The nave was built between about 1180 and 1200. Bishop Eudes de Sully started the façade (which was finished in 1245) about 1200. Towards 1230 the high windows were in place and the chapels of the nave were under construction; those of the choir date from 1296 to 1320. During the third quarter of the 13th century the architects Jean de Chelles and Pierre de Montreuil erected the façades of the transept.

760, 8

783–7

Notre Dame at Paris is the last of the group of great Gothic churches in which galleries reinforced the construction of the nave. Characteristic of this group also is the choir with ambulatory and radiating chapels, but Morienval, Notre Dame at Paris, the cathedral of Laon and the former cathedral of Arras are without radiating chapels. The arms of the transepts of St Lucien at Beauvais, those at Cambrai, at Valenciennes and at Noyon and the southern arm of the transept at Soissons end in a semicircle. In Laon a lantern tower rises over the crossing, and this was formerly to be seen at Cambrai, Valenciennes and Arras. Notre Dame, Paris, has a double row of aisles. The same was planned by Suger for St Denis, but was never built. At Bourges and in the small church at Beaumont sur Oise the double aisles recur at a later date. The height of the rib vault was constantly being raised: at Senlis, to 59 feet, at Noyon, 72, at Laon, 80, and at Paris, 106 feet. The elevation comprised four storeys: large arcades, a massively vaulted and well lighted gallery, a triforium and a clerestory with windows which were still rather small and which had no tracery.

858

785

781, 83

The Gothic cathedral at its zenith

About the same time a great cathedral was built at Sens, situated on the borders of Champagne, Burgundy and the Ile-de-France. It had no galleries and consisted of only three storeys, with large arcades, a triforium and a clerestory. It was covered by highly stilted vaults.

842

Sens influenced the construction of the choirs of St Germain des Prés in Paris, and Vézelay, and was a forerunner of Chartres, the first great Gothic cathedral to be free of the cumbersome galleries which from now on were replaced by flying buttresses. On the 9th June 1194, fire had destroyed the old wooden-roofed cathedral, but had not harmed the western portal and the two bell towers which dated from half a century back. The nave of the new building was completed about 1220, the choir and transepts about 1240.

793–81

797

805

The cathedral of Soissons, begun at the end of the 12th century at the south transept as a four-storeyed building, was continued with three storeys at the choir (completed 1212) and nave.

858

741, 85

In 1210 a fire destroyed the old cathedral of Reims,

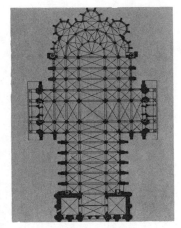

794. Plan, Chartres cathedral.

793. *Left*. GOTHIC. The cathedral of Chartres. Nave, transept and apse erected over the 11th-century crypt. Building begun 1194. The cathedral was consecrated in 1260, in the presence of St Louis.

796. The west front, Chartres cathedral.

795. *Below*. Detail of the south porch, Chartres. 1200–1260. The three portals and the porch, dedicated to the glory of Christ, contained 783 sculptured figures.

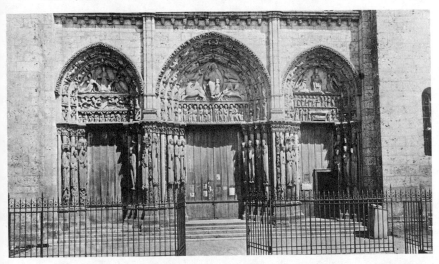

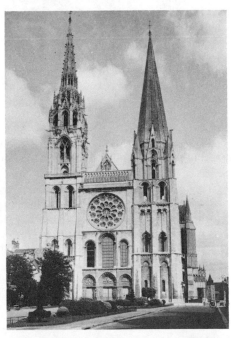

797. *Below*. Royal Portal, west front, Chartres. 1145–1155. Centre: Christ in Majesty with the symbols of the Evangelists.

798. The Annunciation to the Shepherds, tympanum on the Royal Portal, Chartres. 1145–1155.

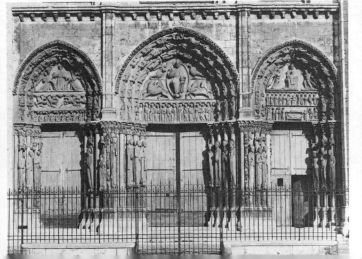

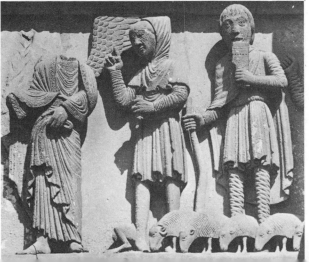

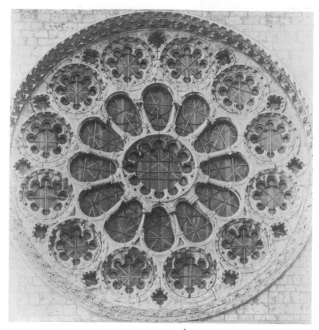

799. Rose window in the west front, Chartres.

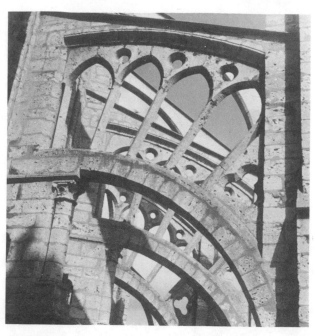

800. Flying buttresses on the apse, Chartres.

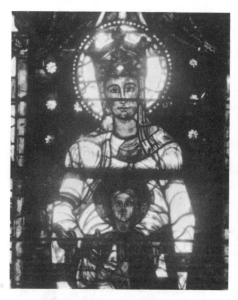

801. Notre Dame de la Belle Verrière (detail). Stained glass window in the choir, Chartres. 12th century.

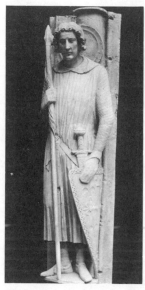

802. Chartres cathedral. St Theodore, from the south transept. 1224–1250.

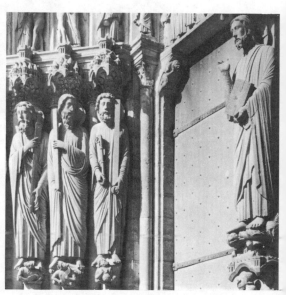

803. Christ teaching (right); St Peter and Apostles (left). Central portal, south porch, Chartres. 13th century.

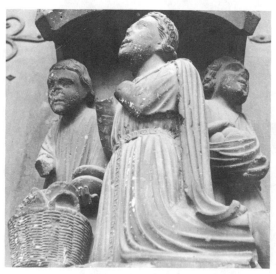

804. The Baker and his Wife. Chartres.

805. Detail of nave, Chartres (three-storey elevation).

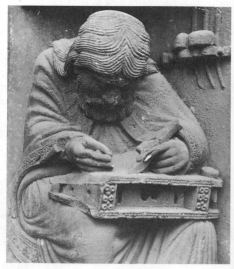

806. Chartres cathedral. Pythagoras, on the right archivolt of the right portal, Royal Portal.

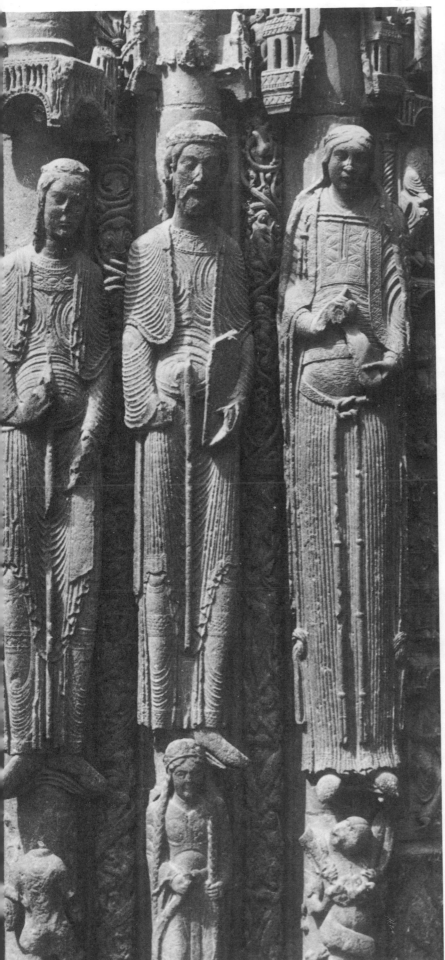

807. Kings and queens of Judah, from the Royal Portal, Chartres. 1145–1155.

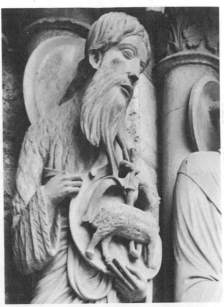

808. John the Baptist (detail), from the north portal, Chartres.

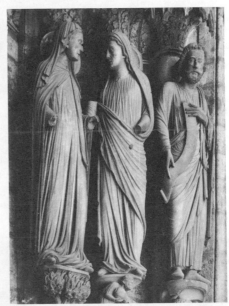

809. The Visitation, and the Prophet Daniel. North portal. *c.* 1230.

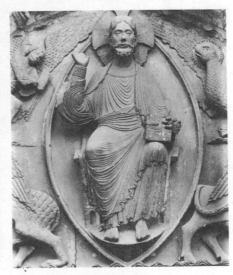

810. Christ in Majesty. Detail from the central tympanum of the Royal Portal, Chartres.

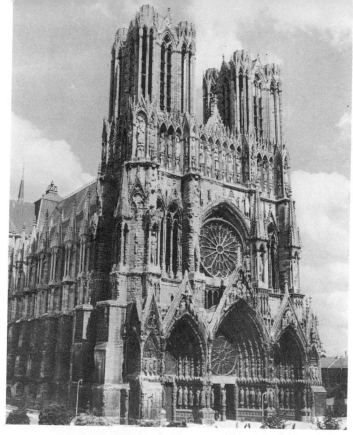

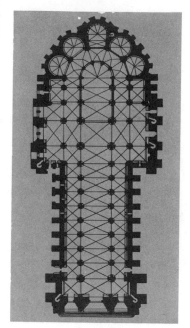

813. Plan, Reims cathedral.

REIMS CATHEDRAL

811. GOTHIC. The cathedral of Reims replaced a cathedral destroyed by fire in 1210. Work began with the apse, choir and transept, lasting from 1211 to 1241; the nave dates from the second half of the 13th century, the façade from the second half of the 13th century and from the 14th century. The upper parts were restored after a fire in 1481. The cathedral, severely damaged during the First World War, escaped total destruction thanks to the solidity of its structure.

812. The nave, looking west. Reims cathedral

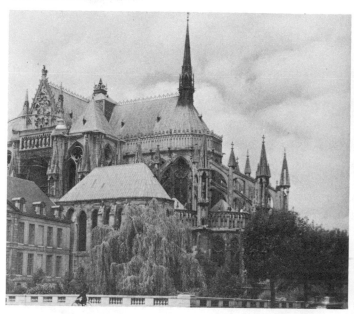

814. Reims cathedral. The choir and apse from the south-east.

815. The Virtues. Detail from tympanum (showing the Last Judgment) on the north porch, Reims. c. 1240.

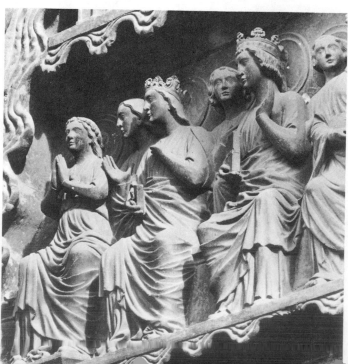

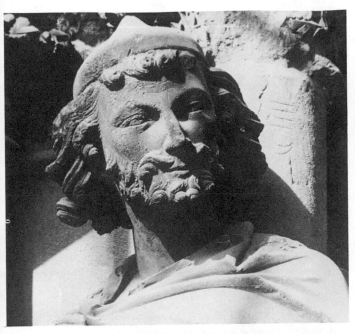

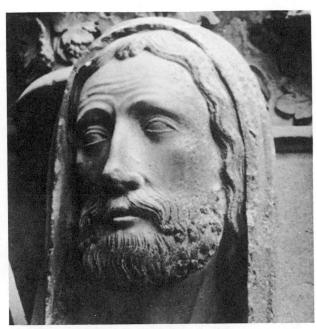

816. Detail of Joseph, from the west front, Reims. *c.* 1260.

817. Detail of John the Baptist. West front, Reims. *c.* 1220.

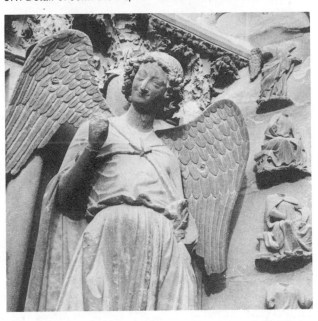

818. Angel musician. Detail from the rose window, Reims. 13th century.

819. The Smiling Angel, from the west front, Reims. Second half of the 13th century.

820. Apostles on the north porch, Reims. *c.* 1240.

821. Abraham and Melchizedek, from the inside of the west front, Reims. Last quarter of the 13th century.

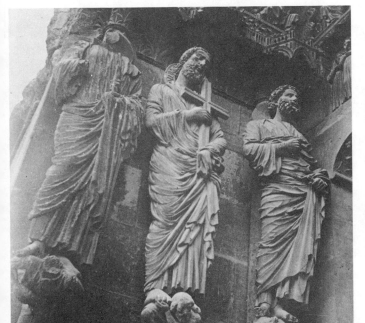

parts of which dated from the 12th century. In the following year the Archbishop Alberic de Humbert began to build the choir according to the plans of Jean d'Orbais.

811–821 Divine service was held there by the chapter in 1241; the nave, which was the work of Gaucher of Reims, Jean Le Loup and Bernard of Soissons, was completed at the end of the 13th century.

In 1218 the cathedral of Amiens also fell victim to fire.
822–834 The new building was started by the master mason Robert de Luzarches; he was succeeded by Thomas de Cormont and his son Renaut. The nave was completed in 1236, the choir in 1269. Seven years after the fire at Amiens, the cathedral of Beauvais was burnt down;
865 Milon de Nanteuil rebuilt the new choir; the whole work was completed in 1272. With every new building the architects felt the need to build bigger, higher and lighter structures. In Beauvais they went too far; in 1284 the vaults collapsed with the exception of the apse; supports and buttresses had to be doubled and the vaults reconstructed.

These great cathedrals represent the zenith of Gothic architecture. Their plan is magnificent. The choir, with an ambulatory surrounded by radiating chapels, is separated from the nave by a vast aisled transept. There are towers on either side of the main façade and the façades of the transepts. The rib vaults are light but stable and compact, resting on high piers of small section and supported by flying buttresses of great height springing from slender supports. The pointed arches of the great arcades of the nave rest on circular pillars with four attached columns. The high windows, with light tracery to hold the glass, occupy the entire space between the triforium and the vault. Abundant light floods the choirs of Amiens and Beauvais, falling through the pierced walls at the back of the triforium galleries. It is the clerestory, appearing in the third quarter of the 13th century, which marks a new stage in the evolution of Gothic art and emphasises the lightness of the whole structure. Ornamentation and mouldings too show a growing sensitivity to the subtle play of light and shade; they were further enhanced by paintings which have now disappeared.

This new art, more subtle and elegant, richer but less powerful than previous styles, evolved in the Ile-de-France about the middle of the 13th century under the influence of the two great Parisian artists Jean de Chelles, architect of the two façades of the transepts of Notre Dame, and Pierre de Montreuil, his pupil and later his rival, who built the nave of St Denis, the refectory at
856 St Germain des Prés and, probably, the Sainte Chapelle. He also completed the south transept of Notre Dame. He died on the 17th March 1267. Among the most important of the works inspired by the two masters were
871 the cathedral and St Urbain at Troyes, the collegiate
837 church of St Quentin, the choir of St Ouen at Rouen, the
841 nave of the cathedral of Auxerre, the transepts of the
874 cathedral of Tours, the façade of the cathedral of Strasbourg, parts of the cathedrals of Metz, Toul, Evreux,
850 Sées, Tréguier, Quimper, St Pol de Léon and, in the south, several of the great churches which imitated the
844 northern examples, such as the cathedrals of Clermont-Ferrand, Narbonne, Limoges and probably Rodez, which was started under the direction of Jean des Champs who
851 worked on the building of Amiens, Bayonne, Toulouse,
847 Bordeaux and the choir of St Nazaire at Carcassonne.
The Gothic art of the Royal Domain spread rapidly

throughout France without, however, suppressing completely the provincial characteristics. The Norman architects showed their independence from the beginning of the 13th century. Typical features of their style were the lantern towers, the raised triforium, a circulating passage 782 at the base of the upper windows of the clerestory, geometrical ornamentation—all features to be seen in the choirs of the cathedrals of Rouen and Lisieux, in La Trinité at Fécamp, in the choir and the upper parts of the nave of the cathedral of Bayeux, and at Coutances, 835 Sées, Dol, Quimper and St Pol de Léon.

In Champagne the pillars are sometimes replaced by double columns, and a small gallery leads along the base of the aisle windows as in the churches of Reims, Orbais, Troyes, Bar sur Aube, Provins and Rampillon. Decoration carved in a soft limestone is abundant and of fine execution. In Burgundy at Auxerre, in the choir of Vézelay and at St Père sous Vézelay, Chablis, Dijon, Semur, Nevers and Clamecy the vaults were still sexpartite in the 13th century, the triforium was tall and slim, 843 and there was a passage along the base of the windows of the clerestory. The wealth of sculptural decoration recalls the great tradition of Romanesque sculpture of this region.

The Gothic churches in the south of France are more typical. Generally they have an aiseless nave, as at Toulouse, Albi, Villefranche de Rouergue, Perpignan, 855 Béziers, Montpellier and Avignon. The nave is covered with a rib vault sprung from interior buttresses between which are chapels. The aiseless nave, a characteristic feature of the Romanesque period in the south of France and the Mediterranean region, facilitated the construction in brick frequent in this region. The aiseless nave was economical and helped the preacher to make a direct impact on the congregation. These plain large naves lighted by high narrow windows have a dignity and simplicity of appearance unknown to the northern edifices, with their soaring height and picturesque splendour. The exterior conveys an impression of power and 854 strength owing to the absence of such elements as attached chapels and flying buttresses; in their place rose large, bare fortress-like walls. Several of these buildings were actually constructed as fortresses. However much they may differ from the northern churches ('. . . they soar to heaven whereas these inhabit the earth,' said Emile Mâle), their construction is nevertheless based on the principle of the rib vault that the masters of the Ile-de-France had elaborated. We have seen how differently the problem evolved in Anjou.

The decoration of the cathedral

The beauty of these Gothic churches springs not only from the magnificent architecture which the master builders had developed in response to the religious enthusiasm of the age; it is due as well to the glowing, colourful and mysterious atmosphere which the glorious stained glass windows give to the interior where the faithful felt sheltered and at peace in a world foreshadowing the joys of paradise and far away from the miseries of this earth. The high bays which let in a flood of light, 'a light of divine essence' as Suger called it, also satisfied

GOTHIC. FRANCE. The Coronation of Charlemagne, from the Grandes Chroniques de France. 14th century. *Photo: Giraudon.*

fitz le roi d'aquitaine & comment il donna
abernart son neueu le roiaume de lombar
die. Et puis coment il fist assembler .v.
concilles el roiaume de france en diuers li
eus. pour amend lestat de sainte eglise.
Et de la desconfiture michel lemp des griex
Et puis coment crumas le roi de bulgrie
fu deseshis deuant constentinnoble.
Ci comence li secons liures de lestoire le gut
roy charlemaine.

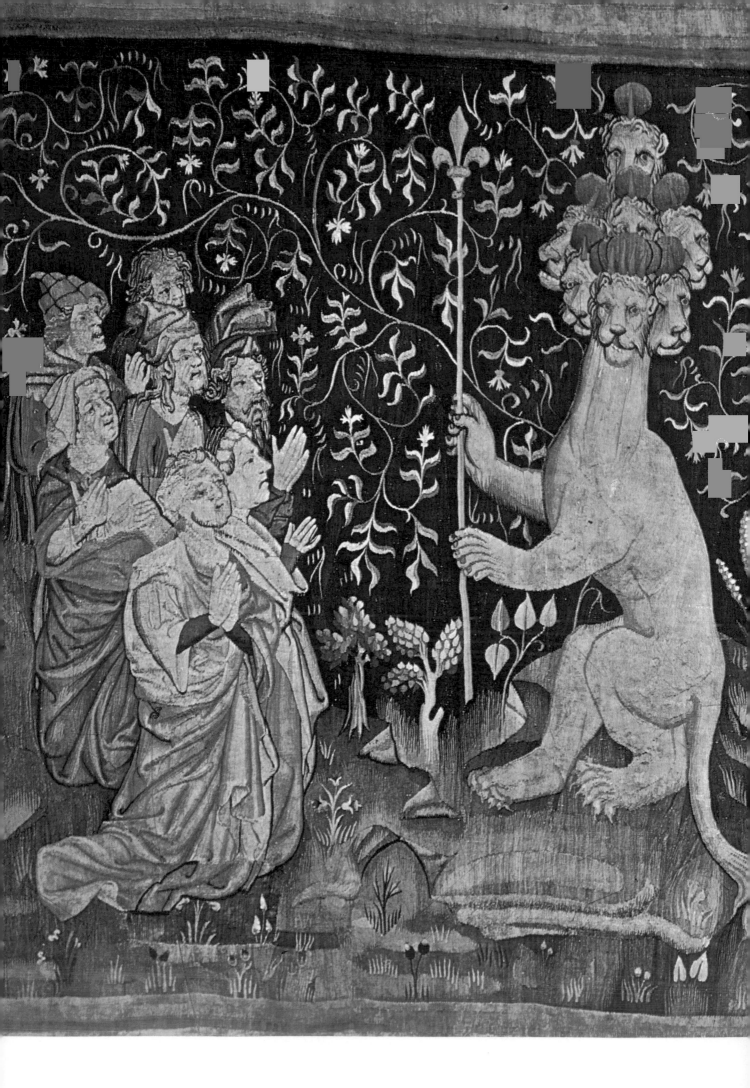

medieval man's love for stained glass windows, in which he could see the great themes of the Old and New Testaments, and the legends of the saints, all bathed in the azure blue of the skies. These were the subjects he had admired formerly on the walls of the Romanesque churches. Medieval man's intense love for colour combined with his love of stories and legends, and together these augmented the efforts of the clergy to teach him through images.

The oldest stained glass windows are the ones that Suger commissioned in the middle of the 12th century for the chapels of the choir of St Denis, and those on the west front of Chartres. Their technique was roughly the same throughout the Middle Ages—the window was composed of a large number of pieces of glass which were stained in the mass, the details being painted on with opaque colour. The pieces were then put together by means of grooved lead strips which outlined the figures and at the same time separated the different coloured parts, thus preserving their individual tones. The pot glass, thick and of irregular surface, full of bubbles, blisters and other impurities, was refracted in the light and produced brilliant effects. The unbroken colours, blues, red, browns and sparingly used greens and yellows, were ingeniously contrasted. The composition was rich and without perspective. The precision of design and the wealth of colour made the stained glass windows of the 12th century an incomparable type of translucent decoration. The very great demand for these windows during the 13th century made for a somewhat hasty production, without, however, impairing technical perfection, composition and colouring.

The beauty of the French cathedral springs also from the many sculptures—of the highest quality—which adorn the façades. The sculptors freed themselves from the traditional decorative forms imposed by an architectural pattern and turned to the study of nature, the flowers of the fields and the leaves of the woods which would soon be praised by St Francis of Assisi. A wealth of new decorative themes taken from nature appeared at the beginning of the 13th century. The human body acquired natural proportions, realistic attitudes and, later, solidity of form. Composition became more distinct and harmonious, expressing ideas of greater simplicity. Sculptured iconographical scenes were transferred from the interior of the building to the portals of the façade, whose design they influenced considerably. In Languedoc and Burgundy the tympana were decorated with large bas-reliefs. The western provinces decorated single voussoirs with statues. Figures on the trumeau (upright dividing a portal) and embrasures were arranged in a new way. They were supported against the shafts of the columns cut from the same stone, and they repeated the upward thrust with conscious rigidity. No longer a mere decoration, the figures take bodily part in the functional structure. Gothic sculpture opposes greater control to the agitation of Romanesque sculpture. To begin with these columnar statues were too elongated, too stiff, but they soon became less rigid, although they kept a measure of reserve in harmony with the general architectural style.

GOTHIC. FRANCE. The Adoration of the Beast. Detail from the tapestry of the Apocalypse of Angers. 14th century. *Tapestry Museum, Angers. Photo: Giraudon.*

Iconography was simplified and systematised like the doctrine of the Church, which tried to bring the lessons of the councils and the Fathers into a system. The warning of St Bernard did not go unheeded; the barbaric monsters and the Oriental bestiary disappeared. The art of the second half of the 12th century and of most of the 13th century rested upon the certainty of knowledge as formulated in an atmosphere of calm and idealism, remote from any suffering and passion, in the great *Summae* and *Specula* of the time.

Gothic sculpture made its appearance in the middle of the 12th century on the portal of St Denis (unfortunately mutilated due to the depredations of the 18th century and the restorations of the 19th century) and on the Royal Portal at Chartres (fortunately almost intact). At Senlis— 797, 807 one of the most charming ancient cities in the very heart of the Ile-de-France, which is dominated by its cathedral topped by a soaring spire and facing the ruins of the old royal castle—the Gothic portal acquired its final form 838 from about 1185 to 1190. Senlis was a model for Laon, Braisne and Mantes. It inspired the façades of the transepts at Chartres, the west front of Notre Dame in Paris and 795, 753 the façade of Amiens. In this masterpiece Gothic sculpture 754, 825 reached the height of its perfection, achieved at the crucial 829, 833 moment when the artist, in complete mastery of his art, has not yet forgotten the lessons of his predecessors, their idealism, nobility of expression and respect for architectural form. The statues gradually became more and more detached from the supporting columns, acquiring a body of their own. The compositions in the tympana grew freer and became precursors of a realism and of a purely picturesque quality which were to erupt in the last third of the 13th century in bas-reliefs and in the great statues on the façades of the transepts of Notre Dame in Paris, at Reims, at Bourges and on the portals of many smaller churches in Normandy, Champagne, Burgundy, Aquitaine and, outside France, in England, Germany, Italy and Spain.

Monastic, military and civil architecture

Medieval art was dominated by religious architecture. Monastic buildings followed the same pattern of development as churches, e.g. Noirlac (Cher), du Val (Seine-et-Oise), Bonport (Eure), Royaumont (Oise), Mont St Michel (1203–1228), crowning the top of the famous rock. 860, 861 It was the same with military and domestic buildings, although their plan was largely dictated by their function. Military architecture, after making considerable progress during the Romanesque period, had to be adapted at the end of the 12th and during the 13th centuries to the requirements of new building techniques and to the needs of effective defence against new weapons increasingly perfected by military engineers. These buildings were successful until the 15th century, when live artillery fire made it prudent to lower the keep and its adjacent fortifications so as to offer a smaller target. The fortifications of Carcassonne are famous. They consist of a double 945, 946 wall strengthened by towers and pierced by four fortified gateways. Those of Aigues Mortes are also well known. 947, 948 Both were completed under St Louis and Philip the Bold. The strong but purely defensive rectangular keeps of the 11th and early 12th centuries were replaced by polygonal or round towers surrounded by a revetment wall and outworks. Philip Augustus created a special engineer corps for the construction and maintenance of

822. Amiens, the nave. Begun 1220.

823. The central portal of the west front, and the front part of the pier separating the portals, Amiens. c. 1230.

AMIENS CATHEDRAL

The cathedral of Amiens was begun in 1220 with the west end, an unusual practice. The construction of the lower parts of the choir followed in 1236; the radiating chapels were completed in 1247. The upper parts of the choir and transept date from 1258 to 1269. The lateral chapels were added from the end of the 13th to the beginning of the 14th centuries. The towers date from the end of the 14th and the beginning of the 15th centuries.

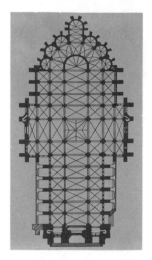

824. Plan, Amiens cathedral.

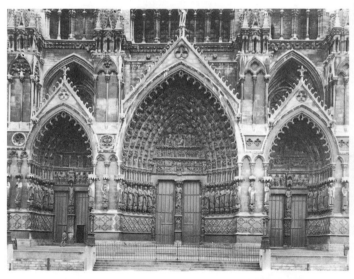

825. Detail of the west front, Amiens. Completed 1236.

826. Detail of the nave, Amiens.

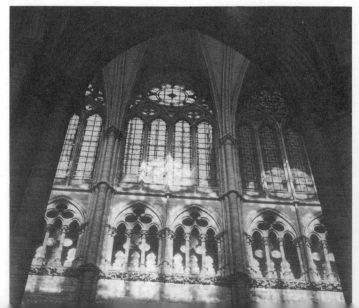

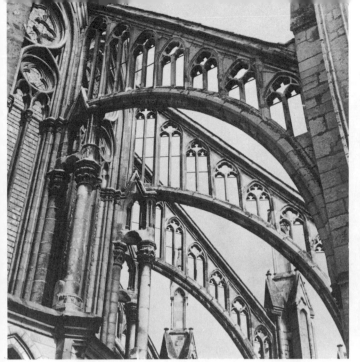

827. Flying buttresses on the choir of Amiens.

828. Amiens. Quatrefoils including the Labours of the Months and the zodiac signs. St Firmin porch, west front.

829. The Annunciation, west front. Amiens. c. 1225.

830. Statue of an unidentified person, north tower, Amiens. End of the 14th century.

831. Amiens. Harvest, from the Labours of the Months. St Firmin porch.

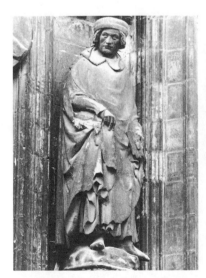

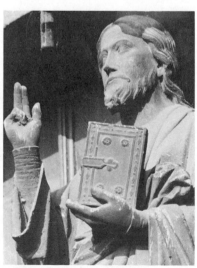

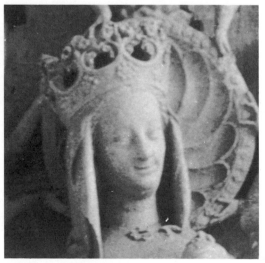

832. Statue of Jean Bureau de la Rivière, north tower, Amiens. End of the 14th century.

833. The Beau Dieu (detail), centre portal, west front, Amiens. c. 1230.

834. The Vierge Dorée (detail), south portal, Amiens. c. 1275.

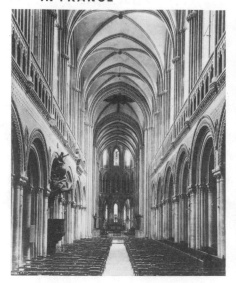

835. Bayeux. Nave of the cathedral.
Second and third quarters of the 13th
century.

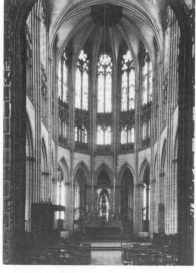

836. Evreux. Interior, cathedral of
Notre Dame. Nave c. 1202–1250. Choir
1298–1327.

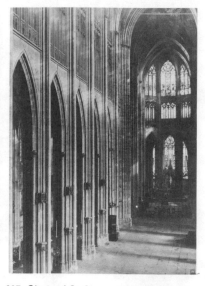

837. Choir of St Ouen at Rouen.
Completed in 1339.

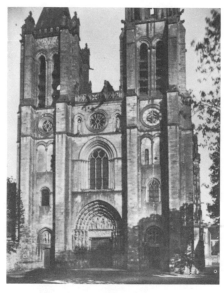

838. Senlis. West front of the
cathedral. 1185–1190.

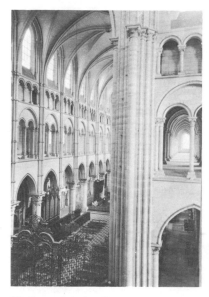

839. Laon. Interior. Begun c. middle
of the 12th century. Completed c. 1350.

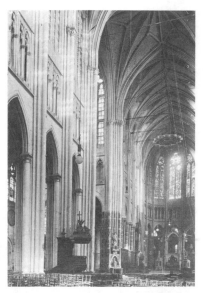

840. St Quentin. Collegiate church.
Choir c. 1230–1257. Nave c. 1340–1430.

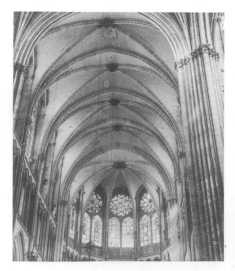

841. Auxerre. Interior, showing
vaulting.

842. *Right.* Sens. Nave. 1143–1168

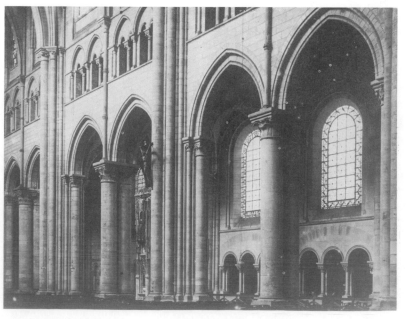

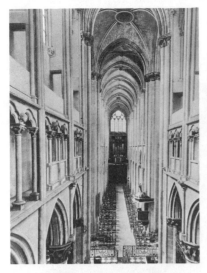

843. Semur en Auxois. Notre Dame. Nave, apse and transept 13th century; façade and porch 14th century.

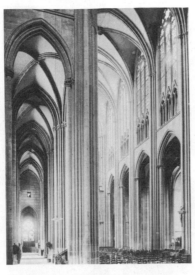

844. Clermont-Ferrand. Nave of the cathedral. Begun 1248.

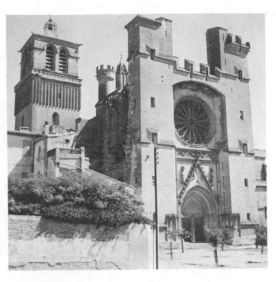

845. Béziers. The cathedral. 13th and 14th centuries.

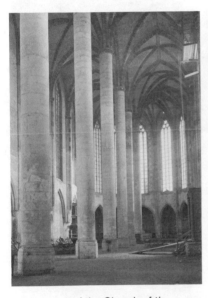

846. Interior of the Church of the Jacobins, Toulouse. 1230–1340.

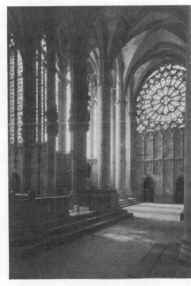

847. Carcassonne. St Nazaire, south transept. Begun 1267.

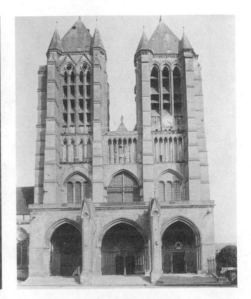

848. Noyon. Façade. Begun 12th century. Completed c. 1220.

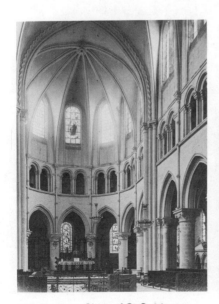

849. Provins. Choir of St Quiriace. 12th, 13th and 16th centuries.

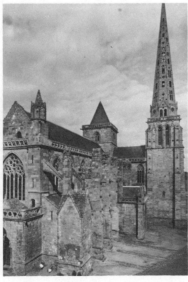

850. Tréguier. Cathedral. 13th–15th centuries.

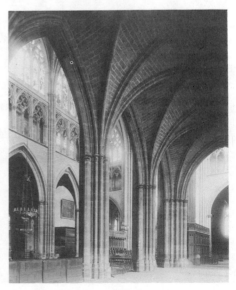

851. Bayonne. Nave and aisles of the cathedral. 13th–14th centuries.

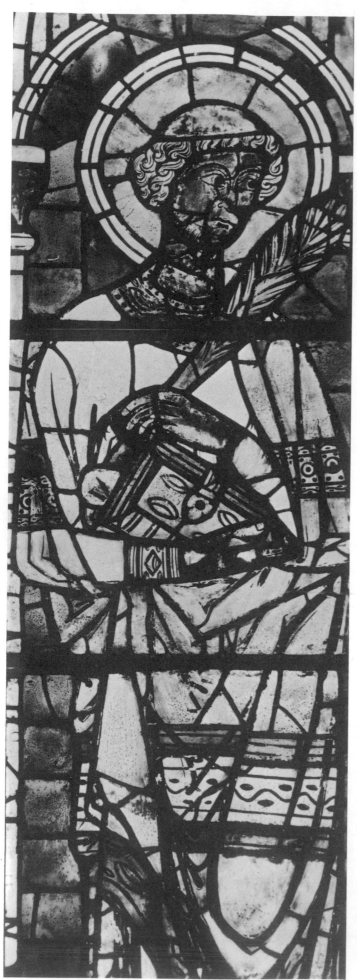

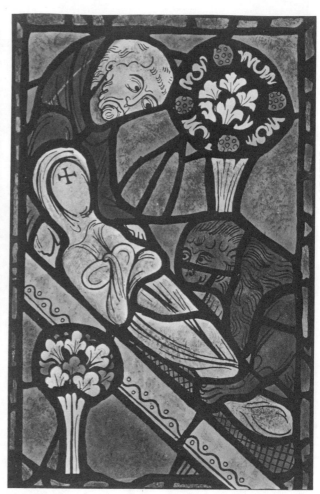

853. Bourges. Detail from a stained glass window of the life of St Mary of Egypt. Zosim and the Lion burying Mary. 13th century.

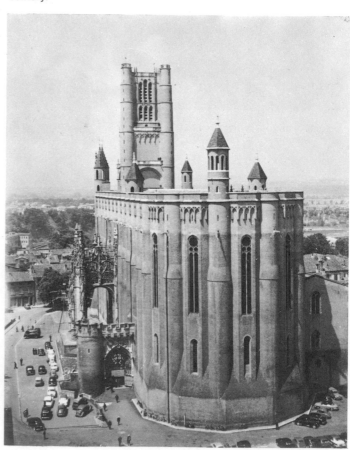

852. St Quentin. St Marcel; stained glass window in the collegiate church. c. 1235.

854. Albi. Cathedral seen from the east. Built from 1282 to the end of the 14th century. Additions in the 15th century.

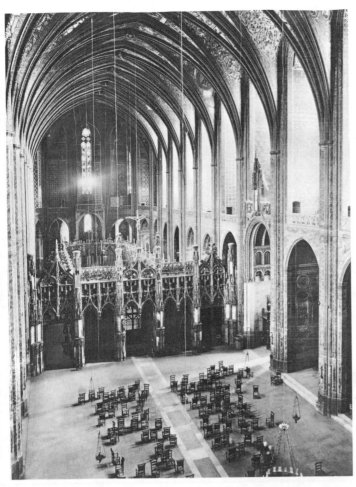

855. Albi cathedral. View of the aisleless nave.

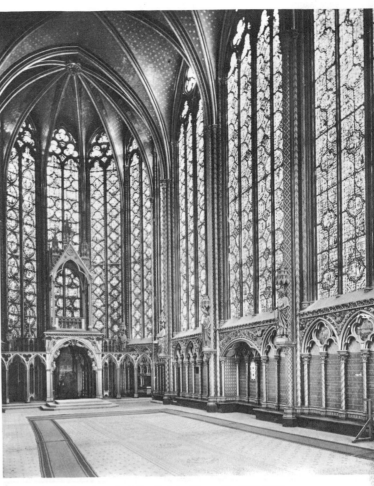

856. Paris. Upper chapel of the Sainte Chapelle. 1203–1248. This chapel was reserved for the royal family. The windows are much restored.

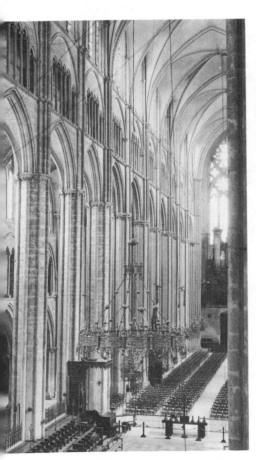

857. Bourges. View of the nave. End of the 12th century.

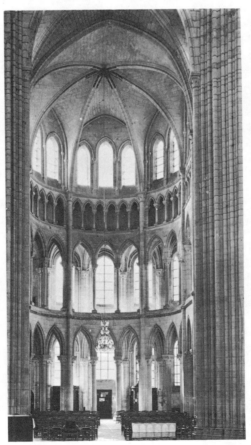

858. Soissons. View of the south transept, showing the semicircular end. Second half of the 12th century.

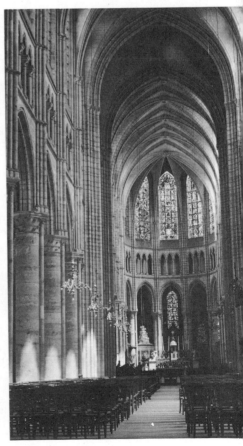

859. Soissons. The nave, looking east. Completed 1225.

these round keeps which were all built on the same plan. At the end of the 12th century the circular towers were buttressed by a counterfort, as at Gisors and Château Gaillard. The latter was erected by Richard Coeur de Lion in 1195–1196 on a projecting rock in the lower Seine valley, in order to bar the king of France from the road to Rouen. Protected by several walls and outworks, the strongpoints were too numerous and could easily be outflanked by assailing forces. The keep, placed, following the tradition of the 11th and 12th centuries, at the strongest point as a last refuge, proved useless in face of the greatly perfected technique of the war engines. Château Gaillard was taken by assault by Philip Augustus on the 6th March 1204.

After this experience the practice of using the keep as a last refuge was abandoned; following the traditions long in use in Syria and Palestine, it was placed now at the weakest point, as at Coucy, built 1225–1240, where the keep was erected at the end of a ridge, well in front of the castle whose entry it commanded.

The spread of the Gothic style

So magnificent were France's cathedrals, and so strong her castles, that from the end of the 12th and during the 13th centuries Gothic art began to spread over the whole of Europe. The monks, particularly the Cistercians, justly called the missionaries of Gothic architecture, brought the new art to the far ends of Hungary, Bohemia, Sweden, England, Italy and Spain. Masons from many countries came to learn at French building sites, and later as masters they taught others. Princes, lords and members of the clergy residing in other lands introduced French artists there, for example, William of Sens at Canterbury, Master Matthew at Santiago de Compostela, Etienne de Bonneuil at Uppsala, Villard de Honnecourt in Hungary, Eudes de Montreuil in Palestine and Pierre d'Angicourt in Cyprus. But the deeper causes of the expansive force of this movement which influenced the architects of the contemporary Christian world and made them imitate the splendours of the new French style must be sought in the eminent position occupied by France in this world. The noble figure of St Louis lent an incomparable lustre to French royalty. 'The throne of France,' declared Jean de Joinville, 'was resplendent in the eyes of all others, like the sun which sends forth its rays.'

France in the 12th and 13th centuries was not only a great kingdom, the eldest daughter of the Church, the protector of the Pope and the home of the great religious reformers and saints, it was also the country favoured by philosophers, theologians, writers and humanists, 'where the spirit of humanity finds its daily bread,' according to Eudes de Châteauroux, a Cistercian monk of the middle of the 13th century who later became a cardinal and legate of the Pope.

In the middle of the 12th century the schools of Chartres, Laon and Paris surpassed all others in the teaching of theology and dialectics. The ideas of Abelard, the great thinker, famous at Ste Geneviève, were echoed far and wide. By the end of the century the superiority of the school of Paris was universally acknowledged. Students and scholars from Italy, Germany, and, especially, from England, were attracted to Paris by the teaching of eminent scholars, the urbanity of customs and the pleasantness of life. Chivalric love was an invention of the French courts; the cult of the Virgin was a

942

862, 863

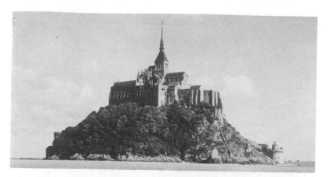

860. GOTHIC. Mont St Michel. 1203–1228. The buildings are massed on three levels.

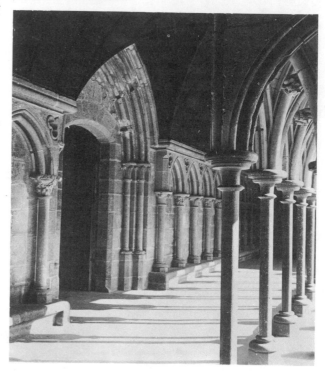

861. The cloisters, Mont St Michel. 1225–1228. The slender columns of the arcades are arranged in quincunx.

sublime expression of it. 'To Paris,' said Pope Innocent IV in 1245, 'comes the whole world in search of the armour of the strong.' Returning to their countries they were satiated with knowledge and their hearts were full of admiration for those marvellous churches that were rising at that time all over France.

The building activities of the Cistercians were influential in Spain at Veruela and Fitero during the second half of the 12th century, and in Portugal, at this time, at Alcobaça, a replica of the second church of Clairvaux which was under construction at St Bernard's death, and later, in the 13th century, at a great number of abbeys. Noteworthy too was the influence of the great churches of the Royal Domain—of Paris and Bourges on Toledo and Burgos, and of Chartres and Reims on León. In north-eastern Spain and in Catalonia Gothic architecture was closely related to that of the south of France, whereas in southern Spain the Islamic tradition continued.

In Italy, especially northern and central Italy, the new art of the Ile-de-France and Burgundy was introduced by the Cistercians. Their architects, apart from building their own abbeys, erected churches for the Dominicans, e.g. Sta Maria Novella in Florence and, among others, the cathedral of Siena. In Genoa we see the influence of Rouen, in Orvieto of Reims, of Paris and Laon at S. Andrea di Vercella, erected by a canon of St Victor

1038
1041
1042

896
1027, 102
1024

in Paris. In the Kingdom of the Two Sicilies the new French art became popular, especially after the crowning in 1266 of Charles of Anjou, the son of St Louis, who brought in architects from France to build cathedrals and abbeys.

Along the Mediterranean coasts the new art was introduced to Syria, Palestine and the Frankish colonies founded by the crusaders in Cyprus, where after the catastrophe of 1291 the Christian colonists found refuge under the French kingdom of the Lusignans. There the influence of the buildings of Champagne and the Ile-de-France was dominant.

In Flanders and the Netherlands French Gothic was received with enthusiasm. In Germany the influence set in later, at the beginning of the 13th century in the Liebfrauenkirche at Trier, the church of St Elisabeth at Marburg, at Limburg on the Lahn, in the cathedral of Cologne and in the Cistercian churches in southern Germany. The particular French form of Gothic prevailed in Germany till the end of the century. In Wimpfen on the Neckar, in the last quarter of the 13th century, a collegiate church was erected in the French style by a master builder from Paris. The cathedral of Paderborn is almost a replica of the cathedral of Poitiers. In Westphalia and Saxony, as well as in the Low Countries, the school of Anjou inspired hall churches with nave and two aisles of equal height. They have no flying buttresses, no transepts and no ambulatory and are covered by excessively curved vaults mounted over square bays decorated with a complicated network of ribs. This type of aisled hall church enjoyed great popularity during the 14th and 15th centuries all over central and northern Europe, especially in the Scandinavian countries. Relations with France established in the middle of the 12th century explain the influence evident at the church of Roskilde in Denmark and at Uppsala in Sweden, where the Parisian architect Etienne de Bonneuil went in 1287. In central Europe apart from Cistercian influences we find traces of famous Gothic masters, i.e. Villard de Honnecourt in Hungary and Matthew of Arras in Bohemia.

In England Gothic architecture, adopted at an early date, soon assumed an independent and original character. Intellectual, social and economic exchanges between the two countries continued without interruption. Since the Norman conquest French had been the official language of the court, the aristocracy and Parliament, and of legal documents and registers. The Hundred Years' War brought many of the English to France, where they acquired a taste for things French, and in the second half of the 12th century we notice the influence of the Ile-de-France appearing against a Norman Romanesque background, especially in the choir of Canterbury, begun in 1175 by William of Sens. However, by the first half of the 13th century the English architects had emancipated themselves from French influence.

In conclusion we may mention that some of the French architects went far into the Orient. When William of Rubruquis arrived at the Tartar court of Genghis Khan as ambassador of St Louis he found there a French architect, Pierre Bourchier.

In short, Gothic art originated in the very heart of France, the Royal Domain, during the second half of the 12th century, spread rapidly over the whole country and soon afterwards inspired the architects of the rest of the Christian world.

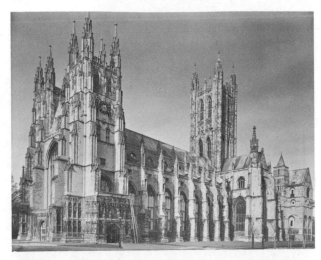

862. GOTHIC. ENGLAND. Canterbury cathedral, from the south-west.

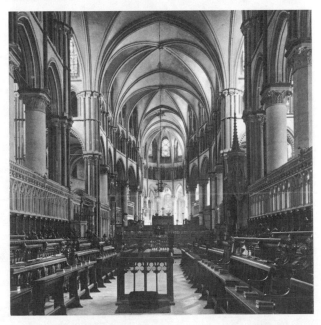

863. GOTHIC. ENGLAND. The choir, Canterbury cathedral. A French builder, William of Sens, directed the work from 1175, after the old building was destroyed by fire in 1174. The choir was completed in 1184, with sexpartite vaults as in Sens and Senlis, at a time when France was discontinuing them.

864. GOTHIC. SPAIN. The Sarmental portal, transept of Burgos cathedral. Middle of the 13th century. The sculptures are closely related to those at Notre Dame in Paris and at Amiens.

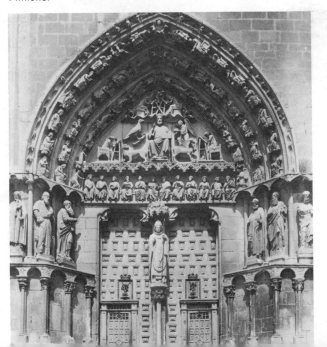

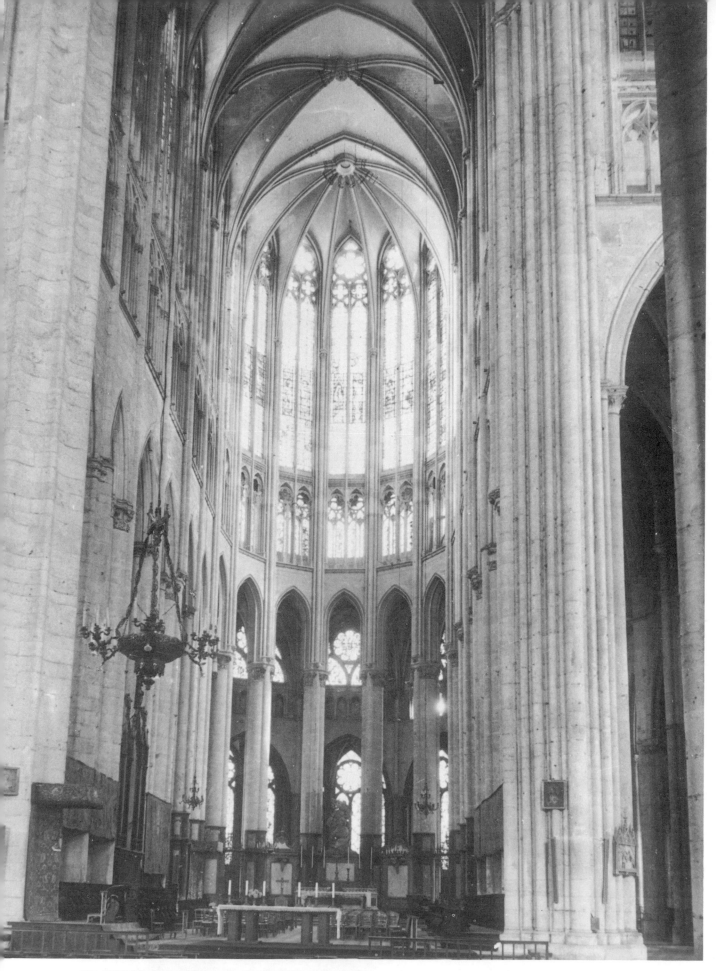

865. GOTHIC. Choir of Beauvais. Height of the vault, 157 ft.
Apse and choir built 1247–1272. Part of the vault collapsed in
1284. Work was resumed in 1337 and continued with
interruptions till 1500. The steeple over the crossing (501 feet
high) collapsed in 1573. The damage was repaired in 1576.
The building was never completed.

THE MATURITY AND THE SPREAD OF GOTHIC ART *Louis Grodecki*

With the 14th century Gothic art showed all the symptoms of an art that has reached its culmination. It lost purity and unity. The twofold trend towards mannerism and naturalism marked the approaching end. At the same time, the great variety of forms it had evolved favoured the development of national schools. Some of them, such as Italian painting and sculpture, went so far on their own way as to prepare a new style of the future, and do not belong, therefore, in a work on medieval art.

865
1011
1042
1043
760
811
74, 1011

About 1260, when the cathedral of Beauvais rose in France (1247–1272), the cathedral of Cologne in Germany (from 1248) and the cathedral of León in Spain (1255–1303), Gothic art had reached and even passed its zenith. As a symbol of the heavenly Jerusalem, of the universal Church and of the world the Gothic cathedral had with each generation grown in size, elongated its choir, enlarged its chapels and widened its transept. It rose higher and higher; the supports multiplied on the outside; flying buttresses were added and there were larger and larger pinnacles. The façades became more and more complex. At Bourges (*c.* 1255) and León five portals were placed in a row; at Reims (*c.* 1255) several cycles of sculpture occupied separate rows. The plans for the façade towers, as for example at Strasbourg and Cologne, became increasingly gigantic, combining and fusing all the ideas of the first half of the 13th century.

Monumental painting and stained glass windows show a similar tendency; taking an ever larger place in the building, the windows reached a final state of perfection. Owing to the successive enlargement of the bays these windows were no longer simple openings pierced through the wall but were transparent screens replacing the wall.

856

The Sainte Chapelle in Paris and the choirs of Le Mans and León had deeply coloured glass of darker and less transparent tones. The stained glass windows of the choir of the cathedral of Tours (*c.* 1260) shed into the interior a much reduced twilight. It was impossible to go any further and impossible, too, to exceed the dimensions

865

and structural complexity of Beauvais (collapsed 1284).

Gothic architecture seemed to have reached the end of its classical stage towards the middle of the 13th century. The type of three-storeyed church generally called the 'Chartres type' was classical because of the admirable balance between weight of masonry and mass and the dynamic force of its structure, vividly underlined by the system of columns. Classical too was the rigorously calculated division of space into self-contained but interdependent units, displaying a kind of constructive rationalism that has been compared with the rationalism (highly individual, it is true) of Thomas Aquinas' philosophic system. The sculptural style of this period was also classical, showing an affinity—as at Reims—with ancient classical, especially Greek, forms, and displaying a quiet assurance of attitudes and gestures, powerful volumes and an admirable calmness of the surfaces. All these characteristics were either disregarded after 1260 or survived only in retardataire (backward in style) works of secondary importance.

The formation and maturing of Gothic art during its classical stage was in fact a single movement expanding from the Ile-de-France. Wherever it appeared it eclipsed the late forms of Romanesque art and overshadowed other tentative forms of early Gothic, such as the Plantagenet style of Anjou or the proto-Gothic style of the sculptures of the Meuse valley and northern Champagne. The Gothic forms after 1260 strengthened local and national tendencies. The countries conquered by the new French style reacted each in its own way to this influence; some interpreted it in their own spirit; others created with its basic elements a new order, as was the case in Italy.

New trends in French architecture of the 14th century

788
811
844, 851

Gothic architecture at the end of the 13th and during the 14th centuries has been termed 'Radiating'. The term is derived from the circular shape of roses and rosettes frequently used in the windows during this period. Though it is hardly justifiable to define a style solely by an ornamental detail, it is certainly true that after 1260 a more subtle and refined form of Gothic art was evolved. This new style is particularly noticeable in the transepts at Notre Dame in Paris (extended *c.* 1254–1270), on the façade of Reims and in a group of larger buildings erected between 1245 and 1275, such as the cathedrals of Tours, Clermont-Ferrand, Bayonne and Limoges. These buildings were all inspired by Jean des Champs, an architect of many talents who came from the workshops of Paris. In his style, often labelled 'doctrinaire', he used in a subtle and highly sophisticated but rather sterile manner the accomplished forms of Amiens and St Denis without making any fundamental innovations.

871
847
874

A real innovation, however, appeared at this time, the first great examples of which are St Urbain at Troyes, the choir of St Nazaire at Carcassonne, the lower parts of the façade of Strasbourg and the choir of Notre Dame in Paris. In Troyes and Carcassonne the elevation was simplified, reduced to immense windows which replaced the clerestory and had blind tracery at the base. The proportions between nave and aisles and the openings to other parts of the building were altered so as to achieve a greater spatial unity of the interior. There was a growing refinement in the execution of decorative details, enhanced by increased and whiter light from the windows, revealed in the pierced double walls and the insertion of decorative gables and tracery breaking up the plain surfaces. Fantasy found expression no longer in the dimensions of the building but in the accumulation and the intricacies of detail. The structure of the building also underwent a change as a consequence of this search for decorative effects. Stability was no longer sought in a judicious redistribution of thrusts but in the resistance of the materials and in the use of iron brackets. In the field of statics this was about the only innovation introduced during most of the 14th century. St Jean des Vignes at Soissons, of which only the façade has survived, and St Ouen at Rouen (from 1308) are both masterpieces of this new style; other examples are the choir of the cathedral of Nevers, the transept and nave of the cathedral

868
837
870

347

of Tours and the beautiful choir of St Thibault en Auxois.

This rich and flowering style, not unrelated to the English Decorated style and its rather fantastic German and Spanish versions, could appropriately be called 'mannerist' as it showed all the characteristics of mannerism, its preciousness, elegance and exuberant ornamentation, in contrast to the monumental aspect of the classical Gothic period. But other forms of mannerism also occur which are by no means unimportant. An architecture appeared as early as the end of the 13th century, and more especially during the 14th century, simplified in structure and articulation and giving back to the wall its true function without, however, giving it the weight and substance it had had in classical Gothic architecture. Probably the best example in France is La Trinité at Vendôme. The severe economy of these buildings evident in their spatial arrangement and their decoration is in no way a result of poverty but is a conscious expression of a new taste, of which we find examples in many countries. This taste for simplicity was no doubt encouraged by the prodigious building activity of the Franciscans and Dominicans. Their aisleless churches, with a single nave or two of equal height, as in the famous Church of the Jacobins at Toulouse, had no flying buttresses and had a uniform arrangement of the masses on the outside. Though conspicuously stripped of decoration this monastic architecture of the 14th century possesses a formal beauty which is in no way inferior to the ornamented buildings of this period. There are many variants in France, e.g. St Maximin (after 1327), St Saturnin (after 1361) and the abbey of La Chaise Dieu (from 1342), foreshadowing the architectural style of the 15th century, and the cathedral of Uzeste (Gironde), enlarged for Clement V. The most representative buildings of the 14th century, however, are to be found outside France.

The rise of national schools

The rhythm in which Gothic architecture developed in England is not the same as that of the continent. In the 13th century England had a kind of classical style of her own, for example at Salisbury cathedral, which was very different from that of France, although in several cases French influence is evident, as at Westminster abbey. The period of ornamental exuberance comparable to the continental Radiating style, however, began with St Hugh's choir in Lincoln cathedral and continued to develop throughout the century. The most perfect expression of this Decorated style never surpassed that of the Angel Choir of Lincoln cathedral (completed 1280), with its complex vaulting to which were added supplementary ribs (liernes and tiercerons) provided with rich mouldings and sculptured spandrels. In another masterpiece, the chapter house of Salisbury (later 13th century), the structure is unusually bold. About 1291–1300 work on the nave of York minster showed a new national variant, the so-called Curvilinear style, a combination of manneristic fantastic motifs, reminiscent of manuscript illumination, and the first Flamboyant forms such as ogee arches, spirals and prismatic mouldings. The best examples of this style are the façade of Carlisle cathedral, the choir of the cathedral of Bristol and the Lady chapel at Wells. Many of these forms spread to Normandy and Norway, especially the latter, e.g. the choir of the cathedral of Trondheim, from 1328.

The later phase of Gothic art in England, the Perpendicular style, the first signs of which appeared in the south transept of Gloucester cathedral, marks the end of the Middle Ages. These peculiarities of English architecture were due to various reasons; some were historical, survivals of deeply rooted Celtic and pre-Romanesque elements; others were purely technical. The structure of English Gothic buildings was on the whole much simpler than that of French buildings. A solid longitudinal wall rising above the piers vertically or projecting to counteract the thrust of the vault sufficed to neutralise the stresses in these naves of limited height. English architects, therefore, were not unduly worried by structural problems and would give free play to their imagination in decoration and the arrangement of surface effects.

In the Low Countries, Germany and central Europe the architectural problems were different. There Gothic architecture was directly imported from France and its influence continued with a certain time lag. These countries developed styles of their own on a French foundation, but they exaggerated French features and rendered them more daring and richer in effect. For purely ornamental invention in the Radiating style the tracery in the aisles of the church of St Catherine at Oppenheim in the Rhineland is unsurpassed. This liking for exaggerated gracefulness and for tracery—very often accompanied by a certain dryness in the profiles—reached its extreme in the choir of the cathedral of Aachen which was added to the old Carolingian central plan church in 1335, and in the cathedral of Regensburg, which is strongly reminiscent of the architecture of Champagne. The choir of the cathedral of Prague, built from 1344 on the plan of Matthew of Arras, a French architect who came from Avignon, is probably the most fantastic example of Gothic church architecture of the 14th century. The upper parts of the choir of the cathedral of Tournai (1300–1325) show an equally original transformation of French influences.

Not all buildings in Flanders and central Europe, however, followed this tendency. The hall church, with a nave and two aisles of equal or nearly equal height, resembling the churches of Anjou of the 12th century, became prominent in Germany during the 13th century. Examples are the cathedral of Minden (nave about 1270), the Church of the Holy Cross at Schwäbisch-Gmünd (1350s) and the cathedral of Vienna. The popularity of this type illustrates the desire for greater spatial unity— a general characteristic of late medieval architecture. Another characteristic feature was the number and beauty of the monastic churches of the mendicant friars who had adopted the 'severe' type of building. A good example of their austere art is the Barfüsserkirche, Erfurt (1291–1316). The very original Gothic brick buildings of the great northern plains extending from the Low Countries to the Baltic regions, with their fine decoration perfectly adapted to the material, are another feature of German Gothic architecture, e.g. the Marienkirche at Lübeck (end of the 13th century), the Liebfrauenkirche at Stargard in Pomerania and the Katharinenkirche at Brandenburg, a late masterpiece.

Similar features are found in the south of France and in northern Spain, though local tradition—in Spain due to Islamic influences—and the effect of a sunnier climate which cut down the need for light inside the churches, gave a different character to the structure and the decora-

749

873, 926

888, 889

891

981

1023

895

893–89.

1012

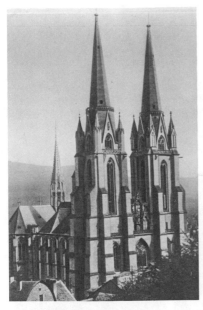

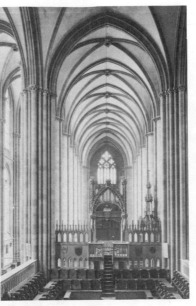

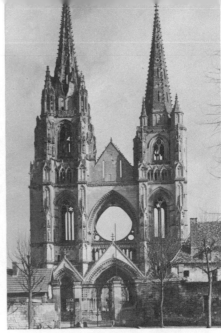

866. GOTHIC. GERMANY. St Elisabeth, Marburg. 1235–1283. The plan is similar to Soissons.

867. GOTHIC. GERMANY. St Elizabeth, Marburg. A typical hall church, with nave and aisles of equal height.

868. GOTHIC. St Jean des Vignes, Soissons. End of the 13th century. Only the facade remains.

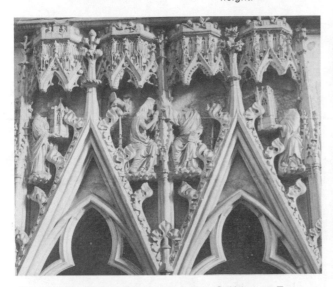

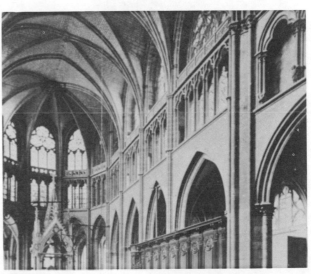

869. GOTHIC. Coronation of the Virgin, St Urbain at Troyes.

870. GOTHIC. Choir, Nevers cathedral. 13th–14th centuries.

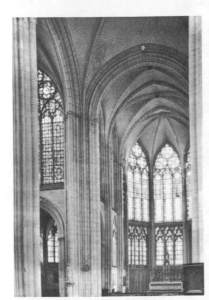

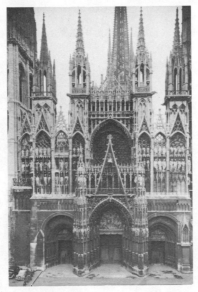

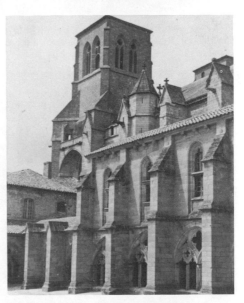

871. GOTHIC. Choir and crossing, St Urbain at Troyes. Begun 1262 at the choir. Transept, 1264–1265.

872. GOTHIC. Façade, Rouen. Centre, early 16th century; sides, late 14th; St Romain tower (left), 12th; Butter Tower (right), 1487–1510.

873. GOTHIC. La Chaise Dieu. The apse, choir and six bays were built between 1342 and 1352.

STRASBOURG CATHEDRAL

Strasbourg cathedral was erected on the foundations of an older building which was destroyed by fire in 1176. Choir and crossing were completed at the end of the 12th century; the transept and the Angels' Column were completed c. 1230. Work on the nave lasted from 1240 to 1275.

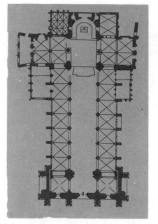
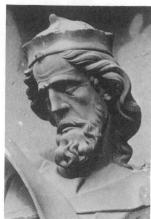

875. Plan, Strasbourg cathedral.
876. Prophet, from the façade, Strasbourg. Early 14th century.

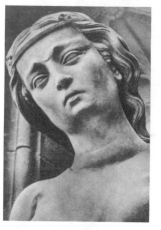
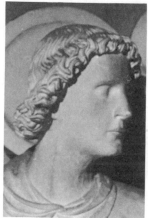

877. Foolish Virgin. Façade, Strasbourg. c. 1280.
878. Head of an angel from the Angels' Column. 1225–1230.

874. The west front, Strasbourg. Begun in 1276 by Erwin von Steinbach. Building was continued during the 14th and 15th centuries.

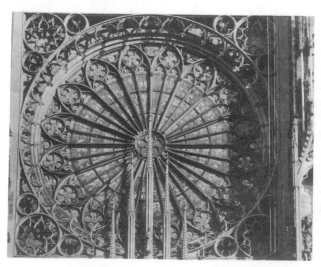

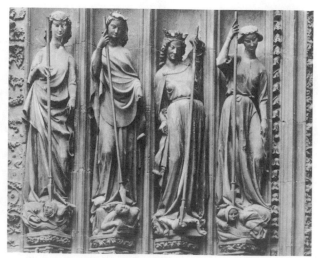

879. Rose window from the façade, Strasbourg, by Erwin von Steinbach. After 1280.

880. Virtues defeating the Vices, from the façade, Strasbourg. End of the 13th century.

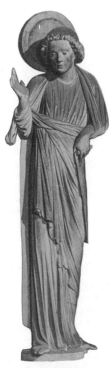
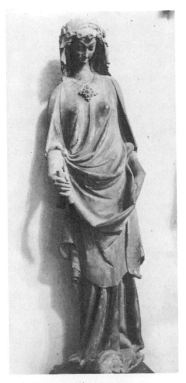

881. St John. Detail from the Angels' Column, Strasbourg.

883. Wise Virgin, from the façade. c. 1280.

882. Virtue, from the façade. End of the 13th century.

884. The Angels' Column. 1225–1230.

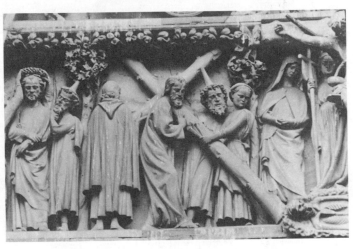

885. Synagogue, from the clock tower. 1220–1230.

886. Scenes from the life of Christ. Façade. c. 1300.

tive forms. In the south of France, side by side with the conventional Gothic type at Narbonne and in the choir of the cathedral of Toulouse (1272), the churches with an aiseless nave mark a return to the old tradition of the south. The nave in the cathedral of Toulouse, too, was originally planned in this form (c. 1210). The best example, however, is the cathedral of Albi (1282–c. 1390); of a similar type are St Michel at Carcassonne and the cathedral of St Bertrand de Comminges. Albi is the largest fortified French medieval church and is certainly the most remarkable building of the period constructed in brick. Its beauty derives largely from the unusual width of its nave and from the flanking chapels inserted between internal buttresses which suffice to stabilise the vaulting without the aid of flying buttresses. Their absence entirely alters the appearance of the outside of the building.

In Spain the great monastic churches, some of them of a very early date (S. Francisco at Barcelona, consecrated 1247), were built with an aisleless nave and with chapels inserted between internal buttresses. Frequently the aisleless nave was combined with a more complex plan including aisles and ambulatory. In Gerona a gigantic nave is prolonged by a choir with ambulatory (begun 1312). At Les Stes Maries de la Mer (1328) and in the cathedral of Barcelona such a fusion was achieved by a considerable elevation of the aisles and by the extremely slender and wide apart piers which give the impression of supporting a single vast vault. This system has great similarity to the German hall churches, at least as regards the unity of the interior space. The Catalan churches often combine an exquisite, refined and exotic decoration (thanks to Mozarabic influences) with a restrained treatment of the effects of light.

In Italy the reception of the Gothic style presents a special case of adaptation on the one hand and of resistance on the other. Accepted at a relatively early date, in the second quarter of the 13th century the new art inspired

855

a perfect work, the basilica of S. Francesco at Assisi. The new fashion was followed at the Dominican churches of Sta Maria Novella Florence (from 1278), and Sta Maria sopra Minerva (1280), Rome. The buildings, though they used Gothic decoration, revealed in their arrangement an entirely different artistic expression. Throughout the 14th century in Gothic buildings proportions were altered in favour of the traditional emphasis on greater width. The organic Gothic decoration was replaced by blank walls or by inlay. Even more important, at Sta Croce, Florence (from 1294), a work of Arnolfo di Cambio, the Gothic vault was abandoned in favour of the old basilican roof. On the campanile of the cathedral of Florence a new decorative style appeared, deriving from the major trends of contemporary Florentine painting and sculpture. Only in places which were less active artistically, such as Bologna and Milan, did the conventional Gothic style persist.

Mannerism and naturalism in French Gothic sculpture

'There can be no doubt that classical Gothic sculpture contains a "humanist" element presenting nothing that is not part of ourselves,' said Focillon, contrasting it with the rigid stylisation of abstract Romanesque art forms. But it would be wrong to assume, as has been done occasionally, that Gothic sculpture was the result of a gradual evolution from architectural formalism to naturalism. During the first half of the 13th century Gothic sculpture was essentially monumental, that is, part of the architectural frame and of the wall; its monumental character, moreover, was strongly emphasised by its solidity and its vertical axes and by the effect of its flat surfaces modelled as if they were elements of the wall (as described by Focillon). Sculptural units, for example the statues on the façade of Amiens, presented impressive masses of almost geometrical outline and of a surface modelling of extreme flatness.

The statues of the Sainte Chapelle in Paris (towards the middle of the 13th century) and those on the façade of Reims, executed by the St Joseph Master, without doubt a Parisian, reveal new plastic values which strike a balance between monumental power and formal refinement clearly marking a new phase in Gothic sculpture, comparable to Greek sculpture of the Hellenistic period. This 'St Louis style' introduced a greater variety of profiles and axes, greater sensitivity in execution, softer modelling and a liking for the dramatic. This is also manifest in the charming carved ivories in which the extraordinary refinement suitable to this precious material gives a quality of unusual elegance rather than of realism. We observe similar tendencies in German and Spanish sculpture of the time.

The success of this Parisian mannerism was considerable in France. Typical examples are the figures on the portals of the transepts of Notre Dame, Paris (tympanum of the St Etienne portal and the Virgin of the north portal), the figures on the façade of the cathedral of Bourges (c. 1255–1260), those at Rampillon on the borders of Champagne and those on the cathedral of Meaux. A very important series—but badly preserved—was executed about 1260–1270 at St Denis: the south portal and the tombs with the memorial statues of the kings of France. All these statues, including those carved at the beginning of the 14th century (nativity scenes on the choir screen in Notre Dame), in spite of their out-

standing craftsmanship crystallise a stereotyped elegance, as if the achievements of the style of 1250 acted rather as a brake on the creative spontaneity of the following generation. A great number of statues of the Virgin and Child, from Paris, for example the Virgin from the church of St Aignan, now at Notre Dame, and the many ivory and metal statuettes (like the Virgin of Jeanne d'Evreux, 1349), continue this style to a much later period. It would be difficult to date such works if the increasingly complicated design of the flattened drapery folds did not mark certain stages in the development. For works of real value, however, we have to look to other regions.

In eastern France—in Champagne, Burgundy and Alsace—the most outstanding works of this period are: the west wall in the interior of Reims (c. 1275?), the base of the portals of Auxerre (c. 1285–1305), the portals of the cathedral of Lyon (c. 1310–1330) and the west portals of the cathedral of Strasbourg (c. 1280). The statues of Strasbourg are remarkable, combining German expressionism with Parisian mannerism. The forms of the refined classical style of the years 1244–1255 are exaggerated to the point of deformation; the faces are either emaciated or swollen, the hair long and unruly; the attitudes, no longer composed, tend to sway in artificial curves; light and shadow playing over the surfaces produce a wealth of contrasts and subtle shading, and the folds of gathered drapery fall down in cascades. The emaciated forms and drawn faces of the small relief figures decorating the bases of the statues exhibit an unreal humanity bordering on caricature. Compared with the balanced and harmonious Parisian sculptures of the same date, this 14th-century art of eastern France is irrational in spirit and extravagant in form. More examples of this kind can be found in southern and northern France, with the exception of Normandy. The Norman sculptors were more faithful to the Parisian tradition, with a predilection for decorative motifs of English origin, e.g. the façade of the cathedral of Rouen, and many individual works such as the statues of Ecouis. Picardy, being closer to the Flemish cities, produced works of greater expressive power—from the Vierge Dorée (c. 1275) on the south portal of Amiens and the individual statues of the Virgin and Child down to the figures on the north tower at Amiens. They combine mannerist refinement with realist features, a fusion of statue and portrait of which the famous figure of Jean Bureau de la Rivière is a good example. In the south of France works worth mentioning are: the memorial niche of Bernard Brun at Limoges (1349), the Rieux statues (c. 1330) at the Toulouse Museum and, finally, a number of statues on tombs.

The sculptures on tombs, more than any others of the 14th century, reveal the conflict of the period, a liking for the precious and fantastic on the one hand and a growing interest in naturalistic portraiture on the other. Outstanding among the masters in the north were Jean Pépin de Huy and Jean de Liège, the fashionable Parisian tomb carver of the second half of the 14th century. The best portrait sculptors of the 14th century, however, came from Flanders and the Meuse valley. André Beauneveu of Valenciennes and Klaus Sluter of Netherlandish origin

FRANCO-FLEMISH. The month of April. From the Très Riches Heures of the Duke of Berry, by the Limbourg brothers. Beginning of the 15th century. *Musée Condé, Chantilly.* Photo: *Giraudon.*

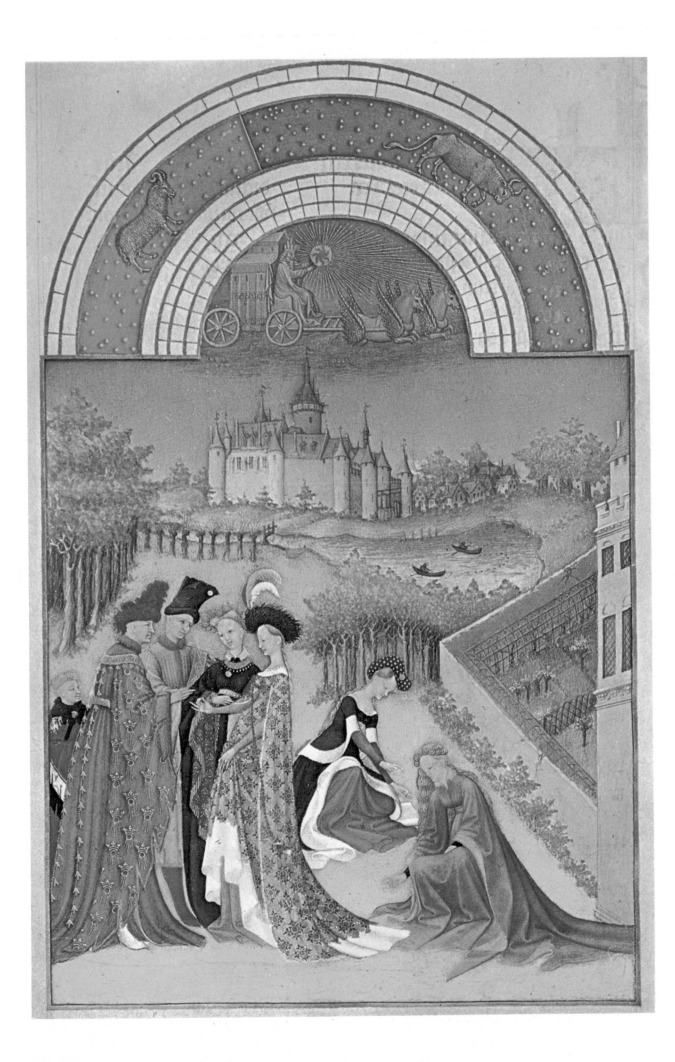

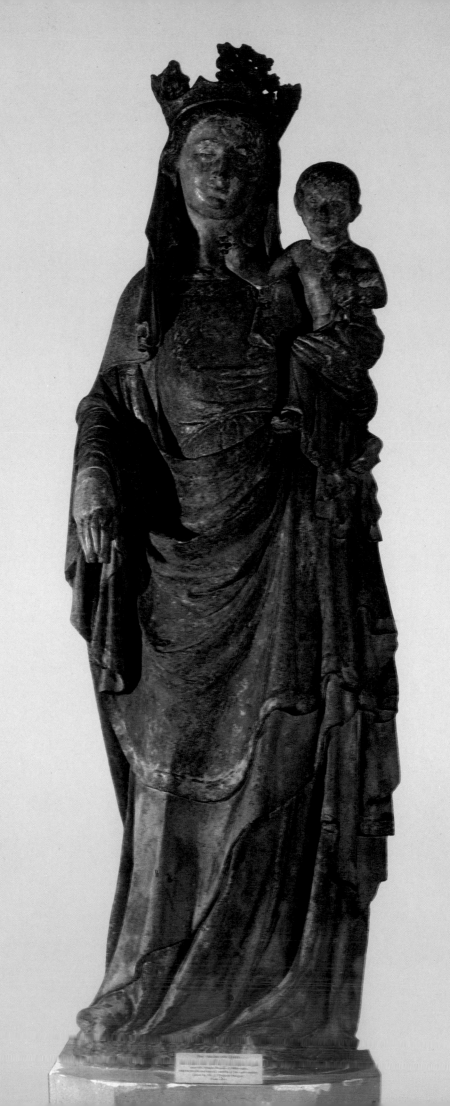

were their great successors. Striking portrait statues in central and southern France are on the tombs of Raymond La Porte (d. 1325) and Bernard Brun (d. 1349) at Limoges, the tomb of Pope Clement V (d. 1314) at Uzeste, that of Clement VI (d. 1352) at La Chaise Dieu and the tomb of Pope Urban V (d. 1370) in the Avignon Museum. The style of these three papal tombs is more Italianate than that of the Parisian royal effigies. Finally, among the masterpieces of medieval art are the statues of the Palais de Justice at Poitiers (c. 1385–1390). Very French, and mannerist in technique and presentation, they reveal better than the tombs of St Denis the dual character of the outgoing 14th century, which was divided between the precious elegance of Gothic art and northern realism.

The development of national trends in Gothic sculpture

It is only in Germany and Italy, at the end of the 13th century and during the 14th century that we find works of sculpture equal in quality and importance to those of France. There were no important monumental cycles in England. The façade of Wells with its numerous isolated figures establishes a type frequently repeated but of restricted artistic interest. The best works are among the 'free-standing' figures, of which there are many fine examples, the tomb figures of the Knights Templars in the London Temple and the great series of royal figures in Canterbury cathedral and in Westminster abbey. As in France, their precious and mannerist style frequently conflicts or combines with the artist's desire to achieve likeness, a dualism that is particularly evident in the tomb of the Black Prince (d. 1376) at Canterbury. The alabaster reliefs from Nottingham, of the 14th and 15th centuries, show the other aspect of English art, its strong link with the non-realistic tradition of the Gothic period.

In Spain only the sculptures of the second half of the 13th century are of interest in a general history of art. The portal of the transept of Burgos (1252) recaptures the art of Chartres and Reims with a more developed sense of movement and a liking for the picturesque. This portal and the reliefs from the cloisters of the same cathedral (c. 1265), however, go far beyond the ideal of Reims in their sensuous, extravagant and highly original mannerism. Spanish tomb sculpture is abundant but little studied as yet. It developed a peculiar heraldic style, rather different from the development taking place in the rest of Europe, upon which it had no bearing.

In Germany and the other northern countries the sculptors followed the inspiration they had originally received from the first French mannerist works. French style penetrated these countries about 1235–1240, at Trier and Mainz, and then at Bamberg and Naumberg. Perhaps the great Master of Naumburg, who is said to have been an apprentice at Amiens and at Noyon, a journeyman at Reims and finally the master of a workshop in his own country, is merely an invention of art historians. He was responsible first for the famous sculpture of Mainz, including the Bassenheim relief and, between 1255 and 1265, for the great memorial statues in the choir of the cathedral of Naumburg and the highly dramatic and moving Passion scenes on the choir screen of the same church. These works of bold and

powerful expression belong to the great masterpieces of this period. The Foolish Virgins on the portal of the cathedral of Magdeburg are of the same date. They show German expressionism in its more extreme form, which borders on caricature. The lyrical and irrational element in Gothic art is noticeable in the 14th century in the statues of the cathedral of Freiburg (inspired by neighbouring Strasbourg) and in those of the choir of Cologne (1310–1320). Though influenced by the sculpture of Champagne they show the imaginative qualities of German art. These sculptures, in a way, anticipate and point to the later achievements of Riemenschneider, Veit Stoss and Lehmbruck. This also applies to German tomb sculpture of the period. From the early phase on, represented by the tomb of Siegfried Eppstein in the cathedral of Mainz (c. 1250), we notice in the recumbent figures on German tombs a definite tendency towards a character interpretation, such as we find in the art of Messerschmidt in the 18th century, rather than the cool and measured observation practised in France by the sculptors of the portraits of Charles V and John of Berry. Impressive examples of this type are the tombs of Wolfhart von Rot in the cathedral of Augsburg and of Friedrich von Hohenlohe in the cathedral of Bamberg (1351). There are, however, other works in central Europe, less tense and more 'International' in character, especially in Prague, where the portrait busts on the triforium of the cathedral and the statues on the fortified bridge (end of the 14th century) show that the conventional mannerist style continued to enjoy favour.

Finally there was Italy, which cannot be divorced from the Gothic even though it reacted and finally won out against it. From the Gothic, Giovanni Pisano, Tino di Camaino and Arnolfo di Cambio borrowed the outer tension of forms and the relationships between sculpture and architecture. The first doors of the baptistery in Florence, by Andrea Pisano (1330), are still Gothic in design. But as in architecture and painting, classical forms underlie this Gothic surface. There is a desire to escape from the artificial representation of space, an attempt to regain the true art of relief, using perspective and restoring the illusionist space of the statue freed from architectural constraint.

Drawing and painting in France

Gothic painting in the 13th century in France is mainly that of the stained glass window. Owing to the enormous space occupied by the windows stained glass replaced wall paintings, which were reduced to a subsidiary role. Closely integrated into the architectural system, this art adjusted step by step to the structural changes of the buildings, producing a world of forms of absolute novelty, which, however, did not survive Gothic architecture. For a time this art overshadowed all other techniques of painting, imposing on them its own laws — the use of intense and saturated colours, forms outlined by lead strips and crisply drawn so that they could stand out against the radiant light, spatial recession of little depth, and composition broken up into medallions, niches and compartments. These windows strongly expressed the irrational and artificial non-naturalistic side of Gothic art.

In the middle of the 13th century the range of colours in the glass windows underwent an important modification. Neutral tints formed the background for figures

GOTHIC. Painted stone statue of the Virgin and Child. c. 1350. *Victoria and Albert Museum, London. Photo: Michael Holford.*

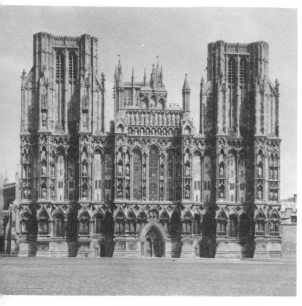

887. GOTHIC. ENGLAND. West front, Wells cathedral. 1230–1239.

888. GOTHIC. ENGLAND. West front, Salisbury cathedral. 1220–1266.

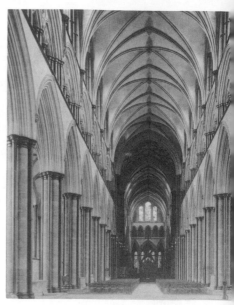

889. GOTHIC. ENGLAND. The nave, looking east. Salisbury cathedral. 1220–1266.

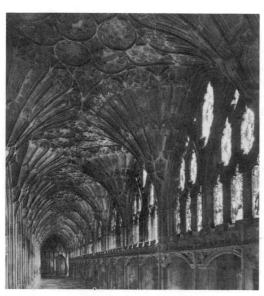

890. GOTHIC. ENGLAND. Fan vaulting in the cloisters of Gloucester cathedral. 1370–1412.

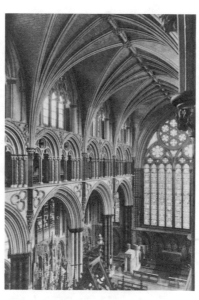

891. GOTHIC. ENGLAND. Angel Choir, Lincoln cathedral. Early Decorated style. 1256–1280.

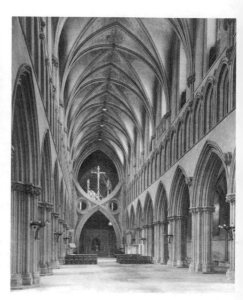

892. GOTHIC. ENGLAND. Nave, and strengthening arches at the crossing, Wells cathedral. Arches added in 1338.

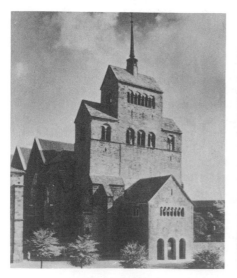

893. GOTHIC. GERMANY. Minden cathedral. Early type of hall church.

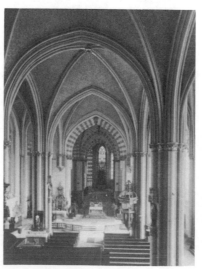

894. GOTHIC. GERMANY. Nave of Minden cathedral. c. 1270.

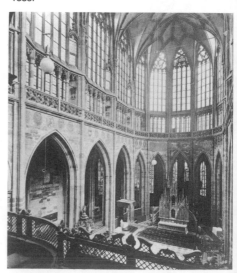

895. GOTHIC. CENTRAL EUROPE. Choir of Prague cathedral. Begun 1344, from the plans of Matthew of Arras.

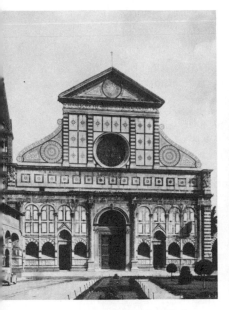

896. GOTHIC. ITALY. Sta Maria Novella, Florence. 1278–1360.

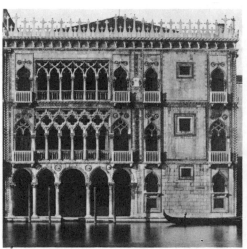

897. GOTHIC. ITALY. The Ca d'Oro, Venice. 1421–1436.

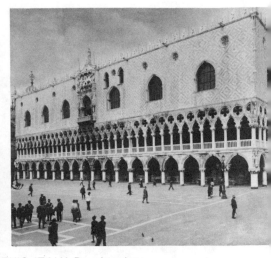

898. GOTHIC. ITALY. Doge's palace, Venice. 14th–15th centuries.

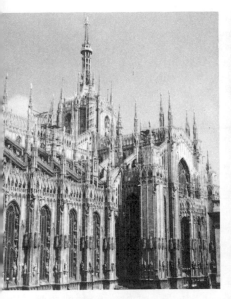

899. GOTHIC. ITALY. Milan cathedral, from the south. Marble. Begun 1386. Continued 15th–19th centuries.

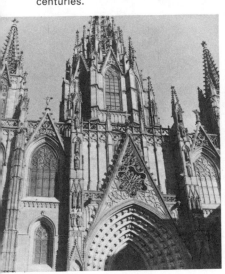

900. GOTHIC. SPAIN. Façade of Barcelona cathedral. Begun at the north side in 1298. The greater part of the building was erected in the 14th century.

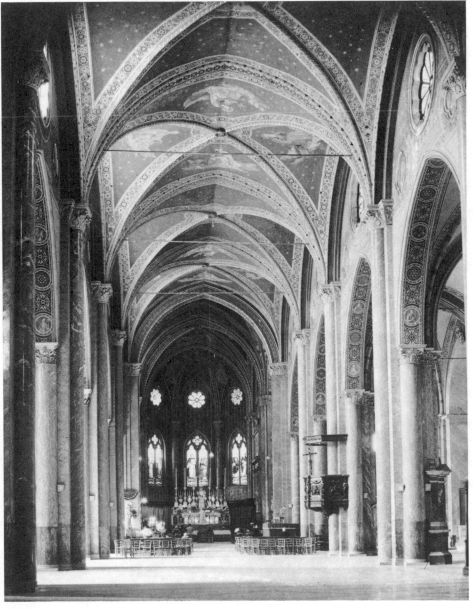

901. GOTHIC. ITALY. Interior of Sta Maria sopra Minerva, Rome. Built 1280, on the site of an ancient temple of Minerva.

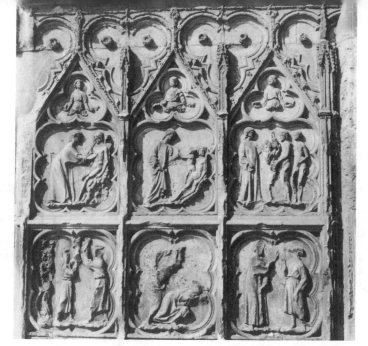

902. GOTHIC. FRANCE. The Creation of Adam and Eve, and the story of Cain and Abel. West portal, Auxerre. c. 1285–1305.

903. GOTHIC. FRANCE. Adam and Eve driven from the Garden of Eden. Detail of west portal, Auxerre c. 1285–1305.

904. GOTHIC. FRANCE. The Creation of Eve. c. 1270–1280. Detail from the west front of Bourges cathedral.

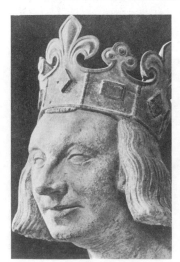

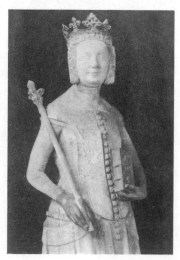

905. GOTHIC. FRANCE. Charles V as St Louis. c. 1390. Louvre.

906. GOTHIC. FRANCE. Jeanne de Bourbon as Marguerite of Provence. c. 1390. Louvre.

and scenes. A variety of broken tones replaced the intense but restricted colour scheme. Human figures grew more slender, more agitated and freer in their movements. We find the best examples of this style in St Urbain at Troyes (c. 1270), in the apse of Beauvais and in the cathedral of Sées. After 1300 the glass of the Parisian region was surpassed by that of Normandy and Champagne, where it developed speedily and with great diversity. (These Parisian works have nearly all disappeared.) A change in technique, due to the invention of silver stain (yellow), added a grace and lightness, permeated with a golden hue unknown before, to the stained glass windows of the 14th century.

The best windows are found in Normandy in the choir of St Ouen at Rouen, in the chapel of the Virgin in the cathedral of Rouen (c. 1325) and in the windows of the cathedral of Evreux. These works are of exquisite style and are equal if not superior to the best manuscript illumination of the period. Less exuberant but of great variety are the windows of the Loire region at Vendôme, Evron, Mézières en Brenne and in the cathedral of Tours. Champagne, too, has some perfect examples at Troyes and Châlons sur Marne. Alsace holds a place of distinction because of the windows in the aisles of the cathedral of Strasbourg and those of Mulhouse and Niederhaslach. The elegance of style and a certain preciousness persisted even when touched by naturalistic influences, as for example in the royal windows at Evreux (c. 1400) and the windows of Bourges, which belong rather to the type of International Gothic which reigned at the court of the 853 Duke of Berry. After 1350 the art of stained glass windows declined, and portraiture and painting on panels came to the foreground.

Manuscript illumination was another medium in which Gothic art was outstanding. After a slow development it matured rather late, during the reign of St Louis. Influenced by the technique of stained glass, these manuscripts followed in their formal development the Gothic style of the period. Good examples are the Psalter of Blanche of Castile, and, especially, the books illuminated for the king in Paris—the Psalter of St Louis and the 917 large Gospels of the Sainte Chapelle. The illuminated book soon became standardised in its form. The historiated letters and the full size illuminations, on a gilt or mosaic-like background reminiscent of stained glass windows, displayed simple compositions with very few figures, painted in plain colours and drawn with sharp lines of a rather affected refinement. The brilliant marginal decoration usually consisted of a veritable forest of decorative leaves and gilt flowers. This design served for more than two centuries as a pattern for manuscripts produced both in France and abroad. The Parisian products—of which there were an enormous number—evolved very little at this time. Towards 1300, however, in the Breviary of Philip the Fair, the first signs of modelling by means of shading appeared. Jean Pucelle (his 918 920 workshop enjoyed a sort of monopoly in France during the greater part of the 14th century) introduced decorative motifs of English origin and made some attempts, inspired by Italian painting, to render perspective, without, however, changing the basic character of his style. The late followers of Pucelle's style—more picturesque in execution but less imaginative in the choice of their subjects—continued their craft into the 15th century, in workshops mainly run by Flemish artists whom the French kings

had invited into the country. Around 1430 their precious art disappeared completely.

There is less to say about murals and panel painting. In France the most important wall paintings of the 14th century are in the Palace of the Popes at Avignon, and at Villeneuve lès Avignon, where Italian artists had worked or had left their influence. This is also noticeable at Cahors and in the Church of the Jacobins at Toulouse. The powerful mural of St George in the cathedral of Clermont-Ferrand is the only painting which can compare with such contemporary works as the stained glass windows of St Père at Chartres. The most famous wall decoration of the second half of the 14th century is not a painting but a tapestry—the Apocalypse of Angers, the only tapestry that has survived of this period apart from a fragment of the Nine Knights. This form of mural decoration assumed a great importance towards the end of the Middle Ages. In style these tapestries give the impression of an enlarged illumination. The mat quality of the dyed material imparted to the style of these decorative compositions an abstract, almost heraldic, character which must have appealed to the romantic tastes of this later period of Gothic art. Pictures painted on panels are rare in France in the 14th century. All that is left (before the Flemish influence made itself felt in the last quarter of the 14th century) are a few works by Sienese artists in Avignon like the Master of the St George Codex, and a few retables in Roussillon—the one from Serdinya (1342), for example. The most famous painting in the International Gothic style is the altar frontal called the Parement de Narbonne, now in the Louvre.

Painting outside France

England produced many handsome stained glass windows during the 13th and 14th centuries. These windows, however, do not form an integral part of the architectural frame as they do in France. For that reason murals had a place in the interior of buildings for a much longer time. The chief stained glass windows, such as those of the 14th century in the cathedral of York (*c.* 1340) and the windows in the apse of the cathedral of Gloucester (*c.* 1350) give some idea of the high standard of English stained glass technique. Panel paintings are rare. The Westminster Retable (*c.* 1270) is astonishingly precocious in its style, in which Italian influences are already perceptible. Noteworthy, too, is the beautiful retable in the Musée de Cluny, Paris (14th century) and the famous Wilton Diptych representing Richard II kneeling before the Virgin (end of the 14th century). A beautiful series of panel paintings of English inspiration is also found in Norway.

England's greatest contribution to the development of Gothic forms at the end of the 13th century is in the field of illuminated manuscripts. In about the middle of the 13th century French models helped the English illuminators to overcome their initial uncertainty about adopting the new style. This uncertainty is still noticeable in the works of Matthew Paris (Historia Anglorum, *c.* 1255). During the last quarter of the 13th century the English illuminators created their own forceful and original style of illumination, the East Anglian style. Its first masterpiece, the Tenison Psalter (*c.* 1280), displayed an extraordinary fantastic ornamentation which revived the old repertory of interlaced patterns and imaginary monsters. The margins teem with grotesques and with small

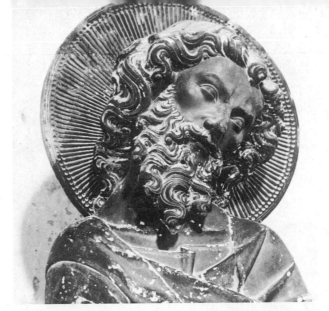

907. GOTHIC. FRANCE. Statue from the church at Rieux Minervois (Aude). *c.* 1330. *Musée des Augustins, Toulouse.*

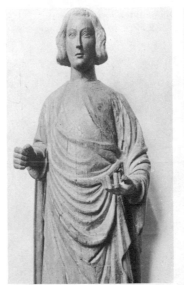
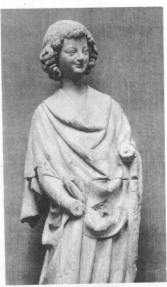

908. GOTHIC. A Magus (?). Wood. late 13th century. *Louvre.*

909. GOTHIC. Angel carved in wood. Late 13th century. *Louvre.*

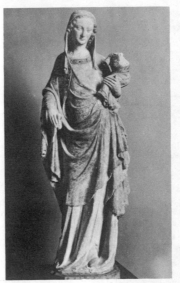
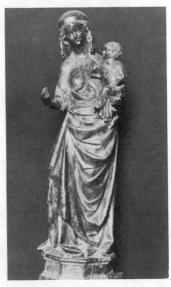

910. GOTHIC. FRANCE. Virgin and Child, Ile-de-France. *c.* 1320–1325. *Louvre.*

911. GOTHIC. FRANCE. Virgin and Child, from Abbeville. Wood. Beginning of the 14th century. *Louvre.*

357

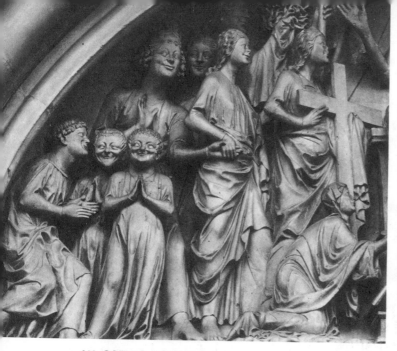

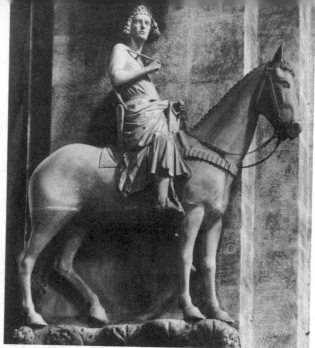

912. GOTHIC. GERMANY. Detail of the Last Judgment, showing kings and angels. *c.* 1235. Prince's portal, Bamberg cathedral.

913. GOTHIC. GERMANY. Equestrian statue (possibly St George) called the 'Rider'. *c.* 1235. Bamberg cathedral.

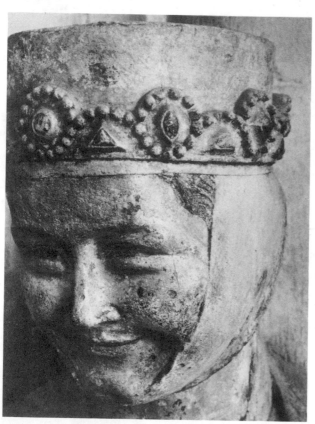

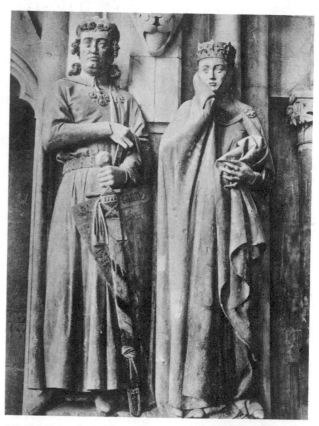

914. GOTHIC. GERMANY. Head of Regelindis. Detail of the couple Hermann and Regelindis in the choir of Naumburg cathedral. 1255–1265.

915. GOTHIC. GERMANY. Ekkehard and Uta. Memorial statues of founders, in the choir of Naumburg cathedral. 1255–1265.

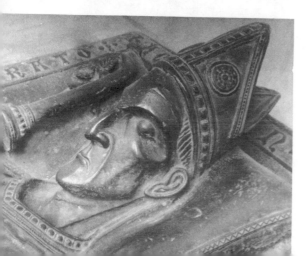

916. *Left.* GOTHIC. GERMANY. Detail of the tomb of Wolfhart von Rot (d. 1302). Augsburg cathedral.

917. *Right.* GOTHIC. FRANCE. Jephtha's Daughter. Psalter of St Louis. *c.* 1256. B. N. Lat 10525. *Bibliothèque Nationale, Paris.* There are two other psalters once belonging to St Louis. One is preserved in the Bibliothèque de l'Arsenal; the other is in Leyden.

anecdotal scenes and caricatures. The eerie and eccentric figures are the work of a virtuoso and are executed with zest and a capricious imagination. The most accomplished works are probably the Ormesby Psalter (1285–1330) and Queen Mary's Psalter, delicately sketched with lightness and speed. The latter had a considerable influence on French and German illumination. After the middle of the 14th century the style of English illumination declined.

In central Europe Gothic painting reached a high perfection at this time. Up to the end of the 13th century rather crude versions of French and English originals predominated in central Europe, both in illumination and in stained glass. A curious angular style developed in Germany and Austria, called *Zackenstil*. It combined characteristics of late Romanesque works, with their decorative overloading, with the innovations of Gothic style, e.g. the impressive stained glass windows of München-Gladbach (*c.* 1265) and the Wise and Foolish Virgins of Friesach in Austria (*c.* 1280). Though basically Romanesque in style, these works are animated in their rhythm and their movements by a definitely Gothic mannerism.

The western style of Gothic painting in its newest form only penetrated into Germany and central Europe about 1300, and assumed at once a form of lyrical exaggeration and dramatic intensity hardly known in France. Striking examples are the stained glass windows of the Frauenkirche in Esslingen, the three Magi in the cathedral of Cologne, the bays of the cloisters of Klosterneuburg in Austria and the chapel of Königsfelden in Switzerland (*c.* 1325), an Imperial foundation where German, French and Italian influences concurred. The central European windows, noticeably different in style from the contemporary French ones, excelled by their powerful broken colours whose effect was heightened by contrasts such as a small but heavy ornamentation. The rather dramatic human figures were strongly characterised. To a greater degree than any others in western Europe these windows anticipated the art of the 15th century. The best 14th-century examples are found in Austria at Wels, Maria-Strassengel and, especially, in the Ducal chapel and the cathedral at Vienna. In Germany no works of similar quality were produced before the end of the 14th century, when the windows of the minster at Ulm and in the church at Rothenburg, both of which date from about 1400, were built.

Panel painting of the first quarter of the 14th century can be traced very easily in Cologne and Vienna. Its linear style was obviously derived from French and English models. In Vienna, however, the Klosterneuburg altarpiece (1329), contemporary with the stained glass windows in Königsfelden, shows Italian influence. The most outstanding paintings of this period were done in Bohemia at the court of Charles IV between 1350 and the end of the century, beginning with the polyptych at Vyšší Brod (Hohenfurt), probably dating from 1359. The expressive and colourful Třeboň altarpiece (*c.* 1390), foreshadowed the art of Broederlam and the Burgundian court. In very few other countries have so many murals and panels of this time survived as we find in the Imperial castle of Karlstein, where artists from the Rhineland, such as Nicolas Wurmser of Strasbourg, worked side by side with Bohemian painters such as Theodoric of Prague. Charles IV acquired also some Italian works by Thomas

995
9, 998

918. GOTHIC. FRANCE. Breviary of Philip the Fair. Mentioned in 1296 in a bill of the treasury of the Louvre. Attributed to Master Honoré. B. N. Lat. 1023. *Bibliothèque Nationale, Paris.*

919. GOTHIC. ENGLAND. Queen Mary's Psalter. Christ teaching in the Temple. Early 14th century. *British Museum.*

920. GOTHIC. FRANCE. Detail from the Breviary of Belleville. Dominican breviary executed in the studio of Jean Pucelle. 1323–1326. B. N. Lat. 10483 and 10484. *Bibliothèque Nationale, Paris.*

of Modena. Moreover, there was a remarkable school of illuminators whose works are among the most brilliant of the period. The Liber Viaticus by John of Streda (Johann von Troppau), though certainly greatly indebted to the style of Pucelle, was enriched by the international culture of Prague, with its Italian influences. It showed such a profusion of new forms—which continued in the reign of Wenceslaus IV—that in France only the books of John of Berry could compete in brilliance of colour and liveliness of expression. Bohemian painting exerted a certain influence on Austrian and south German painting of the beginning of the 15th century, which spread as far as the North Sea, where it is noticeable in the style of Master Bertram of Hamburg. This linked central European painting to the painting of Westphalia, Holland and Flanders, which belonged to the international style of 1400.

Spain, where Gothic painting was almost unknown as late as 1340, adopted the new style about this time and perpetuated it throughout the 15th century. Only a few stained glass windows at León and a few second-rate altar frontals preceded the murals by Ferrer Bassa at Pedralbes (c. 1340), a monastery near Barcelona. These murals show a strong Italian influence. The Catalan painters, who drew their inspiration from both Sienese paintings and the Giotteschi, created an art of great beauty, harsh in colour, expressive and subtle in form, and covered with gilt and ornaments. In the 14th century this art was best represented by the works of Luis Borrassá. During the 15th century Spain became the favourite country of this later phase of Gothic painting, with the works of Bernardo Martorell, which were closer to the French style than were the works of any of his predecessors.

We have repeatedly mentioned the part Italy played in the evolution of 14th-century painting. Italian art deviated frequently from the conventional Gothic style or modified it considerably. Giotto's painting (c. 1300), though undeniably Gothic in form, was a revolution in Italian art. He introduced the idea of realistic space and of monumental form—ideals of the future Renaissance, the very opposite of the contemporary Gothic mannerism. Giotto's efforts were in a way premature. His successors in Florence soon turned away from him, reducing the forms and assimilating their style to the overall trends of the period. Hence the predominance of Sienese painting around the middle of the 14th century; it was much closer to Gothic art. Simone Martini, for instance, was strongly influenced by it and was able in his turn to transmit to the artists of the northern countries many of the elements of his own style which the northerners were perfectly able to assimilate. Italian artists, especially from northern Italy, cooperated closely throughout the second half of the 14th century with the artists of the north and shared with them in the creation of the International style. This style continued to enjoy favour with the painters of Umbria and Verona at the time when in Florence the genius of Masaccio revived Giotto's ideals. Strongly opposing Gothic art, he led Italian painting to the Renaissance.

Late Gothic art

In Italy the 15th century is the century of the Renaissance. This term has also been applied to painting (and by extension to sculpture, too) in the countries north of the Alps in so far as they developed a formal sense that was closer to reality, a more naturalistic presentation of space and more direct interpretation of nature. In the arts the 15th century was a time of crisis and conflicts—a conflict between the old Gothic world and Italy, a conflict too between Gothic mannerism, traditional in the West from the 13th century, and the new, hard, coarse, often violent, baroque style of the painters and sculptors of the north, which was not without repercussions even in Italy with Donatello and Ghirlandaio. In many other ways, however, far from deviating from basic Gothic principles this art of the 15th century carried them out and even exaggerated them.

In this confused and apparently contradictory situation we discern first of all the outdated elements of the preceding style which had survived from the International style of 1400. In Paris for instance this 'pre-Eyckian' style of painting became more and more complicated and provocative, continuing till about 1435 in the Hours of Rohan and the historiated initials of the Histoire de Joseph, which Jean Fouquet completed. The first examples of the particularly conservative art of the stained glass windows executed in the new style are found in the Jacques Coeur chapel in the cathedral of Bourges (1445–1450) and in the transept of the cathedral of Angers. 921

The situation was the same in Germany, Austria and Bohemia. Master Francke in Hamburg, Konrad of Soest in Dortmund, Stephan Lochner in Cologne and Hans von Tübingen in Styria prolonged this style far into the second third of the 15th century. Even in Italy Pisanello, Gentile da Fabriano and especially the Sienese painters, such as Sassetta and Giovanni di Paolo, remained faithful to the Gothic manner which in Florence had a hold even on Uccello, who was in many ways an innovator. The most beautiful works of this International style were produced during the 15th century in Spain. In more distant regions, as for instance in Poland, certain Gothic forms of the style survived in the 16th century, combined with elements of the High Renaissance style.

The reaction inaugurated by Sluter and the brothers van Eyck, and the forms of art which they imposed on central and western Europe, appear when seen at a greater distance to be the ultimate and complete expression of the major characteristics of Gothic art. As Erwin Panofsky has shown, hidden behind van Eyck's and Rogier van der Weyden's apparently realistic imagery is the traditional iconography, the old religious symbolism, while their generalised concept of man and nature and their naturalistic images remain subordinated to an artificial mode of interpretation. Their vision of an almost supernatural precision of colour and form (the way the forms are articulated, placed side by side or contrasted), the irrational quality of light emanating from the objects, the tense gestures and expressions—all these characteristics are basic requisites of Gothic art. Sculpture too remained closely bound up with architectural space, and figures were nearly always seen from the front, because they were placed against a background. Even the works of Sluter and Veit Stoss cannot avoid this condition, which, in fact, is more apparent in these late works than in many works of the preceding centuries. These violent, dramatic and over-characterised forms emphasise by contrast with the architectural frame the structural order of which they are a part.

In the architecture of the 15th century the same basic Gothic principles persisted. Architecture, impervious to

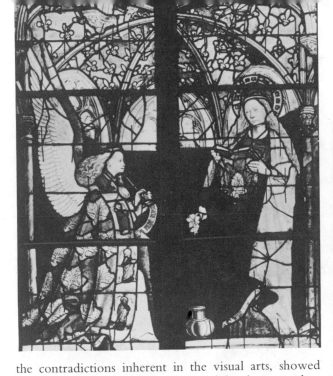

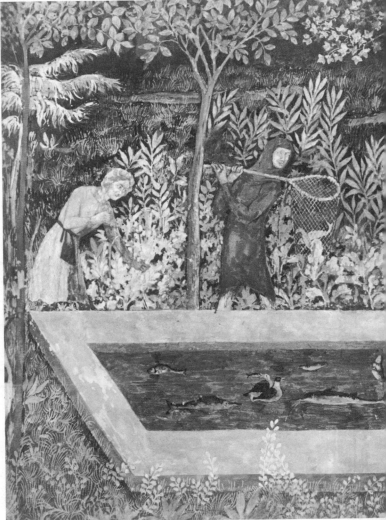

921. GOTHIC. FRANCE. Annunciation. Stained glass window in the Jacques Coeur chapel, Bourges cathedral. 1445–1450.

the contradictions inherent in the visual arts, showed more distinctly in this later phase of development than in the previous period certain characteristics of Gothic style. The Perpendicular style in England, which began about 1350, is a case in point. There the basic traits of English Gothic, a brilliant, capricious decoration on the one hand and a simplified structure on the other, were perfectly expressed in the 15th century. This was achieved by the sharp mouldings of the vaults, of the supports and of the bays, which honeycombed the walls or covered them with veritable flutings. Although curvilinear forms still prevailed in the chantry chapels at Tewkesbury (*c.* 1400), the Divinity School and Merton College in Oxford foreshadowed the famous buildings in the Tudor style, such as King's College chapel at Cambridge and Henry VII's chapel in Westminster abbey (16th century), both typical examples of the flowering of late Gothic in England.

The Flamboyant style in France, subject to various influences, showed less unity. The ogee arch and the web of ribs on the vaults were of English origin; the luxuriant and picturesque decoration was of Flemish origin. In eastern France German influences prevailed. The decoration of façades and steeples became more and more fantastic, e.g. St Wulfram at Abbeville (before 1439), and St Maclou at Rouen (1434–1470)—assuming on the one hand colossal dimensions, and on the other giving way to a staggering accumulation of minute detail such as miniature bits of architecture superimposed or encasing one another. But this is only one aspect of this baroque Flamboyant art. Side by side with these dreams of erecting Towers of Babel there was a genuine return to the appreciation of the solidity of the wall and of structural monumentality. Massive supports—very high and thick as at Mont St Michel, and St Nicolas du Port in Lorraine, or sturdy and low as at Alençon (*c.* 1475)—formed the basis of this return to a new form of monumentality. The general suppression of the triforium at this time—except in Normandy where it persisted, but usually in the form of a blind arcade—created a large wall space between the nave arcade and the clerestory windows—a return to forms long since abandoned. Another typical feature, frequently found in France and Germany, is the unbroken flow of the structural articulations. There were no longer half-columns attached to piers but, instead, mouldings of prismatic shape, which continued, uninterrupted by

984
82, 983

924
925

860

922. *Above.* GOTHIC. FRANCE. Fishing in the pond (detail). Fresco in the Palace of the Popes, Avignon. School of Avignon. *c.* 1343.

923. *Below.* GOTHIC. FRANCE. St Luke. Detail of a wall painting in the church at Carennac.

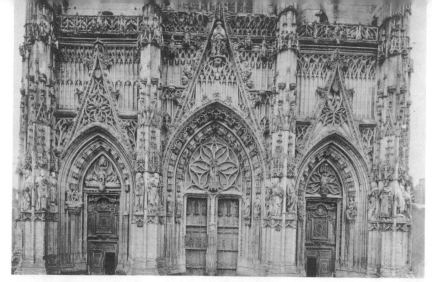

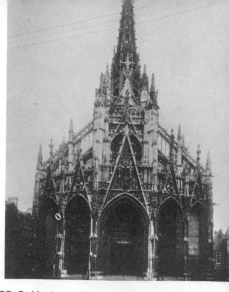

924. GOTHIC. FRANCE. West portal of St Wulfram at Abbeville. Before 1439. One of the most exuberant examples of the Flamboyant style, in which ornament and statuary are interwoven.

925. GOTHIC. FRANCE. St Maclou at Rouen. Façade built between 1434 and 1470. Building consecrated in 1521. Spire rebuilt in the 19th century.

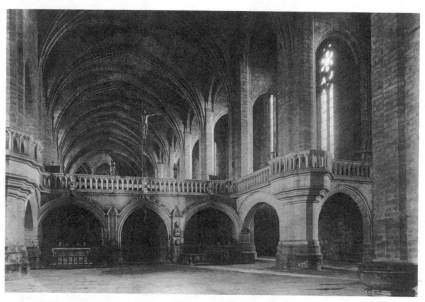

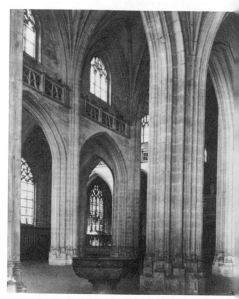

926. GOTHIC. FRANCE. Interior of La Chaise Dieu. Built between 1342 and 1352 by Pope Clement VI; completed between 1370 and 1378 by his nephew Pope Gregory XI. The choir screen dates from the 15th century.

927. GOTHIC. FRANCE. Interior of the church at Brou. Built between 1506 and 1532 to house the tombs of Marguerite of Austria and Philip the Fair.

928. GOTHIC. FRANCE. The Butter Tower, from the west front of Rouen cathedral. 1487–1510.

929. GOTHIC. FRANCE. The south portal of Beauvais cathedral. Flamboyant style.

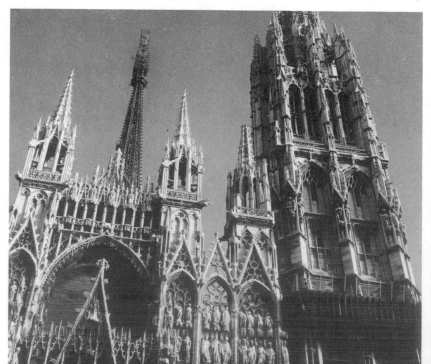

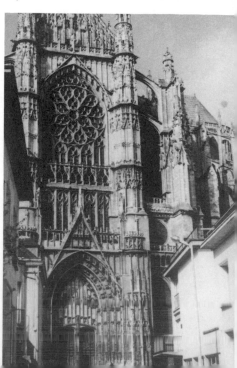

capitals, into the ribs of the vault; or else these elements penetrated into the lateral supports, swelling their surfaces with sinuous undulations. At Brou (Ain) we find a major example of this linear flow of verticals and ribs.

This last building may owe its character to Flemish influence. In Belgium and Holland we find the finest buildings of this ornate Flamboyant style, e.g. the cathedral of 's Hertogenbosch, where the traditional elevation was completely transformed by this new treatment of surfaces (1419–1439), and St Jacques at Liège (1513–1538), only two storeys high but with an interior decoration superimposed on the walls.

As regards Germany and central Europe, we need not stress the decorative character of the Flamboyant style— less typical of these countries—nor even the continuous flow of linear articulations which causes the interior of these buildings to appear as a single spatial unit and blurs the structural divisions (an outstanding characteristic of a baroque style). One famous example may suffice: the church at Kutná Hora (1483–1548) in Czechoslovakia, with its unbelievably intricate network of ribs under the vaults. In Germany it is rather in the end phase of the hall churches that the basic Gothic tendencies culminate in the creation of a new, unified and larger interior space, e.g. the Frauenkirche, Munich (1468) and the Liebfrauenkirche at Pirna (1502–1546)—a tendency that began as early as the 13th century in the cathedral of Bourges. The piers between nave and aisles have almost disappeared, and the aisles are nearly as wide as the nave.

In Spain (where we have already cited several examples of this type of architecture) some of the most beautiful buildings of this final stage were erected. They combine and blend all the characteristics of late Gothic style— English influence, Flemish exuberance—enriched by the country's own inventive genius and its decorative traditions of a rich, exotic and eccentric nature. In the Lonja (stock exchange) at Palma (15th century) a unity of space has been achieved probably superior to that in the German examples. The 16th-century cathedrals of Seville and Salamanca (1512–1591), adhering faithfully to older Gothic traditions in structure and decoration, added a mixed style of Italian inspiration. In Portugal the famous Manueline style, a variation of the Flamboyant, is of great originality, e.g. the churches at Belém (1500) and at Tomar, both showing that structure and arrangement of Gothic forms were able to assimilate the most heterogeneous elements from the colonies and from overseas.

This capacity for assimilating the various decorative tastes prevailing at a given period enabled Gothic art to survive for another two hundred years after it had reached its zenith. In religious architecture the 16th century was still a Gothic century in France, Spain, Germany and England. In the 16th century also Gothic architecture was about to conquer America. The cathedral at Santo Domingo (formerly Ciudad Trujillo) and that at San Juan, Puerto Rico (1528), are Gothic churches. Not until the 17th century did the Counter Reformation relegate Gothic architecture to the background, although St Eustache in Paris was erected in the middle of the 17th century and the Gothic cathedral of Orléans was rebuilt in the 18th century. These, however, were artificially contrived. The pre-Romantics of the end of the 18th century resuscitated a taste for the fantastic and irrational aspect of the art of the late Middle Ages and may have understood it better than do many of us.

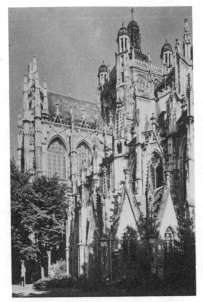
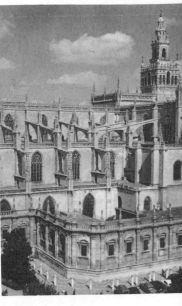

930. GOTHIC. NETHERLANDS. Cathedral of St John's, Hertogenbosch. Flamboyant style. 1419–1439.

931. GOTHIC. SPAIN. Cathedral of Seville. Begun 1402. Completed at the beginning of the 16th century.

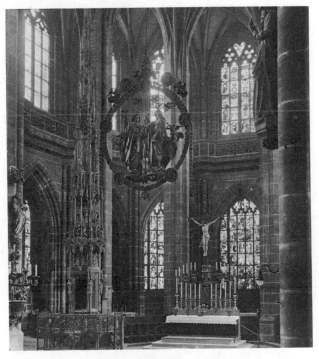

932. GOTHIC. GERMANY. Choir of St Lawrence, Nuremberg. Second half of the 15th century. Hanging from the vault is the Hail Mary medallion by Veit Stoss (1517–1518).

933. GOTHIC. SPAIN. Interior of the Lonja (the old stock exchange) at Palma, Majorca. Begun 1451 by Sagrera.

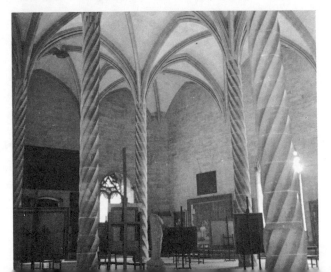

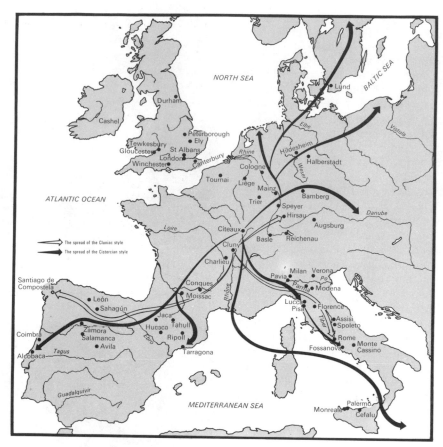

ROMANESQUE EUROPE

Map labels (Romanesque Europe):

NORTH SEA · BALTIC SEA · ATLANTIC OCEAN · MEDITERRANEAN SEA · Rhine · Elbe · Weser · Danube · Vistula · Loire · Rhône · Ebro · Tagus · Guadalquivir · Tiber · Po

Durham · Cashel · Peterborough · Tewkesbury · Ely · St Albans · Gloucester · London · Canterbury · Winchester · Tournai · Liège · Cologne · Mainz · Trier · Hildesheim · Halberstadt · Bamberg · Speyer · Hirsau · Augsburg · Cîteaux · Cluny · Basle · Reichenau · Charlieu · Pavia · Milan · Verona · Parma · Modena · Conques · Moissac · Lucca · Pisa · Florence · Santiago de Compostela · León · Sahagún · Jaca · Tahull · Assisi · Spoleto · Coimbra · Zamora · Salamanca · Avila · Huesca · Ripoll · Rome · Alcobaça · Tarragona · Fossanova · Monte Cassino · Monreale · Palermo · Cefalú

→ The spread of the Cluniac style
➤ The spread of the Cistercian style

GOTHIC EUROPE

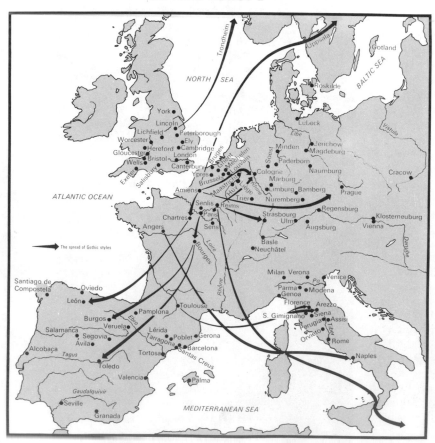

Map labels (Gothic Europe):

NORTH SEA · BALTIC SEA · ATLANTIC OCEAN · MEDITERRANEAN SEA · Trondheim · Uppsala · Gotland · Roskilde · Lübeck · Elbe · Soest · Vistula · Rhine · Loire · Rhône · Ebro · Tagus · Guadalquivir · Tiber · Po

York · Lincoln · Lichfield · Peterborough · Worcester · Ely · Hereford · Cambridge · Gloucester · London · Bristol · Canterbury · Wells · Salisbury · Exeter · Bruges · Ghent · Mechelen · Louvain · Ypres · Brussels · Maastricht · Huy · Liège · Cologne · Amiens · Senlis · Reims · Trier · Paris · Sens · Chartres · Angers · Bourges · Basle · Neuchâtel · Minden · Jerichow · Magdeburg · Paderborn · Naumburg · Cracow · Marburg · Limburg · Bamberg · Nuremberg · Prague · Regensburg · Strasbourg · Ulm · Augsburg · Vienna · Klosterneuburg · Milan · Verona · Venice · Parma · Modena · Genoa · Florence · Arezzo · S. Gimignano · Siena · Perugia · Assisi · Orvieto · Rome · Naples · Santiago de Compostela · Oviedo · León · Pamplona · Toulouse · Burgos · Veruela · Salamanca · Lérida · Segovia · Ávila · Tarragona · Poblet · Gerona · Barcelona · Alcobaça · Tortosa · Santas Creus · Toledo · Valencia · Palma · Seville · Granada

→ The spread of Gothic styles

THE LATIN EAST

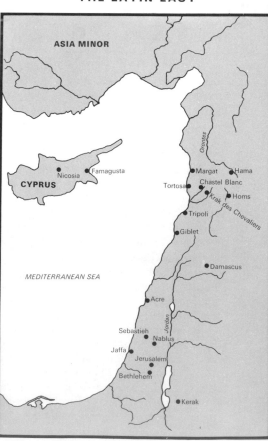

Map labels (The Latin East):

ASIA MINOR · CYPRUS · MEDITERRANEAN SEA · Orontes · Jordan · Nicosia · Famagusta · Margat · Hama · Tortosa · Chastel Blanc · Krak des Chevaliers · Homs · Tripoli · Giblet · Damascus · Acre · Sebastieh · Nablus · Jaffa · Jerusalem · Bethlehem · Kerak

CONTACTS WITH THE NEAR EAST

Paul Deschamps

Although Europe, by creating Gothic art, had asserted her originality and cultural independence, she was in no way isolated from the East. The influence of Byzantium and the Arab world found many ways of infiltration. The pilgrimages to the Holy Land, followed by the crusades, established substantial and lasting contacts with the Moslem world which led to partial cultural fusions which were reflected also in Sicily, under the Norman kings in the 12th century and under Frederick II in the 13th century.

Closer contacts between East and West were established at the end of the 11th century as a result of the first crusade, which led to cultural and economic exchanges between the two civilisations which previously knew little of each other. The successful invasion of the Asiatic coast by the crusaders resulted in the occupation of the Levant for a period of two centuries, and in a permanent colonisation extending over six hundred miles from the Taurus Mountains to the shores of the Red Sea and including Cilicia, parts of Syria, Lebanon, Palestine and Jordan. The two worlds, separated by language, customs and religion, both fanatically opposed to each other, achieved a rapid amalgamation, fighting, respecting and admiring each other in turn.

During the crusades lasting contacts between the West and the Holy Land were established by the pilgrims. In such flasks they brought home holy water. The decoration of these flasks had considerable influence on European iconography.

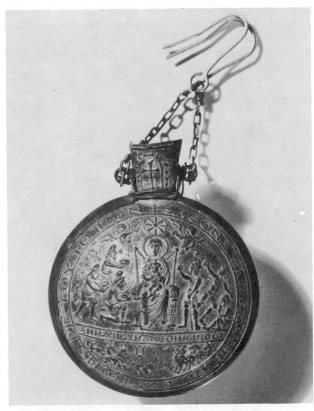

934. Pilgrim's flask from Monza.

The occupying forces, too small in numbers, suffered repeated reverses which were sorely resented in Europe and which called forth further crusades. Eventually, after two centuries of epic events, the great Christian colony in the Levant collapsed in 1291. The first crusade was undertaken as a counter offensive against the encroachment of Islam, which threatened to submerge Christian civilisation. In 1076–1077 the Seljuk Turks invaded Syria and conquered Jerusalem, desecrating the Holy Sepulchre. In 1085 Antioch fell and the Byzantine Empire was in extreme danger. In 1086 the Moors of North Africa, coming to the aid of the Moors of Spain, inflicted a disastrous defeat on the Christian army. The Crescent triumphed at the two ends of the Mediterranean basin. The Pope, in a desperate effort to break the jaws of this vice whose grip threatened Europe, called for an expedition to liberate the Holy Land. Public opinion had been prepared in France by reports brought back by pilgrims who, in spite of cruelties inflicted on them by the Moslems, continued to venture out to the Holy Land in great numbers.

Odo of Châtillon, formerly prior of Cluny and at this time Pope Urban II, came to France in 1095, preaching in Clermont-Ferrand the deliverance of the Holy Places by force of arms. The appeal was received with great enthusiasm. The campaign itself was essentially a French enterprise, and Guibert of Nogent called his history of the first crusade *Gesta Dei per Francos*, 'in honour of our nation'.

Several armies were organised. The crusaders of the Capetian kingdom were led by Hugh of Vermandois, the brother of King Philip I. The great feudal lords, Stephen Count of Blois, Robert Duke of Normandy and Robert Count of Flanders, joined with their vassals. Raymond of St Gilles, Count of Toulouse, led the troops of Languedoc. The crusaders of Lorraine were led by Godfrey of Bouillon, son of Eustace of Boulogne; he was joined by his brother Baldwin, who was to become the first king of Jerusalem. Bohemund, Prince of Otranto and grandson of Tancred of Hauteville, together with his nephew Tancred, commanded the Normans of southern Italy. In addition to these regular troops there was a host of irregular soldiery, badly equipped and led by zealous preachers such as Peter the Hermit or by impoverished knights such as Walter the Penniless. The assistance of the Genoese and Flemish fleets was important for the success of the operation. The latter was commanded by the pirate Guynemer, vassal of the counts of Boulogne. Of 600,000 men who are supposed to have left the West, 40,000 exhausted combatants survived. On the 15th July 1099, after a final splendid effort, they took Jerusalem.

The military architecture of the Crusaders

The next task was the colonisation of the country. The guiding spirit of this enterprise was Godfrey's brother Baldwin, who was crowned king of Jerusalem on Christmas day 1100. After the seizure of Jerusalem the majority of the crusaders returned home; but several of the leaders stayed behind with a small number of knights, resolved to

guard the Holy Places and to extend the conquest further into the East so as to secure natural boundaries for the future colony. Four Christian states were established—in the south the kingdom of Jerusalem, and further to the north the county of Tripoli, the principality of Antioch and the county of Edessa.

Very soon the Frankish lords became efficient colonial administrators; they undertook the exploitation and the development of natural resources, sent for their families and welcomed pilgrims from France and immigrants who were attracted by the large areas of land offered them for colonisation. The indigenous population were on the whole well treated, and their religion and customs were respected; they were even entrusted with the management of local affairs.

The new lords, however, had to guard against a counter-offensive by the Moslem rulers, who had been driven back over the Jordan and beyond the mountain ranges of the Lebanon and the Orontes River.

A system of defences had to be established to protect both the frontiers and the interior. Large mountain fortresses were erected to secure the passes and the river valleys, walls dominated by citadels protected the towns, towers guarded the ports and in watch-towers placed high up fires were lighted to signal the approach of an enemy. In the open plains rose castles which could protect the roads and give shelter against sudden raids.

A number of these large fortifications still survive on their imposing sites, such as Monreal, south of the Dead Sea, named by King Baldwin who personally gave a hand in the construction in 1115, and, east of the Dead Sea, the powerful fortress of Kerak; further to the north, beyond the source of the River Jordan, rose Subeiba.

The rulers of the Frankish states soon realised that they lacked soldiers and resources to man these frontier castles. They sold them to the two military Orders, the Knights Hospitallers and the Templars, who rapidly became both rich and powerful. As a regular army indispensable to the security of the colony, these knights and their men-at-arms (some of whom were indigenous Christians)

formed the garrisons of the fortresses as well as the bulk of the expeditionary forces. The Hospitallers constructed one of the most imposing of the fortified castles, the Krak des Chevaliers, placed on the top of a hill some 2,200 feet high, facing Lebanon and dominating a large valley which formed the communication between the Moslem cities of Homs and Hama on the Orontes and the Christian ports of Tortosa and Tripoli. It was of course necessary to guard carefully this passage opening on to the Christian territory.

The Krak des Chevaliers has remained almost intact, with two concentric walls, twenty towers of admirable stonework and a keep 155 feet high and secured by a defensive wall over 30 feet thick. It contained a Romanesque chapel built in the Provençal style. The great hall and its gallery date from the time of St Louis. The rib vault of the hall, the elegant capitals decorated with foliage and the bays with their delicately articulated backings recall the style of the Sainte Chapelle. The walls bear Latin and French inscriptions. The Hospitallers held this fortress for a hundred and thirty years. Repeated improvements show the progress made in military architecture in the course of the 12th and 13th centuries. This edifice probably influenced Richard Coeur de Lion when, after the third crusade, he built Château Gaillard.

Not far from the Krak des Chevaliers rose Chastel Blanc, held by the Templars. The lower part of the high rectangular keep served as a church; the upper hall and the crenelated terrace above were arranged for the use of engines of war. The castle at Tripoli, still called Kalat Sanjill, recalls the name of Raymond of St Gilles, who built it after the first crusade. Margat, another fortress of the Hospitallers, built to defend the littoral road, had a massive keep some 70 feet across surrounded by a wall projecting into the terrain like the bow of a ship. The well preserved castle of Saône in the mountains east of Latakia was built on an elongated triangular spur. Its fortifications covered an area of more than a square mile and followed the contours of the terrain, dominating from a great height two ravines which met at the apex of

935, 93

935. THE LATIN EAST. Aerial view of the Krak des Chevaliers, built by the Hospitallers. 12th–13th centuries.

936. The Krak des Chevaliers.

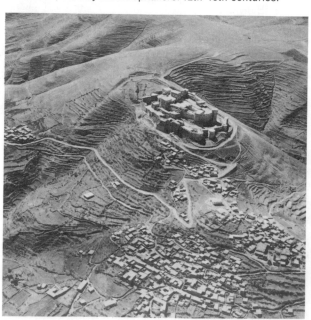

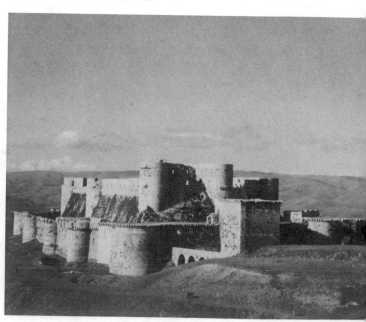

937. Cast of a two-headed capital from the ruins of the basilica of Nazareth. Carved just before 1187.

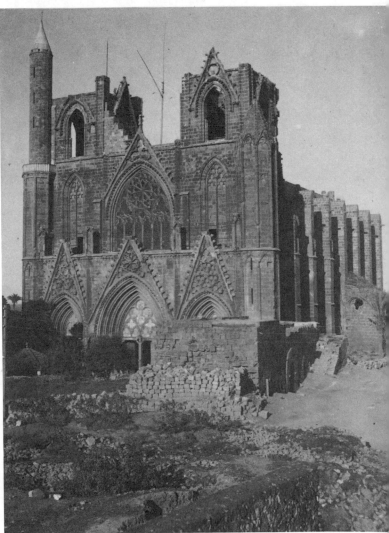

938. Court of the hospital, Rhodes. The Knights Hospitallers settled in Rhodes in 1310, after the loss of the Holy Land. They were driven from the island by Suleiman the Magnificent in 1522.

940. Former cathedral of Famagusta in Cyprus. Begun in 1300. Today the mosque of Sta Sophia.

939. Fortifications of the citadel of Aleppo in Syria.

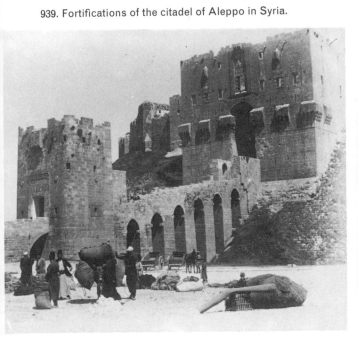

the triangle; its base was formed by carving a deep ditch in the rock. In the middle of the frontal defence, facing the plateau, rose a square keep some 80 feet across. This fortification presents the most typical example of the military architecture of the crusaders at the beginning of their occupation.

Religious and civil architecture in the Holy Land

The architects, masons and sculptors who came from France did not build only fortresses. Religious edifices in the Romanesque and Gothic styles, following French models, were erected in various parts of the colony. Among these were the Church of the Holy Sepulchre at Jerusalem, the basilica at Bethlehem, the cathedrals of Nablus, Sebastieh and Giblet (on the site of ancient Byblos), Notre Dame at Tortosa and such churches as St Anne in Jerusalem. With surprise we discover in these buildings the austere lines of a Romanesque nave of Burgundy or Provence, or 13th-century windows with slender colonnettes and delicately pierced quadrilobes. We find sculptures, also, such as those on the lintels of the Holy Sepulchre or the admirable figure capitals at Nazareth, carved about 1187, which reveal a striking similarity to certain capitals at Plaimpied, near Bourges, which suggests that they may be the work of a sculptor who came from Berry to Palestine.

None of the urban structures or the palaces built by the crusaders has survived. There is no trace, except in the chronicles, of those splendid residences beside the sea where long-forgotten princesses lived, surrounded by luxury and refinement.

A traveller passing through Beirut in 1212 gave the following description of the hall in the castle of the lords of Ibelin: 'This hall faces the sea on one side, on the other the gardens surrounding the town. The floor is paved with mosaic imitating a body of water rippled by a gentle breeze. The walls are inlaid with marble, and the ceiling is painted like an image of the heavens. In this art of decoration the Syrians, the Saracens and the Greeks excel and vie with one another. In the middle of the hall there is a large multicoloured marble basin; in the centre a dragon spouts a jet of clear water which spreads a delicious coolness throughout the hall.'

Contacts with Arab art and thought

A chivalrous spirit reigned in the two hostile camps of the Holy Land. The Frankish and Moslem nobles after having faced each other in bitter combat entertained friendly relations during long periods of armistice, bringing about one of the most unexpected results of the occupation — the awakening and subsequent cultivation of intellectual interests on the part of the Frankish nobles. These rough warriors, coming into contact with Moslem scholars and writers, found that a new world was opened to them. Art and thought appeared to them to be a miraculous well from which they had never drawn. The Arab world introduced them to studies of which they had scarcely heard before, such as geography, astronomy and medicine. The influence of the Arabs in the field of letters was also considerable. To this influence the West owed those historical narratives and memoirs of which the works of Ernoul and Joinville are examples.

If European art penetrated to the Levant, the Latins were no less attracted by the industrial arts in which the Arabs excelled. The Syrian markets offered luxury products unknown to the Occident. The textile trade was particularly flourishing, with watered silks from Tripoli, produced by workshops which in 1283 employed four thousand craftsmen, 'camlets' (a precious textile of camel's hair and silk) from Tortosa, brocades from Antioch, taffetas from Tyre, damasks from Damascus, silks from China and cotton from Persia and Egypt. There were furs from Armenia, ostrich feathers (which were greatly cherished by the European knights as plumes for their helmets) from Arabia, pottery and glassware from Damascus and lamps, beakers and goblets from Acre, Tyre and Jaffa. Perfumes, aromatic plants such as rose-trees, lilies and henna, pharmaceutical plants, balsams, syrups, and digestives, and vegetables hitherto unknown in the West, were all imported from the East. The Europeans also made their acquaintance with sugar, which was introduced into Europe at this period.

The Kingdom of Cyprus

At the end of the 12th century the crusaders annexed Cyprus, which was made an independent kingdom ruled for two centuries by the Lusignans of Poitou. A century later Cyprus benefited greatly from the collapse of the Christian colony in the Holy Land after the capture of Acre in 1291. The island then became the main link between East and West, an indispensable meeting-place for Christian and Moslem merchants after the Pope had prohibited Christian merchants to enter the ports of the infidels. In the 14th century Famagusta was the richest port in the Mediterranean.

The arts flourished in this opulence. Princes and wealthy citizens made considerable donations for religious buildings which were built by French architects. The Gothic churches there show the same beauty and elegance as those of France, with an added charm due to the Oriental sky, the warm tones of the stone and the picturesque setting, among palm trees, which presented an exotic background to churches whose models stood on the banks of the Seine and the Oise. The plan of Sta Sophia, the cathedral of Nicosia (the capital of Cyprus), is that of Notre Dame in Paris and of the church at Mantes. The cathedral of St Nicolas at Famagusta, 940 begun in 1300, is built in the style of the churches of Champagne. An inscription in French indicates the progress in 1311 of the work, which was directed by Bishop Baldwin Lambert. The towers and the portals of the façade, with their large pointed pediments, are reminiscent of Reims; the apse is almost a replica of that of St Urbain at Troyes.

The Lusignans made Cyprus a prosperous island; their splendid feasts and luxurious way of life dazzled travellers. The memory of their daring naval raids on Egypt, Palestine and Armenia has survived in the epic poems and the chronicles of the great feats of prowess which were reported by poets and writers of the time, such as Boccaccio, Petrarch and Froissart, who praised the deeds of the Lusignan King Peter I, 'the gentle king of Cyprus', one of the noblest figures of contemporary knighthood, who stayed for a time at the papal court in Avignon and was present in 1334 at the coronation of Charles V in Reims. Leon VI, king of Cyprus and Armenia, came to France, died in Paris in 1339 and was buried in St Denis. Cyprus thus recalls a past of art, opulence and elegance, and its history forms another chapter of the history of France.

HISTORICAL SUMMARY: Gothic art

Archeology. Jacques Androuet du Cerceau published, in 1576–1579, the first study of medieval monuments. After the initial work of Leroux d'Agincourt in 1822 and the work of J. Labarte, Viet, Ramée, H. Révoil, L. de Linas and F. de Lasteyrie, the Ecole des Chartes undertook in 1847 the teaching of medieval archaeology. Quicherat introduced a strict method which has been further elaborated by Count R. de Lasteyrie, E. Lefèvre-Pontalis, L. Courajod, Emile Mâle, who inaugurated the study of medieval iconography, and, today, by Marcel Aubert.

History. The papacy, still all-powerful under Innocent III (1198–1216) who was able to deprive Otto IV of his Empire and to depose John of England, declined after the death of Boniface VIII (1294–1303) until the schism of 1348. The Church, however, profited from the spiritual impulse of the great monastic Orders—the Franciscans (St Francis, 1182–1226), the Dominicans (St Dominic, 1170–1221), the Carmelites—and the military Orders founded during the crusades—the Hospitallers and Templars.

The 14th century gave birth to the secular state, and national interests began to be predominant (the Hundred Years' War). There was a further decline of the papacy (the Holy See transferred to Avignon under Clement V, in 1309).

The bourgeoisie, a new social class, rose in the course of the 12th and 13th centuries with the growth of towns. First in Italy, then in Flanders, France, Germany and England great cities began to thrive at the junctions of rivers and commercial routes.

The town dwellers, grouped round their bishop, began to build the Gothic cathedrals. The bourgeoisie acquired wealth by trade, industry and finance. Powerful commercial organisations existed in the 13th and 14th centuries in northern Italy and Germany; the bankers of Lombardy, Florence, Cahors and Arras financed the merchants who, encouraged by the crusades, ventured far into the East (Marco Polo's journey to China in 1271–1295).

With the development of administration and the growing wealth, the class of clerks and lawyers became increasingly important. The lawyers, having studied Roman law (at the university of Bologna), admired Roman institutions. In England the lawgivers among the kings (Henry II and Edward I) established a coherent body of secular law with the help of Romanist lawyers, of whom the most famous was Franciscus Accursius, son of Franciscus Accursius of Bologna.

In France lawyers such as G. de Plaisians, G. de Nogaret, P. Dubois and P. Flote favoured the 'centralised state' of the Roman type and propagated the idea of the king as the supreme ruler and lawgiver. Referring to this right, Nogaret made an unsuccessful attempt at Anagni in 1303 to arrest Boniface VIII and thus to break the temporal power of the Pope.

With the end of the crusades, chivalry in Europe lost its heroic glamour. The cosmopolitan aristocracy of the 13th century declined.

Learning and the arts. The desire for learning increased with the improvement in material life. In Italy and Flanders, from the 12th century, public schools independent of the Church were founded, using the vernacular for instruction. Paper, invented by the Chinese and brought by the Tartars to the Arab countries and Spain, was known in Sicily from 1145. At first used only for official documents, it began to play an important role in cultural life during the 14th century, when it came to be used for copies of books.

Universities were founded in the 12th century: Bologna and Paris, c. 1120; Padua, 1222; Naples, 1224. New foundations followed in the 13th century, when they began to play a major role in national and often international life. Their cultural influence replaced that of the great abbeys. The university of Paris, so powerful that it dared, in 1254, to oppose the authority of the Pope, attracted the distinguished scholars of Europe. St Bonaventura (1221–1274), general of the Franciscans, taught there from 1248 to 1255, Albertus Magnus from 1245 to 1248 and St Thomas Aquinas from 1252 to 1259. Roger Bacon was there from 1244 to 1252. John Duns Scotus, too, came to Paris. Around 1270 Oxford became the rival of Paris and contributed much to the triumph of the nominalism of William of Occam (1300–1347). In the course of the 14th century the universities laid the foundations of scientific knowledge. At the same time a mystical movement arose in the monasteries of the Rhineland (St Gertrude, Meister Eckhart, c. 1260–1327, Heinrich Suso, c. 1295–1366, Johann Tauler, c. 1300–1361, 'Anonymous of Frankfurt', author of the *Theologia Germanica*, Ruysbroeck, 1293–1381, whose work is close to the lyrical tenderness of St Francis; he was inspired by the *Fioretti*, a well-known Italian work of the period).

French literature and thought, as well as French art, were predominant in the 13th century. Poet-musicians, called troubadours, used the *langue d'oc* in the south in Limousin, Périgord, Languedoc, Provence and Aquitaine (Marcabru, Guiraut Riquier, Bernard de Ventadour), and the *langue d'oïl* in the north in Champagne, Normandy, Flanders, Hainaut and Artois (Thibaut de Champagne, Gautier d'Epinal, Gautier de Coinci, Adam de la Halle). They introduced into European literature the cults of woman, of the Virgin and of courtly love and the ideals of chivalry. The German Minnesänger were inspired by them during the 13th and 14th centuries. Their court poetry enriched religious and secular iconography with emo-

tional and allegorical refinements. Between 1262 and 1268, French, according to Brunetto Latini in his *Trésor*, was 'the most delectable and universally spoken language'. In the 14th century the literary leadership passed to the Italians, who had absorbed the epics of chivalry, the lyrics of the troubadours and the traditions of courtly love. Dante's *Divina Commedia* (1312–1317) is the consummate expression of this change.

Development of Gothic art. Gothic art evolved in the course of four centuries; in the 12th century it was still a form of Romanesque which had adopted rib vaulting. In the 13th century its structural character was fully developed, i.e. a preponderance of openwork over solid form; an upward thrust—verticality. Gothic style spread over the whole of Europe in the 13th and 14th centuries; only in Italy was its influence of short duration. In northern Europe, especially in Flanders, Gothic survived during the 15th century in its mannerist form as the Flamboyant style, and assumed a quality of 'mystic naturalism'.

FRANCE

Contribution. Gothic art originated and developed in the Ile-de-France. The Capetian dynasty triumphed over the Plantagenets under the capable Philip Augustus (1180–1223) and enlarged the royal possessions under Louis VIII (crusade against the Albigenses), the regent Blanche of Castile and Philip III the Bold.

Two great kings, Louis IX, the legendary St Louis (1226–1270) by his moral example, and Philip IV the Fair by his shrewdness as a politician, made France the leading power in the West. In 1328 the kingdom passed to the younger branch of the house of Valois. Philip VI, John II the Good and Charles V, disputing the right of the English dynasty to the French crown, waged the Hundred Years' War (1337–1453). Its disasters (Sluys, Crécy, Poitiers, Agincourt, the loss of Flanders and Guienne) and its peasant revolts and plagues destroyed the achievements of the 13th century but in the end brought greater national unity, symbolised by the figure of Joan of Arc. Charles V, a great patron of the arts, restored to the Ile-de-France its leading cultural position. His brothers, Louis of Anjou (who commissioned the famous tapestry, the Apocalypse of Angers), John of Berry and Philip of Burgundy—founder of the Chartreuse of Champmol—furthered the arts in their own domains.

Contemporary literature exerted a considerable influence on Gothic imagery. There were, for example, chivalric romances, following Chrétien de Troyes (d. 1195) and Marie de France, the poems about the Round Table, the *Roman de la Rose*, the lyrical poetry of Thibaut de Champagne, Adam de la Halle and Colin

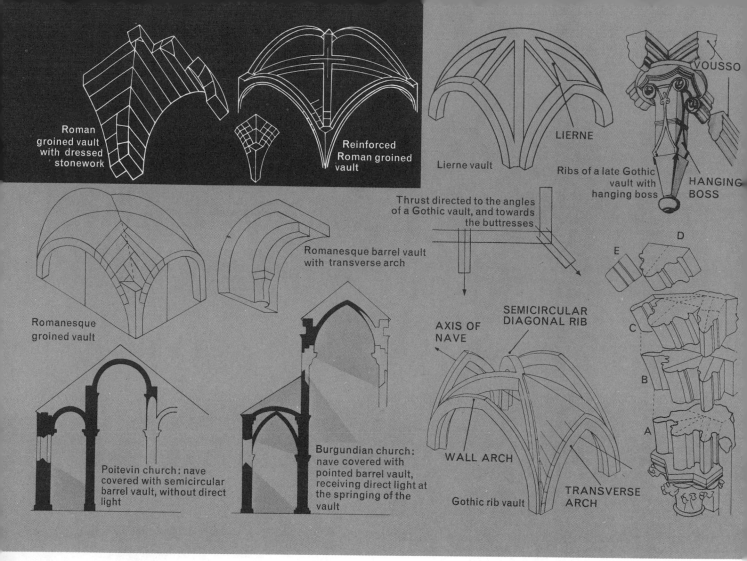

Roman groined vault with dressed stonework

Reinforced Roman groined vault

Lierne vault

LIERNE

VOUSSO

Ribs of a late Gothic vault with hanging boss

HANGING BOSS

Romanesque groined vault

Romanesque barrel vault with transverse arch

Thrust directed to the angles of a Gothic vault, and towards the buttresses

D

E

Poitevin church: nave covered with semicircular barrel vault, without direct light

Burgundian church: nave covered with pointed barrel vault, receiving direct light at the springing of the vault

AXIS OF NAVE

SEMICIRCULAR DIAGONAL RIB

C

B

WALL ARCH

A

Gothic rib vault

TRANSVERSE ARCH

941. Kinds of vaulting.

Muset, the spirited *Roman de Renart* and above all the religious plays originating in the 12th and 13th centuries. Arising in response to the popular desire to act out the sacred stories (miracle and mystery plays), these developed in the 14th century into an independent dramatic form. Special brotherhoods were founded to perform these stories of the lives of Christ and the saints. (The one formed for the Passion of Nantes is the oldest known.)

With the rise of national feeling came a new form of historiography—the Grandes Chroniques de France (written in French, *c.* 1274, at St Denis); the epics of the crusades (Villehardouin, *c.* 1152–1213, Joinville, 1224–1317, the friend of St Louis). With Froissart, 1337–1410, the writing of history became more realistic and closer to life.

In music, Léonin (late 12th century) and Pérotin (13th century) of the school of Notre Dame, perfected the organum style of the 'ars antiqua', while the 14th century of *ars nova* of Philippe de Vitry and Guillaume de Machant, with its freely moving parts, opened the way to 15th-century polyphony.

Religious architecture of the 12th century. Characteristic of the first half of the 12th century is the tentative use of the cross-rib (known before the 12th century). The first attempts in France date from the second half of the 12th century;

examples in the Paris region are St Martin des Champs (still Romanesque in appearance but actually the first Gothic monument in Paris), the collegiate church at Poissy and the choir of St Pierre in Montmartre; examples in the provinces are the church at Bellefontaine, St Etienne at Beauvais and the bishops' chapel at Laon. The two most important monuments are St Denis (dedicated 1144) [**780**] and the cathedral of Sens (begun *c.* 1140), the first large Gothic cathedral. It had little effect on contemporary French architecture though it influenced the plan of Canterbury cathedral [**862, 863**]. The transition towards a pure Gothic style proceeded almost imperceptibly. Anglo-Norman buildings served as models for French Gothic churches of the second half of the 12th century; in this school, in addition to the rib vault with four or six ribs, the characteristic features were common to both Romanesque and Gothic: the façade flanked by two towers; the gallery above the aisles; the circulating passage at window level; the supports of the arcades alternating between columns and compound piers. Typical buildings are: the cathedral of Evreux [**836**] and, at Caen, the Abbaye aux Hommes (St Etienne) and the Abbaye aux Dames (La Trinité) [**646, 647, 752**].

The second half of the 12th century saw the rise of the great cathedrals: Noyon, 1145 [**848**]; Laon, 1155–1160

[**839**]; Soissons, 1180 [**741, 859**], Paris, 1163 [**783–792**]. Characteristic features are: sexpartite vaults and galleries above the aisles. Laon and Noyon cathedrals have an elevation of four storeys, copied from Tournai, consisting of arcades, gallery, triforium and clerestory; at Laon and Soissons the transepts end in a semi-circle [**858**]; at Notre Dame in Paris the alternating supports were replaced for the first time by strong monocylindrical columns. Paris influenced St Germer de Fly, Mantes, Arcueil, St Lev d'Esserent, Moret, Bourges [**857**] and Le Mans. Buildings in the north show a tendency towards verticality; those of the west have robust and thickset architectural masses, closely related to Romanesque tradition.

In Burgundy the architecture of the 12th century was greatly influenced by the ideas of Bernard of Clairvaux, the founder of the Cistercian Order. Characteristics of their buildings were: reduced elevation; absence of sculpture; economy and harmony in the arrangement of masses; simplified proportions; absence of ambulatory and radiating chapels. The Cistercians adopted the rib vault at an early period, e.g. abbeys of Pontigny (1150), Preuilly and Noirlac and the church of Cîteaux (1148, now demolished). The Cistercian style did not dominate the whole of Burgundy (the choir of Vézelay was influenced by St

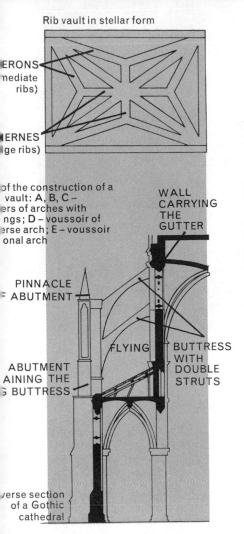

Rib vault in stellar form

ERONS
nediate
ribs)

IERNES
(ge ribs)

of the construction of a
vault: A, B, C –
ers of arches with
ngs; D – voussoir of
erse arch; E – voussoir
onal arch

WALL
CARRYING
THE
GUTTER

PINNACLE
F ABUTMENT

ABUTMENT
AINING THE
G BUTTRESS

FLYING BUTTRESS
WITH
DOUBLE
STRUTS

verse section
of a Gothic
cathedral

Denis, the elevation by Sens), but it had considerable influence at Heisterbach (1202) and Ebrach in Germany and at Fossanova and Casamari in Italy.

Religious architecture of the 13th century.

There are two main periods: 1. 1200–1250 – the 'classical' style of the great cathedrals. 2. After 1250 – the Radiating style.

General characteristics. The plan was the same as that of the Romanesque basilica, with a considerably enlarged choir. At Chartres, Reims and Amiens the choir alone retains the double aisles with radiating chapels (five at Chartres and Reims, seven at Amiens, Clermont-Ferrand and Narbonne, eleven at the old cathedral of Orléans and thirteen at Le Mans [**794, 813, 824**]).

The elevation consisted of three storeys; there was a triforium but no gallery. The nave arcades now rested on compound piers with a column as nucleus to which were added other smaller columns. The windows were considerably enlarged in width and height, the openings being more important than the solid walls. In Chartres for the first time they covered the whole bay [**805**]. Surfaces were increasingly divided into smaller units. The upper part of the façade was perforated by a large round window, the vault divided into four compartments. The bays were rectangular; each aisle bay

corresponded to a nave bay. (Only in Burgundy did the sexpartite vault persist.) The elongated irregular vaults were raised higher and higher; 123 ft at Reims, 140 at Amiens and 157 at Beauvais. The system of buttressing became more and more conspicuous (St Urbain at Troyes); the flying buttresses were crowned with pinnacles frequently transformed into niches to contain statues (Reims). The number of bell towers multiplied: seven at Laon, nine at Chartres; the length of the nave increased (over 390 ft at Bourges, 416 ft at Paris, 427 ft at Chartres, 453 ft at Reims and 475 at Amiens). The façades followed the system developed in the 12th century at Laon and Paris, derived from Norman models, which consisted of two horizontal and two vertical visions, three portals and a rose window in the upper centre.

The great cathedrals. Chartres [**793–810**] was consecrated on 17th October 1260, after two fires (reconstruction begun in 1194; vaulting completed in 1220, the portals about 1240 and the porches about 1250). The plan of the east end was determined by the ancient crypt over which it was erected. The windows are broken up into two lancets; the flying buttresses are traceried [**800**]. Chartres served as a model for the choir of the cathedral of Soissons.

Reims [**811–821**] was begun in 1211, replacing two earlier basilicas – a Merovingian and a Carolingian one. The architects were Jean d'Orbais (1211–1231), Jean Le Loup (1231–1247), Gaucher of Reims (1247–1255) and Bernard of Soissons (1255–1290). The cathedral of Reims combines all the characteristics of classical Gothic art of the 13th century.

Amiens [**822–834**] was begun in 1220. The architects were Robert de Luzarches and Thomas and Renaut de Cormont. The nave was ready for use for divine service in 1236; the choir was completed in 1250. A fire in 1258 necessitated various modifications which marked the beginning of the Radiating style. The east end served as a model for Beauvais, Cologne, Tours, Troyes, Antwerp, Limoges, Narbonne, Clermont-Ferrand, Rodez, Toulouse, Gerona and Barcelona. An innovation was the pierced openwork of the choir triforium.

The three cathedrals described above were erected in the Ile-de-France, Champagne and Picardy.

In Normandy Gothic architecture, though influenced by the Ile-de-France and Burgundy, maintained certain characteristics of its own such as the square lantern tower over the crossing, the sharply pointed arches, the decorative system and the many deeply hollowed mouldings. The finest 13th-century cathedrals in Normandy are found south of the Seine: Lisieux, rebuilt in 1170, the choir between 1226 and 1235; Bayeux, where the Romanesque nave was altered in the middle of the 13th century [**835**] (choir built in 1235); Coutances, where the nave was built 1218–1238, choir and transept, 1251–1274. Coutances was imitated at Le Mans (consecrated in 1254) and at Toledo. Monastic architecture held an important

place in Normandy. Apart from the Cistercians (Mortemer, Savigny) the Benedictines built the most important churches: La Trinité at Fécamp (1187); St Ouen at Rouen (completed in 1339 [**837**]) in the Flamboyant style; Mont St Michel (1203–1228 [**860**]). Norman characteristics were less conspicuous in buildings erected during the 14th century, but reappeared in the 15th century in the Rouen Flamboyant style, influenced by English Gothic [**872, 928**].

In southern France some of the cathedrals followed the example of the north: Clermont-Ferrand [**844**]; Narbonne (choir begun in 1272); Limoges (begun in 1273); probably Rodez (begun in 1277); they were all influenced by Amiens through their architect, Jean Deschamps. Bayonne is related to Soissons and Reims; Toulouse, Bordeaux and the choir of St Nazaire at Carcassonne (*c.* 1267) [**847**] are influenced by northern examples. In contrast to the northern style brick churches with aisleless naves (or sometimes double naves) were characteristic of the south. The finest example of an aisleless nave is the cathedral of Albi [**855**]; the Church of the Jacobins at Toulouse [**846**] has a double nave. This latter type is found in Spain.

In Burgundy in the 13th century the sexpartite vault continued to be used over the nave, and the arcades generally rested on simple cylindrical supports with arches springing from the capitals (Notre Dame, Dijon, 1230–1252, consecrated in 1334; the choir was influenced by Laon; the triforium resembles that of Braisne; there is a square lantern tower over the crossing). The triforium was suppressed early on (St Père sous Vézelay, Semur en Auxois [**843**]).

The Radiating style. This style grew out of the desire to build churches ever higher, lighter and more luminous. To achieve this the windows of the clerestory were enlarged until they replaced the triforium; the large rose windows, cut like spokes of a wheel, were made still larger, more complex and more numerous; the capitals were replaced towards the end of the 13th century by carved bands of foliage and the piers by clusters of smaller columns. Early examples of this new style are the Sainte Chapelle in Paris (consecrated in 1248 [**762, 856**]) and the transept of Notre Dame in Paris (*c.* 1254–1270). Mature examples are St Urbain at Troyes [**871**], St Thibault en Auxois and the choir of the cathedral of Nevers (13th–14th centuries [**870**]). Towards the end of the 14th century curved forms multiply and pervade the decoration of the architecture; it is the beginning of the Flamboyant style.

Civil and military architecture.

The evolution of other architectural forms followed that of the churches. The military buildings had a simpler and more massive structure, preserving an archaic appearance. Several of the royal palaces are known to us from illuminated manuscripts of the 15th century, especially by the illustrations in the Très Riches Heures of the Duke of Berry [**949**]. Of that in the

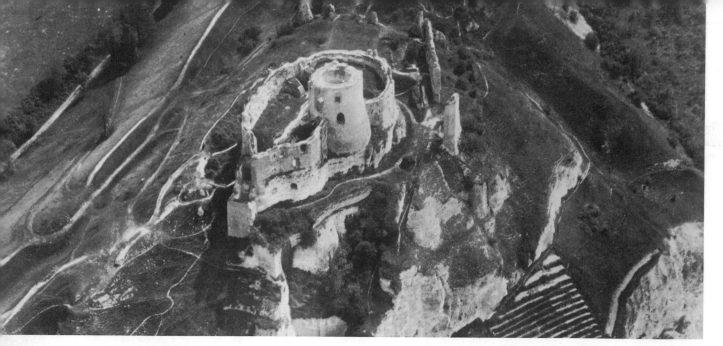

942. ROMANESQUE. Château Gaillard, built by Richard Coeur de Lion. 1195–1196.

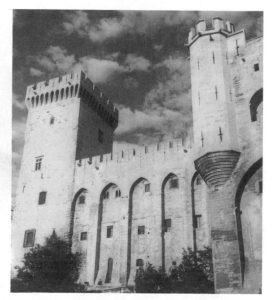

943. GOTHIC. The Palace of the Popes, Avignon.

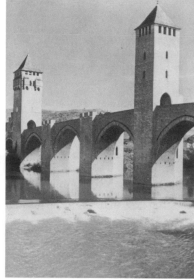

944. GOTHIC. The Pont Valentré at Cahors. c. 1308.

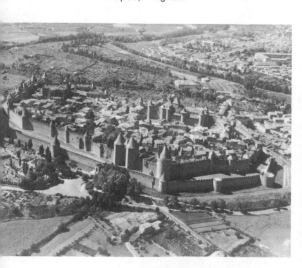

945. GOTHIC. General view of the fortifications of Carcassonne, rebuilt under St Louis and Philip the Bold between 1240 and 1285 on the site of a Visigothic fortress.

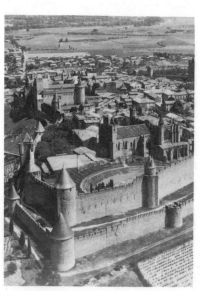

946. GOTHIC. Detail of the fortifications of Carcassonne.

Cité in Paris, apart from the Sainte Chapelle, its oratory, only three halls have survived, within the precincts of the present Palais de Justice. Raymond du Temple turned the Louvre (of which he retained the keep and the old towers) into the favourite residence of Charles V, where he placed his collections and books. The royal castle of Vincennes, begun in 1337, with a square keep with four towers rising 170 feet high at the corners, is typical of these powerful structures. Coucy, destroyed in 1918, was a masterpiece of this type of architecture and had an enormous circular keep; the width of its walls was 24 ft. The château at Angers (1228–1238) [**951**] was built in alternating bands of black slate, granite and light sandstone and had seventeen towers 130 feet high.

In the course of the 14th century these fortresses were changed into fortified residences provided with increasingly luxurious living quarters.

The fortification of towns developed considerably during the 13th century. Carcassonne [**945, 946**], built in the reigns of St Louis and Philip the Bold and restored in the 19th century, had a commanding position overlooking the valley of the Aude. The fortifications consisted of a castle surrounded by a double wall with fifty-two towers. In contrast Aigues Mortes [**947, 948**], built in the reign of St Louis, is a fortified town in flat country. It was protected by a wall system forming a rectangle strengthened at the angles by round towers. The ramparts were pierced by five gates crowned with watchtowers. The fortifications of Villeneuve lès Avignon (1293–1307) had two enormous towers overlooking the Rhône valley and enabled the French king to keep an eye on the Pope in Avignon. The original Palace of the Popes [**943**], built by Pope John XXII on a rock high up on the other side of the Rhône and protected by huge square machicolated towers, was southern in character. The new building, erected in the second half of the 14th century under Clement VI and Innocent VI by

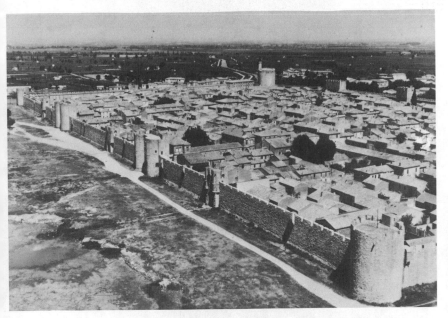

947. GOTHIC. View of Aigues Mortes.

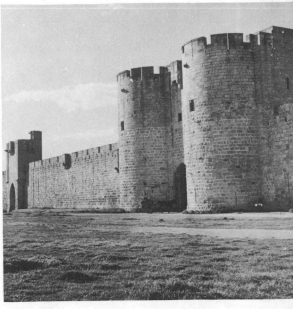

948. GOTHIC. Detail of the walls of Aigues Mortes, completed under Philip the Fair. End of the 13th century.

Jean de Loubières, is much more Gothic on the inside. Remarkable is the great audience hall with a double nave 170 feet long. The city of Cordes (Tarn) [**950**] is an example of southern fortified towns of the 13th and 14th centuries.

In the 14th century the upper parts of defensive structures were improved upon, especially as regards crenelations and machicolations. Bridges over rivers in the centre of towns were frequently fortified by a succession of towers; an excellent example is the Pont Valentré at Cahors (beginning of the 14th century [**944**]).

Sculpture. Sculpture on the early Gothic buildings continued in the Romanesque manner. The columnar statues on the portal of St Denis [**766**], though mature examples of Romanesque art, by illustrating the types and antitypes in the Old and the New Testaments, express an idea which was typical of Gothic iconography. The best preserved and the finest examples of the early period are the statues on the Royal Portal at Chartres (1145–1155) [**797**]. They were no doubt executed by the same workshop as those at St Denis, related to the sculpture of Languedoc (on the tympanum, the Apocalypse with angels and the twenty-four Elders; on the north portal, the Ascension; on the south portal, the childhood of Christ and the Virgin; on the west portal, the columnar statues representing kings and queens of Judah [**807**]). The influence of these sculptures can be seen at Etampes, Bourges, Le Mans, Angers, Provins, St Loup de Naud and Notre Dame in Paris; there is evidence also of their influence in Flanders, Normandy, Champagne, Burgundy, Aquitaine, Languedoc, England, Germany, Spain, Italy and Nazareth in Palestine.

At the end of the 12th century the sculptured iconography acquired a more humanistic quality; during the 13th century the figures became more emotional and even sentimental in their expression. Favourite subjects were the Virgin and the saints; symbolic figures reflected the

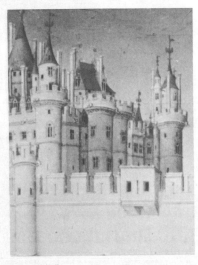

949. The Louvre under Charles V, as seen in the illuminated page of the month of October, in the Très Riches Heures of the Duke of Berry, by the Limbourg brothers. Detail. 1411–1416. *Musée Condé, Chantilly.*

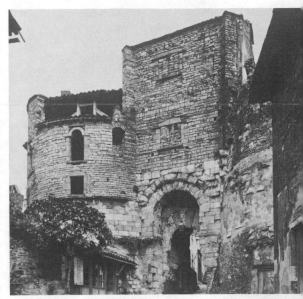

950. GOTHIC. Ramparts of Cordes, which gave its name to Cordova in Spain. 13th–14th centuries.

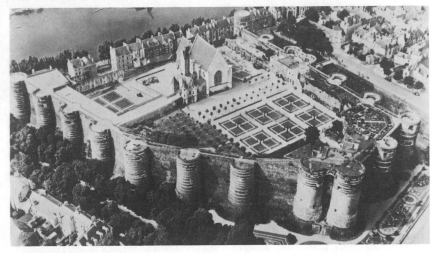

951. GOTHIC. The château of Angers. 1228–1238.

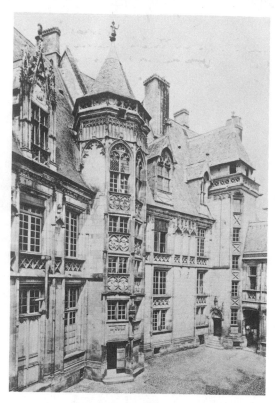

952. GOTHIC. The house of Jacques Coeur at Bourges, built in 1443–1453 for 'the most powerful and richest man of the century', the treasurer of King Charles VII.

953. House of Jacques Coeur. Blind window with sculpture.

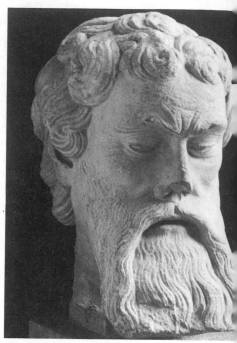

954. GOTHIC. Head of an Apostle, from the chapel of the château of Mehun sur Yèvre, attributed to Jean de Cambrai. 1408–1415. *Louvre.*

intellectualism of the contemporary scholastic philosophy.

The portal of the Virgin on the cathedral of Senlis [**838**] marked the first step towards the classical Gothic sculpture of the cathedral of Laon (Last Judgment and the two portals of the Virgin). At Chartres the many statues on the two façades of the transepts achieved a rare blending of realism and idealism [**803, 809**]. The west front of Notre Dame in Paris is an example of formal beauty and of the harmony between composition and architectural frame (portal of the Virgin [**789, 790**]), perceptible in spite of the restorations by Viollet-le-Duc. The sculptures on the portals of Amiens cathedral are well preserved; though less perfect architectonically, they have given us such masterpieces of Gothic art as the statue of St Firmin, the Vierge, Dorée and the Beau Dieu [**828, 829, 831, 833, 834**].

About the middle of the 13th century the statues tended to become isolated from the architectural background. At Reims, for example, with its welter of ornament, the figures are naturalistic, each one aimed at capturing an individual expression. Portraits are introduced; the foliage is realistic and no longer merely decorative. The sculpture of Champagne during the second half of the 13th century expressed the spirit of Radiating Gothic. It influenced the sculptures at Strasbourg (portals of the Virtues and the Vices and of the Wise and Foolish Virgins [**877, 880, 882, 883**]). Sculpture inside the building becomes more important. Although the figures on the choir screen of Notre Dame, Paris (by Jean Ravy, completed by Jean le Bouteiller in 1351), still preserve the dignified grandeur of the 13th century, the general tendency in the evolution of

sculpture during the 14th century was towards a tormented and expressive realism which anticipated Klaus Sluter and the emotionalism of the 15th century.

Tomb figures mark the development of sculpture towards portraiture. In the 14th and 15th centuries the desire for realistic representation went as far as the use of death masks for this type of statue. The tombs of the French kings at St Denis, in spite of damage inflicted during the Revolution, display some magnificent portraits. The earliest is that of Philip the Bold (1298–1307), carved by Jean d'Arras under the direction of Pierre de Chelles. Jean Pépin de Huy (of Flemish origin), who settled in Paris, worked for Mahaut d'Artois between 1317 and 1320; he carved the tomb of Robert II of Artois [**958**]. His assistants were Beaudoin de Merre and Guillaume Alou. Jean de Liège (d. 1383) was the sculptor in 1372 of the tomb statues (showing the entrails) of Charles IV and Jeanne d'Evreux (in the Louvre), those of Charles V and Jeanne de Bourbon, and of the tomb figure of Philippa of Hainaut, queen of England (in Westminster abbey, 1366–1377); he is probably also the sculptor of the statues of Jeanne de Bourbon and Charles V (Louvre) which came from the hospital of the Quinze-Vingts (*c.* 1390) [**905, 906**]. Other sculptors who worked at the royal court in Paris towards 1360–1370 were Jean de Launay, Jean de St Romain, Jean de Chartres and Guy de Dammartin (d. *c.* 1400). Many artists were patronised by the Duke of Berry, for example André Beauneveu (*c.* 1330–*c.* 1403), painter, illuminator and sculptor, who worked at Amiens and St Denis and in England and the Netherlands before he settled in Bourges. His pupil Jean de Cambrai (d.

1438) executed the Duke's tomb in the cathedral of Bourges and worked in Courtrai and Cambrai. The Nine Knights (les Neuf Preux et Neuf Preuses) of the Tour Maubergeon was a work of this group of artists. The sculptors at the court of the Duke of Burgundy founded the Franco-German school at Dijon. Among them were Jean de Marville (d. 1389) and the great Klaus Sluter (d. 1406), whose art was the perfect expression of the 14th century; Marville was a Fleming trained in Paris, who carved the tomb of Philip the Bold of Burgundy at the Chartreuse of Champmol (1380); Klaus Sluter, born in Haarlem, worked in Brussels before he settled in Dijon in 1385 at the court of Philip of Burgundy; he was the great inaugurator of a powerful realism in portraiture and the creator of a new expressionist treatment of deeply hollowed drapery folds animated by a play of light and shadow characteristic of Burgundian art. His major works were for the Chartreuse of Champmol: the portal of the church, the Calvary in the great cloister and the tomb of the Duke, which was completed by his pupils.

Painting. Monumental painting, though no longer a major art as it had been in the Romanesque churches, was not entirely abandoned (St Martin at Etigny, Apostle figure at Montbellet, Virgin at St Floret, Apostle figure at Vic le Comte, the dome of Cahors, *c.* 1315).

Painting decorated the façades of cathedrals and churches and embellished the monumental statues. In the 14th century the palaces and castles contained mural paintings (Palace of the Popes in Avignon [**922**]).

The stained glass window, as an in

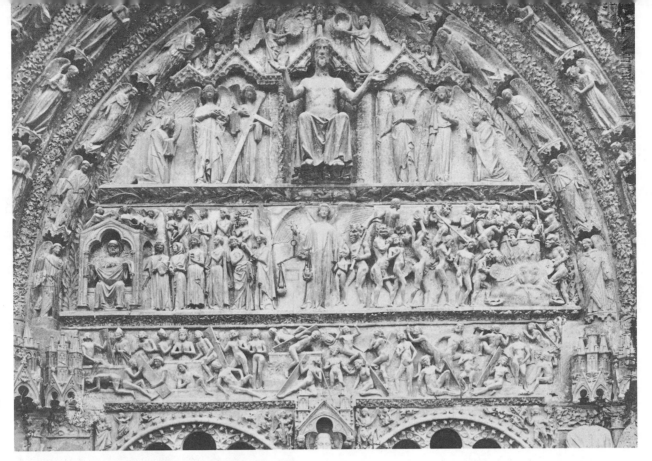

955. GOTHIC. Last Judgment. Central tympanum on the façade of Bourges cathedral. Second half of the 13th century.

tegral part of the architecture and an ideal medium for symbolic expression, held the first place. Between 1145 and 1250, with the enlargement of the bays, the stained glass window grew larger and more intense in colour: deep blues, purplish reds and vivid greens are characteristic of this period (abbey church of Orbais, choir of Le Mans and, above all, Chartres [**801**]); the most magnificent ensemble of stained glass of this period, consisting of 146 windows and 1,395 subjects, is at the Sainte Chapelle [**856**]. After 1260 grisaille (grey monochrome) reappeared, the tones became lighter and yellow was added. The windows gained in refinement what they had lost in monumentality. During the 14th century the first efforts were made to develop a technique of naturalistic painting. Precise outlines and shading which created the illusion of modelling made their appearance in the stained glass window of St Urbain at Troyes, Beauvais, Bourges [**853**], Rouen, Evreux and St Ouen at Rouen.

The manuscript illuminators of the 13th century took their inspiration from the stained glass windows and developed a greater realism without sacrificing their decorative sense. The famous illuminators of Paris were laymen; they worked for the king. Outstanding works were: the Psalter of St Louis (c. 1256) [**917**]; the so-called Psalter of Blanche of Castile (c. 1230); the Breviary of Philip the Fair (attributed to Master Honoré [**918**]). These illuminators also illustrated secular works—poems and romances. The curious notebook of Villard de Honnecourt, travelling architect, is valuable for our knowledge of medieval drawing technique [**758**]. In the 14th century Jean

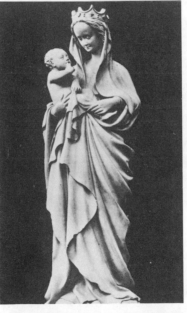

956. GOTHIC. The Virgin of Auzon. Stone. 15th century. *Collegiate Church of St Laurent.*

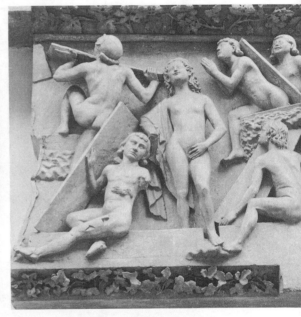

957. Detail of the Resurrection of the Dead (cast), from the Last Judgment (central) tympanum, Bourges.

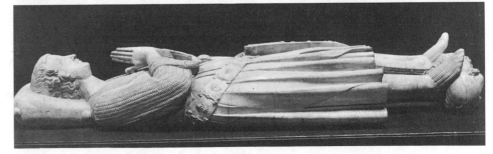

958. GOTHIC. Tomb of Robert II of Artois, in St Denis, by Jean Pépin de Huy. 1317–1320.

375

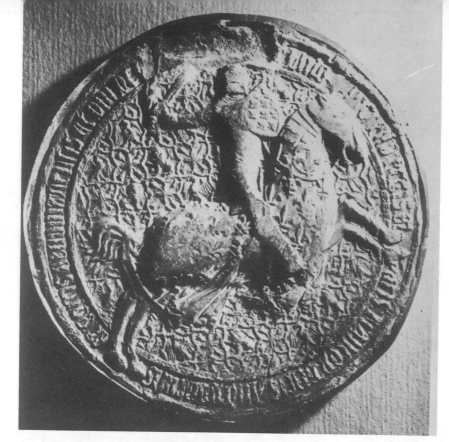

959. GOTHIC. Seal of Louis I, King of
Naples and Duke of Anjou
(1339–1384). *Archives Nationales.*

960. GOTHIC. Chest from St Denis.
Musée Carnavalet, Paris.

961. GOTHIC. Detail from choir stalls
of Poitiers cathedral. 13th century.

Pucelle (Bible of Billyn, Breviary of Belleville [**920**]), with Anciau de Sens and Jacquet Mahiet as his collaborators, brought international fame to the school of Paris with their graceful and elegant illuminations. King Charles V and his brothers, Philip Duke of Burgundy, John Duke of Berry and Louis Duke of Anjou, all bibliophiles and patrons of the arts, invited foreign painters to their courts (Jean de Bruges). The papal court at Avignon introduced Italian artists (Simone Martini, after 1339, and other Sienese painters), who thus established contact with the 14th-century French painters. Paris under Charles VI became a centre where Italian and Netherlandish painters met. After 1385 Dijon, the capital of Burgundy, Melun, and Bourges, where the dukes of Berry resided, attracted a number of Flemish artists.

André Beauneveu (d. *c.* 1403), Jacquemart de Hesdin (d. *c.* 1410), the Master of the Hours of the Maréchal de Boucicaut and the brothers Limbourg were the most outstanding illuminators at the end of the 14th century. The Master of the Bedford Hours and the Rohan Master worked in Paris and in Angers under English occupation. The famous altar frontal, the Parement de Narbonne (in the Louvre), painted in grisaille on silk, and the portrait of King John the Good can be regarded as the first pictures in the sense of easel paintings in France.

The works of Jean de Beaumetz, Melchior Broederlam, Jean Malouel and Henri Bellechose are typical examples of the Franco-Flemish art which was patronised by the Valois.

Woodcuts and engraving developed with the increasing use of paper; though its origin is uncertain, paper was used in France during the 14th century, as is evident by the work of Protat of Mâcon (*c.* 1370). Woodcuts were no doubt inaugurated in the monasteries of Burgundy and spread rapidly over Europe offering to the public inexpensive religious pictures which copied the illuminations.

The minor arts. Tapestry became increasingly important with the growing taste for decoration and luxuries. The Parisian workshops, apparently the leading ones in the 14th century; were surpassed in the 15th century by those of Arras, under the patronage of Mahaut d'Artois. The great work of the period is that of the Apocalypse of Angers. Completed at the end of the 14th century, it was commissioned by the Duke of Anjou and executed by Nicolas Bataille; it was based on cartoons by Jean de Bruges [**967, 968**].

Embroidery followed the general development of the Gothic style and was influenced by architectural decoration (altar frontal in the Musée St Raymond at Toulouse, 14th century).

Religious ivories (statuettes, reliquaries, Crosses, book covers, portable altars) and secular ones (jewel cases, combs, chessboards, etc.) displayed at the end of the 13th and during the 14th centuries a refined mannerism that was greatly

appreciated throughout Europe [**972**]. The elegant figures of the Virgin and Child and the delicately carved triptychs, however, lost some of their charm as they became increasingly precious or realistic towards the end of the 14th century. These small portable works of art played an important part in the diffusion of French Gothic art forms over Europe. A similar role was played by the Limoges enamels.

Limoges enamels and goldsmiths' work, although half a century behind the works of the Ile-de-France in style, were very fine (ciborium of G. Alpais). The goldsmiths of Paris, henceforth laymen, were organised in a flourishing guild under St Louis and produced works inspired by contemporary architecture, e.g. the reliquary of St Taurin of Evreux (1240–1255) [**965**]. In the 14th century the new technique of translucent enamel, which was probably introduced from Italy, helped to perfect the skill of the Parisian goldsmiths. The Virgin of Jeanne d'Evreux (in the Louvre) is their masterpiece [**963**].

The 13th century was an important period in the design of coins and seals. The best pieces of furniture at this time were still made for religious purposes (choir stalls [**961, 962**], pulpits, etc.). From the time of Charles V furniture for everyday use was decorated with carvings, in response to the growing taste for luxuries evident in the extravagance in dress.

ENGLAND

In England in the 13th and 14th centuries the authority of the monarchy was solidly entrenched. Henry II and Richard Coeur de Lion were the most powerful monarchs of their day in Europe.

History. In 1215 the royal authority was opposed by the barons and the clergy and was defined by Magna Carta. This confirmation of ancient rights was endorsed, in some form, a number of times; by Henry III (1217–1272), Edward I (1272–1307), Edward II (1307–1327), Edward III (1327–1377), Richard II (1377–1399) and Henry IV (1399–1413). The contention between the English and the French crown regarding the possession of Guienne led to the Hundred Years' War which was a period which also witnessed the Black Death and the peasant revolt of 1381. The development of trade and shipping enriched England. Cultural life, originally confined to the great monasteries, expanded and flourished. At the university of Oxford, where Robert Grosseteste, John Peckham, Roger Bacon and William of Occam taught, experimental science originated and was henceforth separated from theology. As for literature, the chivalric romances were still written in French, but English was used increasingly, and in 1387 Chaucer published his *Canterbury Tales*.

Religious architecture. From the beginning of the 13th century England developed its own personal Gothic style. Individual characteristics included: 1.

962. GOTHIC. Detail from choir stalls of Poitiers cathedral. 13th century.

963. GOTHIC. Reliquary statue of the Virgin, presented by Jeanne d'Evreux to the abbey of St Denis in 1349. *Louvre.*

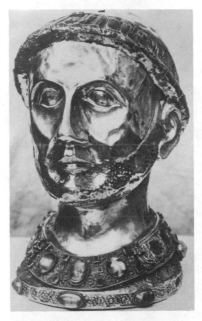

964. GOTHIC. Reliquary head of St Yrieix, with necklace decorated with jewels and filigree. 15th century. *Church of St Yrieix.*

966. GOTHIC. Cover in gilded copper from the Gospels of the Sainte Chapelle, presented by Charles V in 1379. *Cabinet des Médailles, Bibliothèque Nationale, Paris.*

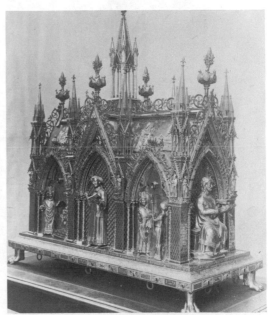

965. GOTHIC. Reliquary of St Taurin in the form of a church, enriched with niello, filigree and precious stones. 1240–1255. *Church of St Taurin, Evreux.*

Moderate height, coupled with an emphasis on length, partly due to the rebuilding of long Romanesque naves and the addition of eastern arms of equal length. 2. Preference for a square east end. The only exceptions are Canterbury, with its unique corona [**863**], and Lichfield and Wells with polygonal Lady chapels [**981**]. 3. Little emphasis on the west front; the triple porch was uncommon and the main entrance was through a lateral porch. 4. Marked projection of the transepts, frequently with additional choir transepts. 5. Retention of a tower over the crossing and two towers at the west end. Only Lichfield retains all three of its spires. 6. Development of the polygonal chapter house with large traceried windows and a

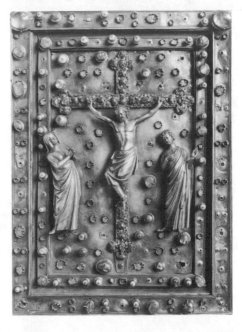

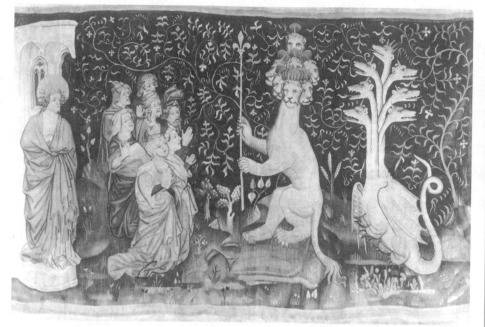

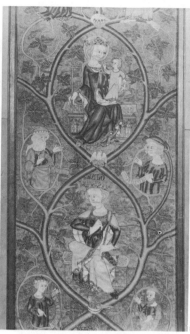

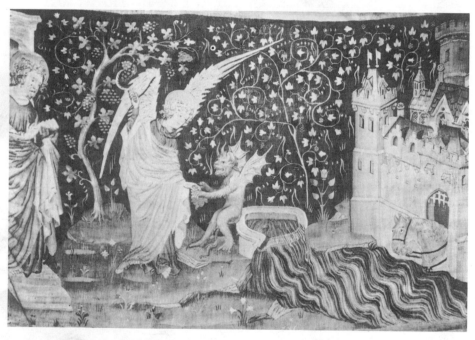

967, 968. GOTHIC. The Apocalypse Angers (details). Tapestry. *Musée des Tapisseries*, *Angers*. Commissioned by Louis of Anjou *c.* 1375. Executed by the Parisian tapestry maker Nicolas Bataille from the cartoons of Jean de Bruges, painter at the court of Charles V. Completed before the end of the 14th century. *Top*. Adoration of the Beast. *Below*. St John watching the angel offering grapes for the demon to throw into the cauldron which subsequently overflows in a river of blood.

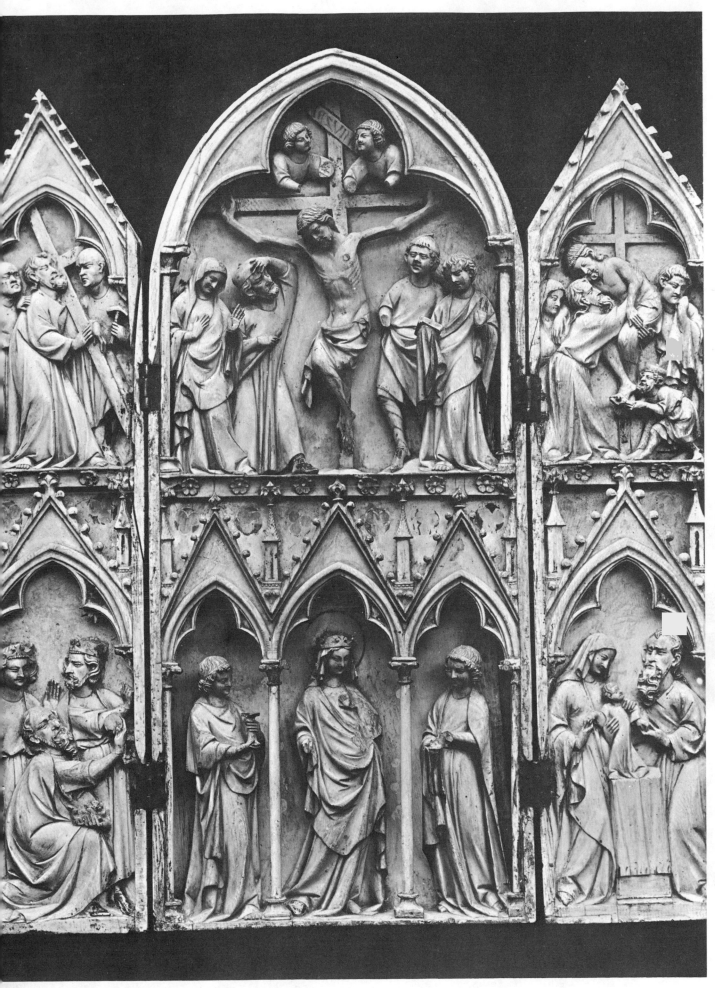

973. GOTHIC. Triptych showing scenes from the life of
Christ. Ivory. Middle of the 14th century. *Musée de Cluny, Paris.*

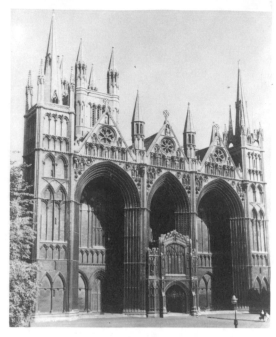

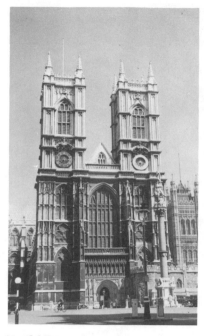

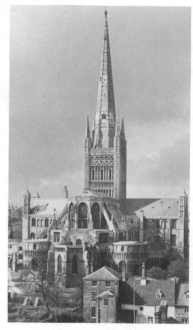

974. GOTHIC. ENGLAND. Peterborough cathedral. The west front. *c.* 1233.

975. GOTHIC. ENGLAND. Westminster abbey. Façade. From 1245.

976. GOTHIC. ENGLAND. Norwich cathedral. View from the east.

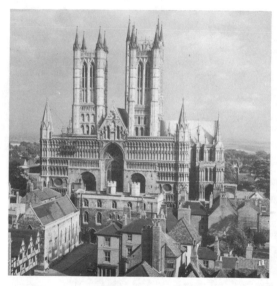

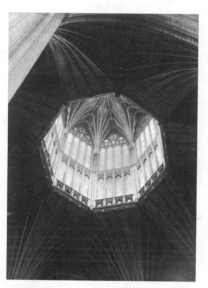

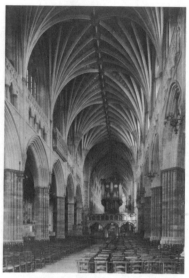

977. GOTHIC. ENGLAND. Lincoln cathedral. The west front *c.* 1220–1230.

978. GOTHIC. ENGLAND. Ely cathedral. View of the octagonal lantern tower. 1342.

979. GOTHIC. ENGLAND. Exeter cathedral. View of the nave, looking east. Begun 1280.

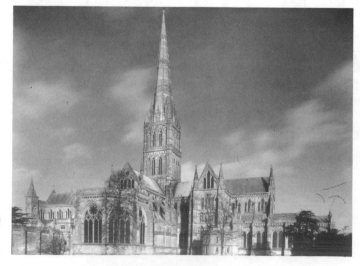

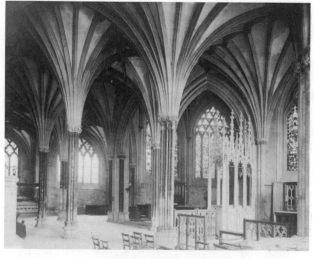

980. GOTHIC. ENGLAND. Salisbury cathedral. View from the east. 1220–1266.

981. GOTHIC. ENGLAND. Wells cathedral. The retro–choir and Lady chapel. 1320–1365.

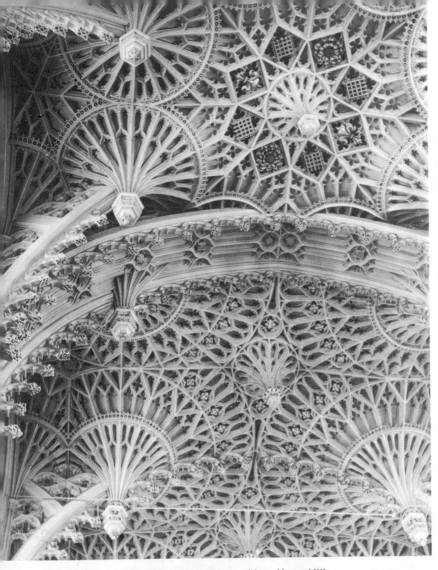

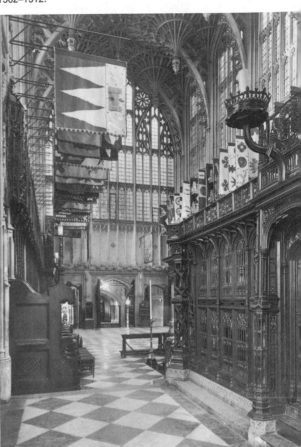

982. GOTHIC. ENGLAND. Westminster abbey. Henry VII's
chapel. Detail of the vaulting.

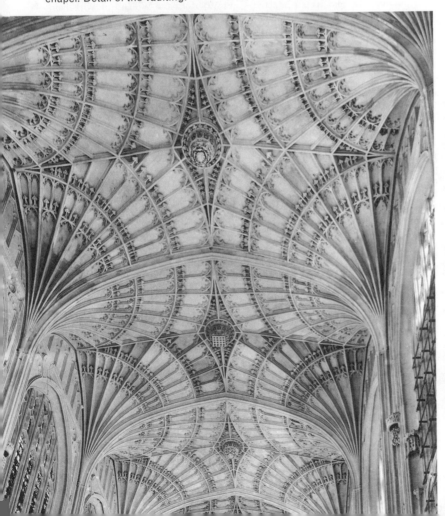

984. *Left*. GOTHIC. ENGLAND.
Cambridge, King's College chapel.
View of the vaulting. 1446–1515.

985. GOTHIC. ENGLAND. St Mary
Redcliffe, Bristol. North porch.
Early 14th century.

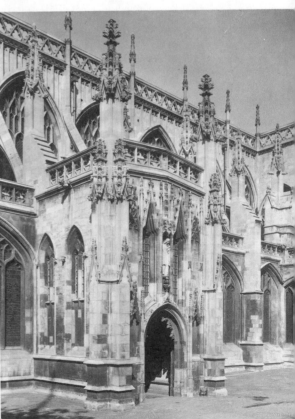

central supporting pillar: Lincoln (1235); Westminster abbey (1254); Salisbury (1265); Wells (1319) [**750**]

Where the majority of French buildings were completed in a generation and from a single design, no English cathedral was finished according to the intentions of the original designer. The nearest are: Salisbury (Early English, with a major addition in the Decorated spire, 1330–1380 [**980**]); Lincoln (Early English, with a Norman front and Decorated retro-choir [**977**]); Exeter (Decorated, with Norman transeptal towers and a Perpendicular west front [**979**]); Bristol (Decorated, with a Perpendicular tower and 19th-century nave).

Three styles can be distinguished: Early English (to 1250); Decorated (1250–1340); Perpendicular (1340–1500)

Early English is characterised by lancet openings, clustered piers with stiff-leaf foliage capitals, lavish use of Purbeck marble and dogtooth ornament. The first three cathedrals with pointed arches and rib vaults were Canterbury, Lincoln and Wells. Canterbury (choir begun after the fire of 1174, on an early 12th-century crypt, by William of Sens) shows French influence in the coupled columns, Corinthian capitals, sexpartite vaults and ambulatory. Lincoln (east end begun 1192) and Wells (choir 1174–1192), with their wider bay design, clustered piers and greater horizontal emphasis, owe nothing to France.

The early 13th century saw the remodelling of eastern arms: Worcester (1224–1232); Winchester (retro-choir); York (transepts); Ely (c. 1240); Durham (Chapel of Nine Altars, 1242–1280)—and the addition of west fronts conceived as a façade with rows of blind arcades and statues: Lincoln (c. 1220–1230) [**977**]; Salisbury [**888**]; Wells (1230–1239) [**887**], a gigantic reredos in effect with the most important cycle of architectural sculpture in England. The finest Early English front is Peterborough (c. 1233) [**974**], its three colossal arches inspired by those at Lincoln. Salisbury cathedral (1220–1266) [**889**], with the advantage of a virgin site and unity of design, yet retains all the English characteristics of length, narrowness, choir transepts, square east end and central tower.

In the Decorated style flowing curves dissolve lines and break up the wall surface. Means include: 1. the three-dimensional ogee arch, enriched with crockets and finials (north porch, St Mary Redcliffe, Bristol [**985**]; Lady chapel, Ely; altar screen, Beverley minster); 2. the niche (Lady chapel, Bristol cathedral); 3. the multiplication of decorative forms such as the ball-flower (towers of Hereford and Salisbury; south aisle, Gloucester), and diapered patterning of the wall surface (choir, Westminster abbey). There is a growing complexity of vaulting ribs, with the consecutive introduction of the horizontal ridge rib (nave, Lincoln c. 1225–1233), the tierceron rib (Exeter), the lierne rib (choirs of Bristol, Ely and Wells) and culminating in the elaborate surface patterning of the Gloucester and

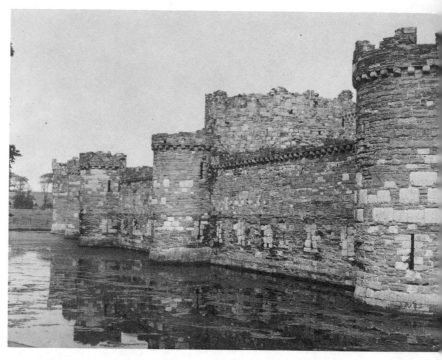

986. GOTHIC. WALES. Beaumaris castle, Anglesey.

Tewkesbury vaults [**890**].

At the beginning of the Decorated period came the rebuilding of Westminster abbey (from 1245) [**975**] by Henry of Reynes under the patronage of Henry III. This influential building shows marked French influence in its verticality, quadripartite vaulting, flying buttresses, bold north transept with cavernous porches and rose window and its introduction from Reims of bar tracery. The most important early Decorated projects were the Angel Choir, Lincoln (1256–1280 [**891**], replacing the earlier apse and ambulatory), and the choir of Lichfield (c. 1265–1293). Then came the transforming of the Norman cathedral of Exeter (1280–1350) [**979**], the reconstruction of York (1291–1354; nave loftiest and widest in England), the rebuilding of the eastern arm of Bristol (1298–1333), the only English hall church, with its omission of capitals in the arcades and its revocation of the importance of the bay division in the lierne vaulting, the Lady chapel and retro-choir of Wells (1320–1365) [**981**], like Sondergotik in their desire for unity of space, and the choir of Ely (1323–1336), with liernes forming six-pointed stars, and the timber star-vaulted octagon (1342) by John Ramsey over the crossing [**978**].

The Perpendicular style shows a reaction in the predominance of straight lines; verticals and horizontals are stressed in a rectilinear grid, and the niche is succeeded by a system of cusped quatrefoiled panelling. The reduction of the wall, the elimination of capitals and the triforium, and the increase of window size are all symptomatic of the desire for unity of space. In the absence of any complete Perpendicular cathedral this desire can be fully appreciated only in outstanding parish churches such as St Mary Redcliffe, Bristol [**905**].

The style was possibly developed by the court school of masons (Old St Paul's chapter house, 1332) and brought by them to Gloucester (south transept, 1331–1337; choir, 1337–1350, where the Norman work is cloaked by a web of openwork stone panelling). Other important Perpendicular rebuildings were the naves of Winchester (from 1394, by William of Wynford for William of Wykeham, on a Norman core) and Canterbury (from 1379 by Henry Yvele), York choir arm (from 1380) and the completion of fine central towers at Worcester, York, Gloucester and Canterbury [**862**].

Vaults reach a limit of complicated surface patterning in the naves of Canterbury and Norwich (1465–1472) and the choir at Oxford cathedral (c. 1480). They culminated in the fan vault, first used in the cloisters of Gloucester (1370–1412) [**890**], developed at Sherborne abbey (1436–1459) and brought to perfection in the aisleless royal chapels of St George at Windsor, of Henry VII at Westminster abbey [**982, 983**] and of King's College, Cambridge [**984**].

Military and civil architecture. With the growing efficiency of weapons, castles had to be adapted for more active defence. The crusaders profited by their experience of the fortifications of Constantinople and Antioch to adopt the projecting mural tower, built at intervals along the wall. Early examples of such flanking towers are at Dover (late 12th century) and Framlingham (c. 1200). The development of the bailey defences, with crenelations and machicolations of the walls and a fortified gateway with barbican, rendered the keep virtually redundant. The result is seen to advantage in the eight new castles erected by Edward I on the Welsh border during the late 13th century

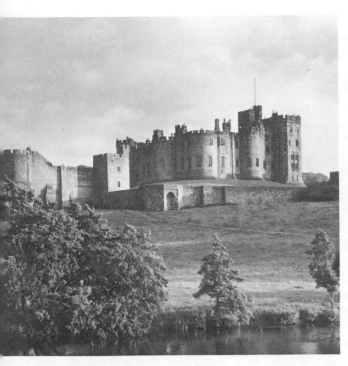

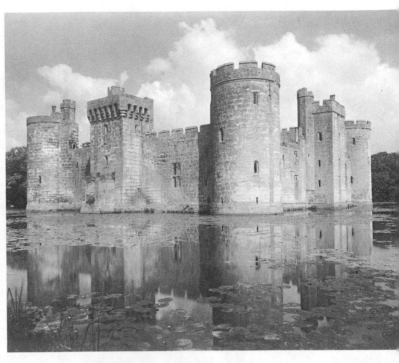

987. GOTHIC. ENGLAND. Alnwick castle, Northumberland.

988. GOTHIC. ENGLAND. Bodiam castle, Sussex, from the south-east.

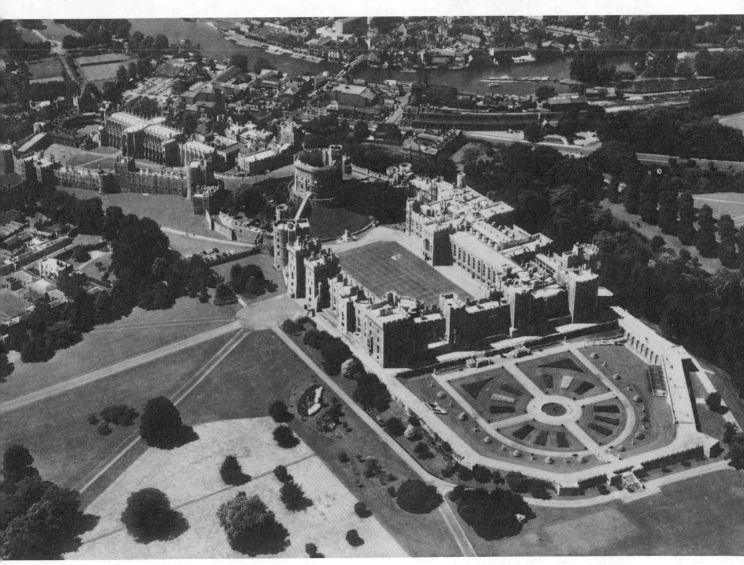

989. GOTHIC. ENGLAND. Aerial view of Windsor castle.

990. GOTHIC. ENGLAND. Wells cathedral. The 'Man with Toothache' capital. South transept. First quarter of the 13th century.

991. GOTHIC. ENGLAND. Westminster abbey, Censing angel.

992. GOTHIC. ENGLAND. Lincoln cathedral. Queen with her dogs, boss in the south aisle, Angel Choir. c. 1260.

(Caernarvon, Conway). Of these, Harlech (1283–1289) and Beaumaris (1295–1323) [986] represent a further extension of the principle of successive lines of defence — the concentric castle, which has a towered wall in duplicate, the main bailey being surrounded by an outer-defence lower wall. Existing castles were strengthened and adapted on these lines (Dover, Warkworth, Corfe, Chepstow, the Tower of London [670], the last transformed into one of the largest concentric fortresses in the country).

In the 14th century, with changed conditions of warfare, the military importance of the castle began to decline. There was an increasing concentration on comfort, and important domestic buildings were added at Windsor [989], Kenilworth and Warwick. In castles on the quadrangular plan (Bodiam [988], Bolton, Lumley) the residential buildings for the first time became an integral part. With the later 14th century came the transition to the fortified manor house. Stokesay (fortified c. 1291) is an early example. The central feature of a hall within a courtyard was developed at Wingfield (c. 1440–1460) and Haddon Hall; by the late 15th century at Oxburgh Hall (c. 1480) plentiful windows, ornamental chimneys, battlements and gatehouse are for display, not defence.

England has no walled towns to compare with those in France or Spain; extensive mural defences survive in only five cities, York's being the finest.

Sculpture. Like architecture, sculpture developed towards greater complexity and richer ornamentation. The particular function of English sculpture was to cover the façades with superimposed rows of figures in niches [887, 888]. They recall the 12th-century Romanesque façades in Poitou. Good examples that were not restored in the 19th century are at Exeter and Wells, where statues in great number are found. After the Black Death, when many workshops ceased to function, English sculpture declined.

Small single figures, usually of angels, were placed in frames and on bosses, corbels and spandrels (Angel Choir, Lin-

coln cathedral) [990–992]. Wood sculptures in buildings were very elaborate (choir screens, porches, pulpits, galleries, stalls, etc.); they formed a part of the interior decoration. Different parts of the country contributed local styles, e.g. the stalls of Winchester (1290) and those of Chester (end of the 14th century).

Tomb sculpture was abundant. Funerary effigies were carved in wood, alabaster (Edward II, Gloucester cathedral, c. 1330), stone and bronze (Eleanor of Castile and Henry III in Westminster abbey, 1291, the work of William Torel). French influence is noticeable in the workshops of London. Alabaster quarries supplied the material for numerous tomb figures ornate with attendant angels or weepers.

Typically English were the brasses with their figures, images and emblems. These plates were set in tomb slabs of black marble. These works, which made their appearance at the end of the 13th century, were still executed during the Renaissance.

Painting. Gothic wall paintings and panel paintings (long neglected by scholars) were of a remarkable elegance; in their linear perfection they approached contemporary illumination. After the murals of Canterbury cathedral were completed, early in the 12th century, Gothic style appeared only in the chapels of the Holy Sepulchre (c. 1225) and the Guardian Angels (c. 1250–1260) at Winchester and in the Crucifixions of the Benedictine school of St Albans. The outstanding painter of the 13th century was Matthew Paris. The influence of his style is seen in the restrained tenderness and delicate colour of the Chichester Roundel (c. 1230–1240, bishop's palace, Chichester). Paintings in Westminster Hall were commissioned by Henry III from foreign masters. The Westminster school flourished under the patronage of the royal court (portraits of Henry III and Edward II; Westminster Retable, c. 1270, Westminster abbey). Under Richard II the International Gothic style of painting was introduced. The famous Wilton Diptych (c. 1396) is one of the great masterpieces of Gothic painting, some-

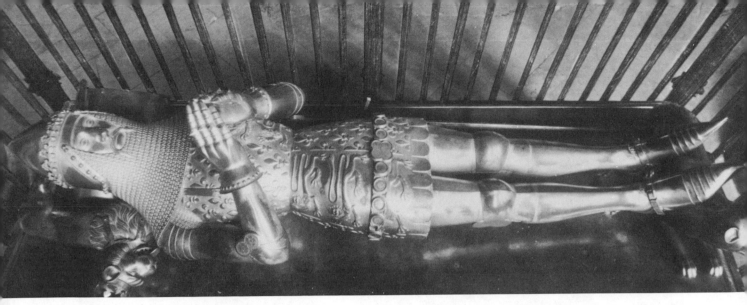

993. GOTHIC. ENGLAND. Detail of the tomb of the Black Prince (d. 1376), in Canterbury cathedral.

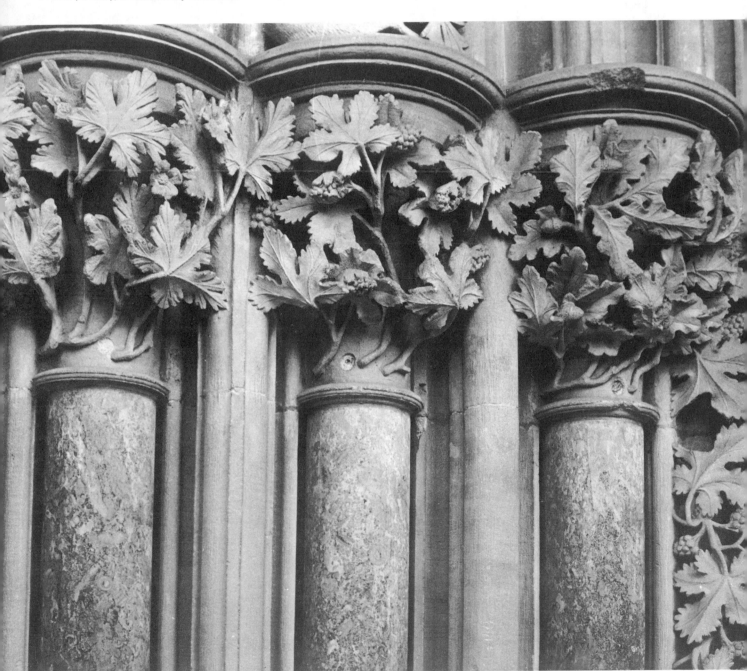

994. GOTHIC. ENGLAND. Southwell minster, Nottinghamshire. Vine leaf capitals.

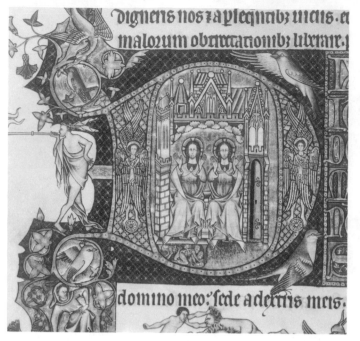

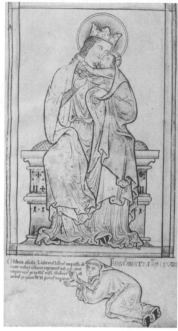

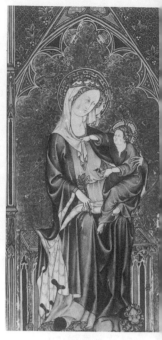

995. GOTHIC. ENGLAND. Detail of Psalm 109 from the Ormesby Psalter, given to Norwich cathedral by the monk Robert of Ormesby. East Anglian school. 1285–1330. *Bodleian Library*, Oxford.

996. GOTHIC. ENGLAND. The Virgin and Child with artist, from the Historia Anglorum by Matthew Paris. Middle of the 13th century. *British Museum*.

997. GOTHIC. ENGLAND. Virgin and Child. A full-page miniature from the Psalter of Robert de Lisle. *c.* 1330. *British Museum*.

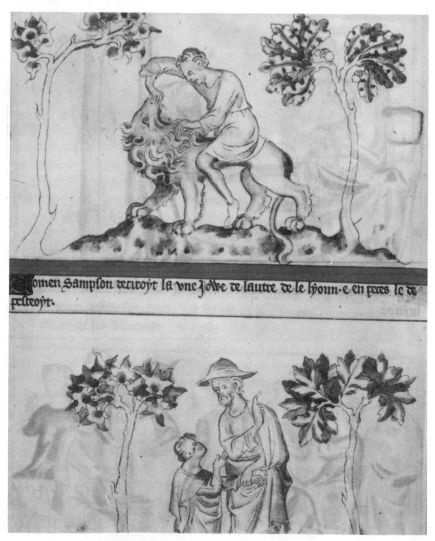

998. GOTHIC. ENGLAND. The life of Samson. Details. Queen Mary's Psalter. Early 14th century. *British Museum*.

times attributed to the school of Paris. Stained glass windows of the end of the 12th and the beginning of the 13th centuries are very close to the French style. The influence of St Denis is noticeable in the windows in York (1175) and in the choir of Canterbury (1190). They show similar principles of composition, the same broad contours and the same colours. The influence of the stained glass of Chartres is evident in York, Salisbury and Peterborough. From the 14th century on, with the invention of silver stain, the drawing became more precise and delicate and the colour disappeared, reduced to grisaille. heightened by the yellow as in the east windows of Wells, Gloucester and York.

Manuscript illumination showed an elegance of forms, flat, precious tones and a use of gold leaf, in both Paris and southern England during the first half of the 13th century (Trinity College Cambridge Psalter, 1220; Psalter of Robert de Lindesey, 1220). Another group, of a less refined character, appeared during the second quarter of the century (Trinity College Apocalypse, 1230, Trinity College, Cambridge; historiated Bibles executed in Paris); they are works of iconographic richness but of less careful execution. The Calendar of Edmund de Lacy (1255), the Missal of Henry of Chichester (1260), the Life of St Alban (1260) and the Apocalypse Douce (1270) resemble in style and spirit the Psalter of St Louis (1256).

At the same time, at St Albans, Matthew Paris, friend of Henry III and head of the scriptorium from 1236 to 1259, retained a monumental and austere drawing style: Historia Anglorum (British Museum [**996**]); Chronica Maiora (Corpus Christi College, Cambridge).

At the end of the 13th century came a change of style culminating in the East

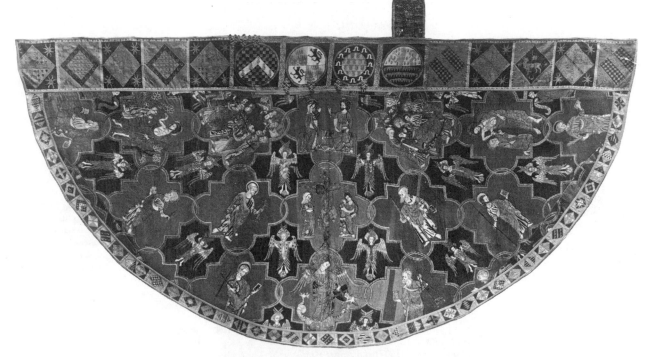

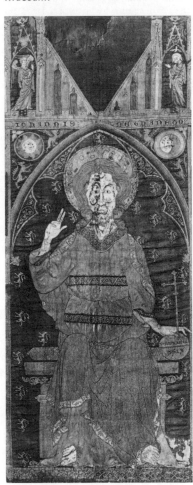

Anglian school, with its love of rich decoration and delight in narrative and marginal grotesqueries. The main centres were Norwich, Peterborough, Bury St Edmunds and York: St Omer Psalter (1325, British Museum); Ormesby Psalter (1285–1330), Bodleian Library, Oxford [**995**]); Gorleston Psalter (*c.* 1322–1325, British Museum); Psalter of Robert de Lisle (1330s, British Museum [**997**]). The fine Queen Mary's Psalter (early 14th century, British Museum [**998**]) stands apart from the group in its rhythmic line and delicate colour washes.

The minor arts. Painted and gilded portable alabaster retables from Derbyshire and Staffordshire were exported in large numbers to France, Italy, Germany, Denmark and Ireland, spreading a popular imagery, always religious in subject.

In the 13th century English embroidery won its greatest reputation and became known all over Europe as *Opus Anglicanum* (embroidery with silk in split-stitch on a ground of couched gold thread [**1000**]). There are contemporary records of royal gifts to France and Italy where the majority of examples exist. The quality began to decline by the middle of the 14th century.

In earlier work the scenes were enclosed in geometrical panels: (i) medallions: Ascoli cope (given to the cathedral by Pope Nicholas IV in 1288); (ii) barbed quatrefoils: Clare chasuble (late 13th century, Victoria and Albert Museum); Syon cope (early 14th century, Victoria and Albert Museum [**999**]). These were superseded by: (i) an architectural framework with arcading: altar dorsal (*c.* 1300, Victoria and Albert Museum); Bologna cope (*c.* 1320); (ii) a radiating trellis-work of branches: Pienza cope; Butler-Bowdon cope (Victoria and Albert Museum).

Medieval goldsmiths' work, as a result

999. GOTHIC. ENGLAND. The Syon cope. *Opus Anglicanum*. Originally a chasuble. Belonged to the nunnery at Syon, Middlesex. First quarter of the 14th century. *Victoria and Albert Museum*.

1000. GOTHIC. ENGLAND. Imperator Mundi. *Opus Anglicanum*. Perhaps the centre of an arcaded dorsal or upper frontal for an altar. *c.* 1300. *Victoria and Albert Museum*.

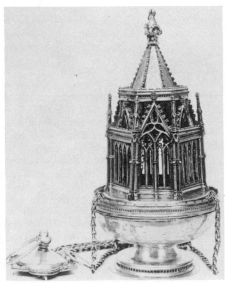

1001. GOTHIC. ENGLAND. The Ramsey abbey censer. Silver-gilt. Second quarter of the 14th century. *Victoria and Albert Museum*.

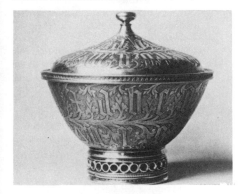

1002. GOTHIC. ENGLAND. The Studley bowl. Silver-gilt, decorated with chased and engraved ornament including black-letter alphabet. For a time the bowl was the property of Studley Royal church, near Ripon, Yorkshire. Late 14th century. *Victoria and Albert Museum*.

387

of the Reformation and the Civil War, is rare; outstanding surviving examples are: the Swinburne pyx (c. 1310); the Ramsey abbey censer and incense boat (early 14th century); the Studley bowl, from Studley Royal, near Ripon (late 14th century) — all in the Victoria and Albert Museum [**1001, 1002**].

THE LOW COUNTRIES

History. The textile industry formed the basis of prosperity in the Low Countries. Wool, the main raw material, was imported from England. Trading with the Rhineland, the Meuse country and Champagne, geographically in a central position, the Low Countries cities became as rich as Italy and conscious of their individuality. The centres of the wool trade, in the 12th century at St Omer, Arras, Lille, Douai and Tournai, shifted in the 13th century to Flanders (Ypres and Ghent, with a population of about 50,000). At the end of the 14th century a production crisis was overcome owing to the development of Hainaut, Brabant, Holland and Liège, and to the wealth of Bruges, where Hanseatic and Italian fleets collected. In spite of shortages, famine, wars (Hundred Years' War) and social unrest (in 1250 the first strike of craftsmen; uprisings in 1379), the Netherlandish communities continued to flourish thanks to the energy and sound political instinct of their citizens (the first constitutions regulating the rights of the various state assemblies: Charter of Cortenberg, 1313; Joyeuse Entrée, 1356; Peace of Fexhe, 1316) and above all to the intelligent policy of Philip the Bold, Duke of Burgundy and Count of Flanders (after his marriage in 1329). There was an intense religious life (*Imitation of Christ*, attributed to Thomas à Kempis; Gerson; the mystics Jan van Ruysbroeck, Gerhard Groot and Deventer). Music and literature flourished (Adam de la Halle of Arras in the 13th century). All this activity anticipated the great achievements of the 15th century.

Architecture. The variety of authority in different districts precluded a homogeneous national style. In the west, French influence was paramount, in the east, German.

Gothic architecture was introduced from Burgundy by the Cistercians at the end of the 12th and the beginning of the 13th centuries. The churches at Aulne, Orval, Villers and Ter Doest show this influence. The main Gothic works are the east end of Ste Gudule (1225), the church of La Chapelle at Brussels, the transept and choir of the cathedral of Tournai (13th century), St Martin at Ypres and the church at Audenarde (1234).

Antwerp cathedral (1352–1411) is the most impressive church in Belgium, with triple aisles, narrow transepts, a lofty clerestory and an immense single west tower (1422–1518).

French influence is more pronounced in the Meuse valley at Tongeren, Aerschot, Huy, St Rombaut at Mechelen and St Paul at Liège, though the style of these

buildings is more robust and majestic and less elegant than that of the buildings in the Ile-de-France.

The most arresting Netherlandish architecture was secular, and no area is richer in town-, trade- and guild-halls, with the development of their towers as an end in itself (Ypres, Bruges [**1004, 1005**]). Fortifications (the Bruges gate, the Hal gate in Brussels) and castles (that of the counts of Flanders at Ghent, 12th–13th centuries) have no exceptional features.

Sculpture. There is little in the way of monumental sculpture (portal of St Servais at Maastricht; Bethlehem portal at Huy; west portal of the cathedral of Tournai; the Coronation of the Virgin at St Jacques at Liège).

Flemish realism found its foremost expression in tomb sculpture (recumbent statues of the dukes of Louvain in the cathedral of Louvain). Many of the Flemish sculptors worked at French courts (Jean Pépin de Huy [**958**], Jean de Liège [**1007**] and André Beauneveu). The sculptors of Tournai travelled to wherever they received commissions.

Painting. Painting before van Eyck was mainly wall painting and manuscript illumination. The famous illuminators of the 15th century who worked for the dukes of Berry and Burgundy, creating a Franco-Flemish art, were André Beauneveu, Jean de Bruges, who drew the cartoons for the Apocalypse of Angers, Jacquemart de Hesdin, Melchior Broederlam, who painted the retable for the Chartreuse of Champmol at Dijon (completed in 1369), and Malouel.

Tapestry became a major art. The famous productions of Arras, greatly appreciated for their material and colouring and their detailed design, were sought all over Europe, and the name *arrazi* was generally applied to cover all tapestry.

The minor arts. Goldsmiths' work of outstanding quality continued to be produced in the Meuse valley. The shrine of St Eleuthère (1247) in the cathedral of Tournai shows Rhenish influence. Notable master goldsmiths of the 13th century were Colars de Douai, Jacquemart de Nivelle and Jacquemont d'Anchin.

GERMANY AND THE HOLY ROMAN EMPIRE

History. After the canonisation of Charlemagne in 1165 the Imperial idea was revised in the powerful personality of Frederick Barbarossa (1152–1190). He wished to form a neo-Carolingian empire on the basis of Roman law and to control the power of the Pope. But in order to maintain their power over Italy and Provence, the Emperors neglected to control the eastern expansion of the border princes and to check the rising power of the rich commercial cities of the Rhineland and later of the Hanseatic League.

Under Henry VI, who became king of Sicily, the centre of the German Empire

shifted southwards. His son Frederick II, European and Mediterranean in outlook, precursor of the Renaissance, attempted to create by force a universal Christian republic based on a common European culture and art. After his death in 1250 the Empire ceased *de facto* to exist and continued only in name. Under Henry VII and Louis of Bavaria it was limited to German territories. The Golden Bull of 1356 reserved the right to elect the Emperor for seven German electors. Germany had ceased to be a Mediterranean and Italian power and she expanded, during the 12th and 13th centuries, eastwards, Christianising Slav territories (conquest of Schwerin, Mecklenburg and Pomerania in 1269). German religious military Orders founded during the crusades came from Palestine to Prussia and Kurland and established there semi-monastic military states, thereby replacing the indigenous population with German peasants and founding new towns. The Baltic Sea thus became an important commercial and fishing centre, opening up the Scandinavian shores and the Hanseatic towns to Western civilisation. As a result of the carving up of the 'principalities', the rich Rhenish cities and Baltic ports created important artistic centres.

The Swiss communities, favourably situated at the Alpine passes (Brenner, St Gotthard), grew into flourishing commercial centres and began to form independent federations leaving the German Empire.

Bohemia under the Emperor Charles IV became one of the great cultural and artistic centres of Europe. Charles IV, a nephew of the French ruler Charles V, educated at the French court, introduced French culture to Prague.

Mysticism in thought, the allegorical mannerism of the Meistersinger in music and linearity and expressionism in art were typical features of German culture of the period.

Religious architecture. Gothic art spread over central and eastern Europe through Germany. Adopted late, it did not assume an independent character in Germany until the 15th century. (The first cross-ribbed vaults appeared about 1200.)

Romanesque lingered longer than in western Europe. As late as the 13th century Hirsau (destroyed) and the abbey church at Jerichow, modelled on it, show the style of Cluny III. Although new structural elements were adopted — rib vaults at Heisterbach (1202) — buildings retained a solid and static character, nave walls were hollowed out rather than dissolved and the upward movement was restricted to towers. The Rhineland retained a profusion of double choirs, transepts, apses, towers and arcaded galleries (St Martin, Cologne, after 1185). Conservative also was the Greek cross plan (St Gereon, Cologne, 1219–1227, and the tri-apsidal choir in the Church of the Apostles, added in 1190 to the 11th-century nave). This centralising aim is seen as late as 1235, when the Liebfrauen-

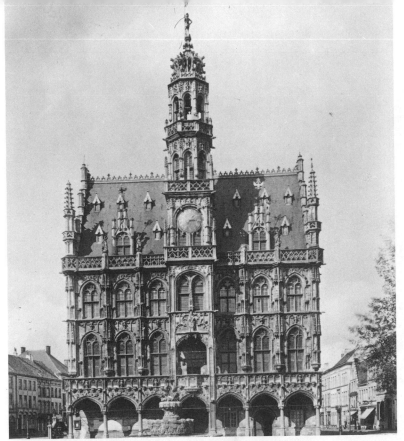

1003. GOTHIC. Town hall, Audenarde, built by Jan van Pede
c. 1527. Based on the town hall at Brussels, it shows a
pre-Baroque spirit.

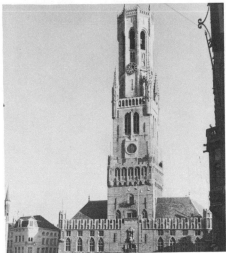

1004. GOTHIC. Cloth hall and belfry,
Bruges. 13th–15th centuries.

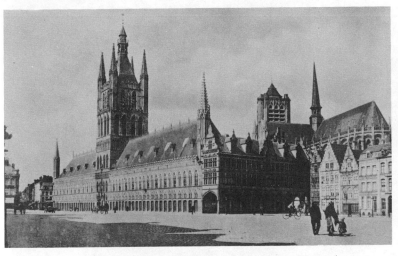

1005. GOTHIC. Cloth hall, Ypres. Built 1202–1304. Destroyed
in the First World War and rebuilt with the old materials.
(Photograph taken before destruction.)

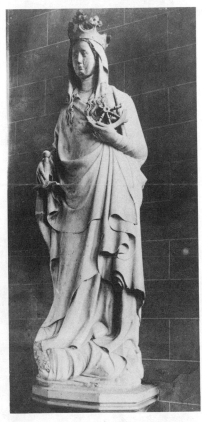

1006. GOTHIC. St Catherine. Marble.
End of the 14th century. *Notre Dame*,
Courtrai.

1008. GOTHIC. Detail of the
Haekendover Retable, Brabant.
Ladies and masons. Wood. End of
the 14th century.

1007. GOTHIC. Recumbent tomb figures. The figure on the
left is Jeanne d'Evreux, by Jean de Liège. 1371–1372.

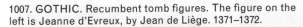

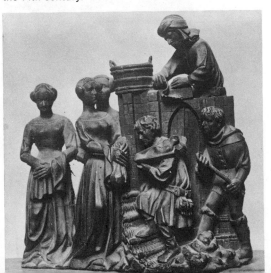

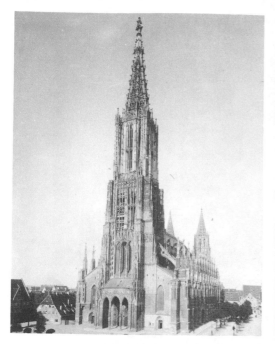

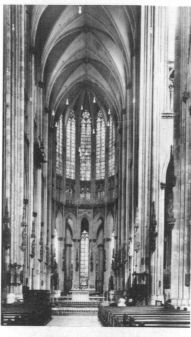

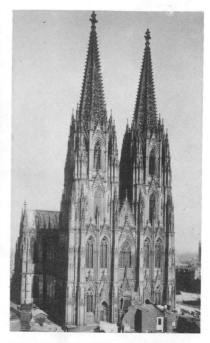

1009. GOTHIC. GERMANY. Ulm cathedral. The façade. 1377–1477.

1010. GOTHIC. GERMANY. The choir and apse, Cologne cathedral. From 1248.

1011. GOTHIC. GERMANY. Façade, Cologne cathedral. From 1248. Completed 19th century.

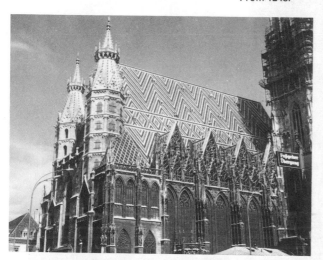

1012. GOTHIC. AUSTRIA. St Stephen's, Vienna. A characteristic hall church. c. 1300–1510.

1013. GOTHIC. GERMANY. Freiburg im Breisgau. Windows in the spire. 1310–1350.

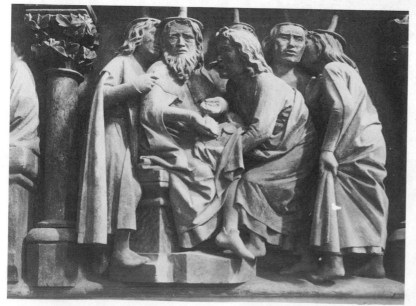

1014. GOTHIC. GERMANY. Naumburg cathedral. Judas, from the choir screen. 1255–1265.

1015. GOTHIC. GERMANY. Naumburg cathedral. Figure from the choir.

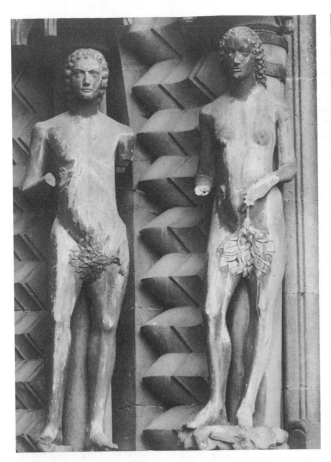

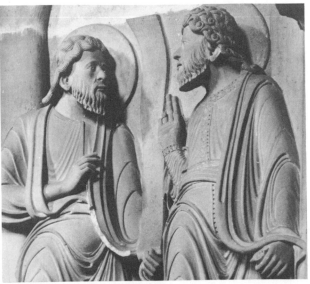

1017. GOTHIC. GERMANY. Bamberg
cathedral. Prophets, choir screen.

1016. GOTHIC. GERMANY.
Bamburg cathedral. Adam and Eve
from the Adam portal. *c.* 1240.

1018. GOTHIC. GERMANY. Bamberg
cathedral. Head of a prophet, from the
choir screen.

1019. GOTHIC. GERMANY. Bamberg
cathedral. The head of Elizabeth, from
the Visitation. *c.* 1240.

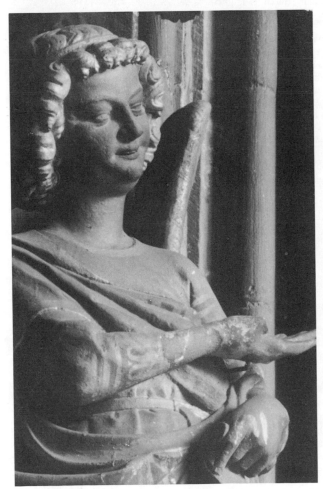

1020. GOTHIC. GERMANY. Freiburg im Breisgau. Smiling
angel.

1021. GOTHIC. GERMANY. Worms cathedral. Figure from
the Entombment.

kirche at Trier and St Elisabeth at Marburg were both begun on a cruciform plan.

New forms were adopted reluctantly, at first in Saxony, where the choir of Magdeburg cathedral was begun 1209 by Archbishop Albrecht, who had studied in Paris. Laon cathedral, with its Gothic impulses expressed in Norman Romanesque language, corresponded to the German ideal, and its influence is strong in the cathedrals of Naumburg, Bamberg and Limburg (1213–1242). At Naumburg (11th century, reconstructed 1207–1242) the nave contains round and pointed arches, but the exterior, with its four towers, double apses and transepts, is still Romanesque in feeling. The delicate pentagonal west choir (1249–1270), with its founders' statues, is flanked externally by towers recalling Laon. Bamberg (founded 1004, rebuilt 1185–1237) has an interior dominated by the pointed arch and rib vault yet retains typically Romanesque traits in the polygonal St George's choir (c. 1230) with its round arches, open gallery and dwarf arcading.

St Stephen, Halberstadt (13th–15th centuries) marks the transition to a national Gothic, where the walls solidify and the clerestory windows narrow and lengthen. This phase is marked by the two major cathedrals of Cologne [**1010, 1011**] and Strasbourg [**874–886**]. At Cologne the choir (begun 1248 by Master Gerhard) is the most outstanding feature; the design recalls Amiens, the double aisles Bourges, the windows on the triforium St Denis, yet the proportions have been transformed by the upward movement of the clustered, 89-foot-high piers, uninterrupted by capitals or shaft rings. The building was abandoned half-finished and was completed only in the 19th century. At Strasbourg the choir (rebuilt 1176–1200, after a fire) still has a Romanesque heaviness; the transept (c. 1220) shows the influence of Chartres, the low nave (1240–1275) of St Denis. The famous west front (1276–1356) with its rose window and double tracery was begun by Erwin von Steinbach; the north tower spire was completed by John Hültz of Cologne in 1439. Such tours de force of masonry in the form of vast single openwork spires are found also at Freiburg im Breisgau (completed c. 1350) [**1013**] and Ulm (rebuilt 19th century [**1009**]).

North Germany and the Baltic developed an individual brick style. The abbey church, Chorin, Brandenburg (1334) is one of the most severe yet expressive examples of this brick Gothic with its sharply pointed towers, sparse decoration and effective contrast of hard, brittle material and glaze. The cities of the Hanseatic League contain notable churches: Jerichow, Danzig, Stralsund, Lübeck (Marienkirche, 1250–1291).

One of the most important contributions of German Gothic was the hall church, a one-storey design with aisles the same height as the nave; the latter being lit through the aisles, the eye is no longer drawn to the altar but is tempted to wander laterally. There is an early proto-type in Poitiers cathedral, but in Germany

the earliest Gothic hall church is St Elisabeth, Marburg [**866, 867**], where the cruciform plan was abandoned in 1249 for a one-storeyed nave and aisles. By 1300 it had been adopted universally in Westphalia, Bavaria and Upper Saxony; the finest examples are Sta Maria zur Wiese, Soest (c. 1340) and St George, Dinkelsbühl (1448–1492), by Nikolaus Eseler. Other examples include many south German churches by the Parler family (Schwäbisch-Gmünd, begun 1350s), and the type is found as far afield as Sweden (Linköping cathedral, begun 1250).

The German tendency to exaggeration, either in height or in over-decoration, is found in late Gothic, where the emphasis on line and upward movement is superseded by a play of light and shade and a wealth of ornament: façade of St Catherine's, Oppenheim (c. 1320–1340); St Lawrence portal, Strasbourg cathedral, by James of Landhut (1494). The extreme of decorative patterning is afforded by stellar vaulting, as in the hall-choir of St Lawrence, Nuremberg (c. 1460) [**932**] where the vaulting luxuriates over the ceiling beyond the bays, and in the interlaced rib vaulting of St Anne, Annaberg (1499–1520).

In Prague, the cathedral was begun in 1344 by Matthew of Arras; in Austria, St Stephen's cathedral, Vienna, was constructed on the hall church plan [**895, 1012**].

Military and civil architecture. The hall of the Landgrave's castle, Marburg is one of the outstanding secular buildings of the period; there are fine Teutonic Knights' fortresses at Marienburg (1280) and Marienwerder (1300–1384), and the fortified town of Rothenburg still retains its medieval walls with defensive towers. Town halls (13th–15th centuries) at Brunswick, Hildesheim, Stralsund, Halberstadt, Munster, Regensburg, Ulm, Lübeck and Hanover are prominent and impressive buildings.

Sculpture. At the beginning of the Gothic period German sculpture, in contrast to French, was used chiefly in interiors, reliefs on choir screens taking the place of portal figures: Gustorf (1160, Bonn Museum); St Michael's, Hildesheim (c. 1186). The expressive reliefs on the St George's choir screen (1220–1230) [**1017, 1018**], Bamberg cathedral, were done by the first Bamberg workshop, a group of sculptors from the upper Rhine. The second Bamberg workshop (active in the 1230s), trained in France, probably at Reims, combines calm monumentality with expressive force: the Visitation; the Bamberg 'Rider' (St George?); Adam and Eve on the Adam portal; the Last Judgment in the tympanum of the Prince's portal. One of the masterpieces of this classical period of German sculpture are the full-length statues of founders in the choir at Naumburg (1255–1265) [**912–915, 1014–1016, 1019**].

In the Rhineland the influence of Reims is strong in the figures on the piers of the choir at Cologne cathedral (early 14th

century), and that of Chartres in the Angels' column at Strasbourg (south aisle of chancel, 1225–1230) and in the figures of Ecclesia and Synagogue (1220–1230, Strasbourg Cathedral Museum). Later at Strasbourg there developed a native style far more subtle and expressive than anywhere else in Germany: Death of the Virgin (c. 1230, tympanum, south portal); Wise and Foolish Virgins, from the south porch of the west portal (about 1280, Strasbourg Cathedral Museum); prophets on the central porch of the west portal (early 14th century) [**876–878, 881, 883–885**]. The growing expressionistic quality of German sculpture is seen in the Foolish Virgins, on the north-west portal, Erfurt cathedral (c. 1360).

In Austria the tympanum of the Singertor, St Stephen's, Vienna (c. 1375), reflects strong German influence.

The 'lyrical' linear style of Bohemian sculpture is evidently of French inspiration. A number of fine works were carved in this style during the 14th century (Virgin of Krumlov).

Painting. Wall paintings continued in the tradition of the Ottonian period, especially in the Rhineland: St Gereon at Cologne; Sta Maria at Soest (1230). The harsh linear drapery folds are characteristic of German design (Frankenberg church at Goslar). The Westphalian Master Bertram (before 1350–c. 1415), working in Hamburg, came under the influence of Master Theodoric of Prague. This Westphalian school cultivated a pictorial naturalism in contrast to the mysticism of the painters at Cologne, who flourished in the early 15th century and showed a close affinity to the contemporary school in Burgundy. The most outstanding Westphalian painter was Konrad of Soest.

In Austria the paintings of Klosterneuburg and those of the Cistercian abbey Heiligen Kreuz show Parisian influences (Annunciation and Betrothal of St Catherine, Vienna Museum).

The paintings of Vyšší Brod in Bohemia (c. 1350s) are in the 'court' style and show an admirable harmony of colours. Two outstanding painters were: Master Theodoric, employed by Charles IV, and the Master of Třeboň, remarkable for the purity of his Gothic style. The Prague school declined after the disasters of the Hussite wars but left its influence in southern and eastern Germany and in Poland.

German stained glass, akin to the 'Dionysian' style of Champagne, was mainly inspired by the art of the Meuse valley (cathedral of Augsburg, 1140). At the end of the 13th century two new features appeared: the predominance of green and yellow tones, and the painted canopies on top of the windows (St Michael at Leoben, 1290; Friesack, 1275).

In Germany in the 13th century there was an original and vigorous art of illumination, continuing the Ottonian tradition. Its centre was in Saxony: Psalter of Herman of Thuringia (1210, Stuttgart Museum). South German illuminations frequently show a blend of

Thuringian and Byzantine elements in rich colours. The Psalter of Bamberg (1240), the Bible of Würzburg (1246) and the Gospels of Mainz show a pronounced Franconian style with certain Franco-English characteristics. Gothic illumination did not appear before 1310. Some illustrations are simply outline drawings, as for example the famous Hortus Deliciarum [**756**] of the Abbess Herrad of Landsberg (end of the 12th century). Such drawings foreshadow German graphic art, which was at its height in the 15th century.

The Bohemian school shows great linear refinement (Bible of Wenceslaus).

SWITZERLAND

Architecture. The churches of the French-speaking part were directly influenced by French Gothic architecture: the cathedral of Geneva (inspired by the cathedral of Lyon); the cathedral of Lausanne (influenced by the Burgundian style). Other churches were: Notre Dame de Valère at Sion; collegiate church at Neuchâtel; the cathedral of Basle, rebuilt in the 14th century.

The military architecture of this period was more individual and interesting. A number of fortresses protected the Alpine routes (castles at Sion, Aareburg, Chillon, Vufflens, Lenzburg and, more Germanic, Thun).

Sculpture. The finest sculptures are those on the cathedral of Lausanne.

Painting Wall paintings played an important part in the decoration of both churches and secular buildings (ceiling in the church at Zillis).

SCANDINAVIA

The growing Baltic trade and the administrative efficiency of the Hanseatic League brought European civilisation to southern Scandinavia. After the slow process of Christianisation by the monks, Gothic art was imported directly from France by the Cistercians to Roskilde in Denmark (13th century) and to Uppsala in Sweden, and from England to Trondheim in Norway. The finest Gothic building is the cathedral of Trondheim [**1022, 1023**].

Architecture in wood, a traditional art of the Vikings, was adapted to Gothic forms in an original manner.

Abstract sculptural decoration of interlaced patterns of old tradition was used in religious art and survived in popular art.

Peculiar art forms developed on the island of Gotland in which Slavic, Byzantine and more recent Western elements were combined.

POLAND

Under King Casimir the Great (1333–1370), who was related to the house of Anjou, Poland enjoyed a long period of peace. The richer towns began to build cathedrals. To this country, which was devastated by incessant warfare, Gothic

was introduced by the Cistercians, who built in brick.

The Cracow style, a variation of the Gothic style of the Baltic countries (without flying buttresses) which the Teutonic Knights had developed, became a model for the buildings of the 14th and 15th centuries (cathedral of Cracow). The German hall church, too, was occasionally used.

Architecture in wood was abundant and original. However, nothing earlier than the 15th century survives.

Fortified castles, belfries (the 14th-century one in Cracow) and other fortifications are numerous.

Sculpture did not develop until the 15th century.

Wall painting (Gniezo, Lond) shows French and Italian influence to which was added an interesting local flavour; the same applies to a number of fine illuminated manuscripts.

ITALY

History. Italy, in spite of being the battle-ground of private wars between rival cities (Milan–Venice; Siena–Florence; Florence–Pisa; Pisa–Genoa — Pisa being defeated by Genoa at Meloria in 1284; Sicily and southern Italy conquered by Charles of Anjou in 1266–1268), made astonishing progress during the 13th century in social, political, intellectual and artistic life.

The old struggle between Pope and Emperor had come to a close about 1250.

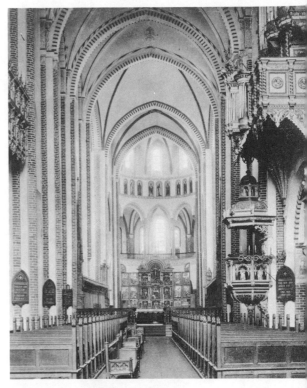

1022. GOTHIC. SCANDINAVIA. Roskilde cathedral, Denmark. Nave and choir. 13th century.

1023. GOTHIC. SCANDINAVIA. Trondheim cathedral, Norway. Façade. 12th–13th centuries.

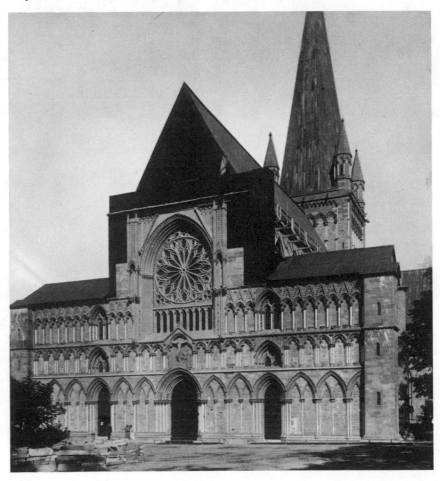

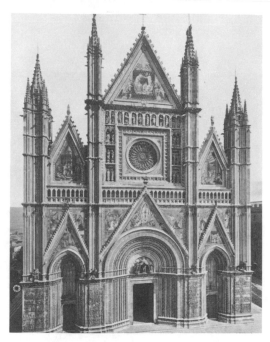

1024. GOTHIC. ITALY. Facade, Orvieto cathedral. Begun 1290.

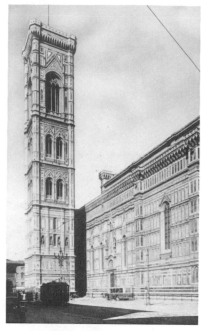

1025. GOTHIC. ITALY. Florence cathedral. View showing the campanile (1334–1337) by Giotto.

1026. GOTHIC. ITALY. Palazzo Vecchio, Florence. 1298. After designs by Arnolfo di Cambio.

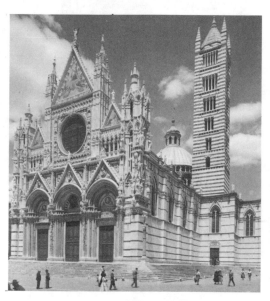

1027. GOTHIC. ITALY. Siena cathedral, façade. 1284–1377.

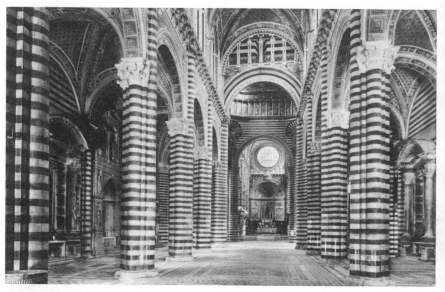

1028. GOTHIC. ITALY. Siena cathedral, interior. Begun 1226.

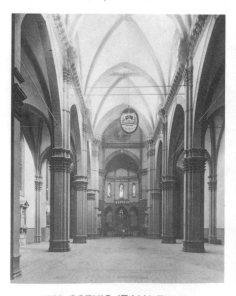

1029. GOTHIC. ITALY. The nave, Florence cathedral. Begun 1296.

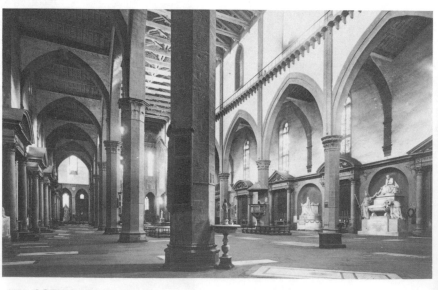

1030. GOTHIC. ITALY. Sta Croce, Florence. View of the nave. 1294–1342.

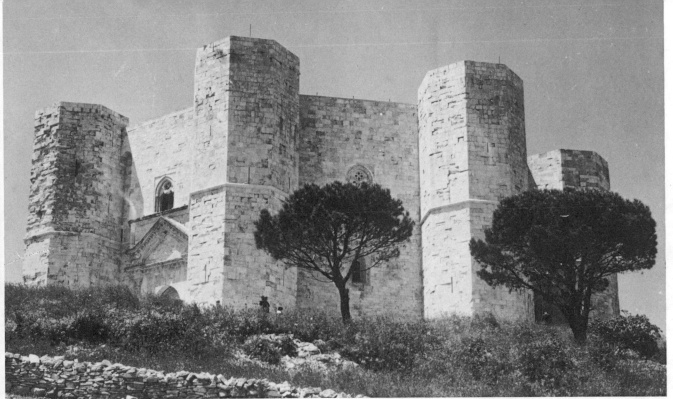

1031. GOTHIC. ITALY Castel del Monte, Apulia. Octagonal castle build under Frederick II. *c.* 1240.

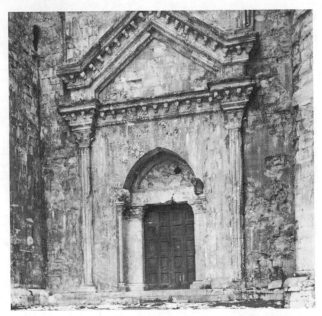

1032. Castel del Monte. Portal.

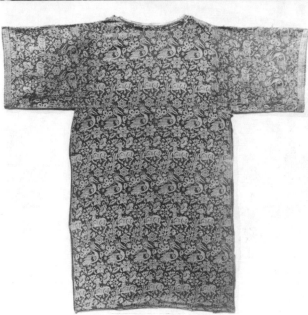

1033. GOTHIC. ITALY. Dalmatic. Silk and silver-gilt tissue. Late 14th century. *Victoria and Albert Museum.*

1034. GOTHIC. ITALY. View of San Gimignano.

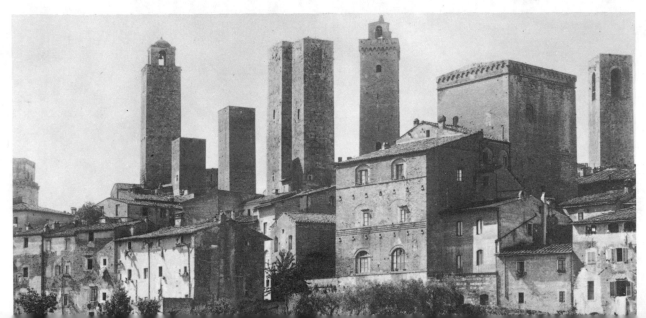

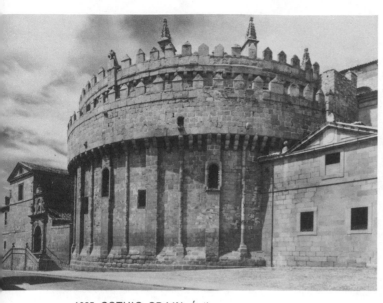

1035. GOTHIC. SPAIN. Ávila
cathedral. View of the east end.

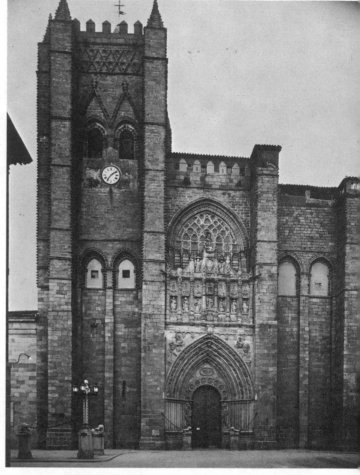

1036. GOTHIC. SPAIN. Ávila
cathedral. The façade.

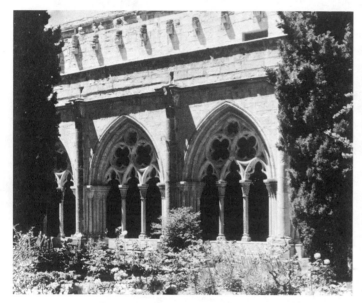

1037. GOTHIC. SPAIN. Poblet, the
cloister.

1038. GOTHIC. SPAIN. West front,
Toledo cathedral. Begun 1225.

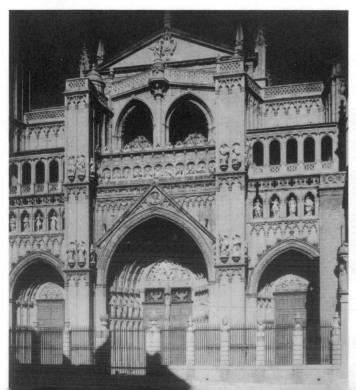

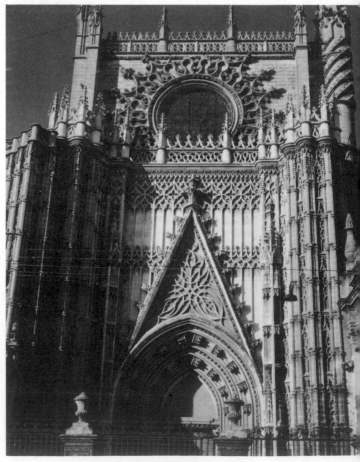

1039. GOTHIC. SPAIN. Portal of
Seville cathedral. 1402–1520.

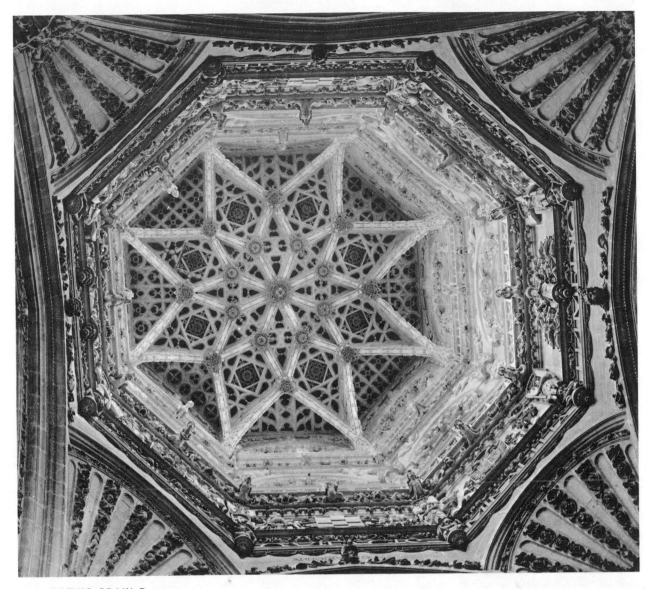

1040. GOTHIC. SPAIN. Burgos
cathedral. Interior of the dome over
the crossing. 1540–1568.

1041. GOTHIC. SPAIN. Façade,
Burgos cathedral. 1220–1500.

1042. GOTHIC. SPAIN. Façade,
León cathedral. Begun 1255.

1043. GOTHIC. SPAIN. León
cathedral. View from the north aisle.

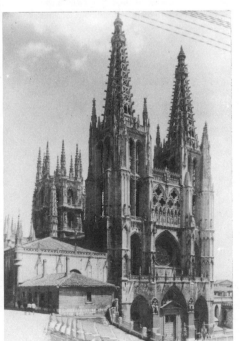

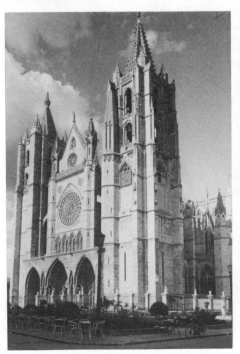

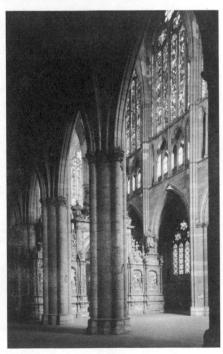

The maritime cities, Amalfi and Pisa, and especially, Genoa and Venice, profited enormously by the crusades, establishing lasting contacts with the Orient. The Venetian merchant adventurers reached as far as China (Marco Polo's journey, 1271–1295). The Genoese Andalo de Savignano became Chinese ambassador in Italy in 1338. Italian merchant ships sailed the Black Sea, establishing trade connections with the Asian steppes through the Sea of Azov, and cruised along the North African coast from Alexandria to Tunis, Bougie and Ceuta. Venice entertained permanent relations with Byzantium, and with the Moslem world by way of Sicily which had become a melting-pot of Byzantine, Arab and Provençal civilisations. The towns in the interior of the country profited equally from this overseas trade. The silk industry of Lucca and the wool industry of Milan exported their products by way of the ports and along the improved Alpine routes and established important trade centres in the Rhineland and Flanders.

Italy's greatest asset was international banking. Bankers of Lombardy, the Piedmont and Florence had their branches abroad, in Bruges, Paris, Avignon and London. Their bookkeeping was greatly facilitated, around 1260, by the introduction of Arabic numerals and of the zero. The gold florin, struck in Florence about 1252, was a symbol of this prosperity. The Italian bankers, lending money to ruling princes, gained in some cases control over the financial affairs of states, as was the case in the 14th century with the kings of Anjou. In the course of the 14th century the towns came under the control of ruling families (Visconti in Milan, Scaliger in Verona, Medici in Florence, Anjou in Naples), causing a concentration of capital in the hands of a few who could afford luxuries and who took an interest in art, and, in the 15th century, in the Latin past (this was comparable to the pre-Renaissance under Frederick II.) The law universities at Bologna, Padua, Modena and Vicenza supported this tendency by teaching Roman law.

Inspired by the poetical language of the Provençal troubadours, Italian poets and writers transformed the Italian vernacular into a literary language (Sicilian, Tuscan and Bolognese poetry), which became, with Dante, the conscious expression of an Italian culture. In 1341 Petrarch was solemnly crowned at the Capitol with the laurels of the triumphant humanism.

Science, too, received a new impetus. Thomism was impregnated with Arab science, which was known through Sicily. Geography was developed in Genoa. Fontana, Cennini, Alberti and Mariano, influenced by Occam, foreshadowed Leonardo. An order issued by Frederick II gave permission to dissect human corpses; anatomy was taught at the university of Bologna from 1316. A tender and lyrical Gothic mysticism and the naive Franciscan love of nature found a congenial expression in the art of Sienese painters. The spiritual revolution of St Francis (1182–1226), reaching far beyond the observ-

ances of his Order, led to a new concept of the world.

Polyphonic music made great strides from 1330 to 1340. Francesco Landini (1325–1397), the greatest musician, blended elegiac and tender lyricism with a sense of grandeur.

Architecture. Italy became acquainted with a Gothic style of Burgundian origin through the Cistercians and, in the south, through the Angevin dynasty. Italian builders, though accepting Gothic ornament, did not appreciate Gothic structure, and the Gothic spirit. Preferring the Romanesque and the simplicity of the basilican plan and the Latin horizontality of alternating bands of colour in the Pisan manner (cathedral of Siena; façade of Orvieto), they rejected Gothic verticality. This verticality was reserved for the campanile (campanile of the Badia in Florence, 1330; that of S. Gottardo, Milan, 1328–1339) [**1025**].

Fossanova (1187–1208) was the first Cistercian church in Italy, followed by Casamari, S. Niccolò at Agrigento in Sicily and S. Galgano near Florence. The cathedral of Siena [**1027, 1028**] was in imitation of S. Galgano. In Naples, Charles of Anjou called in French architects (Pierre d'Agincourt, Jean d'Autun, Guillaume de Bourgogne) to build S. Lorenzo and the cathedral of St Januarius.

Tuscany produced the finest buildings. There are no flying buttresses, lofty vaults or stained glass, but small windows without tracery, bands of coloured marble instead of mouldings and a new internal spaciousness coupled with exuberance of decoration: Orvieto cathedral (from 1290) [**1024**]; Siena cathedral (begun 1226; façade 1284–1377); Florence cathedral (begun by Arnolfo di Cambio in 1296) [**1029**]; continued to 14th century; dome by Brunelleschi, 15th century). In the 14th century the mendicant Orders developed a new type of preaching hall church, plain, severe, with wide arcades, timber roofs and an extended choir, adapted to the preaching of popular sermons. Dominican churches were: Sta Maria Novella, Florence (begun 1278) [**896**]; SS Giovanni e Paolo, Venice (1234–1390). Franciscan churches were S. Francesco at Assisi (founded 1228), Sta Croce, Florence (begun 1294) and Sta Maria dei Frari, Venice (1250–1338) [**1030**].

Milan cathedral (begun 1386) was the greatest architectural project of Italian Gothic [**899**]. Despite a succession of German and French architects, the result is Italian in the lack of height, absence of towers and sense of mass, together with abundant decoration. This love of decoration persists into the 15th century and is seen in its most flamboyant form at Venice, influenced by trade with the East: Doge's palace (1309–1424) [**898**]; Ca d'Oro (1421–1436) [**897**]. Gothic decoration continued until the Renaissance, when it was sometimes added to a classical structure (loggia at the papal palace at Viterbo; Loggia of the Merchants at Bologna) The palazzo publico developed

an original style with alternating stone bands of different colours in the north (Genoa, Piacenza) and at Siena, and powerful masses with soaring towers in Tuscany (Bargello and Palazzo Veechio, Florence). This verticality is most apparent in the thirteen defensive towers at S. Gimignano [**1026, 1034**].

Some of the castles and fortifications are well preserved: San Marino; castle of Ferrara; castle at Volterra; fortifications erected by Frederick II in Apulia, of which the finest is Castel del Monte [**1031, 1032**]; castle of the Gonzagas at Mantua; castle of the Scaligers at Verona; La Rocca at Spoleto. The Castello Nuovo at Naples is of French origin, with fat round towers.

Outstanding architects of the period were: Giovanni di Simone, who worked at the Campo Santo of Pisa (1278); Arnolfo di Cambio, sculptor and pupil of Nicola Pisano, who worked at Sta Maria del Fiore in Florence (1296) and probably at Sta Croce in Florence; Francesco Talenti, Nicola's successor at Sta Maria del Fiore (1357); the two Dominicans Fra Sisto and Fra Ristoro to whom the plans of Sta Maria Novella, Florence, are attributed; Benci di Cione, who worked at the Piazza della Signoria, Florence (1376); Lando di Pietro, who made the new plans for the cathedral of Siena (1339); Lorenzo Maitani (c. 1275–1339), with his Sienese sense of colour; Antonio di Vincenzo, who was active between 1382 and 1401.

The minor arts. The Veneto-Byzantine goldsmiths' work (Pala d'Oro in St Mark's, Venice [**307**], mounted in a Gothic frame in 1345) and the Tuscan goldsmiths' work were adapted to contemporary architecture, as in the reliquary of Caporale da Bolsena at Orvieto (1338), or to sculpture, as for example the bust of St Zenobius in the cathedral of Florence. Other major works are the retable of S. Jacobo at Pistoia and the silver altar in the baptistery of Florence. Frederick II had gold coins struck which showed him crowned with a laurel wreath in the manner of antiquity.

THE IBERIAN PENINSULA

History. At the death of Ferdinand III of Castile in 1252 the reconquest of the peninsula was almost complete. Moslem rule continued in the kingdom of Granada till the end of the 15th century. The Christian kingdoms, however, lived in bitter conflict; Catalans, Aragonese, Castilians, Navarrese and Portuguese fought each other ferociously. After the battle of Aljubarrota (1385) Portugal seceded from Castile.

Ports such as Valencia, and especially Barcelona, profiting immensely from the crusades, became great commercial centres. The kingdom of Aragon, grown equally wealthy, took possession of Sicily in 1282, expelling the Angevin dynasty. The close contact with the Arabs through Sicily and the kingdom of Granada (Averroes and Avempace), with the Jewish communities who had taken refuge in

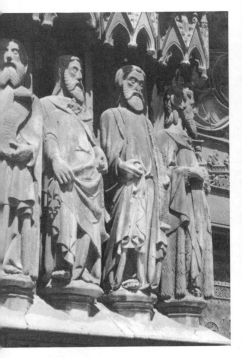

1044. Gothic. SPAIN. Statues from the cathedral of Tarragona.

1045. GOTHIC. PORTUGAL. The cloister, Batalha monastery. Begun 1385.

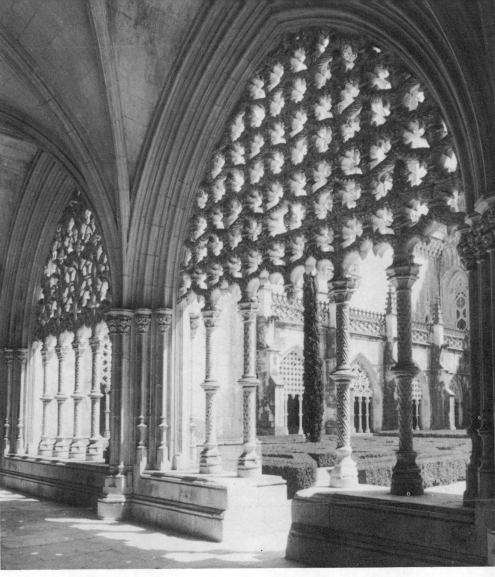

Christian territories (influence of Maimonides; the Cabala) and with French court circles (influence of the troubadours), made the peninsula in the 13th and 14th centuries a melting-pot of various civilisations. Raymond Lull, a rich and ambiguous intellect, wrote in Catalan, lived in Paris from 1298 to 1311, spoke Arabic and died in Tunis in 1315. The first picaresque novels were written in the language of Castile. Auzias March wrote poetry in Catalan. The bitter social criticism of Lopez compares with the French writer Renart. At the end of the 14th century literary court circles were founded by John I of Aragon and Charles III of Navarre who had lived in Paris. Arabic literature, and especially science (the use of the compass), were transmitted to Europe mainly through Spain (*Catalan Atlas of Charles V*, by Abraham Cresques, 1375).

Architecture. The rib vault was first used in 1168 at Santiago de Compostela over the Portico de la Gloria, built by Master Matthew. At the same period it was spread by the Cistercians, who used it in their many abbeys, mainly in northern Spain. Moreruela, their oldest foundation in Spain, whose church dates from 1170, had rib vaulting only over the aisles and the ambulatory. Other Cistercian churches of Burgundian style were: Poblet (Catalonia) [**1037**], Veruela in Aragon and Fitero in Navarre. Alcobaça in Portugal

copied Clairvaux. Burgundian influence predominated in the north-west in Castile and even as far as Galicia in the 12th century. The cathedral of Avila is a copy of the choir of Vézelay; the architects of the cathedral of Salamanca imitated the domical vaults of the churches of south-western France [**1035, 1036**].

As the Moors retreated, buildings were undertaken in the reconquered territories, at first on French models, later under German and Netherlandish influence. Personal Spanish characteristics included: an emphasis on area and width; the coro treated as a separate structure to the west of the crossing, blocking the nave; lateral chapels between the buttresses, resulting in an external outline of irregular mass. In Castile are the three finest cathedrals inspired by French models.

The cathedral of Toledo (begun in 1225; built by Master Martín and Pedro Pérez; the nave was completed in 1493) has double aisles, a double ambulatory (not used in France after the 12th century) and fifteen radiating chapels. The triforium of the apse is blind, perforated at the transept and suppressed altogether in the nave. The design of the bays of the triforium is reminiscent of Arab work [**1038**].

Burgos [**864, 1041**], begun in 1220, was partly finished in 1260. The plan is cruciform with simple aisles; the apse recalls those of Pontigny and Coutances. The elevation is reminiscent of Bourges. Typi-

cally Spanish in character is the large octagonal dome on squinches [**1040**], on enormous pillars, which spans the crossing of the transept (1540–1568). The façade, flanked by two towers (1442–1456), recalls Reims, with German influence in the towers by John of Cologne.

León, begun in 1255, by Master Henri on the lines of Reims, has the finest stained glass in Spain [**1042, 1043**].

The cloisters of Pamplona in Navarre were built in a Radiating style, similar to that of the nave of Bayonne. Many French and Flemish artists were called into the country by the kings of Navarre. Churches in the east at Poblet and Santas Creus and the cathedrals of Tarragona (1174), Lérida (1203) and Valencia (1262) were Romanesque structures covered with rib vaults.

Catalan Gothic has the most specifically national character; the influence of the mendicant hall church with wide, single-span naves, flanked by lateral chapels between the buttresses, appears in the Barcelona churches of S. Francisco (1247) and St Catherine (1247). This ideal of unity of space is developed in Barcelona cathedral (begun 1298), with its high pier arcade and only slightly projecting transepts. In the choir of the cathedral of Gerona (begun 1312) the aisles were raised to the height of the nave and the supports reduced in number, with the result that the interior gives the impression of forming a spatial entity. Of the

same type were the cathedrals of Palma in Majorca and Sta María del Mar in Barcelona. Tortosa cathedral (ambulatory begun 1347) is a complete major cathedral in high Gothic style. National Gothic, with its lavish surface ornament, did not reach its apogee until the cathedrals of Seville (begun 1402, on a vast scale on the site of a mosque), Salamanca (begun 1512) and Segovia (1522) [**931, 1039**].

The most important military and domestic buildings were: the castle of Bellver, near Palma, Majorca (13th century); the episcopal palace and the stock exchange in Tortosa (14th century); the façade and great hall of the town hall of Barcelona; the Serranos gate at Barcelona (1392–1398; the fortifications of Ávila and León [**1046**].

Mudejar art developed in Castile and Aragon, especially in those areas which had been reconquered from the Arabs. Toledo presents the finest ensemble. Covered with a Gothic veneer these buildings were basically Moslem in style, with slender square bell towers reminiscent of minarets and coloured surfaces combined with pointed arches. Masterpieces of this style are: Sta María la Blanca and Nuestra Dama del Tránsito at Toledo. The Alcazars at Toledo, Seville and Segovia are of the same style.

Portuguese architecture of the 13th and especially of the 14th centuries (Batalha monastery, begun by John I, 1385) shows an individual style [**1045**].

Sculpture. A rather heavy Romanesque style persisted in many regions: mausoleum of the kings of Castile in the monastery of Las Huelgas. French influence, noticeable on the portal of the Sarmental at the cathedral of Burgos [**864**], later gave way to Italian influence. French influence, however, persisted in Navarre (cloisters of the cathedral of Pamplona, which were imitated at León and Oviedo) and spread from there to Castile.

Catalan sculpture shows a distinctive character, with a preference for massive forms: portal at Tarragona by Jaime Castayls (1375) [**1044**]; portal at Lérida by Guillén, Çolivella (1391); puerta del Mar at Palma. Tomb sculpture and choir screens became increasingly important from the 14th century. So did large retables carved in Catalan wood.

In Portugal sculpture on church portals was rare. Tomb sculpture of high quality is found in the monastery of Alcobaça (Pedro I and Inès de Castro).

The minor arts. Decorative treatment of leather was transmitted to Spain from the Arab countries.

Ceramics workshops in Majorca, Valencia, Seville, Málaga and Granada produced dishes covered with metal glazes and glazed square tiles of Arab origin known as *azulejos*, which were highly

appreciated throughout Europe.

In Spain the wrought iron industry produced original and artistic grilles.

Catalan goldsmiths produced a number of masterpieces: the silver retable of the cathedral of Gerona; the pulpit called 'King Martin's' in the cathedral of Barcelona.

THE LATIN EAST

History. The crusaders established a number of Christian principalities in the Middle East [**934–940**] which existed for a long time (Cyprus until 1489). The fall of Acre in 1291 and the rise of the Turkish empire in the 14th century liquidated these dominions. The state of Rhodes, founded in 1310 by the Knights of St John of Jerusalem, survived until the 16th century. Malta remained a fief of the Knights of Malta until Napoleonic times.

Architecture. In the Latin East Cyprus, ruled by the Lusignans (1193–1473), became a real province of French Gothic architecture: cathedral of Nicosia (13th century); cathedral of Famagusta (beginning of the 14th century [**940**]) — the façade recalls Reims and the east end St Urbain, Troyes.

Greek architecture of 'Frankish' influence, and that of Rhodes, was essentially military (fortress of Boudroun).

Lydie Huyghe, Adeline Hulftegger and Evelyn King

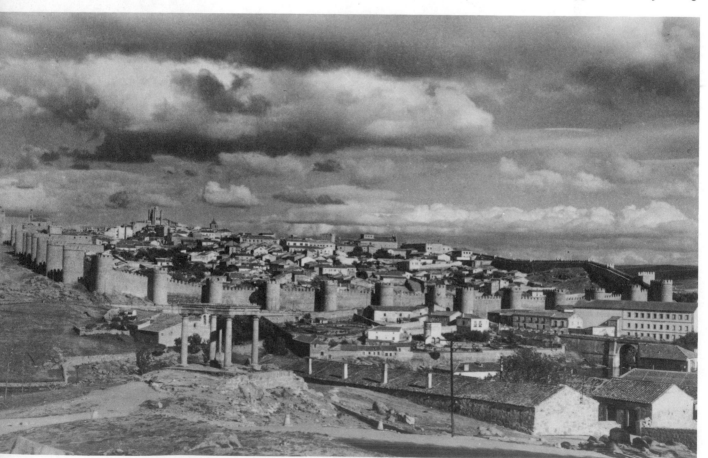

1046. GOTHIC. SPAIN. Ávila. General view showing the surrounding walls.

INDEX

Figures in **bold** type refer to illustrations

A

408